ART
A HISTORY OF PAINTING · SCULPTURE · ARCHITECTURE

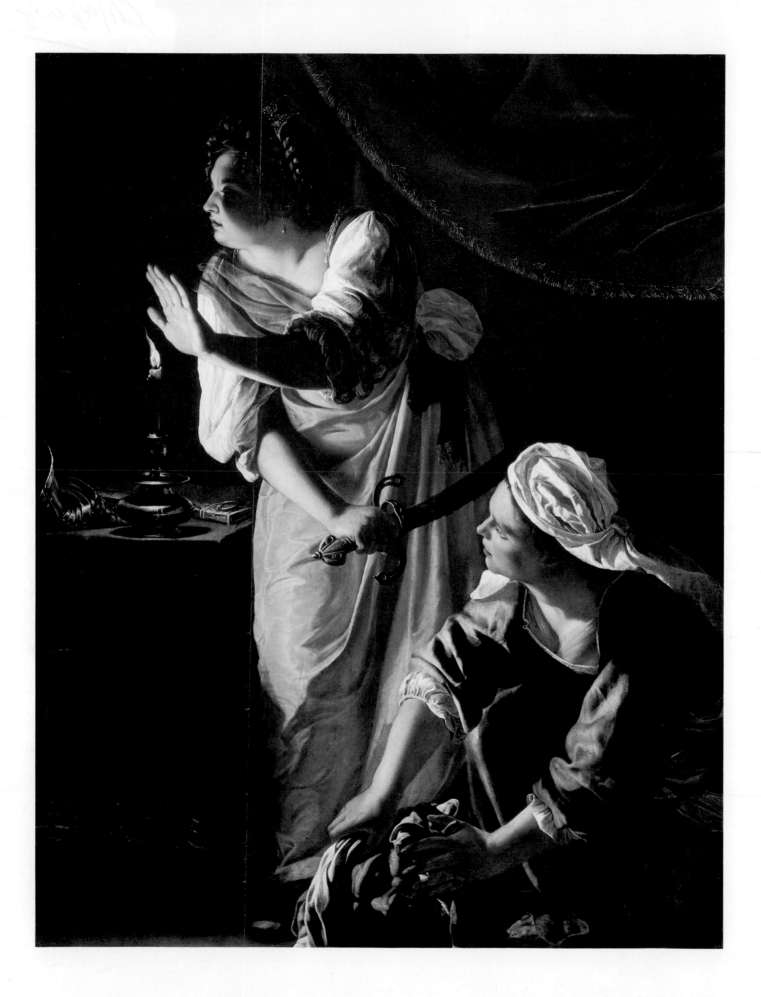

FREDERICK HARTT

ART

A
HISTORY
OF
PAINTING
SCULPTURE
ARCHITECTURE

VOLUME TWO

FOURTH EDITION

PRENTICE HALL, INC., ENGLEWOOD CLIFFS, NEW JERSEY

AND

HARRY N. ABRAMS, INC., NEW YORK

To Meyer Schapiro

Scholar, teacher, counselor, friend

Project Managers: Sheila Franklin Lieber and Julia Moore

Editor: Ellyn Childs Allison

Designers: Dirk Luykx and Ellen Nygaard Ford

Picture Research, Rights and Reproductions: Lauren Boucher assisted by Colin Scott

Frontispiece: Artemisia Gentileschi, *Judith and Her Maidservant with the Head of Holofernes* (figure 26-9)

Library of Congress Cataloging-in-Publication Data
Hartt, Frederick.
Art : a history of painting, sculpture, architecture / Frederick
Hartt.—4th ed.
p. cm.
Includes bibliographical references and indexes.
ISBN 0–13–052416–6 (v. 1 : pbk.).—ISBN 0–13–052424–7 (v. 2 : pbk.)
1. Art—History. I. Title.
N5300.H283 1992

709—dc20 92–5809
 CIP

Fourth Edition 1993
Copyright © 1989, 1993 Harry N. Abrams, Inc.
Published in 1993 by Harry N. Abrams, Incorporated, New York
A Times Mirror Company

CONTENTS

PREFACE

The purpose of this book is to give students of all ages something that really will go on mattering, once the blue books have been handed in and the painfully memorized names and dates have receded into dimmer levels of consciousness. To this end I have tried to put together a usable account of the whole history of the artistic production of men and women—an activity that ranks as the highest of all human achievements (so I maintain), surpassing even the most startling cures of modern medicine and the little machine hurtling past the last planets and out into interstellar space. Obviously no teacher can use all the material assembled here. But I respect teachers enough to give them their choice of what to include and what to leave out and students enough to want them to have a book that they can keep and continue to explore on their own, whether or not they ever take another course in the history of art.

The fourth edition is the product of many months of thought and labor. One hundred more illustrations have been reproduced in color. In order to keep the book within manageable proportions, the number of images remains about the same, although the addition of forty-eight pages has facilitated the enlargement of a great number of illustrations. The reader will note several substitutions in accordance with altered criteria of importance. In the third edition, to my great satisfaction, it was possible to make this book truly global by the addition of chapters on the arts of the three great civilizations of East Asia—India, China, and Japan. These chapters have benefited immensely by the criticism and suggestions of Marsha Weidner. For practical reasons it was necessary to place the chapters at the end of the book. In the fourth edition they have been brought to their most useful position, between the Middle Ages and the Renaissance in the West.

No single scholar can claim specialized knowledge of all periods in the history of art, and I have sought and welcomed criticism, especially of those chapters that lie outside my fields of study. But a committee book runs the same dangers as a committee course. Throughout the book, the interest of the reader has required unity of viewpoint. All the text, therefore, is the work of the same author, since it has luckily been possible for me to see and study in person the vast majority of the monuments and works of art treated here, from whatever region or period.

In the third edition, a pioneer attempt was made to give women something approaching their just position in the history of art. In the present edition, the number of women artists has been somewhat increased. But the reader should understand that the task is not as easy as it might seem. What can one say about women artists in periods when women were systematically excluded from all forms of artistic production except, let us say, embroidery? And what can one write about women as artistic leaders in later periods when they were still permitted only marginal participation? In those chapters in which women either do not appear at all or turn up in minor roles, an attempt is made to explain why. I hope the reader will also understand that what I say in the Introduction about women in art, and what I undertake in other chapters, has been carried out with enthusiasm and conviction. Time alone will tell whether it is sufficient.

The teacher-student relationship is one of the deepest and most productive of all human bonds. How can I forget what my own long career has owed to the teachers,

graduate and undergraduate, who gave me my start? Fifty-nine years ago, as a college sophomore, I registered for a class with Meyer Schapiro, and the whole course of my life was transformed. Not only did he introduce me to the fields of medieval and modern art, in which his knowledge is vast, but he opened my eyes to the meaning of art-historical studies and to methods of art-historical thought and investigation. I am grateful to other magnificent teachers, now no longer living, especially to Walter W. S. Cook, Walter Friedlaender, Karl Lehmann, Millard Meiss, Richard Offner, Erwin Panofsky, George Rowley, and Rudolf Wittkower, and to Richard Krautheimer, abundantly alive and active at ninety-four. The faith, advice, and inspiration of Bernard Berenson stood me in good stead in many a difficult moment. I owe much to the generosity of Katherine S. Dreier, who in 1935 opened to me her pioneer collection of modern art, and to the rigorous discipline of the sculptor Robert Aitken, who taught me what a line means.

At this moment I think also with warmth and happiness of all my students since I began teaching in 1939 — of those seas of faces in the big survey courses at Smith College, Washington University, the University of Pennsylvania, and the University of Virginia, as well as of the advanced and graduate groups, many of whose members have themselves been teaching for a quarter of a century and are now in a position to give me valued criticism and advice.

I am greatly indebted to professional colleagues who read chapters of the manuscript pertaining to their special fields, offered valuable criticism once the book was in print, or otherwise contributed to the first three editions, especially Malcolm Bell III, Miles Chappell, Kenneth J. Conant, John J. Dobbins, Marvin Eisenberg, Karl Kilinski II, Fred S. Kleiner, Keith P. F. Moxey, Marion Roberts, Martin S. Stanford, David Winter, Jeryldene Wood, and John J. Yiannias; and to Samuel Y. Edgerton, Jr., Scott Redford, and Fred T. Smith, who gave me many useful suggestions for the present edition.

I deeply appreciate the confidence of the late Harry N. Abrams for having entrusted me with the task of writing this book and am grateful to the unforgettable Milton S. Fox for starting me off on it. My thanks also go to Margaret L. Kaplan for her able direction of the first two editions, to John P. O'Neill and Margaret Donovan for their painstaking editorship of the first and second respectively, to Sheila Franklin Lieber for coping with the innumerable problems of the third and fourth, to Ellyn Childs Allison for her keen eye and sensitive care in editing them, and to Barbara Lyons and her staff, who — with infinite labor — assembled the illustrative material for all four editions, and especially to Lauren Boucher, who has solved increasingly difficult photographic problems for the present edition. Dirk Luykx brought his great ability to the redesign of the second edition, to the many adjustments in the layout of the third, and to the fresh design for the fourth.

Frederick Hartt
Fall 1991

PUBLISHER'S NOTE Frederick Hartt died suddenly on October 31, 1991, just as he was finishing the revisions for this fourth edition. Harry N. Abrams, Inc., Professor Hartt's publisher for thirty-nine years, notes his passing with great regret and profound respect and thanks Nan Rosenthal for her wise counsel and assistance at a critical time, enabling us to publish the fourth edition of *Art: A History of Painting, Sculpture, Architecture* when Professor Hartt intended it.

INTRODUCTION

What is art? That question would have been answered differently in almost every epoch of history. Our word *art* comes from a Latin term meaning "skill, way, or method," and the most advanced technical procedures are still today characterized as "state of the art." In ancient times and during the Middle Ages all kinds of trades and professions were known as arts. The liberal arts of the medieval curriculum included music but neither painting, sculpture, nor architecture, which were numbered among the "mechanical" arts, since they involved making objects by hand. At least since the fifteenth century, the term *art* has taken on as its principal characteristic in most societies the element of aesthetic appreciation as distinguished from mere utility. Even if its primary purpose is shelter, a great building, for example, is surely a work of art.

The word *aesthetic* derives from a Greek term for "perceive," and perception will occupy us a little farther on. What is perceived aesthetically is "beauty," according to the *Oxford Dictionary*, and beauty is defined as the quality of giving pleasure to the senses. Yet underlying concepts can be experienced as beautiful even when they can be perceived only in their results. Moreover there are paintings, sculptures, plays, novels, films intended to produce terror or revulsion by the vivid representation of tragic or painful subjects. The same goes for certain moments in music, when loud or dissonant sounds, hardly distinguishable from noise, are essential for the full realization of the composer's purpose. These are undeniably works of art in the modern meaning of the term, even though beauty conceived as pleasure is largely excluded—that is, unless we are willing to count the pleasure we feel in admiring the author's ability to present reality or the not especially admirable pleasure a horror film gives to an audience seated in perfect safety.

Clearly something essential has been overlooked in the *Oxford* definition of beauty. To be sure, throughout history beauty has been analyzed on a far loftier plane than mere sensory pleasure, beginning in Greek philosophy with treatments

of a divine order of which the beauty we perceive is a dim earthly reflection. Leonbattista Alberti, architect and the first Renaissance writer on art, defined beauty to be "a harmony of all the parts, in whatsoever subject it appears, fitted together with such proportion and connection, that nothing could be added, diminished, or altered but for the worse." This definition tells us a great deal about the mathematically based art of Alberti's time, with every emphasis on ideal and finite beauty. As fate would have it, Alberti's own buildings were never completed as he wished, yet to our eyes are beautiful. So are Gothic cathedrals, built over long periods of time in different styles and according to different systems. And if one of Claude Monet's huge *Nymphéas (Water Lilies)* (fig. 1) were cut off a bit at either end, how many would consider it less beautiful? Is there not a beauty in thin veils of color or sudden bursts of tone which has nothing to do with proportion? See, for example, the pen-and-wash drawing by Claude Lorrain *On the Slopes of the Janiculum* (fig. 2).

Later writers on the philosophy of art—especially in the eighteenth century and since, culminating in the self-proclaimed "science" of aesthetics—have considered beauty from many different standpoints, constructing elaborate philosophical systems, often on the basis of limited knowledge of art and its history. Is there not some distinguishing quality in the very nature of a work of visual, literary, or musical art that can embrace both the beautiful and the repellent, so often equally important to the greatest works of art? The question may perhaps be answered in the light of a concept developed many years ago by the early-twentieth-century American philosopher of education John Dewey in his book *Art as Experience*. Without necessarily subscribing to all of Dewey's doctrines, one can assent to his basic belief that all of human experience, beautiful and ugly, pleasurable and painful, even humorous and absurd, can be distilled by the artist, crystallized in a work of art, and preserved to be experienced by the observer as long as that work

1. CLAUDE MONET. *Nymphéas (Water Lilies)*. c. 1920. Oil on canvas, 6'8½" × 19'9¼" (2.04 × 5.79 m). Museum of Art, Carnegie Institute, Pittsburgh. Purchased through the generosity of Mrs. Alan M. Scaife

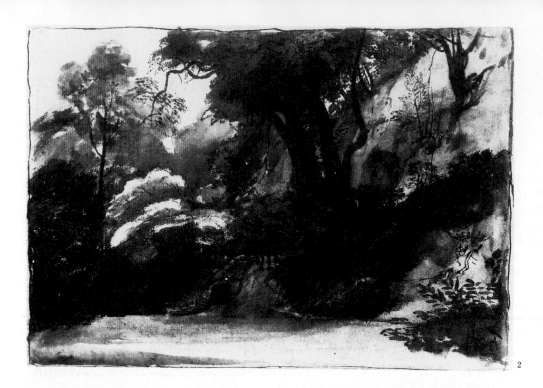

lasts. It is this ability to embrace human experience of all sorts and transmit it to the observer that distinguishes the work of art.

Purpose

If all of human experience can be embodied in works of art, we have then to ask, "Whose experience?" Today we would be tempted to reply, "Obviously the artist's first of all." But in many periods of history the work of art discloses nothing of the artist's existence but is shaped by the requirements of the time in which he or she lived. It may have been ordered by a patron for a specific purpose. If a building or part of a building or a ceremonial image, the work undoubtedly had a role to play in the social or religious life of the artist's time, and nothing of the artist's personality can be determined, aside from his knowledge, taste, and skill. Can we appreciate such works without knowing anything of their purpose, standing as we do at a totally different moment in history?

Perhaps we can. There are many works of prehistoric art—like the animals painted or carved in prehistoric times on cave walls and ceilings—that we cannot interpret accurately in the complete absence of reliable knowledge, but to our eyes they remain beautiful and convincing. This may be because we can easily relate them to our own experience of animals. And there are others, such as the colossal Easter Island sculptures (fig. 3), that are impressive to us even if foreign to every kind of experience we can possibly know. Simply as forms, masses, lines, we find them interesting. Yet how much more articulate and intelligent our response to works of art can be if we know their purpose in the individual or corporate experience of their makers. We can take a part of a building that strikes us as beautiful, study how it was originally devised to fit a specific practical use, then watch it develop under changing pressures, sometimes to the point of total transformation. Or we can watch a type of religious image arise, change, become transfigured, or disappear, according to demands wholly outside the artist's control. Such knowledge can generate in us a deeper understanding and eventually an enriched appreciation of the works of art we study. If we learn to share the artist's experience, insofar as the historical records and the works of art themselves make it accessible to us, then our own life experience can expand and grow. We may end up appreciating the beauty and meaning of a work of art we did not even like at first.

Today people generally make works of art because they want to. In fact, everyone who opens this book has made works of art as a child, and many continue to do so.

2. CLAUDE LORRAIN. *On the Slopes of the Janiculum.* 17th century. Pen and ink, with bister wash shading, 8⅝ × 12½″ (22 × 32 cm). Accademia Nazionale dei Lincei, Rome; on loan from the Gabinetto Nazionale delle Stampe, Rome

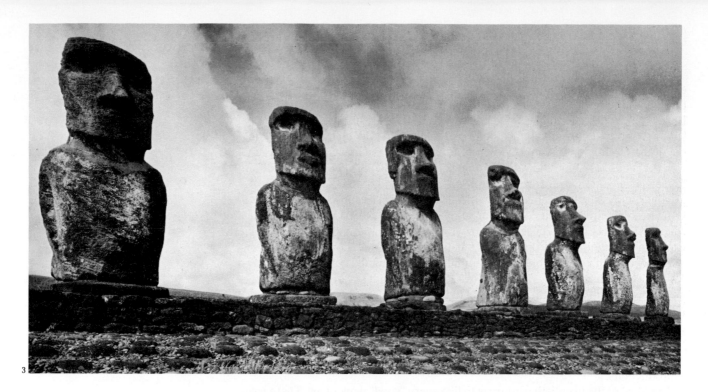

3. Stone images. 17th century or earlier. Height
30′ (9.15 m); weight approx. 16 tons each.
Easter Island, South Pacific

People enjoy the excitement of creation and the feeling of achievement, not to
speak of the triumph of translating their sensory impressions of the visible world
into a personal language of lines, surfaces, forms, and colors. This was not always
so. Throughout most of history artists worked characteristically on commission. No
matter how much they enjoyed their work, and how much of themselves they
poured into it, they never thought of undertaking a major work without the support
of a patron and the security of a contract. In most periods of history artists in any
field had a clear and definable place in society—sometimes modest, sometimes
very important—and their creations thus tended to reflect to a large degree the
desires of their patrons and the forces in their human environment.

In earlier periods in history factors of aesthetic enjoyment and social prestige
were equally important. Great monarchs or religious leaders enjoyed hiring tal-
ented artists not only to build palaces or cathedrals but also to paint pictures, to
carve statues, to illustrate manuscripts, or to make jewels—partly because they
enjoyed the beautiful forms and colors, but partly also to allegorize their power and
prestige, or to set forth the doctrines of their faith in a form designed to impress
their subjects or their followers. Today the desires that prompt patrons to buy works
of art are still only partly aesthetic. Collectors and buyers for museums and
business corporations do really experience a deep pleasure in surrounding them-
selves with beautiful things. But there are other purposes in collecting. Patrons
want to have the best or the latest (often, sadly enough, equated with the best) in
order to acquire or retain social status. Inevitably, the thought of eventual salability
to collectors can, and often does, play a formative role in determining aspects of an
artist's style. It takes a courageous artist to go on turning out works of art that will
not sell, so patronage is a strong force even today.

Unless we are to study the history of art as a chronological series of scientific
specimens, quality is the leading determinant. It certainly was in the selection of
works of art for this book. However much they may tell us about the society they
were made for, works below a certain level of quality tend to be omitted from books
or consigned to museum storerooms. Conversely, an exhibition of paintings orga-
nized to illustrate the life of bourgeois France in the last three decades of the
nineteenth century would attract few visitors unless they happened to notice the
names of the universally beloved Impressionist and Post-Impressionist painters.

If our appreciation of art is subject to alterations brought about by time and
experience, what then is quality? What makes a work of art good? Are there
standards of artistic value? These essential questions, perpetually asked anew,

elude satisfactory answer on a verbal plane. One can only give examples, and even these are sure to be contradictory. The nineteenth-century American poet Emily Dickinson was once asked how she knew when a piece of verse was really poetry. "When it takes the top of your head off," she replied. But what if a work of art that ought to take the top of your head off refuses to do so? Demonstrably, the same work that moves some viewers is unrewarding to others. Moreover, time and repeated viewing can change the attitude of even an experienced person. A work of art one enjoys at a certain period in life may lose its charm ten years later. Conversely, study, prolonged contemplation, or the mere passage of time may render more accessible a once-forbidding work of art. And even observers of long experience can disagree in matters of quality.

The twentieth century, blessed by unprecedented methods of reproduction of works of art, has given readers a new access to the widest variety of styles and periods. Incidentally, André Malraux in his book *The Museum Without Walls* pointed out the dangers of this very opportunity in reducing works of art of every size and character to approximately the same dimensions and texture. There is, of course, no substitute for the direct experience of the real work of art, sometimes overwhelming in its intensity no matter how many times the student has seen reproductions.

The ideal of the twentieth century is to like every "good" work of art. There is an obvious advantage in such an attitude—one gains that many more wonderful experiences. Yet there are inborn differences between people that no amount of experience can ever change. If after reading many books and seeing many works of art ineradicable personal preferences and even blind spots still remain, the student should by no means be ashamed of them. Barriers of temperament are natural and should be expected. But—and this is all-important—such admissions should come *after*, not before, a wholehearted attempt to accept the most disparate works of art on their own grounds; one must not merely condemn them because they are unfamiliar. The world of art is wide and rich; there is room in it for everyone who wants to learn, to experience, above all to *see*.

Destruction and Preservation

Art is an endangered species. It is tragic to think of the countless works of art, many certainly of the greatest beauty and importance, that have been destroyed by natural causes or by human action. Exposure to water and to frost will eventually corrode any work of art, including architecture. If stone and brick buildings are kept in a reasonable state of repair, however, they and their contents may last indefinitely. But repair inevitably includes replacement of weathered stones, some of which may have been richly carved. Eventually, large parts of such a building can only be considered copies, whose accuracy depends on the conscience, skill, and technological equipment of the restorers. The floods to which Florence has been subjected periodically throughout its history have devastated scores of altarpieces and wall paintings. After surviving for millennia in excellent condition masterpieces of Egyptian tomb painting are now threatened by the rise in the water table due to the building of the Aswan dam.

The same humanity that creates works of art also destroys them. Wars and other social upheavals are by no means the only causes of destruction. Human greed is responsible for the disappearance of all the colossal ancient statues in gold and ivory, for the scraping of gold backgrounds from Russian icons, even for the burning of marble statues to produce lime. As a result only a very few surviving works of Greek sculpture bear any claim to the names of the great masters recorded by ancient writers. The demise of paganism left the great temples of Greece and Rome without a purpose, thus obvious sources for marble columns to be used in Christian churches, and soon most other public buildings also disappeared. Entire quarters of eighteenth-century London have fallen to the wrecker, as have innu-

merable historic buildings everywhere, especially in the United States. Not only in the highly publicized incidents but in many cases that never reach public attention hundreds of works of art, many of them world-renowned masterpieces, are stolen every year from museums, private collections, and religious buildings. Less than 10 percent are ever recovered. Deranged persons have defaced works of the importance of Michelangelo's *Pietà* and Rembrandt's *Night Watch*. Industrial pollution is corroding Greek temples, Gothic cathedrals, and the entire city of Venice.

Changes in taste have also been destructive. Countless works of art, many of great importance, have either perished or been substantially altered because the next generation did not like them. For instance, all the stained glass from the side aisles of Reims Cathedral was smashed to provide more light for the coronation ceremonies of King Louis XV of France. Even more unhappily, strict interpretation of the Second Commandment and other religious prohibitions has resulted in enormous destruction, especially of Greek, Roman, early Byzantine, medieval English, and Netherlandish art, even when the very groups doing the hacking and burning nonetheless encouraged the production of secular art, such as plant and animal ornament, portraiture, landscapes, or still lifes. Ignorant or misguided restoration has taken its toll, altering faces, repainting drapery, removing irreplaceable glazes. In the last twenty years great monuments of medieval, Renaissance, and Baroque architecture, especially in England and Italy, have been disfigured by glass and metal doors and enclosures.

The light that illuminates this dismal picture is that from the excellent teams of conservators of painting, sculpture, and architecture, aided by scientists and often subsidized by governments, who battle for the rescue of endangered works and the protection of historic buildings. In the United States private organizations have done heroic but, alas, often unsuccessful work in historic preservation. It is impossible to overestimate either the crucial importance or the magnitude of the task.

Women in Art

Throughout history women's contribution to the visual arts has been significant, yet the art-historical record has not sufficiently reflected that fact. The very terms "old master" and "masterpiece" imply that the creators were men. Even when women managed against great odds to pursue successful artistic careers, their work, while valued in its day, has often been lost, destroyed, or attributed to other artists, and the details of their lives have gone unrecorded. The woman who aspired to status as artist beyond amateur could encounter male opposition at every juncture, whether in the form of a husband, fellow artist, critic, patron, or government official. There were numerous occasions from the sixteenth to the eighteenth centuries when incredulous experts required women to paint in their presence to prove that their pictures were not painted for them by men.

Part of the explanation of women's exclusion from artistic endeavors, as well as from many others, such as politics and business, is to be sought in their virtually complete lack of economic autonomy and the tolls exacted by childbirth and domestic responsibilities. A case in point is Marietta Robusti, daughter of the famous Venetian Mannerist painter known as Tintoretto. After years as an apprentice in her father's studio, she gained international recognition as a portraitist and was called to the Spanish royal court of Philip II. Her father forbade her to go and found her a husband instead. She died four years later in childbirth. Her father, on the other hand, lived to the age of seventy-six. The extreme brevity of the careers of many brilliant women artists has meant that few of their works remain. Such is the case of the talented and highly original sculptor Properzia de' Rossi, who died of illness at an early age, or the French painter Marie Guillemine Benoist, who was forced to abandon her art because her husband's official appointment made it impossible for her to continue to participate in the state-sponsored exhibitions that had been opened to women under the revolutionary government. A notable

exception to these truncated careers is that of a sixteenth-century painter from Bologna, Lavinia Fontana, who painted for several decades in spite of familial duties (with which her husband helped), received papal commissions, and was elected to the Roman Academy.

More commonly, women were not granted membership in the guilds, workshops, studios, and academies where artists were trained. Moreover, they were systematically banned from studying from the nude model in periods when such study was the very foundation of all art involving human representation, which was regarded as the highest form art could attain. As recently as 1931–1934, when I attended drawing and sculpture classes at the Art School of the National Academy of Design in New York City, women and men were required to work in separate life classes, and, although men were permitted to view nude female models, no male model could be shown entirely nude to women. With few exceptions, the traditionally "feminine" arts—miniatures, pastels, portraits, still lifes, and crafts—have been undervalued in cultures that place the greatest stock in the heroics of history painting and monumental sculpture.

Furthermore, a woman tied to domesticity and constant pregnancy would have endured considerable physical hardship in the arduous activities of carpenters or stonemasons, the crafts that traditionally produced professional architects, or of stonecutters, the trade that produced sculptors. Even painting, in the Renaissance, involved strenuous activity high on scaffolding, carrying sacks of sand and lime and pots of water. The only women artists recorded in antiquity painted portraits, which could be done in comfortable surroundings. Alas, their work is all lost. But in the Middle Ages nuns in convents, like monks in monasteries, were considered expert painters of illuminated manuscripts. Five splendid examples known to have been painted by women are included in this book, for the first time in any general text. Then in the sixteenth and seventeenth centuries, painters' daughters (such as Lavinia Fontana, Elisabetta Sirani, Artemisia Gentileschi, and Marietta Robusti) began to produce works of real artistic merit, thanks in part to the training acquired in their fathers' studios, and the occasional woman painter or sculptor appeared independently. But even as late as the eighteenth century women were still mostly limited to portrait painting, though often with excellent results (fig. 4).

The widespread use of the pointing machine eventually relegated stonecutting to expert workmen, and once the procedure of sculpture, now restricted to modeling, became less physically demanding, numbers of women sculptors appeared—in the mid- and late-nineteenth century. Today, women cut stone directly, on the same basis as men. And when architecture began to be taught in schools rather than springing spontaneously from woodworking or stoneworking shops, women became practitioners of the art, although the profession is still male-dominated.

Since the early 1970s, feminist art historians have produced a literature of enormous value, on which I have heavily relied, that has begun to redress the marginal role ascribed to women in the history of art. Although the serious study of women artists is still in its infancy, this literature has helped to reevaluate and, in many cases, rediscover the achievements of women artists of the past. At the same time these authors have examined other gender-related issues that permeate the entire discipline of art history. For it is not simply men and women artists but the entire art apparatus—audiences, institutions, patrons, critics—that has helped to shape attitudes toward women in the visual arts. Although a book like this one is not the place to go into such questions systematically, here and there in the following pages they will be raised.

In periods when women artists are infrequent or absent I have tried to explain why. When they begin to turn up in numbers, they take their place with the men in these pages. Since the final work of art often owes a great deal to the desires of the patron who commissioned it, consideration has also been given to women patrons, who were in general imaginative and original, and who strongly influenced the male artists who worked for them—even by means of direct instruction.

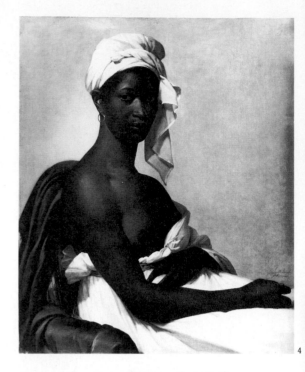

4. MARIE GUILLEMINE BENOIST. *Portrait of a Negress.* 1800. Oil on canvas, 31⅞ × 25⅝" (81 × 65.1 cm). Musée du Louvre, Paris

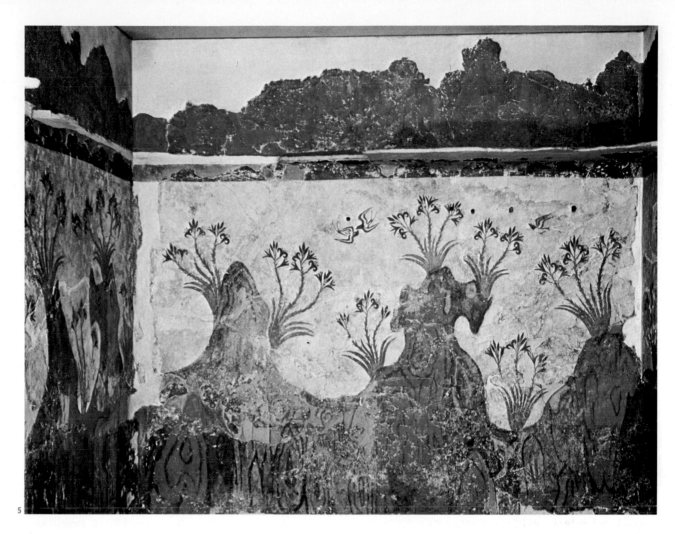

5. *Rocky Landscape with Red Lilies and Swallows,* fresco from Building D in the town of Akrotiri, Santorini (ancient Thera), Cyclades, including areas of modern reconstruction. Before 1500 B.C. National Archaeological Museum, Athens

Style

PERCEPTION AND REPRESENTATION How has the artist perceived and recorded the visible world—trees, let us say—in widely separated periods in the history of art? The earliest known European landscape, a wall painting from the Greek island of Santorini, known in ancient times as Thera (fig. 5), dates from about 1500 B.C. and shows natural forms reduced to what look like flat cutouts. The contours and a few inner shapes of rocks, plants, and birds are drawn in outline (as in most very early art or indeed the art of children or of present-day untrained adults) and simply colored in, accurately enough, however, for identification. Doubtless the occupants of the room felt they were in the midst of a "real" landscape, wrapped around them on three walls, but few today would agree, despite the charm of the murals as decoration and the bouncing vitality of the outlines.

In a work (fig. 6) painted shortly after A.D. 1300 by the Italian artist Giotto, rocks and plants are beautifully modeled in light and shade and do seem to exist in three dimensions, yet they are anything but real to our eyes compared with the figures who stand in front of them. Accounts written by one of Giotto's followers indicate that he advised painting one rock accurately and letting that stand for a mountain or one branch for a tree. Nonetheless we know that Giotto's contemporaries thought that his paintings carried out according to this principle looked very real.

A little more than a hundred years later the Netherlandish painter Jan van Eyck presented in a panel from the *Ghent Altarpiece* (fig. 7) a view of rocky outcroppings and vegetation similar in structure to that of Giotto's fresco, but in a manner anyone

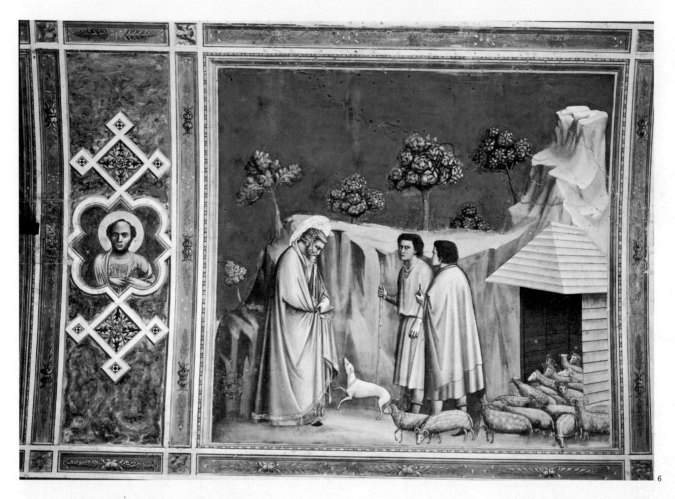

6. GIOTTO. *Joachim Takes Refuge in the Wilderness*. 1305–6. Fresco. Arena Chapel, Padua, Italy

today would easily call realistic. Van Eyck's amazingly sharp perception enabled him to render every object, from the smallest pebble in the foreground to the loftiest cloud in the sky, with an accuracy few photographs can rival. Every tree appears entire and in natural scale, down to the last leaf, and in believable light and shade. Yet is the picture as real as it seems at first sight? Do we encounter in real experience figures looking like this, all turned toward us and lined up on a rocky ledge that is sharply tilted so we can see every object clearly?

A radically different and very modern form of perception is seen in such Impressionist paintings of the late nineteenth century as Pierre Auguste Renoir's *Les Grands Boulevards* (fig. 8), in which all contours and indeed all details disappear, being blurred or lost as the artist seeks to seize with rapid brushstrokes a fleeting view of city life in bright sunlight and in constant motion. Trees and their component branches and foliage are now mere touches of the brush. This was the uncalculated, accidental way in which Renoir and his fellow Impressionists viewed the world, striving in their pictures for the speed and immediacy no snapshot photograph could then achieve and at the same time for a brilliance of color inaccessible to photography until many decades later. Today most viewers accept this image quite happily, but not in Renoir's day, when the Impressionists were violently attacked in print for being so unreal!

Finally, in the twentieth century, painters fully trained in both realist and Impressionist methods transformed the image of trees into a pattern almost as unreal to our eyes as that of the Santorini murals, even though it is often rendered with a freedom of brushwork that owes much to the Impressionists. To the Dutch painter Piet Mondrian, his *Red Tree* (fig. 9), overpowering in its fiery red against a blue sky, translates what may have been the color of sunset light into an expression of the ultimate reality of subjective emotional experience.

Optically, there can have been very little difference in the images of trees transmitted to the retinas of Mondrian, Renoir, van Eyck, Giotto, and the unknown painter of Santorini. The startling difference in the results is due to the differing sets of conventions, inherited or self-imposed, according to which each artist selected, reinforced, and recombined those aspects of the visual image that seemed important. Reality, in the long run, is as elusive and subjective a concept as beauty, yet just as compelling for the artist and for us.

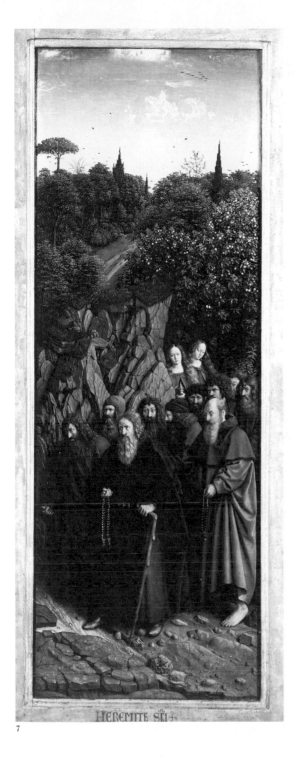

7

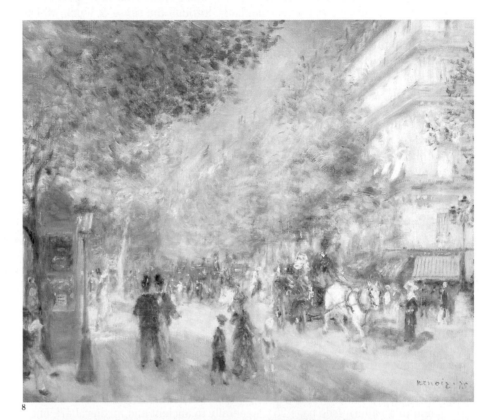

8

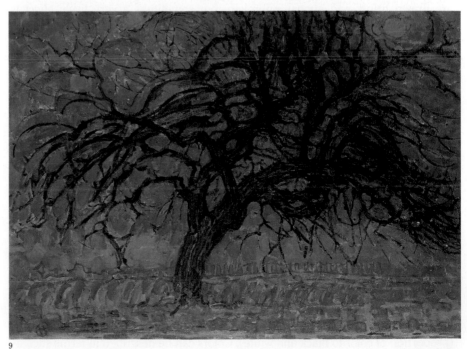

9

7. HUBERT (?) and JAN VAN EYCK. *Hermit Saints*, detail of the *Ghent Altarpiece* (open). Completed 1432. Oil on panel. Cathedral of St. Bavo, Ghent, Belgium

8. PIERRE AUGUSTE RENOIR. *Les Grands Boulevards*. 1875. Oil on canvas, 20½ × 25″ (52 × 63.5 cm). The Philadelphia Museum of Art; The Henry P. McIlhenny Collection in Memory of Frances P. McIlhenny

9. PIET MONDRIAN. *Red Tree*. 1908. Oil on canvas, 27½ × 39″ (69.5 × 99 cm). Collection Haags Gemeentemuseum, The Hague

THE VOCABULARY OF ART

Form. The *form* of an object is its shape, usually considered in three dimensions. (The word *form* is also used in music and literature, and in the visual arts as well, to mean the interrelationship of all the parts of a work.) Visual form is perceived first of all through binocular vision, by means of which each eye sees the object from a slightly different point of view, enabling the mind to create a three-dimensional image. The reader has only to test this proposition by closing one eye and noting the difficulty in perceiving accurately the shapes of objects and their positions in space. Form can also be perceived manually, through the sense of touch, which sends messages to the brain; by its very nature sculpture appeals to this sense. Painting, generally on flat or nearly flat surfaces, can only suggest the "3-D" effect that is the birthright of sculpture. The elements used in painting to indicate form are line, light and shade, and color, each of which as we will see can also play other important parts in the effect of the work of art. The much-used expression *formalist* really means "concerned with style," of which form is only one aspect, and is thus technically a misnomer.

The words *volume* and *mass* are also used almost interchangeably to indicate three-dimensionality, but without the connotation of shape, which is essential to the word *form*. *Volume* can even indicate the spatial content of an interior. The impact of mass on the observer is greatly enhanced by scale, which is an absolute factor in works of art—hence the difficulty in experiencing from small illustrations the breathtaking effect of colossal buildings such as Egyptian or Indian temples or Gothic cathedrals.

Line. *Line* can be seen as an edge or contour, of one shape against another or against distance, by means of which form can be deduced. A line can also be drawn, like the lines of a diagram or those that make up a printed letter of the alphabet. This kind of line can not only convey a great deal of factual information but can also clearly delineate form, as in Greek vase paintings (fig. 10). A line can be tremendously strong; think of the high wire on which daring acrobats perform across great spaces, or the cord that can restrict a person's movements as effectively as a prison cell, or the jagged line of a key, a slight variation in which can render a lock unopenable. Lines can be independent, or several lines can cooperate in the formation of a pattern (see page 25). Generally in ancient and medieval art, lines are drawn firmly and appear unbroken, but sometimes a very lively effect is obtained by preserving in a sketchy line the actual motion of the artist's hand carrying the drawing instrument, whose trajectory eventually gives rise to form (fig. 11). Finally, line can suggest the direction of motion ("line of fire," for example), seen typically in such instances as the "sweep" or "fall" of folds of cloth (*drapery* is the technical term; fig. 12).

Light and Shade. *Light* falling on an object leaves a *shade* on the side opposite to the source of light (see fig. 16); this shade is distinct from the *shadow* cast by the object on other objects or surfaces (see fig. 15). The shade may be hard and clear-cut or soft and indistinct, according to the degree of diffusion of the light that causes it. The relationship of light and shade suggests form but can be deceptive, since shade varies not only according to projections but to the position of the source of light. The same work of sculpture can look entirely different in photographs taken in different lights. Light and shade are also often used very effectively in strong contrast to produce effects of emotion (see fig. 2).

Color. *Color* is subject to more precise and complex scientific analysis than any of the other elements that make up the visual experience of art. For this book the most useful terms are those describing the effects of the various ways the artist employs *hue* (red, blue, yellow, etc.), *saturation* (intensity of a single color), and *value* (proportion of color to black and white). Colors can be described in terms such as

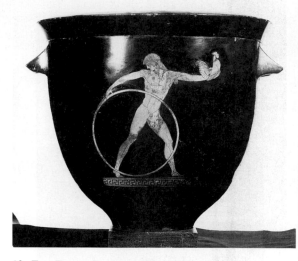

10. THE BERLIN PAINTER. *Ganymede,* painting in the Attic (Athenian) style on a bell-shaped krater found in Etruria, Italy. Early 5th century B.C. Height approx. 13″ (33 cm). Musée du Louvre, Paris

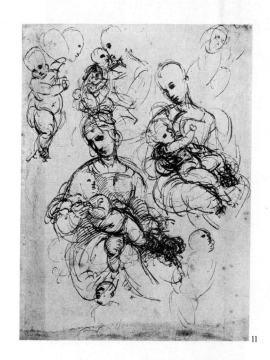

11. RAPHAEL. *Studies of the Madonna and Child.* c. 1505–8. Pen and ink, 10 × 7¼″ (25.5 × 18.5 cm). British Museum, London

12. *Virgin of Paris,* from St.-Aignan. Early 14th century. Stone. Notre-Dame, Paris

13. *Laestrygonians Hurling Rocks at the Fleet of Odysseus,* Second Style wall painting from a villa on the Esquiline Hill, Rome. Middle 1st century B.C. Musei Vaticani, Rome

14. LIANG KAI. *Hui Neng, the Sixth Chan Patriarch, Chopping Bamboo at the Moment of Enlightenment.* Southern Song dynasty, late 12th century–early 13th century. Hanging scroll; ink on paper, height 29¼″ (74.5 cm). National Museum, Tokyo

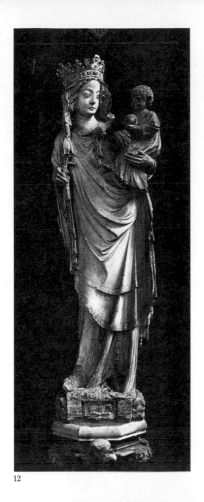

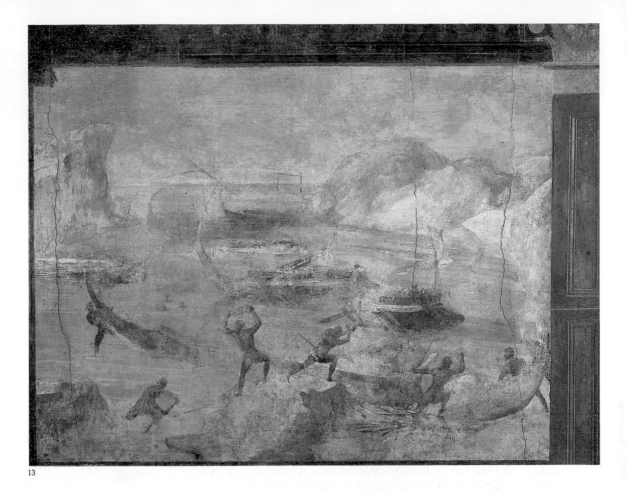

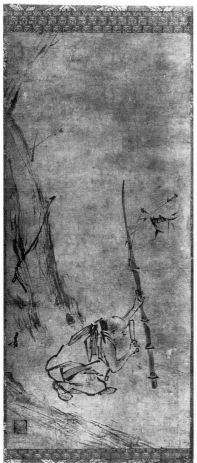

brilliant, soft, harmonious, dissonant, harsh, delicate, strident, dull, and in a host of other ways. Blue and its adjacent colors in the familiar color circle, green and violet, are generally felt as cool, and through association with the sky and distant landscape appear to recede from us. Yellow and red, with their intermediate neighbor orange, are warm and seem nearer. In most early painting, color is applied as a flat tone from outline to outline (see figs. 5, 10). Broken color, in contrast, utilizes brushwork to produce rich effects of light (see fig. 8). Modeling in variations of warm and cool colors suggests form, but color, modeled or not, evokes by itself more immediate emotion than any element available to the artist, to such a degree that extremely saturated color, such as bright red or yellow, would be felt as unbearable if applied to all four walls and the ceiling of a room.

Surface. The physical *surface* of any work of art is potentially eloquent. A painted surface has a *texture* (a word from the Latin for "weave"), which can sometimes be consistent and unaltered; such is the case with many ancient murals (see fig. 5), where the surface declares the clean white plaster of the wall, or with Greek vases (see fig. 10), where red clay slip is set against glossy black. Or it can be enriched as we have seen, in the rendering of light and shade and color, by countless brushstrokes so as to form a vibrant web of tone, as in Roman painting (fig. 13). In the painting of China and Japan surface is of extreme importance and is often left largely untouched, as a foil to deft and varied strokes of an ink-laden brush, which convey inner experience and convert silk or paper into limitless space (fig. 14). In mosaic—the art of producing an image by means of cubes of colored stone or glass—the handling of the surface is especially important. In the Middle Ages these facets were set at constantly changing angles to the light so as to sparkle.

Depending on the inherent properties of the material, sculpture in stone can sometimes be smooth and polished to reflect light (as in fig. 15). Or the crisp details of a marble surface can be filed away so that the crystalline structure of the stone can retain light and blur shadow, or it can be left very rough and unfinished,

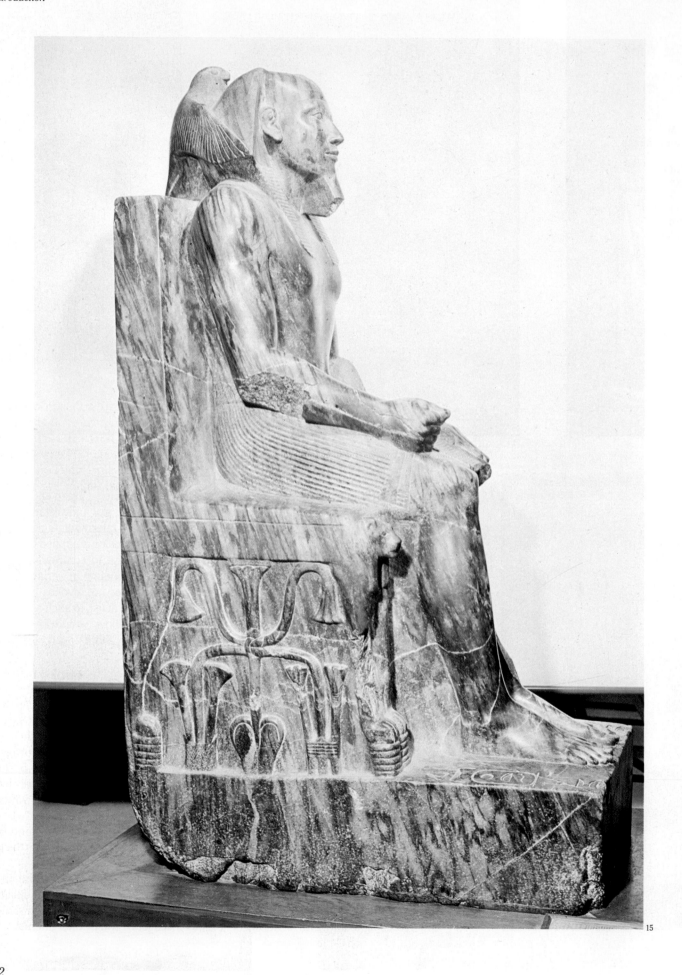

15. *King Chephren,* from Giza, Egypt. c. 2530 B.C. Diorite, height 66⅛″ (1.68 m). Egyptian Museum, Cairo

16. AUGUSTE RODIN. *The Kiss.* 1886. Marble, over life size. Musée Rodin, Paris

17. AUGUSTE RODIN. *Monument to Balzac.* 1897–98. Bronze (cast 1954), height 9′3″ (2.82 m). Collection, The Museum of Modern Art, New York. Presented in memory of Curt Valentin by his friends

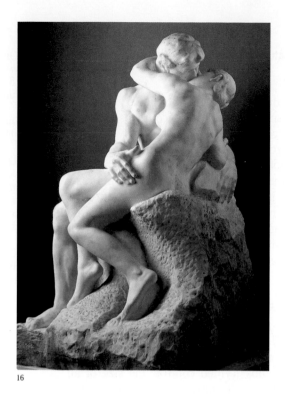

16

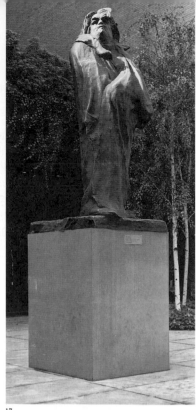

17

18. Valley Temple of Chephren, Giza, Egypt. c. 2530 B.C.

19. The Queen's Chamber, the Alhambra, Granada, Spain. c. 1354–91

showing the tool marks; both techniques are seen side by side in the marble work of the nineteenth-century French sculptor Auguste Rodin, a contemporary of the Impressionists (fig. 16). Sculpture cast in bronze has generally been smoothed by tools after casting to produce a polished surface reflecting light. The tool marks scratched in the original clay model from which the molds were made can be left unaltered or even reinforced by cutting with a sharp metal implement into the final bronze surface. Rodin, however, often allowed the bronze to preserve all the freshness of the soft clay without any attempt to smooth away the marks of the fingers (fig. 17). Such surfaces may be compared with the free brushwork of the Impressionists.

Opposites in architectural surface are the inert, quiet stone of the oldest Egyptian monuments (fig. 18), left untreated to bring out the essential inner power of the stone, and the bewildering shimmer of later Islamic buildings (fig. 19), carved into

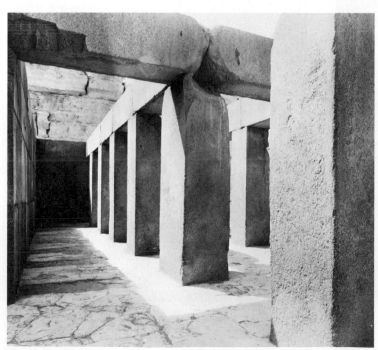

18

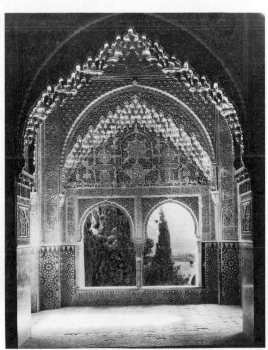

19

a lacework that seems to defy the very nature of stone, dissolving it in countless sparkles of light and shade.

Space.　*Space* may be defined as extent, either between points or limits, or without known limits, as in outer or interplanetary space. Since space encourages, limits, or directs human existence and motion, it constitutes one of the most powerful elements in art just as it does in life. An architect can set boundaries for space in actuality, as a painter or sculptor can through representation. The space of the Pantheon (fig. 20)—a Roman temple consisting of a hemispherical dome on a circular interior whose height is equal to its radius and therefore to that of the dome—has a liberating effect the minute one steps inside, almost like a view into the sky (itself often called a dome). The space would seem to rotate constantly if it were not held fast by a single niche opposite the entrance. In sharp contrast the interior of the French abbey church of Vézelay (fig. 21)—long, relatively low, and cut into segments by heavy, striped arches—seems to constrict and gradually drive the observer inward.

A painter or sculptor can represent space by means of *linear perspective.* This is a system in which spatial depth is indicated by means of receding parallel lines that meet at a vanishing point on the horizon and cross all lines parallel to the surface of the image, as seen in Leonardo da Vinci's preparatory drawing for a painting of the Adoration of the Magi (fig. 22). The grid thus formed controls the size of all represented objects according to their positions in its diminishing squares, so that

20.　Giovanni Paolo Pannini. *Interior of the Pantheon.* c. 1750. Oil on canvas, 50½ × 39″ (128.5 × 99 cm). National Gallery of Art, Washington, D.C. Samuel H. Kress Collection

21.　Interior, Ste.-Madeleine, Vézelay, France. c. 1104–32

22.　Leonardo da Vinci. *Architectural Perspective and Background Figures,* for the *Adoration of the Magi.* c. 1481. Pen and ink, wash, and white, 6½ × 11½″ (16.5 × 29.5 cm). Gabinetto dei Disegni e Stampe, Galleria degli Uffizi, Florence

23.　Decorative page from the *Book of Durrow.* Northumbria, England. Second half of 7th century. Illumination. Trinity College, Dublin

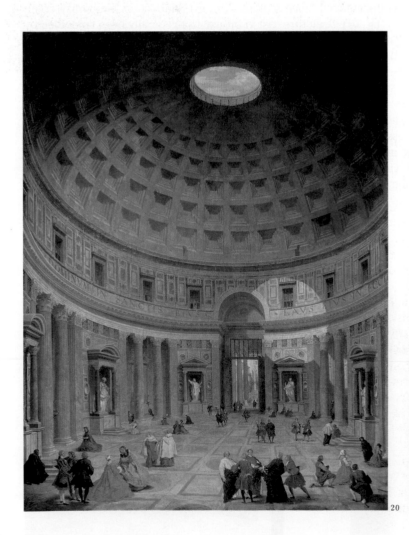

20

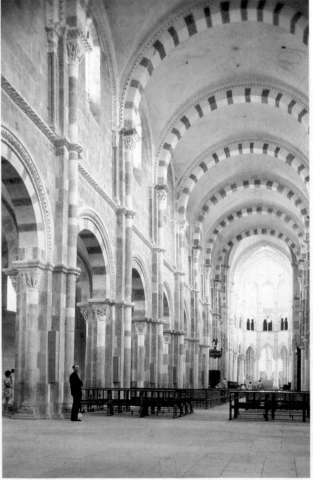

21

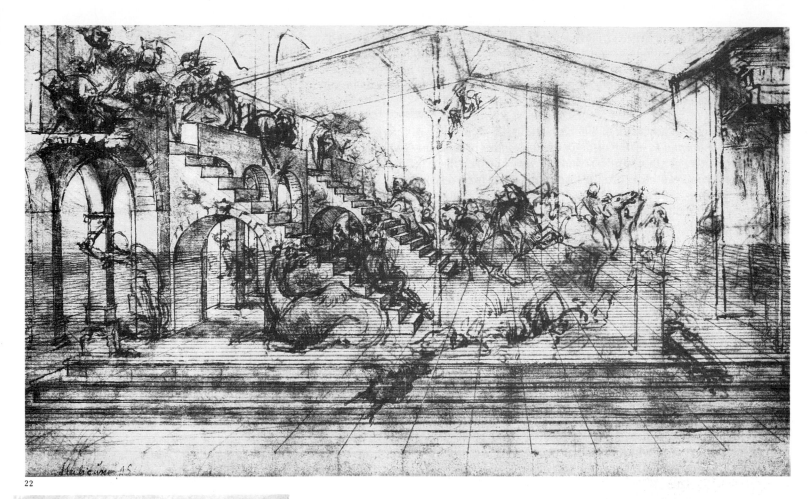

22

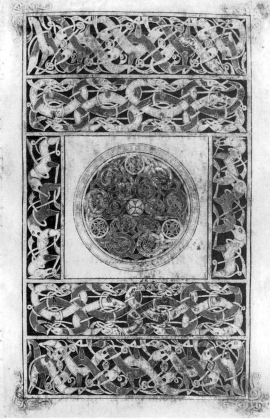

23

they too diminish in an orderly fashion as they recede from the eye. Although diminution takes place just the same indoors and outdoors, a consistent system of linear perspective obviously demands a man-made enclosing structure, composed of regularly recurring elements, such as a colonnade or a checkered floor. Perspective can also be *atmospheric,* that is, objects can lose their clarity according to their distance from us, because of the always increasing amount of moisture-laden atmosphere that intervenes (see fig. 13). In early art, space is generally represented diagrammatically, by superimposing distant objects above those nearby. Space can even be suggested, though not represented, by means of flat, continuous backgrounds without defined limits (see figs. 5, 6).

Pattern. Most of the previously mentioned elements—line, light and shade, color, surface—can be combined to form a *pattern* if the individual sections (known as *motifs* or *motives*) recur with some regularity, either exactly or in recognizable variations. Brilliant examples of pattern raised to a high pitch of complexity are Islamic buildings, an example of which we have just seen, and the Hiberno-Saxon illuminated manuscripts of the early Middle Ages (fig. 23). Generally pattern is considered to operate only in two dimensions, so form and space have been excluded. Pattern is particularly important in decoration of walls, floors, and ceilings as well as in decorative objects such as rugs and ceramics.

Composition. All of the elements we have been discussing, or any selection from them, can be combined to form a *composition,* understood as a general embracing order, if the artist has determined their coherence consistently. The artist may have made a preliminary sketch, as in Leonardo's drawing, showing where the various

sections would go, or they may have fallen into place as the artist worked. Types of composition can be enumerated almost indefinitely, according to the artist's decision to emphasize one element or another or to the kind of system the artist devises to bring all the motifs together. A great many different types will appear in the following pages.

Style. Finally, in any work of art, visual, musical, dramatic, or literary, the total aesthetic character, as distinguished from the *content* or meaning (see page 29), is known as *style*. In other words, style is the way in which the artist has treated the visual elements we have been considering (or such corresponding elements as words, phrases, sentences in literature; tones, melodies, harmonies in music). The process of carefully considering all elements of style is known as *stylistic analysis*. Names, such as primitive, archaic, classic, realistic, abstract, have been developed for styles and are capitalized if they correspond to specific countries, historical periods (Middle Ages, Renaissance), or movements (Impressionism, Cubism). Such names are useful as hooks on which to hang works of art in our minds so that we can find them again. But they can be dangerous if we consider them as entities in themselves. Indeed, if we try to force our observations of works of art into grooves predetermined by names of styles, we may find ourselves shaping our conceptions of various elements in order to make them fit the names, or even ignoring incongruous elements altogether. In many periods, such as Egyptian, a common style was imposed upon all works of art with only occasional exceptions. Nonetheless quite different styles, sometimes many of them, can flourish at the same time and place, and even make war upon each other. Throughout this book an effort has been made to bring out the special style of each work of art and to place it in relation to the complex and perhaps even contradictory stylistic tendencies of the period in which it was produced.

Iconography

In almost every society, up to and including the present, what we call *iconography* (from two Greek words meaning "image" and "write"), that is, the subject matter of art, is of primary importance.

In the past, iconography was generally related predominantly to religion or politics or both and was therefore likely to be systematic. In a religious building the subjects of wall paintings, stained-glass windows, or sculpture were usually worked out by the patron, often with the help of a learned adviser, so as to narrate in the proper sequence scenes from the lives of sacred beings or to present important doctrines in visible form through an array of images with a properly determined order and placing, and even with the appropriate colors. The artist was usually presented with such a program and required to execute it. Sometimes, as in the wall paintings in the interiors of Byzantine churches, the subjects, the ways of representing them, and the places in churches in which they could be painted were codified down to the smallest detail and keyed delicately to the tightly organized Liturgy, which left nothing to the discretion of the individual priest except the language of the sermon. Even in those periods in history when powerful artistic personalities worked in close relationship with the patrons and advisers, artists were seldom free to choose their subjects at will.

In regard to secular subjects as well, when patrons wished to commemorate their historic deeds they were almost certain to direct the artist as to how these should be represented. Only extremely learned artists, in certain relatively late periods of historic development, might be in a position to make crucial decisions regarding secular iconography on their own, and even then only with the general approval of the patron. Often in regard to both religious and secular subjects artists worked with the aid of iconographic handbooks compiled for the purpose and in use for centuries.

Also, although we have little documentary evidence, the desires of the secular or religious patron for an effect—aiming at such qualities as grandeur, magnificence, austerity, or grace—were necessarily taken into consideration by the artist and therefore determined the prevailing mood of a work of art. Both religious and secular works of art were sometimes refused as unsuitable to the purpose for which they had been commissioned; often the artist was required to change certain crucial aspects that offended the patron. A study of the subjects of contemporary art—in those cases in which subjects are still recognizable—might well suggest patterns of social preference that have influenced artists without their being fully aware of them.

Patronage, in exercising an influence on iconography, may also affect style. For example, until the Renaissance Christianity held the representation of the nude human body in horror, save when the soul appears naked before God for judgment or when a saint is stripped (shamed) before martyrdom. It is not likely, therefore, that an art thoroughly dominated by the more rigorous forms of Christianity, as in certain periods during the Middle Ages, could show much comprehension of or interest in the movement of the clothed figure, which can only be understood through study of the nude body. Similarly, a culture such as ancient Greece that placed a high valuation on the total human being, including physical enjoyment and athletic prowess, and displayed nude images, including those of their deities, in places of great prominence was likely to reject instinctively those colors and ornaments that might eclipse the beauty of the body.

The study of iconography can also assist us in understanding what one might call the magical aspects of works of art, for the process of representation has always seemed to be somewhat magical. Totems and symbols in tribal societies warded off evil spirits and propitiated favorable ones. Even today certain peoples defend themselves by force against the taking of photographs, which might drain off some of their strength. Armed police still prevent anyone from taking pictures of the parliament building in New Delhi, which thousands walk past every day seeing all that the camera could record. In many societies the injury of an image of a hated person is deemed to aid in bringing about that person's illness or death. Enemies are still burned in effigy, and a national flag is so potent a symbol that laws are proposed to protect it from disrespect.

When ancient city-states were defeated in battle the conquerors often destroyed or carried off the statues from the enemies' temples in order to deprive them of their gods and therefore their power. The instances of miracle-working images in the history of Christianity are innumerable and still occur. Many today feel a power emanating from a great work of art. A picture may be said to "fill a room," though it occupies only a small space on the wall, or a building to "dominate a town" when it is only one of many on the skyline, because of the supernatural power we still instinctively attribute to images.

Finally, the very existence or nonexistence of works of art has been until relatively recent times due first of all to their subjects. The patron wanted a statue or a picture of a god, a saint, an event, or a person, not primarily because of its beauty but for a specific iconographic purpose. Even in seventeenth-century Holland, in the early days of the open art market, artists often chose certain subjects for their easy salability. The converse is often true. Taken literally, the Second Commandment severely limited if it did not indeed rule out entirely the creation of religious images by the Hebrews, the Muslims, and the Calvinists and, as we have seen, often brought about their destruction in large numbers.

The iconographic purpose of art, especially in the representation of events or ideas but also in the depiction of people and nature, has given the work of art its occasionally strong affinity with religion. Artists can be so moved by religious meditation, or by the contemplation of human beauty or human suffering, or by communion with nature, that they can create compelling works of art offering a strong parallel to religious experience. The religious art of the past generally offers

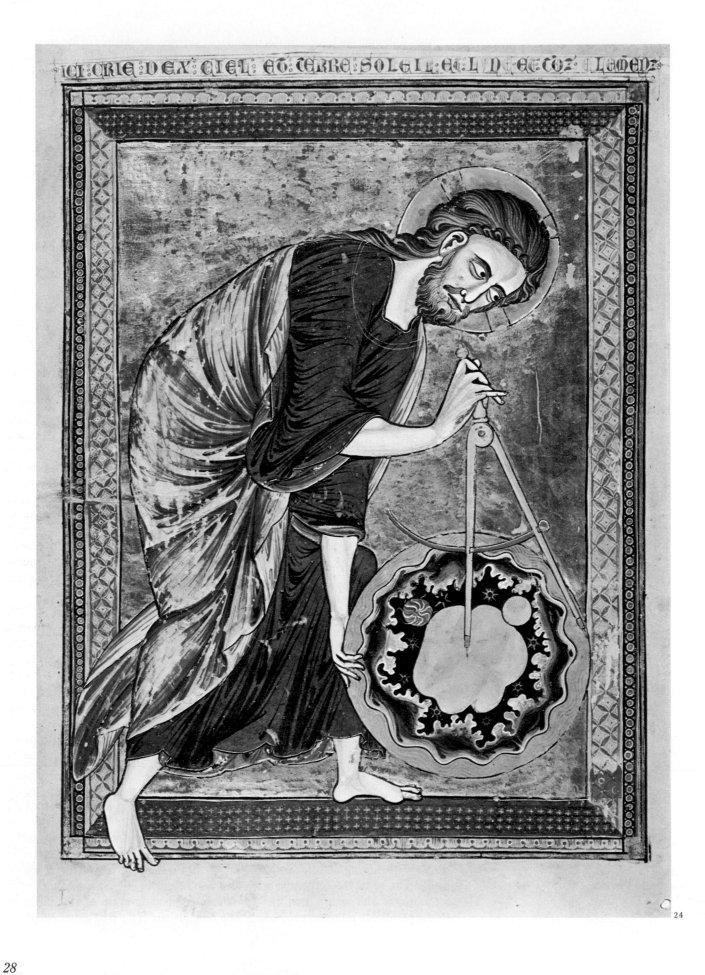

us the most persuasive access to religious ideas. So effective can be religious art that many agnostic scholars find themselves unconsciously dealing with religious images as reverently as if they were believers.

The links between art and religion are observed at their strongest in the creative act itself, which mystifies even the artist. However carefully the process of creation can be documented in preparatory sketches and models for the finished work of art, it still eludes our understanding. In the Judeo-Christian-Islamic tradition, and in many other religions as well, God (or the gods) plays the role of an artist. God is the creator of the universe and of all living beings. Even those who profess no belief in a personal god nonetheless often speak of creative power or creative energy as inherent in the natural world. In medieval art God is often represented as an artist, sometimes specifically as an architect (fig. 24), tracing with a gigantic compass a system and an order upon the earth, which was previously "without form, and void." Conversely, in certain periods artists themselves have been considered to be endowed with divine or quasi-divine powers. Certain artists have been considered saints: soon after his death Raphael was called "divine"; Michelangelo was often so addressed during his lifetime. The emotion art lovers sometimes feel in the presence of works of art is clearly akin to religious experience. An individual can become carried away and unable to move while standing before the stained-glass windows of Chartres Cathedral or the *David* by Michelangelo.

Of course, many works of art in the past, and many more today, were made for purposes that have a merely peripheral iconographic intent. We enjoy a well-painted realistic picture of a pleasant landscape partly because it is a pleasant landscape, with no iconographic purpose save the love of nature or the thought of an enjoyable vacation, and partly because it possesses in itself agreeable shapes and colors. Furthermore, a jewel, an arch or columns, or a passage of nonrepresentational ornament may be felt as beautiful entirely in and of itself. In most societies, however, such works have been limited to decoration or personal embellishment. Only when nonrepresentational images have been endowed with strong symbolic significance, as those in Christian art (the Cross, the initial letters in illuminated manuscripts), have they been raised to a considerably higher level and permitted to assume prominent positions (except, of course, in architecture, where certain basic forms exist primarily through constructional necessity and often symbolize nothing). Only in the twentieth century have people created works of art with no immediately recognizable subjects, the so-called abstractions.

Above, beyond, and within iconography lies the sphere of *content*. While content is not so easy to define as iconography, which can almost always be set down in neat verbal equivalents, it relies on iconography as the blood relies on the veins through which it flows. Like all supremely important matters, content is elusive. Better to try an illustration. Let us imagine two equally competent representations (from a technical point of view, that is), both depicting the same religious subject, such as the Nativity of Christ or his Crucifixion. Each one shows all the prescribed figures, each personage dressed according to expectations and performing just the right actions, the settings and props fitting the narrative exactly. Iconographically, both images could be described in the selfsame words. Yet one leaves us cold despite its illustrational accuracy while the other moves us to tears. The difference is one of content, which we might try to express as the psychological message or effect of a work of art. It is the content of works of art, almost as much as their style, and in certain cases even more, that affects the observer and relates the painter, the sculptor, the architect (for buildings can excite deep emotions) to the poet, the dramatist, the novelist, the composer—indeed to the actor, the musician, the dancer. In a mysterious and still inexplicable fusion, content is at times hardly separable from style, giving it life and meaning. Iconography can be dictated to the artist by his patron; content is the sign of the artist's full allegiance and inspiration. Like style, content is miraculously implicit in the very act of creation.

24. *God as Architect*, from a *Bible Moralisée*. Reims, France. Middle 13th century. Illumination. Österreichische Nationalbibliothek, Vienna

The History of Art

Any form of human activity has its history. The history of art, like the purpose of art, is inevitably bound up with many other aspects of history, and it is therefore generally organized according to the broad cultural divisions of history as a whole. But individual styles have their own inner cycles of change, not only from one period to the next but within any given period, or even within the work of a single artist. Iconography and purpose can be studied with little reference to the appearance of the work of art, but stylistic change, like style itself, is the special province of the study of art history. The individual work of art can and must be considered in relation to its position in a pattern of historical development if we wish to understand it fully. Long ago it occurred to people to wonder whether there might be laws governing stylistic change which, if discovered, could render more intelligible the transformations we see taking place as time is unrolled before us. Of necessity we refer to a succession of such transformations as an evolution, but without necessarily implying the superiority of one stage over another.

The earliest explanations of stylistic development can be classified as *evolutionary in a technical sense*. We possess no complete ancient account of the theory of artistic development, but the Greeks appear to have assumed a steady progression from easy to constantly more difficult stages of technical achievement. This kind of thinking, which parallels progress in representation with that in the acquisition of any other kind of technical skill, is easy enough to understand but tends to downgrade the importance of early stages in any evolutionary sequence. Implicit also in such thinking is the idea of a summit of perfection beyond which no artist can ascend, and from which the way leads only downward, unless every now and then a later artist can recapture the lost glories of a supposed Golden Age.

The metaphor of technical evolution has great weaknesses when confronted with the historical facts. Artistic evolution is not always orderly. In ancient Egypt, for example, after an initial phase lasting for about two centuries, a complete system of conventions for representing the human figure was devised shortly after the beginning of the third millennium B.C. and changed very little for nearly three thousand years thereafter. Certainly, one cannot speak of evolution from simple to complex, or indeed of any evolution at all. Even more difficult to explain in evolutionary terms is the sudden decline in interest in the naturalistic representation of the human figure and the surrounding world in late Roman art (fig. 25) as compared with the subtle, complex, and complete early Roman systems of representation (fig. 26). It looks as if the evolutionary clock had been turned backward from the complex to the simple.

A new pattern of art-historical thinking, which can be characterized as *evolutionary in a biographical sense,* is stated in the writings of the sixteenth-century Italian architect, painter, and decorator Giorgio Vasari, who has often been called the first art historian. He compared the development of art to the life of a human being, saying that the arts, "like human bodies, have their birth, their growing up, their growing old and their dying." Vasari dodged any uncomfortable predictions about the growing old and dying of art after his time, but his successors were not always so wise. Much of the theoretical and historical writing on art during the seventeenth century looks backward nostalgically to the perfection of the High Renaissance.

Imperceptibly, the ideas of Charles Darwin in the nineteenth century began to affect the thought of art historians, and a third tendency, seldom clearly expressed but often implicit in the methods and evaluations of late-nineteenth- and early-twentieth-century writers, began to make itself felt. This theory explained stylistic change according to an inherent process that we might call *evolutionary in a biological sense*. Ambitious histories were written setting forth the art of entire nations or civilizations, as were monographs analyzing the careers of individual artists, in an orderly manner proceeding from early to late works as if from elementary to more advanced stages, less of technical achievement than of visual

25. *The Tetrarchs.* c. 305. Porphyry, height approx. 51″ (1.3 m). Façade of S. Marco, Venice

25

perception. In the early twentieth century the Swiss art historian Heinrich Wölfflin formulated sets of opposed categories according to which the progression from a "classic" phase to a "baroque" one could be understood as a natural law applicable to the artistic development of all major periods and countries. The analysis was brilliant but highly selective, ignoring styles and periods that did not fit the theory. The biological-evolutionary metaphor underlies much art-historical writing and thinking even today and is evident in the frequent use of the word *evolution,* generally in a Darwinian spirit.

A fourth major tendency of art-historical interpretation, which might be described as *evolutionary in a dialectical sense,* developed in Germany through the essentially mystical doctrines of the early-nineteenth-century German philosopher Georg Wilhelm Friedrich Hegel, who adopted from Plato the idea of a world-soul, in accordance with whose laws history proceeds by means of a sort of pendulum-swing from one situation (*thesis*) to its opposite (*antithesis*), union between which results in a new and higher situation (*synthesis*), which in turn becomes the start of a new triple swing. Attractive to those who could not accept the Darwinian theory of continuous progress in one direction, the Hegelian model was adopted by the art historian Erwin Panofsky, who spoke of history as a "spatial spiral," constantly returning to the same place but always on a higher level. But what happens to the law if Panofsky's spatial spiral goes downward, as at the end of the Roman Empire?

Although Karl Marx and his followers rejected the mysticism of Hegel, they adopted his concept of an inherent, dialectical law of history. More recently Neo-Marxist art historians, and others who have no connection with Marxism, have assumed a fifth model, of *evolution in a sociological sense.* Many have written about separate periods or events in the history of art along sociological lines, demonstrating what appear to be strong interconnections between forms and methods of representation in art and the demands of the societies for which these works were produced. Often, however, sociological explanations fail to hold up under close examination. How does one explain, for example, the simultaneous existence of two or more quite different—even mutually antagonistic—styles, representative examples of which were bought or commissioned by persons of the same social class or even by the same person?

Stylistic tendencies or preferences are, in fact, often explicable by widely differing interpretations (the notion of cause and effect in the history of art is always dangerous), sometimes not responsive to any clear-cut explanation. Three of the five theories discussed above—the technical, biological, and sociological—are still useful in different ways and at different moments in the history of art. But Vasari's biographical premise is generally renounced as a fallacious kind of reasoning by analogy. None of the five can be rigorously and consistently applied throughout the history of art. In fact, any deterministic theory that claims to account for styles and their evolution according to a system everywhere applicable will always trip over the maverick case.

Despite its above-mentioned shortcomings, there is something seductive about the Greek theory of technical evolution. This can be shown to correspond, for example, to the learning history of a given individual, who builds new experiences into patterns created by earlier ones, and may be said to evolve from stage to stage of always greater relative difficulty. The stopping point in such a cycle might correspond to the gradual weakening of the ability to learn, and it varies widely among individuals. Certain artists never cease developing; others reach their peak at a certain moment and repeat themselves endlessly thereafter. From the achievements of one artist, the next takes over, and the developmental process continues. The element of competition also plays its part, as in the Gothic period, when cathedral builders were trying to outdo each other in height and lightness of structure, or in the Impressionist period, when painters often worked side by side, competing in their attempt to seize the most fugitive aspects of sunlight and color (see page 18 and fig. 8). Such an orderly development of refinements on the

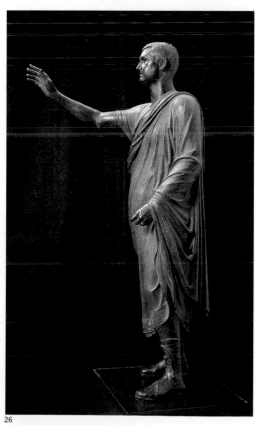

26. *L'Arringatore (The Orator),* portrait of Aulus Metellus, from Sanguincto, near Lake Trasimeno, Italy. c. 90–70 B.C. Bronze, height 71″ (1.81 m). Museo Archeologico, Florence

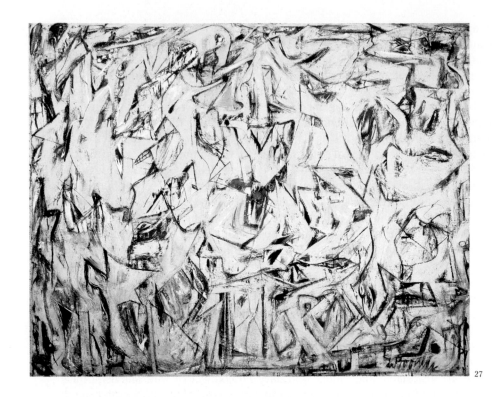

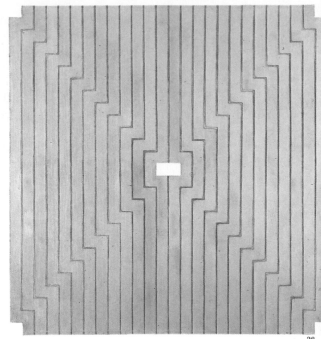

original idea motivating a school of artists can also be made to correspond to the biological-evolutionary theory, showing (as it seems) a certain inherent momentum.

We must face a sixth and totally unpredictable principle dictating change, which might be termed *evolution by mutation*. In art as in any other aspect of human life, changes of style may result from sheer boredom. Especially in our restless era, when a given style has been around to the point of saturation, artists and public alike thirst for something new. A startling case in point is that of Abstract Expressionism, based on emotional violence and the intense, rich, seemingly disordered application of paint (fig. 27), which found its hegemony in the 1950s disputed almost overnight by Pop Art and by color-field and hard-edge painting (fig. 28), with its severe, often ruled lines and mechanized appearance. Mutations may even occur from time to time through purely accidental discoveries, a factor that has yet to be thoroughly explored. On investigation, apparent artistic accidents may turn out to be in reality the result of subconscious tendencies long brewing in an artist's mind, which almost any striking external event could bring into full play.

In the seventies and eighties of this century many art historians have become increasingly dissatisfied with existing method, and a number of new approaches have been recommended, often with great vehemence and intolerance, resulting at times in bitter intradepartmental warfare. This ferment is a part of a wide picture of conflict and disagreement throughout humanistic studies. Proponents of the sharply differing doctrines that comprise the "new art history" have yet to agree on a consistent method and put it into practice. In my opinion important results are being achieved by second-generation feminists who—now that the struggle for the inclusion of women artists in the accepted canon has been launched—are forcing a reexamination of long-cherished viewpoints and terminology in historically male-dominated thinking and writing about the history of art, and are seeking to determine what is feminine in the art of women. Neo-Marxists have produced striking evidence to account with precision for the subject matter of Impressionist pictures and its treatment, but, alas, not for Impressionist style. Some have gone so far as to decry any emphasis on artistic quality and on the "aesthetic emotion" itself, which would have the effect of regarding art as a mere illustration of anthropology,

27. WILLEM DE KOONING. *Excavation.* 1950. Oil on canvas, 6'8⅛ × 8'4½" (2.03 × 2.54 m). The Art Institute of Chicago. Gift of Mr. and Mrs. Noah Goldowsky and Edgar Kaufmann Jr.; and Mr. and Mrs. Frank G. Logan Prize Fund, 1952

28. FRANK STELLA. *Avicenna.* 1960. Aluminum paint on canvas, 6'2½" × 6' (1.89 × 1.83 m). The Menil Collection, Houston, Texas

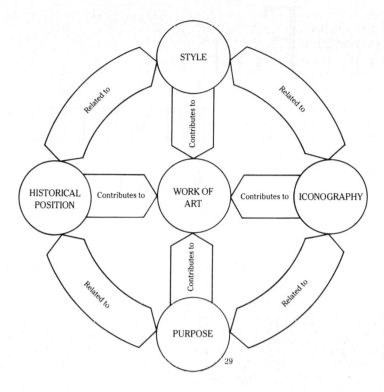

29. The Total Work of Art

or social history, or whatever, and of destroying most students' principal reason for reading a book like this one. Nothing could be more anti-historical than such attempts, which subvert everything that written records tell us about mankind's reasons for creating and looking at works of art.

In my view, any art-historical method can be useful that takes into account all the relevant circumstances, distorting none, and does not lose sight of the work of art itself. It is to be hoped that once the achievements and the shortcomings of the various contending viewpoints become clear that struggle will simmer down, and critics and scholars will come to recognize that what we are all concerned with is the history of art, not the art of history.

The Total Work of Art

The four major factors we have been considering—purpose, style, iconography, and historical position—are involved in the formation of any work of art, and all four should be considered in our study. The total work of art consists of the sum, or more exactly the product, of these four factors. At the risk of oversimplification, we may diagram the total work of art as a series of circles, one for each element, arranged around a larger circle (fig. 29), all contributing to the work of art at the center, and all related to each other. In the effort to interpret any given work of art we can start anywhere in the larger circle and move in any direction, including across it, as long as we realize that those elements that are separated for the purpose of diagrammatic clarity are in reality fused into a transcendent whole, with blurred and shifting boundaries.

The only certainty in art-historical studies is that as we try to penetrate deeply into the work of art, to understand it fully, and to conjecture why and how it came to be as it is, we must examine in each individual instance all the factors available to us that might have been brought to bear on the act of creation and regard with healthy skepticism any all-embracing theory that might tend to place a limitation on the still largely mysterious and totally unpredictable forces of human creativity.

PART FIVE

CHAPTER NINETEEN

ITALIAN ART — THE THIRTEENTH

While Italian Gothic architecture, for all its grandeur, remains essentially a late adaptation to local needs of forms and ideas imported from France and Germany (and is therefore treated in an earlier chapter), Italian painting and sculpture of this same period owe relatively little to the North. They seem to emerge from the Middle Ages into a wholly new era, with such striking force and originality that they are often and with good reason considered separately from the Gothic as forerunners of the Renaissance. For, beginning in the late thirteenth century, Italian artists are, above all, individuals, often intensely so. They are, of course, not the first artists since antiquity whose names we know. But the personalities and ideas of medieval

Map 16. ITALY
ABOUT 1500

- MAJOR CENTERS
- LARGE/MEDIUM CENTERS
- SMALL CENTERS

THE RENAISSANCE
THE DAWN OF INDIVIDUALISM IN
AND FOURTEENTH CENTURIES

artists can be deduced only from their work and occasionally their theological writings, which tell us little about their art. In most cases we have only their signatures. In contrast the Italians have left us mountains of verbal information—contracts, payment records, letters, legal documents, sometimes vividly personal inscriptions. Eventually, in the fifteenth and sixteenth centuries, they were to expound their professional traditions and theoretical ideas at great length in magnificent treatises, read avidly today. We possess precious accounts of Italian artists' lives and achievements by their contemporaries, and they are mentioned glowingly by contemporary chroniclers and poets as great men of their communities.

The individuality of Italian artists arose from the very nature of Italian political and social life. In the later Middle Ages, with the sole exception of a few scattered independent or semi-independent city-states, all of Europe outside Italy was ruled by monarchies of one sort or another still under the feudal system. The princes of central Europe, moreover, all owed allegiance to the Holy Roman Empire, which, by historic right, also claimed control over Italy. But during the eleventh and twelfth centuries the rapidly growing Italian city-states, whose trade and banking connections spanned Europe from England to the Middle East, formalized their communal governments as republics (Venice, owing to special geographical and historical circumstances, had been a republic since the eighth century). Fortified by their immense commercial power, the new republics defied imperial authority. Ruled by members of guilds (associations of merchants, professionals, and artisans), the republics often went so far as to expropriate neighboring feudal domains, forcing the nobles to become burghers if they wished to enjoy the rights of citizenship. The artists, as guild members, participated fully in the vigorous activities of the aggres- 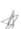 sive and expanding republics, working for the leading citizens as well as for the church and the state. Under such circumstances their new individualism is easy to understand, in contrast to the relative docility and anonymity of the subjects of medieval monarchies. Like the burgher-artisans they were, the artists kept shops in which they produced works on commission and trained apprentices, some of whom were family members. With its strenuous manual activities, however, the Italian late-medieval shop was by custom and law a man's world. No women artistic figures have been identified.

NICOLA AND GIOVANNI PISANO Two extremely original sculptors, Nicola Pisano (active 1258–78) and his son Giovanni (c. 1250–c. 1314), whom we have already encountered as the principal architect of the façade of Siena Cathedral, embody sharply different phases of the rather tardy change from Romanesque to Gothic style in Italian sculpture. Although Nicola's surname indicates his Pisan citizenship, he came to Tuscany from southern Italy, where, since the days of Frederick II (ruled 1215–50)—more Italian king than German emperor—there

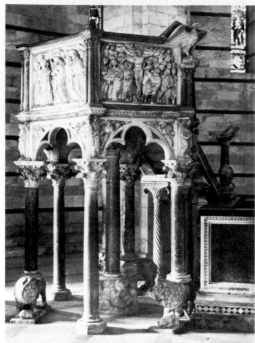

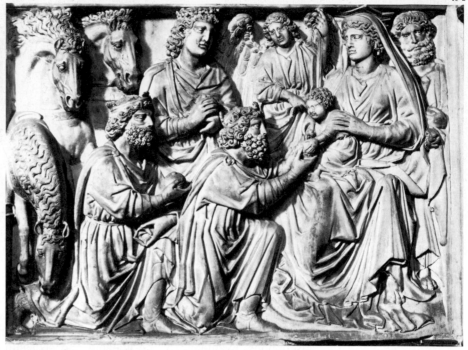

had flourished a strong current of interest in ancient art. More to the point, perhaps, as the studies of Eloise M. Angiola have shown, is the classicism of Pisa, which considered itself a second Rome. Once capital of the ancient Roman province of Tuscany, Pisa, with its vast merchant marine and formidable navy, was favored by the Holy Roman Empire in the Middle Ages and was given sway over a wide territory along the Mediterranean and the entire island of Sardinia. In 1133, in fact, Pisa found itself briefly capital of Western Christendom, chosen as temporary residence by Pope Innocent II, who was excluded from Rome by an antipope.

Nicola's first great work was the hexagonal marble pulpit in the Baptistery at Pisa (fig. 19–1) that he signed with a long, self-laudatory inscription in 1260. Scuptured pulpits were traditional in Italy; that one could be needed in a baptistery may indicate the special importance of the sacrament of Baptism in the Italian republics as the moment in which a child took his place in the Christian community, and of course in the individual Italian commune. Nicola's handsome creation combines elements already familiar from central Italian medieval art, such as columns of red porphyry, red-and-gray granite, and richly veined brown marble, with Gothic trefoil arches. The capitals, partly Corinthian, partly Gothic, seem to partake of both styles. Like his earlier namesake Nicholas of Verdun and like the Visitation Master at Reims, Nicola had a strong interest in ancient art. Luckily, he had no dearth of models in Pisa. The close packing of forms filling the entire frame of the *Adoration of the Magi* (fig. 19–2) recalls the density of Roman sarcophagus relief, and in fact Nicola repeated almost exactly the pose of a seated figure in a sarcophagus still in the Campo Santo in Pisa for his Virgin, who has become a Roman Juno, impassive and grand. The carving of the beards of the Magi and the parallel drapery folds of all the figures also recall Roman examples, but the angular breaking of the folds betrays Nicola's familiarity with Byzantine mosaic art.

Giovanni, who claims in inscriptions to have outdone his father, was responsible for a sharply different octagonal pulpit at Pistoia (fig. 19–3). Dated 1298–1301, it is distinguished by its greater Gothicism in the sharp pointing of the arches as well as in the freer shapes of the foliate capitals, which only here and there disclose classical derivations. As we would expect from the unconventional shapes and animated statuary of the Siena façade, Giovanni's sculptural style is far more dramatic than his father's serene manner and shows almost no interest in classical art. Instead, the relaxed poses and free, full drapery folds of the corner statues

19-1. NICOLA PISANO. Pulpit. 1259–60. Marble, height approx. 15′ (4.57 m). Baptistery, Pisa

19-2. NICOLA PISANO. *Adoration of the Magi,* detail of the pulpit, Baptistery, Pisa. Marble relief, height approx. 34″ (86 cm)

19-3. GIOVANNI PISANO. Pulpit. 1298–1301. Marble. Sant'Andrea, Pistoia

19-4. GIOVANNI PISANO. *Slaughter of the Innocents,* detail of the pulpit, Sant'Andrea, Pistoia. Marble relief, 33 × 40″ (84 × 102 cm)

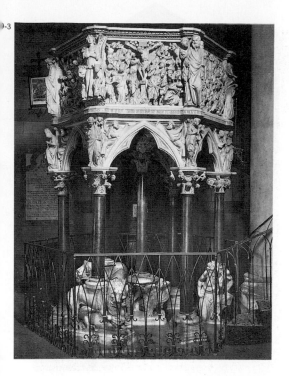

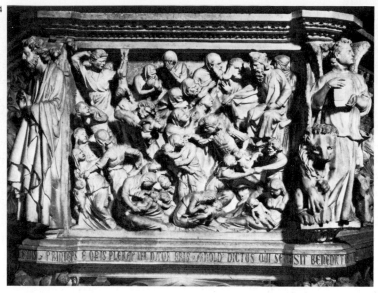

19-5

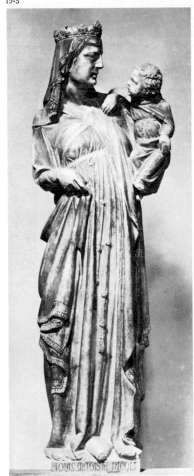

19-5. GIOVANNI PISANO. *Virgin and Child.* c. 1305. Marble. Arena Chapel, Padua

suggest a familiarity with the portal sculptures of Amiens and Reims; Giovanni's inscriptions proclaim him as a traveler, and in all probability he visited the great French cathedrals. In the *Slaughter of the Innocents* (fig. 19–4), a panel of the Pistoia pulpit, he shows himself the master of a free narrative style, depending for its effect on rapid, even violent movement of ferocious soldiers and screaming mothers and on considerable undercutting, which produces sharp contrasts of light and dark. The expressive power of Giovanni's style is brought under firm control, possibly in emulation of the great painter Giotto, in the marble statue of the *Virgin and Child* (fig. 19–5), which Giovanni carved about 1305 for the altar of the Arena Chapel in Padua, whose walls and ceiling were being frescoed by Giotto (see Introduction fig. 6 and figs. 19–9, 19–10). The boldness of the masses, the clarity of the contours, and the firmness of the pose of Giovanni's *Madonna* contrast strikingly with the elegance and lassitude of earlier examples.

Changes in thirteenth-century religious ritual gave rise to the demand for a new kind of image—of immense importance for the development of art, especially painting—the *altarpiece.* Until now the Mass had been celebrated, as again in the Roman Catholic Church since Vatican II, behind the altar, with the priest facing the congregation. This practice precluded the placing of anything more than the required crucifix, candlesticks, and sacred vessels upon the altar. In the course of the century, the celebrant's position was moved to the front of the altar, thus freeing the back of the altar for the development of imagery, both sculptural and pictorial. Although the icon, that all-important focus of Byzantine devotion, had been imported into the West in the early Middle Ages, it had not taken root. But in the thirteenth century, large-scale painted crucifixes, which had already been used in other positions in Italian churches, began to appear on altars. Soon the Madonna and Child competed for this prominent place, and eventually won. The altarpieces, which rapidly grew to considerable size so as to be visible to the congregation, were painted in a technique known as *tempera,* with egg yolk used as the vehicle. The procedure was slow and exacting. A wooden panel had to be carefully prepared and coated with *gesso* (fine plaster mixed with glue) as a ground for the underdrawing. Gold leaf was applied to the entire background, and then the figures and accessories were painted with a fine brush. As egg dries fast and does not permit corrections, the painter's craft called for accurate and final decisions at every stage. Under the impulse of this new demand, and spurred by the intense political and economic life of the Tuscan republics, painting rapidly developed in a direction that had no Northern counterparts until the fifteenth century.

CIMABUE Although at least two generations of Tuscan painters had preceded him in the thirteenth century, the first Italian painter known to Vasari by name was

the Florentine Cenni di Pepi, called Cimabue (active c. 1272–1302). About 1280 Cimabue painted the *Madonna Enthroned* (fig. 19–6), an altarpiece more than twelve feet high, which in Vasari's day stood on the high altar of the church of Santa Trinita in Florence. The derivation of Cimabue's style from that of the Greek painters with whom Vasari said he worked is clear enough in the poses of the Virgin and the Child and also in the gold-striated patterns of their drapery folds. But in the delicate modeling of the faces and drapery of the angels, Cimabue also shows his familiarity with the refined Constantinopolitan style of his own time. Clearly, Cimabue was trying to rival in paint the monumental effects of Byzantine mosaics, but the gabled shape of his huge altarpiece is unknown in the East, as is the complex construction of the carved and inlaid throne; the effect is that of strong verticality, increased by the constant flicker of color in the angels' rainbow wings. Cimabue's insistent linear tension, maintained throughout the gigantic altarpiece, is also alien to the harmony of Byzantine art: it is thoroughly Tuscan, recalling the sculpture of the Pisani.

CAVALLINI An exception to the dominance of the republics in Italian art was the school of Rome. After centuries of repetition of Early Christian models without major innovations, in the last decades of the thirteenth century Roman painting rose to a brief period of splendor, brought to a sudden end in 1305 when its chief patron, the papacy, unable to resist the power of the French monarchy, allowed itself to be carried off to Avignon in southern France, leaving Rome in a state of political and economic decline. The leader among all the gifted Roman painters was Pietro Cavallini, whose documented activities run from 1273 to 1308 but who was said by his own son to have lived nearly a hundred years. Vast fresco cycles by

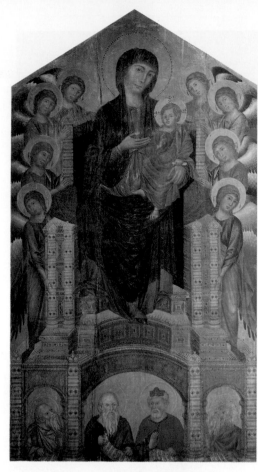

19-6

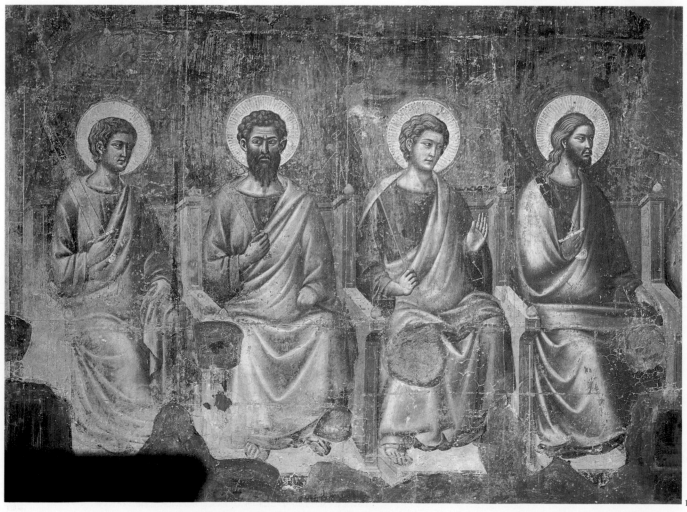

19-7

19-6. CIMABUE. *Madonna Enthroned,* from Sta. Trinita, Florence. c. 1280. Tempera on panel, 12′7½″ × 7′4″ (3.85 × 2.24 m). Galleria degli Uffizi, Florence

Cavallini, in part renewing, in part replacing damaged Early Christian works, once lined the nave walls of two great Roman basilicas, San Giovanni in Laterano (then the seat of the papacy and still today the Cathedral of Rome) and San Paolo fuori le mura (Saint Paul's Outside the Walls), as well as other churches. Almost all of these frescoes are now lost, but in his own time and well into the Renaissance Cavallini enjoyed a towering reputation. Certainly he had a tremendous influence on the art of the more famous Giotto, who surely saw Cavallini's work with a sense of discovery when he came to the Jubilee of 1300 called by Pope Boniface VIII.

Cavallini's major surviving work in fresco is the fragmentary *Last Judgment* of about 1290 in Santa Cecilia in Trastevere in Rome (fig. 19–7). This painting, impossible to photograph as a whole because of a gallery later built in front of it, carries the knowledge of the effects of light to a point inaccessible to Cimabue. Light and light alone brings out the fullness and sweep of the mantles that envelop these majestic figures. Their heads, however, especially those of the beardless Apostle second from the right and the bearded James (?) on the right, show a familiarity with French Gothic sculpture. Surely Cavallini had also studied such advanced Byzantine works as the frescoes at Sopoćani, which show an extraordinary advance in the interrelationship of light and volume. But the final result, endowing the art of painting with a grandeur and nobility of form previously exercised only by sculpture, and with a hitherto unknown beauty and softness of color gradations, is his own achievement.

GIOTTO The final break with Byzantine tradition was accomplished by the Florentine master Giotto di Bondone (c. 1267–1337), the first giant in the long history of Italian painting. Even in his own day Giotto's greatness was recognized by his contemporaries. Dante puts in the mouth of a painter in Purgatory (*Purgatorio* XI, 94–96) his famous remark:

19-7. PIETRO CAVALLINI. *Last Judgment* (detail of a fresco), Sta. Cecilia in Trastevere, Rome. c. 1290

Cimabue believed that he held the field
In painting, and now Giotto has the cry,
So that the fame of the former is obscure.

19-8

19-8. GIOTTO. *Madonna and Child Enthroned,* from the Church of Ognissanti, Florence. c. 1310. Tempera on panel, 10′8″ × 6′8¼″ (3.25 × 2.04 m). Galleria degli Uffizi, Florence

The *Chronicles* of the historian Giovanni Villani (died 1348) list Giotto as one of the great men of the Florentine Republic, a position such as had been accorded to no other artist since the days of ancient Greece. The sources also indicate wherein Giotto's greatness was thought to lie. Vasari summed up Italian estimates when he said that Giotto revived the art of painting, which had declined in Italy because of many invasions, and that since Giotto continued to "derive from Nature, he deserves to be called the pupil of Nature and no other." Cennino Cennini, a third-generation follower of Giotto, wrote in his *Book on Art,* a manual on technical methods, that Giotto had translated painting from Greek into Latin.

A comparison of Giotto's *Madonna and Child Enthroned* (fig. 19–8) of about 1310 with its counterpart by Cimabue (see fig. 19–6) will test these traditional observations. Nature, in the modern sense of the word, would hardly enter our minds in connection with Giotto's picture any more than with Cimabue's. Both are ceremonial images of the Virgin as Queen of Heaven, remote from ordinary experience, and both rule out distant space by the use of a traditional gold background. But in contemporary Italian eyes the step from Cimabue to Giotto was immense in that weight and mass, light and inward extension were suddenly introduced in a direct and convincing manner. In contrast to Cimabue's fantastic throne, which needs a steadying hand from the attendant angels, Giotto's structure is firmly placed above a marble step, which can be climbed, and the Virgin sits firmly within it. The poses of the angels kneeling in the foreground are so solid, in comparison to the uncertain placing of Cimabue's angels, that we are willing to believe that the angels and saints behind them, on either side of the throne, stand just as securely. Light, still diffused and without indication of source, models the forms so strongly that they resemble sculptural masses. By "translating painting from Greek into Latin," Cennini meant that Giotto had abandoned Byzantine models in favor of Western ones, and in the early fourteenth century those could only have been French cathedral statues. Not only do Giotto's facial types and drapery motifs recall Gothic sculptures of the preceding century, but also the Virgin's throne is set in an aedicula whose pointed central arch, trefoil side arches, and culminating pinnacles are taken directly from the French architectural repertory. Giotto's miracle lay in being able to produce for the first time on a flat surface three-dimensional forms, which the French could achieve only in sculpture. Whether or not the Florentines would have admitted this, Giotto also owed a debt to Cavallini, but here he has gone well beyond the Roman master. Effects of shoulders and knees showing through drapery masses, of the Child's body and legs, and of the Virgin's hand holding his thigh are at every point convincing. For the first time since antiquity a painter has truly conquered solid form. Giotto did not, however, adopt as yet a naturalistic scale. The Virgin and Child are represented as almost twice the size of the attendant figures.

Cennini tells us that the painting of frescoes was the most agreeable of all pictorial activities. The technique he describes was probably based on that of Roman painting as handed down through the Middle Ages. The painter first prepared the wall with a layer of rough plaster, on which he proceeded to draw with the brush (probably on the basis of preliminary sketches) the figures and background in a mixture of red earth and water known as *sinopia* (see fig. 19–20). Over this preparatory drawing he laid on as much smooth plaster as he could paint in a day, and painted it while wet so that the color in its water vehicle would amalgamate with the plaster. The following day he added another section, covering up the sinopia as he went. This procedure meant that the fresco was literally built section by section and acquired a solidity of composition and surface handling that would preclude any spontaneous painting technique such as that of the Byzantine artists.

Giotto's masterpiece is the cycle of frescoes dating from 1305–6 that lines the entire interior of the Arena Chapel in Padua in northern Italy, not far from Venice. Here he shows the full range of his naturalism in a new kind of pictorial drama for which nothing we have seen in the history of art could prepare us. The entire interior walls of the chapel, except for windows, is organized in three tiers, showing

19-9. GIOTTO. *Raising of Lazarus,* fresco, Arena Chapel, Padua. 1305–6

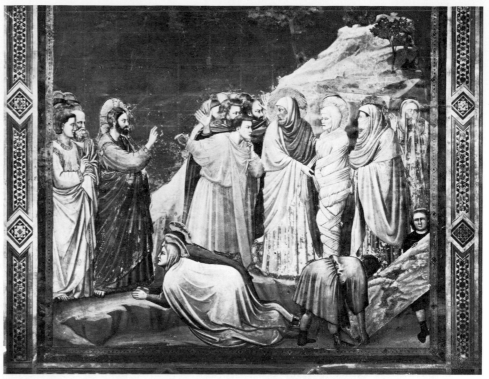

19-9

scenes from the life of the Virgin, the life and mission of Christ, and the Passion and Resurrection. In a scene from the lowest tier Joachim, father of the Virgin, takes refuge with shepherds in the wilderness after his expulsion from the Temple because of his childlessness (see Introduction fig. 6). Humiliated, his head bowed, he stands before two shepherds, one of whom scans his companion's face to see whether they dare receive the outcast. The subtlety of the psychological interplay is enriched by Giotto's delicate observation of the sheep crowding out of the sheepfold and of the dog, symbol of fidelity in the Middle Ages as today, who leaps in joyful greeting.

As in the *Madonna,* Giotto recognizes one scale for the figures, another for the surroundings, including the animals and the sheepfold. Cennini recounts that to paint a mountainous landscape one need only bring a rock into the studio, and that a branch could do duty for a tree. The results of this principle show that Giotto, for all his ability to project three-dimensional form, is far from accepting the notion of visual unity. His landscape, however, has an expressive purpose; the rock behind Joachim bends along with his head, and the jagged edges toward the center underscore the division between him and the shepherds. The cubic rocks form a definite stage in space, limited by the blue background, which does not represent the sky—there are no clouds—but is an ideal, heavenly color continuing behind all the scenes in the same manner as the gold backgrounds for altarpieces, and covering the barrel vault above. In order to emphasize the three-dimensionality of the columnar figure of Joachim, Giotto has designed his halo foreshortened in perspective. The simplicity of the masses, the compact organization, and the noble clarity of the drawing and color create a composition of the greatest beauty.

In the *Raising of Lazarus* in the second tier (fig. 19–9) the composition divides into two groups: one centered around Lazarus, who has just risen from the tomb and is still wrapped in graveclothes, is read together with the rock; the other, beginning with the prostrate Mary and Martha, culminates in Christ, who calls the dead man forth by a single gesture of his right hand against the blue, in a pose and gesture recalling the teaching Christ from the portal of Amiens Cathedral in thirteenth-century France. The calm authority of Giotto's Christ is contrasted with the astonishment of the surrounding figures. Though in the *Lamentation* in the third tier (fig. 19–10) the Byzantine tradition is by no means forgotten, Giotto has

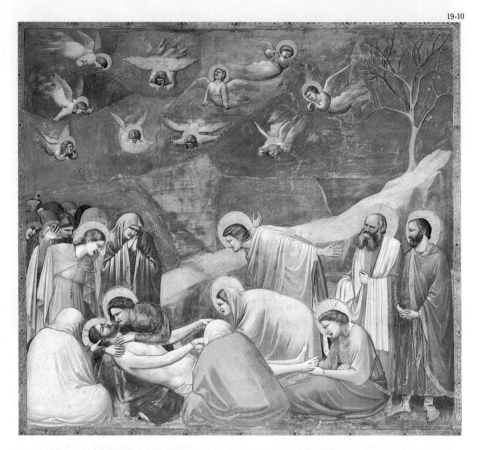

19-10. GIOTTO. *Lamentation,* fresco, Arena Chapel, Padua. 1305–6

19-11. TADDEO GADDI. *Annunciation to the Shepherds,* fresco, Baroncelli Chapel, Sta. Croce, Florence. Begun shortly after 1328

19-12. DUCCIO. *Virgin as Queen of Heaven,* center panel of the *Maestà* altarpiece (now divided), from the Cathedral of Siena. 1308–11. Tempera on panel, 7′ × 13′6¼″ (2.13 × 4.12 m). Museo dell'Opera del Duomo, Siena

enriched the dialogue between life and death with all the subtlety of his psychological observation. Instead of an explosion of grief, he has staged a flawlessly organized tragedy, the equal of Sophocles or Shakespeare in its many-faceted analysis of a human situation. The figures grieve in the manner possible to their individual personalities—John, the beloved disciple, most deeply of all. Giotto has added to the scene anonymous mourners who turn their eloquent backs to us; one upholds Christ's head, the other his right hand. Mary, with one arm around Christ's shoulder, searches his countenance, conscious of the widening gulf between life and death. Only the angels are released to cry in pure grief, each half-hidden in clouds to show that he is supernatural. (Significantly, with Giotto clouds appear only as accompaniments to heavenly figures.)

Giotto's brushwork remains as calm in this scene as in any other. He achieved his effect not only by the grouping of the figures but also by the inexorable diagonal line of the rock, descending toward the faces of Mary and Christ, its course weighted by the downward tug of the drapery folds. At the upper right, as if to typify the desolation of the scene, a leafless tree stands against the blue. Giotto surely expected his audience to remember that, according to medieval legend, the Tree of Knowledge was withered after the sin of Adam and Eve and made fruitful again after the sacrifice of Christ, and that Christ himself was believed to have alluded to this doctrine on his way to Calvary: "For if they do these things in a green tree, what shall be done in the dry?" (Luke 23:31).

Giotto indeed had the cry; within a decade after his great works made their appearance, the style of Cimabue had been relegated to country churches, and Giotto, his many pupils, and still more numerous followers dominated the Florentine scene. For Giotto had transformed the whole purpose and nature of painting, in a revolution whose effects are felt to this day.

TADDEO GADDI One of the closest of Giotto's pupils, Taddeo Gaddi (active c. 1328–c. 1366), although he could never approach the heights of his master's achievements, continued some aspects of his style, in the depiction of solid figural volumes and landscape masses but especially in the representation of light. Shortly after 1328 Taddeo painted a series of frescoes in the Baroncelli Chapel of Santa Croce in Florence, almost adjoining two chapels painted by Giotto only a few years earlier. In the fourteenth century natural light was always diffused and generalized, without indication of a specific source. But Taddeo has shown the traditional scene of the *Annunciation to the Shepherds* (fig. 19–11) as a revelation of light, which in a long Christian tradition symbolizes the second person of the Trinity. After all, every Christian knew the sublime words of John 1:4–5, repeated, until Vatican II, at the close of every Mass:

In him was life; and the life was the light of men. And the light shineth in darkness; and the darkness comprehended it not.

As a devoted follower of Giotto, Taddeo never represents natural light, but he presents the announcing angel in the midst of a wonderful display of light, which descends upon the shepherds who have fallen to the ground in amazement and lights the whole dark landscape with its radiance. We are here experiencing the reversal of the process by which, at the beginning of the Middle Ages, the illusionistic art of the Helleno-Roman tradition was transformed into the otherworldly art of Byzantium. Techniques derived from naturalistic painting were used in the early Middle Ages to represent supernatural light. Now at the end of the Middle Ages, that same spiritual light is used to aid the artist in the rediscovery of material reality.

DUCCIO In Siena the Byzantine tradition continued into the fourteenth century and was refined to the ultimate in the work of Duccio di Buoninsegna (active 1278–

19-13

19-13. DUCCIO. *Temptation of Christ on the Mountain,* from the back of the predella of the *Maestà* altarpiece. 1308–11. Tempera on panel, 17 × 18⅛″ (43 × 46 cm). The Frick Collection, New York

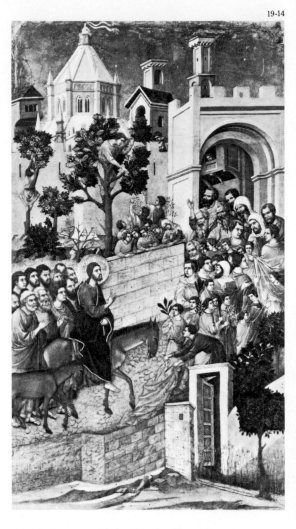

19-14

1318). His great altarpiece, the *Maestà (Madonna in Majesty)*, more than thirteen feet in width, was started in 1308 for the high altar of the Cathedral of Siena. It was considered such a triumph for the artist and such an important contribution to the welfare of the Sienese Republic (whose patron saint was the Virgin) that on its completion in 1311 it was carried at the head of a procession of dignitaries and townspeople from Duccio's studio to the Cathedral, to the ringing of church bells and the sound of trumpets. The high altar was freestanding, so that the back of the altarpiece and even its pinnacles were covered with a cycle of scenes from the life of Christ somewhat more detailed than that Giotto had just painted for the Arena Chapel. In the sixteenth century the altarpiece was taken down and partially dismembered; panels from the pinnacles at the top and from the *predella* (the lower strip at the base of an altarpiece) are scattered through many museums, but most remain in Siena. The central panel shows the Virgin as Queen of Heaven (fig. 19–12), adored by her court of kneeling and standing saints and angels and half-length prophets in the arches above—a sort of cathedral façade in paint. And, though the pose of the Virgin and Child shows that Duccio is still working in the Byzantine tradition, he has nonetheless learned from the works of Giovanni Pisano new and Gothic ways to handle flowing masses of drapery and dense crowds of figures. While the oval shapes of the faces are Byzantine, their small almond eyes bear no relation to the lustrous orbs of the saints in most Byzantine mosaics, frescoes, and icons.

Although Duccio accepted neither Giotto's cubic rocks nor his columnar figures, and although he could not achieve Giotto's subtlety of psychological observation, he was an artist of great individuality especially in the handling of landscape elements, as can be seen in the *Temptation of Christ on the Mountain* (fig. 19–13), once a part of the *Maestà*. The kingdoms of the world, shown to Christ by Satan, were depicted by Duccio, a good republican Sienese, as seven little city-states crowded into a panel not quite eighteen inches square. Obviously, they derive from the late Roman and Early Christian depiction of little nugget-cities, but each one is different, with its own houses, public buildings, city gates, and towers, all modeled in a consistent light. If we are willing to accept the medieval convention of the double scale for figures and setting, we must admit that within it Duccio was very successful in suggesting the scope and sweep of landscape, which soon became Siena's great contribution to the history of art.

In one of the larger panels of the *Maestà*, Duccio set the stage, as it were, for *Christ Entering Jerusalem* (fig. 19–14) in the suburban orchards outside the walls of Siena. We look over trees, garden walls, and a gate in the foreground to the road moving uphill, more garden walls on the other side, the city gates, and houses fronting a street. The towering octagonal building is the Temple, combining travelers' tales of the Dome of the Rock, built on the site of the Temple, with the familiar outlines of the Baptistery of Florence. This setting, of a spatial complexity unprecedented in medieval art, Duccio filled with more than fifty people, all sharply individualized (within the range of Byzantine-Sienese facial types), from the solemn Christ mounted on an ass to the excited populace and children climbing trees, including some inhabitants looking out of windows and over the city wall.

SIMONE MARTINI Duccio's pupil Simone Martini (active 1315–44), while fully abreast of all his master could achieve in the realm of landscape and urban settings, finally broke with the Byzantine tradition in favor of the more fashionable courtly French Gothic manner of the early fourteenth century. He blended these two separate sources into a unified, and in the long run highly original, style of great lyric beauty and material splendor. Simone worked for the French king Robert of Anjou at Naples and brought back to Siena the latest French imports. Even more than the *Maestà* of Duccio, his *Annunciation*, also for Siena Cathedral (fig. 19–15), is a condensed cathedral façade, Gothic this time, with all the richness of Flamboyant double curvature (which had not as yet made its appearance in the architecture

19-14. DUCCIO. *Christ Entering Jerusalem*, from the back of the *Maestà* altarpiece. 1308–11. Tempera on panel, 40½ × 21⅛″ (102.9 × 53.7 cm). Museo dell'Opera del Duomo, Siena

of Giovanni Pisano). The elaborate frame, glittering with Gothic gables, pinnacles, and foliate ornament, all richly gilded, encloses the most sacred of all scenes in Christian art. For according to theological teaching and tradition, the Incarnation of Christ, the second person of the Trinity, in human form occurred at the precise moment when the words of the Angel Gabriel struck the ear of the Virgin Mary.

Simone has enhanced the dramatic impact of the event by a veritable explosion of forms and colors. The center of the altarpiece is occupied only by a great vase containing lilies, symbols of Mary's virginity; there are four of them, the number of the Gospels. Everything else seems to have been blown away from the gold background by the force of the angel's message, "Ave gratia plena dominus tecum" ("Hail thou that art highly favored, the Lord is with thee," Luke 1:28), embossed so as to catch and reflect light. Even the expected two colonnettes, presumably needed to support the central arch, have been omitted, so that the capitals seem to hang in the breeze. The dove of the Holy Spirit ("The Holy Spirit shall come upon thee, and the power of the most High shall overshadow thee," Luke 1:35) flies downward toward Mary and is surrounded by tiny seraphim, whose crossed swallow-wings echo in reverse the cusps of the frame. Unexpectedly, the slender and elegant Mary, "troubled at his saying" (Luke 1:29), recoils almost in terror at her fate, her face clouded with apprehension. The angel is dressed magnificently in white and gold brocade with a floating, plaid-lined mantle, and the Virgin's blue mantle is edged with a deep gold border. The swirling drapery rhythms in their curvilinear exaggerations contrast strongly with the controlled shapes of Giotto and Duccio. This is an extraordinary and unexpected style, graceful in the extreme yet intensely dramatic, with all the characteristic Sienese fluency of line translated from Byzantine Greek into Flamboyant French Gothic.

THE LORENZETTI Giotto's new devices reached Sienese painting in the work of two brothers, Pietro (c. 1280–1348?) and Ambrogio (c. 1285–1348?) Lorenzetti, who, nonetheless, continued independently the Sienese tradition of the exploration of landscape and architectural settings. The Lorenzetti brought Sienese painting to a position of absolute leadership in Europe during the decade following Giotto's death. In Pietro's *Birth of the Virgin* of 1342 (fig. 19–16), another in the cycle of Marian altarpieces for the Cathedral of Siena, we are aware of Giotto's cubic space and columnar figures, but Pietro has taken a significant step in the direction of illusionism. The gold background is eliminated except where it peeks through a tiny window at the left. The architectural setting has been identified with the actual carved shape of the frame, which it was customary for the artist himself to design and which was usually built and attached to the panel before the process of painting was begun. The picture thus becomes a little stage into which we can look, so that we cannot help wondering from the illustration what is carved and what is painted. (This requires a mental effort because, in a misguided devotion to historical "purity" the authorities have removed the later colonnettes substituted for the rotted originals.) Pietro's altarpiece is a pioneer attempt to build up the consistent interior space that never seems to have occurred to the Romans. His perspective is not entirely consistent, but the upper and lower portions of the interior are drawn so that the parallel lines in each converge to a single separate vanishing point. An enormous step has been taken in the direction of the unified perspective space of the Renaissance.

Not even Pietro's formulation of interior space is quite as startling as what Ambrogio had already achieved in the fresco representing the effects of good government in city and country. This panorama fills one entire wall of a council chamber in the Palazzo Pubblico (the Sienese counterpart of the Florentine Palazzo Vecchio) and is in fact so extensive that it requires two photographs to show it in its entirety (figs. 19–17, 19–18). Ambrogio has assumed the high point of view taken by Duccio for his exterior scenes, but he has immensely expanded it. On the right in fig. 19–17 we look over the zigzag line of the city wall into open squares and

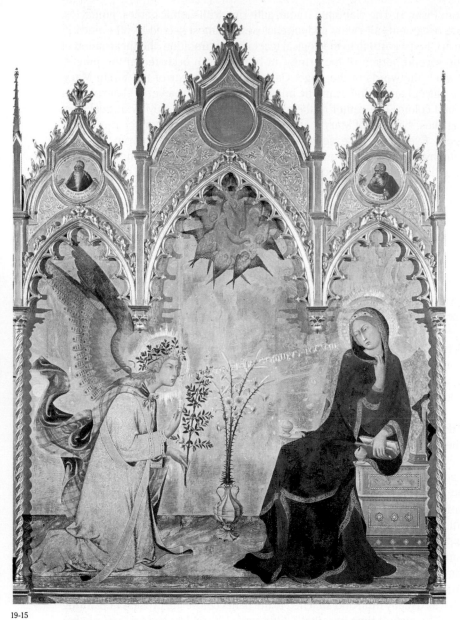

19-15

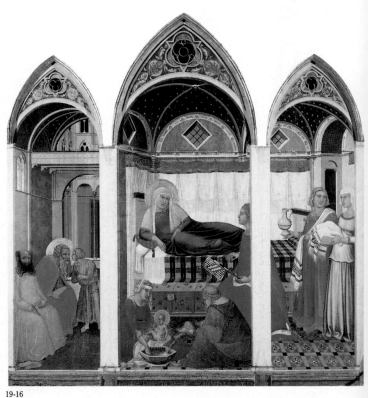

19-16

19-15. SIMONE MARTINI. *Annunciation*. 1333 (frame reconstructed in the 19th century). Panel painting, 10′ × 8′9″ (3.05 × 2.67 m). Galleria degli Uffizi, Florence

19-16. PIETRO LORENZETTI. *Birth of the Virgin*. 1342. Tempera on panel, 73½ × 71½″ (1.88 × 1.82 m). Museo dell'Opera del Duomo, Siena

streets lined with houses, palaces, and towers, some still under construction (note the masons at work under the center beam). At the upper left can barely be made out the campanile and dome of the Cathedral. Richly dressed Sienese burghers and their wives ride by on horseback; one horse has already half-disappeared down a street in the center. The three arches of the building in the foreground contain (from left to right) a shoe shop, a school with a teacher at a desk on a platform and a row of pupils, and a wineshop with a little bar in front. Groups of happy citizens dance in the street.

To the right of the city wall (see fig. 19–18), under a friendly floating near-nude labeled *Securitas,* who brandishes a scroll with one hand and a loaded gallows with the other, the city people ride downhill into the country and the country people walk uphill into the city. The view of the countryside is amazing: roads, hills, farms and orchards with peasants hard at work, a lake, a country chapel, villas and castles, hills beyond hills, stretching to the horizon. But just where we would expect a blue sky with clouds, Ambrogio drops the iron curtain and reminds us that we are

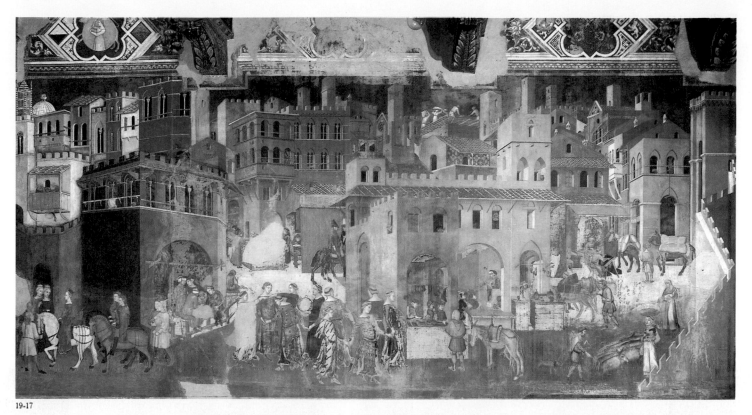

19-17

19-17. AMBROGIO LORENZETTI. *Allegory of Good Government: The Effects of Good Government in the City,* detail of a fresco, Sala della Pace, Palazzo Pubblico, Siena. 1338–39

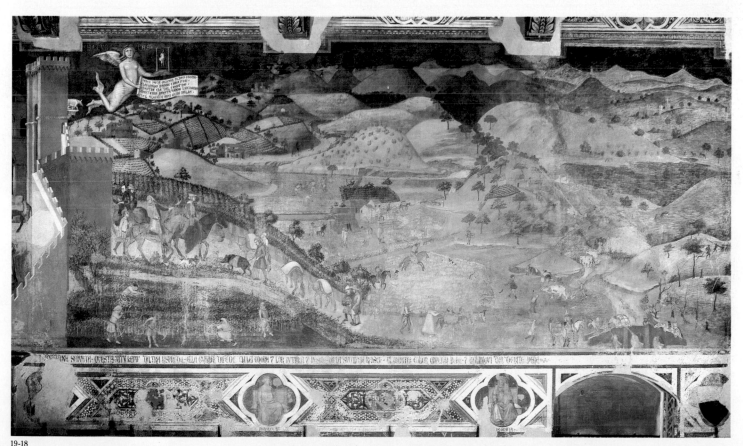

19-18

19-18. AMBROGIO LORENZETTI. *Allegory of Good Government: The Effects of Good Government in the Country,* detail of a fresco, Sala della Pace, Palazzo Pubblico, Siena. 1338–39

still in the Middle Ages. The background is a uniform gray black. This encyclopedic view of the Sienese world and everything in it is an exciting preview of the Renaissance, but there it stops. The Black Death, an epidemic of the bubonic plague that swept Europe in 1348, killed from half to two-thirds of the populations of Florence and Siena, probably including Ambrogio and Pietro Lorenzetti, and put an end to such explorations.

TRAINI The fresco representing the *Triumph of Death* in the Campo Santo, or walled cemetery, at Pisa is probably the work of a local master named Francesco Traini (active c. 1321–63) and has been interpreted as reflecting the universal gloom following the Black Death. Recent research suggests that the fresco may have been painted a year or two earlier, but the plague had already appeared in Tuscany well before the devastating attack in 1348. In this panorama (fig. 19–19), very different from the carefree world of Ambrogio Lorenzetti, no one escapes. At the left three richly dressed couples on horseback, out hunting, come upon three open coffins containing corpses in varying stages of putrefaction, a common enough sight in plague times; they draw back in consternation, one rider holding

19-19. FRANCESCO TRAINI. *Triumph of Death,* fresco, Campo Santo, Pisa. Middle 14th century

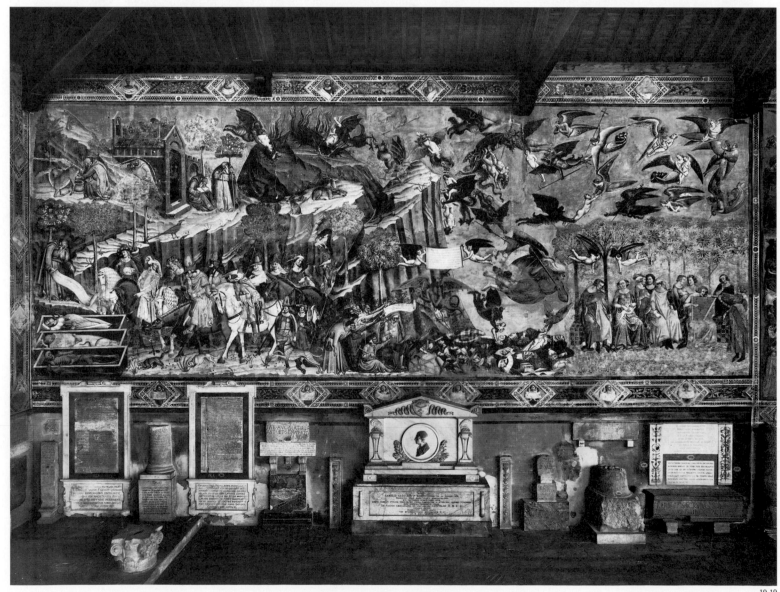

19-19

19-20. Detail of the preliminary brush drawing (*sinopia*) for *Triumph of Death*

19-20

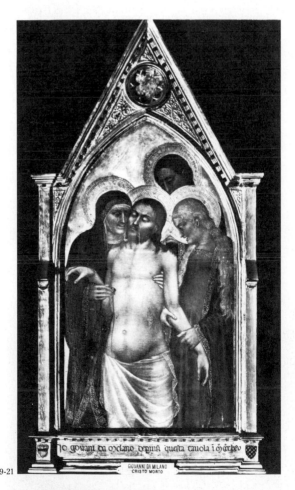

19-21

19-21. GIOVANNI DA MILANO. *Pietà*. 1365. Tempera on panel, 48 × 22¾″ (122 × 58 cm). Galleria dell'Accademia, Florence

his nose. At the right in a grove of orange trees sits a happy group of gentlemen and ladies, engaged in music and conversation, reminding us of Giovanni Boccaccio's *Decameron,* written at the time of the Black Death. They seem not to see Death, a winged, white-haired hag, sweeping down on them with a scythe. In the air above, angels and demons fight over human souls. The rocky path at the upper left leads to hermits' cells, as if to demonstrate that the only road to salvation is retreat from the world. The severe damage suffered by these frescoes in the fire following the fall of random American shells in World War II necessitated the detachment from the wall of all those that still adhered; underneath was found the most extensive series of sinopias then known (fig. 19–20). These sinopias reveal the boldness and freedom of brushwork, recalling Byzantine painting, that underlie the meticulous finish of fourteenth-century frescoes.

GIOVANNI DA MILANO In the wake of the Black Death, no new figures emerged of the stature of the great masters of the early fourteenth century, but many painters showed new observations and insights. One of the most gifted of these was Giovanni da Milano (active 1346–66), a Lombard working in Florence, where in 1365 he signed a new kind of image, a *Pietà* (fig. 19–21), from the Italian word for both "pity" and "piety," both of which it was intended to excite. The intensified religious life of Italy after the catastrophe required new images, which would draw from biblical sources figures, situations, and emotions rather than narrative incidents and recombine them in timeless configurations designed to strengthen the reciprocal emotional bond between sacred figures and the individual worshiper. In an attempt at once to arouse the sympathies of observers and to demonstrate to them that for their salvation Christ had shared the sufferings of all humanity, Giovanni has depicted him after death, being lifted in the arms of Mary, Mary Magdalene, and John. The emotional intensity of the painting has reached fever pitch, but it is no longer expressed in outbursts; it is felt within, rather, like a self-inflicted wound. As impressive as the content of Giovanni's painting is his new attention to muscles, bones, and tendons—not only where they affect the texture of an anatomical surface but also where they appear in profile along the sensitive contour. His art prepares the way for the great discoveries of the approaching Renaissance, in both Italy and the North.

TIME LINE X

Pulpit, by
N. Pisano

*Virgin
and Child,*
by G. Pisano

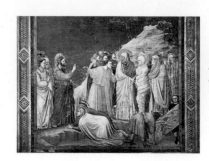

*Raising of
Lazarus,*
by Giotto

POLITICAL HISTORY	RELIGION, LITERATURE	SCIENCE, TECHNOLOGY
1200 Papacy at height of power; dissatisfaction with its worldliness results in proliferation of religious sects; in response, papal Inquisition is established, 1231	St. Francis and St. Clare of Assisi found order of Franciscan nuns, the Poor Clares, 1212 *Dies Irae*, greatest of medieval Latin hymns, is composed, probably by Thomas of Celano (d. 1255), from Abruzzi	
1250 City-republics of Venice and Genoa, enriched by trade and transport during Crusades, are foremost naval powers in Mediterranean		Improvements in rudder make navigation and water commerce less risky
1260 Siena defeats Florence at Montaperti, 1260 Ordinances of Justice in Florence disenfranchise nobles, 1293	Jacobus da Voragine writes *Golden Legend*, 1266–83	Marco Polo returns from China, c. 1295
1300 Visconti family rules Milan, 1312–1447	Dante writes *Divine Comedy*, in Italian vernacular, 1302–21 Petrarch (1304–74), poet and humanist Papacy established in Avignon (1309–78); reforms of Curia begin	Adoption of gunpowder in Europe, 14th century
1325 Duke of Athens expelled from Florence, ending dictatorship, 1343 Black Death in Florence and Siena, 1348	*Chronicles* by Giovanni Villani, first history of Florence, 1348	Guy de Chauliac, French surgeon trained at Bologna University, writes surgical treatise (1343) that remains in use for three centuries Use of guns at battle of Crécy, 1346
1350 Venice defeated by Genoa, 1354	*Decameron* by Boccaccio, 1353	
1375 Reform of constitution of Florence, 1382	St. Catherine of Siena (c. 1347–1380) persuades Pope Gregory XI to return to Rome from Avignon, 1378	Use of artillery at Aljubarrota, Portugal, 1385
1400 Casa di S. Giorgio, first modern bank, founded at Genoa, 1407	Great Schism in Catholic Church, 1378–1417	

THIRTEENTH- AND FOURTEENTH-CENTURY ITALY

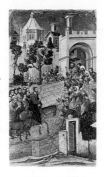

Christ Entering Jerusalem, from *Maestà,* by Duccio

Triumph of Death, by Traini

Pietà, by G. da Milano

PAINTING, SCULPTURE

	1200
	1250

Nicola Pisano, Pulpit, Baptistery, Pisa
Cimabue, *Madonna Enthroned* 1260
Cavallini, *Last Judgment*

Giovanni Pisano, Pulpit, S. Andrea, Pistoia; *Virgin and Child*, Arena Chapel, Padua
Giotto, frescoes, Arena Chapel; *Madonna and Child Enthroned* 1300
Duccio, *Maestà*, with scenes from the life of Christ

Taddeo Gaddi, *Annunciation to the Shepherds*, Sta. Croce, Florence 1325
Simone Martini, *Annunciation*
Ambrogio Lorenzetti, *Allegory of Good Government*, Palazzo Pubblico, Siena
Pietro Lorenzetti, *Birth of the Virgin*

Francesco Traini, *Triumph of Death*, Campo Santo, Pisa 1350
Giovanni da Milano, *Pietà*
 1375

 1400

CHAPTER TWENTY

IN ITALY — THE

Renaissance, the French word for "rebirth," has generally been taken to signify the revival of the knowledge of Greek and Roman civilizations. Writers of the period believed that classical literature, philosophy, science, and art had been lost in an age of darkness after the collapse of the Roman Empire under the onslaught of Germanic invaders and had awaited throughout the intervening centuries resurrection at the hands of the Italians, true heirs of their Roman ancestors. When the Tuscan poet and humanist scholar Petrarch (Francesco Petrarca), who seems to have been the first to proclaim the idea of barbarian decline and contemporary rebirth, was crowned with laurel on the Capitoline Hill in Rome in 1341, it was not in recognition of the beauty of his Italian sonnets but rather in honor of the breadth of his knowledge of ancient history and of the purity of his Latin style.

Petrarch's literary classicism had little demonstrable effect on the art of his own time. Few fourteenth-century artists imitated classical models; ironically, Petrarch's favorite painter was his contemporary Simone Martini and his favorite building the Gothic Cathedral of Cologne. Moreover, Petrarch could not have known that during the period he designated as "dark" repeated efforts had been made to revive one aspect or another of classical art. When in the fifteenth century Italian artists adopted in earnest ideas and motifs from the artistic vocabulary of ancient Rome, their borrowings were restricted to architecture and decoration. Only for limited purposes were sculptors concerned with the imitation of specific ancient models. There were almost no examples left for painters to follow. (Although Athens was for a while under the rule of a Florentine family, and although Greek temples were still standing in southern Italy and in Sicily, almost no attention was paid to Greek art.)

Still, a tremendous change occurred in the visual arts in the fifteenth century, the consequences of which are with us yet, and the revival of classical antiquity is not enough to explain it. The Swiss historian Jakob Burckhardt, writing in 1860, used "The Discovery of the World and of Man" as the title for one major division of his great work, *The Civilization of the Renaissance in Italy*. In the formation of Renaissance art, it is this discovery that distinguishes the artistic revolution of the fifteenth century from earlier classical revivals and gives meaning to its borrowings from ancient art. The new vision of the Renaissance artist, whether in the generally classical setting of Italy or in the still-Gothic enframement of Northern Europe, projects a believable picture of humanity and of the world. In many ways it goes further than ancient art in its inclusiveness and consistency.

At the height of the new movement, in 1451–52, the Florentine humanist Giannozzo Manetti wrote a work entitled *On the Dignity and Excellence of Man,* in which he refuted the claims of medieval theologians that man was worthless in the eyes of God. Manetti extols man as "lord and king and emperor in the whole orb of the world, and not unworthy to dominate and to reign and to rule." He finds not only man's soul but also his body beautiful, every part admirably adapted to its purpose, so perfect indeed that both pagans and Christians were justified in representing their gods in human form and the Greeks in calling the human body a microcosm, since it mirrors in itself the harmony of the entire world. There is no miracle that the human intelligence cannot encompass, Manetti tells us, no mystery of the cosmos that it cannot fathom. But the highest peak of human genius is speculation about the divine. The world was created not for God, who had no need of it, but for

THE EARLY RENAISSANCE
FIFTEENTH CENTURY

man. Man is the most perfect work of God, containing in himself all the beauties scattered in various orders of the universe and revealing them in his creative power, the true marvel of his genius. "Ours then," says Manetti,

are everything which you see, all the homes, the fortresses, the cities, all the buildings in the entire world which are so many and such that they seem the work of angels rather than of men. . . . Ours are the pictures, ours the sculptures, ours the arts, ours the sciences, ours the wisdom. Ours are all the regions of the earth, mountains, valleys, plants, animals, fountains, rivers, lakes and seas, and all the innumerable creatures.

For Manetti man has his end not in God but in a knowledge of himself and his own creativity.

A similar pride inspired the humanist, theorist, and architect Leonbattista Alberti when he wrote in the prologue to his treatise *On Painting* in 1435, "We have dug this art up from under the earth. If it was never written, we have drawn it from heaven." In the prologue he claimed

that it was less difficult for the ancients—because they had models to imitate and from which they could learn—to come to a knowledge of those supreme arts which today are most difficult for us. Our fame ought to be so much greater, then, if we discover unheard-of and never-before-seen arts and sciences without teachers or without any model whatsoever.

This attitude culminates in Leonardo da Vinci's assertion that the painter is "Lord and God" to depict anything in the whole world (a precise and eloquent opposition to the medieval conception of God as an architect; see Introduction fig. 24) and in Michelangelo's comparison of the sculptural process to that of divine salvation.

With few exceptions the humanists considered themselves Christians, and some were in religious orders, but it must be remembered that they represented an elite. Medieval piety still inspired the masses of the people, even in humanist Florence, and could occasionally resume control. During the Counter-Reformation, in the middle of the sixteenth century, the Roman Church put Manetti's work on the *Index Expurgatorius* (List of Forbidden Works).

The Renaissance artist inherited from the Middle Ages such duties as the construction of churches and palaces, the painting of frescoes and altarpieces, the carving of pulpits and tombs. Interest in stained glass declined (although a number of great artists still designed windows), and the illuminated manuscript (a luxury limited to the immensely wealthy but still important in the early fifteenth century) was soon largely replaced by the printed book, which could be bought by any moderately prosperous person. The humanist attitude of the artist and his patron gave rise to three phenomena seldom seen since the eclipse of paganism—the nude human figure, the recognizable portrait, and the landscape, all in keeping with the above passages from Manetti, Alberti, and Leonardo.

In art as in politics, the Early Renaissance was a man's world. Women had been excluded, for the traditional reasons, from all medieval workshops except for the

highly productive convents from which so many beautiful illuminated manuscripts came. Women were not admitted to the Florentine guilds. They were doubly barred from Renaissance studios because of the reliance of Renaissance art on the nude. Only rarely did convents still produce women painters (of marginal interest), and not until the late sixteenth century in northern Italy, outside the stranglehold of the Florentine guild system, did such women artists as Lavinia Fontana and Marietta Robusti emerge in the studios of their painter-fathers. But the woman sculptor Properzia de' Rossi had already made her independent and tragically brief mark in papal Bologna, and toward the end of the century Sofonisba Anguissola appeared in a scholarly and artistic family environment and attracted great fame. By the sixteenth century extraordinary women began to play leading roles in politics. Queens Caterina de' Medici of France, Mary Stuart of Scotland, and Elizabeth I of England, by far the most brilliant ruler of her time, may be especially singled out. At the court of Elizabeth, herself an accomplished musician, literature and music, but not the figurative arts, enjoyed a triumphant rebirth. Occasionally a wealthy and powerful woman played a decisive and highly individual role as a patron of the visual arts. A shining example was Isabella d'Este, dowager marchioness of Mantua, an indefatigable collector of antiquities and gems, who employed Mantegna, Perugino, and other famous masters to decorate her study according to iconographic programs entirely devised by the learned marchioness herself.

Especially important is the versatility of the Renaissance artist. The same man can often excel at two of the three major arts, sometimes at all three. Alberti, Lorenzo Ghiberti, Piero della Francesca, Leonardo da Vinci, Albrecht Dürer, and Andrea Palladio also wrote extensive treatises on the principles of their arts. But the artist did not limit himself to the practice of what today we would call "Art." In the conquest of reality, he turned his attention to the sciences of perspective, anatomy, botany, geology, and geometry. His genius could be placed at the service of the state in peace and war, for he was expected to plan cities, lay out canals and fortifications, and design bridges and arches, floats and pageants, and even weapons and engines of war. The investigation of perspective, one of his great delights, was closely allied to the exploration of *actual* space, which culminated in the late fifteenth century and the sixteenth century in the voyages of the great discoverers and the revolutionary theories of the astronomers and cosmographers. It was no accident that the map that led Columbus to resolve to set forth on his first journey to the New World was produced in Renaissance Florence.

The humanist concerns of the artist opened him to advice from the humanist leaders of the Renaissance state, particularly Florence; he was likewise involved perforce in the destinies of those very leaders. When the fifteenth century began, the artist was still a craftsman, firmly embedded in the system of merchant and artisan guilds that controlled the Florentine Republic. By midcentury he had become, everywhere, except in Venice, an adjunct of the princely society that was rapidly replacing the medieval republics. By the sixteenth century, when absolutism held sway throughout much of Italy, an artist of the stature of Michelangelo, Raphael, or Titian had acquired aristocratic social status, wealth, and influence. He could be and often was a learned man (very occasionally a learned woman). Gradually the medieval workshop, still prevalent throughout the fifteenth century, was replaced by the studio (from the Italian word for "study"), and the artist abandoned the decaying guilds for membership in the learned academies, which offered systematic training not only in the arts but in those sciences considered necessary for an artist.

Outside Italy the Gothic tradition was still strong, and few classical remains were visible to compete with it. Possibly for this reason, Northern and Spanish architecture remains resolutely Gothic well into the sixteenth century, and in spite of the humanists and of the rich commercial contacts between Italy and the rest of Europe, there is little classical influence on Northern painting and sculpture until the High Renaissance. But great discoveries of methods of representing the visible

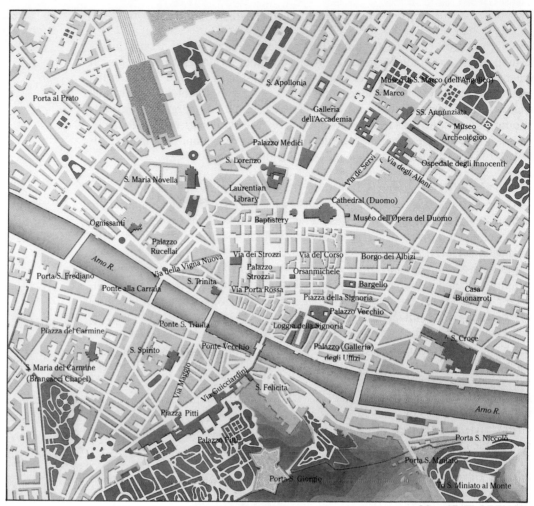

Map 17. FLORENCE

world were made in the Netherlands and spread from there to France, Germany, and Spain. In respect to sheer naturalism the Netherlanders, in fact, far surpassed the Italians of the Early Renaissance, who were the first to recognize the special triumph of their Northern contemporaries. These discoveries, nonetheless, lack the theoretical structure responsible for the inner harmony of Italian Renaissance art.

Netherlandish towns, while possessing nothing like the independence of the Italian city-states, nevertheless enjoyed a measure of autonomy under the relatively enlightened if short-lived rule of the dukes of Burgundy. None of the artistically creative states of the Early Renaissance—the republics of Florence, Siena, and Venice, the Papal States, and the duchy of Burgundy—survive as political entities today. But with few exceptions it was in these relatively small, rich, disordered, and militarily insecure states, rather than in the kingdoms of Naples, France, England, and Spain, or the Holy Roman Empire, that the crucial developments of the Early Renaissance took place. It looks as though the turmoil that characterized the smaller states was more conducive to the development of artistic individuality than was the hierarchical structure of the monarchies. It is also important to note that, once the liberties of the Italian states had become extinguished in the sixteenth century, the Renaissance itself soon came to an end.

Architecture in Florence and North Italy

Architecture is the easiest of the arts in which to follow the rebirth of classical motifs in the Renaissance and their adaptation to contemporary needs. During a period notable for its political turbulence and almost continuous warfare, in which the very existence of the Florentine Republic was repeatedly threatened by outside enemies, the Italian city-states, including Florence, found the energy and the funds to adorn their still-medieval streets and squares with buildings in the new style. The harmony and dignity of these structures made them examples for later architects for five centuries—and their influence continues.

BRUNELLESCHI It is typical of the interchangeability of the arts in the fifteenth and sixteenth centuries that Filippo Brunelleschi (1377–1446), the founder of the Renaissance style in architecture, was trained as a sculptor. After his defeat in 1402 at the hands of Lorenzo Ghiberti in the competition for the bronze doors of the Baptistery of Florence (see page 596, and figs. 20–28, 20–29), Brunelleschi went to Rome, where he spent many months, perhaps together with the somewhat younger sculptor Donatello, studying and measuring the ancient buildings. In 1417 Brunelleschi won the competition to crown the unfinished Gothic Duomo (Cathedral) of Florence with a colossal dome (fig. 20–1). Like many crucial works of the Early Renaissance, Brunelleschi's dome still retains Gothic elements. The octagonal

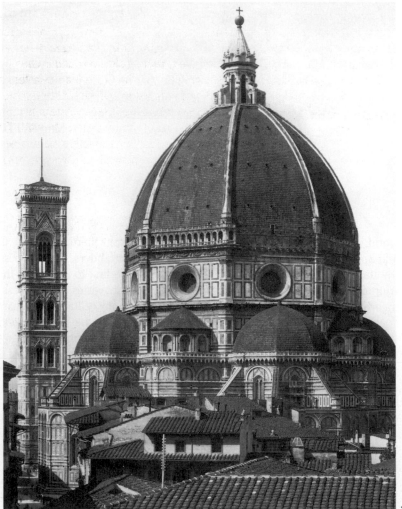

20-1

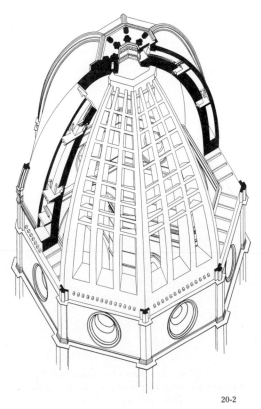

20-1. FILIPPO BRUNELLESCHI. Dome, Cathedral of Florence. 1420–36

20-2. FILIPPO BRUNELLESCHI. Construction of the dome, Cathedral of Florence (modern diagram)

20-2

0-3

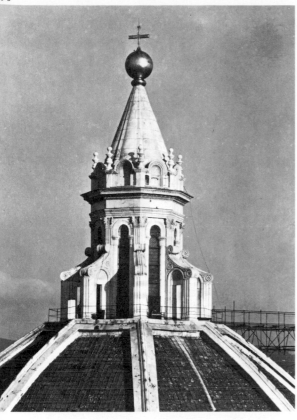

20-3. FILIPPO BRUNELLESCHI. Lantern of the dome, Cathedral of Florence. After 1446

shape of the crossing of the Cathedral required an octagonal drum supporting a dome divided by eight massive ribs and the lantern at its apex. An inner shell of masonry and an outer shell of tiles conceal between them a complex web of smaller ribs and connecting, horizontal buttresses that ties the principal ribs together (fig. 20–2). Brunelleschi's construction system and his device for hoisting the building materials to great heights made it possible to erect the unprecedented structure without the expensive forest of scaffolding (the cathedral actually owned a forest for this purpose) that would otherwise have been necessary.

Only the small semicircular structures between the semidomes over the transepts, with their niches separated by coupled Corinthian columns, and the lantern (fig. 20–3), built from Brunelleschi's still-extant model after his death, show direct classical borrowings. A Corinthian order, complete with pilasters and entablatures, is folded about the corners of the lantern and sustained by a system of supporting arches. Brunelleschi based his masses, spaces, and enclosing surfaces on simple, proportional relationships of basic modules—one to two or two to three—simplifying the more elaborate fourteenth-century paneling of white and green marble in the side-aisle walls to carry out his Renaissance system of rectangles and circles. The result is a structure of overwhelming mass, simplicity, clarity of statement, and intelligibility of design, rising (as Alberti put it) "above the skies, ample to cover with its shadow all the Tuscan people." In the early sixteenth century an attempt was made on one face to fill in the unfinished space between the drum and the dome, for which the architect left no design, with an ornamental gallery (see fig. 20–1). Its trivial scale (Michelangelo called it a cage for crickets) underscores the grandeur of Brunelleschi's shapes.

In the Ospedale degli Innocenti (Foundling Hospital), started in 1419 (fig. 20–4), Brunelleschi had a major opportunity to translate his knowledge of ancient architecture into fifteenth-century terms. The building faces the Piazza della Santissima Annunziata in Florence with a handsome arcade of eleven round arches supported on Composite columns, terminated at each side by Corinthian pilasters and surmounted by a second story of small, pedimented windows. Brunelleschi's proportion system can be easily followed: the height of each column equals the width of the bay between columns, and also its depth from column to wall. Each bay, therefore, becomes a cube of space, surmounted by a squared hemisphere in the shape of the pendentive vault (supported along the wall only by consoles). Both in

20-4

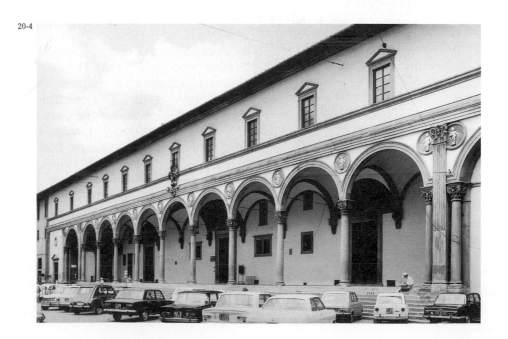

20-4. FILIPPO BRUNELLESCHI. Ospedale degli Innocenti (Foundling Hospital), Piazza della SS. Annunziata, Florence. Begun 1419

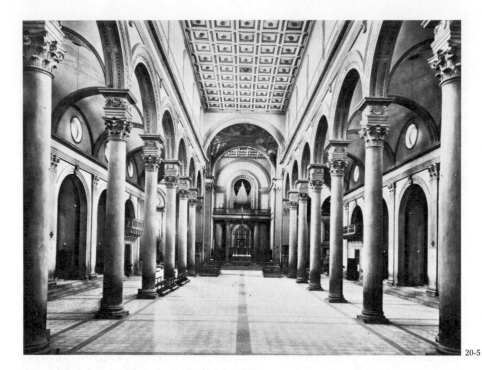

20-5.

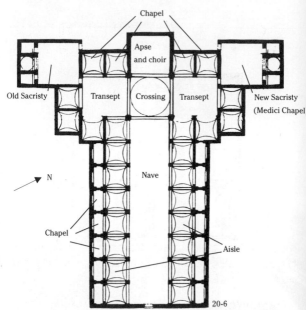

20-5. FILIPPO BRUNELLESCHI. Nave and choir,
S. Lorenzo, Florence. 1421–69

20-6. FILIPPO BRUNELLESCHI. Plan of
S. Lorenzo, Florence

20-6

general disposition and in the character of the capitals and entablatures, Brunelleschi has edited the splendor and richness of the Roman originals he studied in favor of an austere simplicity that emphasizes the clarity of his organization.

The great architect's mathematical turn of mind brought forth not only his system of basic geometrical shapes and simple proportions but also the related invention of what appears to be the first consistent system of one-point perspective—that is, a perspective in which all parallel lines in a given visual field converge at a single vanishing point on the horizon. Brunelleschi's perspective was derived from the observation of actual buildings. In the interior of the Church of San Lorenzo in Florence (fig. 20–5), built at intervals from 1421 well into the fifteenth century under the patronage of the Medici family, circles, half-circles, rectangles, and squares are kept, as at the Ospedale degli Innocenti, within a clear-cut, all-embracing system of modules of surface and space, diminishing systematically as one looks down the nave.

At San Lorenzo Brunelleschi replaced the complexities of Gothic shapes and systems with the basic plan of an Early Christian basilica (fig. 20–6). The nave arcades, supported by unfluted Corinthian columns, sustain a flat wall, without triforium, pierced by a clerestory of arched windows. Flanked by Corinthian pilasters, the side aisles are covered by pendentive vaults supported on transverse arches; the nave is roofed by a flat, coffered ceiling, whose squares provide a convenient graph with which to measure inward spatial recession. Even the floor (the present pavement is nineteenth century) is marked off into squares by stripes, thus measuring not only the perspective recession but also the proportions between the width of the bays, the height of the columns, and that of the arches. All is measure, reason, proportion, and harmony, accentuated by Brunelleschi's choice of a gray Florentine stone known as *pietra serena* (clear stone) for the columns, entablatures, arches, window frames, and other trim to contrast with the white plaster covering the masonry walls. This two-tone color scheme was repeated in Florentine architecture well into the nineteenth century. Within Brunelleschi's structure of harmonious spaces and surfaces, the lofty Corinthian columns stand with the cool perfection of statues, illuminated by the even light from the clerestory. Brunelleschi designed the nave without side chapels, but the families who had paid

20-7. FILIPPO BRUNELLESCHI. Plan of the Pazzi Chapel, Sta. Croce, Florence

20-8. FILIPPO BRUNELLESCHI. Pazzi Chapel, Sta. Croce, Florence. c. 1440–61

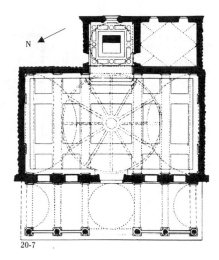

20-7

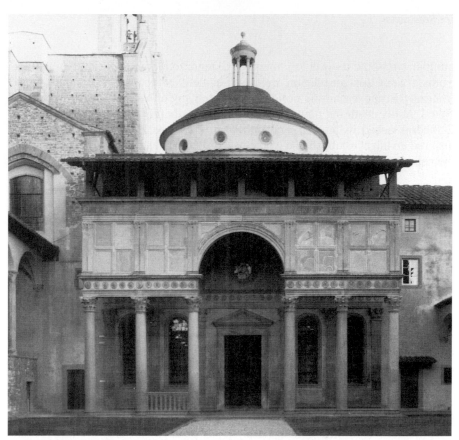

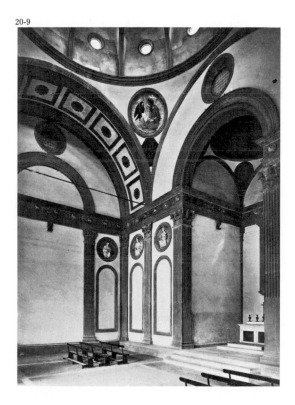

20-9

20-9. FILIPPO BRUNELLESCHI. Interior, Pazzi Chapel, Sta. Croce, Florence

for their chapels in the old Gothic church insisted on their rights. The steps to the chapels shorten the intervening pilasters, with some slight damage to the harmony of the whole.

The gem of Brunelleschi's later style is the chapel (fig. 20–8) given to Santa Croce by the Pazzi family of Florence to be used not only for their family masses but also as the chapter house in which the monks of Santa Croce could meet; it was constructed from about 1440 to 1461. A central square surmounted by a round dome on pendentives is extended on either side by arms equal to half its width (fig. 20–7); their barrel vaults are divided into large panels of *pietra serena* moldings against plaster. The resultant rectangular hall (fig. 20–9) is lined with fluted Corinthian pilasters (again in *pietra serena,* like all the trim) so placed as to appear to support the arches of the barrel vault and of the altar space and even the false arches inserted in the lunettes at either end of the chapel to complete the system. Smaller blind arches, reflecting the windows in the façade, appear in the spaces between the pilasters. These spaces furnish the basic module for the entire chapel. Over each of the twelve blind arches appears a small *roundel* (round panel) containing one of the Twelve Apostles in glazed terra-cotta, blue and white, by Luca della Robbia (see page 599). The pendentives display larger terra-cotta roundels of the Four Evangelists, probably by Brunelleschi himself. The dome with its twelve ribs and twelve oculi seems to be floating, since the lower cornice of the drum does not touch the supporting arches. The portico was added after Brunelleschi's death, possibly by Giuliano da Maiano.

The Pazzi Chapel is one of the masterpieces of architectural history, harmonious and graceful in its proportions and spaces, luminous and simple in its color scheme of gray, white, and blue with occasional touches of green, yellow, and violet. Here we are very far from the Gothic cathedral, which sought at once to enfold and to dazzle us with the infinite complexity of the medieval universe. Yet Brunelleschi, like all great architects of the Renaissance, had foremost in his own mind the idea of the Divine Proportion. When we analyze his relationship of shape, space, line, and

number, we would do well to remember Giannozzo Manetti's declaration that the truths of the Christian religion are as self-evident as the axioms of mathematics. Ironically, Brunelleschi was not destined to see any of his major structures completed. At his death the nave of San Lorenzo was barely begun, the dome of the Cathedral lacked its lantern, and the Pazzi Chapel its façade. Nonetheless, this inspired architect established a whole new order for the art of building, as valid in the century of Le Corbusier and Mies van der Rohe as in his own.

MICHELOZZO We possess no certain example of domestic architecture by Brunelleschi, but we do know that Cosimo de' Medici, uncrowned ruler of the still ostensibly republican Florence, first commissioned him to make a model for his new palace and then rejected it as too grandiose for the Medici's desired image as private citizens. The building, known today as the Palazzo Medici-Riccardi (fig. 20–10), was started in 1444 by the prolific architect and sculptor Michelozzo di Bartolommeo (1396–1472). In considering its present appearance, we have to make several mental adjustments. First, we must remember that the word *palazzo* means to Italians almost any fair-sized urban edifice, even a modern office building. Second, when the Medici Palace was bought by the Riccardi family at the end of the seventeenth century, it was extended on the right by one portal and seven bays of windows, which have to be thought away. Finally, the pedimented windows in the arches of the ground floor were added in the sixteenth century by Michelangelo. The arches originally gave access to a *loggia* (open gallery) for family ceremonies (fig. 20–11).

To modern eyes the building hardly looks palatial. Not only the fortress-like exterior but also the lofty interiors, even when they were filled with the vanished collections of paintings (including battle scenes by Paolo Uccello, see fig. 20–48), sculpture, tapestries, and antiquities, must always have seemed austere. This was

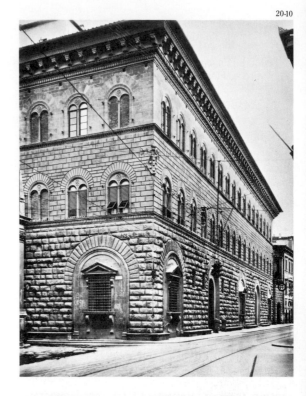

20-10. MICHELOZZO. Palazzo Medici-Riccardi, Florence. Begun 1444

20-11. MICHELOZZO. Plan of the Palazzo Medici-Riccardi, Florence

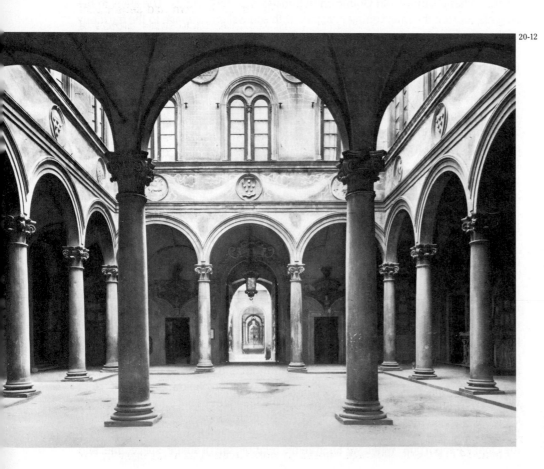

20-12. MICHELOZZO. Interior courtyard, Palazzo Medici-Riccardi, Florence

the taste of the time. Cosimo intended to impress the observer with the fortitude and dignity of his family. The massive lower story, more than twenty feet high, is heavily *rusticated,* that is, built of rough-hewn blocks in a manner somewhat resembling that of the Palazzo Vecchio but actually imitated from ancient Roman structures, such as the exterior walls of the Forum of Augustus. The masonry of the second story, the family living quarters, is cut into flat blocks with strongly accented joints; that of the third is entirely smooth. The building is crowned by a massive cornice, towering some seventy feet above the street and after the example of Roman temples. But this is not the only classical detail: the round arches of the second- and third-floor windows rest on delicate colonnettes with modified Corinthian capitals.

The interior courtyard (fig. 20–12) reminds one of the arcades of Brunelleschi's Ospedale degli Innocenti but the columns have squatter proportions, in keeping with their function of upholding two stories instead of one. The second story is lighted by windows resembling those of the exterior, while the third (not shown in the illustration) is an open loggia, whose columns support a beamed roof. Neither in proportions nor in detail can Michelozzo's palace survive comparison with the masterpieces of Brunelleschi, but it became the model for Florentine patrician town houses for the next two generations.

ALBERTI From the middle of the 1430s, the Renaissance movement, not only in architecture but also in sculpture and painting, fell under the domination of a cultural colossus, Leonbattista Alberti (1404–72). This illegitimate scion of one of the most powerful Florentine families of the Middle Ages was born in exile and revisited Florence briefly and infrequently, functioning by preference as a humanist adviser at the courts of popes and princes. The author of many learned works in classical Latin, Alberti wrote three treatises, *On Painting, On the Statue,* and *On the Art of Building,* that had an immense influence on his own and subsequent generations, and they give us today a welcome insight into many aspects of Renaissance art. The wealthy Florentine merchant Giovanni Rucellai commissioned in 1446 the architect and sculptor Bernardo Rossellino (see page 614 and fig. 20–57) to build a palace from Alberti's designs. The building was later extended (by the two bays at the right, still unfinished) as Giovanni acquired more land. The façade (fig. 20–13), an obvious commentary on that of the Medici Palace, takes us, nonetheless, into a new era of Renaissance thought. In his writings and in his designs, Alberti adopted antiquity as a way of life. While he retains the three-story division, the doubled windows on the second and third stories, and the great cornice of Michelozzo's building, he rejects the heavy rustication of Michelozzo's ground floor as if unsuitable to the residence of a citizen of wealth and taste. Instead, he establishes a uniform system of beveled masonry joints, identical on all three stories. The windows of the ground floor are given handsome, square frames. Then Alberti ornaments his façade by a superimposed three-story system of screen architecture—pilasters that do no work but only appear to uphold the entablatures above them. This device is derived from the superimposed orders of the Colosseum in Rome. It also corresponds to Alberti's doctrine that the basic proportions and divisions of the wall belong to beauty, defined as "the harmony and concord of all the parts, achieved in such a manner that nothing could be added, taken away, or altered," while the column and the pilaster belong to decoration. In contrast to Brunelleschi's columns and pilasters, those of Alberti almost never uphold arches. The arch, he tells us, is an opening in a wall and should remain as such. Today we see only a fragment of the building Alberti designed for Giovanni Rucellai; it would have been completed probably on the right by four more bays and one more portal. Alberti's design remained without a following in Florence but was imitated elsewhere, and its principles were of cardinal importance for the architecture of the High Renaissance.

About 1450 Alberti, although himself in Holy Orders and a secretary in the

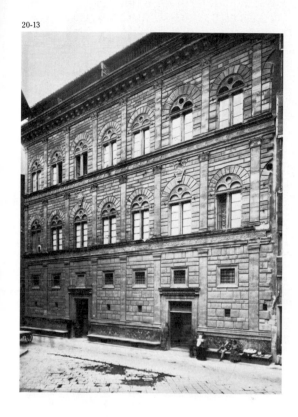

20-13. LEONBATTISTA ALBERTI. Façade, Palazzo Rucellai, Florence. 1446–51; core remodeled and extended 1455–after 1458 by BERNARDO ROSSELLINO

20-14. LEONBATTISTA ALBERTI. Malatesta Temple (S. Francesco), Rimini. c. 1450

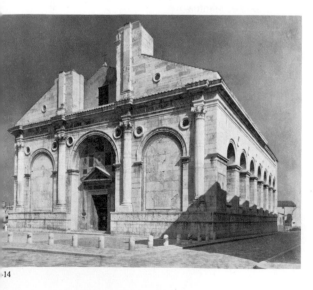

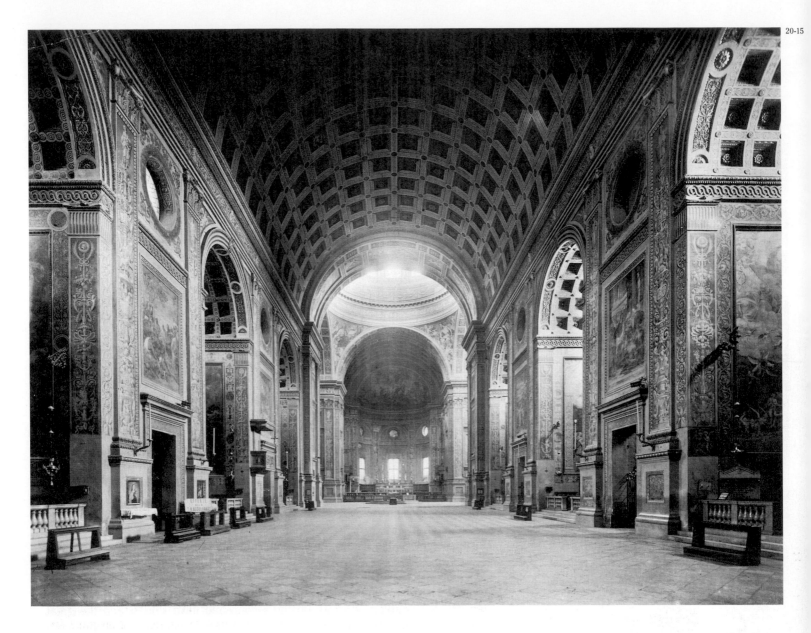

20-15. LEONBATTISTA ALBERTI. Interior, Sant'Andrea, Mantua

household of the pope, prepared for one of the most outrageous tyrants of the Renaissance a design for a building in which every tenet of Catholic Christianity was defied. Sigismondo Malatesta, lord of Rimini, was in the process of converting the Church of San Francesco at Rimini into a temple honoring himself and his mistress Isotta degli Atti. Their tombs were to appear on the façade and those of the court humanists on the flanks of the nave, Greek scholars on one side, Latin on the other. At first Sigismondo seems to have desired only a remodeling of the existing Gothic church, but Alberti persuaded him to enclose it in a wholly new marble structure (fig. 20–14). Only the nave was completed before fortune ceased to smile on Sigismondo, but there is considerable evidence to show that Alberti intended it to terminate in a rotunda, with a hemispheric dome like that of the Pantheon. He considered the central plan ideal for a "temple" (the word *church* does not appear in Alberti's writings), not only on account of the Pantheon, but also because natural organisms are so often centralized, such as flowers, fruits, and cross sections of stems. The central plan, whether circular, square, polygonal, or cruciform, was to become the dominant ideal of church architecture in the High Renaissance, culminating in the design of various architects for Saint Peter's in Rome, because of the possibilities it offered for a harmonious composition of masses and spaces. It

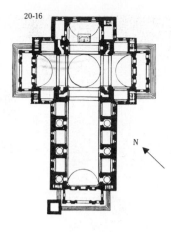

20-16. LEONBATTISTA ALBERTI. Plan of
Sant'Andrea, Mantua. Designed 1470

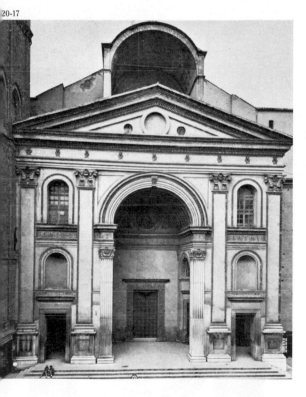

20-17. LEONBATTISTA ALBERTI. Sant'Andrea,
Mantua

must be admitted that the central plan presented obstacles for the Catholic liturgy, since an altar in its logical position under the dome would turn its back to half the congregation. Alberti's churches lead up to the domed space through a great nave, which he felt should be barrel-vaulted. At the Malatesta Temple the vault would probably have been made of wood.

As a general model for the triple-arched façade Alberti chose the Arch of Constantine. Many of the details, however, were patterned on a Roman single arch still standing in Rimini. The central arch contains the portal; the side arches were intended to hold the tombs of Sigismondo and Isotta, who in fact are interred in chapels in the nave. The single arch of the second story was to have been flanked by quarter-circles terminating the side-aisle roofs. As we would expect, the four massive engaged columns, with modified Corinthian capitals, uphold the entablature and embrace the arches. The arches containing the humanists' sarcophagi continue on a somewhat smaller scale on the flanks of the church. In contrast to the lightness, linearity, and flat surfaces of most of Brunelleschi's architecture, the ponderous columns, piers, and arches of the Malatesta Temple produce an effect of imposing sculptural grandeur.

At Sant'Andrea, in the north Italian city of Mantua, a church designed in 1470 and built almost entirely after Alberti's death, his ideas came to fuller fruition. The plan (fig. 20–16) is still a Latin cross, but different from any we have seen so far. On the grounds that the ancient Romans had invented the basilica plan for law courts, and that the colonnades obstructed the view of the ceremony for those standing in the side aisles, Alberti designed a single-aisle interior, crowned by a huge barrel vault, whose inward recession leads the eye to the apse and the high altar (fig. 20–15). The barrel vault is supported on massive piers, separating chapels covered by smaller barrel vaults running at right angles to that of the nave. A single giant order of coupled Corinthian pilasters ornaments the nave, embracing a smaller order flanking the arches of the chapels. In all probability a hemispheric dome would have completed the crossing, but this was never built; the present dome dates from the eighteenth century. The majestic and unified effect of the nave of Sant'Andrea was weakened by the sudden glare from the dome, and further dissipated by the busy, painted ornament that crawls over Alberti's noble pilasters, grimly proving his point about the danger of adding anything to perfect beauty. His plan was imitated by Bramante later on, especially at Saint Peter's in Rome (see fig. 26–12). Since the same plan was adopted by Giacomo da Vignola for Il Gesù in Rome (see fig. 23–35) and subsequently followed in innumerable Baroque churches throughout Europe, Alberti may be said to have dealt the death blow to the basilica plan, which, with few exceptions, had dominated Christian church architecture for eleven centuries.

In keeping with Alberti's belief that the illumination of a temple should be high, so that one could see only the heavens in order to inspire awe and reverence for the mystery of the "gods," the interior of Sant'Andrea is lighted only by oculi in the main and transept façades (invisible from the street) and by smaller oculi between the piers and in the chapels. As in the Pantheon (and most likely in the Malatesta Temple), light would probably have come through an oculus in the center of the dome.

The façade (fig. 20–17), restricted by preceding constructions, is a slightly enriched version of one bay of the nave, surmounted by a pediment. Because of the lack of building stone in Mantua, the church is constructed of brick faced with plaster, save for exposed brickwork trimming the pilasters of the façade. Imported marble, however, was used for the elegant pilasters of the smaller order, including the central arch and entablature, and for the portal. The façade is considerably lower than the church behind it, but, given the angle from which it must be viewed in the constricted piazza in front of it, this discrepancy is not visible. The arched excrescence over the pediment is a later addition, presumably to shade the oculus window from the direct western sunlight.

GIULIANO DA SANGALLO A member of a remarkable family of architects and sculptors, Giuliano da Sangallo (1443?–1516) was a close student of Roman antiquity; in fact, some of our knowledge of now-vanished Roman buildings has been gained from his drawings. Sangallo's Church of Santa Maria delle Carceri at Prato, near Florence (fig. 20–18), built from 1485 to 1492, owes debts to both Brunelleschi and Alberti. The ribbed dome, with its circular drum pierced by oculi, is based on that of the Pazzi Chapel (see fig. 20–7), which will be repeated again and again in the Early Renaissance, as is the contrast between *pietra serena* trim, glazed terra-cotta decoration, and white stucco walls in the interior (fig. 20–19). But the exact centrality of the Greek-cross plan is clearly Albertian, and so is the beautiful exterior with its two stories of superimposed pilasters in white marble against white and green marble paneling.

Sculpture in Florence: The Early Fifteenth Century

Certain ideas essential to the new style appeared in sculpture before they were adopted in painting. This phenomenon was by no means accidental. The commissions offered to painters consisted of altarpieces and frescoes in churches; many painters continued to work in the Late Gothic tradition up to the middle of the fifteenth century. Sculpture, on the other hand, was generally reserved for the exteriors of buildings with a strong civic purpose, such as the façade and Campanile of the Cathedral of Florence, the bronze doors of the Baptistery, or the niches of Orsanmichele, at once chapel and granary of the republic. Sometimes from not far above eye level, it appealed directly to the man in the street. The great sculptural works of the first third of the century were all done at a time when the Florentine Republic was fighting for its life, first against the duke of Milan, then against the king of Naples, then against another duke of Milan. All three of these tyrants aspired to monarchic rule of the entire Italian peninsula, wishing to absorb Florence and her somewhat less energetic ally, Venice, into an imperial superstate to the extinction of republican liberties. The new human being who appears in the works of the great Florentine sculptors, then, is the first image of the man of the Renaissance, aware of danger from without, conscious of his dignity and of the meaning of freedom, self-analytical as never before in history. In a decisive moment, comparable in importance to the fifth century B.C. in Athens or the mid-twelfth century in the Île-de-France, the stage was set for the crucial intellectual and spiritual drama, and the very nature of the sculptors' art cast them in a leading role. It is worth noting that it took another generation before the Renaissance style could be established in either Naples or Milan, and then it was a diluted importation. It should also be noted that none of the thirty-two life-size or over-life-size statues that made their appearance in Florence in this astounding period has any back! All were intended to be seen only as integral parts of the buildings from which they presided over civic life.

DONATELLO Donato di Niccolò Bardi (1386?–1466), to give the great sculptor his full name, scion of an impoverished branch of the Bardi banking family, was recognized in his twenties as one of the two or three leading sculptors in Italy and had established himself as one of the founders of the new Renaissance style. His first work in which his style is clearly evident is the *Saint Mark*, executed from 1411 to 1413, for Orsanmichele. Although each of the guilds of merchants and artisans that dominated the government of the Republic of Florence had held since 1339 the responsibility of filling its niche at Orsanmichele with a statue, only two of these were completed before the opening of the fifteenth century. Donatello's *Saint Mark* (fig. 20–20) is one of a series of statues commissioned of him and of his rivals Lorenzo Ghiberti and Nanni di Banco in a sudden rush by the guilds to fulfill their obligations.

In contradistinction to all medieval statues, the position and function of each

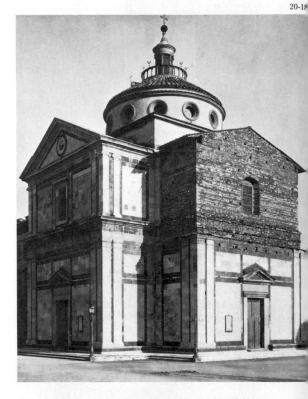

20-18. GIULIANO DA SANGALLO. Sta. Maria delle Carceri, Prato. 1485–92

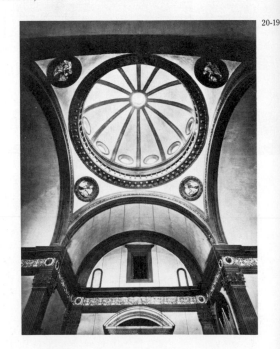

20-19. GIULIANO DA SANGALLO. Interior of the dome, Sta. Maria delle Carceri, Prato

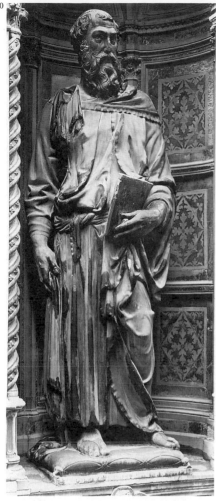

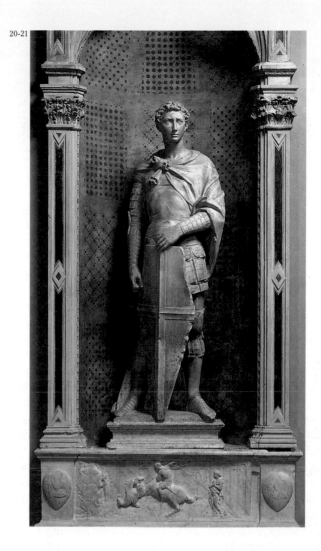

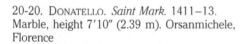

20-20. DONATELLO. *Saint Mark*. 1411–13. Marble, height 7′10″ (2.39 m). Orsanmichele, Florence

20-21. DONATELLO. *Saint George*, from Orsanmichele, Florence (where it has been replaced by a bronze copy). c. 1415–16. Marble, height 6′10″ (2.08 m). Museo Nazionale del Bargello, Florence

limb of the *Saint Mark* and its relation to the next and to the body as a whole are visible under the voluminous drapery. Vasari, the Late Renaissance painter, architect, and first art historian, described how a sculptor, in making a clothed statue, first models it in clay in the nude, then drapes about it actual cloth soaked in a thin slip of diluted clay, arranging the folds to cling or to fall as he wishes. There is evidence to show that Donatello was the first to use this method, so suggestive of the "wet drapery" of fifth-century Greek sculpture, and one must presuppose such a draped clay model for the marble *Saint Mark*. Appropriately enough, the statue was ordered by the guild of linen drapers. Donatello has represented not only a figure whose physical being is fully articulated but also a complex personality summoning up all his psychological resources to confront an external situation. "The depth and passion of that earnest glance," to borrow a phrase from Robert Browning, the anxiety so brilliantly depicted in every detail of the lined face, the beauty of the free and sketchy treatment of the curling hair and beard place the statue in the forefront of the battle for the depiction of the whole human being.

Donatello's next commission for Orsanmichele, the famous *Saint George* (fig. 20–21), carved about 1415–16 for the guild of armorers and swordmakers, crucial for beleaguered Florence, gave him no opportunity to display the movements of the body. But the energetic stance of the young warrior-saint, feet apart, both hands resting on the shield balanced on its point, shows the tension characteristic of all the great sculptor's works, down to the tautness of the folds converging on the knot that fastens the cloak about Saint George's shoulders. The sensitively modeled face is hardly that of a conventional hero but rather that of one who knows fear yet can

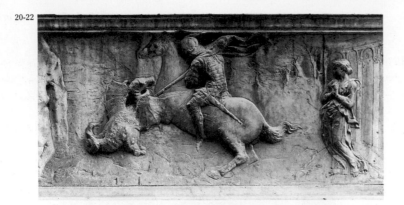

20-22

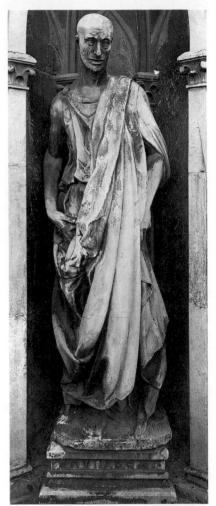

20-22. DONATELLO. *Saint George and the Dragon.* Marble relief on the base of the niche designed for *Saint George* (see fig. 20–21). Height 15¾″ (40 cm). Orsanmichele, Florence

20-23. DONATELLO. *Habakkuk (Lo Zuccone),* from the Campanile of the Cathedral of Florence. 1423–25. Marble, height 6′5″ (1.96 m). Museo dell'Opera del Duomo, Florence

20-23

marshal the strength to overcome it. The head was once helmeted and the right hand carried a sword, jutting out of the niche and into the street.

Perhaps more important historically than the statue itself is the relief representing *Saint George and the Dragon* (fig. 20–22) on the base of the niche. Here Donatello abandoned the time-honored concept of a background treated as a continuous flat surface, which the sculptor either carved down to as he cut away the original block, or built up from if he was working in clay, wax, or plaster. Donatello's innovation was to cut into the slab to any desired depth, counting on protrusions and depressions, as they reflect light or accumulate shadow, to produce on the eye the effect of nearness or distance. He has, so to speak, dissolved the slab, using it as a substance to paint or draw with, relying for his effects on what the eye sees to be there rather than what the mind knows to be there. This point marks, as sharply as any event can mark, the separation between ancient and medieval *ideal* art and Renaissance and modern *optical* art. From Donatello's discovery, adopted with varying rapidity by most sculptors and painters of his own day, spring all the other optical advances of later times, not excluding Impressionism (see Chapter Thirty-Three). Given Donatello's optical method, it is no surprise to find that the little building behind the princess is rendered in an approach to one-point perspective, or that between her and the rearing horse we can see in the distance low hills and a sky filled with clouds—perhaps the first in Italian art, preceded in Europe only by those of the Boucicaut Master and of the Limbourg brothers (see page 634 and figs. 21–4, 21–5). Donatello's series of prophet statues for the niches of the Campanile of the Cathedral of Florence are conceived in optical terms, cut in brutal masses with the features barely sketched in so that they could produce a powerful effect of light and shade from the street about thirty feet below. The most striking of these, possibly representing Habakkuk (fig. 20–23), was nicknamed *Lo Zuccone* ("Big Squash," that is, "Baldy"), for obvious reasons, in Donatello's own time. Fierce, like all of Donatello's prophets, he has little in common with the suave, beautifully draped and groomed prophetic figures, courtiers of the King of Heaven, on the portals of Gothic cathedrals. Swathed in a huge cloak that hangs in deliberately ugly folds, his eyes dilated, his mouth open, he denounces spiritual wickedness in high places.

In a gilded bronze relief representing the *Feast of Herod* (fig. 20–24), done about 1425 for the baptismal font of the Cathedral of Siena, Donatello makes, as far as we know, the first complete visual statement of the new science of one-point perspective, controlling the inward recession and diminution of the masonry of Herod's palace—walls, arches, and columns, down to the very floor tiles—about ten years before Alberti wrote his description of the method of one-point perspective in his treatise *On Painting* of 1435. But this epoch-making centripetal system is used by Donatello as a setting for an episode of passion, a composition organized only by its inherent centrifugal force. The presentation of the severed head of Saint John the Baptist at Herod's table has the effect of a bursting grenade, scattering the spectators to left and right in attitudes and expressions of horror.

In the early 1430s Donatello spent a prolonged period in Rome, reinforcing his knowledge of ancient art. Sometime after his return he must have made for the

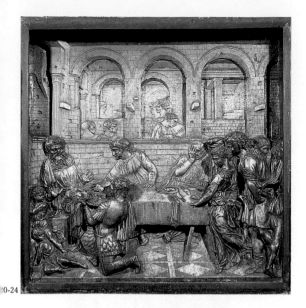

20-24. DONATELLO. *Feast of Herod.* c. 1425. Gilded bronze relief, 23⅝ × 23⅝″ (60 × 60 cm). Baptismal font, Cathedral of Siena

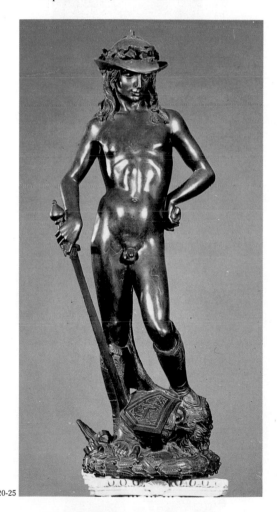

20-25. DONATELLO. *David.* c. 1440. Bronze, height 62¼″ (1.58 m). Museo Nazionale del Bargello, Florence

20-26. DONATELLO. *Equestrian Monument of Gattamelata.* 1443–53. Bronze, height 12′2″ (3.71 m). Piazza del Santo, Padua

Medici family his bronze *David* (fig. 20–25), which is not only the first nude *David* but also possibly the first freestanding nude statue since ancient times (but note in fig. 20–32 that Nanni di Banco shows a sculptor carving one). It is an astonishing work, whose beauty derives more from the sinuous grace of Donatello's line and surface than from the physical properties of the soft, unheroic, and remarkably unclassical youth. The sculptor has exploited the contrast between the detached, impassive stare of the victor and the tragic expression of the severed head, with which David's left foot lightly toys, and between the fluidity of the brilliant surfaces of bronze and the opaque roughness of the shaggy hair. In assessing the meaning of the statue, clothed only in open-toed leather boots and a laurel-crowned hat, it should be remembered that in the Middle Ages and in the Renaissance David's conquest of Goliath symbolized Christ's victory over sin and death, and that nudity still meant the nakedness of the soul before God. So, despite its appearance, the statue may have had a moralistic content.

In 1443 Donatello was called to Padua to create a colossal equestrian statue in bronze representing the Venetian general Erasmo da Narni (fig. 20–26), nicknamed Gattamelata (Calico Cat), which still stands on its original pedestal before the Basilica of Sant'Antonio. Donatello was doubtless impressed by the Roman statue of Marcus Aurelius, but the differences are instructive. The emperor appears unarmed, astride a horse reduced in scale as throughout ancient art. Donatello shows the general clad in a hybrid of Roman and contemporary armor, girded with a huge sword, wielding in his right hand a baton as if marshaling his troops, and guiding his gigantic charger by sheer force of will (the spurs do not touch the flanks and the bridle is slack). Throughout the statue the shapes are simplified to increase their apparent volume. A unifying diagonal axis runs from the lifted baton to the tip of the scabbard. Typical of Donatello's tension are the tail tied so as to describe an arc (repeating those of the buttocks and the neck) and the left forehoof toying with a

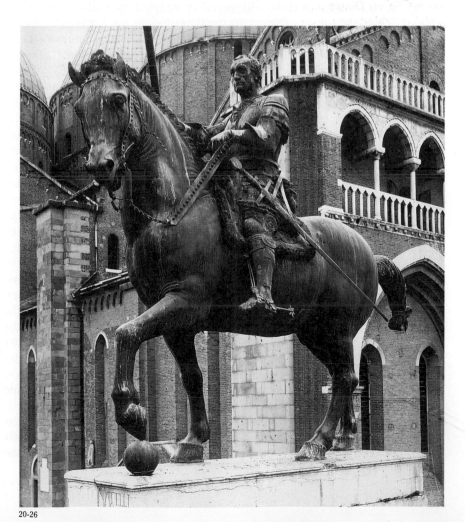

cannonball, as David's left foot does with the head of Goliath. The general is a powerful portrait, but an ideal image of command rather than a likeness; Donatello could never have seen Gattamelata, who died years before the sculptor's arrival in Padua.

On Donatello's return to Florence in 1454 the city was in the throes of a religious reaction dominated by its archbishop, later canonized as Saint Antonine. Donatello in his later years seems to have been swept along by this antihumanist current, whose effects are evident in his *Mary Magdalene* (fig. 20–27) of about 1454–55. This polychromed wooden statue shows the Magdalene in penitent old age, clothed only in her own matted hair, which a recent cleaning has revealed to be lighted by streaks of gold. Horrifying in its extreme emaciation, but even more because of the air of spiritual desolation that radiates from the ravaged features, this work seems the negation of the Renaissance faith in the nobility of man and the beauty of the human body. Writing about the Magdalene, Saint Antonine quotes from Saint Augustine, "O body, mass of corruption, what have I to do with thee?"

GHIBERTI In following Donatello's long life, we have gone past the point where he shared the glories of the Early Renaissance with his slightly older contemporary Lorenzo Ghiberti (1381?–1455). Also the author of three statues at Orsanmichele, Ghiberti is important for this book on account of his two sets of gilded bronze doors for the Baptistery of Florence, especially the second, known as the *Gates of Paradise*. Ghiberti won the first commission in competition with several other Tuscan sculptors, including Jacopo della Quercia. In the finals, in 1401–2, he found himself competing only with Brunelleschi, then still a sculptor, and their sample reliefs in bronze (figs. 20–28, 20–29), with the figures and landscape elements gilded, record the dawn of the Renaissance in the figurative arts. The assigned subject was the Sacrifice of Isaac, and the required shape, the quatrefoil (four-leaf clover), was a French Gothic form previously adopted by Andrea Pisano, the sculptor of the earliest set of doors for the Baptistery in the fourteenth century. Brunelleschi's relief shows the angel grabbing the hand of Abraham, who twists Isaac's screaming head the better to thrust the sword into his throat. Despite Brunelleschi's close observation of naturalistic details, especially in the boy's body, the donkey, and the crouching attendant, his relief is lacking in just the qualities of linear grace and harmony of proportion that we have found essential to his architecture.

Ghiberti's relief substitutes for the jagged shapes and often abrupt and jerky motion of Brunelleschi's a marvelous smoothness and grace, achieved by curves that move as if the figures were performing a slow dance, following in their motions and in the flow of their drapery the curves of the quatrefoil frame. This motion could be described as still Gothic were it not for an ease and balance that make one wonder whether Ghiberti had not seen Greek originals. His Isaac is surely the first nude figure since ancient times to show real interest in the beauty of the human body and knowledge of the interaction of its parts—a generation before Donatello's *David*.

In the doors themselves, whose execution took Ghiberti more than twenty years and whose subject was changed to the Life of Christ, Renaissance elements enter piecemeal. Only in the *Gates of Paradise*, 1425–50, representing scenes from the Old Testament, did Ghiberti absorb the spatial devices of Donatello and the architectural and perspective discoveries of Brunelleschi and Alberti (fig. 20–30). Gone are the small quatrefoils; instead, Ghiberti has enclosed several episodes from each Old Testament story in single, square frames. Each entire relief is gilded, thus unifying figures and background in a space suffused with golden light into which we can look as into a picture.

Especially striking in all ten scenes on the *Gates of Paradise* is the sense of space, not only behind the figures—Donatello and, as we shall see, Masaccio (see figs. 20–24, 20–40) had already achieved that—but *around* them. This effect is managed by

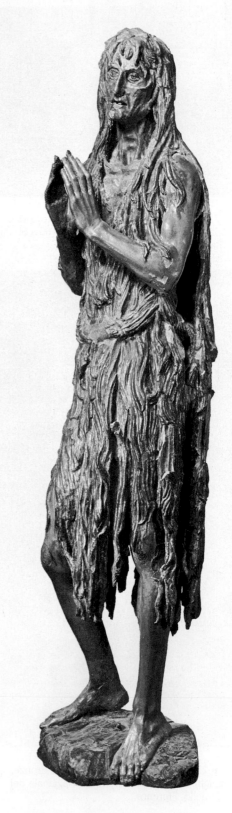

20-27

20-27. DONATELLO. *Mary Magdalene.* 1454–55. Polychromed and gilded wood, height 6'2" (1.88 m). Baptistery of S. Giovanni, Florence

20-28

20-29

20-30

20-28. LORENZO GHIBERTI. *Sacrifice of Isaac,* from the competition to design the north doors of the Baptistery of S. Giovanni, Florence. 1401–2. Gilded bronze relief, dimensions inside molding 21 × 17½″ (53.3 × 44.5 cm). Museo Nazionale del Bargello, Florence

20-29. FILIPPO BRUNELLESCHI. *Sacrifice of Isaac,* from the competition to design the north doors of the Baptistery of S. Giovanni, Florence. 1401–2. Gilded bronze relief, dimensions inside molding 21 × 17½″ (53.3 × 44.5 cm). Museo Nazionale del Bargello, Florence

20-30. LORENZO GHIBERTI. *Gates of Paradise* (east doors), Baptistery, Florence. 1425–50. Gilded bronze, height approx. 15′ (4.58 m)

keeping the scale of the foreground figures roughly the same as in the competition relief, within a frame whose area is quadrupled. Thus at one blow Ghiberti has demolished the age-old convention of a double scale for figures and setting and established a single, unified space in keeping with Alberti's admonitions. This is evident in the *Story of Jacob and Esau* (fig. 20–31). The open portico of Isaac's dwelling, Albertian in the use of pilasters as decorations and arches as supports, is Albertian also in the accuracy of its perspective recession, taking the observer through one arch after another into what appears to be great depth. (The actual projections are never more than an inch or so, and generally a mere fraction.) Renaissance art has here achieved a cubic graph of space, in which the dimensions of every object and every person are determined by the square on which he stands, and therefore by his imagined distance from the spectator's eye. The last traces of Gothicism in line and pose have been transmuted into Hellenic grace and ease. Despite their diminutive scale, such figures as the angry Esau standing before his

20-31. LORENZO GHIBERTI. *Story of Jacob and Esau,* detail of the *Gates of Paradise.* 1425–50. Gilded bronze relief, 31¼ × 31¼″ (79.4 × 79.4 cm). Baptistery of S. Giovanni, Florence

perplexed father or the three beautiful female figures at the left can be set against the masterpieces of Greek sculpture. All ten reliefs were modeled in wax by 1437, two years after the appearance of Alberti's *On Painting.* Well could Ghiberti boast that the new art of his time had achieved values unknown to the ancients. Like Alberti, Ghiberti was the author of a theoretical treatise, called in good Roman fashion *The Commentaries,* a remarkable amalgam of optical knowledge and Renaissance learning.

NANNI DI BANCO A third sculptor highly influential in the development of the Early Renaissance was the short-lived Nanni di Banco (1385?–1421), the most openly classicistic of the entire group. Like Donatello and Ghiberti, he was entrusted with the sculptures for three niches at Orsanmichele. The most impressive is the group of *Four Crowned Martyrs* (fig. 20–32), for the guild of workers in stone and wood, commemorating four Christian sculptors who, according to legend, preferred death to betraying their faith by obeying an imperial command to carve a statue of the god Aesculapius. Nanni intended the observer to draw the comparison between the martyrs and the contemporary Florentines united in defense of liberty. In spite of their still-Gothic niche, the figures are dressed in mantles that fall about them like Roman togas and impart a Roman gravity. Both the mantles and the forthright carving of the individualized faces were doubtless emulated from Roman originals in order to reinforce the resolve of the Florentine Republic by the example of stoic dignity. The stoneworkers in the scene below, who are building a wall, carving a column, measuring a capital, and finishing a statue, are dressed in contemporary clothes. To the end of his brief career Nanni opposed the optical innovations of Donatello, never violating the flat background or sketching a detail he could carve in the round.

LUCA DELLA ROBBIA Nanni di Banco's classicism was continued in a gentler manner by Luca della Robbia (1400–1482), whose name was included by Alberti with those of Brunelleschi, Donatello, Ghiberti, and Masaccio as founders of the new style. Alberti must have been thinking of Luca's *Cantoria* (musicians' gallery; 1431–38; fig. 20–33) for the Cathedral of Florence; the architectural framework, with its Corinthian order of coupled pilasters enclosing square reliefs and upheld by magnificent acanthus consoles, is strongly Albertian, and in the reliefs the sculptor combined a classical harmony of fold structure, emulated from such a monument as the Roman Ara Pacis, with the warm, contemporary naturalness of Filippo Lippi (see fig. 20–45). The words of Psalm 150 (*Laudate Domino*), inscribed in its entirety in Latin capitals on all the horizontal strips of the gallery, are

20-32. NANNI DI BANCO. *Four Crowned Martyrs.* c. 1413. Marble, life size. Orsanmichele, Florence

20-33

20-33. LUCA DELLA ROBBIA. *Cantoria,* from the Cathedral of Florence. 1431–38. Marble, length 17′ (5.18 m). Museo dell'Opera del Duomo, Florence

20-34. JACOPO DELLA QUERCIA. *Creation of Adam,* relief on the main portal, S. Petronio, Bologna. 1425–38. Marble, 33½ × 27¼″ (85 × 69.2 cm)

20-35. JACOPO DELLA QUERCIA. *Expulsion from Eden,* relief on the main portal, S. Petronio, Bologna. 1425–38. Marble, 33½ × 27¼″ (85 × 69.2 cm)

20-34

20-35

illustrated by joyous groups of youths and maidens in the costume of the day, and by small boys in none at all, who praise the Lord in the adjacent words of the psalm with song, with trumpet, with timbrel, with stringed instruments, with the psaltery, with harp, with cymbals, with dance, but not—though they are mentioned in the psalm—with organs, which may mean that actual "portative" organs were played in the gallery. Alberti could not have foreseen that the sculptor would not progress beyond this point. Luca did invent a new technique of producing architectural sculpture in terra-cotta, glazed white for the figures, sky blue for the background, and relieved by occasional touches of color in the ornament. This terra-cotta sculpture was not only cheap and resistant but also extremely effective in the decoration of architecture in the Brunelleschian tradition (see figs. 20–4, 20–9). Luca's many works in this delightful manner conveyed the grace and charm of his personality, but the technique was obviously limited. In the hands of Luca's relatives and successors, who operated well into the sixteenth century, it eventually degenerated into manufacture.

JACOPO DELLA QUERCIA Alberti's inclusion of the latecomer Luca della Robbia in his list of the founders of Renaissance art is no more surprising than his omission of Nanni di Banco and a contemporary Sienese, Jacopo della Quercia (1374?–1438), the elemental power of whose style entitles him to be ranked above every Early Renaissance sculptor save only Donatello and Ghiberti. Alberti's oversight is especially remarkable since Jacopo was one of the runners-up in the competition for the Baptistery doors, created major works in Siena and Lucca, and, at the time Alberti wrote, was engaged in carving the reliefs for the main portal of the Church of San Petronio in Bologna. True, Jacopo's backgrounds were limited to the rock masses and miniature architecture familiar to us from fourteenth-century painting, but never since Hellenistic art had human figures been raised to such a plane of heroic action as in the San Petronio reliefs. In this respect Jacopo can be considered a real pioneer; his powerful compositions, his expressive intensity, and his heavily muscled figures deeply influenced the young Michelangelo in the following century. Although the *Expulsion from Eden* was done after Masaccio had finished painting his version of the subject (see fig. 20–40), it was derived not from Masaccio but from an almost identical composition in Siena by Jacopo himself, executed between 1414 and 1419. In the first of these panels (fig. 20–34) the magnificent Adam, whose name in Hebrew means "from the earth," awakes from the ground at the Lord's command to a realization of his own power; in the second (fig. 20–35), in tragic contrast, Adam and Eve (the latter's pose surely derives from a classical Venus type) struggle helplessly against a powerful angel who lightly expels them from the gate of Eden.

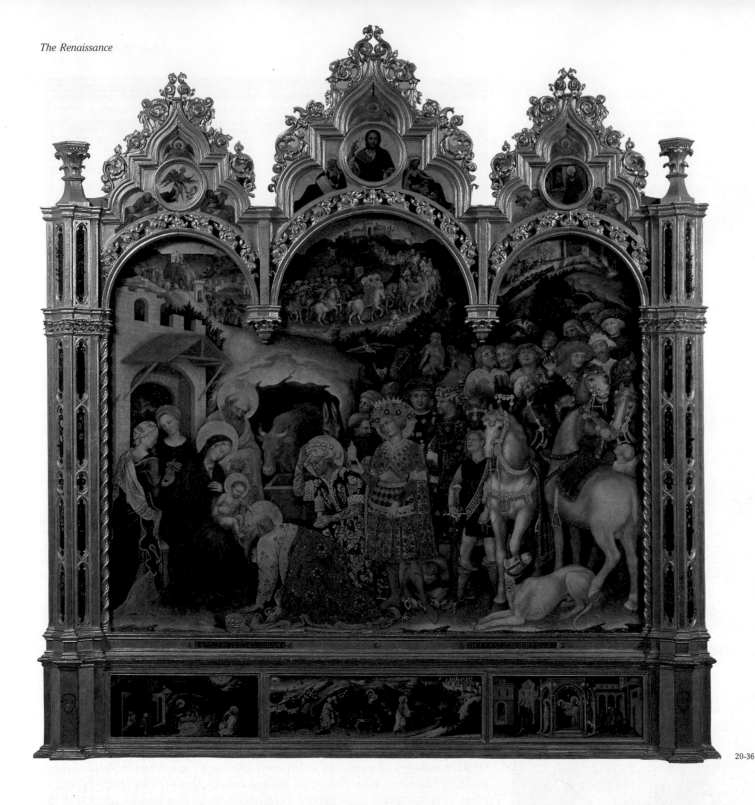

20-36

Painting in Florence: The Early Fifteenth Century

20-36. GENTILE DA FABRIANO. *Adoration of the Magi (Strozzi Altarpiece)*. Completed 1423. Oil on panel, 9'10½" × 9'3" (3 × 2.88 m). Galleria degli Uffizi, Florence

GENTILE DA FABRIANO The appearance in Florence in 1421 of Gentile da Fabriano (1380/5?–1427), a painter from the Adriatic coast of Italy, marked the beginning of a revolution in the art of painting, which thus far had shown little interest in the developments that had just transformed architecture and sculpture. Gentile was probably in his middle or late thirties, and under strong influence from the art of the Burgundian region, where, as we shall see (Chapter Twenty-One), a vivid new naturalism paralleled the discoveries of the Florentine sculptors. He had been highly successful in Venice as early as 1408. If we judge by the completion date of May 1423, inscribed along with his signature on his masterpiece, the

elaborate altarpiece for the Church of Santa Trinita representing the *Adoration of the Magi* (fig. 20–36), Gentile must have started it soon after his arrival in Florence. The altarpiece was painted for Palla Strozzi, the richest man in Florence, and he spared no expense. The Three Magi in the foreground stand or kneel before the cave of the Nativity and an adjacent ruin, inundating the desolate scene with the splendor of their richly colored and gilded robes, crowns, and spurs and disturbing its silence with their restive horses and dogs and their chattering attendants, some of whom play with monkeys while others launch falcons upon their prey. In the distance the Magi and their train can be seen journeying across sea and land and winding up distant hills toward walled cities. Undoubtedly, Gentile had seen works, such as those of the Limbourg brothers (see fig. 21–6), that this scene strongly recalls.

The Flamboyant Gothic frame, alive with red-winged seraphim in the gables and recumbent prophets in the spandrels, with the *Annunciation* in two roundels with a blessing God the Father in a third between them, and bursting with carved and gilded ornament, must have seemed both outlandish and outdated to Brunelleschi and Donatello. But the painting itself overflows with innovations. The horses are foreshortened in a manner unknown to Italian art before this time, and such figures as the groom in blue crouching toward us to remove the spurs of the youngest Magus, and the spherical heads of some of the attendants, are treated in a new manner, revolving convincingly in space. In the body of the altarpiece the landscape goes beyond Ambrogio Lorenzetti (see fig. 19–18) in sheer extent but shows no assimilation of Florentine perspective innovations and ends up with a gold background instead of a sky. Not so the predella scenes, set on little stages and betraying study of Donatello's *Saint George and the Dragon* relief (see fig. 20–22) and with arcades looking a bit like those of Brunelleschi's Ospedale degli Innocenti (see fig. 20–4).

Above all, the magical *Nativity* scene (fig. 20–37) shows a new understanding of the nature of light. It is the first night scene we know in which all foreground illumination comes from a single source within the picture (in this case, the shining Child). Gentile must have experimented with an actual model of the ruined shed, the cave, and the figures, placing a candle in the foreground in order to study how light played upon the objects and the behavior of the shadows (the first cast shadows in Italian art). Nevertheless, the pool of spiritual light around the Child is still gold leaf. The scene, with the adoring Virgin, the gentle animals, the sleeping Joseph, the curious midwives, the secondary illumination from the angel descend-

20-37. GENTILE DA FABRIANO. *Nativity,* scene from the predella of the *Strozzi Altarpiece.* Completed 1423. Panel painting, 12¼ × 29½″ (31 × 75 cm). Galleria degli Uffizi, Florence

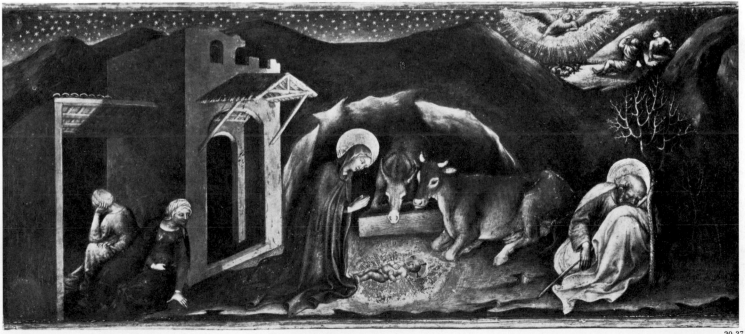

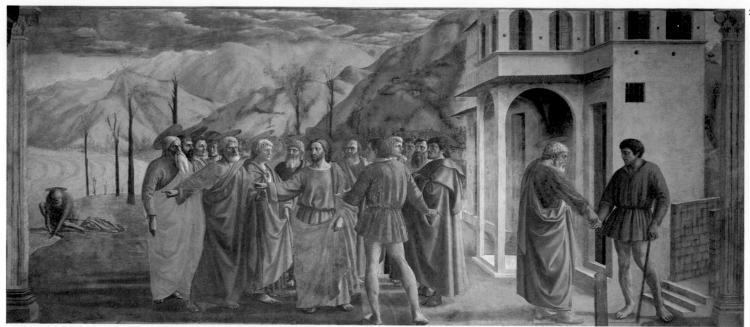
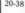

ing toward the shepherds on their dark hilltop under the stars, is intensely poetic. But its importance for developing Renaissance painting is that here Gentile has not only adopted but extended the optical principles first enunciated by Donatello. Gentile's altarpiece was the most advanced painting in Europe in 1423.

MASACCIO An astonishing genius appeared upon the scene to capture Gentile's title almost immediately; Tommaso di Ser Giovanni (1401– 28?) was known to his contemporaries as Masaccio (untranslatable, but *Maso* means "Tom," and the suffix *accio* usually signifies "ugly" but can mean "sloppy"), possibly because he was so completely devoted to his art that he paid little attention to practical matters, including his appearance. In his mid-twenties Masaccio revolutionized the art of painting, and, if the generally accepted date of his death is correct, died just before his twenty-seventh birthday. His innovations are visible in the frescoes he painted about 1425 in the chapel of the Brancacci family in the Church of Santa Maria del Carmine in Florence. Recently and magnificently cleaned, the frescoes, once thought to be heavily modeled in light and dark, now glow with a fresh and flower-like color close to that of Giotto. A glance at the principal scene in this series, the *Tribute Money* (fig. 20–38), would seem to place Gentile's *Adoration* two decades in the past instead of only two years. The lessons of the new optical style, which Gentile had learned piecemeal, were absorbed by Masaccio at once and in their totality, and he created a new and almost hallucinatory sense of actual masses existing in actual space.

The unusual subject (Matthew 17:24–27) recounts how when Christ and the Apostles arrived at Capernaum, the Roman tax gatherer came to collect the tribute; Christ told Peter he would find the tribute money in the mouth of a fish in the nearby Sea of Galilee; Peter cast for the fish, found the coin, and paid the tax gatherer. The solemnity with which Masaccio has endowed so trivial an event may derive from its relevancy to a new form of taxation then being debated among the Florentines to finance their war of survival against the duke of Milan. The artist has arranged the Apostle figures in a semicircle around Christ, with the discovery of the money placed in the middle distance at the left and the payoff at the right. The Apostles (fig. 20–39), as intense, as plebeian, as individualized as Donatello's contemporary prophets for the Campanile, are enveloped in cloaks that give them not only the grandeur of sculpture but also a sense of existence in space that recalls Giotto (see figs. 19–9, 19–10) more than a century before.

But unlike Giotto, Masaccio has performed his miracle almost entirely without the use of line, which for him exists only when a mass of a certain color and degree

20-38. Masaccio. *Tribute Money,* fresco, Brancacci Chapel, Sta. Maria del Carmine, Florence. c. 1425

20-39. Masaccio. *Heads of the Apostles* (detail of the *Tribute Money*)

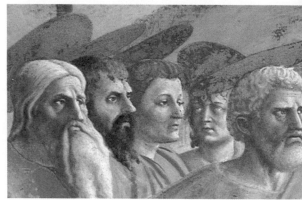

20-39

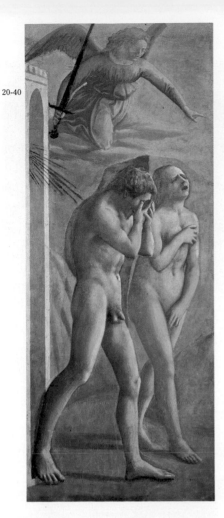

20-40. MASACCIO. *Expulsion from Eden*, fresco, Brancacci Chapel, Sta. Maria del Carmine, Florence. c. 1425

20-41. MASACCIO. *Madonna and Child Enthroned*, center panel of an altarpiece (now divided) painted for Sta. Maria del Carmine, Pisa. 1426. Panel painting, 53¼ × 28¾″ (135.3 × 73 cm). National Gallery, London. Reproduced by courtesy of the Trustees

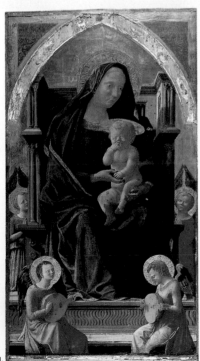

of light overlaps a different mass. Form is achieved by the impact of light on an object. Masaccio does not need Gentile's candle in the darkness before a model; the actual light of the window of the Brancacci Chapel is enough for him. The window, obviously to the right, appears to throw light into the fresco as into a real space, to send the towering figures into three-dimensional existence, and to cast their shadows upon the ground, just as it affirms the cubic shapes of the simple building at the right with actual light and cast shadow. In this picture Masaccio proves the justice of a simple maxim in Ghiberti's *Commentaries,* "Nessuna cosa si vede senza la luce" ("Nothing is seen without light").

Giotto had attempted to take us only a few yards back into the picture, where we immediately encountered the flat, blue wall. Following Donatello and Gentile, but more convincingly than either, Masaccio leads the eye into the distance, over the shore of Galilee, past half-dead trees, apparently with new branches and foliage coming forth, to range on range of far-off mountains, and eventually to the sky with its floating clouds. The foliage, the little chapel on the hillside, and even the faces of the Apostles are painted in with quick, soft strokes of the brush, akin to Donatello's sketchy sculptural surface. The sense of real space is so compelling that we tend to forget the remnants of medievalism that remain (architecture and figures not yet represented according to the same scale). The setting is Florentine; the lakeshore resembles a curve in the Arno, and the mountains the familiar line of the Pratomagno, the range towering beyond Florence to the east. Even more, the simplicity and grandeur of the scene are intensely Florentine. Gone is the magnificence of Gentile's gold and of his splendid fabrics, along with the richness of his detail. Masaccio's style, characterized by Cristoforo Landino, the fifteenth-century commentator on Dante, as "puro, senza ornato" ("pure, without ornament"), deals in this sublime work with the essentials of our relationship to the natural world and, even more, with God's mindfulness of the doings of men and women.

On the narrow entrance wall of the chapel, Masaccio painted his version of the *Expulsion from Eden* (fig. 20–40), obviously related to the composition of Jacopo della Quercia (see fig. 20–35), yet profoundly different. Jacopo had characterized the scene as a losing battle between the resisting Adam and the expelling angel. In Masaccio the clothed angel floats lightly above, sword in one hand, the other hand pointing into a desolate and treeless world. Adam, his powerful body shaken with sobs, covers his face with his hands in a paroxysm of guilt and grief; Eve covers her nakedness with her hands as in Jacopo but lifts up her face in a scream of pain. Never before had nude figures been painted with such breadth and ease, their volume indicated almost solely by light and shade. As the removal of the later girdles of leaves has shown, never before had nudes been painted with such astonishing fidelity to fact. Most important of all, never before had man's separation from God been represented with such tragic intensity. By the late fifteenth century the Brancacci Chapel had become the place where young artists, including Michelangelo, went to learn by drawing from Masaccio—the basic principles of form, space, light, and shade of the Renaissance style in painting.

Masaccio's *Madonna and Child Enthroned* (fig. 20–41), the central panel of a now widely scattered altarpiece painted in 1426 for the Church of Santa Maria del Carmine in Pisa, is less than half the height of the *Madonna and Child Enthroned* by Giotto (see fig. 19–8), which it nonetheless rivals in majesty. In spite of the still-Gothic pointed arches used for the panels and the gold background (possibly both demanded by the conservative Pisan patron), this is a fully Renaissance picture. Masaccio has set the Virgin so high that her feet are about at our eye level, and enthroned her upon a remarkable three-story construction with Corinthian columns, which tends to increase the apparent bulk of the figure. Masaccio's strong side light throws the figures, the drapery, the details of the architecture, even the exquisitely projected angels' lutes into compelling relief against the shadows they cast on other masses. The Virgin, the Child, and the angels are homely types, as if Masaccio were deliberately avoiding the tradition of physical beauty.

Probably the last work of Masaccio we possess before his departure for Rome and his untimely death is the fresco of the *Holy Trinity with the Virgin, Saint John, and Two Donors* (fig. 20–42), whose painted architecture is so Brunelleschian that it seems impossible he could have painted it before the works we have just seen. The perspective view from below, which we have noticed in the *Madonna and Child Enthroned,* is employed systematically here to produce a striking illusion of three-dimensional reality. Vasari speaks of the architecture as a painted chapel piercing the real wall. The Corinthian pilasters, similar to those that terminate the Ospedale degli Innocenti (see fig. 20–4), flank a massive barrel vault supported on Ionic columns two-thirds the height of the pilasters. Diagonals drawn from the Corinthian to the Ionic capitals would exactly parallel the orthogonals of the coffered vault. The viewpoint is precisely that of a person of average height standing on the floor before the fresco. Below the altar slab (now incorrectly restored), recent investigation has uncovered a painted skeleton, accompanied by an Italian inscription that reads in English: "I was once that which you are, and that which I am you also will be." On either side, on a step above the altar, outside the architecture and therefore in the space of the church, kneel two members of the Lenzi family praying for the soul of the departed, portraits of remarkable dignity, naturalism, and sculptural power. Within the painted chapel a solemn Mary and an adoring John flank the Cross of Christ, behind which, on a projecting pedestal, stands God the Father, his arms outstretched to the bars of the Cross, while the Holy Spirit in the form of a dove floats between the heads of Father and Son. The vertical pyramid of figures, from the praying donors through the interceding saints, intersects the descending pyramid of perspective in the body of the crucified Christ. Never have the essential mysteries of Catholicism—the sacrifice of Christ at the will of the Father to redeem man from sin and death and the daily perpetuation of that sacrifice in the Mass—been presented in more compelling terms than in this painting, which also sums up all that the Early Renaissance was trying to say.

FRA ANGELICO Masaccio left no gifted pupils; after his death the mantle of leadership fell on the shoulders of two monks who could scarcely have been more different: Fra Angelico, who was raised as recently as 1986 to the rank of Beatus (Blessed), just below sainthood, and Fra Filippo Lippi, who was eventually defrocked. A year or so older than Masaccio but, if anything, more precocious, Fra Angelico (c. 1400–1455) was still a layman named Guido di Pietro in 1417 and already a painter in the Late Gothic tradition. About 1423 he entered the Dominican Order, and in 1445, succeeding Saint Antonine, became prior of the Monastery of San Marco in Florence. His unworldliness and his veneration for the tradition of Giotto (who came from the valley called the Mugello where Angelico was born) have perhaps been responsible for his incorrect classification as a "conservative" painter. Although he was closed—perhaps by choice—to the world of inner crisis so powerfully set forth by Donatello and Masaccio, Angelico was the greatest master of landscape and light of the 1430s. In 1438 he was mentioned by Domenico Veneziano (see page 609) as one of the two leading masters of Florence (the other was Fra Filippo Lippi), and in the 1440s he was known at the papal court as "famous beyond all other Italian painters."

Before 1434 Palla Strozzi commissioned Angelico to paint a *Descent from the Cross* (fig. 20–43) for the family chapel, the sacristy of the Church of Santa Trinita, where in 1423 he had placed the *Adoration of the Magi* by Gentile da Fabriano (see fig. 20–36). The panel had been prepared and the Gothic frame carved and partly painted by an older master, Lorenzo Monaco, whose work was interrupted by death in 1425. Despite the initial handicap of the pointed arches, Angelico was able to create a composition of the greatest formal, spatial, and coloristic beauty, utilizing the central arch to hold the Cross and the ladders and the side arches to embrace landscape views.

In keeping with its placement in a sacristy, where the clergy prepare to celebrate

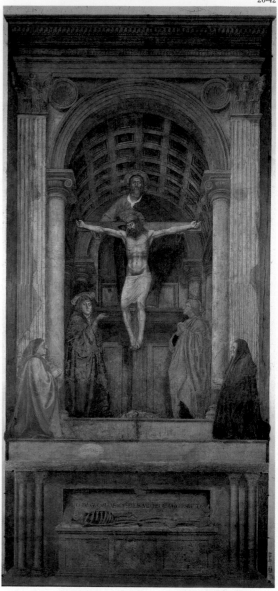

20-42

20-42. MASACCIO. *Holy Trinity with the Virgin, Saint John, and Two Donors,* fresco, Sta. Maria Novella, Florence. c. 1428

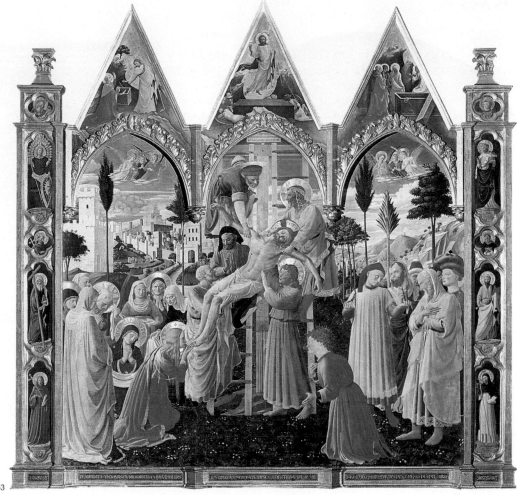

20-43. FRA ANGELICO. *Descent from the Cross* (frame and pinnacles by LORENZO MONACO). Completed c. 1434. Panel painting, 9′ × 9′3″ (2.74 × 2.82 m). Museo di S. Marco, Florence

20-43

the Mass in which the sacrifice of Christ's body is perpetuated, the picture places less emphasis on dramatic elements of pain and grief than on the ritual presentation of the sacrificed Savior. Bathed in strong sunlight, the scene sparkles with bright colors. The ground is a continuous lawn, receding into the middle distance and dotted with wild flowers. A single rocky outcropping supports the Cross and receives streams of the sacred blood from the footrest. The figures are scattered throughout the foreground and even into the middle distance, which is utilized more successfully than in any earlier Italian painting. At the left the Holy Women gather about the kneeling Mary, extending the shroud before her; Mary Magdalene kisses the feet of Christ. At the right a group of Florentines in contemporary dress, contemplating the Crown of Thorns and the nails, may include portraits of Palla Strozzi and his sons. The body of Christ, suffused with sunlight yet still showing the marks of the scourges, is reverently lowered, and at the same time displayed, by five men, including John, Nicodemus, and Joseph of Arimathea. Although Angelico's reluctance to indicate the movements of the limbs within the brilliantly colored, tubular drapery masses makes his figures look at times Giottesque, he establishes them as freestanding volumes in space, modeled by light, in the manner of Masaccio. And in his delicate treatment of the body of Christ he shows an understanding of the nude worthy of the great contemporary sculptors.

The background landscapes are the most advanced in Italian art of the time, startling in the beauty of their space and light. On the left, one looks over field and farm to the cubic, distinctly Florentine ramparts of Jerusalem, saturated by the late afternoon sun. A cloud mass has just rolled away from the city, as if in naturalistic explanation of the darkness that fell over the land while Christ hung upon the Cross. To the right, between the tall trunks of trees, the eye moves into an enchanting view of the landscape visible to the north of Florence, with rolling, olive-colored hills capped by villas and castle towers, receding range upon range to

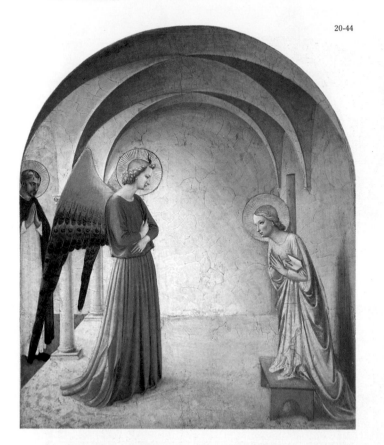

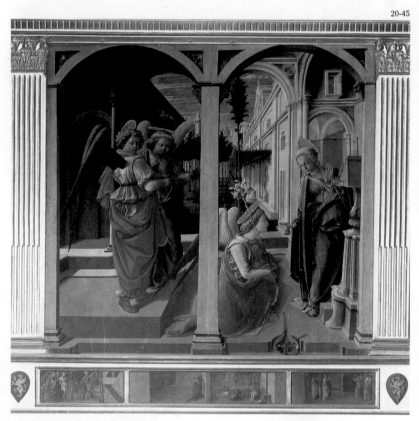

the cloud-filled horizon. In the poetry of this fully Renaissance picture, Christian mysticism is blended with a new joy in the loveliness of created things, transfigured by faith.

The mistaken notion of Angelico's conservatism, easily dispelled by the masterpieces of the 1430s, is doubtless based on his renunciation of natural beauties, in order to enhance contemplation, in the small frescoes he and his pupils painted during the early 1440s in each of the monks' cells in the Monastery of San Marco. In the *Annunciation* (fig. 20–44), for example, the background is reduced to two bays of a white-plastered, vaulted corridor. Mary kneels; the angel appears before her, a flame leaping from his forehead, along with the light, which is at once natural and divine, glowing softly in the midst of the cell and transfiguring the humble maiden with the radiance of eternity. The rhythms of the architecture flow in harmony with the delicate, almost bodiless figures. Mary receives the Incarnate Word with quiet joy, as the monastic spectator, following the example of the adoring Dominican saint, was expected to do in solitary meditation. Due to the stripped-down composition, the picture may seem primitive, yet the knowledge of space and light proclaims it as a Renaissance work; so, in a deeper sense, does its appeal to the individual. This painting is the ancestor of some of the mystical pictures of the seventeenth century, above all those of Zurbarán (see fig. 27–33).

FRA FILIPPO LIPPI Placed in the Monastery of the Carmine at Florence by his father as a child, Filippo Lippi (c. 1406–69) was said by Vasari to have decided to become a painter when, at about nineteen years of age, he watched Masaccio at work in the Brancacci Chapel. An early work, the *Annunciation* (fig. 20–45), still in its beautiful position in San Lorenzo, shows what this wayward master made of his artistic heritage. The cloister background starts as an inward extension of the Brunelleschian frame, but that great architect would have been less than pleased by the constantly shifting levels and odd architectural shapes and proportions. Nonetheless, the perspective view of the closed garden (age-old symbol of the virginity of Mary, drawn from the Song of Solomon) is delightful, with its trees and

20-44. Fra Angelico. *Annunciation,* fresco, Monastery of S. Marco, Florence. 1438–45

20-45. Fra Filippo Lippi. *Annunciation.* c. 1440. Panel painting, 69 × 72″ (1.75 × 1.83 m). S. Lorenzo, Florence

20-46. FRA FILIPPO LIPPI. *Madonna and Child.*
c. 1452. Panel painting, diameter 53″ (1.35 m).
Palazzo Pitti, Florence

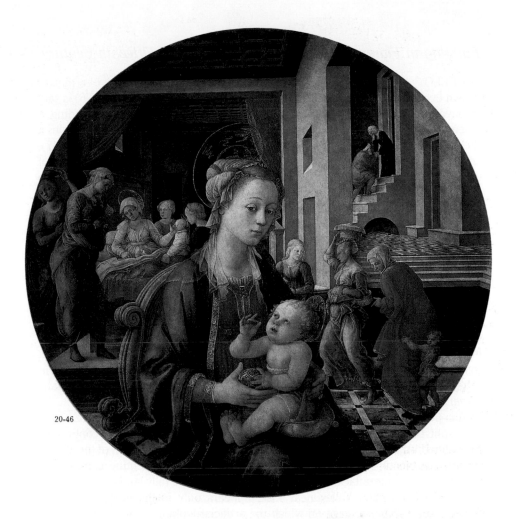

trellis and blue sky streaked with filmy clouds. Within the Masaccesque light and shade of his deep space, Filippo has set not only the agitated Virgin drawn from her reading by the kneeling boy-angel but also two supernumerary angels not mentioned in Scripture, one of whom looks out at the spectator while he points to the action, according to Alberti's directions for composing a picture. The chubby faces and blond curls, as well as the bright and sometimes arbitrary colors (one angel has bronze-green wings, another bright orange), have little to do with Masaccio's severity. The figures are powerfully modeled by direct light and deep shadow but, like all the elements in Filippo's paintings, are bounded by the neat, linear contours that Masaccio had rejected. An element of special beauty is the little crystal vase half full of shining water, in a niche cut out of the foreground step, from which the announcing angel seems to have plucked the lily.

Perhaps the finest example of Filippo's late, even more worldly style is the *tondo* (meaning "round," a shape favored into the sixteenth century in Florence for pictures made to be hung in private homes) representing the *Madonna and Child* (fig. 20–46). The wistful, delicate girl who posed for the Virgin is believed, following an unlikely tradition recorded by Vasari, to have been the runaway nun Lucrezia Buti, mother of the artist's son Filippino and the principal reason for Filippo's expulsion. Unfortunately for the story, at the probable time of the painting Filippo and Lucrezia had not yet met. Painted with a grace that already points toward Filippo's great pupil Botticelli, the foreground figures introduce us to agreeable views of an upper-class Florentine home of the fifteenth century, with its cubic rooms and marble floors, as a setting for the Birth of the Virgin on the left and the Meeting of Joachim and Anna on the right. In this elegant world the severity of Masaccio has been all but forgotten.

Painting in Florence and Central Italy: The Mid-Fifteenth Century

UCCELLO Albertian perspective is carried to extremes in the work of a master known even in the Renaissance as an eccentric. Paolo Uccello (1397–1475) is said to have burned the midnight oil over perspective constructions, including a seventy-two-sided polyhedron, from each facet of which projected at right angles a stick bearing a scroll, all set forth in flawless perspective. His *Deluge* (fig. 20–47), one of a group of frescoes done largely in *terra verde* ("green earth": a type of underpaint) in the Chiostro Verde of Santa Maria Novella in Florence, shows two episodes from the Flood within a single frame. On the left towers the Ark, its massive sides receding rapidly toward the vanishing point, just missed by a bolt of lightning, which illuminates the humans, clothed and nude, trying to keep afloat or clutching desperately at the planks of the Ark. Not only these but also a ladder with its rungs diminishing according to plan and even a *mazzocchio* (the wood-and-wicker construction that supported the turban-like headdress of the Florentine citizen), which has slipped down around the neck of a hapless youth, serve to exhibit Uccello's prowess in forcing unwilling objects to comply with the laws of one-point perspective. On the right the Ark has come to rest on a ground littered with corpses of humans and animals—seen in perspective, of course. Noah leans from a window of the Ark, in colloquy with a majestic but still-unidentified figure, reminiscent of the prophets and apostles of Donatello and Masaccio. Almost in spite of Uccello's obsession with perspective, the *Deluge* exerts great dramatic power.

This power is less evident in the three episodes from the *Battle of San Romano,* now split between three different museums, which once formed a continuous frieze fitted into the elaborate wooden paneling of the state bedroom of the Medici Palace. In one of them (fig. 20–48), which shows the Florentine commander directing the counterattack against the Sienese forces, the hilly landscape near San Romano, in the Arno Valley near Pisa, appears only in the background. The foreground becomes a stage on which the artificial-looking horses with armored riders prance delightfully. Uccello seems less interested in the ferocity of battle than in the patterns that can be formed from armor and weapons. Broken lances have a tendency to fall according to the orthogonals of one-point perspective, and a fallen armored warrior at the left even manages to die in perspective.

20-47. PAOLO UCCELLO. *Deluge,* fresco, Chiostro Verde, Sta. Maria Novella, Florence. c. 1445–47

20-47

20-48. PAOLO UCCELLO. *Battle of San Romano.*
c. 1445. Panel painting, 6′ × 10′6″ (1.83 ×
3.2 m). National Gallery, London. Reproduced
by courtesy of the Trustees

DOMENICO VENEZIANO The new understanding of light and color brought to
Florentine art by Fra Angelico was extended and enriched by an outsider,
Domenico Veneziano (c. 1410–61), who, as his surname indicates, came from
Venice. In a letter of 1438 written to Piero de' Medici, Domenico promised that he
would show the Florentines marvelous things, never before seen. This he indeed
did in his *Saint Lucy Altarpiece* (fig. 20–49), depicting the Madonna and Child
flanked by Saints Francis, John the Baptist, Zenobius, and Lucy, although it is clear
that in turn he had learned much from the Florentines. The setting is a partly
Gothic, partly Renaissance courtyard, whose pointed arches are supported on
colonnettes resembling those by Michelozzo in the windows of the Medici Palace.
Both the architecture and the intricate inlay patterns of the marble terrace are
drawn in strict adherence to one-point perspective. The projection of figures and
drapery and the close attention to anatomical construction, as well as the firm
modeling of the features, betray careful study of the great sculptural and pictorial
achievements of the founders of the Florentine Renaissance. But the powerful
modeling of the Masaccio–Filippo Lippi tradition and the brilliant coloring of Fra
Angelico are alike muted by a new sensitivity to the effects of light. There are almost
no shadows in Domenico's masterpiece. The figures and much of the architecture
are saturated with sunlight, but so indeed are the shadows—with light reflected
from the polished marble surfaces. Domenico takes a special delight in observing
how the colors of the marble niche behind the Virgin are transformed as the eye
moves from light to shadow, just as he sets intense greens against luminous blues
in the Virgin's costume with an un-Florentine sense of the value of a momentary
dissonance in the enrichment of an allover harmonic structure of color. Entirely his
own, too, is the exquisite grace in his observation of faces, particularly that of Saint
Lucy. The later work of Filippo Lippi, such as his tondo (see fig. 20–46), was deeply
influenced by the new poetry of light introduced into Florence by Domenico.

20-49. Domenico Veneziano. *Saint Lucy Altarpiece (Madonna and Child with Saints).* c. 1445. Oil on panel, 6'7½" × 6'11⅞" (2.02 × 2.13 m). Galleria degli Uffizi, Florence

20-50. Domenico Veneziano. *Saint John the Baptist in the Desert,* scene from the predella of the *Saint Lucy Altarpiece.* c. 1445. Panel painting, 11 × 12¾" (28 × 32.4 cm). National Gallery of Art, Washington, D.C. Samuel H. Kress Collection

The predella panels of the *Saint Lucy Altarpiece,* each a miracle of light and color, have been widely scattered; the most surprising is perhaps the tiny panel representing *Saint John the Baptist in the Desert* (fig. 20–50), in which Domenico was able to combine his native feeling for sunlight with a knowledge of the nude worthy of Ghiberti or Donatello. The youthful saint is shown wistfully shedding his garments in the wilderness in order to don a camel's skin. Domenico has turned the incident into an almost pagan enjoyment of the body; the boy seems to revel in the sunlight, which pours upon him from above and is reflected from the spiring rocks. The brushwork with which the artist has depicted the scrubby vegetation is remarkable for its freedom from any Gothic linear convention, recalling the sketchy foliage in Masaccio's *Tribute Money* (see fig. 20–38).

CASTAGNO The third great Florentine master at midcentury was the short-lived Andrea del Castagno (1417/19–1457), who for centuries was believed, following Vasari's account, to have murdered Domenico Veneziano out of jealousy of the latter's skill in the use of the oil medium, until it was discovered that Andrea died four years earlier than his supposed victim. Nonetheless, other stories of the artist's irascible temperament probably have some basis in fact. (Whether Domenico used oil or not is a matter yet to be determined by scientific analysis.)

Castagno's best-known work is the fresco of the *Last Supper* (fig. 20–51), situated

20-50

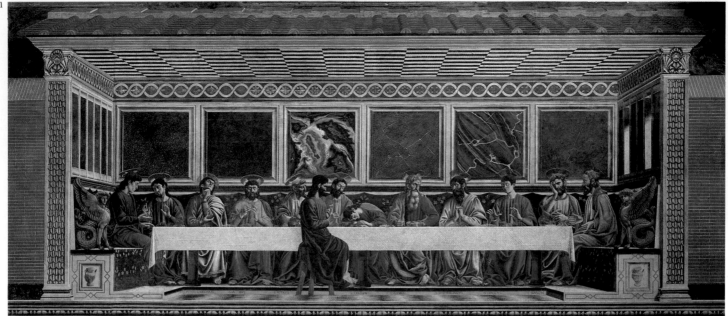

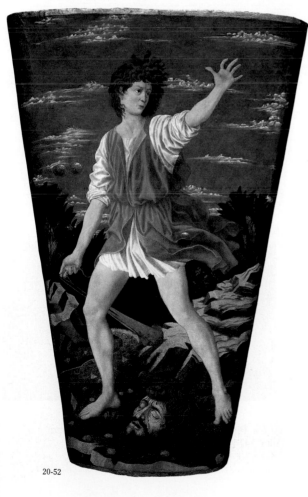

20-51. ANDREA DEL CASTAGNO. *Last Supper,* fresco, Cenacolo di Sant'Apollonia, Florence. c. 1445–50

20-52. ANDREA DEL CASTAGNO. *David.* c. 1448. Paint on leather, height 45½″ (1.16 m). National Gallery of Art, Washington, D.C. Widener Collection

in the refectory of the convent of Sant'Apollonia in Florence, then a convent of cloistered nuns. Following a doctrine that the monastic life is a living death, Castagno paneled the room in which the Last Supper takes place (and which sanctifies the daily meals of the nuns) with a marble paneling strikingly similar to that used in contemporary Florentine tombs (see especially fig. 20–57). Although the construction gives a convincing illusion that the spectator is looking into a stage lighted by actual windows from the right, this effect is achieved by the handling of light and dark on massive forms, reminding us of Masaccio and of the statues at Orsanmichele and on the Campanile—poles apart from the soft textures and glowing sunlight of Domenico Veneziano. An experiment with a straightedge will show the reader that the painter has ignored the laws of one-point perspective; there is no vanishing point governing the recession of the orthogonals, and the distance between the transversals is uniform, both in the ceiling and the floor, instead of diminishing as it ought.

Castagno's mountaineer background seems to have affected his choice of rugged types for the Apostles, indeed even for Christ. He conceived the scene within a tradition of Last Suppers painted for refectories, in which Judas is easily distinguishable, given a chair by himself on the outside. The moment chosen for illustration is that in which Christ signifies who will betray him by saying (John 13:26): "He it is, to whom I shall give a sop, when I have dipped it." Some Apostles converse with each other, but most are shown in intense meditation, each apparently foreseeing the moment of his own death. Bartholomew, for instance (the third on Christ's left), who was later flayed alive, folds his hands and gazes at a knife held up to him by Andrew. In a startling new way Castagno has managed to suggest intense emotion by the activity of the veins within the marble paneling, especially in the expressionistic violence of the veining above the group of Christ, Judas, the grieving John, and the skeptical Peter.

Castagno's sculpturesque figures can sometimes move with unprecedented force, as in his *David* (fig. 20–52), whose odd shape is explained by the fact that it was painted on a leather ceremonial shield. Two moments are shown in one: David is striding forward, his left hand raised, about to cast the fatal stone from his sling, and the severed head of Goliath is shown already lying at his feet. Admittedly a bit stiff, this is a remarkable pioneer experiment in the depiction of motion, soon to be investigated much more fully by Antonio del Pollaiuolo (see pages 617–18) and by the masters of the High Renaissance. Every element of the landscape background is painted with as much insistence on sculptural modeling and sharp contour line as on the figures themselves.

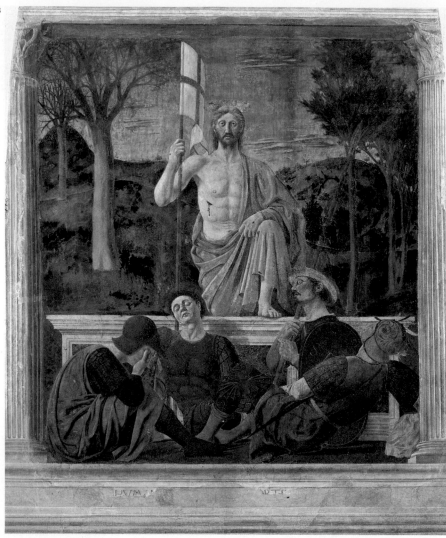

20-53. PIERO DELLA FRANCESCA. *Resurrection,* fresco, Town Hall, Sansepolcro. Probably late 1450s

20-54. PIERO DELLA FRANCESCA. *Discovery of the Wood from Which the True Cross Was Made* and *Meeting of Solomon and the Queen of Sheba,* from the *Legend of the True Cross,* fresco, S. Francesco, Arezzo. c. 1453–54

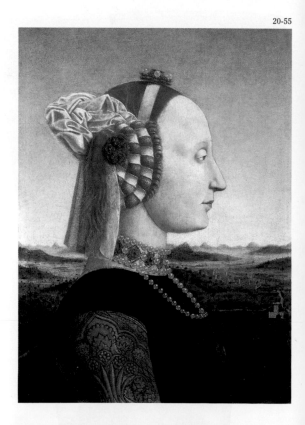

20-55. PIERO DELLA FRANCESCA. *Battista Sforza.* After 1474. Oil (and tempera?) on panel, 18½×13″ (47×33 cm). Galleria degli Uffizi, Florence

PIERO DELLA FRANCESCA For our own time the greatest Tuscan painter of the mid-fifteenth century is Piero della Francesca (c. 1420–92). He is, however, a relatively recent rediscovery, slighted before the beginning of the twentieth century and hardly appreciated in contemporary Florence, for we know of only one sojourn there, in 1439 as an assistant of Domenico Veneziano. His work was largely done for provincial centers in southern Tuscany. More than any contemporary Florentine, however, Piero managed to exemplify not only the knowledge of form that had been achieved by Masaccio and continued by Castagno, and of light and color in which Fra Angelico and Domenico Veneziano had pioneered, but also the principles of space and perspective laid down by Alberti. In fact, in his later years, Piero wrote an elaborate treatise on perspective, postulating and proving propositions in the manner of Euclid's geometry.

Probably in the late 1450s Piero painted the majestic fresco of the *Resurrection* (fig. 20–53) for the town hall of his native Borgo San Sepolcro (now renamed Sansepolcro), on whose coat of arms the Holy Sepulcher appears. Piero has paid little attention to drama but has instead represented the event as a timeless truth. One foot still within the sarcophagus (whose paneling recalls that of the Tomb of Lionardo Bruni by Bernardo Rossellino [see fig. 20–57] and that of Castagno's *Last Supper*), the other planted on its edge, Christ stands as grandly as a Roman statue, gazing calmly toward us and beyond us. Below, the soldiers sleep in varied poses; above, we look into an almost barren landscape. On the left the trees are leafless, on the right covered with foliage, doubtless a symbol of the rebirth of nature in

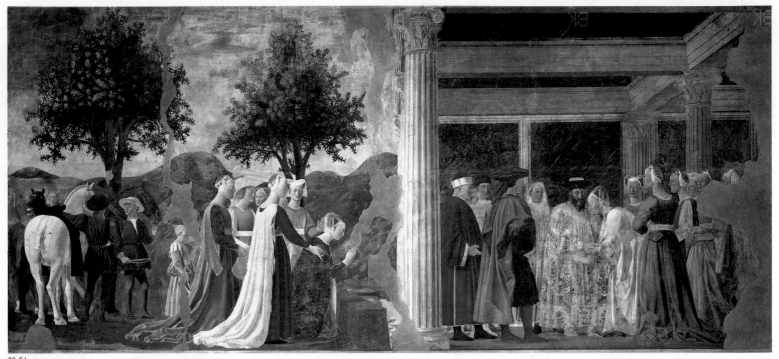

20-54

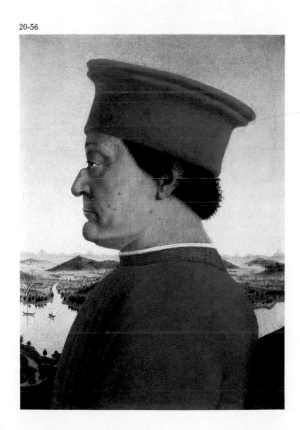

20-56

20-56. PIERO DELLA FRANCESCA. *Federigo da Montefeltro*. After 1474. Oil (and tempera?) on panel, 18½ × 13″ (47 × 33 cm). Galleria degli Uffizi, Florence

Christ's Resurrection (see Giotto's withered tree in the *Lamentation,* fig. 19–10). The cool light of dawn has just touched the gray clouds in the sky and bathes alike the marmoreal surfaces of Christ's body and the gently glowing colors of the soldiers' garments.

Every figural and architectural element in Piero's art was prepared for in perspective drawings and simplified to bring out its essential geometrical character. The grandeur and the mathematical basis of Piero's compositions are nowhere more impressive than in his great fresco series, dating probably from 1453–54, in the Church of San Francesco in Arezzo. In the *Discovery of the Wood from Which the True Cross Was Made* and the *Meeting of Solomon and the Queen of Sheba* (fig. 20–54), the queen kneels before a beam that, it has been revealed to her, will furnish the wood of the Cross; then she is received by Solomon in the portico of his palace. The Albertian architecture, with its fluted Composite columns of white marble and its green marble panels, is no more strongly geometrical than the figures, especially the heads and robes of the attendants of the kneeling queen. Exquisite intellectual touches abound; by placing the point of view just barely to the left of the colonnade, Piero has allowed us to enjoy the systematic diminution of the capitals as we look along it.

Piero's later work shows increasing evidence of his having studied Netherlandish painting (see Chapter Twenty-One), and he used either an oil-and-tempera emulsion or perhaps oil alone to produce the effects of atmospheric perspective and of light on fabrics and jewels that characterize his profile portraits of Federigo da Montefeltro and Battista Sforza (figs. 20–55, 20–56). Shortly before the pictures were painted, Federigo, count of Urbino, a principality owing fealty to the papacy, had been promoted to duke. The countess, who died in 1472 in her twenties after the birth of her ninth child, in a desperate attempt to achieve a male heir, was portrayed from a death mask. There could be no more vivid illustration of the Early Renaissance belief in the inherent nobility of man and his domination over nature than the ascendancy of these impassive profiles over the light-filled landscape. Doubtless at the direction of his noble patron, Piero has not concealed the deformity of Federigo's nose, mutilated in a tourney. His understanding of light enabled him to render the reflections of boats on a distant lake, the glow of sunlight from a chain of square towers as from the countess's necklace of spherical pearls, and the softness of the haze that begins to dim the hills on the far horizon.

Sculpture in Florence at Midcentury

A number of gifted sculptors in marble carried well past the middle of the fifteenth century principles laid down by the innovators of the Early Renaissance. But no extensive statuary series were again attempted before the early sixteenth century. The role of the sculptor was reduced; he was called upon for funerary monuments, pulpits, altar furniture, reliefs that looked like paintings and were intended for private homes, and unsparing portrait busts of contemporary Florentines.

BERNARDO ROSSELLINO The fourth of five brothers, all stonecutters from Settignano outside Florence, Bernardo Rossellino (1409–64) was an architect as well as a sculptor and carried out the building of the Palazzo Rucellai (see fig. 20–13) from Alberti's designs. The architecture of the Tomb of Lionardo Bruni (fig. 20–57), erected for the historian, humanist, and statesman, is so far superior to anything we know Bernardo to have designed by himself that it is probable that Alberti provided the inspiration. After his death in 1444, Bruni was given a state funeral by the republic in "ancient style"; at its close the orator Giannozzo Manetti (see pages 580–81) put a laurel wreath on the dead man's brow. This event is immortalized in the monument, which shows Bruni recumbent on a bier, crowned with laurel, his hands folded upon a book.

Wall tombs were common in Florence in the late Middle Ages and the Early Renaissance, but this is the first to be enclosed in a round arch, supported on Corinthian pilasters of great elegance. The tomb is colorful, with three red porphyry panels set in white marble frames. Originally many of the details, especially the sculptured damask covering the bier, were painted and gilded. On the sarcophagus a tablet bears a Latin inscription recording how the Muses mourned at the death of Bruni. Angels (or are they Victories?) in low relief, resembling the style of Ghiberti, uphold the tablet. Roman eagles support the bier. Nude boy angels (or are they genii?) steady an oak garland surrounding the rampant lion of the Florentine Republic. In the lunette a roundel flanked by praying angels holds a relief representing the Virgin with the blessing Child. This mixture of classical and Christian is typical of the ambiguous position of humanism in the fifteenth century. The face of the deceased was probably carved after a death mask, a universal custom at the time. Grand though it is, the Tomb of Lionardo Bruni tells us less about Bernardo's style as a sculptor than about the society the monument was intended to address. It became the standard for Florentine wall tombs for a generation.

ANTONIO ROSSELLINO A far more sensitive and individual sculptor than his older brother Bernardo, Antonio Rossellino (1427–79) transformed the wall tomb in his monument for the cardinal of Portugal (fig. 20–58), a prelate of royal blood who died in Florence at the age of only twenty-five. The niche is retained, but the arch is partly masked by curtains carved in marble, drawn aside as if to show a vision. The youthful cardinal lies upon a bier above a sarcophagus copied from a Roman original. Winged angels kneel on either side of a cornice above him, as if they had just alighted; other angels, still flying, silhouetted in white against a solid porphyry background, carry a garland containing the Virgin and her smiling Child; against a blue disk dotted with gold stars the sacred figures look gently down toward the dead prelate. Forms and ideas that were static in the Tomb of Lionardo Bruni become dynamic in that of the cardinal of Portugal, which leads the way to the new sculptural action style of the late fifteenth century, especially that of Antonio del Pollaiuolo and Andrea del Verrocchio (see pages 618–19 and figs. 20–63, 20–64).

Antonio's portrait of the aged physician Giovanni Chellini (fig. 20–59) is one of the finest examples of the new type of portrait bust—head and shoulders, without ornamental pedestal—that made its appearance in Florence at midcentury. The glance is always directed straight forward and the head never turned, raised, or

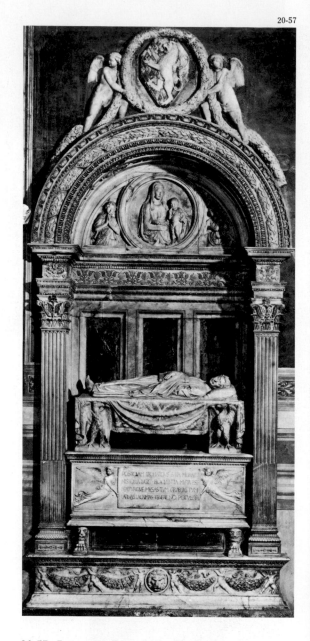

20-57. BERNARDO ROSSELLINO. Tomb of Lionardo Bruni. After 1444. White and colored marbles. Sta. Croce, Florence

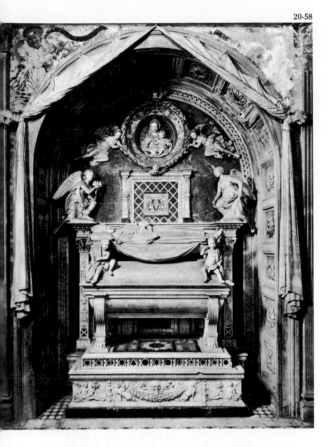

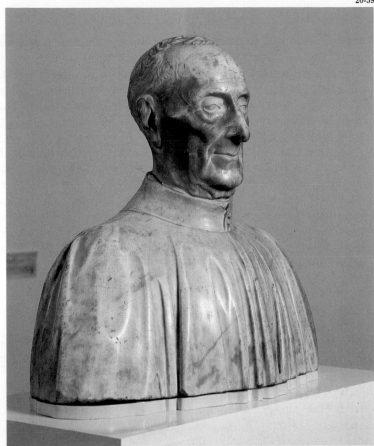

20-58. ANTONIO ROSSELLINO. Tomb of the Cardinal of Portugal. 1460–66. White and colored marbles. Height to top of arch 20′ (6.1 m). Chapel of the Cardinal of Portugal, S. Miniato al Monte, Florence

20-59. ANTONIO ROSSELLINO. *Giovanni Chellini.* 1456. Marble, height 20″ (50.8 cm). Victoria & Albert Museum, London

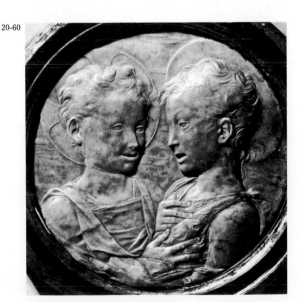

20-60. DESIDERIO DA SETTIGNANO. *Christ and Saint John the Baptist.* c. 1461. Marble. Musée du Louvre, Paris

lowered. Yet in spite of the rigid requirements of the mode, Antonio shows extraordinary sensitivity in the modeling of the wrinkled skin, which betrays the position of the underlying bony structure and yet is so smoothly polished as to reflect the gradations of light over the almost translucent surface. Above all, he communicates to us a convincing characterization of the old gentleman, learned, shrewd, and kindly.

DESIDERIO DA SETTIGNANO From a technical point of view the most remarkable of the marble sculptors is Desiderio da Settignano (c. 1430–64). He carried Donatello's relief style to a new pitch of delicacy and was probably the finest sculptor of children the world has ever known. In a small marble tondo Desiderio shows *Christ and Saint John the Baptist* (fig. 20–60) as boys of about seven or eight. (Although no scriptural evidence indicates their meeting at that age, this was a favorite subject for painting and sculpture at midcentury.) Saint John opens his mouth in speech and places his hand on the wrist of the Christ Child, who gently touches John's camel's-hair garment. Clouds are shown in the background, and a soft breeze agitates the saint's curly locks. The gradations of marble have been so delicately handled that changes of a millimeter in projection alter the effects of light and shadow. Often details are blurred by filing so as to create soft, atmospheric effects as in painting.

Painting and Sculpture in Florence and Central Italy: The Later Fifteenth Century

In the last third of the century, few of the founders of the Renaissance remained alive; with the exception of Alberti, none were still influential. Florence itself had changed—under Medici domination, culminating in the rule of Lorenzo the Magnificent, the republic withered; so did the banking and commercial activity on which its prosperity was founded. Patrician life in urban palaces and country villas

acquired a new tone of ease and luxury. Humanism was concerned less with the moral virtues of the ancients than with an elaborate structure of speculation that under Marsilio Ficino sought to reconcile Neoplatonism with traditional Christianity. In the last decade of the century, Girolamo Savonarola, one of the successors of Saint Antonine as prior of San Marco, sparked a religious reaction that united large sections of the populace against the Medici, who in 1494 were expelled for the second time from Florence.

During this period of deepening crisis, three major currents may be distinguished in Florentine art: a strongly scientific tendency on the part of painter-sculptors exploring the natural world and especially the structure and movements of the human body; a poetic tendency on the part of painters alone, inspired by Neoplatonism and characterized by withdrawal into a world of unreality; and a prosaic tendency on the part of both painters and sculptors, who sought to represent people as they were and upper-middle-class Florentine life under the guise of religious subject matter.

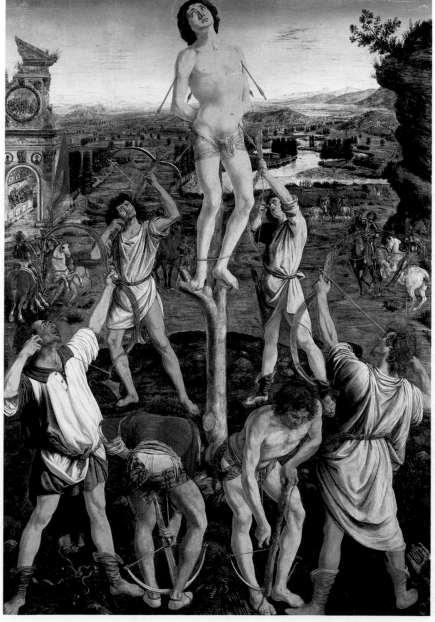

20-61

20-61. Antonio del Pollaiuolo. *Martyrdom of Saint Sebastian.* Completed 1475. Tempera on panel, 9′7″ × 6′8″ (2.92 × 2.03 m). National Gallery, London. Reproduced by courtesy of the Trustees

ANTONIO DEL POLLAIUOLO The most inventive of the scientific artists, and the master preferred by Lorenzo the Magnificent (who spoke scathingly of Botticelli) was Antonio del Pollaiuolo (1431/32–1498), tapestry designer, silversmith, sculptor, and painter. Antonio's major extant painting is a huge altarpiece representing the *Martyrdom of Saint Sebastian* (fig. 20–61), finished in 1475, for which three claims can be made: the background is the most extensive, comprehensive, and recognizable "portrait" of a landscape yet attempted in Italy; the figures are carried beyond anything achieved in the realm of action since ancient times; and, most important, the composition itself is, for the first time in Renaissance art, built up from the *actions* of the figures rather than their *arrangement*.

Let us take up these claims in order. Although the gap between the foreground and the middle distance, always the Achilles' heel of a fifteenth-century painting, has yet to be bridged convincingly, the distant landscape is a view of the Arno Valley at the right and the telescopically remote city of Florence (difficult to make out in reproductions) just below the mountains at the left. The rich plain, the ranges and peaks of the Apennines, the clusters of trees, the Arno rushing toward us—now dimly reflecting the trees along its banks in its troubled surface, now broken into turbulent rapids—have no parallel in the relatively schematic landscape backgrounds of Masaccio or Piero della Francesca. For a competitor one has to look to the landscapes of Flemish masters, such as those of Jan van Eyck (see fig. 21–15), some of which Pollaiuolo may well have known.

The muscular figures, influenced by Castagno's pioneer attempt at motion (see fig. 20–52), are shown under strain as they pull taut their longbows to pierce the patient saint with their arrows while the crossbowmen in the center are still

20-62. ANTONIO DEL POLLAIUOLO. *Battle of the Ten Naked Men.* c. 1465. Engraving. Cincinnati Art Museum. Bequest of Herbert Green French

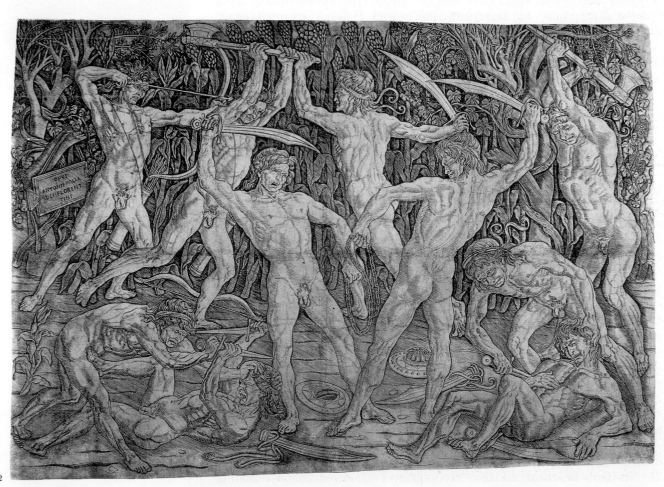

20-62

cranking up their unwieldy weapons. Pollaiuolo may even have made clay or wax models from life because the longbowmen at left and right seem to be the same figure painted from front and rear, as do the crossbowmen between them, differing only in their clothing (or lack of it). Finally, the figures form a pyramid not because of their placement but by virtue of their actions. The moment that the arrows are discharged the figures will assume other poses and the pyramid will dissolve. Whether or not Pollaiuolo could have foretold it, this kind of dynamic composition represented a long step in the direction of the pictorial and architectural principles of the High Renaissance.

Pollaiuolo seems to have placed mankind on a lower level than his Florentine contemporaries or forebears. In many of his works, humans are as cruel as wild beasts, as, for example, in his famous engraving entitled, for lack of any knowledge of its real subject, *Battle of the Ten Naked Men* (fig. 20–62). Before a background of dense vegetation ten men are slaughtering each other in a surprising variety of poses, unprecedented in their freedom of action, though as yet here and there uncertain in their precise anatomical construction. The medium of *engraving,* known earlier as a means of ornamenting suits of armor, was adopted at first by few Italian artists, and this is an early example. The method consisted of incising lines on a plate of copper by pushing a steel instrument called a burin, which raised a continuous shaving of metal and left a groove. The plate was then inked, and the ink wiped off except that remaining in the grooves; a moistened piece of paper was placed over the plate and, under pressure, absorbed the ink from the grooves, resulting in a print or engraving.

Pollaiuolo's most brilliant piece of sculpture is a small bronze group representing *Hercules and Antaeus* (fig. 20–63). Antaeus was the son of the earth-goddess, invincible as long as he was in touch with her. Hercules broke this contact by lifting Antaeus off the ground, and then crushed him to death. Pollaiuolo rendered fiercely the details of the struggle, and created thereby a new kind of sculptural group, as full of movement as his paintings and engravings. Head, arms, and legs fly off in all directions against the embrace of Hercules, enlisting the space around and between the figures in the total composition. Pollaiuolo's invention of the action group was not taken up by his contemporaries; action groups were not seen again until the dynamic sculptures of the later Mannerists and the Baroque (see figs. 23–32, 26–14). It is worth mentioning that we know of nothing by Pollaiuolo in marble; only bronze, cast from a model in wax or clay, was held suitable for compositions of this sort.

VERROCCHIO Known to posterity principally as the teacher of Leonardo da Vinci, Andrea del Verrocchio (1435–88) tends to be overlooked. He was a good painter, but a superb sculptor—in fact, the major monumental sculptor in Florence between the death of Donatello and the first large-scale statues of Michelangelo. His noblest work is the *Doubting of Thomas* (fig. 20–64), placed in a niche at Orsanmichele that had been carved by Donatello and Michelozzo for another statue in 1423. The loose grouping of figures—hardly more than high relief, for, like earlier fifteenth-century statues, they have no backs—flows beyond the limits of the Early Renaissance frame. This composition is again dynamic, seizing the moment when Thomas is about to place his finger in the wound in the side of the risen Christ, who lifts his pierced hand above the Apostle and looks gently down at him, waiting for doubt to be dissolved by belief. The drama of the composition is enhanced by the vitality of the surfaces of hands, faces, and hair; the harsh realism of the open wounds; and the flickering lights and darks produced by the intricate succession of folds and pockets into which the drapery masses are shattered. Not a trace of the broad drapery construction of Donatello or Nanni di Banco remains.

Verrocchio's colossal equestrian statue of the Venetian general *Bartolommeo Colleoni* (fig. 20–65) invites comparison with Donatello's *Gattamelata* (see fig. 20–26). The Early Renaissance sculptor's conception of an ideal commander, wearing

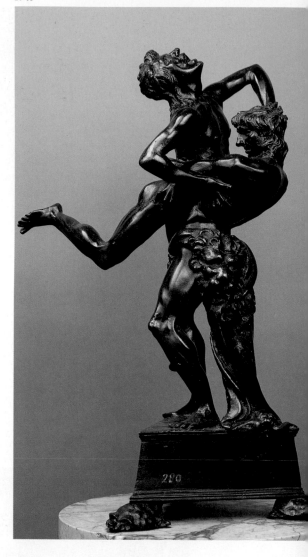

20-63. ANTONIO DEL POLLAIUOLO. *Hercules and Antaeus.* 1470s. Bronze, height (including base) 18″ (45.7 cm). Museo Nazionale del Bargello, Florence

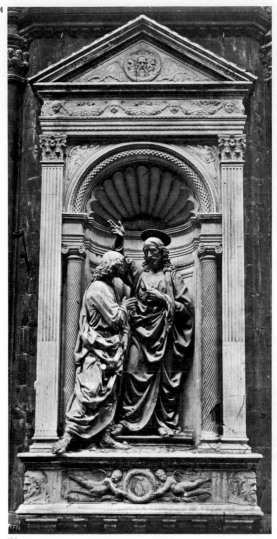

20-64. ANDREA DEL VERROCCHIO. *Doubting of Thomas.* 1465–83. Bronze, life size, Orsanmichele, Florence. (Frame designed by DONATELLO and MICHELOZZO)

20-65. ANDREA DEL VERROCCHIO (completed by ALESSANDRO LEOPARDI). *Equestrian Monument of Bartolommeo Colleoni.* c. 1481–96. Bronze, height approx. 13′ (3.96 m). Campo Ss. Giovanni e Paolo, Venice

classicized armor, is replaced by a spirited one of a helmeted warrior, armed with a mace, glaring fiercely as he rides into battle. Placed in a small square before the Church of Santi Giovanni e Paolo in Venice, the composition builds up powerfully from every point of view, as the general twists in his saddle and the mighty charger strides forward. As in the *Doubting of Thomas,* the *Colleoni* is dependent for much of its effect upon the emotions of the moment and on the brilliant handling of surfaces, especially the tense muscles of the horse, his distended veins, and his dilated nostrils.

BOTTICELLI Among the painters of the poetic current in the late fifteenth century, Sandro Botticelli (1445–1510) stands alone in depth of feeling and delicacy of style. So intense is his concentration on line, so magical his research into the unreal, that it is hard to believe that he studied with Filippo Lippi, a follower of Masaccio. Although aloof from the scientific current and criticized by the young Leonardo da Vinci, Botticelli was the leading painter resident in Florence in the 1480s and 1490s. He was profoundly affected by the preaching of Savonarola, turned to an intensely religious style in his later life, and after 1500 seems to have given up painting altogether. His most celebrated pictures, the *Primavera* (fig. 20–66) and the *Birth of Venus* (fig. 20–67), were apparently painted at a slight distance from each other in time, the first on panel, the second on canvas (rarely used in the fifteenth century and usually for processional banners). Vasari saw them in the same room in the villa of Lorenzo di Pierfrancesco de' Medici, a second cousin of

20-66. SANDRO BOTTICELLI. *Primavera*. c. 1482.
Tempera on panel, 6′8″ × 10′4″ (2.03 × 3.15 m).
Galleria degli Uffizi, Florence

Lorenzo the Magnificent, and apparently the two paintings were then considered companion pieces.

Both have been interpreted in different ways, of late largely through the writings of Marsilio Ficino, leader of the Neoplatonic movement in Florence. While no interpretation of the *Primavera* is wholly successful, the most convincing is based on a letter written by Ficino in 1478 to his pupil Lorenzo, then a lad of fourteen or fifteen years, to whom the philosopher recommends Venus as his "bride" to make happy all his days. By Venus Ficino meant Humanitas, that is, the study of the Liberal Arts. Very recently it has been shown that the painting was incorporated in the paneling above a daybed in the antechamber to Lorenzo's marital bedroom, and thus probably symbolizes his real wedding in 1482.

What has been described as a Christianized Venus, modestly clothed and strongly resembling Botticelli's Madonnas, presides in the midst of a dark grove of trees bearing golden fruit. At the right Zephyrus, the wind-god, pursues the nymph Chloris, from whose mouth issue flowers. She is transformed before our eyes into the goddess Flora, clothed in a flowered gown, from whose folds she strews more blossoms upon the lawn, abundant with flowers that bloom in the surroundings of Florence in the month of May. At the left Mercury, in a pose reminiscent of Donatello's *David,* is dispelling tiny clouds from the golden fruit, which suggest the golden balls symbolic of the Medici family. Between Mercury and Venus dance the Three Graces, as described in a passage from the Roman writer Apuleius. Alberti recommended them as a fit subject for painters, who were instructed to show these lovely creatures either nude or in transparent garments, dancing in a ring, their hands entwined. Botticelli has depicted this complex allegory in an image of utmost enchantment. As in all his mature works, the figures are extremely attenuated, with long necks, torsos, and arms and sloping shoulders. Their delicate faces and the soft bodies and limbs appearing through the diaphanous garments seem almost bloodless as well as weightless; their white feet touch the ground so lightly that not

20-67. SANDRO BOTTICELLI. *Birth of Venus*. After 1482. Tempera on canvas, 5′8⅛″ × 9′1⅛″ (1.75 × 2.79 m). Galleria degli Uffizi, Florence

a flower or a leaf is bent. Although individual forms are beautifully modeled, the composition is based on an interweaving of linear patterns, formed of drapery folds, streaming or braided hair, trunks, and leaves, like the many voices of a fugue. Such a picture, elaborate and artifical both in content and in style, represents a withdrawal from the forthright naturalism of the early Florentine Renaissance. Interestingly enough, although Botticelli at this stage has renounced the mass and space of Masaccio and succeeding generations, their clear and brilliant coloring persists.

The *Birth of Venus* may show the effects of Botticelli's residence in Rome in the early 1480s. Venus, according to an ancient myth, was born from the sea, fertilized by the severed genitals of the god Saturn; this cruel legend was interpreted by Ficino as an allegory of the birth of beauty in the mind of man through fertilization by divinity. Upon a sea represented without concern for space, and dotted with little V-shaped marks for waves, Botticelli's Venus stands lightly upon—rather than in—a beautiful cockleshell, wafted by two embracing wind-gods toward a highly stylized shore. The *Venus pudica* ("modest Venus") type, used by Jacopo della Quercia and Masaccio for Eve, now appears for the first time in her own right as Venus. But what a difference from the splendid Venuses of classical antiquity! Botticelli's wistful lady, proportioned much like the Three Graces, uses the curving streams of her long hair, lightly touched with actual gold pigment, to conceal her nakedness, and seems hardly to be able to wait for the cloak that one of the Hours is about to spread around her. Again Botticelli's allegory is related to the Christian tradition with which the Neoplatonists were trying to reconcile pagan legend; the composition has been compared to medieval and Renaissance representations of the Baptism of Christ.

While the unreality of Botticelli is a blind alley in the development of Renaissance painting, the beauty of his line is not, and it may have influenced considerably the pictorial style of Michelangelo.

GHIRLANDAIO While Pollaiuolo painted for Lorenzo the Magnificent, and Botticelli for a learned elite, Domenico del Ghirlandaio (1449–94) pleased most of all a solid class of bankers and merchants. The host of frescoes and altarpieces produced by Domenico and his numerous assistants rendered his shop the most prolific in Florence in the 1480s and 1490s. Not unconcerned with the rediscovered works of classical antiquity, Ghirlandaio nonetheless had little interest in the mythological fantasies that charmed Botticelli and his followers. His solid paintings are conservative, still Albertian in their emphasis on one-point perspective and clear organization of masses, but matter-of-fact in their attitude toward subject matter. For example, when he filled the chancel of the Church of Santa Maria Novella in Florence with frescoes representing the lives of the Virgin Mary and John the Baptist, he introduced contemporary Florentines in everyday dress as onlookers in the sacred scenes. He set the *Birth of the Virgin* (fig. 20–68), much as Filippo Lippi had the *Madonna and Child* (see fig. 20–46), in a wealthy Florentine home, properly decorated with a sculptured frieze of music-making children above a wainscoting of delicately inlaid wood. Ludovica, daughter of Giovanni Tornabuoni, the wealthy Florentine who commissioned the frescoes, appears, hands folded before her and accompanied by four ladies-in-waiting, all dressed as in real life. The workmanship is good, the drawing solid, the forms agreeable, the colors bright—and imagination is lacking.

Two outsiders complete the roll of major painters working on and off in Florence in the last decades of the fifteenth century.

PERUGINO A master from Perugia, the capital of the region known today as Umbria, Pietro Perugino (c. 1445–1523) was the leading painter of central Italy outside of Florence in the 1480s and 1490s, with a flourishing school that included the young Raphael; Perugino enjoyed, in fact, considerable success in Florence as well. With Botticelli, Ghirlandaio, Luca Signorelli (see below), and a number of other painters, he was called to Rome in 1481 to decorate the walls of the chapel in the Vatican newly built by Pope Sixtus IV and known as the Sistine Chapel. One of Perugino's frescoes, the *Giving of the Keys to Saint Peter* (fig. 20–69), shows him at the height of his powers. The figures are aligned much as in the paintings of Ghirlandaio along the foreground plane, and, as in Ghirlandaio, contemporary figures have intruded at right and left. But unlike Ghirlandaio, whose figures are

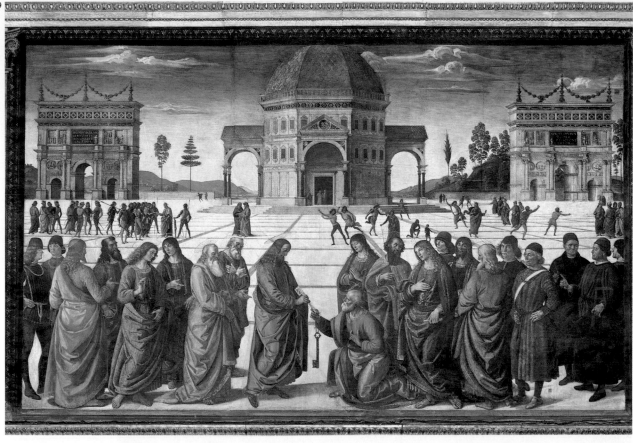

20-69. Pietro Perugino. *Giving of the Keys to Saint Peter,* Sistine Chapel, Vatican, Rome. 1481

often rigid, those of Perugino appear remarkably supple, in spite of their voluminous mantles. They unfold from the ground upward like growing plants, arms moving, heads turning, with a grace that is Perugino's own.

Characteristic of Perugino's art is his extraordinary sense of distance, partly achieved by means of Florentine one-point perspective, by which he constructs the vast piazza, with its scattering of tiny figures forming two more Gospel scenes. Entirely Perugino's own is the remote landscape, its hills sloping on either side to form a bowl of space and filled with soft atmosphere under a serene blue sky.

The architecture in the middle distance, symbolic rather than real, places between two triumphal arches, modeled on that of Constantine, a central-plan structure suggesting the dome of the Cathedral of Florence but adorned with four airy porticoes; this building probably signifies the Church that Christ is depicted founding on the rock of Peter, between relics of the power of imperial Rome.

SIGNORELLI Since the lifetime of Luca Signorelli (1445/50–1523) spans the turn of the century (although slightly older than Leonardo da Vinci, he outlived both Leonardo and Raphael), it is hard to know whether to consider him an artist of the fifteenth or sixteenth century. For pure convenience he appears here in this book, although his major work, the series of frescoes in the Cathedral of the Umbrian town of Orvieto at the turn of the century, representing episodes from the Last Judgment, was influenced by the researches of Leonardo and the youthful works of Michelangelo. Some of the scenes, especially the *Damned Consigned to Hell* (fig. 20–70), represented the artist's most daring venture into a composition made up entirely of a great number of struggling nude figures. The whole scene looks like a colossal sculptured relief. At the upper right three archangels in shining armor exclude the damned from Heaven; they are carried off shrieking by demons into Hell, whose flaming mouth opens at the left. The foreground stage is populated with a struggling web of human and demonic bodies, the mortals colored white or

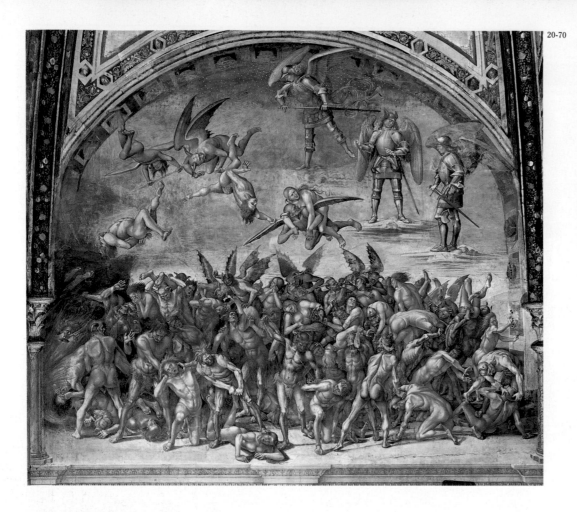

tan, the demons parti-colored in shades of orange, lavender, and green. Fierce tortures are inflicted by the demons, who bite, twist, and tear at various portions of their victims' vividly projected anatomies. From such a work one would hardly realize that Signorelli had been a pupil of Piero della Francesca.

20-70. LUCA SIGNORELLI. *Damned Consigned to Hell,* fresco, S. Brixio Chapel, Cathedral of Orvieto. 1499–1504

Painting in North Italy and Venice

In the first half of the fifteenth century, Venice, the splendid city of the lagoons, empress of a chain of islands and ports protecting her rich commerce in the eastern Mediterranean, gradually extended her dominion over the north Italian mainland so that her frontiers reached within thirty miles of Milan. Becalmed in a local style blended of Byzantine and Gothic elements, Venetian art was occasionally enlivened by visits of great masters from elsewhere. In their youth Gentile da Fabriano, Paolo Uccello, Filippo Lippi, and Andrea del Castagno had stayed for varying lengths of time and left traces on what remained a provincial art. But the eleven-year sojourn of Donatello, champion of the Renaissance, in the Venetian subject-city of Padua brought about a revolution in the art of the Venetian region. Florentine doctrines of form, perspective, and anatomy, not to speak of the Florentine ability to adapt classical architectural elements to contemporary needs, took firm hold and united with a Venetian predilection for richness of color and surface. Before long the last traces of medievalism disappeared from Venetian art, and a parade of great masters developed a new Renaissance style, which, in the sixteenth century, eventually unseated Florence from her throne in painting and at least equaled her in architecture.

MANTEGNA Already a full-fledged painter at seventeen, signing altarpieces on his own, Andrea Mantegna (1431–1506) was the first major north Italian artist to experience the full force of the Florentine Renaissance. In 1454, the year of Donatello's departure from Padua, Mantegna began, with several older artists,

20-71. ANDREA MANTEGNA. Ceiling fresco, Camera degli Sposi, Palazzo Ducale, Mantua. Completed 1474

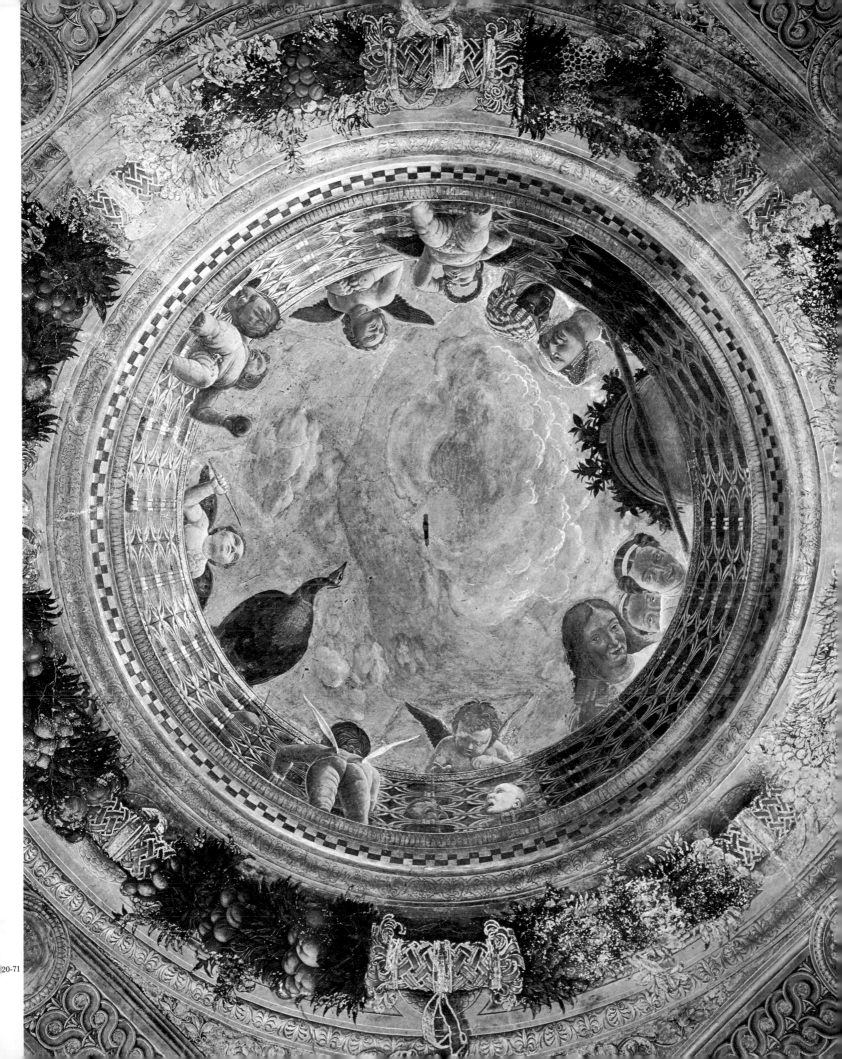

a series of frescoes in the chapel of the Ovetari family in the Church of the Eremitani in Padua. His competitors having been eliminated by death or discouragement, Mantegna finished the series himself in 1457, when he was twenty-six years old. *Saint James Led to Execution* (fig. 20–72) is a triumph of Renaissance spatial construction and Renaissance classicism. The perspective is calculated for the eye level of a person of average height standing on the floor below, and the effect of figures moving in an actual space is even more startling than in Masaccio's *Holy Trinity* (see fig. 20–42) because this fresco begins above eye level. Accordingly, the ground disappears, and as the figures recede and diminish, first their toes, then their feet, and then their ankles are cut off by the lower border. The vanishing point, below this border, controls the rapid recession of the Roman arch at the left and the medieval and Renaissance houses that tower above us at the right.

Mantegna's perspective, however, does not recognize a vertical vanishing point. In actuality, the vertical lines of the architecture should converge as we look up, but that would have dissolved the unity of the wall surface with its superimposed rows of scenes and, consequently, was not attempted until the sixteenth century. Within Mantegna's carefully constructed space, the figures look like animated statues, carved rather than painted. But their marmoreal hardness only intensifies the drama. James, on his way to martyrdom, turns to bless a kneeling Christian who has broken through the Roman guards. The movements of the figures, the gentleness of the saint, and the emotion of the moment are as severely controlled as the perspective. It is tragic to record that the Ovetari Chapel with all Mantegna's frescoes, save two badly damaged scenes removed for restoration, was blown to dust in the spring of 1944 by American bombs intended for the nearby marshaling yard of Padua; only a few pathetic fragments have been recovered.

20-72. ANDREA MANTEGNA. *Saint James Led to Execution*, fresco (destroyed), Ovetari Chapel, Church of the Eremitani, Padua. 1454–57

20-73. ANDREA MANTEGNA. *Arrival of Cardinal Francesco Gonzaga*, fresco, Camera degli Sposi, Palazzo Ducale, Mantua. Completed 1474

20-72

20-73

20-74. ANDREA MANTEGNA. *Dead Christ.* After 1466. Tempera on canvas, 26¾ × 31⅞″ (68 × 81 cm). Pinacoteca di Brera, Milan

In Mantegna's maturity his austerity relaxed a bit, especially in the frescoes he finished in 1474 for the castle of the Gonzaga family, marquesses of the principality of Mantua, at whose court Mantegna remained as official painter until his death. Alberti, let us remember, had also been in Mantua more than once and in 1470, when Mantegna was already in residence, provided the designs for the epoch-making Church of Sant'Andrea (see fig. 20–16). The Gonzaga frescoes are continuous around two sides and over the vaulted ceiling of a square chamber, nicknamed incorrectly the Camera degli Sposi ("marital chamber"), and represent scenes from contemporary court life. In one (fig. 20–73), the thirteen-year-old Francesco Gonzaga is greeted by his father, the marquess Ludovico, and by the bishop of Mantua, other dignitaries, and some charming children on his return from Rome, where he had just been made a cardinal. The background is not Mantua itself, which is perfectly flat and surrounded by lakes, but an ideal Italian city on a conical hill; the circular walls are, of course, seen in perspective. Outside them can be distinguished assorted Roman ruins and statues. Mantegna still takes pleasure in geometrical forms and relationships, especially in the north Italian costumes. The coloring, vivid as it yet is, was undoubtedly more brilliant before certain portions painted *a secco* (on dry plaster; the hose of the marquess and the tunic of the central child, for instance) peeled off in the course of time.

The center of the ceiling (fig. 20–71) is Mantegna's most astonishing perspective prank. We seem to be looking up into a circular parapet as up through the mouth of a well, above which are sky and clouds. Winged children clinging to the parapet are seen in sharp perspective from front and rear, and across one end runs a pole, which, if it rolled a bit, would allow a large tub of plants to fall on our heads. Ladies-in-waiting, including one black servant, peer over the edge, smiling at our discomfiture. Mantegna's visual pranks continue with daring foreshortenings of winged *putti* from front and back, clinging to the inside of the parapet or poking their heads through holes we thought were solid to converse with another leaning over the edge. With this odd beginning commences the long series of illusionistic ceiling and dome paintings that continued for three centuries and spread from Italy throughout Europe (see Correggio's dome fresco for the Cathedral of Parma, fig. 23–19).

Probably late in life, Mantegna painted the *Dead Christ* (fig. 20–74) on canvas

and in *scurto* (extreme foreshortening), intended not as a trick in this case but as a device to bring home to the meditating observer with the greatest possible intensity the personal meaning for him of Christ's sacrificial death. We are permitted even to look into the harshly projected nail holes in the hands and feet of the stony figure on the slab. The weeping Mary and John, very likely later additions, jeopardize neither the picture's scientific exploitation of perspective nor its profound psychological effect.

ANTONELLO DA MESSINA At this point an unexpected ingredient—more important than all the science of the Florentine Renaissance—was added to the amalgam of Venetian style. This essential element, the oil technique fully developed by the painters of the Netherlands (as we shall see in the following chapter), seems to have been brought to Venice by a painter from Sicily, which, since the days of its great Byzantine mosaics, had been something of an artistic backwater. As we know from the discussions of Domenico Veneziano, Castagno, and Piero della Francesca, oil painting, long known to the Italians in theory, was certainly practiced in Italy earlier in the fifteenth century, often in combination with tempera. But the little picture *Saint Jerome in His Study* (fig. 20–75), painted in Sicily by Antonello da Messina (c. 1430–79) long before the artist's departure for Venice, was done in the oil technique, including glazes, as practiced by the Netherlandish masters, especially Jan van Eyck (see page 638). No one has yet been able to determine where Antonello learned the Northern method, but his observation of almost microscopic detail and of minute gradations of light is so close to the great masters of the North that he must have had personal instruction from one of them. We look through an astonishingly real, flattened masonry arch into a large, dim Gothic room, presumably the great hall of a monastery, in which the saint, in cardinal's red garments, is seated in an enviable wraparound study carpentered from unpainted wood, set up without regard to the architecture. The minutely accurate perspective projection of the glazed tile floors and receding colonnade is no more systematically observed than the play of light and dark: the arch throws its shadow on the scene at the left as does the study on the floor at the right; both are gradually conquered by the light from the windows opening on exquisitely detailed Sicilian land- and townscapes. On a step in the foreground stands a peacock, symbol of eternal life; the shining metal bowl of water and the towel hanging in the study are drawn straight from Netherlandish repertory. None of these effects, above all the soft glow of refracted light throughout the tiny scene, could have been obtained by other than the oil technique. Antonello's eighteen-month stay in Venice, beginning in 1475, changed the whole course of Venetian painting.

BELLINI Among the host of good painters who now appeared in Venice and its surrounding territory, the towering master in the last forty years of the fifteenth century, without competition until the appearance of Giorgione in the first decade of the sixteenth (see Chapter Twenty-Four and figs. 24–1, 24–2), was Giovanni Bellini (c. 1430–1516), who came from a family of excellent painters and whose sister married Andrea Mantegna. The early phase of Bellini's long career shows, indeed, considerable relation to the style of his formidable brother-in-law, but the arrival of Antonello put an end to all that. Without abandoning in any way the ideal breadth and harmony that are the essence of Italian art, Bellini was able to absorb rapidly all the wonders that the oil technique was to offer him. In his *Transfiguration of Christ* (fig. 20–77), painted when the artist was perhaps almost sixty, he placed the scene in the midst of a subalpine landscape of a richness and depth that no Italian painter had been able previously to achieve.

A fence of saplings and the edge of a cliff separate us from the sacred figures. In traditional poses, Peter, James, and John crouch in terror, while on the knoll behind

20-75

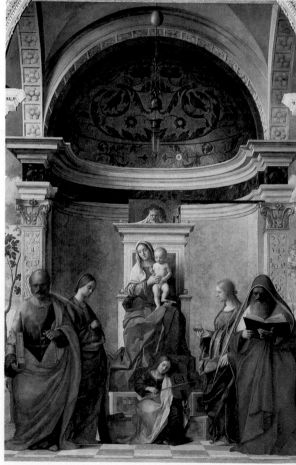

20-76

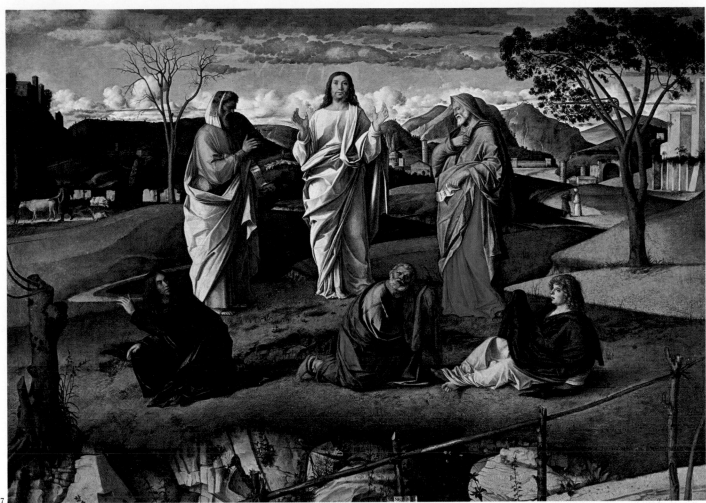

20-77.

and slightly above them the Lord is revealed "in raiment white and glistering" (Luke 9:29) between Moses and Elijah in what appears to be merely the intensified light of the late afternoon; Christ stands calmly against the sky, apparently consubstantial with the white clouds above the distant mountains. At long last halos have disappeared, as in Netherlandish painting; only a faint yellow glow surrounds the head of Christ. The long light models the Old Testament prophets and saturates the landscape and the distant towns at the right, while at the left a cowherd leads his cattle against the gathering shadows. In Bellini's art a new joy in nature is effortlessly blended with profound religious reverence into a landscape poetry the like of which had never been seen before.

When the great German master Albrecht Dürer (see page 736 and fig. 25–1) visited Venice for the second time, in 1506, he found that Bellini, although very old, was still the leading Venetian painter. A work of this time, the *Madonna and Child Enthroned* (fig. 20–76) in San Zaccaria in Venice, proves Dürer's point. In a stately Renaissance shrine, whose lateral arches open onto sky and trees, the Virgin is seated on a marble throne. A soft light bathes her and the four meditating saints, and throws into shadows the gold and peacock-blue mosaic of the semidome above the Virgin's head. The solemnity of the composition, the perfect balance of the figures, the breadth and freedom of the construction of the forms, and the ample, serene areas of glowing color (especially the Virgin's blue mantle against the singing red of Jerome's great cloak) became the basis of the great Venetian style of the High Renaissance.

20-75. ANTONELLO DA MESSINA. *Saint Jerome in His Study.* c. 1450–55. Oil on panel, 18 × 14⅛″ (45.7 × 36 cm). National Gallery, London. Reproduced by courtesy of the Trustees

20-76. GIOVANNI BELLINI. *Madonna and Child Enthroned.* 1505. Oil on canvas (transferred from panel), 16′5½″ × 7′9″ (5.02 × 2.36 m). S. Zaccaria, Venice

20-77. GIOVANNI BELLINI. *Transfiguration of Christ.* Late 1480s. Oil on panel, 45¼ × 59″ (1.15 × 1.5 m). Museo di Capodimonte, Naples

CHAPTER TWENTY-ONE

IN NORTHERN

The developments we have just followed in Italy constitute only one aspect of a complex European situation and cannot be entirely understood without a knowledge of the equally important events going on in Northern Europe, although not in architecture, which, as we have seen (page 562), remained Gothic. For visiting Italian humanists or for Italian bankers and merchants looking out of the windows of their branch offices in Bruges, Ghent, or Paris, Flamboyant Gothic architecture can have held little interest; if we judge from written accounts, Italians considered it barbarous.

Painting was another story. The Italians looked on the achievements of the Northerners with open-mouthed wonder. Here were kindred spirits! Even more—here were artists who had made visual conquests that to the Italians, notwithstanding their articulate theory, came as a total surprise. Cyriacus of Ancona, an Italian humanist who had been to Athens and looked at the Parthenon, recorded in 1449 his astonishment at beholding in a Northern triptych in the possession of Lionello d'Este, duke of Ferrara:

> ... *multicolored soldiers' cloaks, garments prodigiously enhanced by purple and gold, blooming meadows, flowers, trees, leafy and shady hills, ornate halls and porticoes, gold really resembling gold, pearls, precious stones, and everything else you would think to have been produced, not by the artifice of human hands but by all-bearing nature herself.*

The revolutionary developments of Northern art took place, for the most part, in the state of Burgundy. It all started in 1363, when King John the Good of France conferred the duchy of Burgundy on his youngest son, Philip the Bold. Through a series of marriages and inheritances Philip and his descendants acquired a region stretching from the Rhone Valley to the North Sea, including at its height much of eastern France, most of Holland, and all of Belgium and Luxembourg.

Philip called numerous artists to his capital at Dijon, and another royal duke, John of Berry, Philip's older brother, brought equally gifted masters to his court in central France. The French artistic tradition seems, for the moment at least, to have been played out; all the inventors of the new style in the North came from the Netherlands (modern Belgium and Holland), which, during the thirteenth and fourteenth centuries, had not contributed notably to the development of figurative art—except for the metalworkers of the Meuse Valley. In 1430 Duke Philip the Good (ruled 1419–67), grandson of Philip the Bold, transferred his capital to Brussels, where he held the most splendid court in Europe, profiting by the revenues from the prosperous Netherlandish commercial cities. In 1477 his son, Charles the Bold, lost his throne and his life in the Battle of Nancy against King Louis XI of France, and the rich Burgundian dominions reverted to other overlords (Burgundy itself to the French crown, the rest to the growing Habsburg Empire). But the Northern school of painting was by then firmly established, handing down its marvelous skill from one generation to another, and Bruges, Ghent, Tournai, Brussels, Louvain, and Haarlem became artistic centers to rival Florence, Siena, Perugia, Rome, and Venice.

THE EARLY RENAISSANCE

EUROPE

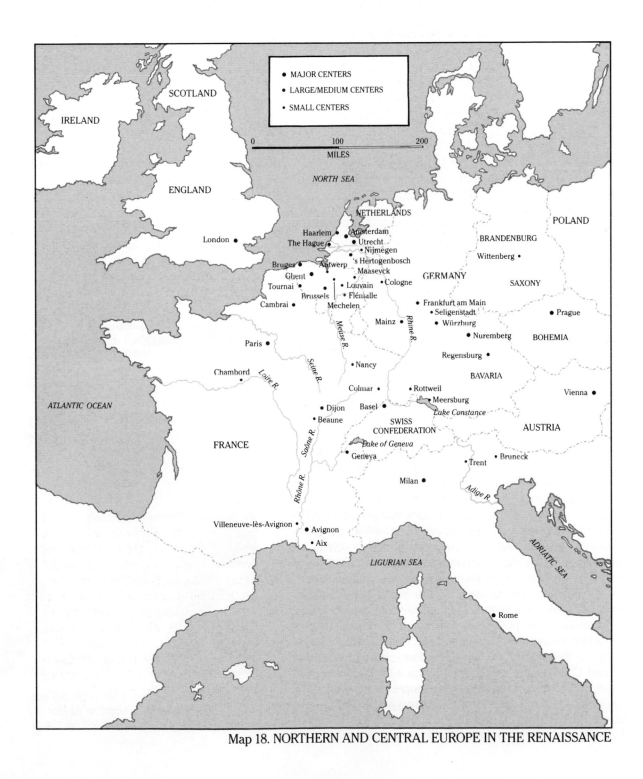

SCOTLAND

IRELAND

- MAJOR CENTERS
- LARGE/MEDIUM CENTERS
- SMALL CENTERS

0 100 200

MILES

ENGLAND

NORTH SEA

NETHERLANDS

POLAND

London •

Haarlem • Amsterdam

The Hague • • Utrecht

BRANDENBURG

Wittenberg •

• Nijmegen

Bruges • 's Hertogenbosch

Antwerp

Ghent • Maaseyck

Tournai • Louvain • • Cologne

Brussels • • Flémalle

Cambrai • Mechelen

GERMANY

SAXONY

• Frankfurt am Main

• Seligenstadt

Mainz • • Würzburg

• Prague

• Nuremberg

BOHEMIA

Paris •

Regensburg •

Chambord •

Loire R.

Seine R.

Meuse R.

Rhine R.

• Nancy

BAVARIA

ATLANTIC OCEAN

Villeneuve-lès-Avignon •

Colmar •

• Rottweil

Vienna •

• Dijon

Basel •

• Meersburg

Lake Constance

• Beaune

SWISS
CONFEDERATION

AUSTRIA

FRANCE

Saône R.

Rhône R.

Lake of Geneva

• Geneva

• Bruneck

• Trent

Milan •

Adige R.

• Avignon

• Aix

LIGURIAN SEA

ADRIATIC SEA

• Rome

Map 18. NORTHERN AND CENTRAL EUROPE IN THE RENAISSANCE

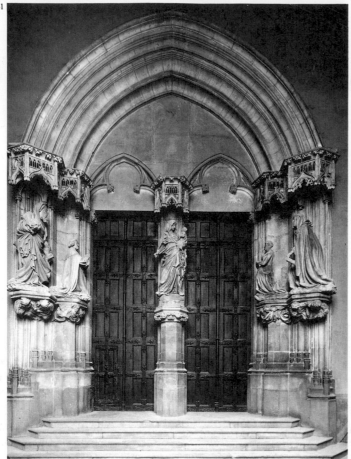

21-1. CLAUS SLUTER. Portal of the Chartreuse de Champmol, Dijon. 1391–97

Netherlandish Art in France

The relations between France and Italy were strong in the fourteenth century. French manuscript illuminators were influenced by fourteenth-century Italian painting, and many Italian artists came to France. The Italian masters at Milan Cathedral showed firsthand knowledge of Notre Dame in Paris; Giovanni Pisano and Giotto probably experienced in person the majesty of French cathedral sculpture. Simone Martini we know worked at Avignon from 1340 to 1344 and may have been to Paris. Doubtless, there were others.

SLUTER Nevertheless, the first revolutionary developments in late-fourteenth-century France show no trace of this Italian heritage. The crucial figure is not a painter but a vigorous sculptor, Claus Sluter (active after 1379/80–1405/6) from Haarlem, near Amsterdam, who arrived at Dijon in 1385 and was set to work as the assistant of the Netherlandish sculptor Jean de Marville, who had planned out the sculptures for the portal of the Chartreuse de Champmol, a Carthusian monastery built by Philip the Bold near Dijon. The Virgin and Child appear in their traditional place on the trumeau (central pier); the kneeling duke and his duchess, Margaret of Flanders, attended by their patron saints, flank them on either side as in paintings. At Jean de Marville's death, only the conventional Flamboyant Gothic canopies were ready. Sluter has paid no attention to them beyond utilizing the space they provide like a gigantic altarpiece. The poses and glances of the powerfully portrayed standing and kneeling figures and their billowing drapery sweep across jambs and even doorways so that we are led from the adoring gaze of duke and duchess to the Virgin and Child in the center (fig. 21–1) with the sense of a dramatic event. Originally, the central canopy supported angels holding forth the symbols of the Passion (Cross, column, lance, crown of thorns, and so forth), from which the Christ Child recoils in terror as his mother endeavors to comfort him. Not only the new formal and spatial dimension he gives to sculpture but also the

21-2. CLAUS SLUTER. *Well of Moses* (*Isaiah* and *Moses*). 1395–1403. Stone, height of figures approx. 6' (1.83 m). Chartreuse de Champmol, Dijon

21-3. MELCHIOR BROEDERLAM. *Annunciation* and *Visitation*, exterior of left wing of the *Chartreuse de Champmol Altarpiece*. 1394–99. Panel painting, 65¾ × 49¼″ (1.67 × 1.25 m). Musée des Beaux-Arts, Dijon

21-4. THE BOUCICAUT MASTER. *Visitation*, illumination from the *Hours of the Maréchal de Boucicaut*. c. 1405–8. Musée Jacquemart-André, Paris

expressive strength of Sluter's art render this earliest complete work a masterpiece.

The only sculptural project that we know Sluter planned from the start is the so-called *Well of Moses*, of 1395–1403, in the cloister of the Chartreuse de Champmol; originally, the monument was a giant crucifix rising from the center of the fountain to symbolize the Fountain of Life in Christ. Only fragments of the crucifix have escaped the sixteenth-century reformers, but the pedestal with its six prophet statues and six grieving angels stands in its original position (fig. 21–2). Architecture is reduced to a secondary role, providing a perch for the angels whose powerful wings uphold the cornice below the original position of the Cross. From his projecting ledge each prophet juts forward, ignoring the architecture and holding a scroll bearing his prophecies of the sacrifice of Christ as he looks either upward toward the Cross, downward in meditation, or out into the future. The aged faces are carved with every facet of flesh, hair, wrinkles, and veins in a boldly naturalistic style.

Claus Sluter's revolution is immediate and far-reaching; in one thrust he has carried us from the delicacy of French court art to the humanism of the Renaissance. His fierce Moses, with his traditional horns and two-tailed beard, his body submerged by drapery folds as he holds with his almost veiled right hand the Tables of the Law, is a worthy precursor to the world-famous *Moses* of Michelangelo (see fig. 22–13). While we are admiring the powerful sculptural style of this majestic figure and the tragic Isaiah, we should recall that the naturalism of the moment required that these stone statues be completely covered with lifelike color applied by a professional painter; Jean Malouel, uncle of the Limbourg brothers (see below), finished the work on Sluter's statues, which had been started by a local painter. Considerable traces of color remain; one prophet was even supplied in 1402 with a pair of bronze spectacles.

BROEDERLAM Sluter's exact contemporary was the Netherlandish painter Melchior Broederlam (active 1385–1409), who contributed the exterior painted wings for an elaborate carved and gilded altarpiece done in 1394–99 for the Chartreuse de Champmol. A delightful painter, if by no means a personality of the creative power of Sluter, Broederlam in his graceful style shows us the somewhat subservient role still occupied by painting—but not for long. His drapery motifs are derived from those of Sluter but treated more lightly and with great ornamental delicacy. The fantastic architectural interiors of the *Annunciation* (fig. 21–3) from the left wing recall remotely those of Pietro Lorenzetti but diminish in perspective at a dizzying rate, just as the fanciful background landscape of the adjacent *Visitation*, which can trace its immediate ancestry to the rocky world of Duccio (see fig. 19–13), soars upward like flames. As in all early Netherlandish painting the figures are shown on a level with our eyes, but in a convention known as "rising perspective" the horizon is high above their heads instead of at eye level, in order to afford the most complete panorama possible. God the Father appears in the *Annunciation* waist-length in a circle of blue angels against the gold; from his mouth a flood of light pours through the tracery of Mary's window, which, as we have seen (page 606), is a symbol of the Incarnation.

THE BOUCICAUT MASTER Early in the fifteenth century a very observant painter known as the Boucicaut Master, after his principal work, the *Hours of the Maréchal de Boucicaut*, illuminated probably between 1405 and 1408, was at work in Paris. The patron who ordered the splendid book was a soldier, whose military service took him to points as distant as Prussia and Mount Sinai. The artist may have been the painter Jacques Coene of Bruges, who was called to Milan in 1398 as an advisory architect for the Cathedral.

In contrast to breviaries, intended for the clergy, Books of Hours were written and illuminated for secular patrons. They contained, in addition to the texts for the seven canonical "offices" (prayer services prescribed for seven different hours of

the day and night, hence the word "Hours"), a varying selection of other services, including the Hours of the Cross, the Hours of the Holy Spirit, the Office of the Dead, litanies, Masses for feast days, the penitential psalms, and a calendar of religious observances. They were illuminated, as splendidly as the patron could afford, with illustrations often not directly related to the text. The best of them were luxury objects in whose perusal our thoughts, like those of the patron, only now and then turn to pious matters; we were intended to be lost in delight at the richness of the gold-studded borders and the brilliance of the color, the delicacy of the style, and the manifold beauties of represented nature.

That the Boucicaut Master was an unusually discerning artist can be seen in the *Visitation* (fig. 21–4), a page from the Boucicaut Hours. The heritage of classical landscape elements seen through Sienese eyes has been so thoroughly transformed that we hardly observe the traditional features. The Boucicaut Master has placed Broederlam's two figures in similar poses (but how much more gentle and gracious!) in front of a distant scene in which we can distinguish a lake with rippling waves and a swan, a hillside with a farmer beating his donkey, grazing sheep (whose shepherd is down by the lake instead of looking after them), and a château with pointed towers, all indicated by delicate touches of the brush. This much we can parallel in Ambrogio Lorenzetti's *Allegory of Good Government* frescoes (see figs. 19–17, 19–18), but immediately above the hills and towers we notice what is the Boucicaut Master's historic breakthrough—just where Ambrogio stopped us at an inert background the Boucicaut Master carries the eye into the hazy horizon, floating clouds, and the bright blue zenith of an infinite sky. This is the first time, to our knowledge, since Roman painting that limitless natural extent has been recognized by an artist—some fifteen years earlier, in fact, than Gentile da Fabriano's *Strozzi Altarpiece* (see figs. 20–36, 20–37). The decisive step in the conquest of nature has been taken. But it is still tentative. The artist retains the traditional double scale for figures and setting, underscored by his introduction of tiny clumps of trees in the foreground less than a quarter the size of the figures. Nonetheless, this enchanting painter has made a further crucial distinction, that between real and spiritual light. In contrast to Giotto and Taddeo Gaddi (see figs. 19–10, 19–11), the Boucicaut Master depicts natural light as the eye sees it; spiritual light is rendered with rays of gold pigment ruled with the precision of an architectural draftsman. This distinction remained in Renaissance art with few exceptions until in his *Transfiguration of Christ* (see fig. 22–34) Raphael perfectly fused natural and spiritual light.

THE LIMBOURG BROTHERS The next joyous assault on the real world was led by three young men, the brothers Paul, Herman, and Jean (also called Jeannequin or Hennequin) de Limbourg, from Nijmegen, now in Holland. They were nephews of Jean Malouel, who finished painting the statues of Claus Sluter. None of the three could have been born before 1385 and all were dead by 1416, possibly in the same epidemic that carried away their princely patron, the duke of Berry. He seems to have thought very highly of his three youthful artists, especially Paul, who by all accounts was the strongest personality and for whom the duke went to the special length of kidnapping a wife and settling the couple down in a lovely house in Bourges. When the duke's estate was inventoried, among the tapestries, jewels, gold and silver plate, and splendid costumes of gold brocade and rich fur, as well as the precious illuminated manuscripts (including some Italian examples) that this insatiable collector loved so dearly and which filled his seventeen châteaus, were found the unfinished and unbound gatherings of a *Très Riches Heures* (Very Rich Book of Hours), which later, in the hands of another collector, were finished by a lesser master. The sections done by the Limbourgs between 1413 and their untimely death are among the loveliest creations of Northern painting. Beautiful as are the traditional illustrations from the Life of Christ and the Life of the Virgin, it is the calendar scenes that above all attract our attention.

21-5. THE LIMBOURG BROTHERS. *February,*
illumination from the *Très Riches Heures du Duc
de Berry.* 1413–16. Musée Condé, Chantilly

These are, so to speak, dramatizations of the paired Signs of the Zodiac and
Labors of the Months sculptured on cathedral façades. Here, however, the appro-
priate signs appear in gold over the chariot of the sun in the blue dome of heaven,
and the labors go on in the landscape below. *February* (fig. 21–5) is bitterly cold,
and the world is deep in snow, never convincingly represented before this moment.
Among white hills nestles a tiny village under a leaden sky. A peasant cuts branches
for firewood, another guides his wood-laden donkey along the snowy road. In the
foreground snow makes fluffy caps on a hayrick and a row of beehives, sheep
huddle for warmth in their sheepfold (which has a hole in its roof), magpies peck at
grain, and a shepherd stamps up and down and blows upon his freezing hands.
Gentlemen and ladies are nowhere to be seen. Inside the farmhouse, with smoke
curling from its chimney and the front wall removed for our convenience, an array
of clothing and towels hangs against the walls, and two peasants, conspicuously
male and female, lift their garments, somewhat too high, to warm themselves
before a (gilded) fire while the mistress of the house turns disdainfully from such
coarseness to warm considerably less of herself.

In ten of the months the manifold labors of the peasants are contrasted with the
delights of the aristocracy, but in such a way as to make the peasants appear

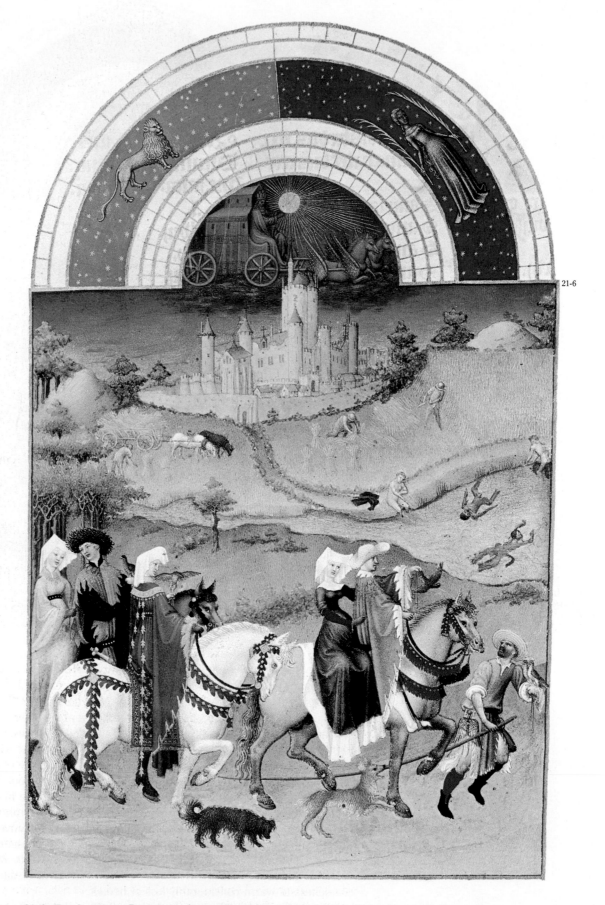

21-6

21-6. THE LIMBOURG BROTHERS. *August,* illumination from the *Très Riches Heures du Duc de Berry.*
1413–16. Musée Condé, Chantilly

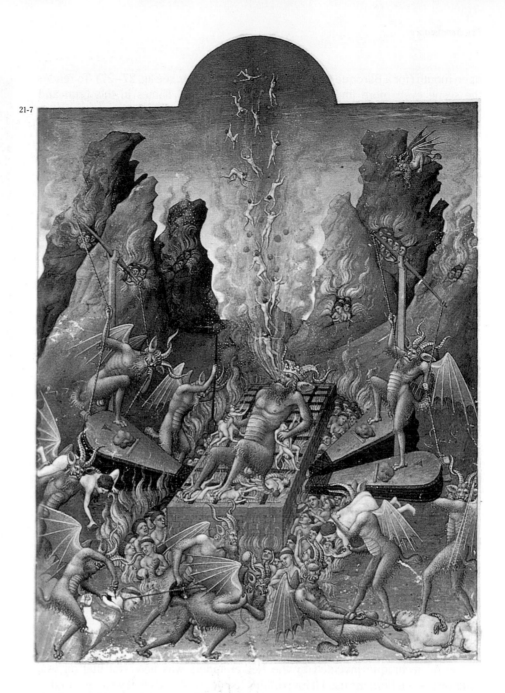

21-7. The Limbourg Brothers. *Hell*, illumination from the *Très Riches Heures du Duc de Berry*. 1413–16. Musée Condé, Chantilly

carefree children of nature while the lords and ladies are prisoners of their own elegance. *August* (fig. 21–6) is hot. A party of gentlemen and ladies, sumptuously dressed in the doubtless smothering fashion of the time (note the sleeves trailing below the horses' bodies), ride off a-hawking. The background has been brought forward as compared with the Boucicaut Master and is dominated by one of the duke's favorite residences, the Château d'Étampes, below which peasants reap wheat, bind it into sheaves, and pile them into a cart. In the middle distance peasants have cast off their clothes and swim delightedly in the River Juine. The artist has even studied the distortion caused by the refraction of light penetrating the water. The arcs above have yet to receive their appropriate letters and numbers.

In contrast to the delights of earthly life, the Limbourg brothers let their imaginations produce a searing image of *Hell* (fig. 21–7), a gray immensity of spiring rocks on which there is, to quote John Milton, "no light but rather darkness visible." Crowned king of this desolate region, Satan extends himself on a giant grill, on which he roasts the helpless damned clutched in his fists, while demons on either side work the giant bellows, whose mechanisms are meticulously represented. From the far dome of Heaven a torrent of naked souls pours down—into Satan's

open mouth (for a Baroque transformation of this theme, see fig. 27–27). To render the scene even more impressive, all the demons and flames in this grim and otherwise colorless region are rendered in gold.

THE ROHAN MASTER After the delicacy of the *Très Riches Heures,* the macabre expressionism of the Rohan Master comes as a shock. So called because he and his assistants illuminated the *Grandes Heures de Rohan* (commissioned by Yolande of Aragon, wife of Louis II of Anjou), this artist is of unknown nationality. He could have been a Netherlander, a German, or even a Spaniard. The only thing certain about him is the devastating originality of his style. In one full-page illustration (fig. 21–8), before the Office of the Dead, he depicts a dying man from whose mouth issue the words, in Latin, "Into thy hands I commend my spirit; thou hast redeemed me, O Lord God of Truth." The first clause was uttered by the dying Christ from the Cross (Luke 23:46), and the rest is a quotation from Verse 5 of Psalm 31. The man's emaciated body, rendered with gruesome fidelity to detail, is stretched upon a black silk shroud embroidered with gold and with a red cross; on the barren ground about him are strewn bones and skulls. From a blue heaven, made up entirely of tiny angels drawn in gold, Christ (so labeled in the halo) bends down, hair and beard as white as wool and bearing a sword, as in Revelation 1:14. He replies, in French, "For thy sins thou shalt do penance; on the day of judgment thou shalt be with me." An angel and a demon struggle over the dead man's soul. The strength of the drawing, the boldness of the composition, and the terrifying reality of the image show an artist of unusual stature, one who leads toward the majesty of Rogier van der Weyden (see fig. 21–21), just as the Limbourg brothers point toward the serene perfection of Jan van Eyck.

Netherlandish Panel Painting

The glowing pages of the Books of Hours could be turned only by the rich and by their fortunate guests. The new style found its complete expression in altarpieces, which, whoever may have commissioned them, were visible to all in churches and addressed a public drawn from every class. Consequently, religious narratives were set in the context of daily life in Netherlandish towns and among the familiar activities of the merchants who dominated them. From a tentative beginning in such rare examples as Broederlam's pair of panels for the Chartreuse de Champmol, these altarpieces were painted with increasing frequency in the 1420s and before the end of the century numbered in the thousands.

The oil technique invented by the Netherlanders was new. Not that oil was unknown—the Romans used it for painting leather or shields that were exposed to weather, and some aspects of oil technique are described in medieval treatises, culminating in Cennino Cennini (see page 568). But it had never before been used for altarpieces. Apparently, the Netherlanders were dissatisfied with the appearance of a tempera surface, which, notwithstanding the varnish universally applied as protection, was dry, mat, and enamel-like, achieving its best effects with brilliant colors. Instead of egg yolk, then, the Northerners used a very refined oil vehicle, starting with linseed or walnut oil that had been fused when hot with hard resin, such as amber or copal, and then diluted with oil of rosemary or lavender. On the gesso panel, smoothed to porcelain finish, the painter drew his forms and light effects with a brush dipped in a single color, usually gray. On this base he applied his colors suspended in oil. The final layers were glazes, that is, solutions of oil and turpentine mixed with color to give a transparent or translucent effect. The final varnishes were also often mixed with color, so that the earlier layers were seen through them as through colored glass. The Netherlanders thus achieved a depth and resonance of color and effects of shadow and half light unobtainable in tempera. Given the optical interests of the fifteenth century, it was only a matter of time, as we have seen, before oil superseded tempera entirely, even in Italy.

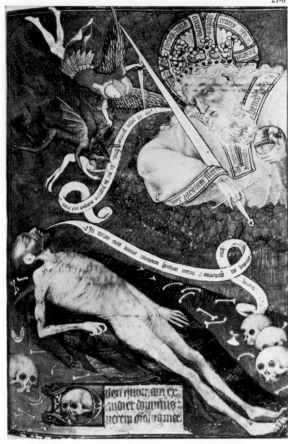

21-8. THE ROHAN MASTER. *Dying Man Commending His Soul to God,* illumination from the *Grandes Heures de Rohan.* c. 1418. Bibliothèque Nationale, Paris

THE MASTER OF FLÉMALLE A tormenting aspect of early Netherlandish paint-
ing is the frequency with which the actual name of a master eludes us, however
keen may be our feeling that we know his personality from his work. One of the
leading pioneers of panel painting is a case in point. His work has been assembled
on the basis of fragments of altarpieces thought to have come from the Abbey of
Flémalle, and it is clear from their style that the artist who painted them must have
been the teacher of Rogier van der Weyden (see below). We have documentary
accounts of a painter from Tournai called ROBERT CAMPIN (c. 1378–1444), whose
principal pupil was Rogier de la Pasture. Since "Pasture" is French for "Weyden,"
this ought to identify Campin with the Master of Flémalle. Although most scholars
accept the hypothesis, we must mournfully admit the lack of absolute proof.

An early work by this brilliant master is the *Nativity* (fig. 21–9), which is thought
to have come from a monastery near Dijon, perhaps even the familiar Chartreuse
de Champmol, and to have been painted about 1425. Campin (to use the name the
majority prefer) has shown the very moment of birth, according to the vision of
Saint Bridget, a Swedish princess who in the late fourteenth century on a visit to
Bethlehem saw the naked Christ Child appear miraculously on the ground before
the fully clothed and kneeling Mary, while Joseph held a candle whose flame and
even the light of the rising sun were set at naught by the light from the shining
Child. Campin has grouped densely before a humble shed Mary, Joseph, and two
midwives—one who believes in the miracle, the other incredulous—while angels
float above. Their glad tidings and the dialogue of the midwives are represented on
floating scrolls as in the Rohan Hours (see fig. 21–8). All the figures and their
massive, broken drapery folds are projected with a sculptural power obviously
derived from Sluter, whose sharp vision has also stimulated the care and subtlety
with which the head of the aged Joseph and the faces of the three shepherds who
lean through the open window are delineated, wrinkle by wrinkle.

The landscape is brought closer to the foreground even than in the *Très Riches
Heures*, and the leafless trees, the rider who has just rounded the bend in the road,
the wayside inn that had no room for the Holy Family, the distant (Gothic) Beth-
lehem, and the lake with its sailboat and rowboat are all shown with scrupulous
care. However, in contrast to Masaccio in the almost contemporary *Tribute Money*
(see fig. 20–38), Campin still retains the convention of "rising perspective," so that
the background can be seen over the heads of the figures. Although he has
rendered beautifully the shadows of the banks and the bushes thrown by the rising
sun on the road, he has attempted nothing like the night-light effects of Gentile da
Fabriano's predella for the *Strozzi Altarpiece* (see fig. 20–37), possibly considering
such darkness unsuitable to his larger panel. The sun, symbol of Christ, shines with
gold rays, as does the Child on the ground below. With the oil medium Campin is
able to achieve a new softness and richness in the tones, from the russet colors of
the landscape and the rich garments of the midwives to the muted gold of the rays
and the delicate lavenders and blues in the shadow of Mary's white tunic. Like all
Netherlanders henceforward, Campin omits the halos still customary in Italian
painting.

A slightly later work, called the *Mérode Altarpiece* because for generations it
belonged to the Mérode family, painted about 1425–26, takes us into a contempo-
rary Netherlandish interior as a setting for the Annunciation (fig. 21–10). Unlike
the generally stationary altarpieces in Italy, Netherlandish equivalents were usually
hinged, so that the side wings close over the central panel like doors; they were
generally painted on the outside as well. The three panels of the *Mérode Altarpiece,*
under the guise of descriptive realism, form a richly stocked triple showcase of
symbols. In the central panel, the Virgin is seated, probably on a cushion, and is still
reading (doubtless Isaiah 7:14, as often in representations of the Annunciation: "A
virgin shall conceive, and bear a son") as she leans against a bench before a fire
screen. On the polygonal table are another open book, a vase of lilies (symbol of the
Virgin's purity), and a still-smoking candle, symbol of the Incarnation (Isaiah 42:3:

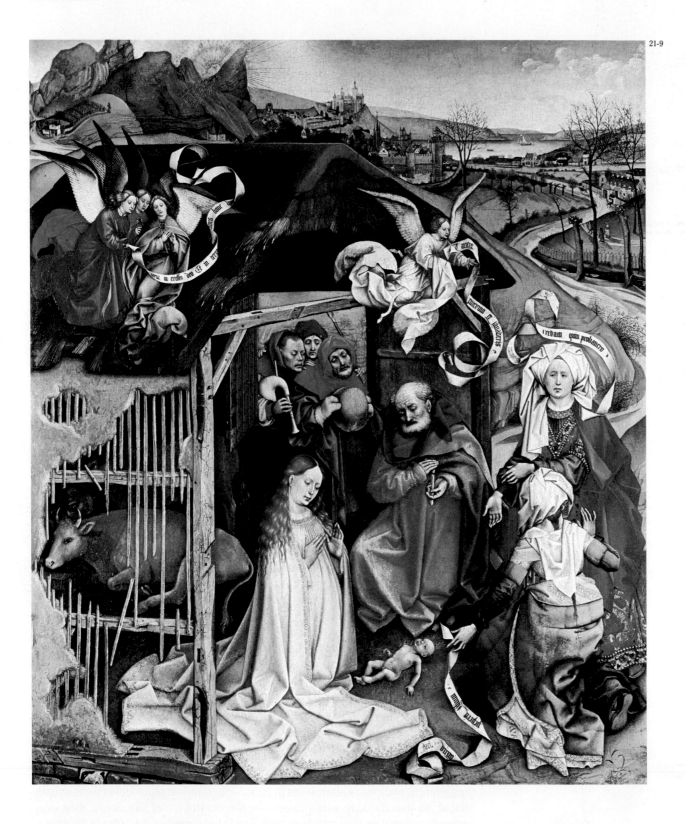

"the smoking flax shall he not quench"); a copper ewer, hanging in a niche, and a towel on a rack have been claimed as an allusion to Christ's washing of the Apostles' feet, and to the washing of the world from sin, predicted for the morrow in the breviary prayers for Christmas Eve. The Christ Child can be seen gliding down golden rays from the nearest round window, carrying the Cross over his shoulder, a representation frequent in Annunciations until now but soon to be forbidden as

21-9. THE MASTER OF FLÉMALLE (ROBERT CAMPIN?). *Nativity.* c. 1425. Oil on panel, 34¼ × 28¾″ (87 × 73 cm). Musée des Beaux-Arts, Dijon

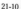

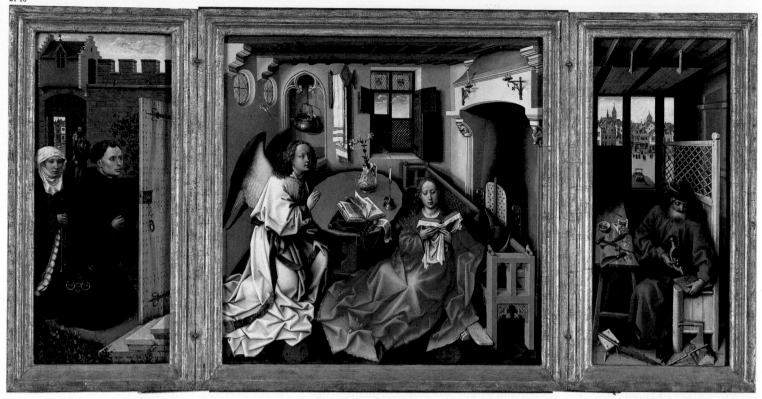

21-10. THE MASTER OF FLÉMALLE (ROBERT CAMPIN?). *Kneeling Donors; Annunciation;* and *Joseph in His Carpentry Shop,* view of the *Mérode Altarpiece* (open). c. 1425–26. Oil on panel, center 25¼ × 24⅞″ (64.1 × 63.2 cm); each wing approx. 25⅜ × 10⅞″ (64.5 × 27.6 cm). The Metropolitan Museum of Art, New York. The Cloisters Collection. Purchase, 1956

heretical. The closed garden in the left panel, in which the kneeling donor and his wife (a couple from Mechelen named Inghelbrechts) receive their view of the miracle through the door left open by the angel, is the closed garden of Mary's virginity (Song of Solomon 4:12: "A garden inclosed is my sister, my spouse") and is filled with flowers symbolic of Mary.

The right wing, Joseph's carpentry shop, is packed with symbols. He is contriving a mousetrap and, according to Saint Augustine, the Cross is the mousetrap and Christ the bait to catch the Devil. Not only are the ax, saw, and rod in the foreground all mentioned in Isaiah 10:15 but also the ax "laid unto the root of the trees" signifies the fate of sinners in Matthew 3:10. The saw is the instrument of Isaiah's martyrdom, and the rod is Joseph's rod, which bloomed miraculously to designate him as the Virgin's husband (see examples by Jean Fouquet, fig. 21–37, and by Raphael, fig. 22–26). This listing by no means exhausts the symbols recently identified by scholars among the collection of Campin exhibits. Well may one ask who, in 1425, was supposed to know all these things and how an artist, who presumably had no theological training, could find them out. One must suppose the existence of a learned adviser, consulted by both patron and painter.

The identification of the interior of the altarpiece as an inward extension of its frame obviously recalls Pietro Lorenzetti's invention (see fig. 19–16), and the drapery folds are clearly Sluteresque. Although the rising perspective is a bit dizzying, Campin's delight in rendering as accurately as possible not only the real objects in the interior but also the views out of Joseph's window and the garden gate into a little Netherlandish town is infectious.

JAN VAN EYCK Among all the masters who outdid each other in efforts to enhance the new naturalism in the early fifteenth century, Jan van Eyck (c. 1390–1441) stood out in the eyes of his contemporaries; about 1456 the Italian humanist Bartolommeo Fazio called him the "prince of painters of our age." Without a doubt

21-11. JAN VAN EYCK. *Baptism of Christ,* illumination from the *Turin-Milan Hours.* c. 1422–24. Museo Civico, Turin

he was one of the greatest artists who ever lived, and to many he shares the summit among Northern painters only with Rembrandt in the seventeenth century. The absoluteness and self-sufficiency of van Eyck's work, which render all words about him superfluous, may be illustrated by a passage from one of Fazio's descriptions of paintings by him that have now disappeared. This passage describes a triptych painted for the Genoese Giovanni Battista Lomellino; he appears in one wing "lacking only a voice, and a woman whom he loved, of remarkable beauty, she, too, carefully represented just as she was; between them, as if peeping through a crack in the wall a ray of sun which you would take to be real sunlight." Other naturalistic artists *represent* nature; van Eyck seems to *reveal* it. Nor can his pictures be reproached with the modern term "photographic," for no camera can approach the reality displayed by his pictures. One immediately accepts that what he shows really exists, down to the most minute detail, not separately catalogued as in the work of Campin but unobtrusively there, one thread in a web of absolute being. And nothing in his paintings is more convincingly real than the segment of atmospheric space his frame circumscribes, in which light, bright or dim, is dissolved, reflecting back to us from countless surfaces and textures. It is strange, therefore, that when the chips are down there should be any doubt as to which paintings are really by a master so universally acknowledged as great and which are not. Yet such is the case with this most enigmatic of artists, around whose work the arguments have reached no better than a cease-fire.

We know little about Jan van Eyck's early life. A sixteenth-century tradition maintains that he came from Maaseyck in the northeast corner of present-day Belgium, across the Maas (Meuse) River from Holland. The first reference to him records his painting a Paschal candle (destined to be consumed) at Cambrai in 1422; thereupon, he entered the service of John of Bavaria, count of Holland, and made decorations for his palace at The Hague. After John's death in 1425, van Eyck became *varlet de chambre* (doubtless, an honorary title) to Philip the Good, duke of Burgundy, and retained the position until his own death. Philip not only considered him irreplaceable as a painter but also sent him on diplomatic missions, including short trips and "long and secret journeys" in 1426, as well as on a trip to Portugal in 1428–29 to bring back Philip's bride, Princess Isabella. At least one of his journeys took him to Italy, where he must have seen the work of Masaccio and met

Florentine artists. In 1430 he settled for good in Bruges, and then the signed and dated works begin, continuing until his death eleven years later.

Part of the controversy centers around the authorship of certain illuminations in the *Turin-Milan Hours,* begun for the duke of Berry, left unfinished at his death, and worked upon thereafter by several painters at different dates. The group in question, done by an illuminator known as Hand G, contains at one point the coat of arms of the noble house of Bavaria, and thus was presumably painted before the death of Count John in 1425 and perhaps even before that of William IV in 1417. The author adheres to the view that Hand G was Jan van Eyck. One tiny miniature, scarcely two inches high, at the bottom of a page, shows the *Baptism of Christ* (fig. 21–11) as only a genius could have painted it, at this or any date. On a rocky ledge in the foreground crouches John the Baptist; he pours water from a pitcher over the head of Christ, who stands in the river. On the distant bank a castle rises from the water's edge; to our right other figures keep their distance, half-concealed by rocks. Upstream the eyes move off to mountain ranges, tiny in the distance, yet hardly above the heads of the figures—rising perspective is abandoned. For the most part the water is smooth, disturbed only by an occasional ripple; behind the Baptist it breaks over the rocks.

Above this vividly real scene descends the dove of the Holy Spirit, sent by God the Father enthroned in the initial D and shedding rays of gold, or "spiritual," light. This illumination is contrasted with natural light as it has never before been observed. Its source is the sun, which has already set, leaving a pearly radiance in the sky; this afterglow is reflected by the water; the water in turn sends the light up to the castle from below; and finally the image of the castle, thus illumined, is mirrored in the stream. Within the microscopic limits of the painting, therefore, the light from the sun (which is no longer there) moves through the atmosphere in no less than four different directions, each serenely recorded. How far away and how naive the Boucicaut Master seems!

The next controversial work, the enormous altarpiece in twenty panels in Saint Bavo's, Ghent, takes us from the microcosm to the macrocosm, encompassing as it does the entire range of Salvation. A damaged and partially destroyed inscription tells us that the work was begun by Hubert van (*e* or "from" in Latin) Eyck and finished by Jan for the leading citizen and later mayor of Ghent, Jodocus Vyd, in May 1432. The story that Hubert and Jan were brothers cannot be pushed farther back than the sixteenth century. It has been proposed by Lotte Brand Philip that the Hubert of the inscription was not Jan's brother but merely came from the same village (Maaseyck means Eyck on the Maas) and that he was not a painter but the sculptor who carved an elaborate frame, destroyed in 1566 by Protestant iconoclasts from whose depredations the paintings of the altarpiece were hidden by the clergy. (In the fourteenth and fifteenth centuries such monumental frames were universally made *before* the paintings to be placed within them; for instance, Lorenzo Monaco carried out such a frame for the altarpiece Palla Strozzi had yet to commission from Fra Angelico: see fig. 20–43.) The proposal is attractive since no signature of Hubert van Eyck appears on a single painting and all attempts to distinguish different hands in the remarkably consistent altarpiece have met with defeat. Jan would then have painted the entire altarpiece after his return from Portugal in 1429.

With the wings closed, the upper level shows the Annunciation (fig. 21–12) taking place as in the *Mérode Altarpiece* in a Netherlandish interior, although more spacious and on an upper floor. The room is still not high enough for the kneeling figures to stand upright. From the windows one looks out at the gables of a town, with people in the streets and storks in the sky. The adjoining, otherwise empty, panel is devoted to an almost ceremonial representation of the familiar niche, towel, and gleaming ewer, with the addition of a basin and a trefoil window, which makes the Trinitarian symbolism explicit. Above the rafters, as in an attic, appear the prophets Zechariah and Micah and the Erythraean and Cumaean sibyls,

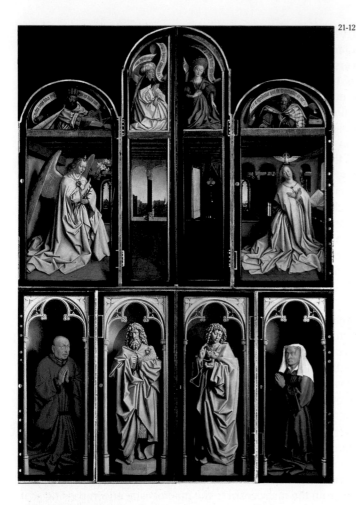

21-12

21-12. HUBERT (?) and JAN VAN EYCK. *Annunciation, Prophets and Sibyls* (above); *Saint John the Baptist and Saint John the Evangelist, Kneeling Donors* (below), view of the *Ghent Altarpiece* (closed). Completed 1432. Oil on panel 11′5¾″ × 15′1½″ (3.5 × 4.61 m). Cathedral of St. Bavo, Ghent

21-13. HUBERT (?) and JAN VAN EYCK. *Adam and Eve, Sacrifice of Cain and Abel,* and *Cain Killing Abel,* view of the upper wings of the *Ghent Altarpiece* (open)

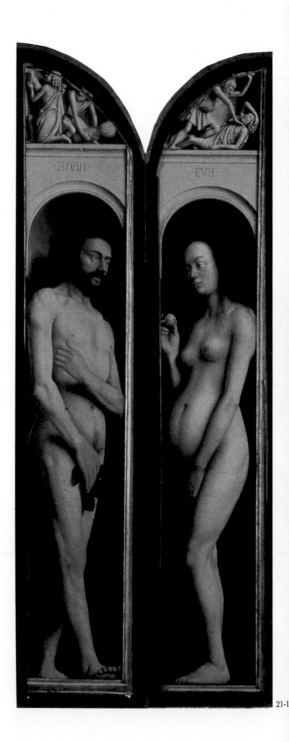

21-1

surmounted by scrolls that contain their prophecies of the coming of Christ. Beneath the floor are four identical niches; in the central pair stand white simulated stone statues of Saint John the Baptist and John the Evangelist (ironic in that Jan was paid for painting in color the surfaces of actual stone statues in Bruges), and at left and right kneel unsparing portrait figures of Jodocus Vyd and his wife Isabel Borluut. These figures forcefully recall the patrons of Masaccio's *Holy Trinity* (see fig. 20–42), which Jan might have seen in Florence only a year or two before, but are here freed from the foreground plane and turned in three-quarters view.

In order to maintain a sense of unity throughout the panels, Mary and Gabriel are robed in white, in keeping with the white statues below, and the four niches and the room are pervaded by a light from the front, clearly the actual light of the chapel because it has thrown the shadows of the vertical supports of the frame onto the floor of the room. This source conflicts with the sunlight from outside, which prints the shape of a double-arched window on the wall behind Mary—a light that could only come from the north and is therefore a symbol of the miracle taking place. The stillness and perfection of the panels are so compelling that we realize almost with a shock that there is no room in their niches for the donors' lower legs and that in the Annunciation figures and setting are still represented in different scales. The angel's Latin greeting to Mary is beautifully lettered from left to right; her response (also in Latin), "Behold the handmaiden of the Lord," is inscribed with equal care but, since it must run from right to left, is written upside down!

The wings open to reveal in the upper story the Deësis, the group of the enthroned Deity between Mary and John (fig. 21–14). The Lord appears in the guise of Christ, crowned with a papal tiara, robed in scarlet with borders of gold and gleaming jewels, and holding a scepter whose component rods of shining crystal

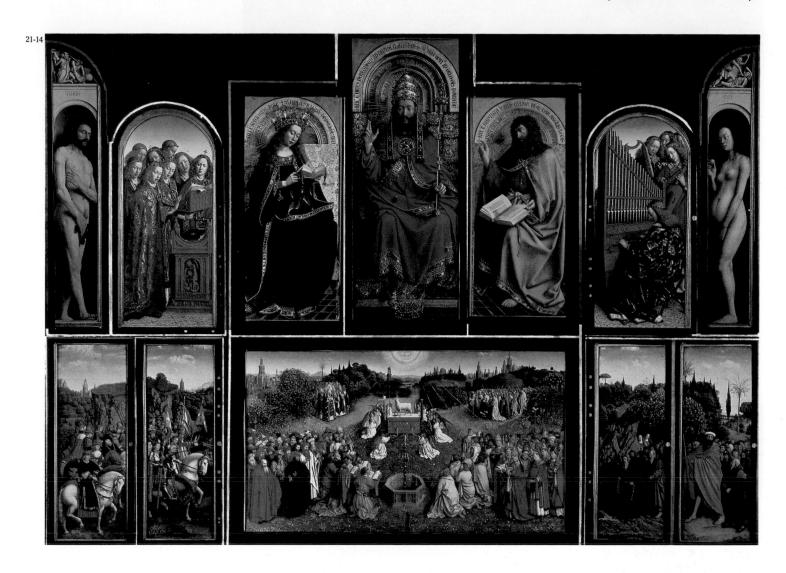

21-14. HUBERT (?) and JAN VAN EYCK. *Adam and Eve with Scenes of Cain and Abel, Music-Making Angels, Deësis* (above); *Paradise with the Lamb of God and the Company of Heaven* (below), view of the *Ghent Altarpiece* (open)

are joined by bands of gold ornament; at his feet rests a jeweled crown. On his right sits the Virgin in brilliant blue, wearing a jeweled crown from which spring roses and lilies and over which hover twelve stars; on his left is John the Baptist, whose camel-skin garment is almost hidden by a cloak of emerald green. On either side are angels robed in gold and velvet brocade, singing and playing on musical instruments; Jan has even defined the mechanism of the revolving carved-wood and brass music stand and given us a tiny glimpse of a figure working the bellows of the organ. In the dark niches at the extreme sides, and seen from below so that they belong to our space, stand Adam and Eve (fig. 21–13), sullen with guilt and shame, Eve still holding the long-withered forbidden fruit. In simulated relief sculptures in the half lunettes the Sacrifice of Cain and Abel and Cain Killing Abel are represented with terrifying power.

The five lower panels of the open altarpiece form a continuous view in rising perspective (see fig. 21–14); in the emerald-green meadow of Paradise, dotted with wild flowers, the Lamb of God stands upon an altar, the blood from his breast pouring into a chalice, surrounded by angels holding the Cross and the column at which Christ was scourged. Below the altar the Fountain of Life pours from golden spigots into an octagonal basin, and thence around the fountain and toward the observer "a pure river of water of life, clear as crystal, proceeding out of the throne of God and of the Lamb" (Revelation 22:1). Through the water one can see (only in the original) that the stream bed is composed of rubies, pearls, and emeralds.

On the left, kneeling prophets holding their books precede standing patriarchs and kings from the Old Testament; on the right, Apostles kneel in front of standing saints, many of whom wear papal tiaras or bishops' miters. From groves in the middle distance at the left advances a choir of confessors; at the right, virgin martyrs bear palms. On the far horizon can be seen the Gothic domes, pinnacles, and spires of the heavenly Jerusalem. In the left-hand panels the just judges and knights approach on beautiful, placid horses through a rocky landscape; in those to the right hermits and pilgrims, led by the giant Saint Christopher, proceed on foot. Above the wonderfully real crowd and the landscape represented down to the tiniest pebble and the last blade of grass, white clouds hang high up in a summer sky. In the center, above the Mystic Lamb and below the throne of God, the dove of the Holy Spirit sheds golden rays, contrasted with the light reflected from armor, gold, and glossy leaves, glowing from grass, flowers, rich fabrics, and the depths of jewels, muted in the footprinted dust. No sun is represented, no source is shown, for "the city had no need of the sun, neither of the moon, to shine in it: for the glory of God did lighten it, and the Lamb is the light thereof" (Revelation 21:23). With total precision van Eyck has encompassed the drama of Salvation in images of another world containing all the beauties of this one, raised, as it were, to a higher power.

 Probably in the year following the *Ghent Altarpiece* van Eyck painted a work of lesser dimensions but equal beauty, the *Madonna of Chancellor Rolin* (figs. 21–15, 21–16), given by this high official of the duchy of Burgundy to the Cathedral of

21-15. JAN VAN EYCK. *Madonna of Chancellor Rolin*. c. 1433–34. Oil on panel, 26 × 24⅜" (66 × 62 cm). Musée du Louvre, Paris

21-16. JAN VAN EYCK. *Madonna of Chancellor Rolin* (detail)

21-16

Autun when his son was made bishop in 1437. The chancellor, stoically calm, kneels before the Virgin in her palace while over her head an angel floating on peacock wings holds a crown similar to that placed before the Lord in the *Ghent Altarpiece,* and from her lap the Christ Child, his nude flesh soft against her scarlet mantle, holds in his left hand a crystal orb surmounted by a jeweled gold cross while blessing his brocade-clad worshiper with his right. The palace is largely Romanesque, a style symbolic (in the fifteenth century) of things ancient and venerated. Van Eyck has displayed his prowess in the minute representation of sculptured scenes from the Old Testament and in the interlace of the capitals, in the distinction between stained-glass and bottle-glass windows, and in the softly diffused light over the inlaid marble patterns of the floor. Through the three arches we look into Mary's garden of roses and lilies and onto a terrace on which peacocks stroll and from whose battlemented wall two men in fifteenth-century costume look down to the river below. The city in the middle distance is complete; its cathedral, resembling that of Utrecht in the Netherlands, rises above a square scattered with strollers; on the bridge move scores of people, to or from the suburb, whose pleasant houses are graced with trees. The river, rich with reflections of banks and islands, flows toward the distant mountains, some covered with snow, veiled in the luminous haze.

One of Jan van Eyck's most celebrated works is the *Wedding Portrait* (fig. 21–17), which Erwin Panofsky in an epoch-making study claimed represents the Sacrament of Marriage (which, like Baptism, need not be dispensed by a priest) being contracted between Giovanni Arnolfini, a silk merchant from Lucca resident in Bruges, and Jeanne Cenami, born in Paris of Italian parents. That the actual sacrament is intended has been recently refuted, but not the rest of Panofsky's arguments. In their bedchamber Arnolfini takes his wife's hand and lifts his right in an oath of fidelity. All the objects in the room, represented with van Eyck's customary accuracy, are so arranged as to participate symbolically in the ritual. The little dog in the foreground is a traditional symbol of fidelity; the clogs, cast aside, show that this is holy ground; the peaches, ripening on the chest and on the windowsill, suggest fertility; the beautifully painted brass chandelier holds one lighted candle—the nuptial candle, according to Netherlandish custom the last to be extinguished on the wedding night. The post of a chair near the bed is surmounted by a carved Saint Margaret, patron of childbirth. On the rear wall is the conspicuous signature (fig. 21–18) adorned by many flourishes, "Johannes de Eyck fuit hic 1434" ("Jan van Eyck was here 1434"); the artist thus takes part as witness in the solemn event. So, too, does the mirror, whose convex shape was essential for large reflections in an era when only small pieces of glass could be manufactured. Not only does the surface reflect the room and the couple from the back but also, barely visible between them, two figures, one possibly an assistant and the other— Jan van Eyck. The "mirror without spot" was a symbol of Mary, and its sanctity is reinforced by the garland of ten Gothic paintings of scenes from the Passion of Christ inserted in its frame and by the Franciscan rosary (differing sharply from the Dominican rosary in use today) hanging beside it. In none of his paintings does van Eyck surpass this subtlety of interior illumination, bringing out the resonance of the red bedspread and hangings and the green costume of the bride, as well as the depth of the groom's purple velvet tunic edged with sable, and leaving on the window-frame reflections of the peaches and on the wall light-prints from the amber beads. In the stillness of this chamber, glowing with color in the deepest shadows, we meditate with the quiet couple on the mysteries of the marriage vows.

Jan van Eyck was at once one of the first and one of the greatest painters of independent portraits, a new art form for the fifteenth century. His painting of a *Man in a Red Turban* (fig. 21–19) shows the subject in middle life, illuminated so as to bring out every facet of the face and even the growth of stubble. The controlled expression and the calm, analytic gaze (this is the earliest known portrait since ancient times whose sitter looks at the spectator) mask but do not conceal the

21-17. Jan van Eyck. *Wedding Portrait (Giovanni Arnolfini and His Bride).* 1434. Oil on panel, 33 × 22½″ (83.8 × 57.2 cm). National Gallery, London. Reproduced by courtesy of the Trustees

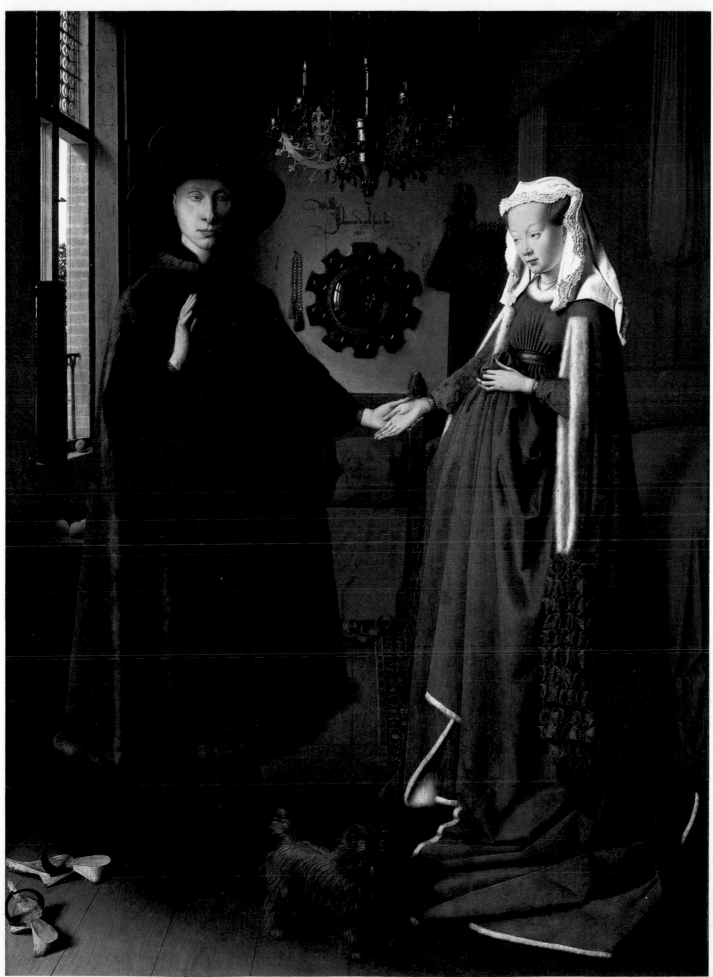

21-18. JAN VAN EYCK. *Wedding Portrait* (detail)

21-18

possibility of deep emotion; it has been plausibly suggested that he may have been no less a person than Jan van Eyck, who signed the picture boldly on the frame, with the date October 21, 1433, and his motto, "Als ich chan" ("As I can"). In view of what we have seen he could do, such reticence is sobering.

VAN DER WEYDEN Van Eyck had imitators but no followers approaching his stature; his style depended on his unique gifts of mind and vision. Rogier van der Weyden (1399/1400–1464), the leading Northern painter of the middle of the fifteenth century, turned sharply away from van Eyck's quiet world of color and light toward monumental pictures whose dramas are played in human terms on stages close to the observer. Both the linearity and the ability to characterize emotional expression, which he had possibly learned from Campin, aided van der Weyden immeasurably in the establishment of his own loftier and more aristocratic style. The large *Descent from the Cross* (fig. 21–20), perhaps once the central panel of a triptych, painted about 1435 for a church in Louvain, shows to the full the brilliance of van der Weyden's early period. The setting is entirely symbolic; the Cross is placed inside the sepulcher. Sacrificing entirely Jan van Eyck's luminous shadows, Rogier reveals the figures to us by a pitiless light that incises every wrinkle, every hair, every tear. The relentless pull toward death is emphasized by the way in which the pose of the swooning Virgin repeats the curve of the body of Christ lowered from the Cross, her hand almost touching Adam's skull. The Sluteresque folds that dominate the paintings of Campin, and that even reappear, greatly softened, in those of van Eyck, are swept away by a line or melody that is perhaps van der Weyden's most effective device for sustaining strong emotion on the plane of high tragedy. Such expressions as that of Joseph of Arimathea at the right, or such poses as the pain-wracked contortion of the Magdalene's shoulders, are never permitted to disturb the beauty of the whole conception.

21-20

21-20. ROGIER VAN DER WEYDEN. *Descent from the Cross.* c. 1435. Oil on panel, 7′2⅝″ × 8′7⅛″ (2.2 × 2.62 m). Museo del Prado, Madrid

21-21. ROGIER VAN DER WEYDEN. *Last Judgment Altarpiece* (open). c. 1444–51. Panel painting, 7′4⅝″ × 17′11″ (2.25 × 5.46 m). Musée de l'Hôtel-Dieu, Beaune

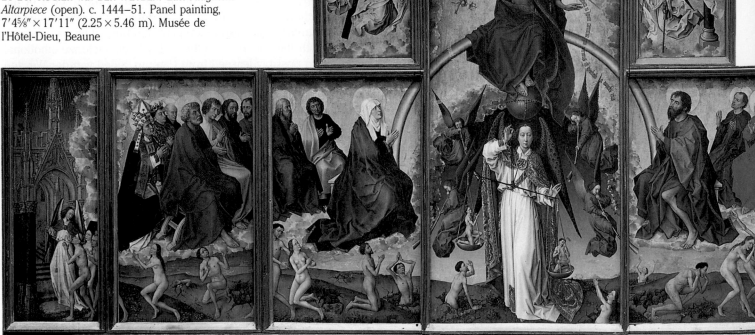

21-22. PETRUS CHRISTUS. *Portrait of a Carthusian Monk*. 1446. Tempera and oil on panel, 11½ × 9″ (29.2 × 22.9 cm). The Metropolitan Museum of Art, New York. The Jules Bache Collection, 1949

In 1435 van der Weyden was made official painter to the city of Brussels, an office he held for nearly thirty years. At the time of the papal Jubilee of 1450 he visited Italy and not only influenced the Italians deeply but also returned with his vision enlarged by the monumentality of Italian painting. Probably in 1451 he finished his most ambitious work, a polyptych representing the *Last Judgment* for the Hôtel-Dieu at Beaune, a splendid Gothic hospital founded by Chancellor Rolin in Burgundy, where it still stands. Van der Weyden has treated the nine panels as one (fig. 21–21) and minimized their frames, except for inscribing through the corners of the panels flanking the central section the slender rainbow of the Judge's throne. At either end of the rainbow Mary and John half sit, half kneel, and around it in two quarter-circles Apostles and saints are seated on the clouds. Below the sphere that is Christ's footstool the drama centers on Gabriel, solemn and peacock-winged, weighing souls in the balance. Heaven and Earth have passed away; the barren ground gives up its naked dead in an amazing variety of beautifully drawn poses. On Christ's right a gentle angel leads the naked blessed into the golden portal of a Gothic Heaven; on his left Hell opens before the damned, its horrors limited, in deference to the sick in the neighboring ward of the hospital, to the expressions on the faces of those about to fall into its depths.

The perfection of Jan van Eyck's vision lay beyond the possibility of effective imitation. Not surprisingly, therefore, it was the grand, monumental style of Rogier van der Weyden that exercised the strongest influence on the art of the next generation, not only in the Netherlands but throughout Northern Europe.

PETRUS CHRISTUS Nonetheless, Jan had a humble follower, Petrus Christus (c. 1410–1472/73), who remained faithful to his luminary vision in spite of occasional shortcomings of draftsmanship and perspective. The most winning of Petrus Christus' evocations of the magic of light is a little *Portrait of a Carthusian Monk* (fig. 21–22), signed and dated in 1446 by an illusionistic inscription on the parapet. Bust-length, the figure looks through the painted border as through the window of his cell, remote and withdrawn in his expression and in his gaze conscious of a mystery unknown to us. Natural light plays full upon his dry skin and feathery two-tailed beard, picking up little of the minute detail that would have fascinated Jan van Eyck but glowing as from an unseen window in the soft, gray background, and contrasted with the spiritual light of the perfectly placed halo, which is reduced to a single golden wire just as the meaning seems suddenly focused—once we notice it—in the personality of the wonderful fly on the parapet. The sitter has been identified as the Carthusian theologian Dionysius of Louvain, and Meyer Schapiro has pointed out that Dionysius described the beauty of the natural universe as a hierarchy starting with the tiniest insect.

BOUTS Among the host of excellent painters working in the Netherlands later in the fifteenth century, Dirc Bouts (c. 1413–75) is impressive because of his striking combination of great technical accomplishments, in the tradition of van der Weyden, with touching naïveté of expression. Born probably in Haarlem, Bouts worked in later life in Louvain, where he painted in 1464–68 a major altarpiece whose central panel represents the *Last Supper* (fig. 21–23). The setting is the familiar Netherlandish interior—a room softly lighted from the side by traceried Gothic windows through which the town can be seen, a view out the door into a garden, a patterned marble (or tiled?) floor seen in rising perspective, a richly veined column with a carved capital. Although Bouts can control every resource of Netherlandish naturalism, the arrangement of the figures seems stiff until one realizes that the composition has been interpreted in the light of its destination for an organization of laity called the Confraternity of the Holy Sacrament.

Two professors of theology at the University of Louvain are known to have dictated the theme (are they the two who look out at us from the pass-through into the kitchen?). At the moment when Christ says, "This is my body which is given for

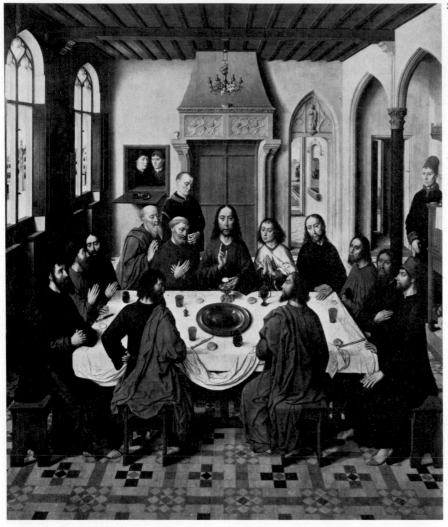

21-23. Dɪʀᴄ Bᴏᴜᴛs. *Last Supper,* center panel of an altarpiece. 1464–68. Panel painting, approx. 72 × 60⅛″ (1.83 × 1.53 m). Church of St. Peter, Louvain

you: this do in remembrance of me" (Luke 22:19), he holds up not an ordinary piece of bread but the disk-shaped wafer of the Western Eucharist, and instead of a wineglass a chalice stands in front of him. Christ's head arrives exactly at the intersection of two mullions in the screen that closes off the fireplace when not in use to suggest a cross, and his face is exactly frontal. All the Apostles' faces are turned so that we can see them, and light falls on them to reveal their reverent expressions; even the two seen from the back are shown in profile; Judas is instantly recognizable with his left hand, a symbol of treachery, hidden behind his back. The combination of symmetry, even lighting, and perspective lines concentrating directly above Christ's head gives the picture a meditative intensity appropriate to its liturgical theme.

VAN DER GOES In the decades following the death of van der Weyden, the greatest Northern painter was Hugo van der Goes (c. 1440–82). Probably born in Antwerp, he moved to Ghent, joined the artists' guild in 1467, and in 1474 was made its dean. In the following year, notwithstanding his worldly success, van der Goes retired to a monastery near Brussels as a lay brother, but continued to paint. In 1481 he experienced a severe mental collapse, followed by fits of insanity, and the next year he died. His pictures are not numerous; all are marked by deep and, at times, disordered feeling and by sonority of color and sensitivity of drawing. His introspective personality stands at the antipodes from the carefree Limbourg brothers. Although he never emulated the jewel-like perfection of Jan van Eyck, the richness of his color and the depth of his shadows owe much to the great master of Bruges. His debt to van der Weyden is somewhat less, residing largely in the beauty of his drapery rhythms.

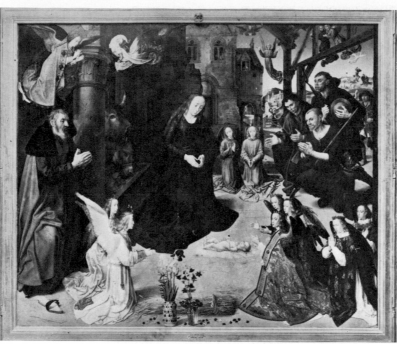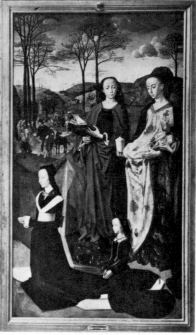

21-24. Hugo van der Goes. *Donors and Their Patron Saints* and *Adoration of the Shepherds,* view of the *Portinari Altarpiece* (open). c. 1476. Tempera and oil on panel, center 8′3⅝″ × 9′10⅝″ (2.53 × 3.01 m); each wing 8′3⅝″ × 4′7½″ (2.53 × 1.41 m). Galleria degli Uffizi, Florence

21-25. Hugo van der Goes. *Adoration of the Shepherds,* detail of the center panel of the *Portinari Altarpiece*

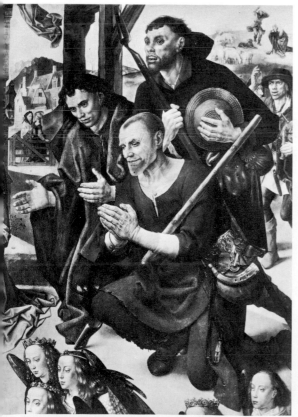

Van der Goes's major work is the *Portinari Altarpiece* (fig. 21–24), painted about 1476 for Tommaso Portinari, an agent for the Medici Bank in Bruges. Probably in 1483, after the master's death, the altarpiece was sent to Florence, where it made a sensation, and was set on the altar of the small hospital-church of Sant'Egidio, whose walls had been frescoed by Domenico Veneziano and Andrea del Castagno. Although the Florentines were familiar with the work of van Eyck and van der Weyden, they had never seen anything like the emotional power of van der Goes, nor the directness with which his new range of content was visually expressed.

The central panel of the *Portinari Altarpiece* shows the Adoration of the Shepherds in a new way. Mary has just given birth to the Child, miraculously while kneeling as in the vision of Saint Bridget, and he lies on the ground inside the half-ruined shed, shining with the gold rays of spiritual light. The brilliantly painted flowers in the majolica *albarello* (apothecary jar) and glass tumbler in the foreground are symbolic—the scarlet lily signifies the blood of the Passion, the columbine is a frequent symbol of sorrow, and the iris (in Latin, *gladiolus:* little sword) refers to the prophecy made by Simeon to Mary in the Temple, "Yea, a sword shall pierce through thy own soul also" (Luke 2:35). These allusions to the sacrifice of Christ are made explicit by the sheaf of wheat (the Eucharist) alongside the flowers, and the mood is established by the reverent poses and expressions and folded hands of Mary, Joseph, and the nearest shepherd, and even by the alert ox, who has stopped eating; the ass, who symbolizes the infidels, keeps on munching.

It has been shown that the angels who attend the scene are dressed as the assistant ministers (archpriest, deacon, subdeacons, and acolytes) would be at the first Solemn High Mass of a newly ordained priest, yet no one wears the chasuble, the garment of the celebrant. This is because the celebrant, the priest, is Christ himself (repeatedly extolled as priest in the Book of Hebrews). The deserted house in the background has been shown to symbolize the house of David, whose harp is sculptured over the door. It is noted here for the first time that this centrally placed door has other meanings: its role as the closed door of Mary's virginity is underscored by the fact that her face partly overlaps it, and the connection of the altarpiece with the Portinari family lies in their very name (that is, "door-keepers"). The atmosphere pervading the picture can best be described as that of solemn joy; the delight that a Child is born is tempered by foreknowledge of his sacrifice, and sadness is in turn transfigured by the revelation of the Eucharist. In the faces of the three shepherds (fig. 21–25) one can discern three stages of understanding, in

terms of nearness to the mystery. The furthest, almost bestial, has removed his hat in mere respect; the second, deeply human, opens his hands in wonder; the third, saintlike, joins his hands in prayer. The wealth of emotion in the central panel is shared by the adults and children of the Portinari family in the wings and by their gigantic patron saints. Even the wintry landscapes participate in the story; in the distance, on the left, Joseph assists Mary, who can no longer stand the pain of riding the donkey on the mountainous road to Bethlehem; and among the leafless trees on the right, an outrider of the Three Magi asks a kneeling peasant the way to the stable.

MEMLINC Van der Goes's passionate and mystical style is worlds apart from that of his pious and prolific contemporary in Bruges, Hans Memlinc (c. 1440–94). Born at Seligenstadt, Germany, Memlinc was trained in the Netherlands, perhaps by van der Weyden, whose influence shows in his work. He became a citizen of Bruges in 1465 and must have studied the work of Jan van Eyck, his predecessor in that city, with whom he was even confused in the eighteenth century as "John of Bruges" ("Hans" and "Jan" are both equivalents of "John"). His tranquil art represents a personal synthesis of those tendencies in Netherlandish painting open to his comprehension, and in that sense he may be considered a parallel to his Florentine contemporary Ghirlandaio (see page 622). Among his numerous works, one that shows both his technical ability and his narrative charm is the *Shrine of Saint Ursula,* consecrated in 1489 (fig. 21–26), a carved and gilded reliquary casket less than a yard high, built like a little Gothic chapel with tracery and pinnacles and painted on all four sides as well as on the gabled roof. Memlinc's depiction of the martyrdom of Saint Ursula would win him no drama prizes, but its naïveté is irresistible. In the left-hand panel, seen in fig. 21–27, the saint, attended by pope and cardinals, leaves Rome accompanied by as many of her eleven thousand virgins as Memlinc could crowd into two ships. On their arrival at Cologne, in the central panel, the waiting Huns slaughter both boatloads of virgins with crossbows, longbows, and swords, in a scene explicitly and calmly represented. In the final panel Ursula, saved on account of her exceptional beauty, refuses an offer of marriage from Julian, prince of the Huns, who has her shot on the spot. With the boats, of course, Memlinc is merely following the age-old principle of double scale for people and settings; otherwise, he would not have been able to depict the martyrdoms in such detail. In the shining armor and in the beautiful landscape,

21-26. HANS MEMLINC. *Shrine of Saint Ursula.* Consecrated 1489. Gilded and painted wood, $34 \times 36 \times 13''$ ($86.4 \times 91.4 \times 33$ cm). Memlinc Museum, St. John's Hospital, Bruges

21-27. HANS MEMLINC. Left to right: *Embarkation from Rome, Martyrdom of Saint Ursula's Companions,* and *Martyrdom of Saint Ursula,* panels of the *Shrine of Saint Ursula*

21-28. GEERTGEN TOT SINT JANS. *Nativity.* c. 1490. Oil on panel, 13⅜ × 9⅞″ (34 × 25 cm). National Gallery, London. Reproduced by courtesy of the Trustees

21-29. HIERONYMUS BOSCH. *Garden of Delights.* c. 1505–10. Oil on panel, center 7′2½″ × 6′4¾″ (2.2 × 1.95 m); each wing 86½ × 38″ (219.7 × 97 cm). Museo del Prado, Madrid

which continues behind all three scenes with great understanding of light and color, Memlinc shows himself a superb technician in the tradition of Jan van Eyck. His delineation of Saint Ursula's loveliness goes far to justify the prince's interest. German by origin, Memlinc has depicted faithfully the Romanesque churches of Cologne and its great, then-unfinished Cathedral (in the right-hand panel). Accepted on its own terms, this little reliquary is a work of magical beauty.

GEERTGEN TOT SINT JANS The magic deepens in the art of a painter called Geertgen tot Sint Jans (Little Gerard from Saint John's) because he was a lay brother at the Monastery of Saint John's in Haarlem. We know little else about him. At his death, which seems to have occurred about 1495, he was only twenty-eight years old, according to Carel van Mander, the Netherlandish Vasari. The brief list of his works includes one of the most enchanting pictures of the fifteenth century, a tiny panel of about 1490 (fig. 21–28) that takes up the theme of the night Nativity where Gentile da Fabriano left off. Mary kneels before the manger at the right, angels at the left; in the shadows Joseph, the ox, and the ass are dimly discernible. The Child in the manger, although he sheds golden rays of spiritual light, is depicted as a real miracle, in that all the illumination in the foreground comes from his tiny incandescent body. In the background the announcing angel high in the night glows with natural light that outshines the fire on the hillside. The poetry of the scene is the more intense in that Geertgen has reduced the faces to egg shapes, whose purity accentuates the calm with which these figures gently accept as fact the miracle of miracles, that a tiny Child can shine in a dark world.

BOSCH The fifteenth century comes to an unbelievable close and the sixteenth to a fantastic beginning in the art of a lonely painter about whose external existence we know little, not even the date of a single picture, and whose inner life is revealed to us only in symbols of a defeating complexity. Hieronymus Bosch (c. 1450–1516) worked largely in the city of 's Hertogenbosch, in present-day southern Holland. The inexhaustible wealth of his imagination fills the enormous triptych known as

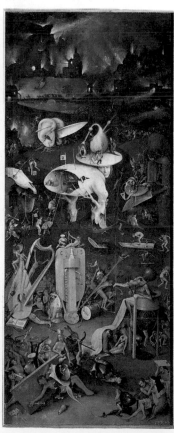

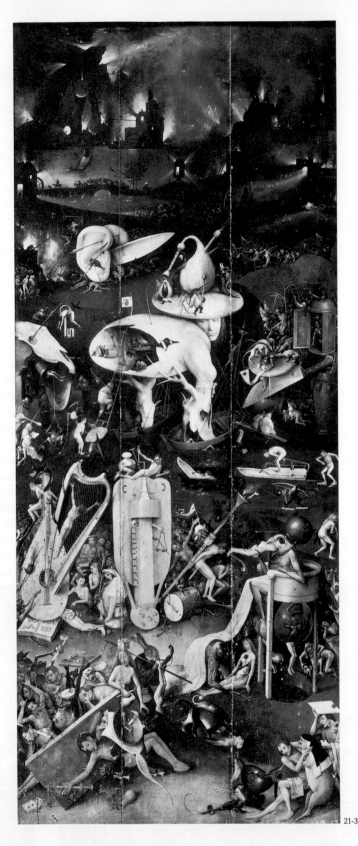

21-30. Hieronymus Bosch. *Hell,* right panel of *Garden of Delights*

21-30

the *Garden of Delights* (fig. 21–29). The left panel, the *Creation of Eve,* is easy enough to read. The Lord, strangely tiny and ineffectual, presents to Adam the already perfectly formed and sly Eve. Clearly, the trouble starts here. In the pool below and in the one around the fountain above move countless animals and birds, including a giraffe, an elephant, and unicorns. Already all is not happy; at the lower left a cat stalks off with a mouse it has caught, and a serpent more than halfway up on the right slithers ominously around a tree—the palm tree, symbol of eternal life,

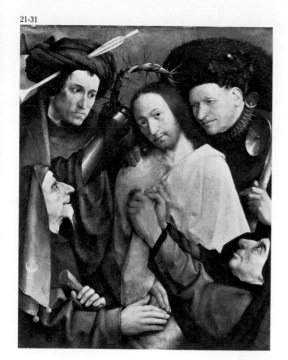

21-31. HIERONYMUS BOSCH. *Crowning with Thorns.* After 1500. Panel painting, 29¼ × 23⅝" (74.3 × 60 cm). National Gallery, London. Reproduced by courtesy of the Trustees

endangered from this moment. Fantastic rocks rise in the background, from one of which emerges a dense spiral of birds.

The central panel shows a plain with rocky outcroppings punctuated by pools and leading toward a lake in whose center is a monstrous mechanism, a gigantic metal sphere from which sprout pinnacles and fishlike forms; round it are four more fantastic combinations of rocks and living beings. In this landscape frolic hundreds of naked young men and women, emerging from or hidden in eggs, a colossal mussel shell, and spheres, domes, and cylinders of glass. All the figures are pale pink, youthful, unmuscular, and weak, and although many appear in couples (or threes and fours), no explicit sexual activity is shown. But the erotic nature of the imagery is unmistakable; some figures caress or embrace gigantic strawberries or other fruit, as well as birds and fish, that have sexual significance in several languages. In the center the little people gaily ride not only horses but also animals legendary for their appetites, such as pigs and goats, in a circle around a little pool in which nude women bathe.

A full description would be endless. Obviously, Bosch is condemning all erotic activity and yet is fascinated by it. His ambivalence is so strong that some writers have suggested that he belonged to a secret sect that looked forward to a Paradise not unlike the one in this picture. This idea has not won wide acceptance, especially since several of Bosch's major works, including this one, were later bought by the fanatically religious Philip II of Spain. Perhaps Bosch is saying that all people really want to do is to indulge their fleshly desires; in the words of Saint Paul (Romans 3:10), "There is none righteous, no, not one." The visual language Bosch uses is in itself so fascinating that he has been claimed as one of theirs by the Surrealists in the twentieth century. But the vocabulary should not surprise us; by and large, it is drawn from the pagan tradition of animal symbolism incorporated in medieval art. What renders the central picture intoxicating is that this incredible repertory of symbols is brightly illuminated, daintily drawn, and suffused with high, pale color.

And yet Bosch is heretical; for such a world he can see no salvation. The common doom is Hell, a panorama of darkness illuminated by firelight, shown in the right panel (fig. 21–30). Instead of Satan this kingdom is presided over by a pathetic monster whose body is a broken egg, whose legs are tree trunks plunged through the bottoms of boats, whose head is crowned with a disk and bagpipe, and whose face turns toward us in despair as tiny people crawl in and out of him like vermin. Above him two immense ears pierced by an arrow and flanking an erect knife blade are pushed like an engine of war across the dark plain; below, the damned are impaled on the strings of musical instruments or eaten by a hawk-headed monster seated on a tall *chaise percée* and then excreted in bubbles. At the top we look across the river Styx to a burning city lost in flame and smoke. Never before had an imagination that could conceive such things been coupled with the ability to paint them. Rather than backward toward the Middle Ages, the imagination of Bosch leads us in the direction of the Calvinist doctrine of predestination and eventually toward the inner world of dream symbols revealed by psychoanalysis.

A very different aspect of Bosch's highly personal art is exemplified by the *Crowning with Thorns* (fig. 21–31), generally considered a late work, that is, one painted after 1500. With no setting whatever, and therefore in the space of our own minds, Christ stands, surrounded by four tormenters who attempt to inflict mental rather than physical pain and whose carefully delineated faces remind us of those seen daily in our own lives. A shriveled old man, marked as a Muslim by the star and crescent on his headcloth, an archer with a crossbow bolt stuck in his turban, a soldier wearing a spiked dog collar, and an ordinary character with a downturned lower lip surround the surprisingly red-haired Christ, as the archer raises the crown of thorns to place it on Christ's head. Yet Christ shows no suffering—his bright blue eyes look out at us with searching yet calm accusation, as if we were the guilty ones. This look will not be easily forgotten, nor will the transparent delicacy of Bosch's light, nor the sensitive quality of his highly personal drawing.

Painting in German-Speaking Lands

The influence of Netherlandish art was immediate and far-reaching, more so in the fifteenth century than was that of the Italian Renaissance, which in the sixteenth broke like a flood over Western Europe. Germany developed a host of competent masters, who were more or less formed by Netherlandish style, but only a few strong individualities.

LOCHNER One charming painter of the early fifteenth century stands out. Stefan Lochner (c. 1415–1451/52), from Meersburg on Lake Constance, was trained in the studio of Campin and achieved great success in Cologne. A delightful late work is his *Presentation in the Temple,* of 1447 (fig. 21–32). Although he adopts the rising perspective of Netherlandish painting for the floor in the foreground, Lochner never relinquishes the gold background of medieval art. In his figures he reveals all the delicacy of his famous "soft" style, dissolving the sculpturesque forms he inherited from Campin into a free movement of brilliant colors. Even when they are old, Lochner's people, with their round foreheads, chubby cheeks, and shy gazes, always resemble children. And such children! His procession of boy-choristers, placed according to size and led by the tiniest of tots, is disarming.

21-32. STEFAN LOCHNER. *Presentation in the Temple.* 1447. Oil on panel, 54¾ × 49⅝" (1.39 × 1.26 m). Hessisches Landesmuseum, Darmstadt

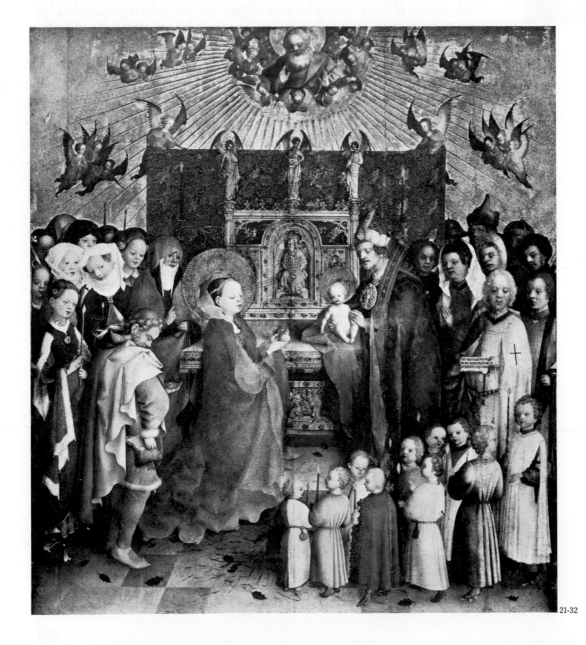

21-32

21-33

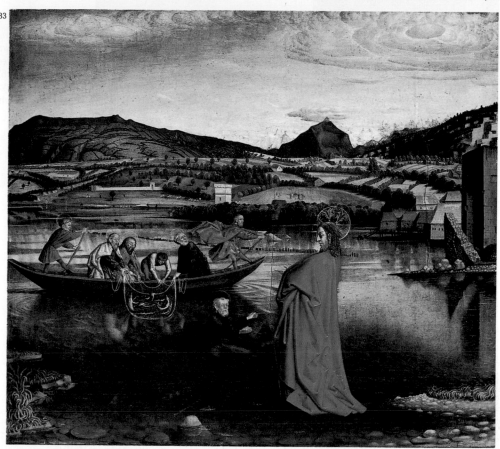

21-33. KONRAD WITZ. *Miraculous Draft of Fish,* from an altarpiece (now divided) depicting scenes from the Life of Saint Peter. c. 1444. Oil on panel, 52 × 60⅝″ (1.32 × 1.54 m). Musée d'Art et d'Histoire, Geneva

WITZ A very different German master, Konrad Witz (c. 1400/10–1445/46), was born at Rottweil in Württemberg but moved to Basel in Switzerland, then the center of a church council that attracted princes and prelates from throughout Europe. Witz was accepted in the artists' guild in Basel in 1434 and bought a fine house. Much of his work fell victim to Protestant iconoclasm during the Reformation, but what survives shows a vigorous and independent personality, with little patience for the niceties of perspective or anatomy but with acute powers of observation, particularly where nature is concerned. His *Miraculous Draft of Fish* (fig. 21–33), part of an altarpiece containing four scenes from the life of Peter installed in 1444 in the Cathedral of Saint Peter in Geneva, displays all his best qualities. The background is the Lake of Geneva with the first structures of the medieval city of Geneva on the right, a landscape "portrait" in the tradition already established by Masaccio and Fra Angelico, exactly painted, with farms and hills in the middle distance and a glittering array of snowcapped Alpine crags on the horizon. More surprising is Witz's observation of water, complete not only with reflections but also with refractions, distorting the stones on the bottom and the legs of Peter seen through its transparent surface; Witz even painted the bubbles thrown up, apparently, by passing fish.

PACHER As a wood-carver Michael Pacher (c. 1435–98) exploited to the full the splendors of the fifteenth-century Austrian version of the Flamboyant Gothic style. But his Tirolean home at Bruneck (modern Brunico; in Italy since 1919) was in the valley of the Adige, along the trade route descending from the Alps into northern Italy, and this location influenced his art profoundly. Strikingly Italianate is such a painting as *Pope Sixtus II Taking Leave of Saint Lawrence* (fig. 21–34), from a cycle of scenes from the life of Saint Lawrence in an altarpiece painted about 1462–70. Pacher's strong interest in perspective recession, the solidity of his forms, and the

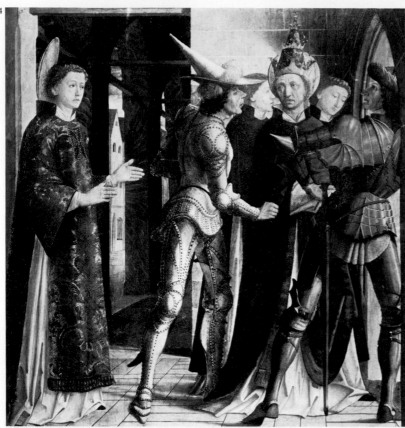

21-34. MICHAEL PACHER. *Pope Sixtus II Taking Leave of Saint Lawrence,* from an altarpiece depicting scenes from the Life of Saint Lawrence. c. 1462–70. Panel painting, 41 × 39½" (1.04 × 1 m). Österreichische Galerie, Museum Mittelalterlicher Österreichischer Kunst, Vienna

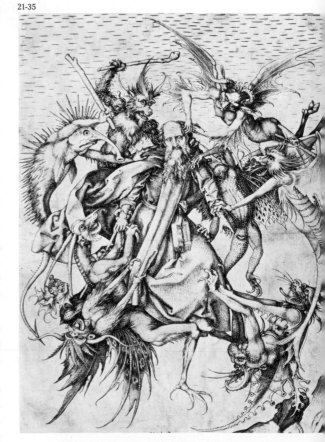

construction of his drapery show so close a study of Mantegna's frescoes in Padua (see fig. 20–72) that the Northern gable seen through an arch at the left comes almost as a surprise. Yet in spite of these Italian elements, Pacher handles light like a Northerner, especially in the exquisite play of tones across Saint Lawrence's brocade *dalmatic* (the slit vestment of a deacon).

SCHONGAUER An important aspect of German art, and the means by which German influence spread throughout Europe, was engraving, whose most important practitioner and innovator was Martin Schongauer (c. 1450–91), from Colmar in Alsace. Schongauer was an excellent painter, in the tradition of Rogier van der Weyden, but was especially known for his copper engravings. As we have seen (page 618), engraving was well known to the Italians and was practiced with distinction by Pollaiuolo (see fig. 20–62), Mantegna, and others. But Pollaiuolo's combination of contours and parallel hatching was simple compared to the elaborate refinements of Schongauer, who stippled and dotted the surface of the copper to produce a veil of shadow ranging from tones of filmy lightness to concentrated darks. His engraving of the *Temptation of Saint Anthony* (fig. 21–35) shows that the demons generated by Northern imagination were far from being the exclusive province of Bosch. The saint floats above the rocks, lifted, beaten, pulled at, mocked by hideous hybrid devils, their bodies prolonged and twisted into a dense foreground composition that recalls the persistent animal interlace of Hiberno-Saxon manuscripts and of the Migrations period. Schongauer's engraving so impressed the boy Michelangelo that he copied it carefully in pen and watercolor in 1488 or 1489, when he was a fourteen-year-old assistant in Ghirlandaio's studio.

Painting in France

The political and military chaos of the early fifteenth century in France, during which the Hundred Years' War with England drew to a close, was not conducive to the development of either bourgeois prosperity or local schools of painting pa-

21-35. MARTIN SCHONGAUER. *Temptation of Saint Anthony.* c. 1470–75. Engraving. The Metropolitan Museum of Art, New York. Rogers Fund, 1920

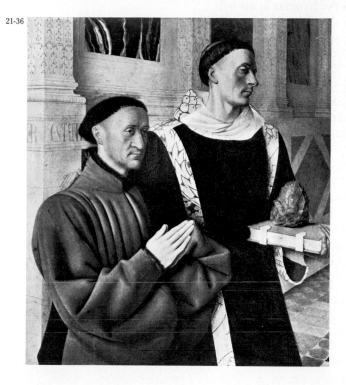

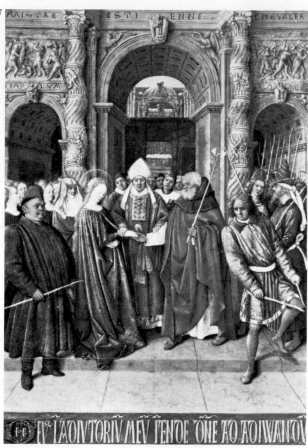

21-36. JEAN FOUQUET. *Portrait of Étienne Chevalier,* left wing of the *Melun Diptych* (now divided). c. 1450. Oil on panel, 36⅛ × 33½″ (91.8 × 85 cm). Staatliche Museen zu Berlin— Preussischer Kulturbesitz

21-37. JEAN FOUQUET. *Marriage of the Virgin,* illumination from the *Book of Hours of Étienne Chevalier.* 1452–56. Musée Condé, Chantilly

tronized by the merchant class. Nonetheless, a few artists of great sensitivity were active, largely in the entourage of royal courts; although under combined influences from both Italy and the Netherlands, they were striking in their own individuality of feeling.

FOUQUET The finest fifteenth-century French artist was Jean Fouquet (c. 1420–before 1481), from the central French city of Tours. Fouquet worked for Charles VII of France, for whom Joan of Arc had fought. Certainly before 1447 Fouquet visited Rome, while Fra Angelico was working there. About 1450, probably in Paris, he painted the quiet and sensitive portrait of Étienne Chevalier, finance minister to Charles VII (fig. 21–36); this is the left wing of a diptych, whose other panel represents the Virgin and Child. The Renaissance architecture with its veined marble paneling is strongly Italianate, in fact Albertian, but the treatment of light and the detailed rendering of the surface, along with the deep inner glow of the coloring, reveal that Fouquet is still a Northern master, well aware of what was going on in Netherlandish art. His instinctive reticence masks great depth of feeling. Saint Stephen, dressed in a deacon's dalmatic, holds in his left hand a book and the jagged stone of his martyrdom (a few drops of blood still cling to his scalp) while his right rests gently on the shoulder of his namesake.

Fouquet continued with great brilliance the art of illumination, which was not renounced by the French in the fifteenth century, although in Italy and the Netherlands it became increasingly relegated to specialists. One of the approximately sixty miniatures that originally adorned the Book of Hours he illustrated for Étienne Chevalier in 1452–56 shows the *Marriage of the Virgin* (fig. 21–37). The scene takes place before a triumphal arch that reminds us of that of Constantine but which is labeled *Templum Salomonis* and decorated with two of the four spiral columns, apparently of Syrian origin, that the artist must have seen in Saint Peter's, Rome, where they were believed to have come from Solomon's Temple. (The actual columns are encased between the crossing piers in the present Basilica of Saint

Peter's, and their gigantic enlargement by Bernini can be seen alongside them in fig. 22–24.) In the brilliant coloring and the harmonious grouping of the figures, the dominant influence is that of Fra Angelico, although the portly character at the left is a meticulously rendered portrait type seldom found outside Northern art.

ENGUERRAND QUARTON Apart from Fouquet, the leading panel painter of France at midcentury was Enguerrand Quarton, also known as Charonton (1410/15–after 1466). The celebrated *Avignon Pietà* (fig. 21–38) has recently been successfully attributed to him by Charles Sterling. In the pose of the dead Christ over the Virgin's knees, as well as in the spareness and austerity of the forms, the picture looks very Italian, but the angular motions and haunting expressions are quintessentially French. Especially touching is the head of Christ, whose mouth hangs slightly open while his eyes are not entirely closed, and whose face is gently illuminated from below. The *Pietà* seems almost to be a vision of the kneeling priest at the left, whose face has been searchingly portrayed. Though long outdated, the gold background into which recedes the domed structure (the Temple at Jerusalem) at the extreme left suggests infinite space; the halos are incised into the gold so that their inscriptions vibrate in tune with that which runs around the border: "All ye that pass by, behold and see if there be any sorrow like unto my sorrow!" (Lamentations 1:12).

21-38. ENGUERRAND QUARTON. *Avignon Pietà.* c. 1460. Oil on panel, 63¾ × 85⅞″ (1.62 × 2.18 m). Musée du Louvre, Paris

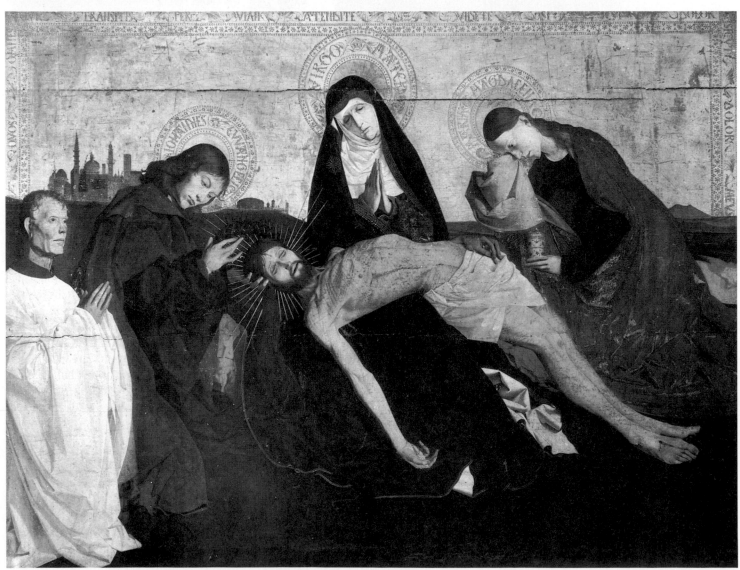

21-38

21-39

21-39. ENGUERRAND QUARTON. *Coronation of the Virgin*. 1453–54. Panel painting, 6′ × 7′2⅝″ (1.83 × 2.2 m). Musée de l'Hospice, Villeneuve-lès-Avignon

After the muted color and intense sadness of this panel, the splendor of Quarton's *Coronation of the Virgin* (fig. 21–39), still in the hospital at Villeneuve-lès-Avignon, comes as a surprise. Painted in 1453–54, according to a minutely detailed contract with the prior Jean de Montagnac, which spelled out everything to be represented, the work shows the coronation taking place against another of Quarton's gold backgrounds—Heaven, this time, with the Virgin and the Trinity depicted on a colossal scale compared with the medievally grouped ranks of saints on either side. Father and Son, mirror images, wear mantles of royal crimson, dissonant against the sharp orange of the surrounding seraphim and almost meeting before the kneeling, porcelain-faced Virgin. Her red and gold tunic is partly covered with a mantle of nearly the same resounding blue as that of the sky below her, which is strewn with tiny clouds and tinier white angels bearing souls upward. The real world is reduced to a strip at the bottom of the panel, showing Rome on the left (a south French Gothic town), with the Mass of Saint Gregory (a miraculous appearance of the sacrificed Christ on the altar before Saint Gregory as he was saying Mass) taking place in Saint Peter's; Jerusalem on the right, with bulbous domes on its towers; and in the center the crucified Christ, before whom kneels the white-clad donor. At the lower left angels assist souls, naked save for their distinguishing headgear, out of Purgatory while at the right the damned suffer carefully delineated torments in a not very terrifying Hell.

The last decade of the fifteenth century was ominous for the Italians. The year 1492 was crucial not on account of Columbus's first voyage to the New World, which attracted little immediate attention, but because in that year the death of Lorenzo the Magnificent removed from the government of Florence, and from the turbulent Italian political scene, a firm and wise hand. The throne of Saint Peter was occupied by the sinister Alexander VI, whose son, Cesare Borgia, was doing his best to turn the Papal States into a hereditary monarchy. In 1494 Piero de' Medici and his brothers were expelled from Florence and the republic was restored; that same year Charles VIII of France descended upon Italy to press his claims to the throne of Naples, thus commencing the cycle of foreign dominations that soon put a virtual end to Italian independence. The Italian response was mixed and confused, but the Florentines, at first under the leadership of Savonarola, rallied to the defense of their reestablished republic against the Borgia, and a coalition expelled the French in 1495—to no avail; in 1499 the French returned under Louis XII and occupied Milan. The death of Alexander VI in 1503 gave the new pontiff, Julius II, a free hand in the organization of papal military power in order to drive out the French and to reform internally the Church, grown corrupt under recent popes.

Nothing less than political unity, which was a practical impossibility, could have maintained Italian independence against the newly consolidated, energetic Western monarchies—France, Spain, and the Holy Roman Empire. Nonetheless, the resistance of the Florentines and the counterattack of Julius II created a heady atmosphere that did much to inspire a new style, the High Renaissance, which can be understood as an attempt to compensate on a symbolic plane for the actual powerlessness of the Italian states, through a new vision of human grandeur and of heroic action and through a dynamic architecture to match. This new vision was expressed in systems of total compositional order and harmony that transcended any imagined by the Early Renaissance, and to these systems all details were firmly subordinated. Like the images and norms created by Periclean Athens in a similarly precarious situation, those of High Renaissance Italy long outlived the collapse of the political entities that gave them birth. Despite the brevity of the High Renaissance—twenty-five years at the outside—the principles established in Florence and Rome in the early sixteenth century provided a set of norms for much of European art for at least three centuries.

Leonardo

High Renaissance style was founded upon the research and experiments of one of the most gifted individuals ever born. Leonardo da Vinci (1452–1519) was not only a great painter and sculptor but also an architect of genius, although he never erected a building. In addition, he was the inventor of an incredible variety of machines for both peaceful and military purposes (some have recently been constructed from his drawings and actually work), an engineer, a musician, an investigator in the field of aerodynamics, and the leading physicist, botanist, anatomist, geologist, and geographer of his time. Much has been said about the ideal of the universal man in the Renaissance; in actuality, there are few examples. Leonardo is the one who most closely approaches the ideal, having left untouched only the fields of classical scholarship, philosophy, and poetry. In a theoretical sense he began where Alberti left off; it is a remarkable coincidence that both were illegitimate, and perhaps thus freed from the trammels of convention. There is,

however, a crucial difference between the two. In an era when the continuing power of the Church competed in men's minds with the revived authority of classical antiquity, Alberti chose the latter; Leonardo, a lifelong skeptic, accepted neither. Throughout the thousands of pages he covered with notes and ideas, God is seldom mentioned, but nature appears innumerable times. Classical authorities were never cited. For Leonardo there was no authority higher than that of the eye, which he characterized as the "window of the soul." In many respects his pragmatic attitude was comparable to that of nineteenth-century scientists. Although he never focused his ideas concerning either science or art into an organized body of theory, Leonardo felt that the two were closely interrelated in that both were accessible to the eye.

Throughout Leonardo's writings we encounter the lament, "Who will tell me if anything was ever finished?" Little that he started was, least of all his lifelong pursuit of the elusive mysteries of nature. It is, therefore, to his drawings that we must look for the secrets of his art. In them, as in his notes, generally side by side on the same page, he analyzed the structure of rocks, the behavior of light, the movement of water, the growth of plants, the flight of birds, and the anatomy of insects, horses, and human beings. Although he derisively termed men "sacks for food," unworthy of the wonderful machine nature had contrived for them, he nonetheless wanted to see how that machine functioned, and did so by means of dissection. Possibly, Pollaiuolo's pioneer anatomical studies (see fig. 20–62) had been based on dissection, which was frowned on by the Church. Certainly in 1495 the young Michelangelo had dissected bodies, but for another purpose, as we shall see when we consider his profoundly different art.

Leonardo's dissections were scientific and went as far as studying the process and the very moment of conception and the growth of the fetus in the womb; his studies of blood vessels enabled him to arrive at a preliminary statement of the circulation of the blood a century before William Harvey expounded his thesis. Hundreds of drawings of human anatomy remain. Fig. 22–1 shows the progressive dissection of the arm and shoulder of a cadaver in order to clarify the shapes of the muscles and tendons, their functions, and their insertion into the bones. In the upper right-hand corner Leonardo has substituted ropes for the muscles so as to clarify the mechanical principles involved. Since he was left-handed, he wrote his notes (but not his letters) from right to left, so that to read them requires not only a knowledge of fifteenth-century script but also a mirror (Leonardo specialists eventually learn to dispense with one).

Nothing in Leonardo's scientific drawings is quite as exciting as his Olympian views of nature, which illustrate his standpoint in the Renaissance debate about the relative importance of the various arts. Leonardo maintained that painting deserved a position as one of the liberal arts, more so than music or poetry. Music, he noted, is dead as soon as the last sound has expired, but a work of painting is always there to be seen. Also, he pointed out, no one ever traveled to read a poem, but people journey hundreds of miles to see a painting. Ingenuous as these arguments may seem, in the Renaissance the issues they countered were burning questions. But Leonardo was unwilling to admit sculpture to the liberal arts; the painter could work in quiet, sitting down, richly dressed, and listen to music while he worked while the sculptor, poor man, was covered with sweat and dust and his ears deafened by the noise of hammer and chisel on stone. It is by no means irrelevant that when Leonardo began his campaign to upgrade painting the artist was still a

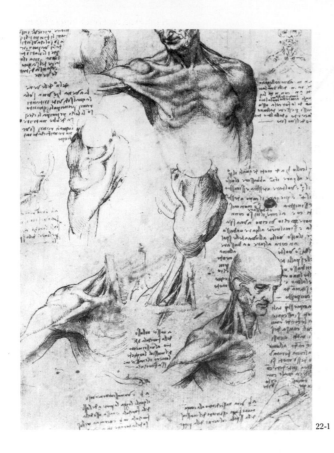

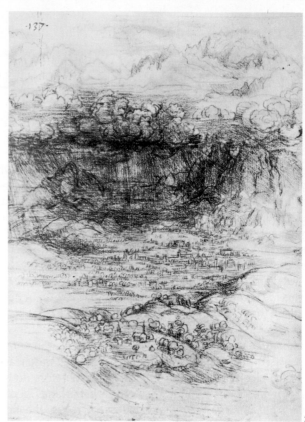

craftsman and a guild member; before the High Renaissance was over a great master could live like a prince, and in the late sixteenth century academies rendered the guilds obsolete.

Whatever the painter wants to do, said Leonardo, he is "Lord and God" to do it. The painter's mind "is a copy of the divine mind, since it operates freely in creating the many kinds of animals, plants, fruits, landscapes, countrysides, ruins, and awe-inspiring places." The painter's genius can take us from the "high summits of mountains to uncover great countrysides," and whatever is in the universe "he has it first in his mind and then in his hands." This claim sounds like an extension of Giannozzo Manetti's paean of praise for humanity (see pages 580–81). In one of Leonardo's comprehensive landscape drawings (fig. 22–2), we look from a high place upon rolling hills bordering a rich plain in whose center rise the domes and towers of a city, then beyond to a valley walled in by mountain crags and shadowed by rain clouds, and finally above the clouds to Alpine summits under eternal snow. Leonardo was an indefatigable mountain climber. Once his exhilaration at seeing the world at his feet subsided, he examined the rocks to discover how they were formed and deduced from fossilized sea animals that they were laid down under-water. The world, therefore, was created far earlier than the date of 4004 B.C. calculated by biblical scholars, although this tradition was not again seriously doubted until the nineteenth century.

To Leonardo as to Alberti, architecture was based on the twin principles of geometric relationships and natural growth, and, therefore, nothing was so impor-tant as the central-plan structure. Although we shall see this new organic architec-ture realized in Bramante's plans for Saint Peter's, Rome (see fig. 22–22), the idea for it originated in the mind of Leonardo. What Vasari derisively called Leonardo's doodles were of vital importance for his architecture since he was trying to elucidate the geometrical permutations and combinations that determine the forms of buildings. Leonardo abandoned both the planar architecture of Bru-

22-1. LEONARDO DA VINCI. *Anatomical Drawings of a Man's Head and Shoulders.* c. 1510. Pen and ink. Royal Library, Windsor

22-2. LEONARDO DA VINCI. *Storm Breaking over a Valley.* c. 1500. Red chalk. Royal Library, Windsor

22-3. LEONARDO DA VINCI. *Plans and Perspective Views of Domed Churches.* 1490. Pen and ink. Bibliothèque de l'Arsenal, Paris

22-4. LEONARDO DA VINCI. *Adoration of the Magi.* Begun 1481. Underpainting on panel, 8′ × 8′1″ (2.44 × 2.46 m). Galleria degli Uffizi, Florence

22-5. LEONARDO DA VINCI. *Madonna of the Rocks.* Begun 1483. Probably oil on panel (transferred to canvas), 78½ × 48″ (1.99 × 1.22 m). Musée du Louvre, Paris

nelleschi and the block architecture of Alberti, and began with plans and perspective drawings of the same structure (fig. 22–3), such as an octagon surrounded by eight circles on which he erects a large dome surrounded by eight smaller ones, and a Greek cross whose arms, terminating in four semicircular apses, embrace four additional octagons on each element of which either a dome, semidomes, or an octagonal tower is then erected (changed to cylinders in the perspective drawing).

ADORATION OF THE MAGI Leonardo's knowledge of Albertian perspective was absolute and was important for him as a mathematical structure for the understanding of space. But no sooner did he establish the linear structure than he began to dissolve it. For he was also acutely conscious of the forces of growth and decay, which provoke continuous change and renewal, and thus precluded his faith in the perfect, unshakable, and therefore somewhat artificial world of Piero della Francesca. A study (see Introduction fig. 22) was made for the architectural setting of one of Leonardo's earliest paintings, an *Adoration of the Magi* commissioned in 1481 for a church outside Florence, but it was never carried any further than the monochrome underpaint. With a dark wash he began by brushing in the shadows and only gradually defined the lighted forms, on the assumption that darkness comes first in the world and light penetrates it. This is the exact opposite of the traditional method of drawing the outlines first and then bringing forms into relief by means of shadow (see the sinopia in fig. 19–20).

22-4 22-5

Leonardo's pyramidal composition (fig. 22–4) is constructed along a principle already established by Pollaiuolo (see pages 617–18 and fig. 20–61): that groups are based on the actions of the component figures and will dissolve as soon as they move. Although Leonardo could not have known it, this very discovery had been made in Greece in the fifth century B.C. The enclosing shed that Leonardo had been at such pains to construct in the drawing is gone, leaving only the ruined arches and steps. Although these are projected in flawless one-point perspective, they no longer show any traces of the mathematical construction on which they are based. With the faces as with the composition, Leonardo starts with the moment of feeling and perception, defining expression first; form will follow. In the background at the right appears for the first time the composition of rearing horses, which has little to do with the ostensible subject of the painting but which will turn up again in magnificent form in the *Battle of Anghiari* (see fig. 22–7).

MADONNA OF THE ROCKS Many of Leonardo's crucial works were executed away from Florence in traditionally hostile Milan at the court of Lodovico Sforza, who had seized the duchy from his nephew and ruled it with wisdom, foresight, and artistic taste, making it during his brief reign the most energetic and lively artistic center in Europe. Lodovico was a perfect patron for so great an artist and Leonardo's almost exact contemporary (born 1451; ruled 1481–99; died 1508). When offering his services to Lodovico, interestingly enough, Leonardo mentioned first his military inventions and his work as a hydraulic engineer, architect, and sculptor, and only at the close his ability to paint. His first great work in Milan was the *Madonna of the Rocks* (fig. 22–5), begun in 1483 for the Oratory of the Immaculate Conception. The doctrine of the Immaculate Conception—unrelated to that of the Virgin Birth—means that at her own conception Mary was freed from the taint of Original Sin so that she could be a worthy vessel for the Incarnation of Christ. Leonardo has interpreted the doctrine dramatically by illuminating Mary in the midst of a dark, shadowy world of towering rock forms and views into mysterious distances. She raises her hand in protection over the Christ Child, who blesses the kneeling infant John the Baptist, indicated by a pointing angel. The picture, almost certainly in oil, benefits from many of the techniques invented by the Netherlanders and in its concentration on the tiniest details of rocks and of plant life in the foreground, as on the glow of light from flesh, eyes, and hair, owes a debt to the encyclopedic naturalism of Jan van Eyck; as in Jan's painting, traditional halos disappear. The wonderful sweetness and grace of faces and figures, treasured by Leonardo's patrons, are his own and inimitable.

LAST SUPPER Contrary to iconographic tradition, especially in Andrea del Castagno and in Dirc Bouts (see figs. 20–51, 21–23), Leonardo's *Last Supper*, painted in 1495–97/98 on the end wall of the refectory of the Monastery of Santa Maria delle Grazie in Milan (fig. 22–6), is only partially concerned with the institution of the Eucharist. Instead, Leonardo has based his composition on the passage that recurs in Matthew, Mark, and Luke, in which Christ says, "Verily, I say unto you that one of you shall betray me. And they were exceeding sorrowful, and began every one to say unto him, Lord is it I?" As in the *Adoration of the Magi,* the composition is a product of the moment of action and of meaning. Donatello had done something similar in the *Feast of Herod* (see fig. 20–24), but with a bombshell effect; Leonardo utilizes the revelation to throw the Apostles into four groups of three each, as if bringing out the inherent properties of the number twelve. Each of these numbers has many meanings—the multiplication of the Gospels by the Trinity is only one of them—and twelve itself is not merely the number of the Apostles but of the months of the year and of the hours of the day and of the night. Even the hangings on each of the side walls and the windows at the end number respectively four and three. The numerical division helps to throw the fundamental character of each of the Apostles into full relief (Leonardo even labeled them in his preparatory drawings),

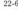

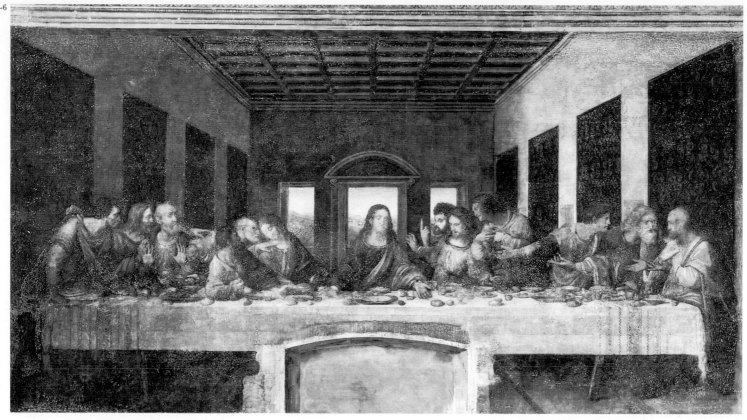

22-6. LEONARDO DA VINCI. *Last Supper,* mural
(oil and tempera on plaster), Refectory,
Sta. Maria delle Grazie, Milan. 1495–97/98

from the serene innocence of John on Christ's right to the horror of James on his left to the protestation of Philip, who places his hands upon his breast. Only Judas, also revealed by the moment of truth, has no doubt, for he already knows, and the light does not shine upon his face.

The *Last Supper* is really a humanistic and mechanistic interpretation of the narrative, yet in composing it the artist, almost without conscious intention, produced figures of superhuman scale and grandeur. These figures operate within a perspective that, for the first time in any major work since Masaccio's *Holy Trinity* (see fig. 20–42), is not related to the actual space of the room; there is no place in the refectory where one can stand to make the perspective "come right." It is as if Leonardo were painting for us a higher reality incommensurable with that in which we live, thus making a complete break with Early Renaissance tradition and establishing the ideal world in which both Michelangelo and Raphael later operated. Tragically enough, Leonardo's masterpiece could not be painted at a speed consistent either with true fresco in the Italian manner or with the Byzantine *secco su fresco*. In order to register all the shades of feeling and veils of tone necessary to his conception, he painted in what is apparently an oil-and-tempera emulsion on the dry plaster, and it rapidly began to peel off. As a result, the surface is severely damaged throughout, but a recent delicate restoration is slowly bringing to light far more of the original painting than anyone had thought possible. (Unbelievably, at one time the monks cut a doorway into the next room right under the center of the table where Christ sits.)

BATTLE OF ANGHIARI For a year the great master worked for the infamous Cesare Borgia, designing battle engines and siege devices and making maps. The Florentines commissioned him in 1503 to paint the *Battle of Anghiari* on a wall of the newly constructed Hall of the Five Hundred in the Palazzo Vecchio. This painting, depicting an event from fifteenth-century history, was part of a general

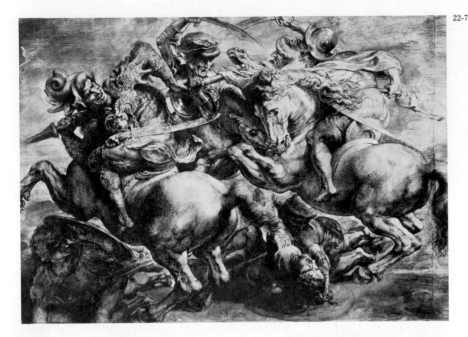

22-7

22-7. PETER PAUL RUBENS. Copy of central section of Leonardo da Vinci's mural *Battle of Anghiari* (1503–6, destroyed). c. 1615. Pen and ink, and chalk. Musée du Louvre, Paris

program of decoration (including a never-executed painting by Michelangelo) to celebrate the newly revived republic. The work was executed according to experimental and unsuccessful methods and was finally abandoned, but we have some knowledge of what the central section must have looked like through an imaginative re-creation made in the seventeenth century by Peter Paul Rubens (fig. 22–7) on the basis of copies. Leonardo's own firsthand experience with battles is transmuted into what may be termed the first completely High Renaissance composition, produced by figures that are, so to speak, no longer added to each other but multiplied by each other. The nucleus, the battle around the standard, is formed of a pinwheel of violently struggling horses and riders, whose whirlwind ferocity makes fifteenth-century battle scenes, such as those by Uccello (see fig. 20–48), seem toylike by comparison. The beautiful fury of Leonardo's rearing horses was never forgotten; his lost composition became the model for scores of battle scenes throughout the late Renaissance, the Baroque period, and even the nineteenth century.

MADONNA AND SAINT ANNE Leonardo's *Madonna and Saint Anne* (fig. 22–8) was designed in Florence in 1501 but probably not completed until a dozen or so years later in Milan. Again he intertwined the figures to form a pyramidal composition. The Virgin, who sits on her mother's lap, as in traditional representations of this theme, is shown reaching for the Christ Child, who in turn attempts to ride upon a lamb, the symbol of his sacrificial death. Saint Anne, from the summit of the composition, smiles mysteriously at the drama being enacted. Even though the painting has been overcleaned in the past, and the surfaces have darkened under later varnish, the magic and beauty of the composition are unsurpassed in any of Leonardo's other surviving works. The background, in fact, is one of the most impressive mountain pictures ever painted; it makes one believe Leonardo had seen and explored the Dolomites, those finger-like Alpine crags in northeastern Italy. Valleys, rocks, and peaks diminish progressively into the bluish haze of the distance until they can no longer be distinguished.

MONA LISA From 1503 until 1506, during the same period in which he was at work on the *Battle of Anghiari*, Leonardo was painting a portrait of Lisa Gherardini del Giocondo, the wife of a prominent Florentine citizen; this painting is known today as the *Mona Lisa* (fig. 22–9). It is inseparable from the *Madonna and Saint*

22-8. LEONARDO DA VINCI. *Madonna and Saint Anne.* c. 1501–13(?). Panel painting, 66¼ × 51¼″ (1.68 × 1.30 m). Musée du Louvre, Paris

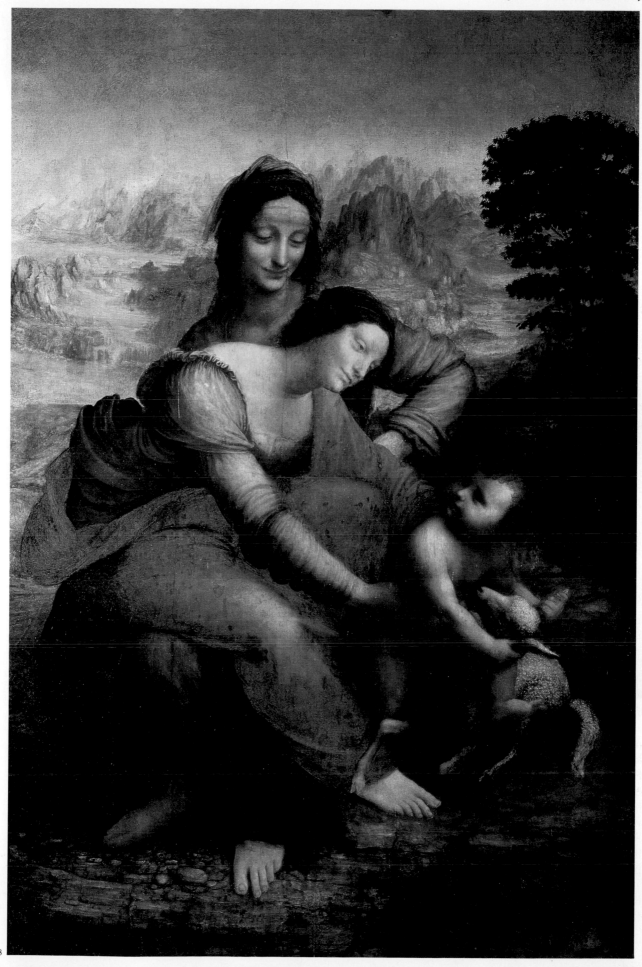

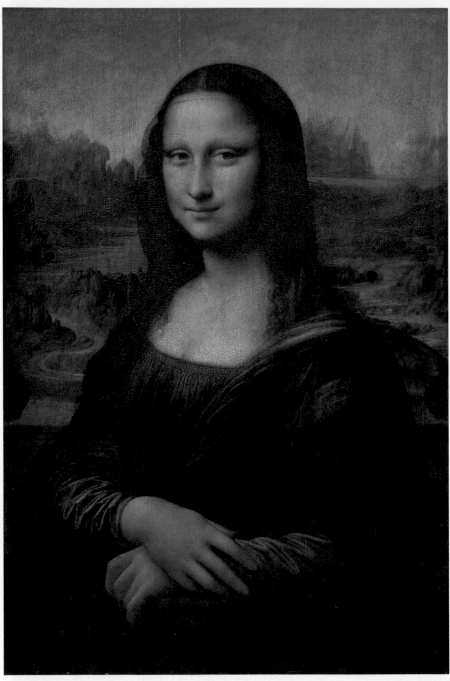

22-9. LEONARDO DA VINCI. *Mona Lisa*. 1503–6. Oil on panel, 30¼ × 21″ (76.8 × 53.3 cm). Musée du Louvre, Paris

Anne, since it must have been done between the date of the drawing for that work and the finished painting. As compared with the rigid profile portraits by Piero della Francesca (see figs. 20–55, 20–56), the figure sits in a relaxed position, with hands quietly crossed, before one of Leonardo's richest and most mysterious landscape backgrounds, traversed by roads that lose themselves, bridges to nowhere, crags vanishing in the mists. This attitude of total calm became characteristic for High Renaissance portraits. The face, unfortunately, has suffered in the course of time—the eyebrows have disappeared—but nothing has spoiled the sad half smile that plays about the lips.

Leonardo's later life was a succession of trips between Florence, Milan, and Rome, where he could see what his younger competitors, Michelangelo and Raphael, had accomplished with principles he had laid down. He painted little in

his later years; in 1517 he accepted the invitation of King Francis I of France to retire to a small château on the Loire, where his sole duty was to converse with the king. The *Mona Lisa,* the *Madonna and Saint Anne,* and a *Saint John the Baptist,* the last now in bad condition, went with him because they had absorbed so much of his inner life that he could no longer part with them. At his death, in 1519, Leonardo's artistic influence was immense, but much of his scientific work had to await later rediscovery.

Michelangelo Before 1516

The sixteenth century in central Italy was dominated by the colossal genius of Michelangelo Buonarroti (1475–1564), whose long life makes it necessary for us to consider him in two separate chapters (see also Chapter Twenty-Three). His personality could scarcely have been more different from that of Leonardo. In contrast to Leonardo's skepticism, we must set Michelangelo's ardent faith; against Leonardo's scientific concern with natural objects Michelangelo's disinterest in any subject save the human body; against Leonardo's fascination with the mysteries of nature Michelangelo's search for God, whose sublime purpose he saw revealed in the beauty of the human form, that "mortal veil," as he put it, of divine intention. Characteristically enough, poetry, the one art in which Leonardo did not excel, was a lifelong vehicle for Michelangelo's meditations, and music, at which Leonardo seems to have been a star performer, held no recorded interest for Michelangelo.

When the long controversy as to the relative merits of painting and sculpture, sparked by Leonardo's claims for painting, was brought before Michelangelo in 1548, he claimed that sculpture was superior to painting as the sun is to the moon, which shines only with reflected light. By sculpture he meant that which is produced "by force of taking away" rather than "by process of putting on"; that is, he meant carving in stone instead of modeling in clay or wax. He began by drawing roughly on the surfaces of the block (in a manner that recalls that of the Egyptians) the contours of a figure, predetermined by preliminary sketches and perhaps models, and then proceeded to carve away the surplus stone. Contour line was, therefore, his dominant concept, and he pursued it passionately around the figure so as to free it from the block. From his many unfinished works one can watch the principles of Michelangelo's style in operation. In the *"Crossed-Leg" Slave* (fig. 22–10), the portion of the figure that the sculptor had thus far shaped is almost finished, save for the final process of smoothing and polishing; the rest is rough marble. Often the figure seems to struggle for liberation within the block, but sometimes, especially at the beginning and the end of Michelangelo's life, human forms are weightless and serene. There is a more than accidental correspondence between Michelangelo's method of liberating the figure from the block and the doctrine of the Neoplatonic philosophers (among whom Michelangelo was brought up as a boy at the court of Lorenzo the Magnificent) that man at death is freed from the "earthly prison" to return to his final home in God. To Michelangelo, as to Leonardo, artistic creation partakes of divinity, but in a diametrically different way: to Leonardo, the artist is himself a kind of deity, who can see with infinite range and precision and who can create objects and beings out of nothing; to Michelangelo, the artist's tools and his stone are instruments of the divine will, and the creative process an aspect of salvation.

Michelangelo learned the techniques of painting during a year of his boyhood spent in Ghirlandaio's studio; sculpture he studied with Bertoldo di Giovanni, a pupil of Donatello, and from works of ancient art in the Medici collections. His earliest masterpiece, the *Pietà* (fig. 22–11), done in 1498–99/1500 during his first sojourn in Rome, is still a fifteenth-century work, almost Botticellian in its grace and delicacy. The perfect formation of the bones and muscles of the slender Christ, lying across the knees of his mother, excited the intense admiration of Michelangelo's contemporaries; this anatomical accuracy is undoubtedly the result of the

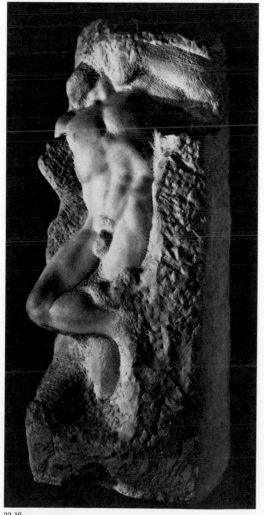

22-10. MICHELANGELO. *"Crossed-Leg" Slave.* 1527–28. Marble, height 8'10" (2.69 m). Galleria dell'Accademia, Florence

22-10

22-11

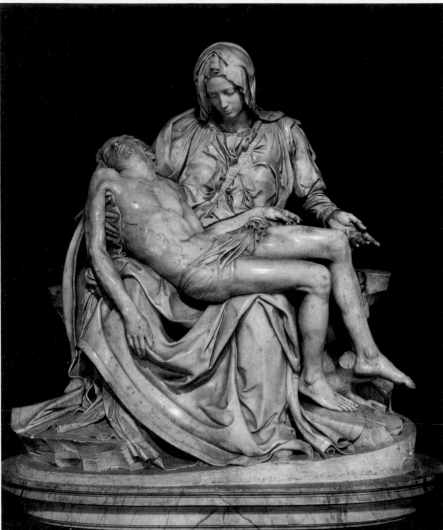

22-11. MICHELANGELO. *Pietà.* 1498–99/1500. Marble, height 68½″ (1.74 m). St. Peter's, Vatican, Rome

22-12

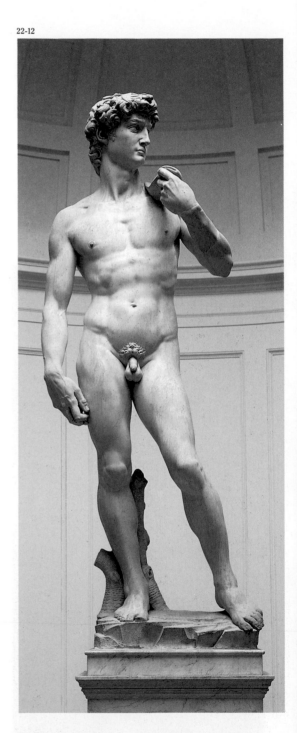

dissections Michelangelo had been permitted to carry out in 1495 at the Hospital of Santo Spirito in Florence. The exquisite Virgin, whose left hand is extended less in grief than in exposition, looks as young as her son; contemporary queries were greeted by Michelangelo's probably facetious rejoinder that unmarried women keep their youth longer. The explanation is more likely to be sought in a line from Dante, whose poetry Michelangelo knew in detail, "Virgin Mother, daughter of thy son!" The ageless Virgin is in a sense a symbol of the Church, who presents for our adoration the timeless reality of Christ's sacrifice. The extreme delicacy in the handling of the marble and the contrast between the long lines of Christ's figure and the crumpled drapery folds produce passages of a beauty Michelangelo was never to surpass, despite the grandeur of his mature and late work.

DAVID The heroic style for which Michelangelo is generally known is seen in the *David* (fig. 22–12), more than fourteen feet in height, which Michelangelo carved in 1501–4 for a lofty position on one of the buttresses of the Cathedral of Florence. (Donatello had done a *Joshua* in terra-cotta, now lost, for an adjoining buttress, and Ghiberti had planned a *Hercules.*) When the work was completed, its beauty seemed to the Florentines too great to be sacrificed in such a position; after long deliberation the statue was placed in front of the Palazzo Vecchio, where it became a symbol of the republic ready for battle against its enemies, much like the statues by Donatello, Nanni di Banco (see figs. 20–20, 20–21, 20–32), and Ghiberti at

22-12. MICHELANGELO. *David.* 1501–4. Marble, height 13′5″ (4.09 m). Galleria dell'Accademia, Florence

Orsanmichele nearly a century before. Almost by accident, therefore, the *David* became the first true colossus of the High Renaissance. (For protection against the weather, it was moved indoors in the nineteenth century and replaced by a copy.)

The block had been cut in the 1460s probably, as has been recently shown, for a *David* designed by the aged Donatello, after whose death the block remained unused. Michelangelo's original small-scale model for the statue, heavily damaged in a later fire, came to light in 1986 and has been published by the author. Michelangelo's conception is totally new; as compared with any earlier *David,* the bronze one by Donatello, for instance (see fig. 20–25), Michelangelo's youth is no longer a child but a heavily muscled lad of the people, still not fully grown, with large hands, feet, and head. As with all Michelangelo's figures, there is nothing anecdotal here; the sling goes over David's left shoulder and the stone lies in the hollow of his right hand, but he is not about to launch it. He stands forever alert in body and spirit, every muscle vibrant with Michelangelo's newly gained anatomical knowledge and with his ability to communicate the life of the spirit through the beauty of the body. The strong undercutting of the hair and the features can be explained by the high position for which the statue was originally destined. Brought to near ground level, the figure towers above us as a revelation of a transfigured humanity; such a vision had inspired no one since the days of Phidias.

THE TOMB OF JULIUS II Mindful of his place in history, the warrior-pope Julius II called Michelangelo to Rome in 1505 to design a tomb for him; it was projected as a freestanding monument with more than forty over-life-size statues in marble and several bronze reliefs. It is typical of the unreality of High Renaissance imagination that it occurred to neither Michelangelo nor the pope that so ambitious a project would require a lifetime (we cannot account for forty over-life-size statues from Michelangelo's entire career, including the lost works). The idea of the tomb was first abandoned by the pope in 1506, possibly because of his plans for rebuilding Saint Peter's, and revived after his death in 1513. After several successive reductions, the tomb was brought to completion only in 1545. Three statues remain from the 1505 version, the last of which was finished only after 1513.

This statue is the world-famous *Moses* (fig. 22–13), intended for a corner position on the second story of the monument so that it could be seen from below as a composition of powerful diagonals. Like all of Michelangelo's works, the *Moses* is symbolic and timeless, and the reader is cautioned to ignore fanciful explanations that suggest that Moses is about to rise and smash the Tables of the Law or that he is glaring out at the Israelites. Moses is conceived as an activist prophet, a counterpart to Saint Paul, who would have appeared on the opposite corner. The bulk of the figure is almost crushing, as is the powerful musculature of the left arm, so unlike any statue created since Hellenistic times. Michelangelo had supervised the excavation of the Hellenistic sculptural group of *Laocoön and His Two Sons,* found in Rome in 1506, and studied it carefully. Moses' head, with its two-tailed beard, is one of the artist's most formidable creations; the locks of the beard, lightly drawn aside by several fingers of the right hand, are a veritable Niagara of shapes. The drapery masses, instead of concealing the figure, as in the Virgin of the *Pietà,* are used to enhance its compactness.

The two *Slaves* for the 1505 and 1513 versions of the tomb were planned to flank niches around the lower story, in which were to stand Victories, an apparent contrast between the soul, held by the bonds of sin and death, and the Christian victory over both. The figure known as the *Dying Slave* (fig. 22–14) is actually not dying but turning languidly as if in sleep; one hand is placed lightly upon his head while the other plucks unconsciously at the narrow bond of cloth across his massive chest. The strikingly different companion figure (the two may have been intended for corner positions directly below the *Moses*), the so-called *Rebellious Slave* (fig. 22–15), twisting in a powerful contrapposto pose, exerts all his gigantic strength in vain against the slender bond that ties his arms. The new figure type created by

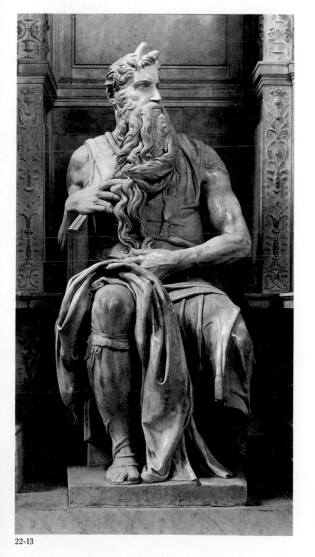

22-13. MICHELANGELO. *Moses.* c. 1515. Marble, height 7′8½″ (2.35 m). S. Pietro in Vincoli, Rome

22-13

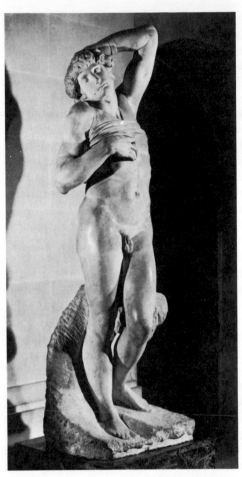

22-14. MICHELANGELO. *Dying Slave.* Before 1513. Marble, height 7′6″ (2.29 m). Musée du Louvre, Paris

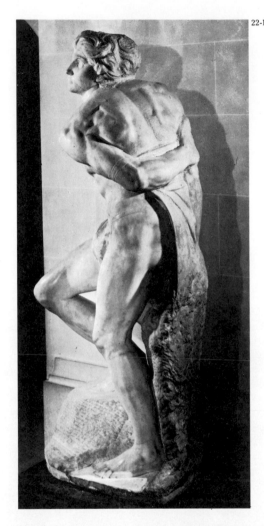

22-15. MICHELANGELO. *Rebellious Slave.* Before 1513. Marble, height 7′5⅝″ (2.15 m). Musée du Louvre, Paris

Michelangelo in the *David* and for the first time here set in action, established a standard that was impossible to ignore and influenced even artists who were temperamentally incapable of experiencing the deep spiritual conflict taking visible form in Michelangelo's heroic nudes. Throughout the Late Renaissance and the Baroque, it is the Michelangelesque heavily muscled figure that was almost universally imitated

SISTINE CEILING In 1508 Michelangelo was given his greatest commission: to fresco the ceiling of the Sistine Chapel, the chapel of the papal court in the Vatican, used for important ceremonies and for conclaves of the College of Cardinals. As we have seen (page 623), the upper walls had been frescoed by several of the leading central Italian painters in the 1480s, including Botticelli, Ghirlandaio, Perugino (see fig. 20–69), and Signorelli, with scenes from the Life of Christ on one side and that of Moses on the other. The ceiling, a flattened barrel vault more than 130 feet long, was merely painted blue and dotted with gold stars, as was common in Italian interiors, including that of the Arena Chapel in Padua. Well aware of the powers of Michelangelo's imagination, Julius II asked this sculptor—with the statues for the tomb temporarily in abeyance—to paint the ceiling, the most ambitious pictorial undertaking of the entire Renaissance. While Michelangelo did complain that painting was not his profession (he said the same later about architecture and at one point in his old age even objected to being addressed as sculptor), there is no indication that he accepted the commission unwillingly.

Originally, the project was to consist of the Twelve Apostles seated on thrones in the spandrels between the arches round about the ceiling. In the minds of the pope

and Michelangelo the program rapidly expanded to its final scope, representing the world before Moses, a synopsis of the drama of the Creation and Fall of Man reduced to nine scenes, four large and five small, beginning with the *Separation of Light from Darkness* above the altar and ending with the *Drunkenness of Noah* near the entrance (fig. 22–16, left to right). These scenes are embedded in a structure of simulated marble architecture, whose transverse arches spring from twelve thrones, five along each side and one at either end, on which are seated the prophets and sibyls who foretold the coming of Christ. Above the thrones, at the corners of the scenes, sit twenty nude, incredibly beautiful athletic youths in poses of the greatest variety and with expressions that run from delight to terror, holding bands that pass through medallions of simulated bronze. In the vault compartments above the windows and in the lunettes around the windows are represented the forty generations of the ancestry of Christ, and in the spandrels at the corners of the chapel are pictured *David and Goliath, Judith and Holofernes,* the *Crucifixion of Haman,* and the *Brazen Serpent Upheld by Moses.*

In this intricate iconographic structure, resembling in its completeness the cycles of Gothic cathedrals and Byzantine churches, the coming of Christ is apparently foretold in the nine scenes from Genesis, according to the principle of correspondence between Old and New Testaments that was announced by Christ himself and illustrated repeatedly throughout Christian art. An added element is the oak tree of the Rovere family, to which Julius II and his uncle Sixtus IV belonged, a symbol repeated innumerable times in the decorations of the lower walls of the chapel as well as in the oak garlands, some wrapped and some open, held by almost all of the twenty nudes. The author has suggested that the Rovere oak tree, even allowed to invade the actual scenes, was intended to allude poetically to the Tree of Life, which stood near the Tree of Knowledge in the Garden of Eden and whose fruit in medieval theology was Christ.

The ceiling was frescoed by Michelangelo, with largely mechanical help from fourteen assistants, as William Wallace has recently shown, in the short time of four years (1508–12); during this period he also produced the hundreds of preparatory drawings and the *cartoons* (full-scale working drawings), which since the middle of the fifteenth century had replaced the traditional sinopias. Michelangelo began painting in reverse chronological order, with the three scenes dealing with the Life of Noah and the adjoining prophets and sibyls; he soon realized that in the *Deluge* he had underrated the effect of the height of the ceiling, more than sixty feet above the floor, and that the figures looked crowded and small. In the two central scenes, the *Fall of Man* and the *Creation of Eve,* painted in 1509–10, and in the final section, done in 1511–12, the size of the figures was greatly increased and the composition simplified. The lunettes above the windows were painted in two groups, each immediately after the section of the ceiling directly above.

When we stand in the chapel, it is impossible to get a comprehensive view of the entire ceiling. If we look upward and read the scenes back toward the altar, the prophets and sibyls appear on their sides; if we turn so that those on one side are upright, those on the other are upside down. If we turn our backs to the altar and look toward the entrance, only *Zechariah*, the first in the succession of prophets and sibyls, is viewed correctly. Only from a diagonal standpoint can the four corner scenes be read. The multiple contrasting directions are bound together by the structure of simulated architecture, with its transverse arches separating the window-like views in the central scenes and its diagonal bands separating the vault compartments. The placing of the twenty nudes at the intersections harmonizes the oppositions since the nudes can be read together with the prophets and sibyls enthroned below them or with the Genesis scenes at whose corners they are placed. Thus the basic High Renaissance principle of composition created by the interaction of the component elements is embodied in the very structure of the ceiling.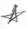

Beginning in 1980, a ten-year campaign of careful cleaning has removed layers of fatty carbons from oil, candle, and incense smoke deposited through the cen-

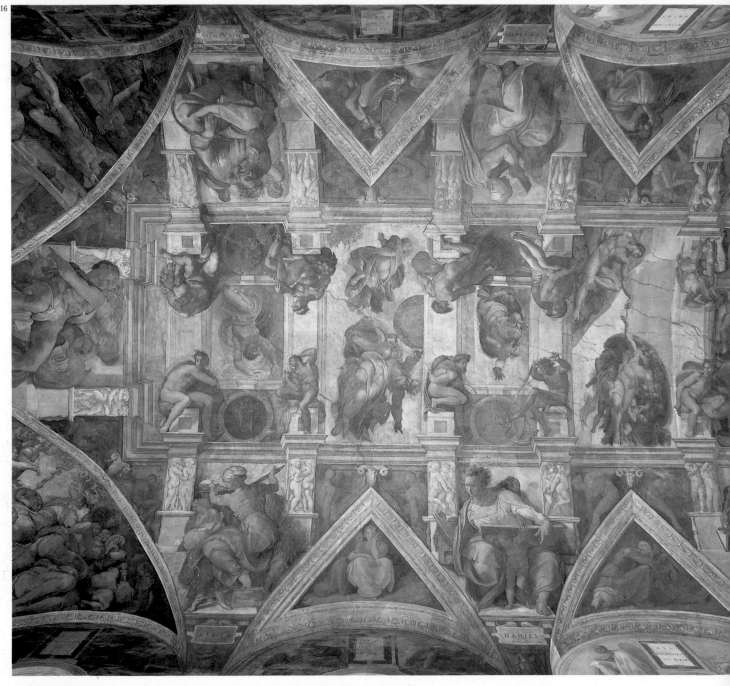

22-16

turies, as well as heavily darkened glue-varnish applied in the eighteenth century, in a misguided attempt to brighten things up. Fig. 22–16, a composite photograph, shows the ceiling from *Jonah* through the *Creation of Adam* as yet uncleaned and from the *Creation of Eve* through *Zechariah* after cleaning. The contrast between the cleaned and the uncleaned sections is astonishing. Michelangelo's original brilliant Tuscan color has at times a surprising intensity and an even more surprising subtlety. *Couleurs changeants* (iridescent colors, as in shot silk) are often used in force, and the flesh tones change from figure to figure, so much so that out of all twenty nudes, only the first two, painted from the same cartoon reversed, have identical coloration. Michelangelo can be truly said to have carved in color, especially in the flesh tones, generally painted with a fine brush and finished with the utmost delicacy, including even veils of one color across another, while sections not

22-16. MICHELANGELO. Ceiling fresco, Sistine Chapel, Vatican, Rome. Left to right (westward from altar).

Before restoration: *Jonah* between *Crucifixion of Haman* (above) and *Brazen Serpent* (below); *Separation of Light from Darkness* between *Jeremiah* (above) and *Libyan Sibyl* (below); *Creation of Sun, Moon, and Plants*; *Lord Congregating the Waters* between *Persian Sibyl*

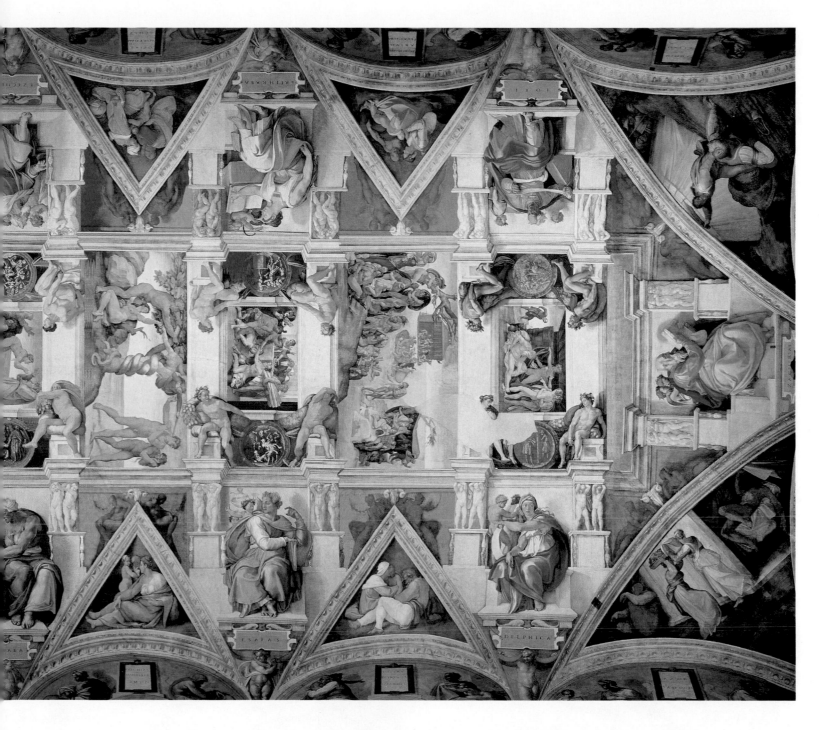

(above) and *Daniel* (below); *Creation of Adam*.

After restoration: *Creation of Eve* between *Ezekiel* (above) and *Cumaean Sibyl* (below); *Fall of Man* and *Expulsion from Paradise*; *Sacrifice òf Noah* between *Erythraean Sibyl* (above) and *Isaiah* (below); *Flood*; *Drunkenness of Noah* between *Joel* (above) and *Delphic Sibyl* (below); *Zechariah* between *David and Goliath* (above) and *Judith and Holofernes* (below)

easily legible from the floor are rapidly painted with broad brushes and striking pictorial effects that seem to reach beyond the Renaissance.

The *Fall of Man* (fig. 22–17) combines the Temptation and the Expulsion in one frame. Michelangelo was aware that his audience would recognize his allusion to the representations of the *Expulsion* by Jacopo della Quercia (see fig. 20–35) and Masaccio (see fig. 20–40), and for that very reason worked the two into a single scene, which in one motion leads the eye from the crime to the punishment, linked by the Tree of Knowledge, represented as a fig tree. It is noteworthy that the tree has only one branch; in balance with it on the right is the angel who expels the guilty pair from the Garden, and he is read together with the leaves of the Rovere oak coming from the nude above the scene at the right. Never in history had nude figures been painted on such a colossal scale; the powerful masses, simple con-

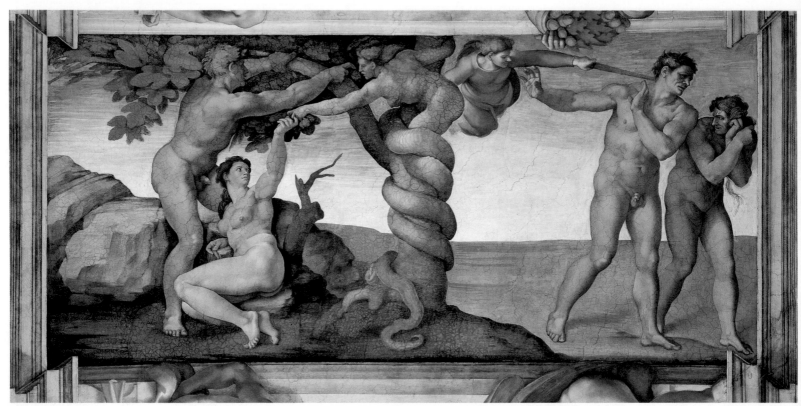

22-17

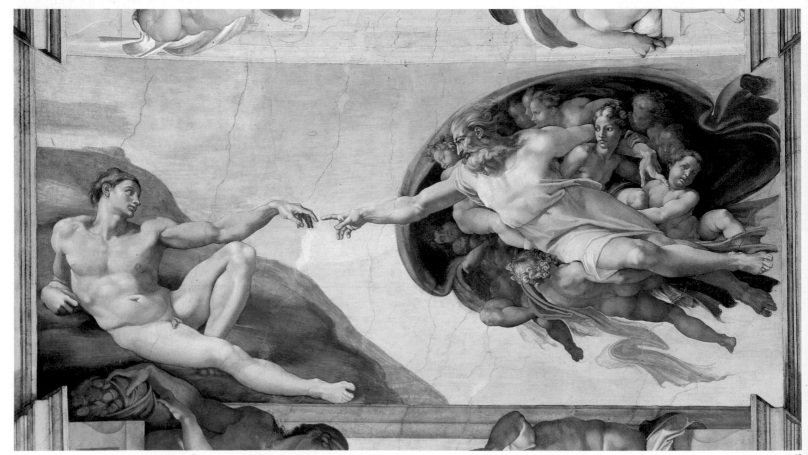

22-18

tours, and intense expressions of Michelangelo's figures operate with great success even at this size. Adam has changed radically from his appearance in the *Creation of Adam* (see fig. 22–18), chronologically earlier but painted later; his hair is a coarse red, his body tanned, his face distorted by greed; Eve is full-bodied and voluptuous as she accepts the Forbidden Fruit (a fig) from the hand of the female figure who issues from the great green and gold serpent wound around the trunk of the Tree of Knowledge. On the other side the magnificent angel, garbed in glowing red, expels into a featureless plain the guilty pair, unrecognizable; their faces are aged and lined, and even the structure of their bodies has collapsed.

Michelangelo's vision of a new and grander humanity reaches its supreme embodiment in the *Creation of Adam* (fig. 22–18). Instead of standing on earth as in all earlier Creation scenes (see fig. 20–34), the Lord floats through the heavens and is enveloped in the violet mantle he wears in all the scenes in which he appears. It was noted for the first time by the author in the third edition of this book that this color conforms to the violet required for the vestments of the clergy during Advent and Lent, the penitential periods before the coming of Christ at Christmas and his resurrection at Easter. The Lord is borne aloft by wingless angels; with only two youthful exceptions, all of Michelangelo's angels are wingless, as if he could not tolerate violation of the beauty of the human body by an attachment from any other form of life. (A widespread misconception holds that the angel under the Lord's left arm is in reality the unborn Eve; it has even been proposed without evidence that the nude figure is really Mary with the Christ Child at her knee. Theologically preposterous, both notions are refuted by the angel's almost flat chest, less developed even than the pectorals of the seated nudes.) Michelangelo's Creator for the first time makes believable the concept of omnipotence. A dynamo of creative energy, God stretches forth his hand, about to touch with his finger the extended finger of Adam. It was shown by the late Charles Seymour that this image of the creative finger derives from the famous medieval hymn "Veni Creator Spiritus" ("Come, Creator Spirit") sung at Pentecost, the festival of the Descent of the Holy Spirit, but also at conclaves in the Sistine Chapel, before the afternoon scrutiny for the election of a new pope. In this hymn the "finger of the paternal right hand" is invoked to bring speech to our lips, light to our senses, love to our hearts, and strength to our bodies. Adam reclines on the barren ground below, conspicuously undeveloped, longing for the life and love about to be instilled by this finger. As we have seen in the discussion of Jacopo della Quercia (see page 599), *Adam* means "from the Earth," and the figure is shown not, as in Jacopo's relief, merely astonished at the appearance of the Lord, but ready to be charged with the energy that will lift him from the dust and make of him "a living soul" (Genesis 2:7).

Adam's body is probably the most nearly perfect Michelangelo ever created, a structure embodying both the beauty of classical antiquity and the spirituality of Christianity. As in all High Renaissance compositions, the action in this one— based on the answering of the convex curve of the fecundating Creator by the concave curve of the receptive creature—will vanish in seconds, and yet it is preserved forever. It should be noted that the oak garland from a neighboring nude is permitted to enter the scene directly below Adam's thigh, so that the Incarnation of Christ, the second Adam (I Corinthians 15:45), fruit of the Tree of Life, is foretold by the creation of the first Adam. The allusion is to the prophecy of the Incarnation in Isaiah (53:2): "For he shall grow up before him as a tender plant, and as a root out of a dry ground." In the newly revealed color the scene is more beautiful than ever; Adam's exquisitely painted body glows with flower-like freshness; the Lord's tunic is a pale violet, his great heaven-mantle a much deeper tone. The distant summit, a sapphire blue, contrasts with the emerald-green slope on which Adam lies, a green picked up in the scarf swinging through the heavens from the shoulder of one of the angels.

The final scenes as one moves toward the altar were also the last in order of execution. The *Lord Congregating the Waters* was held to foreshadow the founda-

22-17. MICHELANGELO. *Fall of Man*, ceiling fresco (after restoration), Sistine Chapel, Vatican, Rome. 1509–10

22-18. MICHELANGELO. *Creation of Adam*, ceiling fresco (after restoration), Sistine Chapel, Vatican, Rome. 1511

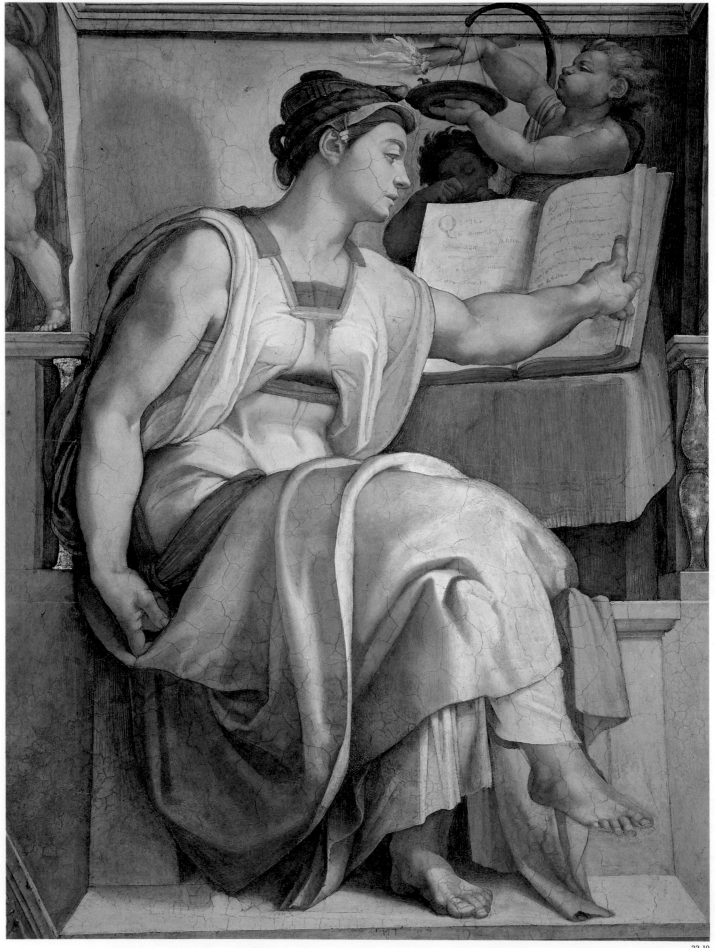

22-19

19. MICHELANGELO. *Erythraean Sibyl,* ceiling fresco (after restoraton), Sistine Chapel, Vatican, Rome. 1509–10

22-20. DONATO BRAMANTE. Tempietto, S. Pietro in Montorio, Rome. Authorized 1502; completed after 1511

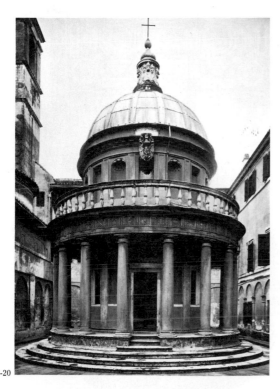

22-20

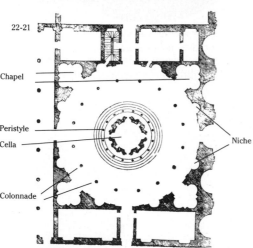

22-21

Chapel

Peristyle

Cella

Niche

Colonnade

22-21. DONATO BRAMANTE. Original plan for the Tempietto (from Sebastiano Serlio, *Il terzo libro d'architettura,* Venice, 1551)

tion of the Church; the *Creation of Sun, Moon, and Plants* shows the Lord twice, once creating sun and moon with a cruciform gesture of his mighty arms, then seen from the rear creating plants, among which the Rovere oak intrudes from under the neighboring nude. Just above the altar, the Lord separates the light from the darkness, which recalls the words of John 1:1: "In the beginning was the Word, and the Word was with God, and the Word was God." The figures have grown to such a scale that the frames will no longer contain them.

The seated prophets and sibyls in gorgeous and fantastic costumes against the simulated marble show the majestic possibilities of the draped figure, related to the conception of the seated *Moses* (see fig. 22–13); Vasari wrote that even when Michelangelo's figures were clothed they looked nude, by which he meant that the powerful motions of his figures could only have been achieved by his total mastery of the nude. *Ezekiel* is represented as a powerful, profoundly excited old man; the *Cumaean Sibyl* as a woman of heroic strength, her left arm close to that of the *Moses;* the *Persian Sibyl* as immensely old; *Jeremiah* as grieving above the papal throne; *Daniel* aflame with prophecy as he writes in a small volume; the *Libyan Sibyl* no longer needing her book as she looks down upon the altar, the eternal Tree of Life; *Jonah* gazing upward in colloquy with the Lord in the *Separation of Light from Darkness.* Drawn from the same male model who posed for one of the nude youths, the *Erythraean Sibyl* (fig. 22–19) shows the full power of Michelangelo's muscular forms, as much under the voluminous drapery as without it. (When writing about Vittoria Colonna, whom Michelangelo loved deeply, he could think of no higher compliment than to say she was a man in a woman's body.) The glowing porcelain surface of the arms, shoulders, and noble face is set forth against the rose bodice, orange cloak folded over to show its violet lining, and green skirt, all set off by the sky blue cover of the little reading desk on which the sibyl opens her book. Each prophet or sibyl is accompanied by two figures, usually children; one of Erythraea's is almost hidden in the shadow of the lamp being lighted by his companion with a blazing torch apparently plucked from the adjacent *Sacrifice of Noah.* The final phase of the Sistine Ceiling is one of the supreme moments in the spiritual history of mankind. It is also significant that it was created during the years when Julius II, who commissioned and to a considerable extent inspired the Sistine Ceiling, was fighting on the battlefield for the continued life of the Papal States against the armies of King Louis XII of France, and completed when the victory was won. Painting would never again be the same, nor would even the concept of humanity in art.

Bramante

For the moment we must leave Michelangelo to consider the work of the last two masters who joined in creating the High Renaissance style. Julius II's favorite architect was Donato Bramante (1444–1514), from Urbino, a congenial spirit, almost exactly the same age as the pope, to whom he used to read Dante in the evenings. Bramante, also a painter, had enjoyed a long and distinguished architectural career in Milan, where he had worked in close touch with Leonardo da Vinci, many of whose ideas he reflects. In fact, the Tempietto (fig. 22–20), a small circular shrine built after 1511 in Rome on the spot where Peter was believed to have been crucified, is a concentration and simplification of Leonardo's central-plan schemes (see fig. 22–3). The cylindrical cella is surrounded by a circular peristyle, in the manner of an ancient tholos of Roman Doric columns, crowned by a balustrade. The cella rises one story above the peristyle and culminates in a slightly more than hemispheric dome, ribbed on the outside. The proportions are simple, harmonious, and unified; in its smooth movement round the building, the peristyle has no equal in Renaissance architecture.

That the basic radial principle is derived from Leonardo can be seen in a sixteenth-century engraving (fig. 22–21) that shows the surrounding courtyard as

it would have looked had Bramante's circular design been carried out. The reader should trace with a straightedge the relationship between the niches in the cella, the columns of the peristyle, the columns of the circular colonnade, and the niches alternating with chapels that ring the colonnade. The result is a radial relationship of all forms and spaces from the center outward, like the rays of a snow crystal, the petals of a flower, or the spokes in a Gothic rose window.

This radial principle determined Bramante's design for rebuilding Saint Peter's in Rome. In 1506 it occurred to Julius II to tear down the Constantinian Basilica of Saint Peter's, then more than eleven hundred years old, and to replace it with a Renaissance church; this new project may well have been the reason for the interruption of work on his tomb by Michelangelo. Several different possibilities for the church's plan may have been considered by Bramante, the architect whom the pope entrusted with the commission, but the one finally chosen was strikingly Leonardesque (fig. 22–22).

Basically, it was a Greek cross with four equal arms terminating in apses. Into each reentrant angle was set a smaller Greek cross, surmounted by a dome, two of whose apses merged in those of the central cross. Four lofty towers were to be erected in the angles of the smaller crosses and linked with the four major apses by triple-arched porticoes. The striking feature of the exterior was the culminating dome, which for the first time in the Renaissance entirely abandoned the vertical-ribbed form in the tradition of Brunelleschi (see fig. 20–1), still followed by Leonardo, and replaced it with an exact hemisphere modeled on that of the Pantheon. But Bramante did not wish to sacrifice the Renaissance notion of the drum, which gives a dome greater height; his drum is again a tholos, surrounded by a peristyle of Corinthian columns. How the whole structure would have looked from the exterior may be seen in the commemorative medal struck by Bramante's collaborator, the sculptor Cristoforo Caradosso, in 1506 (fig. 22–23).

At the time of the pope's death in 1513 and of Bramante's the following year, only the eastern half of the basilica had been demolished, but the four giant piers with their Corinthian pilasters upholding the four arches on which the dome was to rest had already been built. Although Bramante's dome remained a dream, his interior plan was substantially realized (fig. 22–24). The floor level, unfortunately, was raised about three feet and the pilasters thus correspondingly shortened. The idea of the coupled pilasters in one giant story sustaining the barrel vaults and embracing smaller arches was drawn from Alberti's nave of Sant'Andrea in Mantua (see fig. 20–15). Nonetheless, the interior as Bramante originally planned it would have been very complex, as the reader can see by moving in imagination from one of the eight entrance porticoes in the plan into the adjoining apse, then into one of the smaller Greek crosses with its central dome, then through a barrel-vaulted arch into the greater barrel vault of one of the four transept arms, and finally into the central space to look up into the interior of the colossal dome. Bramante's radial design was never carried out in its entirety, but his basic central structure with its four great arches and their piers was on such a scale that it could not be altered by any of the subsequent architects.

Another great dream of Pope Julius II and Bramante, destined to be completed only decades later, was the immense new building of the Vatican, through whose corridors today troop innumerable visitors and pilgrims. This was intended to unite the earlier Vatican structures with the country villa of the Belvedere (the name appropriately means "beautiful view"), nearly a thousand feet away, at the top of a small hill. Bramante projected two long, parallel structures—two stories high at the top, where they are joined by a short side embracing a great exedra, and three stories high in the lower courtyard—with monumental flights of stairs going up the slope, screen architecture on the principle of Alberti's Palazzo Rucellai (see fig. 20–13) with coupled Corinthian pilasters, echoing Saint Peter's, and embracing blind arches, to articulate the steady succession of windows into a larger unity. The lower courtyard was used for pageants; it was even on occasion flooded for mock naval

22-22. DONATO BRAMANTE. Original plan for St. Peter's, Vatican, Rome (after Geymüller). 1506

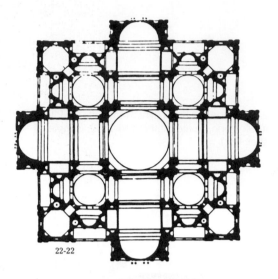

22-22

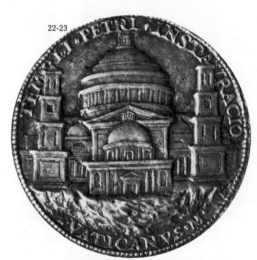

22-23

22-23. CRISTOFORO CARADOSSO. Bronze commemorative medal showing Bramante's design for the exterior of St. Peter's, Vatican, Rome. 1506. British Museum, London

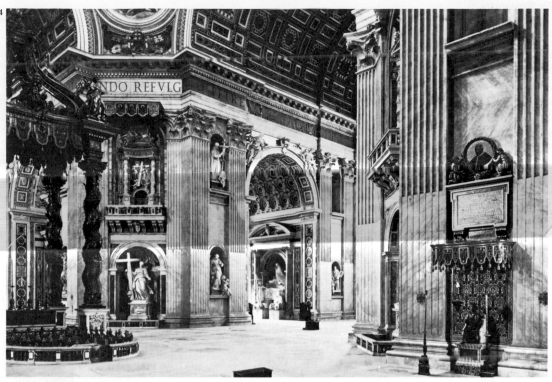

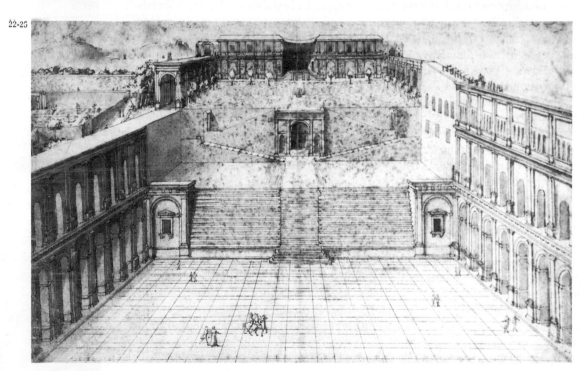

22-24. Interior view at the crossing, St. Peter's, Vatican, Rome (after plan by DONATO BRAMANTE)

22-25. DONATO BRAMANTE. Belvedere, Vatican, Rome. Begun 1505. Sixteenth-century drawing

battles. On a scale to compete with Saint Peter's itself, this was the most ambitious palace plan between the Villa of Hadrian at Tivoli and the Versailles of Louis XIV. In the eighteenth century another wing was run across the vast courtyard cutting the view forever, so it is best to imagine the original appearance from a sixteenth-century drawing of the unfinished building (fig. 22–25).

Raphael

The fourth great master of the Florentine and Roman High Renaissance was Raffaello Sanzio (1483–1520), known by the Anglicized form Raphael. It is in his art that the High Renaissance ideal of harmony comes to its most complete

expression. First taught in Urbino by his father, Giovanni Santi, a mediocre painter, Raphael worked for some time in the studio of Perugino, whose manner he approximated so exactly that it has sometimes been difficult to ascertain whether certain works are by the master or his young pupil. In 1504 Raphael painted for a church in the little town of Città di Castello the *Marriage of the Virgin* (fig. 22–26), which at once recalls the *Giving of the Keys to Saint Peter* by Perugino (see fig. 20–69). Differences are instructive; what is diffuse in Perugino is brought to a focus in Raphael. His central group is unified around the motif of Joseph putting the ring on Mary's finger, and the lateral figures are made to join in this movement, including the disgruntled suitor breaking his rod over one knee. The architecture of the distant polygonal Temple grows out of the wide piazza and is more carefully unified, in the spirit of the Tempietto, than the abrupt shapes of Perugino's octagonal building. Its dome is almost tangent to the arch of the panel, identifying the dome of the Temple with that of Heaven. Moreover, the doors of the Temple are open so that the perspective of the squares in the piazza moves serenely through the building to the point of infinity. This combination of perfect unity and airy lightness in Raphael's composition breathes through the figures as well. Perugino's characteristic S-curve is transformed by Raphael into an ascending spiral beginning at the tip of the toes and rising harmoniously and effortlessly to discharge in the glance.

About 1505 Raphael, twenty-two years old, arrived in Florence and achieved immediate success. Leonardo and Michelangelo had established the High Renaissance style in Florence, but they were accessible to few private patrons and seldom delivered finished works. Raphael met the demand with ease and grace, and during his three-year stay painted a considerable number of portraits and Madonnas, one of the loveliest of which is the *Madonna of the Meadows,* dated 1505 (fig. 22–27). The pyramidal group established by the interaction of its members in Leonardo's design for the *Madonna and Saint Anne* (see fig. 22–8), and certainly the pose of the Virgin with her left foot extended, were strongly influenced by Leonardo's composition. But the Raphael picture is simpler; the gentle master from Urbino dissected no corpses and was only slightly interested in anatomy. Harmony was to him the basic purpose of any composition, and the harmony is beautifully consistent throughout this work, from the balancing of ovoids and spheroids in the bodies and heads of the children to the encompassing shapes of the protective Virgin and finally to the background landscape, which is brought to a focus in her neckline and head, as is that of the *Marriage of the Virgin* in the dome of the Temple. Restful though the final painting may be, like many others the highly successful young master painted in his Florentine years, in true High Renaissance style the sense of repose is based on dynamics, the free motions of the artist's hand and arm, describing the beautiful curves in rapid preparatory pen strokes (see Introduction fig. 11). The landscape bears the same relation to the figural composition as does the encircling courtyard to Bramante's Tempietto. Although Raphael reinstated the traditional halos in his Florentine Madonnas, perhaps at the insistence of his patrons, they appear as slender circles of gold, delicately poised in depth, and as an added element in his composition of circles and ovoids.

Julius II chose the twenty-six-year-old Raphael to supplement in the Stanze (Chambers) of the Vatican the massive program of imagery being painted by Michelangelo in the locked Sistine Chapel across the narrow intervening court. Raphael maintained his position as court painter until his early death. His ideals of figural and compositional harmony, expanding and deepening from their relatively slight Florentine beginnings, came to be recognized as *the* High Renaissance principles, and it was to Raphael, therefore, rather than to Michelangelo, that classicistic artists of succeeding centuries, especially Nicolas Poussin in the seventeenth century (see fig. 27–5) and Jean-Auguste-Dominique Ingres in the nineteenth (see fig. 30–13), turned as the messiah of their art and doctrine. The first room to be frescoed was the Stanza della Segnatura (1509–11), used for the papal

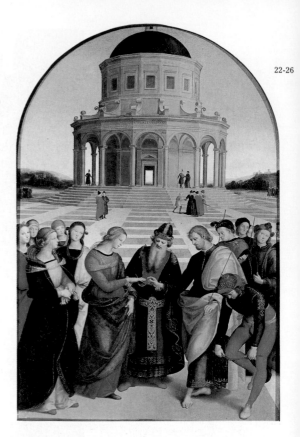

22-26. RAPHAEL. *Marriage of the Virgin.* 1504. Panel painting, 67 × 46½″ (1.7 × 1.18 m). Pinacoteca di Brera, Milan

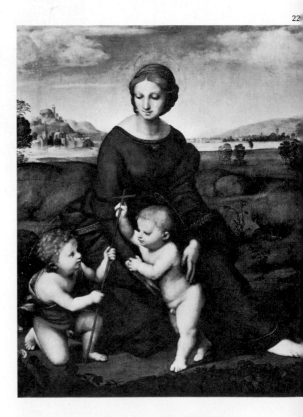

22-27. RAPHAEL. *Madonna of the Meadows.* 1505. Panel painting, 44½ × 34¼″ (113 × 87 cm). Kunsthistorisches Museum, Vienna

22-28

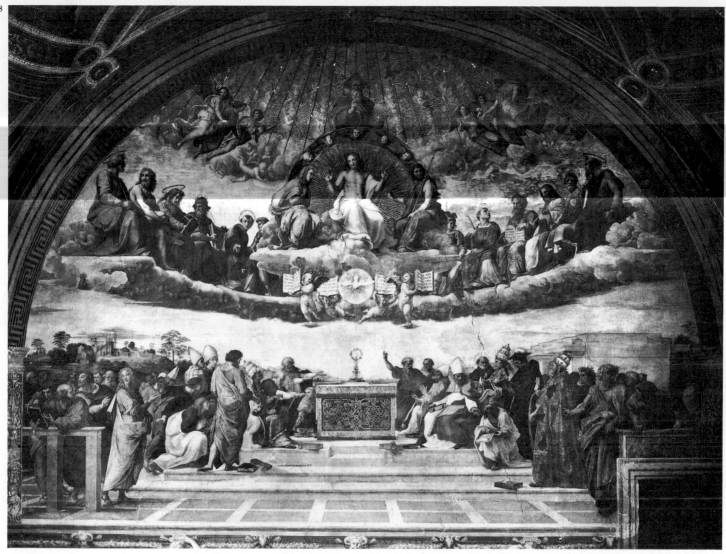

22-28. RAPHAEL. *Disputa (Disputation over the Sacrament)*, fresco, Stanza della Segnatura, Vatican, Rome. 1509

tribunal whose documents demanded the personal signature of the pontiff. From the complex iconographic program we can single out the two dominant frescoes on opposite walls; they typify the classical and Christian elements reconciled in the synthesis of the High Renaissance. The *Disputa (Disputation over the Sacrament;* fig. 22–28), the most complete exposition of the doctrine of the Eucharist in Christian art, faces the *School of Athens,* an equally encyclopedic presentation of the philosophers of pagan antiquity.

The *Disputa* begins in Heaven (still represented by gold, but for the last time in any major work of Christian art). God the Father presides over the familiar Deësis, with Christ enthroned, displaying his wounds; on either side, in a floating semicircle of cloud recalling the arrangement in van der Weyden's *Last Judgment* (see fig. 21–21), Apostles and saints from the New Testament alternate with prophets and patriarchs from the Old. Below the throne of Christ, the Dove of the Holy Spirit, flanked by child angels bearing the four open gospels, flies downward toward the Host, displayed in a gold and crystal monstrance on the altar. On either side of the altar sit the Four Fathers of the Church and, farther out, groups of theologians from all ages of Christianity engage in argumentation over the nature of the Eucharist, their vitality and agitation contrasting with the serenity of Heaven, where all questions are set to rest. Among the recognizable portraits are those of Dante, to the left of the door, and, in front of him, Sixtus IV. From the angels above the Deësis,

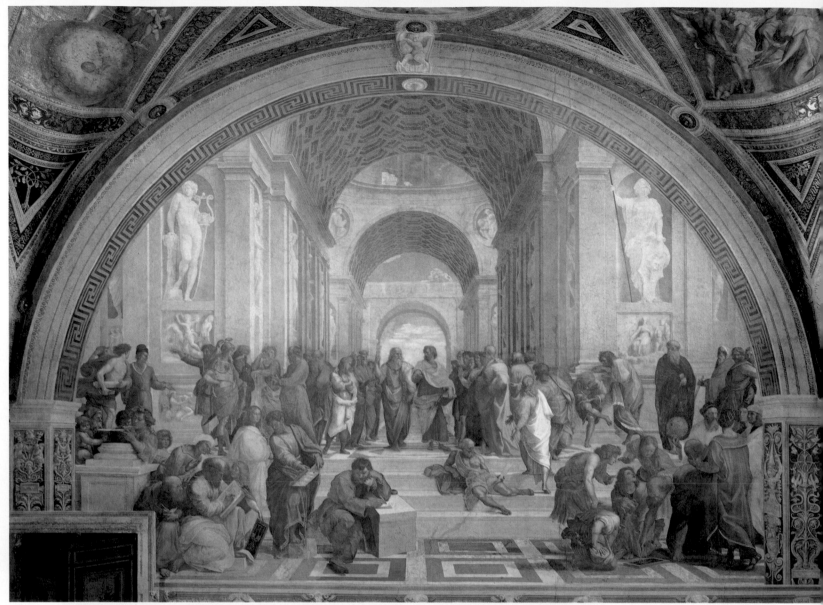

22-29

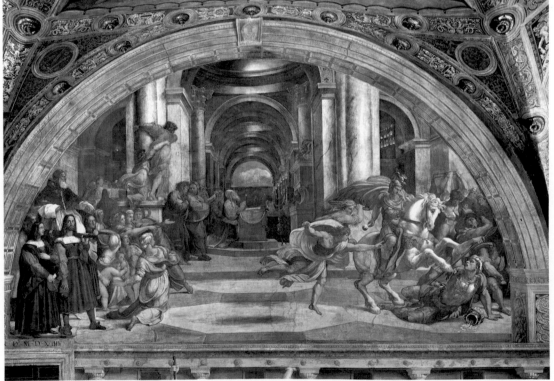

22-30

22-29. Raphael. *School of Athens,* fresco, Stanza della Segnatura, Vatican, Rome. 1510–11

22-30. Raphael. *Expulsion of Heliodorus,* fresco, Stanza d'Eliodoro, Vatican, Rome. 1512

whose spiral forms take on substance along the incised beams of golden spiritual light, down to the statuesque groups of theologians on earth, every figure is based on Raphael's fundamental spiral principle.

More revolutionary in its composition, the *School of Athens* (a misnomer applied in the eighteenth century; fig. 22–29) presents under an ideal architecture the chief philosophers from all periods of Greek antiquity engaged in learned argument. The figures form a circle in depth within the lofty structure, culminating under the central arch, where against the distant sky Plato, holding the *Timaeus,* points toward Heaven as the source of the ideas from which all earthly forms originate while Aristotle, holding the *Ethics,* indicates earth as the object of all observations. At the upper left Socrates may be discerned discussing philosophical principles with the youths of Athens; at the lower left Pythagoras delineates his proportion system on a slate before pupils; at the right Euclid (a portrait of Bramante) uses another slate to demonstrate a geometric theorem.

The embracing architecture, with its statues of Apollo and Minerva in niches (the legs of Apollo repeat those of Michelangelo's *Dying Slave,* but in reverse; see fig. 22–14), is strongly Bramantesque, and in its single giant story and coffered barrel vaults suggests how the spaces of Bramante's Saint Peter's would have looked. Nonetheless, it is background architecture, essentially unbuildable; there are no arches to carry the outer borders of the central pendentives, which begin at the transverse arches and end in nothing. The isolated figure in the lower center, seated with one elbow on a block of stone in a pensive pose resembling that of Michelangelo's *Jeremiah* (see fig. 22–16), has been identified as a portrait of the great sculptor himself, inserted by Raphael after he had seen Michelangelo's frescoes in the Sistine Chapel in 1511.

In the next two Stanze to be painted, Raphael abandoned the perfect but poised and serene harmony of the Stanza della Segnatura in favor of always more dynamic compositions, which brought him to the threshold of the Baroque, under strong influence of the new style he had beheld in the Sistine Chapel. In the Stanza d'Eliodoro, of 1512–14, the principal fresco (fig. 22–30) represents an incident from Maccabees 3 (a book of the Apocrypha, not included in Protestant Bibles), which tells how the pagan general Heliodorus, at the behest of one of the Seleucid successors of Alexander the Great, attempted to pillage the Temple in Jerusalem but was met by a heavenly warrior in armor of gold on a shining charger and by two youths "notable in their strength and beautiful in their glory," who beat him to the ground with their scourges so that he fell blinded. For Julius II this was an omen of divine intervention on his side against the schismatic Council of Pisa, set up by the invading Louis XII to depose him. He thus had Raphael paint him, formidable with his newly grown beard, being carried into the fresco at the left; Raphael appears as one of the chair bearers, directly below the pope's left hand. Under the influence of the marvels Raphael had seen in the Sistine Chapel, the pace has quickened, the volume has increased, and the muscular, Michelangelesque figures have been set in violent motion. But Raphael does not abandon his spiral principle; energy courses through the action figures as through figure eights. The rearing charger recalls those Raphael had seen in Leonardo's *Battle of Anghiari* (see fig. 22–7); this kind of reference was not considered plagiarism in the Renaissance but recognition of greatness, in the same sense as Michelangelo's bow to Masaccio and Jacopo della Quercia (see page 681). Because the figures have been enlarged to Michelangelesque dimensions, the architecture has decreased in scale but gained in mass and power. Heavy columns and massive piers have replaced the slender pilasters of the *School of Athens.*

From this same period dates the *Sistine Madonna* (fig. 22–31), so called because Saint Sixtus II, patron of the Rovere family, kneels at the Virgin's right. The picture was probably intended to commemorate the death of Julius II in 1513; the saint's cope is embroidered with the Rovere oak leaves, and the bearded face, a little older and less pugnacious than that in the *Expulsion of Heliodorus,* is a portrait of the

22-31. RAPHAEL. *Sistine Madonna.* 1513. Oil on canvas, 8′8½″ × 6′5″ (2.65 × 1.96 m). Gemäldegalerie, Dresden

aged pontiff. Saint Barbara, patron saint of the hour of death, looks down on his coffin, on which the papal tiara rests, and the Virgin, showing us the Child, walks toward us on luminous clouds in which more angelic presences can be dimly seen. In harmonizing form and movement this painting represents the pinnacle of Raphael's achievement; the dynamic composition should be compared with the static one of the *Madonna of the Meadows* (see fig. 22–27). The broad, spiral shapes rise from the tiara through the cope of the kneeling saint up to and around the bodies of the Virgin and the Child, and downward again through the glance of Saint Barbara. Even the curves of the curtains, drawn apart to display the vision, harmonize in alternating tautness and fullness with the lines of the entire composition. The motif of the Virgin and Child walking toward us on the clouds may have been suggested by the visionary Christ of the mosaic of Saints Cosmas and Damian in Rome. The two figures in their perfect beauty, warmer and more human than their counterparts in the *Madonna of the Meadows,* represent the ultimate in the High Renaissance vision of the nobility of the human countenance and form.

The death of the warrior-pope was followed by the election of Giovanni de' Medici, younger brother of the exiled Piero and a boyhood acquaintance of Michelangelo at the table of Lorenzo the Magnificent. The thirty-eight-year-old Leo X was unmoved by the ideals of church reform and political power that had driven Julius II to such extraordinary feats; nevertheless, he was delighted with his new position, which gave him the opportunity to spend lavishly on worldly enjoyment the revenues accumulated by his predecessor to finance his conquests. In 1512, as Cardinal de' Medici, backed by Julius II, Giovanni had entered Florence and governed it through his younger brother Giuliano. Raphael has shown Leo X as he really was in an unsparing portrait (fig. 22–32)—corpulent, shrewd, pleasure-loving—engaged in the examination of an illuminated manuscript (the original still exists) with a gold and crystal magnifying glass; a gold and silver bell to summon servants is close to the pope's hand. On his left is Cardinal Luigi de' Rossi, his sister's son, and on his right his cousin Cardinal Giulio de' Medici, later Pope Clement VII. The portrait was probably painted in 1517, the fateful year when Martin Luther, whom the pope excommunicated in 1520, nailed his ominous theses to the door of the castle church of Wittenberg. Raphael was able to endow his subjects with the new mass and volume he had learned from Michelangelo's seated figures, but his analysis of character is unexpected and profound. He has shown us all too clearly the pope who was incapable of holding the Western Church together.

Among the offices to which the pope appointed Raphael was that of inspector general of antiquities, the first known attempt to place under legal authority all ancient objects excavated on purpose or by chance. The so-called Golden Age of Leo X produced as perhaps its most delightful monument the Villa Farnesina, then overhanging the Tiber, built to the order of the pope's banker Agostino Chigi, an important personage considering the huge financial demands of the Medici court. Raphael, his pupils, and other High Renaissance painters decorated room after room with frescoes entirely devoted to scenes from classical antiquity, completely pagan in subject. In the *Galatea* (fig. 22–33), of about 1513, he shows the sea-nymph in triumph on a shell drawn by dolphins and attended by sea-nymphs and Tritons. Above her, three winged Loves draw their bows in a useless attempt to inflame her heart with passion for the Cyclops Polyphemus, who is pictured in a neighboring fresco by another painter. Raphael's figure-eight form underlies the entire composition. Galatea, in her physical abundance, little resembles the slender Venus of Botticelli. She stands in a Hellenistic contrapposto pose, in the plenitude of her powers, as do the other figures, male and female, whose white or tanned anatomies glisten against the green sea.

The identical figure-eight composition was employed by Raphael for a diametrically opposed purpose in one of his last and greatest paintings, the *Transfiguration of Christ* (fig. 22–34), painted in 1517 for the Cathedral of Narbonne, of which Cardinal Giulio de' Medici was bishop. The completed painting was so

22-32. RAPHAEL. *Pope Leo X with Cardinals Giulio de' Medici and Luigi de' Rossi.* c. 1517. Panel painting, 60½ × 47" (1.54 × 1.19 m). Galleria degli Uffizi, Florence

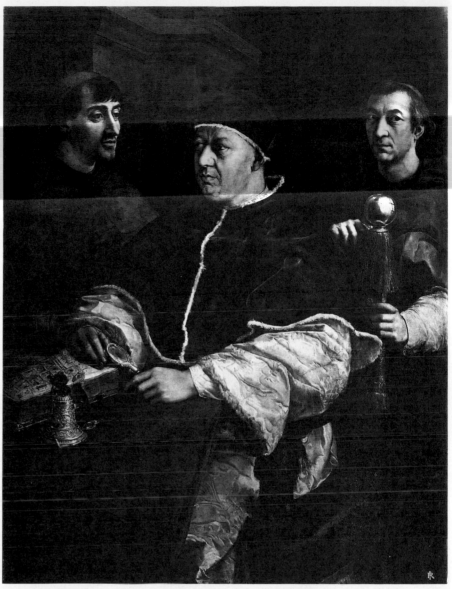

22-32

glorious, however, that the cardinal kept it in Rome. In contrast to the traditional renderings of the subject (see that by Bellini, fig. 20–77), Raphael painted an accompanying incident as well, told by Matthew and Luke. When Peter, James, and John had accompanied Christ to the top of a high mountain, the remaining Apostles were unable without his presence to cast out the demons from a possessed boy. The lower section of the figure eight is composed of the agitated and distraught figures of the Apostles and the youth (in part executed by Raphael's pupils, especially Giulio Romano) plunged into semidarkness, with shadows of fantastic blackness, lit only from above. The upper loop is composed of Christ, Moses, Elijah, and the three Apostles. Christ and the prophets soar in the air as if lifted up by the spiritual experience, their garments agitated as if from the center of brightness, which is Christ, came not only light but also the wind of the spirit, which has cast the Apostles to the ground in terror. They, too, have fallen in Raphael's spiral poses.

Raphael, who at this point in the High Renaissance had at his fingertips the full resources of natural light, apparently no longer felt any need to distinguish it from spiritual light (gold rays are gone forever). Raphael may have been connected with a small group of priests and laymen called the Oratory of Divine Love, which, in the

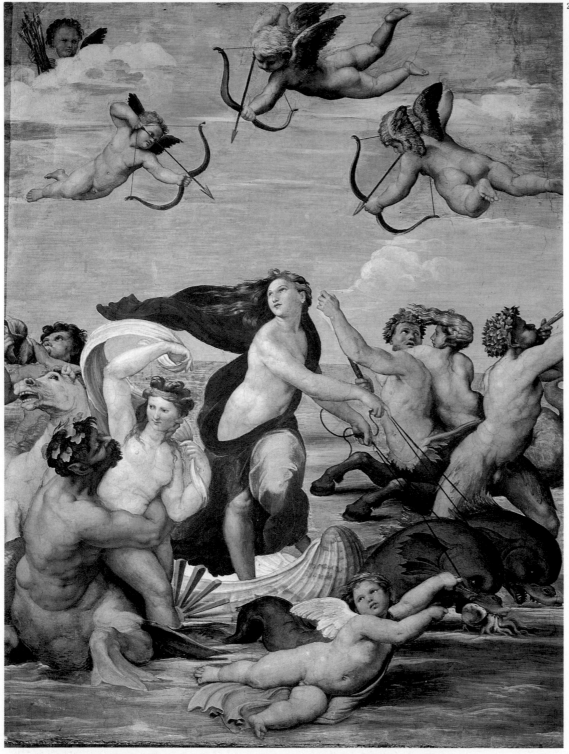

half-pagan magnificence of the Rome of Leo X, attempted to reform and rejuvenate the Church from within through frequent Communion and prayer. In this vision of Christ, shining with delicate colors through his "white and glistening" garments, Raphael may well have embodied his beliefs. The great painter died on Good Friday, April 6, 1520, of unknown causes, at the age of thirty-seven. At his request his funeral was held in the Pantheon and the *Transfiguration* placed above his bier; his tomb is also there, lighted only by the sky through the great round opening in the dome. To his contemporaries Raphael's death seemed the end of an era.

22-33. RAPHAEL. *Galatea*, fresco, Villa Farnesina, Rome. c. 1513

22-34. RAPHAEL. *Transfiguration of Christ*. 1517. Panel painting, 13′4″ × 9′2″ (4.06 × 2.79 m). Pinacoteca, Vatican, Rome

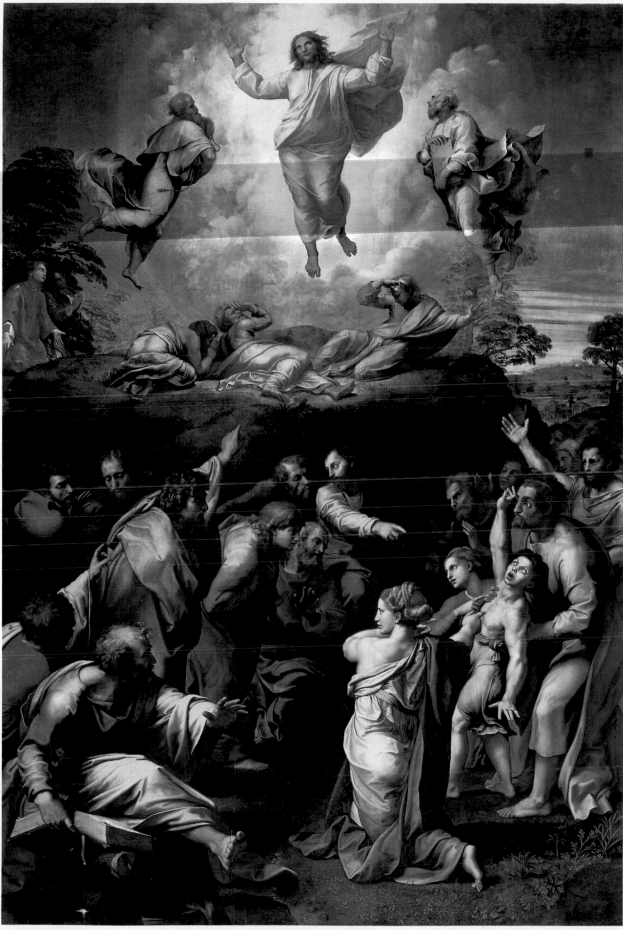

CHAPTER TWENTY-THREE

The High Renaissance in Rome and Florence was as brief as it was unpredictable—hardly more than twenty-five years from its tentative beginnings in Leonardo's *Last Supper* to the death of Raphael in 1520. A new style succeeded it, after existing for a while side by side with the latest phases of High Renaissance art. This new style has come to assume the name of *Mannerism*. The terms *Romanesque* and *Gothic* are now considered inadequate to characterize their periods, presumably because they were invented by writers of the past not fully informed about the facts. The name *Mannerism* was proposed by art historians in the twentieth century, and yet it is even less able to suggest the strange beauty and emotional depth of the art it ought to be describing, only the artificiality of its latest phase. Like the terms *Romanesque* and *Gothic,* however, *Mannerism* is here to stay.

Mannerism comes from the Italian word *maniera* ("manner"), derived in turn from *mano* ("hand"); it should indicate a style founded upon repetition of acquired manual techniques at the expense of new observations. True enough, in the later phases of sixteenth-century art in central Italy there is indeed much rote repetition of types and devices invented earlier, especially those of Michelangelo, but the artists involved, although numerous, are seldom of sufficient quality for inclusion in a book like this one. There is nothing mechanical about what went on in Florence, Siena, Parma, and many other Italian cities just before and just after 1520. That moment has been recognized as a genuine psychological, even spiritual, crisis. For graphic evidence of this crisis we have only to compare such typical Mannerist paintings as those by Jacopo Pontormo (see figs. 23–15, 23–16), Rosso Fiorentino (see fig. 23–17), and Parmigianino (see figs. 23–25, 23–26) with those of the great masters of the High Renaissance. Just a glance, before undertaking closer study, will show that something very strange has happened. Where in such pictures as these are the spatial depth and harmony, the understandable arrangements of figures, the natural proportions and graceful poses, above all the mood of well-being, that we have enjoyed in High Renaissance art? In these nervous, spaceless compositions, crowded with twisting, often turbulent figures, unnaturally lengthened and sometimes arbitrarily colored, and yet compellingly beautiful, we seem to have entered a dream world, which comes to a special focus in the haunted or at times tormented expressions of the people represented. Compare also Benvenuto Cellini's *Perseus and Medusa* (see fig. 23–31), heavily ornamented and dripping gore, with the noble simplicity of Michelangelo's *David;* or the structures of Giulio Romano (see fig. 23–22), Giorgio Vasari (see fig. 23–33), and Bartolommeo Ammanati (see fig. 23–34), riven by built-in and insoluble conflicts, with the grand harmonies of Bramante's architecture; or the later work of Michelangelo himself with the *Moses* or the Sistine Ceiling.

The change is real and abrupt. Obviously, the same concepts we have used for the High Renaissance will no longer describe the deeply disturbed art of the Mannerists. What can explain such a strange phenomenon? There are, apparently, two principal causes, which eventually fused. The first was political. The Florentine Republic, though its external forms were still preserved, lost its independence to the Medici in 1512. On his election as pope in 1513, Leo X governed Florence through his brother Giuliano, and later replaced Giuliano with his nephew Lorenzo. After the death of Lorenzo in 1519 the rule of Florence passed to Cardinal Giulio de' Medici (on the pope's right in the Raphael portrait; see fig. 22–32). Conditions were dismal in Florence, and the populace resented the loss of its ancient liberties.

The second cause was religious. Horrified by the excesses of luxury at Pope Leo's court, and by the sale of indulgences (remittances of time in Purgatory) to build the new Saint Peter's, the Lutherans defied the papacy, sometimes with reason and

MICHELANGELO AND MANNERISM

generally with success, and went farther to challenge all sacraments save Baptism and Holy Eucharist, vitiating even the latter by denying the Real Presence. The split in Western Christendom grew almost daily wider and deeper. Much of central and northern Europe went over to Protestantism, and Luther had many followers even in Italy. The universal authority of the Roman Catholic Church was thus discredited and one of the major bastions of spiritual strength in the Western world irretrievably weakened.

When Giulio de' Medici became pope as Clement VII in 1523, after the brief pontificate of the Dutch Adrian VI (1522–23), religious and political causes became one. Clement's political machinations brought upon the papal city a scourge that had not been experienced since the days of the barbarians: armies supposedly owing allegiance to Holy Roman Emperor Charles V, but actually out of control, sacked Rome in 1527. German Lutherans and Spanish Catholics outdid each other in acts of cruelty and greed, and much of High Renaissance Rome was reduced to wreckage. The pope himself, a prisoner in Castel Sant'Angelo, escaped to Orvieto, where he lived under beggarly circumstances and from which he returned to an impoverished and devastated Rome. Eventually the emperor descended to Italy in person, and a new order was reestablished by treaty between emperor and pope at Bologna in 1530, a site chosen so as to allow the emperor to depart rapidly to come to the aid of his brother against the conquering Turks in Hungary.

It was painfully obvious that not only Florence but all of Italy—even the Church itself—had lost its liberty. Italian politics, including those of the papacy, were dictated by Charles V, not only as emperor but as king of Spain, the Netherlands, Milan, Naples, and Sicily, not to speak of most of the New World. In this atmosphere of gloom, economic ruin, disappointment, and foreboding, the new style developed. No wonder that so many aspects of Mannerism suggest the art and spirit of our own troubled times. Long before the end of the century only Genoa, Venice, and tiny Lucca remained of the once-numerous Italian republics; the others had all succumbed to princely regimes, absolute save only for the shadowy overlordship of the Empire.

Most of the doctrines that Lutheranism, later augmented by Calvinism, continued to attack were reaffirmed by the authoritarian religiosity of the Counter-Reformation and formalized in the proceedings of the Council of Trent (beginning in 1545 and continuing off and on until 1563). It was a solution by decree, at the expense of most if not all of the conquests of Renaissance humanism.

Michelangelo after 1516

Although Michelangelo retained his own individuality and shunned some of the extremes of younger Italian artists, his overpowering presence in Florence from 1516 to 1534 inevitably meant that much of the new style would be derived in one way or another from his art. In fact, the real moment of crisis, just before 1520, was seen largely through the eyes of the "divine Michelangelo" (he was often addressed that way in letters!). Before turning to the works of his younger contemporaries, therefore, we must follow the rest of Michelangelo's long artistic career.

THE MEDICI CHAPEL This was the very period when Michelangelo, despite his republican sympathies, found himself working for the Medici on a funerary chapel, begun in 1519 for the entombment of Lorenzo the Magnificent, his murdered brother Giuliano, and the two recently deceased dukes, also confusingly named Giuliano and Lorenzo, son and grandson respectively of Lorenzo the Magnificent. The Chapel was built as the right-hand sacristy of San Lorenzo, symmetrical in

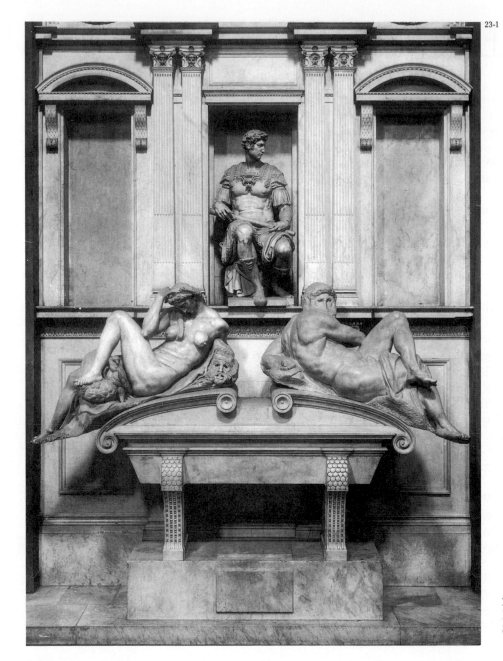

23-1. MICHELANGELO. Tomb of Giuliano de' Medici. 1519–34. Marble. Medici Chapel (New Sacristy), S. Lorenzo, Florence

plan with the left-hand sacristy by Brunelleschi (see fig. 20–6). Michelangelo's more or less Brunelleschian architecture of white walls and *pietra serena* supports and trim encloses the only tombs ever even partially completed, those of the two dukes. Each tomb is a marble architectural composition, incommensurable with the enclosing architecture (see figs. 23–1, 23–2). In simple rectangular niches sit the two dukes, dressed in Roman armor in their roles as captains of the Roman Catholic Church. The statues are idealized because Michelangelo said that a thousand years from now no one would know what the dukes had looked like and because he wanted to give them the dignity that belonged to their positions. The ornamental tabernacles on either side of each niche remain blank, although they may have been intended for statues.

The strangely shaped sarcophagi appear to have been split in the center to allow the emergence of the ideal images of the dukes. On either side recline figures of the times of day, *Night* (left) and *Day* under *Giuliano* (fig. 23–1), *Dawn* (right) and *Twilight* under *Lorenzo* (fig. 23–2). A hypothesis that these statues were not made for sloping, curved supports has been proclaimed without foundation; Michelan-

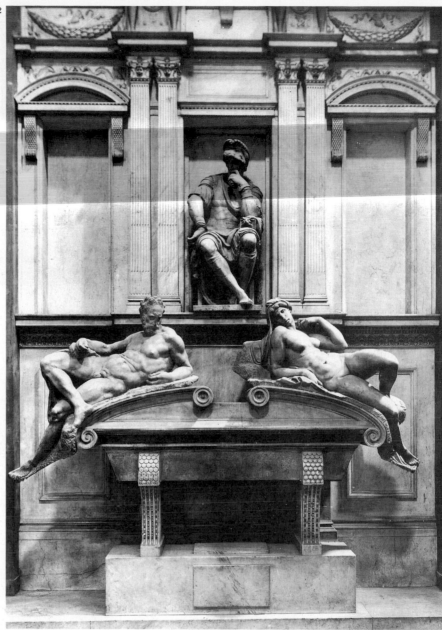

23-2

23-2. MICHELANGELO. Tomb of Lorenzo de' Medici. 1519–34. Marble. Medici Chapel (New Sacristy), S. Lorenzo, Florence

gelo's drawings for the tombs show how the tomb architecture and these very figures were developed together from early stages in his imagination. The compositions should, however, be completed by reclining figures of river-gods, their feet pointing inward, in the empty spaces at right and left below the tombs. According to the sculptor's own explanation, written on a sheet of drawings for architectural details, *Night* and *Day*, who have brought the duke to his death, are subject to his revenge, for in his death he has slain them. In other words the timeless symbol of princely power that the dukes represent has conquered the powers of time (the times of day) and of space (the four rivers). It is especially significant that when Michelangelo was engaged on this work glorifying Medici power, the Sack of Rome destroyed temporarily the power of his Medici patron; the republic was revived for the third and last time, and Michelangelo was placed in charge of its defenses. The ambivalence of his position must have been painful to the artist, who, when the Medici troops reentered the defeated city in 1530, escaped assassination only through the personal intervention of the pope.

In the languid figure of *Giuliano* the conviction and power of the Sistine Ceiling

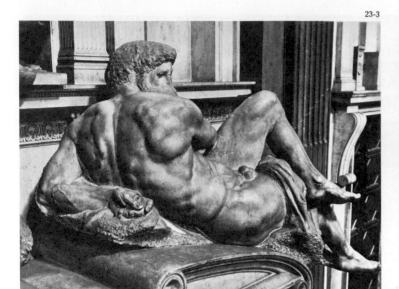

are absent. Muscular though the duke may be, he seems overcome by lassitude. *Night,* her body and breasts distorted through childbirth and lactation, a grinning mask (symbol of false dreams) below her shoulder, and an owl under her leg, is contrasted with the mighty *Day* (fig. 23–3), probably Michelangelo's most heavily muscled figure, turning in a gigantic motion as if to throw off his covers and arise to do battle. Yet each of these figures is trapped in a contrapposto pose that defeats the very meaning of contrapposto, originally an attempt to endow the figure with complete freedom of motion. For all their immense power, the statues of the Medici Chapel seem their own prisoners. A tragic view of human destiny has superseded the triumphant faith of the Sistine Chapel, and it is no wonder that the project, intended eventually for paintings as well, was never finished. Michelangelo continued work until Clement's death in 1534 and then, in fear of the wicked Duke Alessandro, departed for Rome, never to return, leaving such a passage as the head of *Day* barely blocked out and the statues strewn about the chapel.

THE LAURENTIAN LIBRARY At the same time as his work on the Medici Chapel, however, and beginning in 1524, Michelangelo was designing for Clement VII a library (to be placed literally on top of the Monastery of San Lorenzo) to contain the rich Medici collection of books and manuscripts. The reading room can be seen through the entrance door; it is divided into a succession of equal bays by continuous rows of pilasters, ceiling beams, and floor ornaments. The entrance hall (fig. 23–4), too high and narrow to be photographed in its entirety, is even more extraordinary, for the columns that should support the entablature are withdrawn into recesses in the wall, segments of which, bearing empty tabernacles, protrude between them. The effect is menacing, like the collapsing room in Poe's "The Pit and the Pendulum." These columns that support nothing are themselves apparently supported by floating consoles. The narrow pilasters flanking the tabernacles are divided into three unequal segments, each differently fluted, and taper downward like Minoan columns (which Michelangelo never could have seen). Architecture as anticlassical as this would have shocked Alberti, Brunelleschi, and Bramante, but Vasari delighted in it since it seemed to show that Michelangelo was superior to classical rules.

The strangest of all the spaces of the Laurentian Library would have been the never-built rare-book room at the far end of the reading room. The only remaining area was a triangle; undaunted, Michelangelo planned to turn it into a triangular room, perhaps the only one ever designed, with two triangular reading desks fitting one inside the other and encompassing a V-shaped central desk in the manner of a

23-3. MICHELANGELO. *Day,* from the Tomb of Giuliano de' Medici. Designed 1521; carved 1524–34. Marble, length 6'8¾" (2.05 m). Medici Chapel (New Sacristy), S. Lorenzo, Florence

23-4. MICHELANGELO. Entrance Hall, Laurentian Library, S. Lorenzo, Florence. 1524–33; staircase completed 1559

maze. For nearly a quarter of a century the library was left with a temporary wooden staircase; Michelangelo finally sent to Vasari in 1557 the design for a permanent version from Rome, which he said had occurred to him in a dream—hardly a pleasant one, to judge from the result. While the central staircase with its bow-shaped steps seems to pour downward, ascending lateral stairs besiege it from either side. Walking up or down this amazing structure is a profoundly disturbing experience, duplicating in the visitor's own body and patterns of movement the conflicts of the Mannerist era.

LAST JUDGMENT The poverty-stricken Rome after the Sack of 1527 was very different from the splendid capital of the High Renaissance. The building of Saint Peter's was at a standstill. In 1534 Clement VII asked Michelangelo to paint the Resurrection on the end wall of the Sistine Chapel above two frescoes and an altarpiece by Perugino from the cycle commissioned by Sixtus IV in 1481. After Clement's death later that year, the new pope, Paul III (see fig. 24–9), the leader of the Counter-Reformation and initiator of the Council of Trent, ordered instead a huge fresco on an appropriate subject for the period, the *Last Judgment* (fig. 23–5), painted from 1536 to 1541. In order to paint it, Michelangelo had to utilize the whole end wall, tearing down Perugino's frescoes and even mutilating his own masterpiece, the Sistine Ceiling, by destroying the two lunettes that contained the first seven generations of the ancestry of Christ. He conceived the fresco according to the account in Matthew 24:30–31:

> And then shall appear the sign of the Son of man in heaven: and then shall all the tribes of the earth mourn, and they shall see the Son of man coming in the clouds of heaven with power and great glory.
> And he shall send his angels with a great sound of a trumpet, and they shall gather together his elect from the four winds, from one end of heaven to the other.

The earth below has been reduced to just enough ground to show the dead rising from their graves. A great circle of figures rises on the left toward Christ, following the commanding gesture of his left hand, and sinks on the right away from him in obedience to the gesture of damnation of his raised right arm. There are no thrones nor any of the other machinery of a traditional Last Judgment scene, and since, originally, all the male figures were nude, the dominant color is that of human flesh against blue sky and gray clouds. (Situated directly over the altar, the *Last Judgment* has been even more heavily coated with fatty carbons than the Sistine Ceiling. In the restoration, barely under way at the time of writing, initial soundings have shown that the flesh colors are very bright and the blue clear and intense.) To Michelangelo there was nothing improper about so much nudity in such a place, but given the prudery of the Counter-Reformation, he came under severe attack, and one of his pupils was eventually summoned to paint bits of drapery here and there. Even more were added in later centuries.

The massive figures show little of the ideal beauty of those Michelangelo had painted on the ceiling more than twenty years before. The scale changes sharply with the rising levels; the lower figures, emerging from their graves at the left or pushed from the boat crossing the Styx at the right, are hardly more than half the size of the next rank of ascending or descending figures, which are about on a level with the wall frescoes; the group of saints and blessed surrounding Christ, on a level with the windows, are almost twice the size of the figures below them. Finally, the scale diminishes again for the mighty angels in the two lunettes, bearing aloft the Cross and the column.

In contrast to the delicate and slender Christ of the *Pietà* (see fig. 22–11), the Heavenly Judge is a giant, immensely powerful, his raised right arm dominating the entire scene. The mood of awe and doom and the artist's own sense of guilt become clear in the figure of Bartholomew (fig. 23–6), who was martyred by being flayed

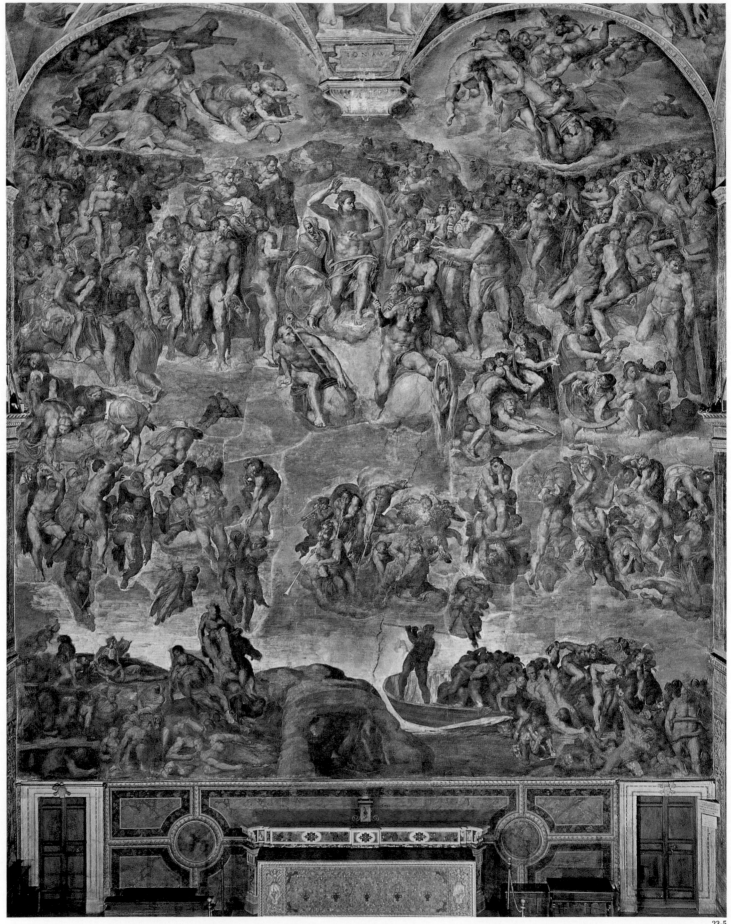

23-5

23-5. MICHELANGELO. *Last Judgment,* fresco (before restoration), Sistine Chapel, Vatican, Rome. 1536–41

23-6. MICHELANGELO. *Saint Bartholomew* (detail of *Last Judgment*)

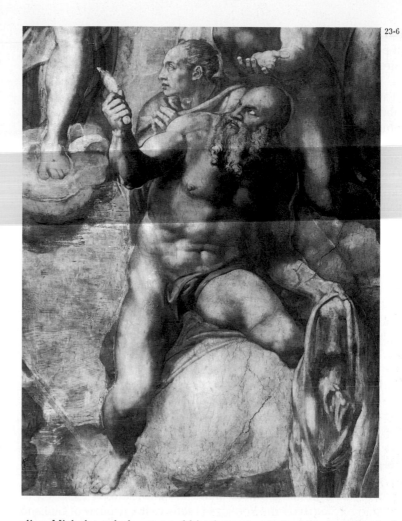

23-6

alive. Michelangelo has turned him into a portrait of the poet Pietro Aretino, who, despite his own authorship of scandalous sonnets, was the artist's bitterest critic of the nudes in the *Last Judgment*. Even more unexpected, the face of the empty skin dangling from the Apostle's left hand is a self-portrait of the aging Michelangelo in a moment of torment. As a final reminder of the Last Judgment, Hell-mouth—a dark cavern in the rock—opens directly above the altar where the celebrant at Mass might be the pope himself. Oddly enough, the demons within wait in vain for sinners. The *Last Judgment* set the pattern for many imitations, but none were so devastating because only Michelangelo could handle the human body with such authority, communicating to the tortured poses the inner tragedy of the spirit.

SAINT PETER'S In 1546 the artist, then seventy-one years old and in poor health, accepted without salary the greatest of his architectural commissions, the continuation of the building of Saint Peter's, which had been left untouched for so long that trees were growing out of the four great arches built by Bramante. Other architects had proposed extensive alterations in the plan, but Michelangelo brought it back to the general dimensions laid down by Bramante, at the same time simplifying it greatly. A comparison of his scheme (fig. 23–7) with Bramante's plan (see fig. 22–22) shows that Michelangelo eliminated the corner towers and porticoes, doubled the thickness of the four central piers, reduced the four Greek crosses to squares, and preceded the whole by a portico of freestanding columns. From the exterior Michelangelo's transformation was well-nigh total (fig. 23–8). His dome is a fusion of Brunelleschi's dome for the Cathedral of Florence and Bramante's design, retaining the verticality and the ribs of the one and the peristyle of the other. The result is a peristyle broken into paired Corinthian columns

between the windows. The motif of paired supports starts from the ground, with a giant order of paired Corinthian pilasters, an attic story of paired pilaster strips, a drum with paired columns, a dome with paired ribs, and finally the paired columns of the lantern. The colossal cage of double verticals encloses firmly the stories of windows and niches, which no longer struggle against the supports as in the Laurentian Library (see fig. 23–4). Of special significance for the architecture of the following century is that Michelangelo accompanied each pair of pilasters with a narrow pilaster strip on both sides, omitting the capital but including a section of entablature and attic, thus obliterating the clear distinction between pilaster and wall that had been maintained throughout Renaissance architecture, and creating a wholly new impression of organic motion inside the building mass akin to the muscular activity of his figural groups. Now architecture, as well as painting and sculpture, would never be the same.

The appearance of Michelangelo's Saint Peter's is that of a colossal work of sculpture, whose masses are determined by the paired verticals rather than by a radial plan. This impression would have been even more powerful had the dome been completed according to Michelangelo's designs with a hemispheric inner shell and an outer shell only slightly pointed (fig. 23–9). He died when only the drum was completed, and his pupil, Giacomo della Porta (see below), heightened the profile of the dome considerably. Michelangelo had also intended to set colossal statues on the projecting entablatures of the paired columns of the peristyle in order to bridge the gap between their cornices and the dome. In the early seventeenth century the nave was prolonged (see pages 775–76), so that from the front the effect of the dome is lost; only from the Vatican Gardens can this noble building be seen as the artist intended.

LAST WORKS The difference between Michelangelo's organic, dynamic architecture and the geometric, static architecture of his predecessors and, indeed, of his contemporaries is made abundantly clear in the courtyard of the Palazzo Farnese, the largest secular palace in Rome, whose third story Michelangelo took over in 1546 from ANTONIO DA SANGALLO THE YOUNGER (1485–1546), nephew of Giuliano da Sangallo (fig. 23–10). Sangallo had commenced a remarkably faithful recapitulation of the superimposed Doric, Ionic, and Corinthian orders of the Colosseum. The open travertine arches of the ground level were to be filled on the upper stories by fine brickwork walls pierced by pedimented windows standing firmly like little temples on the same stylobate as the engaged columns or behind balustrades. Michelangelo's third story substitutes pilaster bundles—Corinthian pilasters echoed on each side by a complete half-pilaster, including capitals—and the windows with their richly articulated round pediments are balanced above, but not quite touching, a stringcourse as if on wires.

Michelangelo's ideas are responsible for the present appearance of one of the first great civic centers of the Renaissance, the Campidoglio (Capitol) in Rome (fig. 23–11). His first commission was merely to build a handsome double staircase at the end of the piazza in front of the medieval Palazzo dei Senatori in 1538 and to move—much against his will—the Roman statue of Marcus Aurelius to a central position in the piazza. The refacing of the Palazzo dei Senatori and the construction of two confronting palaces were begun only in 1563, the year before Michelangelo's death, and completed in the seventeenth century, and they do not reflect his intentions in all details. Nonetheless, the general ideas are his, especially the interlocking and radiating ovals of the pavement centering around the statue (not executed until 1937), and the details of the facing palaces are all from his designs. The spatial effect is difficult to photograph and is therefore shown in a sixteenth-century engraving made before the buildings were complete, in fact, before the refacing of the tower. The Palazzo dei Conservatori (fig. 23–12), the only building of the three commenced to which the aged master could give any attention, is a two-story structure compressed into a block by a single giant order of Corinthian

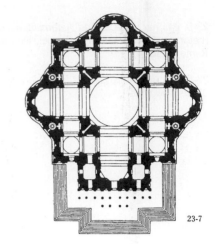

23-7

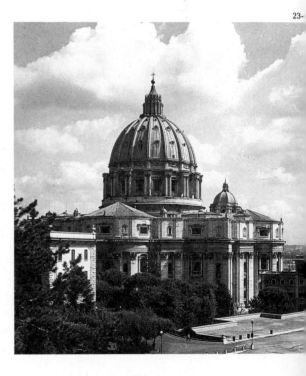

23-

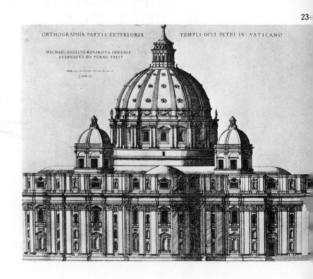

23-

23-7. MICHELANGELO. Plan of St. Peter's, Vatican, Rome. 1546–64

23-8. MICHELANGELO. St. Peter's, Vatican, Rome (view from the southwest). Dome completed by GIACOMO DELLA PORTA

23-9. MICHELANGELO. Elevation of St. Peter's, Vatican, Rome (engraving by Étienne Dupérac). The Metropolitan Museum of Art, New York. Harris Brisbane Dick Fund, 1941

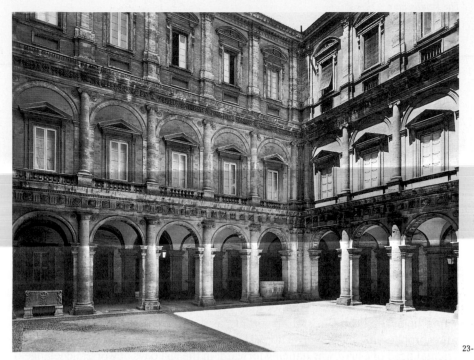

23-10

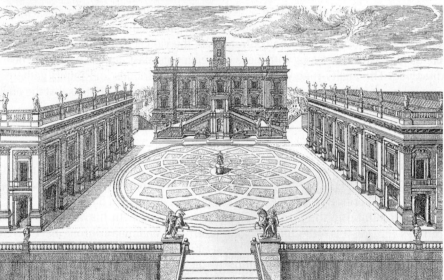

23-11

23-10. ANTONIO DA SANGALLO THE YOUNGER and MICHELANGELO. Courtyard, Palazzo Farnese, Rome. 1517–50

23-11. MICHELANGELO. Campidoglio, Rome. 1538–64 (engraving by Étienne Dupérac, 1569)

23-12. MICHELANGELO. Palazzo dei Conservatori, Rome. Begun 1563

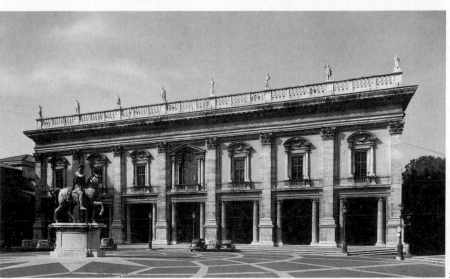

23-12

pilasters. These are tied into the wall by accompanying pilaster strips as at Saint Peter's, embracing the smaller elements of the building masses in contrast to Sansovino's superimposed independent stories in the contemporary Library of San Marco in Venice (see fig. 24–17). The majestically framed windows stand with their balconies on monolithic entablatures that Michelangelo substituted for arches, and these are supported on the sides by stumpy Ionic columns that huddle into the Corinthian order as if seeking shelter. If Michelangelo's work can ever be described as Mannerist—and art historians are by no means agreed on this point—the powerful, positive solutions of his late architectural style certainly cannot.

During his last years, occupied with vast architectural projects he was too unwell to supervise in person, Michelangelo in his thoughts, his poems, and his sculpture was concerned almost exclusively with death and salvation. Many drawings of the Crucifixion and two *Pietàs* date from this final period; on one unfinished group he worked until six days before his death (fig. 23–13). From an earlier stage of about 1554 remain the beautifully carved slender legs, close to those of the early *Pietà* (see fig. 22–11), and a severed arm retained temporarily as a model for the new arm being carved below it. Rather than across her lap, as in the early *Pietà,* the Virgin holds the dead Christ up before us, as if, instead of grieving over him, she were prophesying his Resurrection. The line of the severed arm shows that the original head of Christ was hanging forward; in the last days of work Michelangelo cut it away and began to carve a new head from what had been the Virgin's shoulder. Both figures are as slender as the early sculptures at Chartres and weightless, almost ghostly. The contrapposto, the violence, the contrasting movements have vanished; along with these vital elements mass and life itself have been dissolved. The eighty-nine-year-old artist asked the friends and pupils gathered around his deathbed to remember in his death the death of Christ, as if at the end, freed from guilt and pain, his mortality was fused in the love of the Savior.

Painting

ANDREA DEL SARTO We now return to the moment of Michelangelo's arrival in Florence in 1516. The other Florentine artists could scarcely help but be influenced by so overpowering a personality, but one of them, Andrea del Sarto (1486–1530), remained faithful to the ideals of the High Renaissance. In his *Madonna of the Harpies* (fig. 23–14)—the harpies that adorn the Madonna's throne have given their name to the painting—the Virgin and Child, steadied on their pedestal by two child angels, communicate something of the harmony and grace of Raphael's *Sistine Madonna* (see fig. 22–31), and the figure of John reflects in reverse the pose of the writing philosopher just to the left of the portrait of Michelangelo in the *School of Athens* (see fig. 22–29). However, some of the marmoreal quality of Michelangelo's figures is also suggested, and the folds break into cubic masses recalling those of Michelangelo's characteristic drapery forms in sculpture and in painting. The ideal facial types of Andrea del Sarto, calm, grand, and often very beautiful, show in their typical mood of reverie little of the torment that contorts the faces of his more overtly Mannerist contemporaries.

PONTORMO A gifted pupil of Andrea del Sarto and friend of Michelangelo during this Florentine phase, Jacopo Carucci da Pontormo (1494–1557), like most of the early Mannerists a neurotic in this neurotic period, responded very differently to the psychic pressures of the moment. Quite literally withdrawn, Pontormo in his later years worked in a studio accessible only by means of a ladder, which he drew up on entering, closing the trapdoor behind him and not responding to visitors, whom he could see through the window, sometimes even when they were his pupils and closest friends. One of his strangest and most outspokenly Mannerist works is a painting done in 1518, unbelievably enough while Raphael was still alive, as one of a series painted in collaboration with Andrea del Sarto and

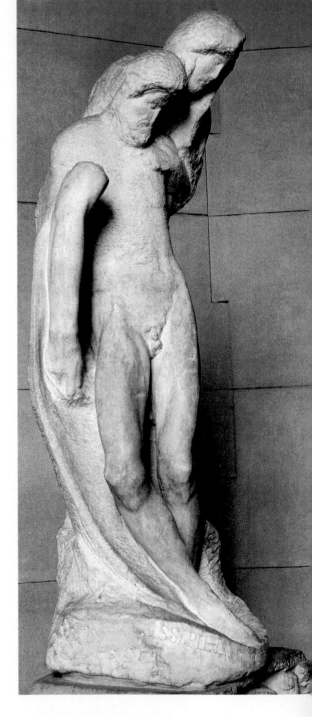

23-13. MICHELANGELO. *Rondanini Pietà.* c. 1554–64. Marble, height 63⅜″ (1.61 m). Castello Sforzesco, Milan

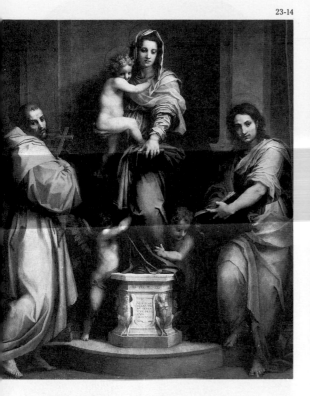

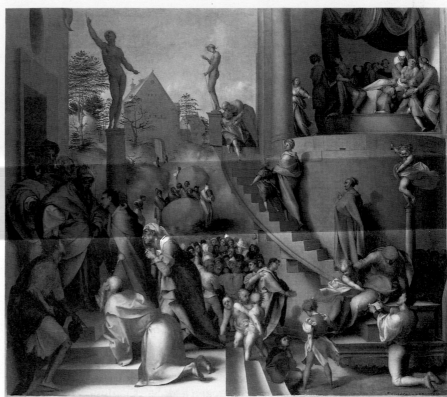

23-14. ANDREA DEL SARTO. *Madonna of the Harpies.* 1517. Oil on panel, 81½ × 70″ (2.07 × 1.78 m). Galleria degli Uffizi, Florence

23-15. JACOPO PONTORMO. *Joseph in Egypt.* 1518. Oil on canvas, 38 × 43⅛″ (96.5 × 109.5 cm). National Gallery, London. Reproduced by courtesy of the Trustees

other eminent Florentine masters for the bedroom of a Florentine palace. *Joseph in Egypt* (fig. 23–15) shows three successive scenes within the same frame. At the upper right is Pharaoh's dream, in the center the discovery of the cup in Benjamin's sack, and at the left Joseph's brethren are reconciled to him. But instead of the unified space of a High Renaissance picture, the work is split into compartments by such devices as a neatly projected winding staircase to nowhere, with no balustrade and few supports, Pharaoh's bedroom in a niche open to the world, and statues gesturing like living people on columns and pedestals. The chaotic groupings of excited figures have been made even stranger by the flickering lights and darks playing over bodies and drapery masses. Not only the compositional devices but also the very mood of the picture negate everything for which the High Renaissance stands.

Pontormo's *Entombment* (fig. 23–16), of about 1525–28, hardly seems a Renaissance picture. Once it has been established at the bottom of the picture, the ground never reappears, and there is no setting whatsoever. Mathematically constructed space, the triumph of Early Renaissance thought, has vanished without a trace. The figures tiptoe as in Botticelli; the towering compositional structure rises parallel to the picture plane in a web of shapes recalling Cimabue's *Madonna Enthroned* (see fig. 19–6) of nearly two hundred and fifty years before rather than moving harmoniously into depth in the manner of a Renaissance composition. Christ is being carried toward the tomb, yet neither tomb nor crosses can be seen. It is not clear whether the Virgin is seated or standing, or on what. Figures float upward around her with the lightness of the cloud that hangs above, curving over at the top in conformity with the forces of the frame, so designed as to amplify the upward movement of the figures. These are enormously attenuated; the bearer at the left is more than eight heads high. While the poses echo those of Michelangelo, like earthquake shocks felt on a ship at sea, the figures are devoid of both strength and substance and are deprived of their natural coloring by the adhering garments some of them wear, which look as if strobe lights were playing on them. The expressions of paralyzed wonder, rather than sorrow, contribute to the dreamlike character of the painting, poignant and lyrical, floating between earth and sky.

707

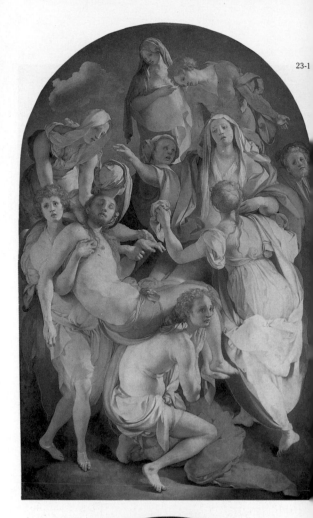

23-1

Rather than any specific movement in New Testament narrative, Pontormo has presented here the mystery of the Eucharist—the perpetuation of the sacrifice of Christ's body—in the Mass taking place on the altar directly below. But this essential Christian theme is no longer depicted, as in Raphael's *Disputa,* with the scriptural passages and Christian theologians marshaled in ordered ranks to demonstrate the doctrine. Instead, Pontormo has made a direct appeal to the heart of the observer. In such pictures as these Pontormo appears as the most gifted of all Florentine painters of the period, except for Michelangelo himself.

ROSSO Even more unexpected than Pontormo is his contemporary Rosso Fiorentino (1495–1540), who painted—only a year after Raphael's death—the profoundly disturbing *Descent from the Cross* (fig. 23–17). Instead of centralizing the composition as in a High Renaissance picture, Rosso has dispersed the elements toward the frame, so that they make a latticework of shapes, and instead of the harmonious, spirally moving figures of Raphael, he set stiff, angular beings in the spasmodic motion of automatons. The background landscape has shrunk almost to the bottom of the picture, so that the whole structure of figures, Cross, and ladders is erected against a sky like a slab of blue-gray stone. Expressions, when we are allowed to see them, range from a look of anguish on the face of one of the Holy Women, to what can only be described as a leer on that of Joseph of Arimathea at the upper left, to a smile as of pleasure derived from pain on the face of the dead Christ. The nude figures look deliberately wooden, the draped ones like mere bundles of cloth. John has collapsed into broken folds like shards of glass; strangest of all, the prostrate Magdalene, embracing the Virgin's knees, is turned into an almost cubist construction by a sharp crease that runs down her side from shoulder to waist, from waist to knee, and then into the shadows. (This device Rosso appears to have borrowed, and intensified, from one of Michelangelo's lunettes in the Sistine Chapel.) Even the gold sash at her waist breaks as if her body were constructed like a box.

The strangeness of both style and content in this painting—and others even more startling, before he toned them down—together with the eccentricities of Rosso's frequently outrageous behavior give us to wonder what, if anything, he really did believe. Incapable of Pontormo's flight from unbearable reality to a spiritual refuge, Rosso seems to have responded to the desperation of this moment in history with a nihilism more in keeping with the twentieth century than the sixteenth. Rosso suffered severely in the Sack of Rome, wandered from city to city for three years thereafter, and then went to France, where he was instrumental in founding the School of Fontainebleau (see page 749).

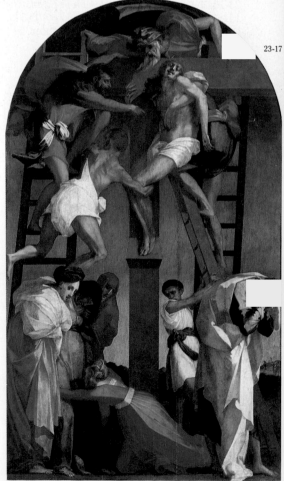

23-17

CORREGGIO In Parma, a handsome city in the Po Valley, a vigorous school of painting developed unexpectedly in the sixteenth century, led at first by Antonio Allegri (1494–1534), called Correggio after the small town of his birth, and later by his younger contemporary Parmigianino. Correggio, first influenced by Mantegna and then by Leonardo, may never have visited Rome, but he was profoundly affected by the Roman High Renaissance, possibly through works by Raphael he had seen and by engraved copies. After an uncertain start, he rapidly became a master of great importance, in fact, one of the most independent and original painters in northern Italy. Like Titian (see Chapter Twenty-Four), Correggio tried to break up High Renaissance symmetrical arrangements, but on the basis of a buoyant naturalism rather than the deliberate chaos of Florentine Mannerism. Correggio's *Holy Night* (fig. 23–18), for example, painted in 1522, is an Adoration of the Shepherds, the same theme as that depicted by van der Goes in fig. 21–25, but—for the first time—Correggio has treated the subject on a large scale with life-size figures, entirely illuminated by the light from the Child, as in Gentile da Fabriano (see fig. 20–37) and Geertgen tot Sint Jans (see fig. 21–28). The glow illuminates the soft features of the happy and adoring mother, the shepherds, and

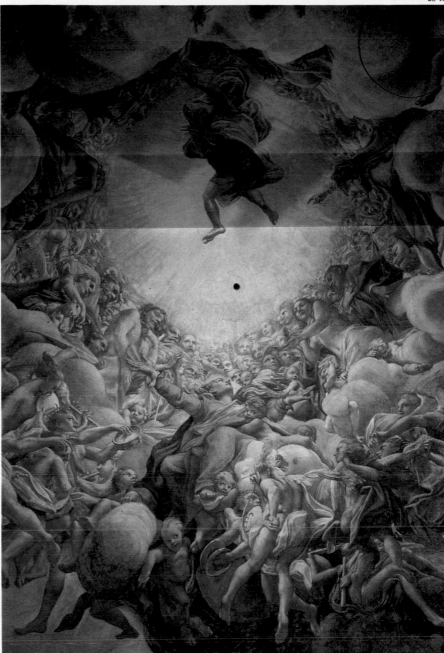

23-16. JACOPO PONTORMO. *Entombment.*
c. 1525–28. Panel painting, 10′3″ × 6′4″
(3.12 × 1.93 m). Capponi Chapel, Sta. Felicita,
Florence

23-17. ROSSO FIORENTINO. *Descent from the Cross.* 1521. Panel painting, 11′ × 6′6″
(3.35 × 1.98 m). Pinacoteca Communale,
Volterra

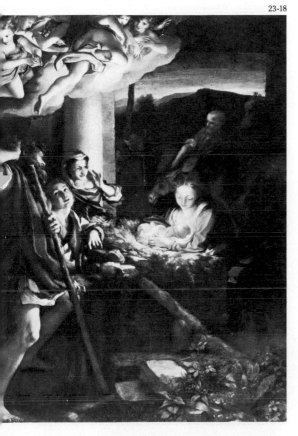
23-18

23-18. CORREGGIO. *Holy Night (Adoration of the Shepherds).* 1522. Panel painting, 8′5″ × 6′2″
(2.57 × 1.88 m). Gemäldegalerie, Dresden

23-19. CORREGGIO. *Assumption of the Virgin,*
detail of the dome fresco, Cathedral of Parma.
1526–30

the astonished midwife, but it barely touches Joseph, the ox, and the ass against the dark sky. Far off, the first light of dawn appears above the hills. Most unconventional is the rush of adoring angels, seen from above and from below in amazing foreshortening and exhibiting the soft, voluptuous flesh that is Correggio's specialty. As in most of his pictures, a bond of warmth and tenderness is the motive force that draws all the figures together.

Correggio was given an opportunity to demonstrate his unconventional art on a colossal scale in the now-damaged frescoes of the dome of Parma Cathedral; their effect is extremely difficult to communicate in reproductions. A section of the fresco of the *Assumption of the Virgin,* of 1526–30 (fig. 23–19), suggests the extraordinary brilliance of the young painter, who followed Mantegna's lead in dissolving the interior of the vault, so that one seems to be looking directly upward into the clouds at the Virgin borne by angels toward Heaven through ranks upon ranks of saints. The effect is of an enormous bouquet of beautiful legs, all seen from below in daring foreshortening. It is as if Correggio had turned Titian's *Assumption of the Virgin* (see fig. 24–5) into a cylindrical rather than a flat composition and placed the

observer below it, looking up. This fresco and Correggio's other painted domes are the direct origin of the illusionistic ceilings of the Baroque (see figs. 26–1, 26–2, 26–4, 26–6, 26–28, 26–29).

Almost contemporary with the *Assumption* is Correggio's series of the *Loves of Jupiter,* painted for Federigo II Gonzaga, last marquis and first duke of Mantua, but never delivered. To elude the jealous Juno, Jupiter visited the maiden Io in the form of a cloud; Correggio has shown us the warm, yielding Io, her face lifted in rapture in the midst of a cloudy embrace (fig. 23–20). The delicate quality of Correggio's flesh has never been surpassed, and, despite the strength of Venetian influence in north Italy, it retains a firm sculptural consistency. The union of human and divine, frankly sensual in this uninhibited representation of physical climax, is a secular parallel to the sacred rapture of the Assumption. As if to emphasize Correggio's unembarrassed parallel between pagan and Christian, the stag about to drink from a spring in the lower right-hand corner is an age-old symbol drawn from Psalm 42 (41 in the Catholic Bible): "As the hart panteth after the water springs so longeth my soul after thee, O God."

GIULIO ROMANO Some of the most amazing and delightful aberrations of Mannerism—veritable mass attacks on the classical ideals of Bramante and Raphael—are the work of Raphael's favorite pupil, Giulio Pippi, known as Giulio Romano from his Roman birth (c. 1499–1546). We do not know the exact date of his entry into Raphael's studio, nor even how old he was, although Vasari says he was a *putto* ("boy"). He seems to have learned rapidly and was soon entrusted with much of the preliminary work and eventually some of the actual painting, such as the rather bombastic group of figures around the demoniac boy in Raphael's *Transfiguration of Christ* (see fig. 22–34). If the dates given in the entry recording his death in Mantua are correct, he would then have been eighteen, an age at which both Andrea del Castagno and Andrea Mantegna were accepting independent commissions. After Raphael's death Giulio headed the studio and continued to carry out with the other assistants major commissions in the Vatican and, independently, at palaces and villas in Rome.

In 1523 Giulio accepted the position of princely artist at the court of Federigo II Gonzaga. His major commission was the Palazzo del Te in Mantua, which began as a banqueting room connected with the stables for Federigo's favorite strain of battle stallions. Although the date of commencement of the palace is not known, the pictorial decoration of its many rooms, directed by Giulio with a small army of assistants, is clocked from 1527 to 1534, straddling the period of the Sack of Rome and the division of power in central and northern Italy between Empire and papacy in 1530, when Federigo appears to have allied himself with Charles V; the emperor made two prolonged visits to the Palazzo del Te while work was under way, in 1530 and 1532.

The blocklike building, a story and a half high, has only two exterior façades; the place of the third is taken by the stables, and the fourth, of an entirely different character, faces the enclosed garden. The two exterior façades mark one of the first appearances of the giant order that Michelangelo was later to use in the Palazzo dei Conservatori; above the cornice we should add in our mind's eye a low attic story— no more than a parapet—long since removed, which originally concealed the tiled roof and the chimneys (fig. 23–21). The basic principle, a screen of pilasters against a rusticated wall, is Albertian, repeated in many a building of the fifteenth century and early sixteenth century. The choice of the Roman Doric reflects Bramante's Tempietto (see fig. 22–20), with even the same slender stylobate. There the resemblance to the classical tradition stops. The rustication becomes violent below, menacing the perfect Doric order. Huge, rough archivolts radiate from the portals, rupturing the stringcourse and invading the orderly Albertian panels in the mezzanine. This drama becomes all the more fantastic when we realize that the building is built of brick, not stone, and the surface is merely stucco.

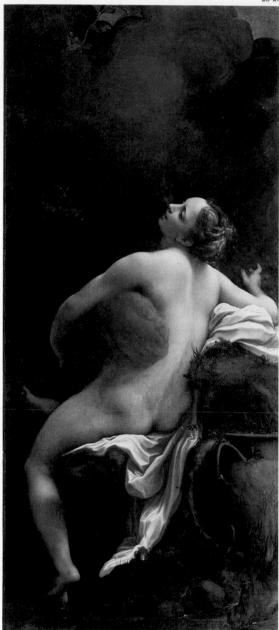

23-20

23-20. CORREGGIO. *Jupiter and Io.* Early 1530s. Oil on canvas, 64½ × 28″ (163.8 × 71 cm). Kunsthistorisches Museum, Vienna

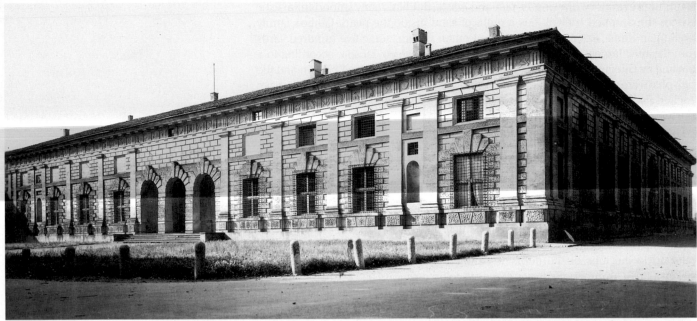

23-21. GIULIO ROMANO. Façade, Palazzo del Te, Mantua. 1527–34

23-22. GIULIO ROMANO. Courtyard, Palazzo del Te, Mantua

The conflict between order and disorder intensifies in the courtyard, finished several years later (fig. 23–22). The barrier between main story and mezzanine has dissolved, and the two different kinds of rustication merge like infantry battalions in hand-to-hand conflict; one never knows which soldier will turn up where. In the battle the classical elements lose. The rusticated keystones push upward and split in two the pediments over the windows, and, most amazing of all, the noble Doric columns that substitute for the pilasters of the exterior facades can no longer support the entablature; in the center of each intercolumniation on two facing sides of the courtyard a section of architrave along with the triglyph above it has simply dropped, leaving a hole above. There could scarcely be a more dramatic example of Mannerist conflict. Giulio even studied in detail how this one would work in a

beautiful preparatory drawing in pen and wash. But like many important artistic devices the dropped triglyph has a grain of sand inside the pearl. Giulio's family dwelling in Rome was at the edge of the Roman Forum, some five hundred yards from the now largely destroyed Basilica Aemilia, in whose façade, according to a drawing by Giuliano da Sangallo, the Doric architraves had indeed broken and the triglyphs were slipping. At the Palazzo del Te, the sense of conflict must have reached its height in the impenetrable maze of hedges that at one time filled the courtyard.

The chambers in the interior of the palace were frescoed with complex allegorical and mythological subjects, largely by assistants working from Giulio's designs, in the most elegant classical style. Only here and there did the harried impresario have the time to paint something himself. The northeast corner, with windows facing the garden, is formed by the Sala di Psiche, intended for banquets of whose lascivious nature the learned Isabella d'Este, Federigo's mother, bitterly complained. The vaulted ceiling, supported on huge, gilded consoles, spells out in detail the legend of Cupid and Psyche in octagons, triangular coves, and lunettes. The walls up to the tops of the doors were lined with leather, gilded designs on a background of turquoise, Federigo's favorite color; turquoise and gold predominate in the lyrical frescoes painted by Giulio himself, representing on two adjacent walls the *Wedding Feast of Cupid and Psyche.* One half, a veritable chain of glowing nudes whose rosy color complements the gold of the ceiling ornament, is shown in fig. 23–23. Here the newlyweds recline on a gold couch while attendants offer a bowl and a pitcher to wash their hands. Under a trellis of grapevines in the center a happily

23-23. GIULIO ROMANO. *Wedding Feast of Cupid and Psyche,* detail of a fresco, Palazzo del Te, Mantua. 1527–30

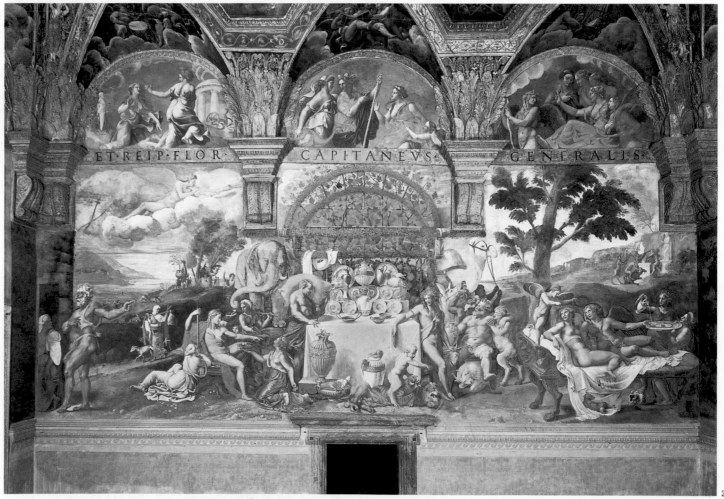

23-23

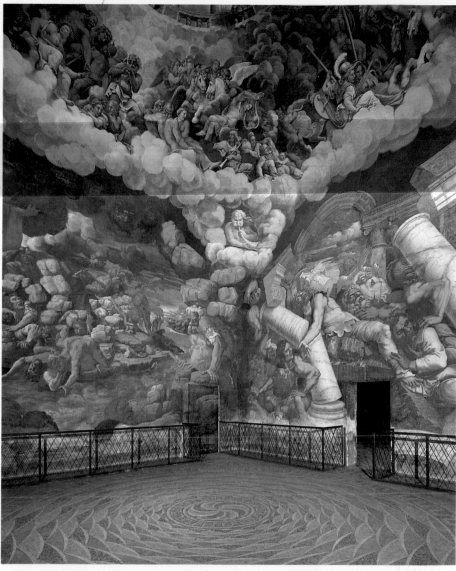

23-24. GIULIO ROMANO. *Fall of the Giants,* fresco, Palazzo del Te, Mantua. 1530–32

inebriated Bacchus leans against a sideboard stacked with splendid gold and silver dishes, jars, and cups, recalling to mind that Giulio designed such a set—now lost—for Federigo. Next to Bacchus the fat and drunken Silenus, riding a goat, is steadied by baby satyrs while on the left an ideal Apollo, gracefully seated, is adored by nymphs. The tigers rolling on the ground below, with whom a baby satyr daringly plays, and the elephant and camel, who offer uncertain support to the heavy consoles above them, are surely memories of the famous zoo assembled in the Vatican Gardens by Leo X, as is the giraffe in the background at the left. In the hills at the right satyrs sacrifice a goat to a statue of Bacchus.

This gorgeous display of pagan sensual indulgence contrasts with the corresponding chamber on the southwest corner, surely the most astonishing room in Western art, the Sala dei Giganti (Hall of the Giants; fig. 23–24). All four walls and the pendentive ceiling, even the door and window frames and the mantel, are one continuous fresco. In the ceiling all the deities of Olympus gather in terror on a ring of clouds (perhaps influenced by Correggio) as Jupiter destroys with his thunderbolts the palaces of the rebellious giants on the four walls, an obvious allegory of the emperor reestablishing order in Italy. Since the insides of the doors are painted with collapsing rocks, when they are closed the visitor feels that the entire chamber is crashing down on him. While on three walls the giants live in caverns, on the fourth wall beautiful monolithic, veined-marble Roman columns and a grand

entablature shatter about them, making one wonder whether Giulio as a child had not seen the destruction of the columns of Old Saint Peter's, pulled to the floor by Bramante against the strenuous protests of Michelangelo. Even the acoustics collaborate. The room echoes horribly and is also a whispering gallery: a murmur into one wall emerges magnified from the opposite one as if from the mouths of the giants under their rubble. One of several contemporary allegories of cosmic punishment—earlier in that respect than Michelangelo's *Last Judgment*—the Sala dei Giganti represents the most violent expression of the Mannerist crisis.

PARMIGIANINO If Correggio represents a late phase of north Italian High Renaissance, almost—like the mature Roman work of Raphael—on the edge of the Baroque, his slightly younger rival, Francesco Mazzola (1503–40), called Parmigianino, was much closer to the Mannerist currents then developing in Florence and Siena; the contrast between the two leaders of the Parmesan School can be compared with that between Andrea del Sarto and Pontormo. Unlike Correggio, Parmigianino went to Rome to absorb the principles of High Renaissance style and in fact just escaped the Sack of 1527. In 1524 the painter, then twenty-one years old, executed one of the most original of all self-portraits (fig. 23–25), a paradigm of the Mannerist view of the world; he used the familiar convex mirror—in this case borrowed from a barber—to achieve his distorting effect, and even painted his picture on a section of a wooden sphere to complete the illusion. Jan van Eyck (and many Netherlandish imitators) had contrasted the distortions of a mirror with the correct proportions in the real world surrounding it, and although Leonardo had recommended the use of a mirror, he warned against the false reflections given by a convex one. Parmigianino has identified the distortion with the entire pictorial space, curving the sloping skylights of his studio and greatly enlarging what appears to be his right hand but is in reality his left so that it seems larger than his face—which in the middle of this warped vision remains cool, serene, and detached. The work is painted with exquisite freshness of color and delicacy of drawing and touch. Contemplating this beardless youth, it is hard to convince oneself that only a few years later the gifted young painter would become a morose, long-bearded misanthrope. Parmigianino fled Parma in fear of a lawsuit from disappointed clients, only to die—like Raphael, at thirty-seven—in lonely poverty.

In the *Madonna with the Long Neck* (fig. 23–26), thus nicknamed for obvious reasons, painted between 1534 and 1540, he glories in distortion. The Virgin is impossibly but beautifully attenuated, even her fingers represented as long and as slender as those of the Madonnas by Cimabue and Duccio (see figs. 19–6, 19–12). She looks downward with a chill prettiness—the very opposite of Correggio's warmth—at the Child, whose pose reminds one of a Pietà (compare fig. 22–11). The surfaces resemble cold porcelain, even those of the exquisite leg of the figure at the left carrying an amphora (possibly John the Baptist). Additionally, the perspective is distorted; the gaunt figure unrolling a scroll in the middle distance, perhaps the prophet Isaiah, seems a hundred yards away. In spite of the perfection to which all the surfaces of flesh, metal, stone, and drapery have been brought, the picture is unfinished. Parmigianino's drawing for the composition shows that he intended a complete Corinthian temple portico in the background, but he has painted only one of the columns, lovingly polished up to the necking band but with blank underpainting left where capitals, entablature, and pediment should be. The enigma of the unfinished painting has never been solved; possibly Parmigianino, always perverse, did not want it to be.

BRONZINO Parmigianino has clearly moved into a second phase of Mannerism, usually destined for princely courts, in which elaborate conceits, involved and artificial poses, exquisite drawing and color replace the sincere outcry of the Mannerist crisis. The most brilliant of the later Mannerists was the Florentine Agnolo Tori, called Bronzino (1503–72), portrayed by his teacher Pontormo as the

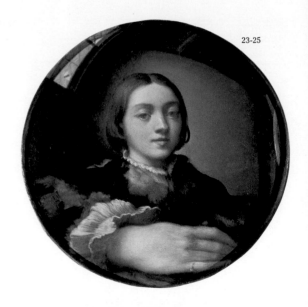

23-25

23-25. PARMIGIANINO. *Self-Portrait in a Convex Mirror.* 1524. Oil on panel, diameter 9½" (24 cm). Kunsthistorisches Museum, Vienna

23-26. PARMIGIANINO. *Madonna with the Long Neck.* 1534–40. Oil on panel, 85 × 52" (2.16 × 1.32 m). Galleria degli Uffizi, Florence

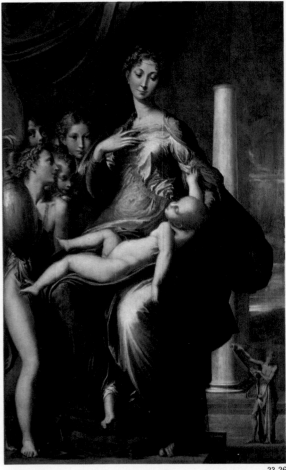

23-26

23-27

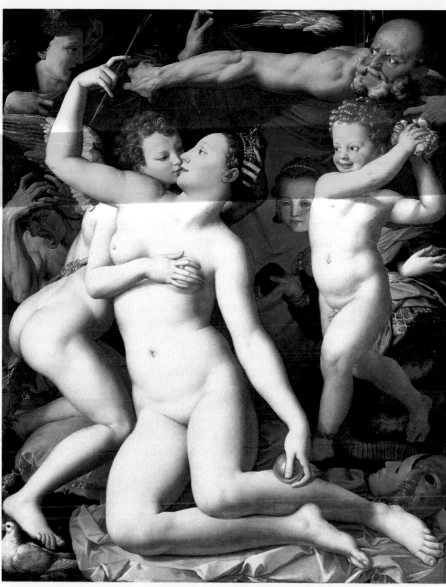

23-27. BRONZINO. *Exposure of Luxury.* c. 1546. Panel painting, 61 × 56¾" (1.55 × 1.44 m). National Gallery, London. Reproduced by courtesy of the Trustees

boy huddled on the steps in *Joseph in Egypt* (see fig. 23–15). Official painter at the court of Cosimo I de' Medici, duke of Florence and later grand duke of Tuscany, Bronzino developed his master's haunting style into formulas of icy refinement. His allegory painted about 1546 and formerly called *Venus, Cupid, Folly, and Time,* but more likely depicting the *Exposure of Luxury* (fig. 23–27), displays the ambivalence of the age in life and art. Bald, bearded Time at the upper right, assisted by Truth at the upper left, withdraws a curtain to display a scene of more than filial affection between Venus and the adolescent Cupid, pelted with roses by a laughing boy. At the lower left Venus' doves bill and coo, the old hag Envy tears her hair at center left, and at the right Fraud, a charming girl whose body ends in the legs of a lion and a scaly tail, extends a honeycomb with her left hand attached to her right arm; the message is characterized by masks, symbols of false dreams, as in Michelangelo's *Night* (see fig. 23–1). With magical brilliance Bronzino projects every surface, every fold, yet the substances of his nudes resemble marble more than flesh, and the hair seems composed of metal shavings. The Mannerist principle of interlaced figures seeking the frame rather than the center is brought to its highest pitch, as if to savor every lascivious complexity. Paradoxically, the very sixteenth century that repainted Michelangelo's nudes (and at the Council of Trent forbade all nudes in religious art) and condemned Luxuria (sensual indulgence) as the queen of vices

could create and enjoy works such as this one, ordered by Duke Cosimo and presented by him to King Francis I of France, both of them delighted by what their religion told them to condemn.

Women Artists of Northern Italy

In all probability the guild system in force in Florence and Siena was much more relaxed in northern Italy, outside of the Venetian Republic; this may well be the reason why so many women artists flourished in this region during the sixteenth century. Three in particular deserve special notice.

ROSSI The distinction of being the first woman sculptor of whom we have any certain surviving work, as well as the first female artist in Italy of real quality, is enjoyed by a Bolognese, Properzia de' Rossi (1500?–1530), who died at the height of her youth and creativity on the very day of the coronation of Charles V as Holy Roman Emperor in Bologna, by his former enemy Pope Clement VII. Rossi's early work, miniature carvings of figures and scenes (including the entire Passion of Christ), bears slight relation to the handful of highly original marble sculptures on which her fame in the Renaissance and now depends. How and when Rossi mastered the art of carving in marble is unknown; perhaps she received instruction from the Florentine sculptor Andrea Sansovino, who in 1518–20 was carving reliefs for the Holy House in Loreto, on the east coast of Italy, about two days' journey from Bologna. In 1525 she was commissioned to do figures and reliefs for the façade of San Petronio in Bologna, as had Jacopo della Quercia a century earlier (see page 599). The following year two reliefs were paid for, one of which is probably the extraordinary *Joseph and Potiphar's Wife* (fig. 23–28). In a tempest of drapery folds compressed within the limits of a rectangle, which the disruptive sculptural forces seem to break apart, the scorned woman reaches with the awkwardness of desperation to grasp the cloak of the man she desires. In a striking borrowing, doubtless intended to be recognized as such, the canopy is taken directly from the one over the chaste bed of the Virgin in Sansovino's *Annunciation* at Loreto. The soft body of Potiphar's wife is visible through her translucent garment, and passion darkens her classic profile. The superb—and anatomically correct—rendering of Joseph's limbs suggests that Rossi had freed herself from the restrictions that hampered the work of so many protected women artists by learning about the male figure at the source. She was listed in court documents as the mistress of Anton Galeazzo Malvasia, who eventually abandoned her. It was suggested by Vasari, who was in Bologna for the coronation, that Rossi's treatment of this scene reflects her tragic experience. Again according to Vasari, Clement VII heard of this gifted woman and sent for her with a commission in mind, but she had already died, her promising career cut short in the Ospedale dei Morti, which means at the end she was either destitute or friendless or both.

ANGUISSOLA The first Italian woman painter to receive almost universal admiration, Sofonisba Anguissola (c. 1532/35–1625) was also the first Italian woman painter not the daughter of a painter. Because she was not allowed to receive instruction in anatomy, Anguissola specialized in portraits, and hers show keen penetration into human feelings, especially those of women, and a firm mastery of brushwork in the Venetian manner (see Chapter Twenty-Four for comparisons). Anguissola was the eldest of six daughters born to a wealthy patrician in the north Italian city of Cremona, not far from Parma, where all six received special instruction in the arts. Vasari described and praised her work, and she also received a complimentary letter from Michelangelo. In 1559 she was called to Madrid as lady-in-waiting to the queen of Spain, but this opportunity to move from Cremona into a loftier social sphere seems to have had the sad effect of stifling her creativity. During her ten years at court only a single picture is recorded: Pope Pius IV

23-28

23-28. PROPERZIA DE' ROSSI. *Joseph and Potiphar's Wife.* 1520. Marble bas-relief, 21½ × 23¼″ (54.6 × 59.7 cm). Museo di San Petronio, Bologna

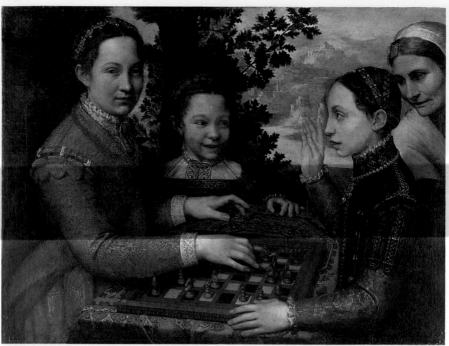

23-29. SOFONISBA ANGUISSOLA. *Portrait of the Artist's Three Sisters with Their Governess.* 1555. Oil on canvas, 27⁹⁄₁₆ × 37″ (70 × 94 cm). Narodowe Museum, Poznan

requested from her a portrait of the queen (now lost), for which he thanked her in glowing terms. As this edition is being prepared, several portraits are undergoing scrutiny and may eventually be firmly attributed to this delightful artist. In 1624, in extreme old age (Anguissola was the only Mannerist to survive well into the Baroque period), she was painted by Anthony van Dyck. Her *Portrait of the Artist's Three Sisters with Their Governess* (fig. 23–29), painted in 1555, shows Sofonisba at the height of her mastery of what Erwin Panofsky used to call the "portrait situation," a kind of Renaissance pictorial talk show that reveals the sitters' personalities. Each player has taken one of the other's chessmen. The oldest sister seems about to move again, confident of her tactics; the next oldest, searching her opponent's face, appears ready to pounce in counterattack; the beguiling youngest, smiling impishly, seems to foresee the next move; while the wise old governess looks on. The exquisite modeling of the faces and the careful delineation of the gold brocade seem close to the High Renaissance while the fantastic mountain landscape (Cremona is flat as flat) suggests a familiarity with Giulio Romano's frescoes in neighboring Mantua.

FONTANA Daughter and pupil of a Bolognese Late Mannerist painter appropriately christened Prospero, in whose home she met all the great artistic, literary, and musical figures of the period, Lavinia Fontana (1555–1614) was extremely active during her entire adult life. She thus enjoys the distinction of being the first woman artist we know to have had a long and continuous career—135 pictures are preserved, covering a period of approximately forty years. She was also the first woman painter to whom large altarpieces were entrusted in addition to the usual formal portraits. Received like a princess in noble houses, admired and patronized by the Bolognese Pope Gregory XIII, she was honored with a medal struck by the government of Bologna; on it she is first portrayed as a stately lady encased in the elaborate garments of the period, then on the reverse at her easel, in a storm of creativity, her unbound hair streaming behind her. Her composition is always imaginative, her perception always sensitive, and her colorism invariably resonant. She chose almost exclusively feminine subjects, drawn from Scripture or from mythology. Fontana's best pictures rank her high in lists of her north Italian contemporaries.

A work of stunning coloristic richness, painted before 1577, when the artist was probably in her early twenties, is *Christ and the Canaanite Woman* (fig. 23–30). The subject, drawn from Matthew 15:21–28, tells how a Canaanite—and therefore

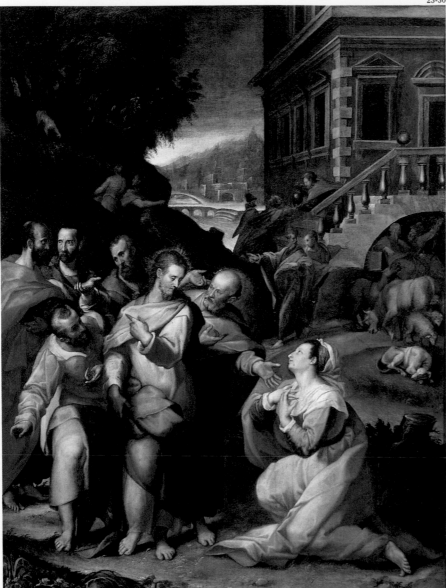

23-31. BENVENUTO CELLINI. *Perseus and Medusa*. 1545–54. Bronze, height 18′ (5.49 m). Loggia dei Lanzi, Piazza della Signoria, Florence

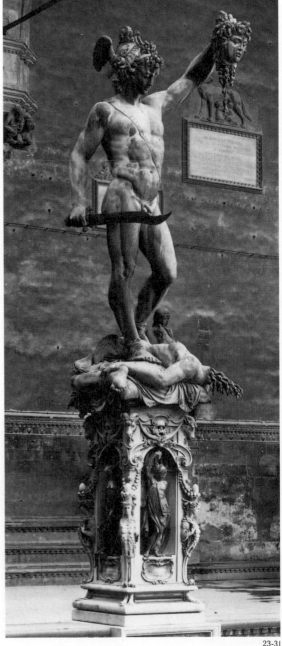

pagan—woman appealed to Christ to cure her daughter, who was "grievously vexed with a devil." As the Apostles pleaded with Christ to send her away, he tested her with three refusals, claiming that he had been sent only to succor "the lost sheep of the house of Israel" (that is, the Jews) and adding, "It is not meet to take the children's bread, and to cast it to the dogs." The woman answered him, saying, "Yet the dogs eat of the crumbs that fall from their master's table." Then, on account of her great faith, he granted her prayer, and the child was "made whole from that very hour."

Fontana has showed all the acts of the emotional drama in a color composition of stunning richness against a shadowed background. In a Michelangelesque pose, Christ stands partly enwrapped in a mantle of vibrant ultramarine over a rose-colored tunic; these bold primary colors are played like major thirds against subtler chords of close harmonies and dissonances in the other figures—the chattering Apostles on one side and the kneeling woman on the other—all brushed to enamel-like smoothness. Especially moving is the contrast between the Canaanite woman's pale neck, with its bluish undertones, apparently damp with excitement, and her flushed cheeks. A sudden light picks out the dog from the other animals in the middle distance, where the woman's friends rush up steps leading to her grand Renaissance house. The wonderful picture was acquired by the art-loving cardinal Ferdinando de' Medici and may have been commissioned by him.

Sculpture in Tuscany

CELLINI Excellent Mannerist sculptors were legion, but few escaped the domination of Michelangelo's personality sufficiently to become first-rate masters. One of the first to achieve partial independence was the engaging braggart Benvenuto Cellini (1500–1571), whose *Autobiography* paints a vivid picture of sixteenth-century life, including the Sack of Rome in which the artist was trapped. Cellini was a first-rate sculptor who got his start as a jeweler and goldsmith, and whose work always betrays his expert knowledge of metals and his ornamental taste. His *Perseus and Medusa*, of 1545–54 (fig. 23–31), like Bronzino's *Exposure of Luxury* commissioned by Duke Cosimo, shows a treatment of form that can be read as a sculptural counterpart to Bronzino's painting (see fig. 23–27). Obviously influenced by the tradition of Michelangelo, the powerfully muscled figure and its elaborate pedestal are strongly ornamentalized. It is typical, perhaps, that the moment chosen—the decapitation of the dreaded Gorgon—is that when the blood gushing from her neck and severed head turns to precious coral, dripping in ornamental forms of great complexity.

GIOVANNI BOLOGNA The most original sculptor working in Italy between Michelangelo and Gianlorenzo Bernini was a Netherlander, Jean Boulogne (1529–1608), Italianized as Giovanni Bologna. Although the identity of the subject mattered little to him, he eventually decided on the *Rape of the Sabine Woman* as the title for his colossal marble group (fig. 23–32) set in 1583 in the Loggia dei Lanzi, near Cellini's *Perseus*. In contrast to earlier statues, which almost invariably concentrate on a principal view to which all others are subordinated, Bologna's composition sends us constantly around the group from one view to the next; as all the figures are engaged in the spiral movement, it is impossible to choose a principal view. The way arms and legs fly off into space as if ejected from the spinning group was, of course, a violation of everything for which Michelangelo stood, but it was also a dazzling display of Bologna's skill in handling marble. As the forms and spaces of Giacomo da Vignola and Giacomo della Porta at Il Gesù (see below) lead us to the brink of Baroque architecture, so does the new diffuse sculptural composition of Giovanni Bologna point toward Bernini (see Chapter Twenty-Six).

Architecture

VASARI The most striking works of Mannerist architecture are those produced for princely or ecclesiastical patrons, well into the sixteenth century, when Italy had recovered economically from the turmoil attendant on the imperial invasion and the Sack of Rome, and when absolutist dynasties had been well established throughout the peninsula, paralleling the absolutism of the Counter-Reformation in the sphere of religion. The architectural style of Michelangelo was generally the dominant influence, and nowhere more strongly than in the work of Giorgio Vasari (1511–74), a painter of limited ability but a brilliant architect, also profoundly influenced by the work of Giulio Romano, who showed him his buildings in and around Mantua and a closetful of drawings. Oddly enough, despite his activities in recording with great labor the history of the Renaissance and its fourteenth-century predecessors, as an artist Vasari is a thoroughgoing Mannerist. His solution for the Palazzo degli Uffizi (fig. 23–33), a collection of preexisting structures revamped between 1560 and 1580 to house the offices of the Duchy of Florence, later the Grand Duchy of Tuscany, as well as some of the vast Medici collections, bears no relationship to its counterpart in Michelangelo's designs for the Campidoglio but is strongly influenced by memories of the reading room at the Laurentian Library (see fig. 23–4). The seemingly endless porticoes are surmounted by a mezzanine, then by a second story, and finally by what was originally an open upper portico, now

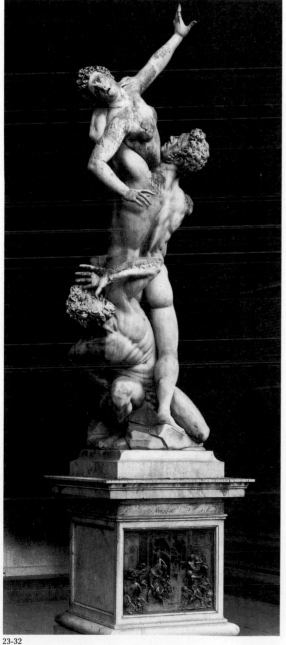

23-32. GIOVANNI BOLOGNA. *Rape of the Sabine Woman*. 1583. Marble, height 13′6″ (4.12 m). Loggia dei Lanzi, Piazza della Signoria, Florence

23-32

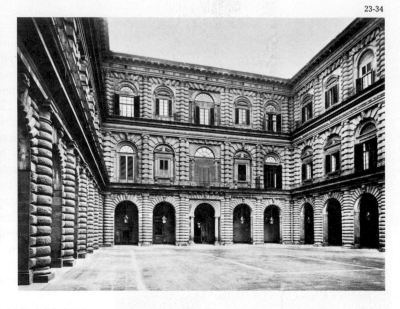

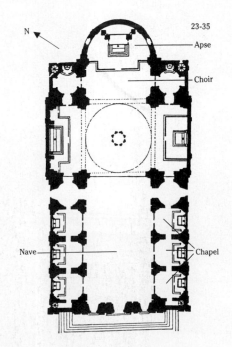

unfortunately glassed in. Conceivably, one could cut the building anywhere or extend it indefinitely without altering its effect; if, as Alberti says, beauty is that to which nothing can be added and from which nothing can be taken away without damage, then the severe and barren beauty of Vasari's design lies in its very endlessness. When the structure does finally arrive at the Arno, it opens in a strangely slender arch, through which one looks out not to an open prospect but only across the narrow river to the buildings on the other side.

The countless thousands of visitors who crowd the galleries of the Uffizi, the Pitti, the Accademia, the Bargello, the Museo San Marco, and the Medici Chapel every year would do well to remember that they owe their enjoyment of the wonderful collections intact to a woman, Anna Maria Ludovica, last of the Medici, electress of the Holy Roman Empire, illegally passed over in the succession to the grand-ducal throne on the death of her brother Gian Gastone in 1737. While the new Austrian government was already installed in the Pitti Palace, this farsighted and courageous princess gathered all the Medici art collections and libraries from the many family villas. Mindful of the Austrian despoilment of Ferrara, Parma, and Modena, reduced to artistic ghost towns while their treasures went to Vienna, and the sale of the Gonzaga collections in Mantua, which ended up in the National Gallery in London and the Louvre in Paris, Anna Maria Ludovica devised an unshakable legal instrument willing this incalculable treasure to the people of Tuscany, never to be removed from Florence. She thereby established at one blow the modern principle of the national and civic museum as distinguished from royal and princely collections, surely to be considered one of the great achievements in cultural history.

AMMANATI A different kind of princely architecture is seen in the courtyard of the Pitti Palace (fig. 23–34), a fifteenth-century residence bought by Duke Cosimo I and enlarged from 1558 to 1570 by the architect and sculptor Bartolommeo Ammanati (1511–92). The courtyard is spectacular; rather than Vasari's principle of endlessly repeated equal elements, Ammanati has superimposed on the standard succession of Doric, Ionic, and Corinthian, derived from the Colosseum, an allover rustication of all the elements except the entablatures, capitals, and bases— a kind of architectural overkill, in which every drum is enlarged in the manner of the tires in a Michelin advertisement. In its own way the effect is quite as overpowering as that of the Uffizi as an architectural symbol of political absolutism. But while these two Mannerist architects were dominant in Florence, and their style was widely emulated throughout Tuscany and northern Italy, their work was a blind alley. The Mannerist movement had come to the end of its course.

23-33. GIORGIO VASARI. Palazzo degli Uffizi, Florence. 1560–80

23-34. BARTOLOMMEO AMMANATI. Courtyard, Palazzo Pitti, Florence. 1558–70

23-35. GIACOMO DA VIGNOLA. Plan of Il Gesù, Rome. 1568

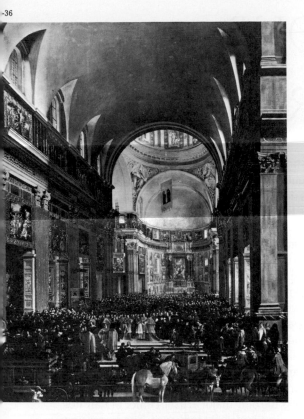

23-36. ANDREA SACCHI and JAN MIEL. *Urban VIII Visiting Il Gesù*. 1639–41. Oil on canvas. Galleria Nazionale d'Arte Antica, Rome (view showing original interior by GIACOMO DA VIGNOLA)

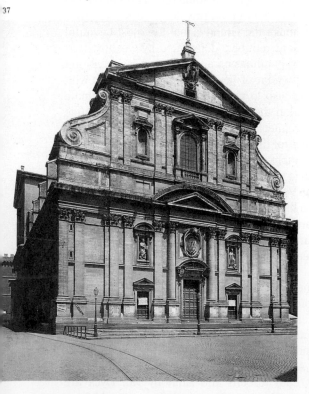

23-37. GIACOMO DELLA PORTA. Façade, Il Gesù, Rome. c. 1575–84

VIGNOLA This was not so in Rome, where the gathering force of the Counter-Reformation, largely led by the two powerful religious orders of the Jesuits and the Theatines, needed a new architecture for the intense religious purposes of the times. A north Italian architect who built important churches and palaces in Rome and magnificent villas outside it, Giacomo da Vignola (1507–73) designed the most influential Counter-Reformation church plan in Rome (fig. 23–35). It was that of Il Gesù, the mother church of the powerful Jesuit Order, founded by Saint Ignatius Loyola, which spearheaded Catholic revival not only in Europe but also in missionary work from Latin America to India and China. It was they who persuaded Gregory XIII to move the beginning of the year, March 25 in the Julian calendar, to January 1, the celebration of the Circumcision, and thus of the adoption of the sacred name of Jesus. As originally built, beginning in 1568, the interior was extremely austere. Its single, overwhelming, barrel-vaulted space, with paired pilasters flanking side chapels rather than side aisles, is based on Alberti's Sant'Andrea in Mantua (see fig. 20–15; repeated in Bramante's nave for Saint Peter's), save only for the small clerestory let into the barrel vault (the painting in fig. 23–36 shows the original appearance of the nave before its enrichment in the seventeenth century). The purpose of this plan, of course, was to draw all the forces of the building and the attention of the worshipers to the Eucharist at the high altar. This single-minded concentration on the humanity of Christ may be illuminated by the intensity of Saint Ignatius' famous prayer:

> *Soul of Christ sanctify me,*
> *Body of Christ save me,*
> *Blood of Christ inebriate me,*
> *Water from the side of Christ wash me,*
> *Passion of Christ comfort me,*
> *O good Jesus hear me,*
> *Within your wounds hide me,*
> *Nor permit me ever to be separated from thee!*

Unrelated to Michelangelo's architecture, Vignola's plan for Il Gesù cannot be called Mannerist; neo-Renaissance might be a better term if one is needed. The new solution—really the revival of one a hundred years old—was adopted in the seventeenth century throughout Europe, and it became the Baroque plan for larger churches. But the decision was made for religious rather than aesthetic reasons. Vignola's façade plan, essentially classicistic, was not, however, adopted.

DELLA PORTA The pupil who completed Michelangelo's dome on Saint Peter's, Giacomo della Porta (1541–1604), received the commission to design the façade for Il Gesù, built from about 1575 to 1584 (fig. 23–37). His design was a tentative but important step in the direction of Baroque architecture, within the artistic vocabulary of Michelangelo. Basically, the scheme consists of two superimposed orders although there are no side aisles; the lateral chapels posed a similar problem and were masked by giant consoles. Coupled Corinthian pilasters enclose an inner architecture of doors, windows, and niches, increasing in concentration and projection as they approach the center. On the lower story, for example, the outside pairs of pilasters support a continuous entablature; the next is enriched by an added half-pilaster (related to a device Michelangelo had invented at Saint Peter's) and more strongly projected, breaking the entablature above; and at the center of the lower story the pilasters support an arched pediment enclosing a gabled one that projects beyond it and is supported by columns in the round. The progression in projection and vitality as the elements approach the center prepares the observer for the dramatic experience of the unified interior. Like the interior, the dynamic façade prepared the way for the more richly articulated and easily moving structures of the Baroque.

CHAPTER TWENTY-FOUR

RENAISSANCE

With the exception of Michelangelo, who remained the dominant force in central Italy, artistic preeminence in the sixteenth century passed gradually from Florentine to Venetian hands. After Raphael's death, Venice was unchallenged in Europe in the field of oil painting. Politically, the Republic of Saint Mark was in by no means so favorable a position. During the papacy of Julius II, she found herself isolated, with all of Europe united against her, and temporarily stripped of her mainland possessions. By the 1520s her fortunes, like those of the other Italian states, were compromised by the continuing warfare between France and the Empire (which, under Charles V, included Venice's neighbor, the duchy of Milan). But Venice escaped the grim fate of Rome and recovered faster from the effects of the imperial invasion. Regardless of political upheavals, the Venetian School expanded in new aesthetic directions, aided by the adoption of flexible resins that made painting on canvas instead of on the traditional panels possible. Giovanni Bellini survived until 1516 (see page 628), still respected and productive. Under some Roman and Florentine influence, the High Renaissance style rapidly took root in Venice, even in Bellini's late works. But since Venice was the only major artistic center in Italy not to fall a prey to despotism, Tuscan Mannerism had slight influence. The increasing prosperity of the widespread Venetian empire (consisting largely of seaports throughout the eastern Mediterranean) and the success of the Venetian trade network were reinforced by the victory of Christian naval forces over the Turks at Lepanto in 1571, in which Venetian warships played a leading role. Throughout the sixteenth century there was a strong demand for grand private palaces and public buildings, whose magnificence was to make the Grand Canal the most beautiful thoroughfare in the world. In this opulent republic, dominated by wealthy merchants, there was also a special need for paintings on a wholly new scale, vibrant with a richness of color to match the splendor of Venetian life. Concomitant with their own prosperity, the oligarchs had also to meet the needs of less fortunate segments of the population, an obligation they fulfilled by commissioning huge paintings for charitable foundations. Architects and painters met the challenge of all aspects of Venetian life with new ideas for the deployment of both human figures and architectural elements, new and more energetic principles of composition, indeed, a new vision of the possibilities of art. The Florentines chided them for neglect of drawing and of form. But the Venetians were not turned inward, as were the Tuscan Mannerists, on the troubled life of the spirit or constrained to gratify the ambitions and tastes of absolute rulers. Rather, they were encouraged to explore highways of pictorial and architectural imagination—fortified by a continuing Renaissance enthusiasm for visual reality—which opened constantly toward the future.

The prolonged afterlife of the Venetian Late Renaissance is one of the most striking phenomena in the history of post-medieval art. The new pictorial and architectural standards and methods established in sixteenth-century Venice were rapidly exported to Northern Europe and became dominant in the art and taste of the Catholic regions of the Netherlands in the seventeenth century and then of Protestant England and democratic America in the eighteenth and nineteenth. Without Titian and Veronese, Peter Paul Rubens and Anthony van Dyck are unthinkable, just as neither Christopher Wren nor Thomas Jefferson could have created their masterpieces without the example and principles of Andrea Palladio.

Painting

GIORGIONE The founder of a new and at first exclusively Venetian tendency was Giorgione da Castelfranco (c. 1475/77–1510), according to Vasari a happy and carefree personality given to a life of music and merrymaking. Among the small body of paintings attributed to Giorgione none, unfortunately, are dated. Probably about 1505, the date of Bellini's *Madonna Enthroned* (see fig. 20–76), Giorgione painted the same subject (fig. 24–1) for the cathedral of his native city of Castelfranco. At first sight the compositions are similar, but the differences are crucial. Giorgione's spacious picture is mysterious in that the Virgin and Child are placed on a high throne without visible means of access, which renders the image incommensurable with the real world, like Leonardo's *Last Supper* (see fig. 22–6) or Raphael's *School of Athens* (see fig. 22–29), in spite of Saint Francis's appeal to the observer. Also, through careful adjustments of directions, such as the parallelism between the lance of Saint Liberalis in his gleaming armor and the diagonals in the Virgin's robe, Giorgione unified his composition beyond the stage of Bellini. The landscape, seen over the low wall, dominates the picture, from the partially ruined castle at the left to the trees and port scene at the right. The soft modeling of the gracious and

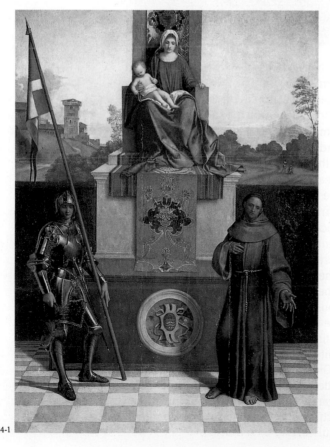

24-1

24-1. GIORGIONE. *Enthroned Madonna with Saint Liberalis and Saint Francis.* c. 1505. Panel painting, 78¾ × 60″ (2 × 1.52 m). Cathedral of Castelfranco

24-2

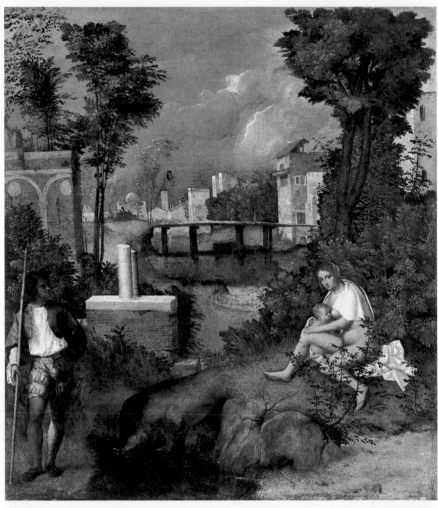

24-2. GIORGIONE. *The Tempest.* c. 1505–10. Oil on canvas, 31 × 28¾″ (79.4 × 73 cm). Galleria dell'Accademia, Venice

simplified faces is even broader than that of the aged Bellini in its reliance on light and shadow rather than on definition of forms.

Giorgione's most influential picture, painted about 1505–10, is a small canvas called *The Tempest* (fig. 24–2), showing a landscape in which a soldier, leaning on his lance, gazes quietly toward a young woman, insufficiently draped in a towel, who nurses her child as she looks out toward us. Scholars have ransacked literature in vain for the subject. The futility of further search was indicated by the X-ray discovery of a second nude woman underneath the soldier. Moreover, a Venetian diarist in 1530 recorded the picture as "the little landscape on canvas with the tempest, with the gypsy and the soldier." Clearly, Giorgione intended us to know no more than this about the subject; it is significant that the diarist was prompted to mention the landscape first. Up to this moment we have encountered landscapes as backgrounds for figures; the roles are now reversed, and the figures are present here only to establish scale and mood for the magical landscape. Nature, around the figures, is wild, weedy, and unpruned. The air is pregnant with storm. Ruins, a river crossed by a plank bridge, and the houses of a village are illuminated by a lightning flash, which casts the shadow of the bridge upon the water. The lightning is serpentine rather than jagged for the first time in any painting known to us, and looks the way lightning really looks. In this little painting, exploiting to the full the luminary possibilities of the oil medium, Giorgione established a new and immensely influential theme, which might be described as the landscape-and-figure poem. In its free-form shapes, its ruins, and its lighting and coloring wholly determined by the moods of nature, the picture is the ancestor of European and eventually American landscape art for centuries.

TITIAN The monarch of the Venetian School in the sixteenth century, analogous to Michelangelo in Florence and Rome, was Tiziano Vecellio (c. 1490–1576), anglicized to Titian. A robust mountaineer who came to Venice as a boy from the Alpine town of Pieve di Cadore, Titian was long believed to have survived well into his nineties, but recent research has shortened his life span somewhat. The young painter was trained in the studios of both Gentile Bellini and Giovanni Bellini and then assisted Giorgione with some of the lost frescoes that once decorated the exteriors of Venetian palaces. Once he became independent, Titian—on the basis of the new principles of form and color announced by the late Giovanni Bellini and by Giorgione—succeeded in establishing color alone as the major determinant. He did not visit central Italy until 1545–46, when he was accorded Roman citizenship on the Capitoline Hill, but he was aware much earlier, probably by means of engravings, of what was going on in Florence and Rome and rapidly assimilated High Renaissance innovations to his own stylistic aims. Titian generally began with a red ground, which communicated warmth to his coloring; over that he painted figures and background, often in brilliant hues. He is reported to have turned his half-finished pictures to the wall for months, then to have looked at them as if they were his worst enemies, and finally to have toned them down with glazes, as many as thirty or forty layers. Always imparting unity to the whole, these glazes became deeper and richer as Titian's long career drew toward its close.

It was a life marked by honors and material rewards. Titian's prices were high, his financial acumen the subject of caricature, and, like Raphael and Michelangelo, he made himself wealthy. His palace in Venice was the center of a near-princely court, fulfilling the worldly ideal of the painter's standing as formulated by Leonardo. In 1533 began his acquaintance with the emperor Charles V, whose rule comprised all of western Europe save France, Switzerland, central Italy, and the Venetian Republic, and most of the New World. There is a legend to the effect that this potentate, on a visit to Titian's studio, stooped to pick up a brush the painter had dropped. Titian was called twice to the imperial court at Augsburg and was ennobled by the emperor.

An early work, painted about 1515, is generally known as *Sacred and Profane Love* (fig. 24–3), although its actual subject, in spite of much research, has not been satisfactorily determined. Two women who look like sisters sit on either side of an open sarcophagus, which is also a fountain, in the glow of late afternoon. One is clothed, belted, and gloved and holds a bowl toward her body with one hand and

24-3. TITIAN. *Sacred and Profane Love.* c. 1515. Oil on canvas, 47 × 110″ (1.19 × 2.79 m). Galleria Borghese, Rome

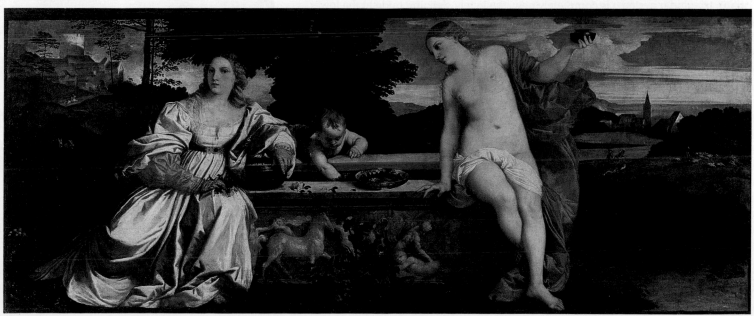

24-3

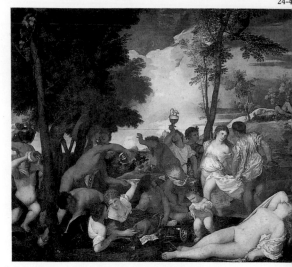

24-4. TITIAN. *Bacchanal of the Andrians.* c. 1520. Oil on canvas, 69 × 76″ (1.75 × 1.93 m). Museo del Prado, Madrid

24-5. TITIAN. *Assumption of the Virgin.* 1516–18. Panel painting, 22′6″ × 11′10″ (6.86 × 3.61 m). Sta. Maria Gloriosa dei Frari, Venice

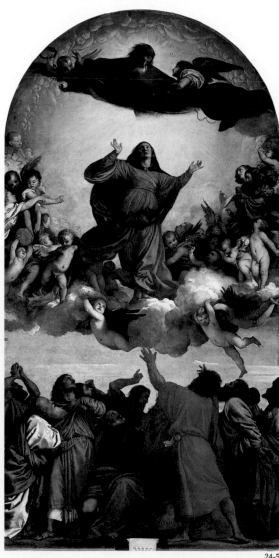

pink roses with the other, as she listens intently to the earnest discourse of her sister, nude save for a white scarf thrown lightly about her loins and a rose-colored mantle flowing over her left arm, uplifted to hold a burning lamp against the sky. The shadowed landscape behind the clothed sister leads up to a castle, toward which a horseman gallops, while two rabbits play in the dimness; behind the nude sister the landscape is filled with light, and huntsmen ride behind a hound about to catch a hare while shepherds tend their flocks before a village with a church tower, touched with the evening light. Cupid stirs the waters in the sarcophagus-fountain, on which is represented, to the left, a figure leading a horse and followed by attendants and, on the right, a nude man being beaten and a nude woman grasped by the hair. A golden bowl partly filled with water rests on the edge of the sarcophagus, from which water pours through a golden spout to a plant bearing white roses. The roses and the sarcophagus filled with water are drawn from a passage in a widely read Renaissance romance, *The Strife of Love in Poliphilo's Dream,* which relates how white roses were tinted red by the blood of the dying Adonis.

What Titian's picture may refer to is the passage from virginity (symbolized by the clothed body and hands, the locked belt, the guarded bowl, the dark fortress, and the huntsman returning empty-handed) through the water of suffering, a kind of baptism through the death of the old self, to a new life in love, conceived as a sacred rite (the church spire, the lamp lifted heavenward). The picture then becomes an exaltation of the beauty and redeeming power of love in terms of the ample forms and perfect health characteristic of Titian's conception of womanhood. As compared with Giorgione's less attractive nude, Titian's glorious creation shares the classical beauty of Raphael's *Galatea* (see fig. 22–33). Even the landscape, wild in Giorgione, is here subjected to discipline in the measurement of its elements. Just as characteristic of his art as the glowing colors of metal, heavy silks, white clouds, red-gold hair, and warm flesh is Titian's manner of composing the group in terms of triangles, a device that runs through his entire career.

Comparable to the pagan works that Raphael and others painted for the Villa Farnesina in Rome is a series of mythological paintings made by Titian for a chamber in the palace of the duke of Ferrara. One of these, the *Bacchanal of the Andrians* (fig. 24–4), executed about 1520, is based on a description by the third-century-B.C. Roman writer Philostratus of a picture he saw in a villa near Naples. The inhabitants of the island of Andros disport themselves in a shady grove in happy abandon to the effects of a river of wine. The freedom of the poses (within Titian's triangular system) is completely new; the lovely sleeping nude at the lower right reclines in a pose later to be often imitated, notably by Goya (see fig. 31–2). Titian has extracted the greatest visual delight from the contrast of warm flesh with shimmering drapery and of light with unexpected dark, such as the shadowed crystal pitcher lifted against the shining cloud and the golden light on the drunken river-god on his hill against the dark blue sky.

Like his mythological pictures, Titian's early religious visions are warm affirmations of health and beauty. The *Assumption of the Virgin,* of 1516–18 (fig. 24–5), is his sole venture into the realm of the colossal; it represents the moment (according to a belief not made dogma until 1950) when the soul of the Virgin was reunited with her dead body so that she might be lifted corporeally into Heaven. His dramatic composition is a Venetian counterpart to Raphael's *Sistine Madonna* (see fig. 22–31). Above the powerful, excited figures of the Apostles on earth, Mary— abundant and beautiful as the two sisters of the *Sacred and Profane Love*—is lifted on a glowing cloud by innumerable child angels, also rosy, robust, and warm, into a golden Heaven, where she is awaited by God the Father, foreshortened like Michelangelo's Creator in the *Lord Congregating the Waters* on the Sistine Ceiling (see fig. 22–16), of which the artist must surely have known. The glowing reds, blues, and whites of the drapery, the rich light of the picture, and the strong diagonals of the composition (in contrast to Raphael's spirals) carry Titian's triumphant message

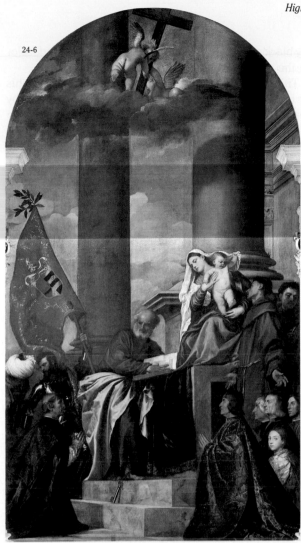

24-6. TITIAN. *Madonna of the House of Pesaro.* 1519–26. Oil on canvas, 16' × 8'10" (4.88 × 2.69 m). Sta. Maria Gloriosa dei Frari, Venice

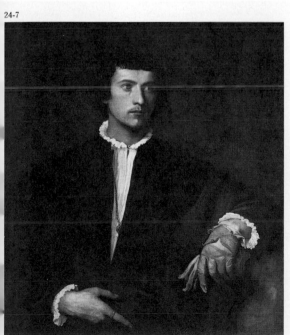

24-7. TITIAN. *Man with the Glove.* c. 1520. Oil on canvas, 39⅜ × 35" (100 × 89 cm). Musée du Louvre, Paris

through the spacious interior of the Gothic Church of the Frari in Venice, upon whose high altar it still stands.

In his *Madonna of the House of Pesaro*, of 1519–26 (fig. 24–6), Titian applied his triangular compositional principle to the traditional Venetian Madonna group (compare figs. 20–76, 24–1), breaking up its symmetry by a radical view from one side. The scene is a portico of the Virgin's heavenly palace, the actors kneeling members of the Pesaro family, including Jacopo Pesaro, bishop of Paphos, and an armored figure who presents to the Virgin as a trophy a Turk captured in battle. The steps plunge diagonally into depth, and the columns are seen diagonally, their capitals outside the frame; reciprocal diagonals in one plane or in depth, in the pose of Peter, for example, or in the angle of the Pesaro flag, build up a rich fabric of forces and counterforces. At the top, clouds float before the columns, on which stand nude child angels, one seen unceremoniously from the back, bearing the Cross. As compared with other paintings of the second decade of the century, the colors have become extremely rich and deep, veiled by glaze after glaze.

One would expect Titian's portraits to sparkle with color, but this does not often happen, partly because the male costume of the sixteenth century was characteristically black. In his *Man with the Glove* (fig. 24–7), possibly a portrait of Gerolamo Adorno, which Titian delivered to Federigo Gonzaga, duke of Mantua, in 1527, his triangular principle is embodied in the balanced relationship of the gloved and ungloved hands to the shoulders and the youthful face. The smooth and carefully modeled hands and features are characteristic of Titian's portraits, contrasting with the ideal simplification of the heads in his allegorical and religious paintings. Even

in this picture, dominated by black and by the soft greenish-gray background, color is everywhere, dissolved in the glazes, which mute all sharp contrasts.

A subject that occupied Titian, and presumably delighted his patrons, in his mature and later years is the nude, recumbent Venus—a pose originally devised by Giorgione. In 1538 Titian painted the *Venus of Urbino* (fig. 24–8) for Guidobaldo della Rovere, then duke of Camerino (the duke's eager letters refer to her only as a nude woman). Without any of the verve of Titian's earlier jubilant nudes, the opulent figure relaxes in pampered ease on a couch in a palace interior whose inlaid marble floor and sumptuous wall hangings make a golden, greenish, soft red-and-brown foil for the beauty of her abundant flesh and her floods of warm, light brown hair. Pure color, almost divorced from classical form, rules in the pictures of Titian's middle period.

In his later years form appealed to Titian even less; in fact, substance itself was almost dissolved in the movement of color. In *Portrait of Pope Paul III and His Grandsons,* a full-length painting of 1546 (fig. 24–9), the question even arises, as with many of Titian's later works, whether the picture is really finished, especially when compared with a central Italian High Renaissance rendering of a similar subject, Raphael's *Pope Leo X* (see fig. 22–32). There can be no doubt that this painting was carried to a point that satisfied both artist and patron, but as compared with the consistent surfaces of the foreground figures in Titian's early works, it is far from finished. The brushstrokes are free and sweeping, especially in the drapery. The artist has applied to the whole picture the sketchy technique characteristic of the backgrounds in his earlier works. Veils of pigment are roughly applied with the fingers as much as with the brush, if we are to believe Titian's contemporaries, transforming the entire picture into a free meditation in color. Color, indeed, is the principal vehicle of the pictorial message.

In the paintings of his extreme old age, form was to a certain extent revived and color grew more intense, but always looser and freer. The old man seems to have experienced a resurgence of passion, and his late paintings of pagan subjects are unrestrained in their power and beauty. Like so many of the artist's later works, the *Rape of Europa* (fig. 24–10) was probably painted off and on during several years, in this case about 1559–62. The white bull, one of the many disguises of Jupiter, carries the distraught yet yielding Europa, in one of the most beautiful poses of

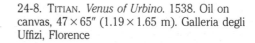

24-8. TITIAN. *Venus of Urbino.* 1538. Oil on canvas, 47 × 65″ (1.19 × 1.65 m). Galleria degli Uffizi, Florence

24-9. TITIAN. *Portrait of Pope Paul III and His Grandsons.* 1546. Oil on canvas, 78½ × 49″ (1.99 × 1.25 m). Museo di Capodimonte, Naples

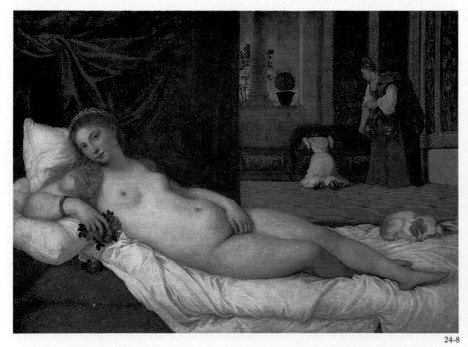

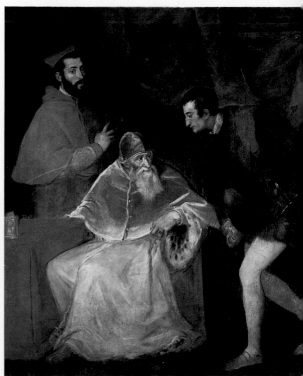

24-8 24-9

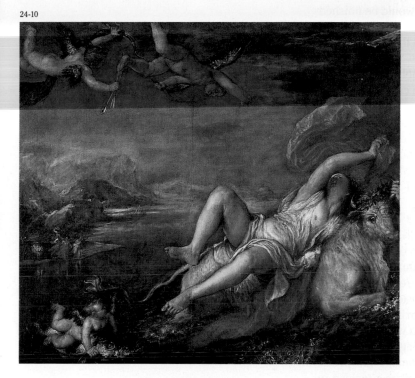

24-10. TITIAN. *Rape of Europa.* c. 1559–62. Oil on canvas, 70 × 80¾″ (1.78 × 2.05 m). Isabella Stewart Gardner Museum, Boston

24-11. TITIAN. *Crowning with Thorns.* c. 1570. Oil on canvas, 9′2″ × 5′11½″ (2.79 × 1.82 m). Pinakothek, Munich

Renaissance art, combining surprise, abandon, and unconscious grace, over a glittering blue-green and foam-flecked sea. Cupid floats on a dolphin, and a glittering golden fish surfaces below. The nymphs left wailing on the shore are seen against a landscape that contains no solid forms or shapes—all is dissolved in veils of blue and violet.

The same devices of rapid movement and transcendent color, ignoring detail, were used to shattering emotional effect in the very late *Crowning with Thorns* (fig. 24–11), probably painted about 1570, six years before the artist's death. The hail of brushstrokes creates cloudy shapes; the agony of Christ and the fury of his tormentors are expressed in storms of color. The thick masses of impasto are contrasted with the encompassing glazes to create an effect as somber as if a cloud of smoke had engulfed the brilliant coloring of the *Rape of Europa*. The last religious works of Titian reached a point beyond which only Rembrandt in the seventeenth century would proceed.

TINTORETTO By the middle of the sixteenth century two great painters, sharply opposed in style, temperament, and methods, disputed the field with the aged Titian. Jacopo Robusti (1518–94), called Tintoretto ("Little Dyer") after his father's profession, was the more impulsive of the two, in fact, the most dramatic painter of the sixteenth century. Impatient with Titian's painstaking methods, Tintoretto was determined to cover as much canvas as possible with his rushing, soaring, or hurtling figures. His means could have been successful only in the hands of a painter of intense emotion and daring imagination. He began by arranging little modeled figures like puppets on small stages, or in the case of flying figures by hanging them from wires. He was thus enabled to draw the composition accurately,

with the foreshortening predetermined. Then he enlarged the drawings to the enormous dimensions of his canvases by means of proportionate grids (fresco in the traditional Italian manner had been given up as hopeless in the damp atmosphere of Venice). He next primed the canvas with a dark tone, such as gray green or deep brown, or divided it into areas of several dark hues. Once the preliminary sketch had been enlarged, he could paint in the light areas with great rapidity in bright colors, leaving the priming for the darks, and the painting would be finished save for contours and highlights. His paintings often look like night scenes illuminated by flashes of light, even more so since in the course of time the dark priming has come through the overlaid colors.

Tintoretto advertised outside his studio the drawing of Michelangelo and the coloring of Titian, but neither claim was strictly true. He has been called a Mannerist, but it is hard to find any common ground between his stormy creations and the calculated works of Pontormo or Rosso. For all their speed of execution with broad brushes (the nineteenth-century English critic John Ruskin accused him of painting with a broom), Tintoretto's paintings have an inner harmony born of their own momentum. His almost weightless figures swoop and swirl with unheard-of speed, but they never display the irresolutions and dissonances of central Italian Mannerism.

Saint Mark Freeing a Christian Slave, of 1548 (fig. 24–12), was Tintoretto's first brilliant success in his new style. According to legend a Christian slave left Provence, without his master's permission, to venerate the relics of Saint Mark in Alexandria; on his return he was condemned to have his eyes gouged out and his legs broken with hammers, whereupon Saint Mark rushed down from Heaven. The ropes were snapped and the hammers shattered, to the consternation of all, especially the master, ready to fall from his throne. Tintoretto's daring foreshortenings take up in an authoritative way what Mantegna had achieved with much labor in the *Dead Christ* (see fig. 20–74) and the ceiling of the Camera degli Sposi (see fig. 20–71). The dazzling colors and the summary brushwork intensify the prearranged movement of the figures, always so constructed as to achieve a tension in depth between figures pouring out of the composition and those rushing into it; Saint Mark, for example, dives in upside down and feet toward us, his figure painted with only a few rapid strokes of lighter rose and orange against the dark red priming, his head merely suggested against a sunburst of rays.

Tintoretto's style was not a matter of mere virtuosity; it sprang spontaneously from the depths of a sincere and uncomplicated personality. He had no ambition to compete with Titian's life of ease; sometimes he painted only for the cost of the materials, and he left his widow in poverty. His personal style enabled him to communicate religious experience with the force of revelation. He was an ideal painter for the societies of laypersons, the so-called *scuole* ("schools"), which, under ecclesiastical supervision, carried out works of charity in Venice. The walls of the hall on the lower floor of the Scuola di San Rocco, and both walls and ceilings of the great hall and chapel on the upper floor, are covered with a continuous cycle comprising more than fifty canvases by Tintoretto, separated only by the width of their frames, executed throughout an almost twenty-five-year period (1564–87) for a small annual salary after 1577. These render the Scuola di San Rocco a monument to compete with the Arena Chapel, the *Ghent Altarpiece,* and the Sistine Ceiling for sustained intensity of creative imagination.

The largest of the canvases, more than forty feet long, is the *Crucifixion* (fig. 24–13), painted in 1565, a work of such power that no reproduction can do it justice. The reader should attempt to imagine the enveloping effect of the total image, stretching from wall to wall and from wainscoting to ceiling, with foreground figures more than life size. The Cross appears to sustain the ceiling; at its base the swooning Mary, the comforting Holy Women, and John looking upward form a pyramid of interlocking figures, powerfully constructed in light and dark. The turbulent crowds of soldiers, executioners, and bystanders move about the Cross as

24-12. TINTORETTO. *Saint Mark Freeing a Christian Slave.* 1548. Oil on canvas, 13'8" × 11'7" (4.17 × 3.53 m). Galleria dell'Accademia, Venice

24-13. TINTORETTO. *Crucifixion.* 1565. Oil on canvas, 17'7" × 40'2" (5.36 × 12.24 m). Sala dell'Albergo, Scuola di S. Rocco, Venice

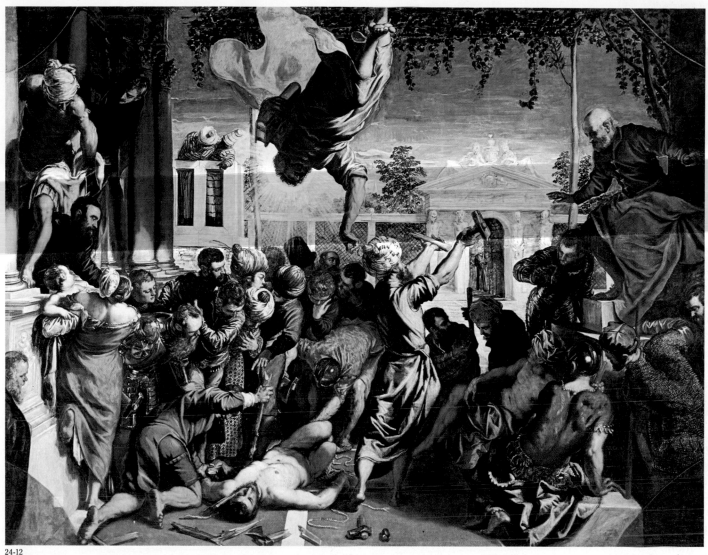

24-12

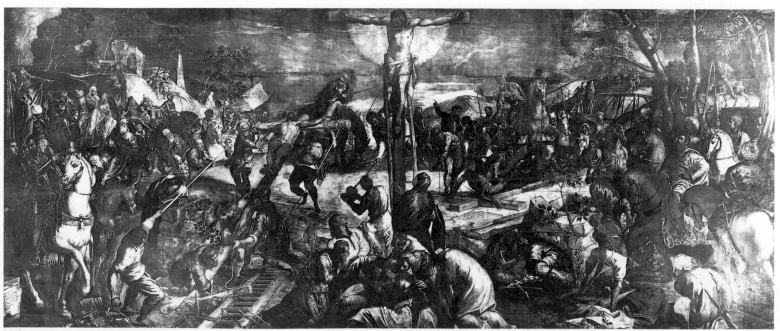

24-13

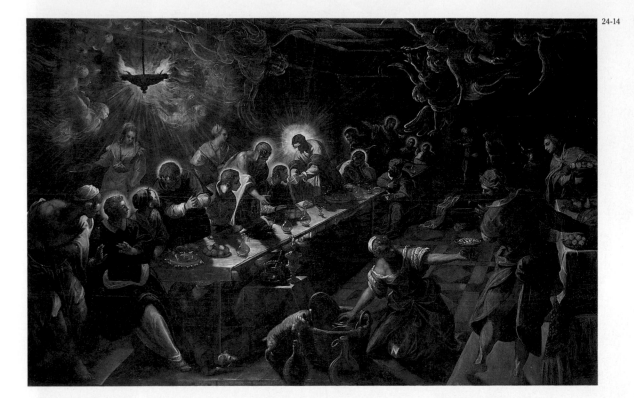

24-14

if in the grip of forces beyond their understanding. Rays pouring from the head of the Crucified provide the light for the scene, the sun and moon having been darkened at Christ's death. The ropes, the ladders, and the cross of the penitent (but not that of the impenitent) thief move upward along these rays, as if in fulfillment of the passage (John 12:32): "And I, if I be lifted up from the earth, will draw all men unto me." This is indeed the effect of the composition on all who enter the room.

Like those of Titian, Tintoretto's later works were inspired by the intense religiosity of the Counter-Reformation, and nowhere more than in the paintings he did in the last year of his life for San Giorgio Maggiore in Venice, a church whose luminous beauty (see page 735) seems unrelated to such emotional outpourings. The *Last Supper* (fig. 24–14) breaks with the tradition of Castagno (see fig. 20–51), Bouts (see fig. 21–23), and Leonardo (see fig. 22–6). Judas is reduced to a subsidiary role on the outside of the table, which moves into the picture in a typical Tintoretto diagonal in depth; toward its center Christ rises in the act of distributing the bread, which is his body, to the Apostles. In the foreground, as if to contrast earthly with heavenly sustenance and greed with spiritual longing, the servants take away the uneaten food, a cat looks into the basket for tidbits, and a dog gnaws a bone. All except these foreground figures are insubstantial; the rays Tintoretto had used around the head of Saint Mark in the *Saint Mark Freeing a Christian Slave* now blaze around that of Christ; light starts like fire from the Apostles, blending with the rays from the hanging lamp. In Tintoretto's lightest of touches, angels are sketched in white strokes only, as if with chalk on a blackboard. All the substantiality and form of the Renaissance, hard-won in many an intellectual battle, are renounced in favor of inner mystical experience, which brings us to the threshold of a new era.

VERONESE Tintoretto's chief competitor in late-sixteenth-century Venice was Paolo Caliari (1528–88), called Veronese because he came from Verona on the Venetian mainland. Until the very end of his life, there is little spirituality in Veronese's paintings, concerned with the beauty of the material world—less landscape, which plays a minor role in his works, than marble, gold, and, above all,

24-14. TINTORETTO. *Last Supper.* 1592–94. Oil on canvas, 12′ × 18′8″ (3.66 × 5.69 m). Chancel, S. Giorgio Maggiore, Venice

24-16. PAOLO VERONESE (and pupils). *Triumph of Venice,* ceiling decoration (oil on canvas), Hall of the Grand Council, Palazzo Ducale, Venice. c. 1585

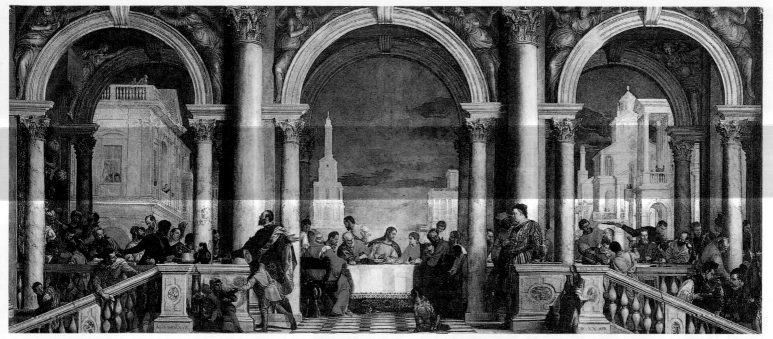

24-15

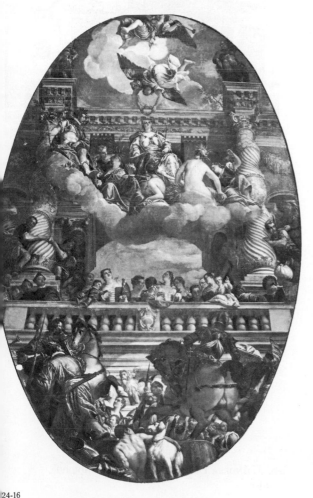

24-16

24-15. Paolo Veronese. *Feast in the House of Levi*. 1573. Oil on canvas, approx. 18′3″ × 42′ (5.56 × 12.8 m). Galleria dell'Accademia, Venice

splendid fabrics. In contrast to Tintoretto's turbulent and dissolving world, everything in a Veronese picture appears under perfect control—solid, gorgeous, and very expensive. Venetian architecture, especially that of Sansovino and Palladio (see below), forms the setting for a succession of celebrations; in fact, Veronese is known above all else for the pomp and splendor of his banqueting scenes. One of these paintings got him into trouble with the Inquisition, as the third session of the Council of Trent, 1562–63, had promulgated a series of decrees governing religious imagery. Veronese's brush with the authorities was occasioned by a canvas more than forty feet long (fig. 24–15) representing Christ at supper under a portico of veined-marble Corinthian columns and bronze relief-sculptures intercepting a view of Renaissance (and Gothic) palaces and towers. The minutes of the trial make amusing reading. The artist was asked to justify the "buffoons, drunkards, dwarfs, Germans, and similar vulgarities" who crowded his supposedly sacred picture, and he answered, tongue in cheek, that it was all a matter of the license enjoyed by artists, poets, and madmen.

The Inquisitors thought they were looking at a Last Supper, so to lay all doubts to rest Veronese painted on the balustrade the number of the chapter in Luke (5:29–31) that narrates how Christ feasted in the house of Levi with "a great company of publicans and of others"—clearly casting the Inquisitors in the role of the Pharisees, who objected to his dining among publicans and sinners. Veronese was a colorist second in the sixteenth century only to Titian, although like Tintoretto he had worked out his own technical shortcuts for giant canvases. He adopted from fourteenth-century tempera technique the procedure of painting a whole area of color—the garment of one figure, let us say—in a single flat tone, then modeling highlights and shadows with lighter or darker mixtures of the same hue. His harmonies were obtained by a magical sensitivity to color relationships rather than by the overglazes that unify Titian's much smaller canvases.

Also like Tintoretto, Veronese was no stranger to the laws of perspective, which he utilized in a Mantegnesque manner. His oval ceiling decoration for the Hall of the Grand Council in the Doges' Palace, painted about 1585 with the help of his pupils (fig. 24–16), shows spiral columns seen from below, which carry the eye upward. Between them, above a balustrade crowded with richly dressed people, sits the allegorical figure of Venice, borne aloft on clouds, enthroned between the towers of her Arsenal, and surrounded by other allegorical figures as Fame (drawn

24-17

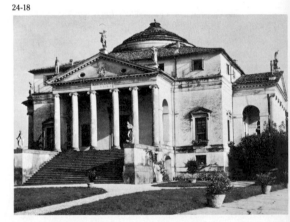

24-18

24-18. ANDREA PALLADIO (completed by VINCENZO SCAMOZZI). Villa Rotonda (Villa Capra), Vicenza. Begun 1550

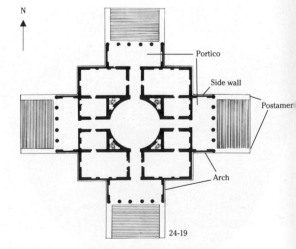

24-19. ANDREA PALLADIO. Plan of Villa Rotonda, Vicenza

directly from an angel in a fresco by Giulio Romano in the cathedral of Veronese's native city) holds a laurel wreath above her head. This work was the inspiration for many Baroque ceiling compositions (compare figs. 26–6, 26–28).

Architecture

SANSOVINO Few of the churches and palaces that make Venice one of the most beautiful cities in the world were built by Venetian architects. Until the seventeenth century Venice drew on foreign masters, generally from Lombardy. The High Renaissance architectural style was brought to Venice by a Florentine refugee from the Sack of Rome in 1527, Jacopo Tatti (1486–1570), called Sansovino after his master, the sculptor Andrea Sansovino. But Sansovino erected buildings in Venice that would have been impossible to build in the narrow streets of turbulent Florence. Moreover, the almost fleshy richness of Sansovino's buildings is so Venetian in spirit as to make us forget Sansovino's Florentine origin. His greatest achievement is the Library of San Marco (fig. 24–17), which he began in 1536; its construction, interrupted in 1554, was completed only in 1588, years after the architect's death. An even greater architectural genius, Palladio—who as we shall see continued the High Renaissance architecture of Sansovino on a somewhat more rarified intellectual plane—called this edifice the "richest ever built from the days of the ancients up to now."

In the two superimposed arcades that form the structure, Sansovino has translated into Renaissance terms the splendor of forms and colors of such Venetian Gothic buildings as the Doges' Palace, which the Library faces, and the Ca' d'Oro. The Bramantesque Roman Doric order of the ground story is entirely open, embracing an arcade running around three sides of the building; the second story

is Ionic and embraces a smaller order of paired Ionic columns two-thirds the height of the principal ones, arranged in depth so as to flank the arched windows of the reading room. The vertical axes of the columns are prolonged against the sky by obelisks at the corners and by statues at every bay, interrupting the balustrade. The spandrels of the arches are sculptured with figures, and the massive frieze of the second story, interrupted by the oval windows of a mezzanine, is also decorated with figures and garlands. The great sculptural and (given the Venetian light, colored by reflections from the water) pictorial richness would provide the perfect architectural background for a Veronese feast.

PALLADIO The greatest north Italian architect of the Renaissance, indeed, the only sixteenth-century architect who ranks with Bramante and Michelangelo, was Andrea di Pietro (1508–80), known as Palladio, a nickname derived from the Greek goddess Pallas Athena and given him by his first patron, a humanist of Vicenza, a city between Verona and Padua, where Palladio was brought up. Insofar as a city can derive its character from the ideas of a single architect, Vicenza is Palladio's creation. Several of its palaces, its town hall, and its theater were built by him, and other buildings were erected by his pupils and followers. In 1570 Palladio published a beautifully illustrated work on architecture that became a kind of bible for Neo-Renaissance architects everywhere, particularly in England and the United States in the eighteenth century, culminating in the designs of Thomas Jefferson (see figs. 30–1, 30–3).

As beautiful as Palladio's palaces are his villas, erected near Vicenza and along the Brenta Canal, which connects Padua with the Venetian lagoon. The most influential example of Palladio's villa types is the Villa Capra, nicknamed Villa Rotonda (fig. 24–18), begun in 1550 on an eminence above Vicenza as a summer retreat and not meant for year-round habitation. Palladio revived the form of the ancient Roman Pantheon in the central hemispheric dome, but with significant changes. The villa is a square block, almost a cube, with an Ionic portico on each of its four sides affording different views over Vicenza and the surrounding subalpine hills (fig. 24–19). Each portico is protected against sun and wind by side walls pierced by arches, and the owners and their guests could therefore enjoy the views through Ionic columns according to the movement of the sun and the temperature of the day. As in the architecture of Sansovino, the axes of Palladio's buildings are prolonged by statues against the sky and, in this case, by long postaments that flank the stairs like those of a Roman temple. It has been demonstrated that Palladio's system for the proportions governing the shapes and sizes of his spaces was based on mathematical ratios drawn from the harmonic relationships in Greek musical scales; in that sense his architecture really is "frozen music."

Like Sansovino, Palladio contributed to the incomparable picture of the canal in front of San Marco, Venice. In his Church of San Giorgio Maggiore (fig. 24–20), begun in 1566, he at last solved the problem that had plagued architects of basilicas ever since the days of Constantine—what to do with the awkward shape determined by the high central pediment and the lower sloping side-aisle roofs. Romanesque and Gothic architects had masked the juncture with screen façades, pinnacles, and towers; Alberti had used giant consoles (see fig. 20–17). Palladio conceived the notion of two interlocking Corinthian temple porticos, one tall and slender with engaged columns, the other low and broad with pilasters. His solution worked so well and became so well known that it could never be tried again without a charge of plagiarism. Visually, the relationships between the two dovetailing façades are a source of never-ending pleasure because of the alternation of low and high relief, flat and rounded forms. The interior (fig. 24–21) is a single giant story of Corinthian engaged columns, paired at the crossing with pilasters. Coupled Corinthian pilasters in depth sustain the nave arcade. With its contrast of stone and plaster, the interior is severely harmonious in its effect, needing no color to disturb the organic volumes and spaces.

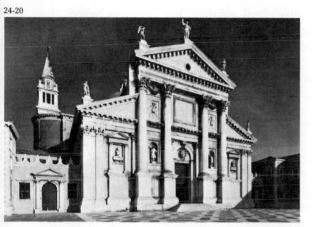

24-20. ANDREA PALLADIO. Façade, S. Giorgio Maggiore, Venice. Begun 1566

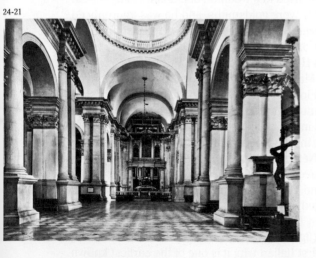

24-21. ANDREA PALLADIO. Interior, S. Giorgio Maggiore, Venice

CHAPTER TWENTY-FIVE

RENAISSANCE

Germany

In the fifteenth century, Germany followed at a certain distance the great innovations taking place in Italy and the Netherlands. But in the early sixteenth century, German painting (but not architecture or sculpture) moved to a commanding position, definitely surpassing that of the Netherlands in quality and inventiveness, competing with High Renaissance Italy, and at times influencing the greatest Italian masters. The sudden rise of the German School is no more surprising than its precipitate decline. All of the leading sixteenth-century German painters were contemporary with the Italian High Renaissance artists; in the second half of the century, no new artists appeared to replace them, and German art had passed its great moment.

Despite their mastery of the technique of oil painting, the Germans never understood the free Venetian interpretation of the medium or the Venetian range of coloring. Nor, try as they would, could they ever equal the Italians in their instinctive understanding of the beauty of the human body. The classical tradition had to be imported and was always ill at ease in a Northern environment. What the Germans did understand, and practiced with incomparable dexterity and expressive power, was line, which goes far back in the Germanic heritage and which more immediately was exemplified in the tradition of Flamboyant Gothic architecture and in the art of engraving, at which Martin Schongauer (see fig. 21–35) outshone his Italian contemporaries.

DÜRER The founder of the German High Renaissance was Albrecht Dürer (1471–1528), who, on account of the breadth of his knowledge and the universality of his achievements, is often characterized as a German Leonardo da Vinci. Yet he was not a scientific investigator in the manner of Leonardo; his research into perspective and the theory of proportion was wholly dedicated to artistic purposes. Born in the city of Nuremberg, he was raised in a tradition of craftsmanship—both his father and his maternal grandfather were goldsmiths, and he was apprenticed to a wood engraver. He shared, however, Leonardo's belief in the inherent nobility of art, which he endeavored to raise from its craftsmanly status in Germany to the almost princely level it had attained in High Renaissance Italy. He made two trips to Italy (1494–95 and 1505–7), visiting Mantua and Padua and staying for prolonged periods in Venice but never reaching Florence, with whose intellectual activities his interests would seem to have had much in common. In fact, he absorbed the scientific, above all the mathematical interests of the Italian Renaissance masters, especially of Mantegna and Leonardo, in his studies in proportion, enriching Italian theory with a close knowledge of the Netherlanders' command of every facet of the natural world. He, too, seems not to have shared the Italian fascination with human anatomy. For a while, during his second Venetian sojourn, his style grew softer and his colors freer in emulation of the aged Giovanni Bellini and the young Giorgione, but Dürer never outgrew his German linear heritage and soon returned to it.

His brilliant *Self-Portrait* of 1498 (fig. 25–1) shows the artist at twenty-seven, three years after his return from his first Italian trip; it is one of the earliest known independent self-portraits, and one of the finest ever painted. The artist shows himself attired in the piebald costume fashionable in the late fifteenth century

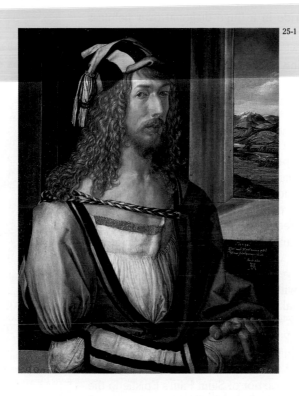

25-1. ALBRECHT DÜRER. *Self-Portrait.* 1498. Panel painting, 20½ × 16″ (52 × 40.6 cm). Museo del Prado, Madrid

(soon to be replaced by the sober dress of the High Renaissance), his gloved hands folded in aristocratic ease, his handsome face gazing out with calm self-possession from what appears to be a tower room, with a view over mountains and valleys. Despite the obvious Italianism of the pose, Dürer has not caught the secret of Italian form; we are everywhere conscious of lines and surfaces rather than of masses, even in the architecture. And what lines! Even Dürer's love for engraving is not enough to explain the intensity of the linear activity in the serpentine curls of the hair or in the twisted cord of the mantle whose every nuance is accurately recorded. Bellini, who was the only Venetian painter who really admired Dürer, asked him to paint something as a favor to him and wanted to see the special brush Dürer used to paint hair. It is a strange example of the fascination of a master who had freed himself from line for the style of one immersed in it.

But Dürer's greatest achievements were always in the realm of graphic art, which, in the manner of many ventures intended for the buyer of modest means, eventually made him rich. In the very year of this self-portrait he published his series of fifteen large woodcuts illustrating the Apocalypse (Revelation), with accompanying texts in Latin and German, bringing the technique of the woodcut to an unforeseeable level of virtuosity and expressive power. Unlike copper engraving (see page 618), in which the line is incised, woodcuts require the artist to draw his design in black on a block of wood, smoothed and painted white. All but the black lines are then cut away, leaving the lines standing in relief. A slip of the knife or the gouge cannot be repaired, so the technique requires extreme accuracy. Since in Dürer's time the blocks were printed by the same method as pages of type,

woodcuts could be reproduced at considerable speed, even as illustrations for printed books incorporated in a page of text. The accepted procedure utilized the relief lines as contours only; Dürer's refinement lay in his use of lines for shading, making them resemble the parallel hatching of copper engravings. Such a page as the *Four Horsemen of the Apocalypse* (fig. 25–2) shows the subtlety of shading Dürer was able to achieve in the changing tones of sky and cloud and the different methods of rendering shadow on flesh, hair, and drapery. The work derives its power from the energy of Dürer's design; the Four Horsemen—War, Conquest, Famine, and Death (Revelation 6:2–8)—ride in a huge diagonal over helpless humanity, drawn with a breadth of vision and a linear intensity that recall medieval art, yet fortified with the Renaissance knowledge of anatomy and drawing.

In the subtler medium of copper engraving, Dürer pushed the limits of the style even beyond those fixed by Schongauer. Dürer's *Adam and Eve,* of 1504 (fig. 25–3), shows his application of straight and curved hatching, cross-hatching, and stippling to Italian ideals of sculptural form and physical beauty, as well as to the menacing shadows of the forest. His interest in the religious subject seems secondary to his fascination with physical perfection; the nude classical figures were not drawn from life but constructed after many preliminary proportion studies. They nonetheless exist in a world of dangers, by no means limited to the serpent who brings Eve the fig. The sleepy cat in the foreground has not forgotten the mouse; the distant chamois on a crag contemplates the gulf before him. Adam still holds to a bough of the mountain ash, probably signifying the Tree of Life, on which a wise parrot sits and to which Dürer has tied a tablet seen in perspective, bearing his Latinized signature.

The three so-called Master Prints of the years 1513 and 1514 show, as Dürer intended they should, that he could achieve with copper results comparable to what the Netherlanders could do with oil or the Italians with fresco or with bronze. The *Knight, Death, and the Devil,* of 1513 (fig. 25–4), recalls Verrocchio's *Equestrian Monument of Bartolommeo Colleoni* (see fig. 20–65), which was under completion when Dürer first arrived in Venice. Dürer's knight sits on a charger whose muscles ripple with all the anatomical knowledge of the Italians, but Dürer has reinterpreted the image in the light of the Christian warrior of Saint Paul's Epistle to the Ephesians, 6:11: "Put on the whole armour of God, that ye may be able to stand against the wiles of the devil." Grimly, the knight rides through the Valley of the Shadow—tended by his faithful dog, impervious alike to Death, who shakes his hourglass, and to the monstrous Devil, who follows.

In contrast to the *Knight, Death, and the Devil,* which symbolizes the life of the Christian militant, *Saint Jerome,* of 1514 (fig. 25–5), a combined tribute to Italian perspective and Netherlandish light, depicts the existence of the Christian scholar. The saint is shown in his study, deep in thought and in writing, with the instruments of knowledge, piety, and study arranged on the window ledge and table and hanging on the wall—a skull, books, a crucifix, a cardinal's hat, an hourglass, primitive prayer beads, scissors, letters, and a whisk broom—in an atmosphere so calm that both his tame lion and his dog are asleep. Reminiscent of Jan van Eyck's *Wedding Portrait* (see fig. 21–17) are the light from the bottle-glass window on the embrasure and the shoes put aside, for this too is holy ground.

The *Melencolia I,* also of 1514 (fig. 25–6), deals instead with the inner problems of the artist. The seated winged genius, invested with all the grandeur of Michelangelo's sibyls, symbolizes a special kind of Melancholy that afflicts creators; with burning eyes in a shadowed face, she sits among the useless tools of architecture, draftsmanship, and knowledge—plane and saw, a ruler, a hammer, compasses, a rhomboid, a book, a crucible, a ladder to nowhere, a tablet on which all the numbers add up to thirty-four whether one reads them vertically, horizontally, or diagonally, a chipped millstone, a silent bell, an empty purse, a sleeping dog, a child writing aimlessly, and the keys to nothing—all signifying the brooding sadness that overcomes the artist in the absence of inspiration. Her label is borne aloft by a bat

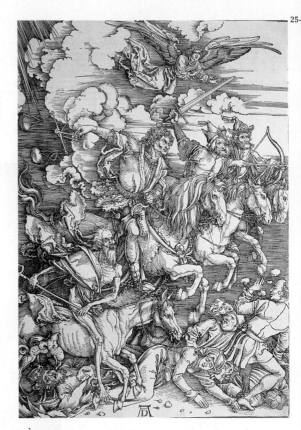

25-2. ALBRECHT DÜRER. *Four Horsemen of the Apocalypse,* from the *Apocalypse* series. c. 1497–98. Woodcut. British Museum, London

25-3. ALBRECHT DÜRER. *Adam and Eve.* 1504. Engraving. Courtesy, Museum of Fine Arts, Boston. Centennial Gift of Landon Clay

25-4. ALBRECHT DÜRER. *Knight, Death, and the Devil.* 1513. Engraving. Courtesy, Museum of Fine Arts, Boston

25-5. ALBRECHT DÜRER. *Saint Jerome.* 1514. Engraving. British Museum, London

25-6. ALBRECHT DÜRER. *Melencolia I.* 1514. Engraving. The Metropolitan Museum of Art, New York. Harris Brisbane Dick Fund, 1943

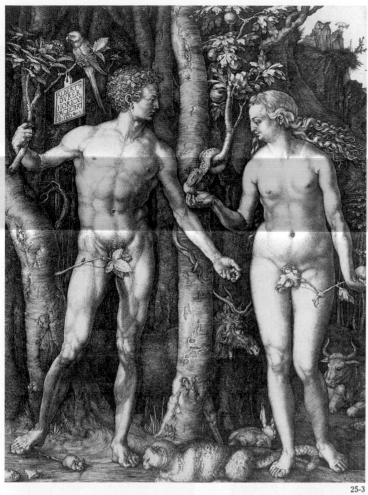

25-3

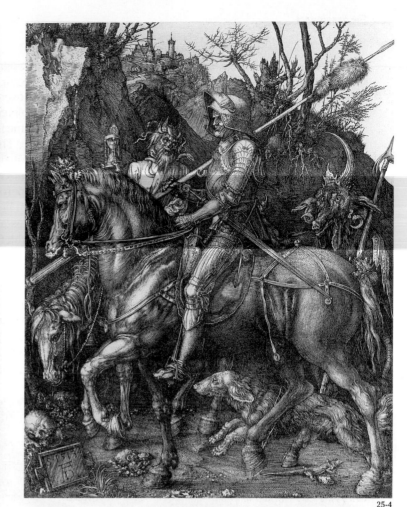

25-4

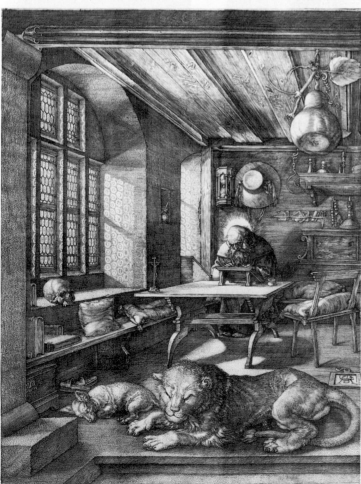

25-5

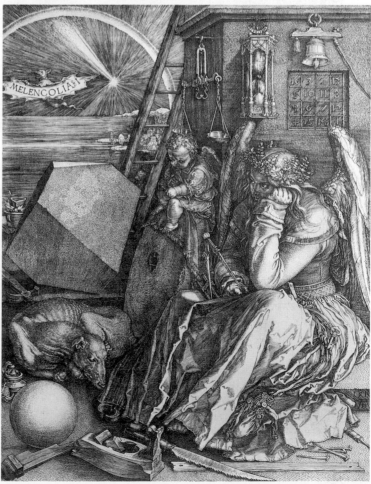

25-6

below a comet and a lunar rainbow. In all three of these autobiographical works Dürer—in middle life—has shown an hourglass half run out.

On occasion Dürer could lift painting to the level of his beloved engraving. A glorious example is the *Adoration of the Trinity* (fig. 25–7), completed in 1511 for a chapel dedicated to the Trinity and All Saints in a Nuremberg home for twelve aged and poor citizens (in commemoration of the Twelve Apostles). The lovely landscape at the bottom of the picture encloses a tranquil harbor, probably symbolic of the home. Most of the picture is occupied by a heavenly vision: God the Father, enthroned upon a rainbow and robed and crowned as an emperor, upholds the crucified Christ against his resounding blue tunic while the green lining of his gold mantle is displayed by angels; above, the Holy Spirit appears as a dove, and on either side angels with softly colored wings hold the symbols of the Passion. To the left, kneeling and standing female martyrs, many recognizable through their symbols, are grouped behind the Virgin; to the right, Old Testament prophets flank John the Baptist. The lowest rank of floating figures includes, apparently, portraits of many still alive at the time Dürer painted the picture—popes (including the bearded Julius II), a cardinal, emperors, kings, and common folk; among them at

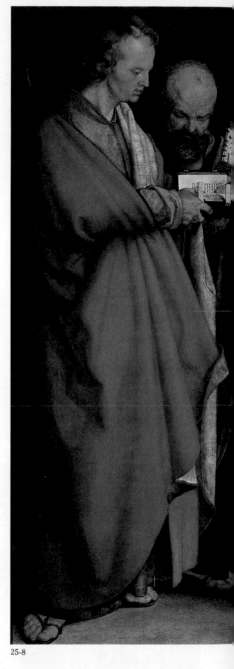

25-8

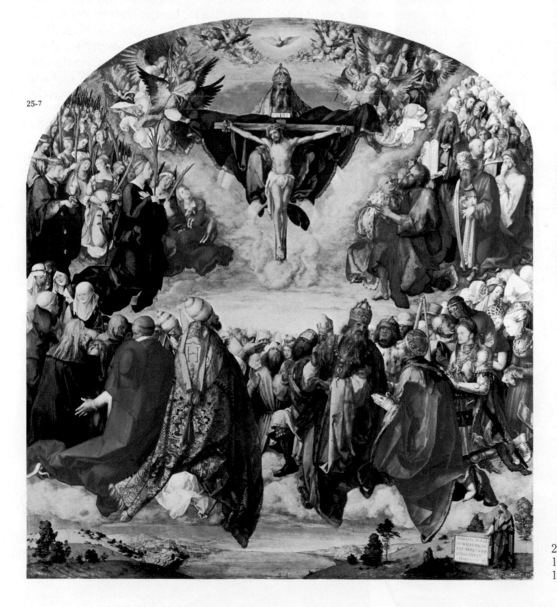

25-7

25-7. ALBRECHT DÜRER. *Adoration of the Trinity.* 1508–11. Oil on panel, 53⅛ × 48⅝″ (1.35 × 1.24 m). Kunsthistorisches Museum, Vienna

the extreme left, bearded and with long blond locks streaming over his shoulders, kneels Matthaeus Landauer, one of the two patrons of the chapel. On the ground below, Dürer himself exhibits his usual tablet with its Latin inscription. It has been claimed that the picture is based on Saint Augustine's conception of the City of God, existing throughout all time, partly on earth and partly in Heaven. In its spectacle of blazing reds, yellows, blues, and greens, the *Adoration of the Trinity* can stand as one of the most beautiful religious visions of the Renaissance.

Dürer's last major work is the diptych now known as the *Four Apostles* (fig. 25–8), a misnomer since it represents not only the Apostles John and Peter, to the left, but also Mark, who was not an Apostle, and Paul, who only became one after Christ's death and his own conversion. These paintings were originally intended as wings for an altarpiece, whose central panel, a Madonna and Child with Saints, was never painted because the rising tide of Protestantism, which Dürer himself eventually embraced, rendered such a picture impossible in Nuremberg in 1526. Dürer presented his panels to the city, supplying them with inscriptions from Luther's translation of the New Testament that warn all who read them not to mistake human error for the will of God. Dürer had taken his position along with Luther, against papal supremacy on the one hand and on the other against Protestant extremists who advocated radical experiments ranging from polygamy to a kind of communism and who instigated the Peasants' War (1524–25). The professional calligrapher who wrote the inscriptions recalled later that Dürer intended his "Four Apostles" to typify the four bodily liquids or humors—sanguine, phlegmatic, choleric, and melancholic—believed to govern the four major psychological human types. When all is said and done on this complex subject, what remains are four forthright figures of extraordinary grandeur, summing up better than anything else Dürer achieved all he had learned from the tradition of Giotto, Masaccio, Michelangelo, and Raphael.

GRÜNEWALD About Dürer's greatest German contemporary we know far less—neither the date of his birth (he died in 1528, the same year as Dürer) nor, until the

25-8. ALBRECHT DÜRER. *Four Apostles.* c. 1526. Panel painting (diptych), each wing 84½ × 30″ (214.6 × 76.2 cm). Pinakothek, Munich

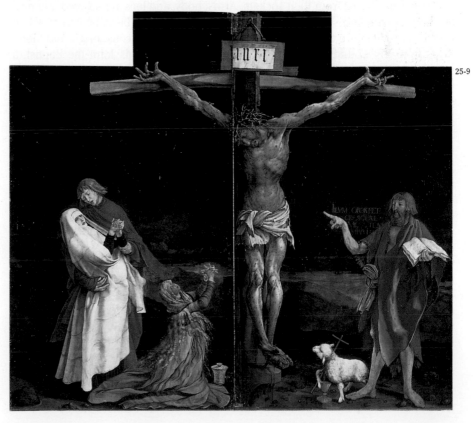

25-9

25-9. MATTHIAS GRÜNEWALD. *Crucifixion,* view of the center panel of the *Isenheim Altarpiece* (closed). c. 1512–15. Oil on panel, 8′10″ × 10′1″ (2.7 × 3.1 m). Musée Unterlinden, Colmar

present century, his real name. He was listed as Matthias Grünewald by the German writer Joachim von Sandrart in the seventeenth century, and the misnomer stands through long usage. His actual surnames were Gothardt and Neithardt. The leading humanist, Melanchthon, three years after the artist's death ranked him second only to Dürer among German masters. He may have been born in Würzburg, and worked for a while in Aschaffenburg. He was also an architect and hydraulic engineer, and remained for many years in the service of the prince-bishop of Mainz. He never went to Italy. Unlike the aristocratic Dürer, Grünewald was implicated in the Peasants' War and had to flee to Halle in Saxony, where he died. Since few of the early documents, listing only a certain Master Mathis, can be securely connected with him, guesses concerning his birthdate range from 1455 to 1483. Since the dated pictures are all within the sixteenth century, the latter date is probable.

Grünewald's greatest work is the *Isenheim Altarpiece*, probably begun in 1512 and finished in 1515 for the church of the Hospital of Saint Anthony in the Alsatian hamlet of Isenheim near Colmar, where Schongauer had lived and worked. It is a creation of such shocking intensity that many are repelled by it, yet the central *Crucifixion* (fig. 25–9) is one of the most impressive and profound images of the culminating tragedy in the life of Christ. The altarpiece was hinged originally in three layers, each containing pictures and sculptures (by another master) to be displayed at different seasons of the Christian year. The *Crucifixion* is on the outermost wings, visible when the altarpiece is closed. Few monumental representations make any real attempt to show the horror of the event, which is strange because devotional literature, particularly during the fifteenth and sixteenth centuries, was by no means so reticent.

Grünewald has shown the Cross as two rough-hewn logs, still green, the crossbar drawn down by its dreadful weight. Christ has already expired in agony. Rigor mortis has set in; his fingers are frozen in a clutching position. The crown of thorns is a fearsome bunch of brambles, beneath which the face, contorted with pain, is greenish gray in death. The weight of the tormented body has drawn Christ's arms almost from their sockets. Arms, body, and legs are scarred and torn by the scourges and studded with thorns, as if Christ had been beaten by thorn switches. His feet are crushed together by a giant spike. Viscous, bright red blood drips from his wounds. Below the Cross on the right stands John the Baptist, a blood-red cloak thrown over his camel skin, and above his pointing arm his words (John 3:30) appear: "He must increase, but I must decrease."

The Lamb of God stands below, a chalice to his wounded breast. On the left Mary Magdalene, in a transport of grief, has thrown herself at the foot of the Cross, and John the Evangelist, also in blood red, holds the swooning, death-pale Virgin. This is one of the earliest nocturnal *Crucifixions*; over distant hills the sky shows greenish black. While the horror of the scene can be traced to a current in German popular art and literature reaching as far back as the violent expressionism of German medieval works, the emphasis on the most physically repulsive details is traceable to the fact that this masterpiece was intended for a hospital church, where patients were brought before it in order to realize that Christ understood their torments because he had suffered as they did. Only thus can we explain that Christ's loincloth is made of the old torn linen used for bandages and that Mary Magdalene's jar of ointment appears in the painting, although it relates to a much earlier scene in Christ's life. The genius of Grünewald lies in his ability to raise mere horror to the level of high tragedy and so to unify deformed and broken shapes that the final composition is as beautiful as the greatest Italian work of the High Renaissance. The diagonals of the arms, for example, seem to erupt from the volcanic body as if in a gesture of self-immolation, linking the Cross to the inner angles of the T-shaped segments of the frame. These diagonals bind together all the other forces of the composition, sustaining by their positive strength the diagonals of the collapsing group at the left, of the ominous gesture of John the Baptist, and of

the low-lying, distant hills. The final image is one of absolute unity and monumental grandeur.

Once the doors are open (the joint runs next to Christ's right flank), the tones of greenish black and blood red are transformed to flame red, gold, and blue (fig. 25–10). The left panel is the *Annunciation,* which shows the angel appearing to Mary in a chapel whose Gothic vaults and tracery are drawn and painted with the understanding of a trained architect. The Bible is open at Isaiah's prophecy and the Prophet himself appears in the vault above in the midst of a vinescroll in reference to another biblical passage (Isaiah 11:1): "And there shall come forth a rod out of the stem of Jesse, and a Branch shall grow out of his roots." Mary turns in terror while the angel in his flame-colored cloak points to her with the same gesture used by John the Baptist toward the crucified Christ. Above Mary floats the dove of the Holy Spirit in a thin film of mist.

The central panel shows Mary caring for the Christ Child in the manner of a nurse for a patient before a richly carved and painted portico, symbolizing the Temple, in and before which several angels play on Renaissance viols and a viola da gamba as others sing, and a crowned saint (Catherine?) kneels in an aureole of flame. Mary holds her Child—in torn linen rags—whom she has taken from a cradle. A wooden tub covered by a towel and a perfectly recognizable chamberpot (surely its only appearance in Christian iconography) show again that Christ in his humanity took upon himself *all* the indignities of humanity. Yet in the heavens, far above a mass of glittering Alpine summits, the immaterial, ultimate Deity shines on his luminous throne, sending down tiny ministering angels through the blue clouds. Along with Grünewald's intensity of expression went a freedom of brushwork and color inaccessible to the tense and intellectual Dürer.

The cycle culminates in the most astonishing *Resurrection* in Christian art, shown in the right panel. A storm wind seems to have burst from Christ's tomb, blowing off the lid and bowling over the guards, and a flamelike apparition emerges, iridescent in blue, white, red, and gold—his grave clothes transfigured, as the patient's bandages will be—against the blue-green night dotted with stars. In the midst of an aurora borealis of red and gold rimmed with green soars the snow-white Christ, his body utterly pure, his hair and beard turned to gold, his wounds changed to rubies, surely in reference to the words of Saint Paul (Philippians 3:21): "Who shall change our vile body, that it may be fashioned like unto his glorious body." The transformation is complete; agony and ugliness have been burned away in a vision of transcendent light.

ALTDORFER A painter of great imaginative powers, closer to Grünewald than to Dürer, was Albrecht Altdorfer, probably born about 1480 in Regensburg, a Bavarian city on the Danube River, where he lived and worked until his death in 1538. His special gift was for landscape; his most celebrated painting is the *Battle of Alexander and Darius on the Issus,* of 1529 (fig. 25–11), in which the defeat of Darius III at the hands of Alexander the Great in 333 B.C. is seen in the guise of a "modern" battle, such as the Battle of Ravenna in 1512 or that of Pavia in 1525, the first mass conflicts since late antiquity. In a picture only a little more than five feet high Altdorfer has painted so many soldiers that it would be a hopeless task to count them—doubtless there are thousands, yet they never repeat.

The picture is a complete about-face from the battle scenes by Paolo Uccello (see fig. 20–48) and Leonardo (see fig. 22–7), in which a small group of warriors pitted against each other forms the nucleus of the battle and symbolizes the whole. Altdorfer, by means of a lofty point of view as if he were in flight, has spread out before us entire armies, tides of soldiers glittering in steel armor—bristling with spears and flags—yet painted down to the last tent and the last helmet. The eye roams freely over a landscape surpassing in extent even those of Leonardo. We look over a city, castles, Alpine lakes, islands, a river delta, range beyond range—with always another row of peaks when we think we have seen the last—and finally

25-10. MATTHIAS GRÜNEWALD. *Annunciation; Virgin and Child with Angels;* and *Resurrection,* view of the *Isenheim Altarpiece* (open). Oil on panel, center 8'10" × 11'2½" (2.69 × 3.42 m); each wing approx. 8'10" × 4'8" (2.69 × 1.42 m). Musée Unterlinden, Colmar

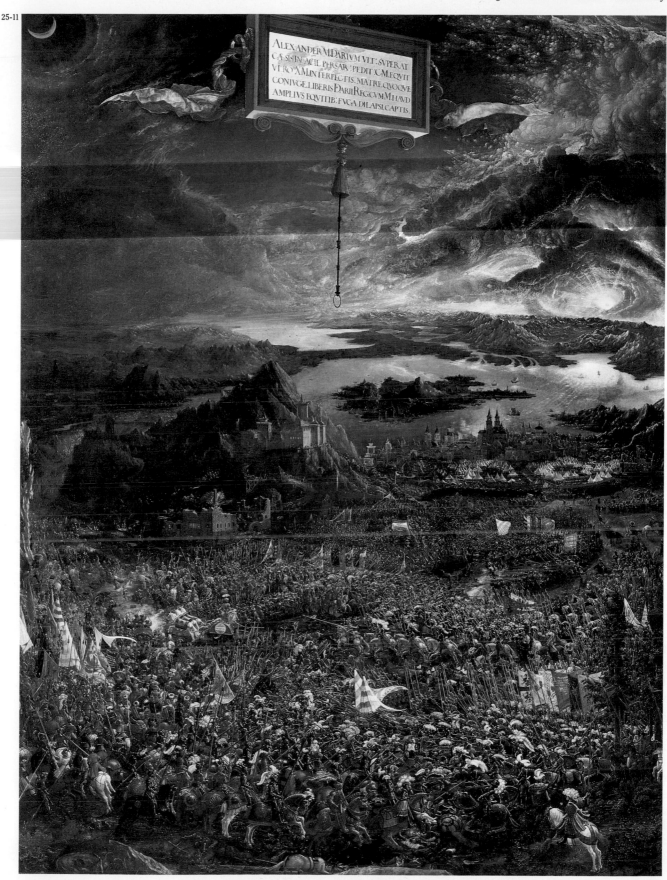

25-11. ALBRECHT ALTDORFER. *Battle of Alexander and Darius on the Issus.* 1529. Oil on panel, 62 × 47″ (1.58 × 1.19 m). Pinakothek, Munich

to the sun sinking in boiling clouds, which appear themselves to be in combat, and to the crescent moon rising on the upper left. The plaque with its lengthy Latin inscription and streaming drapery, like Dürer's tablets in perspective, floats as if by miracle. Altdorfer's panoramic vision, which could only have been obtained from a mountaintop, reveals even the curvature of the earth. The sparkling colors of the garments, caparisons, and flags give way before the green forests, the blue distance, and the blaze of orange and yellow in the stormy sunset.

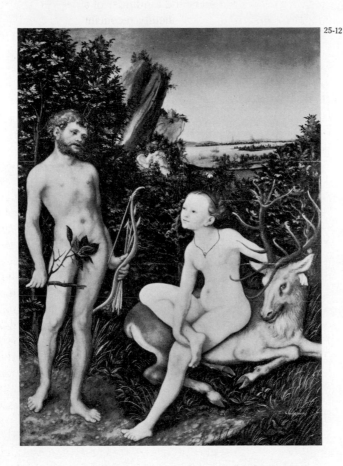

25-12

25-12. LUCAS CRANACH THE ELDER. *Apollo and Diana.* c. 1530. Oil on panel, 18½ × 13¾" (47 × 35 cm). Staatliche Museen zu Berlin— Preussischer Kulturbesitz

CRANACH A charming interlude in the study of the great German painters is offered by Lucas Cranach the Elder (1472–1553), a Protestant painter and friend of Luther, attached to the court of the elector of Saxony at Wittenberg. In collaboration with his sons and pupils, Cranach in a long and productive career turned out an astonishing number of agreeable paintings. He remained a provincial; although he accepted the frank sensuality of much of Italian Renaissance art, he had no interest in such arcane matters as classical literary texts or theories of harmonious proportion. His *Apollo and Diana* (fig. 25–12; though many Cranachs are undatable, this one was painted about 1530) should be compared with Dürer's elaborately constructed *Adam and Eve* (see fig. 25–3). Apollo is just a contemporary Saxon, beard and all, making up for his lack of clothes with a huge fig leaf and branch. A slinky Diana, cuddling her right foot above her left knee, perches on a patient stag. The specialty of Cranach and his shop was the contrast of flesh, at once soft and enameled, with shaggy, wild landscape, and in this they had no peer.

HOLBEIN The last great German painter of the High Renaissance was Hans Holbein the Younger (1497/98–1543); he was also one of the greatest portraitists who ever lived. He came from a family of Augsburg painters (his father, his uncle,

and his brother) but excelled them all. His wide travels included journeys in France and in north Italy, where he was deeply influenced by the works of Mantegna and Leonardo. Nonetheless, his artistic activity was almost entirely limited to the widely separated cities of Basel and London, the latter mostly after 1532, until his untimely death. From 1536 onward Holbein was the favorite painter of Henry VIII, who fitted up for "Master Hans" a studio in St. James's Palace. Although Holbein produced book illustrations by the hundreds, designs for stained glass, exterior frescoes (now lost) for houses in Basel, and a number of altarpieces, he is chiefly known for his portraits. At first he had difficulty reconciling a native interest in expressionistic wildness, in the tradition of Grünewald, with his careful study of Italian art, but by the mid-1520s the synthesis had been achieved, resulting in a style of cool reserve, total control of surface and design, and a neo-Eyckian concentration on the rendering of the most minute objects. The new style was stated in terms of enameled color and a linear accuracy in which he has never been equaled. It can be counted as perhaps Holbein's greatest achievement that he transformed the Germanic linear tradition, still untamed in Dürer, into his major instrument for the conquest of visual and psychological reality.

The *Madonna of Burgomaster Meyer* (fig. 25–13), painted in 1526, is an early triumph of Holbein's mature style. As originally set up on the altar of the chapel of the burgomaster's castle, Gundeldingen, near Basel, the painting lacked the most distant female figure in profile, a portrait of the donor's first wife, who had died in 1511, represented with her jaws bound in death. Neither this inconvenient insertion nor the still later addition of a third kneeling woman could disturb Holbein's sense of design; he was able to work both easily into the composition. The gracious Madonna and Child, the Italianate niche, and the charming portraits of Meyer's adolescent son and nude baby boy are quite Leonardesque, but in the delineation of contour, so sensitive that it picks up the slightest nuance of form, Holbein displays the phenomenal accuracy of his vision. The flow of the Virgin's fingers, the rendering of the foreshortened left arm of the Child, and the searching definition of the burgomaster's features are the achievements of this linear analysis. Holbein went out of his way to exhibit his virtuosity in the rendering of the Oriental rug, rumpled so that every variation of its pattern had to be separately projected in perspective. By 1531, alas, the picture had become a funerary monument, for both the burgomaster and his sons were dead.

Another tour de force is the splendid *French Ambassadors,* painted in London in 1533 (fig. 25–14), representing the emissaries Jean de Dinteville and Georges de Selve full-length and life-size, flanking a stand on which, along with the inescapable Oriental rug, are exhibited geographical, astronomical, and mathematical instruments, an open book of music, and a lute with one of its strings broken, all seen in flawless perspective. Holbein distills the quintessence of his subjects' characters all the more effectively in that no slightest change of expression is allowed to disturb the cool faces. The green damask curtain, the white fur, and the inlaid marble floor are all rendered with Holbein's characteristic steely control. The startling object in the foreground is a systematically distorted death's head, with which Holbein has toyed in fascination with the fact that his name means "hollow bone," or "skull."

In England Holbein painted an extensive series of portraits of Henry VIII, four of his six wives, scores of his courtiers, and many German merchants of the Steel Yard, a German enclave in London; we also know of a life-size group portrait, now lost, of the king surrounded by courtiers. In their quiet strength Holbein's English portraits are so compelling as to enhance our feeling that we know the unpredictable monarch and his contemporaries. His Germanic feeling for linear pattern has adorned the ceremonial portrait of the king (fig. 25–15), dating from 1539–40, with an endless interlace of damask, embroidery, and goldsmith work, but this is only a frame for the royal face, drawn in all its obesity yet endowed with demonic intensity of will. We can only mourn the fact that "Master Hans" did not survive to leave us portraits of Queen Elizabeth I and her brilliant court.

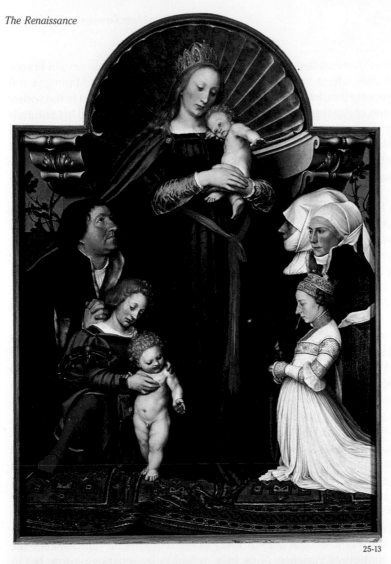

25-13

25-13. Hans Holbein the Younger. *Madonna of Burgomaster Meyer.* 1526. Panel painting, 56¾ × 39¾" (1.44 × 1.01 m). Schlossmuseum, Darmstadt

25-14. Hans Holbein the Younger. *French Ambassadors.* 1533. Panel painting, 6′9⅛″ × 6′10¼″ (2.06 × 2.09 m). National Gallery, London. Reproduced by courtesy of the Trustees

25-15. Hans Holbein the Younger. *Portrait of Henry VIII.* 1539–40. Oil on panel, 32½ × 29½" (82.6 × 75 cm). Galleria Nazionale d'Arte Antica, Rome

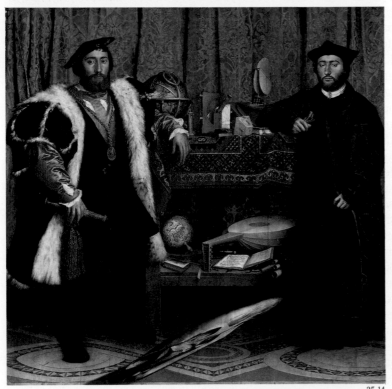

25-14

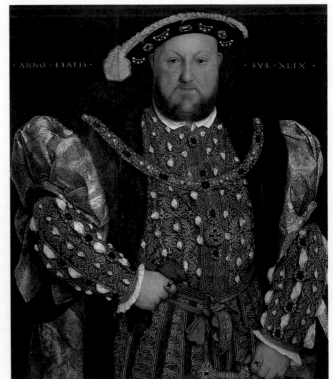

25-15

France

In sixteenth-century France there were no artists of the stature of Jean Fouquet or Enguerrand Quarton; nonetheless, the total picture of artistic activity at the courts of Francis I (ruled 1515–47) and Henry II (ruled 1547–59) offers a fascinating spectacle of artificial elegance. Francis, who greatly admired the achievements of the Italian Renaissance, tried to coax one Italian master after another to his court; as we have seen, Leonardo spent the last two years of his life in France, and at one time Michelangelo seriously considered accepting the king's invitation. However intensely Francis may have thirsted for the Italian Renaissance, what he eventually got was Mannerism. Benvenuto Cellini spent several years in his service, and Rosso Fiorentino and a lesser, decorative artist, Francesco Primaticcio, who had worked from Giulio Romano's designs at the Palazzo del Te in Mantua, carried out the king's ambitious projects.

The best portraitists at Francis's court were, nonetheless, French, and the most important one was JEAN CLOUET (c. 1485–1541), whose stiff and formal likenesses of the king may have influenced the visiting Holbein. Although Clouet cannot be ranked with the leading Italian or German masters, his characterization of the self-indulgent, calculating monarch, whose Don Juanism was notorious, in a portrait painted between 1525 and 1530 (fig. 25–16) is keen and unsparing. Especially effective is the concentration of all the stripes and brocade patterns of the costume into a vortex, focused on the king's left hand, which nervously toys with his poniard.

The decorations in stucco and fresco for Francis I's palace at Fontainebleau, unfortunately much repainted, rank among the richest of Mannerist cycles. A detail from the room of the king's mistress, the Duchesse d'Étampes, stuccoed and painted in the 1540s (fig. 25–17) by FRANCESCO PRIMATICCIO (1504–70), indicates the character and aesthetic level of this court style. It is as though something of the spirit of Flamboyant Gothic architecture and decoration still lingered on in France to transform, willy-nilly, the imported Italian style. The Mannerist figures, with their leg-crossed poses and sly concealment of some parts while exhibiting far more, form an endless pattern of modeled plaster decoration that eclipses the paintings. This one discloses Alexander the Great in amorous dalliance with the fair Campaspe while Apelles stands at his easel, busily recording the scene for Francis and his mistress. Male and female stucco nudes, at which Primaticcio excelled, intertwined with garlands of fruit in Mannerist luxuriance, almost overwhelm the actual painting.

Despite Francis I's incessant wars with the emperor Charles V and his disastrous attempts to claim the thrones of Naples and Milan and suzerainty over the southern Netherlands, his reign was prosperous, and he and his court built a chain of opulent châteaus along the Loire River in which were imaginatively combined the French Gothic heritage and Italian ideas. Chambord (fig. 25–18) is the most formidable example. Begun in 1519, the immense château has a central block with round corner towers clothed with a screen architecture of Renaissance pilasters in three stories; its plan is related to ideas developed by Leonardo for the dukes of Milan and may have issued from the mind of the aged genius then still living at nearby Cloux, although a model was provided by Domenico da Cortona, a pupil of Giuliano da Sangallo. The central block of the château, far larger than one would suspect from a photograph, is divided into self-sufficient apartments, each concentrated on a corner tower and entered from a central double staircase, whose flights are so intertwined that pedestrians going up can only hear but not see those coming down. The southern outer walls and corner towers were not completed. The native French style conquered in Chambord in an eruption of dormers, ornamented chimneys, and openwork turrets stemming directly from the Gothic tradition; in the lovely light of the Loire Valley, the two opposites coexist in an enchanting harmony.

A style at once wholly French and wholly Renaissance did not develop in

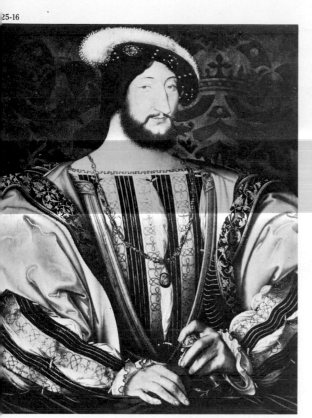

25-16. JEAN CLOUET. *Portrait of Francis I.* 1525–30. Tempera and oil on panel, 37¾ × 29⅛″ (96 × 74 cm). Musée du Louvre, Paris

25-17. FRANCESCO PRIMATICCIO. *Apelles with Alexander the Great and Campaspe.* Stucco and painting. 1540s (restored in the 18th century). Chambre de la Duchesse d'Étampes, Château of Fontainebleau, France

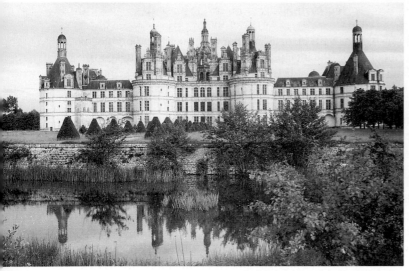

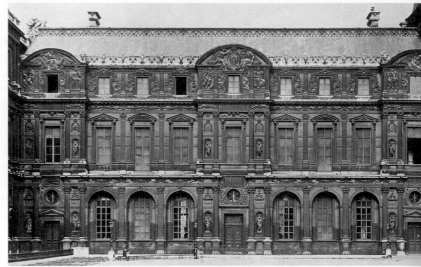

25-18 25-19

architecture and sculpture until midcentury in the Square Court of the Louvre, Paris (fig. 25–19), begun in 1546, the last year of Francis's reign, by the architect PIERRE LESCOT (1510–78) and the sculptor JEAN GOUJON (c. 1510–68). Given the northern climate, steep roofs and large windows were necessities, but these are not the only French features; the façade is punctuated by pavilions, recalling the towers of château architecture, which are crowned by arched pediments and linked by curtain-walls, rather than being a block as in the Italian manner. The pavilions project only slightly, but their dominance is underscored by the pairing of engaged Corinthian columns in contrast to the single pilasters that emphasize the transitory character of the connecting walls. In the final analysis the effect is Gothic. The sculptures in the niches and the rich reliefs of the attic story are of a type by no means unknown in Italy (see Sansovino's Library of San Marco, for example; fig. 24–17), but such decorative work on Italian palazzo exteriors was more commonly painted in fresco, and little has survived. The style of Goujon is seen at its best in the turning and twisting figures from his now-dismantled *Fountain of the Innocents,* of 1548–49 (fig. 25–20). The clinging drapery is probably derived from Roman models. But the figures, whose poses are certainly inspired by Italian Mannerism, are in the last analysis Goujon's own. Supple, graceful, moving with fluid ease in nonexistent spaces, these lovely creatures are supremely French, foreshadowing in their diaphanous beauty the widely divergent arts of the Rococo and Neoclassicism.

25-18. Château of Chambord, France. Begun 1519

25-19. PIERRE LESCOT and JEAN GOUJON. Square Court (Cour Carrée), the Louvre, Paris. Begun 1546

25-20. JEAN GOUJON. *Nymphs,* from the *Fountain of the Innocents* (dismantled). 1548–49. Marble reliefs. Musée du Louvre, Paris

25-21. GERMAIN PILON. *Deposition.* Bronze relief. c. 1580–85. Musée du Louvre, Paris

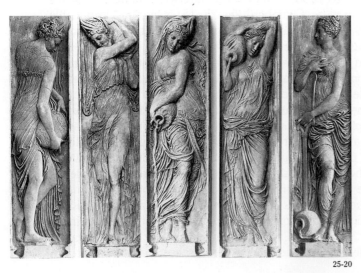

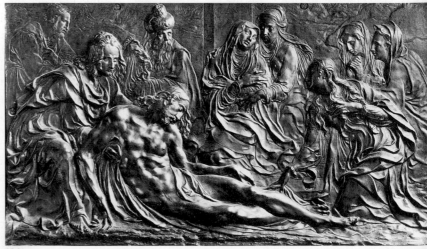

25-20 25-21

The linearity of the French Renaissance takes on an unexpected expressive intensity in the sculpture of GERMAIN PILON (c. 1535–90), whose grim tombs at Saint-Denis are less interesting than some of his relief sculpture, such as the bronze *Deposition,* of about 1580–85 (fig. 25–21). Not the lines alone, as in the work of Goujon, but entire surfaces and underlying masses of figures and drapery heave and flow as if molten. It is this inner movement, together with the striking freedom of the poses, rather than the somewhat standardized facial expressions that act as a vehicle for emotion.

The Netherlands

The reversion of Burgundy to the French crown and the Netherlandish provinces to the Holy Roman Empire after the Battle of Nancy in 1477 had slight effect on the school of painting that had developed in the Netherlands under Burgundian sovereignty. Far more important were the tides of religious reform throughout the Netherlands in the sixteenth century, especially in the northern provinces. Before the abdication of Emperor Charles V in 1558, rule over the Netherlands, as well as Spain, had been given to his fanatical son Philip II, and massive tyranny, including the Inquisition, had been imposed upon the Netherlands. The response of the Protestants, commendable enough insofar as it was directed toward political and religious freedoms, also took the less agreeable form of iconoclasm, and thousands of paintings and sculptured images were destroyed; in 1566 the *Ghent Altarpiece* had a narrow escape. The southern provinces, which today constitute Belgium, were pacified in 1576, but in 1579 the Union of Utrecht forged the northern provinces into the nucleus of present-day Holland, whose independence was assured early in the seventeenth century.

Little by little the novelty of the Netherlandish discovery of reality wore off. Although there were many competent painters in the opening decades of the sixteenth century, all were working more or less along lines laid down by van Eyck, van der Weyden, and van der Goes. Inevitably, Italian influence crept in, and just as inevitably it was misunderstood. Little wonder that when Dürer—a German master—visited the Netherlands in 1520 he was hailed as a messiah. Rather than discussing conservative or Italiante works, it seems preferable to underscore what was original and new in Netherlandish art in the early sixteenth century: an increased sensitivity to the moods of nature.

GOSSAERT Jan Gossaert (c. 1478/88–1532), who eventually signed himself Mabuse, after his native town of Maubeuge, visited Italy in 1508–9 and later won Vasari's approval as the first Netherlander to compose with nude figures in the Italian manner. In 1517 his allegiance was still so uncertain, however, that he copied a famous early work by Jan van Eyck. Gossaert's special ability to render the effects of space and light is seen at its best in the *Agony in the Garden* (fig. 25–22), whose composition is indebted to a celebrated one by Mantegna, which Gossaert doubtless saw in Italy; he transformed it by his new and magical rendering of moonlight and clear night air. Christ kneels, as in Luke 22:42–43:

> *Saying, Father, if thou be willing, remove this cup from me: nevertheless not my will, but thine, be done.*
> *And there appeared an angel unto him from heaven, strengthening him.*

The angel hovers in the moonlight, against the dark blue sky with its shining clouds; moonlight touches the edges of the rocks and the chalice (the "cup") together with the host of the Eucharist, dwells on the violet tunic of Christ, touches the face of Peter, shines on the armor of one of the soldiers, but leaves the ominous Judas among the soldiers on the right in shadow. Jerusalem looms in the distance, dim and foreboding.

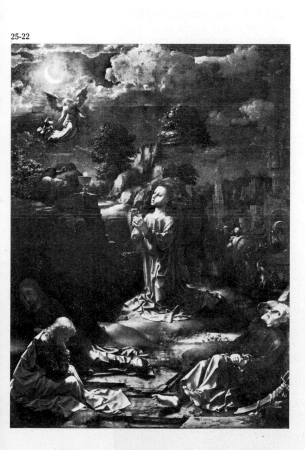

25-22

25-22. JAN GOSSAERT (Mabuse). *Agony in the Garden.* c. 1510. Panel painting, 33½ × 24¾″ (85 × 63 cm). Staatliche Museen zu Berlin—Preussischer Kulturbesitz

PATINIR A special kind of romantic landscape was invented by Joachim Patinir (active 1515–24); his *Saint Jerome* (fig. 25–23), of about 1520, shows the typical wild landscape forms in which he specialized. Saint Jerome in the Wilderness was a frequent subject in the second half of the fifteenth century in Italy, but Patinir's interpretation is his own. The figure of Saint Jerome merely establishes an ascetic mood for the wild landscape background, seen from a high vantage point. The towering, jagged rocks, introduced for expressive purposes, seem more invented than real, understandably considering the flat fenland in which Patinir lived. Invariably in Patinir's landscapes the foreground is dominated by brown, the middle distance by green; the rocks are blue-gray; and a dark blue storm, generally raging in the distance, sends the crags into bright relief. The broad sweep of Patinir's landscapes emancipates them almost entirely from the ostensible subject; only after experiencing their immensity does one think to look for hermitages, travelers, and the meditating saint.

BRUEGEL The one Netherlandish master of universal importance in the sixteenth century was Pieter Bruegel the Elder (c. 1525/30–1569). He may have been born near 's Hertogenbosch, the home of Hieronymus Bosch; deeply influenced by both Bosch's pessimism and his fantasy, he turned out a number of designs for engravings on Bosch-like themes. He spent the years between 1551 and 1555 in Italy, going as far south as Sicily, and brought back wonderful drawings of mountainous landscapes he had traversed on his journey. As for the lessons of Italian art, always dangerous for a Northerner, Bruegel mastered them in their essence. Rather than adopting Italian nude figures, which always seem to shiver in the North, he interpreted the message of Italy as a harmony of form and space, and remained as strongly Netherlandish in his outlook and subject matter as before his trip.

Bruegel's love for the beauty of south Italian landscape prompted the blue harbor and silvery cliffs of his *Landscape with the Fall of Icarus,* of about 1554–55 (fig. 25–24). Icarus, who against the advice of his father, Daedalus, flew so high that

25-23. JOACHIM PATINIR. *Saint Jerome.* c. 1520. Panel painting, 14⅛ × 13⅜″ (36 × 34 cm). National Gallery, London. Reproduced by courtesy of the Trustees

25-24. PIETER BRUEGEL THE ELDER. *Landscape with the Fall of Icarus.* c. 1554–55. Panel painting (transferred to canvas), 29 × 44⅛″ (73.7 × 112 cm). Musées Royaux des Beaux-Arts de Belgique, Brussels

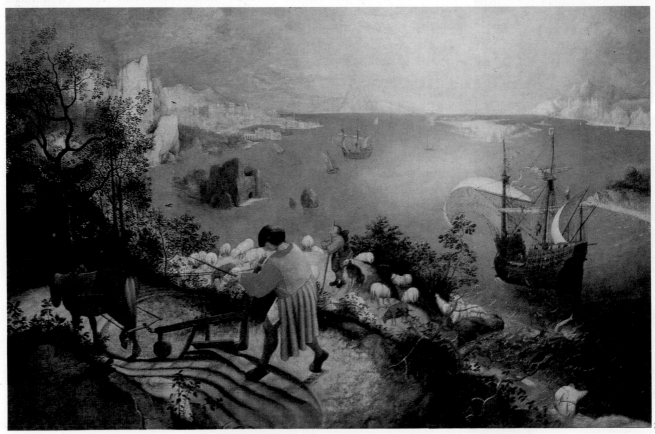

the wax that held the wings to his body was melted by the sun, had appeared from time to time in Italian art not only as a symbol of overweening ambition but also because his depiction gave the artist an opportunity to display anatomical knowledge of a body in flight or falling. Bruegel instead concentrates on the farmer plowing furrows behind his horse in a foreground field high above the sea, on a singing shepherd, and on a galleon with bellying mainsail and lateen buffeting the whitecaps in a stiff breeze. It takes a moment to find Icarus; only his waving legs are still out of water. No one pays his tragedy the faintest attention. An old Netherlandish and German proverb maintains that "when a man dies no plow stops." That brings us to the widely held belief that Bruegel belonged to a circle of Antwerp humanists who maintained that man is driven to sin by foolishness, and that he is bound to the inevitable cycle of nature, from which it is folly to attempt escape. With his vision liberated by the wide landscape prospects of Patinir, Bruegel was able to project the monumentality of Italian art in Netherlandish terms. The plowman's ancestry can be traced from Michelangelo, through Masaccio, back to Giotto; however, he remains Netherlandish all the while.

About 1561–62 Bruegel painted the devastating *Triumph of Death* (fig. 25–25), a barren landscape of dead trees, burning cities, and sinking ships in which no one will survive. An amorous couple make music, with Death looking over their shoulders; a feast is overturned by Death, who assails kings and cardinals; on a pale horse he mows down the living with his scythe. The chanting monks turn out to be skeletons; corpses hang from gallows, are stretched on wheels for the ravens to eat, and float bloated upon the sea. Those who remain alive are driven toward a gigantic coffin, whose end is lifted open like a trap; it is guarded by phalanxes of skeletons defending themselves with shields. Although the Dance of Death was a subject favored by sixteenth-century artists for woodcuts (Holbein, for example), never in a single painting had such a remorseless panorama of human mortality been attempted.

25-25. PIETER BRUEGEL THE ELDER. *Triumph of Death.* c. 1561–62. Panel painting, 46 × 63¾″ (1.17 × 1.62 m). Museo del Prado, Madrid

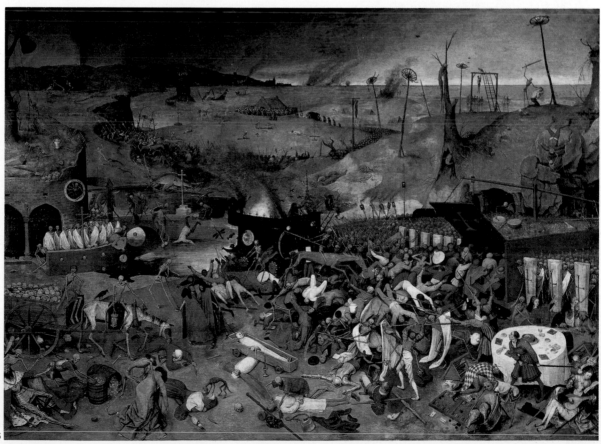

25-25

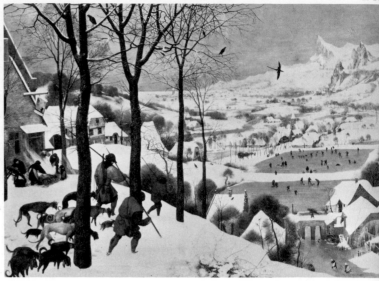

To Bruegel the peasant was an especially attractive subject because he typified the acceptance of man's link with the earth and with the cycle of the turning year. Five remaining paintings belong to a series that Bruegel made to illustrate the labors of the months, as in the calendar scenes of the *Très Riches Heures* (see figs. 21–5, 21–6). The picture signed and dated in 1565 called the *Harvesters* (fig. 25–26) represents July or August. A sky veiled in summer heat-haze extends over harvested fields and those still to be cut. The heads of plodding peasants are scarcely visible above the standing grain. Under what shade a tree can give on such a day, other peasants eat bread (made, doubtless, from the grain they raised last year), porridge, and fruit. One, his breeches loosened, his stomach distended, sleeps off the meal. A companion piece, the *Hunters in the Snow*, also from 1565 (fig. 25–27), represents January or February. The world is covered with snow, against which are silhouetted the weary hunters returning to the village and their pack of dogs with drooping tails. Below the village skaters move over the frozen ponds. A crane flies above, lending greater distance to the Alpine peaks. Never again in Netherlandish art is there anything to equal the simple humanity of Bruegel's peasants or the breadth and dignity of his landscape. The fatality that binds man and nature is stoically accepted, and in this acceptance Bruegel is able to communicate an unexpected peace.

25-26. PIETER BRUEGEL THE ELDER. *Harvesters.* 1565. Oil on panel, 46½ × 63¼″ (1.18 × 1.61 m). The Metropolitan Museum of Art, New York. Rogers Fund, 1919

25-27. PIETER BRUEGEL THE ELDER. *Hunters in the Snow.* 1565. Oil and tempera on panel, 46½ × 63¾″ (1.18 × 1.62 m). Kunsthistorisches Museum, Vienna

Spain

Under Charles V, who lived by preference in Spain and considered himself Spanish, the Holy Roman Empire dominated most of Europe and almost all of the known New World. Under his son and successor, Philip II, who governed Spain, southern Italy and Sicily, and the Netherlands, Spanish rule of Central America and much of South America was consolidated. Intense devotion to the Counter-Reformation may have played a part in blinding the Spanish conquerors to the value of the indigenous culture of Central America and South America; they totally destroyed it with the same abandon with which they mutilated or slaughtered local populations all the way from Peru to the Mississippi Valley. The leaders of the Spanish Inquisition burned heretics publicly and routinely in Spain as *autos-da-fé* ("acts of faith") and repressed both Calvinist belief and nationalist political movements in the Netherlands. In spite of splendid art collections formed by his father and extended by Philip himself, artistic life in Spain remained provincial. In the fifteenth century, Spanish art was dominated by the influence of the Netherlandish masters, and in the sixteenth by the Italians. Yet Spain still produced some remarkable works of Renaissance architecture, marked by a special taste for austerity and rigidity. The spiritual aspect of the Counter-Reformation was led by such ardent souls as Saint Theresa of Avila and Saint John of the Cross, and provided a fertile

terrain for the amazing development of El Greco, one of the leading creative geniuses of the entire Western tradition.

THE ESCORIAL The finest and also the largest Renaissance building in Spain is the Escorial (fig. 25–28), built at the command of Philip II in fulfillment of his father's charge to erect a "dynastic pantheon" for the Spanish Habsburgs. The immense structure, in open pastureland on a grand slope some thirty miles northwest of Madrid, with the Guadarrama range in the background, therefore combines palace, monastery, church, and mausoleum. Started by Juan Bautista de Toledo in 1563 and continued by his assistant Juan de Herrera until 1584, the building displays as much the desires and tastes of the king, who gave explicit directions and followed the construction closely, as it does the style of any architect. The monastery was dedicated to Saint Lawrence, on whose day Philip had won a victory in France, and the plan is that of the gridiron on which the saint was martyred. Although supplied with corner towers, the building was not fortified. Its austere grandeur symbolizes rather the king's determination to support the Counter-Reformation by all psychological as well as material means. The Escorial marks the triumph, indeed, of sixteenth-century absolutism in both religious and secular spheres.

The local granite used for construction, hard and intractable, was perfectly suited to the design. A church façade based on Roman Mannerist prototypes, severely simplified, as compared with the almost contemporary façade of Il Gesù in Rome, and restricted to an Ionic temple superimposed on a Doric lower story, provides the only real interruption in the monotonous succession of identical small windows piercing the seemingly endless exterior walls. Save for the heaviness of its architectural members, whose coupled Tuscan columns embrace large arched windows, the crowning dome looks very Roman. The severity of the building comes to a climax in the interior of the church (fig. 25–29), designed and built by Herrera after Juan Bautista's death. A single colossal Doric order, classically correct but without any of the resiliency of Italian architecture, is enriched by no decoration what-

25-28. JUAN DE HERRERA (begun by JUAN BAUTISTA DE TOLEDO). The Escorial, Madrid. 1563–84

25-29. Interior of the church, the Escorial, Madrid

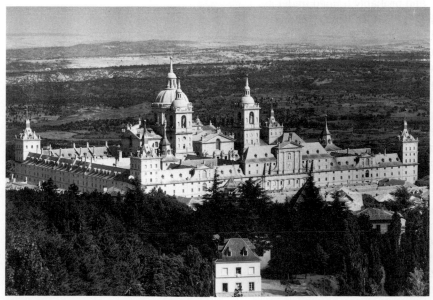

25-28

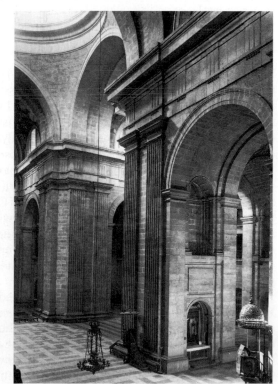

25-29

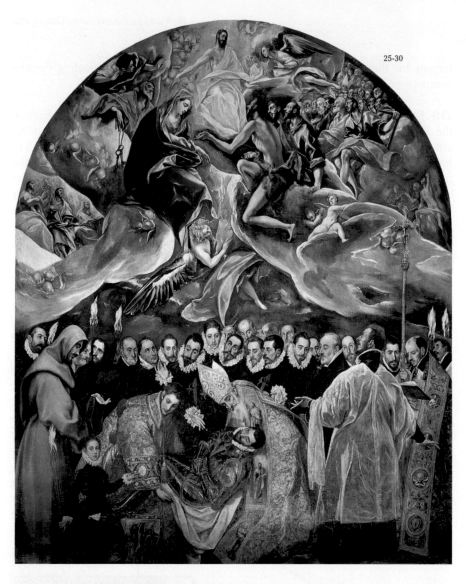

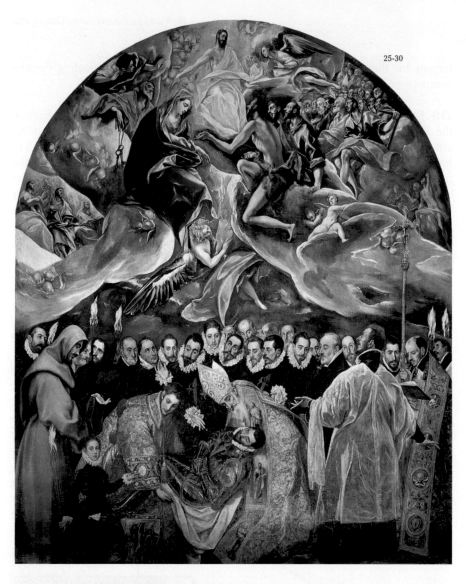

25-30. El Greco. *Burial of Count Orgaz*. 1586. Oil on canvas, 16′ × 11′10″ (4.88 × 3.61 m). S. Tomé, Toledo, Spain

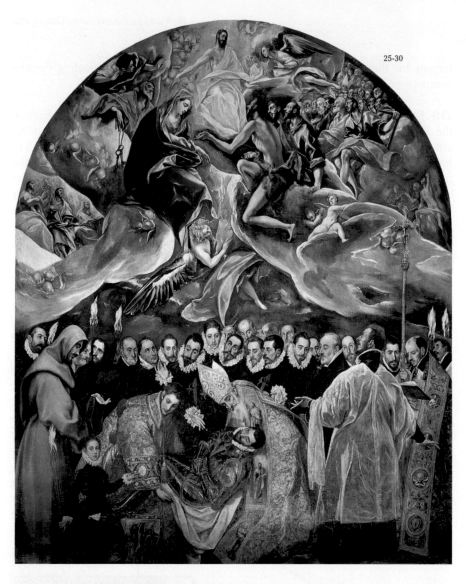

soever, and designed on so impersonal a scale that one realizes with a shock its actual colossal dimensions.

EL GRECO Domenikos Theotokopoulos (1541–1614), generally known as El Greco, was born in Crete, then a Venetian possession, and probably trained under icon painters still working in the Byzantine style. In 1567 he went to Venice, where a small group of Greek painters was active in translating compositions by Venetian masters from Giovanni Bellini to Tintoretto into Byzantine style for the local Greek colony. During his stay in Venice El Greco absorbed from the great Venetian masters their whole range of luminary and coloristic achievements and every nuance of their brushwork. After a Roman sojourn during the 1570s, he arrived in Spain in 1576, where, in the heady atmosphere of Counter-Reformation mysticism, his work took fire. It was as if, under the new religious inspiration, he were suddenly able to re-create on a contemporary plane the splendors of Byzantine art. Undeniably, the Byzantine spirit remains in his work; in a sense he may be thought of as the last and one of the greatest of Greek painters, the heir of the rich Byzantine pictorial tradition.

In the *Burial of Count Orgaz* (fig. 25–30), painted in 1586, El Greco's synthesis of Venetian color, Spanish mysticism, and the Byzantine tradition is complete. The subject is the interment in 1323 of a nobleman who had lived a life of such sanctity that after his death Saints Stephen and Augustine came down from Heaven to lay his body reverently in the tomb. El Greco has shown the burial in the lower half of the picture as if it were taking place in his own time. The priest on the far right

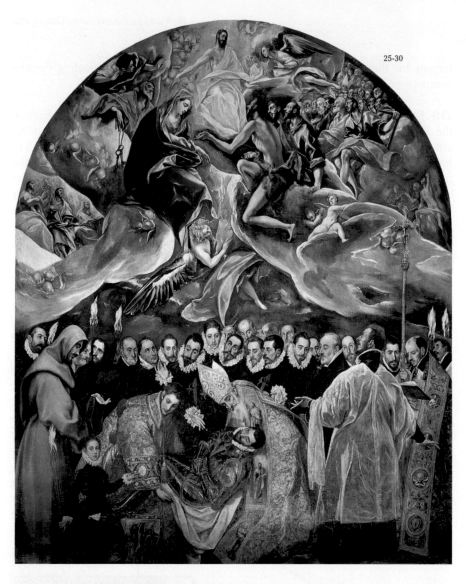

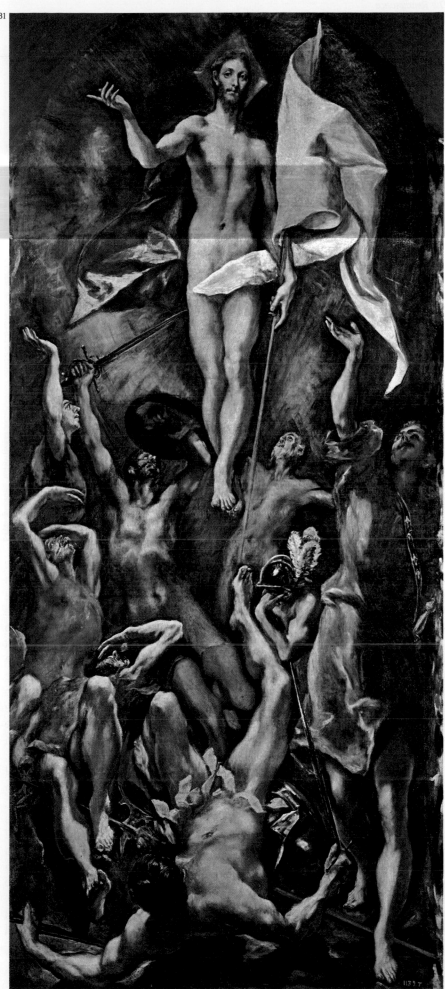

25-31. EL GRECO. *Resurrection.* c. 1597–1604.
Oil on canvas, 9′1¼″ × 4′2″ (2.75 × 1.27 m).
Museo del Prado, Madrid

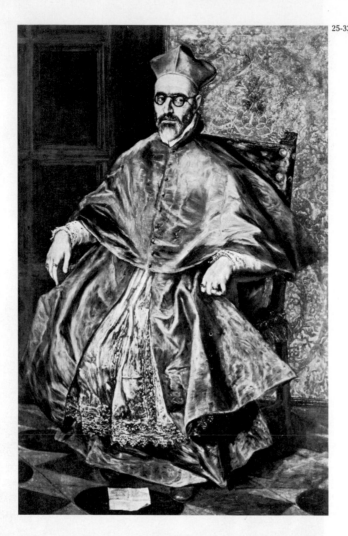

25-32

25-32. El Greco. *Grand Inquisitor Don Fernando Niño de Guevara.* c. 1600. Oil on canvas, 67½ × 42½″ (1.72 × 1.08 cm). The Metropolitan Museum of Art, New York. Bequest of Mrs. H. O. Havemeyer, 1929. The H. O. Havemeyer Collection

reading the committal office and the solemn-faced Spaniards of all ages have accepted the miracle calmly. The black sixteenth-century costumes contrast with the splendor of the priest's cope, embroidered in gold, and with the sparkle of the white-and-gold damasks of the saints. These and the myriad reflections on the polished steel armor with its bands of gilded ornamentation are painted with a brushwork and quality of light that equal the highest Venetian achievements. But the upward glance of the central mourner and the pose and gesture of the priest in a surplice at the right draw our attention upward to an even greater miracle: the clouds of Heaven have descended close above the heads of the living and have divided to allow an angel to transport the tiny cloudy soul of the count toward the Deësis above—Mary and Saint John the Baptist fairly near us, but Christ more remote, and robed in snowy white. Here and there, vortices filled with saints open in the clouds, and frosty cloud banks pile up, within which crowd angelic heads. The figures have already begun to assume the attenuated proportions of those in El Greco's later work, and light, from no visible source, seems to originate from within the figures.

It makes no sense to talk of Mannerism in connection with El Greco; his profoundly spiritual art has nothing to do either with the first generation of Florentine and Sienese Mannerists or with the later art of Counter-Reformation Rome and grand-ducal Florence. It is an anachronistic and personal amalgam, an art period in itself, and it hardly survived the artist's death. El Greco's mystical late style is seen at its most exalted in his *Resurrection,* of about 1597–1604 (fig. 25–31), in which Christ soars above us against a background of night, acting as a magnet that pulls upward the surrounding figures—drawn out to unbelievable lengths—of

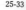

25-33. EL GRECO. *Toledo.* c. 1600–1610. Oil on canvas, 47¾ × 42¾″ (1.21 × 1.09 m). The Metropolitan Museum of Art, New York. Bequest of Mrs. H. O. Havemeyer, 1929. The H. O. Havemeyer Collection

the Roman soldiers in an ecstasy of pain. In contrast to Christ's body in Grünewald's *Resurrection* (see fig. 25–10), El Greco's Christ is more solid—white and glowing like the Eucharist in the light of an altar—his eyes looking calmly toward the observer. The Renaissance is now far behind us, but, as with the visionary late paintings of Tintoretto, El Greco does not lead toward the Baroque. The utter abandonment of physical reality in his personal and spontaneous surrender has nothing in common with the calculated art of the founders of the Baroque style in Italy.

Every few years one or another oculist announces with an air of discovery that El Greco's astigmatism was responsible for his figural distortions. His malady must have been widely shared, for his work was commissioned by every patron in central Spain who could afford it and was imitated, distortions and all, by a busy studio of pupils. His distortions were, moreover, abandoned at will when the subject required him to do so. His portrait of the *Grand Inquisitor Don Fernando Niño de Guevara* (fig. 25–32), painted about 1600, is naturalistically proportioned in the Venetian manner. The direct, piercing gaze, which makes one wonder how many heretics the Inquisitor has committed to the flames, the dry features, the grizzled beard, and the glasses are all rendered with the same close observation that picks up the nervous clutch of the jeweled fingers of the left hand on the arm of the chair. In the crimson tunic, however, El Greco let himself go in an outburst of lightning brushstrokes.

An astonishing production of combined mysticism and virtuosity is El Greco's compressed view of one section of his adopted city, Toledo, painted about 1600–1610 (fig. 25–33), all in greens, blue grays, black grays, and silver grays, looking as if light were glowing from within the grassy slopes and witches were riding through the wild clouds. Tiny washerwomen in the river and travelers on the road are hardly more than touches of the brush. On this otherworldy note we close the Renaissance, which had begun and continued in Italy with such noble ambitions and unbounded hopes for an idealized mankind and come to grief on the rocks of human frailty. In both its triumphs and its defeats the Renaissance, perhaps more vividly than any other period except the twentieth century, illustrates the unpredictable opposites of human character and destiny.

TIME LINE XI

Dome, Florence
Cathedral, by
Brunelleschi

David, by
Castagno

*Man in a
Red Turban*,
by Jan
van Eyck

*Miraculous
Draft of Fish*,
by Witz

	POLITICAL HISTORY	RELIGION, LITERATURE, MUSIC	SCIENCE, TECHNOLOGY
1400	Death of Giangaleazzo Visconti of Milan, 1402, removes threat to political independence of Florence Death of King Ladislaus of Naples, 1414, removes second threat to independence of Florence	Council of Constance, 1414–17, ends schism within Catholic Church Martin V reestablishes united Papacy in Rome, 1420 Leonardo Bruni (1369–1444) Joan of Arc (1412–31)	
1425	Battle of San Romano, 1432 Medici family dominates Florence, 1434–94	St. Antonine of Florence (1389–1459) Guillaume Dufay (c. 1400–74) *Il libro dell'arte* by Cennino Cennini, c. 1430 Council of Basel, 1431–49 Leonbattista Alberti writes *Della Pittura*, 1436	Prince Henry the Navigator of Portugal (1394–1460) promotes geographic exploration
	Habsburgs begin rule of Holy Roman Empire, 1438		
1440	Florence and Venice defeat Filippo Maria Visconti at Anghiari, 1440		Earliest record of suction pump, c. 1440
		Papacy of Nicholas V, 1447–55	
1450	Sforza family rules Milan, 1450–1535 Hundred Years' War ends, 1453 Constantinople falls to Turks, 1453	*De re aedificatoria* by Alberti, c. 1450 *On the Dignity and Excellence of Man* by Giannozzo Manetti, 1451–52 Papacy of Pius II, 1458–64 Giovanni Pico della Mirandola (1463–94) Marsilio Ficino (1433–99) translates Plato's works into Latin, 1463 (published 1484)	Paolo dal Pozzo Toscanelli (1397–1482), author of map used by Christopher Columbus Invention of movable type by printer Johann Gutenberg, 1454
	Brothers Giuliano and Lorenzo de'Medici rule Florence, 1469–78 Ferdinand and Isabella marry, uniting the Spanish Kingdoms, 1469		
1470	Pazzi conspiracy in Florence; Giuliano de'Medici assassinated, 1478; Lorenzo rules Florence, 1478–92	Josquin des Prés (c. 1450–1521) Papacy of Sixtus IV, 1471–84 Papacy of Innocent VII, 1484–92	
1480	Henry VII, first Tudor king of England (r. 1485–1509) Granada, last Muslim holding in Spain, falls to Spanish, 1492 Piero de'Medici flees unrest in Florence, 1494 John Cabot claims eastern North America for England, 1497	Papacy of Alexander VI, 1492–1503 *Ship of Fools* by Sebastian Brant, 1494 Girolamo Savonarola, (1452–98), reforming preacher, burned at stake for heresy in Florence	Bartholomew Diaz rounds Cape of Good Hope, 1487 Columbus lands in the West Indies, 1492

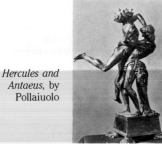

Hercules and Antaeus, by Pollaiuolo

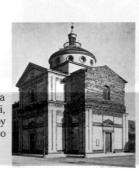

Sta. Maria delle Carceri, Prato, by G. da Sangallo

Madonna of the Rocks, by Leonardo

Nativity, by Geertgen

PAINTING, SCULPTURE, ARCHITECTURE

ITALY	NORTHERN EUROPE	
Ghiberti, Brunelleschi: competition reliefs for Baptistery doors, Florence	Sluter, portal and Well of Moses, Chartreuse de Champmol, Dijon	1400
Donatello, *St. Mark; St. George*	Boucicaut Master, *Hours of Boucicaut*	
Nanni di Banco, *Four Crowned Martyrs*	Limbourg Brothers, *Très Riches Heures*	
Brunelleschi, dome of Florence Cathedral begun; Ospedale degli Innocenti	Rohan Master, *Grandes Heures*	
Gentile da Fabriano, *Adoration of the Magi*		
Donatello, *Habbakuk; Feast of Herod*	Master of Flémalle, *Mérode Altarpiece; Nativity*	1425
Masaccio, frescoes, Sta. Maria del Carmine, Florence; *Enthroned Madonna and Child; Holy Trinity*	Hubert(?) and Jan van Eyck, *Ghent Altarpiece*	
Jacopo della Quercia, portal, S. Petronio, Bologna	Jan van Eyck, *Man in a Red Turban; Madonna of Chancellor Rolin; Wedding Portrait*	
Luca della Robbia, *Cantoria*		
Fra Angelico, *Descent from the Cross; Annunciation*		
	Van der Weyden, *Descent from the Cross; Last Judgment*	1440
Filippo Lippi, *Annunciation*	Witz, *Miraculous Draft of Fish*	
Donatello, *David; Gattamelata*	Lochner, *Presentation in the Temple*	
Michelozzo, Medici Palace, Florence		
Bernardo Rossellino, Tomb of Lionardo Bruni		
Uccello, *Battle of S. Romano; Deluge*		
Domenico Veneziano, *St. Lucy Altarpiece*		
Castagno, *Last Supper; David*		
Alberti, Palazzo Rucellai, Florence; Malatesta Temple, Rimini	Fouquet, *Melun Diptych; Chevalier Hours*	1450
Piero della Francesca, *Meeting of Solomon and Sheba; Resurrection*	Quarton, *Coronation of the Virgin; Avignon Pietà*	
Donatello, *Mary Magdalene*	Pacher, *Life of St. Lawrence* altarpiece	
Mantegna, frescoes, Church of the Eremitani, Padua	Bouts, *Last Supper*	
Antonio Rossellino, Tomb of the Cardinal of Portugal; *Giovanni Chellini*		
Verrocchio, *Doubting of Thomas*		
Pollaiuolo, *Battle of Ten Naked Men; Martyrdom of St. Sebastian; Hercules and Antaeus*		
Alberti, S. Andrea, Mantua	Schongauer, *Temptation of St. Anthony*	1470
Mantegna, frescoes, Palazzo Ducale, Mantua	van der Goes, *Portinari Altarpiece*	
Perugino, *Giving of the Keys to St. Peter*		
Botticelli, *Primavera; Birth of Venus*	Memlinc, *Shrine of St. Ursula*	1480
Ghirlandaio, *Birth of the Virgin*	Geertgen tot Sint Jans, *Nativity*	
Giovanni Bellini, *Transfiguration of Christ*	Dürer, *Self-Portrait*	
Leonardo da Vinci, *Madonna of the Rocks; Last Supper*		
Giuliano da Sangallo, Sta. Maria delle Carceri, Prato		
Signorelli, *Damned Consigned to Hell*		

TIME LINE XI

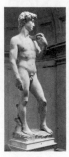

David, by
Michelangelo

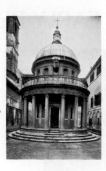

Tempietto,
Rome, by
Bramante

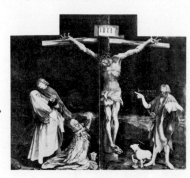

Crucifixion, by
Grünewald

*French
Ambassadors,*
by Holbein

	POLITICAL HISTORY	RELIGION, LITERATURE, MUSIC	SCIENCE, TECHNOLOGY
1500	Spain rules Kingdom of Naples, after 1504 Restoration of the Medici in Florence, 1512 Charles V, Spanish king, reigns as Holy Roman Emperor, 1519–56 Hernando Cortés conquers Aztec empire in Mexico for Spain, 1519–21 Henry VIII rules England, 1509–47	Papacy of Julius II, 1503–13 *In Praise of Folly* by Erasmus (1469–1536), 1509 Papacy of Leo X, 1513–21 Niccolò Machiavelli writes *The Prince,* 1513 Sir Thomas More writes *Utopia,* 1516 Martin Luther (1483–1546) posts 95 theses at Wittenberg, 1517	Paracelsus (1493–1541) opposes humoral theory of disease; crusades for use of chemicals in treatment of disease Balboa sights Pacific Ocean, 1513 Portuguese reach China, 1514; hold trade monopoly in the Far East until 1602 First circumnavigation of globe, by Magellan and crew, 1519–22
1520	Peasants' Revolt in Germany, 1524–25 Sack of Rome by Spanish and German mercenaries of Charles V, 1527 Medici power reestablished in Florence, 1530 Act of Supremacy adopted in England, 1534	Papacy of Clement VII, 1523–34 Baldassare Castiglione writes *The Courtier,* 1528 Papacy of Paul III, 1534–49 François Rabelais writes *Gargantua,* 1534 English Reformation begins, 1534	Copernicus refutes geocentric view of universe, 1530–43 Principle of triangulation in surveying discovered by Gemma Frisius, 1533
1535	Cosimo I de'Medici rules as duke of Florence, 1537–74 Ivan the Terrible rules Russia, 1547–84	St. Teresa of Avila (1515–82) John Calvin publishes *Institutes of the Christian Religion,* 1536 Society of Jesus founded by St. Ignatius Loyola and St. Francis Xavier, 1540 Council of Trent, 1545–63, undertakes reform of abuses and definition of doctrine in Roman Catholic Church	Andreas Vesalius writes *On the Structure of the Human Body,* first systematic treatise on human anatomy, 1543
1550	Wars of Lutheran vs. Catholic princes in Germany end in Peace of Augsburg, 1555, allowing each sovereign to decide religion of his subjects Charles V abdicates, 1556, and empire is divided; his brother Ferdinand I receives Habsburg lands; his son Philip II becomes king of Spain, the Netherlands, and the New World Elizabeth I rules England, 1558–1603	Giovanni da Palestrina (1525–94) Michel de Montaigne (1533–92) St. Charles Borromeo (1538–84) Miguel de Cervantes (1547–1616) Giorgio Vasari publishes *Lives of the Most Eminent Painters, Sculptors, and Architects,* 1550 Papacy of Paul IV, 1555–59 Benvenuto Cellini writes *Autobiography,* 1558–62 John Knox founds Presbyterian Church, 1560 Andrea Palladio publishes *Four Books on Architecture,* 1570	Georgius Agricola's *De re metallica,* a basic treatise on metallurgy and mining, published, 1556 Gerardus Mercator devises mercator projection for maps, 1569 Tycho Brahe observes supernova, in constellation Cassiopeia, 1572; accumulates accurate data on planetary and lunar positions and produces first modern star catalogue
1580	Northern provinces of the Netherlands declare independence, 1581 Spanish Armada defeated by English, 1588	William Shakespeare (1564–1616) Papacy of Sixtus V, 1585–90 Edict of Nantes, 1598, establishes religious tolerance in France Giordano Bruno (1548–1600)	Pope Gregory XIII introduces Gregorian calendar, 1582

HIGH AND LATE RENAISSANCE, AND MANNERISM

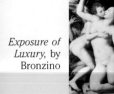

Exposure of Luxury, by Bronzino

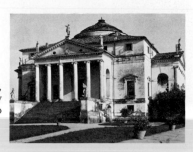

Villa Rotonda, Vicenza, by Palladio

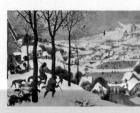

Hunters in the Snow, by Bruegel

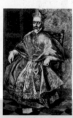

Grand Inquisitor, by El Greco

PAINTING, SCULPTURE, ARCHITECTURE

ITALY

Michelangelo, *David*
Leonardo da Vinci, *Madonna and St. Anne; Battle of Anghiari; Mona Lisa*
Raphael, *Marriage of the Virgin; Madonna of the Meadows*
Bellini, *Madonna and Child Enthroned*
Giorgione, *Enthroned Madonna; The Tempest*
Bramante, plan for St. Peter's; Tempietto, Rome
Michelangelo, *Sistine Ceiling; Slaves*
Raphael, *Disputa; School of Athens; Sistine Madonna; Galatea; Transfiguration*
Andrea del Sarto, *Madonna of the Harpies*
Titian, *Sacred and Profane Love; Assumption of the Virgin; Bacchanal; Pesaro Madonna*

Michelangelo, Medici Tombs; Laurentian Library, Rome; *"Crossed-Leg" Slave*
Rosso, *Descent from the Cross*
Pontormo, *Entombment*
Correggio, *Holy Night; Assumption of the Virgin; Jupiter and Io*
Parmigianino, *Self-Portrait*
Giulio Romano, frescoes, Palazzo del Te, Mantua

Michelangelo, *Last Judgment;* plan for Campidoglio, Rome, begun
Titian, *Venus of Urbino; Paul III and His Grandsons*
Bronzino, *Exposure of Luxury*
Sansovino, Library of San Marco, Venice
Tintoretto, *St. Mark Freeing a Christian Slave*
Cellini, *Perseus and Medusa*

Titian, *Rape of Europa; Crowning with Thorns*
Palladio, Villa Rotonda, Vicenza; S. Giorgio Maggiore, Venice
Michelangelo, *Rondanini Pietà*
Anguissola, *Portrait of the Artist's Sisters*
Tintoretto, *Crucifixion*
Ammanati, Courtyard of Palazzo Pitti, Florence
Vasari, Palazzo degli Uffizi, Florence
Vignola (interior), Della Porta (façade), Il Gesù, Rome

Fontana, *Christ and the Canaanite Woman*
Veronese, *Triumph of Venice*

EUROPE OUTSIDE ITALY

Bosch, *Crowning with Thorns; Garden of Delights* 1500
Gossaert, *Agony in the Garden*
Dürer, *Adoration of the Trinity; St. Jerome; Knight, Death, and the Devil; Melencolia I*
Grünewald, *Isenheim Altarpiece*

Patinir, *St. Jerome* 1520
Clouet, *Portrait of Francis I*
Dürer, *Four Apostles*
Holbein, *Madonna of Burgomaster Meyer*
Altdorfer, *Battle of Alexander and Darius*
Cranach, *Apollo and Diana*
Holbein, *French Ambassadors*

Holbein, *Henry VIII* 1535
Lescot, Square Court of Louvre, Paris, begun
Primaticcio, decorations, Fontainebleau
Goujon, *Fountain of the Innocents*

Bruegel, *Landscape with the Fall of Icarus; Triumph of Death; Harvesters; Hunters in the Snow* 1550
Herrera, Escorial

Pilon, *Deposition* 1580
El Greco, *Burial of Count Orgaz; Resurrection; Grand Inquisitor; Toledo*

PART SIX

The word *Baroque* is often claimed to derive from the Portuguese word *barocco,* of unknown origin, meaning "irregular" or "rough," used specifically to describe pearls of distorted shape. As originally applied to art the term conveyed the contempt felt by Neoclassicists of the late eighteenth century and early nineteenth century for what seemed to them exaggerated and perverse in the art of the preceding period. For about the last hundred years or so, the term, shorn like *Gothic* of any derogatory meaning, has been in general use to designate the architecture, painting, and sculpture of Western Europe and the Americas from about 1590 to 1750, a much briefer period than the Renaissance. The period had its own problems and its own goals, and it makes sense, therefore, to preface our study of this age's arts with a consideration of the general situation in which European humanity found itself about the year 1600.

By the end of the sixteenth century, the "discovery of the world and of man" had wrought fundamental changes in man's views of himself, of society, and of the Christian religion. The frontiers of the world known to Europeans had been extended during the Renaissance voyages of discovery to include much of the Americas, Asia, and Africa. European authority, established by force, held sway throughout many of the newly discovered regions. The Copernican view of the universe was empirically confirmed after Galileo's invention of the telescope in 1609, which extended man's intellectual frontiers into outer space. In spite of his trial by the Inquisition in 1633, it was only a matter of time before the Aristotelian system, which maintained that the earth was the center of the universe, would collapse.

The religious divisions of Western Europe were well-nigh complete. After the religious persecutions, expulsions, and wars of the sixteenth century were over, Spain, Portugal, France, Italy, and the provinces that today form Belgium remained Roman Catholic. England, Scotland, Scandinavia, most of the Swiss Confederation, and most of the area comprising modern Holland were solidly Protestant (with Catholic minorities). In spite of continuing warfare between Holland and Spain, there was little serious possibility of change in either religious camp. In central Europe wars, religious in origin but eventually political as well, raged until the Peace of Westphalia in 1648, which left, by and large, the Rhineland, Austria, Bohemia, Hungary, and Poland Catholic, and north Germany Protestant. Along with the victory of Catholicism in the Mediterranean and in central Europe and of Protestantism in the North came the triumph of absolutism almost everywhere. With the exceptions of Holland, Venice, Genoa, and Switzerland, medieval and Renaissance republics were dead.

After the artistic experiments and achievements of the Renaissance, no problems of representation or composition offered any serious difficulties to a diligent and properly trained artist. Academies were established in major European centers, and instruction in them and in artists' studios was thorough. The wide differences in national styles can no longer be explained in terms of stages in the conquest of reality or of changes in technical procedures but in the light of the demands made by patrons, religious or secular, actual or potential, and local traditions. Architecture, sculpture, and painting of a dramatic nature were powerful tools in the hands of religious and secular absolutism, and flourished in the service

of the Catholic Church and of Catholic monarchies. Protestant countries, on the other hand, had just completed an appalling destruction of religious images, including all Dutch religious painting of the Middle Ages and the Renaissance, and permitted no resurgence of pictorial imagery in their whitewashed church interiors. Even palace and villa architecture under Protestant monarchies was notably restrained, in England, for example, relying strongly on Italian Renaissance models, especially the buildings of Andrea Palladio, and only occasionally accepting elements from contemporary Continental currents. With rare exceptions, in Protestant countries painters were thrown on the open market, where they competed for the attention of prosperous middle-class buyers with scenes drawn from daily life, history, or the Bible, intended for homes rather than churches.

It may well be asked what it is that draws together these widely varying styles and tendencies. The key word is probably *allegiance*. The religious division of Europe had placed a new emphasis on the inner life of the individual, for which both Catholicism and the various Protestant sects competed. The religious wars of the sixteenth century, still ablaze in central Europe in the first half of the seventeenth, provided an object lesson in the dangers of dissent. In Catholic countries the punitive force of the Inquisition was supplemented by a more positive campaign to enlist and intensify personal conviction, for which there had been less need in the Middle Ages, when occasional serious heresy could be rapidly extirpated and a general unity of Catholic faith in the West was taken for granted. The decorations, the lighting, and even the shapes of Baroque churches and palaces were calculated for maximal emotional effect. Cities and towns were planned or replanned in order to impress not only the population but the visitor with the power of divine-right monarchy, and especially of the Church in Catholic countries. For this purpose Rome became, in the expression of the most ambitious of papal builders, Alexander VII (ruled 1655–67), a "theater."

Although religious outpourings on the order of those of the Counter-Reformation mystics were over, artists in every sphere turned toward these great figures of the recent past and contrived, so to speak, rationally planned stage sets for the experience of the irrational, so that the worshiper could achieve at least the illusion of that union with the Divine that had been granted to Saint Theresa, Saint John of the Cross, and other Catholic and also Protestant mystics of the sixteenth century.

Rather than the miracles of saints (as in medieval and Renaissance art), their martyrdoms, transmuted to heavenly bliss at the very moment of agonized death, and their ecstasies, interpreted as an earthly form of martyrdom, were the themes set before Baroque artists. The visual settings for divine-right monarchy in palaces, decorations, and festivals and in costumes, furniture, and carriages were conceived in the same climactic pattern. In Calvinist Holland, without either ecclesiastical or monarchical demand for art, the traditionally reverent Netherlandish approach to the most minute aspects of visual reality gave way to a climactic experience of natural forms, spaces, colors, and lights and the relationship between the observer and the literary or portrait subject in order to produce a strong, if muted, emotional experience. What unites the most disparate phases of the Baroque in European countries, therefore, is a common pattern of experience shared at all social levels by Catholic and Protestant alike.

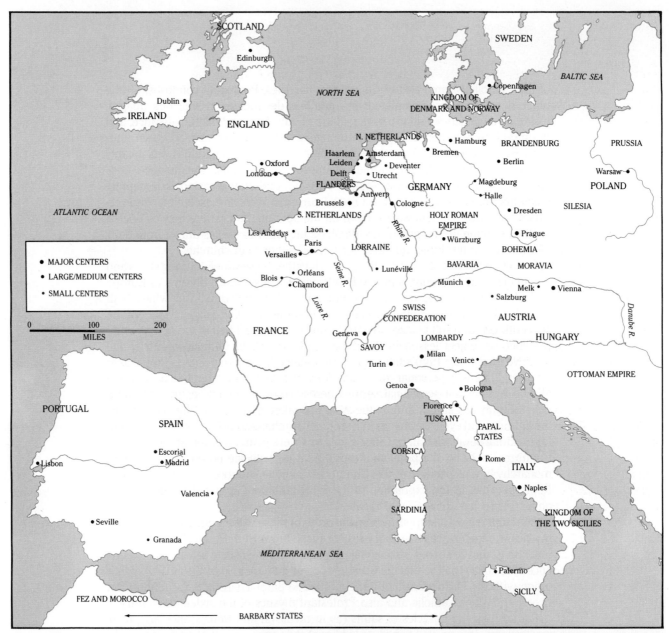

Map 19. EUROPE AT THE TIME OF THE PEACE OF WESTPHALIA (1648)

SEVENTEENTH CENTURY IN ITALY

The transformation from late Mannerism to Baroque took place toward the end of the sixteenth century in Rome, where the ground had already been prepared by the late architecture of Michelangelo and his pupils, especially in the new spaces and forms of Saint Peter's and Il Gesù (see figs. 23–8, 23–37). In the last decade of the century the presence of an extraordinary group of north Italian painters in Rome heralded the beginning of the new era and its expression in two strongly divergent styles. Within twenty years forms and images established in Rome began to be diffused throughout Western Europe, carrying the message of a humanity at ease with both its Christian religion and its classical heritage and conscious of newly revealed depths of inner experience.

THE CARRACCI The pioneers of Baroque monumental painting in Rome were the brothers Agostino and Annibale Carracci and their cousin Ludovico, all from Bologna, a city to the north of Florence across the Apennines with a long artistic tradition and a heritage of Renaissance masterpieces from other schools. Bologna was the northernmost city of the Papal States and had a direct cultural connection with the Eternal City. Annibale (1560–1609) was historically the most important artist of the Carracci family and artistically the most gifted. In Bologna in the 1580s all three Carracci had been instrumental in the formation of a new kind of renaissance—not a revival of classical antiquity nor a discovery of the world and of man (because the Renaissance had already achieved both) but a revival of the Renaissance itself on a new plane after the long Mannerist interlude. The Carracci aimed at a synthesis of the vigor and majesty of Michelangelo, the harmony and grace of Raphael, and the color of Titian, less through direct imitation of these High Renaissance artists than through emulation of their method of idealizing nature. It will hardly be surprising to learn that this academic attempt at the revival in the 1580s of the situation prevailing in 1510 was connected with the Academy of Bologna, in whose life the Carracci played an important part.

The first major undertaking of Baroque painting in Rome was the Gallery (or formal reception hall) of the Palazzo Farnese, painted almost entirely by Annibale Carracci in 1597–1600 (the vault) and 1603–4 (the side walls). The frescoes were commissioned by Cardinal Odoardo Farnese, son of Alessandro Farnese, late duke of Parma, and great-great-grandson of Paul III, the Farnese pope painted by Titian (see fig. 24–9). The ceiling frescoes (fig. 26–1) adopted from the Sistine Ceiling (see fig. 22–16) such ideas as large scenes, small scenes, apparently real seated nudes, and simulated marble architecture and both marble and bronze sculpture. But these were organized according to a new principle in the illusionistic tradition of Mantegna (see fig. 20–71) and Correggio (see fig. 23–19). The simulated architecture applied to the barrel vault (and at times piercing it) is "sustained" by the simulated sculptural caryatids that, along with the "real" youths, flank pictures incorporated into the structure. Four additional paintings with gilded frames, one at each end of the vault and one at each side, are made to look as if they had been applied later by their overlapping of the architecture and their covering up of parts of the medallions. The complex layer of forms and illusions comes to a climax in the central scene.

A recent study has shown that the subject matter, the Loves of the Gods, on the face of it incompatible with the ecclesiastical status of the patron, is by no means so frivolous as the decorations of the Palace of Fontainebleau (see fig. 25–17) and veils a deeper, Christian meaning that accounts for the complex organization and for the central climax. In summary, the four smaller lateral scenes represent incidents in which the loves of gods for mortals were accepted, the two horizontal

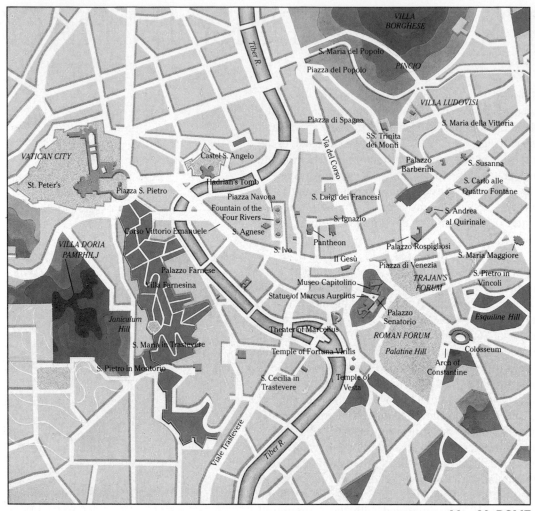

Map 20. ROME

framed pictures those in which mortals refused, the two end ones (of which only one lunette may be seen in the photograph) the disastrous love of the one-eyed Cyclops Polyphemus for the nymph Galatea, and the central panel the Triumph of Bacchus and Ariadne. This central scene is flanked by Mercury and Paris and by Pan and Selene. With its buoyant composition in which the chariots of the god and the mortal he redeemed from despair are borne along in splendid procession, accompanied by deities and Loves and victorious over all obstacles, the central scene explains the extraneous framed pictures and justifies the four unframed lateral scenes. The entire complex structure of eleven scenes thus symbolizes the Triumph of Divine Love, although in physical form. After the Mannerist interlude of public prudery and private prurience, it is typical of the new Baroque attitude that a cardinal could commission a monumental Christian interpretation of ancient erotic myths. Even more, it is essential for our understanding of the Baroque that divine love, conceived as the principle at the heart of the universe, should be the motive power that draws together all the elements of the ceiling and resolves all conflicts in an unforeseeable act of redemption.

At the time it was painted, the Farnese Gallery was widely proclaimed as a worthy sequel to the Sistine Ceiling and the paintings in the Vatican Stanze by Raphael. While few today would place it so high, it is a superb creation, whose full beauty can be experienced only by the observer in the actual room. Seventeenth-century viewers were delighted by the coloring of the shadows, which eliminated

26-1. ANNIBALE CARRACCI. Ceiling fresco (detail), Palazzo Farnese, Rome. 1597–1600

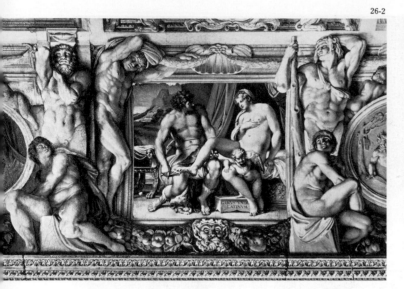

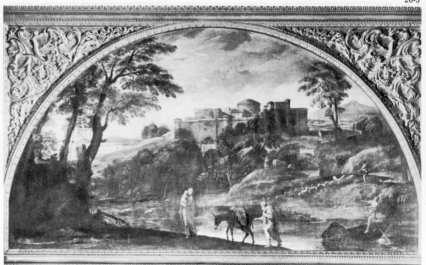

black, and they testified to their difficulty in distinguishing reality from representation. No wonder, because "real" and "sculptured" figures are expertly foreshortened, and the light, coming from windows along one side of the room, casts their shadows onto the surrounding elements. The love of Anchises for Venus, whom he is in the last stages of disrobing before their union, which was to produce Aeneas, ancestor of the founders of Rome, is typical of the directness of the representations and the physical abundance of the figures (fig. 26–2). In the experience of the entire work the weight of the figures is carried easily along by the energy and gay coloring of the whole. Both the substance and the drive of the Farnese Gallery proved definitive for most other ceiling compositions of the seventeenth century, and for Baroque monumental painting in general, especially the work of Peter Paul Rubens (see pages 802–7), profoundly influenced by Annibale's style.

In addition to the principles of ceiling painting, Annibale established a new type of landscape with figures, in such works as his *Landscape with the Flight into Egypt*, of about 1603–4 (fig. 26–3). Although the tiny scale of the sacred figures in relation to the vastness of the landscape may recall Patinir (see fig. 25–23), there are two important differences. First, the high point of view has been abandoned so that the figures are on a level with the observer and, second, the landscape is no longer fantastic but based on a real one, in this case the actual surroundings of Rome—the Tiber, a fortified village, and the distant Alban Hills. The landscape in this painting, as almost always in the seventeenth century, was derived from studies made outdoors but was constructed in the studio.

OTHER BOLOGNESE PAINTERS IN ROME A conservative solution to the problem of ceiling painting was offered by GUIDO RENI (1575–1642), whose *Aurora* (fig. 26–4), painted in 1613 for the ceiling of a garden house behind the Palazzo Rospigliosi, could as easily have been designed for a wall. As the chariot of Apollo, radiant with light, surrounded by dancing Hours, preceded by Cupid with a torch and by Aurora, goddess of the dawn, rolls away the clouds of night over the distant landscape, one can hardly help thinking of Raphael. While in no sense a copy, the Cupid is based on the three winged Loves in the *Galatea* (see fig. 22–33), and Aurora herself is close to the angels at the upper left in the *Disputa* (see fig. 22–28); the spiral construction of all the figures is obviously Raphaelesque. But the freshness and luminosity of the picture are new, and so indeed is its subject. The swift pursuit of darkness, the moment of revelation in light were vital for Baroque subjects and for Baroque style.

26-2. ANNIBALE CARRACCI. *Venus and Anchises* (detail), ceiling fresco, Palazzo Farnese, Rome. 1597–1600

26-3. ANNIBALE CARRACCI. *Landscape with the Flight into Egypt.* c. 1603–4. Oil on canvas, 48¼ × 98½″ (1.23 × 2.5 m). Galleria Doria Pamphili, Rome

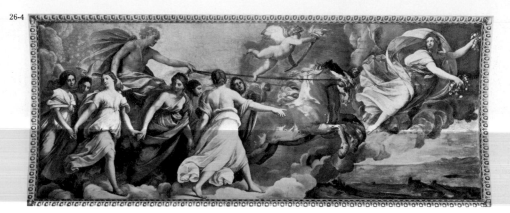

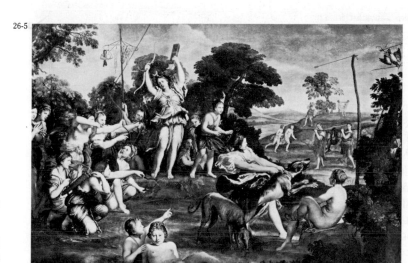

26-4. GUIDO RENI. *Aurora*, ceiling fresco, Casino Rospigliosi, Rome. 1613

26-5. DOMENICHINO. *Hunt of Diana*. c. 1615. Oil on canvas, 7'4⅝" × 10'6" (2.25 × 3.2 m). Galleria Borghese, Rome

Equally conservative is the work of another Bolognese master in Rome, Domenico Zampieri (1581–1641), called DOMENICHINO. His delightful *Hunt of Diana*, of about 1615 (fig. 26–5), with its parade of lovely figures draped and nude, is a slightly unstable combination of Raphael and Titian, but the harmonious way in which the figures are grouped in a Carraccesque landscape leads the way to the classical figural compositions of Nicolas Poussin (see pages 790–92).

The final important Bolognese painter of the Early Baroque, Giovanni Francesco Barbieri (1591–1666), called GUERCINO because of his squint, was the first to apply the lessons of Mantegna, Correggio, and Annibale Carracci to an illusionistic ceiling fresco seen from a single point of view. In his *Aurora* (fig. 26–6), painted between 1621 and 1623 for the garden house of the Villa Ludovisi, not far from the Palazzo Rospigliosi, in which Reni's treatment of the same subject may be seen, Guercino makes his comment on Reni's conservatism by carrying the actual architecture of the modest-sized room upward into the vault so accurately that his prank of ruining it (at the lower right in the illustration) is alarmingly effective. The dark clouds still shadow the Villa Ludovisi and its gardens (which are right outside the actual room); above them rolls Aurora's chariot drawn by piebald horses seen from below. Birds soar beyond it, a Cupid holds a crown of roses over Aurora's head, and she drops blooming oleander twigs on the spectators below. Although the horses and chariot make a convincing impression as they thunder overhead, Guercino was obliged to place them at one side and to tilt them slightly so they would not seem grotesquely foreshortened. The opulence and grace of his style, the rich soft coloring, and the strong light-and-dark contrasts place him in a more naturalistic current than the Carracci, Reni, or Domenichino.

26-6

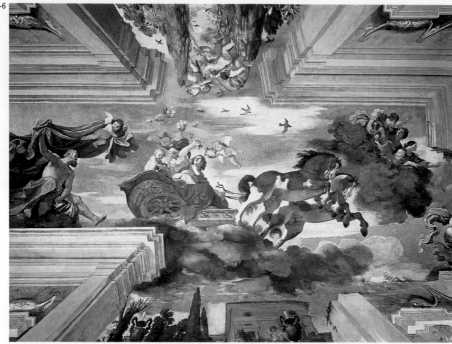

26-6. GUERCINO. *Aurora,* ceiling fresco, Casino Ludovisi, Rome. 1621–23

CARAVAGGIO The one real giant of seventeenth-century painting in Italy is Michelangelo Merisi (1573–1610), called Caravaggio after his native town in Lombardy. After studying with an obscure local master, he arrived in Rome about 1590 in his late teens; he lived on the fringe of respectable society, his short life being marked by violence and disaster. A lifelong rebel against convention, Caravaggio is the first artist on record who went out of his way to shock conventional people, chiefly by representing religious scenes in terms of daily life, no matter how seamy. He was in chronic trouble with authority and had to flee Rome in 1606 after he killed the referee in a tennis match. During the next years he wandered around,

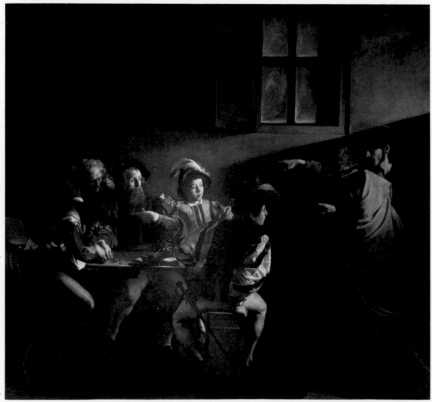

26-7. CARAVAGGIO. *Calling of Saint Matthew.* c. 1599–1600. Oil on canvas, 11′1″ × 11′5″ (3.38 × 3.48 m). Contarelli Chapel, S. Luigi dei Francesi, Rome

26-7

like Orestes pursued by the Furies, from Naples to Palermo, Messina, and Malta; he died of malaria in his thirty-seventh year on his return journey to Rome, with a papal pardon in sight.

Nevertheless, it is to this unruly genius that we must look for the style that was to revolutionize European art, less on account of its visual naturalism—the Netherlanders had already carried that as far as it could go—than on its psychological realism, which plumbed the depths of human feeling in a manner comparable in some respects to the insights of his slightly older contemporary, William Shakespeare, and its extraordinary sense of solid reality projected in actual space.

The young man came to the attention of the powerful Cardinal del Monte, who obtained for him, probably in 1597, the commission to paint three pictures of Saint Matthew and scenes from his life for the Contarelli Chapel in the Church of San Luigi dei Francesi in Rome. The greatest of these is the *Calling of Saint Matthew* (fig. 26–7), painted about 1599–1600, an event often represented but never in this soul-stirring way. The background is a wall in a Roman tavern; a window—age-old symbol of revelation—whose panes are the oiled paper customary before the universal use of glass, is the only visible background object. The publican Matthew

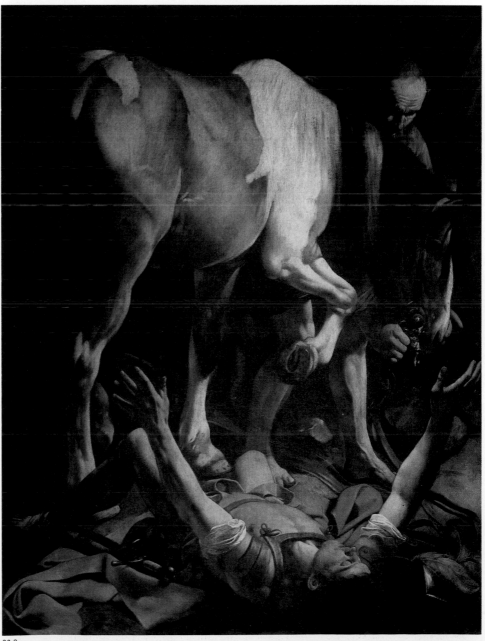

26-8. CARAVAGGIO. *Conversion of Saint Paul.* c. 1601. Oil on canvas, 90½ × 68⅞″ (2.3 × 1.75 m). Sta. Maria del Popolo, Rome

26-8

is seated "at the receipt of custom" (Matthew 9:9) with three gaudily dressed youths at a rough table on which coins are visible; figures and objects are painted in a hard, firm style that seems to deny the very existence of Venetian colorism. Suddenly, Christ appears at the right, saying, "Follow me." His figure almost hidden by that of Peter, Christ shows only his face and his right hand, illuminated by a strong light from an undefined source at the upper right.

Despite his oft-expressed contempt for Renaissance masters, Caravaggio never forgot that he shared a common Christian name with Michelangelo Buonarroti, whom he often quoted visually, as if in a vernacular translation. Christ points along the beam of light with a strikingly real hand whose gesture repeats that of God the Father in the *Creation of Adam* (see fig. 22–18). Matthew points to his own breast as if to say, "Who, me?" What happens in this apparently realistic scene is the essence of the complex contemporary allegory of the Farnese Gallery: the triumph of divine love. With the same gesture by which God made Adam "a living soul" Christ instills a new soul in Matthew.

An even more drastic breakthrough is the *Conversion of Saint Paul*, painted about 1601 (fig. 26–8); a favorite subject during the Counter-Reformation, this scene was usually shown with a vision of Christ descending from heaven, surrounded by clouds and angels. Caravaggio represented the miracle as an interior event. Against a background of nowhere, as in Jan van Eyck's portraits (see fig. 21–19), Saul (not yet called Paul) has fallen from his horse toward us, drastically foreshortened like the Christian slave in Tintoretto's *Saint Mark Freeing a Christian Slave* (see fig. 24–12), his arms rigidly outstretched as in a catatonic trance, his eyes closed. He hears the words, "Saul, Saul, why persecutest thou me?" (Acts 9:4), but his servant hears nothing and looks down at his master, unable to account for the light that shines all around and has blinded Saul. Climax reaches in this picture the stage of cataclysm, the more intense for the hardness with which everything is represented, down to the horseshoe, the rivets in Saul's armor, and the varicose veins in the servant's leg. A remarkably similar appeal to violent inner conversion beyond reason can be seen in a sonnet by John Donne, written little more than a decade after this painting was finished. It is all the more impressive as an example of a principle common to the Baroque throughout Western Europe, since Donne, an Anglican clergyman, was unlikely to have had any direct knowledge of Caravaggio's painting:

> *Batter my heart, three person'd God; for you*
> *As yet but knocke, breathe, shine, and seeke to mend,*
> *That I may rise, and stand, o'erthrow mee,'and bend*
> *Your force, to breake, blowe, burn and make me new.*
> *I, like an usurpt towne, to'another due,*
> *Labour to'admit you, but Oh, to no end,*
> *Reason your viceroy in mee, mee should defend,*
> *But is captiv'd, and proves weake or untrue.*
> *Yet dearely'I love you,'and would be loved faine,*
> *But am betroth'd unto your enemie:*
> *Divorce mee,'untie, or breake that knot againe,*
> *Take mee to you, imprison mee, for I*
> *Except you'enthrall mee, never shall be free,*
> *Nor ever chast, except you ravish mee.*

Caravaggio's hard, clear image, which presents inner reality less to our senses than to our minds, is almost contemporary with El Greco's diametrically opposite attempt to paint the unpaintable in the *Resurrection* (see fig. 25–31).

Caravaggio's paintings were understandably condemned by Bolognese artists and critics in Rome, and some were even refused by the clergy. Nonetheless, a decade after his death Caravaggio's everyday naturalism, his hard pictorial style,

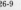

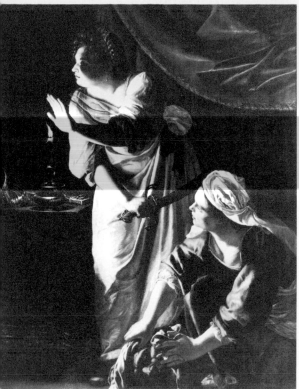

26-9. ARTEMISIA GENTILESCHI. *Judith and Her Maidservant with the Head of Holofernes.* c. 1625. Oil on canvas, 72½ × 55¾" (1.84 × 1.42 m). The Detroit Institute of Arts. Gift of Leslie II. Green

26-10. CARLO MADERNO. Façade, Sta. Susanna, Rome. 1597–1603

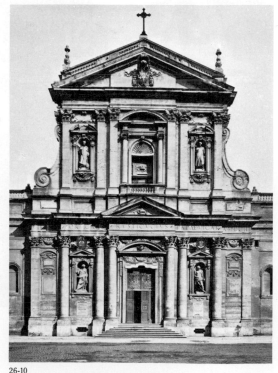

26-10

his intense light-and-dark contrasts, and above all his way of using these as devices to open the inner recesses of the soul had inspired a host of followers in Rome, Naples, Spain, France, and the Netherlands. His revolutionary art must be considered a major factor in the formation of two of the greatest painters of the seventeenth century, Rembrandt (see pages 825–29) and Diego Velázquez (see pages 812–15).

GENTILESCHI One of the most influential Italian artists in the tradition of Caravaggio was Artemisia Gentileschi (1593–1652/53), who was trained by her considerably less imaginative father, Orazio. Gentileschi was raped by a fellow pupil, Agostino Tassi, in Orazio's studio. In the course of the resultant trial in Rome the victim was tortured with the thumbscrew to elicit the truth while the attacker suffered little damage to his reputation. Gentileschi's subsequent marriage to a Florentine seems to have broken up. She worked with great success not only in Rome and Florence but also in Naples, where she was responsible for consolidating the Caravaggist tradition, and also in England at the court of Charles I. Not surprisingly, a large proportion of her almost uniformly feminist subjects reflects the traumatic effect of her youthful disaster by depicting women wronged by men. Sometimes the women take heroic revenge, as in Gentileschi's five separate renderings of the popular theme of Judith and the lustful pagan general Holofernes. In all Gentileschi's paintings the female protagonist is a recognizable self-portrait. The magnificent *Judith and Her Maidservant with the Head of Holofernes*, of about 1625 (fig. 26–9), shows the victorious Hebrew heroine casting one last glance backward into the darkened tent as her servant prepares to wrap the severed head. The grand diagonals of the figures and the curtain fill the space almost to bursting. The only light is that of a candle, soon to become the typical means of accounting for the dramatic chiaroscuro of the Caravaggist formula.

MADERNO The first definitive steps in Early Baroque architecture were taken by Carlo Maderno (1556–1629), another Lombard working in Rome. His façade for the Church of Santa Susanna, of 1597–1603 (fig. 26–10), must be considered the first true Baroque façade in Rome. Nonetheless, it recalls della Porta's façade for Il Gesù (see fig. 23–37) so insistently that for a moment we are hard put to define the differences. Both are two stories high, crowned by pediments; in both the lateral extension of the lower story forced by the side chapels is masked and joined to the central block by consoles; in both the movement of the orders toward the center is dramatized by an increase in projection. But the differences are crucial. The movement in Il Gesù seems tentative, halting, incomplete. At Santa Susanna it is definitive, rapid, and fulfilled. The lateral sections of the façade are set back slightly so that the entire central block emerges unified and dominant.

Columns are consistently restricted to the lower story of the central block and pilasters to the upper. Both columns and pilasters are single in the outer bays, double in the center. The clumsy device of a triangular pediment enclosed by an arched one is renounced in favor of a single gabled pediment so related to the crowning pediment of the façade that diagonals drawn through the outer corners of both converge on the worshiper about to cross the threshold. This, in turn, is approached by an easy flight of steps. The result is a steady crescendo of forms and spaces culminating in the central climax of the portal in the lower story and the window in the upper—the breakthrough into the building, which may be compared with the stylistic and ideological climax in the Farnese Gallery and the psychological rupture in Caravaggio. From this moment on, the numerous architects transforming Rome into a predominantly Baroque city outdid each other in always more dramatic effects achieved by clustered columns, broken pediments, even pulsating wall surfaces, but they concentrated all effects toward the central climax.

Maderno's work at Saint Peter's was not entirely fortunate. Pope Paul V (ruled

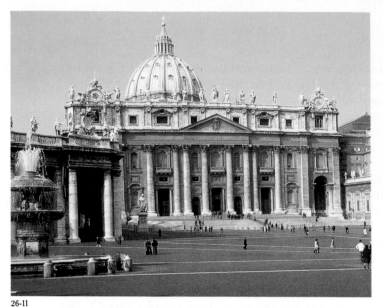

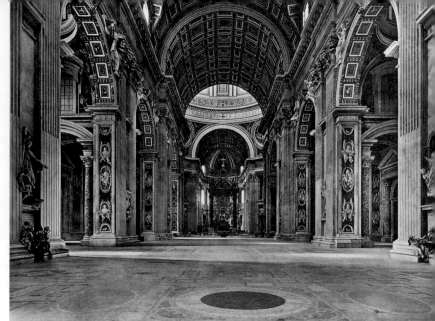

26-11

26-12

1605–21) commissioned him to extend the Greek-cross plan of Bramante and Michelangelo in order to cover all the consecrated ground once enclosed by the Constantinian basilica of Saint Peter's. From the exterior the effect is unhappy in that Michelangelo's mighty dome is dwarfed by the nearer façade (fig. 26–11) and appears to descend behind it as one approaches; also, the effect of a close-knit sculptural mass he intended Saint Peter's to produce can now be experienced only from the Vatican Gardens. The width of Maderno's façade would have been acceptable enough if his projected *campanili* (bell towers) over the lateral arches had ever been built. Unfortunately, Pope Alexander VII later commissioned Bernini to build higher towers, for which the foundations proved inadequate, and the one actually erected had to be torn down. Maderno was also trapped between his respect for Michelangelo and the ceremonial requirements imposed by the pope. He maintained the general lines of Michelangelo's façade but telescoped his projecting portico (see fig. 23–9) into mere engaged columns so as to provide the essential loggia over the portal, to accommodate the papal benediction of the city and the world.

Although in the interior Maderno had to retain Bramante's giant order and barrel vault, he adapted these elements successfully to Baroque requirements, providing lateral views into side aisles, whose bays are divided by climactic broken-arched pediments supported on richly veined columns. The splendid decoration of the gilded coffering in the vaults and arches is due to Maderno's Baroque taste (fig. 26–12), although the marble paneling and sculptures on the piers are the additions of Bernini (see below). Inevitably, the prolongation of the nave (now the longest in Christendom) by three bays in a single giant order, on the models of Alberti's Sant'Andrea (see fig. 20–15) and Vignola's Il Gesù (see fig. 23–36), led to a curious falsification of scale. One hardly notices the immense dimensions of the interior until one has been walking for a while in the direction of the papal altar without seeming to get much nearer.

BERNINI The undisputed monarch of the Roman High Baroque, and one of the three or four most influential artists in Europe in the seventeenth century, was Gianlorenzo Bernini (1598–1680), architect and sculptor of genius, and in a smaller way painter, dramatist, and composer. Born in Naples of a Florentine father and Neapolitan mother, he seems to have combined the intellectuality of the former with the passionate nature of the latter. He was the first of the great Baroque sculptors; moreover, no sculptor until the early twentieth century was entirely able to escape his influence. A brilliant youthful work, the *David,* of 1623 (fig. 26–13), done for Cardinal Scipione Borghese when the artist was twenty-five years old, shows the extraordinary transformation sculpture underwent at Bernini's hands

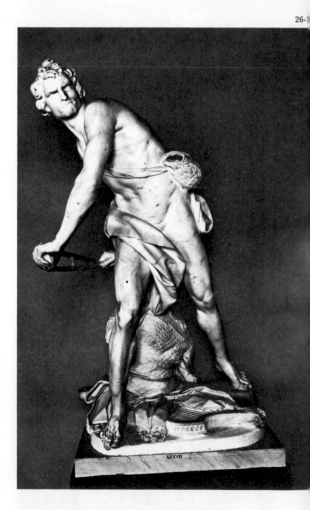

(compare the *David*s by Donatello and Michelangelo; figs. 20–25, 22–12). Bernini has captured the precise moment in which the young prophet—now a full-grown youth of about seventeen or eighteen—is twisting vigorously, about to launch the stone at Goliath. The pose, derived from Annibale Carracci's Polyphemus (see the lunette painting in fig. 26–1), is carried out with complete devotion to physical and psychological reality. The left hand's tightening about the sling and stone produces sharp tensions in the muscles and veins of the arm, the toes of the right foot grip the rock for further purchase, and the expression, unprecedented even in Hellenistic sculpture, shows the boy biting his lips with the strain. A contemporary source tells how Bernini carved the face while studying his own in a mirror, sometimes held for him by Cardinal Maffeo Barberini, later Pope Urban VIII. The intensity of Bernini's personal identification with the subject can be felt in every detail of the vibrant body.

An even more transient moment of climactic action, perception, and feeling is represented by a companion work for Cardinal Borghese, the *Apollo and Daphne* (fig. 26–14), started the year before the *David* and finished two years later. Bernini has seized on the second in which the panting god, in hot pursuit of the chaste Daphne (Ovid, *Metamorphoses* I:450–567), is foiled when she calls on her father, the river-god Peneus, for rescue and is transformed into a laurel tree. The toes of her left foot have already taken root, bark has shot up around her left leg and started to enclose her waist, her fingers and her hair are already turning into leaves

26-14. GIANLORENZO BERNINI. *Apollo and Daphne*. 1622–24. Marble, height 8′ (2.44 m). Galleria Borghese, Rome

26-15. GIANLORENZO BERNINI. *Ecstasy of Saint Theresa*. 1645–52. Marble, height of group approx. 11′6″ (3.51 m). Cornaro Chapel, Sta. Maria della Vittoria, Rome

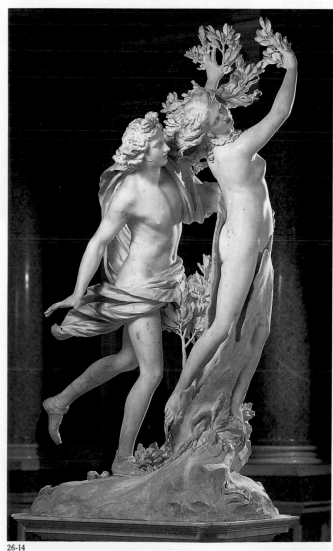

26-14

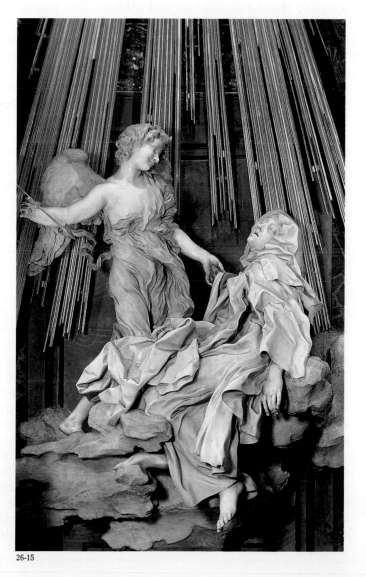

26-15

and twigs, but the change is so sudden that the expression of terror has not yet left her face nor that of desire the classical features of Apollo. The fidelity with which the softness of female flesh; the lithe body of Apollo; the textures of hair, bark, and leaves are rendered is no more dazzling than Bernini's craftsmanship in carving the scores of minute and slender projections from fragile marble. He has reached in his mid-twenties the height of his ability at pictorial sculpture—the negation of everything Michelangelo stood for, but the fulfillment of promises made by the daring Ghiberti in the *Gates of Paradise* (see fig. 20–31) and by Desiderio da Settignano in his marble reliefs (see fig. 20–60). Evanescent effects of melting texture, translucency, and sparkle so dissolve the group into the surrounding space that it is as if Bernini had been able to carve light and air as well as marble.

The culminating moment of that special blend of intense religiosity and theatrical splendor that constitutes the Roman High Baroque is the Cornaro Chapel at Santa Maria della Vittoria, of 1645–52, centered around the *Ecstasy of Saint Theresa* (fig. 26–15). The entire chapel was designed by Bernini as an "environment" for this sculptural group. The total effect eludes photography and is best reproduced by an anonymous eighteenth-century painting (fig. 26–16). The barrel-vaulted ceiling is painted away in a burst of clouds and light, disclosing angels adoring the dove of the Holy Spirit, executed by a decorative painter from a sketch by Bernini. The altarpiece becomes an operatic stage, convex as if swelling toward us, the pediment breaking apart to display the vision within. The moment represented is the Transverberation of Saint Theresa, a vision in which she beheld a smiling youthful angel of surpassing beauty, who pierced her heart again and again with a golden arrow, producing a "pain so great that I screamed aloud; but simultaneously I felt such infinite sweetness that I wished the pain to last eternally." The saint hangs strengthless on marble clouds, her eyes closed, her mouth open, in an almost clinically accurate study of her rapture. (In this respect it should be remembered that Bernini not only attended Mass daily but practiced every day the *Spiritual Exercises* of Saint Ignatius of Loyola, intended to induce in the worshiper exact physical and spiritual counterparts of the experiences of Christ and the saints.)

There could hardly be a more compelling embodiment of the Baroque climactic experience of divine love than this group, in which Bernini has reinforced the concept with his usual virtuosity in the handling of textures of flesh, drapery, feathers, and hair. The background of richly veined marble is the same that clothes the actual interior of the chapel, thus placing the saint in our own space. The gilded bronze rays descending in clusters come apparently from a concealed window, identified with the breakthrough in the ceiling. The side walls are simulated theater boxes, in which kneel in marble relief members of the Cornaro family, who appear to witness the Ecstasy, and we along with them.

Baroque Rome is a city of fountains, which were practical as well as ornamental, providing the water supply for the growing populace; indeed, we should imagine them surrounded by crowds, mostly women and children, carrying buckets. Bernini's *Fountain of the Four Rivers* (fig. 26–17) was the most spectacular of its name. Pope Innocent X (ruled 1644–55) commissioned the fountain in 1648 as part of the Baroque transformation of the Piazza Navona, once the site of the stadium of Domitian; his palace fronted the piazza, adjacent to the Church of Sant'Agnese (see fig. 26–25) by Bernini's rival, Francesco Borromini (see below). An actual Egyptian obelisk, one of several set up as focal points in the new city plan adopted in the late sixteenth century by Pope Sixtus V, stands on a mock mountain of rough travertine, made to look "natural" but carefully calculated for its effects of light and form by Bernini in preparatory drawings. The giant marble statues of Nile, Ganges (in the illustration), Danube, and Plata were designed by Bernini and carved by his pupils. The playful contrast of the muscular white figures with the rough gray rocks, vegetation, and animals is enriched by the water jets, all designed by Bernini to emerge miraculously for the populace in spouts, ribbons, or dribbles. If he could sculpture light, why not water?

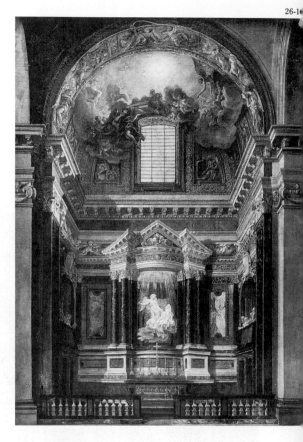

26-16. ANONYMOUS. *Cornaro Chapel.* Eighteenth-century painting, 66¼ × 47¼" (168 × 120 cm). Staatliches Museum, Schwerin

When his friend Cardinal Barberini ascended the Throne of Saint Peter as Pope Urban VIII (ruled 1623–44), Bernini entered on the parade of commissions for Saint Peter's and its surroundings that was to occupy him on and off from youth to old age and that was to determine more than any other single factor the relation of the immense structure to the individual pilgrim and tourist. His first undertaking was the baldachin or canopy of gilded bronze, nearly one hundred feet high (fig. 26–18), erected between 1624 and 1633 over the high altar and just behind the

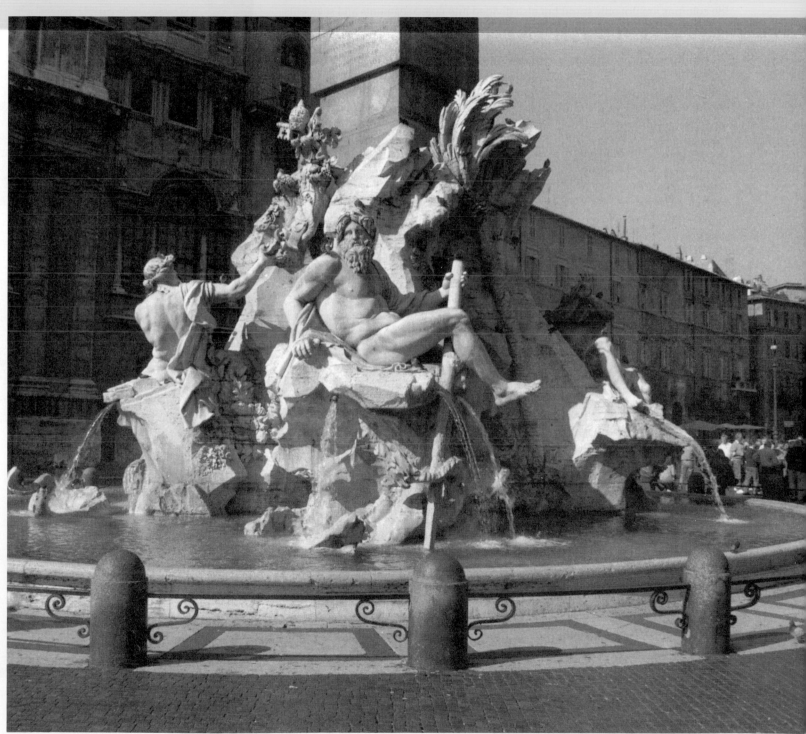

26-17. GIANLORENZO BERNINI. *Fountain of the Four Rivers.* 1648–51. Travertine and marble. Piazza Navona, Rome

26-17

opening in the floor above the tomb of Saint Peter. Bernini took as his theme the eight spiral columns (probably Syrian but supposedly from Solomon's Temple), which Jean Fouquet had seen in Old Saint Peter's (see fig. 21–37) and which Bernini later incorporated in the niches he carved from the four piers upholding Michelangelo's dome (see fig. 22–24). It was his brilliant idea to translate these small columns to gigantic scale and to set them in a kind of dance, still upholding their massive entablatures as well as a simulated valance, angels, and the four consoles that form the open top, crowned by the orb and cross under the dome. The contrast of the columns with the piers of the dome, in fact, is the only element that helps the visitor grasp the true scale of Saint Peter's. Like their ancient prototypes, the columns are not only spiral but also divided into fluted segments and segments entwined by vinescrolls; golden bees, the Barberini emblem, displayed on the bronze valance, have alighted here and there among the leaves.

Bernini's work for Saint Peter's included the complete sculptural program for the nave—the white marble cartouches and medallions against colored marble panels in the piers, and the figures dangling out of the spandrels (see fig. 26–12). The scale can be imagined by recalling that the child angels upholding the holy water stoups on either side are nine feet high. Designed in 1645–46, the work was carried out in the incredibly short period of 1647–48 by no fewer than thirty-nine sculptors and stonecutters under Bernini's supervision. Like all his work at Saint Peter's, these sculptures have the effect of enlivening what had become almost too large and impersonal a structure. His final creation in the interior was the colossal Cathedra Petri (fig. 26–19), of 1657–66, a reliquary to enshrine what was believed to be the chair of Peter (but has turned out on recent examination to be Carolingian). The result is an incredible amalgam of marble, bronze, gilded bronze, stucco, and stained glass between and overflowing Michelangelo's pilasters in the apse. Again we have a rupture of the surrounding structure in that the vision of the dove of the Holy Spirit, in stained glass surrounded by clouds of gilded angels and golden rays, seems to have burst the very architecture above the chair, carried on clouds above four Fathers of the Church, two Latin (Augustine, Ambrose) and two Greek (Athanasius and John Chrysostom), who supported Roman Catholicism's claim to universality.

In its climactic character, exuberance of forms, textures, colors, and materials, and theatrical brilliance of effect, the Cathedra Petri would seem to have spelled the ultimate in Bernini's long career. The final surprise, therefore, is the austere simplicity of his designs of 1656, carried out over many years, for the enclosure of the whole piazza in front of Saint Peter's by means of two facing exedrae of Tuscan columns, each four columns in depth, supporting an unbroken entablature, surmounted by a statue above each column of the inner row (fig. 26–20). The oval form of the piazza is based on a central obelisk as its focus; two magnificent fountains flank it left and right. The dynamism of the design lies in the power of its movement; it suggests two gigantic arms outstretched to embrace the approaching pilgrim. The intended climactic effect of this experience of space and light, intense when one emerged into the piazza from the narrow and dark adjacent streets, was unfortunately lost when the area between the piazza and the Tiber was modernized in the 1930s, including the demolition of several blocks of Renaissance houses. Nonetheless, as one moves through the tall colonnades, apparently in motion, the experience of form and space, constantly changing as if in obedience to unalterable law, is one of the most compelling of any Baroque design, surpassing even the effect of the imperial Roman forums, which must have inspired Bernini.

Sculptors and architects trained by Bernini carried the principles of his style throughout Italy and into Northern Europe. In 1665 he was called to France by Louis XIV, the most powerful European monarch of the age, for whose ambitions Bernini's grandiose ideas would seem to have been especially appropriate. That his projects for the completion of the Louvre were not accepted, and that his one statue of the king was altered to represent a figure from Roman history and banished to a

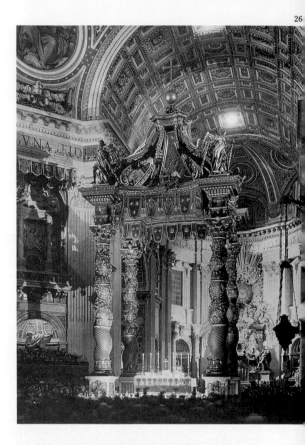

26-18. GIANLORENZO BERNINI. Baldachin. 1624–33. Gilded bronze, height approx. 100′ (30.48 m). St. Peter's, Vatican, Rome

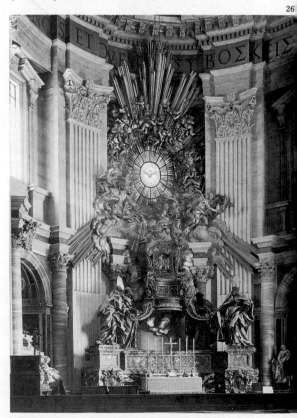

26-19. GIANLORENZO BERNINI. *Cathedra Petri.* 1657–66. Marble, gilded bronze, stucco, and stained glass. St. Peter's, Vatican, Rome

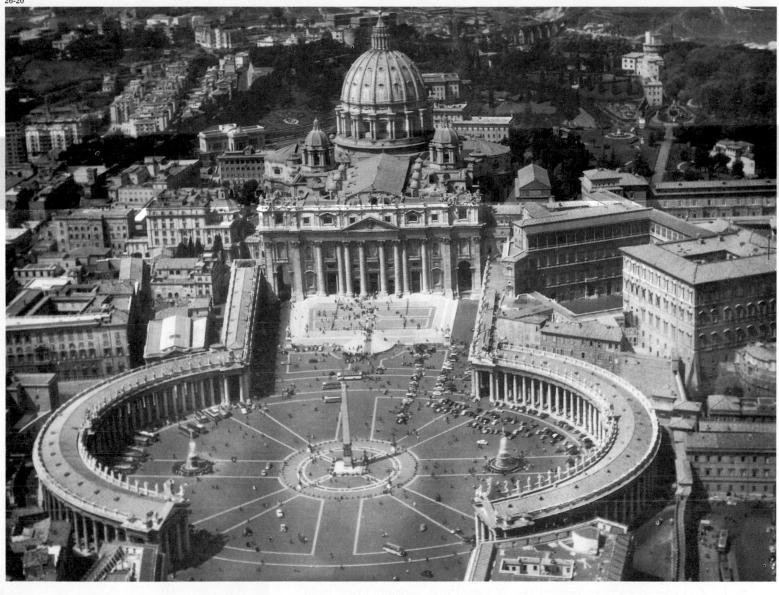

26-20. Aerial view of St. Peter's, Vatican, Rome. Colonnade by GIANLORENZO BERNINI begun 1656

remote spot in the park at Versailles, tell us much about the fundamental differences between Italian and French attitudes toward the Baroque style.

BORROMINI A strong countercurrent to Bernini in High Baroque Rome was offered by the at once capricious and austere architecture of Francesco Borromini (1599–1667), a solitary genius born at Bissone, on Lake Lugano, whose brooding, introspective nature was the very opposite of that of the easygoing, expansive Bernini. Rather than the splendid accompaniments of richly veined marbles and decorations in stucco and painting, as often as not designed by others, in which Bernini reveled, the essentially linear and spatial interiors of Borromini resisted encroachments from other arts and needed only occasional accents of gold against white plaster. Bernini sketched out his projects with sovereign ease and left the details to an army of assistants; Borromini instead worked obsessively on the designs for the tiniest object or decorative motif, rejecting many before approving his final choice with the word *questo* ("this one") on his careful drawings, and supervised with a craftsman's care the execution of his designs.

The Baroque preoccupation with the organization of colossal spaces was matched by its concern for the very small, finding expression in the building of *oratories* (chapels intended for small groups or for private prayer); it is not beside the point that the seventeenth century saw the invention not only of the telescope but also of the microscope. Borromini's plan for the small monastic Church of San Carlo alle Quattro Fontane, of 1638–41 (fig. 26–21), was immediately and widely emulated throughout Catholic Europe, probably because it touched the very fountainhead of Baroque individual piety. The shape was based, after characteristically long geometrical experimentation, on intersecting ellipses dissolving into each other. Standing inside the church (fig. 26–22), however, one feels the effect is that of a central-plan structure, in Byzantine or Renaissance tradition, but one made of soft and elastic materials, in fact, alive and pulsating; if it were compressed from side to side and lengthened along its axis, the viewer feels it could reverse itself in the next pulsation, on the principle of a beating heart. To enhance the systolic and diastolic motion of the components, even the Corinthian capitals were so designed that the volutes of one turn over and out, the next under and in. The dynamic plan was intended to arouse a state of instability preparing the worshiper for the Baroque goal of divine union in ecstatic meditation.

The brilliance of Borromini's imagination is manifest on a considerably larger scale in his spectacular Church of Sant'Ivo, erected between 1642 and 1660 (fig. 26–23), set at the end of the courtyard of the Sapienza (later the University of Rome), which had been designed in the late sixteenth century by Giacomo della Porta. The ornamentation of the exterior and interior of the church was carried out later during the pontificate of Alexander VII (ruled 1655–67), a member of the Chigi family, whose arms, an eight-pointed star shining from the top of a mountain, are the principal ornaments. Borromini wisely continued della Porta's Late Renaissance arcades of superimposed Doric and Ionic orders, but made the court terminate in a shallow exedra, actually a concave façade, later surmounted at each end by the Chigi mountain and star. Above towers the six-lobed drum of a fantastic dome, surmounted by a step-pyramid whose lobes are separated by concave buttresses terminating in volutes and balls. The lantern obviously suggests in its concave faces the apse of the third-century-B.C. Temple of Venus at Baalbek in Lebanon, whose design had been known in Europe as early as the sixteenth century. Unconventional even in his choice of sources, Borromini may have derived his spiral spire from the great minaret at Samarra in Iraq; it was to be repeated again and again throughout Europe as far north as Copenhagen. The work culminates in an open construction of forged iron, a dainty linear motif carrying aloft the orb of power and the Cross. The concave and convex movements work against one another like motifs in the polyphony of Bach, with whose music Borromini's architecture has often been compared; the whole design has the effect of a great organ fugue.

Not even the complexity of the exterior quite prepares us for the exquisite mathematical logic of the interior. The plan is an equilateral triangle overlapping a trefoil so that the intersections establish the points of a regular hexagon. The points of the triangle, in turn, are cut into concave arcs, the radius of each of which is equal to that of the adjacent sides. This plan, perfectly preserved in the crowning cornice, governs the convexities and concavities of the pulsating walls and their giant Corinthian order like a perfectly executed rhythmic dance figure. The fantastic shapes blend smoothly together at the apex of the dome to meet in a circle (fig. 26–24). Originally, the only color on the white walls, dome, and pilasters (the imitation marble is nineteenth-century repaint) was the gold of the ornamentation, the eight Chigi stars on each rib and above the windows the Chigi mountain decorated with the three crowns of the papacy, alternating with Borromini's favorite motif of interlaced palms.

In one lordly work, the design for the Church of Sant'Agnese in Piazza Navona (figs. 26–25, 26–26), where Bernini's *Fountain of the Four Rivers* (see fig. 26–17)

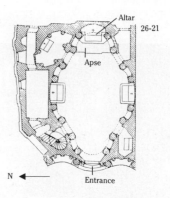

26-21. FRANCESCO BORROMINI. Plan of S. Carlo alle Quattro Fontane, Rome. 1638–41

26-22. FRANCESCO BORROMINI. Interior, S. Carlo alle Quattro Fontane, Rome

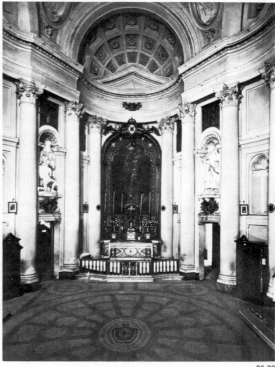

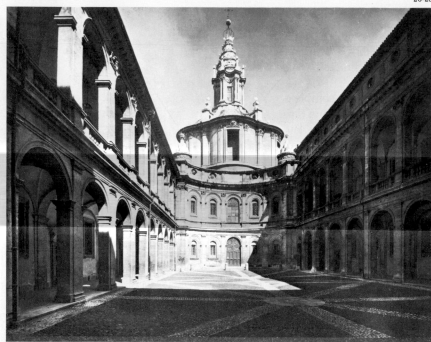

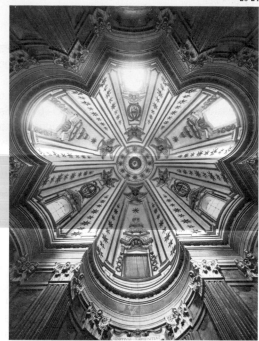

26-23. FRANCESCO BORROMINI. Sant'Ivo della Sapienza, Rome. 1642–60

26-24. FRANCESCO BORROMINI. Interior of dome, Sant'Ivo della Sapienza, Rome

26-25. FRANCESCO BORROMINI. Façade, Sant'Agnese in Piazza Navona, Rome. 1653–66

26-26. FRANCESCO BORROMINI. Plan of Sant'Agnese in Piazza Navona, Rome. Begun 1652

was nearing completion, Borromini was able to carry his ideas into a major Roman square. His façade, on which he worked from 1653 to 1666, was eventually completed by others. The heavy attic story and the conventional pediment are foreign to his artistic vocabulary, but the basic ideas and proportions are his. For the first time the relationship between central dome and flanking campanili, which had been the dream of Maderno and Bernini at Saint Peter's, was actually realized. The concave façade working against the convex dome and the beautiful convex shape of the campanili are typical of Borromini's thinking. The group was repeated innumerable times in Italy, in central Europe (see fig. 29–21), in England (see fig.

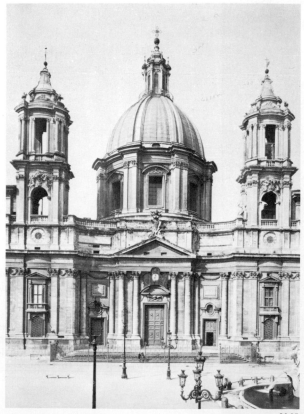

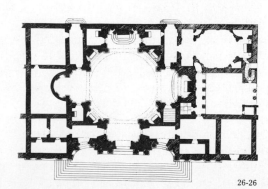

26-26

26-25

28–28), and even in Mexico, finding universal acceptance possibly because in essence it is a revival of the Gothic combination of two-tower façade and crossing tower or lantern.

At his death Borromini was still at work on his most subtle and complete expression, the façade added in 1665–67 to San Carlo alle Quattro Fontane (fig. 26–27), whose interior he had designed nearly twenty-five years before. His favorite intertwined palms framing the windows on either side of the portal may serve as symbols of the rich interrelationships of concave and convex that continue throughout the masses of the undulating structure and all the minor elements. Had Bernini designed such a façade he would have carried the image in the upper story effortlessly through the cornice, clouds, angels, and all; Borromini allows it merely to lift the elastic balustrade—and then compress it, as if struggling for final release from this world.

ROMAN BAROQUE CEILING PAINTERS In the wake of Annibale Carracci and Guercino, many large Roman Baroque palace and church interiors—with the notable exception of Saint Peter's, too large for the purpose—were endowed with illusionistic ceiling paintings. All of them take for granted what ordinary reason denies: that with or without the support of an occasional cloud human beings

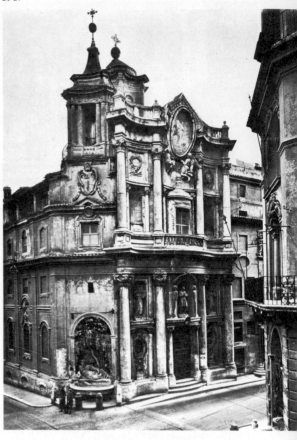

26-27. FRANCESCO BORROMINI. Façade, S. Carlo alle Quattro Fontane, Rome. 1665–67

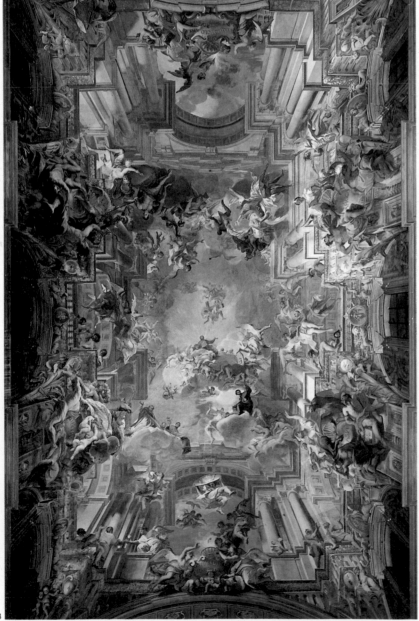

26-28. ANDREA POZZO. *Missionary Work of the Jesuits,* ceiling fresco, Sant'Ignazio, Rome. 1691–94

26-29. BACICCIO. *Triumph of the Sacred Name of Jesus,* ceiling fresco, Il Gesù, Rome (figures and ornamentation in white and gilded plaster by ANTONIO RAGGI). 1676–79

26-29

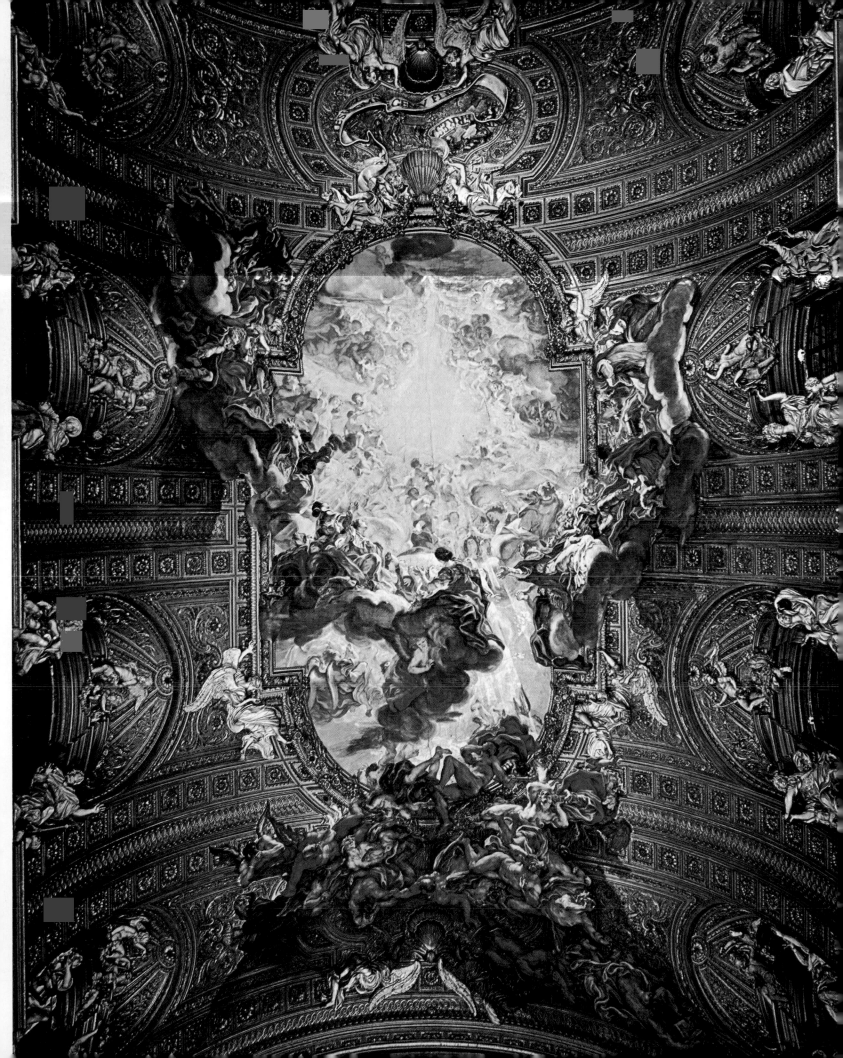

customarily fly through the air. Careful study of perspective and expert manipulation of foreshortening, overlapping, and contrasts of light and dark and color precalculate the effects so accurately as to overwhelm both reason and experience and turn the most unrealistic of situations into believable reality. All formalize the basic pattern of Baroque experience in the establishment of a reasonably acceptable order, the violation of that order by forces also presented as real, and the final deliverance in an upper luminary realm.

A splendid theatrical effect was achieved by the Genoese painter Giovanni Battista Gaulli (1639–1709), called BACICCIO, in collaboration with the sculptor ANTONIO RAGGI (1624–86), a pupil of Bernini. Vignola's severe barrel vault in Il Gesù was covered with rich ornamentation in ribs and fields of gilded stucco between 1676 and 1679 (fig. 26–29). Allegorical figures modeled by Raggi in white stucco, in violent motion, flank or surmount the windows, and four white stucco angels, also by Raggi, uphold the central frame. Into and through the frame float Jesuit saints and angels on clouds painted by Baciccio on fields of plaster laid on the vault outside the frame, so that we can follow with precision their progress from the space of the church across the frame and into Heaven above, drawn upward by the dazzling brightness of the Sacred Name of Jesus, made deliberately almost indistinguishable in white on yellow as if we were looking into the sun. The same force hurls downward with alarming speed evil spirits and vices, who pour pell-mell through the opening and fall toward us as if to crash at any moment on the floor at our feet. To complete the illusion, all the figures and clouds outside the frame cast shadows on the gilded ceiling.

The *ne plus ultra* of the illusionistic ceiling, reaching a phase properly termed Late Baroque, is represented by the allegory of the *Missionary Work of the Jesuits* (fig. 26–28), of 1691–94, painted in the Church of Sant'Ignazio by a Jesuit lay brother, ANDREA POZZO (1642–1709) from Trent, author of an elaborate perspective treatise on how to design and execute complex ceiling projects. The entire barrel vault is painted away and the architecture of the church carried up an additional story beyond the windows, in front of, through, and above which float allegorical figures. Between the windows appear the four continents, each labeled. America is at the upper left, wearing an Indian crown of red, white, and blue feathers. On clouds, leading Jesuit saints follow Christ, carrying the Cross over his shoulder, high in the heavens at the apex of the perspective. A moment's reflection will indicate that such perspective triumphs correspond to the actual perspective lines of the church only from a single point of view. Pozzo thought of that. In each of the churches in which he painted an illusionistic ceiling, he indicated with a square of white marble in the floor just where to stand to make the illusion "come right."

NORTH ITALIAN BAROQUE ARCHITECTURE Some strikingly independent Baroque developments occurred in northern Italy. Although the Venetian school of painting was almost dormant in the seventeenth century, awaiting its triumphant reawakening in the eighteenth, Venice could boast one native architect of genius, BALDASSARE LONGHENA (1598–1682), whose masterpiece, Santa Maria della Salute (fig. 26–30), begun in 1631 and finished only in 1687, after the architect's death, is as inseparable a component of the central Venetian picture as San Marco, the Doges' Palace, the Library of San Marco, and San Giorgio Maggiore. The ideas we have followed throughout the Roman Baroque cannot help us here; Longhena makes no reference to them. His church was based on local Byzantine and Renaissance traditions, and only in the profusion of its shapes and in the multiplicity of its inner views can it be said to be truly Baroque. The plan (fig. 26–31) is an octagon surrounded by an ambulatory, obviously related to the type that from San Vitale at Ravenna was carried into Germany in the Carolingian period. Each bay of the ambulatory frames a separate projecting rectangular chapel, illuminated by mullioned lunettes as in Roman baths. The main façade with its flight of steps spilling down to the Grand Canal is related to Roman triumphal-arch designs. The

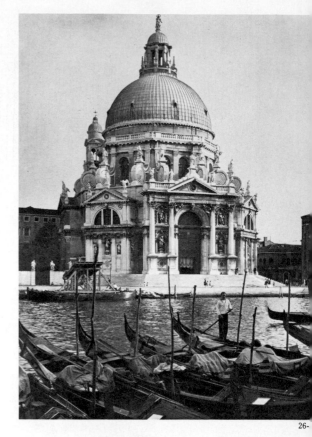

26-

26-31

26-30. BALDASSARE LONGHENA. Sta. Maria della Salute, Venice. 1631–87

26-31. BALDASSARE LONGHENA. Plan of Sta. Maria della Salute, Venice

26-32. GUARINO GUARINI. Façade, Palazzo Carignano, Turin. 1679–92

26-33. GUARINO GUARINI. Interior of dome, Chapel of the Holy Shroud, Turin. 1667–94

sixteen buttresses of the lofty dome rest on the outer walls of the chapels. All the basic elements, therefore, are structural, with a rational relationship between interior and exterior. But the buttresses are gratuitously prolonged into huge spirals, on which float rather than rest the podia for sixteen statues. The relatively unobtrusive Doric pilasters of the drum recede behind these splendid ornaments. The almost white tone of the Istrian stone, used here as well as in so many Venetian buildings, and the pale gray of the lead covering of the dome make the structure appear to shimmer over the water like the large, irregular pearls that may have given the Baroque its name.

More startling buildings were erected in the western side of north Italy in Piedmont, where the Theatine priest GUARINO GUARINI (1624–83), from Modena, worked out a brilliant new architectural style under the influence of Borromini, whose early work he had seen in Rome, and of Islamic architecture, which he had studied in detail in Sicily and possibly in Spain, not to speak of Gothic, which he had encountered in France and praised glowingly in his treatise on architecture for its daring lightness and fantasy. He invented a new kind of brick architecture in the Palazzo Carignano at Turin, begun in 1679 (fig. 26–32); for all the classical and Baroque derivations of its ornament (Borromini's palms flanking the windows) and its undulating façade, its linearity recalls Flamboyant Gothic architecture. Guarini's structural feeling for the material forbade him from masking it with stucco, as was customary; every detail of the ornament, even the capitals, is of brick or terra-cotta.

His most amazing achievements were his domes. In the Chapel of the Holy Shroud, built between 1667 and 1694, which towers above the relatively modest Renaissance Cathedral of Turin, the interior is entirely paneled in a funereal dark-gray marble, almost black. The arches of the drum (fig. 26–33) support segmental arches bridging the intervening spaces, from keystone to keystone. The entire fabric of the dome, in fact, is made up of such arches superimposed in a staggered system to form an open web. Although the idea was derived from Islamic flying arches, such as those in the Great Mosque at Córdoba, the result is as light as any High Gothic structure; the top of the dome has been glazed to eliminate the outer surface entirely. The light filtering through the openings into the dark sanctuary communicates to it a mysterious effect beyond description, surely one of the most original inventions of the Baroque period.

CHAPTER TWENTY-SEVEN

CATHOLIC EUROPE

In the first half of the seventeenth century, Europe was torn by violent divisions between Catholic countries (the Italian states, France, Spain, Portugal, and the Holy Roman Empire, which included the southern Netherlands) and Protestant countries (much of central and northern Germany, most of the northern Netherlands, England, and Scandinavia). The Thirty Years' War (1618–48) began as a conflict for religious domination but kept assuming more and more irrational forms, devastating and depopulating much of Germany to such an extent that it took generations for full recovery. The Peace of Westphalia, a treaty signed in 1648, brought the warfare to an end and settled major political and religious divisions in Europe for the rest of the century. German Protestant princes were fully independent, and the emperors ruled only in Austria, Hungary, and the Slavic states of central and southeastern Europe.

The territorial split between Catholic and Protestant regions had profound consequences for the visual arts. In general, Catholic countries were monarchical and absolutist. For such regimes the splendors of the Italian Baroque held great emotional appeal. All the dramatic Italian devices, all the riches of form, space, and color were warmly welcomed as visual reinforcements of the intensity of Catholic faith and the grandeur of monarchical rule. Germany was in no condition to demand much in the way of works of art, especially architecture, while Calvinist Holland, predominantly bourgeois, and Protestant England, alternating between Anglican monarchism and Calvinist republicanism, destroyed wholesale as many works of art as possible in the interiors of vast Gothic churches (see fig. 28–10) and sternly forbade the creation of any new ecclesiastical imagery.

Diluted only by regional and national traditions and preferences, the stylistic currents set in motion in the early seventeenth century in Rome, the spiritual center of Catholicism, flowed out over Catholic Europe in an overwhelming tide.

France

The earlier religious wars of the sixteenth century had left France in a prostrate economic and political condition, from which the country was rescued by a succession of ambitious monarchs, each assisted by an able minister — Henry IV by Sully, Louis XIII by Richelieu, and Louis XIV (see fig. 27–9) by Colbert (see fig. 27–22). Deeply though the influence of Caravaggio and Bernini penetrated the French consciousness, in their age of power and glory the French rejected the excesses of Baroque enthusiasm and forged a temperate, elegant, classicizing style, which they are today reluctant to call Baroque. Its ties with Italy are so strong, however, that the term can hardly be avoided. Paradoxically enough, the most classicistic painter of the seventeenth century, Nicolas Poussin, preferred to live and work far from his native France, in Rome, the epicenter of the Baroque earthquake, to whose contemporary art he remained sublimely indifferent. During the seventy-two-year reign of Louis XIV, in the second half of the seventeenth century and the early eighteenth, Paris began to replace Rome as the principal artistic center of Europe, a position it maintained almost unchallenged until World War II.

LA TOUR Like most European countries, France experienced its wave of Caravaggio imitators, none of the highest rank. The first truly important French painter of the seventeenth century, Georges de la Tour (1593–1652), was highly regarded

THE SEVENTEENTH CENTURY IN OUTSIDE ITALY

in his own time but soon slipped into oblivion, from which he has been rescued only in the present century. Born in Lorraine, La Tour worked in Lunéville and traveled in Italy and Holland. Although there is little direct influence of Caravaggio in his work, he was affected by the tide of psychological realism Caravaggio set in motion; in his hard and polished surfaces and in his strong light-and-dark contrasts he even intensifies elements of Caravaggio's style. But his content could hardly be more different. While his works do indeed deal with religious subjects in terms of everyday life, La Tour's special quality is an intimate poetry engendered by night light. The *Newborn,* painted about 1630 (fig. 27–1), is in the tradition of Geertgen (see fig. 21–28) and of Correggio (see fig. 23–18), though the light comes from a candle held by the midwife rather than emanating from the Child. Yet La Tour allows us only to surmise that the picture represents Mary and Jesus. The quiet humanity breathing through all his paintings renders the question of identity almost irrelevant. The beginning of new life is a sacred moment; its mystery is silently shared by mother and midwife and made manifest by the candle, whose effect on the pure sculptural forms and surfaces, and on the glowing red garments, is exquisitely studied.

THE LE NAIN BROTHERS Another relatively recent rediscovery has been the art of the three Le Nain brothers—Antoine (1588–1648), Louis (1593–1648), and Mathieu (1607–77). Born in Laon, they lived and worked together in placid harmony in the Saint-Germain-des-Près quarter of Paris, then a suburb and, as ever since, the home of artists. Louis seems to have been the most important artist of the three; as they never signed their first names to their pictures, the assignment of many works is still conjectural. All three were devoted to scenes of daily life, although Louis was apparently responsible for the most convincing of the peasant scenes. Nothing in Louis's *Cart,* of 1641 (fig. 27–2), recalls the bumptiousness of

27-1. GEORGES DE LA TOUR. *Newborn.* c. 1630. Oil on canvas, 29⅞ × 35⅞″ (76 × 91 cm). Musée des Beaux Arts, Rennes

27-2. LOUIS LE NAIN. *Cart.* Oil on canvas, 22 × 28¼″ (56 × 71.8 cm). Musée du Louvre, Paris

27-1

27-2

Bruegel's peasantry; there could be nothing more ordinary than their activities, yet these people are treated as reverently as La Tour's religious subjects. They stand or sit calmly among the poultry and pigs of a farmyard, in groups composed with such dignity that the rough cart is endowed with monumental grandeur. The wheat, related to the Eucharist, and the brass pot, related to ritual cleansing as in Early Netherlandish paintings (see figs. 21–10, 21–12), may here retain a hint of their former symbolism. The richly painted colors—muted grays, tans, and browns in the clothing with an occasional touch of red, soft grays and blues in the pearly sky, grays and greens in the landscape—make this little masterpiece a worthy ancestor of Chardin in the eighteenth century (see fig. 29–13) and Corot in the nineteenth (see fig. 32–5). The profound spiritual identification of the two oldest brothers with the peasantry did not prevent their pictures from being avidly collected by nobility and even royalty.

POUSSIN To his era and to us today, Nicolas Poussin (1593/94–1665) is the very embodiment of the classical spirit, not in the Renaissance sense of adapting ancient ideas to contemporary needs but rather in an attempt to take contemporaries back to antiquity. His paintings are the product not only of great imagination and pictorial skill but also of a discipline and control that grew firmer as the painter aged. Born near the small town of Les Andelys on the Seine in Normandy, Poussin went to Paris in late adolescence and seems to have had access to the royal collection of paintings, where he was chiefly impressed by the works of Raphael and Titian, and to the royal library, where he studied engravings after Raphael. After two trips to Italy he settled down for good in Rome in 1624, returning to France only for a single unsuccessful visit. Given his stubborn personality and his overriding classical interests, it was unlikely that he would ever enjoy official success. The world of prelates, nobles, popes, and monarchs in which Bernini moved was not for him. Poussin made only one large (and very beautiful) altarpiece for Saint Peter's, and was dissatisfied with it.

An attempt by King Louis XIII to have Poussin work on ceiling paintings for the Long Gallery of the Louvre ran afoul of the artist's refusal to consider ceiling paintings different from those on walls, to adopt a low point of view (he maintained that people do not normally fly through the air), and to turn over the execution of vast projects to assistants. The latter objection effectively ruled out the customary colossal Baroque monumental commissions. In Rome he preferred the society of learned Parisian visitors, who bought (and sometimes ordered) his paintings, and the antiquarian Cassiano dal Pozzo, who commissioned artists to draw for him every work of ancient sculpture and architecture he could track down. Like his Dutch contemporaries (see Chapter Twenty-Eight), Poussin reflects to an extent the ideas and tastes of a class—in this case, one intensely interested in antiquity and in Stoic philosophy.

In such early works as the *Inspiration of the Poet,* painted about 1628–29 (fig. 27–3), with its classical figures arranged before a landscape in low afternoon light, Poussin revealed his allegiance to the Bolognese tradition (see Chapter Twenty-Six). Even more important, he attempted independently to recapture the magic of Titian through warm coloring unified by soft glazes and through subtle and surprising passages of lights and darks, especially the way light touches the edge of Apollo's lyre and part of his cheek, leaving the rest in shadow. But a comparison with Titian's *Bacchanal of the Andrians* (see fig. 24–4), to which this picture is in some ways related, shows that Poussin had no intention of reviving the frank sensuality of the great Venetian. This is an allegorical scene in keeping with seventeenth-century ideas; the yearning poet (one could as easily view him as a painter) owes his gifts to divine inspiration. The works of ancient sculpture from which Poussin derived his poses are evoked as memories of a vanished past (existing largely in imagination), for which the artist's nostalgia makes these early paintings poignant in the extreme.

27-3. NICOLAS POUSSIN. *Inspiration of the Poet.*
c. 1628–29. Oil on canvas, 6½′ × 7¼′
(1.84 × 2.14 m). Musée du Louvre, Paris

About 1630 a severe illness provided a break during which Poussin could formulate the theoretical basis of his art. He abandoned his earlier lyric style and Venetian color in favor of what in his notes and letters he called *la maniera magnifica* ("the grand manner"), which required first of all a subject—drawn from religion, history, or mythology—that avoided anything "base" or "low." One wonders, parenthetically, what he must have thought of La Tour, of the Le Nain brothers, or, for that matter, of the whole Caravaggist movement. Poussin maintained that the subject must first be so clarified in the painter's mind that he will not clog the essence of the narrative with insignificant details. The painter must consider the conception, that is, the couching of "the story," in an impressive way, such as Phidias' idea of the Olympian Zeus as a god who by a nod could move the universe. Then the artist must devise the composition, which must not be so carefully constructed that it looks labored, but should flow naturally. Last comes the style or manner of painting and drawing, which Poussin considered innate in the painter.

At another point Poussin expounded his theory of the modes of painting by analogy with the modes or scales in Greek music, and mentioned five: the Dorian, the Phrygian, the Lydian, the Hypolydian, and the Ionic. He carried his ideas of the modes systematically into execution. His *Rape of the Sabine Women,* of about 1636–37 (fig. 27–4), exemplifies the Phrygian mode adapted to "frightful wars"; nonetheless, its "modulations are more subtle than other modes," and Plato and Aristotle "held in high esteem this vehement, furious, and highly severe Mode, that astonishes the spectator." The picture also fulfills all Poussin's requirements for *la maniera magnifica*. The subject is lofty, for the abduction of the Sabine women by the bachelor Romans assured the perpetuation of the Roman race; the conception is powerful; the composition effortless and natural for all its references to ancient and Renaissance statuary figures and groups; and the style beyond all praise. In comparison with works of Poussin's early period, the picture seems drained of atmosphere; in this vacuum his colors ring brilliantly clear, dominated by the primary hues of red, blue, and yellow, each self-contained without the tendency to melt into or to reflect one another (which forms one of the delights of much Baroque painting). The composition is staged in a limited space, flanked on one side by the temple portico in which Romulus stands and limited at the rear by a structure whose appearance is reconstructed from Vitruvius' description of a

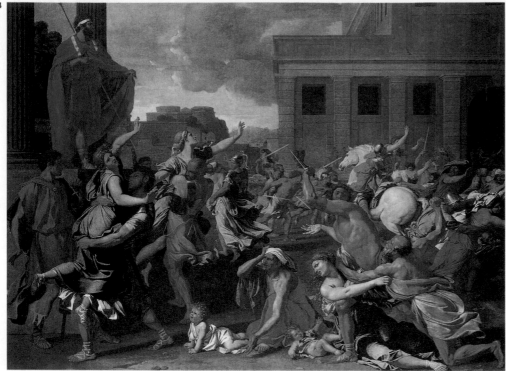

basilica. The building in the landscape in the background recalls the hill fortress of Annibale Carracci's *Landscape with the Flight into Egypt* (see fig. 26–3). The rhythm surges along with the driving energy of a fugue by Bach or Handel, every melody of torso or limb clearly distinguishable and perfectly modeled. Although the result may seem artificial, accepted on Poussin's own intellectual premises the painting is extremely effective. And, perhaps in spite of Poussin, the grand sweep of forms and colors has an indefinable something that we can call Baroque.

A later work, the *Holy Family on the Steps,* of 1648 (fig. 27–5), is probably in the Hypolydian mode, which "contains within itself a certain suavity and sweetness which fills the soul of the beholders with joy. It lends itself to divine matters, glory and Paradise." The pyramidal composition suggests the Madonna groups of Leonardo (see fig. 22–5) and Raphael (see fig. 22–27), which Poussin knew and studied. Like Tintoretto, but for different reasons, he arranged little draped wax figures on a stage, with the lighting carefully controlled and with a backdrop of landscape and architecture. He would experiment with figural relationships until he found the right grouping, then build a larger and definitive arrangement of modeled and draped figures and paint from it, referring to reality only when necessary. This procedure is evident in the present picture. The grave, ideal quality of Poussin's art triumphs in such classical compositions arranged before simple, cubic architecture that bypasses the Baroque, the Renaissance, and the Middle Ages, going straight back to Roman models. While the faces of his figures often appear standardized and almost expressionless, the grandeur of Poussin's art— always on an intimate scale—appears in the balance of forms, colors, and lights. Such compositions were to inspire Ingres in the early nineteenth century (see fig. 30–13) and to form the basis for the landscape, still-life, and figure paintings of Cézanne in the late nineteenth century and early twentieth century (see figs. 34–2 to 34–4).

CLAUDE LORRAIN A diametrically different aspect of the relationship of figures and landscape forms the lifelong theme for the paintings of Poussin's fellow émigré, Claude Gellée (1600–1682), called Claude Lorrain from his origin in Lorraine, who settled in Rome at an early age and never left. Lorrain had so little interest in narrative that he often commissioned others to paint the tiny figures in his pictures. Nonetheless, these figures form an indispensable element in the composition, less

27-4. NICOLAS POUSSIN. *Rape of the Sabine Women.* c. 1636–37. Oil on canvas, 6'1½" × 7'¼" (1.55 × 2.1 m). The Metropolitan Museum of Art, New York. Harris Brisbane Dick Fund, 1946

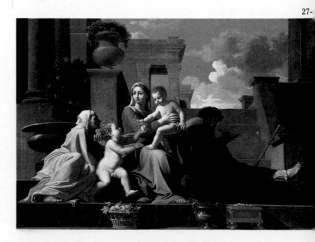

27-5. NICOLAS POUSSIN. *Holy Family on the Steps.* 1648. Oil on canvas, 27 × 38½" (68.6 × 97.8 cm). National Gallery of Art, Washington, D.C. Samuel H. Kress Collection

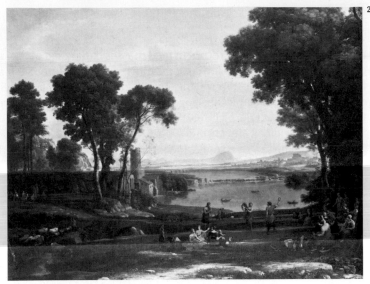

27-6. CLAUDE LORRAIN. *Marriage of Isaac and Rebecca.* 1648. Oil on canvas, 58¾ × 77½" (1.49 × 1.97 m). National Gallery, London. Reproduced by courtesy of the Trustees

to suggest a mood as in Giorgione (see fig. 24–2) and Patinir (see fig. 25–23), for historical, religious, and mythological subjects were interchangeable in his mind, than to establish scale—and scale is all-important. The tiny figures make Lorrain's landscapes at once habitable and immense. In the *Marriage of Isaac and Rebecca,* of 1648 (fig. 27–6), the typical spacious background of the Roman Campagna appears. The Tiber River, in the center, has been widened a bit for pictorial effect. Such landscapes, like those of Annibale Carracci and Domenichino, and the landscape backgrounds of Poussin, were constructed in the studio. The giant tree on the right is an obvious *repoussoir* (a device to suggest recession in space) from which the eye moves to the trees in the middle distance, then to the shape of Mount Soracte on the horizon. The mood is provided by Lorrain's soft light, usually the idyllic and dreamy light of late afternoon or sunset, and from visual memories of landscapes he knew.

Lorrain's connection with landscape was intimate and profound. He was almost uneducated, wrote in a mixture of French and Italian, and went off for long periods to live in communion with nature with shepherds in the Campagna. In the open air he produced rapid sketches in pen and ink, with shading in ink wash (see Introduc-

27-7. CLAUDE LORRAIN. *Embarkation of Saint Ursula.* 1641. Oil on canvas, 44½ × 58½" (1.13 × 1.47 m). National Gallery, London. Reproduced by courtesy of the Trustees

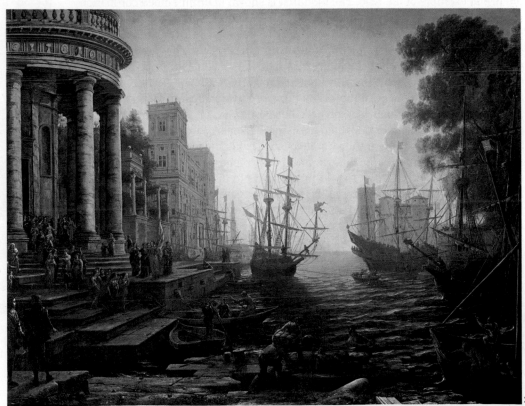

tion fig. 2), which not only record in fluid masses of dark the play of light and shade on foliage but also convey a rhapsodical response to nature. Such an attitude was the direct ancestor of that of the early-nineteenth-century English Romantics, especially John Constable (see pages 895–97). These rapid notes were the foundation of Lorrain's studio pictures.

Strikingly original are Lorrain's port scenes, recalling his love for the Bay of Naples, which he saw as a youth, and pervaded by the light of gentle Italian sunsets, which last for hours. In the *Embarkation of Saint Ursula*, of 1641 (fig. 27–7)—which could just as well be the embarkation of almost any other group of ladies—the rippling surface of the water leads the eye effortlessly to the point where perception dissolves in the soft gold sunlight. The foreground figures serve as a foil, and the water is framed on one side by the meticulously rendered shipping, on the other by a fanciful architecture that transports Bramante's Tempietto (see fig. 22–20) to the seashore, along with a two-tower Roman Renaissance villa.

OTHER FRENCH PAINTERS Among the many French painters who stayed at home the most gifted was PHILIPPE DE CHAMPAIGNE (1602–74). Born in Brussels, Champaigne was brought up in a strong Flemish Baroque tradition, but after 1643, the probable date of his conversion to the austere Catholic Jansenist movement, his work underwent a fundamental change. His most original paintings are his sober portraits, painted in a cool, exactly controlled style, such as *Arnauld d'Andilly* (fig. 27–8), of 1650, which shows a man in an aperture that functions as a window but looks little like one, framed by roughly planed and joined strips of wood whose illusion of tactile reality is enhanced by the subject's hand, lying gently over the edge to unite the dim space within the picture with the bright light outside. His calm face is illuminated in a clear, almost Eyckian glow that reveals every wrinkle and every vein. Yet the face, ravaged by time and emotion, shares the common Baroque experience of suffering undergone, assimilated, and overcome.

Such simple and unsparing portraits contrast sharply with the official art that dominated the period of Louis XIV. Among the principal practitioners, HYACINTHE RIGAUD (1659–1743) more than any other was responsible for determining the character of ceremonial Baroque portraiture throughout Europe. His *Portrait of Louis XIV* (fig. 27–9), painted in 1701, when the king was sixty-three years old, is the prime example of the type. The monarch is shown in ermine-lined coronation robes tossed jauntily over his shoulder to reveal his white-stockinged legs, the feet pirouetting in the high-heeled shoes the king invented to compensate for his diminutive stature. The Baroque magnificence of the pose and the dramatic array of gorgeous fabrics and bits of architecture are deployed climactically in an effort to endow divine-right absolutism with some of the air of revelation derived from the images of ecstatic saints. Rigaud worked out a production system for such official portraits: he alone painted the subject's head from life on a small canvas, and designed the whole composition; then his assistants enlarged the design, gluing the the head in the proper place. A team of specialists in painting armor, fur, fabrics, architecture, and at times landscapes and battle scenes then went to work. The theatrical quality of the result should not blind us to the fact that as a portraitist Rigaud was unexcelled anywhere at the turn of the century; his delineation of the face of the king in old age, who still acted the Grand Monarch in spite of severe military setbacks, is chilling in its directness.

ARCHITECTURE AND DECORATION: THE ROAD TO VERSAILLES The truly original contributions of French seventeenth-century architecture lay in the secular sphere, especially the châteaus built for royalty, nobility, and wealthy officials, culminating in the Royal Palace at Versailles (see figs. 27–13 to 27–17). An early leader was FRANCOIS MANSART (1598–1666), who built in 1635–38 a wing for the earlier Château of Blois (fig. 27–10) that takes its name (the Orléans Wing) from the patron, Gaston, duke of Orléans. The three-story façade with steep roofs and

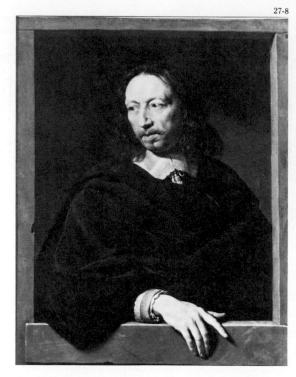

27-8. PHILIPPE DE CHAMPAIGNE. *Arnauld d'Andilly.* 1650. Oil on canvas, 35¾ × 28¾″ (90.8 × 73 cm). Musée du Louvre, Paris

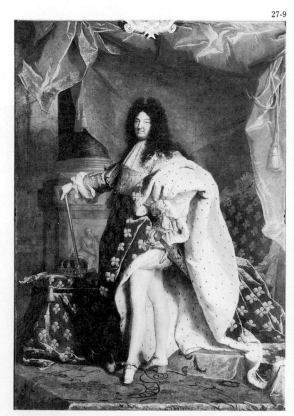

27-9. HYACINTHE RIGAUD. *Portrait of Louis XIV.* 1701. Oil on canvas, 9′2″ × 7′10¾″ (2.79 × 2.4 m). Musée du Louvre, Paris

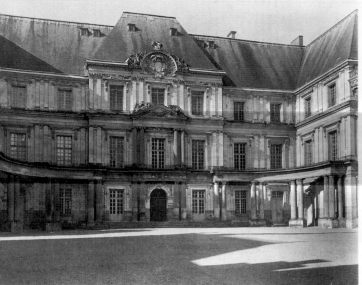

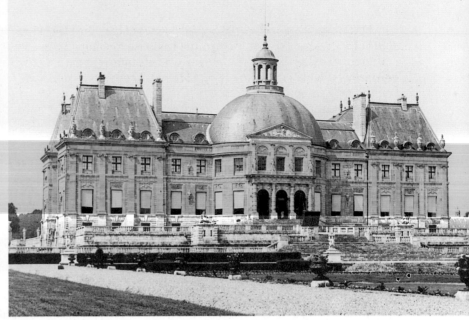

27-10. FRANÇOIS MANSART. Orléans Wing, Château of Blois, France. 1635–38

27-11. LOUIS LE VAU. Garden façade, Château of Vaux-le-Vicomte, France. 1657–61

central pavilion derives from the tradition established by Lescot in the Square Court of the Louvre (see fig. 25–19). In its canonical superimposition of Doric, Ionic, and Corinthian orders, Mansart's façade is, if anything, more classical than Lescot's. But the Mannerist linear web of architecture and sculptural decoration is here replaced by a new mastery of space and mass. The dominant central pavilion comes to a subdued Baroque climax around and above the entrance in engaged columns, rather than the pilasters used elsewhere throughout the façade; the effect is completed by a gabled pediment in the second story and an arched pediment in the third, which receive the only sculptural decoration on the otherwise austere exterior except for that around the portal. In a bold and novel invention, a quadrant of freestanding, paired Doric columns on each side leads up to the entrance and bridges the gap between the central structure and the projecting wing. These dramatic effects, however, are moderated by a lightness, elegance, and precision remote from the dynamism of Italian Baroque designs.

Oddly enough, the first French Baroque venture into grandiosity, the Château of Vaux-le-Vicomte (fig. 27–11), was built in 1657–61 for a commoner, Nicolas Fouquet, finance minister of Louis XIV, who was determined to erect the most splendid château in France. His success also proved his undoing because three weeks after his lavish housewarming, which included fireworks and a specially commissioned comedy by Molière in the presence of the king and queen and the entire court, Fouquet was arrested and imprisoned for life on orders from Colbert for embezzlement, and all his property, including Vaux-le-Vicomte, was confiscated by the king. The architect, LOUIS LE VAU (1612–70), the landscape designer ANDRÉ LE NÔTRE (1613–1700), and the mural painter and interior designer CHARLES LE BRUN (1619–90), who had functioned so brilliantly as a team at Vaux-le-Vicomte, were absorbed into royal service, and within a few years achieved their triumph at Versailles.

The garden façade of Vaux-le-Vicomte, despite its adoption of such Italian elements as a central dome (over an oval grand salon) and a giant Ionic order for the side pavilions, would probably have impressed an Italian of the period as timid; nonetheless, the characteristic elegance and grace of the elements and their articulation are typical of French taste of the period and were carried out in harmony with the broken silhouette and lofty lantern that recall Chambord (see fig. 25–18). The formal gardens, with their elaborate geometrical planting, urns, and statues, contained the germ of ideas Le Nôtre later carried out on a colossal scale in the gardens and park at Versailles.

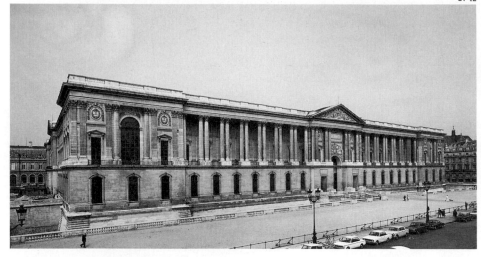

27-12

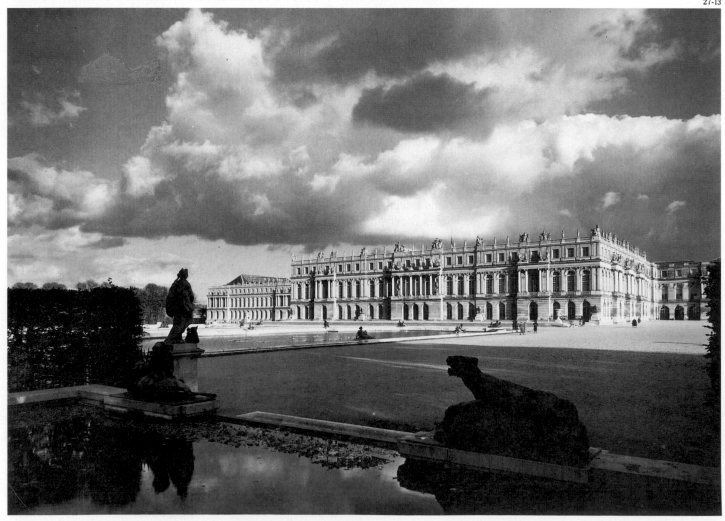

27-13

27-12. Claude Perrault. East façade, the Louvre, Paris. 1667–70

27-13. Louis le Vau and Jules Hardouin-Mansart. Garden (west) façade, Palace of Versailles. 1669–85

Louis XIV had summoned Bernini to France to complete the east façade of the Louvre. Bernini, arrogantly critical of everything French, submitted gorgeous designs that would have dwarfed the sixteenth-century sections of the palace and completely encased the court by Lescot. They were rejected as impractical and incompatible with French taste, and the great Italian master returned to Rome. The design finally accepted was so classicistic that it has little connection with anything in previous French (or, for that matter, Italian) architectural history (fig. 27–12). The authorship of the east façade of the Louvre, of 1667–70, is still a matter of

27-14

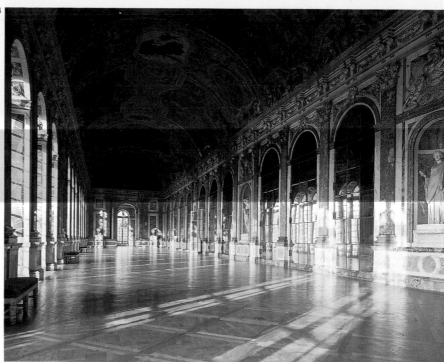

27-14. JULES HARDOUIN-MANSART and CHARLES LE BRUN. Hall of Mirrors, Palace of Versailles. Begun 1678

dispute; apparently, both Le Vau and Le Brun helped with its design, but the decisive idea seems to have come from an amateur archaeologist and architect (and professional physican), CLAUDE PERRAULT (1613–88). All that remains of traditional French design is the idea of central and terminal pavilions and connecting walls, restated in terms of a stately peristyle of coupled Corinthian columns two stories high, with a central pediment. Since the ground story is treated as a podium, for the first time a French building presents itself as a single giant story embracing the entire structure. Although both the rigorous classicism and the airy lightness of the peristyle are alien to Italian Baroque architecture, the giant order on a podium and the balustrade against the sky were taken over from Bernini's designs. The new severe mass of the east façade of the Louvre, with its hidden roof and unbroken architectural profile, proved definitive for French palace architecture for the next century.

Despite the pleas of Colbert, who wanted to keep the king in Paris, at the time the east façade of the Louvre was still under construction Louis XIV decided to move the court to Versailles, a few miles outside the capital, in order to concentrate the endemically rebellious nobles where he could keep an eye on them; every noble had to spend some portion of the year at court, and accommodations—often minimal—were provided for them in the vast structure. The king envisioned an ideal architecture and landscape, centering on the royal person and taking no note of the commonplaces of urban existence. The result was one of the most ambitious constructions ever conceived. The nucleus, a hunting lodge built by Louis XIII, was enveloped in 1669–85 by a new structure, originally designed by Le Vau. His west or garden façade consisted of what is now the central block (fig. 27–13). A lightly rusticated podium supports the principal story, with arched windows and a modest Ionic order, and a massive attic story, whose balustrade is enriched by urns and trophies. Le Vau's original façade was set back between narrow projecting wings in a flattened horseshoe. The wings were connected, beginning in 1678, at the king's command, by the construction of the immense Hall of Mirrors (see fig. 27–14), designed by JULES HARDOUIN-MANSART (1646–1708), grandnephew of François Mansart, thus creating a unified façade.

In order to house the nobility and to provide for royal offices and guards, a small city was built to the east of the palace, and the original block extended by enormous

wings to a total length of six hundred yards, often criticized as out of scale with the proportions of the Ionic order used throughout. Judged by Italian standards, the final effect of the palace is disappointing, but viewed from the gardens, with which it forms a whole, it looks unexpectedly fragile and very beautiful, especially on bright days when the warmth of the creamy stone glows against the sky. On such a scale a giant order in the Italian manner might have proved crushing, and it also might have spoiled the festive lightness of the exterior, intended as a backdrop for gorgeous festivities, often lasting for days, with comedies, balls, music, fireworks, and torchlight suppers in the open air. Even today the full effect of the architecture cannot be appreciated unless the fountains are functioning.

The central axis of the landscape design is the east-west path of the sun—which Louis XIV adopted as his symbol—as it travels along the road from Paris and passes through the king's bedroom, at the exact center of the palace, and out along the walks and canals that extend some three miles through the park to set over the low hills in the distance. It is no accident that the great event of each day at Versailles was the *levée* ("rising"), a term applied indiscriminately to the appearance of the sun over the horizon and the emergence of the Sun King from his bed, a daily event accompanied by elaborate ritual and awaited by courtiers in the Hall of Mirrors (fig. 27–14), whose central doorway was that of the royal bedchamber. No wonder that the principal theme of the Hall of Mirrors is light; the sunlight through the seventeen arched windows is reflected in seventeen matching mirrors and illuminates a vaulted ceiling decorated by frescoes on mythological and historical subjects relating to royalty, framed by gilded stucco ornamentation on the model of the gallery of Palazzo Farnese (see fig. 26–1), all designed by Charles Le Brun. Enhanced by acres of transparent or reflecting glass, the effect of the pink marble pilasters, the gilded Corinthian capitals and entablatures, and the colors and gold of the ceiling decorations yields in splendor to no Roman Baroque interior in spite of the typical French primness of long straight lines. But the frescoes, rapidly executed by battalions of painters, scarcely hold up under inspection. The brilliant interior should be supplied in our imagination with the complete set of massive solid-silver furniture that once adorned it, further reflecting the western sunlight; alas, it all had eventually to be cashed in to pay the king's armies.

Le Brun, whose administrative authority extended the absolute power of the monarchy even into the sphere of the arts, was an ingenious designer, and no detail of decoration, furnishings, or hardware was too small to escape his attention, but the monarchical system was unlikely to produce great art. It had, nonetheless, been codified regarding the arts since 1648 in the formidable institution of the Royal Academy. Under Le Brun, director from 1663 until his death, a program of instruction and a series of rules were devised to enforce conformity to official standards, exalting the ancients, Raphael, and Poussin; the consequences of the academic codes and norms were felt acutely into the late nineteenth century, and periodic revolts against them characterized the initial stages of most new movements in European art.

Perhaps the single best decorative work at Versailles is *Louis XIV on Horseback* (fig. 27–15), a white stucco relief in the Salon de la Guerre, by ANTOINE COYSEVOX (1640–1720). Garbed as a Roman imperator, the king tramples on enemies on whom he does not deign to bestow a glance, while Eternity, embracing a pyramid, extends the French royal crown over his bewigged head. She competes uselessly for his attention with marble Victories who lean into the frame, one blowing a trumpet, the other offering a laurel crown, while wretched prisoners are fettered to consoles below and Fame, in the lowest relief, writes the king's immortal deeds upon a shield. Strongly influenced by Bernini, the style is nonetheless French in its measured pace, its linearity, and the careful control of all details.

Hardouin-Mansart's triumph at Versailles, freed from any inheritance of Le Vau's proportions, is the Royal Chapel (fig. 27–16), of 1689–1710, a work of extreme classicism yet exceeding lightness. The lower story, intended for courtiers, is

27-15. ANTOINE COYSEVOX. *Louis XIV on Horseback*, stucco relief, Salon de la Guerre, Palace of Versailles. 1683–85

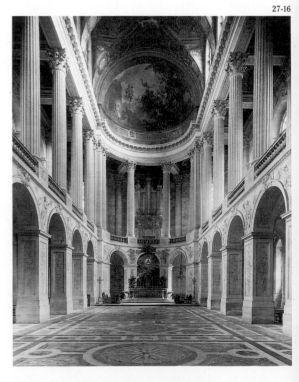

27-16. JULES HARDOUIN-MANSART. Royal Chapel, Palace of Versailles. 1689–1710

27-17. Plan of the Palace of Versailles and the gardens designed by ANDRÉ LE NÔTRE (17th-century engraving by NICOLAS DE FER)

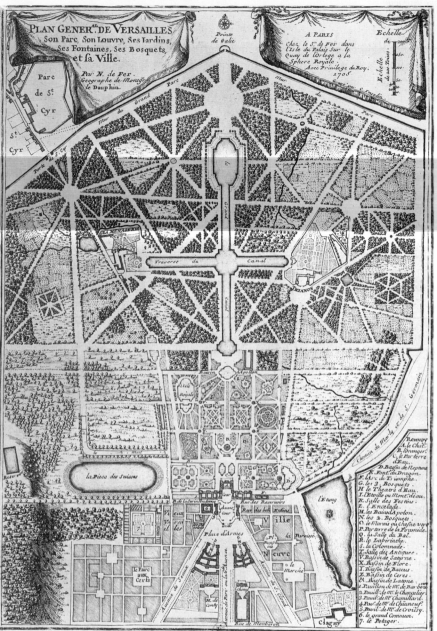

27-18. JULES HARDOUIN-MANSART. Grand Trianon, Versailles. Begun 1687

formed by an arcade supported by piers, and serves as a support for the principal story, a widely spaced, archaeologically correct colonnade of fluted Corinthian columns running round the apse, which provides a deep gallery for the royal family. The frescoed, groin-vaulted ceiling, pierced by an arched clerestory, is subordinated to the grandeur of the columns, and the altar itself seems hardly more than a necessary piece of furniture.

The formal gardens, with their geometrical flower beds, urns, statuary, trimmed hedges, grottoes, planted groves, lofty fountains, canals, and pools, are an extension of the palace itself over the landscape (fig. 27–17). They are the masterpiece of Le Nôtre, who also designed systems of avenues through the park, radiating from circles or ovals, as if to submit the last recesses of nature to the royal will. It is not surprising that from time to time the king found it necessary to escape from his mythological self and live the life of a human being. In consequence he set aside a section of the park for a one-story dream house, the Grand Trianon (fig. 27–18), designed by Hardouin-Mansart in 1687. The two sections of the house are united by a peristyle, arched on the entrance side, but supported on the garden front by an exquisite colonnade of paired, pink marble Ionic columns, continuing as pilasters

between the arched windows. The enchanting little building is a triumph of grace and intimacy, in perfect union with the out-of-doors, which flows through its very center. While the peristyle provided a cool place to sit or dine in summer, the interior spaces, of modest size and unceremonious arrangement, were grouped in apartments of four rooms, united at the corners by efficient porcelain stoves for winter comfort. All glass, white limestone, and pink marble, the Grand Trianon is as colorful and insubstantial as a soap bubble.

ARCHITECTURE AND SCULPTURE AWAY FROM VERSAILLES In his Church of the Invalides (fig. 27–19), built in 1676–1706 as an addition to a home for the constantly growing host of disabled veterans of the Sun King's wars, Hardouin-Mansart displayed an unexpectedly close connection with Roman tradition as exemplified by Michelangelo, della Porta, Maderno, and Bernini. The dome with its paired columns recalls Saint Peter's (see fig. 23–8); the two-story façade with its central crescendo of clustered columns derives from such models as Il Gesù (see fig. 23–37) and Santa Susanna (see fig. 26–10). Yet the Baroque climax is attained by methods sedately French; there are no broken pediments, no floating sculpture, no concavities or convexities. Columns are fully in the round rather than engaged, as in Italian Baroque façades, and classically correct. The structure is bound together by delicate adjustments of its components, which make it one of the most harmonious exteriors of the seventeenth century. For example, to establish the dominant role of the central pediment, Hardouin-Mansart suppressed the central pair of columns directly above it in the drum of the dome and crowned the whole with a highly original rectangular lantern whose roofline, seen in perspective from the street, carries the angle of the pediment to the apex of the entire structure. Characteristically for Hardouin-Mansart, the four great arches upholding the dome in the interior are fronted by four pairs of huge Corinthian columns in the round upholding sections of entablature curved as arcs of the dome, to overwhelming effect (fig. 27–20; compare them with the pilasters fulfilling the same function at Saint Peter's in Rome, fig. 26–12). Hardouin-Mansart recognized that from the interior it is impossible to assess the true upward extent of a dome; he therefore designed a shallow inner dome pierced by a huge oculus, through which we look up into a second, closed dome, painted to show Saint Louis, patron saint of France, carried up into heaven, lighted mysteriously by windows in the upper drum, which are invisible from below (see the cross section in fig. 27–21). Again the French

27-19. JULES HARDOUIN-MANSART. Façade, Church of the Invalides, Paris. 1676–1706

27-20. JULES HARDOUIN-MANSART. Interior, Church of the Invalides, Paris

27-21. JULES HARDOUIN-MANSART. Cross section of the Church of the Invalides, Paris (after a 17th-century engraving by F. Blondel)

27-22. ANTOINE COYSEVOX. *Portrait Bust of Jean Baptiste Colbert*. 1677. Marble. Palace of Versailles

27-23. FRANÇOIS GIRARDON. Tomb of Richelieu. 1675–77. Marble. Church of the Sorbonne, Paris

27-24. PIERRE PUGET. *Milo of Crotona*. 1671–83. Marble, height 8′10½″ (2.71 m). Musée du Louvre, Paris

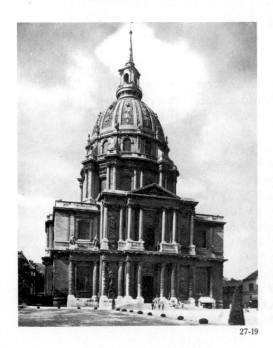

27-19

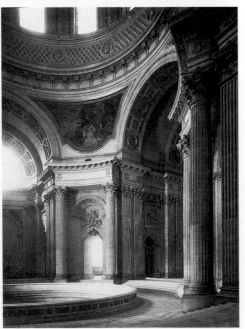

27-20

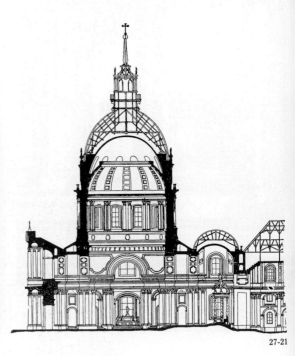

27-21

27-22

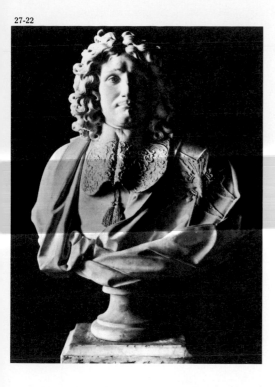

27-23

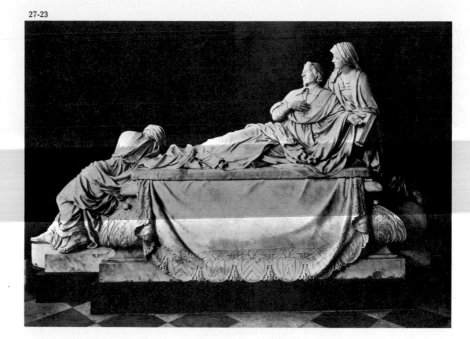

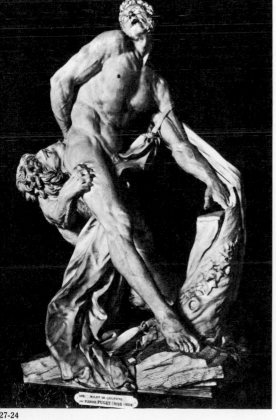

27-24

version of the Baroque climax is achieved by exact calculation rather than by the dramatic pictorial methods of the Italians. The outer dome, of no structural function, is a towering balloon of timber covered with lead, exalting the lantern to its dominant position on the Paris skyline.

When not restrained by officialdom, Coysevox maintained a portrait style second only to that of Bernini in seventeenth-century sculpture. His bust of the king's powerful finance minister Jean Baptiste Colbert, of 1677 (fig. 27–22), while recalling the movement of line and surface of the great Italian sculptor who had so recently visited France, nonetheless preserves a sobriety not far from the honest pictorial style of Philippe de Champaigne (see fig. 27–8) and is far more impressive than the decorative works commissioned for Versailles and its gardens. Coysevox's contemporary FRANÇOIS GIRARDON (1628–1715), author of an immense amount of decorative and official sculpture of high quality, was responsible for a new type of freestanding dramatic tomb showing the deceased at the moment of translation to a higher realm without any of the Italian machinery of angels, clouds, rays, and billowing curtains. His Tomb of Richelieu, of 1675–77 (fig. 27–23), still in its original position in the Church of the Sorbonne in Paris, was intended to be seen from all sides. Its principal group, the dying cardinal upheld by Piety, facing the altar and looking toward Heaven, builds up with the dignity of a composition by Poussin, although the contrast between the crumpled masses of the cloak and the billowing pall was derived from a study of Bernini's technique. From the altar the composition, seen foreshortened in depth, is equally effective.

The maverick among French Baroque sculptors was PIERRE PUGET (1620–94), whose independence of official taste cost him popularity at court. His *Milo of Crotona*, of 1671–83 (fig. 27–24), shows with brutal realism the fate of the Greek athlete Milo. Unable to extricate his hand from a split tree stump, he was attacked from behind by a lion. Obviously, Puget had studied Michelangelo's *Rebellious Slave* (see fig. 22–15) and Bernini's *David* (see fig. 26–13). The rendering of the abdominal muscles pulsating with pain and the convulsed facial expression shows that Puget had also learned a great deal from independent observation. The group is a work of tremendous emotional and compositional power. Tradition has it that the statue was uncrated at Versailles in the presence of the queen, who, when she came to a full realization of its subject, murmured, "Ah, le pauvre homme!" Puget's vivid Baroque realism was better appreciated in Italy, where he had considerable success.

Flemish Painting

The separation of the Netherlandish provinces into what are today the independent kingdoms of Belgium and Holland was, first and foremost, a division along religious lines, but it had far-reaching political and economic consequences. The Calvinist northern provinces, democratic in outlook under their chosen governors, conducted a flourishing trade with most of the known world and established a major empire in the East and West Indies. The Catholic southern provinces remained under Habsburg control; the archduchess Isabella of Austria and her husband Albert, brother of the emperor, encouraged learning and the arts, but commerce stagnated. During its period of artistic preeminence, in the first half of the seventeenth century, the southern Netherlands was in constant political and economic difficulties. Although *Flanders* and *Flemish* properly refer to only one of the ten southern Netherlandish provinces, they are the most convenient words to designate the entire region and its inhabitants during the period before the founding of the kingdom of Belgium in 1830. None of the major European architects or sculptors of the age were Flemish; the glory of Flemish art during this brief period derives principally from the work of a single extraordinary painter.

RUBENS Peter Paul Rubens (1577–1640) exercised in Flanders a stylistic authority at least as great as that of Michelangelo in central Italy a century before and surpassing that enjoyed by Bernini in contemporary Italy. Born near Cologne, the son of a Protestant émigré from Antwerp, he spent his childhood in Germany. He received a thorough grounding in Latin and in theology, spent a few months as page to a countess, and grew up as an unparalleled combination of scholar, diplomat, and painter. He spoke and wrote six modern languages—Italian with special ease—read Latin, and was probably the most learned artist of all time. Through wide travels in diplomatic service, he established contacts with kings and princes throughout western Europe. His house in Antwerp, which still stands, well restored, was a factory from which massive works emerged in a never-ending stream. Two of its most impressive features are the balcony in the studio, from which Rubens could survey the work of his assistants in the laying out of colossal altarpieces and display them to powerful patrons, and the door, only about three feet wide but at least twenty feet high, through which the monumental panels and canvases were carried sideways to be shipped to destinations near and far. He charged in proportion to his own participation in a given work, and although most paintings were designed by him in rapidly painted color sketches on wood, all the large ones were painted by pupils and then retouched by the master, who provided his inimitable brushwork and glowing color in the final coat—or, if the price was not high enough, he left the students' work untouched. To understand Rubens's production system, one has also to grasp his extraordinary character and intelligence; one visitor recounted how Rubens could listen to a reading of Roman history (in Latin, of course), carry on a learned conversation, paint a picture, and dictate a letter all at the same time.

Rubens first emerged on the international scene during his visit to Italy in 1600, where, except for a diplomatic mission to Spain, he remained for eight years. More than anything else, artistically at least, Rubens was an adopted Italian, with surprisingly little interest in the Early Netherlandish masters, whom he apparently regarded as too remote to be any longer relevant. With rigorous system and indefatigable energy, he set out to conquer the fortress of Italian art, beginning with ancient Rome and skipping to the High and Late Renaissance. He made hundreds of drawings and scores of copies after Roman sculpture as well as paintings by Mantegna, Leonardo (see fig. 22–7), Raphael, Michelangelo, Correggio, Titian, Tintoretto, and Veronese, not to speak of the Carracci and Caravaggio, then still working busily in Rome. He commissioned assistants to make hundreds more drawings from the masters, many of which he retouched. From this comprehensive

27-25

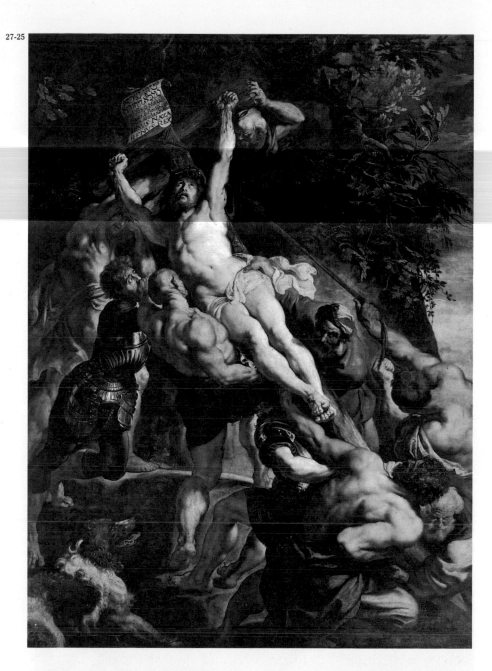

27-25. PETER PAUL RUBENS. *Raising of the Cross* (center panel of a triptych). 1610–11. Oil on panel, 15'1⅞" × 11'1½" (4.62 × 3.39 m). Cathedral of Our Lady, Antwerp

record he evolved a personal style characterized by abundant physical energy and splendid color; the seventeenth-century critic Giovanni Pietro Bellori spoke of his "fury of the brush."

An early work in Antwerp Cathedral, the *Raising of the Cross* (fig. 27–25), a panel more than fifteen feet high, painted in 1610–11, shows the superhuman energy with which Rubens attacked his mighty concepts. The central panel of a triptych, the picture is, nonetheless, complete in itself. Interestingly enough, there is no hint of Caravaggio's psychological interests. The executioners, whose muscularity recalls the figures in Michelangelo's *Last Judgment* (see fig. 23–5), heave and tug the Cross upward, forming a colossal pyramid of struggling figures, an enriched version of the characteristic High Renaissance interfigural composition transformed into a Baroque climax. The sheer corporeal force of the painting makes it hard to realize that at this very moment in Spain El Greco was painting his most disembodied and mystical visions.

As his style matured, Rubens's characteristic spiral-into-the-picture lost the dark shadows of his early work and took on an always more Titianesque richness and

translucency of color. His *Rape of the Daughters of Leucippus,* of about 1616–17 (fig. 27–26), recalls forcibly Titian's *Rape of Europa* (see fig. 24–10), which Rubens carefully copied while in Spain. Although the figures have been made to fit into Rubens's mounting spiral, such is the buoyancy of the composition that the result does not seem artificial. The act of love by which Castor and Pollux, sons of Jupiter, uplift the mortal maidens from the ground draws the spectator upward in a mood of rapture not unrelated to that Bernini was soon to achieve in the *Ecstasy of Saint Theresa* (see fig. 26–15). The female types, even more abundant than those of Titian, are traversed by a steady stream of energy, and the material weight of all the figures is lightened by innumerable fluctuations of color running through their pearly skin, the tanned flesh of the men, the armor, the horses, even the floods of golden hair. The low horizon increases the effect of a heavenly ascension, natural enough since this picture, like the ceiling of the Farnese Gallery (see fig. 26–1), constitutes a triumph of divine love; the very landscape heaves and flows in response to the excitement of the event.

The power of Rubens can be seen at its greatest in the *Fall of the Damned* (fig. 27–27), painted about 1614–18, a waterspout of hurtling figures—Rubens's spiral in reverse—raining down from Heaven, from which the rebels against divine love are forever excluded. It is hard for English-speaking viewers to avoid thinking of the torrential lines from Milton's *Paradise Lost* (I, 44–49):

> *Him the Almighty Power*
> *Hurld headlong flaming from th' Ethereal Skie*
> *With hideous ruine and combustion down*
> *To bottomless perdition, there to dwell*
> *In Adamantine Chains and penal Fire,*
> *Who durst defie th' Omnipotent to Arms.*

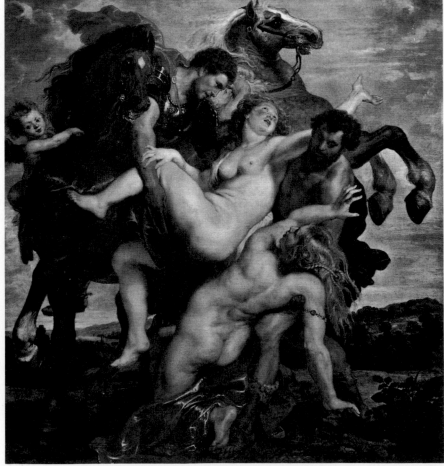

27-26. PETER PAUL RUBENS. *Rape of the Daughters of Leucippus.* c. 1616–17. Oil on canvas, 7'3½" × 6'10¼" (2.22 × 2.09 m). Pinakothek, Munich

27-26

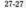

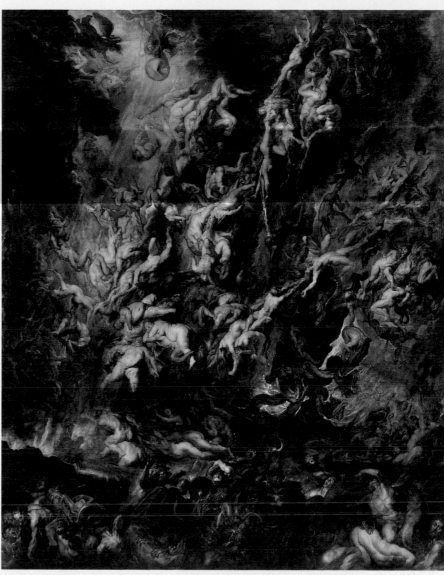

27-27. PETER PAUL RUBENS. *Fall of the Damned.*
c. 1614–18. Oil on panel, 9′4½″ × 7′4⅛″
(2.86 × 2.24 m). Pinakothek, Munich

Nor is it difficult to see in Rubens's mighty conception the origin of the falling figures in Baciccio's ceiling for Il Gesù (see fig. 26–29).

In 1621–25 Rubens carried out a splendid commission from Maria de' Medici, dowager queen of France, widow of Henry IV, and regent during the minority of her son Louis XIII. The twenty-one large canvases represent an allegorized version of the queen's checkered career, showing her protected at every point by the divinities of Olympus. The series was originally installed in a ceremonial gallery in the Luxembourg Palace, a Baroque Parisian version of the Pitti Palace in Florence (see fig. 23–34). While all the canvases show the magnificence of Rubens's compositional inventiveness and the depth of his classical learning, they are not of uniform quality in detail. *Henry IV Receiving the Portrait of Maria de' Medici* (fig. 27–28) is one of the best, a brilliant achievement not only in composition but also in every detail, surely finished throughout by Rubens's own hand. The aging king, whose helmet and shield are purloined by cupids, is advised by Minerva to accept as his second bride the Florentine princess, whose portrait is presented by Mercury, as Juno and Jupiter smile upon the proposed union. The promise of divine intervention; the radiant health of the youthful nude figures; the sage grandeur of the armored king; the splendor of the coloring of flesh, metal, drapery, clouds, even Juno's gorgeous peacocks; and the opulence of the distant landscape render this

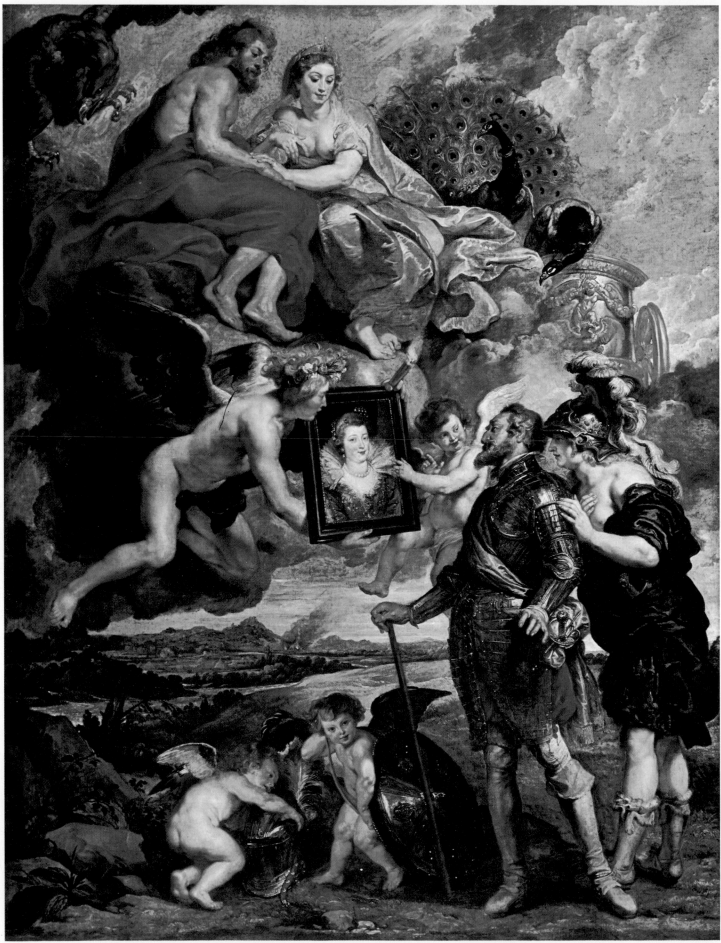

27-29

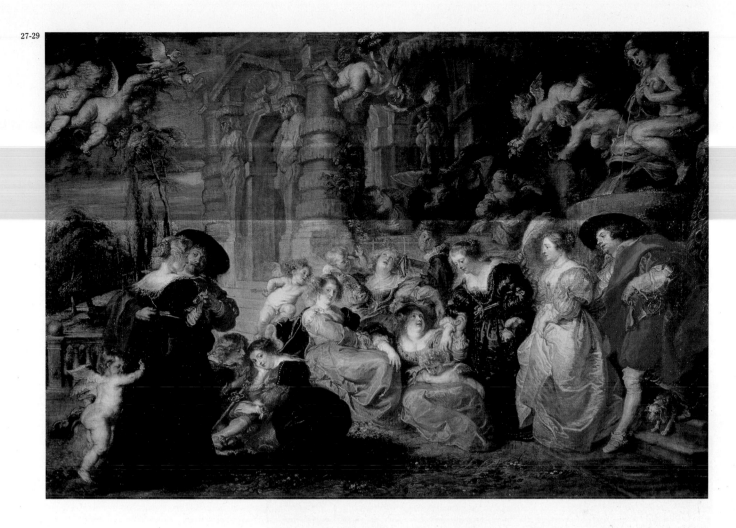

27-28. PETER PAUL RUBENS. *Henry IV Receiving the Portrait of Maria de' Medici*. 1621–25. Oil on canvas, 12′11⅛″ × 9′8⅛″ (3.94 × 2.95 m). Musée du Louvre, Paris

27-29. PETER PAUL RUBENS. *Garden of Love.* c. 1638. Oil on canvas, 6′6″ × 9′3⅜″ (1.98 × 2.83 m). Museo del Prado, Madrid

one of the happiest of Rubens's allegorical works. He decided to abandon a second series, the *Life of Henry IV,* because the first was never paid for, but when the queen, driven out of France by her former protégé Cardinal Richelieu, took refuge in Flanders, it was Rubens who helped to support her during her twelve years of impecunious exile—a remarkable tribute not only to the generosity of a great man but also to the position of a Baroque artist who could finance a luckless monarch.

During his second stay in Madrid, in 1628–29, Rubens is reported to have exclaimed that he was "as in love with Titian as a bridegroom with his bride." This was not only an apt simile for the startling rebirth of poetic beauty and coloristic vitality in the artist's later works, founded on his Baroque reinterpretation of Titian, but also a prophecy as well; in 1630, then fifty-three years old and a widower, Rubens married Hélène Fourment, a girl of sixteen, who was to bear him five healthy children. Her golden loveliness illuminates a score of pictures, and the artist's radiant happiness during his final decade received its perfect embodiment in the *Garden of Love* (fig. 27–29), painted about 1638, a fantasy in which seven of the Fourment sisters are disposed throughout the foreground, some with their husbands (Rubens himself, somewhat idealized, with Hélène at the extreme left), before the fantastic fountain-house in Rubens's garden at Antwerp. Cupids, emulated from Titian, fly above the scene with bows, arrows, a rose garland, and torches, and on the right sits a statue of Venus astride a dolphin, pressing jets of water from her abundant breasts. All Rubens's love of Titian, all the movement of his color, all the energy of his composition are summed up in the radiance of this picture, the most felicitous of Baroque testaments to the redeeming power of love.

VAN DYCK Rubens's assistant and later a friendly rival in Flanders, Italy, and England was Anthony van Dyck (1599–1641), already an accomplished painter at sixteen. His extreme sensitivity to color and shape separates him at once from the less subtle, more vigorous and robust Rubens. Like his master, van Dyck was aristocratic by training and preference; unlike him the pupil was arrogant and wayward, shuttling impetuously back and forth between Antwerp, Genoa, Palermo, Paris, and London, where he became court painter to King James I and later to his successor Charles I, remaining nonetheless resolutely Catholic. King Charles was, indeed, a frequent and willing guest at sumptuous dinners given by the ambitious young painter. For that monarch he painted in 1629 one of his loveliest works, *Rinaldo and Armida* (fig. 27–30), whose subject was drawn from *Gerusalemme Liberata* by the late-sixteenth-century Italian poet Torquato Tasso, the king's favorite poem. Rinaldo, a Christian knight dedicated to the Crusaders' attempt to liberate Jerusalem from the Muslims, has fallen asleep, bewitched by the song of a voluptuous river-nymph, in whose fingers flutters a page of music recently identified as probably from a lost opera on the same subject by the pioneer Baroque composer Claudio Monteverdi. The sorceress Armida, intending to kill Rinaldo to prevent him from reaching the Holy City, is shown at the exact moment when she falls in love with him as he sleeps, thus beginning her conversion. Locked by Armida's passionate gaze, the two figures seem to turn on the canvas like a wheel of colored fire, their motion flowing outward to the river-nymph, the attendant cupids, and the wonderful, floating rose-colored cloak of Armida. Echoes of Titian's great erotic paintings, the *Rape of Europa,* the *Bacchanal of the Andrians,* and above all *Sacred and Profane Love* (see figs. 24–10, 24–4, 24–3), which van Dyck had

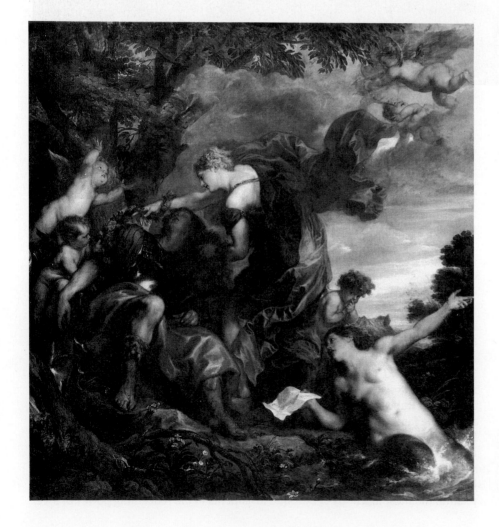

27-30. ANTHONY VAN DYCK. *Rinaldo and Armida.* 1629. Oil on canvas, 7′9″ × 7′6″ (2.36 × 2.29 m). The Baltimore Museum of Art, Epstein Collection

27-31

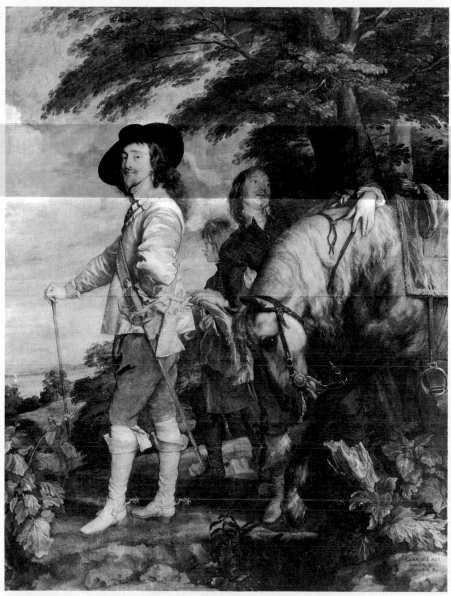

27-31. ANTHONY VAN DYCK. *Portrait of Charles I in Hunting Dress.* 1635. Oil on canvas, 8′11″ × 6′11½″ (2.72 × 2.12 m). Musée du Louvre, Paris

studied and sketched, are drawn into a rhapsodical Baroque whole by this grand spinning motion and by the Flemish artist's piercingly sweet reinterpretation of the light, shadow, flesh, silks, shining armor, and glowing color of his great Venetian forebear.

No seventeenth-century painter could rival his refinement and delicacy, and it is no wonder that he became famous for his portraits of nobility and royalty, which generally show the subjects as vastly more elegant and beautiful than we know them to have been. From van Dyck's superb portraits we would never guess that in reality the king was short and undistinguished in appearance; in his *Portrait of Charles I in Hunting Dress* (fig. 27–31), of 1635, van Dyck endows him with extraordinary dignity and an air of romantic melancholy. Despite the relative informality of the costume and moment—the king seems ready to mount his horse and ride off to the chase—this is a state portrait; only van Dyck's inspired ease of composition and of statement prevents it from seeming artificial and posed. The verve of his lines and the sparkle of his color, even to the shimmer of the horse's mane and the liquid softness of its eyes, render this one of the most impressive of all official portraits; van Dyck, in fact, set the tone for such images in England for more than a century.

Spanish Painting and Sculpture

Although Spain, like England, produced writers and musicians of great importance during the Renaissance and few painters of interest, the country had been strongly impressed by the work of a foreign master of first importance, El Greco. It is surprising that the great creative development of Spanish painting in the seventeenth century owed little or nothing to El Greco's mysticism, which had vibrated in such perfect harmony with Spanish Counter-Reformation thought. Nor did the new art in Spain spring from the central region dominated by El Greco; the painters of the seventeenth century who suddenly established Spain in the forefront of Baroque visual creativity were all southerners.

RIBERA One of the earliest of these, Jusepe de Ribera (1591–1652), from Valencia province—although not the earliest Spanish master to feel the force of the Caravaggesque revolution but arguably the most important link between Spain and Italy—went to Italy probably soon after 1610 and settled in Naples, at the time a Spanish province, where he immediately came under the influence of Caravaggio's numerous Neapolitan followers, known as the *tenebrosi* ("shadowy ones") because of their exaggeration of Caravaggio's strong light-and-dark contrasts.

Ribera's best-known work, the *Martyrdom of Saint Bartholomew* (fig. 27–32), probably painted in 1639, shows an obvious reliance on Caravaggio in its emphasis on direct experience; it is surprising after El Greco that this experience is predominantly physical, even when the subject is religious. Bartholomew was flayed alive (see fig. 23–6 for Michelangelo's personal interpretation). Ribera has spared us any clinical rendering of the event, yet the picture is dominated by pain and fear. The almost naked saint is being hauled into position by his executioners, straining gigantically like Rubens's figures in the *Raising of the Cross* (see fig. 27–25). Ribera had no interest, however, in either Italian physical beauty or Rubens's spiral surge. These straining, sweaty figures against the blue sky look devastatingly real, and the

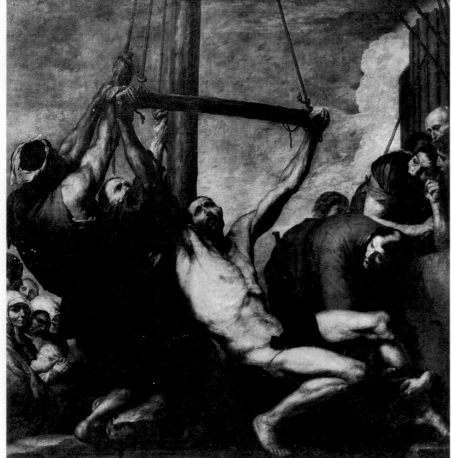

27-32. JUSEPE DE RIBERA. *Martyrdom of Saint Bartholomew.* c. 1639. Oil on canvas, 7'8⅛" × 7'8⅛" (2.34 × 2.34 m). Museo del Prado, Madrid

27-32

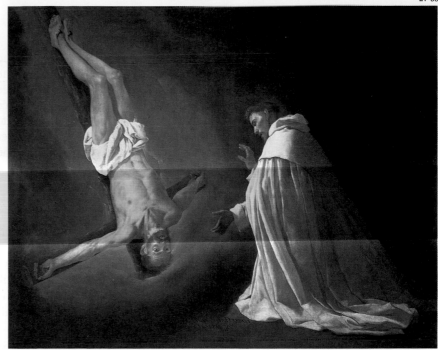

27-33. FRANCISCO DE ZURBARÁN. *Vision of Saint Peter Nolasco.* 1629. Oil on canvas, 70½ × 87¾" (1.79 × 2.23 m). Museo del Prado, Madrid

27-34. PEDRO DE MENA. *Penitent Magdalene.* 1664. Polychromed wood. Museo Nacional de Escultura, Valladolid

act they are about to perform will be seen by a very real crowd, including women and children. Such vivid concentration on the immediate is significant, for Spain's greatest contribution to European art, in the painting of Velázquez at midcentury, is purely optical, without spiritual purpose or overtones. The harsh reality of the scene prefigures some of the most powerful Spanish art of later periods, notably that of Goya (see pages 879–83).

ZURBARÁN A translation of the spiritual into direct physical terms communicates a special element of magic to the work of Francisco de Zurbarán (1598–1664), who never visited Italy but settled and worked in Seville. Like La Tour (see fig. 27–1), with whose poetic work that of Zurbarán has something in common, he experienced the Caravaggesque revolution at second hand, yet his art is closer to the basic message of Caravaggio—the externalization of inner experience—than is the more strident realism of Ribera. Like Caravaggio's, Zurbarán's light is clear, sharp, and real, his surfaces hard and smooth, his darkness total. In the *Vision of Saint Peter Nolasco,* of 1629 (fig. 27–33), the Apostle Peter—who had been crucified upside down at his own request to avoid comparison with Christ—appears in a vision to his meditating thirteenth-century namesake in the darkness of his cell. The room has disappeared; bright light reveals vision and visionary, both equally tangible, as if suspended, one surrounded by the darkness of this world, the other revealed by the light of the next.

PEDRO DE MENA A number of gifted Baroque sculptors carved statues and reliefs, often in polychromed wood, for Spanish churches. In many ways the most impressive of these masters is Pedro de Mena (1628–68) from Granada, whose images are even more startlingly real and direct than the paintings of Zurbarán. To reinforce the immediate impact of his statues Mena did not shrink, at times, from inserting glass eyes and porcelain teeth. The message of Mena continues and reinforces that of Zurbarán—an intense spirituality within the appearance of physical reality. Mena uses this reality in a deliberately empathetic sense for the provocation of religious experience. Rough and smooth, hard and soft, sharp and blunt are felt in our very flesh as we watch.

The *Penitent Magdalene,* of 1664 (fig. 27–34), shows the saint clothed not in the visually repellent tangle of hair Donatello carved and painted so convincingly (see fig. 20–27) but in a sleeveless garment of woven reeds, as harsh as a doormat, tied

about her waist with a belt of reeds. Mena's Magdalene is young and beautiful and has just begun her penitential sojourn in the wilderness. We are made to feel the sharpness of the woven reeds, like the traditional hair shirt, against her delicate skin in painful contrast with and in penance for the amorous bodies that once caressed it (Mary Magdalene was traditionally believed—with no evidence—to have been a prostitute). Indeed, she presses the matting against her breast with her right hand, pouring forth her soul in guilty weeping as she gazes on the crucifix she holds before her, a roughly carved image nailed to a cross of untrimmed logs.

VELÁZQUEZ The supreme native master of painting in Spain was Diego Rodríguez de Silva y Velázquez (1599–1660). Born in Seville, Velázquez studied with a local Mannerist named Francisco Pacheco. In 1623 he was appointed court painter and the following year settled permanently in Madrid; by 1627 he was established in the royal household, eventually attaining the rank of court chamberlain, which gave him a residence attached to the palace and a studio inside it. For more than thirty years Velázquez painted King Philip IV and members of the royal family and court, yet such was his originality and candor that not one of his paintings can be reproached with being a mere state portrait.

Although a close friend of Rubens at the time of the great Fleming's second visit to Madrid in 1628, Velázquez never deserted the integrity of his own style, and not once did he adopt the characteristic machinery of allegorical figures, columns, curtains, and boiling clouds utilized by most Catholic painters in the seventeenth century. Temperamentally little suited to religious subjects, he painted them rarely and with varying degrees of success. Like Frans Hals and Jan Vermeer (see pages 822, 829), with whose works he could hardly have been familiar, Velázquez was profoundly attached to nature as revealed to human vision through light. He visited Italy twice and expressed a frank distaste for Raphael—and thus in all probability for the Italian idealism of which Raphael was the chief exponent—while admiring Titian and copying Tintoretto as an exercise in freedom of the brush. Lest one think that Velázquez had no interest in Renaissance ideas, however, it is worthwhile noting that his private library contained the works of the principal Italian architectural theorists. Throughout his life he was deeply concerned with the principles of composition and design, no matter how immediate his subject matter.

Caravaggesque realism had already penetrated Spain and must have been felt as a liberation by the young Velázquez. His own interpretation of the movement is original and irresistible. His *The Drinkers (Los Borrachos)*, of about 1628, which was originally called the *Triumph of Bacchus* (fig. 27–35), contains numerous reminiscences of Titian's *Bacchanal of the Andrians* (see fig. 24–4), reinterpreted in basically Caravaggesque terms. Bacchus is a rather soft Spanish youth, with nothing but a towel and a cloak around his waist, as if he had just climbed out of a neighboring stream, and is anything but classical in appearance. Crowned with vine leaves himself, he mischievously bestows a crown upon a kneeling worshiper, who is a simple Spanish peasant. Other peasants are gathered round; one, with bristling mustache and hat pushed back to show the white forehead of a farmer's grinning, sunburned face, hands a cup of wine toward the spectator while another tries roguishly to grab it. The genial proletarian invitation to join in the delights of wine is painted with a brilliance unequaled by any other Latin painter in the seventeenth century. Yet the crusty surface and the emphasis on the solidity of flesh, rough clothing, and crockery show that Velázquez is basically a Mediterranean painter, concerned with substance, and unlikely to indulge in such fireworks of the brush as those of Frans Hals. It is no wonder that this picture excited the admiration of Édouard Manet in the nineteenth century.

At the time of Velázquez's second trip to Italy (1649–51), he fell even deeper under the influence of the great Venetians of the preceding century, but never that of his Italian Baroque contemporaries, nor of the austerely classical Poussin. In the gardens of the Villa Medici, he painted small studies (fig. 27–36), the earliest

27-35

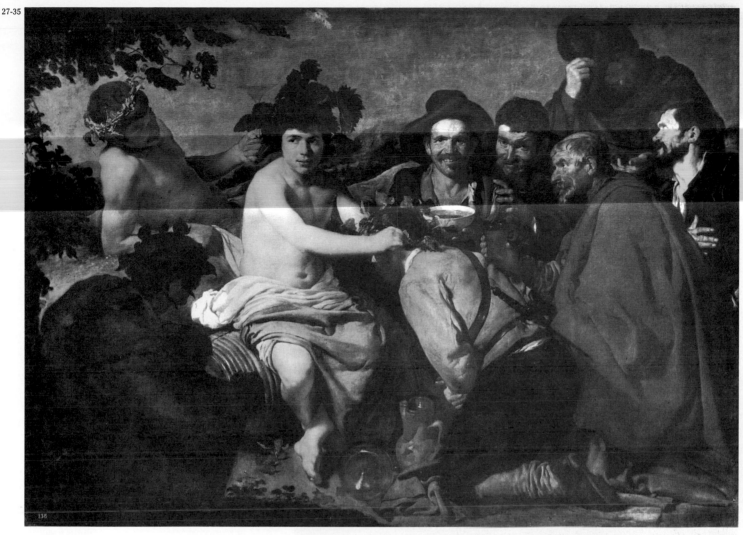

27-35. DIEGO VELÁZQUEZ. *The Drinkers (Los Borrachos).* c. 1628. Oil on canvas, 65 × 88⅝″ (1.65 × 2.25 m) Museo del Prado, Madrid

examples we know of landscapes not composed in the studio but done outdoors with a directness hitherto restricted to the preliminary sketch in wash (see Introduction fig. 2). This great historic step was not to be followed until the English landscape painters of the early nineteenth century. In his attempt to seize the immediacy of the moment of vision, Velázquez painted with free, light strokes of differing hues—browns, greens, blue greens, and whites. The subject and the method were important steps in the direction of nineteenth-century landscape art.

Velázquez's acknowledged masterpiece, and one of the most original paintings of the entire seventeenth century, is *Las Meninas (The Ladies-in-Waiting;* its original title was simply *Portrait of the Family),* of 1656 (fig. 27–37). The painter is shown in his studio in the royal palace, at work upon a canvas so large that it can only be this very picture, unique in scale in his entire production. In the center the light falls most strongly on the glittering figure of the five-year-old princess, who has paid the court painter a visit, accompanied by two ladies-in-waiting, one of whom kneels to hand her a cup of water. On the right are shown two dwarfs—those playthings of the Spanish court, whom Velázquez always painted with humanity and comprehension—one gently teasing with his foot an elderly and somnolent dog. Through an open door in the background wall, light falls on a court official, pausing for a moment on the steps. Most important of all, the mirror alongside the door reflects the king and queen—thus outside the picture—who also honor the painter

27-36

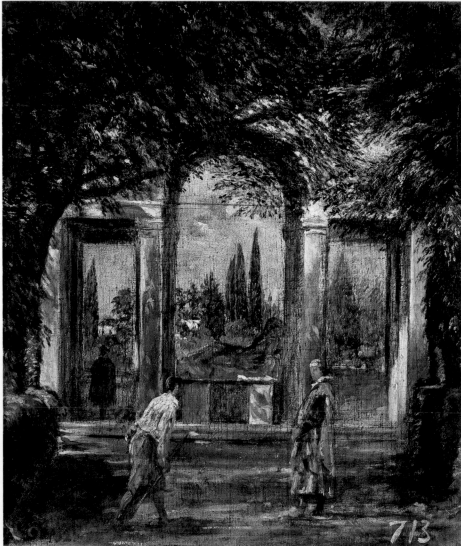

27-36. DIEGO VELÁZQUEZ. *Garden of the Villa Medici, Rome.* c. 1649–51. Oil on canvas, 17⅜ × 15″ (44 × 38 cm). Museo del Prado, Madrid

with their presence. Today the painting prompts speculations on the relationship of reality and image, space within the picture and figures outside it, as in Manet's *A Bar at the Folies-Bergère* (see fig. 33–8). However, it has been recently shown that this picture is connected with Velázquez's attempts to be recognized as a noble, which met with some difficulty at first but in 1658 were rewarded with the Order of Santiago at the hands of the king, who after the painter's death in 1660 caused the cross of Santiago to be painted on his doublet in this picture. Since the only obstacle to his admission to the order was his profession of painting, then considered a manual trade, the artist demonstrates in this picture the nobility of his art, favored with familiarity by the king, the queen, and the little princess in an allegory all the more effective for being so strikingly real. Despite the apparent ease and informality of the subject, the picture, like all Velázquez's compositions, is carefully balanced, in a series of interlocking pyramids that can be ranked with the greatest designs of the Renaissance.

Totally and dazzlingly new, however, is Velázquez's optical method of painting, paralleled (independently) only by Vermeer's (see pages 829–32). In light and dark the illusion of the picture is as startlingly real as the intimate and quiet mood. Velázquez's brush suggests convincingly the reality of objects entirely through the sparkles and reflections of light on hair, silks, flowers, and embroidery. We could

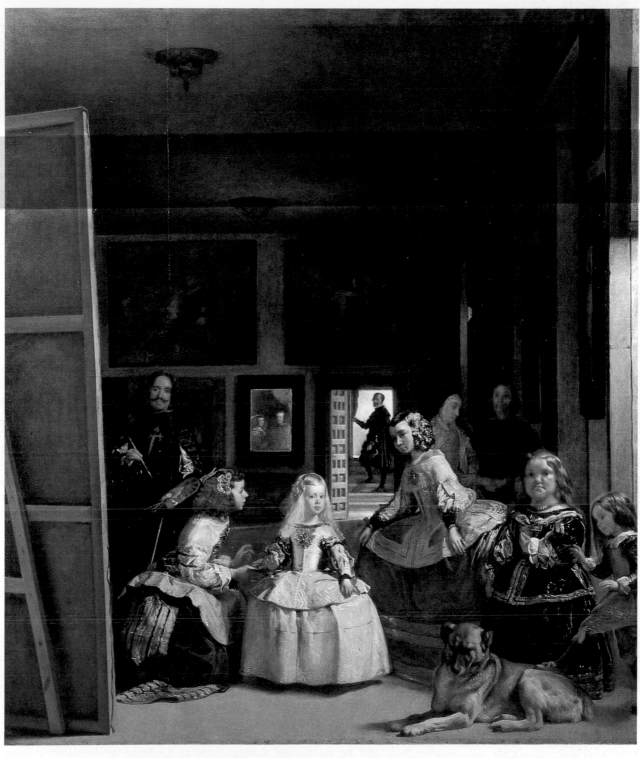

27-37. DIEGO VELÁZQUEZ. *Las Meninas (The Ladies-in-Waiting)*. 1656. Oil on canvas, 10′5″ × 9′1½″ (3.18 × 2.76 m). Museo del Prado, Madrid

hardly be further from the linear precision of Holbein, let us say (see figs. 25–13, 25–14); nothing is drawn, nothing has visible edges. Only spots of light and color, set down by dexterous touches of the brush, create an illusion of form, in the last analysis more accurate than Holbein's method because more closely related to the actual phenomena of instantaneous vision. In *Las Meninas* Velázquez demonstrates not only to his contemporaries but also to all time the nobility of his art—a rank that no king can confer.

CHAPTER TWENTY-EIGHT

IN PROTESTANT

Dutch Painting

The name *Holland,* which belonged to only one of the seven United Provinces of the Netherlands, is now popularly extended to the eleven that make up the modern kingdom; the word *Dutch* (derived from *deutsch,* meaning "German") is even less appropriate as a name for the inhabitants of the northern part of the Low Countries; but, like all the other misnomers we have encountered, these two are fixed. In democratic and predominantly Calvinist Holland in the seventeenth century the traditional patrons of art were conspicuous by their absence. Calvinism opposed imagery in church buildings. There was no monarchy, and the princes of Orange, whose function in the republic was generally military, turned to Flemish masters or to such Italianate painters as Gerrit van Honthorst for palace decorations. Neither was there any hereditary aristocracy.

As early as the late sixteenth century, the artist was for the first time in recorded history thrown entirely on the open market; this was fertile, and its effect on art enormous. In spite of wars with Spain, France, and England, the country was extremely prosperous. Although New Netherlands was soon lost to the English, the Dutch founded and maintained a large overseas empire in both hemispheres and enjoyed worldwide commerce; to protect their trade, they established a powerful navy. Not only did the commercial families suddenly want pictures — so did almost everybody else, down to social levels that never before had been able to afford anything more than a crude wood-block print or a bit of folk art. Peter Mundy, a British visitor to Amsterdam in 1640, at the height of Dutch artistic activity, wrote:

> As For the art off Painting and the affection off the people to Pictures, I thincke none other goe beeyond them, . . . All in generall striving to adorne their houses, especially the outer or street roome, with costly peeces, Butchers and bakers not much inferiour in their shoppes, which are Fairely sett Forth, yea many tymes blacksmithes, Coblers, etts., will have some picture or other by their Forge and in their stalle.

With great skill and industry, and in unbelievable numbers, Dutch painters set about supplying this new demand for paintings (not sculpture, which apparently nobody wanted). That they were able to do so, and to maintain so consistently high a level of quality, is one of the miracles of history; only in Periclean Athens or fifteenth-century Florence had there been anything like this number of good painters in proportion to the general population. Under such circumstances there could be no artistic dictator such as Le Brun or dominating figures such as Michelangelo, Bernini, or Rubens. On entering the galleries devoted to Dutch painting in any museum, the visitor is struck by the difference between the character and outlook of the Dutch masters and their contemporaries anywhere else in Europe. One would never know that Rubens was working at the same time in Antwerp, less than a hundred miles from Amsterdam. There are few large pictures; almost everything is living-room size. There are no visions or ecstasies of saints, no images of royal power, no allegorized historical events; classical mythologies are rare, and when they do occur, they are, like biblical scenes, often stated in terms of everyday life.

THE SEVENTEENTH CENTURY

COUNTRIES

In preference to such narratives or allegorical scenes, Dutch painters generally concentrated on images of daily life and the immediate environment, and in a sense were the heirs of the early-fifteenth-century Netherlandish naturalists. But there is a striking difference; almost never do we find representations of economic activity, like the farming or artisan scenes so vividly presented by the Limbourg brothers (see figs. 21–5, 21–6) and the Master of Flémalle (see fig. 21–10) or later by Pieter Bruegel (see figs. 25–24, 25–26). We are shown upper-middle-class interiors or gardens with or without celebrations, but never the shops, factories, or banks that supported them or the kitchens that prepared food for them; people dressed in silks and satins, but seldom the work of the weavers, tailors, and dressmakers who made their clothes; farmers carousing in taverns, but no scenes of plowing, harvesting, or brewing; still lifes of wine, oysters, tobacco, and exotic fruits, but not the activity of importing these delicacies; and, strangest of all, fertile landscapes whose fat clouds never rain.

In short, what people wanted to see and were willing to pay for were not images of production, in which their days were largely spent, but of leisure-time enjoyment, and for such representations they demanded a workmanly and pleasing style. They got what they wanted in immense profusion, with an optical perfection unequaled in any other country (it is not irrelevant that Amsterdam was the world center of the optical industry). Therefore, although the painters' skill was seemingly unlimited, their variety copious, and their number legion, their productions, exhibited today in endless Dutch galleries in leading museums, tend to become repetitive. No more so, however, than Italian Gothic altarpieces, which were also not intended to be seen at once in large numbers. Viewed two or three at a time, in small rooms like those of the Dutch houses for which they were painted (see fig. 28–6), Dutch seventeenth-century pictures are deeply satisfying. Nonetheless, only three Dutch masters of the period rise above the general high level of technical excellence into a universal sphere—Frans Hals, Jan Vermeer, and, above all, Rembrandt. It is an apt commentary on the effects of the free market that all three were in severe financial difficulties in their later years—Hals, in fact, throughout his whole life.

THE CARAVAGGESQUES During the late sixteenth century, Holland underwent strong influences from the final phase of Italian Mannerism. Even the naturalism of the seventeenth century was sparked by Italy, in fact by the same fire from Caravaggio that was at the same time lighting candles in France (La Tour, for example; see fig. 27–1). The two chief Dutch Caravaggesque painters, HENDRICK TERBRUGGHEN (c. 1588–1629) and GERRIT VAN HONTHORST (1590–1656), made the mandatory pilgrimage to Italy, where they came under Caravaggio's spell. Terbrugghen, in fact, seems to have settled in Rome as an adolescent in 1604 while Caravaggio was still there; he returned to the Netherlands in 1614. Honthorst arrived in Rome later, about 1610–12, after Caravaggio's death, and stayed until 1620. Both were from Utrecht (Terbrugghen was probably born at Deventer, but his family moved to Utrecht a few years after his birth), then as now a strong Catholic center; both were Catholics all their lives. Their religious paintings show understanding of Caravaggio's new vision of ordinary humanity reached by divine love, although they never attain the depth and power of the great Italian innovator.

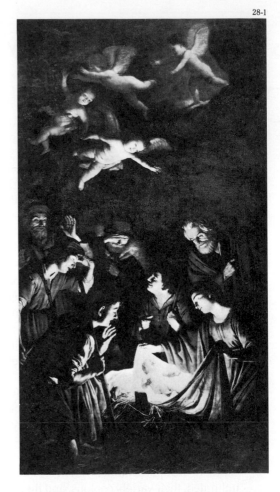

28-1

Honthorst had considerable success in Italy, where he acquired the nickname Gherardo delle Notti ("Gerrit of the Nights") because nocturnal pictures were his specialty; many of his works are still on Italian altars and in Italian museums. His *Adoration of the Shepherds,* of 1621 (fig. 28–1), could almost be taken for an Italian painting; Caravaggio's influence can be seen in the smooth, hard style and in the mysterious background, and there is even a reference to Correggio (see fig. 23–18) in the light radiating from the Child. But there is something a little trivial in Honthorst's naturalism and in his too agreeable facial expressions. He distinguishes meticulously between degrees of illumination in terms of nearness to the Child (as had Geertgen; see fig. 21–28) and even between the light reflected from the smiling faces and that filtering through the sheet held up by Mary. Terbrugghen was a different sort of painter, whose work is not to be seen in any Italian church. His *Incredulity of Saint Thomas* (fig. 28–2), painted probably between 1623 and 1625, imitates a composition by Caravaggio and states the Baroque psychic climax in Caravaggio's physical terms—understanding of the miracle breaking through the resistance of reason by means of direct contact between the finger and the wound. Nonetheless, his painting, for all its Caravaggesque derivation (including the background of nowhere), retains echoes of Dürer, Grünewald, and Bruegel in the very un-Italian faces. Painted several years after the artist's return to Holland, the painting softens considerably the sharp light-and-dark contrasts of Caravaggio. It remained for Rembrandt to open up again and to deepen immeasurably the vein of Baroque experience brought to the North by these two painters.

THE "LITTLE MASTERS" The open-market system, under which pictures were sold by the artists themselves, by dealers (who might also be painters), or at booths in fairs, tended to produce specialists, each recognizable by his prowess in painting a particular type of subject. There were specialists in landscapes, riverscapes, seascapes, cityscapes, even travelscapes; in skating scenes, moonlight scenes, ships, shipping, and naval battles; in interiors and exteriors, conspicuously scrubbed or conspicuously dirty; in gardens, polite conversations, genteel games, parlor intrigue, light housekeeping, riotous parties, and tavern brawls; in cows, bulls, horses, and hunting scenes; in churches with or without services taking place; and, of course, in still lifes (raised for the first time to the dignity of independent subjects) and in portraits, single, double, or multiple. At least forty of these "little masters" were extremely skillful, and any choice among them is sure to be arbitrary.

All Dutch seventeenth-century landscapes were, like those of the Italians and the French, painted in the studio from memory, sketches, or both and constructed according to compositional principles that involved the device of a psychological climax common to much Baroque experience—transferred from the religious, mythological, or historical spheres in which it can easily be described to the subtler, purely visual realm of space, light, and atmosphere. An early leader of Dutch landscape painting, JAN VAN GOYEN (1596–1656), although a prolific painter, dealer, valuer, and speculator in everything from land to tulip bulbs, died poor. He was one of the first Dutch masters to relegate human figures to a position in which they could no longer determine the mood of a scene but merely establish its scale. Like many of his Dutch contemporaries, van Goyen was fascinated by water, from which the Dutch had reclaimed much land, against whose incursions they erected dikes, and on whose navigation they founded their prosperity. Even more important than water in Dutch landscape, however, is the celestial architecture of shifting clouds, which towers over the flat land and reduces the works of man to insignificance.

In *River Scene* by van Goyen (fig. 28–3), painted in the last year of his life, the horizon has sunk to less than a quarter of the picture's width from the bottom, and the land, with marsh grasses, fishermen's cottages, windmills, and a distant church, is visible only as tiny patches. All else is clouds and water, save for two sloops whose

28-1. GERRIT VAN HONTHORST. *Adoration of the Shepherds.* 1621. Oil on canvas, 51½ × 37¾″ (130.8 × 96 cm). Galleria degli Uffizi, Florence

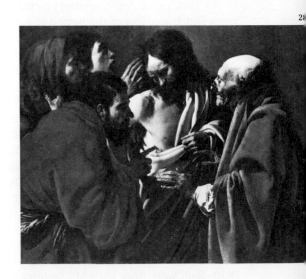

28

28-2. HENDRICK TERBRUGGHEN. *Incredulity of Saint Thomas.* c. 1623–25. Oil on canvas, 42⅛ × 53¾″ (1.07 × 1.37 m). Rijksmuseum, Amsterdam

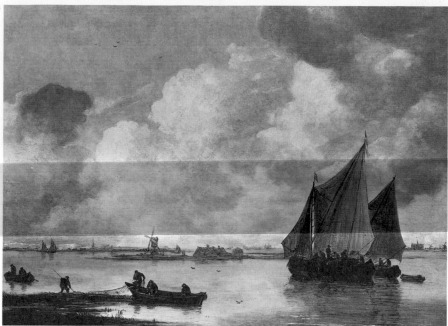

28-3. JAN VAN GOYEN. *River Scene*. 1656. Oil on canvas, 14⅛ × 24¾″ (36 × 63 cm). Städelsches Kunstinstitut, Frankfurt

slack sails, spread to catch the slight breeze, move slowly into the luminous area of cloud toward the center, reflected in the water below. People are mere spots, as are the low-flying gulls. An almost monochromatic vision, limited to translucent browns in the foreground and gray greens elsewhere, is registered by means of light, sketchy touches of the brush in ground, moving beings, shimmering water, and distant land.

A *View of Haarlem* (fig. 28–4), of about 1670 or later, by the younger painter JACOB VAN RUISDAEL (1628/29–1682), opens up a vast prospect from the vantage

28-4. JACOB VAN RUISDAEL. *View of Haarlem*. c. 1670 or later. Oil on canvas, 22 × 24⅜″ (56 × 62 cm). Mauritshuis, The Hague. The Johan Maurits van Nassau Foundation

point of the dunes. The city appears only on the flat horizon, a sparkle of windmills and spires dominated by the mass of the Grote Kerk ("Great Church"). The immensity of the space is increased by the climax falling in the form of light between clouds on the farmhouses and the linens bleaching in the foreground. The very birds fly higher and the clouds seem more remote than in van Goyen's picture. One of the grandest of Dutch landscapes is the *Avenue at Middelharnis* (fig. 28–5), of 1689, by MEYNDERT HOBBEMA (1638–1709), Ruisdael's pupil, who painted little in later life, when he enjoyed a lucrative position levying taxes on wine for the city of Amsterdam. Constructed on the humble theme of a rutted country road plunging into the picture between feathery trees that have long lost their lower branches for use as firewood, the spatial crescendo is as compelling on a small scale as that of Bernini's colonnade for Saint Peter's (see fig. 26–20).

The gentle art of PIETER DE HOOCH (1629–after 1684) celebrates the harmony of the perfect bourgeois household, with everything in its proper place and respect for cleanliness and order raised to an aesthetic, almost religious level. In the *Linen Cupboard,* of 1663 (fig. 28–6), de Hooch's Baroque climax, illuminated by an unseen window, is the simple act of counting neatly folded sheets taken from their carved and inlaid cabinet in an interior whose cleanliness matches its perfect perspective and its clear, bright colors; the black-and-white marble floor leads the eye through the door to the view across the street, reminiscent of the backgrounds of van Eyck (see fig. 21–15) in its rich atmospheric and spatial quality and its reverence for the object. By means of pictures on the wall the painter takes pains to show that art is a part of the ideal daily life.

The exact opposite of de Hooch's religion of order is uproariously extolled by JAN STEEN (1625/26–1679), who revived the humor of the Late Gothic *drôleries.* To this day a "Jan Steen household" is the Dutch expression for a ménage in which nothing can go right. In fact, nothing does in the *World Upside Down* (fig. 28–7), which might well be a parody on de Hooch's *Linen Cupboard* and was probably painted in the same year. It was also, doubtless, intended as a moralizing picture in a tradition going back as far as Bruegel. Steen, the son of a brewer, dabbled in brewing and even kept a tavern; he never tired of representing the effects of his products, shown in this picture as almost universal. Here the scene shifts to the kitchen; the same lady of the house in the same costume as in the de Hooch has fallen asleep; beer runs from the keg over a floor strewn with pretzels, a pipe, and a hat; children, a pig, a dog, a duck, and a monkey are where they ought not to be and are doing what they ought not to do. The sodden housemaid, over whose knee an admirer has thrown a possessive leg, hands him absentmindedly another glass of wine, and nobody pays the slightest attention to an elderly man (doctor or preacher?) reading

28-6. PIETER DE HOOCH. *Linen Cupboard.* 1663. Oil on canvas, 28⅜ × 30½" (72 × 77.5 cm). Rijksmuseum, Amsterdam

28-7. JAN STEEN. *World Upside Down.* c. 1663.
Oil on canvas, 41⅜ × 57⅛″ (1.05 × 1.45 m).
Kunsthistorisches Museum, Vienna

28-8. ADRIAEN BROUWER. *Boors Drinking.*
c. 1620s. Oil on panel, 11½ × 8¾″ (29.2 × 22.2
cm). National Gallery, London. Reproduced by
courtesy of the Trustees

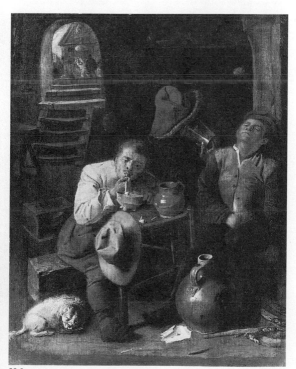

28-8

from a book or to an old woman trying to bring some order into the situation. To
make it all the more effective, Steen is at least as good a painter as de Hooch,
handling his figures with conviction and power, and has a splendid sense of both
composition and color. If his humor can at times be resisted his children cannot,
and his joy of life is infectious.

So indeed is the enthusiasm with which a whole group of Dutch (and Flemish)
painters represented scenes several notches lower in the social scale. The best of
these was a Fleming, ADRIAEN BROUWER (1605/6–1638), who spent the formative
years of his brief career in Haarlem in the 1620s, working in the circle of Hals. His
peasants drink, rollick, play cards, fight. Three of them are shown in varying stages
of intoxication, all fairly advanced, in his *Boors Drinking* (fig. 28–8). One has
drowned not only his sorrows but also his face; nothing can be seen of him but his
hands holding a tankard up to his hat-covered visage. The dashing brushwork and
the strong light-and-dark contrasts that make Brouwer's pictures so lively derive
more or less directly from Hals and Rembrandt.

Dutch still lifes were often intended to appeal to the eye and the palate at once.
Some are crowded with an unappetizing profusion of fruit or game, but the most
tasteful (and tasty) are those restricted to the makings of between-meals snacks
(they are traditionally referred to as "breakfast pieces"). White wine, a bit of
seafood or ham, lemon, pepper, and salt are the subjects, along with polished silver,
knobby crystal goblets to keep wine cool, and a rumpled tablecloth. The spectator is
tantalized not only by the delicacy with which the carefully selected objects are
painted but also by the expensive carelessness with which a lemon has been left
partly peeled and a silver cup overturned. WILLEM CLAESZ HEDA (1599–1680/82)
was one of the chief practitioners of this art in which, despite what might seem
severe limitations of subject matter, he demonstrates (fig. 28–9) an unexpected
eloquence in the rendering of golden light, as well as a sensitivity in establishing
the precise relationships between transparent, translucent, reflecting, and matte
surfaces—a silent drama of pure sense presented in the style of a Caravaggio
religious scene against the typical background of nowhere, fluctuating between
shadow and light.

At the other extreme from such Epicureanism are the Spartan architectural paintings of the period, especially those of PIETER SAENREDAM (1597–1665), a lonely hunchback who found a certain solace in painting the interiors of Dutch Gothic churches, especially whitewashed Protestant ones, stripped of decorations and altars; his works show only enough figures to indicate their scale. Saenredam described his meticulous procedure; he started with exact line drawings made on the spot, then enlarged them to construction drawings in his studio on the basis of measured plans, and finally executed his painting on panel. Predominantly white, austere, apparently inhuman, these quiet pictures nonetheless distill their own beauty of form and tone and an unexpected meditative poetry. The *Church of Saint Bavo,* of 1660 (fig. 28–10), an interior view of the great church in Saenredam's home city of Haarlem and in which he was eventually buried, is one of his finest paintings. It shows a superb control of space and a knowledge of the relationships of planes, which was not to be attained again until the wholly different but also monochromatic solutions of the Cubists in the twentieth century (see Chapter Thirty-Six).

HALS Recognized today as one of the most brilliant of all portraitists, Frans Hals (1581/85–1666) was probably born in Antwerp and was brought to Haarlem as a child. Interested in little but the human face and figure, Hals was blessed with an unrivaled gift for catching the individual in a moment of action, feeling, perception, or expression and for recording that moment with tempestuous but unerring strokes. There could hardly be a stronger contrast than that between his electric characterizations of people and the calm, deliberately controlled portraits of the essential person by such great painters of the Renaissance as Piero della Francesca, Titian, Dürer, and Holbein (see figs. 20–55, 20–56, 24–9, 25–1, 25–14). Although he doubtless saw works by the great Venetian masters in Dutch collections, there is no indication that Hals had much interest in Mediterranean art of any period; his discoveries about the rendering of light in paint seem to have been almost entirely his own. He owed something to the new naturalism of his Caravaggesque contemporaries (see figs. 28–1, 28–2), especially Terbrugghen, who were roughly the same age, but he himself never visited Italy.

Among his early commissions were group portraits of the militia companies that had been largely responsible for defending the new Dutch republic in a hostile world; these paintings radiate its self-confidence and optimism. By the 1620s, however, these companies had largely outworn their military function; Hals usually shows the citizen-soldiers in the midst of one of those stupendous banquets that the civic authorities pleaded with them to reduce from a week's duration to three days or at the most four. Such compositions, picturing a dozen or more men, mostly corpulent and middle-aged, each of whom had paid an equal amount for his portrait and expected to be recognizable, were not conducive to imaginative painting. Hals's predecessors generally had composed these group portraits in alignments hardly superior compositionally to a modern class-photograph, and it was to take the genius of Rembrandt to raise them to the level of high drama (see fig. 28–17). But Hals, in his *Banquet of the Officers of the Saint George Guard Company,* of 1616 (fig. 28–11), has done a superb job within the limitations of the traditional type. The moment is relaxed, the wine and beer have apparently worked their effect, and the gentlemen turn toward each other or toward the painter as if he had been painting the whole group at once, which was certainly not the case. Massive Baroque diagonals—the curtain pulled aside, the flag, the sashes, the poses, the ruffs—tie the picture together into a rich pattern of white and flashing colors against the shimmering black costumes. Broad brushstrokes indicate the passage of light on color with a flash and sparkle unknown at this moment even to Rubens.

The genial warmth of Hals's early style is seen at its most engaging in a portrait that is brought to an unusually advanced state of completion, the *Laughing Cava-*

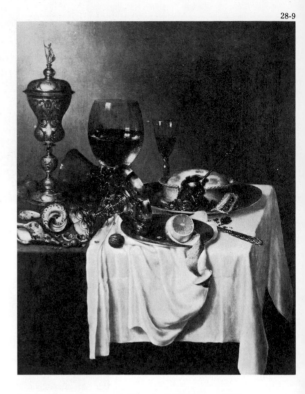

28-9

28-9. WILLEM CLAESZ HEDA. *Still Life.* c. 1648. Oil on panel, 34¾ × 27½" (88.3 × 70 cm). Fine Arts Museums of San Francisco. Mildred Anna Williams Collection

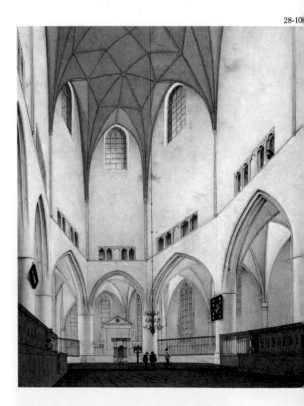

28-10

28-10. PIETER SAENREDAM. *Church of Saint Bavo.* 1660. Oil on panel, 27¾ × 21⅝" (70.5 × 55 cm). Worcester Art Museum, Worcester, Massachusetts

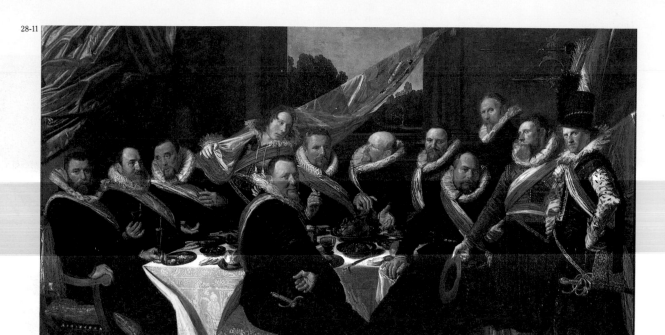

28-11. FRANS HALS. *Banquet of the Officers of the Saint George Guard Company.* 1616. Oil on canvas, 5′8⅞″ × 10′7½″ (1.75 × 3.24 m). Frans Halsmuseum, Haarlem

28-12. FRANS HALS. *Laughing Cavalier.* 1624. Oil on canvas, 33¾ × 27″ (85.7 × 68.6 cm). Permission of Trustees of The Wallace Collection, London

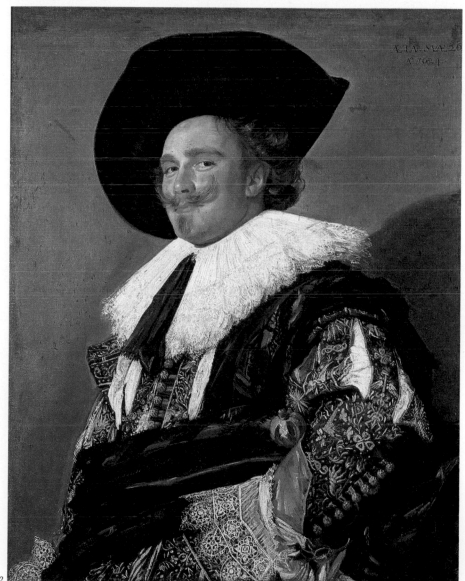

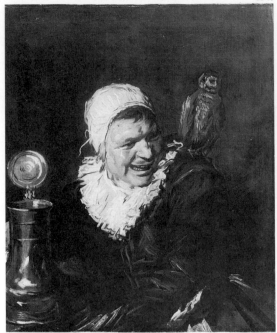

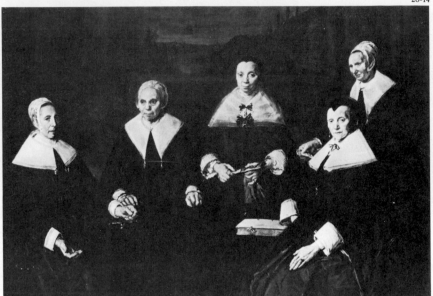

lier (fig. 28–12). The date of 1624 and the subject's age of twenty-six are inscribed on the background, and since the cavalier's diagonal shadow also falls on it, it is clearly a wall; the Caravaggesque nowhere is thus converted into a definite here, yet the wall is irradiated with light and seems insubstantial. The amorous proclivities of the young man may be indicated by the arrows, torches, and bees of Cupid and the winged staff and hat of Mercury embroidered in red, silver, and gold on the dark brown of his slashed sleeve. With his glowing complexion, dangerous mustaches, snowy ruff, and dashing hat, the subject is the very symbol of Baroque gallantry; the climax of the painting is the taunting smile on which every compositional force converges.

The opposite of this glittering portrait is the somber *Malle Babbe*, of about 1629–30 (fig. 28–13). No one knows who the old creature was or the meaning of her probably uncomplimentary nickname, written in an eighteenth-century hand on the original stretcher. Often called an "old crone," she might be anywhere from forty to sixty years old. She has obviously soaked up the contents of the (two-quart?) tankard she holds, and Hals has caught her in the midst of a fit of insane laughter. Possibly she is the town idiot. The owl on her shoulder is a symbol not of wisdom, as with Minerva, but of foolishness. The astounding expression, seized in a storm of strokes, is rendered with a demonic intensity that shows that Hals, concerned from youth to age with human character as revealed in expression, could plumb depths that excite the horrified compassion of most viewers. About 1664, when he was past eighty, Hals, already on a pension from the city of Haarlem, showed a still different side of his character and ability in the *Regentesses of the Old Men's Almshouse* (fig. 28–14). Painted almost entirely in black and white and shades of gray, this solemn picture is united by diagonal movements differing in tempo and verve but not in strength from those building up the composition in the *Saint George Guard Company,* even though the painter had only the devastated faces and white collars of the women as component elements. Each of the subjects has reacted in a separate way to age and experience, yet all participate in a calm acceptance of the effects of time. In its simplicity and austerity the composition shows an expressive depth unexpected in the generally ebullient Hals.

LEYSTER Frans Hals's most gifted pupil, Judith Leyster (1609–60), shares the honors with Artemisia Gentileschi as one of the two most accomplished women painters of the seventeenth century. Less original than her Italian contemporary, she was, nonetheless, a brilliant technician whose portraits are often confused with

28-13. FRANS HALS. *Malle Babbe.* c. 1629–30. Oil on canvas, 29½ × 25¼″ (75 × 64 cm). Staatliche Museen zu Berlin—Preussischer Kulturbesitz

28-14. FRANS HALS. *Regentesses of the Old Men's Almshouse.* c. 1664. Oil on canvas, 67⅛ × 98⅜″ (1.71 × 2.5 m). Frans Halsmuseum, Haarlem

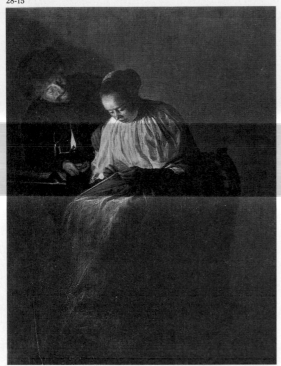

28-15. JUDITH LEYSTER. *The Proposition*. 1631. Oil on canvas, 11¹¹⁄₁₆ × 9½" (29.7 × 24 cm). Mauritshuis, The Hague. The Johan Maurits van Nassau Foundation

those of her master. She married a well-known painter, Jan Molinaer, whose works—attractive as they are—do not rank with hers technically. Leyster's *The Proposition* (fig. 28–15), painted in 1631, when the artist was only twenty-two years old, depicts a sensitive subject. A young girl, humbly but decently dressed and seated in a simple chair, quietly works away at her embroidery frame, aware of yet silently rejecting a handful of coins offered by a middle-aged man whose features and fur cap reveal him as a trader from Eastern Europe. The psychological tension of the situation, involving the young woman's human integrity to a degree that only a woman artist would have conceived and projected with such power, is intensified by the light of the oil lamp. Again, in the Caravaggesque tradition, the scene takes place in nowhere, as a symbol of the predicament of a woman of modest origins rather than as an isolated incident. In the delicacy of her brushwork and the sensitivity of her expressions, Leyster owes nothing to Hals.

REMBRANDT The greatest of Dutch masters, indeed one of the supreme geniuses in the history of art, is Rembrandt van Rijn (1606–69). To this day the art of Rembrandt (he signed his work by his first name only, and the world has chosen to remember him thus) remains at once one of the most profound and one of the most intimate witnesses of the progress of the soul in its earthly pilgrimage toward the realization of a higher destiny. Although this universal artist dealt with many worldly subjects as well as with his favorite biblical themes and painted a great number of vivid portraits, it is always the spirituality of his art—subtly visible in his early work but overpowering in his last masterpieces—that distinguishes Rembrandt from all his Dutch contemporaries and which, with varying degrees of success, was imitated by a host of followers. It is ironic that the very century and society that refused artists the possibility of showing their paintings in churches produced one of the greatest of Christian artists. But this very denial of access to the *congregations* gave Rembrandt the opportunity of addressing the *individual* through his own personal means, most of all by radiant light against and through a special kind of warm, glowing, and vibrant shadow, receptive to the deepest resonances of human feeling.

The son of a prosperous miller, Rembrandt was born in Leiden. He was trained as a painter by two minor local artists and finally by the Early Baroque history painter Pieter Lastman. His rapid success prompted him to move in 1631 to Amsterdam, the principal Dutch city. Soon he had more commissions and pupils than he could accept; he married Saskia van Uylenburgh, the lovely daughter of a wealthy family; bought a splendid house; started a collection of paintings and rarities; and, in addition to his handsome, lucrative portraits, began to paint in a highly imaginative Baroque style under two combined influences—Caravaggio for sharp light-and-dark contrast and Rubens for spiral composition and speed of execution. A dazzling example is the *Angel Leaving Tobit and Tobias*, of 1637 (fig. 28–16). Rembrandt has followed exactly the Book of Tobit (not included in Protestant Bibles but available to him as a source in the Apocrypha). The formerly blind Tobit, cured by the Archangel Raphael, prostrates himself in gratitude while his son Tobias looks upward in wonder at the departing figure; Anna, the wife of Tobit, Sarah, Tobias's bride, and even the dog mentioned in the text are shown, yet subordinated to the miracle of the "light of heaven" formerly denied to Tobit and now falling around him in floods. Seen sharply from the back, the angel is taken from their sight into an open cloud in a flash of light. Along with the luminary effects that create this resounding climax goes a new technical freedom. The smooth, detailed manner of Rembrandt's early portraits is gone; the forms are quickly sketched, although without Hals's virtuosity of the brush, and the masses of light are done in a rich impasto against the deep, characteristically brownish glazes used to veil and intensify the shadows.

In 1642, the year of Saskia's untimely death, both the element of mystery and the technical innovations that accompany and reinforce it began to conquer even

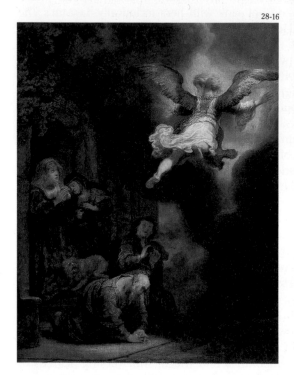

28-16

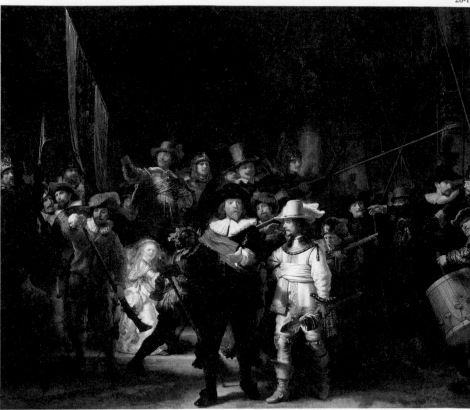

commissioned subjects, such as Rembrandt's painting of the Company of Captain Frans Banning Cocq and Lieutenant Willem van Ruytenburch; this painting, through a misunderstanding natural enough considering its formerly darkened condition, is called *The Night Watch* (fig. 28–17). The account that the members of the company were dissatisfied with their colossal group portrait is legendary, but Rembrandt's commissions in the 1640s did slacken off, whether or not as a result of this unconventional painting. It was cut down in size in the eighteenth century to fit into a space in the Town Hall of Amsterdam, and it is no longer evident that the group is about to cross a bridge. Even a cleaning, shortly after the close of World War II, which revealed the original brilliance of the color, did not restore any semblance of natural light.

The subject was probably the formation of the militia company for a parade. Not only through Hals's device of diagonals but also through irrational and wonderfully effective lighting Rembrandt has turned narrative prose into dramatic poetry. We are never really told what is happening; real events are submerged in the symphonic tide of the coloring, dominated by the lemon yellow of the lieutenant's costume and the captain's scarlet sash against shadows that, even after cleaning, are still deep and warm. As with Hals's group portraits, all the men had paid equally to have themselves depicted, yet some are sunk in shadow; one man is concealed except for his eyes. It was inevitable that Rembrandt would lose popularity as a portrait painter, although this did not happen at once.

During the 1640s Rembrandt may have joined the Mennonites, who believed in the sole authority of the Bible and in silent prayer. His luminary visions of scriptural subjects become deeper and more tranquil. The Supper at Emmaus, in which Christ, on the evening of the first Easter when "the day is far spent" (Luke 24:30–31), reveals himself to two of his disciples in the breaking of bread, is a natural subject for the Baroque, and the climax is often represented with great psychological intensity or as a burst of light. In Rembrandt's version of 1648 (fig. 28–18), all is still. A niche behind Christ becomes an apse, the table an altar, both gently illumined by rays from Christ's head. The servant perceives nothing, and only an

28-16. REMBRANDT. *Angel Leaving Tobit and Tobias*. 1637. Oil on panel, 26¾ × 20½″ (68 × 52 cm). Musée du Louvre, Paris

28-17. REMBRANDT. *The Night Watch*. 1642. Oil on canvas, 12′2″ × 14′7″ (3.71 × 4.45 m). Rijksmuseum, Amsterdam

28-18. REMBRANDT. *Supper at Emmaus*. 1648. Oil on canvas, 26¾ × 25⅝″ (68 × 65 cm). Musée du Louvre, Paris

28-18

involuntary motion of hand to mouth on the part of one disciple and a drawing back of the other betray their sudden recognition of their companion.

In 1655 Rembrandt found himself in the midst of severe financial troubles, which reached disastrous proportions the following year, forcing the eventual sale of his house and his collections in an attempt to satisfy his creditors. His common-law wife, Hendrickje Stoffels, and his only surviving child, Titus, formed a company to discharge the master's debts and to assume him ostensibly as an employee. At the beginning of this unhappy period, about 1655, Rembrandt painted the *Polish Rider* (fig. 28–19). It recalls Dürer's *Knight, Death, and the Devil* (see fig. 25–4), which Rembrandt surely knew. The precise meaning of this painting has not yet been determined, but there can be little doubt that in some way it is an allegory of man's earthly journey, its many dangers, and its uncertain destination. One cannot go far wrong to cite the words of Psalm 84:5–6, on which Rembrandt must often have dwelt: "Blessed is the man whose strength is in thee. . . . Who passing through the valley of Baca [that is, tears] make it a well; the rain also filleth the pools." In the grim and rocky valley a pool can be seen. Against the dark hill with its suggestions of habitations—here and there a hut; near the crest a ruined castle—the youth rides in light, alert, his weapons at the ready. The figure and his mount stand forth in a new sculptural grandeur, intensified by the fact that many of the impastos have been laid on not with a brush but with a palette knife; the artist literally carved the pigment, especially in the dark rocks and in the bony forms of the horse and the masses of his mane.

28-19. REMBRANDT. *Polish Rider.* c. 1655. Oil on canvas, 46 × 53″ (1.17 × 1.35 m). The Frick Collection, New York

A special role in Rembrandt's vast production is played by his etchings. Etching was a medium known to the Renaissance but relatively little used. In contrast to copper engraving (see figs. 25–3, 25–5), etching exacts little manual tension. The plate is coated with wax on which lines are drawn with a metal stylus, as rapidly as desired but always firmly enough to penetrate to the copper. The plate, wax and all, is then put in an acid bath; whatever has been uncovered by the stylus is eaten into by the acid. The plate is then heated, the wax runs off, and the etched (bitten) lines are ready for printing. Because of the greater flexibility of the process itself and the range of values attainable by sensitive printing, the results are freer and more fluid than engraving. Etching can capture the lightness of a fugitive sketch or the tonal resonance and depth of an oil painting. Rembrandt's etchings deal with every conceivable subject, from landscape and daily life to the Scriptures. Often they went through several phases, known as "states," rewaxed and in part re-etched, before Rembrandt was satisfied. In its early states the *Three Crosses* depicts in detail an elaborate drama. In the fourth and final state, of 1663 (fig. 28–20), clusters of lines are so bitten as to flood down in darkness at the right and in rays of light at the center like those that descend upon Bernini's Saint Theresa (see fig. 26–15). The penitent thief hangs upon his cross, dimly seen, but many of the other figures sink into shadow. Only a tip of the impenitent thief's cross still appears, as if his guilt were canceled out; the rest is obliterated by the darkness that fell over the land. We are left alone in the tumult with the Crucified, on whom the rays of light fall, and with the centurion, glorifying God and saying, "Certainly this was a righteous man" (Luke 23:47).

Hendrickje died in 1662. Ill, Titus continued to help his lonely father until death claimed him, too, in 1668. Probably in 1669, the year of his own death, Rembrandt painted his *Return of the Prodigal Son* (fig. 28–21), which stands at the ultimate peak of Christian spirituality, illuminating the relationship of the Self to the Eternal. The parable (Luke 15:11–32) was a favorite in Baroque art; its meaning, in general, can be discerned in Saint John of the Cross's words about union with divine love:

> *God communicates himself to the soul in this interior union with a love so intense that the love of a mother who so tenderly caresses her child, the love of a brother, or the affection of a friend bear no likeness to it, for so great is the tenderness and so deep the love with which the infinite Father comforts and exalts the humble and loving soul.*

In Rembrandt's dark background, a rich and luminous brown, one makes out two dim faces, a seated figure, and, more brightly lighted, the eldest son, hurt and uncomprehending because there was never a celebration for him, the law-abiding. In a spontaneous gesture of loving forgiveness, the gentle, aged father comes into the light to press to his bosom the cropped head of his ragged son. Faces have been reduced to little more than the essential angle between forehead and nose, framing the deep eyes. Only the hands of the father and the tired feet of the son—the left bared by its disintegrating shoe—are painted in any detail. The picture is, as Christ intended his parable to be, an allegory of the earthly pilgrimage of man finding rest and meaning in divine redemption. But Rembrandt's language in these late works is almost entirely that of color and texture. Rich tans and ochers in the prodigal's worn garments are inundated by the glowing red of his father's festal cloak against the deep browns of the encompassing dark; solid masses in thick impastos gleam against the translucent glazes.

In paintings, etchings, and drawings, Rembrandt depicted himself, in known examples, nearly a hundred times; all except a few of the earliest lack any trace of vanity. The Baroque was the age of the self-portrait; many a minor artist has left us a self-portrait superior in quality to any of his other works. Such revelations are foreign both to the High Renaissance and to Mannerism. Dürer, for example, shows us a self-possessed, self-contained, self-directed human being (see fig. 25–1),

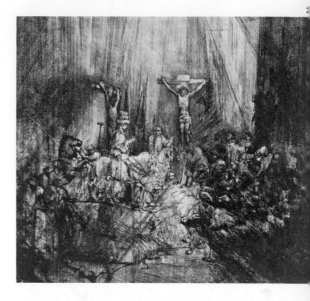

28-20. REMBRANDT. *Three Crosses* (fourth state). 1663. Drypoint and burin. The Metropolitan Museum of Art, New York. Gift of Felix M. Warburg and his Family, 1941

28-21. REMBRANDT. *Return of the Prodigal Son.* c. 1669. Oil on canvas, 8′8″ × 6′8¾″ (2.64 × 2.05 m). The State Hermitage Museum, St. Petersburg

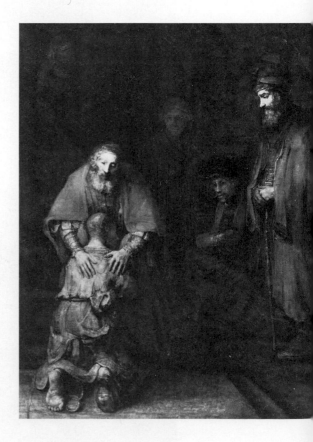

28-22

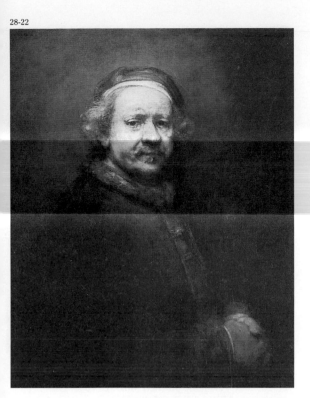

28-22. REMBRANDT. *Self-Portrait.* c. 1667. Oil on canvas, 33⅞ × 27¾″ (86 × 70.5 cm). National Gallery, London. Reproduced by courtesy of the Trustees

Parmigianino a congealed self in a distorted world (see fig. 23–25). Baroque self-portraits generally aim at revealing the artist as open to the world outside and beyond him, sensitive and responsive to higher powers. The Jesuit Cardinal Robert Bellarmine, who taught at Louvain in neighboring Flanders and whose work may well have been known to Rembrandt, proclaimed that "he that desires to erect a ladder by which he may ascend so high as to God Almighty, ought to take the first step from the consideration of himself." This is indeed what Rembrandt did, with increasing depth as the difficult and often tragic circumstances of his later life compelled constantly changing self-assessments in relation to God.

In a series of self-portraits painted in the final decade of his life, he attained a spiritual level that can only be compared with that of Michelangelo in his last *Pietà* (see fig. 23–13). One of the most moving of these last self-portraits (fig. 28–22) must date from the period of grief over the loss of Hendrickje. Although the face is impassive and the hands folded in resignation, the picture radiates quiet loneliness and the head is surrounded by light as by a halo. The masses of face, hair, and garments are kept as simple as in the *Return of the Prodigal Son*—mere blocks of pigment laid on with the knife, or perhaps even with the fingers, against the glowing dark. In these ultimate self-revelations, one recalls the opening words of Psalm 139, which Rembrandt must often have read, "O Lord, thou hast searched me, and known me," and in the interpenetration of impasto and glaze, mass and space, darkness and light, Verse 12: "Yea, the darkness hideth not from thee; but the night shineth as the day: the darkness and the light are both alike to thee."

VERMEER In the seventeenth century, Jan Vermeer of Delft (1632–75), probably a Catholic convert, must have seemed to be another of the "little masters," hardly different in range and style from de Hooch, whose domestic interiors (see fig. 28–6) those of Vermeer superficially resemble. Contemporary sources either barely mention Vermeer or omit his name entirely from lists of prominent artists. In the eighteenth century the British painter and art theorist Sir Joshua Reynolds considered Vermeer's *Kitchen Maid,* of about 1658 (fig. 28–23), one of the finest pictures he saw on a trip to Holland, but only in the nineteenth, with the rise of interest in naturalistic color, were Vermeer's paintings truly appreciated. Today he is universally considered second only to Rembrandt among Dutch painters. It is not difficult to see why. Although he has none of Rembrandt's mystery or passion and avoids the master's supernatural lighting effects, his message is immediate, deep, and lasting. He was able, as were none of his contemporaries (and none of his predecessors save perhaps van Eyck and Piero della Francesca), to transmute simple actions into eternal symbols through the magic of pure perception and the perfect adjustment of space, tone, and color.

Because of his slow and painstaking methods, Vermeer seems to have painted very few pictures. He earned his living principally from art dealing, at which he lost heavily; he left a wife and eleven children in debt. Only about thirty-five of his paintings survive, and all but three represent interiors modest in size and sparsely furnished. The background wall, when visible, is invariably parallel to the picture plane. All but two of the interiors are lighted strongly from one side—the left in all but three instances. In all but five the source of light is represented as a window; never is the spectator permitted to see through the window to the world outside. No matter what Vermeer may suggest or summarize of the outer world or invite the spectator to imagine, wisdom begins and ends in the room, conceived as a cube of shining space in which the figures and their transitory actions seem forever suspended in light.

It has been suggested, and generally accepted, that Vermeer utilized for his pictorial compositions and techniques the device of the *camera obscura,* a darkened enclosure with an opening on one side and a flat, light surface on the other. Rays of light reflected from objects outside the camera obscura pass through the aperture to project the image on the light surface, upside down, even without a

lens. By the interposition of a mirror before the opening, the image may be rectified, and the insertion of a lens provides the possibility of focus. The camera obscura (in principle first described by Aristotle) was used without a lens by Islamic scientists in the tenth century, and with a lens by Italians in the early sixteenth. Such devices were popular in the seventeenth century throughout Europe. There are two types, one in which the viewer is inside the box, the other in which he looks through a peephole. Only the first, which may be portable like a sedan chair or supplied with a hood to envelop the viewer, will project an image onto a flat surface on which it may be studied, drawn, or painted.

Vermeer seems to have used the camera obscura at first to unify the planes of light and dark and the patches of color into a coherent image. The camera obscura tends to turn all reflections of light into tiny blobs of white; these are clearly visible in the *Kitchen Maid,* especially on the pointed bread rolls on the table and on the fresh cheese in the basket, but also on the rim of the pitcher and on the puckered hem of the maid's apron. Vermeer has treated them as indications of volume in light, in the manner of the necklace of pearls around the subject's neck in Piero della Francesca's *Battista Sforza* (see fig. 20–55). The camera obscura also allowed Vermeer to escape from the conventional coloring of his Dutch predecessors and contemporaries, dominated even in outdoor scenes by grays, greens, and browns, into a world of brighter, purer hues, such as the strong blue of the maid's apron and the bright yellow of her bodice. These colors are seen reflected through the other colors in the room, notably in the bluish shadows on the creamy wall. Although with true Dutch naturalism Vermeer depicts a brass brazier and a hamper hanging in the corner, as well as a foot warmer on the floor with a pot of hot ashes inside, he concentrates all attention on the nobility of the simple action of the maid pouring milk and the purity of the spherical and cylindrical volumes, producing a composition as monumental as anything that ever issued from High Renaissance Italy.

Vermeer's careful optical studies made it possible for him to paint his rare outdoor scenes with a glowing intensity of color unknown before his time. There is nothing contrived about the composition of the *View of Delft,* of about 1662 (fig. 28–24). We seem really to be there, and to experience the warm red of the old bricks and tiles with our own eyes. Even the clouds have a sultriness and weight that none of the professional landscapists of the seventeenth century could quite capture, and the characteristic climax of the picture, the sudden stab of light on the distant

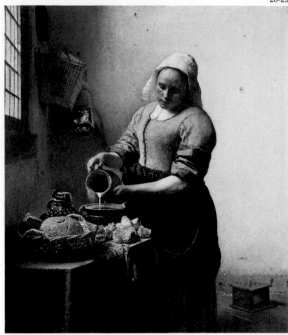

28-23. JAN VERMEER. *Kitchen Maid.* c. 1658. Oil on canvas, 17⅞ × 16⅛″ (45.4 × 41 cm). Rijksmuseum, Amsterdam

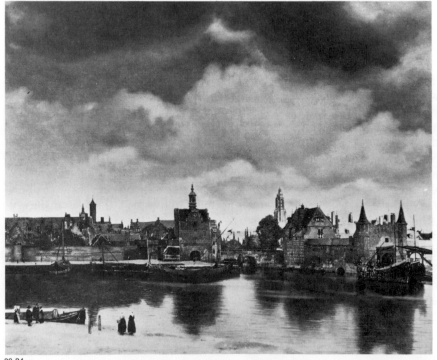

28-24. JAN VERMEER. *View of Delft.* c. 1662. Oil on canvas, 38½ × 46¼″ (97.8 × 117.5 cm). Mauritshuis, The Hague. The Johan Maurits van Nassau Foundation

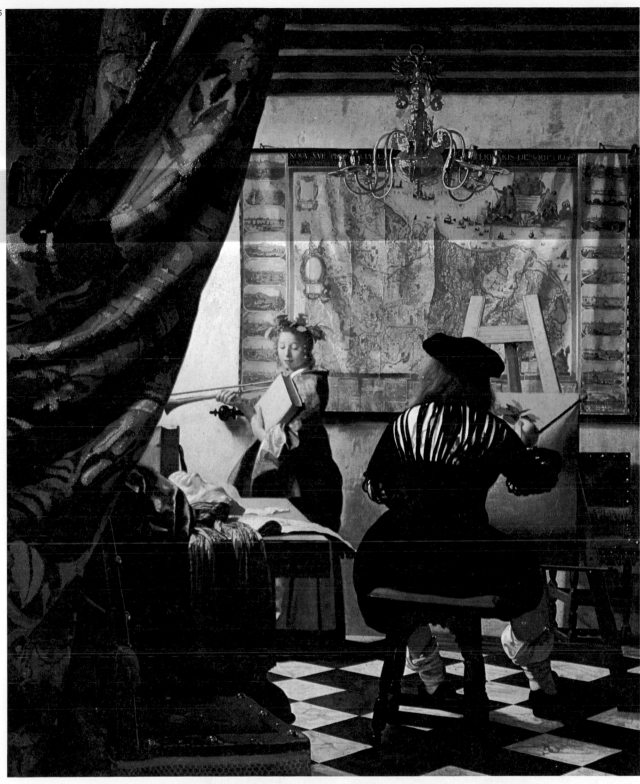

28-25. JAN VERMEER. *Allegory of the Art of Painting.* c. 1670–75. Oil on canvas, 52 × 44″ (1.32 × 1.12 m). Kunsthistorisches Museum, Vienna

church spire, seems wholly accidental. Never again until the work of Jean-Baptiste-Camille Corot in the nineteenth century were tonal values to be so exquisitely adjusted, or the still figures of ordinary people to be used to induce so quiet a contemplation of the beauty of timeworn structures and vessels in diffused light and moisture-laden air.

Vermeer's art is summed up in his *Allegory of the Art of Painting* (fig. 28–25), probably dating from near the end of his brief life. The subject is not entirely clear; the artist—probably not Vermeer, as he is dressed in late-sixteenth-century

costume—is painting a model robed as Clio, the muse of history, equipped with laurel wreath, book, and trumpet, according to her description in the *Iconologia*, a treatise on allegorical representations by Cesare Ripa, first published in Italy in 1593 and widely read throughout Europe. The painter is making a picture that could hardly be further from Vermeer's own work. Steadying his right hand on a maulstick (a rod with a cushioned tip), he has already executed the general contours of Clio's pose in white, filling the canvas with her half-length figure, and is now painting the leaves of her crown. She stands in the light of an unseen window, against a huge map representing both northern and southern Netherlands, bordered by views of twenty cities (maps appear in several of Vermeer's backgrounds). Thus the outer world is permitted to invade the picture, but only symbolically, along with the muse of history. The map looks as though it could be read in detail, like the open manuscripts in the works of Jan van Eyck; only the largest letters, however, are actually legible, as if Vermeer had interposed a threshold between the object and the viewer that permitted only elements of a certain size to be clearly distinguished.

The magic fascination of the picture lies less in the subject than in Vermeer's brilliant perspective contrasts, made possible by his use of the camera obscura, which even exaggerates such phenomena. Compare, for instance, the interior by de Hooch (see fig. 28–6), which avoids any strong foreground elements, with this painting. In this symbolic image of the artist faced with geography and history, time and space, congealed in planes of clear, bright color in a light-filled room, Vermeer has created a perfect Baroque counterpart to the Early Renaissance interior in van Eyck's *Wedding Portrait* (see fig. 21–17), which it so strongly suggests.

English Architecture

The Tudor monarchs and nobles built handsome palaces and country houses, for the most part along Perpendicular Gothic lines, studded here and there late in the sixteenth century with occasional Italian details. Not until the eighteenth century did English concern for the visual arts begin to rival the passions for poetry and music that won for England so high a place in the creative life of the Renaissance and Baroque periods. During the seventeenth century the best painters in England were Flemish visitors, notably Peter Paul Rubens and Anthony van Dyck (see pages 802–9), who painted some of their finest works in England. But under the Stuart monarchs English architecture designed by Englishmen entered a new period of intense productivity.

28-26

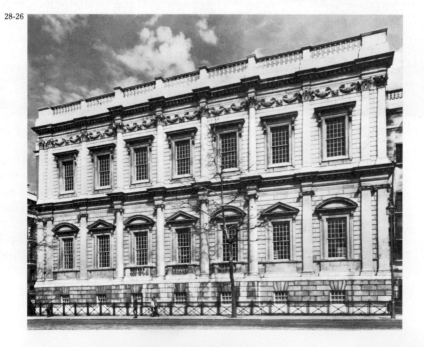

28-26. INIGO JONES. West façade, Banqueting House, Whitehall Palace, London. 1619–22

28-27. CHRISTOPHER WREN. Plan of St. Paul's Cathedral, London. 1675

28-28. CHRISTOPHER WREN. West façade, St. Paul's Cathedral, London. 1675–1710

28-29. CHRISTOPHER WREN. Interior, St. Paul's Cathedral (view of the nave from the choir)

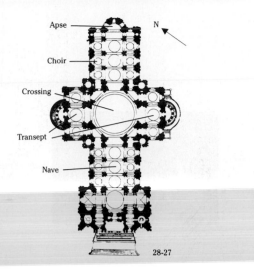

28-27

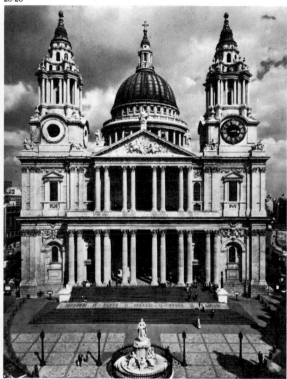

28-28

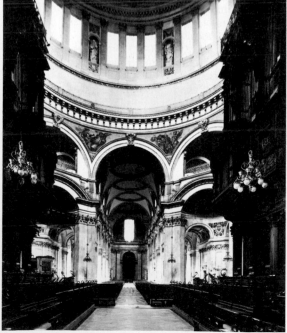

28-29

INIGO JONES On his tour of Italy about 1600, Inigo Jones (1573–1652) seems to have been unimpressed by the beginnings of the Italian Baroque. The style he brought back was pure if simplified Palladianism, destined for a long and fruitful life in England and North America. The Banqueting House (fig. 28–26) that Jones built for King James I in 1619–22 as an addition to the now-vanished Palace of Whitehall in London does not reproduce any specific building by Palladio; in its cubic severity, in fact, it avoids any of the more pictorial aspects of Palladio's architecture. The façade is a firm restatement of basic Italian Renaissance principles; a lightly rusticated building block is articulated by a screen architecture of superimposed Ionic and Corinthian orders, pilasters in the two bays at either side, and engaged columns in the three central bays, unrelieved by any ornamentation save for the sculptured masks and swags that unite the Corinthian capitals. It cannot by any stretch of the term be called Baroque; like all of Jones's structures, it is an elegant and purified revival of a style the Italians themselves had abandoned.

WREN The great flowering of English architecture in the late seventeenth century was largely due to a single disaster and a single genius. The fire of 1666, which destroyed most of the City of London (the central district, on the old Roman site), gave an unparalleled opportunity to a youthful professor of astronomy at Oxford, Dr. Christopher Wren (1632–1723), subsequently knighted for his achievements in his adopted profession of architecture. He used it not only to bring English buildings into line with Continental developments but also to produce in the course of his long life an array of handsome structures unequaled in number and variety by any other Baroque architect. The very year of the fire, Wren had projected for the Gothic Cathedral of Saint Paul's a central dome with a Bramantesque peristyle (see fig. 22–23). After the fire King Charles II intended to rebuild the City on Wren's rational Baroque plan with broad avenues, squares, and vistas. For considerations of private property this proved impracticable. Wren was called upon first to redesign the choir of Saint Paul's and then to rebuild the entire cathedral; eventually, almost every church in the City was rebuilt on a Wren design, so that the present picture of bristling Baroque steeples (those that survived the Blitz of World War II) is due to Wren. His first attempt at the total rebuilding of Saint Paul's was more Renaissance than Baroque, and in most respects brilliantly original. Its centralized design impressed the king but not the clergy; liturgy and custom demanded a longitudinal axis. Regretfully, Wren abandoned this scheme and worked out two others, one of which was substantially adopted in 1675, although the dome and bell towers did not receive their final form for years. The essentially Gothic directional plan was reinstated (fig. 28–27); flying buttresses to support the vaults were concealed on the exterior by a second story that is merely a screen. The façade with its magnificent central climax (fig. 28–28) derives in part from the east façade of the Louvre (see fig. 27–12), recapitulated in two stories of paired Corinthian columns, the lower story wider to accommodate the side portals. The flanking towers, reviving the Gothic tradition, are Baroque campaniles along lines established by Borromini in Sant'Agnese (see fig. 26–25). For all Wren's debt to Continental models, his cathedral, not completed until 1710, stands as one of the finest Baroque architectural compositions anywhere. The dome, combining a Bramantesque peristyle with a Michelangelesque verticality, punctuates the peristyle with a wall containing an arch after every fourth intercolumniation. The host of imitations of Wren's dome, in Europe and North America, attests to the finality of his solution. In comparison with Continental churches, the interior (fig. 28–29) strikes one as cold, perhaps inevitably in view of Anglican opposition to gilding and profuse ornamentation. The long Gothic space is divided by giant Corinthian pilasters supporting transverse arches on whose pendentives are floated saucer domes; a smaller order of paired pilasters sustains the nave arcade. As in all Wren's interiors, the emphasis is placed on the linear elements of arches, rectangular frames, and circles.

TIME LINE XII

Conversion of St. Paul, by Caravaggio

David, by Bernini

The Drinkers, by Velázquez

Holy Family on the Steps, by Poussin

POLITICAL HISTORY	RELIGION, LITERATURE, MUSIC	SCIENCE, TECHNOLOGY
1590 Philip III of Spain (r. 1598–1621) James I rules England, 1603–25	John Donne (1572–1631) Shakespeare writes *Midsummer Night's Dream*, 1595–96	
1600 Twelve-year truce between Holland and Spain signed, 1609	Papacy of Paul V, 1605–21	East India Company chartered, 1600 Dutch lens-grinders construct refracting telescope and compound microscope, c. 1600 Arctic voyages of Henry Hudson, 1607–11
1610 Marie de'Medici regent of France during minority of Louis XIII, 1610–14 Thirty Years' War, 1618–48		Johannes Kepler (1571–1630) announces his first two laws of planetary motion, 1609; third law, 1619
1620 Cardinal Richelieu, chief minister and adviser to Louis XIII, consolidates power of monarchy, 1624–42	Heinrich Schütz (1585–1672)	William Harvey (1578–1657) describes circulation of the blood, 1628
1630 Founding of Massachusetts Bay Colony in North America; 16,000 settlers arrive by 1642	René Descartes (1596–1650) publishes *Discourse on Method*, 1637 Pierre Corneille (1606–84)	Galileo Galilei (1564–1642) publishes *Dialogue on the Two Major Systems of the World*, 1632 Russian pioneers reach Pacific coast of Asia, 1637
1640 Frederick William, Great Elector of Brandenburg (r. 1640–88) Cardinal Mazarin governs France during minority of Louis XIV, 1643–61	Papacy of Innocent X, 1644–55 Royal Academy of Painting and Sculpture founded in Paris, 1648 J.-B. Molière (1622–73)	Evangelista Torricelli (1608–47) discovers principle of the barometer and devises earliest form of the instrument, 1643 Blaise Pascal (1623–62)
1650 English Commonwealth under Cromwell, 1649–53; Protectorate, 1653–59 Charles II (r. 1660–85) restores monarchy in England Louis XIV assumes absolute rule of France, 1661 Great Fire of London, 1666	J.-B. Racine (1639–99) Thomas Hobbes publishes *Leviathan*, 1651 Papacy of Alexander VII, 1655–67 French Academy in Rome founded, 1666 John Milton publishes *Paradise Lost*, 1667	Robert Boyle (1627–91) formulates law that the volume of gas varies inversely as the pressure, 1660 Charles II charters Royal Society, London, 1662; establishes Royal Observatory, Greenwich, 1675 Christiaan Huygens invents pendulum clock, 1673
1675 Louis XIV revokes Edict of Nantes, 1685 Glorious Revolution against James II of England, 1688 Peter the Great (r. 1689–1725) begins modern reform of Russia	Spinoza (1632–77) John Locke (1632–1704) *Pilgrim's Progress* by John Bunyan, 1678 Giambattista Vico (1668–1744)	Isaac Newton (1642–1727) sets forth idea of universal gravitation in *Principia*, 1687, and publishes *Optics*, 1704 Thomas Savery patents steam engine, 1698

Sta. Maria della
Salute, Venice,
by Longhena

*Kitchen
Maid,* by
Vermeer

Self-Portrait,
by Rembrandt

St. Paul's
Cathedral,
London,
by Wren

PAINTING, SCULPTURE, ARCHITECTURE

ITALY	CATHOLIC COUNTRIES OUTSIDE ITALY	PROTESTANT COUNTRIES	
Annibale Carracci, Palazzo Farnese frescoes			1590
Caravaggio, *Calling of St. Matthew; Conversion of St. Paul*			
Maderno, Sta. Susanna, Rome; nave and façade, St. Peter's, Rome			1600
Reni, *Aurora* Domenichino, *Hunt of Diana*	Rubens, *Raising of the Cross; Fall of the Damned; Daughters of Leucippus*	Hals, *Banquet of the Officers of the St. George Guard* Jones, Banqueting House, Whitehall, London	1610
Guercino, *Aurora* Bernini, *Apollo and Daphne; David;* Baldachin of St. Peter's, Rome Artemisia Gentileschi, *Judith with the Head of Holofernes*	Velázquez, *The Drinkers* Poussin, *Inspiration of the Poet* Van Dyck, *Rinaldo and Armida* Zurbarán, *Vision of St. Peter Nolasco*	Honthorst, *Adoration of the Shepherds* Terbrugghen, *Incredulity of St. Thomas* Brouwer, *Boors Drinking*	1620
Longhena, Sta. Maria della Salute, Venice, begun	La Tour, *Newborn* Van Dyck, *Portrait of Charles I* Mansart, Orléans wing, Blois Rubens, *Garden of Love* Ribera, *Martyrdom of St. Bartholomew*	Hals, *Laughing Cavalier; Malle Babbe* Leyster, *The Proposition* Rembrandt, *Angel Leaving Tobit*	1630
Borromini, interior, S. Carlo alle Quattro Fontane, Rome Bernini, *Ecstasy of St. Theresa; Fountain of the Four Rivers*	Louis le Nain, *Cart* Claude Lorrain, *Embarkation; Marriage of Isaac and Rebecca* Poussin, *Rape of the Sabine Women; Holy Family on the Steps*	Rembrandt, *Night Watch; Supper at Emmaus* Heda, *Still Life*	1640
Borromini, S. Agnese, Rome Bernini, *Cathedra Petri;* colonnade of St. Peter's, Rome	Champaigne, *Arnauld d'Andilly* Velázquez, *Las Meninas* Le Vau, Vaux-le-Vicomte Perrault, east façade, Louvre, Paris	Rembrandt, *Polish Rider* Van Goyen, *River Scene* Vermeer, *Kitchen Maid; View of Delft* Saenredam, *Church of St. Bavo* De Hooch, *Linen Cupboard* Steen, *World Upside Down* Hals, *Regentesses* Rembrandt, *Return of the Prodigal Son* Vermeer, *Allegory* Ruisdael, *View of Haarlem*	1650
Guarini, Chapel of the Holy Shroud, Turin; Palazzo Carignano, Turin Baciccio, ceiling fresco, Il Gesù, Rome Pozzo, ceiling fresco, S. Ignazio, Rome	Le Vau and Hardouin-Mansart, Versailles Puget, *Milo of Cortona* Girardon, Tomb of Richelieu Coysevox, *Bust of Colbert* Hardouin-Mansart, Church of the Invalides, Paris Hyacinth Rigaud, *Louis XIV*	Wren, St. Paul's Cathedral, London Hobbema, *Avenue at Middelharnis*	1675

CHAPTER TWENTY-NINE

The eighteenth century did not produce a single figure in the visual arts to rank with the universal masters of previous epochs. The seventeenth century can boast Caravaggio, Bernini, Borromini, Rubens, Rembrandt, Vermeer, and Velázquez, all artists of the highest stature. In the eighteenth century the palm passed to music—Bach, Handel, Vivaldi, Haydn, and Mozart. Paradoxically, it was a period of intense creative activity, with countless artists of talent, many delightful, yet all limited. Nothing completely new was created except the Rococo style (see below), and even that was a lighthearted version of Baroque grandiloquence, as if the overinflated Baroque balloon had burst and the floating pieces had alighted wherever they could find a perch. After the grandeur of the Catholic triumph in Rome and the pomposity of the Age of Louis XIV in France, grace, charm, and wit substituted for majesty and splendor. Yet all the time in the background flowed the strains of classicism and realism, which in the seventeenth century had formed countercurrents to the more outspokenly Baroque styles, and when least expected one or the other could move into the light. Aside from its frequent lack of seriousness, the most striking aspect of eighteenth-century art is the contrast between international styles on the continent of Europe and an assertive nationalism in England, where the Rococo was never more than partially accepted no matter how much of it the English lord or wealthy merchant might have absorbed on the Grand Tour.

Italy

JUVARA In Italy the international dimension of eighteenth-century style emerged in the architecture of Filippo Juvara (1678–1736), a Sicilian brought to Turin by Vittorio Amedeo II, duke of Piedmont and Savoy. In and around the Piedmontese capital, already studded with brilliant works by Guarino Guarini, Juvara turned out an astonishing array of churches and royal residences, and from this center he either traveled or sent designs throughout central and western Europe. A very agreeable phenomenon of the Late Baroque in Italy is the mountaintop sanctuary, intended to bring a vast landscape into focus. The shrine of

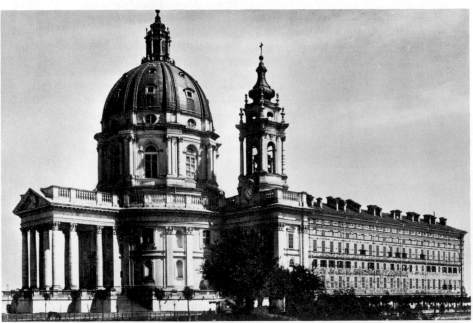

29-1. FILIPPO JUVARA. Superga, monastery church, near Turin. c. 1715–31

29-1

THE EIGHTEENTH CENTURY

Superga (fig. 29–1), commissioned from Juvara by Vittorio Amedeo in 1715 or 1716 in gratitude to the Virgin for assistance in battle, and completed in 1731, looks across Turin to a rampart of Alps. Only the battalions of windows and chimneys relieve the brick mass of the monastery intended to serve the shrine. Growing out of the very mountain, the structure reaches a crescendo in the white stone church, a circular structure on an octagonal core, preceded by a temple portico and crowned by a circular dome and flanked by a campanile on each side. A somewhat similar arrangement of church and monastic buildings had already been devised at Melk in Austria (see fig. 29–21). The coupled pilasters and columns are more widely spaced than in domes by Michelangelo or Borromini, the latter quite freely grouped in the portico, and the airy campaniles abound in double curvature.

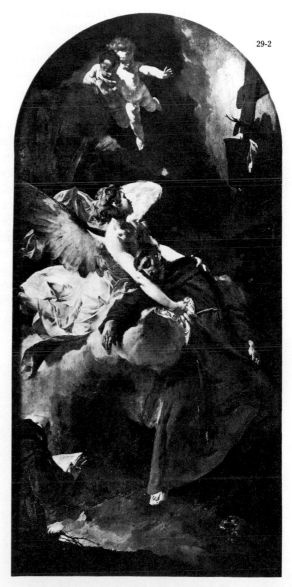

PIAZZETTA Among all the Italian schools of painting, only that of Venice survived with real originality and vigor into the eighteenth century; the revived Venetian School was, in fact, the only serious rival to that of France on the Continent. Interestingly enough, the period was one of political stagnation; the thousand-year-old republic ruled by an oligarchy was incapable of competing with the imperialist monarchies to the north and west. The splendid city had become a playground for the rich and great of all Europe, the first tourist center of the modern world. Old themes, transformed in content and lightened in style, remained in the new painting that decorated church and palace interiors in a burst of creative energy. The first important master of eighteenth-century Venice was Giovanni Battista Piazzetta (1682–1754), who spent most of his long life in the city of the lagoons. While his pictures often retain something of the darkness of the Caravaggio followers and the drama of the Roman High Baroque, they already show something of the lightness and grace of the eighteenth century. His *Ecstasy of Saint Francis,* of about 1732 (fig. 29–2), echoes at a distance Bernini's *Ecstasy of Saint Theresa* (see fig. 26–15), but with far less intensity. The emphasis is less on the climax than on the moment of healing; an angel has come down to stanch the blood from the saint's miraculous wounds, and light plays softly on this scene and the two child angels above, creating delicate rhythms remote from the powerful forms of the High Baroque, just as the figures are relieved from the weight of Caravaggio and Rubens. As compared with the serious themes of the seventeenth century, the mood is exquisite and almost playful.

TIEPOLO The supreme Venetian master of the period, and one of the two or three finest painters of the eighteenth century, was Giovanni Battista Tiepolo (1696–1770), active not only in Venice and throughout the cities and country villas of northern Italy but also in Germany and in Spain; he died in Madrid while in the course of grandiose projects at the royal palace. Tiepolo's greatest achievements were his vast decorative frescoes. The damp salt air of Venice was not kind to true fresco in the traditional Italian style; as we have seen, Venetian painters of the sixteenth century (see Chapter Twenty-Four) preferred to cover large surfaces with detachable canvases. But Tiepolo, doubtless under the influence of Roman illusionist frescoes of the High and Late Baroque (see Chapter Twenty-Six), wanted a completely unified surface throughout entire interiors. His technique made considerable use of sand in the mixture and was carried out *secco su fresco.* By these means he was able to cover enormous surfaces but with a completely new lightness, combined with a mathematical perfection of perspective in no way inferior to that of Andrea Pozzo (see fig. 26–28). The walls and ceiling of the great hall in the Palazzo Labia in Venice (fig. 29–3), probably finished before Tiepolo's trip to

29-2. GIOVANNI BATTISTA PIAZZETTA. *Ecstasy of Saint Francis.* c. 1732. Oil on canvas, 12′4½″ × 6′1⅛″ (3.77 × 1.85 m). Museo Civico d'Arte e Storia, Vicenza

Germany in 1750, are completely painted away with illusionistic architecture of such accuracy that it is often next to impossible to tell from photographs what is real and what is fiction; it is difficult even when one is standing in the room. Actually, only the narrow rectangular marble door frames shown in the illustration are real.

The story of Antony and Cleopatra is treated as a continuous festival surrounding the entire room, like a greatly expanded Feast by Veronese (see fig. 24–15), from which one picks out with difficulty even the figures of the principal actors; drama hardly matters—important are the operatic splendor of the conception, the colors of the marbles and the costumes, and the free flow of forms and light. Architecture and figures are bathed in a luminous atmosphere that had not been seen since ancient Roman painting, which Tiepolo must have known at least in engravings, since excavation of the Roman cities near Naples had begun in the 1730s and 1740s.

Tiepolo showed his magical facility and feather lightness in decorations on an even more ambitious scale in the ceiling frescoes for the archiepiscopal Residenz in Würzburg, finished in 1753 (fig. 29–5). The central ceiling decoration of the Kaisersaal (Imperial Hall) reminds one of Pozzo's Sant'Ignazio frescoes though it is shorn of all weight and solemnity. The mighty, upward-boiling geyser of the Baroque pictorial composition has dissolved into scraps floating in light and color in the pearly immensity of space. In the *Investiture of Bishop Harold,* gilded plaster curtains are drawn aside as if the ceiling itself were opening and the splendid pageantry were spilling forth into the very room.

GUARDI A new category of Venetian eighteenth-century painting was that of views, whether of Venice itself or of Venetian buildings recombined in imaginary landscape settings. These works were generally intended for the wealthy international public who thronged Venice and took them back as mementos to their splendid houses throughout Europe. Some of the view-painters were accurate perspective theorists who made wide use of the camera obscura (see pages 829–30), but in modern eyes the most gifted were several brothers of the Guardi family, whose sister married Tiepolo. Experienced in the painting of altarpieces, the Guardi brought to view-painting a special kind of fantasy and a dazzling lightness of touch. To us their paintings seem the very embodiment of the carnival atmosphere of the last century of the republic's life (see fig. 29–4). Francesco (1712–93) is generally considered the most important, but the situation is still very confused, and it may never be possible completely to disentangle the styles of the brothers and their assistants.

29-3. GIOVANNI BATTISTA TIEPOLO. *Banquet of Anthony and Cleopatra,* fresco, Palazzo Labia, Venice. Before 1750

29-4. FRANCESCO GUARDI. *Piazzetta San Marco.* Date unknown. Oil on canvas, 17¾ × 28⅜" (45 × 72 cm). Ca' d'Oro, Venice

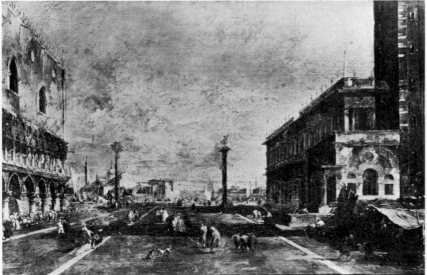

29-5. GIOVANNI BATTISTA TIEPOLO. *Investiture of Bishop Harold,* detail of ceiling frescoes, Kaisersaal, Residenz, Würzburg. 1750–53 (architecture by BALTHASAR NEUMANN)

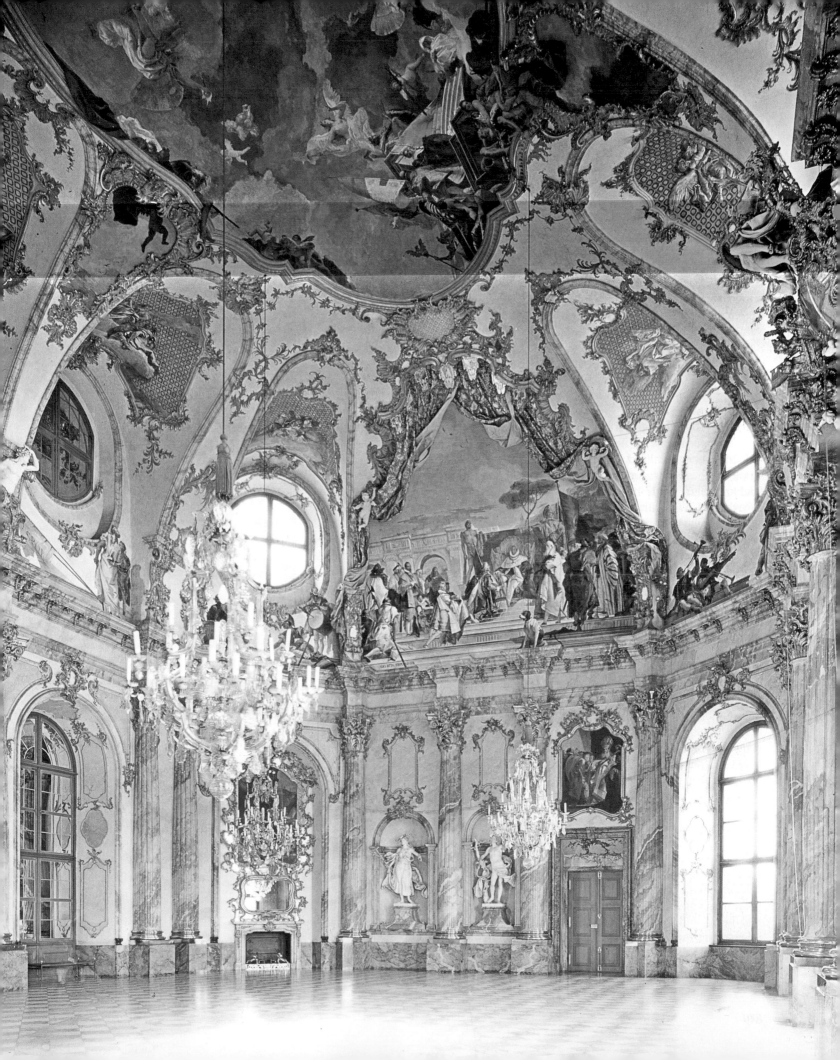

Not until he reached seventy-two was Francesco elected to the Venetian Academy, in the category of view-painter. Even for eighteenth-century Venice his technique is so brisk and his vision so unconventional that his work must have been at times hard to digest. In *Piazzetta San Marco* (fig. 29–4), instead of dignified monumentality, the familiar shapes of the Doges' Palace, the Library of San Marco, and the façade of San Giorgio Maggiore take on a quality of tattered age in the long light of afternoon, with elegant strollers out to enjoy the air and a bit of intrigue, lower classes busy at an awninged shop at the base of the Campanile, and two dogs in the exploratory stage of courtship. Actually, Guardi's fantasy and light touch revive an ancient tradition, that of the freely painted view in the Fourth Pompeiian style of Roman art, with the same delightful combination of poetry and wit.

PIRANESI Guardi's contemporary Giovanni Battista Piranesi (1720–78) was also a topographical artist, but his medium was etching. Like Guardi, he profited from the eighteenth-century passion for educational travel, finding customers for his views among the flocks of foreign visitors to the picturesque cities of Italy. Piranesi also turned to good account—and, in fact, himself stimulated—the eighteenth-century interest in classical antiquities. While he was still a young man, the ancient Roman cities of Herculaneum and Pompeii were just being disinterred from the lava that had buried them in A.D. 79, and by the time he reached artistic maturity, all Europe was following with breathless interest the further progress of the archaeological excavations. Trained as an architect in his native city of Mogliano on the Venetian mainland, he first visited Rome in 1740. There he worked for two painters who specialized in scenes of ruins and stage sets for the theater. He also studied briefly with the etcher Giuseppe Vasi. After a brief trip back to Venice and a visit to Naples, where he became friendly with the director of the museum of the excavations at Herculaneum, Piranesi settled in Rome for good. During the next thirty years he turned out hundreds of etchings of the ancient city buildings, many of which he himself measured, studied, and even, as at Hadrian's Villa at Tivoli, helped to excavate, hacking at the overgrowth of vines with a hatchet and burning out the snakes and spiders that lived under the broken walls. He came passionately to believe that ancient Roman architecture owed nothing to ancient Greece—was, in fact, richer and more varied—and he quarreled bitterly with such scholars as Johann Joachim Winckelmann, James Stuart, and Nicholas Revett (see pages 854–55), whose publications in the 1750s and 1760s initiated the Europe-wide movement in art and architecture inspired by Greek antiquities.

In 1748 Piranesi began to publish volumes of etchings of the monuments of his adopted city. His *Le Antichità Romane* (1756) and *Vedute di Roma* (1751–) stirred the imagination of his contemporaries not so much because of their pioneering nature (they were not the first architectural views of ancient Rome) or their accuracy (other scholars and artists were also producing careful renderings of the ruins) but because he perfected a superb etching technique—flexible, subtle, and poetic—through which he was better able than anyone else to convey the grandeur that had been ancient Rome.

In 1741 Piranesi began a series of etchings called *Carceri di Invenzione (Imaginary Prisons)*, studies of vast underground structures filled with flights of stairs to nowhere, shadows pierced by bars of dusty light, swags of rope and tackle, cantilevered beams, barred windows, and the tiny human figures of prisoners and jailers. Reflecting his knowledge of Baroque stage sets, these gloomy works of genius had immense influence, but less so in Piranesi's own time than among the Romantic writers of the nineteenth century and the Surrealist artists of the twentieth, many of whose works explore the frontier in the human mind between the real world and the world of dreams. In 1761 Piranesi returned to the *Carceri*, intensifying the contrasts between light and shadow, increasing their sense of menace by adding objects of torture and constraint, and elaborating the backgrounds to reveal rooms behind rooms, level above towering level. Fig. 29–6

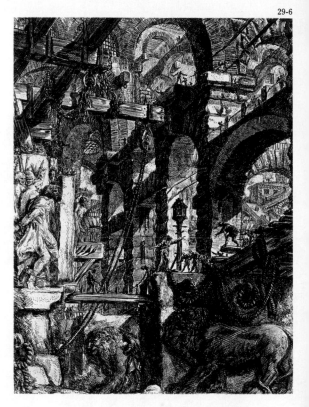

29-6

29-6. GIOVANNI BATTISTA PIRANESI. *The Lion Bas-Relief*, from *Carceri di Invenzione (Imaginary Prisons)* series. c. 1761. Etching. The Metropolitan Museum of Art, New York. Rogers Fund, 1941

shows one of two plates Piranesi added to the collection as he reworked the series. The foreground is dominated by three classical bas-reliefs. two lions carved on the postaments of what may once have been the stairway to an emperor's palace and, at left, the crumbling remains of a scene of Roman victory with a bound captive being paraded past spear-bearing soldiers. Other writers have observed that in this new plate for the *Carceri,* the only prisoners we see are in the bas-relief; the other human figures seem to be those of visitors to the subterranean world of the past, and they gesticulate in apparent wonder at the marvels they have found there, just as the eighteenth-century visitors to Pompeii and Herculaneum must have done.

Though he was trained as an architect, Piranesi carried out only one major building commission, the renovation of the Church of Santa Maria del Priorato on the Aventine Hill. Like his contemporary the French architect Étienne-Louis Boullée, Piranesi was one of the first in a long line of so-called visionary architects, who are best remembered for their provocative, ingenious, and poetical architectural drawings rather than for what they actually built. In our own time, Paolo Soleri carries on this tradition (see fig. 39–33).

France—The Rococo and Classicism

In France the Late Baroque took on a new flavor and lightness after the demise of Louis XIV, which freed the courtiers for a life in Paris considerably more agreeable than their virtual imprisonment at Versailles. A number of *hôtels particuliers* (town mansions) were built by the aristocracy in fashionable quarters of the capital. Although their exteriors were designed in a tradition flowing directly from that of the seventeenth century, in the interiors everything was transformed. Nothing was more odious to the eighteenth century than the pomposity of *Le Roi Soleil.* The new and delightfully irresponsible style has won the name *Rococo,* derived from the word *rocaille* (the fantastic decoration of rocks and shells lining grottoes in Mannerist and Baroque gardens) because of its frequent use of shell forms, which are combined with scrolls, flowers, ribbons, and other caprices in a decoration that obliterates form and direction and defies analysis.

One of the most successful examples of this characteristically intimate and small-scale decoration is the Salon de la Princesse in the Hôtel de Soubise (fig. 29–7), designed in 1732 by GERMAIN BOFFRAND (1667–1754), a pupil of Jules Hardouin-Mansart, and supplied with paintings by CHARLES JOSEPH NATOIRE

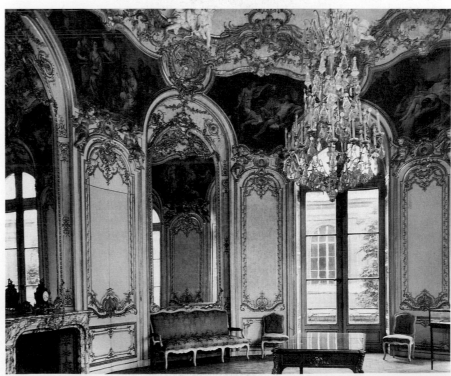

29-7. GERMAIN BOFFRAND and CHARLES-JOSEPH NATOIRE. Salon de la Princesse, Hôtel de Soubise, Paris. 1732

29-7

(1700–1777). The plan is oval and the walls so treated that it is difficult to decide where they end and the ceiling begins. The room is a mere bubble of plaster, paint, gold, and glass. The eight openings oscillate between windows and mirrors so arranged as to provide reflections that further confuse one's sense of direction. There are no classical orders (although there are many on the exterior of the building); the walls are treated as panels, surrounded by gilt moldings whose only straight lines are the verticals. On them scraps of gilt decoration, blown like thistledown, seem to have come momentarily to rest. In frames whose double curvatures elude geometrical definition, the lighthearted paintings unfold the romance of Cupid and Psyche. The central chandelier, its scores of faceted pendants reflecting and multiplying the light of the candles, is an essential element in the fragile web of color and light. In assessing such extreme examples of the Rococo, however, it should be borne in mind that Boffrand's more monumental buildings, both exteriors and interiors, derive from the sober, classicistic Baroque style of Hardouin-Mansart (see figs. 27–16, 27–19).

The same society that demanded such frivolities as the Salon de la Princesse for aristocratic diversions required a wholly different mode for serious buildings, increasingly classical—in fact, Augustan—toward the middle of the century. The Panthéon, in Paris (fig. 29–8), built in 1757–90 after the designs of GERMAIN SOUFFLOT (1713–80) as the Church of Sainte-Geneviève, shows a classicism more thorough and severe than that of Claude Perrault (see fig. 27–12). Trained in Rome, Soufflot admired High Renaissance architecture and originally planned a Greek-cross structure with a hemispheric dome reflecting Bramante's designs for Saint Peter's. Following the wishes of the clergy, he prolonged his design to its present Latin-cross shape (fig. 29–9), and the dome consequently had to be heightened; Soufflot obviously followed Christopher Wren's dome for Saint Paul's (see fig. 28–28), eliminating the niches. The portico is, of course, the pronaos of a Roman temple, although with a projecting wing on each side. Interestingly enough, Soufflot was an admirer of Gothic constructional principles and concealed not only a clerestory but an elaborate system of supports for his interior vaulting behind the lofty screen wall and balustrade, which make the two-story building appear one story high on the exterior. The cold aspect of the blank outer walls is due to the walling-up of the windows during the Revolution, in 1791, when the building was converted to its present purpose as a memorial to France's illustrious dead; traces of the original windows can still be seen in the illustration.

WATTEAU One of the greatest French painters of the eighteenth century, and one of the two or three anywhere to be ranked with Tiepolo, was Jean-Antoine Watteau (1684–1721), whose paintings embody the interests of the Rococo raised to the plane of lyric poetry. Born in the Flemish town of Valenciennes, Watteau never forgot his Flemish heritage, especially his allegiance to the Baroque colorism of Rubens. After an impoverished and difficult beginning in Paris, which undermined his health, the young painter rapidly achieved recognition. In 1712 he was invited to join the Academy and was permitted to write his own ticket for a reception piece. His remaining nine years of life, constantly clouded by illness, were largely devoted to the production of an enchanting series of canvases idealizing the themes of courtship and of outdoor festivals and plays popular during the last years of Louis XIV and overwhelmingly so during the Regency. His special category was the *fêtes galantes,* which can best be described as festivals attended by exquisitely dressed young ladies and gentlemen in gardens or parks.

The loveliest of these is *A Pilgrimage to Cythera* (fig. 29–10), the artist's reception piece for the Academy, painted in 1717, intended to evoke memories of Rubens's *Garden of Love* (see fig. 27–29). The subject is a day's journey of youthful couples to the island of Cythera, sacred to Venus, whose statue, hung with rose garlands, stands at the right. At its base Cupid has hung his quiver of arrows, and the couples, still exchanging vows in the light of early evening, prepare to embark for the shore

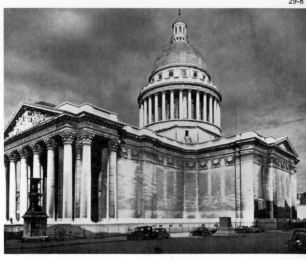

29-8. GERMAIN SOUFFLOT. Panthéon (Church of Ste.-Geneviève), Paris. 1757–90

29-9. GERMAIN SOUFFLOT. Plan of the Panthéon (Church of Ste.-Geneviève), Paris

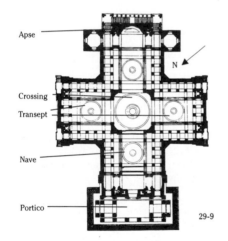

Apse

Crossing

Transept

Nave

Portico

29-9

29-10. JEAN-ANTOINE WATTEAU. *A Pilgrimage to Cythera*. 1717. Oil on canvas, 51 × 76½″ (1.3 × 1.94 m). Musée du Louvre, Paris

in a golden boat attended by clouds of cherubs, not without a mournful look backward at the pleasures of the enchanted isle. This wistful evocation of the transience of love is carried out with an unrivaled grace of drawing and delicacy of color. Watteau usually covered his canvases with a heavy coating of pearly color, shifting from white to blue and sometimes to rose. Once the underpaint was dry, he indicated the trees in swiftly applied washes of green, blue green, and golden brown, somewhat in the manner of Jan van Goyen (see fig. 28–3) but so transparent that the pearly undercoat shows through. The figures were then touched in with fairly thick impastos, in tones predominantly of rose, blue, yellow, and white. The whole was then glazed in the manner of Titian, so that the impastos would gleam richly through an atmosphere determined by the surrounding washes. The figures are generally very small in relation to the space and invariably based on pointed forms—triangles delicately supported by the toes of shoes, the tips of canes, or the pointed ends of ladies' trains; even the faces are generally conceived in terms of pointed shapes. All were painted on the basis of drawings from life, hundreds of which survive, in which every facet of form, light and shade, and

29-11. JEAN-ANTOINE WATTEAU. *Signboard of Gersaint*. c. 1721. Oil on canvas, 5′4″ × 10′1″ (1.63 × 3.07 m). Staatliche Museen zu Berlin—Preussischer Kulturbesitz

expression was carefully studied. These were then translated into paintings that depend largely on poise for their effect and on brushstrokes of great accuracy and delicacy, communicating color of jewel-like intensity.

The conditions under which works of art were bought and sold in the eighteenth century are depicted by Watteau with wit and grace in an extraordinary picture, the *Signboard of Gersaint* (fig. 29–11), painted in only eight mornings during the last year of the artist's life for his friend the art dealer Gersaint. The work had to utilize two canvases to fill the space, a low arch protected by a canopy above the entrance to the shop, which was situated on the Pont Notre Dame, a bridge across the Seine in the center of Paris. The original arched shape and the break between the two canvases can still be made out in the illustration. The picture was slightly cut down at the sides and expertly extended at the top by a pupil when it was purchased, two weeks after being put in place. The shop was called *Au Grand Monarque,* which explains the Rigaud-style portrait of Louis XIV, who had died six years earlier, being packed into a box at the left. At the right, a lady dressed as a widow gazes into the landscape of an oval picture while a white-wigged gentleman goes down on one knee, the better to examine the female nudes. Behind the counter salespersons engage the attention of a seated lady of exquisite beauty. The probably symbolic paintings that line the walls, frame to frame, are in the styles of masters Watteau admired and had studied in the royal collections, such as Correggio, Titian, Veronese, and Rubens, but the only one identifiable (by the Flemish painter Jacob Jordaens) is in the portion not by Watteau. At the back one can see dimly into an inner room, built out over the Seine. The rough cobblestones of the bridge pavement in the foreground contrast with the elegance and richness of the shop, brought to precise focus in the gleaming satins of the female customers.

29-12. FRANCOIS BOUCHER. *Triumph of Venus.* 1740. Oil on canvas, 51⅛ × 63¾″ (1.3 × 1.62 m). Nationalmuseum, Stockholm

29-12

BOUCHER The painter who more than any other epitomizes the pleasure-loving aspect of the Rococo is François Boucher (1703–70), the favorite painter of Madame de Pompadour, the king's mistress, whose influence on the arts in France was enormous. There is little in Boucher's work of the mystery and poetry of Watteau, but for sheer sensuous charm his paintings, overflowing with voluptuous nudes, are hard to equal. The *Triumph of Venus*, of 1740 (fig. 29–12), shows the goddess of love half-seated, half-reclining on silks and satins in a huge shell, drawn across the sea by dolphins, accompanied by Tritons and sea-nymphs, one of whom offers her a shell of pearls, while cupids race in twos and threes through the trailing clouds, carrying a miraculously graceful salmon-and-silver-striped scarf that resembles a gigantic banner. In contrast to Watteau, Boucher retains Rubens's device of the spiral into the picture, and his colors—sensuous shades of pink and blue—are richly enameled and dense, with little or no use of glazes. Frivolity, grace, and charm are pushed almost to the point of surfeit, but just when one has had enough sweetness, the authority of Boucher's drawing steps in and provides solid support for his fantasies.

CHARDIN To modern eyes, one of the most impressive French eighteenth-century painters was Jean-Baptiste-Siméon Chardin (1699–1779). Yet his contemporaries held him in somewhat lower esteem, save for Denis Diderot, the encyclopedist and critic of art, literature, and music, whose reports on the Salons (the biennial exhibitions of the Royal Academy) are a major source for our knowledge of eighteenth-century French art and a barometer of the taste of the intellectuals. In an age when the highest honors went to those who could celebrate its fantasies and gratifications, veiled or naked, Chardin displayed a disconcerting interest in its realities. His subjects and style celebrate a lifelong allegiance to the Parisian lower middle class, from which both he and Boucher (though one would hardly have known it in the case of Boucher) had sprung. His early work consists almost entirely of still life, but not of the Dutch epicurean variety; he transferred the scene of his pictures from the gardens of Watteau and the gilded salons or boudoirs of Boucher, and even the bourgeois living room of the Dutch, to the kitchen. It is the more surprising that aristocrats should have bought his work.

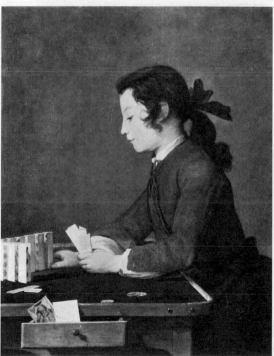

29-13. Jean-Baptiste-Siméon Chardin. *House of Cards*. 1741. Oil on canvas, 32⅜ × 26″ (82.2 × 66 cm). National Gallery of Art, Washington, D.C. Andrew W. Mellon Collection

29-13

His *House of Cards,* of 1741 (fig. 29–13), shows us a simply dressed boy toying with his cards as delicately as a Watteau lady with her suitor, and presents an image as fragile—a breath will blow the house of cards over. Yet for as long as it lasts, the fantasy of a child is set forth as a structure of great dignity. The *Copper Cistern,* of about 1773 (fig. 29–14), presents the water vessel as a monumental object (despite its tiny dimension), surrounded by a pitcher, a pail, and a dipper as is a planet by satellites. To endow such humble objects with nobility required a sense of the dènsity and richness of pigment equal to the artist's respect for their copper and zinc, and for the rough wall, which is the only background. His thick impastos are derived from a study of Rembrandt, and they communicate to his subjects a glow as satisfying as that of Watteau's silks and satins. Chardin's figure studies are concerned with Rococo ideals of transience and lightness, but without abandoning his bourgeois loyalty.

GREUZE AND FRAGONARD Chardin's honest devotion to bourgeois subjects was unconsciously parodied by Jean-Baptiste Greuze (1725–1805) and flouted by Jean-Honoré Fragonard (1732–1806), both of whom managed to subsist in relative independence from the Academy. Both had the ill fortune to survive into the revolutionary era, which Greuze limped through while Fragonard had to flee Paris. Greuze's sentimental and moralizing pictures, on subjects of his own invention, struck the taste of the 1760s and 1770s exactly right; they were warmly praised by Diderot, who condemned Boucher on both moral and stylistic grounds. *The Son Punished,* of 1777–78 (fig. 29–15), is a sermon on family solidarity. The young man who had braved his father's curse and gone off with the recruiting sergeant so that he might taste the adventures of military life returns to find his father dead and his family plunged in reproachful grief. While the types are supposedly drawn from real life, they actually echo stock classical poses. The mother gestures like a Roman orator, and the figures move on their narrow stage in a strict relief plane. This type of composition provided the basis for the later Neoclassical formulas of Jacques-Louis David (see fig. 30–9), and also for innumerable nineteenth-century storytell-

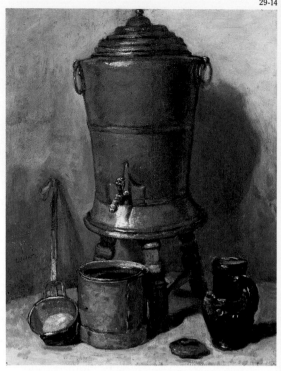

29-14. JEAN-BAPTISTE-SIMÉON CHARDIN. *Copper Cistern.* c. 1733. Oil on panel, 11¼ × 9¼" (28.6 × 23.5 cm). Musée du Louvre, Paris

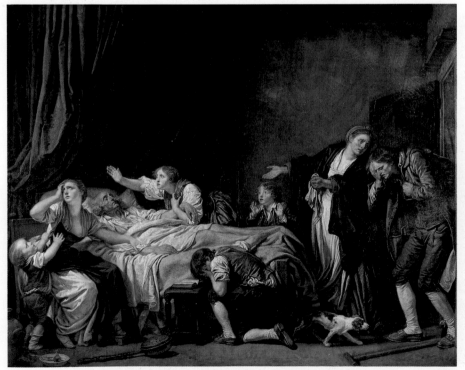

29-15

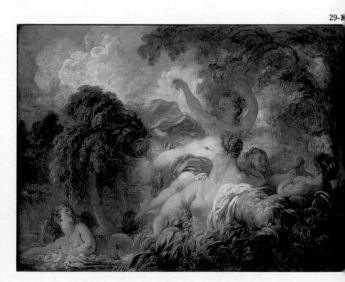

29-15. JEAN-BAPTISTE GREUZE. *The Son Punished.* 1777–78. Oil on canvas, 51 × 65" (1.3 × 1.65 m). Musée du Louvre, Paris

29-16. JEAN-HONORÉ FRAGONARD. *Bathers.* c. 1765. Oil on canvas, 25½ × 31½" (64.8 × 80 cm). Musée du Louvre, Paris

ing pictures. A moment's comparison will show the qualitative gulf between Greuze and Chardin in such matters as the handling of furniture and crockery.

Fragonard functioned on a far higher artistic level. After six months in Chardin's studio, for which he was temperamentally unsuited, he went on to study with Boucher, whose style he was able to imitate with ease. Rapidly, however, he moved forth on his own and developed a buoyant composition and spontaneous brushwork, both highly original. In the *Bathers* (fig. 29–16), of about 1765, he adopted a Rubens-like spiral movement. The picture erupts in a geyser of nudes, water, clouds, and trees, all apparently composed of much the same soft, sweet substance. In contrast to the enameled surfaces of Boucher, Fragonard often attacked the canvas with a brushwork even more energetic than that of Frans Hals and discharged with refreshing effervescence. Despite his attempt to recoup his lost popularity in later life by exchanging voluptuous subjects dear to the aristocracy for didactic ones, this delightful painter died in relative obscurity.

LABILLE-GUIARD AND VIGÉE-LEBRUN Two French women painters, immensely successful as artists and teachers in their own time and considered by specialists today to be among the most accomplished portraitists of the eighteenth century in any country, suffered the fate that too often has befallen women artists. Both hyphenated their family names with those of their husbands. Both were admitted to the French Academy on the same day in 1783. Both were roundly attacked for being painters at the sacrifice of their precious "modesty" and were libeled both verbally and in print (anonymously) for supposedly immoral conduct. Labille-Guiard was given the double-edged compliment of "painting like a man"; both were accused of having men paint their pictures for them.

Both painters depicted convincingly the post-Rococo naturalness and charm of the ill-fated court of Louis XVI. Adélaïde Labille-Guiard (1749–1803), original and direct in her compositions, seems to have been the inventor of a new type of intimate group portrait in which the sitters do not appear to be separately posed, as in examples by Hals (see fig. 28–11), but united with each other and with us in a

29-17. ADÉLAÏDE LABILLE-GUIARD. *Portrait of the Artist with Two Pupils*. 1785. Oil on canvas, 83 × 59½″ (2.11 × 1.51 m). The Metropolitan Museum of Art, New York. Gift of Julia A. Berwind, 1953

29-18. MARIE-LOUISE-ÉLISABETH VIGÉE-LEBRUN. *Marie-Antoinette and Her Children*. 1788. Oil on canvas, 9′1¼″ × 7′5⅝″ (2.75 × 2.15 m). Musée National du Château de Versailles

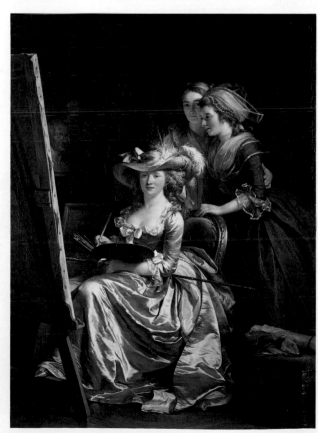

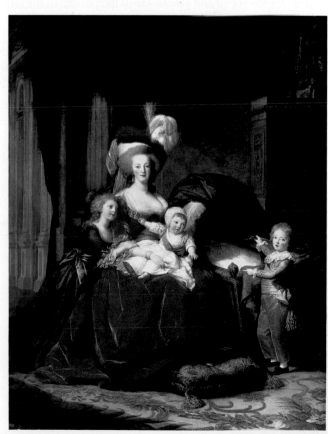

29-17

29-18

common psychological situation. Her superb *Portrait of the Artist with Two Pupils,* of 1785 (fig. 29–17), is the handsomest of these. The painter, wearing a plumed hat and the silks she knew so well (her father was a cloth merchant), sits on a velvet-covered chair before her easel, serenely holding the palette, brushes, and maulstick of her profession. She looks calmly through and beyond the spectator while one of her pupils gazes happily on her teacher's work and the other looks out directly toward us, as if to admit us into the calm of the studio. In the background one sees a bust by Augustin Pajou, a friend of the family, as if to remind us that as a child Adélaïde learned much about three-dimensional form from the sculptors of the neighborhood. Her composition, grandly staged like all her full-length portraits, reveals her command of mass and space, not only in the handling of the figures and their drapery, freed from any trace of Rococo frivolity, but even to the projection of the easel in depth, in delicate adjustment with the parquet of the floor. In spite of her connections with the royal family—Labille-Guiard painted highly original if unflattering portraits of the king's sisters—she sympathized with the Revolution and remained in France until her untimely death. She achieved, incidentally, the abolition of the limit of four women allowed as members of the Academy.

After her death Labille-Guiard became obscured by the success of her bitter rival Marie-Louise-Élisabeth Vigée-Lebrun (1755–1842), who outlived her by nearly forty years, producing more than six hundred portraits and many other works. Vigée-Lebrun did not share her competitor's honesty or brilliance, but her remarkable ability to flatter her sitters may have been as much the secret of her worldly success as her facility with the brush. Her group portrait of *Marie-Antoinette and Her Children,* of 1788 (fig. 29–18), certainly depicted the queen as she wanted to be painted, with three of her children and the empty cradle of the recently deceased fourth. The queen sits, clad in gorgeous red velvet and superbly plumed, against the traditional background of architecture, with a view of the Hall of Mirrors at the left. In 1789, a year after the completion of the painting, both king and queen were brought to Paris against their will by a cheering mob, never to leave it alive. Vigée-Lebrun fled, moving from one princely, royal, or imperial capital to the next, always pleasing her aristocratic sitters. She wrote letters and memoirs, both of them rich sources for the social and artistic life of the period. In the latter she confessed, "with those who lack character (they exist), I painted dreamy and languid poses."

CLODION In some ways a sculptural parallel to Fragonard was Claude Michel (1738–1814), known by his nickname of Clodion. His *Satyr and Bacchante,* of about 1775 (fig. 29–19), revives on a miniature scale the immediacy and dyna-

29-19. CLODION (CLAUDE MICHEL). *Satyr and Bacchante.* c. 1775. Terra-cotta, height 23″ (58.4 cm). The Metropolitan Museum of Art, New York. Bequest of Benjamin Altman, 1913

29-20. JOHANN BERNHARD FISCHER VON ERLACH. Façade, Karlskirche, Vienna. 1716–37

29-21. JAKOB PRANDTAUER. Benedictine Abbey, Melk, Austria. Begun 1702

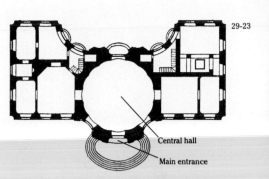

29-23

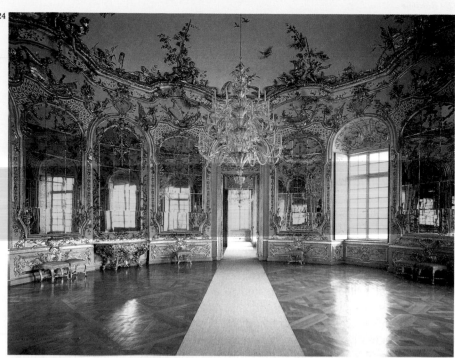

29-24

29-23. FRANÇOIS DE CUVILLIÉS. Plan of the Amalienburg, Nymphenburg Park, Munich. 1734

29-24. FRANÇOIS DE CUVILLIÉS. Hall of Mirrors, the Amalienburg, Nymphenburg Park, Munich. 1734–39

29-22. JAKOB PRANDTAUER and JOSEPH MUNGGENAST. Interior, Benedictine Abbey, Melk (galleries by ANTONIO BEDUZZI)

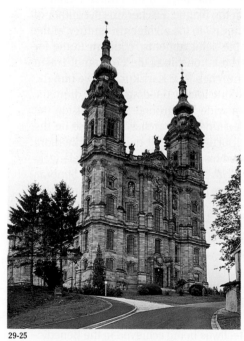

29-25

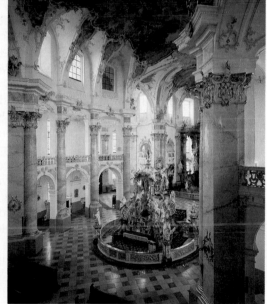

29-26

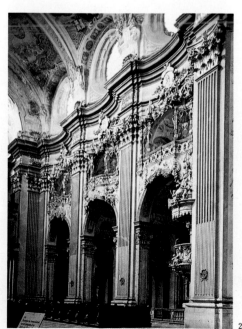

29-22

29-25. BALTHASAR NEUMANN. Pilgrimage Church of Vierzehnheiligen, near Staffelstein, Germany. 1743–72

29-26. BALTHASAR NEUMANN. Interior, Pilgrimage Church of Vierzehnheiligen

29-27. BALTHASAR NEUMANN. Plan of the Pilgrimage Church of Vierzehnheiligen, near Staffelstein

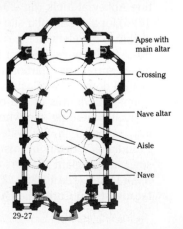

29-27

849

mism of Bernini. His groups of accurately modeled figures in erotic abandon are made all the fresher and more alluring by his knowing use of pinkish terra-cotta as if it were actual pulsating flesh, rendering each incipient embrace "forever warm and still to be enjoyed." Clodion, too, outlived the popularity of his early subjects but was able to make the switch to themes more likely to be approved by the Revolution and had a considerable success with heroic Neoclassical groups and with bas-reliefs for monuments in Paris.

Austria and Germany—The Baroque and Rococo

In central Europe the Thirty Years' War, concluded in 1648, left most countries so devastated that construction was next to impossible for many years. Not until later in the seventeenth century did monumental projects really get under way, and the Late Baroque current at the turn of the century under Italian influence soon collided with a wave of French Rococo. Throughout the Austro-Hungarian Empire works of great brilliance were created in a hybrid style, involving at times the transformation of such medieval cities as Prague, Salzburg, and Warsaw, down even to the houses of the bourgeoisie, into constantly changing pictures of Late Baroque imaginative grace. An architect of great importance for the formation of Austrian style was JOHANN BERNHARD FISCHER VON ERLACH (1656–1723), whose career culminated in the majestic Karlskirche in Vienna (fig. 29–20). Begun in 1716 and finished in 1737, this church was commissioned by the emperor Charles VI in gratitude for the delivery of Vienna from the plague. Fischer was the author of a substantial history of architecture from antiquity to the eighteenth century, at the end of which he placed his own considerable achievements. While in Rome for years of study, he had enjoyed the unplanned relationship of the Column of Trajan to neighboring Italian Renaissance domed churches. The Karlskirche gave him the opportunity to translate this historical accident into a building whose dramatic effect was increased by its relationship to a wide foreground space outside the fortifications of the city. The broad façade terminates in arches like those on the façade of Saint Peter's (see fig. 26–11), supporting low bell towers, hardly more than pavilions. The central portico was imitated from that planned by Michelangelo for Saint Peter's and is almost contemporary with the design by Juvara for Superga (see fig. 29–1). The church itself is a Greek cross intersecting an oval, culminating in a splendid invention of Fischer's, an oval dome, whose drum is richly articulated with paired engaged columns alternating with paired pilasters, flanking the arched windows. Above the drum, oval windows crowned by arched pediments and flanked by sculptures erupt into the shell of the dome. The two gigantic columns, whose spiral relief-bands symbolize the victory of faith over disease, are tucked into exedrae between the pavilions and the portico with spectacular results. Their severity is decreased by the eagles that enrich the square corners of the abaci and by little domed turrets.

Meanwhile, a different kind of pictorial effect was being achieved in the Benedictine Abbey at Melk (fig. 29–21), designed in 1702 by JAKOB PRANDTAUER (1660–1726) for a spectacular site on a rocky eminence above a curve in the Danube and visible to travelers on the river in both directions. The long wings of the monastery burst forth above the river in a climax of giant orders, gables, balustrades, and a great central arch, harboring the façade of the church, with its two bell towers and central dome. The pilasters articulating the surfaces are subordinated to the rich double curvatures of the onion domes, which contrast with the severity of the monastic building, the whole producing the impression of a glittering, heavenly city, reflected in the water below. The interior (fig. 29–22), continued after Prandtauer's death by his cousin and pupil JOSEPH MUNGGENAST (died 1741), suggests the giant pilasters and imposing barrel vault of Carlo Maderno's nave for Saint Peter's (see fig. 26–12), but, in apparent emulation of Borromini's undulating façade of San Carlo alle Quattro Fontane (see fig. 26–27), the walls between the

29-28

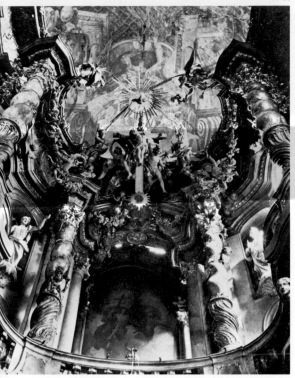

29-28. Cosmas Damian Asam and Egid Quirin Asam. *Holy Trinity.* 1733–46. Polychromed wood. Church of St. Johannes Nepomuk, Munich (ceiling paintings destroyed in World War II)

pilasters belly outward like sails in the breeze. Antonio Beduzzi provided galleries that, with their lighthearted Rococo decorations, look like boxes at the opera and were indeed intended for nobles and distinguished visitors; sometimes in Austrian churches such boxes were glazed so that aristocratic conversation might continue without disturbing Mass.

The princely states of south Germany were not long in following the Austrian lead. One of the triumphs of secular Rococo architecture is Amalienburg, a small hunting lodge in the park of Nymphenburg Palace, near Munich, built for the electress of Bavaria by François de Cuvilliés (1699–1768). Cuvilliés had been trained in Paris in the early 1720s and was among the first architectects to bring the Rococo style to Germany. In plan (fig. 29–23), Amalienburg is orderly, convenient, and inviting. There are plenty of windows to admit light (the Rococo abhorred dark corners), and the fluidity of the bowed-out front and embracing wings at the back settles the little building pleasantly within the landscape. As with many Rococo structures (for example, the pilgrimage church of Vierzehnheiligen; see figs. 29–25, 29–26), the rather plain exterior of the lodge gives no hint of the magnificence awaiting the visitor, especially in the circular central hall (fig. 29–24). The close relationship between this mirrored room and the Salon de la Princesse at the Hôtel de Soubise is apparent (see fig. 29–7)—in the shape and size of the windows, the cartouches below the chair rail, and the lavish use of glass. Yet the distinction between forms and structures in the German room has been nearly eliminated by the playful ornament run wild; it spills over walls, window embrasures, and even the white ceiling, which is enlivened by an informal decoration of trees, birds, and animals of silvered stucco.

The principal German architect of the Late Baroque and Rococo was Balthasar Neumann (1687–1753), who carried out grandiose designs for the palace of the prince-bishops of Würzburg from 1719 to 1750, under direct advice from Germain Boffrand, designer of the Salon de la Princesse. The palace, partly destroyed in World War II but since rebuilt, retains its magnificent interiors, whose architectural splendor is fully worthy of their ceiling frescoes by Tiepolo (see fig. 29–5). Neumann's exhilarating pilgrimage church of Vierzehnheiligen, of 1743–72, is reservedly Rococo on the exterior (fig. 29–25), with its undulating façade, broken pediment, quivering bell towers crowned by onion domes and steeples, and gesticulating statues. The gorgeous interior (fig. 29–26) is completely Rococo; the plan (fig. 29–27), based on seven adjacent or interlocking ellipses, is an expansion of that of Sant'Ivo (look at the shape of the cornice in fig. 26–24) without any of Borromini's spirituality. The ceiling, surrounded by a linear Rococo decoration of scrolls, dissolves the vault into an airy fresco so decorative that its subject scarcely attracts attention. With this and the columns and friezes painted to resemble pink marble, and the nave altar pulsating with columns, decorations, and apparently dancing statues of the fourteen auxiliary saints (*Vierzehnheiligen*) to whom the church is dedicated, the structure recalls the entrance hall at Amalienburg more than any Roman seventeenth-century church.

In Munich Egid Quirin Asam (1692–1750), a sculptor and architect, built at his own expense and endowed the Church of Saint Johannes Nepomuk, 1733–46, next to his own dwelling. His brother, Cosmas Damian (1686–1742), a painter, assisted in the design of the church and its decoration. The interior (fig. 29–28), embellished by paintings and sculptures from their hands, pushes the Rococo style to its ultimate limits. The spiral columns of the gallery support an undulating entablature, almost masked by garlands with child angels; the climax is a vision of the Holy Trinity, carved in wood and painted, suspended in midair against ceiling decorations and illuminated from an unseen source; the painting visible below was, unfortunately, substituted in the nineteenth century for a statue of Saint Johannes Nepomuk looking upward at this heavenly vision, and lighted in much the same fashion. The Rococo style could be carried no farther, and an eventual reaction became inevitable.

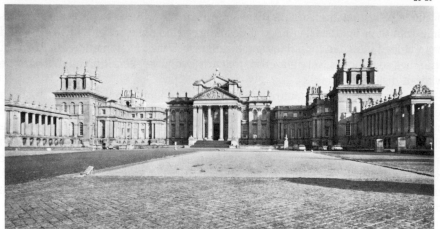

29-29

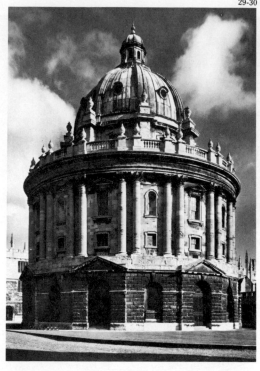

29-30

England

The prosperity of eighteenth-century England, little affected by the loss of her North American colonies in 1776, gave rise to a wave of building unprecedented since Gothic times and favored the development of a national school of architectural design as well as, for the first time since the late Middle Ages, a national school of painting. The Baroque in England, founded by Christopher Wren (see pages 832–33), was continued by his pupils and by another amateur, SIR JOHN VANBRUGH (1664–1726), equally well known as one of the wittiest dramatists of the post-Restoration period. When Queen Anne decided in 1704 to present her victorious commander, the duke of Marlborough, with a suitable residence, Vanbrugh was called upon to design Blenheim Palace (fig. 29–29). The result, built between 1705 and 1722, was impressive, but the splendor of the building does not entirely make up for its pomposity, lacking the organic richness of Italian Baroque or the tasteful balance of the French equivalent. The colonnades of Saint Peter's did not take root easily in Oxfordshire, nor were chimneys successfully masked as classical urns. The impracticality of the plan (the kitchens are a quarter of a mile from the dining salon) netted Vanbrugh ridicule in his own day; he was eventually dismissed by the duchess, who had taken over supervision of the project, and his grandiose dream was finished by a pupil.

The followers of Wren continued building Baroque structures, especially churches, well into the eighteenth century. JAMES GIBBS (1682–1754) was the most gifted of these. Having worked with the Late Baroque architect Carlo Fontana in Rome, he returned with a full repertory of Continental ideas. His superb Radcliffe Library at Oxford, of 1739–49 (fig. 29–30), is like a Roman or Parisian dome grounded; the coupled columns are derived from Michelangelo (see fig. 23–8) and Hardouin-Mansart (see fig. 27–19), and the continuous entablature comes from Bramante (see fig. 22–20) by way of Wren (see fig. 28–28), but the design has a grandeur all its own, enriched by such subtleties as wide bays between the buttresses alternating with narrow ones above, the placing of the buttresses between the paired columns rather than in line with them, and the alignment of the entrances only with the central two columns of each group of four. The building profits especially by its position as the only large dome placed at ground level so one can walk around it rather than having to gaze up at it.

With the accession of George I in 1714, the Baroque became discredited as a leftover from the Stuart kings, and the Palladian style of Inigo Jones (see page 833) was revived in mansions, town houses, country houses, streets, squares, circles, crescents, and eventually churches. One of the strongest supporters of the Palladian movement was Richard Boyle, third EARL OF BURLINGTON (1695–1753), a

29-29. SIR JOHN VANBRUGH. Entrance façade, Blenheim Palace, Woodstock, Oxfordshire. 1705–22

29-30. JAMES GIBBS. Radcliffe Library, Oxford. 1739–49

widely traveled nobleman of considerable learning and taste, friend of Pope, Swift, James Thomson, and Handel, and a gifted architect in his own right. His best-known work is Chiswick House, of 1725–29 (fig. 29-31), in whose elaborate interiors he was assisted by WILLIAM KENT (1685–1748); the exterior, however, is entirely by Burlington. The little cubic structure, intended for receptions and conversation, was connected by means of an unobtrusive wing with a Jacobean manor house (torn down in 1788). While Burlington obviously emulated the general conception of Palladio's Villa Rotonda, near Vicenza (see fig. 24–18), the details are sharply different. As the structure was not to be freestanding and had no mountain view, it needed only a single portico. The order was changed from Ionic to Corinthian, the dome from round to octagonal and raised on a drum to admit more light to the central hall. The double staircases with their balustrades and decorative urns were derived from Italian models.

Soon, under the influence of the excavations at Pompeii and Herculaneum, a third style made its appearance, a classicism far more thoroughgoing than its French counterpart, led by ROBERT ADAM (1728–92). At Syon House (fig. 29–32), remodeled by Adam beginning in 1762 for Sir Hugh Smithson, the entrance hall attempts archaeological correctness. Copies of ancient statues in marble or in bronze are ranged about the walls or set in an apse with an octagonally coffered semidome. Actually, Roman interiors were very richly adorned, and the austerity of Adam's design, with its unrelieved wall surfaces and sparing, chaste decoration, was symptomatic of his personal taste.

The fourth eighteenth-century architectural style would be totally unexpected if we did not know that in England the Gothic had never really died out. Wren and his pupils, as well as Vanbrugh and Kent, all built or extended Gothic structures at one time or another. Usually, these were churches or colleges, deriving from a long Gothic tradition. By the 1740s, however, country houses were being built in Gothic style, and a textbook appeared on how to design them. Needless to say, the organic principles of Gothic building were little understood save by such masters as Guarini or Soufflot. The usual result was a merely decorative use of motifs drawn from Gothic architecture. In addition to the Renaissance revival of classical antiq-

29-31. EARL OF BURLINGTON (RICHARD BOYLE). Chiswick House, Middlesex. 1725–29

29-32. ROBERT ADAM. Entrance hall, Syon House, Middlesex. Remodeling begun 1762

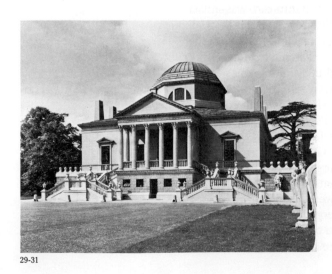

29-31

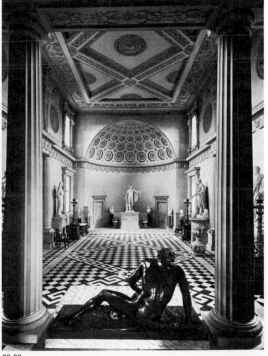

29-32

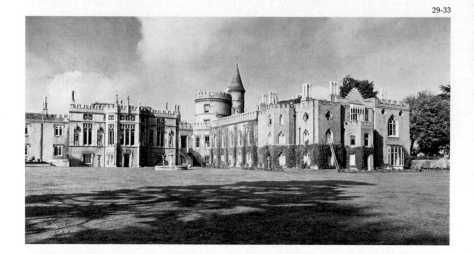

29-33

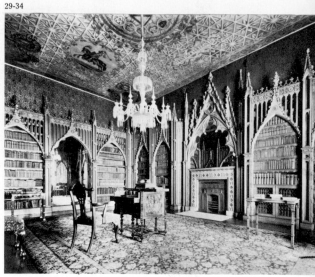

29-34

uity, the eighteenth-century revival of the Renaissance, and the eighteenth-century attempt to revive antiquity independently, a revival of just what the Renaissance had fulminated against—the "barbarous" Gothic taste—now occurred. The eighteenth century found the Gothic interesting in itself—always picturesque and at times sublime. Eighteenth-century Gothicism in art was, of course, connected with contemporary interest in medieval history and the vogue for "Gothic" romances and poems.

At the culmination of this movement, rather than at the beginning, stands Strawberry Hill, built at intervals from 1748 onward (fig. 29–33), the home of HORACE WALPOLE (1717–97), a wealthy amateur who hired professionals to construct it according to his own ideas. So greatly was the mansion admired by his contemporaries that he had to limit visiting parties to one a day. A completely asymmetrical disposition of elements, which in medieval art had been the result of accident rather than intention, includes a huge round tower in one angle, balanced by nothing elsewhere; windows, large and small, with or without tracery; and battlements, buttresses, and other Gothic elements spread over the surface haphazardly. The library (fig. 29–34) is decorated with tracery, imitated from Perpendicular churches (such as Gloucester Cathedral), used as frames for bookcases; even the rectangular eighteenth-century mantelpiece and the cast-iron forms of the fireplace frame are clothed in Gothic detail.

Fascination with the picturesque led to the construction of sham ruins in the wandering complexities of English parks, whose apparent naturalism was in fact achieved only by great labor and at vast expense. The park surrounding Hagley Hall in Worcestershire, laid out for Lord Lyttelton, contains both a ruined Gothic castle built from scratch in 1749 by Sanderson Miller, a gentleman architect, and a Greek Doric portico, based on the Propylaia at Athens, added in 1758 by James Stuart (1713–88). The latter was the first known attempt to revive in architecture pure Greek principles based on the monuments of Athens, which Stuart, in company with Nicholas Revett (1720–1804), had studied exhaustively and measured on the spot. Their sumptuous engravings were published in a famous work, *The Antiquities of Athens,* the first of four volumes appearing in 1762; the second was not issued until 1790, two years after Stuart's death. A similar study by J.-D. Le Roy also appeared in France. Studies of other classical monuments, such as the Temple of Venus at Baalbek and the Palace of Diocletian at Split, were also published. Along with these earliest archaeological studies came the theoretical and art-historical writings of Johann Joachim Winckelmann, a German art critic, who lived in Rome and never visited Greece but who nevertheless, on the basis of Roman copies,

29-33. HORACE WALPOLE, with WILLIAM ROBINSON and others. Strawberry Hill, Twickenham, Middlesex. Begun 1748

29-34. HORACE WALPOLE. Library, Strawberry Hill, Twickenham

29-35

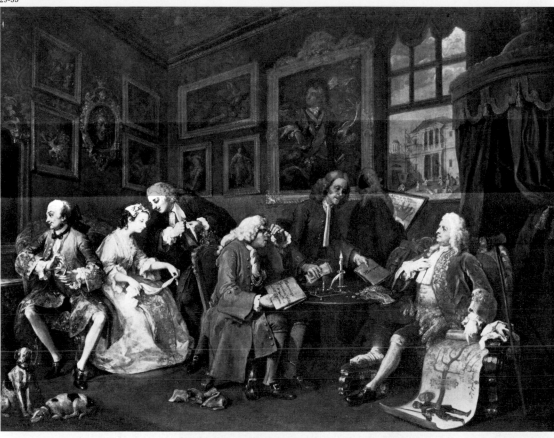

29-35. WILLIAM HOGARTH. *Marriage à la Mode: Signing the Contract.* 1743–45. Oil on canvas, 28 × 35⅞″ (71 × 91 cm). National Gallery, London. Reproduced by courtesy of the Trustees

proclaimed Greek art as the ideal that later periods had only remotely approached. (He detested both the Rococo and the French who had invented it.) As yet, however, both Gothic and Greek buildings were built for dilettantes only; no one seemed to think either mode suitable for monumental civic structures, and no one saw in either any principles useful for political ideology. Therein lies the crucial difference between these mid-eighteenth-century revivals and those of the late eighteenth century and the nineteenth century.

HOGARTH A strikingly original school of painting arose in eighteenth-century England—the first, in fact, since the Gothic period—under limited influence from Continental Rococo, but with little of the frivolity so delightful in French painting of the period. The most engaging of the new English painters and the real founder of the modern British school was William Hogarth (1697–1764), a Londoner whose narrative candor and satiric wit are as effective as his dazzling pictorial skill. Although he tried his hand occasionally at mythological and historical subjects, Hogarth was at his best in quintessentially English portraits and in pungent moralistic cycles, the counterparts of the novels of Fielding and Smollett; these were painted as bases for engravings, which Hogarth sold widely and profitably. The most successful were *A Scene from the Beggar's Opera,* illustrating John Gay's famous work; *A Rake's Progress; A Harlot's Progress;* and *Marriage à la Mode,* of 1743–45, whose opening episode is *Signing the Contract* (fig. 29–35). The scene is set diagonally in depth for greater theatrical effect. In a room of his London house, lined with Old Masters (which Hogarth professed to hate), the gouty alderman, father of the bride, sits before a table spread with the golden coins of the dowry and expatiates on his family tree, to which he proposes to add the earl. That gentleman, who has exhausted his fortune in building the Palladian mansion seen out the window (Hogarth detested the Palladian style, as well as both Burlington and Kent), admires himself in a mirror. His betrothed, meanwhile, is listening to the

blandishments murmured in her ear by the attorney. Clearly, the story will come to a bad end. While the energetic composition owes much to the Rococo, Hogarth's robust handling of poses and his special variety of bold yet soft brushwork are as original as his caustic wit.

GAINSBOROUGH The most accomplished and in the long run the most influential English painter of the century was Thomas Gainsborough (1727–88), who studied briefly in London with a pupil of Boucher. Until 1774 he painted landscapes and portraits in various provincial centers before settling in London for the last fourteen years of his life. Although the elegant attenuation of his lords and ladies is indebted to his study of Anthony van Dyck, Gainsborough achieved in his full-length portraits a freshness and lyric grace all his own. Occasional objections to the lack of structure in his weightless figures are swept away by the beauty of his color and the delicacy of his touch, closer to the deft brushwork of Watteau than to Boucher's enameled surface. The figure in *Mary Countess Howe* (fig. 29–36), painted in Bath in the mid-1760s, is carefully posed, as usual in front of a landscape

29-36. THOMAS GAINSBOROUGH. *Mary Countess Howe.* Middle 1760s. Oil on canvas, 96 × 60″ (2.44 × 1.52 m). Courtesy of The Greater London Council as Trustees of the Iveagh Bequest, Kenwood, London

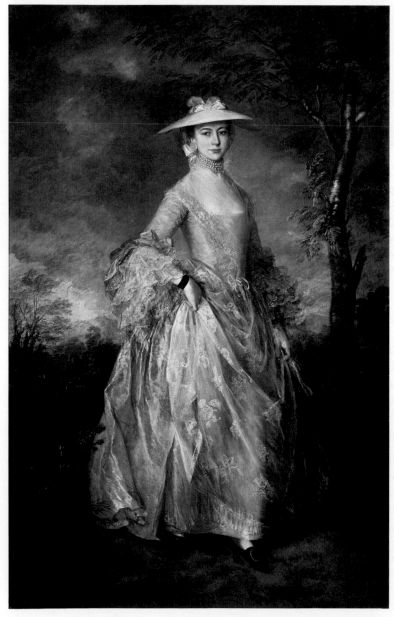

29-36

29-37. THOMAS GAINSBOROUGH. *Market Cart.*
1787. Oil on canvas, 72½ × 60⅝″ (1.84 ×
1.54 m). The Tate Gallery, London

background. Gainsborough has expended his uncanny ability on the soft shimmer
of light over the embroidered organdy of her overdress and the cascades of lace at
her elbows, sparkling in the soft English air; the only solid accents in the picture are
her penetrating eyes. Gainsborough was country-born, but his landscape elements
seem artificial, added like bits of scene to establish a spatial environment for the
exquisite play of color in the figure.

In later life Gainsborough painted always more freely and openly. Although his
landscapes, which he preferred to his portraits, exhale a typically English fresh-
ness, they were painted in the studio on the basis of small models put together from
moss and pebbles, still in the tradition recorded by Cennino Cennini (see page
569). Constructed in the grand manner of such a seventeenth-century Dutch
master as Meyndert Hobbema (see fig. 28–5) and painted largely with soft strokes
of wash like those of Watteau, the *Market Cart,* of 1787 (fig. 29–37), shows an
almost rhapsodic abandonment to the mood of nature, which led as surely to John
Constable and Joseph Turner, the great English landscapists of the early nineteenth
century (see pages 895–99), as did the nature poetry of James Thomson to the
meditative lyricism of William Wordsworth. Constable said that Gainsborough's
landscapes moved him to tears, and contemplating the freedom and beauty of the
painting of the cart and the boy gathering brushwood, not to speak of the glow of
light seeming to come from within the tree in the center, one can understand why.

REYNOLDS The third English master of the period, Sir Joshua Reynolds (1723–
92), while less attractive than the other two, was in his own day a commanding
figure, whose authority outlived him and who eventually became a target for
Romantic attacks. Neither Hogarth nor Gainsborough traveled outside England
(Hogarth once tried to reach Paris but got no farther than Calais), but Reynolds did
the Grand Tour and remained in Rome spellbound by the grandeur of Michelan-
gelo and Raphael. He acquired a respectable knowledge of European painting of
the preceding two centuries and gave at the Royal Academy of Arts—which he

helped to found in 1768—the famous *Discourses,* which, in published form, remain a formidable body of classical doctrine and the most extensive attempt at art theory by any Englishman. Reynolds's success as a portraitist was so great that he had to hire assistants to lay out the canvases for him and to do much of the mechanical work. There is inevitably something artificial about the grandiloquence of the classical or Renaissance poses in which he, without either the humor of Hogarth or the poetry of Gainsborough, painted the very solid English of his own day, investing them with qualities borrowed from a noble past. It is, nonetheless, to his majestic portraits, with their contrived backgrounds of classical architecture and landscape, that we owe our impression of English aristocracy in the eighteenth century. *Lady Sarah Bunbury Sacrificing to the Graces* (fig. 29–38), painted in 1765, is a case in point and speaks eloquently for itself.

KAUFFMANN No other woman painter of the eighteenth century achieved the success, reputation, and influence of Angelica Kauffmann (1741–1807). This is difficult to understand today, for in terms of quality she cannot equal either Labille-Guiard or Vigée-Lebrun, but she is a fascinating figure who hit the taste of her time exactly right. Although born in Switzerland and resident in Italy for most of her life, Kauffmann is best considered in the context of English art. Her patrons were predominantly English and the years she spent in Britain from 1766 to 1781 were crucial. She was enormously popular there, partly on account of her beauty and charm, but even more because of her ability as a composer of large pictures on classical themes for the interiors designed by Robert Adam and others. Kauffmann was the first woman ever to work on so grand a scale. She was also respected for her quiet determination and hard work, and was one of the founders of the Royal Academy of Arts. After an invalid marriage to a pretended nobleman, she eventually married the Venetian decorative painter Antonio Zucchi (the couple kept their styles firmly separate) and settled down for good in Rome, where she joined the cultural circle dominated by Johann Wolfgang von Goethe, who admired her work in spite of its limitations, and Winckelmann. There she was visited by many artists, including Vigée-Lebrun and the young Jacques-Louis David, whom she certainly influenced.

Like other woman painters, Kauffmann was forbidden to work from the nude, either male or female, and related that all the life studies she ever made were from models draped by sheets, in the presence of her father. The results of this proce-

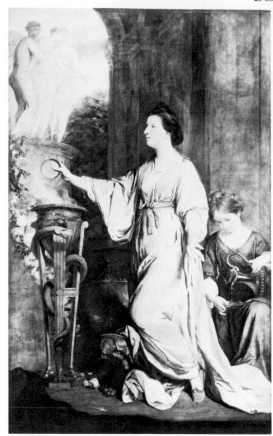

29-38. Sɪʀ Jᴏsʜᴜᴀ Rᴇʏɴᴏʟᴅs. *Lady Sarah Bunbury Sacrificing to the Graces.* 1765. Oil on canvas, 94 × 60″ (2.39 × 1.52 m). The Art Institute of Chicago. Mr. and Mrs. W. W. Kimball Collection

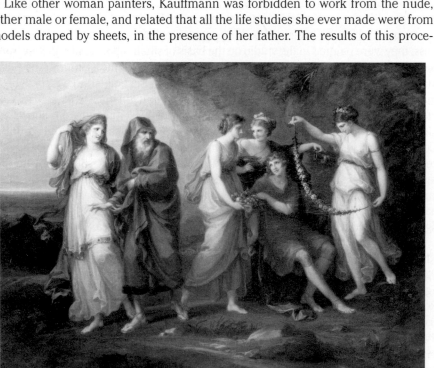

29-39. Aɴɢᴇʟɪᴄᴀ Kᴀᴜꜰꜰᴍᴀɴɴ. *Telemachus and the Nymphs of Calypso.* 1783. Oil on canvas, 32½ × 44¼″ (82.5 × 112.4 cm). The Metropolitan Museum of Art, New York. Bequest of Collis P. Huntington, 1925

dure can unfortunately be seen in her historical compositions, such as *Telemachus and the Nymphs of Calypso* (fig. 29–39), of 1783. The incident is drawn from Homer's *Odyssey;* the enchantress Calypso is shown trying to win over the son of Odysseus. Kauffmann has been reproached as having had little conception of Homeric grandeur. But her style and its shortcomings are best judged when her works are envisioned in the settings for which they were made. In classicistic interiors like those of Syon House or Chiswick (see fig. 29–32), the airy grace of her compositions must have been delightful. If they lack the bite and force of historical paintings of the next two generations (see Chapters Thirty and Thirty-One), Angelica Kauffmann herself is a historical phenomenon of major importance.

Painting in Colonial America

The modest beginnings of colonial American painting in the work of self-taught limners achieved a surprising degree of maturity in the style of JOHN SINGLETON COPLEY (1738–1815), son of Irish immigrants to Boston. Whatever Copley may have known of the grand English portrait style of the eighteenth century through engravings, he rapidly evolved an original manner, which concealed occasional deficiencies of drawing under a smooth hardness of surface unexpected and refreshing in the eighteenth century, when dexterity of the brush was so highly prized (compare Watteau's *Signboard of Gersaint,* fig. 29–11). Copley's *Paul Revere,* of 1768–70 (fig. 29–40), dispenses with the column and red curtain that often seem incongruous in his portraits of stolid Yankee merchants. The firm, unflattering portrait of the eminent silversmith and patriot shows him in shirtsleeves beside his worktable, strewn with engraving instruments, and holding a glittering silver teapot. The honest provincialism of the work and Copley's inborn sense of form make it more attractive than the accomplished portraits and historical scenes he painted after his emigration to England in 1775.

BENJAMIN WEST (1738–1820), from Pennsylvania, left for Europe before Copley, in 1759, became an overnight celebrity in Rome, and settled in London, where he enjoyed a success to which neither his imagination nor his pictorial skill would seem to have entitled him. He rose, in fact, to become president of the Royal Academy of Arts and historical painter to the king. Historically, West is an important figure. His paintings of Roman subjects are forerunners of the more successful and significant classical scenes by David (see pages 868–71), and his *Death of General Wolfe,* of about 1770 (fig. 29–41), with its still-Baroque lighting and pathos, led directly to the great battle pieces of the nineteenth century (see fig. 31–7). Characteristically, in spite of his own leanings toward classicism, he resisted the temptation to dress this celebrated event of the French and Indian War in classical costume, which would certainly have been the recommendation of Winckelmann, his Continental and English disciples, and even the great Sir Joshua.

In these four chapters we have followed many aspects of the Baroque climactic experience of human life and destiny, ranging from shattering immediacy to classic control; from theatrical display to spiritual inwardness; from otherworldly ecstasy to meditation on everyday reality. We have seen works of art embodying this experience assume every extreme of style, from steely surfaces to free brushwork; from idealized forms and balanced compositions to direct images; from clustered columns, broken pediments, and ruptured ceilings to stately colonnades and organized vistas. And we have watched the serious dedication of the seventeenth century to both religious and stylistic commitments evaporate in the early eighteenth century in the frivolity of the Rococo, only to crystallize a few decades later in mutually exclusive classical and Gothic play-worlds.

Looking back, as we attempt to organize our thoughts about such diversity of experience and of style, we begin to distinguish three major artistic currents or tendencies:

1. A current owing sovereign allegiance to classical antiquity and exalting qualities of intellectual command, compositional balance, structure, integrity of form, clarity of drawing, and distinctness of color
2. A tendency placing ultimate value on emotional expression and resulting in imaginative compositions, intense movement, loose interaction of figures, spontaneous brushwork, strong contrasts of light and dark, and rich coloristic changes
3. A current closely rooted in faithful visual analysis of the natural world, including human life at every economic level, basing composition, drawing, and color on direct observation, even through the medium of devices such as the camera obscura.

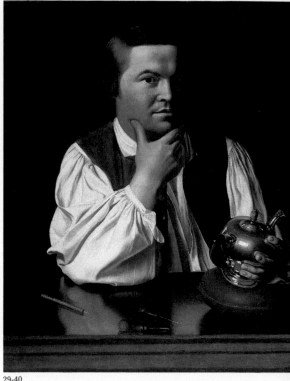

29-40

These three tendencies are only partly explicable in terms of national or religious boundaries. For instance, there were realistic still-life painters in Catholic Italy, painters of classical history in Calvinist Holland, and painters of peasant life in monarchist France. Also, these tendencies were interrelated and often influenced each other, and not every artist can be classified convincingly according to just one of the three: Caravaggio, for example, realistic enough in his psychological impact and almost photographic powers of observation, can be classical in his control of form and composition; or Rembrandt, so universal in his range and depth and original in his methods, escapes all attempts at categorization.

These three are the principal currents dominating the art of the seventeenth and eighteenth centuries. In the concluding part of this book it will be easy to see that these three basic tendencies continue in full activity and validity throughout the eighteenth, nineteenth, and twentieth centuries to the present day.

TIME LINE XIII

POLITICAL HISTORY	RELIGION, LITERATURE, MUSIC	SCIENCE, TECHNOLOGY
1700 War of Spanish Succession, 1701–14 English and allies defeat French at Blenheim, 1704 Louis XV rules France, 1715–74 Economic decline of Dutch Republic begins, 1715	Antonio Vivaldi (1678–1741) Johann Sebastian Bach (1685–1750) Alexander Pope (1688–1744) Voltaire (1694–1778)	G. W. Leibniz (1646–1716) discovers new notations of calculus; publishes *Théodicée*, 1710 Edmund Halley (1656–1742) observes patterns in the paths of comets, 1705
1725 Frederick William I (r. 1713–40) lays foundation of future power of Prussia Frederick II the Great of Prussia (r. 1740–86) defeats Austria in War of Austrian Secession	*Gulliver's Travels* by Jonathan Swift, 1726 Wesley brothers found Methodism, 1728 *A Treatise of Human Nature* by David Hume, 1739–40	Charles du Fay (1698–1739) discovers positive and negative electric charge Carolus Linnaeus (1707–78) publishes *Systema Naturae*, 1735 Excavations begin at Herculaneum, 1738; later at Paestum and Pompeii
1750 Seven Years' War, 1756–63; England shows her great colonial and naval power Catherine the Great (r. 1762–96) extends Russian power to Black Sea	Edmund Burke (1729–97) Denis Diderot edits *Encyclopedia*, 1745–72 Samuel Johnson completes English dictionary, 1755 J.J. Rousseau publishes *Social Contract* and *Émile*, 1762	Coke-fed blast furnaces for smelting iron perfected, c. 1760–75 Textile spinning mechanized, 1764–93 Joseph Priestley (1733–1804) discovers oxygen, 1774
1775 American Revolution, 1775–83; Declaration of Independence, 1776; Articles of Confederation, 1781	Adam Smith writes *Wealth of Nations*, 1776 Franz Joseph Haydn (1732–1809) Wolfgang Amadeus Mozart (1756–91)	Capt. James Cook (1728–1779) explores South Pacific, 1768–79 Antoine Lavoisier (1743–94) Metric system adopted in France, 1790

29-40. JOHN SINGLETON
COPLEY. *Paul Revere*. 1768–70.
Oil on canvas, 35 × 28½"
(89 × 72.4 cm). Courtesy,
Museum of Fine Arts, Boston.
Gift of Joseph W., William B.,
and Edward H. R. Revere

29-41. BENJAMIN WEST. *Death
of General Wolfe*. c. 1770. Oil on
canvas, 59½ × 84" (1.51 ×
2.13 m). The National Gallery of
Canada, Ottawa. Gift of the
Duke of Westminster, 1918

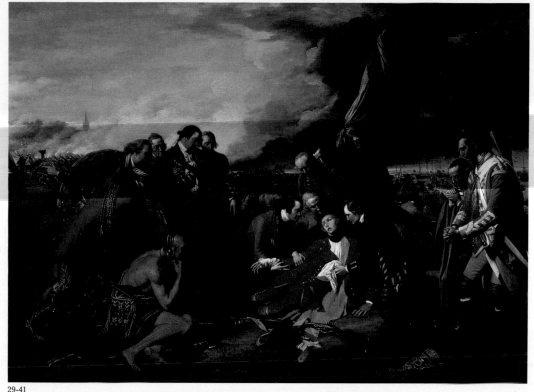

29-41

EIGHTEENTH CENTURY

PAINTING, SCULPTURE, ARCHITECTURE

ITALY AND FRANCE	GERMANY AND AUSTRIA	ENGLAND AND AMERICA	
Watteau, *Pilgrimage to Cythera; Signboard of Gersaint* Juvara, Church, Superga, Turin;	Prandtauer, Abbey, Melk	Vanbrugh, Blenheim Palace	1700
Piazzetta, *Ecstasy of St. Francis* Boffrand and Natoire, Hôtel de Soubise, Paris Chardin, *Copper Cistern; House of Cards* Boucher, *Triumph of Venus*	Fischer von Erlach, Karlskirche, Vienna Neumann, Residenz, Würzburg François de Cuvilliés, Amalienburg	Lord Burlington, Chiswick House Gibbs, Radcliffe Library, Oxford Hogarth, *Marriage à la Mode* Walpole, Strawberry Hill	1725
Tiepolo, frescoes, Venice; Würzburg Piranesi, *Carceri* Soufflot, Panthéon, Paris Gabriel, Petit Trianon, Versailles; Place de la Concorde, Paris Fragonard, *Bathers*	Neumann, Vierzehnheiligen Church, Staffelstein	Adam, Syon House Gainsborough, *Mary Countess Howe* Reynolds, *Lady Sarah Bunbury* Copley, *Paul Revere* West, *Death of General Wolfe*	1750
Guardi, *Piazzetta S. Marco* Clodion, *Satyr and Bacchante* Greuze, *The Son Punished* Labille-Guiard, *Portrait of the Artist* Vigée-Lebrun, *Marie-Antoinette*		Kauffmann, *Telemachus and the Nymphs* Gainsborough, *Market Cart*	1775

PART SEVEN

Modern is an even less accurate period designation than the others we have had to use. Since the late sixteenth century, when it was adopted into the English language, the word has meant "pertaining to the present or very recent past," and so it has already referred to a number of disparate periods. Judging by the standard of nearness to the present, our modern period probably began in Europe and in America in the late eighteenth century. We feel kinship with the people who lived then and can easily understand their ideas and accept their customs. The historical figures of the American and French revolutions seem near to us, although the princes of the Baroque era appear remote. We could settle down comfortably at Monticello but would feel out of place in Versailles or the Hôtel de Soubise.

The political and social conditions of the late eighteenth century recall those with which we are familiar—if not from the present, at least from the recent past. Religion in the West, for example, was no longer a belief that could be legally enforced. Culture had become strongly secularized by the end of the century in Western Europe and in America, and the two basic forces that shape our lives today—the idea of social democracy and the notion of scientific progress—were already clearly in operation. Before long these two forces almost fused. The idea of a universal democracy arose first in France under the influence of the philosophers of the Enlightenment, although its earliest successes were in America, insofar as success was permitted by the institution of chattel slavery. Scientific technology first influenced social and economic structure in England during the Industrial Revolution, spreading in the nineteenth century to all Western nations and furnishing the material foundation for modern bourgeois capitalism.

It is in its internationalism that we must seek the basic nature of the modern world, throughout vast areas of the globe, including countries with long historical traditions hitherto hardly touched by Western culture. The seeds of this new internationalism were planted in the late eighteenth century, and they have brought forth some striking similarities of customs in developed areas of the world. For example, cultural activities have come to resemble each other across wide distances. Japanese musicians play Mozart and Bartók with technical perfection, convincing "westerns" are filmed in Italy, rock concerts take place in Belgrade, and after initial opposition abstract art, much of it Russian in origin, has been shown in Moscow. The open market for works of art, forcing the artist to rely on dealers, was—as we have seen—first predominant in seventeenth-century Holland; it is now universal. The commissioned work of painting or sculpture is now the exception. Nor in the secularized society of modern times is the Church a major patron of the arts.

Although new artistic movements are still being born or devised at single points in time and space, they rapidly spread everywhere. Impressionism, for example, invented in Paris and its suburbs, soon took hold in every Western country. In such international movements ("isms") we must look for the basic artistic phenomena of the modern world. The modern era declared independence from its predecessors to a startling degree and has accordingly developed a perspective from which it can look at history as a study of social and cultural movements rather than the story of the deeds of great personages.

Beginning in the late eighteenth century and throughout the nineteenth, comprehensive histories of entire civilizations, as well as of art, music, literature, philosophy, and religion, were written; these volumes are still read, and they provide the foundations for today's more limited historical studies. Only in the modern period did it become evident that the forces of ceaseless change were

THE MODERN WORLD

bound to affect artistic production and render antiquated tomorrow what was new yesterday.

Along with historical detachment there arose in the late eighteenth century and in the nineteenth century the ability to appreciate widely different forms and periods of artistic creation. As a result, museums have proliferated, the past is preserved where it can be protected, and conscious efforts are made to keep works of art from disintegrating, to restore them to their original appearance, to publish correct texts of older authors, and to perform older music on the instruments for which it was composed.

Together with the historical view of art, styles have arisen that deny the validity of the past search for visual reality, and that exalt as models for the art of today the arts of remote periods or cultures whose aesthetic significance has been newly appreciated by Western audiences. Not only have nature and the object lost their control over the work of art but also such technological innovations as laser beams, taped communications, microelectric waves, and the televised image have been proclaimed as the province of artistic creation.

The modern period as we have known it may have come to an end. The collapse of ancient Oriental empires was welcomed in the early twentieth century as heralding the spread of democracy. So was the breakup of the European capitalist empires in Africa and the Far East, not to speak of the smaller American empire in the Pacific. Today, the African nations liberated from European domination, and certain previously democratic countries of Latin America, have fallen under military dictatorships; certain Islamic nations have repudiated all of Western culture save its technology and its money, and have even reinstated such ancient punishments as flogging, stoning, and mutilation. Though few lament the dissolution of the Soviet Union, the economic and political consequences of its gradual collapse and the resurgence of ethnic rivalries have not yet fully unfolded. We no longer await in optimistic confidence the triumph of Western-style democracy.

Welcomed too was the emancipation of modern men and women from daily chores and the restrictions of time by mechanical and electronic inventions. But the cost of convenience is high. The internal-combustion engine brought freedom from the restrictions of distance, yet it has impoverished the centers of our cities, devastated the landscape, and poisoned both atmosphere and water. Nuclear discoveries threaten universal catastrophe. Chemical innovations menace our environment, our bodies, our genetic capacity to survive, and the ability of the planet to support life.

In this the last decade of the millennium, according to many specialists we are living in a "post-modern" world. When *that* period began, however, and how it may be defined are endlessly debated. If we have indeed entered a different era, one thing is certain: the collapse of faith in technology and progress has been accompanied in art by a lull in that succession of artistic movements that used to take place every generation, then every decade, then every year, each declaring its predecessors extinct, each claiming to have refined the formal means of art and to have achieved a new, improved artistic expression. The barriers that once separated art from life were gradually eroded by the modernists, and the art of today has seemingly approached the limits of technical innovation, for it can now be made of virtually anything—detritus, oil on canvas, or nothing tangible at all, simply the thoughts or actions of the artist. Although the art of our own era is characterized by an unprecedented pluralism of style, of means, and of content, it is perhaps more than ever engaged in a continuing dialogue with the art of the past.

CHAPTER THIRTY

The forty-year period from 1775 to 1815 marks one of the great upheavals of Western history, comparable in scope only to the barbarian invasions of the fifth century and to the two world wars of the twentieth. The rebellion of England's North American colonies, the product of tensions that had developed for generations, was rapidly transformed into a genuine revolution (1775–83), resulting in independence from the mother country. Power was transferred to a republic, dominated by landowners and merchants. The success of the American Revolution encouraged the French followers of the eighteenth-century philosophers of the Enlightenment. During the extreme economic and political crisis in France in 1789, a constitutional monarchy was proclaimed, followed in 1792 by a republic. The revolutionary movement culminated in the Reign of Terror, in which thousands of aristocrats, relatives of aristocrats, officials of the royal government, and suspected sympathizers of the old order lost their lives. Temporarily, at least, a classless form of government was in control.

Under the Directory (1795–99) the middle classes assumed power; then unexpectedly the Revolution, which was supposed to bring about a new era of freedom for all, fell a victim to its own most successful military leader. Under the dictatorship of Napoleon Bonaparte—the Consulate (1799–1804) and the Empire (1804–14 and 1815)—colossal military force was unleashed upon the continent of Europe and swept the Baroque monarchies great and small into the discard, dissolved the thousand-year-old Holy Roman Empire, and, in a series of military exploits unrivaled since the days of Alexander the Great, threatened Russia on the one hand and England on the other. After Napoleon's military collapse many, but by no means all, of the monarchies were restored, but the work of the Revolution and of Napoleon could not be entirely undone; the efficient revolutionary administrative system has been retained in France to this day, and the Code Napoléon remains the basis of many Western European legal systems. Even more important, monarchy had been exposed as vulnerable, and revolutions were to erupt at intervals throughout the nineteenth century.

It might have been expected that the American and French revolutions would inspire a generation of inflammatory art. The reverse was the case; not until the Napoleonic slaughters did an art develop that registered directly the drama of the moment. Revolutionary art was by choice sternly Neoclassical. The distinction between the classicism of the mid-eighteenth century and the Neoclassicism of the revolutionary period may seem subtle, but it is important. To most architects and cultivated patrons in the mid-eighteenth century, classicism was a fashion, one that could easily be exchanged for Gothic. To the revolutionary period, Neoclassicism was a way of life, affecting not only the arts but also all aspects of existence from religion to the dress of ordinary men and women, and in France even the calendar. Moreover, it was not imperial but republican Rome that the revolutionary period attempted to revive. Despite its origins, Neoclassicism survived both the Revolution and Napoleon and persisted as a fashion throughout the Continent and England well into the nineteenth century.

Architecture

The well-known shape of Monticello (fig. 30–1) by THOMAS JEFFERSON (1743–1826) illustrates the process that had taken place. Jefferson intended to reform the Georgian architecture current in colonial Virginia by a sweeping application of the principles he was studying in Andrea Palladio's treatise on architecture of 1570. As first built from 1770–84, Monticello, commanding from its hilltop a magnificent view of mountains, valleys, and plains, was a two-story structure adorned with a

two-story portico like those on some of Palladio's villas. During his long stay in Europe as minister to France, Jefferson had a chance to study not only the classical French architecture of the eighteenth century but also the Roman temple called Maison Carrée at Nîmes, which he said he contemplated "as a lover gazes at his mistress." Beginning in 1796, he rebuilt Monticello as a Neoclassical temple, apparently one story high, although a second story is concealed behind the entablature and balustrade, and a third under the roof. Clearly, Jefferson had both Chiswick (see fig. 29–31) and its ancestor, the Villa Rotonda (see fig. 24–18), in mind, but his mansion differs from both in being a permanent residence rather than a pleasure house. It is built, moreover, of local brick rather than stone, with brick columns stuccoed and painted white and with white wood trim.

The octagonal dome is mirrored in semi-octagonal shapes at either side of the building (fig. 30–2). The central portico is treated like a Roman pronaos and united with the ground by a single flight of steps. As the citizen of a republic, Jefferson chose the Doric order, always considered the simplest and most masculine, in preference to the Ionic of the Villa Rotonda or the Corinthian of Chiswick. The illusion of simplicity, in fact, is artfully maintained throughout the building and grounds through the device of hiding the many service elements behind simple brick colonnades under the sides of the lawn terraces.

Jefferson's cherished dream was the University of Virginia, at Charlottesville, which he brought to reality only in his old age. Built from 1817 to 1825, the central "Lawn" (fig. 30–3) constitutes not only the masterpiece of early Federal architecture in the United States but also one of the finest Neoclassical ensembles anywhere. From the central Pantheon-like Rotunda, planned as the library following a suggestion made by the professional architect Benjamin H. Latrobe (see below), low colonnades on either side in front of student rooms unite ten pavilions — Roman prostyle temples spaced at ever-increasing intervals. These provided lower rooms for the ten "schools" and upper rooms for the professors' living quarters. The colonnades are Tuscan; the pavilions, each different in a deliberate avoidance of symmetry, exploit the varying possibilities of Doric, Ionic, and Corinthian orders drawn from classical monuments, so that the students could have before them a full vocabulary of classical style, the visual counterpart of the humanistic education to which Jefferson was devoted. The Composite, the richest of the orders, was re-

30-1. THOMAS JEFFERSON. Monticello, Charlottesville, Virginia. 1770–84; rebuilt 1796–1800

30-2. THOMAS JEFFERSON. Plan of Monticello, Charlottesville, Virginia

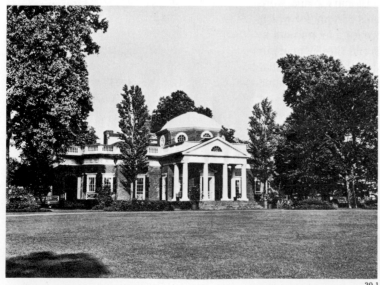

30-1

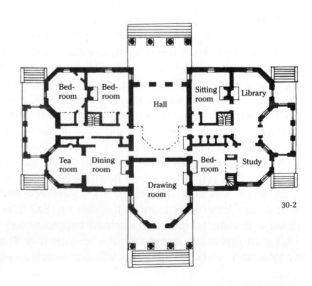

30-2

30-3 30-4

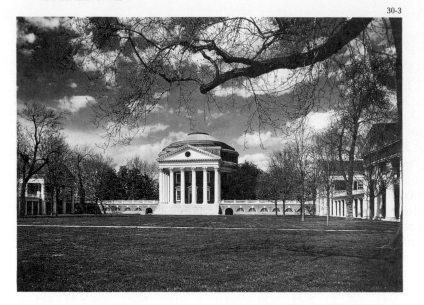

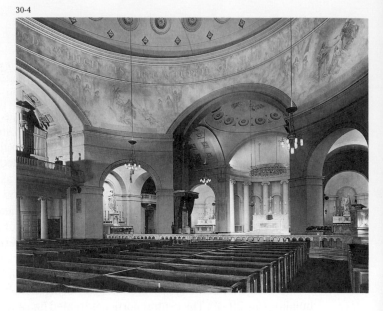

served for the interior of the Rotunda. Although the Doric and Tuscan capitals could be turned locally, the others had to be ordered from Italian marble-carvers in Carrara, who would copy the appropriate plates in Palladio's book on architecture. The result, clearly related to Hellenistic stoas, an "environment" of magical harmony, is still in daily use. The Neoclassical style became immediately the style for the buildings of the new republic and its various states and reappeared in innumerable variations in Washington, D.C., and in state capitals into the middle of the twentieth century. It was also used throughout the republic for country houses and town houses, great and small.

An English-born architect, BENJAMIN H. LATROBE (1764–1820), who furnished the self-taught Jefferson with much professional counsel, brought with him to the United States the capability of building in both Neoclassical and Gothic styles. Only the former was in demand for his work in Washington, where he collaborated in the building and rebuilding of the United States Capitol. For the Catholic Cathedral of Baltimore in 1805 he submitted designs in both styles. His Gothic design was not accepted. His handsome Neoclassical interior (fig. 30–4) is roofed in a succession of hemispheric domes, lighted from above like that of the Roman Pantheon. The grandeur of the effect is enhanced by the sparse ornamentation, recalling the austerity of Robert Adam (see fig. 29–32).

During the French Revolution little could be built but much was dreamed, especially by ÉTIENNE-LOUIS BOULLÉE (1728–99), whose visionary plans were intended to establish a new architecture symbolizing the Rights of Man, for which the Revolution had, presumably, been fought. Boullée's design for a monument to the mathematician and natural philosopher Sir Isaac Newton (fig. 30–5), made in 1784, five years before the Revolution got under way, reduced the mass to essential forms of sphere and cylinder, stripped even of the conventional orders. The titanic scale can be deduced from the size of the humans at the base and the groves of trees that encircle the sphere at various levels. The minute entrance was to lead the awestruck visitor through a long, dark tunnel to the interior, lighted only by holes so spaced as to suggest the moon and stars of the night sky.

When architecture recommenced under Napoleon, the classical orders in their severest form dominated. For forty years ideas for a church of the Madeleine, to head the Rue Royale in Paris, had been under consideration. When the final competition was held in 1806, Napoleon decreed that the structure should be a Temple of Glory (he renounced the idea in 1813 after his defeat at Leipzig) and chose a Roman peripteral Corinthian temple design by PIERRE VIGNON (1762–1828), the first to be erected since the third century. The colossal structure (fig. 30–6) took until 1843 to build and still dominates an entire quarter of Paris. The

30-3. THOMAS JEFFERSON. "The Lawn," University of Virginia, Charlottesville. 1817–25

30-4. BENJAMIN H. LATROBE. Interior, Catholic Cathedral of the Assumption, Baltimore. Begun 1805

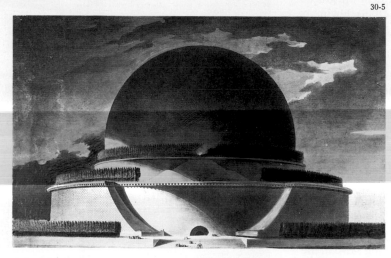

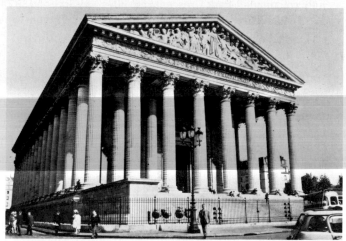

30-5. ÉTIENNE-LOUIS BOULLÉE. Design for a monument to Newton. 1784

30-6. PIERRE VIGNON. Church of the Madeleine, Paris. 1806–43

30-7. KARL LANGHANS. Brandenburg Gate, Berlin. 1789–94

Madeleine is the most thoroughgoing example of the Neoclassical attempt to live in ancient style. Inside, of course, it could not work; a windowless Christian interior is an impossibility, and the nave had to be vaulted by domes on pendentives hidden under the roof and pierced by skylights.

A different kind of quotation from the ancient world is the Brandenburg Gate at Berlin (fig. 30–7), built by KARL LANGHANS (1733–1808) in 1789–94, while Jefferson was in Europe. A direct imitation of the Propylaia at Athens, this is the first public building in Greek rather than Roman style, incongruously enough bearing an imitation of a Roman four-horse chariot as on a triumphal arch. Doubtless the virile Doric order was connected in the minds of both the architect and his patron, King Frederick William II, with the martial vigor of the Prussian kingdom. Neoclassical architecture was carried the length and breadth of Europe, from Copenhagen and Saint Petersburg—where the mile-wide stretch of the Neva River was lined on both sides with columned structures—as far south as Rome, Naples, and Athens. Greek independence was celebrated in the 1830s by the erection of a host of Greek Revival structures within sight of the Parthenon. The loveliest of all Neoclassical cityscapes, although much of it has been lost to twentieth-century commercialism, is early-nineteenth-century London. Cumberland Terrace, Eaton

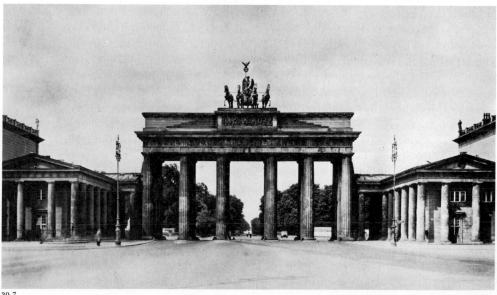

30-7

Square, and dozens of enchanting side streets still stand, among them the gracefully colonnaded Park Crescent (fig. 30–8) by JOHN NASH (1752–1835), begun in 1812 while Jefferson's ideas for the University of Virginia were beginning to mature.

Painting

DAVID The official artist of the French Revolution was Jacques-Louis David (1748–1825), who was eventually entrusted with commemorative portraits of martyred revolutionary leaders, the design of public pageants, celebrations, state funerals, and even the designs for the costumes to be worn by the citizens and citizenesses of the republic. At his decree the aristocratic powdered wigs, silk and velvet coats, and lace ruffles worn by men were replaced by natural hair (eventually worn short and tousled), woolen jackets, and linen shirts. Women shed their towering headdresses adorned with ribbons and feathers for a simple style in imitation of the ancient Greeks, and their hoopskirts, lace, and furbelows for a muslin tunic belted high above the waist. Yet David's most rigidly doctrinaire painting, the *Oath of the Horatii* (see fig. 30–9), which was the opening salvo in the Neoclassical battle against both the dying Rococo and the nostalgic classicism of the mid-eighteenth century, was commissioned in 1784 for Louis XVI. Nine years later this monarch was to lose his head under the guillotine because of the very forces David had helped to unleash.

Historical circumstances elucidate the apparent paradox. The French Royal Academy held, at first in odd-numbered years, much later annually, a large public exhibition known as the Salon. In the nineteenth century this institution became a brake on artistic innovation, but in the eighteenth it was a strong stimulus. The great galleries, first in the Louvre and later in the Tuileries, formed a kind of theater, with all Paris as the audience. The more dramatic a picture and the greater the attention it attracted the better were the artist's chances of obtaining the portrait commissions that often provided his principal livelihood. In addition, pictures were commissioned by the royal superintendent of buildings, who under Louis XVI was the comte d'Angiviller, a man with a passion for elevated subjects. Jean-Baptiste Greuze, limited as he seems to us today (see fig. 29–15), filled the bill nicely; so did an array of minor painters now almost entirely forgotten, who covered the walls with historical paintings intended to demonstrate moral truths. The *Oath of the Horatii,* finished in Rome in 1785, was one of these pictures, but it pointed a message whose implications neither d'Angiviller nor the king, nor probably even David at that moment, understood.

David arrived at the French Academy in Rome in 1775, a thoroughly accomplished Rococo painter in the general tradition of François Boucher but already devoted to the approved moral subjects. When he came in contact with classical art in its native land, he said that he felt as if he "had been operated on for cataract." This statement not only expresses vividly the new clarity demanded of Neoclassical vision, in contrast to the softness and vagueness of the Rococo, but also characterizes that voluptuous style as a malady demanding surgical removal. The new art was not achieved rapidly; during much of his first year in Rome, whose culture was dominated by Goethe, Winckelmann, and Angelica Kauffmann, David devoted himself to drawing eyes, ears, feet, and hands from the most beautiful statues. Most of his paintings during these formative years are lost, but from all accounts they were drowned in black shadow like those of Caravaggio and the *tenebrosi* (see figs. 26–7, 28–1). But by 1781 the new style was established, and in 1783 David, then thirty-five, was elected to the Academy, which he soon came to detest, along with all royal officials, whom he called *les perruques* ("the wigs").

The *Oath of the Horatii* (fig. 30–9) shows the three Horatii brothers, chosen to defend Rome in combat against the three Curiatii, representing neighboring Alba, to one of whom Horatia, sister of the Horatii, was betrothed. The incident was recorded by Roman historians, and although it took place under the kingdom was

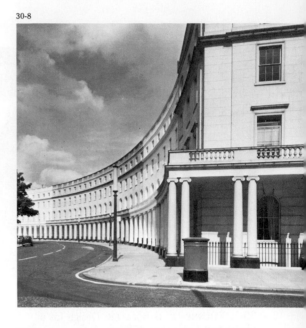

30-8. JOHN NASH. Park Crescent, Regent's Park, London. 1812–22

believed by the French to have been an example of republican patriotism. The oath of the three brothers on the swords held aloft by their father appears to be an invention on David's part. As in the compositions of Greuze (see fig. 29–15), the figures move in a strict relief plane, against a background of what David considered historically correct early Roman architecture, in sharp reaction to the spiral into the picture characteristic of the compositions of Boucher and Jean-Honoré Fragonard. The martial resolve of the young heroes is displayed in stances as grand as those of statues, although more rigid than most, while Horatia, her sister, her mother, and a tiny niece and nephew mourn the approaching conflict between brothers and lover in attitudes of classical grace. Every form, masculine and feminine, is exactly projected with a hallucinatory clarity going beyond anything demanded by Nicolas Poussin in the seventeenth century (see fig. 27–4); superb male musculature and smooth female arms and legs—even drapery folds—are as hard as the steel of the uplifted swords. The coloring, inert like the surfaces, is restricted to individual areas, without any of the reciprocal exchange of colors typical of Baroque and Rococo traditions.

Although the picture was not recognized as potentially revolutionary in a political as well as an artistic sense, it was the direct forerunner of openly republican political allegories. After several such heroic paintings, David weakened his ties with the Royal Academy. During the Revolution he became a friend of Robespierre and ally of the Jacobins, and he presided briefly over the National Convention. In 1793 he had the satisfaction of seeing the Academy dissolved to be replaced with a society of revolutionary artists. Thereafter, his stern style served as the funnel through which all new talent was poured, and the most important new artists of France were either his pupils or his imitators. In enforcing his sculptural discipline, he is reported to have advised his pupils, "Never let your brushwork show."

30-9. JACQUES-LOUIS DAVID. *Oath of the Horatii.* 1784–85. Oil on canvas, 10′8¼″ × 14′ (3.26 × 4.27 m). Musée du Louvre, Paris

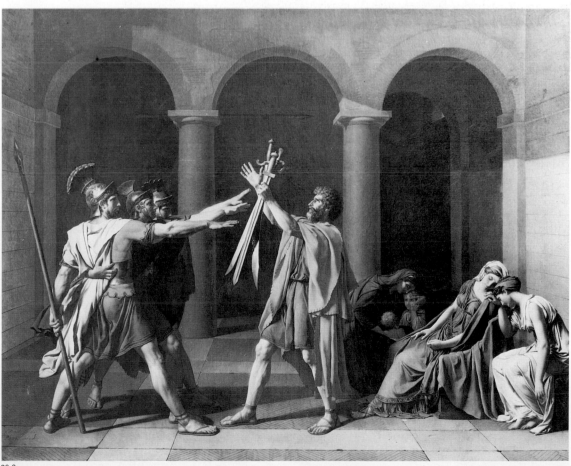

30-9

David's most memorable work is the *Death of Marat* (fig. 30–10), a painting of tragic grandeur because the subject is presented directly, stripped of allegorical disguise. Marat, one of the leaders of the Revolution, was constrained to work in a medicated bath on account of a skin disease he had contracted while hiding from the royal police in the Paris sewers before the Revolution. His desk was a rough packing box. On July 13, 1793, the young counterrevolutionary Charlotte Corday gained admittance to this unconventional office with a note reading, "It suffices that I am very unhappy to have a right to your benevolence," and then plunged a knife into his chest. David was called in immediately to draw the corpse still in position, and from the drawing the painting was made, the elements slightly rearranged for greater theatricality. It should be recalled that David had arranged the actual funeral of an earlier martyred revolutionary, Le Peletier de Saint-Fargeau, exhibiting the seminude corpse propped up so as to display the wound in imitation of his own painting of the slain Hector.

Not only classical history is recalled in the *Death of Marat* but also the traditional rendering of the dead Christ (Michelangelo's *Pietà,* for example; see fig. 22–11) and the high side-lighting of Caravaggio and his followers, with the setting in nowhere (see fig. 26–8). The box, the bloodstained towel, and the tub were venerated as relics by the populace. David has painted the rough boards as well as Chardin might have, but arranged them parallel to the picture plane like a classical tablet and supplied them with the words (in French): "To Marat, David, Year Two" (the picture was completed in the second year of the French revolutionary calendar). The stony treatment of head and figure shows an unexpected feeling for impasto in the handling of the flesh, and the rich treatment of the background in a basketwork of tiny, interlocking brushstrokes that endow it with a vibrant texture gives the lie to David's own advice to his students.

A new turn of the Revolution a year later brought Robespierre to the guillotine

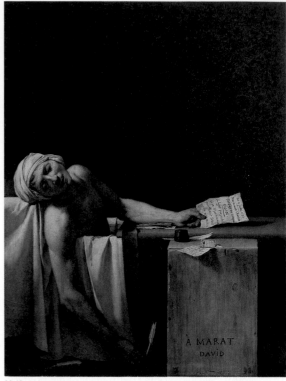

30-10

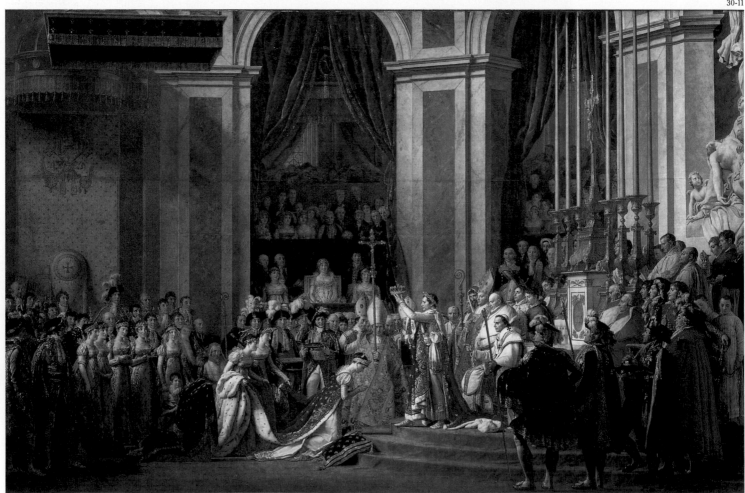

30-11

and David to prison and a narrow escape from death. On his release he became increasingly interested in Napoleon as the man who could bring order out of revolutionary chaos. Although by no means the only painter to the emperor, David was entrusted with such important commissions as the *Coronation of Napoleon and Josephine*, commissioned in 1804 and painted 1805–7 (fig. 30–11), a majestic work in which the painter's hard-won Neoclassicism survives only in the projection of individual forms. The stiff solemnity of the courtiers gathered at the ceremony recalls Byzantine mosaics rather than Roman statues, but the unexpected sparkle of color from gold, jewels, velvets, and brocades derives from the Venetian tradition, especially Paolo Veronese (see fig. 24–15). At the Restoration of the monarchy, the aging painter, who had turned his republican coat once for Napoleon, could not turn it again and spent his remaining years in exile in Brussels.

BENOIST One of David's most distinguished students, Marie Guillemine Benoist (née Marie Guillemine Leroux de la Ville; 1768–1826), began her academic training with Marie-Louise-Élisabeth Vigée-Lebrun in the early 1780s. While her studio was being remodeled, Vigée-Lebrun sent her protégée to David's studio in the Louvre. The fact that the young painter gained entrée to the prestigious studio is an indication of her considerable talent, as women artists had been banned from working in the Louvre by royal decree in 1785. (Benoist eventually opened her own studio for women.) Under David's tutelage she abandoned the softly modeled contours that characterize the paintings of her former teacher in favor of David's more rigorous draftsmanship, and by 1795 she was exhibiting regularly in the Salon. Her remarkably sensitive and skillful *Portrait of a Negress*, of 1800 (see Introduction fig. 4), ranks with the best of David's own portraits. The beautifully modeled forms of the sitter's face and torso are set against a background of astonishing simplicity when compared with some of the architectural settings of Vigée-Lebrun (see fig. 29–18). In the best Neoclassical tradition, the model is partially draped in the current Empire style of a simple white tunic and matching turban, all fashionably "antique." Benoist survived the Revolution, in spite of her marriage to a royalist, and subsequently won Napoleon's patronage and was much admired for her portraits of the emperor and his family.

INGRES Although not only David's followers but also the master himself in later life turned away from the more doctrinaire aspects of Neoclassicism, Jean-Auguste-Dominique Ingres (1780–1867), the greatest of David's pupils, remained faithful to Neoclassical ideals to the end of his life, and eventually formed the center of a conservative group that utilized the principles of Neoclassicism, forged in the Revolution, as a weapon for reaction. Ingres was an infant prodigy, attending art school at eleven and already a capable performer on the violin. He entered the studio of David at seventeen; although as long as he lived he never let his brushwork show, neither did he accept the cubic mass of David's mature style, preferring curving forms flowing like violin melody. Winner of the Prix de Rome, he remained in that city from 1806 until 1820 and returned there from 1835 to 1841, absorbing not only ancient but also Renaissance art, especially that of Raphael. He also stayed four years in Florence (1820–24), where he was one of the first to appreciate not only the Florentine Mannerists but also Fra Angelico. The first pictures he exhibited at the Salon were almost uniformly ridiculed, accused of being everything from Gothic to Chinese, and his special brand of nonpolitical Neoclassicism was worked out in isolation.

In 1808 Ingres did one of his finest figure studies, whose pose he revived again and again in later works, the *Valpinçon Bather* (fig. 30–12), named after the collection it first adorned. While the coolness of this lovely nude may at first sight recall Bronzino (see fig. 23–27), whom Ingres admired, it is drawn with a contour line as subtle and as analytic as that perfected by Holbein the Younger but infinitely more musical, gliding in delicate cadences over shoulders, back, and legs. The surface is modeled to porcelain smoothness but is never hard; Ingres was always at

30-10. Jacques-Louis David. *Death of Marat.* 1793. Oil on canvas, 65 × 50½″ (1.65 × 1.28 m). Musées Royaux des Beaux-Arts de Belgique, Brussels

30-11. Jacques-Louis David. *Coronation of Napoleon and Josephine.* 1805–7. Oil on canvas, 20′ × 30′6½″ (6.1 × 9.31 m). Musée du Louvre, Paris

30-12. Jean-Auguste-Dominique Ingres. *Valpinçon Bather.* 1808. Oil on canvas, 56⅝ × 38¼″ (143.8 × 97.2 cm). Musée du Louvre, Paris

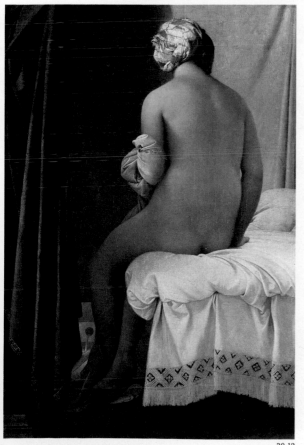

30-12

his best with delicate flesh and soft fabrics. His frequent subtle linear distortions have less to do with Raphael than with the attenuated forms of Parmigianino (see fig. 23–26), as does his sense of space—for example, the sudden jump between the foreground and the tiny spigot at an unexplained distance, from which water pours into a sunken bath.

Ingres fancied himself a history painter, although too many of his narrative pictures are weakened by his inability to project a dramatic situation. A work that embodies his ideal (rather than any political) program for Neoclassicism is the huge *Apotheosis of Homer* (fig. 30–13), a new *School of Athens* (see fig. 22–29), painted in 1827 and intended for the ceiling of a room in the Louvre, where it would undoubtedly have been more effective than at its present height on a wall. Ingres made no concessions to the principles of illusionistic ceiling perspective from below. Like Poussin he preferred the High Renaissance tradition, as exemplified by Michelangelo (see figs. 22–16, 22–18) and his contemporaries. Before an Ionic temple dedicated to Homer, the blind poet is enthroned, crowned with laurel by the muse of epic poetry. Below him sit two female figures, the one with a sword representing the *Iliad,* the one with a rudder the *Odyssey*. Around are grouped the geniuses from antiquity and later times whom Ingres considered truly classical. In homage, Pindar extends his lyre, Phidias his mallet, Apelles his palette and brushes, and Aeschylus his scroll. Apelles holds by his hand Raphael, admitted to the upper level but not, alas, to the front row; on the other side Leonardo and Fra Angelico may be discerned. Dante, at the left, is presented by Virgil, and lower

30-13. JEAN-AUGUSTE-DOMINIQUE INGRES. *Apotheosis of Homer.* 1827. Oil on canvas, 12′8″ × 16′11″ (3.86 × 5.16 m). Musée du Louvre, Paris

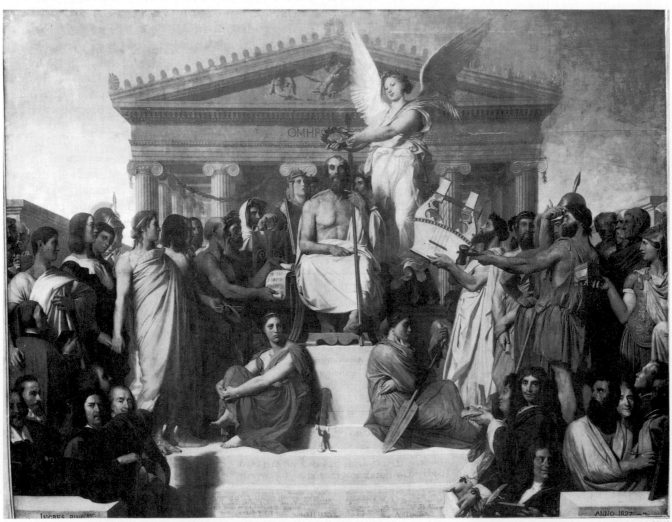

30-13

30-14

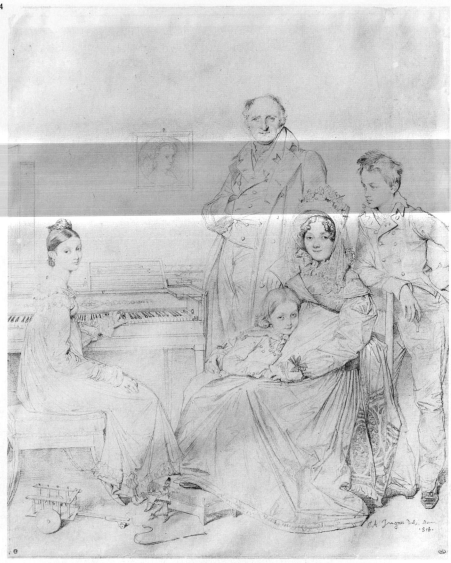

down Poussin may be seen, copied from the great master's self-portrait. At the lower right are grouped three French classical writers, Boileau, Molière, and Racine. Shakespeare and Corneille just make the scene in the lower left-hand corner, and Mozart, a subject of torment to Ingres, who repeatedly put him in and dropped him out, was finally omitted from the company of the immortals. The cool light of an ideal realm binds the figures together in the kind of artificial composition that became definitive for classicizing muralists even into the twentieth century.

Much of the time Ingres was financially obliged to accept portrait commissions, which he considered a waste of time, although today his portraits are accepted as his greatest works. He even drew portraits of visitors to Rome, who trooped to his studio, in such meticulous pencil studies as the *Stamaty Family,* of 1818 (fig. 30–14), which show the exquisite quality of his line. Knowing that lead pencil is disagreeable in excess, he carefully kept it off the paper save where strictly necessary, only here and there suggesting the darkness of hair or of clothing, but concentrating on the precision of facial delineation and on the interweaving of the folds of the costumes into a fabric of gossamer fineness, as delicate as a pearly roulade from the keys of the piano in the background.

Ingres said, "There is no case of a great draftsman not having found the exact color to suit the character of his drawing." Debatable though the point may be, Ingres's own paintings are almost invariably perfect in color, in a high range related

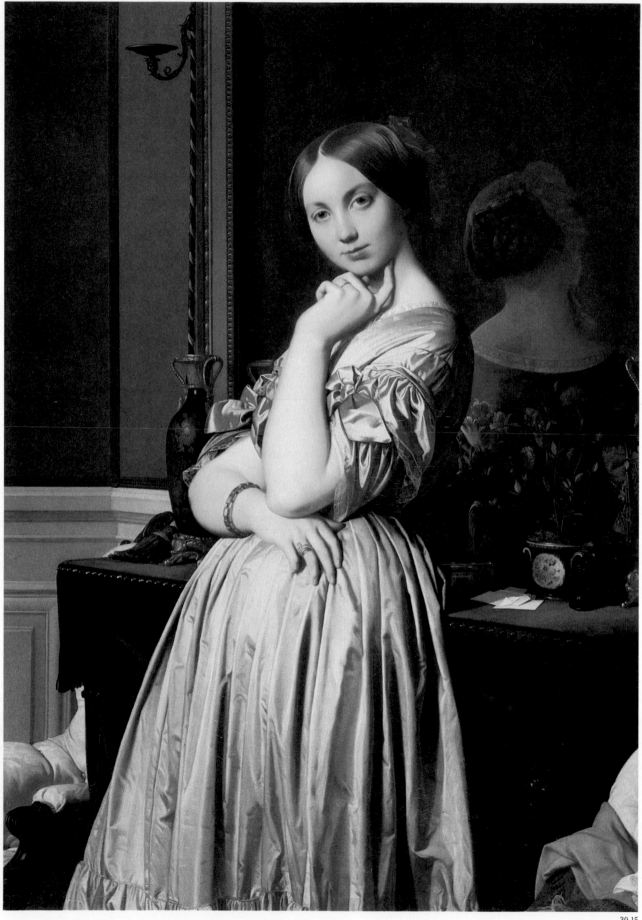

to that of Holbein or Bronzino or even Fra Angelico. All the beauty of Ingres's color and the perfection of his form are seen in *Comtesse d'Haussonville* (fig. 30–15), painted in 1845; the young woman is pensively posed in a corner of her salon, in an attitude clearly derived from classical art. No Dutch painter ever produced still lifes more convincingly than the vases on the mantel, and for all its precision the glow of the color has something in common with that of Jan Vermeer. The reflection in the mirror, going back through Diego Velázquez to Jan van Eyck (see figs. 27–37, 21–18), reappears again and again in nineteenth-century art (see fig. 33–8, for example), deeply concerned as it was with optical phenomena.

Although many of his subjects were drawn from the medieval history and poetry dear to the Romanticists (see Chapter Thirty-One), Ingres was resolutely opposed to their abandonment to emotion, and indeed to the artistic sources on which they drew. Peter Paul Rubens he called "that Flemish meat merchant." Eugène Delacroix, the leader of the Romanticists, was the devil incarnate; at a hanging at the Salon, after Delacroix had left the room, Ingres said to an attendant, "Open the windows, I smell sulfur." Yet his influence later in the century was very great. Edgar Degas (see Chapter Thirty-Three), whose vision was sharpened by his knowledge of Ingres's line, was one of the great innovators of the late nineteenth century.

Sculpture

HOUDON Although sculpture would seem to have been predestined for a dominant role in Neoclassicism, that art produced no genius to rank with David or Ingres at their best. The finest French sculptor of the eighteenth century was Jean Antoine Houdon (1741–1828). His life span overlaps that of David at both ends, but his style was formed in the classicistic period of the eighteenth century and survived somewhat anachronistically during the revolutionary phase of Neoclassicism, through which he managed to function with a certain agility; the basic honesty of his style won only grudging acceptance from Napoleon. Nonetheless, Houdon pertains to this moment because his work was greatly admired by the philosophers who provided the intellectual basis of the Revolution, many of whom he portrayed with phenomenal accuracy. Houdon was devoted to perfection of naturalness; he studied anatomy with exhaustive care and did not disdain the use of plaster casts from life and meticulous measurements. Nonetheless, his scientific precision in no way deadens his work. He declared that his purpose was "to present with all the realism of form and to render almost immortal the image of the men who have contributed the most to the glory or the happiness of their country." Every one of his portraits impresses the contemporary observer with the feeling that across the barriers of time and substance Houdon has made him actually acquainted with the subject, shown in a characteristic pose and in a moment of thought, feeling, or speech.

Houdon's numerous busts and statues of Voltaire sparkle with the aged philosopher's wit. Seated in his armchair, a classicistic piece typical of the taste of Louis XVI, he wears only his dressing gown and the cap donned by eighteenth-century gentlemen at home in place of the wig worn in public (fig. 30–16). The folds of the gown fall like those of a toga, without sacrificing the intimacy of the moment. Every facet of the papery wrinkled skin, showing the bones beneath, is drawn with delicacy and accuracy, and the eyes twinkle in a wry, half-sad smile. Houdon brought draftsmanship in sculpture to its highest pitch, a kind of accuracy rivaled in painting only by Holbein and Ingres.

Due to his friendship with Benjamin Franklin and Jefferson, both of whom he portrayed, Houdon was invited to America in 1785 to measure and study George Washington at Mount Vernon for the superb statue he carved in marble between 1788 and 1792 for the rotunda of Jefferson's State Capitol at Richmond, Virginia, where it still stands (fig. 30–17). Houdon's brilliant realism was tempered somewhat by the demands of a ceremonial image. Washington, standing in a pose of

30-15. JEAN-AUGUSTE-DOMINIQUE INGRES. *Comtesse d'Haussonville.* 1845. Oil on canvas, 53¼ × 36¼″ (135.3 × 92 cm). The Frick Collection, New York

classical dignity, wears his general's uniform, leans lightly on his baton of command, and rests his left arm upon a fasces (the bundle of rods signifying authority carried before magistrates in Roman processions); attached to it are the sword and the plowshare, indicating the hero's preeminence in war and peace. Seen in the actual space for which it was designed, the statue radiates all the grandeur Houdon desired, and has succeeded in implanting its image of the Father of His Country on nearly two centuries of American thought and feeling.

CANOVA A much stricter adherence to the principles of Neoclassicism is shown by the Italian Antonio Canova (1757–1822), who after Venetian training moved to Rome in 1779. Revered in his lifetime, he was vilified soon after; more recently, the pendulum has come to rest in an appreciation of Canova as a gifted but limited artist, who combined great technical ability with reverence for Greek originals. He studied enthusiastically the Parthenon sculptures brought to London by Lord Elgin but declined an invitation to restore them. Canova made no attempt at precise portraiture in the manner of Houdon but produced idealized images, such as a nude statue of Napoleon as a Greek hero and one of Washington in classical garb for the State Capitol in Raleigh, North Carolina, unfortunately destroyed by fire. The alluring life-size marble statue of Napoleon's sister Maria Paolina Borghese, as Venus Victrix, of 1805–7 (fig. 30–18), shows the princess partly nude, reclining in a classical pose on marble cushions on a gilt bronze couch, holding the apple given the goddess as the prize by Paris in the earliest recorded beauty contest—a triumph to which the subject's charms clearly entitle her. The chill of Canova's smooth surfaces, which converts the natural translucency of marble into something as opaque as cake frosting, cannot obscure the eventual Baroque derivation of his

30-16. JEAN ANTOINE HOUDON. *Voltaire.* 1781. Terra-cotta model for marble statue, height 47″ (1.19 m). Musée Fabre, Montpellier, France

30-17. JEAN ANTOINE HOUDON. *George Washington.* 1788–92. Marble, height 6′2″ (1.88 m). State Capitol, Richmond, Virginia

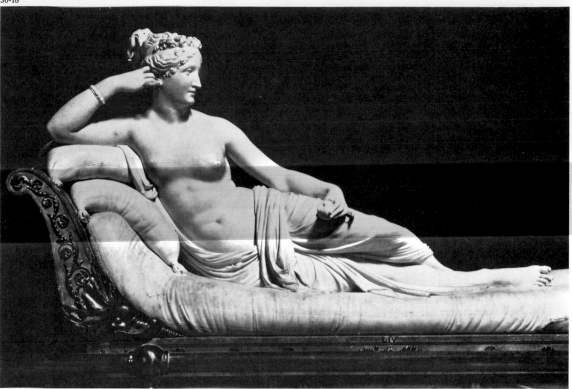

30-18. ANTONIO CANOVA. *Maria Paolina Borghese as Venus Victrix.* 1805–7. Marble, 62⅞ × 78¾", including bed (1.6 × 2 m). Galleria Borghese, Rome

30-19. ANTONIO CANOVA. *Tomb of the Archduchess Maria Christina.* 1798–1805. Marble, life size. Augustinerkirche, Vienna

30-19

style. The head is close to that of Apollo in Gianlorenzo Bernini's *Apollo and Daphne* (see fig. 26–14), then as now in the Borghese collection, which Canova must have studied with loving care.

Canova transformed the character of the dramatic tomb (see the Rossellino tombs, figs. 20–57, 20–58) into imagery deprived of any reference to Christianity in his pyramidal monument to Maria Christina, archduchess of Saxe-Teschen (fig. 30–19), erected to her memory by her husband, Archduke Albert, between 1798 and 1805. Her portrait is upheld by a soaring classical figure representing Happiness, while her ashes are borne in an urn by Piety into the open door; to the right the winged genius of Mourning rests upon the lion of Fortitude, and to the left youthful, mature, and aged figures symbolize the Three Ages of Man. The contemporary Italian critic Francesco Milizia declared that a monument should "demonstrate in its simplicity the character of the person commemorated and bear no symbols that are not immediately intelligible." He must have been pleased by this one, although today's viewer requires a word of explanation. Nonetheless, the mystery of the unknown Beyond is beautifully dramatized by the soaring line of the pyramid and by the curve of the cloth sweeping the figures inexorably on to the dark and silent door.

Neoclassicism, whose gods were Poussin, Raphael, and a simplified version of classical antiquity, held the Baroque (outside of Poussin) in abhorrence and stood ironclad against all other currents in the nineteenth century, maintaining its own ideals and principles as the only valid ones. (Curiously enough, however, even the most doctrinaire Neoclassicists eventually proved vulnerable to the charms of North Africa.) Foredoomed to defeat as such dogmatism might appear, it did not entirely vanish but lived a submerged existence throughout the nineteenth and twentieth centuries, ready to surface at unexpected moments. For despite the exaggerated claims of the Neoclassical movement, its exponents were still in charge of the art schools and did indeed provide essential basic training in form drawing and composition. However distasteful at times, this discipline proved of inestimable value to generations of artists, and will doubtless continue to do so.

CHAPTER THIRTY-ONE

In contrast to Neoclassicism, which is easily recognizable, the parallel current of Romanticism is vague indeed. The characterizations of Romanticism and the lists of artists to be included are as numerous as the writers on the subject. The term *Romantic* appears to have originated in the type of late-medieval narrative in which the adventures of a legendary hero were spun out to great length. From the very start, Romanticism involved connotations of unreality and of distance, in time or space or both. The Gothicism of Horace Walpole, expressed in architecture at Strawberry Hill (see figs. 29–33, 29–34) and in literature in his Gothic novel *The Castle of Otranto* (1764), has often been called Romantic, although *pre-Romantic* might be a better term. By the middle of the eighteenth century, the term *Romantic* was applied to the "natural" English garden with its winding walks, pools, and groves. Thus, to the literary elements of the exotic and the remote the ingredient of the natural was added, finding its philosophical support in the writings of Jean-Jacques Rousseau.

The culminating aspect of Romanticism is its interest in the sublime, as distinguished from the beautiful, deriving from a tradition that originated in the treatise *On the Sublime,* once attributed to Longinus, a Greek Platonic philosopher of the third century A.D. but now believed to date from the first century. The sublime, which contains elements of pain, terror, majesty, and above all awe before the unknown and the unknowable, constitutes a strong component of ancient art during the Hellenistic period, in contrast to the clearly defined classical standards of beauty prevailing in Greek art of the fifth century B.C. The sublime was the object of meditation by the French critic Nicolas Boileau in the seventeenth century and almost against his will by the rationalistic Voltaire, who had trouble with Shakespeare's greatness in spite of his violation of all classical rules—"a savage who could write."

Although so many of the elements of Romanticism already existed in the eighteenth century, like eighteenth-century classicism they may be considered rather as an elegant pose of cultivated society; in fact, the two attitudes could easily coexist. Not until the French Revolution did a general Romantic attitude become widespread and definitive for works of art of a very high order. In English poetry the new freedom of Wordsworth, Byron, Keats, Shelley, and Scott differs from the measured cadences of their precursors Pope, Thomson, Gray, and Cowper; in music the new movement was expressed in the greatly expanded symphonies, concerti, and sonatas of Beethoven and Schubert and in the flowering of Italian tragic opera. Eighteenth-century principles of form were swept away by a new emotionalism that generated its own forms. Like Neoclassicism, Romanticism became a way of life, affecting not only art but also conduct, an elevation of emotion above intellect, content above form, color above line, intuition and passion above judgment, resulting in an entirely new ideal hero—Byron's Childe Harold and Goethe's Werther. While Neoclassicism exalted Poussin, Raphael, and the "antique" (classical art seen through Roman eyes), Romanticism extolled the Baroque, especially Rubens and Rembrandt, Michelangelo, the Middle Ages, and the East.

Except in architecture, Neoclassicism was relatively weak in England; even English Neoclassical architects could just as happily practice in classical, Gothic, or Oriental styles. In France, however, Romanticism, arising before he knew it in the very studio of David, eventually declared against him and the whole Neoclassical movement. Interestingly enough, Neoclassicism and Romanticism soon changed sides politically. The first allegiance of the Romanticists was to the Napoleonic dream of a united Europe. After his fall the Romanticists often sided with new revolutionary movements, while the late phase of Neoclassicism under Ingres associated itself with the restored Bourbon monarchy, later with the Second Em-

pire, and as well with the ever more repressive force of the Academy. The account given here is selective in that it attempts to present only works of enduring quality, but they should be recognized as part of a vast movement invading all aspects of nineteenth-century life in every European country as well as in the United States.

Painting and Sculpture on the Continent

GOYA Although hardly known to the French Neoclassicists or—except for his prints—even to the early Romanticists, the greatest artistic genius of the turn of the eighteenth century was a Spaniard, Francisco José de Goya y Lucientes (1746–1828), whose long lifetime overlaps that of David. Goya made the required obeisance to Italy, but only briefly, and seems to have been unimpressed either by antiquity or by the Renaissance. He was a lifelong rebel against artistic or intellectual straitjackets and could never have tolerated the stern doctrines of David; in fact, he managed to skip the Neoclassical phase entirely, even though one of its most influential practitioners, the German painter Anton Raphael Mengs, friend of

31-1. Francisco Goya. *Family of Charles IV.* 1800. Oil on canvas, 9'2" × 11' (2.79 × 3.36 m). Museo del Prado, Madrid

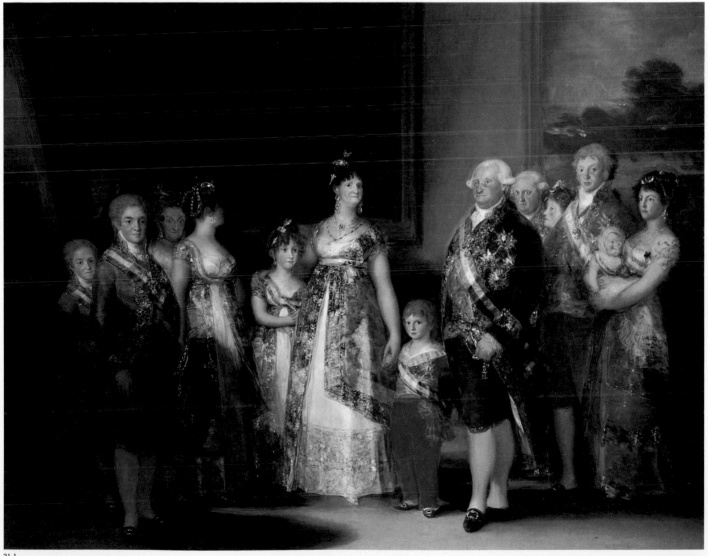

31-1

Winckelmann, was in a position of authority in Madrid. Goya was more influenced by Giovanni Battista Tiepolo, who worked in Madrid from 1762 until his death in 1770, and thus passed directly from a personal version of the Rococo, with a strong admixture of Spanish folklore, to a style we can hardly call anything but Romantic.

In 1786 Goya was appointed painter to the king and in 1799, already more than fifty, first court painter. After 1792 Goya was totally deaf, a disability that may have been responsible for liberating him from some of the trivialities of life for meditation on its deeper significance. Goya's remarkable portraits of the royal court may have been influenced by the light, free brushwork and diaphanous forms of Thomas Gainsborough, whose works were then widely known in accurate engravings. But his characterizations are far more vivid, intensely human, and at times bitingly satiric. His supreme achievement in portraiture is the *Family of Charles IV,* painted in 1800 (fig. 31–1), an inspired parody of Velázquez's *Las Meninas* (see fig. 27–37). Thirteen members of the royal family, representing three generations, are assembled in a picture gallery of the palace, with Goya himself painting at a large canvas in the shadows at the left, a sardonic commentator on this parade of insolence. The king, with his red face and with his chest blazing with decorations, and the ugly and ill-natured queen are painted as they undoubtedly were. Alphonse Daudet called them "the baker's family who have just won the big lottery prize," but Goya's real purpose is deeper than satire: he has unmasked these people as evil. Only some (not all) of the children escape his condemnation. Unexpectedly, the result is a dazzling display of color in the lighting, the costumes, and the decorations—brilliant sparkles of impastos against rich, deep glazes—all touched in lightly and swiftly without a hint of the formal construction and composition of the contemporary French Neoclassicists.

A still-unexplained picture, probably painted in the same year, is the *Maja Desnuda* (fig. 31–2)—the word *maja* is untranslatable; the French *coquette* is an approximation—one of the most delightful paintings of the female nude in history. The pose is an updated and very awake transformation of the sleeping nude in the lower right corner of Titian's *Bacchanal of the Andrians* (see fig. 24–4), at that time in the Spanish royal collections. There exists a second, much sketchier clothed version of the picture. The nude was formerly explained as an unconventional portrait of the duchess of Alba, a patron and close friend of Goya's, and the clothed replica as an attempt to account for the artist's time, hastily painted against the duke's return. The sitter has more recently been identified as a mistress of the queen's favorite, Manuel Godoy. In any event the seductive pose is entrancing, as is the delicacy of Goya's unusually smooth and polished modeling of the flesh, contrasted with the crisp brushwork of the white satin sheet and pillow slips and lace ruffles and with the intensity of the blue velvet cushions.

The frivolity of the picture hardly prepares us for Goya's denunciations of the inhumanity of warfare, of which the most monumental example is the *Third of May, 1808, at Madrid: The Shootings on Principe Pío Mountain* (fig. 31–3), depicting the execution of Madrid rebels by Napoleonic soldiery. Commissioned by the liberal government after the expulsion of the French in 1814, this painting is the earliest explicit example of what has come to be known as "social protest" in art, as distinguished from the allegorical allusions to contemporary events common enough in the Renaissance and the Baroque. Despite written meditations, such as those of Leonardo da Vinci, on the cruelties and terrors of battle, warfare itself had generally been depicted as glorious and cruelties as inevitable (see figs. 20–48, 22–7). Goya treats the firing squad as a many-legged, faceless monster, before whose level, bayoneted guns are pushed group after group of helpless victims, the first already shattered by bullets and streaming with blood, the next gesticulating wildly in the last seconds of life, the third hiding the horror from their eyes with their hands. A paper lantern gives the only light; in the dimness the nearest houses and a church tower of the city almost blend with the earth against the night sky. The conviction of reality conveyed by the picture, painted so long after the event, is a

31-2. FRANCISCO GOYA. *Maja Desnuda.* 1800. Oil on canvas, 37⅜ × 74¾" (95 × 190 cm). Museo del Prado, Madrid

31-3. FRANCISCO GOYA. *Third of May, 1808, at Madrid: The Shootings on Principe Pío Mountain.* 1814. Oil on canvas, 8'9" × 13'4" (2.67 × 4.06 m). Museo del Prado, Madrid

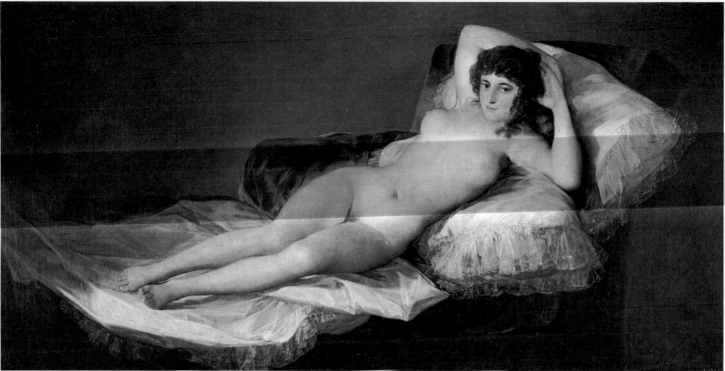

31-2

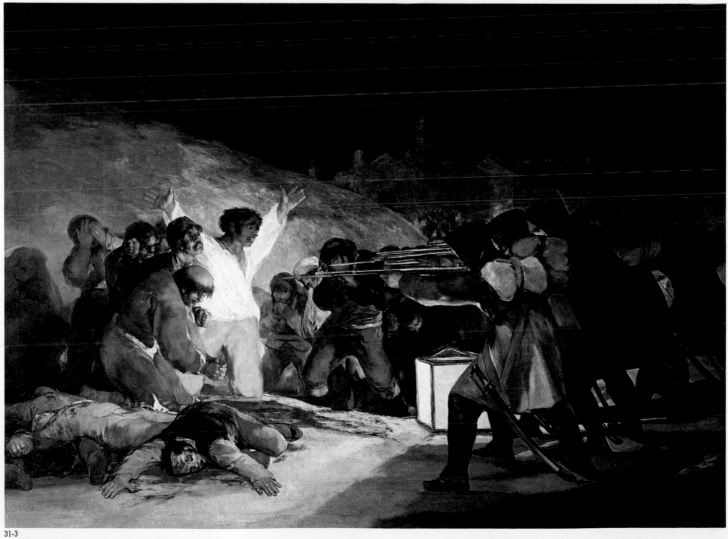

31-3

testament to the extraordinary powers of Goya's imagination and to the depth of his inner participation in human suffering. Through the medium of brushstrokes as broad as those of Tintoretto, he communicates unbearable emotion with thick pigment, which, as if sacramentally, becomes the still living or already rent flesh and streaming blood, achieving at once a timeless universality and an immediacy that bring to mind all too effectively the reality of similar events we read and hear about almost daily.

Goya's passionate humanity speaks uncensored through his engravings. These rely for their effect on a combination of traditional etching with the newly invented technique of *aquatint,* in which rosin is utilized to cover the areas between etched lines. When the plate is heated, the rosin creates a granular surface; ink applied and wiped off then produces a rich, gray tone, greatly expanding the expressive range of the print medium and bringing it close to wash drawing. Goya made several series of etching-aquatints, the earliest of which, *Los Caprichos (The Caprices),* of 1796–98, is wildly imaginative. The first section, dealing satirically with events from daily life, is surpassed by the second, devoted to fantastic events enacted by monsters, witches, and malevolent nocturnal beasts from the demonic tradition of Spanish folklore. The introductory print of the second section (fig. 31–4) shows the artist asleep at his table loaded with idle drawing instruments, before which is propped a tablet inscribed, "El sueño de la razon produce monstruos" ("the sleep of reason produces monsters"). Reason, the goddess of eighteenth-century philosophers, to whom the Cathedral of Notre-Dame in Paris had been temporarily rededicated during the French Revolution, once put to sleep, allows monsters to arise from the inner darkness of the mind. Goya's menacing cat and the rising clouds of owls and bats glowing in light and dark are lineal descendants of the beasts of medieval art and the monsters of Hieronymus Bosch (see figs. 21–29, 21–30).

Instead of merely threatening human life, as in *Los Caprichos,* the monsters take over entirely in Goya's final series, *Los Disparates (The Follies),* engraved between 1813 and 1819. In a print entitled *Unbridled Folly* (fig. 31–5), a wildly rearing horse, resembling a natural force erupting from the ground, carries off a woman whose garments it has seized with its teeth, while at the left the earth turns into a bestial maw devouring humanity. The ultimate horror of Goya's imagination seethes through the series of dark frescoes the artist painted with fierce strokes on

31-4

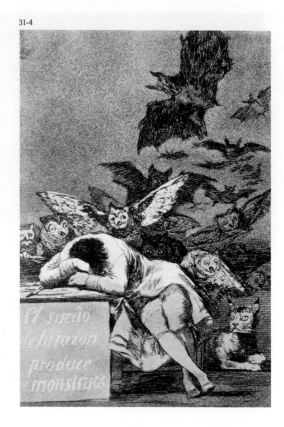

31-4. FRANCISCO GOYA. *The Sleep of Reason Produces Monsters,* from *Los Caprichos (The Caprices)* series. 1796–98. Etching and aquatint

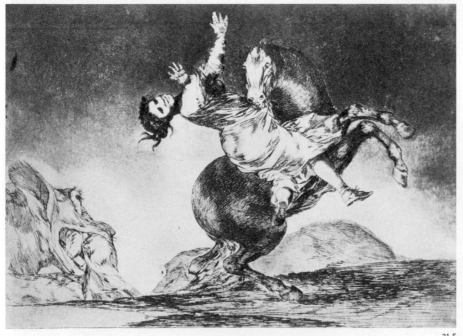

31-5

31-5. FRANCISCO GOYA. *Unbridled Folly,* from *Los Disparates (The Follies)* series. 1813–19. Etching and aquatint

31-6

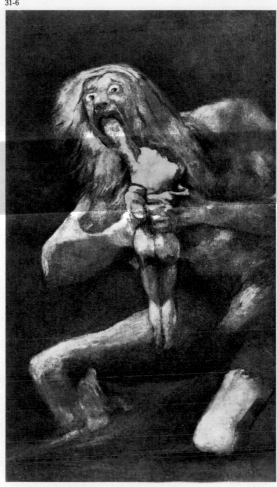

31-6. FRANCISCO GOYA. *Saturn Devouring One of His Sons.* 1820–22. Fresco (transferred to canvas), 57⅞ × 32⅝" (147 × 83 cm). Museo del Prado, Madrid

the walls of his own house from 1820 to 1822, depicting a universe dominated by unreason and terror and making cruel mock of humanity. One of his rare references to classical mythology illustrates the most savage of Greek legends. *Saturn Devouring One of His Sons* (fig. 31–6) is an allegory of Time, which engulfs us all. The glaring, mindless deity holds with colossal hands the body of his helpless son, from which he has torn and is chewing the head and the right arm—all indicated with brushstrokes of a hitherto unimagined ferocity.

Now nearing eighty, the great painter was not to live long with these creatures of his despairing imagination. After the restoration of a reactionary monarchic government in 1823, he left for France the following year, and, like his complete opposite David, he died in exile. In the formative stages of the Romantic movement in France, Goya's paintings seem to have been unknown; of his engravings, only *Los Caprichos* were published, but even they had a limited effect; it remained for the late nineteenth century to rediscover Goya in full.

GROS The transformation of Davidian Neoclassicism into Romanticism was initiated by one of David's own pupils, Antoine Jean Gros (1771–1835), torn between his loyalty to the doctrines of his master and his admiration for the color and movement of the hated Rubens. The young Gros actually accompanied Napoleon on his north Italian campaign. Later, he painted enormous canvases commissioned to display the alleged humanitarianism of the emperor rather than his military glory. Such subjects, aptly described as "pious lies," would have nauseated Goya, but Gros's treatment of them is impressive. *Napoleon on the Battlefield at*

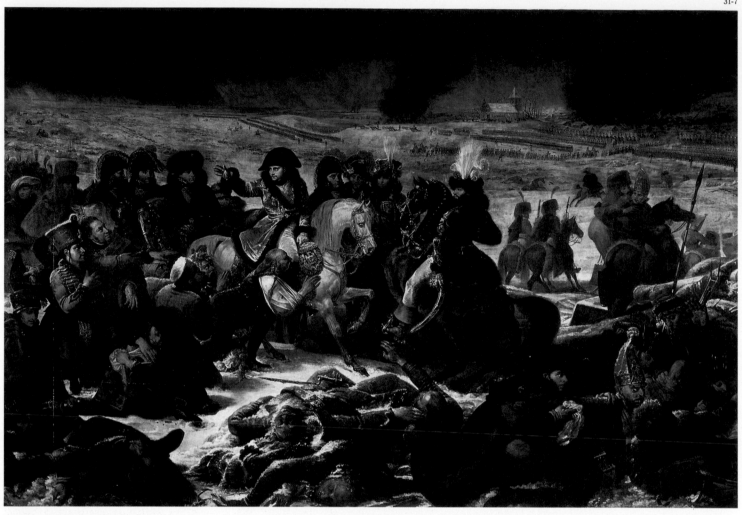

Eylau (fig. 31–7) was painted, in 1808, according to a fixed program that prescribed the persons, actions, and background to be represented. Among the heaped-up bodies of the dead and dying, after the bloody but indecisive battle, the emperor appears on a white horse as a kind of savior, commanding that proper care be taken of the wounded Russian and Prussian soldiers. Across the snowy fields in the background the imperial armies are arrayed for the triumphal march past the conqueror, while long lines of Russian prisoners are led away. The fact that the commission was intended to counteract public knowledge of the inadequacy of Napoleon's medical services does not weaken the drama of the composition, with its hundreds of near and distant figures. The reference to Roman battle compositions in the emperor's gesture and the packed bodies is all that remains of Neoclassicism. The colors of the uniforms are muted by the gray sky and the snow; the latter has sifted onto the greenish-gray faces of the frozen corpses in the foreground. The painter's interest in color and in the sufferings of the wounded opened the way to the passionate outbursts of the Romantic style. Gros himself, however, bitterly criticized by David from Brussels for his contemporary subjects, could never reconcile the opposites in his life and work, and despite his elevation to a barony by the restored Bourbons, he eventually ended his life in the Seine.

GÉRICAULT Hero of the formative stage of French Romanticism, Théodore Géricault (1791–1824) was a Romantic figure in his own right in his disdain for his personal safety, his dedication to the life of the emotions, and his espousal of the

31-7. ANTOINE JEAN GROS. *Napoleon on the Battlefield at Eylau.* 1808. Oil on canvas, 17′6″ × 26′3″ (5.33 × 8 m). Musée du Louvre, Paris

31-9. THÉODORE GÉRICAULT. *Raft of the Medusa.* 1818–19. Oil on canvas, 16′1″ × 23′6″ (4.9 × 7.16 m). Musée du Louvre, Paris

31-8

31-8. THÉODORE GÉRICAULT. *Officer of the Imperial Guard.* 1812. Oil on canvas, 9′7″ × 6′4½″ (2.92 × 1.94 m). Musée du Louvre, Paris

cause of the downtrodden and rejected. Although only three of his paintings were publicly exhibited during his brief lifetime, he exerted an enormous influence on the whole of the Romantic movement. His *Officer of the Imperial Guard* (fig. 31–8), shown at the Salon of 1812, is a dazzling performance for a twenty-one-year-old artist, already in full command of pictorial technique in a tradition stemming from the later Titian and Tintoretto. The guardsman is mounted on a rearing horse, which, while resembling that of Marshal Murat to the emperor's left in Gros's *Napoleon on the Battlefield at Eylau,* was probably also inspired by Leonardo's composition of the *Battle of Anghiari,* known to Géricault from Rubens's imaginative re-creation (see fig. 22–7), not to speak of the spiral composition and the rich colorism of the great Flemish master himself, which have caused Géricault's style to be termed "Neo-Baroque." Although he had studied with Pierre-Narcisse Guérin, a follower of David, Géricault lets his brushwork show brilliantly, just as David claimed it should not. He wholeheartedly accepted the Napoleonic mystique, and in his painting has nothing to say about the sufferings of war; the young officer is a hero, braving not only the smoke and flame of the battle but also attempting to tame the turbulence of nature itself, expressed in the fiery stallion and the surging storm clouds. The theme of man pitted against nature in eternal combat runs through most of Géricault's paintings.

In 1816–17 he lived in Florence and Rome, but paid less attention to antiquity and to Raphael than to Italian street scenes, especially those involving horses, and to the paintings of Michelangelo, whose grandeur and violence thrilled him. Out of his study of the great High Renaissance master came the young artist's only monumental canvas, the huge *Raft of the Medusa* (fig. 31–9), on which he worked from 1818 to 1819. The government vessel *Medusa,* bound for Senegal, was wrecked in July 1816. After abandoning ship, 149 passengers were crowded onto a raft in tow by the officers' boats; the cable broke and the raft was cut adrift. Only

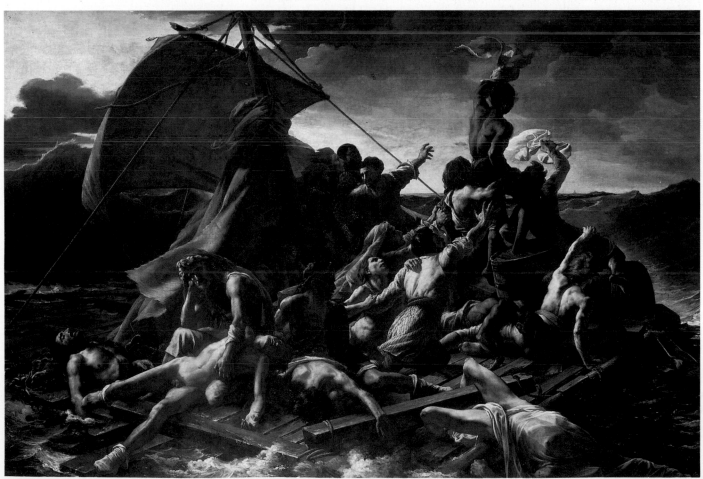

31-9

fifteen passengers were eventually rescued by the brig *Argus,* after they had suffered the torments of thirst and starvation under the equatorial sun.

A political scandal because of the incompetence of the captain, who owed his appointment to his support of the monarchy, the incident seems to have obsessed the artist rather as a supreme instance of the tragic conflict between man and nature. He interviewed the survivors, read the newspaper accounts, even painted corpses and the heads of guillotined criminals in an attempt to achieve the highest fidelity to truth. Yet the final result, achieved after endless sketches and preliminary compositions, was by no means a realistic picture. Géricault chose to depict the moment when the brig was first sighted on the horizon. The composition results from a pyramidal surge of agonized figures, rising higher than the threatening sea, and culminates in two men waving garments against the clouds. In essence, it is a translation into multifigural design of the motif of the *Officer of the Imperial Guard,* the sea substituting for the horse as a symbol of hostile nature. While the rendering of the corpses and the maddened survivors recalls Gros's *Napoleon on the Battlefield at Eylau,* their heroic muscularity and the mood of titanic struggle are clearly affected by the grandeur of Michelangelo's *Last Judgment* (see fig. 23–5).

The artist was far from pleased by the public reception of this work as more a political than an artistic event, and he accompanied it to London, where he showed it for a year at considerable profit from the admissions. He learned much about color from English painters, especially John Constable (see pages 895–97), and would have seemed destined for a leading role in French painting on his return. Especially impressive are his studies of the insane, done in Paris in 1822–23 at the suggestion of a psychiatrist friend and given titles that look a little strange to present-day students of psychiatry. *Madwoman* (fig. 31–10; which was actually entitled *Monomania of Envy*) discloses in the inner world of thoughts and feelings the same struggle between man and nature that the artist had previously studied in the realm of physical action. It was foreordained that Géricault should lose the battle. A passionate horseman, he was injured by a fall from a horse, insisted on riding again too soon, fell a second time, and died, probably of his injuries. More than any of his contemporaries, he may be considered the founder of the veritable religion of emotional violence championed by Delacroix.

DELACROIX The torch of Romanticism passed from the hands of Géricault to those of his seven-years-younger friend and, in a sense, pupil, Eugène Delacroix (1798–1863), who shared with Ingres, despite their bitter professional enmity, the leadership of French and indeed European painting for more than a generation. He seems the archetype of the Romantic—solitary, moody, inexhaustibly imaginative, profoundly emotional. He confided to his journal, the most complete record we have of the thoughts and feelings of any great artist, that he was never without a slight fever. Yet in contrast to Géricault he lived an existence marked by few external events. Although he admired Italian art and said he wanted to go to Italy, he never went there; his journeys were to England, Belgium, Holland, Spain, and North Africa. Save for one youthful adventure, no enduring amorous connections are known, and he remained unmarried. He was haughty toward most other artists. His real life, of great intensity, was lived on the canvas. "What is most real in me," he wrote, "are the illusions I create with my painting; the rest is shifting sand." In the course of his life he produced literally thousands of oil paintings and watercolors and innumerable drawings, and not long before his death he claimed that "in the matter of compositions I have enough for two human lifetimes; and as for projects of all kinds, I have enough for four hundred years."

At first Delacroix wrote in his journal lists of subjects he wanted to paint, invariably scenes of emotional or physical violence; later, discovering that the creative urge was dissipated in setting down the titles, he abandoned this practice. Often he drew his subjects from English poetry, especially Shakespeare and Byron, and from medieval history. Music enthralled him; he knew Chopin personally and

31-10. THÉODORE GÉRICAULT. *Madwoman (Monomania of Envy).* 1822–23. Oil on canvas, 27⅝ × 22″ (70.2 × 56 cm). Musée des Beaux-Arts, Lyons

analyzed his music with keen understanding, aware at once of its beauty and its limitations. At first he admired Beethoven but later found his music noisy and exaggerated. From youth to old age his one idol in music was "the divine Mozart," which tells us at once much about the fire and imagination of Mozart and about the discipline of Delacroix's art, despite its apparent impetuosity always under firm intellectual control. As a youth, he was drawn to Michelangelo, whose paintings he knew only from engravings and from the accounts of his mentor Géricault. But as Delacroix matured, the influence of the great Florentine waned along with that of the departed friend, and his lifelong loyalty to the sixteenth-century Venetians (see Chapter Twenty-Four) and to Rubens (see pages 802–7), apostles of colorism, constantly strengthened.

In the *Bark of Dante* (fig. 31–11), which Delacroix exhibited in 1822 at the age of twenty-four, he illustrates a moment from the *Divine Comedy* in which the poet, accompanied by Virgil, is steered across the dark tides of the lake surrounding the city of Dis, assailed in the sulfurous dimness by damned souls rising from the waves against a background of towers and flames. The obvious Michelangelism of the figures (compare the *Last Judgment,* fig. 23–5), not to speak of the frail craft on heaving waters, reminds us of Géricault's *Raft of the Medusa,* exhibited only three years earlier. But there are already significant differences. Delacroix has broken up the pyramidal grouping and is more concerned with effects of color and of light and dark than with form, however strongly modeled here and there. Some of the drops of water are painted in pure tones of red and green. Throughout his entire career his basic compositional principle is a series of free curves, emanating from the central area but always returning to it, with a responsive logic unshaken even in the moments of greatest violence. Gros praised the picture highly, calling it a "chastened Rubens."

31-11. EUGÈNE DELACROIX. *Bark of Dante.* 1822. Oil on canvas, 6'2⅜″ × 8'7⅞″ (1.89 × 2.46 m). Musée du Louvre, Paris

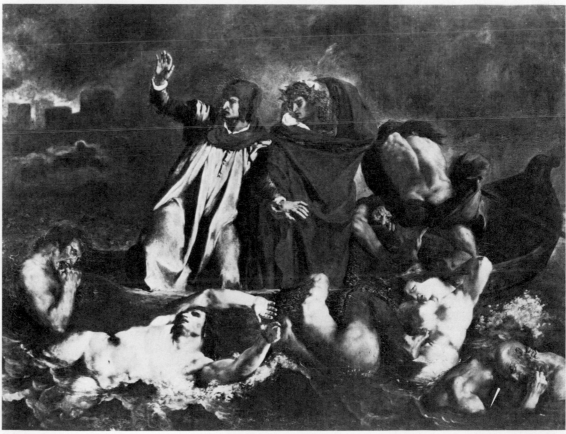

31-11

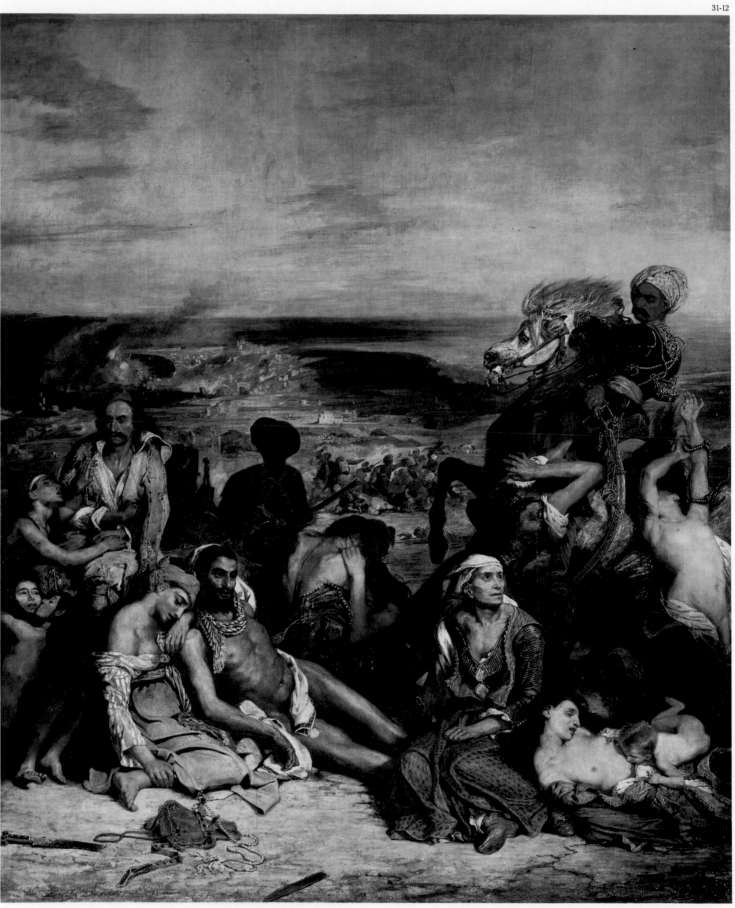

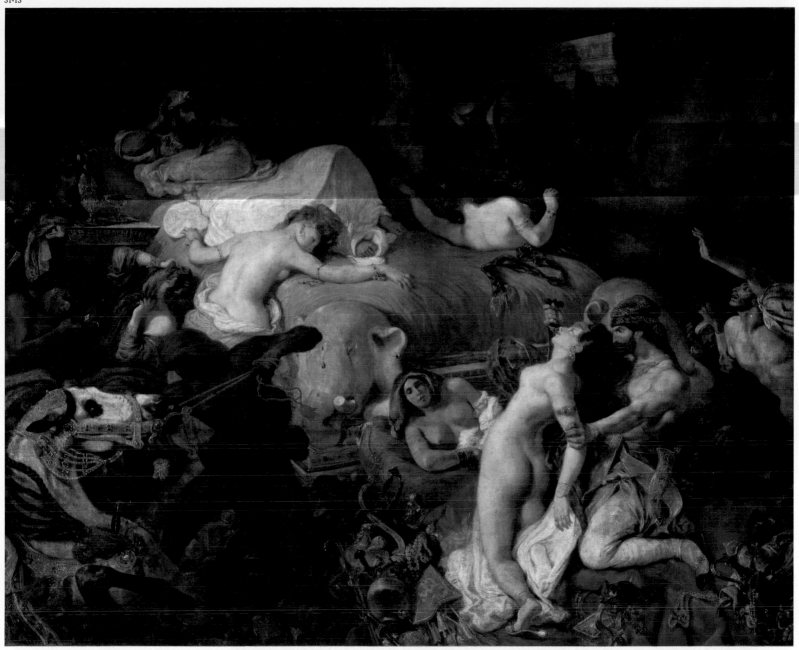

31-12. Eugène Delacroix. *Massacre at Chios.* 1822–24. Oil on canvas, 13'10" × 11'7" (4.22 × 3.53 m). Musée du Louvre, Paris

31-13. Eugène Delacroix. *Death of Sardanapalus.* 1827. Oil on canvas, 12'1½" × 16'2⅛" (3.7 × 4.95 m). Musée du Louvre, Paris

Delacroix's next major effort, however, the *Massacre at Chios* (fig. 31–12), which he exhibited in 1824, was not so easily accepted. Like that of the *Raft of the Medusa,* the subject was a cause célèbre, in this case an incident from the Greek wars of liberation against the Turks, which had excited the sympathies of Romantic spirits everywhere, notably Lord Byron. While the foreground strewn with bodies and the panoramic background are related to Gros's *Napoleon on the Battlefield at Eylau,* and the Turk on his rearing horse to Géricault's *Officer of the Imperial Guard,* great changes have taken place. The Neo-Baroque composition is diffused in Delacroix's centrifugal curves, which part to display the distant slaughter and conflagration. And although our sympathies are supposed to be enlisted by the sufferings of the Greeks, their rendering lacks the conviction of the *Raft of the Medusa.* Clearly, Delacroix did not investigate the subject with Géricault's reportorial zeal. In fact, the expressions tend to become standardized; the head of the young woman at the

lower left almost exactly repeats that of the dead mother at the lower right. Suffering, violence, and emotional excess of all sorts are reveled in rather than lamented.

Gros called this picture the "massacre of painting," and not only because of Delacroix's treatment of the subject. As we see the picture today, the color shows a richness and vibrancy not visible in French painting since the Rococo. Delacroix saw and was amazed by John Constable's *Hay Wain* (see fig. 31–20), brought to Paris for the Salon of 1824, and before the exhibition opened he took down his huge picture and in a few days repainted it extensively in tones emulating those he found in Constable.

From here on, Delacroix's interest in color was greatly heightened. He recounts in his journal his exhaustive attempts to investigate the relationship of color contrasts through experience of their effects next to each other on the canvas, as well as from visual observation of nature, deriving from these lists a law—"the more the contrast the greater the force." His contrasting hues, set side by side unmixed, caused conservative painters great distress but marked an important step in the direction of the color effects to be derived from sunlight by the Impressionists (see Chapter Thirty-Three). In 1847 Delacroix wrote, "When the tones are right, the lines draw themselves," the exact opposite of Ingres's dictum on the same subject (see page 873).

With the *Death of Sardanapalus* (fig. 31–13), as much a manifesto for Romanticism as was Ingres's *Apotheosis of Homer* for Neoclassicism (see fig. 30–13; ironically enough, both paintings were exhibited at the Salon of 1827), the artist drew down upon himself the execration of conservatives and the disapproval of royal administrators. The legendary subject concerns the last of the Assyrian monarchs, besieged in his palace for two years by the Medes. On hearing that the enemy had at last breached his walls, the king had all his concubines, slaves, and horses slaugh-

31-14. EUGÈNE DELACROIX. *Women of Algiers.* 1834. Oil on canvas, 70⅞ × 90⅛" (1.8 × 2.29 m). Musée du Louvre, Paris

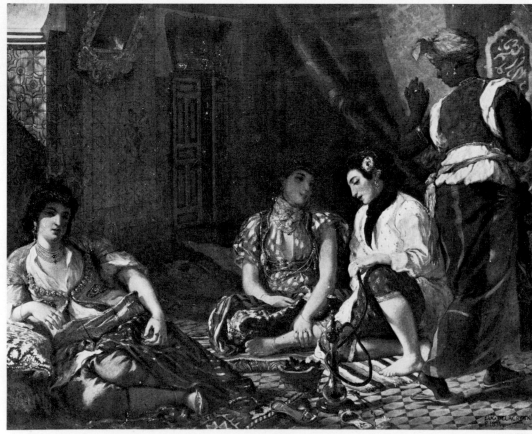

31-14

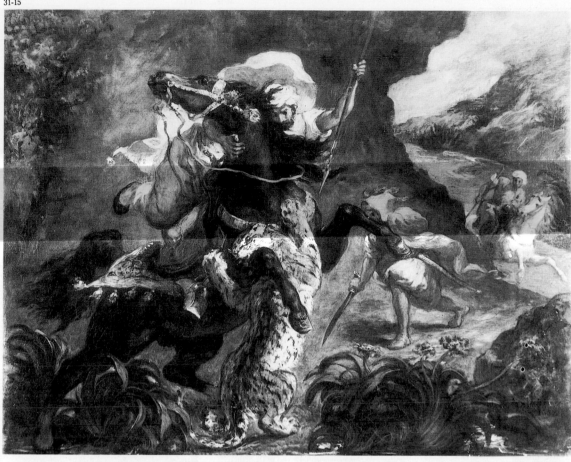

31-15. Eugène Delacroix. *Tiger Hunt*. 1854. Oil on canvas, 29 × 37″ (73.7 × 94 cm). Musée du Louvre, Paris

tered and his treasures destroyed before his eyes as he lay upon a couch soon to become his funeral pyre. Lacking the pretext of humanitarianism that justified the *Massacre at Chios* and other pictures inspired by the Greek struggle for independence, the painting becomes a veritable feast of violence, spread out in glowing colors against the smoke of distant battle. With the brooding king and three excited male servants as foci, the movement surges about the couch in Delacroix's characteristic curves. Yet the picture is a phantasmagoria in which no real cruelty is exerted. Faces are contorted with destructive fury or paralyzed with fear, but no blood flows from the breast of the naked woman in the foreground into which a dagger has been plunged. Quivering female flesh is heaped in every conceivable position, like flowers or fruit, among the glittering jewels and the fabrics of crimson or turquoise, all brilliantly painted. In this solitary fantasy the artist, identifying himself in imagination with the king and the executioners, discharges all his creative—and destructive—energy in an explosion of tones that foreshadows the Venusberg music of Wagner and the Immolation scene from his *Götterdämmerung* but is in reality as harmless as a still life.

The Revolution of 1830, which placed on the throne Louis Philippe, the "Citizen King," brought Delacroix major mural commissions and relief from poverty. Early in 1832 he traveled through North Africa with a French delegation. He was the first major painter of modern times to visit the Islamic world, and this was the one real adventure of a lifetime otherwise fairly tranquil—externally, at least. Although he had no opportunity to paint, and sometimes found even drawing dangerous on account of Islamic hostility to representation, he managed to bring back with him hundreds of sketches in pencil or pen, some touched with watercolor. These, his memory of exotic sights and colors, and his vivid imagination provided him with endless material for paintings for the next thirty years.

Delacroix's memories of North Africa were brought to realization in *Women of Algiers* (fig. 31–14), a picture of exquisite intimacy and charm, painted and exhib-

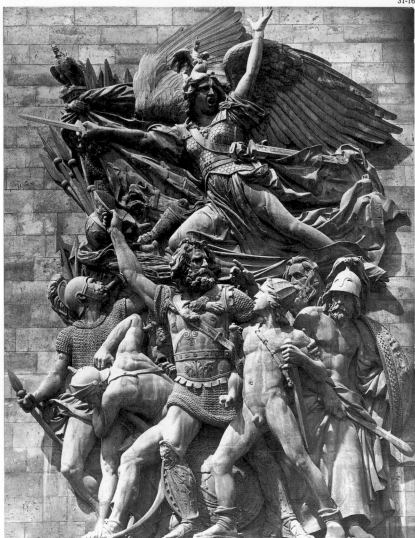

ited in 1834. Delacroix had managed to gain entry to a harem and was delighted with "the charm of the figures and the luxury of the clothing." The languorous poses, soft flesh, and somnolent eyes of the women, the varying textures and colors of the striped and figured fabrics, the light and luminous shadow of the interior, and the endless arabesques of the tiles form a constantly changing tissue of line and tone. This picture had an enormous influence on the Impressionists of the late nineteenth century and on many painters of the early twentieth century, especially Henri Matisse (see figs. 35–4, 35–7).

Most of the pictures of North African subjects painted during Delacroix's later years, however, were less tranquil. The *Tiger Hunt* (fig. 31–15), of 1854, is typical, with forms and poses born almost entirely of the artist's unbridled imagination. "When the tones are right, the lines draw themselves," and so they do, in the movements of the raging animals and furious huntsmen, flowing out from the center and back again with passionate intensity and perfect logic. Almost weightless, liberated from matter, these late fantasies of violence carry the artist into a phase of free coloristic movement pointing directly toward the twentieth century.

SCULPTURE Romantic sculpture never quite reached the plane of painting; there were no geniuses to catch the fire of Goya or Delacroix. Nonetheless, some powerful and effective works were conceived and executed in large scale for important Parisian buildings. The grandest of these is *La Marseillaise* (fig. 31–16; its full title is *Departure of the Volunteers in 1792*), by FRANÇOIS RUDE (1784–1855). Although the work was done in 1833–36, one can still catch echoes of the *Oath of*

31-16. FRANÇOIS RUDE. *La Marseillaise (Departure of the Volunteers in 1792)*. 1833–36. Stone, approx. 42 × 26′ (12.8 × 7.93 m). Arc de Triomphe, Place de l'Étoile, Paris

31-17. JEAN-BAPTISTE CARPEAUX. *The Dance*. 1867–69. Plaster model, approx. 15′ × 8′6″ (4.57 × 2.59 m). Musée de l'Opéra, Paris

the *Horatii* (see fig. 30–9) in the bombastic mood and vigorous classical poses and costumes. Under the thundering folds of Liberty's flying garments, the massed figures, with their rich light-and-dark contrasts, are deployed to great effect against the clifflike surface of the Napoleonic Arc de Triomphe de l'Étoile, center of the radiating avenues the emperor designed for a new quarter of Paris. In contrast, the sculpture of JEAN-BAPTISTE CARPEAUX (1827–75) seems almost Rococo in its grace and sensuousness. In spite of its enormous scale, *The Dance* (fig. 31–17), of 1867–69, reminds one of Clodion (see fig. 29–19). Its energy and sparkle are seen better in the plaster cast after Carpeaux's original work in clay than in the somewhat more frigid version executed in limestone for the façade of the Paris Opéra. The irresistible verve of the work certainly influenced the sculpture of Auguste Rodin (see Introduction fig. 16) and even the paintings of Matisse (see fig. 35–3).

GERMAN ROMANTICISM A complete survey of Romanticism, like a thorough treatment of any other artistic style, would inevitably take in many phenomena of limited aesthetic interest. Even more than Neoclassicism, Romanticism was enthusiastically accepted in Germany, predisposed by the poetry of Goethe and Schiller and the music of the great Romantic composers. Unfortunately, no consistent pictorial tradition had existed in Germany since the sixteenth century, and many of the dreams of German Romantic painters were beyond their powers of execution, and immeasurably below the level of contemporary German music. A conspicuous exception is the art of CASPAR DAVID FRIEDRICH (1774–1840), a North German painter whose landscapes are of high artistic quality and great poetic depth.

31-18. CASPAR DAVID FRIEDRICH. *Abbey in an Oak Forest*. 1809–10. Oil on canvas, 44 × 68½″ (1.12 × 1.74 m). Staatliche Museen zu Berlin—Preussischer Kulturbesitz

31-18

Friedrich was as deeply imbued with love of nature as his English contemporaries but shared neither Constable's rhapsodic self-identification with natural forces nor J. M. W. Turner's desire to project his own emotions into natural lights and spaces. Friedrich was by inclination melancholy but deeply religious. His landscapes are a testament to the Romantic belief that religious faith could be expressed not only through traditional Christian subjects but also through the secular forms of nature. Meditations on solitude, alienation, and death predominate in his pictures; not surprisingly, his style shows none of the spontaneity of color and freedom of brushwork so impressive in his English contemporaries. "You shall keep holy every pure emotion of your soul," he said; "you shall esteem holy every pious presentiment. In an exalted hour it will become visible form and this form is your work."

Friedrich's mystical doctrines are set forth with great precision of form and surface. In his meticulously painted *Abbey in an Oak Forest,* of 1809–10 (fig. 31–18), the ruined Gothic choir of a monastic church near his native town of Greifswald combines with the gnarled profiles of leafless, wintry trees to define a space suggesting profound desolation. Since the shattered church had long been abandoned when Friedrich painted it, and since funerals do not take place in ruins, the lonely procession of monks following a coffin through the portal in the snow, is clearly intended as a visionary evocation of the vanished past. The intensity of the mood and the clarity of the surface rendering foreshadow aspects of Surrealism in the twentieth century (see Chapter Thirty-Seven).

Painting in England

Romantic art in England lacked the ideological impetus of the Revolution and the Napoleonic wars, and like much of English Romantic poetry was highly personal. The strangest figure of the period was WILLIAM BLAKE (1757–1827), a visionary poet and painter, who was vehemently opposed both to Sir Joshua Reynolds and to the teaching of the Academy. Trained in a severe classical style by drawing from plaster casts of ancient art, and influenced deeply by the art of Michelangelo he knew only from engravings, he was also familiar with medieval churches and steeped himself in the Bible, in Dante, and in Milton. In addition to his own mystical poems, which he illustrated himself, he created an amazing series of illustrations of his favorite literary works both in engravings, which he hand-tinted, and in watercolors, marked by surprising distortions of anatomical reality and by

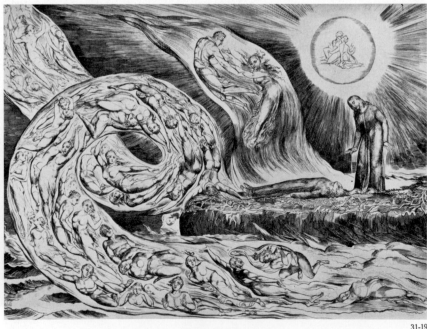

31-19. WILLIAM BLAKE. *Circle of the Lustful,* illustration for Dante's *Inferno.* 1824–27. Ink and watercolor on paper. Birmingham Museums and Art Gallery, Birmingham, England

31-19

strong abstract movement of form and color. In his *Circle of the Lustful* (fig. 31–19), of 1824–27, Blake illustrates Canto V of Dante's *Inferno,* in which Virgil shows the poet a whirlwind carrying lovers from the past who had abandoned reason for a life of passion and are doomed to be swept along by the tempest for eternity without rest. At Dante's request Virgil beckons nearer Paolo and Francesca, and as they tell their story of guilty love, and as their first kiss appears above in a vision, Dante falls in a swoon. Blake's startling simplifications of the human form derive from its subjection to mystical forces, in this case the mighty spiral that heaves the various lovers up and around in the foreground and off into the distance. A strong believer in genius as a God-given force within the artist, Blake is often cited as a precursor of certain aspects of twentieth-century art; Oskar Kokoschka, for example, may have known this watercolor when he painted *Bride of the Wind* (see fig. 35–18).

CONSTABLE The mainstream of English painting in the first half of the nineteenth century was landscape; Constable and Turner, the greatest of the landscapists, approached nature with an excitement akin to that of the poets Wordsworth, Keats, and Shelley. It is not beside the point that nature itself was beginning to be swallowed up by the expanding cities of the Industrial Revolution, then in full swing. The effects of that transformation were lamented by Oliver Goldsmith in his *The Deserted Village* in 1770, and William Blake had deplored the "dark Satanic mills." John Constable (1776–1837), son of a miller on the River Stour in Suffolk, celebrated all that was natural and traditional, including the age-old occupations of farmer, miller, and carpenter, close to the land whose fruits and forces they turned to human use. As we have seen (page 857), he loved the poetic landscapes of Gainsborough, but he also studied the constructed compositions of the Baroque, especially those of Claude Lorrain, then considered the standard for all landscape painting, and of Jacob van Ruisdael, whose skies he particularly admired (see figs. 27–6, 28–4). Rebelling against the brown tonality then fashionable in landscape painting—actually the result of discolored varnish darkening the Old Masters—he supplemented his observations of nature with a study of the vivacity of Rubens's color and brushwork (see fig. 27–28).

As early as 1802, Constable had started to record the fugitive aspects of the sky in rapid oil sketches made outdoors, the earliest series of outdoor paintings of which we have any record. "It will be difficult to name a class of landscape in which sky is not the keynote, the standard of scale, and the chief organ of sentiment," he wrote. His systematic studies of cloud formations, done in 1821–22, were influenced by the scientific research on cloud types and formations conducted by the contemporary Englishman Luke Howard. But even more important than their devotion to actual appearances, Constable's studies show an abandonment to the forces of nature, a passionate self-identification with sunlight, wind, moisture, and light. One is reminded of Shelley's invocation to the west wind, "Make me thy lyre, even as the forest is." Constable allowed nature to play upon his sensibilities as on an instrument. At first he made dutiful sketching tours through regions of acknowledged scenic beauty (he never left England) but before long came to the conclusion that "it is the business of the painter to make something of nothing, in attempting which he must almost of necessity become poetical." He returned to the quiet landscape of the Stour Valley with a special delight. "The sound of water escaping from milldams, etc.," he wrote, "willows, old rotten planks, slimy posts, and brickwork—I love such things."

His superb *Hay Wain* (fig. 31–20), of 1821, sums up his ideals and his achievements. No longer contrived but composed as if accidentally—though on the basis of many preliminary outdoor studies—the picture, painted in the studio, shows Constable's beloved Stour with its trees, a mill, and distant fields, and all the slimy posts his heart could desire. In his orchestra of natural color the solo instrument and conductor at once is the sky. The clouds sweep by, full of a light and color not even the Dutch had ever attained, and their shadows and the sunlight dapple the

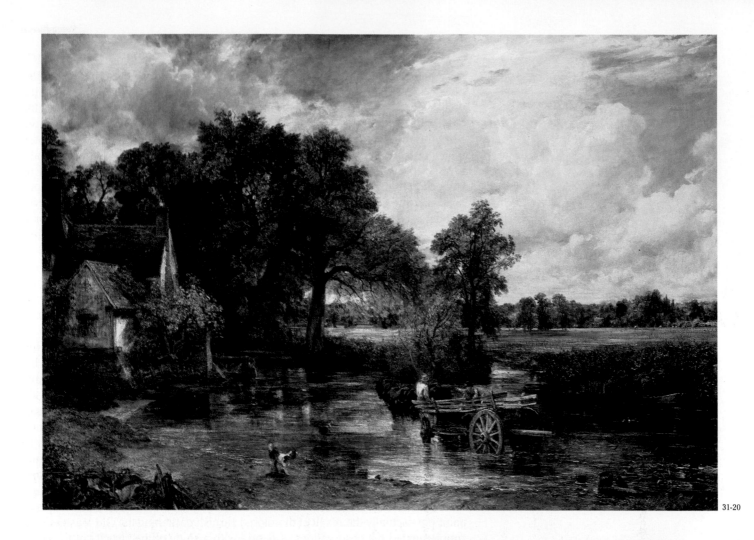

31-20

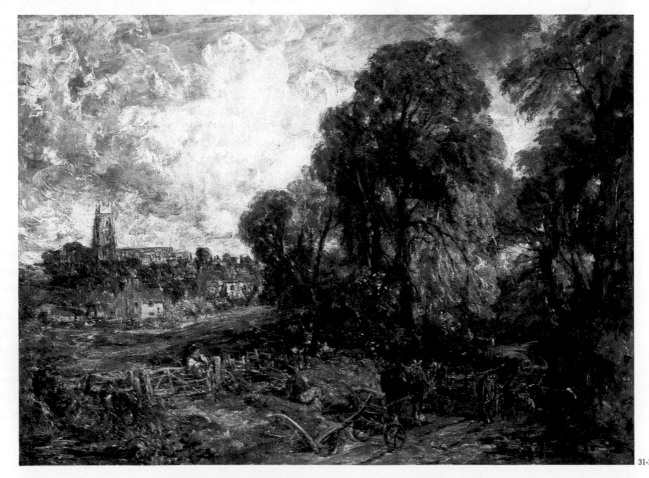

31-21

31-20. JOHN CONSTABLE. *Hay Wain.* 1821. Oil on canvas, 51¼ × 73″ (1.3 × 1.85 m). National Gallery, London. Reproduced by courtesy of the Trustees

field with green and gold. As the stream ripples, it mirrors now the trees, now the sky, breaking blues and greens into many separate hues, including touches of white when direct sunlight sparkles back. The trees themselves, in fact, are made up of many shades of green, set side by side, and patches of light reflect from their foliage. These white highlights were incomprehensible to many contemporary viewers, who called them "Constable's snow."

This comment is one of the first of the adverse reactions that became common in the nineteenth century on the part of a public that resented being shown what it actually saw, instead of what it had been taught by tradition and Old Masters it ought to see. Under Impressionism in the 1870s (see Chapter Thirty-Three), the detachment between artist and public was to become extreme, but enough people appreciated Constable's new vision of nature that his work could be exhibited at the Royal Academy, of which he was belatedly made a member in 1829. Géricault saw and was impressed by Constable's painting during his English trip, and the *Hay Wain* was, as we have seen, triumphantly exhibited at the Salon of 1824, where Constable's broken color and free brushwork were a revelation to Delacroix. Although the later Impressionists were not directly influenced by Constable, he may be said to have set in motion a new current in French landscape art, which later culminated in the Impressionist movement.

In later life, after the death of his wife, Constable entered a period of depression in which his passionate communion with nature reached a pitch of semimystical intensity that competes with the visions of El Greco (see fig. 25–33) in vibrancy and force. One of these late pictures is *Stoke-by-Nayland,* of 1836–37 (fig. 31–21), a large canvas in which the distant church tower, the wagon, the plow, the horses, and the boy looking over the gate are instruments on which light plays. The symphonic breadth of the picture, and its crashing chords of color painted in a rapid technique using the flexible steel palette knife to apply the paint as much as the brush, bring to the finished painting the immediacy of the color sketch. Such pictures are equaled in earlier art only by certain landscape backgrounds in Titian (see fig. 24–10) or by the mystical reveries of Rembrandt late in his life (see fig. 28–19).

TURNER Constable's contemporary Joseph Mallord William Turner (1775–1851) was like Hogarth a Londoner and had none of Constable's mystical attachment to nature. Nor did he remain fixed in England, but for many years made frequent trips throughout the Continent, especially Germany, Switzerland, and Italy, reveling in mountain landscapes, gorgeous cities (especially Venice), and the most extreme effects of storms, fires, and sunsets. Once he even had himself tied to a mast during a storm at sea so that he could experience the full force of the wind, waves, and clouds swirling about him. Although he made beautiful and accurate color notes on the spot in watercolors—a traditionally English medium that he pushed to its utmost limits of luminosity—he painted his pictures in the studio in secrecy, living under an assumed name and accepting no pupils. He was the first to abandon pale brown or buff priming, still used by Constable, in favor of white, against which his brilliant color effects could sing with perfect clarity.

Turner often painted historical subjects, usually like those of Delacroix involving violence, as well as shipwrecks and conflagrations, in which the individual figures appear as scarcely more than spots in a seething tide of humanity. He liked to accompany the labels with quotations from poetry, often his own. Nonetheless, at his death a great many unfinished canvases were found that had no identifiable subject or representation at all. What he really enjoyed and painted first was the pure movement of masses of color without representational meaning, although natural forces and effects are often suggested—a kind of color music, strikingly relevant to Abstract Expressionism of the 1950s (see pages 1019–25). Shortly before the opening of an exhibition at the Royal Academy, the aging Turner would send in such unfinished works and on varnishing day would paint in the details to make the pictures exhibitable to a nineteenth-century public.

31-21. JOHN CONSTABLE. *Stoke-by-Nayland.* 1836–37. Oil on canvas, 49½ × 66½″ (1.26 × 1.69 m). The Art Institute of Chicago. Mr. and Mrs. W. W. Kimball Collection

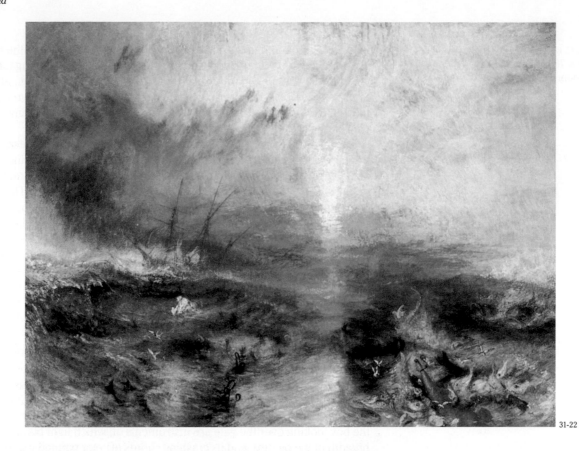

31-22

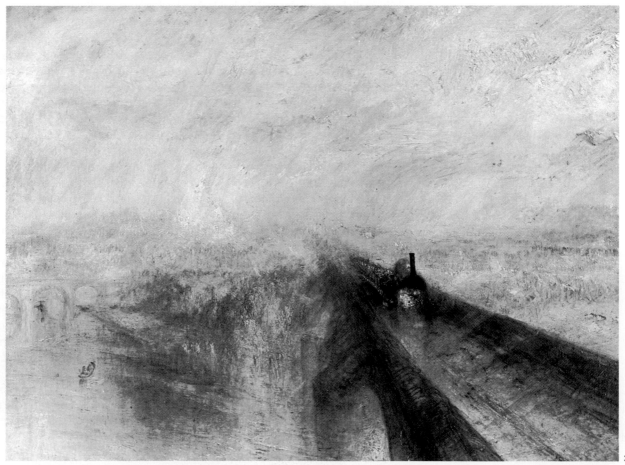

31-23

31-22. JOSEPH MALLORD WILLIAM TURNER. *Slave Ship.* 1840. Oil on canvas, 35¾ × 48″ (90.8 × 122 cm). Courtesy, Museum of Fine Arts, Boston. Henry Lillie Pierce Fund (Purchase)

31-23. JOSEPH MALLORD WILLIAM TURNER. *Rain, Steam, and Speed.* 1844. Oil on canvas, 35¾ × 48″ (90.8 × 122 cm). National Gallery, London. Reproduced by courtesy of the Trustees

Slave Ship, of 1840 (fig. 31–22), represents an incident all too common in the days of slavery, when entire human cargoes were pitched into the sea, either because of epidemics or to avoid arrest. The ship itself, the occasional figures, and the fish feasting on the corpses in the foreground were obviously painted at great speed only after the real work, the movement of fiery waves of red, brown, gold, and cream, had been brought to completion.

Rain, Steam, and Speed, of 1844 (fig. 31–23), is one of the very first paintings of a railway train, and its Romantic idealization of progress—man conquering nature by utilizing its forces—should be compared with the more objective, visual approach of Claude Monet in 1874 (see fig. 33–6). The train with its lighted carriages (preceded by a speeding rabbit, impossible to see in the illustration) moving across the high bridge is enough of a subject already, but Turner lifts it to an almost unearthly realm in which insubstantial forces play through endless space. The veils of blue and gold are the real subject of the picture, and it was Turner's heightened and liberated color sense that proved as much of a revelation to those Impressionists (especially Monet) who took refuge in London in 1870 as had Constable's *Hay Wain* to Delacroix nearly half a century before.

Architecture

Like Romantic sculpture, the architecture of the Romantic movement is often of uncertain and irregular quality, yet it can be extremely successful in its picturesqueness; like Romantic painting, Romantic architecture seeks above all to establish a mood. Some architects entrusted with Romantic schemes had already carried out major Neoclassical projects. John Nash, for instance, the architect of Park Crescent (see fig. 30–8) in 1812, was asked in 1815 to begin the remodeling and enlargement of the Royal Pavilion at Brighton (fig. 31–24), a pleasure dome for the prince regent, later George IV, with forms imitated from Islamic architecture in India. This kind of thing is a lineal descendant of the Chinese pagodas that often rose in eighteenth-century gardens, but it is one of the earliest instances of a pseudo-Oriental building intended for habitation. The interiors are derived from a variety of sources—Greek, Egyptian, and Chinese—but the exterior with its tracery and onion domes, and its chimneys masquerading as minarets, is a delightful bit of Oriental fantasy, whose changing forms and surfaces are calculated for the soft sea light of Brighton.

To the English, Gothic architecture was an indigenous style (notwithstanding its French origin), and it is hardly accidental that Gothic was adopted for the Houses of

31-24. JOHN NASH. Royal Pavilion, Brighton, England. Remodeling begun 1815

31-24

31-25

31-25. Sir Charles Barry and A. Welby Pugin. Houses of Parliament, London. 1836–c. 1860

Parliament, begun in 1836 and completed only after 1860. The immense structure adjoins the older, truly Gothic Westminster Hall, and from many points of view can be seen together with the Gothic Westminster Abbey. Two architects of diverse tastes, Sir Charles Barry (1795–1860), a Neoclassicist, and A. Welby Pugin (1812–52), a Gothic revivalist, collaborated on the design. At first sight (fig. 31–25) Gothic irregularity seems to predominate, in view of the asymmetrical placing of the major towers, but it soon becomes apparent that in Barry's plan around a central octagon, and especially the handling of the masses along the river front, the building is as symmetrical as any Renaissance or Baroque palace. In its linearity and abundance Pugin's detail is derived from Perpendicular Gothic, for example, such monuments as Gloucester Cathedral and Henry VII's Chapel.

Although in England the Gothic style could be used for anything from public buildings to distilleries and sewage plants, in France it appeared suitable only for churches, often built in imitation of High Gothic cathedrals. For other structures classicism continued well into the nineteenth century, gradually modified by a revival of the French Renaissance. The city of Paris itself is the triumphant result of this revival. Napoleon I had designed a system of avenues radiating outward from the Arc de Triomphe de l'Étoile and connected this monument to imperial glory with the Louvre by a prolongation of the Champs Élysées, so that artillery could, if necessary, rake a considerable area of the city. His nephew Napoleon III (ruled 1852–71) employed the engineer Georges Eugène Baron Haussmann (1809–91) to interconnect these radiating avenues with new boulevards, in order to ring the city after the destruction of the medieval walls, and with new broad avenues cut through older quarters. This network of stately thoroughfares was bordered by trees and lined with limestone façades whose design, while not absolutely uniform, was controlled in the interests of consistency and imposed upon owners and builders alike. Generally, the houses consisted of six stories; the first was occupied by shops, the second and third were united by pilasters delicately projected like those of Pierre Lescot's Square Court of the Louvre (see fig. 25–19), the fourth, above the entablature, remained plain like a Renaissance attic story, and the fifth and sixth were tucked into a towering, bulbous roof known as a *mansard* (after the seventeenth-century architect François Mansart). The regulations prevented the construction of buildings of any great individuality but created a homogeneous urban picture unequaled in known history, which remained intact until the tragic depredations under the Pompidou regime in the 1970s. The long avenues and

31-26. CHARLES GARNIER. Opéra, Paris.
1861–75

31-27. CHARLES GARNIER. Plan of the Opéra,
Paris

31-27

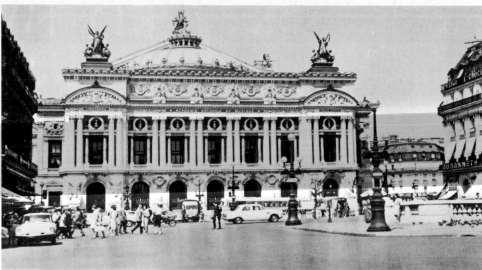

31-26

31-28. CHARLES GARNIER. Grand Staircase,
Opéra, Paris

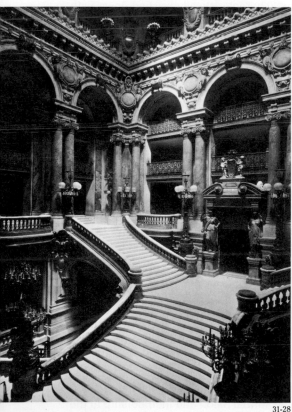

31-28

gently curving boulevards provided airy, luminous vistas extremely important for the Impressionists, who found in them a new and vital subject for their paintings (see Introduction fig. 8 and fig. 33–10).

Here and there in the Haussmann plan loomed monumental structures, some preexistent, such as Notre-Dame, the Panthéon (see fig. 29–8), and the Madeleine (see fig. 30–6), some extended under Napoleon III, such as the Louvre, and some entirely new, such as the Opéra (figs. 31–26, 31–27), designed in 1861 by CHARLES GARNIER (1825–98) and intended as the focus of the new Paris. Actually, the structure was detested by the Empress Eugénie, who would have preferred a less ostentatious building, but it epitomized the taste of the new industrial bourgeoisie who had supported King Louis Philippe, become stronger yet under Napoleon III, and dominated the Third Republic (1871–1940); it was completed only in 1875, four years after the collapse of Napoleon III and his Second Empire. With its giant order of coupled Corinthian columns supported by an arcade and connecting two terminal pavilions, the façade is clearly derived from the twin palaces by Ange-Jacques Gabriel (1698–1782) on the Place de la Concorde, but immensely enriched with sculptural ornament (including Carpeaux's *The Dance;* see fig. 31–17). The low, bulbous dome with its sculptured lantern, and the allegorical groups imitated from classical Victories create a rich, Neo-Baroque profile sharply different from the compact masses favored by eighteenth-century classicism.

The barely tolerable splendor of the exterior becomes offensive to many in the Grand Staircase (fig. 31–28), a setting calculated for the display of wealth and luxury, which encloses approximately as much space as the auditorium itself. With its cascading flights of steps, ponderous sculptural decorations—including even the light fixtures (intended for gaslight)—and veined marble columns, the Grand Staircase is the swan song of Neo-Baroque magnificence, the kind of aberration against which architects in that very period were beginning to react (see figs. 32–14, 32–15), later to be jettisoned entirely by the progressive designers of the late nineteenth century and twentieth century. It is, however, the direct ancestor of many grandiose buildings throughout the world, including the movie palaces that rose in cities everywhere in the 1920s and 1930s to gratify a different sort of collective fantasy. To be understood, the Grand Staircase, like the Hall of Mirrors at Versailles, must be peopled in our imagination with the classes for whom it was intended—men in black tailcoats and women in gorgeous fabrics, bustles, and trains, representing the old nobility; the new Bonapartist aristocracy; the industrialists; and, surprisingly enough, a wholly new class of prosperous courtesans that battened on all three.

CHAPTER THIRTY-TWO

While the battle between the Neoclassicists and the Romanticists was reaching its height, a third group of artists was at work, inconspicuously at first—then more and more vocally—for whom the struggle had no meaning; for them, both sides were wide of the mark. The term *Realism,* applied to the new movement only in the 1840s and grudgingly accepted by its protagonists, can be extended to cover its beginnings two decades or more earlier. For the entire group, history had no artistic importance. Gustave Courbet, its most powerful champion, declared that Realism was a "human conclusion that awakened the very forces of man against paganism, Graeco-Roman art, the Renaissance, Catholicism, and the gods and demigods, in short against the conventional ideal." The Realist revolt was even directed against the rendering of any contemporary events, military or political, in which the artist had not actually taken part.

To the Realists the only worthy forebears were the Dutch and Flemish naturalists of the seventeenth century, the study of whom was led by one of the principal apologists of Realism, Théophile Thoré (1807–69), who may be said to have rediscovered Jan Vermeer. In 1850 Champfleury (Jules Fleury-Husson, 1821–89), another theorist of the movement, wrote the first appreciation of the Le Nain brothers, expanded into a book in 1862, *Les peintres de la réalité sous Louis XIII: Les frères Le Nain.* Soon critics began to reevaluate earlier naturalists—some of the neglected Venetian minor painters, for example—and the great Netherlandish and Italian masters of the fifteenth century. Jean-Baptiste-Siméon Chardin and other eighteenth-century naturalists were at last fully understood.

It is hardly surprising that most of the Realists were staunch republicans, dedicated along with their literary friends to the establishment of a new social order founded on justice for the working class. Artists, politicians, economists, critics, and philosophers met and exchanged ideas in the Andler Keller, a Parisian brasserie (a type of restaurant serving food at all hours, characteristically washed down with beer), which became known as the "temple of Realism." Significantly enough, the Realists ran afoul of organized authority. Courbet's paintings were refused by the director of the imperial museums, Count Nieuwerkerke, at the Universal Exposition of 1855, and eventually the split between progressive artists and conservative power became so great that in 1863 a Salon des Refusés (Salon of the Rejected) was organized, which exhibited the works of those who are now recognized as the best painters of the period. As a consequence of their participation in social movements, two of the greatest Realist masters, Honoré Daumier and Courbet, were actually forced to serve prison sentences.

The break between new and accepted art, which seems to have been heralded in the seventeenth century by the refusal of two of Caravaggio's paintings by the patrons who had commissioned them and by the declining material success of Rembrandt in his middle age, reached a crisis in the mid-nineteenth century. From our present vantage point it is a little hard to understand why, for to twentieth-century eyes Realist painting looks eminently conservative. On leaving a gallery devoted to Neoclassicism and Romanticism, one is instantly aware of a lowering of the general tonality of color in Realist painting, as well as of action and emotion. For the Realists the brightly tinted linear constructions of Ingres and the rich chromatic fantasies of Delacroix were equally luxurious, even self-indulgent. One had to begin again, with the sensations of actual existence, the brown of the earth, the blue of the sky, the green of foliage, the gray of stone, the drab colors of everyday garments. This resolute, almost puritanical concentration on fact instead of fancy was a shock to Parisians, and by no means universally accepted. They preferred not only the work of Ingres, Delacroix, and their followers but also meticulously painted storytelling pictures, which won prizes at the annual Salon and membership in the

Academy for their painters by cheapening the ideas of both Neoclassicists and Romanticists. Attempts have been made in recent years by revisionist art historians to reinstate the works of these official painters—Thomas Couture, William-Adolphe Bouguereau, Jules Bastien-Lepage, to mention only a few, and their imitators in Central and Eastern Europe—in spite of the aesthetic dullness and emotional triviality of some of their work, not to speak of their predictable opposition to progressive trends in art. But some of these Salon regulars do merit reexamination, in particular Jean-Léon Gérôme, who was a highly skilled painter and acute chronicler of contemporary life in the Near East (see fig. 32–13).

Despite official condemnation of the Realists, many critics, notably the poet Charles Baudelaire, found something deeply satisfying in the solidity of these matter-of-fact painters, who could and did discover poetry and even drama of a high order in the prosaic phenomena of existence as revealed by sight. Their concentration on visual reality, moreover, was to stimulate the Impressionists, all of whom began as Realists and continued to call themselves such in their revolutionary exploration of the perception of light.

For it was light that concerned the nineteenth century most intensely, in art and life. New methods of illumination, first by kerosene lamps, then by gas, and finally by electricity, irradiated homes and banished night from the streets. For the first time pictures created by light and light alone could be made permanent: The moment of the action of light on a sensitive surface—whether the human retina or a piece of metal, glass, or paper—was revealed as a source of knowledge about reality, confirming and raising to a higher power the investigations of such Renaissance pioneers as Leonbattista Alberti, Lorenzo Ghiberti, and Leonardo. The interrelations between photography and the other arts, important as they are, yield before the fact that in the amazing nineteenth century all the progressive arts including architecture moved in the same direction, with or without knowledge of each other, toward the understanding and exploitation of natural light. Unexpectedly, the rapid development and spread of photography meant that for the first time the great art of past and present in whatever country was universally accessible, in photographic monochrome translation, without the intervention of any engraver.

Photography

As its title indicates, this book cannot accord photography the full treatment as an independent art that its importance demands, but unless we give brief consideration to photography and photographers—here and in Chapter Thirty-Eight—we will fail to gain an adequate understanding of nineteenth- and twentieth-century art. In a remarkably short time, as Gene Markowski has observed, "photography has become not only a phenomenal technical means of communication and visual expression, but unquestionably the world's most powerful image-making system. . . . No one alive today, save perhaps in a handful of remote mountainous, oceanic, or jungle areas, can escape the media of illustrated publication and television, and thus photography has provided the form in which our view of the world and of ourselves is inevitably cast."

The idea of photography was not new. As we have seen, it had been known for centuries that light passing through a small aperture registers an image of objects upon any surface it may strike. Such devices as the camera obscura by which this image could be carefully controlled (see pages 829–30) were used by many artists in the sixteenth, seventeenth, and eighteenth centuries, especially Vermeer, though such academically minded painters as Sir Joshua Reynolds warned against reliance on such mechanical aids at the expense of ideal concepts. But as long as an image

32-1. Louis-Jacques-Mandé Daguerre. *Paris Boulevard.* 1839. Daguerreotype (original destroyed). Bayerisches Nationalmuseum, Munich

required the intervention of a mechanical device before it could be seen at all, and changed or perished altogether as objects moved or light waned, its usefulness was limited. During the eighteenth century, scientists endeavored to sensitize by means of chemicals various surfaces to arrest the action of light after the image had been projected upon them, but not until the 1820s with the experiments of the French chemist Nicéphore Niépce (1765–1833) did the process begin to succeed. In 1826 Niépce made the first surviving photograph, a dim and hazy view on polished pewter of the courtyard outside his home. The exposure took eight hours—a length of time too great for portraiture and during which shadows could change totally. Dissatisfied, Niépce enlisted the collaboration of Louis-Jacques-Mandé Daguerre (1789–1851); Daguerre was a scenic artist, skilled in the elaborate construction of pictorial sets and systems of illumination for the Paris Opéra, and of dioramas, which entertained the public with gigantic moving views of cities and historical scenes.

After Niépce's death Daguerre perfected the new process using a plate of copper coated with silver, which was sensitized chemically in darkness, then inserted into a camera obscura provided with a focused lens, exposed to light, and again treated in chemical baths first to develop the image and then fix it—a procedure whose basic steps are familiar to professional and amateur photographers today. The result was an image of a degree of detail not achieved since early Netherlandish painting—silvery, shimmering, and soft brown in tone; moreover, exposure time was reduced to between ten and fifteen minutes. However, three problems remained: the *daguerreotype* (as its inventor called it) was unique, unless rephotographed; it was reversed, since it was, after all, a mirror image; and it could be seen only in the right light, otherwise it reflected. On August 7, 1839, the new procedure of photography was described to the French Academy of Sciences. Before the year was out, the directions had been translated into all Western languages. Daguerreotypes were soon made by the hundreds of thousands, cheaply enough for most to afford, on copper plates one-fourth the original size. The first bona fide photoportrait was made by Samuel F. B. Morse, inventor of the telegraph. The sitter had to be anchored to a rigid, hidden frame, and since bright sun was a requisite, the eyes had to be closed and were often painted in later. The earliest known photograph of a human being, taken by Daguerre in 1839 (fig. 32–1), shows a Paris boulevard which at the time, according to Morse, was crowded with people and horse-drawn vehicles. Knowing this makes the picture a bit uncanny since nearly all have

disappeared. The only person who stood still long enough for his image to register was a man having his shoes shined—of all prosaic activities to be the first ever permanently recorded by light! Rapidly the necessary exposure times were reduced to as little as thirty seconds in bright sun.

The possibilities of the new discovery were enormous. Painters were afraid their art was doomed (and indeed the art of painting miniature portraits really did disappear as a direct result of photography), yet they used photographs consistently as shortcuts for the painted portraits that were their bread and butter. Now the innumerable sittings could be reduced to just those required to assure the correctness of the coloring. Ingres objected vigorously to the photograph as an art form but could not get away from its usefulness. His portrait of the comtesse d'Haussonville (see fig. 30–15), painted just six years after the announcement of the new procedure, was surely based on daguerreotypes, whose influence is apparent in the silvery precision of the painter's style. Delacroix welcomed photography as a way of fixing hard-to-hold poses and used it insistently in his later work; he also accepted photography as an independent art.

At the same time Daguerre was making his first experiments, the Englishman William Henry Fox Talbot (1800–1877) was devising another process called *calotypy,* which involved paper negatives and paper prints, and he announced it the same month. Calotypes were a little blurred as compared with daguerreotypes, but innumerable prints could be made from the negatives, their image was not reversed, and they could be viewed in any light. An even more successful improvement was the *collodion* or *"wet-plate" process,* invented by the sculptor and photographer Frederick Scott Archer, who published his discovery in 1851. At last the print could be almost as precise as a daguerreotype, and the negative could be made much faster. An immense amount of equipment was required for wet-plate photography, but clearly both daguerreotype and calotype were doomed. Archer's process flourished for the next thirty years, until the invention of the *gelatine-coated dry plate.* By 1858 instantaneous photography was an assured fact, and photographers were able to prove at last how living beings really look in motion, to the great discomfiture of artists in the classic tradition with their contrived poses.

The great master of wet-plate portraiture was GASPARD-FÉLIX TOURNACHON (1820–1910), a French caricaturist and novelist who went by the pseudonym of NADAR. Almost immediately after its invention Nadar began to exploit the possibilities of the new art from every conceivable direction, including up (he invented aerial photography, from balloons). Nadar's Paris studio became a meeting place for all the intellectual and artistic figures of mid-nineteenth-century Paris, a much wider circle than that of the Andler Keller. His portraits of painters, writers, composers, and scientists are not mere documents like those of Daguerre but works of art—so conceived, posed, and lighted as to bring out the full psychological and spiritual depth of a sitter without the aid of any of the props common in nineteenth-century photography studios. For prototypes one can think only of the searching portraits of Raphael and Rembrandt. It does not matter that Nadar had no painting or drawing instrument in his hand—neither does an actor, but what he creates is art. According to Eugène de Mirecourt, a contemporary of Ingres, as early as 1855 the great Neoclassicist sent all his sitters to Nadar first, and then worked from the photographs. Nadar's *Portrait of George Sand,* made in 1870 (fig. 32–2), shows the photographer at his grandest. The Romantic novelist who shocked conventional France by daring to live as freely as all men of her class (she was actually the Baroness Dudevant; like many women writers in the nineteenth century she took a pen name) appears at the age of sixty-six. A white streak is visible in the part of her dyed hair; it was not retouched. The pose, the sculptural folds of her dress, and the lighting are so arranged as to suggest all the richness of her emotional life.

By 1860 the art of photography had become a fiercely competitive business. Countless practitioners of negligible technical or creative skill eagerly fed the ever-

32-2. NADAR. *Portrait of George Sand.* 1870. Wet-plate photograph. International Museum of Photography at George Eastman House, Rochester, New York

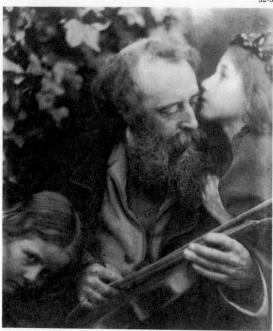

increasing public appetite for photographs, particularly portraits. The British amateur photographer JULIA MARGARET CAMERON (1815–79), a woman of indomitable energy and generosity, was a notable exception to this trend. In 1864 she consciously set out to elevate the status of photography from a commercial trade to a fine art. At her home in Freshwater Bay on the Isle of Wight, Cameron took up photography—in the form of the cumbersome collodion process—at the age of forty-eight. Like Nadar, she turned for her subject matter to her illustrious circle of friends, which included many of the leading writers, painters, and scientists of the day. The Victorian painter George Frederic Watts, who is depicted in the *Whisper of the Muse* (fig. 32–3), was Cameron's chief artistic mentor and close friend. Although only in his late forties or early fifties at the time of the portrait (about 1867), Watts appears as a kind of ancient bard, propping up a violin and dreamily listening to the inspirational murmurings of two child muses. The soft, slightly unfocused quality of the photograph was no accident. Cameron had little regard for the tight, crisp images provided by the daguerreotype, for her aim was not a precise likeness but a poetic idea. The innovative methods Cameron employed to create soft chiaroscuro and evocative images made her an important forerunner of the international Pictorialist movement in photography that flourished between 1890 and 1910. Exponents of Pictorialism, such as Gertrude Käsebier, Alvin Langdon Coburn, Edward Steichen, and Alfred Stieglitz (see pages 1054–55), stressed the intuitive and subjective nature of the photographic process and technically manipulated their photography to achieve hazy, moody images more concerned with making an aesthetic statement than documenting a visual fact. By so doing, they hoped to demonstrate photography's affinity with painting and to elevate its status to that of a fine art. This tender image of artistic inspiration may appear sentimental to us today, but Cameron's contribution to the aesthetics of photography was significant, and her work shared many affinities with contemporary painting, particularly that of the Pre-Raphaelites (see below). Of one of her photographs Watts declared, "I wish I could paint such a picture as this."

32-3. JULIA MARGARET CAMERON. *Whisper of the Muse.* c. 1865. Platinum print made by ALVIN LANGDON COBURN in 1915 from the original negative. International Museum of Photography at George Eastman House, Rochester, New York. A. L. Coburn Collection

Painting in France

COROT Conceived in total isolation from the earliest photographic experiments, yet mysteriously parallel to them, the new objective style becomes apparent first in the quiet early landscapes of Jean-Baptiste-Camille Corot (1796–1875). Son of a moderately prosperous businessman, Corot was enabled by a paternal allowance to leave business for the study of painting at the unusually late age of twenty-six. After three years of study, he made his first trip to Italy in 1825, remaining until 1828. It is typical of his attitude toward Italian art that not until his third visit to Italy in 1843 did he pay what he termed a "courtesy call" on the Sistine Chapel. What interested him was not the long Italian artistic tradition from the ancient world, the Middle Ages, the Renaissance, and the Baroque, but the harmony of man and nature in the Italian landscape and the beauty of Italian light, which erases differences of time and unifies all objects, natural or man-made, in the serenity of vision.

Although he occasionally painted pictures on religious or mythological themes for exhibition at the Salon or on commission, the figures in these paintings are usually quite small, and the artist's primary concern is the landscape. Corot's little landscape studies done outdoors, like the contemporary oil sketches of Constable, were sometimes used as themes for larger, finished works painted in the studio; in the twentieth century these studies are valued for their own sake, as tiny miracles of color, form, and light. In fact, not since Piero della Francesca (see figs. 20–53 to 20–56), whose work Corot probably never saw, had form been so beautifully constructed through the play of light. Looking at such a masterpiece as the *Island of San Bartolomeo,* of 1825 (fig. 32–4), it is hard to believe that Corot had only begun to paint three years before. No matter what their age or historical importance, the buildings and bridges of Rome were to him cubes bounded by planes, revealed by

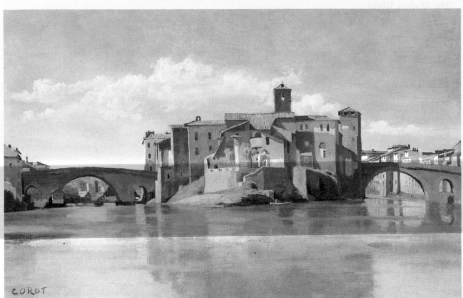

32-4. JEAN-BAPTISTE-CAMILLE COROT. *Island of San Bartolomeo.* 1825. Oil on canvas, 10½ × 17″ (26.7 × 43.2 cm). Formerly Collection Florence Gould

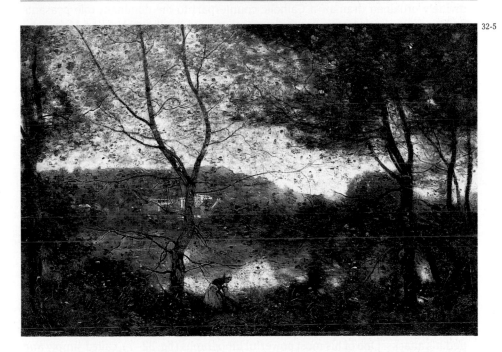

32-5. JEAN-BAPTISTE-CAMILLE COROT. *Ville d'Avray.* 1870. Oil on canvas, 21⅝ × 31½″ (55 × 80 cm). The Metropolitan Museum of Art, New York. Bequest of Catherine Lorillard Wolfe, 1887

delicate changes of hue and value. Corot claimed that he could distinguish no fewer than twenty gradations between pure white and black, but in his landscape he restricts himself generally to the upper and middle ranges; there are seldom any deep shadows. Pearly tones of blue gray, blue, tan, and rose establish the existence of forms in clear Italian air and prolong them in reflections on the surface of the river, disturbed only here and there by ripples. It is typical of Corot's detachment that in these early cityscapes not a human or animal can be seen—again mysteriously, as in early depopulated photographs. The timelessness of these meditations on form and light anticipates in many ways the art of Paul Cézanne toward the close of the nineteenth century (see pages 941–45) and that of the Cubists in the early twentieth (see Chapter Thirty-Six).

Although toward the end of his career Corot returned to the objectivity of his early work, in middle life he took to painting dreamy landscapes in the studio either from memory or imagination. He had a house at Ville d'Avray, a hamlet on the edge of the Forest of Fontainebleau. The silvery light of Corot's woodland studies, such as *Ville d'Avray* (fig. 32–5), of 1870, is broken by fugitive touches indicating foliage, in reminiscence of the technique of Constable. The Impressionists found these later landscapes lacking in devotion to reality, and twentieth-century critics have gener-

ally preferred the cubic forms of Corot's earlier work. But the landscapes were immensely popular and widely imitated—even forged—in Corot's own time. Their velvety gray and olive tones, suggesting layers of space seen through superimposed films of light and shade, are very beautiful; so, indeed, is their unique personal poetry. A frequent visitor to Nadar's studio, Corot experimented with photographic procedures in making his engravings and was surely influenced by photography in the nearly monochromatic and soft-focus landscapes of his later years.

MILLET Another painter who settled in the Forest of Fontainebleau, at the village of Barbizon, and was not likely to be found among the Realists of the Andler Keller, was Jean François Millet (1814–75). Born in Normandy of a peasant family, he preferred to live like a peasant, with his family of fourteen children, dedicating his life to the painting of peasants in whose attachment to the soil he found a religious quality. Generally, before his time peasants had been portrayed as stupid or even ridiculous, even when Pieter Bruegel the Elder (see figs. 25–24, 25–26) permitted them to exemplify the blind forces of nature. Millet saw them as pious actors in a divinely ordained drama—a Catholic counterpart to the dominant role peasants and workers were assuming at that very moment in the thought of Karl Marx, who would have had little but contempt for Millet's peasants' acceptance of their humble lot. Millet invests the solitary figure in his *Sower,* of about 1850 (fig. 32–6), with a Michelangelesque grandeur as he strides over the plowed land, and the broad strokes of rich pigment emulate Rembrandt.

DAUMIER One of the Realists who met in the Andler Keller and in Nadar's studio was Honoré Daumier (1808–79), a man of profound moral conviction who was known to most Parisians of his day solely as a caricaturist. He worked in the *lithograph* technique, which involved drawing on porous stone with a fatty pencil; the image could be printed easily and in large numbers along with blocks of type, which made it ideal for newspaper illustration. Both Géricault and Delacroix had made lithographs, but Daumier poured out more than four thousand of them in the course of some thirty years for such satirical weeklies as *Caricature* and *Charivari*. He was one of the most brilliant and devastating caricaturists who ever lived, satirizing unmercifully the Royalists, the Bonapartists, politicians in general, and lawyers in particular, and mocking somewhat more indulgently the foibles of the bourgeois class on whom the shifting governments of nineteenth-century France depended for their support. He was imprisoned for six months in 1832 for a caricature of King Louis Philippe. Even after his imprisonment, Daumier continued his attacks. One of his most powerful lithographs (fig. 32–7), called simply *Rue*

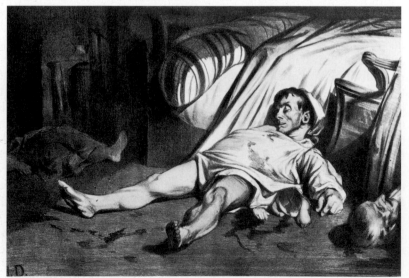

32-6. JEAN FRANÇOIS MILLET. *Sower.* c. 1850. Oil on canvas, 40 × 32½″ (101.6 × 82.6 cm). Courtesy, Museum of Fine Arts, Boston. Gift of Quincy Adams Shaw through Quincy A. Shaw, Jr., and Mrs. Marion Shaw Haughton

32-7. HONORÉ DAUMIER. *Rue Transnonain, April 15, 1834.* 1834. Lithograph. Bibliothèque Nationale, Paris

Transnonain, April 15, 1834, depicts an incident during the insurrection of that month in which the inhabitants of a working-class house were butchered in reprisal for shots fired at a soldier. With its dramatically low angle, seemingly accidental cropping, and flashbulb-like illumination, the image reads like a modern journalistic snapshot. The masterly sculptural rendering of the central figure and the powerful foreshortening are in the tradition of Géricault, but the intense pathos is Daumier's own.

After the suppression of *Caricature* in 1835, he turned to social satire, and after the revolution of 1848 he took up painting in earnest and largely in secret. He developed a style at once individual, simple and powerful, and surprisingly spontaneous when compared with the precision of the early lithographs. In spite of the fact that he knew Michelangelo's paintings only from engravings, Daumier managed to invest his working people with the grandeur of the Sistine prophets and sibyls (see fig. 22–19). His *Third-Class Carriage,* of about 1862 (fig. 32–8), is the earliest known painting to be concerned with the effect of a modern conveyance on human beings (as distinguished from Turner's hymn to modernity in *Rain, Steam, and Speed,* fig. 31–23). Ordinary people of both sexes and all ages are brought together physically yet remain spiritually isolated in the cramped interior, which Daumier has painted in Rembrandtesque light and shade. In spite of their close quarters, Daumier's humble passengers possess a quiet dignity. Their massive forms are indicated with quick and summary contours even freer than those of Delacroix at the end of his career. Not until 1878, a year before Daumier's death, when increasing blindness had forced him to give up painting, did he receive his first one-man show—organized for him by artist friends—bringing him at long last recognition as a great painter.

COURBET The most aggressive, even noisy, apostle of the new school, as well as the most influential habitué of the Andler Keller, was Gustave Courbet (1819–77). Born in the bleak village of Ornans in the mountainous Jura region of eastern France, he came to Paris determined to create a lasting effect on the art of the capital, not only through his devotion to concrete reality but also through his study of the art of the past, which he hoped would place his own in the tradition of the museums. In both respects he reminds us of Caravaggio (see pages 772–75), equally truculent in his insistence on reality and respectful toward those aspects of the past he found relevant to his own art. Like Daumier, Courbet was a strong

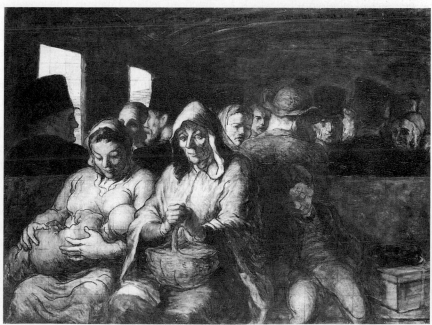

32-8. HONORÉ DAUMIER. *Third-Class Carriage.* c. 1862. Oil on canvas, 26 × 35½″ (66 × 90.2 cm). The Metropolitan Museum of Art, New York. Bequest of Mrs. H. O. Havemeyer, 1929. The H. O. Havemeyer Collection

32-8

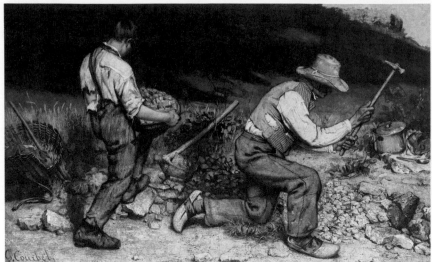

32-9. GUSTAVE COURBET. *Stone Breakers*. 1849. Oil on canvas, 5'3" × 8'6" (1.6 × 2.59 m). Formerly Gemäldegalerie, Dresden (destroyed 1945)

32-10. GUSTAVE COURBET. *A Burial at Ornans*. 1849–50. Oil on canvas, 10'3⅜" × 21'9⅜" (3.13 × 6.64 m). Musée d'Orsay, Paris

republican and champion of working-class rights and ideas. A friend and disciple of the Socialist writer Pierre Joseph Proudhon, Courbet wanted his art to embody his ideas concerning society. At the start, at least, he was completely consistent. "The art of painting should consist only in the representation of objects which the artist can see and touch,..." he declared; "I hold that the artists of a century are completely incapable of reproducing the things of a preceding or a future century.... It is for this reason that I reject history painting when applied to the past. History painting is essentially contemporary."

His paintings, therefore, are wholly concerned with events of his own time. *Stone Breakers*, of 1849 (fig. 32–9), fully embodies his artistic and social principles and caused a scandal when it was exhibited at the Salon of 1850. A public accustomed to the grandiloquence of the Neoclassicists and the Romanticists, and the trivia of much of the new official art, had no way of understanding such a direct and hard study of reality. Impressed by a sight he had actually seen, Courbet depicted the dehumanizing labor of breaking stones into gravel for road repairs, undertaken calmly and anonymously—their faces are almost concealed from us—by a grown man and a boy, without any of the religious overtones of Millet, yet with perfect dignity. Proudhon called it a parable from the Gospels. The simplicity of the relief-like composition is so deeply classical as to render the *Oath of the Horatii* (see fig. 30–9) empty in contrast. Yet its stern objectivity betrays Courbet's own devotion to the new art of photography, which he practiced as an amateur. The power of Courbet's compositions was matched by the workmanliness of his methods. His paint was first laid on with the palette knife, which both Rembrandt and Delacroix had used for expressive purposes; Courbet handled it as though it were a trowel and he were laying plaster on a wall. His unfinished works, done entirely in palette knife, are to twentieth-century eyes very beautiful. When the knifework was dry, he worked up the surface effects of light and color with a brush, but it is the underlying palette-knife construction that gives his figures their density and weight.

In the same Salon of 1850 he showed *A Burial at Ornans* (fig. 32–10), which fulfilled exactly his requirements for true history painting. The inescapable end of an ordinary inhabitant of the village (the identity of the deceased is unknown) is represented with sober realism and a certain rough grandeur. Accompanied by altar boys and pallbearers, and women in regional costume, the parish priest reads the Office of the Dead before the open grave, around which stand family and friends, some with handkerchiefs to their eyes, and the mayor in his knee breeches and cocked hat, not to speak of the kneeling gravedigger and the perplexed dog (who always appears in illustrations of the Office of the Dead in Books of Hours). The canvas, about twenty-two feet long, was so large that the artist could not step back in his studio to see the whole work, yet it is thoroughly unified. In a great S-curve in depth, the figures stand with the dignity of the Apostles in Masaccio's

32-11. GUSTAVE COURBET. *The Studio: A Real Allegory Concerning Seven Years of My Artistic Life*. 1854–55. Oil on canvas, 11'10" × 19'7¾" (3.61 × 5.99 m). Musée d'Orsay, Paris

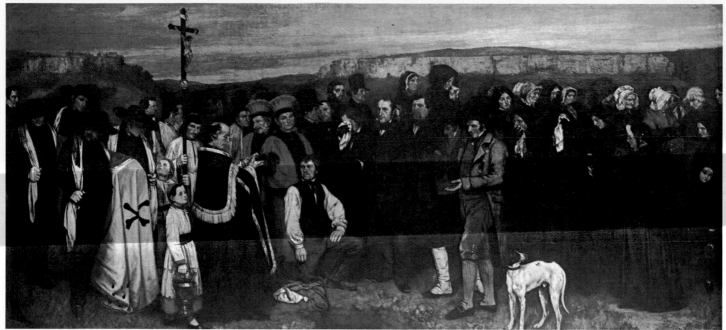

32-10

Tribute Money (see fig. 20–38). Locked between the rocky escarpment above and the grave beneath, these people realize their destiny is bound to the earth (as securely as that of Bruegel's peasants), yet they seem in contrast better to comprehend their fate. Each face is painted with all of Courbet's accustomed dignity and sculptural density, recalling the prophets of Donatello (see fig. 20–23), yet sometimes unexpectedly beautiful, as the face of the boy looking up in conversation with one of the pallbearers. This is one of the strongest and noblest works of all French painting.

In 1855, as we have seen, Courbet's paintings were rejected by the Universal Exposition. These works included not only the *Burial at Ornans,* which had been

32-11

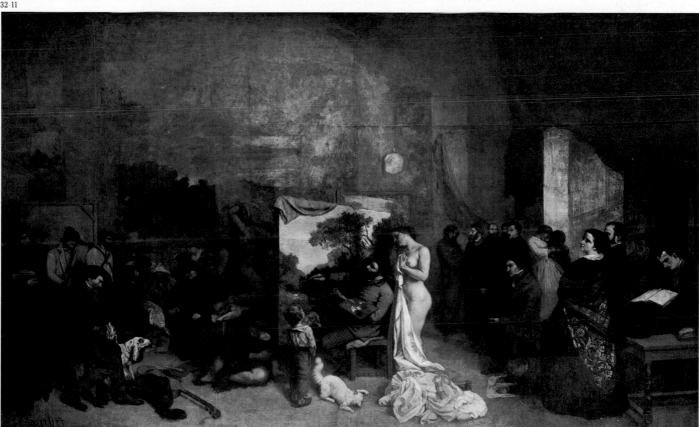

accepted by the Salon of 1850, but also a more recent programmatic work, *The Studio: A Real Allegory Concerning Seven Years of My Artistic Life,* painted in 1854–55 (fig. 32–11). Courbet's friend and patron J. L. Alfred Bruyas helped to finance the construction of a special shed for a large exhibition of Courbet's paintings, including the rejected works; the artist called this building the Pavilion of Realism. For the catalogue he wrote a preface setting forth the principles of his art. In *The Studio* the relationship between artist and sitters as seen by Velázquez and Goya (see figs. 27–37, 31–1) is exactly reversed; instead of playing a subsidiary role at one side, painting a canvas seen only from the back, the artist displays himself in the center, at work on a completely visible landscape, similar to those that adorn the walls of the dim studio. A model who has just shed her clothes, probably representing Truth (painted from a photograph), looks on approvingly, her voluminous figure revealed in light. Courbet provided a lengthy explanation of his picture, but the group at the left remains, perhaps deliberately, somewhat obscure; we know that it comprises figures drawn from "society at its best, its worst, and its average," with whom the painter had come in contact. Among the gathering of friends on the right is recognizable the poet and critic Baudelaire reading a book. Few of the figures look at the artist; all are silent. Interestingly enough, Delacroix called the picture a masterpiece, reproaching the jury for having "refused one of the most remarkable works of our times."

Once Courbet had won material success, however, something of the rude power of his early works vanishes from his portraits of the French aristocracy and his often provocative nudes. After the revolution of 1870 he joined the short-lived civil uprising known as the Paris Commune and took part in the commission that decreed the dismantling of the lofty Colonne Vendôme, a Napoleonic monument in central Paris. For this he was condemned under the Third Republic to six months in prison, which he spent in painting still lifes of extraordinary clarity and simplicity and landscapes from photographs, since the real ones could not be seen from his cell. Later, he was charged a huge sum for rebuilding the monument, fled to Switzerland, and died in exile, after all his belongings had been sold by the authorities to pay the debt.

BONHEUR One of the most popular painters of the nineteenth century, by far the best of the animal artists so beloved at the time, was Rosa Bonheur (1822–99). Bonheur was too independent in life and in art to classify easily, but she is especially significant in relation to the Realist movement. She never married, lived with a female friend, smoked cigarettes (considered unladylike), cut her hair like a man, and wore trousers (for which she had to have police permission). Interested from childhood in the psychology and behavior of animals, in rendering whose fierce energy she had no rivals but the great Romantics, she had a distinct advan-

32-12. ROSA BONHEUR. *Plowing in the Nivernais.* 1849. Oil on canvas, 5′9″ × 8′8″ (1.75 × 2.64 m). Musée d'Orsay, Paris

tage over other women artists because she, at least, could study from living models. So as to gain a complete knowledge of animal anatomy she even worked in slaughterhouses, to use her own words, "wading in pools of blood." Bonheur's most famous painting in America is the *Horse Fair,* of 1853–55, some thirty-three feet in length. Not only did she spend many months working with live horses but she kept photographs of Géricault's horse paintings at hand. But for her *Plowing in the Nivernais,* of 1849 (fig. 32–12), Bonheur owed a debt to nobody. Oxen, those beasts on whose immense strength used to depend the entire rhythm of European agriculture, had never been painted with such conviction. Her two teams move diagonally forward and uphill out of the picture with a power no one who has not seen these grand animals at work can entirely appreciate. The quality of the landscape and the monumentality given to the animals and even to clods of earth relate Bonheur to Courbet and to Millet. She was made an Officer of the Legion of Honor, an award that the empress Eugénie, then regent of France in the absence of her husband, Napoleon III, came to her studio to bestow.

GÉRÔME Though tremendously famous and successful in his day, the painter Jean-Léon Gérôme (1824–1904), five years Courbet's junior, has been reviled throughout most of this century as a reactionary "official" painter who stood in the way of all that was progressive in the second half of the nineteenth century. Contemptuous of everything Courbet stood for, Gérôme claimed that such artists had abandoned themselves to "commonplace and indiscriminating realism." In his old age he disparaged the Impressionists above all and formally protested the spectacular collection of Impressionist paintings bequeathed to the French state by the painter Gustave Caillebotte. Nevertheless, Gérôme's reputation has been rehabilitated of late in view of his accomplishments as a painter and his enormous influence as a teacher. His innovative treatment of history subjects, the compelling veracity of his genre paintings, and the sheer technical wizardry of his brush have caused museums to bring out works by Gérôme that have languished in storage for decades.

Gérôme is best known today for the Orientalist subjects he began to paint in the 1850s. Like Delacroix, this artist was charmed by North Africa but he traveled beyond Morocco—to Egypt, the Near East, and Asia Minor—leading safaris and filling his notebooks with landscape sketches and portraits of the inhabitants. These he turned into paintings upon his return to Paris, where he regularly exhibited in the annual, state-sponsored Salon. His exacting portrayals of Muslim life in Cairo or Constantinople (today Istanbul) were much in demand with the Parisian public, who had acquired a taste for exotic Orientalist subjects by the second quarter of the century. Gérôme's *Dance of the Almeh* (fig. 32–13), of 1863, demonstrates how little his highly polished, immaculate surface has in common

32-13. Jean-Léon Gérôme. *Dance of the Almeh.* 1863. Oil on panel, 19¾ × 32″ (50.5 × 82 cm). The Dayton Art Institute. Gift of Mr. Robert Badenhop

32-13

with the paint-encrusted canvases of Courbet. Yet his subject was also drawn from everyday life, albeit one far from the provinces of France. The "Almeh" of the title derives from an Arabic word for "female entertainer," here in the form of a belly dancer who, accompanied by the musicians at the right, performs her seductive dance. Her audience is a group of soldiers called Bashi-Bazouks, who were irregular Turkish troops of the Ottoman Empire. Their colorful costumes and ferocious reputation (their guns hang on the wall behind them) made them one of Gérôme's favorite subjects. The full force of the artist's powers of observation can be felt in the precisely rendered details of the dancer's diaphanous blouse or the patterned coils of the soldiers' headdresses. Such titillating images—this one was exhibited in the Salon of 1864—were ingeniously designed to appeal to Western tastes.

Metal Architecture

This is perhaps the best moment to discuss the new forms of architecture made possible by the Industrial Revolution. Metal had been used from time to time in the history of architecture as an adjunct to other materials, such as often the bronze or iron dowels in the centers of Greek columns and the iron frames used to enclose sections of stained-glass windows in Gothic cathedrals. Iron beams had even been inserted in the sixteenth century to strengthen the fragile outer walls of the Palazzo degli Uffizi in Florence (see fig. 23–33). Cast iron came into use on a grand scale in England and France toward the end of the eighteenth century in bridges and for the inner structures of factories, and in the 1830s for railway stations. Almost invariably buildings using cast iron were intended for purely utilitarian purposes. A conspicuous exception was the Royal Pavilion at Brighton (see fig. 31–24), whose onion domes were carried on iron frames, but when the iron was exposed in the same building in a "Chinese" staircase and in palm-tree columns in the kitchen it was cast into shapes previously familiar from work in stone or wood. During the 1840s and 1850s, the use of cast iron became widespread, even in Gothic-revival churches. The mid-nineteenth-century iron façades common in office buildings still standing in downtown New York City, and the iron dome (1850–65) of the United States Capitol in Washington, D.C., by Thomas U. Walter (1804–87), are outstanding examples.

An early and brilliant use of exposed iron for architectural purposes is the Reading Room of the Bibliothèque Sainte-Geneviève in Paris (fig. 32–14), built in 1843–50 by HENRI LABROUSTE (1801–75). The exterior of the building is arched like the flanks of the Malatesta Temple (see fig. 20–14), but the interior is roofed by two parallel barrel vaults of iron plates, resting on iron rivets cast with a perforated vinescroll design of the greatest lightness; these are supported in the center by iron arches springing airily from slender Corinthian colonnettes, recalling the fantastic elements of pictorial architecture at Pompeii. The precast elements made it possible to assemble a large structure in comparatively short time and seemed a great advantage to the architects of the mid-nineteenth century.

The triumph of iron architecture was the Crystal Palace (fig. 32–15), built in the astonishing space of nine months in 1850–51 by SIR JOSEPH PAXTON (1801–65), who had learned the principles of construction in iron and glass from building greenhouses. No glass-and-iron structure had ever before been put up on such a scale, however, and the airy interior with its barrel-vaulted transept and multiple galleries all of glass on an iron skeleton showing throughout was the luminous wonder of the London Great Exhibition—the first in a long procession of world's fairs. Its seemingly infinite space, pervaded by light at every point and utterly weightless, doubtless shimmering with color in a rosy glow of good weather, must have been a perfect counterpart to the paintings of Turner. A comparison with the Bibliothèque Sainte-Geneviève will show that iron has now developed an ornamental vocabulary of its own. No more colonnettes, no more vinescrolls; the elements are cast with only the lightest of surface ornament.

32-14. HENRI LABROUSTE. Reading Room, Bibliothèque Ste.-Geneviève, Paris. 1843–50

32-15. SIR JOSEPH PAXTON. Interior (view of transept looking north), Crystal Palace, London. 1850–51. Cast iron and glass. Lithograph by Joseph Nash, Victoria & Albert Museum, London (Crown copyright reserved)

The rapid end of cast-iron architecture was spelled by its unsuspected vulnerability to fire. The Crystal Palace (the first of many in Dublin, New York City, and elsewhere) was reconstructed at Sydenham, south of London, in supposedly permanent shape in 1852–54, but it perished by fire in 1936. However, the utility of metal for architecture had been established, and the material was to be revived for a somewhat different constructional role, giving rise to strikingly new architectural forms after the invention of a method of making steel in 1855 by Sir Henry Bessemer.

Painting in the United States

The influence of Realism spread throughout Europe. Gifted American artists arriving in France in the 1860s were deeply impressed by the work of the group of painters settled at the village of Barbizon, at the edge of the Forest of Fontainebleau, who made studies of landscape for its own sake; by Corot (who is often associated with the Barbizon painters, although his lyrical late canvases have little in common with their sober productions); and by Courbet. A formidable figure in American nineteenth-century art was WINSLOW HOMER (1836–1910). Self-taught and active as an illustrator and documentary artist during the Civil War, he underwent the influence of Realism during a visit to France in 1866–67, at which time his early style crystallized. A typical early work is the *Croquet Game* (fig. 32–16), of 1866, in which the clarity of forms and spaces and the beautiful adjustment of tones betray the influence of Corot, while the density of substance and of pigment reflects an indebtedness to Courbet. In later life Homer developed a strongly individual style as a marine painter, in relative isolation on the Maine coast, with trips to the Caribbean.

An equally important figure, considered by many to have been America's greatest native-born artist, is THOMAS EAKINS (1844–1916). After early study at the Pennsylvania Academy, he, like Homer, visited France in 1866. He also went to Spain, where he was profoundly affected by Velázquez, and returned to America in 1870 to paint powerful works uncompromisingly founded on fact. His insistence on posing a nude male model before female students forced his resignation from the directorship of the Pennsylvania Academy, and his honest realism cost him fashionable portrait commissions. Fortunately, he enjoyed a small independent income and was able to continue doing portraits of friends—searching psychological analyses of great depth and emotional intensity, dryly painted, without the richness of pigment in which Corot and Courbet delighted. Eakins was fascinated by the new art of photography and used it as an aid in his researches into reality, becoming a remarkably proficient photographer himself (see fig. 33–12).

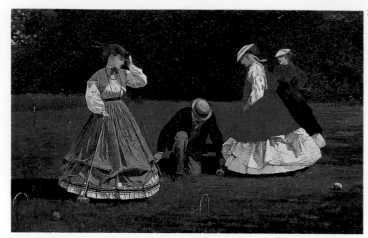

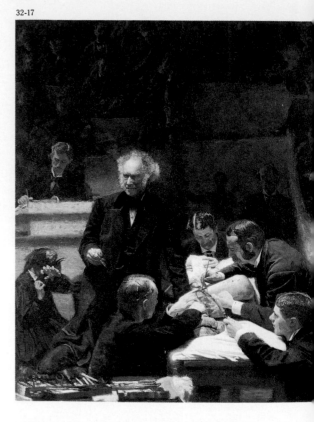

Eakins's masterpiece is a monumental painting called the *Gross Clinic* (fig. 32–17), painted in 1875 for the Jefferson Medical College in Philadelphia, where Eakins had studied anatomy. The life-size group represents an actual operation being performed by an eminent surgeon and his staff in an operating theater before medical students. The composition was undoubtedly influenced by Rembrandt's *Anatomy Lesson of Dr. Tulp,* of 1632, a study of the public dissection of a corpse by a distinguished lecturer in the interest of medical research. Like that great painting, Eakins's work deals with an inherently repulsive subject not only in a direct and analytical manner but also with a certain reverence for the mystery of human existence. He goes far beyond the seventeenth-century prototype in his depiction of the drama of the moment; the careful portraiture of the surgeons absorbed in their task is unforgettable, as is the compulsive gesture of the female relative of the patient, who draws her arm before her face. The noble and seemingly spontaneous grouping, enriched by strong contrasts of light and shade, is one of the most powerful pictorial compositions of the nineteenth century, worthy to be set alongside *A Burial at Ornans* (see fig. 32–10).

32-16. WINSLOW HOMER. *Croquet Game.* 1866. Oil on canvas, $16 \times 26''$ (40.6 × 66 cm). The Art Institute of Chicago. Friends of American Art Collection

32-17. THOMAS EAKINS. *Gross Clinic.* 1875. Oil on canvas, $8' \times 6'6''$ (2.44 × 1.98 m). Jefferson Medical College, Philadelphia

The Pre-Raphaelites

At the same time as the Realist movement in France and the United States an independent but related revolution against official art was taking place among a group of extremely young and gifted English artists. In 1848, when the movement was founded, William Holman Hunt, its leader (1827–1910), was twenty-one years old and JOHN EVERETT MILLAIS (1829–96) only eighteen. The group included, among others, the poet-painter Dante Gabriel Rossetti and later the painter FORD MADOX BROWN (1821–93). Their title, the Pre-Raphaelite Brotherhood, was chosen because of their belief that in spite of Raphael's greatness the decline of art since his day was attributable to a misunderstanding of his principles. They did not revert to fifteenth-century Italian style but demanded a kind of precise realism in the smallest detail founded perhaps on the early Netherlandish painters but betraying inevitably the influence of the daguerreotype. Visual honesty was only the beginning; in contrast to Courbet's standpoint, the subject itself had to be important and invested with moral dignity, and the artist had to interpret it directly, as if it were happening in front of the observer, without any reference to accepted principles of composition, posing, or color. At first their name was kept secret because in the late 1840s any "brotherhood" might suggest revolution. When made public, however, the title elicited an outcry as an insult to a universally revered master.

Millais's *Christ in the House of His Parents* (often known as *The Carpenter's Shop,* fig. 32–18), exhibited at the Royal Academy in 1850, when the painter was twenty-one, was a striking example of the new style. The colors were unexpectedly bright, and the figures, based on working-class models, reflected no interest in conventional beauty. The ordinary faces, particularly that of the weary Virgin Mary,

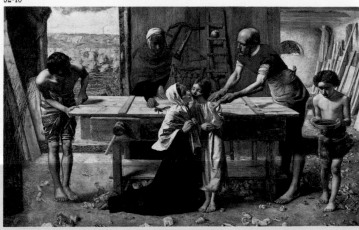

32-18. JOHN EVERETT MILLAIS. *Christ in the House of His Parents (The Carpenter's Shop).* 1850. Oil on canvas, 33½ × 54″ (85 × 137.2 cm). The Tate Gallery, London

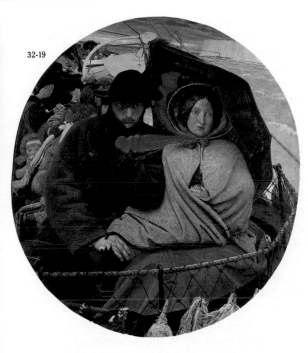

32-19. FORD MADOX BROWN. *The Last of England.* 1852–55. Oil on panel, 32½ × 29½″ (82.6 × 75 cm). Birmingham Museums and Art Gallery, Birmingham, England

brought down the denunciation of no less a figure than Charles Dickens. The work was generally regarded as blasphemous, although the intent of the artist was transparently symbolic and prophetic. Arranged in front of a foreshortened door suggesting the horizontal bar of the Cross (Christ said, "I am the door of the sheep," John 10:7), the boy Jesus, in dead center, has wounded his hand on a nail. The group of figures, despite their natural poses, is as symmetrical as any Crucifixion. A ladder, resembling the one used to take down the body from the Cross, hangs on the wall. Saint John the Baptist contemplates a bowl of water. The sheep are seen in the background. Despite all Millais's astonishing fidelity to life and to reality, one misses the deep inner knowledge of the craft of painting that ennobles the art of the great French Realists. One wonders what Courbet would have thought of this painting, or of the equally catchy *The Last of England* (fig. 32–19), of 1852–55, by Ford Madox Brown. The subjects, the Pre-Raphaelite sculptor Thomas Woolner and his wife, sit at the stem of a steamer—another is seen in the background—from whose rail hangs a row of English cabbages. The young couple, whose baby is protected inside the wife's cloak so that one just sees a tiny hand, are leaving for the goldfields of Australia—their expressions appropriately solemn at the prospect of a voyage which in the days before the Suez Canal lasted months. We see them through a circle that at once suggests a favorite Renaissance form and the porthole of a vessel. By artful arrangement one of the white cliffs of the island at which the young couple gaze so mournfully is visible in the background. Their expressions contrast with the oblivion of a little girl eating an apple at the left and with the rage of a man above her, shaking his fist at an England he loves somewhat less than they. The metallic precision with which the Woolners' faces are drawn—compare them with the faces in the background—makes it evident that they are based on a daguerreotype, for which presumably they posed before they sailed.

The Pre-Raphaelites' position of transcendent honesty and moral dignity was perhaps too rigid to be maintained indefinitely. Although they were all long-lived, their styles changed eventually, and by the 1880s the movement had been transformed into a new mixture of medievalism and aestheticism in which the original purity of purpose was lost.

The doctrines of the Realists, like those of the Neoclassicists and the Romanticists, in fact like all artistic dogmas, could not be maintained for long in their original form. Too many aspects of natural human feeling and imagination were excluded. But the immense historic value of Realism lay in its insistence on the priority of vision over either abstract principles of form and composition or emotional and narrative content. The Realist emphasis on the here and now was essential to the formation of Impressionism, the one really crucial movement of the nineteenth century and surely the most important for all succeeding generations. Unexpectedly, but with some force, Realism was to reappear at intervals throughout the twentieth century, as doctrinaire as ever, and at times even more fanatical.

CHAPTER THIRTY-THREE

The new Realist movement gave rise in the mid-1860s and throughout the 1870s to the first complete artistic revolution since the Early Renaissance in the fifteenth century and to the first universal style to originate in France since the birth of the Gothic in the twelfth century. The Impressionist movement was born in 1874, when a group of artists banded together in Paris with the express purpose of circumventing the official system of annual Salons by organizing an exhibition of their own work. Between 1874 and 1886 the artists would mount eight such shows, although membership in the group would periodically change as some artists dropped out (only Camille Pissarro participated in all eight shows) and new ones joined. The term *Impressionism* by no means describes a homogenous group of painters who worked in identical styles under some unified theoretical program. The Impressionists made up a stylistically diverse group. Claude Monet painted landscapes, for example, and Edgar Degas hardly ever; the painting methods of Pierre Auguste Renoir have virtually nothing to do with those of Gustave Caillebotte. What all these artists did share was a growing dissatisfaction with official art in France and a commitment to the painting of what the poet Baudelaire had called "modern life." The subjects of their paintings derive not from history or mythology, nor even from the fields and rural toil of Courbet or Millet. They looked instead to the streets and cafés of Paris and the landscapes of its surrounding suburbs for artistic material, that is, to the fabric of their own lives. Although these snapshots of everyday, middle-class existence would occasionally reveal men and women at work, it was predominantly leisurely activities that the Impressionists chose to depict, reason enough to explain the enduring popularity of their work today.

The new movement almost immediately became known as Impressionism, and although it lasted hardly more than a decade in its purest form, it determined in one way or another nearly every artistic manifestation that has taken place since, with consequences apparent in contemporary art more than a hundred years later. "Nothing is seen without light," wrote Ghiberti, and while that master and his Florentine contemporaries were aware, as had been the ancient Greeks before them, of the role of light in establishing the existence of objects and determining their forms and colors, it had never occurred to Renaissance artists that light might also function in the opposite way to deform, denature, or dissolve objects.

Starting on the basis of Courbet's solid Realism and the graduated light effects of Corot, the Impressionist artists, working from start to finish outdoors, became fascinated by the transformations wrought by light on natural objects, surfaces, and atmospheric spaces. It soon became clear to them that color, for example, is not the property of the object itself but of the moment of perception of light, and thus changes constantly with the times of day, the movement of the sun, and the density of the atmosphere. Baroque artists, especially Rubens and Vermeer, followed in the nineteenth century by Delacroix, had studied the effect colors have on each other when juxtaposed and the reflection of one color in another—observations sternly rejected by classical tradition from Poussin to Ingres. Much earlier, in the Renaissance, Alberti and Leonardo had noted that if a person passed through a sunlit field both face and clothing would appear greenish. Yet neither they nor any other Renaissance artist had deemed such a scientific curiosity worthy of painting. In the twentieth century, due chiefly to the Impressionists, we take such phenomena for granted. We all know that when we drive toward the western sun the glare on a black asphalt road will turn it yellow or even white, and that many an accident has been caused by the transformation of images of form, substance, and distance by the combination of night lights and rain. We need no proof that an object can be so altered by mist or haze that neither its size nor its material composition can be grasped. And, of course, stage lighting converts the local color of objects and

persons to any desired hue just by a transparent sheet of colored gelatin interposed in front of the light source.

Nonetheless in the 1860s and 1870s such facts, if realized at all by the general public or by most artists, were automatically discounted and were compensated by readjustment of tones and contours in favor of the known rather than the seen qualities. This habitual compensation the Impressionists stubbornly refused to accept, and we are eternally in their debt for a brilliant new vision of the world about us. They were the first to render the full intensity of natural light and the glow of natural colors. If the general tone of a gallery hung with Realist paintings seems dark to us after experiencing the rich colors of the Romantics and the delicate tints of the Neoclassicists, that of an Impressionist gallery is keyed up to such a degree that we feel as though we had suddenly stepped from a dim interior into the full blaze of sunlight. To quote Paul Signac, a painter who helped to transform the Impressionist style in the 1880s, "The entire surface of the [Impressionist] painting glows with sunlight; the air circulates; light embraces, caresses and irradiates forms; it penetrates everywhere, even into the shadows which it illuminates." It was light, perceived in a flash too quick to permit the eye to focus on detail, judge contours, enumerate elements, and assess weights and densities, that the Impressionists tried to capture. Monet, leader of the movement, called his goal "instantaneity." However, this was not the minutely detailed flash-frozen instantaneity the photographers had been able to present since 1858, but a total instantaneity of light, motion, and eventually even temperature. Given their devotion to optical truth, it is not surprising that the Impressionists were influenced by photography; yet they reacted to the medium in a totally unexpected way. The artists of the movement did not merely utilize the supposed accuracy of photography, as did the Neoclassicists and the official painters, nor were they bound to its monochromatic translation of the objective world, as were the Realists. They considered photography false to the psychological perception of reality in color and motion, however precisely it might fix the retinal image of shape and of tonal relations. Their goal was to beat photography at its own game and supply the essentials that the camera missed.

It is now our task to trace how the Impressionist movement came about, how it spread, and how it became transformed into a radically different style. The well-nigh unanswerable question is why the revolution in vision occurred when and where it did. It is not enough to point out that much of what the Impressionists achieved in the perception of color in painting had already been formulated scientifically in research conducted during the 1820s, and embodied in a book published in 1839 by the French chemist Michel Eugène Chevreul (1786–1889); the Impressionists were not influenced by Chevreul's work, which was not systematically studied by painters until the days of Georges Seurat in the 1880s (see Chapter Thirty-Four). One important factor in Impressionist experience was the spectacle of Baron Haussmann's Paris, which had taken shape around them, with its seemingly infinite perspectives of straight avenues and curving boulevards lined with almost identical structures. Buildings and their details, trees, carriages, pedestrians—all became particles in an endless web of color, subject to the changes of light in the soft, moisture- and smoke-laden air of Paris, in which no form is clear and all elements tend to be reduced to particles of more or less the same size (see figs. 33–6, 33–10). The most striking aspect of the rapid development of Impressionism is that it was in no way retarded by the defeat of France in the Franco-Prussian War of 1870–71, the devastation of Paris by Prussian shelling during the siege, and the disorders of the brutally repressed Commune of 1871. As if nothing had happened, the Impressionist friends, with few exceptions, tem-

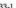

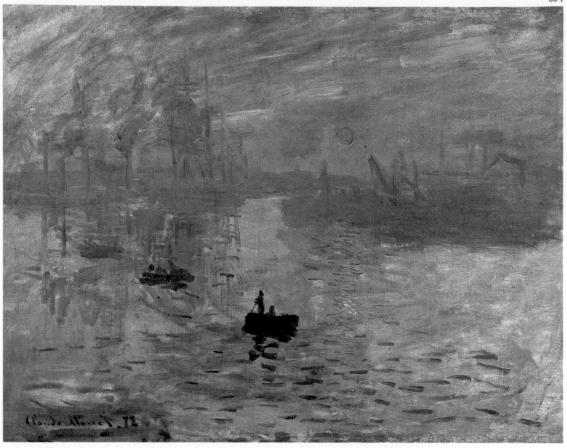

porarily dispersed from the capital, returned to it immediately, and heightened their dazzling colors and intensified their perceptions of the light of the metropolis and its surrounding country.

33-1. Claude Monet. *Impression: Sunrise*. Dated 1872. Oil on canvas, 48 × 63″ (1.22 × 1.6 m). Musée Marmottan, Paris. Bequest of Mme. Donop de Monchy

Manet and Monet

The use of the name *Impressionism* to characterize the new movement came from the first group exhibition at the recently vacated former studio of the photographer Nadar in 1874, where the artists had often encountered the leaders of Parisian intellectual and cultural life. Claude Monet (1840–1926) exhibited among others an extraordinary painting entitled *Impression: Sunrise*, painted two years earlier (fig. 33–1). The title gave rise to the name applied to the entire movement, one that its members soon adopted, some more readily than others. The exhibition was greeted with public derision, the like of which had never been experienced in Paris. Though the Impressionists did have their supporters in the press, many of the reviews were vociferously negative. One newspaper story recounted solemnly how a visitor was driven mad by the paintings and rushed out onto the Boulevard des Capucines where he started biting innocent passersby. In this picture, for example, every tradition of European painting seemed to have been thrown aside. Not only form but also substance itself has vanished. The picture was a mere collection of colored streaks and blobs on a light blue ground. Today observers have no difficulty recognizing a rowboat in the foreground and sailboat beyond, masts and rigging, haze, and smoke, all reflected in the rippled surface of the water. This revolutionary painting, intended to correspond to the image the eye sees in an instantaneous glimpse of the port of Le Havre at sunrise, summed up for the critics the most radical characteristics of the school.

33-2

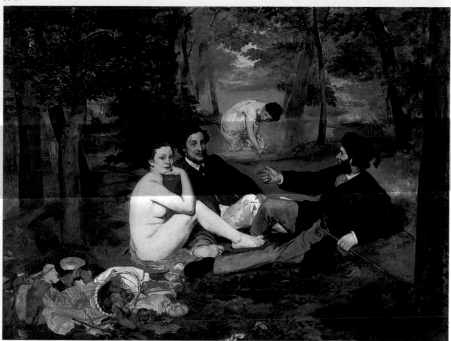

33-2. ÉDOUARD MANET. *Luncheon on the Grass (Le Déjeuner sur l'Herbe)*. 1863. Oil on canvas, 7′ × 8′10″ (2.13 × 2.64 m). Musée d'Orsay, Paris

The beginnings of the movement, from which no one, least of all the artists themselves, could have predicted its culmination, seem light-years earlier. The germs of the new perception are apparent in the art of Édouard Manet (1832–83), the similarity of whose surname to that of Monet causes confusion today and at first distressed Manet, who thought it was a bad joke. Scion of a well-to-do and cultivated Parisian family, the young Manet was trained for a naval career but then was permitted to enter the studio of the conservative painter Thomas Couture, where he received thorough training. Trips to Italy, the Netherlands, Germany, and Austria in the 1850s brought him into contact with the work of the Old Masters, through careful copying. He was particularly impressed by the optical art and brilliant brushwork of Velázquez, whose work he saw during a brief visit to Spain in 1865 and to whom he remained permanently indebted. He also admired Goya and among the artists of his own time preferred Courbet and Daumier.

In 1863 Manet exhibited at the Salon des Refusés a canvas entitled *Luncheon on the Grass (Le Déjeuner sur l'Herbe)* (fig. 33-2), which created an uproar. The nonchalant grouping of a nude female figure and two fully clothed men in what appears to be a public park shocked the Parisians as flagrant immorality. In actuality Manet had wittily adapted the pyramidal composition and the poses from a sixteenth-century engraving after a design by Raphael. Giorgione also had painted a similar subject, which Manet had copied in the Louvre as a student. But Manet had modernized the clothing, surroundings, and accessories. These were no classical gods but unmistakably contemporary Parisians, and one of them was looking out unabashedly at the viewer. It was not just the subject that outraged exhibition-goers but the way in which the picture was painted. Even Courbet joined the chorus of denunciation, finding the painting formless and flat. This flatness, however, was just what Manet was striving for. He discarded Courbet's characteristic lighting from one side and strong modeling in favor of broadly painted areas silhouetted in light and dark. Illumination seems to come from the direction of the observer and eliminates mass. It is as though Manet were using the "indecent" subject for its shock value to point up his belief that the important thing about a picture is not only what it represents but how it is painted. The suppression of three-dimensional form allows him to concentrate on the luminosity of the grass and foliage, the sparkling remains of the picnic, and the glowing flesh of the nude.

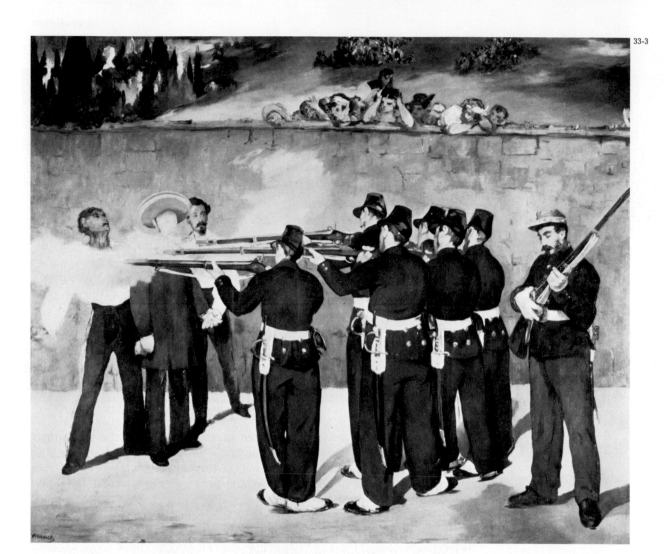

33-3. ÉDOUARD MANET. *Execution of the Emperor Maximilian of Mexico*. 1867. Oil on canvas, 8'3¼" × 12'⅛" (2.52 × 3.66 m). Städtische Kunsthalle, Mannheim

Manet soon went even farther; in 1867 he painted a subject from contemporary history, the *Execution of the Emperor Maximilian of Mexico* (fig. 33–3), which records an event that had deeply shocked the French public and for which Napoleon III and his government, who had installed Maximilian, were generally blamed. Manet treated the incident in a totally unexpected way, almost as a reaction against such elaborately staged protest compositions as Géricault's *Raft of the Medusa* (see fig. 31–9) and Goya's *Third of May, 1808, at Madrid* (see fig. 31–3). He made a close study of newspaper accounts and composite photographs of the execution, and even of portrait photographs of the slain emperor, but rather than arranging the figures for maximum emotional effect he seems almost to have taken a snapshot of the scene. One can scarcely make out the expressions of the doomed men. No longer the embodiment of mechanized cruelty as in Goya, the soldiers are just doing their job. If any figure receives special attention it is the officer preparing his rifle for the coup de grace. The onlookers peering over the wall are merely curious. The picture consists largely of colored uniforms, a briskly painted background, and puffs of smoke. Another traditional subject, this time a tragic one, has been modernized in terms of immediate vision.

One of Manet's staunchest defenders against the onslaught of criticism his paintings engendered was the great naturalist novelist and critic Émile Zola. In gratitude for his support, Manet painted the *Portrait of Émile Zola* (fig. 33–4), which he exhibited at the Salon of 1868. What seems at first glance a straightforward portrayal of the writer in his study is in fact an ingenious, highly contrived allegory of the painter himself. Zola sat for the portrait not in his own study but in the studio of the painter, and he is surrounded by artifacts of Manet's own choosing. Among the objects cluttered on the desk is a pamphlet prominently displaying Manet's

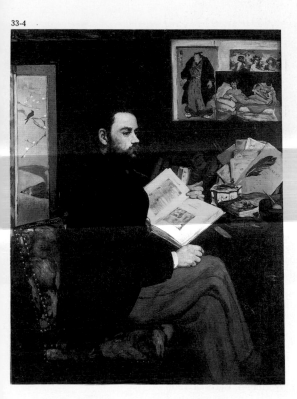

33-4. ÉDOUARD MANET. *Portrait of Émile Zola.* c. 1868. Oil on canvas, 57⅛ × 44⅞″ (1.45 × 1.14 m). Musée d'Orsay, Paris

name. It is the very pamphlet Zola published in 1867 to defend Manet's work, in particular his depiction of a modern courtesan, *Olympia,* which scandalized Parisians at the Salon of 1865. Tacked to the bulletin board at the upper right is a reproduction of that painting. Above it is a print made after *The Drinkers (Los Borrachos)* by Manet's beloved Velázquez (see fig. 27–35), and to the left is a Japanese print of a wrestler, alluding, along with the folding screen at the far left, to the pervasive influence of Japanese art on advanced French painting of the 1860s. In the midst of these accoutrements the writer sits rigidly, the brilliant flesh tones of his face set off against the dark beard and the flat, unmodulated black of his jacket. Manet reinforces the inherent two-dimensionality of the picture plane by situating Zola against a black background that precludes any discernible recession in space. Not surprisingly, the book he holds is not one of his own novels but a history of painting that Manet used on countless occasions.

At first Manet maintained a certain distance from the members of the Impressionist group; he went to chat with them at the Café Guerbois but never exhibited with them. His younger contemporary Monet came from a different background. Although he also was born in Paris, his father, a grocer, soon moved with the family to Le Havre on the coast of Normandy to become a ship chandler, and the boy could constantly observe ships and the sea. This circumstance was important for Monet's later preoccupation with light, water, and human experience in relation to the unending stream of time. After starting as a caricaturist, the young artist was introduced to landscape painting in 1858 by a gifted marine painter, Eugène Boudin. In 1867 he submitted to the Salon a revolutionary work, the huge *Women in the Garden* (fig. 33–5), painted the preceding year. The model for all the figures was the artist's mistress, whom he later married, Camille Doncieux. In each of the four poses, she wears the latest Parisian style. The entire picture, more than eight

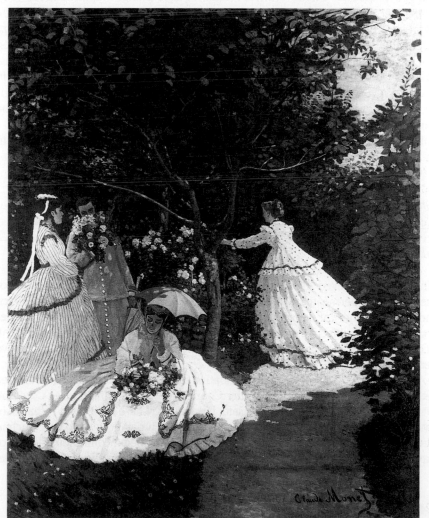

33-5. CLAUDE MONET. *Women in the Garden.* 1866. Oil on canvas, 8′4½″ × 6′8¾″ (2.55 × 2.05 m). Musée d'Orsay, Paris

feet high, was painted outdoors. Monet had already developed in the direction of instantaneity, and the picture required him to devise new methods in order to record the immediate impression of light on the muslin dresses, the flowers, and the trees without the aid of preliminary sketches. To the astonishment of Courbet, he refused to paint at all when the sun went under a cloud. And since in order to paint the upper portions of the picture he would have had to climb a ladder, thus altering his view of the subject, he dug a trench and built a device for lowering and raising the canvas so that all parts of it could be painted from the same point of view. The feeling of sunlight is warm and rich but the colors are still local, though soft blue and lavender shadow does reflect into the faces of the women and their flowing dresses. The leaves are colored in varying shades of green, which means that Monet had not really gone further than Constable in his perception of the makeup of any given hue. But the general impression is far brighter than anything Manet had achieved in the *Luncheon on the Grass* of only three years before. Already Monet has begun to divide the entire surface into patches of color of roughly uniform size. Even more important, now that Manet had demolished the emotional drama as a subject, Monet in this and other pictures established the new Impressionist subject—the moment of contemporary experience in light.

However successful from an artistic and historical point of view, like most of the artist's early works the painting was a worldly failure. Not only was it rejected from the Salon of 1867 but also when it was shown in a shop window Manet poked fun at it. Interestingly enough, a few years later, when he had come to understand Monet's style and adopted his brilliant coloring, Manet bought the picture for himself.

Although Manet remained in Paris during the disorders of 1870–71, Monet fled, first to London, where he experienced a different kind of light and studied the art of Constable and Turner, then to Holland and Belgium, where he was interested chiefly in landscape. On his return to France his style changed rapidly and radically. *Impression, Sunrise,* which we can now see in its place in the perspective of the Impressionist movement, marks very nearly the apogee of Monet's attempt to seize instantaneity. The actual visual impression he rendered was of such brief duration that the touches of color on the surface, indicating the water, the boats and rigging, and their reflections, could hardly have taken more than an hour. In the *Women in the Garden,* he had proclaimed the Impressionist subject as the moment of experience of light; in *Impression, Sunrise,* he demonstrated that color belongs not to the object but to the moment of visual experience.

This was hard for his contemporaries to accept. Monet explained his method to an American woman:

> *When you go out to paint, try to forget what objects you have before you, a tree, a house, a field or whatever. Merely think, here is a little square of blue, here an oblong of pink, here a streak of yellow, and paint it just as it looks to you, the exact color and shape, until it gives your own naive impression of the scene before you.*

What Monet achieved in the 1870s was the dissolution of the object. Substance itself becomes permeated with air and light. The difference between his approach and that of Turner (of whose art Monet never entirely approved) was that Turner began with the subjective experience of color and painted reality into it as he went, while Monet began with reality and made it entirely subservient to the objective perception of color.

As early as 1873 Monet had set up a floating studio in a boat on the Seine, an idea he borrowed from the Barbizon painter Charles-François Daubigny. If to Corot the art of painting consisted, as he once said, in knowing where to sit down—that is, in choosing the perfect point of view—to Monet it lay in judging where to drop anchor. The world passing before his eyes at any one spot formed a continuous stream of experience, from which he singled out moments, recorded in series. For example,

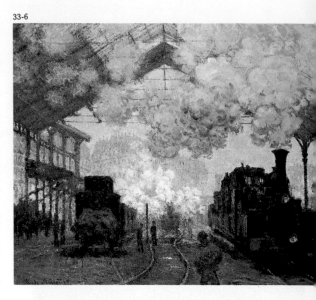

33-6

33-6. CLAUDE MONET. *Gare St.-Lazare; Arrival of a Train.* 1877. Oil on canvas, 32¾ × 39¾″ (83.1 × 101 cm). Courtesy of the Fogg Art Museum, Harvard University, Cambridge, Massachusetts. Bequest—Collection of Maurice Wertheim, Class of 1906

at the financially disastrous third Impressionist exhibition of 1877 he showed eight canvases in which he had studied from his own objective point of view the theme of the railway. But it was neither the idea of man's victory over nature that fascinated him as it did Turner (see fig. 31–23) nor sympathy with the plight of humanity trapped in a modern machine as in Daumier (see fig. 32–8), but the simple spectacle of a locomotive drawing cars into a station, as depicted in the *Gare Saint-Lazare; Arrival of a Train,* painted in 1877 (fig. 33–6).

The iron-and-glass train shed offered to him a tissue of changing light and color, dominated by blue and silver in this instance, but touched unexpectedly on the ground with tan, green, rose, and gold. The shadows and the massive black locomotive were painted in deeper shades of these hues, chiefly blue, for many of the Impressionists had begun frequently to eliminate black from their palette. Rather than acknowledging black as the absence of color, their work shows what from experience we know to be true, that black absorbs and to a degree reflects colors in the surrounding atmosphere. The people in Monet's picture are spots of blue, their faces rose and gold; the puffs of steam are bubbles of blue and pearl, whose dissolution we can watch under the glass roof. The only local color remaining is the bright red of the locomotive's bumper, necessary as a foil to the myriad blues. Just as instantaneity was the basic principle of Monet's vision, accidentality produced his compositions, yet in every case they show extraordinary power and consistency.

Obviously, the fleeting effects that absorbed Monet's attention could not pause long enough for him to paint them. A picture like this one, therefore, had to be the product of several sessions. Layers of superimposed strokes can be distinguished in Monet's mature and late canvases, in contrast to the fresh and sketchy touches of *Impression: Sunrise.* Monet's instantaneity carried within itself the seeds of its own dissolution. The moment of experience had become a palimpsest of several similar moments isolated from the stream of experience and blended and overlaid upon each other in various stages of completion.

There were periods when Monet could not work for lack of money to buy materials, and one moment when he slashed a number of canvases so that his creditors could not attach them. But by the 1880s his paintings were beginning to sell, and he threw himself into his work with a fierce passion as if nature were at

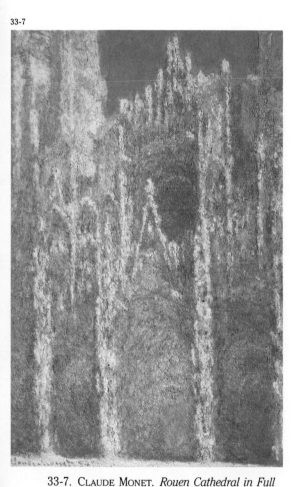

33-7. CLAUDE MONET. *Rouen Cathedral in Full Sunlight.* 1892–93. Oil on canvas, 39½ × 25¾″ (100.3 × 65.4 cm). Courtesy, Museum of Fine Arts, Boston. Juliana Cheney Edwards Collection. Bequest of Hannah Mary Edwards in memory of her mother, 1939

33-8. ÉDOUARD MANET. *A Bar at the Folies-Bergère.* 1881–82. Oil on canvas, 37½ × 51″ (95.3 × 129.5 cm). Courtauld Institute Galleries, University of London

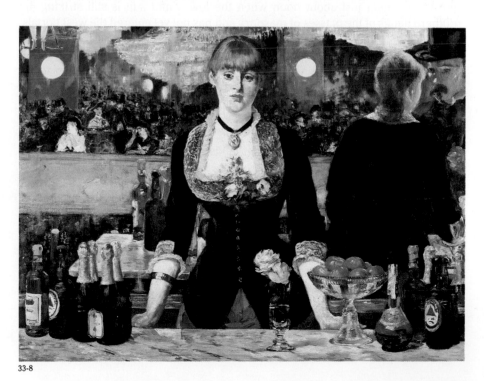

once a friend and an enemy. He waded through ice floes in hip boots at the risk of his health to record the dazzling effects of light on snow, ice, and water. He painted on a beach during a storm to ascertain the height and power of wind-driven waves, one of which swept him under (he was rescued by fishermen). He wrote to the sculptor Auguste Rodin (see below) that he was "fencing and wrestling with the sun. And what a sun it is. In order to paint here I would need gold and precious stones."

By the 1890s, still faithful to Impressionist principles when others had long deserted them, Monet brought with him daily in a carriage to the place chosen to paint, stacks of canvases on each of which he had begun the study of a certain light effect at a given moment of the day. To achieve his effects he now chose to work in series. He would select the canvas that corresponded most closely to the moment before him and recommence painting—not without periods of desperation when the desired light effects refused to reappear.

Monet painted series of cliffs, of haystacks, of poplars bordering a river, of the Thames at London and the Grand Canal at Venice. Most impressive was the series of views of Rouen Cathedral. During the winters of 1892 and 1893, when he could not easily paint outdoors, Monet, now critically accepted and financially successful, rented a second-story window in a shop opposite the principal façade of the cathedral. This building, an extreme example of Flamboyant Gothic dematerialization of stone, doubtless appealed to him as an analogue of Impressionist insubstantiality. Systematically, he studied the effects of light and color on the lacy façade in the dimness of dawn, in the morning light, at noon, in the afternoon, at sunset. In 1895 he exhibited eighteen views of the façade and two other views of the cathedral, an occasion that brought forth paeans of praise and torrents of condemnation. But Monet's moments had, in the very process of being painted, become the work of art, and were at once superimposed and suspended in time. Sky and ground were all but eliminated. The façade was coextensive with the canvas, covered with a tissue of spots of contrasting colors, a kind of cloth of gold embroidered in silver and studded with diamonds and sapphires, just as he had declared. The light permeating the shadows and the stone had now obviously become the object of intense emotional involvement on the part of the artist.

The painting known as *Rouen Cathedral in Full Sunlight* (fig. 33–7) must represent the moment just about noon when the low winter sun is still striking the southern flanks of the masses of masonry and has not yet entered the west portals, illuminated by reflections from the square in front. Dazzling as the cathedral paintings are, Monet himself was so discouraged by the impossibility of registering with his hand what he saw with his eyes that he thought of abandoning them. However, he took them all back to his home at Giverny, between Paris and Rouen, and worked on them, significantly enough, away from the object, with only his memories of light to guide him and his constantly deepening and intensifying knowledge of the poetry of color.

In 1899 Monet began a series of water landscapes that were to occupy him until his death twenty-seven years later. In some ways these late pictures are the most magical of all. He won his battle with nature by annexing it. At Giverny, dissatisfied with painting experiences chosen from the chaotic stream of the outside world, he constructed an environment that he could control absolutely, a water garden filled with water-loving trees and flowers and crossed at one point by a Japanese footbridge. Here, in canvases as gigantic as any by David, Gros, or Géricault, he submerged himself in the world of changing color, a poetic fabric in which visual and emotional experience merge. Eventually abandoning the banks entirely, the aged artist gazed into the water, and these paintings (see Introduction fig. 1) show a surface in which the shimmering reflections of sky and trees blend between the floating water lilies. Two series of these canvases were designed to join, in ellipses that envelop entire rooms, without beginning or end. In Monet's last works the stream of experience has become timeless without renouncing its fluidity; despite

his failing vision and his sense that he had attempted the impossible, Monet had, symbolically at least, conquered time.

In the early 1870s Manet, at the height of his career, suddenly gave up his flat style and adopted both the brilliant palette and the broken brushwork of the Impressionists. Some of his later pictures are well-nigh indistinguishable from theirs. But the most memorable of these, *A Bar at the Folies-Bergère* (fig. 33–8), painted in 1881–82, only two years before the artist's premature death at the age of fifty-one, is an arresting restatement—in Impressionist terms—of Manet's earlier interest in the human figure.

The entire foreground is constituted by the marble bar, laden with fruit, flowers, and bottles of champagne and liqueurs, forming one of the loveliest still lifes in all of French painting. As the nearer edge of the bar is cut off by the frame, we have the illusion that its surface extends into our space, and that we as spectators are ordering a drink from the stolid barmaid who leans her hands on the inner edge. This illusion is reinforced by the reflection in the mirror, which fills the entire background of the picture. Defying logic, Manet has shifted the entire reflection to the right so we can make out clearly a back view of the barmaid, in conversation with a top-hatted gentleman who, by elimination, must be identical with the spectator. Beyond the bar, shimmering chandeliers hover above the noisy crowd, and from the upper left corner dangle the legs of a performing acrobat. Manet was certainly remembering Velázquez's *Las Meninas* (see fig. 27–37), in whose background mirror appear the king and queen. But his extension of the mirror to the top and sides of the painting substitutes for the expected space within the picture the reflected interior of the cabaret, which is behind the spectator and, therefore, outside the picture. Spatially, this is the most complex image we have seen thus far in the history of art. In his early works Manet had modernized the subject. Monet in the 1870s had dissolved the object. It remained for Manet in this painting to eliminate the last vestiges of that Renaissance pictorial space that Alberti had defined as a vertical section through the pyramid of sight. Manet's masterpiece is painted with a brushwork that combines memories of Velázquez's virtuosity with the most brilliant achievements of the Impressionists. Paradoxically, the imposing dignity and centrality of the figure and the straight lines of the bar that frame her make this work his most monumental achievement.

Morisot

The Impressionist group had one founding woman member, Berthe Morisot (1841–95), who exhibited with them from the start (Mary Cassatt joined in 1879) and was treated on a par with her male colleagues—the first time in the history of art since the Middle Ages that a woman artist enjoyed such a position of unquestioned equality in any artistic movement. Morisot was a grandniece of Fragonard, who died more than a generation before her birth, but contrary to the common situation in which women artists were daughters of painters, she was the only talented member of her immediate family. After a long platonic association with Manet, she married his brother Eugène, with whom she was especially happy because he understood and encouraged her in her work and assisted in planning and hanging the Impressionist exhibitions. Much of her technical excellence—for in some ways she was the most skillful member of the group—she disciplined by assiduous copying of Old Masters in the Louvre. In her youth, moreover, she profited by the guidance of Corot, whose silvery tonalities she emulated in her early landscapes. Her friendship with Manet was mutually beneficial; Morisot mastered the figure, which soon showed off her talents at their best, and Manet lightened his dark palette. Although by no means such an innovator as Monet, Manet, or Renoir, Morisot was a painter of great sensitivity of observation, insight, and touch and, above all, unrivaled lyric intimacy. Her landscapes and domestic interiors, often small, are invariably jewels. After the great burst of Impressionism in the 1870s,

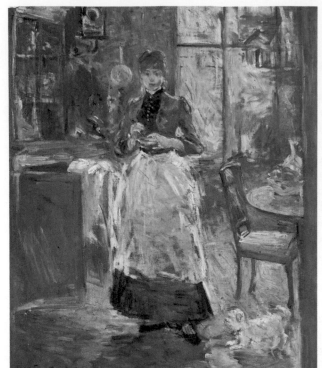

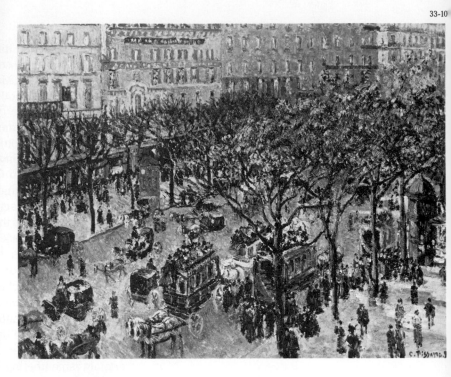

she continued to develop; in her painting of 1886 *In the Dining Room* (fig. 33–9), she has transformed the artistic vocabulary of Impressionism into something more than purely retinal, as indeed had Monet and Renoir. The young servant looks up at us with total self-possession while she works with a mortar and pestle in the midst of a controlled tempest of strokes in subdued but sparkling colors. The painter has celebrated an exquisite but temporary bit of domestic disorder—the fruit is still on the table after lunch, the used tablecloth is flung over a half-open cabinet door, the white dog demands attention. This picture, as John Walker put it, "could never have been painted by a man."

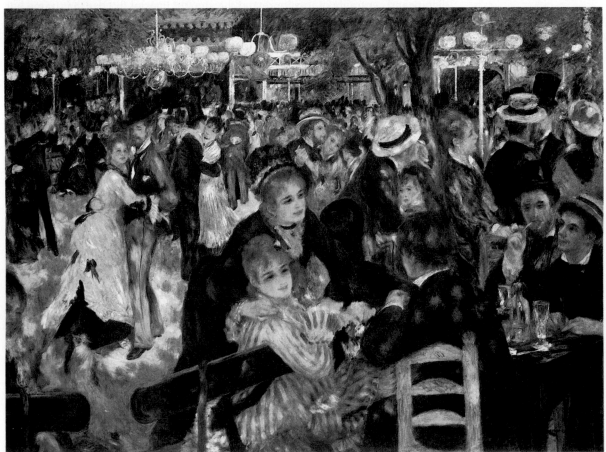

33-9. BERTHE MORISOT. *In the Dining Room.* 1886. Oil on canvas, 24⅛ × 19¾" (61.3 × 50.2 cm). National Gallery of Art, Washington, D.C. Chester Dale Collection, 1962

33-10. CAMILLE PISSARRO. *Boulevard des Italiens, Paris—Morning Sunlight.* 1897. Oil on canvas, 28⅞ × 36¼" (73.3 × 92 cm). National Gallery of Art, Washington, D.C. Chester Dale Collection

33-11. PIERRE AUGUSTE RENOIR. *Le Moulin de la Galette.* 1876. Oil on canvas, 51½ × 69" (1.31 × 1.75 m). Musée du Louvre, Paris

Pissarro and Renoir

An extremely gifted member of the Impressionist group, if less spectacular than Monet and Manet, was Camille Pissarro (1830–1903), whose father, a Portuguese Jew living in the West Indies, had become a French citizen. From the very first, Pissarro exhibited with the Impressionists. He was the most careful and craftsmanly of them all, and it was his companionship and advice that provided a much-needed technical foundation for the more impetuous Cézanne (see pages 941–45), who called him (very appropriately) "humble and colossal." He is both in the scrupulously painted *Boulevard des Italiens, Paris—Morning Sunlight,* of 1897 (fig. 33–10). With infinite care he recorded the innumerable spots of color constituted by people, carriages, omnibuses, trees, windows, and kiosks in this view of one of the great metropolitan thoroughfares, whose activities provided the subject for so many Impressionist paintings. In fact, Impressionist artists often worked side by side painting the same view of a street, a café, or a riverbank at the same moment of light and atmosphere, and it is often only the special sensibility and personal touch of each painter that make it possible to tell their works apart.

Although the sparkling *Les Grands Boulevards,* of 1875 (see Introduction fig. 8), by Pierre Auguste Renoir (1841–1919) was not such a collaborative venture, it shows us how much latitude remained for individuality in treating a similar subject at the height of the collective phase of the Impressionist movement. Renoir, the most sensuous and effervescent of the group, has not bothered with the detail that occupied Pissarro. Rather he has captured a moment of high excitement as we look across a roadway from the shadow of the trees to the trotting white horse pulling a carriage filled with people in blazing sun. Warmth, physical delight, and intense joy of life are the perpetual themes of Renoir; as a painter his touch is correspondingly both silkier and more spontaneous than that of Pissarro. Trained at first as a painter on porcelain, he later studied with the academic painter Charles Gabriel Gleyre, who also taught Monet, and soon made the acquaintance of the Impressionist group, with whom he exhibited until 1886.

The most exuberant image from the Impressionist heyday is Renoir's *Le Moulin de la Galette,* of 1876 (fig. 33–11), depicting a Sunday afternoon in a popular Parisian outdoor *café dansant* on Montmartre. Young couples, bewitching in their freshness, are gathered at tables under the trees, or dancing happily through the changing interplay of sunlight and shadow. Characteristically, there is not a trace of black; even the coats and the shadows turn to dark blue, delicious as a foil to the higher tones of pearly white and soft rose. One could scarcely imagine a more complete embodiment of the fundamental theme of Impressionist painting, the leisurely enjoyment of the moment of light and air. Although he later turned toward a Post-Impressionist style (see Chapter Thirty-Four), Renoir never surpassed the beauty of this picture, which sums up visually the goal he once expressed in words: "The earth as the paradise of the gods, that is what I want to paint."

Degas and Caillebotte

There could be no more complete opposite to Renoir than Hilaire Germain Edgar Degas (1834–1917). Although Degas exhibited with the Impressionists, he did not share their interest in landscape, and his version of their cult of instantaneity concerned itself solely with people, in a detached way; as a person, Degas was apt to be remote and difficult. His apparent haughtiness concealed a profound sense of his own limitations and a continuing reverence for the Old Masters. Partly Italian by ancestry, he made several trips to Italy and both there and in the Louvre copied Italian paintings and, particularly, Italian drawings. Taught by a disciple of Ingres, he was a deep admirer of the great Neoclassicist's linear perfection and learned much from his analytic style. An amateur photographer himself, he studied the work of the British-American pioneer photographer Eadweard Muybridge (1830–

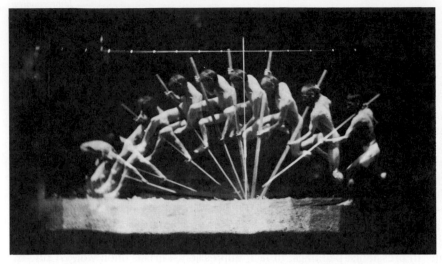

33-12. THOMAS EAKINS. *George Reynolds, Pole-Vaulting.* 1884–85. Multiple-exposure photograph. The Metropolitan Museum of Art, New York. Gift of Charles Bregler, 1941

1904), who collaborated with Thomas Eakins in an attempt to analyze accurately the motion of human beings and horses through photographs of stages of their actions. A brilliant example is Eakins's *George Reynolds, Pole-Vaulting,* of 1884–85 (fig. 33–12). Nonetheless, Degas had actually drawn and painted instantaneous poses *before* the experiments of Muybridge and Eakins.

Degas defined the goal of his own style succinctly as "bewitching the truth." There could be no more apt phrase for his art, at once convincingly real and magically beautiful. Like Monet, Degas painted many variations on the same subject. One subject that fascinated him, and that he explored for decades, was the dance. He had no interest in such allegorical groupings as those of Carpeaux (see

33-13. EDGAR DEGAS. *Rehearsal on Stage.* Probably 1874. Pastel over brush and ink on paper, 21 × 28½″ (53.3 × 72.4 cm). The Metropolitan Museum of Art, New York. Bequest of Mrs. H. O. Havemeyer, 1929. The H. O. Havemeyer Collection

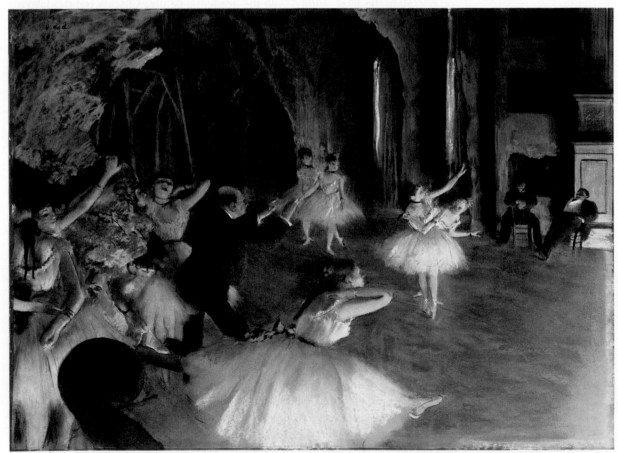

33-13

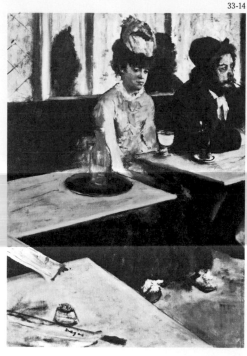

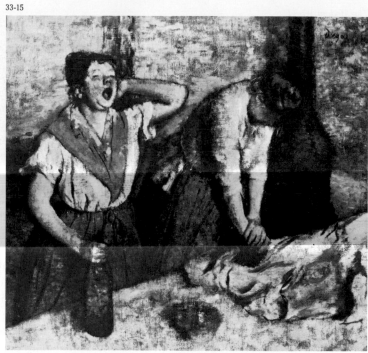

33-14. EDGAR DEGAS. *Absinthe*. 1876. Oil on canvas, 36 × 27″ (91.4 × 68.6 cm). Musée d'Orsay, Paris

33-15. EDGAR DEGAS. *Two Laundresses*. c. 1884. Oil on canvas, 29⅞ × 32¼″ (76 × 82 cm). Musée d'Orsay, Paris

33-16. EDGAR DEGAS. *Woman Bathing in a Shallow Tub*. 1885. Pastel, 32 × 22″ (81.3 × 55.9 cm). The Metropolitan Museum of Art, New York. Bequest of Mrs. H. O. Havemeyer, 1929. The H. O. Havemeyer Collection

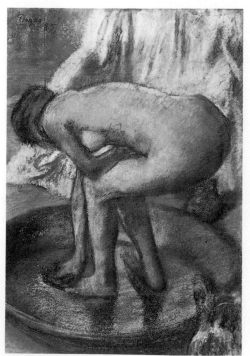

33-16

fig. 31–17) but in real dancers and in every facet of their activities, from their grueling workouts at the barre to their rehearsals and their triumphant performances. His dancers are never idealized; they are little, sometimes scrawny, women in tulle skirts, either working hard to produce an illusion of exquisite lightness and ease or merely lounging about onstage, stretching, yawning, or scratching, as in the *Rehearsal on Stage,* probably of 1874 (fig. 33–13). The view of the stage is not that enjoyed by most of the audience but is located far forward in a box at one side, giving an informal and diagonal aspect. At the left, the ballet master directs two dancers in a *pas de deux* at center stage. Although Degas never adopted the Impressionist color fleck and preferred the exploration of indoor light effects, this and all of his mature pictures were conceived according to the same principles of accidentality and instantaneity that govern Monet's *Gare Saint-Lazare.* Each painting is a kind of snapshot of a moment of action, with nothing edited out, not even the two relaxed onlookers at the right, who are no doubt more interested in visiting the young girls backstage than in the intricacies of ballet, or the volute of a double bass that abruptly juts up from the orchestra pit. The subtle coloration is indicated in pastel over soft, rather thin washes of tone over drawing of uncanny accuracy.

Like many artists of the last decades of the nineteenth century, Degas was fascinated by café life, including its seamier aspects. His *Absinthe*, of 1876 (fig. 33–14), shows a sodden couple, beyond communication, merely tolerating each other's presence. The woman's glass of milky green liqueur is the addictive, stupor-inducing absinthe. The picture is a superb composition of apparently accidental diagonals in depth, composed of the tables, the bench, and even the diagonal relationship between the couple and their reflections in the mirror. The same kind of closed-in space, extending forward into that of the spectator in the manner of Manet's *A Bar at the Folies-Bergère,* is exploited in *Two Laundresses* (fig. 33–15), of about 1884, one of a series. The exhausting pressure on the flatiron and the sleepiness of the workers in the steam of the stuffy interior are rendered with sovereign authority. Degas composes these figures as powerfully as had Courbet in his *Stone Breakers* (see fig. 32–9), but with a more arresting immediacy.

In later life Degas made extensive use of the medium of *pastel* (powdered color compressed into sticks so it can be applied almost like chalk), which had been employed for delicate effects by French portraitists of the Rococo. Degas's experiments with this medium, combining it at times with water so it could be worked into

a paste, and holding it to the paper surface with a special fixative varnish, gave him at once great resonance of color and bloomlike freshness. Casting aside all allusions to classical poses (which linger on even in Courbet's *The Studio;* see fig. 32–11), he painted a strikingly original series of female nudes, seen, as he put it, "through a keyhole." To the disgust of the Parisians, whose taste in nudes had been nourished on Ingres and the Italian Renaissance tradition, he depicted "the human beast occupied with herself. Until now," he claimed, "the nude has always been represented in poses that presuppose an audience. But my women are simple, honest people, who have no other thought than their physical activity." *Woman Bathing in a Shallow Tub,* of 1885 (fig. 33–16), concentrates all the forces of the composition on the simple activity of drying oneself with a towel; not even the face is shown. Unclassical though the figure may at first sight appear in its proportions and attitudes, Renoir recognized the sculptural power of Degas's nudes when he said that one of them looked like a fragment from the sculptures of the Parthenon. Tragically, like Piero della Francesca, an earlier apostle of the poetry of sight, Degas was destined to spend his last years in near-blindness and inactivity.

One Impressionist who looked to Degas's art for guidance was the young painter Gustave Caillebotte (1848–94). Independently wealthy, Caillebotte was able to pursue his artistic course with little concern for the marketability of his work and to underwrite the Impressionist cause with great generosity. A discerning collector of Impressionist painting, he left his magnificent collection to the Louvre upon his premature death, at the age of forty-five. Caillebotte's masterpiece is a large painting of 1877, *Paris Street: Rainy Weather,* which depicts with extraordinary clarity and boldness a casual slice of modern Parisian life (fig. 33–17). Rather than adopting Pissarro's balcony view (see fig. 33–10), Caillebotte drops the viewer to street level, and the fashionably dressed strollers in the foreground seem about to step across the threshold of the canvas into our own space. Beyond these strollers the artist creates an expansive space as the new radiating boulevards of Haussmann's Paris plunge into depth. Caillebotte's tight draftsmanship has more in common with Degas than with the broken brushwork of Monet or Renoir, as does his subdued palette of cool, gray hues that here re-create the atmosphere and reflections of a rainy day in the city. His pedestrians, isolated from one another and lost in thought beneath their silvery umbrellas, belong to a strangely quiet, static vision of the modern urban environment, one that would not be seen again until an even more radical conception appeared in the following decade (see fig. 34–7).

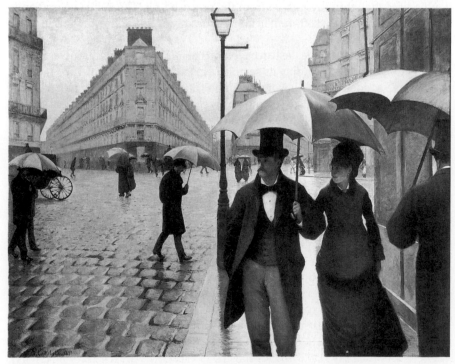

33-17. Gustave Caillebotte. *Paris Street: Rainy Weather.* 1877. Oil on canvas, 6′11½″ × 9′3¾″ (1.12 × 2.76 m). The Art Institute of Chicago. Charles H. and Mary F. S. Worcester Collection, 1964

33-17

Whistler, Cassatt, and Sargent

The reputation and eventual financial success of the Impressionist movement owed a great deal to American interest. Even today some of the most extensive and best-chosen collections of Impressionist art are in the United States. Long before Monet's death, Giverny became a kind of pilgrimage goal for American painters of all degrees of talent. But they were preceded in devotion to Impressionist ideals by three highly individual artists, one of them a woman, who spent much of their lives in Europe yet brought American art out of isolation into the mainstream of world culture.

WHISTLER The Impressionist movement attracted quite early the partial allegiance of a young American, James Abbott McNeill Whistler (1834–1903), who had been living in Paris since 1855. Whistler admired the work of Courbet in the famous Pavilion of Realism at the Universal Exposition in that year (see page 912), and for a while he worked with Courbet. He also came in contact with the major figures of the Impressionist movement, but he never joined the group. His *Portrait of Thomas Carlyle: Arrangement in Gray and Black, No. 2* (fig. 33–18), painted in England in 1872 but first shown in Paris at the Salon of 1884, is still reminiscent of the flattened style of Manet. Whistler never emulated Manet's vigorous brushwork, however, but developed his own method of sensitive gradations and adjustments of tone. He was strongly influenced by Japanese prints, which Degas also admired for their originality of viewpoint and subject, but whose systematic silhouetting was more thoroughly adopted by Whistler and the American Impressionist painter Mary Cassatt (see below).

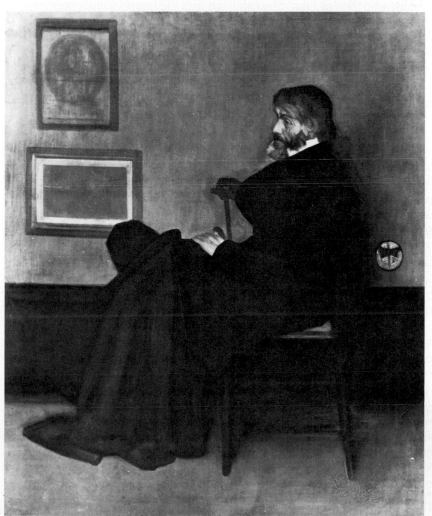

33-18. JAMES ABBOTT MCNEILL WHISTLER. *Portrait of Thomas Carlyle: Arrangement in Gray and Black, No. 2.* 1872. Oil on canvas, 67⅜ × 56½″ (1.71 × 1.44 m). Glasgow Art Gallery and Museum

33-18

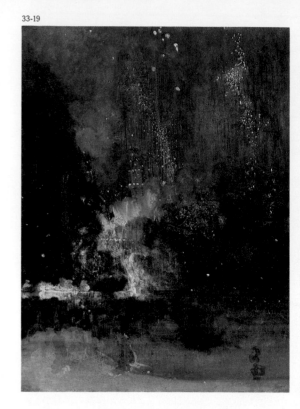

33-19

In an ostensible attempt to win for art the freedom from natural resemblances always accorded to music, Whistler called his paintings *Harmonies, Symphonies, Nocturnes,* or *Arrangements. Nocturne in Black and Gold: Falling Rocket* (fig. 33–19), painted in England about 1874 and exhibited there in 1876, was described in an article by the English critic John Ruskin—a supporter of "truth" in art and of craftsmanship in what he believed to be the medieval sense—as "a pot of paint [flung] in the public's face." Any apparent prophetic resemblance between this daring picture and the Abstract Expressionist works of the 1950s (see Introduction fig. 27 and fig. 38–17), especially the "drip style" of Jackson Pollock, is dismissed by the subtitle. In brilliant and witty testimony during a lawsuit he brought against Ruskin, Whistler claimed that his art was "divested from any outside sort of interest . . . an arrangement of line, form and color first." The last word in the sentence discloses its true substance, however, because even if Whistler felt that his pictures were arrangements first, there is nothing by his hand that is not at the same time thoroughly representational. He never attempted to break the tie connecting the work of art with the visual image of the object. Even the picture at issue is in fact a realistic portrayal of the clouds of sparks from a falling rocket, as much the record of an instantaneous impression as the railway stations of Monet or the ballet dancers of Degas.

CASSATT More directly involved than Whistler with the Impressionist movement was Mary Cassatt (1845–1926), whose prosperous Philadelphia origins have obscured the fact that her financial well-being in later life was due wholly to the sale of her paintings, pastels, and prints. Cassatt was trained as an artist in Philadelphia, Paris, and Rome, and was for a while a regular exhibitor at the Paris Salon. There in 1875 her work attracted the enthusiastic attention of Degas, who exclaimed, "Here is someone who feels as I do!" She exhibited with the Impressionists beginning in 1879. Although she adopted the compressed Impressionist space (hers is particularly close to that of Degas), contemporary subject matter, and snapshot vision, she never accepted, as had Morisot, the brisk, divided touch that dematerialized objects and persons alike. She knew and respected the work of all the great Impressionists, however, and her connections with American collectors were a godsend to the struggling painters. It is largely due to Cassatt's efforts that the major private American collections of Impressionist art were formed, later the nuclei of those in American museums, so it can be fairly claimed she was responsible for the education of the American public in the new style—the first woman in history ever to exert such artistic influence.

Cassatt devoted herself entirely to her art, an art that was never detached and impersonal like that of Monet. It might be said that her attitude was coolly human. Her subjects, almost exclusively female but not always conventionally pretty, do not smile or attempt to ingratiate themselves with the observer in any way. They exist in their own right as women, girls, and children, with total dignity.

Cassatt's flesh tones are dense, her color clear and bright—sometimes sharp, sometimes blond—and always under perfect control. Her figures are so firm, her backgrounds so consistent, and her sense of structure so rigorous that one might easily place her among the Post-Impressionists, save that she, like Degas, never distorts in the interest of form as, for example, does Cézanne.

Degas, with whom she had an intense but thorny professional relationship, proposed to Cassatt a series of studies of mothers and children, which became in some ways her major achievement. Effective in their human interest, these pictures are nonetheless free from the sentimentality that too often plagues the smiling pictures of motherhood painted by men. *The Bath,* of 1891 (fig. 33–20), with its clear delineation of forms and graphic patterning, derives in part from the example of Japanese prints. And Cassatt owes a clear debt to such works by Degas as *Woman Bathing in a Shallow Tub* (see fig. 33–16). The intimate Impressionist point of view is strengthened by a superb sense of color and design, the three-tone stripes of the

33-19. JAMES ABBOTT MCNEILL WHISTLER. *Nocturne in Black and Gold: Falling Rocket.* c. 1874. Oil on oak panel, 23¾ × 18⅜″ (60.3 × 46.7 cm). The Detroit Institute of Arts. Gift of Dexter M. Ferry, Jr.

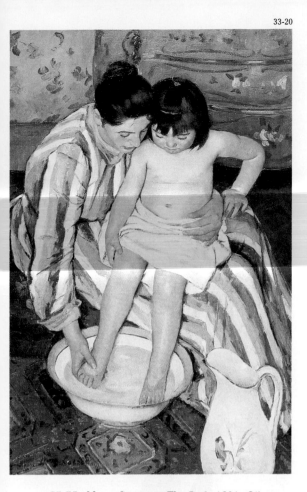

33-20. MARY CASSATT. *The Bath.* 1891. Oil on canvas, 39½ × 26″ (100.3 × 66 cm). The Art Institute of Chicago. Robert A. Waller Collection

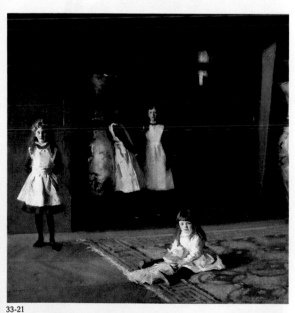

33-21

33-21. JOHN SINGER SARGENT. *Daughters of Edward Darley Boit.* 1882. Oil on canvas, 7′3″ × 7′3″ (2.21 × 2.21 m). Courtesy, Museum of Fine Arts, Boston. Gift of Mary Louisa Boit, Florence D. Boit, Jane Hubbard Boit, and Julia Overing Boit in memory of their father, Edward Darley Boit

mother's dress serving as a kind of architectural enframement for the sturdy little girl, fascinated at having her feet washed. Like her mentor, Degas, for whom she cared in her generous way during his own blindness, Cassatt eventually lost her sight and passed her final years alone and embittered in the château she had bought in France, among beautiful works of art she could no longer see.

SARGENT In total contrast with Cassatt was John Singer Sargent (1856–1925). Born in Florence of American parents, he returned to the United States infrequently, only to execute commissions or to protect his American citizenship, to retain which he declined a British knighthood. He was trained in the 1870s by academic artists in France and Italy and soon became deeply interested in Impressionism. He never formally joined the group, however, in spite of his close relationships to several of its members. A measure of the essential barrier that kept Sargent from fully accepting the objectivity of Impressionist theory was his inability to understand how Monet could paint without black. He painted portraits, landscapes, scenes of figures outdoors, watercolors, and—alas—murals, only the last of which are ranked today as failures. His fortunes at the critics' hands were as volatile as his style: praised one year, he was attacked the next, and always for different reasons. Though eventually he was recognized as the leading painter in the English-speaking world, no one has ever called him great. Like Cassatt, he did not cross the watershed to Post-Impressionism by deserting visual reality in the interests of form or expression. But Sargent was without doubt a brilliant master of the brush as a communicator of optical effects. His accidental groupings of figures were arresting and compelling, as were his portraits. And not only is his virtuosity dazzling but his penetration of character is so intense that he makes Reynolds look ponderous and Gainsborough decorative. He depicted members of high society in England and America not always as they wanted to be seen (save for the externals of costume and setting) but as they were, with a psychological intensity that renders him at his best the artistic equivalent of the novelist Henry James.

Sargent's large picture the *Daughters of Edward Darley Boit,* painted in Paris in 1882 (fig. 33–21), is one of the most innovative portraits of the nineteenth century. The artist casually arranged four girls, daughters of his friend the painter Boit, around a Paris apartment, the darkness and scale of which threaten to engulf them. The starched white pinafores, loosely sketched in with a few bravura strokes, are set off dramatically by deep black shadows. Additional accents of color, in the giant Japanese vases, the reflections on the mirror in the background, and the flash of a red screen at the right, are set on the canvas with astonishing breadth, speed, and accuracy, bringing to mind Manet. But Sargent's pictorial concept is directly based on a specific source, that of Velázquez's *Las Meninas* (see fig. 27–37), a painting that has confounded artists through the centuries with its magic. As in that seventeenth-century work, three of the girls in Sargent's portrait confront the viewer directly, as if we had just entered the room, while another seems indifferent to our presence. Sargent managed to capture some of the psychological mystery of Velázquez's composition, creating an image that is at once instantaneous and timeless. Henry James praised the work in the press, marveling at "the sense it gives us as of assimilated secrets."

Sculpture

During the eighteenth and nineteenth centuries, sculpture had lagged behind both painting and architecture as a medium of artistic expression. Among all the sculptors of this period the only one to compare with his contemporaries among the painters was Houdon. Nonetheless, public squares throughout Europe and America were filled with large-scale monuments topped by galloping generals or frock-coated dignitaries and loaded with allegorical figures and attributes, supplying in sheer volume what they too often lacked in aesthetic interest or even good taste.

The most original sculptor of the mid-nineteenth century was the painter Daumier, whose little caricatures in clay were hardly known before his death and only afterward evaluated and cast in bronze. Likewise, Degas produced hundreds of small sculptures of figures in action poses, few of which were known in his day. It would hardly seem likely that Impressionism, in its beginnings so strongly opposed to form—in fact, dissolving it utterly in the paintings of Monet, Renoir, and Pissarro—could be accompanied by a comparable current in sculpture, by definition the art of form. Yet a backward glance at the history of sculpture, particularly during the Hellenistic period, the Early Renaissance, and the Baroque, shows that at moments sculpture could and did emulate the effects of painting without sacrificing quality.

RODIN The only contemporary of the Impressionists who could rival their inventiveness in bronze and marble was Auguste Rodin (1840–1917), a creator of masterpieces of a sculptural power not seen since Michelangelo. In fact, Rodin is one of the few great sculptors of Western tradition since the Middle Ages (in addition to Michelangelo, one would have to count Donatello, Claus Sluter, Gianlorenzo Bernini, and, in the twentieth century, Constantin Brancusi). Yet although Rodin had single-handedly revived sculpture as a leading art, his style was so strongly personal that he attracted few followers. Nearly all the leading sculptors of the early twentieth century moved in directions opposed to those he had so thoroughly explored.

Sympathetic though Rodin was with the aims of Impressionism—to the point of exhibiting with Monet—Impressionist technique was, of course, denied to sculpture; Rodin's timeless and heroic themes have little to do with the contemporaneity of Impressionist subjects drawn from everyday life. He was exclusively concerned with the human figure. Like those Impressionist painters who treated the figure, he saw it in action and in light but also, unlike them, in moments of great physical and emotional stress. He is, therefore, more closely related to both Donatello and Michelangelo, whose works he studied with a passion, and whose expressive intensity he was the first sculptor of modern times to revive and the only one to rival. His art was always controversial. At the Salon of 1877 he exhibited the *Age of Bronze* (fig. 33–22), a superb statue he had created the preceding year. Its realism, as compared with the idealized nudes then found palatable, produced a storm of indignation and the accusation that he had passed off a cast from a living figure as an original work. (Interestingly enough, this was actually done in the late twentieth century with no protest whatever.)

What Rodin had in fact done, and what he was to continue to do throughout his long career, was to experiment with transient poses and accidental effects, without predetermined compositions and often without preestablished meaning, much in the manner of Degas's studies of dancers. In this instance he was modeling in clay the figure of a young Belgian soldier of exceptionally harmonious physique and had posed him with a pole in his left hand as a support, according to the custom of life classes, while his right rested on his head in an attitude reminiscent of Michelangelo's *Dying Slave* (see fig. 22–14) in reverse. He then noticed that by omitting the pole from his statue he left the figure in a state of unexplained tension, which, combined with the closed eyes and partly open mouth, seems to communicate some nameless anguish. Rodin thought up the mystifying title for the work only as it approached completion. In consequence no satisfying interpretation has ever been advanced, or can be.

The patches of clay, sometimes smoothed in the final bronze, sometimes left rough, cause light to flicker over the surface. Rodin found that he could similarly exploit the luminous properties of marble, as in *The Kiss*, of 1886 (see Introduction fig. 16), whose first version dates from 1880–82. In the nineteenth century the actual cutting of marble was done by stonecutters, working from plaster casts of the sculptor's original models in clay. Rodin was fascinated by the unfinished portions

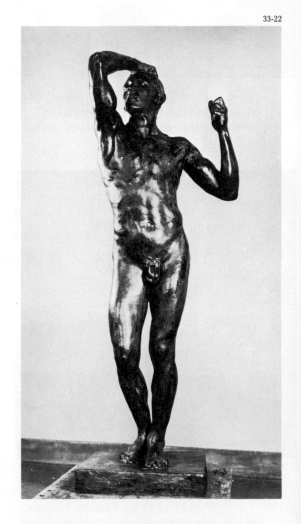

33-22

33-22. AUGUSTE RODIN. *Age of Bronze*. 1876. Bronze, height 71″ (1.8 m). The Minneapolis Institute of Arts. John R. Van Derlip Fund

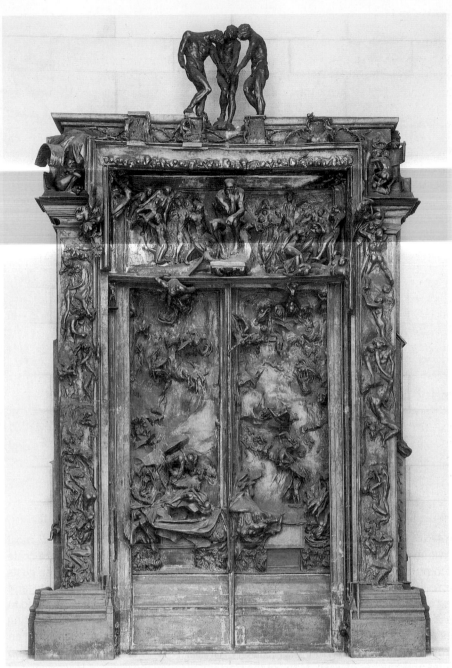

33-23. AUGUSTE RODIN. *Gates of Hell.* 1880–1917. Bronze, 18 × 12' (5.49 × 3.66 m). Rodin Museum, Philadelphia

of many of Michelangelo's statues (see fig. 22–10) and stopped the stonecutter when he found a roughly carved mass that had expressive possibilities. Generally, but not always, he finished the smooth portions himself, avoiding both Michelangelo's sharp undercuttings and high polish. He preferred a softly blurred surface in the manner of Desiderio da Settignano (see fig. 20–60), so that light, absorbed and reflected by the crystals of the marble, would create a subtle glow around the figures, intensifying the sensuous immediacy of the sculpture.

This and many other statues in marble and bronze by Rodin originated in a large-scale commission he received in 1880 for the doors of the Museum of Decorative Arts in Paris. Still unfinished at the sculptor's death, the *Gates of Hell* (fig. 33–23) was inspired by Dante's *Inferno*. It is the most ambitious sculptural composition of the nineteenth century and one of the great imaginative conceptions of modern times. Although an obvious counterpart to Ghiberti's *Gates of Paradise* (see fig. 20–30), the cosmic scope of the work was clearly indebted to Michelangelo's *Last Judgment* (see fig. 23–5) and to Rubens's *Fall of the Damned*

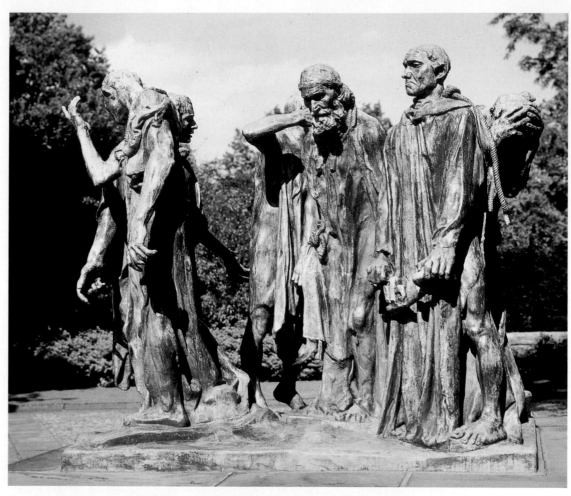

33-24. AUGUSTE RODIN. *Burghers of Calais.* 1884–86. Bronze, 6′10½″ × 7′11″ × 6′6″ (2.07 × 2.41 × 1.98 m). Hirshhorn Museum and Sculpture Garden, Smithsonian Institution, Washington, D.C.

(see fig. 27–27). Before its completion, many of the figures in the *Gates of Hell*, most notably the Thinker (at the upper center), emerged as individual large-scale sculptures. Rodin admits us to a world of flame and smoke, through whose gusts tormented spirits are propelled in poses and groups of great originality and expressive power. Always intensely interested in the figure in motion, Rodin used to ask his models to move at random through his studio, turning, jumping, squatting as they wished; when he spotted an unusual attitude, he would signal for an immediate freeze, and then capture the essence of the pose in a few split-second lines and touches of wash. Many of the startling poses in the *Gates of Hell* originated in this manner. He strongly objected to reliance on the poses shown by such photographs as those by Eakins and Muybridge, claiming that his method corresponded more accurately to our vision.

Revolted by the (as he saw it) hypocritical conventionality of most nineteenth-century commemorative sculpture, Rodin tried to make his monuments as arresting and immediate as possible. The *Burghers of Calais* (fig. 33–24) was commissioned in 1884 as a memorial to the six heroic citizens who in 1347 came before the conquering King Edward III of England in sackcloth with halters around their necks, offering their own lives that the city of Calais might be spared. The work, finished two years later, after arduous labors, is a testament to Rodin's greatness as a bronze sculptor. The roughness of the drapery surfaces is masterfully exploited, in heavy folds and masses, against which the twisted gestures, taut limbs, and tragic faces communicate heroism, self-sacrifice, and the fear and inevitability of death. No sculptural figures of such rugged honesty had been created since Donatello's *Habbakuk* (see fig. 20–23). The apparent accidentality of the grouping, nonetheless, builds up to noble masses from every point of view. It is typical of the expressive intent of Rodin that he wanted the monument to be placed at street level

among the cobblestones so that the observer could participate as directly as possible in the emotional and physical tensions of the figures. Rodin's wishes, at first disregarded, were finally carried out in 1924. This bold move, to remove a sculpture from its pedestal, would form a major feature of much later-twentieth-century sculpture (see figs. 38–9, 38–45, 38–54).

Few of Rodin's monuments reached completion, and some were rejected by the patrons, including one of his greatest late works, the *Balzac* of 1893–97 (see Introduction fig. 17). Condemned as a menhir (Stone Age monolith), the statue is actually an attempt to convey in sculptural masses of the greatest harshness the intensity of the very moment of artistic creativity. Rodin has shown the great novelist wrapped in his bathrobe, stalking through his house as the characters of his novels have seized upon him like demons and possessed him utterly. The throes of creative emotion have never before or since been so convincingly portrayed, and the rude resulting form, with its drastic simplifications and distortions, brings Rodin to the brink of twentieth-century sculpture.

CLAUDEL The nineteenth century produced few women sculptors of note, but one shining exception is Rodin's pupil Camille Claudel (1864–1943). Until the long-overdue retrospectives of her work in the 1980s, Claudel was remembered as Rodin's emotionally disturbed model and mistress. It is true that she was committed to mental hospitals for the last thirty years of her life and that she was involved in a long, stormy love affair with Rodin that ended drastically. But she was also one of Rodin's chief studio assistants and a gifted sculptor. In 1884, after a brief period of training, she entered Rodin's studio, a precociously talented twenty-year-old, and by 1887 she was exhibiting at the Salon. *Maturity* (fig. 33–25), arguably Claudel's most important work, is a highly original sculpture around the theme, according to the artist, of destiny. The nude figure of a man, now past his prime, is carried off by Old Age in the form of a haggard old woman, while the comely figure of Youth, kneeling to one side, futilely implores him to stay. The tragic implications of this moment can be felt in the man's excruciatingly furrowed visage, large arthritic hands, and knotty anatomy. The challenge of successfully integrating three separate figures into a unified narrative whole is formidable. Claudel's ingenious solution was to design the figures at gradually ascending heights and then lock them together with fluid, expressive gestures. This compositional device endows the sculpture with a forceful rush of movement, given even greater dynamism by the jagged profile of windswept drapery that swells up behind Old Age like an enormous wave and wraps around her prey. Although originally created as a state commission in two successive versions (this is the second), *Maturity* was in the end abandoned by the state and was not cast in bronze until 1902, under private auspices. Finally, in 1982, thirty-nine years after the artist's death, the work was acquired by the French government for a museum in Paris.

33-25. CAMILLE CLAUDEL. *Maturity (L'Âge Mûr)*. 1895. Bronze, 44⅞ × 64⅛ × 28⅜″ (114 × 163 × 72 cm). Musée d'Orsay, Paris

33-25

CHAPTER THIRTY-FOUR

For a wide range of reasons, from personal crises to national economic disasters, the Impressionist movement gradually dissolved in the 1880s. The exhibitions continued, but one after another the original members ceased to send their paintings to the group shows. Renoir visited Italy and found a new stylistic direction based partly on his study of Raphael. Monet himself had come to realize that what he was really creating was a prolonged moment, the accumulated evidence of many similar moments—a horizontal rather than a vertical section through the stream of time—and came to rely increasingly on memory and work in the studio. One member of the original group, Cézanne, who had been considered by many a minor painter and whose works had been especially derided by the public at the Impressionist exhibitions and regularly refused at the Salons, dropped out of the Impressionist group even before the end of the 1870s—in fact, left Paris to work out a new style in isolation. Significantly, alongside the old guard in the Impressionist exhibitions, younger artists such as Paul Gauguin and Georges Seurat showed works that, while indebted to Impressionsim, pointed in a new direction.

The separate tendencies, which we now group loosely together under the general title of *Post-Impressionism,* had little in common save their derivation from the Impressionist aesthetic. *Post-Impressionist* is not a name the artists called themselves. The actual term was not invented until 1910, for lack of a better one, by a very supportive critic. While the artists retained the bright Impressionist palette and even to some extent the Impressionist color patches, these acquired a new shape and a new function, in keeping with the personal artistic goal of each painter. In a negative sense, however, the Post-Impressionists were united in regarding Impressionism as too fugitive in its aspirations to achieve an art of lasting value. Each Post-Impressionist artist created a sharply individual style, which could no longer be mistaken for that of any of his contemporaries or former associates in its subject matter, its content, or its technique. Whatever their direction, the Post-Impressionists traveled the road opened up for them by Impressionist immediacy

Map 21. PARIS

into a new artistic region where the artist alone was autonomous. Post-Impressionism established the supremacy not of visual but of creative experience. This breakthrough marked the birth of modern art in the familiar sense of the word.

Among the variety of Post-Impressionist styles in France (for it was arguably an international phenomenon), we can distinguish two major tendencies. One, led by Cézanne and Seurat, sought permanence of form, though in radically different ways; the other, represented chiefly by van Gogh and Gauguin, gave first place to highly personal emotional expression. Both began with color. And both demonstrated a willingness to depart from objective transcriptions of the real world in favor of a more internal vision, what Gauguin would call "the mysterious centers of thought." Many of the new forms of so-called Symbolist art owed little or nothing to Impressionism, but aimed at liberating fantasy from the shackles of observation. From these general trends, clearly distinguishable by the late 1880s, spring the principal currents of twentieth-century art.

Cézanne

One of the leading painters of the late nineteenth century in France, indeed one of the most powerful artists in the history of Western painting, was Paul Cézanne (1839–1906). Son of a prosperous banker in the southern French city of Aix-en-Provence, Cézanne experienced none of the financial difficulties that plagued Monet and Renoir during the formative period of Impressionism. He received some artistic training in Aix, and although he arrived in Paris for the first time in 1861, he never set up permanent residence there; after visits of varying duration, he always returned to his Provençal home. At first he was interested in the official art of the Salons but soon achieved an understanding of Delacroix and Courbet and before long of Manet as well. His early works are still Romantic, thickly painted in a palette limited to black, white, tans, and grays, and an occasional touch of bright color. Not until the early 1870s, during two years spent at Pontoise and Auvers, in the Île-de-France, not far from Paris, did he adopt the Impressionist palette, viewpoint, and subject matter, under the tutelage of Pissarro. He showed at the first Impressionist exhibition in 1874 at Nadar's and at the third in 1877. Only in 1882 was one of his paintings exhibited at the Salon.

During most of his independent career, save for visits to Paris, its environs, and to the Mediterranean village of L'Estaque, as well as a trip to Switzerland, Cézanne remained in Aix. His isolation from other artists he considered essential for his intense concentration on the formation of a new style of painting. His great pictorial achievements date from those lonely middle and later years. His mature style is often interpreted in the light of two celebrated sayings: "I want to do Poussin over again, from nature," and "I wish to make of Impressionism something solid and durable, like the art of the museums." Less often quoted but equally important is his remark to the painter Émile Bernard: "Drawing and color are not distinct. . . . The secret of drawing and modeling lies in contrasts and relations of tones."

Cézanne painted only after long reflection, and his slow, calculated method is very different from the Impressionists' spontaneous recording of light effects. Although it retains the high-keyed palette and luminous atmosphere of Impressionism, *Houses in Provence (Vicinity of L'Estaque),* of 1879–82 (fig. 34–1), demonstrates Cézanne's deliberate reformulation of that style. Monet's network of broken strokes is here carefully regimented into a dense pattern of short, distinctly parallel touches, which are for the most part diagonally aligned. Rock, soil, or grass—under Cézanne's brush they all maintain one texture, as though composed of a single elemental substance, for all are described with the same characteristic stroke. Yet

34-1. PAUL CÉZANNE. *Houses in Provence
(Vicinity of L'Estaque)*. 1879–82. Oil on canvas,
25⅝ × 32″ (65.1 × 81.3 cm). National Gallery of
Art, Washington, D.C. Collection of Mr. and Mrs.
Paul Mellon

34-2. PAUL CÉZANNE. *Mont Sainte-Victoire*.
c. 1885–87. Oil on canvas, 25½ × 32″ (64.8 ×
81.3 cm). Courtauld Institute Galleries,
University of London

these forms do not become mottled Impressionist surfaces that dissolve under the force of the sun's blaze. And neither are they built up with traditional chiaroscuro, a gradation of shades from light to dark. Instead, Cézanne uses his "constructive" stroke to build shapes with only a few contrasting colors—brilliant ochres, blues and greens—creating crystalline forms that read as palpable volumes in space. His houses consist of horizontal and vertical planes that form solid structures in a world of durability and convincing geometric order.

Among the subjects Cézanne studied repeatedly was Mont Sainte-Victoire, the rugged mass that dominates the plain of Aix. He never tired of painting the mountain, and today its familiar silhouette stands as a symbol of Cézanne's accomplishment. The version illustrated (fig. 34–2) was painted about 1885–87. In contrast to the momentary glimpses Monet was painting, Cézanne's landscapes rarely indicate the time of day or even the season. In this he was assisted by the fact

34-3. PAUL CÉZANNE. *Still Life with Apples and Oranges*. 1895–1900. Oil on canvas, 28¾ × 36¼″ (73 × 92 cm). Musée du Louvre, Paris

that in Provence there are many evergreens, and winter wheat is green in December. It neither rains nor snows in his landscapes, and there are seldom any recognizable clouds. Time is defeated by permanence, even in the subject. In this panoramic view Cézanne has not even informed us clearly where we stand. A bit of rock in the foreground could be near or at a little distance. We do not know where the tree that frames the composition at the left is rooted, and only a few branches appear from an unseen tree at the right. At no point in the picture are objects described even as much as in a Monet. Some objects are identifiable as houses, trees, fields, and the arches of a viaduct, but Cézanne's visual threshold is high, and below that level nothing is defined. He has broadened his earlier parallel brushstrokes into multidirectional lines and patches, transforming the landscape into a colossal rock crystal of color—a cubic cross section of the world, as it were, its foreground and background planes established by the branches and by the mountain whose rhythms they echo, its floor by the valley, its ceiling by the sky. The constituent planes embrace a great variety of subtly differentiated hues of blue, green, yellow, rose, and violet, and it is the delicate differentiation between these hues that produces the impression of three-dimensional form.

Putting it simply, to create form Cézanne has modified the very color patch the Impressionists had employed ten years before to dissolve it. He has indeed achieved from nature a construction and intellectual organization much like that Poussin had derived from the organization of figures and made of Impressionism something durable, reminding us inevitably of the stable world of Piero della Francesca (see figs. 20–53 to 20–56) and even of the airless backgrounds of Giotto (see Introduction fig. 6 and fig. 19–9). In so doing, however, he has created a world remote from human experience. A road appears for a few yards but we cannot walk on it; there are houses but few windows. There are in fact no people, animals, or birds in Cézanne's landscapes, nor any moving thing. The beauty of his color constructions is abstract, and it is no wonder that many artists of the early twentieth century, especially the Cubists, claimed him as the father of modern art.

Second only to landscape, still life was to Cézanne the principal subject for his analyses of form through color, for his drawing and modeling in contrasts and relationships of tones. They owe little to Dutch still lifes (see fig. 28–9) or to those of Chardin (see fig. 29–14). The monumental *Still Life with Apples and Oranges* was painted between 1895 and 1900 (fig. 34–3). His arrangements of fruits, bottles, plates, and a rumpled cloth on a tabletop never suggest the consumption of food or

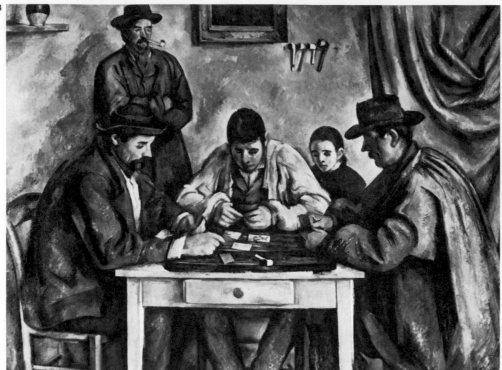

drink; they are spheroid or cylindrical masses, and the planes of color that build them up are solely responsible for their revolution in depth. Often the appearance of reality is neglected. The entire still life sits atop a table that tilts at an alarmingly vertiginous angle and that has a tendency to disappear under the tablecloth at one level and emerge from it at another. The shape of the plate is strangely irregular, and the base of the dish filled with oranges disappears into a white cloth that assumes a nearly impossible configuration. Yet Cézanne managed to impose on this fundamentally unstable ensemble a classical calm. In spite of the table's precarious position, the dish is nearly level, and the apples and oranges do not threaten to tumble from their perch. Whether Cézanne was simply not bothered by such discrepancies in his search for just the right color to make a form go round in depth or whether he decided on deformations consciously in the interests of abstract relationships of design has never been convincingly determined. He cared for subjects as arrangements of form and color, but Meyer Schapiro has noted that they also possessed for him strong psychological significance. His procedure was so time-consuming that apples and oranges began to rot before a painting could be completed and had to be replaced by wax ones.

For his rare figure pieces, Cézanne chose during the 1890s—the great decade for his classical constructions of pure form—subjects as quiet, impersonal, and remote as his still lifes. The *Card Players*, of about 1890–92 (fig. 34–4), shows three men, two of whom are clad in the blue smock of the farmer or country laborer, sitting around a table, while a fourth gazes downward, arms folded. The card game had been a favorite subject among the followers of Caravaggio and was usually set forth dramatically with strong light-and-dark contrasts underscoring suspicious expressions; one player is often shown cheating. Nothing could be further from Cézanne's timeless and immobile scene, which recalls in its symmetrical disposition parallel to the picture plane Rembrandt's *Supper at Emmaus* (see fig. 28–18). The quiet figures contemplate the cards, themselves (like Cézanne's paintings) planes of color on white surfaces. No expression can be distinguished; the downcast eyes are mere planes of color. The Giotto-like tubular folds of the smock of the man on the right echo in reverse those of the hanging curtain, locking foreground and background in a single construction. Yet the background wall fluctuates at an indeterminable distance like the sky in one of Cézanne's landscapes, and the pipes on their rack seem to float against it. These perfect constructions of Cézanne's maturity were

34-4. PAUL CÉZANNE. *Card Players*. c. 1890–92. Oil on canvas, 52¾ × 71¼" (1.34 × 1.81 m). The Barnes Foundation, Merion Station, Pennsylvania

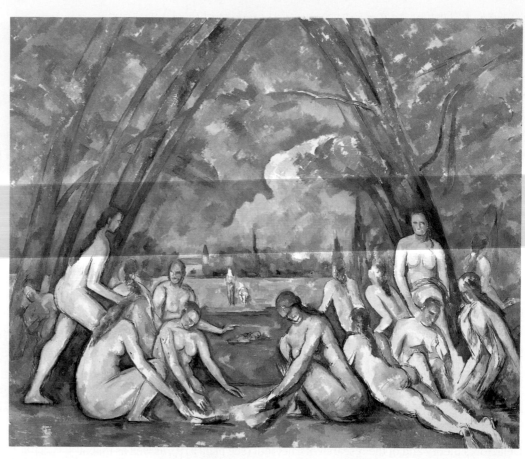

34-5. PAUL CÉZANNE. *Bathers.* 1898–1905. Oil on canvas, 6'10" × 8'2" (2.08 × 2.49 m). Philadelphia Museum of Art. The W. P. Wilstach Collection

painted very lightly as compared with the pictures in his early Romantic style; the planes are indicated in veils of color so thin as to be almost transparent.

Toward the very end of his life, Cézanne's development toward abstraction became more and more evident. The large *Bathers,* of 1898–1905 (fig. 34–5), is the culmination of a series of nude compositions that had occupied Cézanne's imagination again and again. These nudes were never painted from life, nor in the open air. The subject, of course, is as unlikely as that of the bubbly *Bathers* of Fragonard (see fig. 29–16), from which this carefully constructed picture differs in almost every way. Women in the eighteenth and nineteenth centuries did not bathe naked in streams and sun themselves on the banks. But the fantasy gave Cézanne the materials with which to build a grand imaginary architecture composed of strikingly simplified figures, overarching tree trunks, blue sky, and white clouds—a modern cathedral of light and color. Many areas of the figures are still in the white priming stage because Cézanne had not yet found the right planes of color. But even if he had, the bold, sometimes multiple contour lines of the figures and heads would have remained as schematic as they now are; features are suppressed and mouths omitted entirely so as not to break the ovoid forms of the heads. Within the context of Impressionist accidentality—the women are strewn about in relaxed poses or engaged in spreading a luncheon cloth on the ground—the figures are organized as closely as any in a composition by Poussin (compare fig. 27–4). The end result, perhaps as much to Cézanne's surprise as to our own, is a simplification of the human figure that had not been seen since the Middle Ages.

Seurat and Neo-Impressionism

While Cézanne was pursuing his lonely search for a new monumentality based on Impressionist discoveries, a younger painter, Georges Pierre Seurat (1859–91), was working toward similar goals but with radically different methods and results. During his tragically brief career (he died before reaching thirty-two), Seurat attempted to embody in a quasi-scientific style the results of his close study of

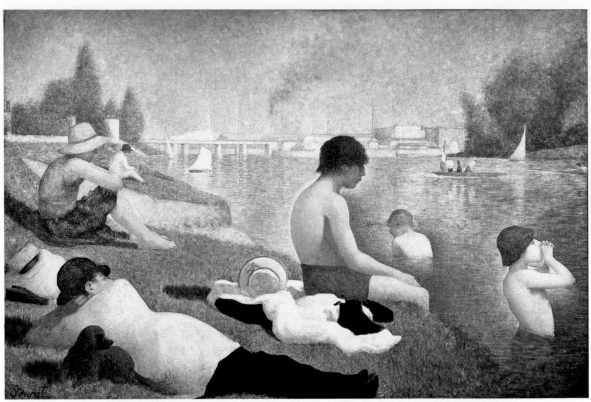

Delacroix's theory and of the research of Chevreul (see page 919), as well as that of Hermann von Helmholz and Ogden N. Rood, into the physical nature of color and the chromatic structure of light.

His first major achievement in this direction was the *Bathers at Asnières,* of 1883–84 (fig. 34–6), which shows still another possibility for the traditional bather composition. This is not an ideal bathing scene, like those of Cézanne, but a real one, taking place along the Seine just to the northwest of Paris, with working-class people in the foreground and boats, a bridge, and factory chimneys in the background. The picture is as completely dedicated to the enjoyment of sunlight as any of Monet. But instead of that master's instantaneity, it communicates a mood of quiet permanence and has often been compared in this respect with the calm compositions of Piero della Francesca (see figs. 20–53 to 20–56), whom Seurat admired, although he could have known the originals only from photographs and copies. He prepared for this composition by careful preliminary figure drawings done in *conté crayon,* a rich black drawing stick that gives a luminous effect when rubbed on rough-grained white paper, and by tiny color sketches on wood panels, which look very like Impressionist paintings in their immediacy and brightness.

The final picture, however, painted in the studio in a return to traditional practice, achieves a kind of compositional grandeur absent from French painting between David and Cézanne. In contrast to the style of Monet, Renoir, and Pissarro, contours are strongly in evidence, very simple ones, outlining forms reduced to the appearance of cylinders or spheroids. These are not the drawn lines one finds in some late Cézannes, but rather hard, clear edges between darker and lighter areas. Along these edges contrasts of color and light and shade intensify abruptly, as happens in nature and can be verified in photographs. For example, it can be seen in the illustration that the water becomes lighter near the shadowed side of a figure and darker near the lighter one. These are changes of hue as well as of value. Within the firm, unbroken contours, which establish a dense pattern of masses and spaces, the brushstrokes resemble a slow, methodical stippling of the surface rather than the quick strokes of the Impressionists. Also, each touch of the brush represents a separate color, set down at full intensity and contrasting with its neighbor to mix not on the palette but in the eye. This effect, drawn from the

scientists' analysis of light, was called Divisionism by Seurat's friend Paul Signac. The method won for Seurat and his associates the title of Neo-Impressionists. It has been pointed out by Meyer Schapiro that the extraordinary sense of restful horizontality in this picture is produced partly by psychological means. The few actual horizontals in the background are reinforced by the implied horizontal gazes of the figures, although in only two cases is an eye actually indicated.

In many ways the culmination of Seurat's mature style is the huge *Sunday Afternoon on the Island of La Grande Jatte* (fig. 34-7), on which Seurat worked from 1884 to 1886. About forty preliminary color studies were necessary, all done outdoors. On the basis of these accurate studies and his thorough, scientific knowledge of color, Seurat was able to paint the magically sunny picture not only in his studio but also at night, by gaslight. When it was first shown at the eighth and last Impressionist exhibition in 1886, the work was denounced by some critics and praised by others as being "Egyptian." The customary Impressionist theme is indeed treated with almost Egyptian formalism and rigidity. The foreground figures are arranged as if in a frieze, but their movement back in depth on the sunny lawn, with light and shadow coordinated with the cylindrical figures, recalls the Italian Quattrocento, especially the space of Masaccio, Uccello, and again Piero della Francesca. In his own theoretical way Seurat has done just what Cézanne was doing empirically—he has converted Impressionism into something as durable as the art of the museums.

By now, however, his divided touch has become systematized into tiny round particles, which are generally and not inaccurately compared to the tesserae of classical and medieval mosaics. Each patch of light, each area of shadow is composed of countless such particles, of almost identical size and shape. From close up, their colors appear absolutely pure, the quality of shading or color transition being controlled by the numerical proportion of colors of varying value or hue. Although these are intended to mix in the observer's eye, the mixture is never complete, and the little spots retain their autonomy, like the notes in music,

34-7. GEORGES SEURAT. *Sunday Afternoon on the Island of La Grande Jatte.* 1884–86. Oil on canvas, 6'9¼" × 10' (2.06 × 3.05 m). The Art Institute of Chicago. The Helen Birch Bartlett Memorial Collection

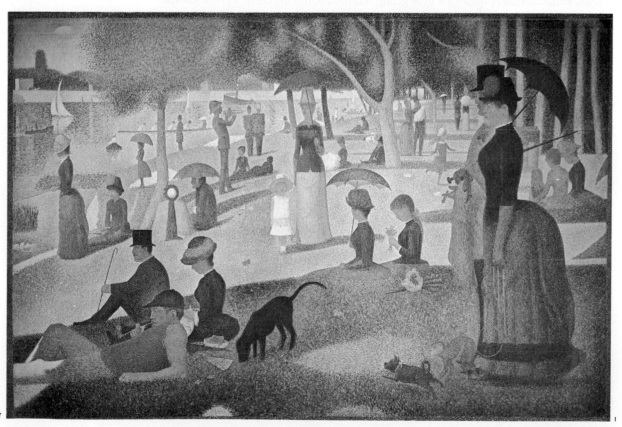

34-7

giving the picture even at a distance a grainy texture. The mock solemnity of Seurat's composition is lightened by many touches of wit and whimsy, such as the details of costumes and accessories, and the drama between the pug-dog and the ringtail monkey at the lower right. It is amazing that a revolutionary work of such skill and brilliance could have been completed by Seurat at the age of twenty-seven. The history of modern painting might well have been different had he lived an ordinary life span. As it was, even Pissarro, the oldest of the Impressionists, was for a while won over by the style of this twenty-nine-years-younger genius, and joined the Neo-Impressionists. The art of the Fauve painters in the early twentieth century (see Chapter Thirty-Five) was profoundly indebted to Seurat's discoveries.

Toulouse-Lautrec

A maverick on the Parisian art scene at the end of the century was Henri de Toulouse-Lautrec (1864–1901). Born to one of the oldest noble families in France, he broke both legs in early adolescence and they never developed properly. For the rest of his brief existence he remained a dwarf, alienated from his family's fashionable life. He learned to paint and took refuge in the night life of Paris, which he depicted with consummate skill—scenes of cafés, theaters, and cabarets, and even a witty series of bordello interiors. All of his portrayals are prompted by the same uncritical acceptance of the facts of Parisian nightlife that he wished for his own deformity and found only in this shadowy world. *At the Moulin Rouge,* of 1892 (fig. 34–8), was strongly influenced by Degas, whom he deeply admired (see especially fig. 33–14). Toulouse-Lautrec's line was sure, almost as much so as that of his idol, but his tolerant humanity was entirely his own. The little artist can be made out toward the top of the picture in profile, just to the left of center alongside his towering cousin and constant companion. It is significant that, to reinforce the psychological impact of the picture, Toulouse-Lautrec extended it on all four sides, especially at the bottom and at the right. The plunging perspective of a balustrade in the added section pushes the little group huddled about the table into the middle

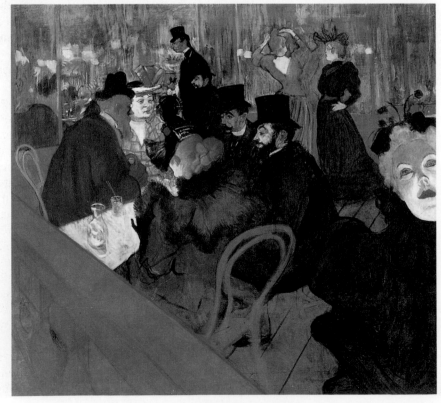

34-8

34-8. HENRI DE TOULOUSE-LAUTREC. *At the Moulin Rouge.* 1892. Oil on canvas, 48⅜ × 55¼″ (1.23 × 1.4 m). The Art Institute of Chicago. The Helen Birch Bartlett Memorial Collection

distance, while it forces toward us with startling intensity the face of a heavily powdered entertainer, so lighted from below that the shadows are green. Toulouse-Lautrec's smart and vivid drawing style, his brilliant patterning, and his surprising color contrasts were the dominant influence in Paris, particularly in the form of popular lithographic posters, when in 1900 the young Pablo Picasso arrived there from Spain.

Gauguin

Although he thought highly of Degas and Toulouse-Lautrec, the artist Paul Gauguin (1848–1903) did not share their enthusiasm for Parisian life and he eventually traveled as far from its influence as any Western artist ever had. In addition to his achievements as a painter, Gauguin, along with Degas and Toulouse-Lautrec, was one of the most original European printmakers of the nineteenth century. Moreover, he carved marvelous wooden sculptures, revolutionized the art of ceramics, and, like his friend Vincent van Gogh, was a writer of genuine significance. Although without formal artistic training, this successful businessman became intensely interested in art and began painting as an amateur. Under strong influence from Pissarro, he rapidly absorbed Impressionist ideas and techniques, and from 1879 to the last Impressionist exhibition in 1886 exhibited regularly with the group. In 1881 he came in contact with Cézanne and bought some of the great painter's work. But there was a streak of the drifter in Gauguin, and rapidly, to the great gain of art but the consternation of his family, this tendency became dominant. He was partly of Peruvian (Indian) extraction, had spent four years of his childhood in Peru, six years of his youth as a sailor, and was incurably drawn to the exotic and the remote.

Gradually, painting itself became identified with his wanderlust and drew him away from all his daily associations. In 1883 he gave up his business career, and in 1885 he abandoned his wife, his children, and his bourgeois existence to devote his life to art. Convinced that European urban civilization and all its works were incurably sick, he spent less and less time in Paris. Henceforward his life was nomadic; he moved back and forth between villages in Brittany (because it was the most remote and "backward" of French regions), the island of Martinique, Brittany again, Arles (where for a brief and stormy period he lived with van Gogh), Brittany for a third time, Tahiti, Brittany for a fourth time, Tahiti again, and finally—impoverished, terminally ill, and in trouble with the law—the Marquesas Islands, where he died.

Gauguin's departure from Western artistic tradition was prompted by the same rebellious attitude that impelled his break from middle-class life. He renounced not only the instantaneity and formlessness of Impressionist vision but also Western devotion to naturalistic effects, which had been carried to its final flowering in Impressionism. Instead, he recommended a return to archaic and, for the first time in the history of art, "primitive" styles as the only refuge for art. What he sought, however, was still immediacy of experience, but intensified. "A powerful sensation," he said, "may be translated with immediacy; dream on it and seek its simplest form." This is just what Gauguin did in his brilliant *Vision after the Sermon* (fig. 34–9), painted in 1888 during his second stay in Brittany. In the background Jacob is shown wrestling with the angel (Genesis 32:22–31). It has been demonstrated that this event forms the lesson in the Breton rite for the eighth Sunday after Trinity (August 5 in 1888). On the preceding day took place the blessing of horned beasts, followed by wrestling contests and a procession with red banners, and at night fireworks, a bonfire that turned the fields red with its glow, and an angel descending from the church tower.

Gauguin has shown in the foreground at the extreme right the head of a priest and next to it those of praying women in Breton costume, whose vision fuses the events of the preceding day and night with the lesson on Sunday morning. The

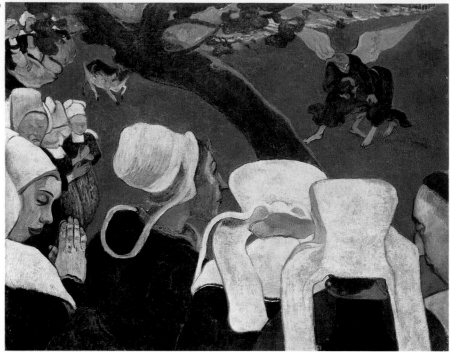

34-9. PAUL GAUGUIN. *Vision after the Sermon.* 1888. Oil on canvas, 28¾ × 36½″ (73 × 92.7 cm). The National Galleries of Scotland, Edinburgh

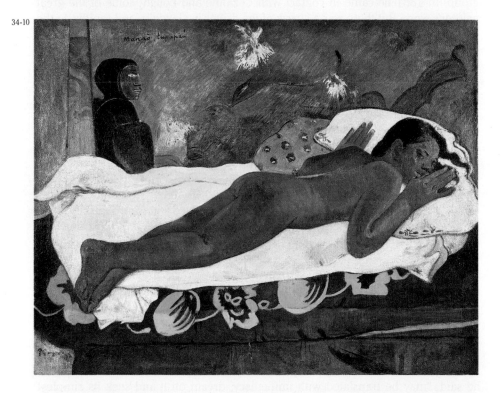

34-10. PAUL GAUGUIN. *Manao Tupapao (The Spirit Watches Over Her).* 1892. Oil on burlap mounted on canvas, 28½ × 36⅜″ (72.4 × 92.4 cm). Albright-Knox Art Gallery, Buffalo, New York. A. Conger Goodyear Collection, 1965

apparently arbitrary intense red of the ground is an immediate translation, in Gauguin's terms, of the powerful sensations of the folk festival. Although the figures are outlined with the clarity that Gauguin derived from his study of Oriental, medieval, and primitive arts, the contrast between the large foreground heads and the sharply smaller groups in the distance still presupposes Western perspective and is drawn from theater subjects developed by Daumier, Degas, Renoir, and Toulouse-Lautrec.

In Oceania, Gauguin did not encounter many of the great *tiki,* statues of ancient Polynesian deities, he had hoped to find. Instead, he studied the native folklore and religion and invented his own highly imaginative versions of these gods and spirits.

In one of his best-known paintings from the first Polynesian voyage, the sumptuously colored *Manao Tupapau (The Spirit Watches Over Her;* Gauguin usually gave Tahitian titles to his South Seas works), the artist's young mistress lies prone on a bed, her flesh dramatically silhouetted against a yellow sheet (fig. 34–10). Behind her on the violet wall are white *hotu* blossoms, the phosphorescent "flowers of the tupapaus." The girl is terrified by the Tahitian night, which she believed was haunted by ancestral spirits. She has conjured up one of these *tupapaus,* whose hooded profile looms at the foot of the bed. This—the subject matter of the painting—Gauguin referred to as its "literary" part. But it was the formal aspect of the painting, what he called the "musical" part, that mattered to him most. This he described as "undulating horizontal lines—harmonies in orange and blue linked by yellows and violets." This fundamental idea, that formal properties—line, color, and structure—could function independently of any subject, would make an indelible impact on many artists of the early twentieth century, for example, Henri Matisse (see Chapters Thirty-Five and Thirty-Six).

Van Gogh

As much as Cézanne was the leader of those who sought spiritual ultimates in form, Vincent van Gogh (1853–90) was surely the champion of those who identified art with emotion. The son of a Protestant Dutch minister, the young van Gogh was by turns the employee of a firm of art dealers in The Hague, London, and Paris; a language teacher in Ramsgate and Isleworth, England; a student of practical evangelism in Brussels; and a missionary to the downtrodden coal miners of a village in southern Belgium. Through these fragmentary careers, and indeed through his personal relationships, including several impossible love affairs and his disastrous friendship with Gauguin, runs the same theme—a love of humanity, of life, and of things, whose inevitable corollary was a sense of failure and betrayal. This love was the theme of his art as well, and was to produce one of the most intensely personal styles in the history of Western art. Even van Gogh's mental illness, severe enough to bring about his frequent hospitalization and his untimely death, did not prevent him from becoming the only Dutch painter whose stature could set him on a level with the greatest Dutch masters of the seventeenth century.

Van Gogh's earliest drawings and paintings date from his association with the Belgian miners and from a later stay among the peasants of northern Holland. Only in 1881 did he embark on the formal study of art but remained in a somewhat provincial Dutch tradition, out of touch with the new coloristic discoveries of Impressionism. In 1886 he came to Paris for a two-year stay with his brother Theo, and under the joint influences of Impressionism and Japanese prints freed his palette and worked out a fresh, new sense of pattern in contour not unrelated to Seurat, but already highly original. Having shown signs of depression and emotional instability, he left the north early in 1888, hoping to find a happier and more healthful existence at Arles, in Provence (not far from Cézanne's home at Aix), although there seems to have been no contact between the two. The south was linked in his mind with an idealized notion of Japan: "I thought that to observe nature under a clearer sky would give me a better idea of the way the Japanese feel and draw." During the next two years, which were all that remained of life to van Gogh, he painted at white heat—often a canvas a day—landscapes, interiors, portraits of the few Arles residents who agreed to sit for him, and, of course, magnificent still lifes. He showed little interest in the Roman and Romanesque antiquities of Arles but was enraptured by the beauty of the landscape and above all by the clear southern light, utterly different from that of northern France with its mists and rain.

A superb example of this first, highly productive summer in Provence is *The Harvest* (fig. 34–11), painted in June 1888. With its almost Renaissance perspective, this charming picture depicts cultivated fields at La Crau, near Arles. It figured

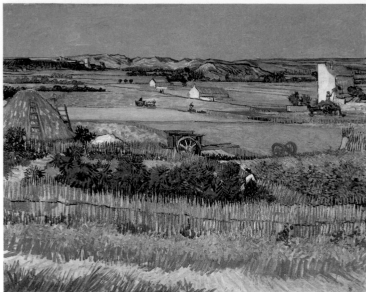

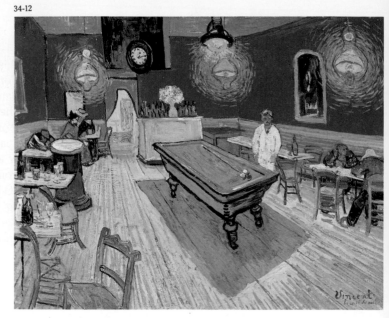

among van Gogh's favorite works and is painted with all the affection he felt for the area. The layers and patches of land, in luminous golds, blues, and greens, move back in space toward a high horizon line, creating wonderfully striated patterns. To van Gogh, however, space construction became an expressive device, propelling the observer forcefully toward the distant hills. The thick pigment, blazing color, and strong, straight strokes are van Gogh's personal transformation of Impressionist technique.

In September of the same year, a month before the eagerly awaited arrival of Gauguin to share his house, van Gogh painted a far less optimistic picture, the *Night Café* (fig. 34–12), which cannot be better described than in his own words:

> *I have tried to express the terrible passions of humanity by means of red and green.*
> *The room is blood red and dark yellow with a green billiard table in the middle; there are four lemon yellow lamps with a glow of orange and green. Everywhere there is a clash and contrast of the most alien reds and greens in the figures of little sleeping hooligans, in the empty dreary room....*
> *I have tried to express the idea that the café is a place where one can ruin one's self, run mad or commit a crime. So I have tried to express as it were the powers of darkness in a low drink shop.*

A sense of dissonance is conveyed in the bright but acidic palette of harshly contrasting colors, and the perspective, used for uplifting effect in *The Harvest*, is here so exaggerated that the pool table threatens to slide right out of the picture. During a period of mental collapse in late December of the same year van Gogh hurled a knife at Gauguin; then he cut off part of his ear and gave it to a prostitute; consequently, Gauguin fled Arles. Cared for at first in the hospital at Arles, then in the asylum at nearby Saint-Rémy, van Gogh was allowed to paint and produced some of his most beautiful and moving works. His *Self-Portrait* (fig. 34–13), painted in the asylum in September 1889, betrays the period of desperation through which the artist had passed. In a mood of renewed confidence, for he painted only during highly lucid periods, the artist presents himself at work, displaying his palette and brushes. The vigorous brushstrokes, now curved to conform to the shape of the head, pulsate intensely throughout the picture, and the artist's ivory face, gold hair, and red-gold beard float in tides of ever deeper and more sonorous blue. Only in the greatest self-portraits of Rembrandt do we find such intense self-revelation, or such a triumph over sorrow.

In the fields near the asylum, by day or even at night, van Gogh drew and painted

34-11. VINCENT VAN GOGH. *The Harvest.* 1888. Oil on canvas, 28½ × 36¼″ (72.4 × 92 cm). Vincent van Gogh Foundation; Rijksmuseum Vincent van Gogh, Amsterdam

34-12. VINCENT VAN GOGH. *Night Café.* 1888. Oil on canvas, 28½ × 36¼″ (72.4 × 92 cm). Yale University Art Gallery, New Haven, Connecticut. Bequest of Stephen C. Clark

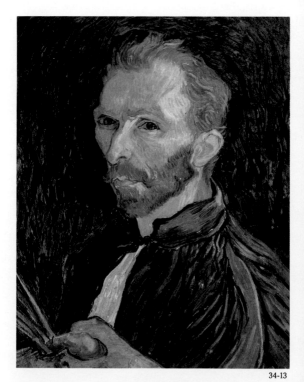

34-13

34-13. VINCENT VAN GOGH. *Self-Portrait.* 1889. Oil on canvas, 22½ × 17″ (57.2 × 43.2 cm). Collection Mrs. John Hay Whitney, New York

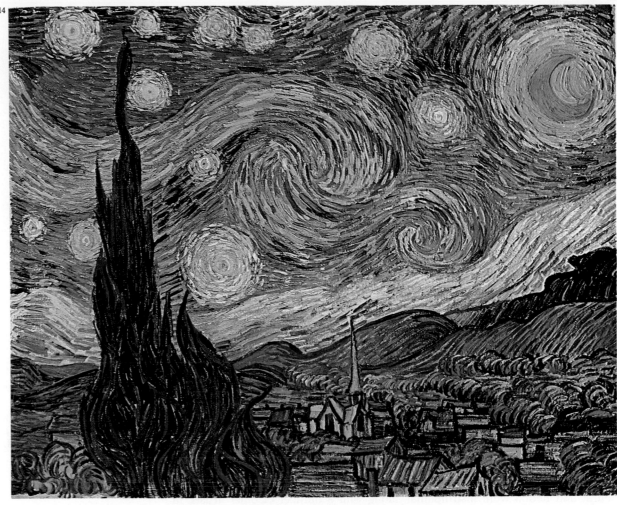

34-14. VINCENT VAN GOGH. *Starry Night*. 1889.
Oil on canvas, 28¾ × 36¼″ (73 × 92 cm).
Collection, The Museum of Modern Art, New
York. Acquired through the Lillie P. Bliss Bequest

from nature, for which he felt a kind of pantheistic reverence, no longer explicable
in terms of conventional religion. Yet these pictures communicate a mood of self-
identification with the infinite, which is the mark of religious ecstasy in van Gogh as
much as in the visions of the Counter-Reformation mystics (see pages 754, 765). In
Starry Night (fig. 34–14), painted in June 1889, he shows not the stars he observed
but exploding masses of gold fire expanding against the blue. Two of these swirl
through the sky in a kind of cosmic embrace, unimagined by the denizens of the
sleeping town below but attainable through the intermediary of the dark green
cypresses that swirl upward into their visionary midst.

In May 1890, van Gogh went to Paris for a three-day stay with his brother, then to
Auvers, which had sheltered many of the Impressionists and Post-Impressionists,
where he placed himself under the care of Dr. Paul Gachet, friend and patron of
artists. Despairing of a cure, he shot himself on July 27 and died two days later. For
all the tragic circumstances of his life, van Gogh won a spiritual victory in opening a
new path for artistic vision and expression.

Symbolism

The anti-Impressionist reaction of the 1880s was directed not only against the
formlessness of Impressionism, which had disturbed Cézanne and van Gogh, but
also against its objectivity. A tendency to penetrate beyond the surface of visible
reality into the world of folklore, mythology, fantasy, and dreams (beloved by many
Romanticists) soon began to make its presence felt in the French art scene. The
individual artists and the shifting groups to which they belonged can be loosely
classified under the term *Symbolism*. Not surprisingly, Gauguin and van Gogh were
heralded as their artistic forebears.

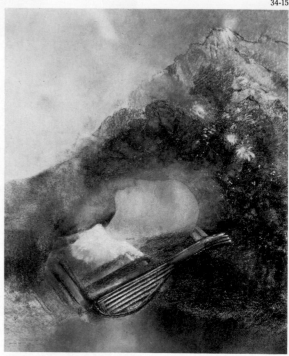

34-15. ODILON REDON. *Orpheus.* 1903. Pastel, 27½ × 22¼" (70 × 56.5 cm). The Cleveland Museum of Art. Gift of J. H. Wade

A solitary apostle of this tendency—and in many ways the most gifted—was ODILON REDON (1840–1916), much admired by Gauguin, whose activity parallels that of Monet in time but could scarcely have been more different. After training in architecture and painting, he studied anatomy and microscopic biology. Throughout the 1870s and 1880s, calling black "the prince of colors," he turned out series after series of fantastic lithographs, often based on such poets of the imagination as Baudelaire and Edgar Allan Poe. In the 1890s he burst forth with a steady succession of brilliantly colored works in oil and in pastel in which, according to his own words, he desired "to make improbable beings live, like human beings . . . by putting insofar as possible the logic of the visible at the service of the invisible." A striking example of his later art is *Orpheus,* of 1903 (fig. 34–15). The Greek legend tells us how the great musician, after the death of his wife, Eurydice, wandered the earth, lamenting her loss in song, and refused to submit to the blandishments of the Maenads, female followers of Dionysos, who in revenge tore him to bits and threw the pieces in a stream. The frightful legend is muted by Redon into the magic of a waking dream. There is no blood. The head shines in an opalescent dusk, floating with a fragment of the singer's lyre, and sparkling flowers cluster about it. Intended to evoke the magical power of music to transfigure violence and tragedy, the picture also provides the solace of a retreat into fantasy. Redon's rich imagination and his glowing color made him the immediate precursor of a major current of twentieth-century art (see Chapter Thirty-Seven) in which the private fantasy of the artist has free rein in escaping from the increasingly onerous restrictions of modern urban society.

The phenomenon of the independent exhibition, beginning with Courbet's Pavilion of Realism in 1855 and continuing with the officially sponsored Salon des Refusés of 1863, became increasingly important as the gulf between radical artists and conservative public and critics widened and deepened. The eight group-exhibitions of the Impressionists from 1874 to 1886 are a case in point. In 1884 Seurat and Redon were instrumental, along with a number of other artists, in organizing the Société des Artistes Indépendants, as a counterforce to the all-powerful Salon, and it was at the exhibitions of this society that the innovators showed their work.

At various moments during the nineteenth century, veritable brotherhoods of artists were formed, fewer in France than in England and in Germany. During the last two decades of the nineteenth century, these brotherhoods began to include more and more of the most gifted artists. Van Gogh dreamed of such a brotherhood, through which he and Gauguin could lead the reform of European art. A small group of Symbolist artists, starting at Pont-Aven in Brittany around Gauguin, continued to meet in Paris. The most vocal members of the Pont-Aven group, although by no means the most talented, were Émile Bernard (1868–1941) and Maurice Denis (1870–1943). Bernard claimed more influence on Gauguin than the facts justify, and even priority in the invention of a linear, bright-colored, and flattened style. The lasting value of the Symbolist movement in its Pont-Aven phase is found less in the works of these two artists than in Denis's dictum in 1890 that a picture is first of all "an arrangement of colored shapes." The Pont-Aven artists, especially Gauguin with his arbitrary forms and colors, came much closer to this principle than had Whistler to his similar pronouncement. Some of the group joined a new brotherhood of Symbolists, which met weekly for discussions in Paris, beginning in 1888, and monthly for semi-secret ceremonial dinners in costume. The group called themselves the Nabis, a name derived from a Hebrew word for "prophet," and included not only Denis but also such far more gifted artists as ÉDOUARD VUILLARD (1868–1940), and Aristide Maillol, then a painter but better known for his later work in sculpture.

The mystical doctrines of the Nabis, allied to Rosicrucianism, included a strong devotion to home life, including the artistic decoration of domestic interiors, in spite of the group's supposed opposition to bourgeois values. The most eloquent

34-16

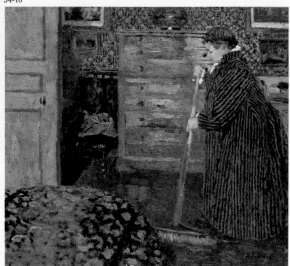

34-16. ÉDOUARD VUILLARD. *Woman Sweeping in a Room.* 1892–93. Oil on cardboard, 17⅜ × 18⅝″ (44.8 × 47.3 cm). The Phillips Collection, Washington, D.C.

34-17. JAMES ENSOR. *Entry of Christ into Brussels in 1889.* 1888. Oil on canvas, 8′5″ × 12′5″ (2.57 × 3.79 m). Collection of the J. Paul Getty Museum, Malibu, California

paintings of the Nabis are those of Vuillard, who never married, lived with his mother until her death, and produced intimate paintings of interiors unrivaled in their delicacy and charm in spite of the airless and crowded nature of their subjects. In *Woman Sweeping in a Room,* of about 1892–93 (fig. 34–16), every inch is packed with domestic detail, which by his own personal magic Vuillard is able to translate into exquisite pattern, relying on the juxtaposition of areas of great richness and constant variety. Sometimes his technique recalls that of Seurat and the Neo-Impressionists in its use of tiny dots; at other moments parallel lines or stripes and decorative opposition of softly painted flat surfaces foretell the work of Matisse (see fig. 35–4), who was deeply indebted to Vuillard's acute sensitivity to the relationships among the most ordinary objects.

Forerunners of Expressionism

Toward the end of the nineteenth century, a number of artists outside of France, notably in Brussels, Oslo (then named Christiania), and Vienna, attempted the direct expression of emotion in pigment with relatively little care for the Impressionist aesthetic, considering style, color, form, and surface as subservient to the prime necessity of emotional expression. JAMES ENSOR (1860–1949), a Belgian born of an English father, absorbed Impressionist style and method but soon turned to the most daring treatment of unexpected and shocking themes and to the sharp, often horrifying contrast of colors and shapes. Interestingly enough, there seems to be no evidence that, at the moment of his most revolutionary works, Ensor had any knowledge of the roughly parallel development of van Gogh. His mother kept a souvenir shop, selling among other wares the masks used at Flemish carnivals, and these obsessed Ensor as symbols of the basic evil of contemporary existence. His huge canvas entitled *Entry of Christ into Brussels in 1889* (fig. 34–17; the work was painted in 1888) so shocked his contemporaries that even The Twenty, a group of radical Belgian artists to which Ensor belonged, refused to exhibit it. Under a broad red banner inscribed "VIVE LA SOCIALE" (a reference to Belgium's growing Socialist movement) Christ, who can barely be distinguished at the upper center, enters the claustrophobic streets of Brussels. The seething tide of hideously masked figures is the artist's deeply cynical vision of the parade of humanity. The crowds form a cacophonous mass of brilliant color that engulfs a Christ as powerless as in a painting by Bosch (see fig. 21–31).

In Norway a similar tendency is seen in the art of EDVARD MUNCH (1863–1944), whose work had little in common with the academic current of Norwegian art, but showed quite early an understanding of the bright palette of the French Impressionists. Munch was associated with the great Norwegian psychological dramatist

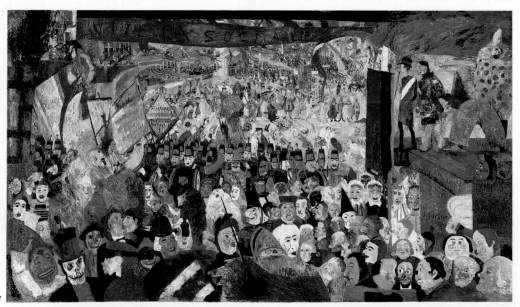

34-17

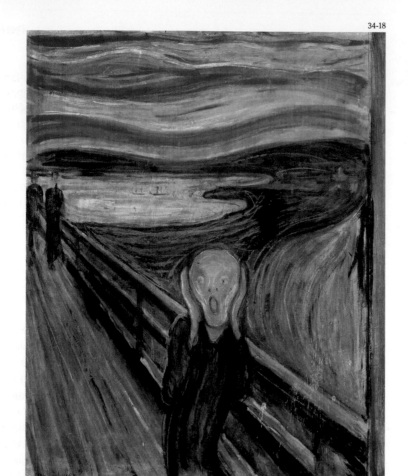

34-18. EDVARD MUNCH. *The Scream*. 1893. Tempera and casein on canvas, 36 × 29″ (91.4 × 73.7 cm). Nasjonalgalleriet, Oslo

Henrık Ibsen, for whom he designed stage sets, but he went past Ibsen in his treatment of themes involving obsession with sex and death. *The Scream* (fig. 34–18), painted in 1893, is a work one can hardly contemplate without horror. A person walking along a seashore promenade puts his hands to his head, bursting with anguish, while the very landscape about him heaves in waves as if vibrating along with his intolerable inner conflict, intensified by the arbitrary use of red, yellow, and green throughout the background. Munch's paintings created such an uproar when shown in Berlin in 1892 that the authorities forced the closing of a group exhibition in which he participated. Both he and Ensor were strongly influential in the development of the German Expressionist movement of the early twentieth century (see Chapter Thirty-Five).

Unexpectedly enough, England in the 1890s saw the flowering of a movement that prided itself on its "decadence," centering around the controversial figure of the poet and dramatist Oscar Wilde. The short-lived and highly imaginative draftsman AUBREY BEARDSLEY (1872–98) illustrated a number of literary works, including Wilde's *Salome*, with drawings matchless in their bravura handling of flowing line and surprising contrasts of black and white areas and scale. Such a drawing as his *The Dancer's Reward*, of about 1894 (fig. 34–19), with its flat, gracefully curving forms and strong erotic content, is also allied to the current known by nearly as many names as there are countries on the Continent but in England, where it originated, as Art Nouveau.

An exponent of Sezessionstil or Jugendstil, as Art Nouveau was called in Austria and Germany, respectively, was the Viennese artist GUSTAV KLIMT (1862–1918), whose style of hothouse eroticism is comparable to Beardsley's. Son of a goldsmith, Klimt was trained as a decorative artist, and he executed large historical murals in the theaters and public halls of Vienna. In 1897 he was elected president of the newly formed Vienna Sezession, a group of artists who, following the lead of their contemporaries in Paris and Munich, withdrew from the city's mainstream artists' society to work and exhibit on their own. Within two years Klimt's style had

34-19. AUBREY BEARDSLEY. *The Dancer's Reward*, illustration for Oscar Wilde's *Salomé*. 1894. Black ink and graphite on white paper. Courtesy of the Fogg Art Museum, Harvard University, Cambridge, Massachusetts. Bequest of Grenville L. Winthrop

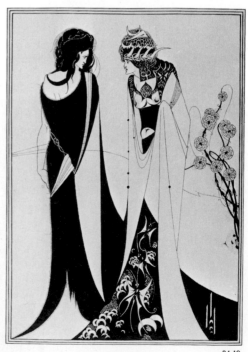

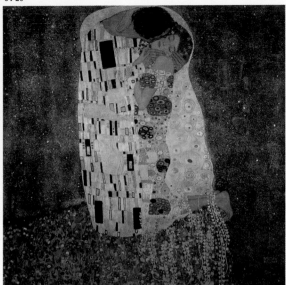

34-20. GUSTAV KLIMT. *The Kiss.* 1907. Oil on canvas, 70⅞ × 70⅞″ (1.8 × 1.8 m). Österreichische Gallerie, Vienna

matured and he soon found himself in the midst of an enormous controversy over the literal nudity in his paintings about life's passages—birth, sexual union, and death. *The Kiss* (fig. 34–20), made in 1907, at the height of Klimt's later "gold period," demonstrates the essentials of his decorative style. With virtually no regard for illusionism, Klimt depicts an embracing couple who kneel on a bed of flowers against a ground as gold as that of a Byzantine mosaic. The figures convey no sense of corporeality, and their sinuous shapes are subsumed into the flat, decorative scheme of the painting. It is easy to see how this ornamental style could be integrated with architecture, and it was in architecture and decoration that Art Nouveau found its richest expression (see pages 1066–68).

Rousseau

An utterly unexpected and delightful apparition on the Parisian art scene at the close of the nineteenth century was the self-taught painter Henri Rousseau (1844–1910). Having earned his living in the prosaic calling of toll collector, Rousseau retired early on a small pension and devoted himself entirely to painting. His combination of straight-faced whimsy, imagination, poetry, and real artistic sensitivity caused his work to be rapidly known and appreciated in the most advanced artistic circles. As early as 1886, he exhibited at the Société des Artistes Indépendants, to the universal derision of the public. Yet, although the artists of his day never took him quite as seriously as he took himself, for a quarter of a century, from the days of Degas to those of Picasso, Rousseau was received everywhere. He is the first untutored, "primitive" artist to be highly valued in modern times; his naive style is a product of imagination and visual experience rather than of visual analysis in the Western tradition that culminated in Impressionism. *Sleeping Gypsy* (fig. 34–21), of 1897, shows an entirely new style in its smooth surfaces with no visible brushstrokes, its immense night sky, and its delightful air of mystery. Only recently has it been discovered that both the sleeping gypsy in her coat of many colors and the sniffing, harmless lion were modeled from children's toys on sale in Parisian shops; while painting them with utter literalness, Rousseau distilled from these toys his own delicate poetry. His art of the enigma was as important an element as the poetic fantasy of Redon in the development of the fantastic current in twentieth-century art.

34-21. HENRI ROUSSEAU. *Sleeping Gypsy.* 1897. Oil on canvas, 51 × 79″ (1.3 × 2.01 m). Collection, The Museum of Modern Art, New York. Gift of Mrs. Simon Guggenheim

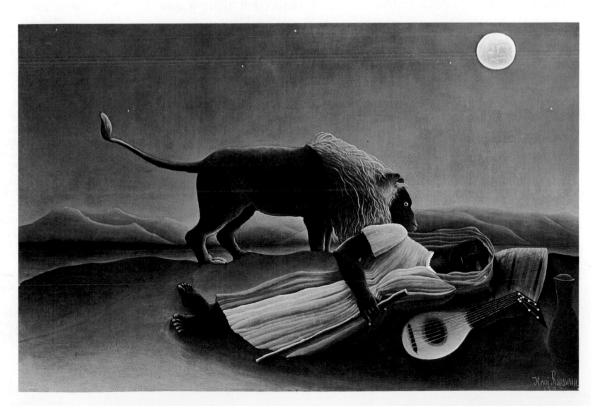

TIME LINE XIV

Death of Marat, by David

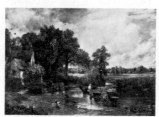

Hay Wain, by Constable

Stone Breakers, by Courbet

Houses of Parliament, London, by Barry and Pugin

POLITICAL HISTORY

1780

U.S. Constitution adopted, 1788
French Revolution, 1789–97; Louis XVI beheaded, Reign of Terror, 1793
Consulate of Napoleon, 1799

1800

Napoleon crowns himself emperor, 1804; defeated at Waterloo and banished to St. Helena, 1815
Return of Bourbon Dynasty to French throne under Louis XVIII, 1814

1825

July Revolution in France, 1830
Victoria governs England, 1837–1901
Revolutions in Paris, Berlin, Vienna, and Milan, 1848
Unification of Italy, 1849–70

1850

Crimean War, 1853–56
German National Union founded, 1859

1860

American Civil War, 1861–65
First International Workingmen's Association, 1864

1870

Franco-Prussian War begins, 1870; France defeated, 1871
Bismarck made chancellor of German Empire, 1871

1880

Bismarck signs "Reinsurance Treaty" with Russia, 1887
Internationalization of Suez Canal, 1888

1890

Spanish-American War, 1898; U.S. gains Philippines, Guam, and Puerto Rico

RELIGION, LITERATURE, MUSIC

Critique of Pure Reason by Kant, 1781
Lyrical Ballads by Wordsworth and Coleridge, 1798

Jane Austen (1775–1817)
Beethoven (1770–1827)
Sir Walter Scott (1771–1832)
Shelley (1792–1822)
Schubert (1797–1828)
Hegel, *Phenomenology of Mind*, 1807
Faust (Part I) by Goethe, 1808
Dickens (1812–1870)

Kierkegaard publishes *Either/Or*, 1843
Communist Manifesto by Marx and Engels, 1848
John Ruskin writes *Seven Lamps of Architecture*, 1849
Verdi (1813–1901); Wagner (1813–83)
Walt Whitman publishes *Leaves of Grass*, 1855

Crime and Punishment by Dostoyevsky, 1866
First Vatican Council, 1869
First performance of Moussorgsky's *Boris Godunov*, 1874
Zola (1840–1902)
Mallarmé (1842–98)
Henry James (1843–1916)

Nietzsche (1844–1900)
George Bernard Shaw (1856–1950)
W. B. Yeats (1865–1939)
Illuminations by Arthur Rimbaud, 1886

First complete performance of Tchaikovsky's *Swan Lake*, 1895

SCIENCE, TECHNOLOGY

First aerial crossing of English Channel, 1785
Edward Jenner discovers smallpox vaccine, 1798
Georges Cuvier publishes work on comparative anatomy, 1798
Alessandro Volta invents electric battery, 1800
First voyage of Robert Fulton's steamship *Clermont*, 1807
Michael Faraday discovers principle of electric dynamo, 1821

First railway completed, England, 1825
Explorer James Ross reaches magnetic North Pole, 1831
Charles Daguerre establishes a viable photographic process, 1839

First transatlantic telegraph cable, 1858–66
Charles Darwin publishes *On the Origin of Species*, 1859
First oil well drilled, U.S., 1859
Gregor Mendel publishes first experiments in genetics, 1865
Suez Canal opened, 1869
Heinrich Schliemann starts excavations at Troy, 1871
Wilhelm Wundt establishes first official laboratory of psychology in Leipzig, 1879
Edison invents incandescent bulb, 1879
Pasteur and Koch advance germ theory of disease, 1881
First internal combustion engines for gasoline, 1885

Wilhelm Röntgen discovers X rays, 1895
Lumière brothers invent motion pictures, 1895
Marie Curie discovers radium, 1898

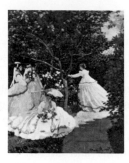

Women in the Garden, by Monet

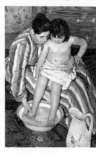

The Bath, by Cassatt

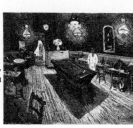

Night Café, by van Gogh

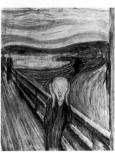

The Scream, by Munch

PAINTING, SCULPTURE, ARCHITECTURE

NEOCLASSICISM	ROMANTICISM	REALISM	
Jefferson, rebuilding of Monticello, Charlottesville			1780
David, *Oath of the Horatii; Death of Marat*			
Houdon, *George Washington*			
Langhans, Brandenberg Gate	Goya, *Los Caprichos; Family of Charles IV*		1800
David, *Coronation of Napoleon*			
Canova, *Maria Paolina Borghese*			
Vignon, Madeleine, Paris	Gros, *Napoleon*		
Ingres, *Valpinçon Bather*	Friedrich, *Abbey in an Oak Forest*		
Nash, Park Crescent, London	Nash, Royal Pavilion, Brighton		
Jefferson, University of Virginia, Charlottesville	Géricault, *Officer; Raft of the Medusa*		
	Constable, *Hay Wain*		
	Delacroix, *Massacre at Chios; Death of Sardanapalus*	Corot, *Island of San Bartolomeo*	1825
	Constable, *Stoke-by-Nayland*	Daumier, *Rue Transnonain*	
	Rude, *La Marseillaise*	Daguerre, *Paris Boulevard*	
	Turner, *Slave Ship; Rain, Steam, and Speed*	Courbet, *Stone Breakers*	
		Bonheur, *Plowing in the Nivernais*	
	Barry and Pugin, Houses of Parliament, London	Millet, *Sower*	
Ingres, *Apotheosis of Homer; Comtesse d'Haussonville*		Millais, *Christ in the House of His Parents*	1850
		Paxton, Crystal Palace	
		Ford Madox Brown, *Last of England*	
		Courbet, *The Studio*	
IMPRESSIONISM	Garnier, Opéra, Paris	Daumier, *Third-Class Carriage*	1860
Manet, *Luncheon on the Grass; Execution of Maximilian*		Homer, *Croquet Game*	
Monet, *Women in the Garden; Impression, Sunrise*	Carpeaux, *The Dance*	Corot, *Ville d'Avray*	1870
Whistler, *Thomas Carlyle; Nocturne*		Eakins, *Gross Clinic*	
Degas, *Rehearsal on Stage*			
Renoir, *Le Moulin de la Galette*			
Rodin, *Age of Bronze*			
Manet, *A Bar at the Folies-Bergère*		POST-IMPRESSIONISM	1880
Sargent, *Daughters of Edward Darley Boit*		Seurat, *Bathers at Asnières*	
Rodin, *Burghers of Calais*		Cézanne, *Mont Sainte-Victoire*	
Degas, *Two Laundresses*		Gauguin, *Vision after the Sermon*	
Morisot, *In the Dining Room*			
Cassatt, *The Bath*		Van Gogh, *The Harvest; Night Café; Starry Night*	1890
Monet, *Rouen Cathedral*		Vuillard, *Woman Sweeping*	
Pissarro, *Boulevard des Italiens*		Toulouse-Lautrec, *Moulin Rouge*	
		Munch, *The Scream*	
		Cézanne, *Still Life with Apples; Bathers*	

CHAPTER THIRTY-FIVE

In retrospect the opening decade of the twentieth century impresses us today as an era of revolution. Fundamental changes transformed the relationship between art and nature that had been traditionally accepted ever since the beginning of the Renaissance. To a great extent this impression is founded on fact; the innovators of this crucial decade did achieve often unforeseeable and strikingly new results. These amounted at times to a sharp break with the past and were largely to determine the course of twentieth-century art up to the present.

The Impressionist and Post-Impressionist movements had already deprived visual reality of its permanent properties of color, shape, and space. The artist himself now assumed the prerogative of determining these qualities, either as his eye saw them (Impressionism) or as his ideas, emotions, or fantasy might dictate (Post-Impressionism). So the path had already been prepared for even the most radical of twentieth-century artists.

The innovators of the first, heroic decade of the twentieth century were a hardy band. Most official, critical, and financial forces were arrayed against them. But the precedent had long been established. At least since Gros called Delacroix's *Massacre at Chios* the "massacre of painting" at the Salon of 1824, most new tendencies in modern art have had to establish themselves as avant-garde movements by a revolutionary exhibition or even, in the twentieth century, by provocative actions. Courbet's Pavilion of Realism and the Impressionist group exhibitions are examples of such gestures of defiance. Women artists, still in the minority, played a role in every one of the artistic movements of the twentieth century. Sometimes that role was major, sometimes truly innovative.

Artistic scandals, while hardly conducive to profitable sales, always drew public attention, and they tended to nourish the artist's courage and self-esteem. Early in the twentieth century new movements often required explanatory writings or manifestos. A rich literature of aggressive art criticism arose paralleling the provocative writings that generally attended contemporary political and social tendencies. By the early 1970s the phenomenon of the self-proclaimed avant-garde had become so generally accepted that its significance had waned. It is by no means certain whether the idea of the avant-garde still has a productive future in the few remaining years of the century.

In the early 1900s, however, the avant-garde was real enough; so indeed were the financial hardships inflicted on its members. The first unmistakable avant-garde event of the new century was the exhibition of an extraordinary roomful of pictures at the Salon d'Automne of 1905. According to a still not absolutely verified story, the critic Louis Vauxcelles gazed about the room in horror and, seeing in the center a work of sculpture in Renaissance tradition, exclaimed, "Donatello au milieu des fauves!" ("Donatello among the wild beasts!"). The name *Fauves* immediately stuck to the new movement. While today its joyous productions hardly seem to show the ferocity implied by the nickname, it is not hard to understand that to an academic critic in 1905 such explosions of brilliant color, not to speak of the rough brushstrokes and antinaturalistic drawing and perspective, seemed bestial indeed.

Matisse and Derain

When the twentieth century opened, Henri Matisse (1869–1954) was already past thirty. He was a competent painter in a modified Impressionist style and had executed an impressive series of copies of Old Masters, some quite literal, others delicately altered to bring out those aspects that interested him the most. Yet he had shown no awareness of the innovations of the Post-Impressionists. Soon after the turn of the century, however, he began experimenting with figures so simplified

THE FAUVES AND EXPRESSIONISM

that their masses could be stated in bold areas of pigment. Rapidly he turned to the divided touches of bright color introduced by the Neo-Impressionists. Then in 1905 came the Fauve explosion. Matisse burst upon the art world with an astonishing series of paintings in which masses of brilliant color—reds, red oranges, greens, blues, blue greens, yellows, and violets—were applied at full intensity with broad brushstrokes or in large, flat areas and juxtaposed with jarring results.

Matisse's *The Green Stripe*, of 1905 (fig. 35–1), exhibited in the celebrated group of Fauve pictures at the Salon d'Automne of that year, excited special notice because this blazing bouquet of colors was applied not only to the arbitrarily divided background and the dress and collar but also, only slightly diluted by flesh tones, to the face, dominated by the vivid green stripe through the center of the forehead and down the nose. Not even Gauguin had dreamed of such distortions. What Matisse had done was to intensify the differentiation of hues already analyzed by the Impressionists, thereby producing a strong effect of "deliberate disharmonies," in the words of another leading French Fauve painter, André Derain (1880–1954). In *Mountains at Collioure,* a Mediterranean landscape of the same year (fig. 35–2), Derain paints with short, choppy brushstrokes inspired by van Gogh but also creates larger, lozenge-shaped areas of flat, even color, reminiscent of Gauguin and of the Art Nouveau decorative arts that sprang up in Gauguin's wake. Cézanne's method of shading from light to dark by means of contiguous patches of warm and cool hues is reduced to stark juxtapositions of unmodulated complementary colors: green leaves beside red tree trunks and branches, red-orange mountainsides in the sun against blue slopes in shadow or the blue-green sky. Like Matisse, Derain has energized the surface of his painting by allowing the white ground to show through between brushstrokes.

35-1. HENRI MATISSE. *The Green Stripe (Madame Matisse).* 1905. Oil and tempera on canvas, 15⅞ × 12⅞″ (40.3 × 32.7 cm). Statens Museum for Kunst, Copenhagen. J. Rump Collection

35-2. ANDRÉ DERAIN. *Mountains at Collioure.* 1905. Oil on canvas, 32 × 39½″ (81.5 × 100 cm). National Gallery of Art, Washington, D.C. John Hay Whitney Collection

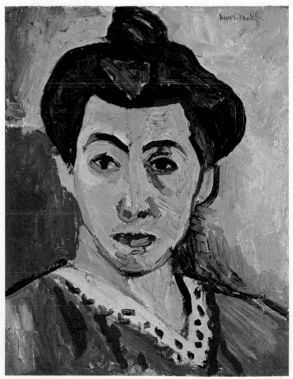

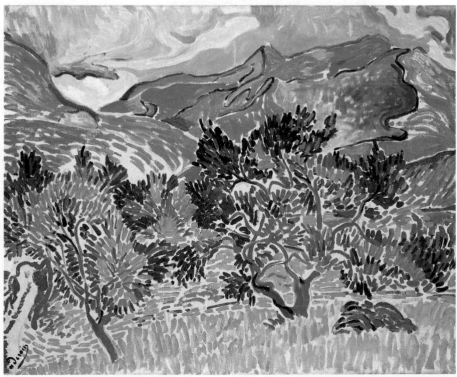

35-1 35-2

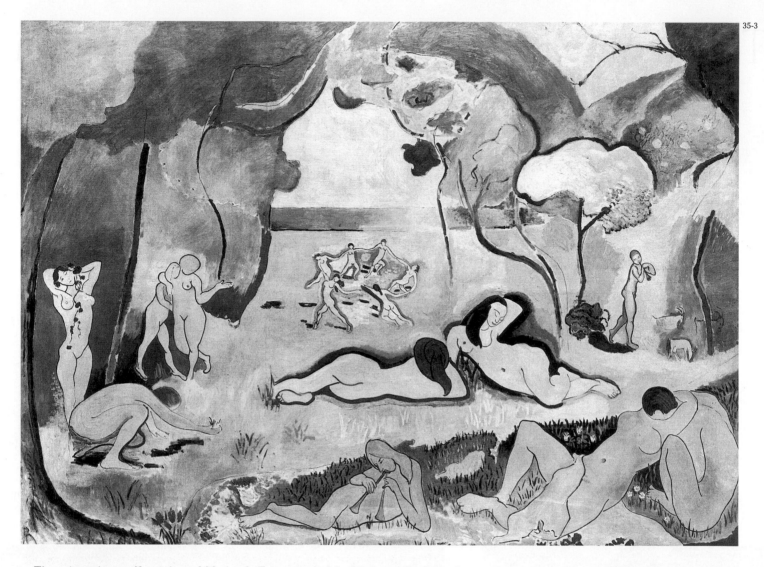

The triumphant affirmation of Matisse's Fauve period is the huge *Bonheur de Vivre (Joy of Life)*, of 1905–6, nearly eight feet long (fig. 35–3). In this bacchanal in a forest glade, space is pushed back into depth by a series of trees, exaggeratedly flat like the side scenery of a theater stage, and by the abrupt diminution in size of the figures ringing the central clearing. The result is a picture in which flat planes appear more dominant than spatial recession. This pastoral scene is inhabited throughout by a happy company of male and female nudes, embracing, playing pipes, picking flowers, draping garlands about their bodies, or dancing, all indicated with fluid, unbroken contours and broad, thinly brushed areas of color. Matisse's new scale and color were both in a sense prepared for by Gauguin (see figs. 34–9, 34–10). The primitivism or otherness desired by Gauguin has here been achieved without reference to the exotic tribal cultures brought to European consciousness by nineteenth-century colonial expansion. Instead, Matisse referred in the *Joy of Life* to a hypothetically lighthearted, calm society, distant in time but not in geography: the mythical golden age of the Greek gods, known to Europeans of the Christian era through Greek and Latin literature and known to Matisse particularly through visual interpretations of ancient stories in Italian Renaissance painting.

In 1908 Matisse published his "Notes d'un peintre," in which he explained:

What I am after, above all, is expression.... Expression to my way of thinking does not consist of the passion mirrored upon a human face or betrayed by a

35-3. Henri Matisse. *Bonheur de Vivre (Joy of Life)*. 1905–6. Oil on canvas, 68½ × 93¾" (1.74 × 2.38 m). The Barnes Foundation, Merion Station, Pennsylvania

violent gesture. The whole arrangement of my pictures is expressive. The place occupied by figures or objects, the empty spaces around them, the proportions, everything plays a part.... What I dream of is an art of balance, of purity and serenity devoid of troubling or depressing subject matter.

Matisse's *Red Studio,* of 1911 (fig. 35–4), is another large, key work in which he expressed in several ways his intense thinking about issues of modern art. Just as the nearly monochrome, unmodulated red across the entire surface of the painting calls our attention to the notion that a picture is in fact a flat surface, the subject matter of the painting announces itself as the art of painting itself, in the form of the interior of Matisse's own studio. Against the studio walls, recognizable canvases by Matisse (a veritable gallery of his pictures of the preceding five years or so) either hang parallel to the canvas surface or slant back into space to establish a suggestion of perspective. Among the seemingly transparent pieces of furniture, contoured in wavering yellow lines, are modeling stands bearing small sculptured nudes by Matisse, including the sinuous, long-limbed *Decorative Figure,* of 1908 (fig. 35–5), one of nearly seventy sculptures Matisse produced in his lifetime. The sculptures in the round depicted in the *Red Studio,* together with the numerous wall-hung and stacked canvases, echo the dialogue between three-dimensionality and flat surface announced by Matisse's lines receding into space and the conspicuous absence of them, for example, at the corner of the room. Renaissance illusion of perspective, the window into an imaginary space behind the picture surface, survives here only as one alternative to the actuality of the flat, stretched canvas.

For more than forty years longer Matisse continued to paint the relaxed, classic themes he loved. Save for a brief flirtation with Cubism (see Chapter Thirty-Six), he never deserted his basic Fauve message of linear and coloristic freedom, calm, and beauty. In 1921, following several trips to Morocco and the south of France, he took up residence at Nice, on the Riviera. Typical of his Nice period paintings, large and small, is *Decorative Figure against an Ornamental Background,* of 1925 (fig. 35–7). The strongly modeled, grandly simplified forms of the nude are played off against the movement of the Rococo shapes in the wallpaper and the frame of the mirror. Between the browns, rose tones, blues, and yellows of the Oriental rug and the wallpaper the richness of color is almost overwhelming.

In 1943 Matisse moved to the Riviera hill town of Vence, where during a serious illness he was cared for by Dominican nuns. In gratitude he created and financed a wonderful chapel for them—he designed the architecture, murals, stained glass, vestments, and even the altar, its candlesticks, and crucifix, between 1948 and 1951 (fig. 35–6). Innumerable preparatory drawings are preserved, often complex at the start but in final definition starkly simple. The murals, one of Saint Dominic (visible in the illustration), one of the Virgin and Child, and one grouping the fourteen Stations of the Cross on a single wall, are drawn with a spareness that reflects the Dominican way, in black brushstrokes on ceramic tile glazed white. Color in the interior is provided entirely by the chasubles worn by the priests and by the stained glass. The light from the windows bathes the white chapel in yellow, blue, and green hues, as if the space were enchanted. Despite the fact that Matisse professed no formal religion, his labor of love is one of the few great works of religious art done in the twentieth century and provides for the prayers and liturgies of the nuns an environment of untroubled beauty.

Although in old age Matisse was confined to his bed, the scope and freedom of his art achieved new heights. Unable to paint at an easel, he refined and turned into a major art medium a technique he had used since the early 1930s for planning the compositions of large decorative commissions: pasted paper cutouts. These were made mostly from large pieces of heavy paper, prepainted with gouache in sundry bright colors by studio assistants according to the bedridden artist's instructions. Matisse then "carved" the painted sheets into various shapes by cutting fluidly with a scissors, as if he were drawing. The colored shapes were next pinned to white

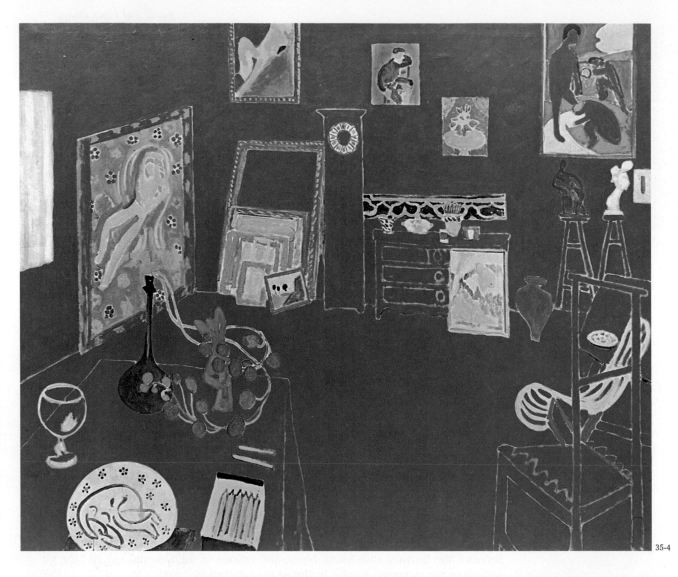

35-4. HENRI MATISSE. *Red Studio*. 1911. Oil on canvas, 5′11¼″ × 7′2¼″ (1.81 × 2.19 m). Collection, The Museum of Modern Art, New York. Mrs. Simon Guggenheim Fund

35-5. HENRI MATISSE. *Decorative Figure*. 1908. Bronze, height 28¼″ (71.8 cm). Hirshhorn Museum and Sculpture Garden, Smithsonian Institution. Gift of Joseph H. Hirshhorn, 1966

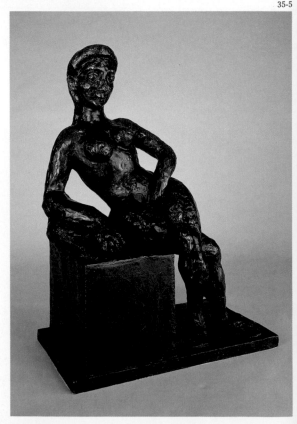

walls and then to enormous paper surfaces onto which they were later pasted, after Matisse had decided on their precise location in a composition. *Woman with Amphora and Pomegranates,* of 1952 (fig. 35–8), is an example of the spontaneous verve of these pasted paper works. Their pulsating contours, flat surfaces, and brilliant color revive on a new scale the energy of Matisse's *Joy of Life,* painted nearly half a century before. To many critics Matisse remains, from a purely pictorial standpoint, the most sensitive painter of the twentieth century.

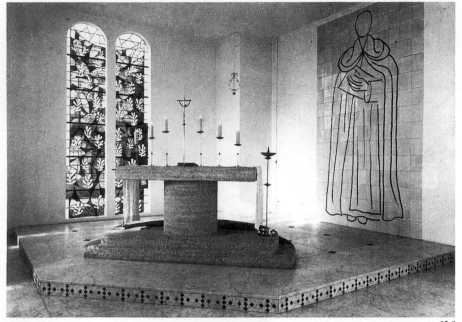

35-6

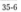

35-6. HENRI MATISSE. Chapel of the Rosary of the Dominican Nuns, Vence, France. 1948–51 (consecrated June 25, 1951)

35-7. HENRI MATISSE. *Decorative Figure against an Ornamental Background*. 1925. Oil on canvas, 51½ × 38⅜″ (130.8 × 97.5 cm). Musée National d'Art Moderne, Centre Georges Pompidou, Paris

35-8. HENRI MATISSE. *Woman with Amphora and Pomegranates*. 1952. Collage of cut and pasted papers, 96 × 37⅞″ (243.8 × 96.2 cm). National Gallery of Art, Washington, D.C. Ailsa Mellon Bruce Fund

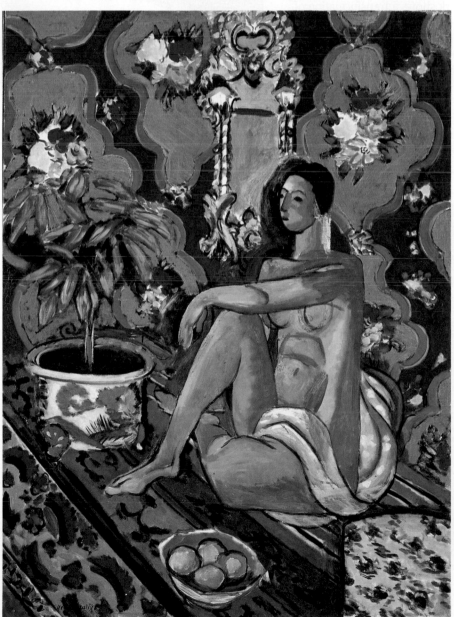

35-7 35-8

Rouault

At the same Salon d'Automne of 1905 when the works of the Fauves first astonished Paris, there were also exhibited paintings by a companion of Matisse in student days, Georges Rouault (1871–1958). The intensely Catholic Rouault could not accept the hedonistic view of existence so delightful throughout the work of Matisse. Rouault's early paintings embody an attitude of rebellion against the life around him. His sympathies are reserved for society's outsiders, such as circus performers, whom he sees as tragic figures, as compared with the middle classes. In contrast to the gentle, cynical acceptance of prostitutes by Toulouse-Lautrec in his bordello series of the 1890s, Rouault paints them with savage fury. Expression to him is just what Matisse said it was not: "the passion mirrored upon a human face or betrayed by a violent gesture." The fierce contours of *Prostitute at Her Mirror,* of 1906 (fig. 35–9), describe volumes of surprising force. This malevolent woman, exposed as an incarnation of evil, takes on a strange rhythmic beauty as if Rouault, like Bosch but without his fantasy (see fig. 21–29), was fascinated by what the hypocrisy of society most condemns. Like many of Rouault's early works, this one is painted in oil on cardboard, which gives a quality at once matte and translucent to the blue contours and shadows. The violence of such paintings relates Rouault less closely to the French Fauves than to contemporary German Expressionists, especially the Blaue Reiter (see below). Rouault's later work shows a transformation of his early moral indignation into a gentler mysticism in some ways reminiscent of Rembrandt. His early training as a stained-glass maker is doubtless influential in the way he bounds masses of brilliant impasto with broad, black lines recalling the lead separations between the pieces of glass in medieval windows.

Expressionism

The name *Expressionism* is loosely applied to various avant-garde movements in Germany in the early twentieth century, which recall at times the emotional

35-9. GEORGES ROUAULT. *Prostitute at Her Mirror.* 1906. Oil on cardboard, 27⅝ × 20⅞″ (70.2 × 53 cm). Musée National d'Art Moderne, Centre Georges Pompidou, Paris

35-10. KÄTHE KOLLWITZ. *Outbreak,* from *Bauernkrieg (Peasants' War)* series. 1903. Etching. Kupferstichkabinett, Staatliche Museen zu Berlin — Preussischer Kulturbesitz

35-10

violence of Grünewald and other German masters in the sixteenth. Two pioneer Expressionists were women; both worked independently of any group. KÄTHE KOLLWITZ (1867–1945) throughout her richly productive career as sculptor and printmaker was deeply concerned with the problems of working people, in whom she found a special nobility and beauty. For a while she exhibited with the Berlin Sezession, a group of Socialist artists. In her devastating etching *Outbreak,* of 1903 (fig. 35–10), the direction of her interests, and to a certain extent her methods, is already clear. This was the first of a series depicting with fierce intensity events from the history of the great Peasants' War in early-sixteenth-century Germany, a revolution put down by the threatened overlords with barbaric violence. An almost legendary figure, Black Anna, stands with her back toward us and her arms upraised as if opening the floodgates for a tide of angry humanity, on which are tossed howling faces, flying hands and feet, and farm implements used as weapons. Kollwitz does not conceal her debt to Goya (see figs. 31–4, 31–5), but she has gone even farther in the suppression of detail and distortion of form in the interests of expression. Her harsh lines and rough light-and-dark contrasts opened the path not only for her own greatly simplified later work but for the painters of Die Brücke (see below) to follow in a year or two.

Another individual whose work appears to tremble with the emotion characteristic of the Expressionist art arising in many different parts of Germany is the sculptor and printmaker WILHELM LEHMBRUCK (1881–1919). A miner's son from the Rhineland who lived during much of his career in Düsseldorf, Lehmbruck was deeply influenced at first by the immediacy and strong feeling in the work of Rodin and then, after going to Paris in 1910, by the French sculptor Aristide Maillol (1861–1944), who was reviving for figurative sculpture classical values of balance, repose, and restraint. Although Lehmbruck was acquainted with some of the most advanced sculptors of the time, notably Constantin Brancusi (see figs. 36–16, 36–17), he remained faithful to the unfragmented human figure and continued to work, as had Rodin and Maillol, by modeling in clay. Only during the last eight years of his brief and haunted life did he produce the series of masterpieces in which he combined a classicism derived from Maillol with an exaggerated elongation recalling both that of the Gothic figures of Chartres Cathedral's Royal Portal and the tormented inhabitants of Rodin's *Gates of Hell* (see fig. 33–23). Lehmbruck's strange combination of touching, bony awkwardness and Botticellian grace was also influenced by the Renaissance sculpture he had seen in Italy. His almost emaciated *Standing Youth,* of 1913 (fig. 35–11), shows less concern with mass than Maillol exhibited and more with space. The direction of the youth's brooding, introspective glance and the strong projections of his bony limbs extend implied movement into the surrounding atmosphere. Although he did not carve directly in his materials, as other sculptors, such as Brancusi, were beginning to do, Lehmbruck was interested in a rocklike surface. Thus, after modeling his work in clay he ordered it cast in artificial stone—an amalgam of pulverized stone and cement, which provided a velvety blend of the texture of stone and the plasticity of clay.

Even more original a painter than Kollwitz, and by contrast profoundly quiet, was the short-lived PAULA MODERSOHN-BECKER (1876–1907), whose visits to Paris brought her in contact with the work of Cézanne, Gauguin, Vuillard, and other Post-Impressionists. Since she had apparently no knowledge of the innovations of Matisse and the other Fauves, she seems to have made the transition to a completely modern style, based on arbitrary distortions, entirely on her own. Her *Self-Portrait,* of 1906 (fig. 35–12), one of a series of such neo-primitive self-images, is a curious combination of harshness of mass and contour, roughness of texture, and a deep gentleness. The great, calm eyes and the gesture of self-display are typical of the poetry of the last full year of her activity, in which she rejoiced in the density and warmth of her own body. Modersohn-Becker returned to Germany, became pregnant, and died three weeks after childbirth.

35-11

35-11. WILHELM LEHMBRUCK. *Standing Youth.* 1913. Cast stone, height 7′8″ (2.34 m). Collection, The Museum of Modern Art, New York. Gift of Abby Aldrich Rockefeller

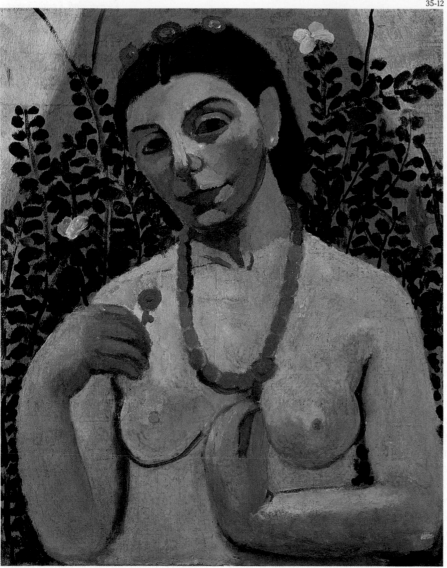

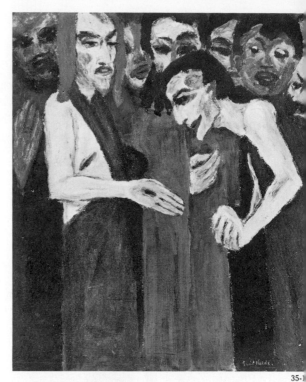

35-12. PAULA MODERSOHN-BECKER. *Self-Portrait.* 1906. Oil on canvas, 24 × 19¹¹⁄₁₆″ (61 × 50 cm). Öffentliche Kunstsammlung, Kunstmuseum, Basel

35-13. EMIL NOLDE. *Doubting Thomas.* 1912. Oil on canvas, 39⅜ × 33⅞″ (100 × 86 cm). Nolde-Museum, Seebüll, Germany

35-14. KARL SCHMIDT-ROTTLUFF. *Two Heads.* 1918. Woodcut. Staatliche Museen zu Berlin–Preussischer Kulturbesitz

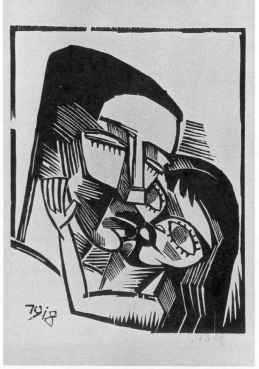

DIE BRÜCKE A rebel group called Die Brücke ("The Bridge") was formed in Dresden in 1905, the very year the Fauves first showed in Paris. This was a brotherhood, not unlike those that had appeared in France and England at various moments in the nineteenth century and especially close to what van Gogh had envisioned in Arles (see page 954). The most gifted member of the group was EMIL NOLDE (1867–1956), who belonged only briefly. In masses of pigment unfettered by any structural contours like those of Rouault, he expressed themes of equally fierce intensity, all the more shocking on account of the unexpected content he discovered in such traditionally Christian themes as that of the *Doubting Thomas,* painted in 1912 (fig. 35–13; compare an example from the Baroque, fig. 28–2) as part of a nine-canvas polyptych, the *Life of Christ.* The Apostles gathered behind Christ in Nolde's *Doubting Thomas* seem to be engaged in some barbaric ritual. Below their frontal row of heads, recalling Ensor's masks (see fig. 34–17), an emaciated Thomas gazes gloatingly at Christ's wounds. All the figures are painted with a deliberate awkwardness in savage, unnaturalistic reds, greens, blues, and yellows. The passionate feeling in Nolde's religious paintings earned the rejection, rather than the approval, of the clergy. Nolde was also an extraordinarily gifted watercolorist, often of landscapes and flower still lifes imbued with intense, sometimes clashing hues, and he was a prolific printmaker who, like Gauguin and Munch before him, used the medium of woodcut for expressive purposes.

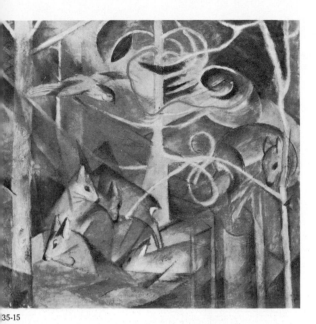

35-15

35-15. FRANZ MARC. *Deer in the Wood, No. I.*
1913. Oil on canvas, 39¾ × 41″ (1.01 × 1.04 m).
The Phillips Collection, Washington, D.C.

35-16. WASSILY KANDINSKY. *Improvisation 30
(Cannon)*. 1913. Oil on canvas, 43¼ × 43¼″
(1.1 × 1.1 m). The Art Institute of Chicago.
Arthur Jerome Eddy Memorial Collection

35-17. WASSILY KANDINSKY. *Composition 238:
Bright Circle*. 1921. Oil on canvas, 54½ × 70⅞″
(1.38 × 1.8 m). Yale University Art Gallery, New
Haven, Connecticut. Gift of Collection Société
Anonyme

Located at first in Dresden and after 1911 in Berlin, the Brücke group, which included the painters Ernst Ludwig Kirchner, Erich Heckel, and Karl Schmidt-Rottluff and later Max Pechstein and Otto Müller, and still others, showed frequently in various German cities in the years just preceding World War I. Most were highly imaginative printmakers as well as painters. KARL SCHMIDT-ROTTLUFF (1884–1976) was perhaps the boldest colorist of the group. He also brought tremendous power of expression to woodcuts in black ink on pale paper, such as *Two Heads,* of 1918 (fig. 35–14). The tension between the volumetric qualities of the couple's facial features and the flatness of the printed sheet seems reflected in the intense emotions of the embracing woman and man. Schmidt-Rottluff's effort to contrast volume and flatness by exaggerating the hatch marks used for shading shows his interest in and understanding of Cubism (see Chapter Thirty-Six), by the date of this woodcut already developed in France.

DER BLAUE REITER Among the constantly dissolving and recombining artist groups formed in Germany just prior to the outbreak of World War I, only Der Blaue Reiter ("The Blue Rider") surpasses the Brücke in importance. This group did not share the Brücke's revolutionary attitude of social protest, nor did it comprise a brotherhood; in the end the Blaue Reiter was far more influential in the development and dissemination of the most imaginative tendencies in twentieth-century art. In fact, three painters of first importance, the German Franz Marc, the Russian Wassily Kandinsky, and the Swiss Paul Klee (see pages 995–96), were the leaders in the group of exceptional talents who exhibited together in Munich in the winter of 1911–12, including in their exciting avant-garde shows a number of experimental artists from Paris and members of the Brücke as well. The Blaue Reiter also published a yearbook in which tribal art from Africa and Oceania and the art of children and the art of the insane were featured alongside Blaue Reiter painting.

FRANZ MARC (1880–1916) was a highly imaginative animal painter. His poetic art sought liberation from the conventions of human existence in the world of animals, thus—whether or not he was consciously aware of it—reviving a tradition that had played an important part in medieval art and had surfaced from time to time in such manifestations as the fantasies of Bosch. A splendid example is Marc's *Deer in the Wood, No. I,* of 1913 (fig. 35–15). Under influence from both Cubism and Futurism (see Chapter Thirty-Six), Marc crisscrosses the enchanted glade with the verticals of the trees, diagonals being derived from the slopes of the hills, and curves suggested by the flight of the hawk at the upper left; in this woodland interior nestle four deer (apparently does or fawns—certainly no antlered stags), resting or

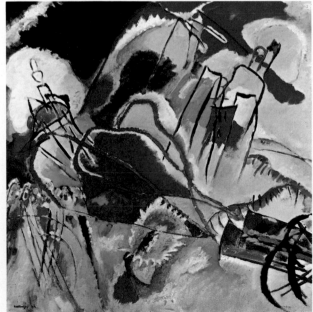

35-16

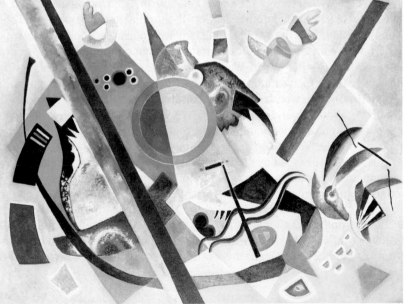

35-17

moving in poses of unconscious grace. Marc's coloring is brilliant and arbitrary, in hues generally of symbolic significance to him, and is carefully applied without the explosive roughness of the Brücke artists. The loss of Marc, killed in World War I, cut short one of the most promising careers of the twentieth century.

WASSILY KANDINSKY (1866–1944) has been credited with the first entirely abstract paintings. The truth may never be determined, but in his book *Concerning the Spiritual in Art,* written in 1910 and published in 1912, Kandinsky warned specifically against total abstraction, which might degenerate into decoration. As early as 1909 he had begun to paint his series called *Improvisations,* referring as had Whistler's titles to those of musical compositions. But Whistler implied the intervention of conscious planning in his *Harmonies, Symphonies, Arrangements,* and the like. Improvisations are unplanned, and Kandinsky wrote that his were "largely unconscious, spontaneous expressions of inner character, non-material in nature." *Improvisation 30 (Cannon),* of 1913 (fig. 35–16), at first sight seems to be a meaningless assortment of freely brushed shapes and colors of astonishing brilliance. Then one begins to notice not only the cannons at the lower right but also what appear to be hills and houses moving at odd angles, and clouds in the sky. Kandinsky suggested that the cannons might be explained by the war talk that had been commonplace during the year, but that the name was selected by him purely for convenience and did not refer to any meaning in the picture, "painted rather subconsciously in a state of strong inner tension."

The year it was painted, the picture was exhibited in London and accepted as "pure visual music" by the critic Roger Fry, who also discerned a kind of logic in the apparently spontaneous oppositions of shapes and colors. In a strange combination of Russian mysticism, theosophy, and a feeling that Impressionism had destroyed the object and atomic research had dissolved all substance, Kandinsky had, in fact, proposed a completely subjective, symbolic meaning for colors, as had Marc, and also a new theory of abstract structural relationships. At some moment during the creation of the *Improvisations,* possibly during 1910, Kandinsky happened to see one of them upside down and was impressed by its beauty when nothing in it could any longer be recognized. But not until late in 1913 did he completely desert representation. After his return to Russia in 1914, where he was in touch with the Constructivist movement, whose members had arrived at abstraction by a different route (see Chapter Thirty-Six), Kandinsky's abstract paintings began to assume considerable dimensions. *Composition 238: Bright Circle* (fig. 35–17), painted just before his return to Germany in 1921, shows the influence of his fellow Russians Kasimir Malevich and El Lissitzky in the ruled lines and geometrical shapes, but the intensity of feeling that drives the freely associated shapes is pure Kandinsky. The painting appears to show a kind of celestial explosion, whereby the viewer observes flotation in "galactic" space rather than the illusion of a world with familiar, feet-on-the-ground gravity. During 1922 and 1923 Kandinsky taught at the Bauhaus, the experimental art school in Weimar (see page 1072), where an academy of fine arts and a school of applied arts, or crafts, had been combined after World War I to create a new kind of education in art and design that was soon to influence the teaching of art, product design, and graphic design around the world. From 1933 until his death Kandinsky lived in the Paris suburb of Neuilly-sur-Seine. The true heirs of his imaginative legacy of form inflamed by emotion were the American progenitors of the Abstract Expressionist movement after World War II (see Chapter Thirty-Eight).

The forces unleashed by the Brücke were, however, by no means forgotten. The movement had exalted individual emotional experience to the plane of the ultimate determinant of moral as well as artistic values. The Austrian painter OSKAR KOKOSCHKA (1886–1980) continued the Expressionist freedom of statement and technique until long after World War II without ever abandoning his loyalty to the visible world. In his early portraits Kokoschka shows that he had absorbed much from his study of van Gogh; these works are crafted with a heavy application of

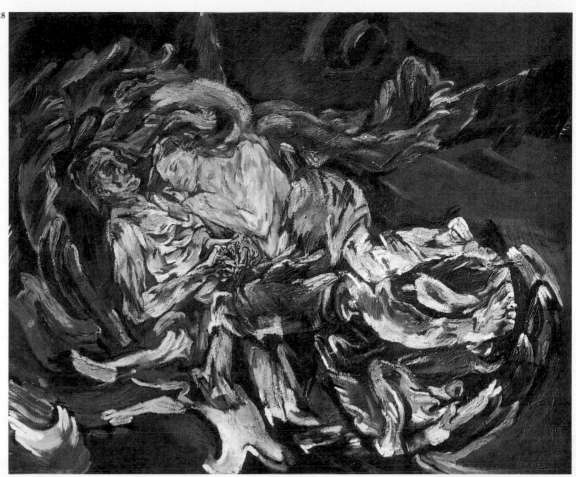

35-18. OSKAR KOKOSCHKA. *Bride of the Wind (The Tempest)*. 1914. Oil on canvas, 71¼ × 86⅝″ (1.81 × 2.2 m). Kunstmuseum, Basel

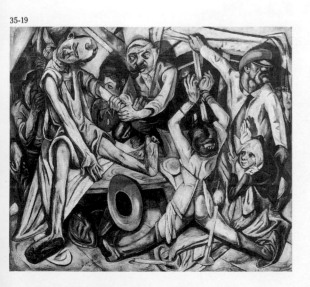

35-19. MAX BECKMANN. *The Night*. 1918–19. Oil on canvas, 52⅜ × 60¼″ (1.33 × 1.53 m). Kunstsammlung Nordrhein-Westfalen, Düsseldorf

pigment to convey an intense, often haunting, emotional state. Following the staging of two wildly sadistic dramas he had written and produced in 1909, Kokoschka was obliged to leave Vienna for a more sympathetic atmosphere in Berlin, where Expressionist artists from all over central and eastern Europe were gathering. His glorious *Bride of the Wind,* of 1914 (fig. 35–18), is one of the rare unabashed celebrations of romantic love in the twentieth century. The artist and his mistress, like Dante's Paolo and Francesca in Blake's illustration (see fig. 31–19), are swept in a whirlwind above a blue mountain valley before glittering crags illuminated by a crescent moon, lost in their emotion like the ecstatic saints in the depths of an El Greco cloud.

MAX BECKMANN (1884–1950), a powerful artist, picked up the legacy of the Brücke after World War I and carried it to midcentury. Trained and successful as an academic painter, Beckmann was spiritually devastated by the wave of disillusionment in Germany after World War I. *The Night,* of 1918–19 (fig. 35–19), is a terrifying indictment of official cruelty, difficult to connect with any specific historical incident, except perhaps the fierce repression of the Communist "Spartacus" attempt to seize power in Germany in January 1919. The tortures and the powerful, jagged forms are reminiscent of Grünewald in their horror, yet the coloring is almost monochromatic. In retrospect the picture seems prophetic of Nazism, which designated Beckmann, like all modern artists in Germany, "degenerate." He fled to Amsterdam and, after the German occupation of the Netherlands, went into hiding. After World War II Beckmann came to the United States, where he spent the last three years of his life. His majestic triptychs, painted during the 1930s and 1940s, preserve the angular figural composition of the earlier works, reinforced now by strong black contours reminiscent of Rouault and by brilliant coloring. Still tormented and full of enigmatic symbols insoluble by any known iconographic method, and never fully deciphered even by Beckmann himself, these paintings are as effective as if they had been planned for mural decoration.

CHAPTER THIRTY-SIX

At about the same time as the Expressionist outburst of emotion, and equally instrumental with Expressionism in eventually dissolving most ties with visual reality, came a succession of movements that attempted to explore ideas about form more than obvious expression of feeling. As the Fauves and the Expressionists derived largely from the pioneer explorations of Gauguin and van Gogh, so the Cubists of the early twentieth century entered the field under the banner of Cézanne. Yet Cézanne had achieved form through careful integration of color, while the Cubist painters often restricted color, reducing its intensity severely, and sometimes their successors, painters of pure geometric abstraction, denied color altogether.

Picasso, Braque, and the Cubist Style

The long career of Pablo Ruiz y Picasso (1881–1973) cast across the twentieth century a shadow as long as those of Michelangelo and Titian across the sixteenth. Picasso initiated, along with his associate Georges Braque, the most revolutionary painting movement of the century, Cubism. This led in turn to a radical new approach to sculpture. Picasso participated in a succession of painting styles and influenced every phase of artistic activity throughout Europe and the Americas in

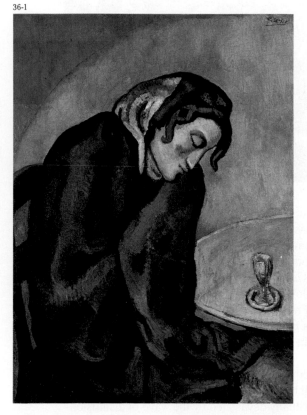

36-1

36-1. PABLO PICASSO. *Absinthe Drinker.* 1902. Oil on canvas, 31½ × 23⅝" (80 × 60 cm). Private collection

36-2. PABLO PICASSO. *Family of Saltimbanques.* 1905. Oil on canvas, 6′11¾″ × 7′6⅜″ (2.13 × 2.3 m). National Gallery of Art, Washington, D.C. Chester Dale Collection

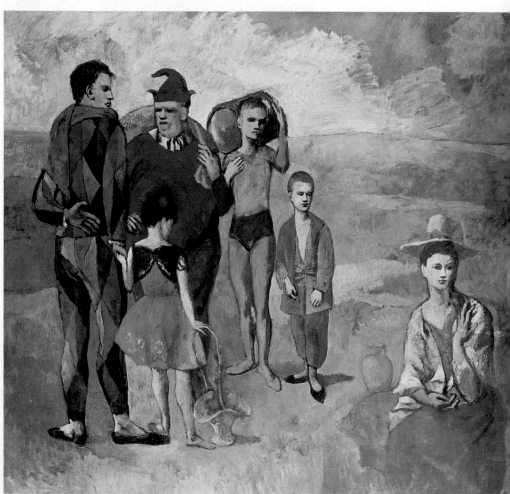

36-2

CUBISM AND ABSTRACT ART

one way or another until his extreme old age. Throughout his entire life he showed a vast range of ideas, in printmaking and stage design as well as in painting and sculpture, and he remains a towering figure. His best works take their place among the masterpieces of art, and his extraordinary productivity and breadth of accomplishment continue to challenge artists today.

A fully trained painter at the age of only nineteen, the Spanish-born Picasso took up residence in France in 1900 and thereafter returned only for brief visits to his native land. In Paris he fell under the spell of the work of Toulouse-Lautrec, an influence that he soon managed to absorb and convert into a highly original style. He became concerned with the lives of those who lived, as he did, on the periphery of society, identifying his misery with theirs. He saw prostitutes, beggars, street musicians, and blind people from within and was able to project their moods with overpowering intensity. The woman in his *Absinthe Drinker*, of 1902 (fig. 36–1; compare with fig. 33–14), sits lost in the stupefying liqueur, the bowed curve of her

36-3. PABLO PICASSO. *Les Demoiselles d'Avignon.* 1907. Oil on canvas, 8′ × 7′8″ (2.44 × 2.34 m). Collection, The Museum of Modern Art, New York. Acquired through the Lillie P. Bliss Bequest

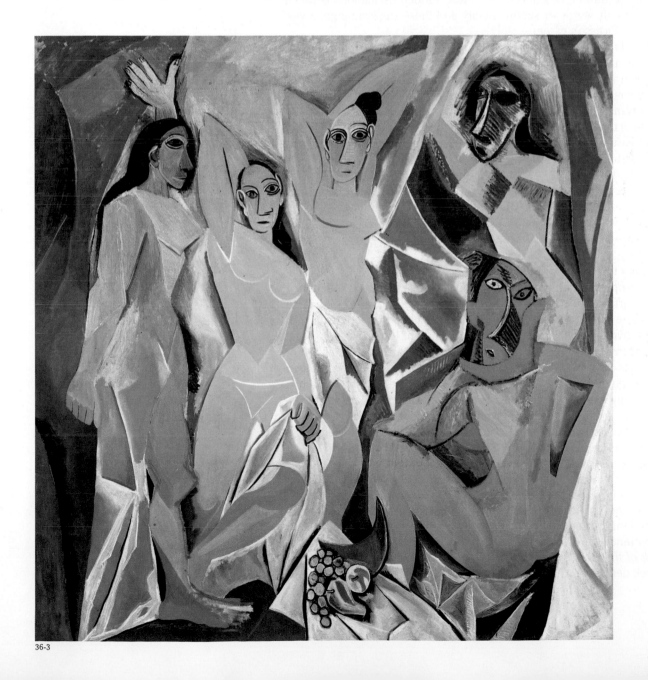

36-3

back and the wisps of her curls echoing the sinuous, arabesque patterns of much later Symbolist art and of Art Nouveau (see fig. 34–19). The entire surface of the canvas is colored an all-pervading, dark turquoise-blue—the proverbial color of melancholy—which has given its name to this so-called Blue period in Picasso's evolution, lasting about four years (1901–4). For the young painter, hardly known to the art world of Paris, it was a period of poverty and loneliness, punctuated by frequent, dejected returns to Barcelona.

By late 1904 Picasso's mood of depression had lightened, and so also had his palette. A briefer Rose period ensued (1904–6), in which he was somewhat less concerned with the tragic aspects of society than with gently portraying the introspective otherness of itinerant circus performers, who were themselves artists of a kind. *Family of Saltimbanques,* of 1905 (fig. 36–2), shows a band of these strolling players in an unidentified landscape; they appear grouped together physically yet detached emotionally. Figures and costumes, surely and deftly drawn and modeled, blend with the ground and the sunny haze in tones of softly grayed blue, rose, and beige, creating mother-of-pearl effects of the greatest delicacy. This, one of the loveliest pictures of the twentieth century, hardly prepares us for the fierce outburst that followed in 1907 in an even larger work, *Les Demoiselles d'Avignon* (fig. 36–3), which heralds the beginning of Cubism. But these sudden oscillations between paintings whose moods verge on sentimentality and those suggesting great violence are typical of Picasso's career.

The attitudes and methods of the Cubists are not easy to explain. It may help to remember that the automobile, the cinema, and the airplane were born at the turn of the century or in its early years. Their very existence changed the way artists thought about their perceptions of the natural world, whether or not the two inventors of Cubism—Picasso and the Frenchman Georges Braque (1882–1963)—spent much time driving in a car or going to the movies, much less flying in a plane, at the time Cubism came into being. Picasso, in fact, loved the movies from his adolescence in Barcelona, and during the formative Cubist years between 1908 and the start of World War I in 1914, he and Braque often addressed each other as "my dear Wilbur" and "my dear Orville" in jesting reference to the American pioneers of flight, the Wright brothers, who were great heroes in France. Although neither artist had flown, we know that Picasso and Braque were fascinated by the idea of changing views of the earth as seen from the sky, a bird's-eye vista Picasso knew from mountain climbing in Spain.

In thinking about the Cubist revolution it also helps to keep firmly in mind the conventions of European painting since the Renaissance: a picture is a bounded two-dimensional surface that acts as a window into an imaginary world behind that surface, where three-dimensional objects are convincingly portrayed, usually in one-point perspective and with gradual shading from light to dark to create the illusion of roundness or solidity. Painters also produced the illusion of three-dimensional objects on a two-dimensional surface by using easily understood symbols or signs to guide the eyes of their audience; at the same time they enriched their pictures by using the same signs and symbols to tell stories or parts of stories. Not all the possible meanings of these symbols were immediately clear to all viewers (and this became increasingly the case as audiences for art widened in modern times). For example, when in *Joy of Life* (see fig. 35–3) Matisse showed a foreground figure blowing on double pipes, he was making at least two references or signs and perhaps a third. The first is an obvious visual pun—joined pipes and the concept of coupling, one of the main themes of Matisse's painting. The second is a literary reference, not particularly obscure, to physical lovemaking—Pan, the god of woods and wild things, seduced maidens and nymphs with his piping in Greek myth. A third reference, hardly obvious, may be to a sixteenth-century painting by Titian, the *Feast of the Gods,* which depicts an outdoor banquet held in a forest clearing by Greek deities, at which a Pan figure in the middle ground blows on a pipe.

In creating *Les Demoiselles d'Avignon,* Picasso appears to have been challenged by Matisse's big pastoral to produce an obverse in technique and feeling. Picasso's scene also shows a group of nudes, but instead of frolicking and making love in an airy woodland glade, they inhabit the compressed space of the parlor of a notorious brothel on Carrer d'Avinyó (Avignon Street) in Barcelona, where they work—these nudes are prostitutes. (In some of Picasso's many preliminary sketches and water-colors for this painting, there are patrons present in the brothel, a seated sailor and a young man holding a skull, sometimes identified as a medical student.) Space in *Les Demoiselles d'Avignon* is reduced to an almost suffocatingly shallow stage, pushed forward toward the viewer by curtains that, unlike the trees in *Joy of Life,* seem to fill in the back of the canvas rather than extend the view. Unlike the dreamy, self-contained gazes of the nudes in Matisse's pastoral—or, indeed, of the acrobats in Picasso's own *Family of Saltimbanques*—are the grim, dehumanized expressions, hinting at violence in their daily lives, of Picasso's young women. Three of them confront the viewer very directly. Their stark looks also seem to announce the great liberties that Picasso, an immensely fluent draftsman, has begun to take with established conventions of painting.

The figure at left, who holds up a curtain, is seen in profile, yet her eye is shown full face, as an Egyptian artist of the Old Kingdom would have shown it in a carved and painted wall relief, and with this detail Picasso begins to provide more information about a subject than can actually be seen from one position. The seated and standing women at the right have faces that closely resemble African tribal masks, a selection of which was on view in 1907 in the ethnographic museum in Paris. For these figures, instead of using softly graduated tonal shading to establish the curve of a cheek and the protruding volume of a breast, Picasso has substituted a kind of mockery of shading: red and green parallel hatch marks that resemble scarification. The expressive geometry and dramatic jutting volumes of African tribal sculpture stimulated Picasso in many ways.

Picasso has shown other things from several points of view at once: the seated figure with her back to the viewer is partly visible from the front as well as from behind; the fruit on the table tilts up on the picture plane and thus is seen from above; and the woman second from the left appears to be both standing and lying down, as an architect shows a building in plan and in elevation. This shifting viewpoint, used on occasion by Cézanne, can provide descriptive data about a subject that might be missing when conventional illusionistic techniques such as one-point perspective are ignored. Two exhibitions of Cézanne's work, in a room of watercolors at the Salon d'Automne of 1906, the year of the great master's death, and in the large posthumous retrospective at the Salon d'Automne of 1907, influenced Picasso's and Braque's thinking about the depiction of volumes—three-dimensional objects on a two-dimensional surface—as they began to develop the first phase of Cubism. This phase was later termed "analytic," in part because objects have been subjected to rigorous scrutiny from different viewpoints.

Having abandoned one-point perspective, Picasso and Braque gradually developed a system of signs to suggest their subject matter, and it becomes a job for the minds and the memories as well as the eyes of viewers to decode these signs. In Braque's *Violin and Palette* (fig. 36–4), of 1909–10, there are sundry witty signals that the artist is playing sophisticated games with traditional pictorial space: the *repoussoir* (view-extending) device, or curtain, at upper right appears to be in *back* of the rest of the picture rather than near the front, where it would act to push the rest of the space back; the nail at the top casts a very believable shadow onto the palette, although in the rest of the picture light comes from several conflicting directions and thus renders shadows an impossibility; the staves on the sheet music floating above the violin appear to lift from the pages and align themselves with the flat surface of the picture. In Picasso's *Portrait of Daniel-Henry Kahnweiler* (fig. 36–5), done several months later, a few caricatural clues signify the presence of his art dealer: wavy hair and a tiny smile—or is it a mustache?—are echoed lower down

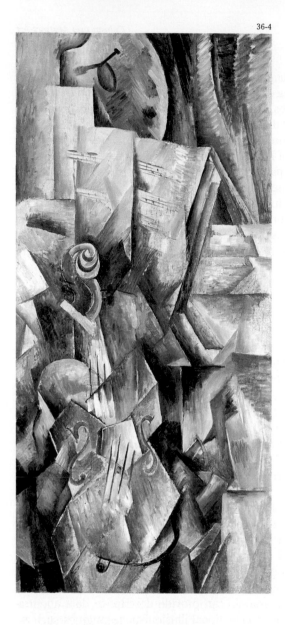

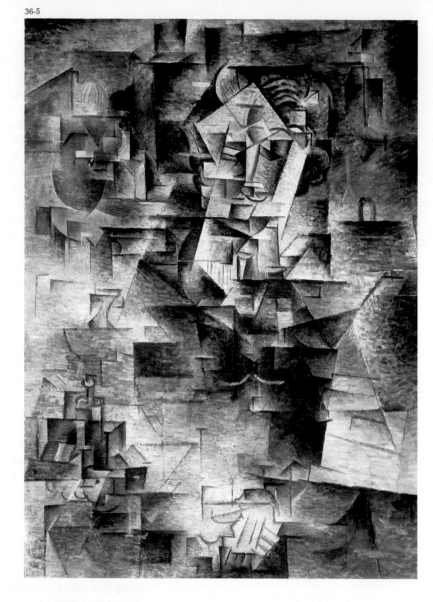

by the double curve of a waistcoat, below which are faint traces of clasped hands. Ironically, the tonal modeling of objects, one method traditionally used to achieve the illusion of three-dimensionality, remains very apparent in Analytic Cubist paintings; however, as in the Kahnweiler portrait, it is always fractured. By separating the outlines of Kahnweiler's upper body and head from the modeling that denotes his bulk, Picasso has turned that modeling into a conceptual tool that signals to the viewer the *idea* of roundness—rather than presenting the image of a contained body. Keeping to a nearly monochromatic palette of delicately graduated beige, ochre, greenish gray, gray, and gray-blue tones, sometimes heightened with touches of white and black, Picasso and Braque reinforced the idea of going from light to dark (tonal modeling) rather than from one bright hue to another. In this phase of Analytic Cubism they usually organized the disembodied, floating, nearly transparent shards of modeling into a kind of grid system that echoed the vertical and horizontal perimeter of their pictures. This called attention to the fact that the pictures were just that, painted objects, rather than imaginary scenes *behind* the canvas surface.

Like Impressionism, Cubism rapidly became a common style among avant-garde artists, but Picasso and Braque remained its masters. Working in nearby studios, in 1911 they turned out paintings remarkably similar in color, subject, and even touch. On occasion only a knowledgeable critic could be sure of telling the difference between works by the two artists. Their ostensible subjects were some-

36-4. GEORGES BRAQUE. *Violin and Palette.* 1909–10. Oil on canvas, 36⅛ × 16⅞″ (91.8 × 42.9 cm). Solomon R. Guggenheim Museum, New York

36-5. PABLO PICASSO. *Portrait of Daniel-Henry Kahnweiler.* 1910. Oil on canvas, 39⅝ × 28⅝″ (100.7 × 72.7 cm). The Art Institute of Chicago. Gift of Mr. Gilbert W. Chapman in Memory of Charles B. Goodspeed, 1948

times so difficult to read, subordinated to the new geometrical structures formed by the floating planes, that this brief, transitional phase of Cubism became known, especially in France, as "hermetic." As the familiar appearance of objects waned, and the location of a painted scene was indicated by just a few hints, such as the tassel of a curtain or a bit of wainscoting on the wall of an interior, the artists began to leave clues about their subjects in the form of words or parts of words. This lettering was in itself flat and thus called attention both to the flat surface of the picture plane and to the faint, shallow illusion of space still appearing to hover behind it. About 1912 Braque and Picasso also began to incorporate materials, such as sand and sawdust, into their paint and in that way to stress a tactile surface over an illusion of depth. They played still further games with illusion by using a housepainter's "comb" to rake through the oil paint and simulate the grain of wood convincingly.

This shuttling back and forth between the painted illusion of reality and the actual reality of a tactile surface led Picasso in 1912 (nearly forty years before Matisse's pasted paper works) to invent *collage* (from the French word *coller,* to glue), a new way of making pictures by cutting out shapes from paper and other materials and then pasting them onto the picture surface. Picasso's first collage, *Still Life with Chair Caning,* of 1911–12 (fig. 36–6), just a little over a foot wide, is a tour de force game with illusion and reality. On top of part of the oval canvas Picasso pasted another piece of cloth, oilcloth commercially printed with an illusionistic design of chair caning. He left ambiguous whether the oilcloth was meant to stand for a chair with a woven seat or a cloth printed in a common pattern covering a round café table. On top of the printed oilcloth is painted a group of objects that might typically rest on a Paris café table: a newspaper, indicated by the letters *JOU* (standing for *journal,* French for "newspaper," and also, perhaps, for *jouer,* French for "to play"); a pipe seen at an angle in perspective; a stemmed glass seen head on and again partially from above; and, to the right of the glass and the oilcloth, perhaps a lemon and a scallop shell left over from a snack. At the lower left a corner is painted over the oilcloth chair caning, proposing that the table may be rectangular instead of round—or reminding us that most paintings are rectangular, not oval. The entire oval canvas is ringed by an ordinary braid rope, a double visual pun on a gold-leaf picture frame and carved wooden molding edging a table. As in a number of Picasso's important Cubist works, an elevation view (looking more or less straight ahead at the table and the upright glass) and a plan view (looking down upon the tabletop) appear to be collapsed into one image.

Both collage and *papier collé* (French for "pasted paper," or collage in which only cut or torn pieces of paper, including newsprint and trompe l'oeil wood grain, are used), invented by Braque the same year, had enormous repercussions on developments in painting and sculpture. During the same spring of 1912 when Picasso made *Still Life with Chair Caning,* he also made a wall-hung construction in relief, *Guitar* (fig. 36–7), first in a cardboard maquette version and then in sheet metal with wire. Built up of flat planes, it was a three-dimensional counterpart of Cubist painting and collage. The fact that *Guitar,* like collage, was made by an additive process—that is, constructed—rather than modeled from clay or carved from stone suggested an entirely new kind of twentieth-century sculpture. Together with collage, this piece announced the second major phase of Cubism, known as "synthetic" (meaning not "artificial" but "integrative"). In Synthetic Cubist painting, developed—first by Picasso and Braque and then by others—between 1913 and 1921, the translucent modeled shards of Analytic Cubism gave way to opaque, flattened forms with clean, sharp-edged, often descriptive silhouettes. These painted forms sometimes appear as if they had been cut out and pasted to the canvas and thus almost advertise their debt to collage. At the same time the subtle, nearly monochromatic surfaces of Analytic Cubism changed to surfaces vibrant with contrasting color. Picasso experimented almost immediately with the additive process suggested by collage and by *Guitar* in a series of wooden wall-reliefs of still-

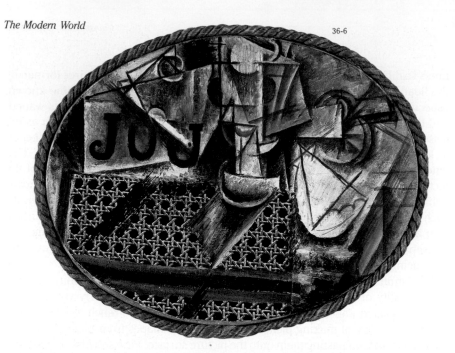

36-6

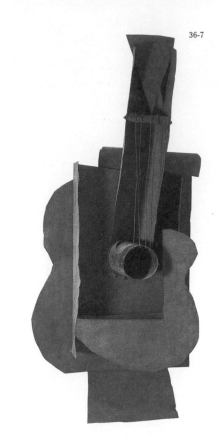

36-7

life subjects, and then in 1914 in a cast-bronze sculpture, the *Glass of Absinthe* (fig. 36–8), to which he added an *objet trouvé,* or "found object," much as he had added commercially printed oilcloth to his first collage. The found object (something lifted from ordinary, daily existence and turned, often without modification, into an art material) was a silver strainer, the kind served in Paris cafés with sugar cubes to sweeten absinthe. In Picasso's sculpture the real strainer is surmounted by a bronze sugar cube, painted, like the rest of the sculpture. With this work the artist once again demonstrated his interest in combining (and confusing) the real with an illusion of the real. Picasso cast the bronze absinthe glass in an edition of six, each one painted differently and, in some cases, textured with sand, but each in some fashion suggesting the translucency of the vitreous material it represents.

The found object would lead a rich existence in Dada and Surrealist art (see Chapter Thirty-Seven). It reappears in Picasso's work often, for example, fifteen years after the *Glass of Absinthe,* in a sculpture, *Head of a Woman* (fig. 36–9), which shows once again Picasso's gift for combining high humor and grave seriousness in a single work. Aided by his friend the Spanish sculptor Julio González, who knew welding techniques, Picasso constructed the bust of a woman. Her head is formed from two found objects, vegetable colanders welded into a hollow sphere, with hair made from coiled springs and curves of welded iron; sticklike facial features—an eye, nose-triangle, and curved lips—protrude from a concave sheet-metal face. Work such as this would have an enormous influence on the American sculptor David Smith (see page 1042).

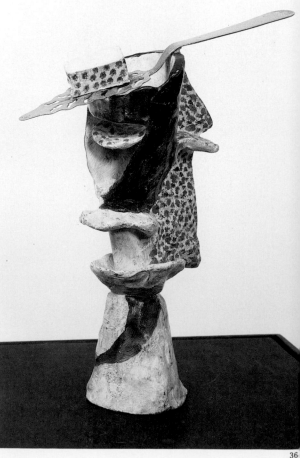

Once established, the Cubist mode of vision and construction continued vital for many years. Its emphasis on the supremacy of the plane and, later, on the capacity of planes that meet at angles to form voids had far-reaching effects not only in painting and sculpture but also in architecture and most aspects of commercial and industrial design. Every major current in abstract art from the 1910s to the present owes a debt to Cubism; some important tendencies, such as Futurism, Constructivism, and De Stijl (see below), were outgrowths of Cubist theory and practice. Picasso continued throughout the rest of his life to make use of Cubist forms and ideas, however often he changed styles.

During the years immediately after World War I, it is no longer possible to talk of "periods" in Picasso's work. Two different styles—Cubist and classical—exist side by side. The monumental yet engaging *Three Musicians,* of 1921 (fig. 36–10), marks the culmination of Synthetic Cubism: flat planes are locked into a total design governed by recognizable, indeed easily readable, shapes. We have no doubt that the three musicians are there. Two are based upon *commedia dell'arte*

36-

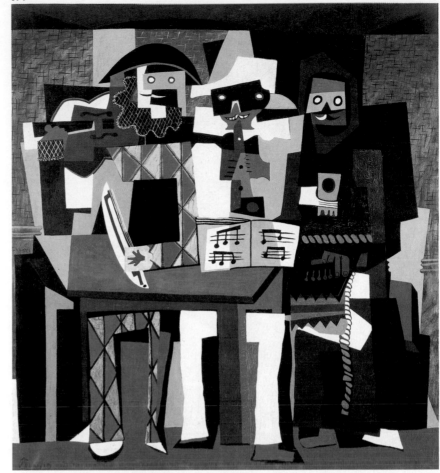

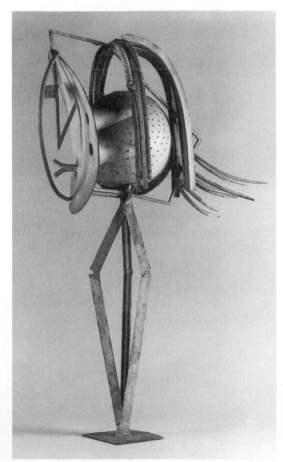

36-6. PABLO PICASSO. *Still Life with Chair Caning.* 1911–12. Oil, oilcloth, and paper on canvas with rope trim, 10⅝ × 13¾″ (27 × 34.9 cm). Musée Picasso, Paris

36-7. PABLO PICASSO. *Guitar.* 1912. Sheet metal and wire, 30½ × 13⅛ × 7⅝″ (77.5 × 33.3 × 19.4 cm). Collection, The Museum of Modern Art, New York. Gift of the artist

36-8. PABLO PICASSO. *Glass of Absinthe.* 1914. Painted bronze with silver sugar strainer, 8½ × 6½ × 3⅜″ (21.6 × 16.5 × 8.6 cm). Collection, The Museum of Modern Art, New York. Gift of Mrs. Bertram Smith

36-9. PABLO PICASSO. *Head of a Woman.* 1930–31. Painted iron, sheet metal, springs, and colanders, 39⅜ × 14½ × 23¼″ (100 × 36.8 × 59.1 cm). Musée Picasso, Paris

36-10. PABLO PICASSO. *Three Musicians.* 1921. Oil on canvas, 6′8″ × 6′2″ (2.03 × 1.88 m). Philadelphia Museum of Art. The A. E. Gallatin Collection

36-9

36-10

characters, Italian strolling players of the seventeenth and eighteenth centuries, and Picasso shows them off with visual wit that describes their stage personalities. The Harlequin at left, a personage identified by his diamond-patterned costume who appears often in Picasso's work in various styles and various moods (remember the *Family of Saltimbanques,* fig. 36–2), is wearing his customary bicorne and plays the violin. In the middle, a Pierrot figure, who also recurs in Picasso's work, is dressed traditionally in a floppy white clown costume and peaked hat; he looks through his dark eye-mask at sheet music while blowing on a reed instrument, most likely a clarinet. To the right the third musician, playing a zither, is garbed as a Franciscan monk, his habit tied in place by one of Picasso's ropes that resembles wooden molding which, at the same time, looks like a Franciscan's rough hemp belt. The coloring and sharp contrasts of black and white are brilliant. The hard, clear planes, together with the great size of the picture, nearly seven feet high, create a splendid decorative effect reminding us that in 1917 Picasso had had considerable experience in stage design. A slightly wider version of *Three Musicians,* painted at the same time, is in the collection of the Museum of Modern Art in New York. The figures in both paintings are set in a fairly shallow interior space like that of a stage, and the background planes are as uncompromisingly parallel to the picture surface as they are in David's *Oath of the Horatii* (see fig. 30–9). Both versions of the *Three Musicians* have a freshness, smartness, and gaiety that are invigorating and rare in the large-scale compositions of the troubled twentieth century.

While Picasso was in Italy in 1917 preparing stage designs for the Ballets Russes, he had been greatly impressed by the grandeur of the Italian past, especially Roman sculpture and the mural paintings of Giotto and Piero della Francesca. Quite unexpectedly he developed, at the same time as the brilliantly colored Synthetic Cubism of *Three Musicians,* a monumental and largely monochromatic

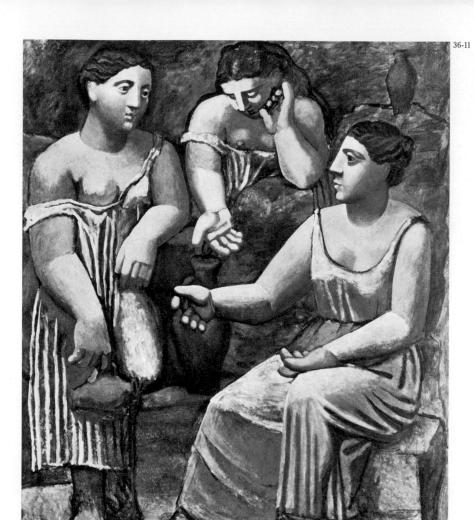

36-11. PABLO PICASSO. *Three Women at the Spring.* 1921. Oil on canvas, 80¼ × 68½" (2.04 × 1.74 m). Collection, The Museum of Modern Art, New York. Gift of Mr. and Mrs. Allan D. Emil

classical style with complete figures heavily modeled as if they were statues. He experimented with every aspect of classical style, from imitations of Etruscan painting and Greek vases to the pencil line of Ingres, but his most imposing classical creations are the majestic compositions involving seated giantesses seeming to derive from a legendary past. The best of them are overpowering in their cylindrical mass and stony implacability. In *Three Women at the Spring,* of 1921 (fig. 36–11), Picasso has deliberately made the figures graceless, emphasizing the bulk and weight of their hands and feet, and intensifying the impersonality of their stony faces.

The lightning changes of style that characterize Picasso's post-Cubist work are too many to record here. Sometimes seemingly incompatible styles appear in the same painting. During the 1930s Picasso's art had much in common with Surrealism (see Chapter Thirty-Seven), but his best-known work of this decade, and in many ways one of the most remarkable pictures involving social protest, is *Guernica* (fig. 36–12). Picasso executed this mural, twenty-five feet long, to fulfill a commission for the pavilion of the Spanish Republican government at the Paris Exposition of 1937, while the Civil War was still going on in Spain. Intended as a protest against the destruction of the little Basque town of Guernica in April 1937 by Nazi bombers in the service of the Spanish Fascists, the picture has become in retrospect a memorial to all the crimes against humanity in the twentieth century. The painting is not a literal narration in the tradition of Goya, which would have been foreign to Picasso's nature and principles, or even an easily legible array of symbols. As he worked, Picasso seems to have decided, perhaps subconsciously, to combine images drawn from Christian iconography, such as the Slaughter of the

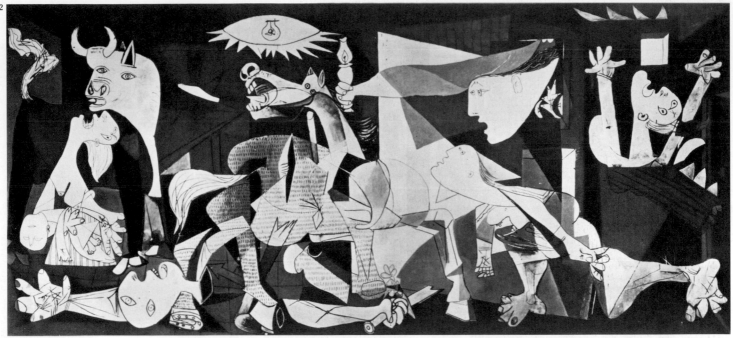

36-12. PABLO PICASSO. *Guernica*. 1937. Oil on canvas, 11'5½" × 25'5¾" (3.49 × 7.77 m). Museo del Prado, Madrid

Innocents, with motifs from Spanish folk culture, especially the bullfight, and from his own past. Actual destruction is reduced to fragmentary glimpses of walls and tiled roofs and to flames shooting from a burning house at the right. A bereft mother rushes screaming from the building, her arms thrown wide. Agonized heads and arms emerge from the wreckage. At the left a mother holding her dead child looks upward, shrieking. The implacable bull above her, the adversary in Spanish popular experience, is surely related to the dread Minotaur, adopted by the Surrealists, as an embodiment of the irrational in man, for the title of their periodical in Paris, to which Picasso had contributed designs. If the bull then signifies the forces of Fascism, the dying horse, drawn also from the bullfight ritual, suggests the torment of the Spanish people, and the oil lamp held above it the resistance of humanity against the mechanized eye, whose iris is an electric bulb. The spiritual message of combined terror and resistance is borne, unexpectedly, by Synthetic Cubist aesthetic means stripped of color. Black, white, and gray planes are composed into a giant pyramid, as if triumphant even in destruction.

After the Spanish Civil War and World War II Picasso continued with great energy to paint and to make sculpture, prints in various mediums, and even highly original ceramics. Often he accomplished remarkable new achievements, particularly in sculpture.

The Influence of Cubism

Although Picasso and Braque remained aloof from group exhibitions, their principles were avidly adopted by a number of lesser masters. Treatises on Cubism soon appeared, notably that in 1912 by the painters Albert Gleizes and Jean Metzinger, which went through fifteen editions in less than a year and was published in English in 1913. Cubist principles influenced painters and sculptors everywhere, even for a while Matisse and certainly Kandinsky and Marc. Cubist principles also exercised a formative influence on new styles, especially that of FERNAND LÉGER (1881–1955), who applied the notion of fragmentation to his vision of an industrialized world. Léger was delighted by certain severely formal arts of the past, such as those of Egypt and Sumeria, and had little use for European painting since Giotto. His *Disks,* of 1918 (fig. 36–13), shows circles and arcs suggesting dynamos dominating the grid of a city, punctuated here and there by the form of a human being. The hard, geometrical forms, often modeled in light, and mechanically inert surfaces of machinery, which were interchanged and recombined from one of his

36-13 36-14

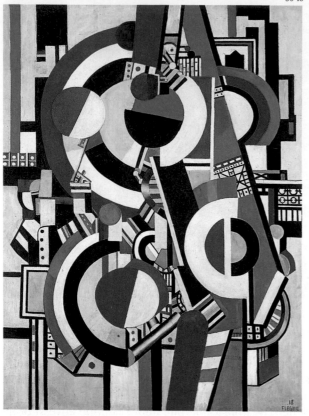
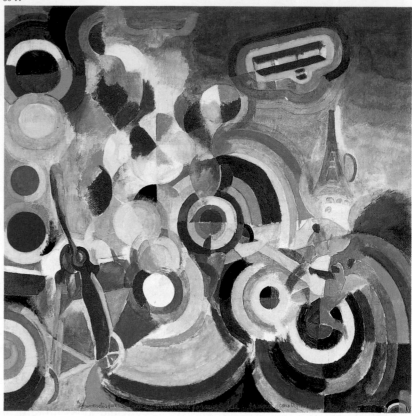

pictures to the next, control the composition, just as the bright, crude colors of illuminated signs determine the color.

Whirring disks had, however, already appeared in the art of ROBERT DELAUNAY (1885–1941), who found in the industrialized world an imaginative excitement more loosely expressed than it was in the stern order of Léger. Disks of brilliant color and constantly changing size and speed interlock and fuse, while never losing motion or atmospheric resonance, in Delaunay's *Homage to Blériot,* of 1914 (fig. 36–14), which celebrated the first flight by a heavier-than-air craft across the English Channel in 1909. Above the tumult of form and colors a biplane and the Eiffel Tower can be seen at the upper right. Delaunay worked in constant collaboration with his equally gifted artist-wife, Sonia (1885–1983), so that it is difficult to tell some of their paintings apart, and even more so to assess the extent of Sonia's influence on Robert's art.

A notorious French painting seemingly inspired by Cubist principles of fragmentation is the *Nude Descending a Staircase, No. 2* (fig. 36–15), painted in 1912 on the basis of a study done the preceding year, by MARCEL DUCHAMP (1887–1968), a still-controversial artist whose major contributions will be studied in Chapter Thirty-Seven. Though it was not strictly a Cubist work, the uproar the picture created at the Armory Show of modern art in New York in 1913 established a popular, if erroneous, notion of Cubism. The picture was not influenced by Futurism, of which Duchamp knew little at the time of the preparatory study, but was suggested, in part at least, by books of photographs popular at the time (descendants of the experiments of Muybridge and Eakins) that showed stages of movement succeeding each other so rapidly that one could flip the pages and obtain the effect of a motion picture. Duchamp's painting superimposes the images of such a series, so that the descending nude is seen in many successive moments simultaneously. As a result, they fuse to form a web of movement in which time is at once affirmed and denied,

36-13. FERNAND LÉGER. *Disks.* 1918. Oil on canvas, 94½ × 71″ (2.4 × 1.8 m). Musée d'Art Moderne de la Ville de Paris

36-14. ROBERT DELAUNAY. *Homage to Blériot.* 1914. Tempera on canvas, 8′2½″ × 8′3″ (2.5 × 2.52 m). Öffentliche Kunstsammlung, Kunstmuseum, Basel

and thus forever suspended, just as it was at the same moment in the *Water Lilies* series (see Introduction fig. 1) in which Monet was prolonging to infinity the instantaneity of Impressionist vision. Paradoxically, the exquisite resiliency of the figural movement is, if anything, enhanced by the apparent substitution of tubes of celluloid pierced by flexible steel rods for flesh and bones. In the course of the fluid motion, all forms fuse into a magical shimmer of golden tan and brown rhythms in space.

Cubism and the First Abstract Sculpture

Despite the crucial importance of Cubism for many modern movements, including some in sculpture, the earliest severely modern sculpture was an independent development. The leading pioneer, indeed one of the two or three greatest sculptors of the twentieth century, was a Romanian, CONSTANTIN BRANCUSI (1876–1957), who, after thorough academic training in Bucharest, arrived in Paris in 1904. He was at first influenced by Rodin, for whom he worked, and emulated the great master's atmospheric dissolution of mass. Brancusi had, however, been once apprenticed to a cabinetmaker and his love of craftsmanship seems to have prompted him to abandon the by then universal practice of turning the actual execution of a work of sculpture over to a professional stonecarver working from the sculptor's clay model cast in plaster. As early as 1907, he began carving directly and simplifying his shapes to elemental forms of universal beauty. "What is real," he said, "is not the external form but the essence of things," and this essence he found in subtle shapes of deceptive simplicity, approaching those of the egg, the wave-worn pebble, and the blade of grass. Some traces of African sculpture may be also discerned in the bulging eyes of the bust of Mademoiselle Pogany, of 1912 (fig. 36–16), but the spiral of the composition is derived from a delicate study of the inner rhythm of the dancer's pose. The mouth has been resorbed into the ovoid of the head, and the shapes caressing the face might be the subject's hands and wrists or the long folds of a scarf. Their exact identity no longer matters—only the delicate suggestion of movement.

The fact that a work like *Mademoiselle Pogany*, originating in marble carefully

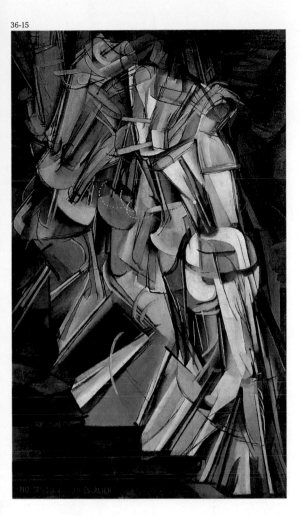

36-15. MARCEL DUCHAMP. *Nude Descending a Staircase, No. 2.* 1912. Oil on canvas, 58 × 35″ (147.3 × 89 cm). Philadelphia Museum of Art. Louise and Walter Arensberg Collection

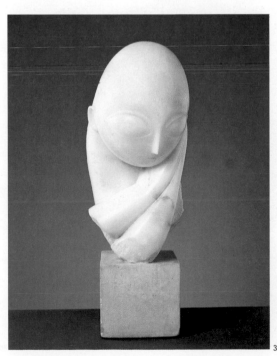

36-16. CONSTANTIN BRANCUSI. *Mademoiselle Pogany.* 1912. Marble, height (without base) 17½″ (44.5 cm). Philadelphia Museum of Art. Gift of Mrs. Rodolphe M. de Schauensee, 1933

36-16

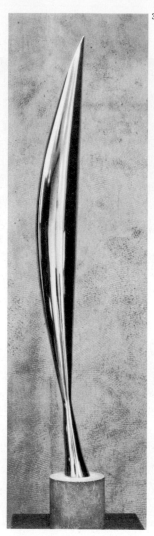

selected for its coloring and texture and lovingly smoothed by Brancusi's own hands, could be further refined in other materials and even cast in bronze or brass to take a high polish shows that the forms derived from universal ideas originating in Brancusi's mind and not in the nature of the material. The extreme of reduction to pure shape in his style is the *Bird in Space* (fig. 36–17), which began in more representational form but through constant refinement in the course of the late 1910s and 1920s evolved into a symbol suggesting a generic bird or a feather that conveys the purity, swiftness, and solitude of flight. The beauty of Brancusi's surfaces caters as much to the desire to touch as to the eye, and it was in recognition of the tactile appeal of his work that the artist created a sculpture for the blind. Brancusi often carved in wood, sometimes with a certain heroic roughness, utilizing forms derived from the highly imaginative porch pillars and corbels of Romanian peasant houses. He also used such carved-wood forms and still others distantly indebted to African sculpture to create remarkable bases for his sculpture, taking delight in contrasting coarse-textured and highly refined materials and in establishing a relationship between his sculpture and the environment in which it was shown. No doubt it was his interest in the environment around a sculpture that led Brancusi to become an excellent photographer of his work and in the late 1930s to design a gate and furniture—tables and seats—and a 96-foot-tall variant of his *Endless Column,* first begun in 1911, for permanent installation in a park in the Romanian town of Tîrgu Jiu.

After a period of considerable indebtedness to the simplifications of early Cubism, RAYMOND DUCHAMP-VILLON (1876–1918) gave promise of the highest originality, but like too many others his career was cut short by World War I. His *Horse,* of 1914 (fig. 36–18), is an extraordinary work. Its shapes suggest the elemental fury of a rearing horse chiefly through their spirited curvilinear rhythms. As in the *Nude Descending a Staircase, No. 2,* by Duchamp-Villon's younger brother, Marcel

36-17. CONSTANTIN BRANCUSI. *Bird in Space.* 1928. Bronze, height 54″ (1.37 m). Collection, The Museum of Modern Art, New York. Given anonymously

36-18. RAYMOND DUCHAMP-VILLON. *Horse.* 1914. Bronze, height 39⅜″ (1 m). The Art Institute of Chicago. Gift of Miss Margaret Fisher

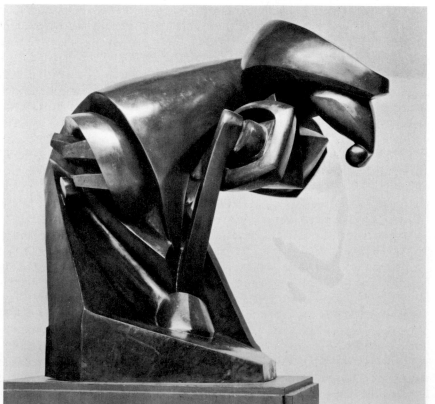

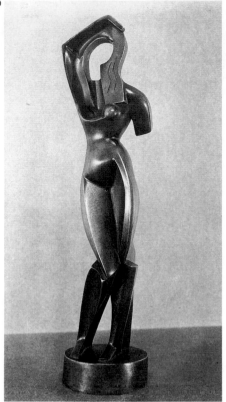

36-19. ALEXANDER ARCHIPENKO. *Woman Combing Her Hair.* 1915. Bronze, height 13¾″ (34.9 cm). Collection, The Museum of Modern Art, New York. Acquired through the Lillie P. Bliss Bequest

36-20. JACQUES LIPCHITZ. *Standing Personage.* 1916. Limestone, height 42½″ (1.08 m). Solomon R. Guggenheim Museum, New York

Duchamp, the animal body appears mechanized, as elements of equine anatomy seem to metamorphose into turbines and pistons.

Although by no means an artist of the power of Duchamp-Villon, the Ukranian-born ALEXANDER ARCHIPENKO (1887–1964) rapidly absorbed the principles of Cubism after his move to Paris, particularly in regard to the fragmentation of figures, and he produced a series of remarkably original Cubist sculptures. Often these were reliefs, painted to resemble pictures or executed in contrasting materials to produce a pictorial effect. His *Woman Combing Her Hair,* of 1915 (fig. 36–19), exploits the principle of empty spaces in sculpture. While noticeable voids had appeared as a by-product of Baroque movement in such works as Bernini's *Apollo and Daphne* (see fig. 26–14), the holes in Archipenko's sculpture are as much a part of the composition as the solids and serve to describe parts of the figure's anatomy. It remained for the Constructivists (see below) to take the next step by substituting directly assembled flat, folded, or carved sheets of material enclosing compartments of space for the modeled or carved masses of traditional sculpture.

Another sculptor of great ingenuity was the Lithuanian-born JACQUES LIPCHITZ (1891–1973), who worked in Paris beginning in 1909, formed acquaintanceships with Cubist artists, and after 1941 lived and worked in the United States. Lipchitz declared that there was "no difference between painting and sculpture," and was for a while drawn totally into the Cubist orbit. Some of his early works, such as the *Standing Personage,* of 1916 (fig. 36–20), are a direct sculptural counterpart of Synthetic Cubist painting. The flat and curving planes interpenetrate to produce a play of light and shadow analogous to the vibrant pictorial surfaces of Braque and Picasso (see, for example, fig. 36–10). In his work much later, Lipchitz moved from the cerebral geometry of Cubism to forms that were laden with expressive symbolism and showed his preference for modeling over carving.

Futurism

In Italy in the first decade of the twentieth century was born a movement violently opposed to the character of that ancient land as a vast museum of the past. At first Futurism was a literary movement, conceived and championed by the writer Filippo Tommaso Marinetti as early as 1908, and proclaimed in a series of manifestos in 1909 and later. Stimulated by the growing industrialization of the great cities of northern Italy, the Futurists launched an ideological program that raised the machine-Romanticism of Léger and Delaunay to the status of a religion, attacking the artistic weight of the past, advocating the destruction of academies, museums, and monumental cities as barriers to progress, extolling the glories of industrial achievement and even of modern war, and leading, alas, in the direction of Italian Fascism. The aesthetic derivation of the Futurist artists inspired by Marinetti's ideas came from a variety of sources, chiefly Neo-Impressionism and Cubism. The latter is dominant in the *Funeral of the Anarchist Galli* by CARLO CARRÀ (1881–1966), a brilliant work of 1910–11 (fig. 36–21). The cinematic aspects of Duchamp's *Nude Descending a Staircase, No. 2* are paralleled in a vast crowd composition, composed of a multitude of superimposed simultaneous images. The fragmented and shuffled views, stated as Cubist planes, appear animated by an irresistible surge of motion, as crowds of enraged anarchists intersect with attacking police and lifted weapons with floating banners, in a tempest of red and black planes.

The most gifted member of the Futurist group was UMBERTO BOCCIONI (1882–1916), who lost his life in World War I by a fall from a horse far from the scene of battle. His immense *The City Rises,* of 1910–11 (fig. 36–22), is a panegyric to "modern" industrialism, a tidal wave of rearing draft horses and laborers hauling cables, above which rise the scaffolding and unfinished walls of a modern city in the process of building, and factory chimneys belching smoke into the air. The movement is achieved by means drawn from Géricault (see fig. 31–8), but the color is

36-21. CARLO CARRÀ. *Funeral of the Anarchist Galli.* 1910–11. Oil on canvas, 6'6" × 8'6" (1.98 × 2.59 m). Collection, The Museum of Modern Art, New York. Lillie P. Bliss Bequest

36-22. UMBERTO BOCCIONI. *The City Rises.* 1910–11. Oil on canvas, 6'6" × 9'10" (1.98 × 3 m). Collection, The Museum of Modern Art, New York. Mrs. Simon Guggenheim Fund

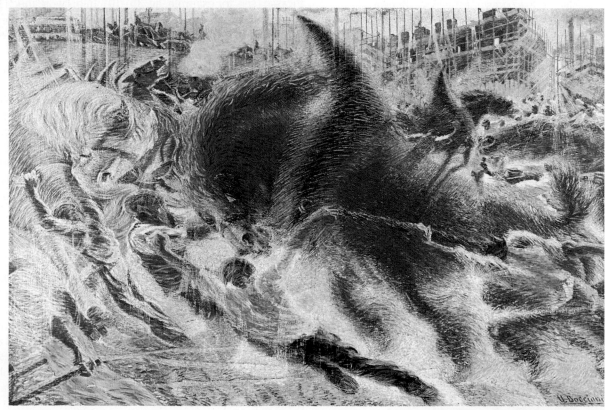

36-22

stated in terms of the divided palette of Seurat. Boccioni's finest achievement was in sculpture. Despite the Futurist purpose to shrug off the cultural load of the past, Boccioni's *Unique Forms of Continuity in Space,* of 1913 (fig. 36–23), is a tour de force reminiscent of such wind-whipped Hellenistic sculptures as the *Nike of Samothrace* and the Baroque forms of Bernini. The charging male figure evokes

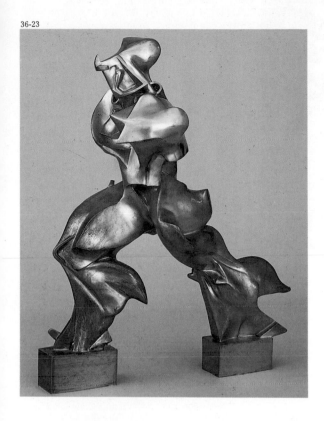

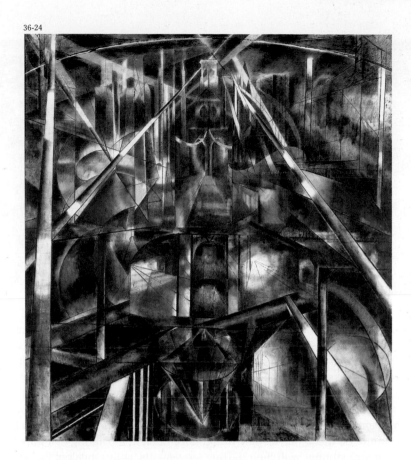

36-23. UMBERTO BOCCIONI. *Unique Forms of Continuity in Space.* 1913. Bronze, height 43⅞" (1.11 m). Collection, The Museum of Modern Art, New York. Lillie P. Bliss Bequest

36-24. JOSEPH STELLA. *Brooklyn Bridge.* 1917–18. Oil on bed sheeting, 7' × 6'4" (2.13 × 1.93 m). Yale University Art Gallery, New Haven, Connecticut. Collection Société Anonyme

symbolically the powerful dynamism Boccioni pronounced necessary in his manifesto on Futurist sculpture, issued in 1912. There he called for an end to closed, finite form and demanded that figural sculpture be broken open "to enclose the environment in it," a program hinted at by the jutting planes and voids of the head of his *Unique Forms.*

One of the last exponents of Futurism was JOSEPH STELLA (1877–1946), who came to the United States to live in 1902 but revisited his native Italy during the formative period of the Futurist movement. Stella's cinematic vision in *Brooklyn Bridge* (fig. 36–24), one of a series painted in 1917–18, celebrates a structure that had become for the late nineteenth and early twentieth centuries a symbol of industrial and engineering triumph. Towers, cables, lights and beams of light, distant skyscrapers, tunnels, water, and night are woven into a symphonic structure of interpenetrating form, space, light, and color. Exhilaration in man's engineering victories had found its first artistic expression in Turner's *Rain, Steam, and Speed* (see fig. 31–23) and would continue to be celebrated during the 1920s by the Constructivists (see below). But rarely after the Futurists would it be possible to view in a completely positive, uncritical sense modern industrial life, which is sometimes described in later twentieth-century art as dehumanizing.

Rayonnism, Suprematism, and Constructivism

The modern movement, in which the Russian Kandinsky played such a crucial role in Germany, enjoyed a magnificent chapter in Russia itself just before, during, and just after World War I, coming to a brief climax in the early years of the Soviet Republic. Through the influence of Russian collectors, especially Sergei Tschukine in Moscow, the new artists were thoroughly familiar with the work of the French Post-Impressionists and were able to study the innovations of the Fauves and the Cubists at first hand, sometimes the very year they were painted. A remarkable couple, Mikhail Larionov (1881–1964) and NATALYA GONTCHAROVA (1881–1962),

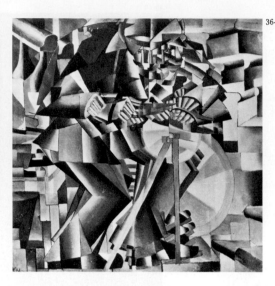

founded in 1911 a movement they called Rayonnism, based on a somewhat romanticized interpretation of the discoveries of twentieth-century physicists, especially Albert Einstein. The visual field was penetrated by a host of rays, crisscrossing like searchlights, to produce exciting and ever-changing patterns. As in the case of the Delaunays, the work of the couple was at times almost indistinguishable, but that of Gontcharova was generally superior in quality. *Cats* (fig. 36–25), painted in 1913, is a delightful example of the style. The animals themselves cannot be made out, as they would have been in a painting by Franz Marc, but the picture vibrates with their darting movements, not to speak of the rhythms of their tails, their plunging paws, even their ears. Rayonnism came to a sudden end in 1914, when the couple moved to Paris. There Gontcharova spent much of her productive life designing splendid sets for the Russian ballet.

After several years of producing Post-Impressionist and Fauve-like paintings, KASIMIR MALEVICH (1878–1935) developed very rapidly, at first merging the principles of Cubism and Fauvism in works such as the *Knife Grinder,* of 1912 (fig. 36–26). The light-struck geometrical solids of early Léger appear to combine with the cinematic multiple visions of the Futurists. Malevich shows the knife grinder in a series of yellow, blue, green, and white images, sitting on the steps before a town house, his head bobbing up and down, his left foot pumping a treadle, and his hands moving back and forth with the grinding wheel and the knife. We are hardly prepared by such a picture for Malevich's radical invention, an art of pure geometric abstraction that he called Suprematism and initiated the following year with a black square on a white ground, a stage design for a Russian Futurist opera written by a poet friend, which he then translated into an oil painting. Two years afterward, in 1915, Malevich showed a number of paintings with constellations of soaring solidly colored rectangles, trapezoids, and squares on neutral grounds, work that surely inspired the slightly later geometric abstractions of Kandinsky (see fig. 35–17), who during World War I returned to Russia. Malevich's process of simplification went on to include triangles, other polygons, circles, and other curved elements; it culminated in the reduction, about 1918, of the whole pictorial field to a single white square floating on an ever so slightly different square white ground (fig. 36–27). The *White on White* series, at this early stage of twentieth-century art, represents very nearly the ultimate in abstraction. Yet contemplating a series of these ascetic pictures hung side by side, one is astonished at the range and variety Malevich can find in so austere a theme. A mystic, an idealist, and a teacher before and for several years after the Russian Revolution of 1917, Malevich was an immensely influential artist whose vision was brought to Western Europe in several ways: by an exhibition of vanguardist Russian art held in Berlin in 1922; by

36-25. NATALYA GONTCHAROVA. *Cats.* 1913. Oil on canvas, 33¼ × 33″ (84.5 × 83.8 cm). Solomon R. Guggenheim Museum, New York

36-26. KASIMIR MALEVICH. *Knife Grinder.* 1912. Oil on canvas, 31⅜ × 31⅜″ (79.7 × 79.7 cm). Yale University Art Gallery, New Haven, Connecticut. Collection Société Anonyme

36-27. KASIMIR MALEVICH. *Suprematist Composition: White on White.* c. 1918. Oil on canvas, 31¼ × 31¼″ (79.4 × 79.4 cm). Collection, The Museum of Modern Art, New York

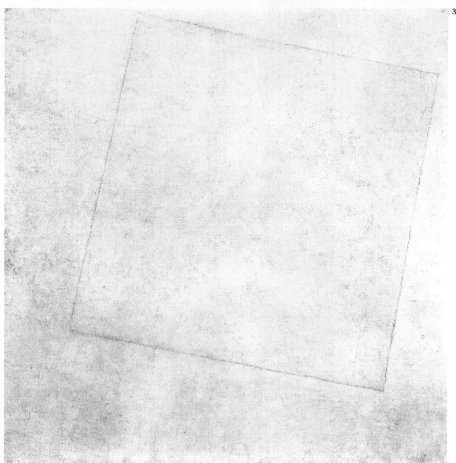

his visit to the German Bauhaus in 1927; and by his disciple for a period, EL LISSITZKY (1890–1941), a Russian painter and notable graphic designer, originally trained as an engineer, who shuttled between his native country and Germany, Holland, and Switzerland during the 1920s, spreading information about Suprematism and Constructivism. In a series of paintings and architectural designs that he called *Proun,* a fabricated word meaning "for a new art," Lissitzky developed geometric abstractions in which the painted forms were distinct illusions of three-dimensional solids floating in horizonless space. *Proun 99,* of 1924–25 (fig. 36–28), is an elegant play with two-point perspective, circular elements, and a cube that seems ready to come forward from the picture plane into the viewer's own space.

Only in recent decades has the work of LIUBOV POPOVA (1889–1924) been reevaluated in the West, along with that of several other Russian avant-garde painters. Popova was profoundly influenced by French Cubism, and during 1912 she worked in the Paris studio of the minor Cubist Jean Metzinger. At home in Russia after the outbreak of World War I, Popova produced a series of innovative abstractions with opaque triangular and trapezoidal shapes. Her *Architectonic Painting,* of 1917 (fig. 36–29), has none of the floating quality of Malevich; rather, powerful flat polygons, parallel to the picture plane, are anchored to each other and the frame in a rugged design, well on the way to the Constructivism of just a few years later.

In 1913 VLADIMIR TATLIN (1895–1953) visited France and was fascinated by the relief constructions Picasso was making, such as the *Guitar* of 1912 (see fig. 36–7) and slightly later wood reliefs of still-life subjects. When Tatlin returned to Russia, he put together a series of relief sculptures (now destroyed and known chiefly through photographs) from a wide range of materials, such as wood, tin, and glass,

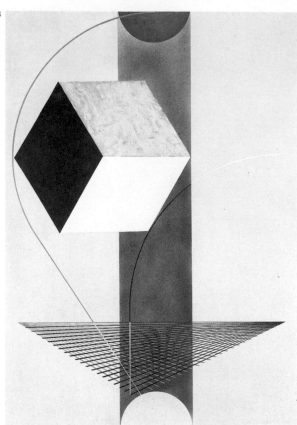

36-28. EL LISSITZKY. *Proun 99*. 1924–25. Oil on canvas, 50¾ × 39″ (129 × 99 cm). Yale University Art Gallery, New Haven, Connecticut. Collection Société Anonyme

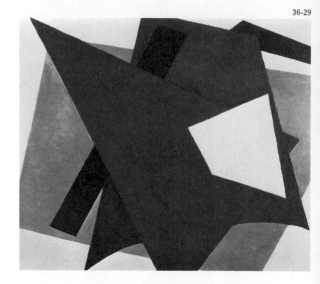

36-29. LIUBOV POPOVA. *Architectonic Painting*. 1917. Oil on canvas, 31½ × 38⅝″ (80 × 98 cm). Collection, The Museum of Modern Art, New York. Philip Johnson Fund

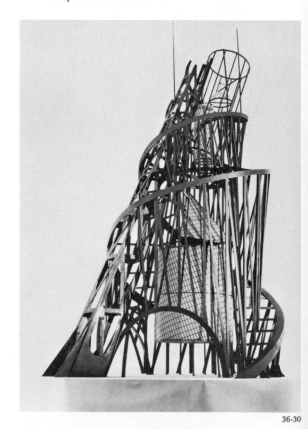

36-30. VLADIMIR TATLIN. *Monument to the Third International*. Model. 1919–20. Wood, iron, and glass (re-created in 1968 for the Tatlin Exhibition, Moderna Museet, Stockholm)

for the most part reused. Some of these abstract constructions were suspended at corners of a room, from one wall to the wall perpendicular to it, and thus invaded the environment of the viewer in a quite literal fashion. Unlike Malevich and Kandinsky, who believed art was a spiritual activity, Tatlin and other Constructivists, such as Alexander Rodchenko, Varvara Stepanova, Alexander Vesnin, Alexandra Exter, as well as Popova, were adherents of the new post-revolutionary Soviet state, and they believed art's primary purpose was a social one. For a time Tatlin designed furniture, clothing, stoves, and other goods for mass production. He is perhaps best known for his ambitious *Monument to the Third International*, for which only the model (fig. 36–30) was ever carried out, in 1919–20. If built, the *Monument* would have been about 1,300 feet in height, taller than the Eiffel Tower. As much architecture as sculpture, the *Monument* was to have had three glass-walled buildings within, housing assembly halls and meeting rooms; these were intended to revolve at separate speeds, one daily, one monthly, and one yearly, while light projections into the sky from the top of the *Monument* broadcast messages to the masses.

Two brilliant brothers, Anton Pevsner (1886–1962) and NAUM GABO (1890–1977), who changed his surname to avoid confusion with his older brother, carried Constructivism, as the new style came to be called, to a high pitch of intellectual and formal elegance. Gabo was the more inventive of the two; he was producing Constructivist sculpture, such as *Constructed Head No. 1* (fig. 36–31), based on the human form but executed in sheets of plywood, as early as 1915 in Norway, where the brothers were caught by World War I. Gabo's great innovation, exemplified in this work and subsequent constructions, was to create sculptural forms that are perceived as volumes even though they consist of space rather than mass. In works such as the *Constructed Head*, intersecting planes imply volumes, which the viewer's eye fills in from the edge of one plane to the edge of the next. The planes of such constructed sculpture have their aesthetic origin in the translucent modeled shards of Analytic Cubist painting, which Picasso and Braque had used to signify volume. After the 1917 revolution Gabo returned to Moscow, where he was inspired by Tatlin's nonobjective relief constructions, and he began to create com-

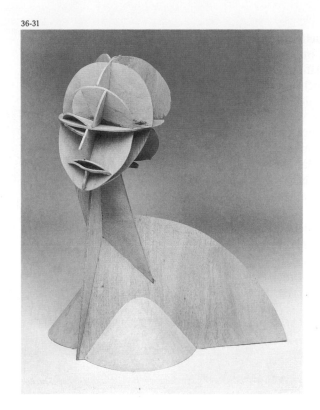

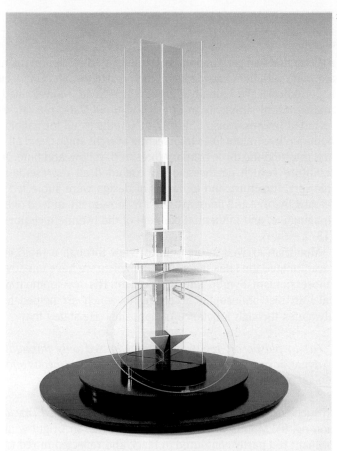

36-31. NAUM GABO. *Constructed Head No. 1.* 1915. Triple-layered plywood, height 21¼″ (54 cm). Collection Miriam Gabo

36-32. NAUM GABO. *Column.* 1923. Perspex, wood, metal, and glass; 41½ × 29 × 29″ (105.4 × 73.7 × 73.7 cm). Solomon R. Guggenheim Museum, New York

pletely abstract works. One of these, among the first truly kinetic (mobile) sculptures, consisted of a rotary motor installed at the base of a vertical rod; when the motor was turned on, the rod spun rapidly around, producing the illusion of a solid object—a so-called virtual volume. In a posted printed tract of 1920, the Realistic Manifesto, Gabo put forth his ideas about the future of sculpture, including his belief that it should be kinetic. A number of Gabo's abstract constructed sculptures of the 1920s or drawings proposing such sculptures made allusion to architectural forms. For example, *Column,* of 1923 (fig. 36–32), follows the principle of the virtual volume, the circular forms implying that the entire vertical member describes a column. Pevsner, trained as a painter, developed under his brother's influence a somewhat weightier and more static version of the virtual-volume style.

The freedom accorded to the ideas of the Constructivists in the early days of the revolution came to a gradual end after 1920, when the Soviet government decided that only a representational style could enlist the adherence of the masses. The result was a partial diaspora of the Russian modernists, who brought their ideas to Germany, France, England, and the United States with results that continue in unchecked vitality to the present day.

A number of the finest avant-garde artists remained in Russia; some, like Rodchenko, turned to new mediums that lent themselves to realism, such as photography; some, for example Malevich, returned to painting but in a representational style.

De Stijl

World War I was responsible for the early deaths of Marc and Duchamp-Villon and, indirectly, those of Boccioni and Lehmbruck. It also cut all contact between the groups of artists who had owed their intellectual origin to Cubism. In Holland during the war years the painters Theo van Doesburg and Piet Mondrian, the Belgian sculptor Georges Vantongerloo, the architect J. J. P. Oud, and others formed

a group that had certain points of similarity with Suprematism and Constructivism, although with little knowledge of their existence. The Dutch circle founded in 1917 a periodical called simply *De Stijl* (The Style), consecrated to the exaltation of mathematical simplicity in opposition to all "baroque" styles, among which they included Impressionism. Sternly, they reduced all formal elements to flat surfaces bounded by straight lines intersecting at right angles, and all colors to black, white, and gray and the three primary hues, red, yellow, and blue. Not only paintings and sculpture (which needless to say excluded all representation) but also houses, interiors, furniture, and all forms of design were subjected to this principle. The leading theorist and finest artist of the movement, indeed one of the most sensitive, imaginative, and influential painters of the twentieth century, was PIET MONDRIAN (1872–1944).

Mondrian arrived at his point of view through a rapid evolution, in which he recapitulated the later stages of modernism we have already seen, including Post-Impressionism, Symbolism, and Cubism. His development was guided by a mystical Calvinist philosophy, according to which art helped him to attain spiritual absolutes through a balance of opposites. He stated that

> *(a) in plastic art reality can be expressed only through the equilibrium of* dynamic movements *of form and color; (b) pure means afford the most effective way of attaining this [equilibrium].*

In such early, still Post-Impressionist works as the *Red Tree,* of 1908 (see Introduction fig. 9), Mondrian reduced a leafless tree in bright winter sun to rhythms of brilliant red partly contoured in black and reflected in red touches throughout the intense blue of ground and sky. Although strongly indebted to van Gogh, Mondrian has already negated distance and emphasized the division of the plane of the canvas into colors united by movement. The intense excitement of this early work is maintained undiminished in his ascetic later creations.

In 1911 Mondrian came under the influence of Cubism in Paris and rapidly developed on the basis of Cubist segmentation a style that reduced Cubist planes to an almost entirely rectilinear grid completely covering the picture surface, through which floated still rather soft colors indebted to Cubist limitations of hue. In such paintings as *Composition in Line and Color,* of 1913 (fig. 36–33), Mondrian has obeyed the implications of his title, as Whistler did not, and almost all reference to natural appearances has vanished. It is very important for the understanding of Mondrian's style that none of the scores of rectangles in the painting is identical to any other, that each functions (as in the city views of the Impressionists) like a single unit subject to the crosscurrents of an urban conglomeration. The enlarging or narrowing of the intervals in the grid produces the impression of surge, flow, constriction, and impulses of varying speeds.

Contending that Cubism "did not accept the consequences of its own discoveries," Mondrian by 1919 had identified the picture firmly with the foreground plane. In his *Composition,* of 1925 (fig. 36–34), a system of broad black lines intersecting at right angles rules the field into rectangles of white, red, and blue. The effect is unexpectedly intense and lyrical. The white frame, designed by Mondrian himself, is set back from the canvas and thus does not appear to limit the movement of colors and lines, which usually run to the edge and sometimes appear to continue beyond it. The color surfaces are delicately brushed and never appear slick and inert, like those of Léger. The red and blue are exquisitely weighted so that a system of poise and counterpoise emerges. The result is, as Mondrian intended it to be, a dynamic rather than a static expression, yet it establishes a serene harmony not unlike that of the Parthenon. If imitation is the sincerest flattery, Mondrian might have been pleased by the spread of his ideas throughout all forms of twentieth-century art, including in the United States where, fleeing World War II, he spent the last five years of his life.

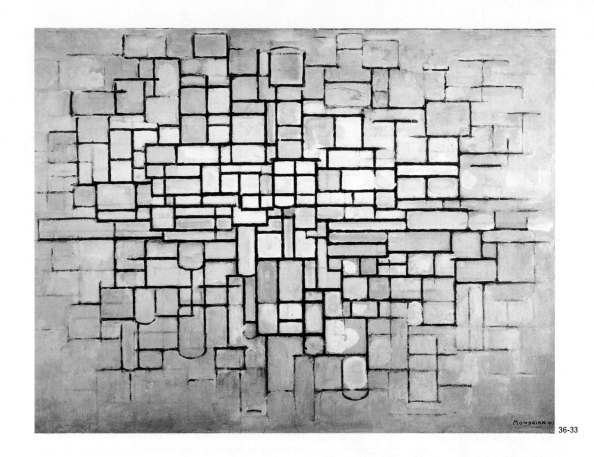

36-33

36-33. PIET MONDRIAN. *Composition in Line and Color*. 1913. Oil on canvas, 34⅝ × 45¼″ (88 × 115 cm). Rijksmuseum Kröller-Müller, Otterlo, the Netherlands

36-34

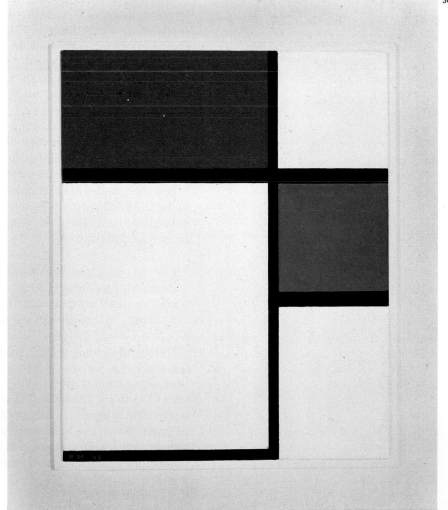

36-34. PIET MONDRIAN. *Composition*. 1925. Oil on canvas, 15⅞ × 12⅝″ (40.3 × 32 cm). Collection, The Museum of Modern Art, New York. Gift of Philip Johnson

CHAPTER THIRTY-SEVEN

DADA, AND

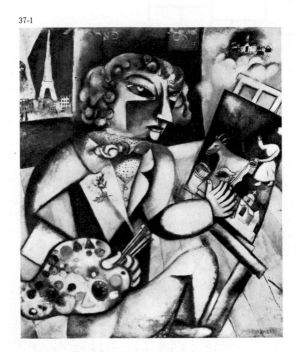

37-1. MARC CHAGALL. *Self-Portrait with Seven Fingers*. 1912. Oil on canvas, 50⅜ × 42⅛″ (1.28 × 1.07 m). Stedelijk Museum, Amsterdam

Throughout history, fantasy and imagination have always underlain the most apparently rational thought processes. During the twentieth century, despite severe attempts to rationalize human behavior, even to control it by totalitarian systems, the stubbornly irrational inner life of individuals and societies, illuminated by Sigmund Freud and his followers, has persisted. Throughout this scientific century, the current of fantasy has been fully as productive and important as those tendencies that seek an outlet in emotional expression or exalt the ideal of pure form. The first representatives of this fantastic tendency in the twentieth century were, like their precursors in the nineteenth, isolated individuals, but soon groups arose, notably Dada and the Surrealists, at least as cohesive as the Impressionists or the Cubists and far more vocal.

Fantastic Art

CHAGALL A pioneer of twentieth-century fantastic art, and in a sense the heir of Henri Rousseau, was the Russian painter Marc Chagall (1887–1985). From the treasury of Russian and Jewish folklore remembered from his youth in the western Russian city of Vitebsk, he created a personal mythology of childlike directness and intimacy. After a brief training in Vitebsk and Saint Petersburg, in 1910—the year, by coincidence, of Rousseau's death—he was drawn inevitably to Paris, artistic capital of the world. There in 1912 he painted his *Self-Portrait with Seven Fingers* (fig. 37–1), in which the brilliant colors and delightful imagery of Russian-Jewish folk tradition and the fragmented forms of Cubism are combined with an overflowing richness of imagination. The artist's quite normal right hand holds his brushes and his palette dotted with bright colors, as if studded with jewels, while his left, with the inexplicable seven fingers, indicates the canvas he has just painted, representing a pink cow standing by a pail, attended by a soaring milkmaid, near a little Russian church. Another vision of Russia appears in the clouds above the painting on the easel, while out the studio window searchlights comb the sky beside the Eiffel Tower. This visionary personal disclosure takes place in a studio with a yellow floor, shaded here and there with red, and bright red walls curving like those in the distorting mirror in Parmigianino's *Self-Portrait* (see fig. 23–25). Lest we be enticed into hazardous interpretations of this and other Chagall pictures, the artist himself said of his works:

> I do not understand them at all. They are not literature. They are only pictorial arrangements of images which obsess me.... The theories which I make up to explain myself and those which others elaborate in connection with my work are nonsense.... My paintings are my reason for existence, my life, and that's all.

During the exciting artistic developments after the Russian Revolution, Chagall was as active as his other great compatriots, Kandinsky and the Constructivists, and later joined some of them in the exodus of numerous modern artists from Russia after 1920. In 1923 he settled in Paris, moved to New York City during World War II, and in 1948 to Vence in southern France. For more than three-quarters of a century he continued to pour out a prodigious series of paintings, stage designs, large-scale murals, etchings, lithographs, and some of the finest stained glass of the twentieth century, all in much the same personal idiom.

SURREALISM

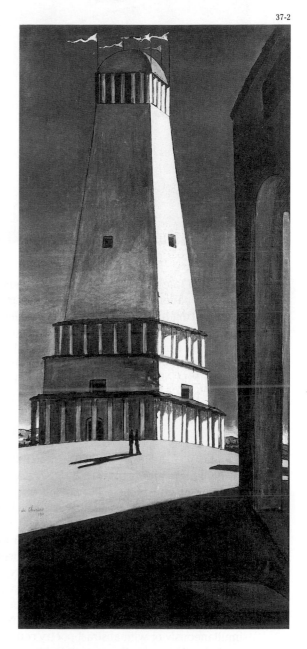

DE CHIRICO An even more independent figure was the Greek-born Italian Giorgio de Chirico (1888–1978), of cardinal importance to the Surrealists, who deeply admired his early work. His youthful training in Athens and his adolescent years in Munich brought him in contact with classical antiquity and German philosophy, particularly that of Friedrich Nietzsche, who had disclosed his "foreboding that underneath this reality in which we live and have our being, another and altogether different reality lies concealed." In Paris from 1911 to 1915, De Chirico had little interest in Impressionism, whose concern with sunlight seemed to him superficial, nor even in the Cubists or Fauves, then at the height of their fame. He produced a disturbing series of barren cityscapes, as monolithic as if carved from cliffs, lighted from the side so that long shadows fall across squares deserted save for occasional tiny figures. His *Nostalgia of the Infinite* (fig. 37–2), painted about 1913–14 in Paris, shows a mysterious tower at the summit of a gently rising square, flags flying triumphantly from its domed top, unapproachable and frightening. The inert surfaces deny completely the Impressionist tradition. The subconscious significance of De Chirico's paintings is often easy to interpret in Freudian terms. In this less transparent instance, the tower may be a paternal symbol. Along with Carrà, whom he met in 1917, and the painter Giorgio Morandi, De Chirico formed a short-lived group of "metaphysical artists." Soon he deserted his earlier manner in favor of a softer, pseudoclassical style of considerably less interest and, later, imitations of Baroque painting. He even disowned some of his more psychoanalytically revealing early paintings, made copies of others, and in general played little part in the later development of contemporary art.

KLEE The most intimate, poetic, and resourceful of the independent fantastic artists was Paul Klee (1879–1940), born in Switzerland of a German father, an organist. Klee, himself a trained violinist, studied in Munich and considered himself German. Early trips to Italy and North Africa broadened his artistic horizons. In 1911 he settled in Munich, where he formed a friendship with Marc and exhibited with the Blaue Reiter. In straitened circumstances, he had no studio and worked on the kitchen table while preparing meals for his wife, a piano teacher. His work was of necessity on a small scale—drawings, watercolors, and etchings. From 1921 to 1931 he taught at the Bauhaus (see page 1072), first in Weimar and then, when the school moved, in Dessau. At the Weimar Bauhaus Klee had his first studio and lived in a two-family house, the other half of which was occupied part of the time by Kandinsky. The two artists respected each other's work greatly, yet exerted surprisingly little influence on each other. Both wrote important theoretical works while at the Bauhaus.

Klee was deeply interested in the art of children, which he felt could reveal much about the mysteries of creativity. This insight he combined with a wholly adult sophistication of wit in a uniquely personal, poetic way. *Dance, Monster, to My Soft Song!* (fig. 37–3), of 1922, shows a tiny pianist and singer, whose music compels a floating creature, consisting largely of an inflated head with a purple nose, to dance in the air, much to its surprise. The delicacy of the apparently spontaneous scratchy line and the softness of the tone are characteristic of much of Klee's work, which has been likened to a letter or a poem to be read in the hand, rather than a picture to be hung on a wall. *Ad Parnassum,* of 1932 (fig. 37–4), a painting on canvas, is apparently based on the celebrated series of piano exercises known as *Gradus ad*

37-2. GIORGIO DE CHIRICO. *Nostalgia of the Infinite.* c. 1913–14 (dated 1911). Oil on canvas, 53¼ × 25½" (135.3 × 64.8 cm). Collection, The Museum of Modern Art, New York. Purchase

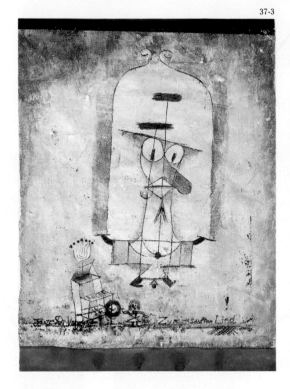

Parnassum (Steps to Parnassus), whose endlessly repeated notes merge as in the mind of a patiently practicing child into a mystical mountain of musical achievement, soaring higher than the sun. After Klee was forced into exile in Switzerland by the Nazi regime in 1933, his art grew more intense and solemn and the scale of his forms became larger and more powerful. In 1940, the last year of the artist's life, certain pictures rich with ghostly hieroglyphs refer to the disaster that had befallen Western Europe in the dreadful months of the fall of France, the Low Countries, and much of Scandinavia before Nazi Germany's onslaught.

37-3. PAUL KLEE. *Dance, Monster, to My Soft Song!* 1922. Watercolor and oil transfer drawing on plaster-grounded gauze, 17⅝ × 12⅞" (44.9 × 32.7 cm). Solomon R. Guggenheim Museum, New York. Gift, Solomon R. Guggenheim, 1938

37-4. PAUL KLEE. *Ad Parnassum.* 1932. Casein and oil on canvas, 39⅜ × 49⅝" (1 × 1.26 m). Kunstmuseum, Bern

Dada

As early as 1915, it became apparent that the static trench warfare of World War I was unlikely to produce any result more decisive than continuing mass slaughter. A number of young intellectuals, notably the German writers Hugo Ball and Richard Huelsenbeck and the Alsatian artist Jean (Hans) Arp, sought refuge in Zurich, in neutral Switzerland, where they were soon joined by others, notably the Romanian poet Tristan Tzara. In Zurich in 1916 Ball founded the Cabaret Voltaire, named after the great French skeptic of the eighteenth century, as a center for protest against the entire fabric of European society, which could give rise to and condone the monstrous destruction of the war. At first the evenings were literary, musical, or both. "Noise-music," a phrase the group borrowed from the Futurists (with whom they had little in common), alternated with readings of poems in several languages simultaneously or with abstract poetry composed of meaningless syllables chosen purely for their acoustic interest. Public reaction at times approached actual violence, which was just what the members of the group wanted. They attacked every cultural standard and every form of artistic activity, including even what had been avant-garde a decade earlier. It is characteristic of the movement that there should be several contradictory explanations of how its name, *Dada,* arose, but all agree that the title was intended as nonsense, and it was accepted by acclamation.

Dada soon became international. In New York the like-minded Frenchman Marcel Duchamp (see pages 997–1000), together with the Cuban artist Francis Picabia, met often for activities in the Dada spirit at the apartment of the poet and

37-5

37-5. JEAN (HANS) ARP. *Mountain, Table, Anchors, Navel.* 1925. Oil on cardboard with cutouts, 29⅝ × 23½″ (75.2 × 59.7 cm). Collection, The Museum of Modern Art, New York. Purchase

37-6. HANNAH HÖCH. *Cut with the Kitchen Knife Dada through Germany's Last Weimar Beer Belly Cultural Epoch.* 1919. Collage of pasted papers, 44⅞ × 35⅜″ (114 × 89.9 cm). Staatliche Museen zu Berlin—Preussischer Kulturbesitz

37-6

scholar Walter Arensberg and at the gallery at 291 Fifth Avenue, which had been founded by the photographer Alfred Stieglitz (see page 1006). Huelsenbeck returned to Germany from Zurich in 1917, when defeat seemed only a matter of time, and early in 1918 launched Dada in Berlin, largely as a literary movement. The artists involved, in addition to Huelsenbeck, included the satirical painter George Grosz, Johannes Baader, John Heartfield, Hannah Höch, and Höch's companion in the Dada years, Raoul Hausmann. After the close of hostilities, Dada burst out in Cologne, instigated by the arrival of Arp and sparked by the imaginative activity of Max Ernst, a local painter. Independently, Kurt Schwitters, also a painter, began his long Dada activity in Hanover. With the convergence of Tzara, Duchamp, and Picabia on Paris, Dada enjoyed a brief life there from 1919 until its dissolution in 1923. There was always a certain mad logic about even the most perverse and apparently destructive manifestations of Dada humor, and the very ferocity of the Dada offensive unleashed a remarkable amount of creativity, manifesting itself in spontaneous expressions that exalted artistic activity or chance occurrences.

JEAN ARP (1887–1966), born in Strasbourg, then a German city, was the most gifted visual artist of the Zurich group and a poet as well. He often worked in close collaboration with his wife, Sophie Taeuber-Arp (1889–1943), a specialist in textiles designed in a geometric abstract style who believed there should be no hierarchical distinction between the so called fine arts, such as painting, and the applied arts, such as tapestry. Arp exploited accidents, experimenting with collages of torn paper in arrangements produced by chance. Tzara was at the same moment making collage-poems out of words and phrases clipped from newspapers, shaken in a paper bag, and pulled out one by one at random; the words of the finished poem were to remain in that accidental order and, Tzara claimed, the poem would turn out to resemble any poet who used the method. Arp began to experiment with pieces of wood cut out freely in curvilinear shapes with a band saw, suggesting amoebas or other primitive forms of life. Later, he used cutout cardboard, mounted and painted, in biomorphic shapes or configurations echoing nature as seen through moving water or a distorting glass. *Mountain, Table, Anchors, Navel,* of 1925 (fig. 37–5), in white, brown, black, and sky blue, is a particularly engaging example of Arp's whimsical juxtapositions. In their freedom from such restrictions as the straight lines of table legs or anchor shafts, these collapsed shapes, indirect ancestors of the soft machines of Claes Oldenburg in the 1960s (see fig. 38–37), exert a special charm. After the dissolution of Dada, Arp continued to work as a sculptor in the free forms he had invented, promoting his earlier silhouettes to three-dimensional marble or polished bronze forms that seem to melt into each other with exquisite grace, appearing to swell and contract as if the hard sculptural materials were breathing.

The most original and resonant development among the Dada artists in Berlin was *photomontage,* that is, collages made up of cut and pasted photographic material and, often, typography. When published in Dada journals, these took on a seamless life of their own, but they originated as pieced-together works, not in the darkroom. A number of photomontages by HANNAH HÖCH (1889–1978) ironically explore traditional female roles in German society, roles that apparently existed even in the left-wing vanguard artists' community where Höch was living at the time. In the title of one of her largest and best-known works, *Cut with the Kitchen Knife Dada through Germany's Last Weimar Beer Belly Cultural Epoch,* of 1919 (fig. 37–6), the artist claims a domestic tool as her chief instrument in making this group portrait of her fellow Dadaists. In its cheekiness, its not-so-veiled threat of social upheaval, and its willingness to take risks with means to achieve new artistic ends, this photomontage is a quintessential expression of the Dada spirit.

The leading protagonist of Dada, although at a certain distance from any organized manifestations, was Marcel Duchamp, whom we have already encountered in the wake of Cubism. His greatest work, the *Bride Stripped Bare by Her Bachelors, Even (Large Glass),* executed for the most part in New York between 1915 and 1923

37-7. MARCEL DUCHAMP. *Bride Stripped Bare by Her Bachelors, Even (The Large Glass).* 1915–23. Oil, lead foil, and quicksilver on plate glass, 9′1¼″ × 5′9⅛″ (2.76 × 1.77 m). Philadelphia Museum of Art. Louise and Walter Arensberg Collection

(fig. 37–7), is a very large construction for the period, made up of two superimposed double layers of plate glass. The image is generally done on the inside of one layer and protected by the other, like the filling in a sandwich, and executed in paint, lead foil, and quicksilver by techniques sometimes used to apply lettering to shop windows. The work eludes final interpretation—indeed, it deliberately provokes a wide range of interpretations—but insofar as it can be explained it depicts erotic frustration, the result of unconsummated relations between the Bride and her Bachelors. Duchamp has recorded that while creating the *Large Glass* (as the work is called for short) he kept notes which were destined to complement the visual experience, like a guidebook. These penciled notes on torn scraps of paper, as well as some sketches and photographs, he published in facsimile form in a limited edition in 1934, assembling them in a green flocked cardboard box on

which he wrote a title, *Green Box*. The publication of the *Green Box* notes, which disseminated more information than could be deduced from the *Large Glass* alone, prompted the Surrealist theorist and poet André Breton almost immediately to provide an interpretation of the *Large Glass*. We learn from the *Green Box* notes and from Breton's essay that the Bachelors are the nine machine molds at the lower left, united by a "bachelor-machine" to a water mill and a chocolate grinder; they are rendered with the precision of an engineering diagram and in perspective so that they seem to float. Especially delicate are the three designs of rays or concentric circles in quicksilver. The Bride is the mechanized, flesh-colored creature at the upper left, a descendant of the *Nude Descending a Staircase, No. 2* (see fig. 36–15). She is suspended beneath a cloudlike horizontal form called the Milky Way; this form is pierced by windows, whose quivering outlines were arrived at by chance (Duchamp traced the perimeter of three squares of gauze left in a crossdraft).

Duchamp intended the transparency of the glass to draw the environment, including the observer, into the work, endlessly diversifying the visual and conceptual experience it offers. In 1926 the *Large Glass* was accidentally shattered; Duchamp welcomed the cracks (which he meticulously repaired) as elements in his work of art. The end result of deliberate planning, mechanical drawing, imagination, accident, and seemingly one-time yet replicated textual explanation is a work of indefinable magic, as evocative of new interpretation as James Joyce's difficult experimental novel *Finnegans Wake,* which was begun the year before the *Large Glass* was completed. Although the fragility of the *Large Glass* has prevented it from traveling, and although it was seen only by permission during the years before 1952—when Katherine S. Dreier bequeathed it to the Philadelphia Museum of Art, there to join much of the rest of Duchamp's work—this creation has exercised an enormous influence on subsequent art, up to and including very recent work.

Not long after Picasso brought a found object (the mechanically printed oilcloth in his first collage) into a work of art, Duchamp conceived the unsettling idea of the Readymade: an ordinary mass-produced object is substituted for the traditional work of art crafted by the artist's hand. The ordinary object is taken out of its quotidian context, deprived of its original function, and given artistic status by the pronouncement of the artist. Sometimes Duchamp's Readymades were, as he put it, "assisted": the first, conceived in 1913, was a bicycle wheel mounted on a kitchen stool. Among the others were a snow shovel purchased at a hardware store in 1915 and ominously titled *In Advance of the Broken Arm,* and in 1917 a coat rack, nailed to the floor instead of the wall, titled *Trébuchet* (French for the word "trap"; *trébuchet* is also a chess term for a pawn moved so as to "trip" an opponent's piece—Duchamp was a master chess player). One of the most notorious Readymades, *Fountain,* of 1917 (fig. 37–8), was a urinal Duchamp purchased from a New York manufacturer of plumbing equipment, signed with the pseudonym R. Mutt, and turned, like the *Trébuchet,* ninety degrees for display. That year Duchamp submitted *Fountain* to the liberal, jury-free Independents exhibition in New York, but the hanging committee concealed the work behind a curtain, no doubt proving to Duchamp's satisfaction that even avant-garde artists' organizations may be provoked into conservative reactions. The same year Duchamp published another Readymade, a reproduction of Leonardo's *Mona Lisa* (see fig. 22–9), supplied with a mustache and goatee and the title *L.H.O.O.Q.;* the letters pronounced in the French manner create a mildly obscene pun meaning "she has hot pants."

One of Duchamp's last oil paintings was *Tu m',* of 1918 (fig. 37–9), long installed in the library of Katherine S. Dreier's home. Shadows cast by Readymades—the *Bicycle Wheel* and a *Hatrack,* of 1917, for example—appear to float across the canvas, penetrated by a procession of what look like color-sample cards. These are actually painted; seen in perspective they seem to be rushing out of the picture but are restrained—by a real metal bolt. Duchamp hired a professional sign painter to paint the hand with pointing index finger, which the man, A. Klang, signed.

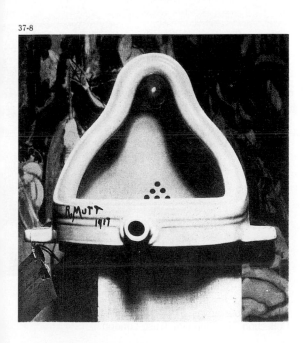

37-8

37-8. MARCEL DUCHAMP. *Fountain.* 1917. Readymade (urinal turned on its back). The original was lost and its size was not recorded. Photograph courtesy Philadelphia Museum of Art. Louise and Walter Arensberg Collection

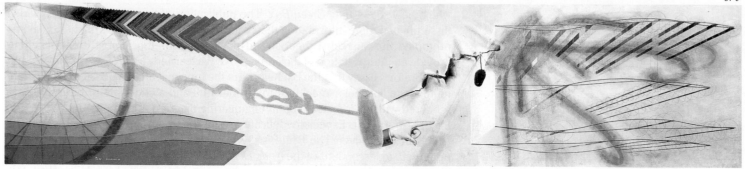

Duchamp then painted the illusion of a jagged rip in the canvas, apparently made by the protrusion through the canvas of a real bottle brush that sticks out in the direction of the viewer, casting a real shadow on the painting. The painted rip is "fastened" by real safety pins. The enigma suggested by the incomplete and perhaps insulting title and the interpenetration of reality and illusion make this one of the most challenging paintings of the twentieth century. After devising miniature reproductions of his works—in effect, a portable museum of his ideas that he conceived in the late 1930s and published in 1941 as the *Boîte en Valise (Box in a Suitcase)*—Duchamp announced that he was abandoning art for chess. Actually, between 1946 and 1966, he was producing in secret an elaborate peep show of a nude woman (the Bride finally stripped bare) in a vegetation-lined box, *Étants Donnés: 1 La Chute d'eau, 2 Le Gaz d'éclairage (Given: 1. The Waterfall, 2. The Illuminating Gas)*. Its existence, in a permanent installation at the Philadelphia Museum of Art, was revealed only after Duchamp's death, in 1968.

A kindred spirit was MAX ERNST (1891–1976), a self-taught Cologne painter whose university training was in philosophy and psychiatry. The barren world of De Chirico perhaps influenced Ernst's magical *Elephant of the Celebes,* of 1921 (fig. 37–10). The painting, one of his masterpieces, is informed by his belief in the symbolic power of images, and here, typically, the symbols Ernst creates and juxtaposes seamlessly rely on his knowledge of various cultural sign systems, from the worlds of theology, eroticism, and magic, as well as from memories of his own psychologically compelling experiences. The foreground of the painting is filled with a mechanical monster, towering above a floorlike plain, which ends in a distant range of snowcapped mountains. The creature is composed of a washboiler fitted with various attachments, including a hose that serves as both neck and trunk, leading to a mechanical head sprouting horns; a pair of tusks emerges from the creature's rear. In the foreground a headless female mannequin gestures with a gloved hand next to a perilous tower of coffeepots.

In Hanover, meanwhile, a lonely and sensitive spirit, KURT SCHWITTERS (1887–1948), was producing marvelous pictures out of the ordinary discards rescued from the wastebasket or the gutter—tags, wrappers, tram tickets, bits of newspapers and programs, pieces of string. In a sense they resemble Cubist collages, and are as well put together as the best of them, but they lack the unifying temporal experience of the café. Only the detritus of society interested Schwitters, a kind of poetic scavenger who could create beauty from what is ordinarily considered less than nothing—aided from time to time with a few strong touches of a color-laden brush. His *Picture with Light Center,* of 1919 (fig. 37–11), is typical of what he called his *Merz* pictures. This nonsense syllable was drawn from the word *Kommerzbank* (bank of commerce), and he used *Merzbau* to describe the fantastic structure of junk he erected that eventually filled two stories of his house in Hanover. After the destruction of this concretion by the Nazis, Schwitters began another in Norway and yet a third in England, where he had emigrated. His *Merz* pictures, often tiny and jewel-like in their delicacy and brilliance, continued some of the principles of Dada until the middle of the century.

37-9. MARCEL DUCHAMP. *Tu m'.* 1918. Oil and graphite on canvas, with bottle brush, safety pins, and nut and bolt, 2'3½" × 10'2¾" (70 × 311.8 cm). Yale University Art Gallery, New Haven, Connecticut. Collection Société Anonyme. Bequest of Katherine S. Dreier

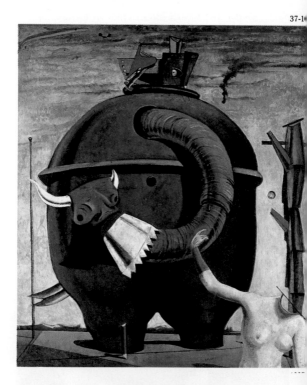

37-10. MAX ERNST. *Elephant of the Celebes.* 1921. Oil on canvas, 51⅛ × 43¼" (1.3 × 1.1 m). Collection The Elephant Trust, London

37-11

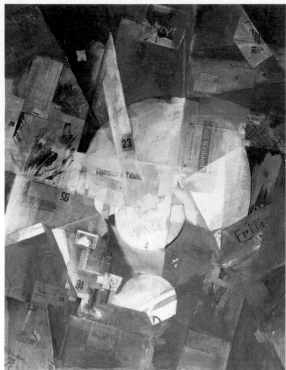

37-11. KURT SCHWITTERS. *Picture with Light Center.* 1919. Collage of pasted papers with oil on cardboard, 33¼ × 25⅞″ (84.5 × 65.7 cm). Collection, The Museum of Modern Art, New York. Purchase

37-12. MAX ERNST. *Europe after the Rain.* 1940–42. Oil on canvas, 21⅝ × 58¼″ (54.9 × 148 cm). Wadsworth Atheneum, Hartford, Connecticut. Ella Gallup Sumner and Mary Catlin Sumner Collection

Surrealism

By 1923 the iconoclasm and the nihilism of Dada had begun to fade, and most artists had deserted the movement. Nonetheless, Dada had performed a valiant service in liberating the creative process from logical shackles. Surrealism took the next step—that of exploring illogic on Freudian principles in an endeavor to uncover and utilize for creative purposes the "actual" (as opposed to the logical) processes of thought. In 1924 the French author André Breton launched his first Surrealist manifesto. At the outset Surrealism was a thoroughly literary movement, based on the free association of mental images through automatic writing, hypothetically uncontrolled by conscious thought, thus putting in lasting form the fleeting configurations that occur ordinarily through subconscious activity only in dreams or waking reverie. Goya had already shown the way in his celebrated print *The Sleep of Reason Produces Monsters* (see fig. 31–4). Methodical, even doctrinaire, as was Breton's approach, the resulting combinations of images could and often did exert a commanding power or even a poetic charm, as in a striking simile borrowed by the Surrealists from the nineteenth-century writer Lautréamont: "As beautiful as the chance encounter on a dissecting table of a sewing machine and an umbrella."

Although Breton was at first hostile to painting, artists were not slow in seeing the possibilities inherent in his emphasis on subconscious association. In 1925 the first Surrealist group exhibition took place at the Galerie Pierre in Paris; among the exhibiting artists, Arp, De Chirico, Ernst, Klee, and Picasso are already familiar to us; of these only Ernst would today be classified as a true Surrealist. A brilliant new name was that of Joan Miró. René Magritte joined the group in 1927, and in 1929 Salvador Dali became a member, although he was formally read out of the party by Breton only five years later.

Ernst at first studied what could be accomplished by recombining figures, backgrounds, and accessories cut out of nineteenth-century wood-engraved illustrations, assembling them—or so he claimed—only as dictated by free association and pasting the results into illustrations for a subconscious collage "novel." The pseudonarrative thus produced resembles a continuous dream that at times becomes a nightmare. Ernst also discovered accidentally the effects obtainable by laying a piece of paper over a rough surface, such as wood, stone, leaves, or sackcloth, and rubbing the paper with soft pencil; in the variegated flow of tones thus produced he discovered imagery, which he then exploited in painting. He called this technique *frottage* (from *frotter*, meaning "to rub"). Later, he spread

37-12

paint on canvas and compressed it while still wet, forming free shapes analogous to those produced by frottage. Since conscious choice could be involved in the selection of the surfaces to be used, and in the placing of the image on canvas, it may be questioned whether the frottage technique was a true analogue of Breton's unconscious writing. Ernst used frottage in the production of some of his most compelling Surrealist works, a series of fantastic views suggesting jungles or underwater or lunar landscapes, among whose apparently living heaps figures can at times be discerned. A terrifying example is *Europe after the Rain,* of 1940–42 (fig. 37–12), done while the artist was in hiding from the Germans during the occupation of Paris and suggesting the desolation of a collapsed civilization.

MIRÓ In contrast to the nightmare world of Ernst, the Catalan painter Joan Miró (1893–1983) revels in a fantasy as unbridled as that of the other Surrealists and in a wit sharper than that of any other of them. His *Harlequin's Carnival,* of 1924–25 (fig. 37–13), depicts in sparkling colors a room furnished only with a table but inhabited by a delightful menagerie of improbable beasts and facial features, some resembling cats, some insects, some ears, some eyes, and others serpents and fish. Most are as flat as paper cutouts and painted black, white, red, yellow, blue, and green in combinations that do not reflect natural reality. One serpent is headless, another terminates in a boxing glove. All are celebrating happily with the exception of an anthropoid creature at the left, whose eyes cross in a face half red and half blue, while a serpent winds around what appears to be a horn. A black and blue comet joins in the festivities, and a view out the window discloses a black pyramid, a tongue of red flame, and a black and blue star. Biomorphic shapes reminiscent of Arp's are elegantly silhouetted or, sometimes, rendered chiefly in outline. Miró went

37-13. JOAN MIRÓ. *Harlequin's Carnival.* 1924–25. Oil on canvas, 26 × 36⅝″ (66 × 93 cm). Albright-Knox Art Gallery, Buffalo, New York. Room of Contemporary Art Fund

37-13

37-14. SALVADOR DALI. *Persistence of Memory.* 1931. Oil on canvas, 9½ × 13″ (24 × 33 cm). Collection, The Museum of Modern Art, New York. Given anonymously

37-14

on to produce magnificent, nearly abstract paintings with thinly applied fields of color and also, during the 1930s, sculptural objects in which were paramount the bizarre juxtapositions so admired by the Surrealists (see fig. 37–17).

DALI The flat, unmodeled shapes of Miró offer a total contrast to the work of his compatriot Salvador Dali (1904–89), who in the minds of many typifies in his art, his writing, and his deliberately outrageous public behavior the Surrealist movement at its height in the late 1920s and early 1930s. After his visit to Paris in 1928 Dali experimented briefly with semi-abstract forms, as he was then under the influence of Picasso and Miró. Soon Dali set out on his individual path, based on his extensive study of Freud, which seemed to clarify to him his personal fantasies and obsessions. Dali began producing what he called "hand-colored photographs of the subconscious," based, as he put it, on the "three cardinal images of life: blood, excrement, and putrefaction." If Dali had in fact limited his subject matter to these three substances he would have attracted only passing notice. What he called his desire to "materialize images of concrete irrationality with the utmost imperialist fury of precision" resulted in pictures of a brilliance that cannot be ignored. His works painted between 1929 and 1933 are virtual miniatures, done in bright enameled color, with an exactitude of statement that at times recalls less his idols Vermeer and Velázquez than the technique of the nineteenth-century Salon painter Ernest Meissonier, whose painting Dali also admired. Sometimes Dali's sexual symbolism is explicit enough to suggest pornography. Usually, however, it is veiled, but the terrifying images are always brought home with tremendous force by the virtuosity of his draftsmanship and modeling.

The tiny yet powerful *Persistence of Memory,* of 1931 (fig. 37–14), is one of Dali's most suggestive and best-known early Surrealist paintings. Dali said later, no doubt in jest, that the idea for the work occurred to him while he was eating ripe Camembert cheese. Actually, the softening of hard objects had already appeared, as we have seen, in the work of Arp, and as one early historian of Surrealism has argued, given Dali's frequent reference in his paintings of this period to sexual functions, the limp watches may well be symbols of sexual dysfunction. Whatever their origin, the three flaccid watches are disturbing in their destruction of the very idea of time. At the left a fourth timepiece may in its turn symbolize fears of

castration, as the watch is being devoured by ants. Dali's often-repeated image of a reclining, severed, chinless head—its tongue hanging from its nose, its enormous eyelashes extended on its cheek—lies equally limp on a barren plain reminiscent of the early work of Ernst or of De Chirico. In the background, rendered with hallucinatory precision, are the rocky cliffs of a Catalan bay.

Dali's considerable talent led him into diverse fields: stage design, jewelry design, the crafting of Surrealist objects, and even shop-window decoration. Beginning in the late 1930s he frequently explored Christian subjects. While his technical skills remained formidable, the evaporation of his personal fantasy is regrettable, and from a religious standpoint, his later work shows neither the passion of Rouault nor the dispassionate clarity and grace of Matisse.

MAGRITTE The Belgian painter René Magritte (1898–1967) emerged as a Surrealist in the mid-1920s and for three years, between 1927 and 1930, lived near Paris and participated in the Surrealist movement, contributing to the last issue of the journal *La Révolution surréaliste*. There he showed in a series of visual and verbal propositions that an image of an object and the word we use to designate an object are not necessarily the same: our verbal designations of signs are arbitrary. In a now-famous painting of a pipe, executed in a carefully shaded realism rivaling Dali's, Magritte wrote under the image, "Ceci n'est pas un pipe" ("This is not a pipe"). And, indeed, it was not a pipe; rather, it was a painting—a representation— of a pipe. Magritte was a conscious and ironic heir to the Northern Renaissance tradition of meticulously naturalistic painting in oils that shimmer on the picture surface. Like Jan van Eyck (see fig. 21–14), he painted in oils in a style of precise, detailed realism; his picture surfaces, however, are conspicuously matte, as if to express his questioning of the truths of pictorial naturalism. One of Magritte's most thought-provoking works, *The Human Condition*, of 1934 (fig. 37–15), depicts an easel supporting a painting of a landscape that is coextensive with the view we see to one side of it through a glass window. Curtains—the pictorial device used since the Renaissance to enhance the power of linear perspective, and by Picasso as a signal that he would no longer participate in that game of illusion (see fig. 36–3)— hang beside the window, demanding with a childlike directness that the whole idea of picture-as-window be reexamined. In other paintings, by exaggerating the size of objects relative to their setting and by juxtaposing objects that in reality would probably never be seen together, Magritte questioned the capacity of illusionistic pictures to tell the truth. He often chose to paint banal objects such as bowler hats and loaves of bread, and his deadpan presentation challenges the very premises of bourgeois existence. In retrospect, Magritte's painting seems more closely related to semiotics, the theory of signs developed early in the twentieth century, than to the Freudian ideas that kindled the Surrealist movement.

PICASSO Although the versatile Picasso was never officially a Surrealist, from the beginning André Breton hailed him as a kind of model for the movement. Breton was responsible for bringing *Les Demoiselles d'Avignon*, rolled up for years in a corner of Picasso's studio, before the public, reproducing it for the very first time in *La Révolution surréaliste* in 1925. From the mid-1920s to the late 1930s, Picasso's work was often shown with the Surrealists', and he was friendly with members of the Surrealist circle in Paris, especially the poet Paul Éluard. While Picasso's painting and sculpture in those decades were as always grounded in observed reality, they nonetheless shared with Surrealist art bizarre juxtapositions and exaggerations of form and made frequent reference to dreams, hallucinatory visions, and states of mind. Picasso's chief model of the period, his companion Marie-Thérèse Walter, had a tranquil, round countenance, full features, a smooth blond pageboy, and a voluptuous body; these characteristics are perhaps perceptible in certain aspects of the 1930–31 welded Cubist construction titled *Head of a Woman* (see fig. 36–9). Walter became the subject of many works that may be

37-15. René Magritte. *The Human Condition.* 1934. Oil on canvas, 39⅜ × 31½″ (100 × 80 cm). National Gallery of Art, Washington, D.C. Gift of the Collectors Committee

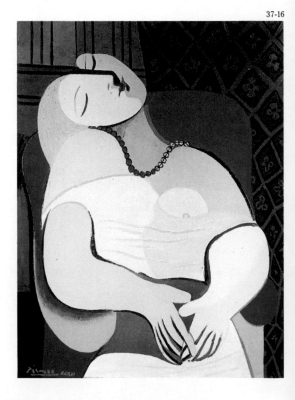

37-16. Pablo Picasso. *The Dream.* 1932. Oil on canvas, 51¼ × 38½″ (130.2 × 97.8 cm). Collection Mrs. Victor W. Ganz

37-17

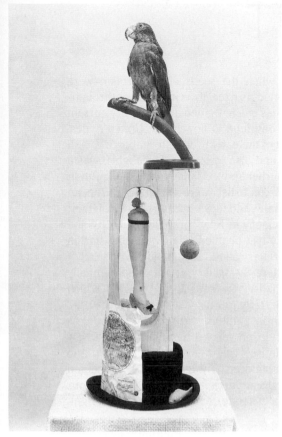

37-17. JOAN MIRÓ. *Object.* 1936. Assemblage: stuffed parrot on wood perch, stuffed silk stocking with velvet garter and doll's paper shoe suspended in hollow wood frame, derby hat, hanging cork ball, celluloid fish, and engraved map, 31⅞ × 11⅞ × 10¼″ (81 × 30 × 26 cm). Collection, The Museum of Modern Art, New York. Gift of Mr. and Mrs. Pierre Matisse

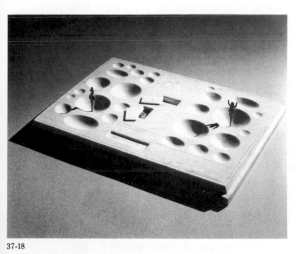

37-18

37-18. ALBERTO GIACOMETTI. *No More Play.* 1931–32. Marble, wood, and bronze, 1⅝ × 22⅞ × 17¾″ (4.1 × 58.1 × 45.1 cm). National Gallery of Art, Washington, D.C. Gift (Partial and Promised) of Raymond D. Nasher

described as Surrealist in conception, such as *The Dream* (fig. 37–16). It is one of a series of paintings of 1932 showing a woman seated in sleepy repose in an armchair, a book in her lap, one breast revealed, her face shown both in profile and fully frontal. In some pictures of the 1932 series Picasso's profile appears in a painting (or mirror) hanging on the wall behind the model; in this one Picasso perhaps appears in the guise of male genitalia, doubling as the left half of his model's dreaming face.

In a fundamental sense Picasso's collages, sculptures such as the *Glass of Absinthe* that include found objects, and later welded pieces such as *Head of a Woman* inspired the Surrealists to develop their ideas in three-dimensional works. Indeed, Breton encouraged them to scour the Paris streets, especially the flea markets, for *objets trouvés* that might stimulate their unconscious minds to create. Like the figures in Duchamp's *Large Glass,* certain Dada sculptures were eerie hybrids of mechanical and human forms. An unforgettable example, the *Object to Be Destroyed,* conceived in 1922 by the American photographer Man Ray (see page 1056), consisted of a metronome to which, at the top of the oscillating bar, the artist paper-clipped a photograph of a staring eye. Such mecanthropomorphic objects continued to be made throughout the 1930s. Many of the makers of Surrealist objects were painters. Miró, for instance, in 1936 produced the remarkable *Object* (fig. 37–17). A seemingly nonsensical assemblage of, for the most part, found objects, the work suggests an erotic narrative in which a lovebird (the stuffed parrot) presides over a meeting between a female symbol (the mannequin's gartered calf and foot in a high-heeled shoe) and a masculine symbol (the hanging cork ball). The mysterious fantasy is perhaps taking place in the racing thoughts of a brain under the black hat, which bears a map—of the unconscious?—and a red plastic fish on its band. Some years later, in the mid-1940s, Miró embarked on a series of masterfully modeled clay maquettes of imaginary animals that were subsequently cast in bronze; still later he combined the techniques, as Picasso had also done, of assemblage and casting to make small editions of painted bronze works whose shapes originated in assemblages of found objects.

GIACOMETTI Perhaps the greatest Surrealist sculptor was Alberto Giacometti (1901–66). The son and nephew of Swiss Post-Impressionist painters, Giacometti moved to Paris in 1923. At first he made carvings that employed a Cubist vocabulary of form, then turned his back on traditional sculpture with mass and bulk to produce works that are semitransparent cages. In these he hung figures and sexually allusive anatomical parts, such as a suspended cloven ball which the viewer may move back and forth over a crescent shape. Giacometti also made a series of tabletop sculptures meant to be viewed from above, apparently at an oblique angle. These have been characterized as game boards: reversing the usual role of sculpture and base, they seem to be almost entirely base, on which stand tiny objects that invite the viewer to move them around. *No More Play,* of 1931–32 (fig. 37–18), is the culmination of a series of such board sculptures, which may also be thought of as sculptural stage sets. Carved in marble by a craftsman from the sculptor's plaster model, the form of *No More Play* may ultimately have originated in a found object, such as a pharmacist's cutting board for measuring dry chemicals. The marble slab is pitted with craters, and down the center run three tombs, two of which contain tiny bronze skeletons. The title (in French: *On ne joue plus*) is inscribed on the slab in mirror writing. On either side, standing in a crater, is a carved wooden figure, the one with the womblike torso probably a woman, the other, with arms raised, a male. Giacometti later renounced his innovative Surrealist objects, preferring the roughly modeled, cast, and sometimes painted bronze figures he made during and after World War II (see fig. 38–13), but it seems clear that his Surrealist cages and slabs, haunted by isolated figures, initiate the theme of existential loneliness that characterizes much of Giacometti's better-known, postwar work.

CHAPTER THIRTY-EIGHT

At the opening of the twentieth century, when the seeds of modernism were germinating in Europe, American art remained provincial, as it had been throughout most of its history despite the original ideas of a few gifted artists. Every current of European nineteenth-century painting continued to flow in the United States, and the most vigorous American movement of the early twentieth century, the Ash Can School (so called by their detractors, and also known as The Eight), was a group of neo-realists indebted largely to Courbet and to Manet's early work. But in these same years, a number of young American artists were absorbing European modernism during trips to France and Germany, and they returned to develop their newly acquired ideas in the United States, chiefly in New York. There in 1905 the American photographer Alfred Stieglitz, who had been educated in Berlin, started the Little Galleries of the Photo-Secession (later called "291" after the address of the brownstone on lower Fifth Avenue where the gallery was located). Initially Stieglitz exhibited photography in the Pictorialist style (see pages 1053–54), which he was also publishing in his influential quarterly journal, *Camera Work*. In 1907 the gallery at 291 Fifth Avenue began to show painting and sculpture as well as photography, and in the course of the next dozen years it mounted the first New York exhibitions of works by Cézanne, Matisse, Henri Rousseau, Picasso, and Brancusi; of African art; and of the art of children. The gallery also pioneered exhibitions of the new American painting and sculpture, including works by Arthur Dove, John Marin, Marsden Hartley, Georgia O'Keeffe, Stanton Macdonald-Wright, and Max Weber.

Then came the Armory Show or, to give it its full title, the International Exhibition of Modern Art, held in 1913 at the New York National Guard's Sixty-Ninth Regiment Armory. The enormous exposition was organized by three Americans, the painters Arthur B. Davies and Walt Kuhn and the photographer Walter Pach, after months spent visiting centers of the new art in Europe. Though few German Expressionists were included, and no Italian Futurists, the United States public was given its first opportunity to view in some depth the important masters of Post-Impressionism, the Fauve movement, and Cubism. The works of many American innovators were also shown. Important sections of the exhibition traveled to Chicago and to Boston. Hundreds of thousands of Americans received their first exposure to the new art through the Armory Show, and at first only a few liked what they saw. Many reactions in the press ("a serious danger to public morals") and in art schools were violent.

Nonetheless, the ice had been broken, and galleries devoted to modern art sprang up in many cities, especially New York. In 1920 Katherine S. Dreier, one of the first American abstract painters and a foresighted collector of modern art, founded with Marcel Duchamp and Man Ray the itinerant Société Anonyme: Museum of Modern Art (as it was first called), using rented quarters or sometimes her own apartment for exhibitions of American and European avant-garde artists. Before her death, in 1952, the bulk of the Société Anonyme collection, including many nonobjective paintings, was given to Yale University. In 1927 A. E. Gallatin lent his collection to New York University under the title of the Gallery of Living Art. In 1929 the Museum of Modern Art first opened its doors in temporary quarters in New York, with the young Alfred H. Barr, an art-history instructor from Wellesley College, as director; Barr went on to obtain a great number of masterpieces for the museum's permanent collection and to curate exhibitions with catalogues that virtually defined the history of twentieth-century art, including brilliant accounts of the careers of Matisse and Picasso.

In 1926 the young businesswoman Edith Halpert founded the Downtown Gallery in Greenwich Village in New York; Stieglitz opened a new, larger gallery called

THE SPREAD OF MODERNISM

An American Place in 1930; and soon other galleries devoted to the new movements became established in New York. Halpert went on to show American folk art and in 1941 held the first gallery exhibition of work by black artists. After Stieglitz's death (in 1946), she exhibited most of the artists in his stable. Meanwhile in Paris, the Stein family, originally from Oakland, California, including the writer Gertrude and her brothers, Leo and Michael, had been putting together remarkable collections of European modernist art since the early years of the century. Much of Gertrude's collection was eventually purchased by patrons of the Museum of Modern Art for the permanent collection. A sometime rival of the Steins for choice avant-garde works, Dr. Albert C. Barnes, of Merion Station, Pennsylvania, amassed an impressive collection, including large groups of Cézannes, Renoirs, Gauguins, and Matisses; the pictures he owned were initially held up to scorn in neighboring Philadelphia. Nonetheless, the Barnes Foundation continued selective educational work on the basis of its treasures and was opened to the public, with some restrictions, in 1960. Courses in the history of contemporary art, pioneered at Columbia University by Meyer Schapiro in 1932, have by now found their way into the curriculum of well-nigh every department of the history of art in the country.

In the 1930s and early 1940s, the politically reactionary and fascist forces that incited World War II were also responsible for the emigration of important European painters and sculptors to the United States, among them the Bauhaus teachers Josef Albers and László Moholy-Nagy; Naum Gabo, Marcel Duchamp, and Hans Hofmann, who eventually became American citizens; Max Ernst, Piet Mondrian, Max Beckmann, and Jacques Lipchitz; and, for a while, Fernand Léger, Salvador Dali, Surrealist painter André Masson, and Surrealist poet-theoretician André Breton. The European art world recovered only slowly from the catastrophe of the war and Nazi occupation, and although many of the leading masters resumed their activity (some, indeed, had never stopped), fewer new figures of importance appeared than earlier in the century. Quite the opposite was true in the United States. Some artists of European birth and training—but many more Americans—participated in new movements, generally centering in New York, which replaced Paris in the 1950s, 1960s, and 1970s as the artistic capital of the world. Important local schools also grew up in Washington, D.C., Chicago, San Francisco, and Los Angeles.

While European artists continued to create in their own independent idiom, many felt strongly the influence of the new American ideas, which remain of extreme importance at the time of the present edition of this book. In the 1980s fresh European movements gained worldwide attention, notably Neo-Expressionism in Germany, with prompt repercussions in America. So international is the outlook of contemporary art in the age of instant telecommunications that national, even continental, boundaries are becoming less and less relevant, as indeed are the traditional distinctions between painting and sculpture, the relation of the work of art to a wall or an architectural space, the sacrosanct hierarchy of materials, or even the traditional concept of durability. Certainly the 1970s and 1980s were decades of change, whose effects, even whose next manifestations, are beyond the possibility of prediction.

Pioneers of American Modernism

One of the earliest American painters to break with naturalism was MARSDEN HARTLEY (1878–1943). Financed by Stieglitz, he went in 1912 to Paris and then to Berlin, where he came in contact with the Blaue Reiter group. In the years just before World War I Hartley painted a remarkable series of still lifes based on

German military regalia. Although the elements of his *Portrait of a German Officer,* of 1914 (fig. 38–1), clearly derive from such artifacts as the celebrated Prussian Iron Cross decoration, regimental flags, and uniform epaulets, Hartley has locked the stripes and checkerboards of brilliant color into flat, patterned designs arrayed against a black background. This and the other pictures in the series come close to being abstractions and are very advanced for the time, yet they did not lead Hartley to experiment further with abstract art. For more than twenty-five years, he continued to paint Maine landscapes and groups of figures whose elements are vigorously simplified for expressive purposes.

JOHN MARIN (1870–1953) spent the years 1905–11 in Europe. He was deeply impressed by the later work of Cézanne and then by early Cubism and the dynamic art of Robert Delaunay (see fig. 36–14). Marin's career was spent principally in painting watercolors; among the best are those in which he tried to embody the energy and vitality of New York City. *Lower Manhattan (Composing Derived from Top of Woolworth),* of 1922 (fig. 38–2), is a composition, typically centered, that surveys a panorama of skyscrapers in clashing and intersecting views. These suggest but do not really emulate Cubism, and they are painted with an almost Expressionist vigor of brushwork and color that is nonetheless rendered with a light touch.

One of the leading artists of the Stieglitz circle, GEORGIA O'KEEFFE (1887–1986), was trained entirely in the United States, taking drawing lessons as a child, then studying anatomy at the Art Institute of Chicago, and later studying at the Art Students League in New York and then at Columbia University with Arthur Wesley Dow, whose knowledge of Far Eastern abstract design and fund of ideas related to Symbolism contributed strongly to her growth as a modernist. O'Keeffe's first show, a group of nearly abstract charcoal drawings, was held at "291" in 1916. She began to live with Stieglitz in 1919 and in 1926 they were married. Over the years O'Keeffe was the subject of a remarkable series of his photographs. In its extraordinarily subtle modeling from light to dark and in its perceptive use of enlargement, O'Keeffe's painting reflects her familiarity with photography as a medium. Throughout her long life, the artist developed a vocabulary of small natural forms, which she often showed in vastly magnified close-ups. In *Black Iris III,* of 1926 (fig. 38–3), for example, the voluptuous, oversize petals of the velvety flower fill the entire canvas. Here, characteristically, one natural form, the iris, appears at an

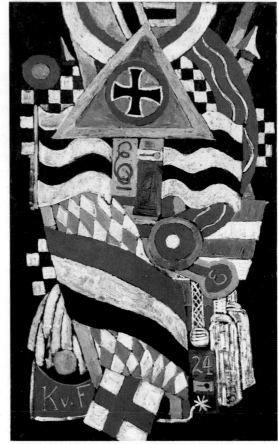

38-1

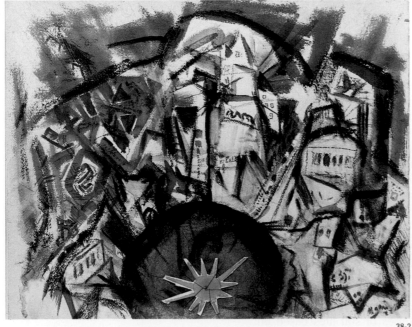

38-2

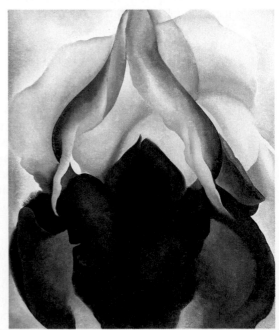

38-3

unfamiliar scale to allude effortlessly to another natural form, female genitalia, and both may be associated with the idea of creative life. At the same time, O'Keeffe was producing some light-filled views of New York at night. Yet she preferred to be away from the city and in the early 1920s began regularly to visit the Southwest; after Stieglitz's death, and for the last four decades of her life, she lived in New Mexico, gradually adjusting her iconography to reflect the local desertscape of adobe architecture, bleached animal skulls, driftwood, and sky.

After World War I a number of gifted American artists turned to new forms of realism, focusing on, even glorifying, the dreariness and banality of much of American urban and rural life. One of the best of these so-called American Scene painters was EDWARD HOPPER (1882–1967). He presents us with a bleak world made up of dingy streets, gloomy houses, comfortless rooms, and dismal restaurants—such as we see in *Automat*, of 1927 (fig. 38–4). Yet the apparent hopelessness of the inhabitants and their lack of aesthetic or spiritual rewards are mysteriously compensated by an austere beauty of form, of space, and especially of light, whether by day or by night, which transforms the dullest scene into a harmonious construction of planes and spaces. By no means unaware of the formal conquests of abstract art, Hopper is a precursor of both Pop Art of the 1960s and the more recent Photo-Realists (see below).

Aspects of American life appear in a very different guise in the painting of STUART DAVIS (1894–1964), who was for decades the most accomplished American modernist painter. As a nineteen-year-old art student and associate of some members of the radical group of realists called The Eight, Davis exhibited watercolors in the Armory Show, which provided him with his first exposure to European modern art, including such important works as Matisse's *Red Studio*, of 1911 (see fig. 35–4). In the course of the 1920s, already aware of the irreverent spirit of New York Dada, Davis familiarized himself with the work of Picasso, Braque, and Léger, especially with the flat, planar syntax of Synthetic Cubism evident in paintings such as

38-1. MARSDEN HARTLEY. *Portrait of a German Officer.* 1914. Oil on canvas, 68¼ × 41⅜" (1.78 × 1.05 m). The Metropolitan Museum of Art, New York. The Alfred Stieglitz Collection, 1949

38-2. JOHN MARIN. *Lower Manhattan (Composing Derived from Top of Woolworth).* 1922. Watercolor and charcoal, and paper cutout attached with thread, 21⅝ × 26⅞" (55 × 68.3 cm). Collection, The Museum of Modern Art, New York. Acquired through the Lillie P. Bliss Bequest

38-3. GEORGIA O'KEEFFE. *Black Iris III.* 1926. Oil on canvas, 36 × 29⅞" (91.4 × 75.9 cm). The Metropolitan Museum of Art, New York. The Alfred Stieglitz Collection, 1969

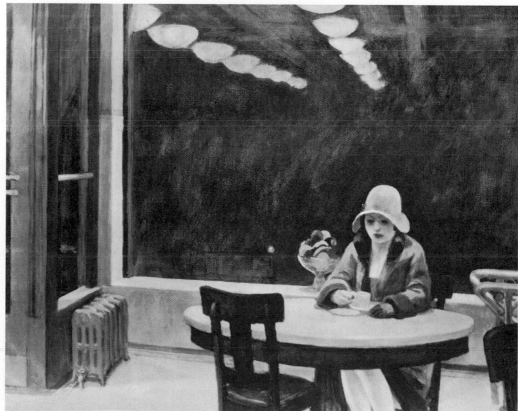

38-4. EDWARD HOPPER. *Automat.* 1927. Oil on canvas, 28 × 36" (71 × 91.4 cm). Des Moines Art Center, Iowa. Edmundson Collection

38-4

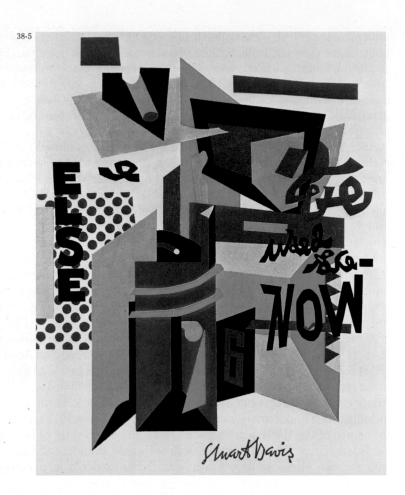

38-5

38-5. STUART DAVIS. *Owh! in San Pao*. 1951. Oil on canvas, 52¼ × 41¾″ (1.33 × 1.06 m). Collection of Whitney Museum of American Art, New York

Picasso's *Three Musicians* (see fig. 36–10). Davis went on to develop a personal style that combined Synthetic Cubist technique with popular American imagery, particularly themes drawn from modern transportation and communications technology and from jazz, whose syncopation seems to inflect his formal strategies. Increasingly he used words and witty variants of idiomatic phrases to inject subject matter into paintings whose geometric elements bordered on abstraction. *Owh! in San Pao,* of 1951 (fig. 38–5), is a superb example of Davis's coloristically bold mature work, and like many of his later paintings it is based closely on a more muted and wordless one, *Percolator,* of 1932 (the coffee maker in the earlier work maintains a subliminal presence in the red, green, and blue forms at the lower center of the painting). The title of *Owh! in San Pao* refers to Davis's participation as the United States representative in 1951 at the biennial exhibition of art in São Paulo, Brazil. "NOW" written on the canvas rhymes with the "Owh" and "Pao" of its title. The lettering in script, which reads "we used to be," in combination with "NOW" may describe how Davis felt about the fact that younger artists, soon to be known as Abstract Expressionists (see below), were beginning to replace him as the makers of "now" art. Yet Davis's ability to combine vernacular pizzazz with a sophisticated awareness of modernism and inventive color provided a vital example to the Abstract Expressionists of what might be accomplished on home ground.

The more conservative American Scene painters as well as such avant-garde artists as Davis and a number of the younger artists who became Abstract Expressionists all received a tremendous opportunity during the Great Depression, when the Roosevelt administration's Federal Art Projects commissioned murals for government buildings throughout the country. Many of the paintings were of considerable quality; many have been lost through carelessness or bad judgment.

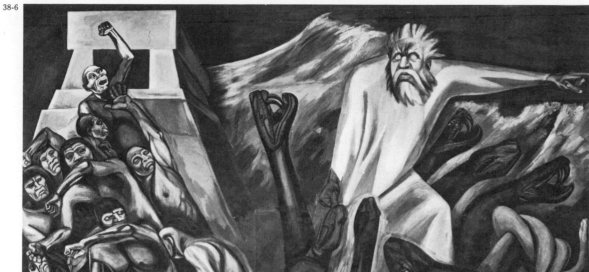

38-6. José Clemente Orozco. *Departure of Quetzalcoatl,* detail (panel 7) of *The Epic of Civilization.* 1932–34. Fresco, 10 × 17′ (3.05 × 5.21 m). Commissioned by the Trustees of Dartmouth College, Hanover, New Hampshire

The Mexicans

The decade of the 1920s saw the rise of a vigorous school of strongly Marxist mural painters in Mexico, favored by the revolutionary government with public commissions for frescoes covering vast surfaces on a scale not seen since the days of the Baroque ceiling painters. Among the leading Mexican muralists was Diego Rivera (1886–1957), who from 1909 to 1921 lived in Europe, where he was a skilled practitioner of Cubism. With limited success, slightly later Rivera attempted to

38-7. David Alfaro Siqueiros. *Portrait of the Bourgeoisie,* mural, Electrical Workers' Union Building, Mexico City. 1939

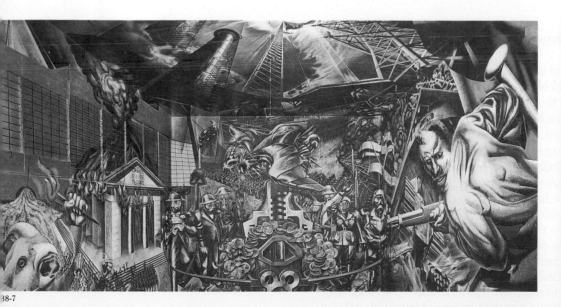

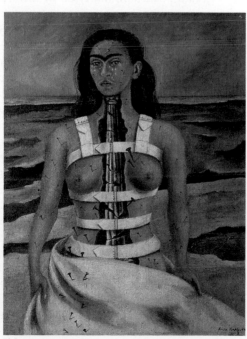

38-8. Frida Kahlo. *The Broken Column.* 1944. Oil on canvas, 15¾ × 12¼″ (40 × 31.1 cm). Collection Dolores Olmedo, Mexico City

create an easily understood popular style based on Mexican folk art and a study of Italian fourteenth-century fresco techniques. Far more impressive was Rivera's collaborator, JOSÉ CLEMENTE OROZCO (1883–1949), who, after a massive series of mural commissions in Mexico, was invited to paint a cycle of frescoes at Dartmouth College, Hanover, New Hampshire, in 1932. *Departure of Quetzalcoatl* (fig. 38–6) from the Dartmouth frescoes, executed between 1932 and 1934, verges dangerously on bombast and is unnecessarily crude in detail, but its strength and sincerity are nonetheless impressive. In the midst of his sacred serpents the god angrily leaves his pyramid-temple, while the Aztecs recoil in dismay. DAVID ALFARO SIQUEIROS (1896–1974) is blatantly propagandistic in his *Portrait of the Bourgeoisie,* a mural of 1939 in the Electrical Workers' Union Building in Mexico City (fig. 38–7), covering a thousand square feet with hundreds of figures and symbols. The temple of Liberté, Egalité, Fraternité (the motto of the French Revolution) is on fire. An eagle with jointed metal wings dominates the scene; factory chimneys and steel towers rise against the sky; hordes of marching soldiers are harangued by political leaders in bourgeois dress on the left, and on the right by others in Fascist uniforms, wearing helmets and gas masks, while money pours out of a huge machine. The spectator is overwhelmed, as Siqueiros intended, by the sheer volume of his descriptive rhetoric.

Among the most gifted Mexican painters of the first half of the twentieth century was FRIDA KAHLO (1907–54), one of numerous women artists attracted to Surrealism because of its emphasis on personal vision. Kahlo's work was greatly admired by André Breton when he visited Mexico in the late 1930s, and he arranged to have a selection of it shown in Paris; one result of that exhibition was a modest international reputation during the artist's lifetime. Kahlo was crippled in a trolley accident as an adolescent, and complications from the injury persisted throughout her life. A striking woman with dark, vivid brows, who chose to dress and often to paint herself clothed in traditional Mexican costume, Kahlo was married to the painter Diego Rivera, a relationship so stormy that she referred to him as her second accident. In a self-portrait of 1944 titled *The Broken Column* (fig. 38–8), Kahlo presents herself simultaneously in two guises, one erotically alluring, the other pitiful. She stands before us naked to the waist, both revealed and literally held together by an imaginary version of the therapeutic corset she was forced to wear regularly. Pins penetrate the exposed areas of her skin, as if she were a female Saint Sebastian, martyred by arrows.

International Developments in Modern Sculpture

Constructivist and Surrealist theory and form (see Chapters Thirty-Six and Thirty-Seven) deeply affected the development of vanguard sculpture in the 1930s, 1940s, and 1950s in the United States and Europe. One American artist whose work reflects both movements was ALEXANDER CALDER (1898–1976). The son and grandson of artists, Calder was trained as a mechanical engineer. After a brief period of study at the Art Students League in New York, he went to Paris in 1926 and during the next few years developed a vocabulary of colorful biomorphic shapes based on Miró's painting and Arp's sculpture. In 1932 he began to produce kinetic sculptures, a few of which were motorized, most driven by currents of air. Duchamp, who was intrigued by Calder's work, dubbed his kinetic sculpture "mobiles." Calder soon developed these Constructivist abstractions into a series of witty creations that caricature aspects of nature, whether animal, vegetable, or mineral. Imaginary, yet familiar in a generalized way, they seem to lead a rich life of their own, especially when in motion. Because its tripod base does not move—only the arms, linked in a catenary, are free to respond to the flow of air—*The Spider* (fig. 38–9) belongs to a group of works termed mobile-stabiles. Made with painted sheet metal and curved steel rod, materials that Calder used throughout most of his career, *The Spider* is a fully mature work of 1940. Best known for mobiles that hang

38-9 38-10

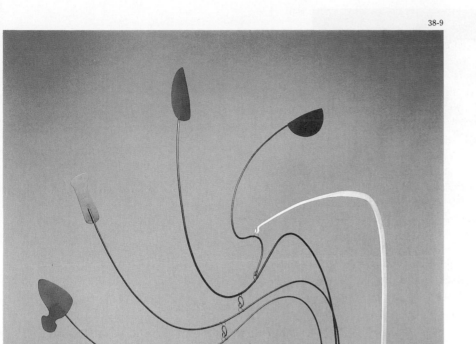

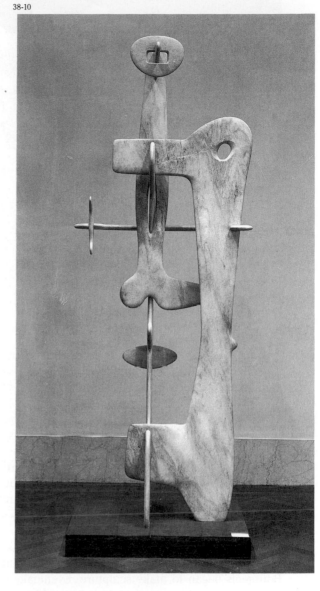

38-9. ALEXANDER CALDER. *The Spider.* 1940. Painted sheet metal and steel rod, 7′11″ × 8′3″ × 6′1″ (2.41 × 2.52 × 1.85 m). From the Patsy R. and Raymond D. Nasher Collection, Dallas, Texas

38-10. ISAMU NOGUCHI. *Kouros.* 1944–45. Marble with slate base, height approx. 9′9″ (2.97 m). The Metropolitan Museum of Art, New York. Fletcher Fund, 1953

from the ceiling, Calder also made large, freestanding painted metal constructions that do not move at all, and these became known as stabiles. Brancusi had initiated the disappearance of the base from modern sculpture by designing bases that were as sculpturally significant as the works themselves; Calder eliminated bases entirely.

ISAMU NOGUCHI (1904–88), an American of Japanese descent, worked for a period during the late 1920s as Brancusi's assistant in Paris, where he learned the appeal of seemingly simple forms carved in wood and marble and highly polished. During the 1940s, in sophisticated, elegant works such as *Kouros* (fig. 38–10), Noguchi adapted the curved slabs he had developed out of the biomorphic language of Surrealism and then slotted them together in self-supporting assemblies. The work is reminiscent of Gabo's *Column* (see fig. 36–32) in that its crossing planes also imply a volume—here a human figure. Noguchi's title, which means "youth" in Greek, confidently asserts his sculpture's place within the 2,500-year-old tradition of standing male nude sculpture in the West. Noguchi also designed furniture and stage sets. His later sculpture, carved from large, solid blocks of stone quarried in Japan, is related in feeling to the Zen rock gardens of Kyoto. In his final years, after establishing a museum for his work in a former factory in New York's Long Island City, Noguchi worked almost exclusively in Japan.

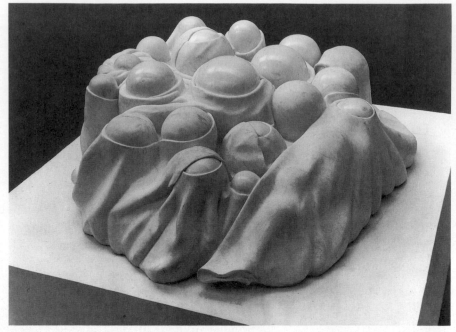

38-11. LOUISE BOURGEOIS. *Cumul I.* 1968. Marble, 22⅜ × 50 × 48″ (56.8 × 127 × 122 cm). Musée National d'Art Moderne, Centre Georges Pompidou, Paris

The French-born American sculptor LOUISE BOURGEOIS (born 1911), the daughter of Parisian dealers in fine tapestries, was raised and educated in Paris. After studying at the Sorbonne and art schools in France, she married an American art historian and in 1932 moved to New York. In a series of oil paintings dating from 1946–47 that she called *Femmes-Maisons (Woman Houses),* Bourgeois depicted female nudes with house forms instead of heads, symbolizing cages of domesticity. Like the American Abstract Expressionist painters, who were of her own generation and most of whom she knew well, Bourgeois absorbed the ideas of Surrealism from exiled artists who had fled Paris for New York at the outbreak of World War II. Unlike Calder or the Abstract Expressionist painter Arshile Gorky (see below), what Bourgeois took from Surrealism was not its style and forms but its belief in unearthing and utilizing psychological motivations for the creation of art, and she began to make work rooted in painful situations of her childhood, such as her father's liaison with a young woman who was her tutor in English. In the mid-1940s Bourgeois began to make sculpture. Eventually she worked in a wide range of materials, including wood and plaster, rubber latex, marble, and bronze. After some years of carving slender, vertical, primitive-looking figural forms in wood, Bourgeois embarked during the 1960s on a series of objects consisting of low-lying clustered elements set on a base. She called these marble mounds *Cumuls,* alluding to the resemblance of their swelling, billowy forms, massed together, to cumulus clouds. *Cumul I,* of 1968 (fig. 38–11), exemplifies her use of Surrealist literalness with sexual allusion for expressive purposes. Bourgeois's work did not receive widespread public recognition until the 1970s, when the women's movement in art (see below) identified her as a significant precursor. In 1982 a traveling retrospective of Bourgeois's work was organized by the Museum of Modern Art, New York.

The immensely successful English sculptor HENRY MOORE (1898–1986) came to maturity as an artist in the 1930s, aware of both Surrealist sculpture, particularly that of Picasso, and Constructivist principles, especially those of Gabo (who in 1935 moved to England, where he remained until after World War II). Like the British intellectuals Clive Bell and Roger Fry, Moore appreciated sculptural forms outside the classical tradition, from the megaliths of Stonehenge to artifacts of the Maya-Toltec culture that he viewed at the British Museum, and he was interested also in natural forms, such as well-worn bones and pebbles. In his figural sculpture of the 1930s, carved from wood or stone, he sought to be true to the nature of the materials, allowing the grain of the wood, for example, to determine the path of his

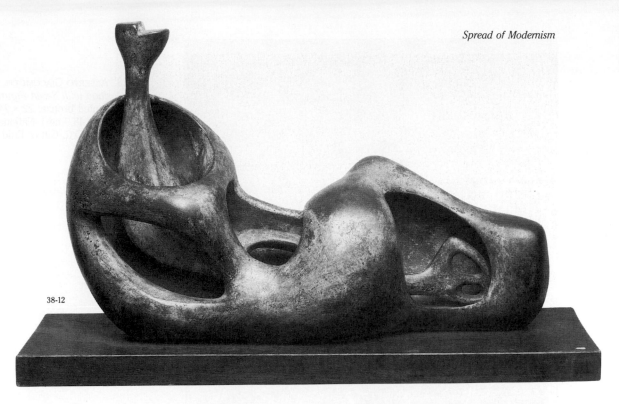

38-12

38-12. HENRY MOORE. *Interior-Exterior Reclining Figure.* 1951. Bronze, height 14″ (35.6 cm). Hirshhorn Museum and Sculpture Garden, Smithsonian Institution, Washington, D.C.

carving. His favorite subject was always the reclining female figure leaning on one elbow and with raised knees. *Interior-Exterior Reclining Figure,* of 1951 (fig. 38–12), is an example of one of these dignified, archetypal earth-mothers. Moore's concern in this work—to show an exterior shell cradling a mysterious, internal void—seems distant from the Constructivist goal of substituting a volume of air for a solid mass, yet that tradition lies behind the openings in his sculpture. After World War II Moore turned from carving to modeling. Although his life-size figures today decorate urban plazas around the globe, Moore preferred to see his work installed in nature, on the gently rolling lawns of his home in the Yorkshire countryside, for example, or in a spacious park for sculpture, such as the one at the Rijksmuseum Kröller-Muller in Otterlo, the Netherlands.

European Painting and Sculpture in the Aftermath of World War II

The global devastation caused by World War II—the bombing of London in 1940–41, the occupation of France and the Low Countries, the invasion of Eastern Europe by the Germans, the unspeakable horrors of the Holocaust, and the explosion of atomic bombs by the United States over Japan—had a profound influence on a number of artists. Many works of art developed during the war and in the decade after it reflect the pointlessness and absurdity of so much violence and suggest as well an awareness of existentialist philosophy. Existentialism holds that concrete, individual existence takes precedence over abstract, conceptual essence and that therefore human beings are free and responsible for their acts. This vast responsibility is in turn the source of feelings of dread and anguish. In a general rather than a specific manner, the wartime and postwar sculpture (and painting) of Alberto Giacometti, whose work we examined in Chapter Thirty-Seven, as well as the painting of the Frenchman Jean Dubuffet and of the Irish-born Londoner Francis Bacon express an existential response to the war and to the disintegration of the social and moral fabric of human life that both produced and resulted from the conflict. After his return from neutral Switzerland to Paris in 1945, Giacometti ceased assigning craftsmen to execute his ideas for sculpture and began himself to model his conceptions in clay. These took the form of extremely attenuated human figures (frequently the same sitters, often the artist's wife and his brother). After having his clay models cast in bronze, Giacometti patinated and in

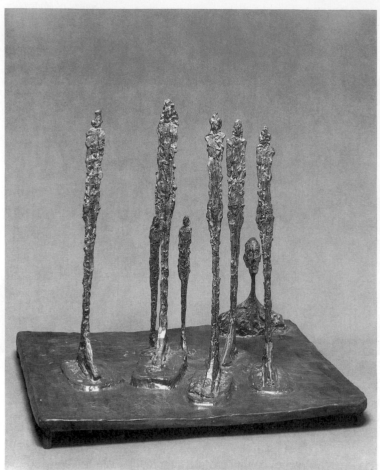

38-13. ALBERTO GIACOMETTI. *The Forest: Composition with Seven Figures and a Head.* 1950. Painted bronze, 22 × 24 × 19¼" (55.9 × 61 × 48.9 cm). National Gallery of Art, Washington, D.C. Gift of Enid A. Haupt

some cases painted them, varying the surfaces of successive casts from the same edition. The modeling process, by which his hands worked and reworked the clay, is conspicuous in the finished works and reads as a kind of excoriation of flesh. Giacometti often fashioned an environment for these exaggeratedly thin figures—in *The Forest: Composition with Seven Figures and a Head* (fig. 38–13) the setting is a thick base, reminiscent of the game board in *No More Play* (see fig. 37–18). The effect is to increase the sense of loneliness, for though they share common ground each of the figures stares straight ahead, unaware of or unable to acknowledge the presence of others. In this work of 1950, the fact that the figures are shown at three different scales, as if they were inhabitants of three different worlds, reinforces their separateness from one another.

JEAN DUBUFFET (1901–85) was the most original and forceful painter of the immediate postwar period in France. A friend of many interesting Parisian poets and playwrights, whom he caricatured brilliantly in a series of portraits, Dubuffet did not have his first one-person show until 1944. His activity was prodigious and his interests, in part sparked by his study of Klee, ranged over every variety of what he called *art brut* ("rough" or "raw art"). He collected and studied thousands of examples of the art of children and the art of the insane—as well as the graffiti that appeared on Parisian buildings, scratched on layer over accumulated layer of affixed posters—in an attempt to discover how the uncensored and untutored human animal draws and paints. His own paintings often had a high-relief or textured surface formed from varying mixtures of materials—cement, tar, pebbles, straw, and so on, as well as paint—and he often incised images in these thick, pasty surfaces. In one of his most shocking series, *Corps de Dames (Ladies' Bodies)*, of 1950, female nudes appear crude and bloated, much like a young child's rendering of his nurse or mother. One of the first of these is titled *Olympia*, in mock homage to Manet's famous painting of a nude prostitute, which was itself modeled ironically

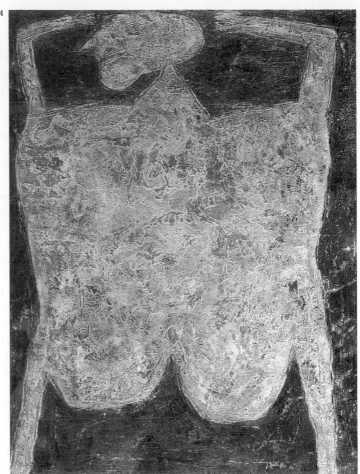

38-14. Jean Dubuffet. *Triumph and Glory.*
1950. Oil on canvas, 51 × 38″ (128.5 × 96.5 cm).
Solomon R. Guggenheim Museum, New York

on the dreamy *Venus of Urbino* by Titian (see fig. 24–8). One of the last paintings in the *Corps de Dames* series, the burgundy-colored *Triumph and Glory* (fig. 38–14) shows a hairless woman with a wedge-shaped neck, small circular breasts, and oversized, sagging buttocks. Her body is enormous in relation to her limbs. This frontal form fills the canvas to the edges (indeed, the skinny legs are cut off by the bottom of the picture), in a centered composition that entirely lacks the balanced relationships of form that most European painters since the Renaissance have prized. An influence on both sides of the Atlantic, Dubuffet also made important sculpture and prints as well as paintings, and he recorded his output in a series of published volumes of photographic reproductions as he went along—a sign of his awareness of the proliferation of art reproductions in the postwar era, which has enabled critics and historians to study artistic careers with a new exactitude.

Francis Bacon (1910–92), who shared with Lucien Freud a clear claim to being the most significant British representational painter of the postwar era, devoted himself to making highly disturbing single pictures and triptychs of one or sometimes two figures, with some perspective lines and large areas of color as background. These figures—usually men, occasionally women—are often based upon important paintings of the past. *Head Surrounded by Sides of Beef,* of 1954 (fig. 38–15), for example, is one of several pictures modeled on Velázquez's *Portrait of Pope Innocent X,* of 1650. Bacon's "pope" is seen as through a transparent curtain that grotesquely distorts his features; unlike the unperturbed subject of Velázquez's portrait he appears to be grimacing in agony as paint drips from his face like a cascade of tears. On either side of this trapped and wretched prelate, in ghastly mockery of angelic wings, are two sides of beef, which allude to Rembrandt's paintings of animal carcasses. While Bacon's figures often seem caught in a moment of action like people in a snapshot, his canvases are quite large, typically measured in feet rather than inches, and it is a further disturbing irony of his work

that the artist usually framed his canvases with wide gilded molding and placed them under glass.

Abstract Expressionism

America's greatest single contribution to the history of modern art is the Abstract Expressionist movement, which dominated the New York scene for about fifteen years after the end of World War II. Through the medium of mass magazines such as *Life* as well as through art periodicals, the work of the pioneers was very rapidly transmitted through much of the world, and in Europe and to some extent in Japan parallel manifestations of the new style appeared with far greater speed than had reflections of Impressionism in late-nineteenth-century art. An Abstract Expressionist exhibition organized in 1958 by the Museum of Modern Art in New York, "The New American Painting," toured eight European countries the following year. No consistent mode of vision or method of applying paint united the artists of the movement in the way that the Impressionists and the Cubists were united, but almost all of them questioned the strict geometry that had characterized much of abstract art in New York until that time, inspired by aspects of Cubism and by the painting of Mondrian, who was present and influential in New York from 1940 until his death in 1944. The sharp differences among the personal styles of the Abstract Expressionist leaders are implicit in the very nature of the movement, which exalted individualism and the expression of the inner life through the application of paint. No one before the best Abstract Expressionist painters had ever painted abstract pictures of such emotional intensity on such a scale.

Some of the roots of Abstract Expressionism can be found in the early work of Kandinsky, for example his *Improvisation 30 (Cannon),* of 1913 (see fig. 35–16), and his slightly later, freely painted abstractions, which were on view in New York at Solomon R. Guggenheim's Museum of Non-Objective Painting beginning in 1937. The importance of the unconscious for creativity preached by the Surrealists, and the automatic-painting techniques employed by such members of that group as Miró and André Masson, also played a critical role. Less obvious, perhaps, but also a very significant factor in the development of Abstract Expressionism was a great increase in sophisticated understanding among painters of the work of Matisse and Picasso. Both of these artists, in different ways, had radically reduced the illusion of deep space in painting, and each had called attention to the picture surface, Matisse with large areas of flat, unmodulated color, Picasso with collage.

GORKY One of the last of the Surrealists, who may also be regarded as the first of the American Abstract Expressionists, was the Armenian-born Arshile Gorky (1904–48), who took his close study of living painters—Picasso, Miró, Matisse, and Léger—as seriously as other artists took the Old Masters and in doing so was an influential example. As early as 1931 Gorky wrote admiringly that in practicing a homegrown Cubism Stuart Davis was "one of but few [American artists] who realizes his canvas as a rectangular shape with [a] two-dimensional surface plane. . . . [and] forbids himself to poke bumps and holes upon that potential surface." At the outset of his career Gorky worked in a belated Impressionist manner but soon fell under the influence first of Picasso, then of Miró, and eventually of Antonio Matta Echaurren, a Chilean Surrealist who had arrived in the United States in 1939. By 1944, encouraged by the European Surrealists exiled in New York to take his automatic drawings seriously, Gorky was painting in a new style, a synthesis of Cubism and Surrealism, strongly automatic, and gaining an intense poetic effect from the movement of clearly contoured biomorphic shapes against freely brushed tides of color. In such works as *The Liver Is the Cock's Comb* (fig. 38–16), of 1944, for which there are preparatory drawings produced partly by automatic techniques, Gorky incorporated personal references drawn from his life and from nature. The often erotically suggestive shapes move, swell, and turn

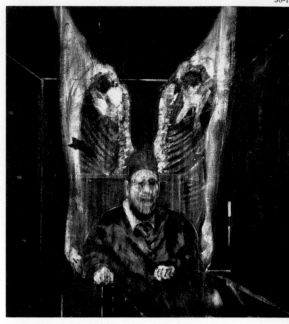

38-15. FRANCIS BACON. *Head Surrounded by Sides of Beef.* 1954. Oil on canvas, 51⅛ × 48″ (1.3 × 1.22 m). The Art Institute of Chicago. Harriott A. Fox Fund 1956

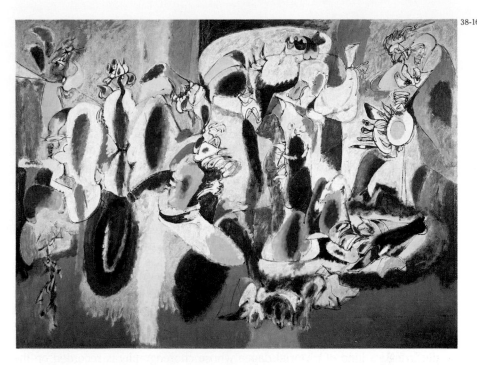

38-16

38-16. ARSHILE GORKY. *The Liver Is the Cock's Comb.* 1944. Oil on canvas, 6'1¼" × 8'2" (1.86 × 2.49 m). Albright-Knox Art Gallery, Buffalo, New York. Gift of Seymour H. Knox, 1956

freely, yet with a distinct rhythmic relationship to the delicate calligraphy of the colorful brushwork. The haunting mood of Gorky's paintings from 1944 to 1948, their disturbing combination of linear delicacy and implicit violence, and, alas, their rarity have rendered them jewels of early Abstract Expressionism.

POLLOCK In the minds of many observers, the hero of the Abstract Expressionist drama is Jackson Pollock (1912–56). His short and turbulent existence encompassed remarkable artistic inventions, and his death came tragically soon. Born in

38-17. JACKSON POLLOCK. *Number 1, 1950 (Lavender Mist).* 1950. Oil, enamel, and aluminum on canvas, 7'3" × 9'10" (2.21 × 3 m). National Gallery of Art, Washington, D.C. Ailsa Mellon Bruce Fund

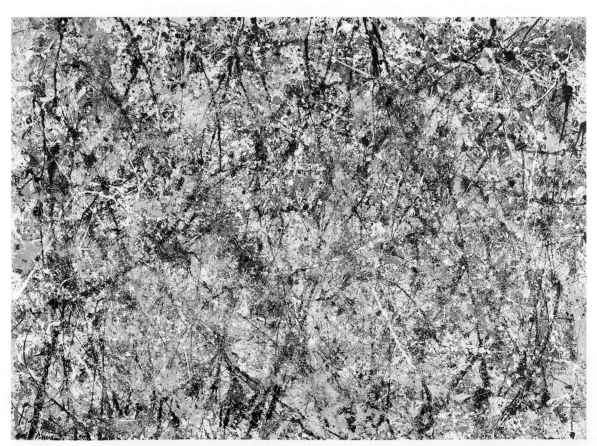

38-17

Wyoming, Pollock passed his childhood and a rebellious and nomadic adolescence in southern California. At seventeen he began studying under the buoyant American Scene muralist Thomas Hart Benton at the Art Students League in New York and made powerful drawings after Renaissance masters of action and emotion— Michelangelo, Tintoretto, and El Greco. At twenty-one he was already working in a semi-abstract manner. Although labored and uncertain, his early works show the broad curves that later, in skeins of line, became his virtual signature. In 1944, at thirty-two, he began the free motion of the arm that characterized his mature style, and in 1946 he began to exploit the drip. Pollock was well aware of modern French art and discussed it with artist friends; he was interested in Jungian, rather than Freudian, psychology; and he admired the sand paintings of the Navajo Indians, which are executed rhythmically as part of a religious rite and then erased. He may have known the tiny drip paintings of Hans Hofmann (see below). In 1945 Pollock and his wife, the painter Lee Krasner, moved to the eastern end of Long Island where, except for weekly trips to New York City, they lived until Pollock's death. In 1947 Pollock commenced working on very large canvases (several were as wide as seventeen feet), which he tacked to the floor unstretched. He declared that proceeding in this fashion made him feel "more a part of the painting, since this way I can walk round it, work from the four sides and literally be in the painting." With a can of Duco enamel or aluminum or thinned oil paint in one hand, he moved freely, dripping and pouring paint fluidly from the end of a stick held in the other hand, as he performed a kind of pictorial dance whose choreography is recorded on the canvas. Pollock allowed this activity to be photographed and filmed by a friend and said about his method: "When I am painting I have a general notion as to what I am about. I can control the flow of the paint; there is no accident, just as there is no beginning and no end."

The paintings Pollock completed between 1948 and 1950 are his finest. A masterwork such as *Number 1, 1950 (Lavender Mist)* shows that the artist's energetic, direct method of applying paint, without a brush, from all four sides of the canvas, in overlapping loops and streaks of line, produced a new, painterly kind of drawing (fig. 38–17). The paint does not outline either figurative images or abstract shapes that were set out in a balanced composition; that is, the looping lines encase nothing but are themselves distributed all over the broad field of the canvas. Although the paint decreases slightly in density toward the sides, top, and bottom of the picture, with some bare canvas showing through, the flow of the lines nonetheless suggests the possibility that the paint may extend beyond the perimeter of the canvas. In *Lavender Mist* and closely related works also made with black and white as well as reflective aluminum paint, which has dimmed somewhat over time, and some pale colors, such as the pinkish lavender in the illustrated work, Pollock's skeins of line on bare canvas seem almost to be on top of the picture plane, projecting toward the viewer rather than into depth as in most painting since the Renaissance. The freshness and intensity of the act of painting—its sincerity—were important to Pollock, and in 1951 and 1952, perhaps concerned that his method was becoming formularized, he made a number of partially figural paintings using black only, often allowing the thinned paint to soak into the canvas, staining it.

DE KOONING A somewhat different direction was taken by Willem de Kooning (born 1904), who shares with Pollock preeminence among the Abstract Expressionists whose gestural application of paint to canvas has been appropriately described as "action painting." Born in Holland and trained as a draftsman during eight years at the art academy in Rotterdam, De Kooning settled permanently in New York in 1926, already steeped in traditional painting and knowledgeable about the art of Picasso and other modernist artists. Not until 1948 did he develop an Abstract Expressionist style, using pigments at first limited to black and white enamel house paints. Brushed over, rubbed, scraped, painted, and then repainted again and again, the surface of large-scale works such as *Excavation* (see Introduc-

38-18

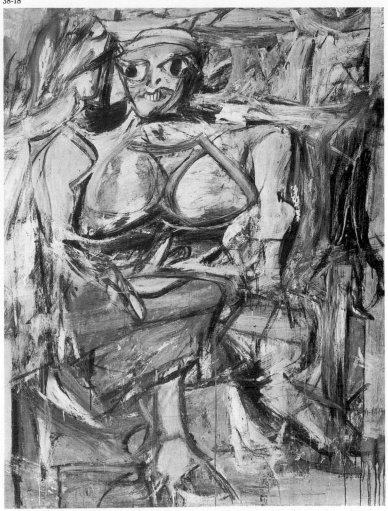

38-18. Willem de Kooning. *Woman I.* 1950–52. Oil on canvas, 75⅞ × 58″ (1.93 × 1.47 m). Collection, The Museum of Modern Art, New York. Purchase

tion fig. 27), of 1950, shows off De Kooning's strident painterly gestures and reveals the traces of his many acts of revision. In the predominantly black-and-white paintings of this period it is nearly impossible to discern differences between what might be termed "figure" and what might be termed "ground," and a sense of the painter's act of slashing the brush back and forth across the canvas remains alive in the finished work. The interpenetrating brushstrokes are given structure and a kind of coherence by a scaffolding of repeating verticals and horizontals, reminiscent of Analytic Cubism. They form an allover compositional texture of tremendous vigor, very different from the overlapping whorls of Pollock's drips, yet similarly evocative of speed and nervous energy. In De Kooning's slightly later paintings, such as *Woman I* (fig. 38–18), of 1950–52, the figure reappears, bursting forth from an indeterminate shallow space that also resembles in its compressed depth the backgrounds of Analytic Cubism. *Woman I* is one of a series of paintings executed in the early and middle 1950s of almost demonic women, terrifying in their hostility and ferocity, yet voluptuous and seductive at the same time. Color reappears in these works, and De Kooning's fleshy pinks and yellows are at times close to those of Rubens. As can be said of De Kooning's abstract landscapes of the later 1950s, the apparent spontaneity and freshness of surface handling in the *Woman* series are the result of intensive labor and continual reworking. De Kooning's gestural painting of the late 1940s and early 1950s was enormously influential and much imitated by younger artists, who admired the intensity of the man as well as his work. He became a hero to the next generation and was thought to be the model for the painter described in a widely read essay of 1952 by the critic Harold Rosenberg, "The American Action Painters," which gave the movement another name.

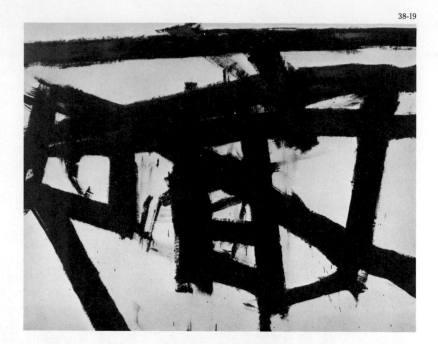

38-19. FRANZ KLINE. *Mahoning.* 1956. Oil on canvas, 6'8" × 8'4" (2.03 × 2.54 m). Collection of Whitney Museum of American Art, New York. Gift of the Friends of the Whitney

KLINE Until 1949 Franz Kline (1910–62) was a representational painter not associated with any advanced movement. His work, nonetheless, showed a strong sense of draftsmanship and bold brushwork. Then in 1949, while looking at enlarged projections of some of his black-and-white sketches made on pages of a telephone book, he discovered that small sections of them made powerful abstract configurations. The transformation of his style was immediate. He abandoned representation and, for the moment, even color, and proceeded to work on an increasingly large scale—*Mahoning,* of 1956 (fig. 38–19), is more than eight feet wide—with powerful strokes of black and white paint laid rapidly on the canvas with a housepainter's brush. Chinese and Japanese calligraphy had no influence on Kline's style, but his massive strokes, building up entirely abstract images with the greatest freedom, have often been compared to the large, freely brushed characters highly prized in the Far East. Although, in reproductions, Kline's paintings often read as black figures on white grounds, in fact great patches of white typically overlap areas of black, confounding any illusion of spatial depth and calling attention to the surface of the paintings. In contrast to much contemporaneous European abstract painting, Kline's wide brushstrokes of the early and middle 1950s extend to the very edges of the canvas and appear to have the velocity to extend beyond its perimeters into the real space of the viewer. A few years before his premature death, Kline varied his style by including masses of smoldering color between the black strokes.

HOFMANN An unexpected apparition on the New York scene was Hans Hofmann (1880–1966), who belonged to an earlier generation than most of the Abstract Expressionists. Born in Bavaria, he lived and worked in Paris from 1903 to 1914. His surviving works from this period show the influence of Robert Delaunay and of Matisse, both of whom he knew. When he arrived in the United States in 1930, his reputation was that of an extremely successful European teacher, and he continued to teach in the United States, exerting a tremendous influence on younger artists through his coherent instruction about the formal properties of European modernism, particularly the highly saturated color of Fauvism and the spatial play and compositional grids of Cubism. Hofmann was also known for encouraging his students to exploit intuition and spontaneous gestures when painting. Among Hofmann's many students were the painter Helen Frankenthaler (see below) and the critic Clement Greenberg, who further disseminated kernels of

38-20

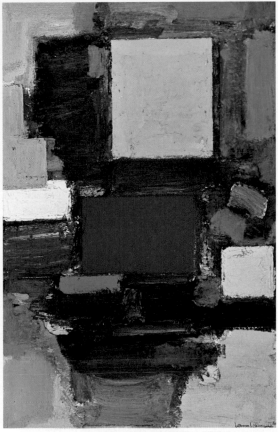

38-20. HANS HOFMANN. *The Gate*. 1960. Oil on canvas, 74⅝ × 48¼″ (1.9 × 1.23 m). Solomon R. Guggenheim Museum, New York

Hofmann's teaching in his essays about Matisse, Cubism, and Color-Field painting.

In 1940 Hofmann began experimenting with a drip technique that in a modest way prefigured some aspects of Pollock's work, but he is best known for his canvases of the 1960s in which heavily impastoed slabs of brilliant color assert themselves with forceful yet lyrical intensity. Characteristic of Hofmann's Abstract Expressionist style at its height is *The Gate* (fig. 38–20), painted by the artist in 1960 at the age of eighty, after he had retired from teaching. Its great rectangles of yellow and red are aligned parallel to the picture plane in a balanced asymmetry distantly reminiscent of the grids of Mondrian. But Hofmann's jarring, even dissonant, color patches are imbedded in the rich surface, and the colors change in the more loosely brushed areas from primaries to green, blue, beige, pale yellow, and violet.

By about 1950 it was becoming clear to the loose community of Abstract Expressionist artists in New York that their work had divided into two tendencies, the "action painting" or gestural abstraction practiced by the artists just discussed and another, usually called Color-Field painting or chromatic abstraction. The inventors of the latter were Barnett Newman, Mark Rothko, and Clyfford Still. What both styles had in common were an expanded sense of scale—many paintings were of almost mural size—and a deep commitment to the individual expression of each artist.

STILL Born in North Dakota and raised on the American West Coast and in Canada, Clyfford Still (1904–80) embarked about 1947 on the Color-Field abstractions for which he is best known. This major step followed a long period of growth, during which Still absorbed the work of Gauguin and Miró (both artists had

38-21. CLYFFORD STILL. *1951–N*. 1951. Oil on canvas, 92½ × 69″ (2.35 × 1.75 m). National Gallery of Art, Washington, D.C. Robert and Jane Meyerhoff Collection, Gift (Partial and Promised) in Honor of the Fiftieth Anniversary of the National Gallery of Art

38-21

exploited the effects of large areas of flat color, as would Still) and made pictures of upright figures in immeasurable prairie landscapes. The paintings of Still's mature style are characterized by thick, dry crusts of pigment clearly laid on with a palette knife. One type contains shapes with jagged contours that appear torn, drawn with the palette knife in contrasting colors on unpainted canvas. Another type is nearly monochrome, and large areas of paint, also with jagged contours, cover the entire surface. In *1951–N* (fig. 38–21), an example of the second type, two earthy browns, close to each other in hue and riven by a streak of alizarin crimson, appear to slot tightly into one another. This wall of brown paint is interrupted at the very top by a patch of yellow and at the bottom right by a tiny sliver of blue, most of which is overpainted. Still's composition completely eschews the formal convention of traditional European painting, which dictates that a shape at the right must be balanced by a shape at the left. In its openness the design suggests the vast stretches of wilderness country in the American West.

NEWMAN A born-and-bred New Yorker who studied philosophy at City College and admired the writings of the naturalist Henry David Thoreau and the anarchist Peter Kropotkin, Barnett Newman (1905–70) was a metaphysician who expressed himself in essays and in sculpture as well as in the expansive, chromatic abstract paintings for which he is most famous. Newman believed deeply in the importance of the artist's intellect and rejected some of the fuzzy-minded mythology accumulating about Abstract Expressionism, particularly about Action Painting. He objected to the popular notion that the artist is a mere "intuitive executant . . . largely unaware of what he is doing." Newman destroyed most of the paintings he made prior to 1945 and then embarked on a series with elements of both figuration and abstraction. These new pictures suggest acts of procreation and show how firmly he rejected the rigidly geometric work so prevalent among abstract painters in the United States in the 1930s and early 1940s. Early in 1948 Newman made a breakthrough with a small but crucial painting, *Onement I* (fig. 38–22), that prefigured in its formal qualities his subsequent, much larger abstractions, including five more works done in the same palette and also titled *Onement*. He brushed the sized surface of *Onement I* with dark cadmium-red and placed a strip of masking tape vertically down the center. He then painted the tape with a lighter red-orange, applying the paint so that his brushwork showed—on the one hand avoiding the strict geometry of Mondrian and on the other hand eschewing the obvious painterly flourishes of much Action Painting. He had found a straightforward and dignified manner of working that he felt expressed his metaphysics, and he continued using "zips," as he named his strips of paint, in a large number of symmetrical works with intensely saturated fields of color. It was Newman's large paintings of the 1950s, with their conspicuous absence of depth and broad areas of color, that led the critic Greenberg to describe such works as "fields."

ROTHKO A deeply expressive manner of exploiting the effects of color was worked out slowly by Mark Rothko (1903–70). In the late 1940s Rothko was painting in a biomorphic abstract style close to that of Gorky. Gradually, influenced by the flat color shapes of Matisse, whose work he deeply admired, and also by the large areas of thinned flat color in the figurative paintings of his friend the American artist Milton Avery, he began to eliminate contours around shapes, leaving only color areas without clear-cut edges. Through soft, blurred borders these color areas seem to dissolve into each other as if the artist were emulating in oil (or in the acrylic colors with which he was one of the first painters to experiment) the effect of watercolor allowed to spread on wet paper. In the 1950s Rothko began a majestic series of canvases in which he abandoned all suggestions of figuration in favor of the two or three superimposed rectangular shapes of color with cloudy edges that constitute his dominant theme. These shapes float as if bathed in a continual misty sunset light at sea, seeming to project their hues forward from the canvas surface.

38-22. BARNETT NEWMAN. *Onement I.* 1948. Oil on canvas, 27 × 16″ (68.6 × 40.6 cm). Reproduced courtesy Annalee Newman

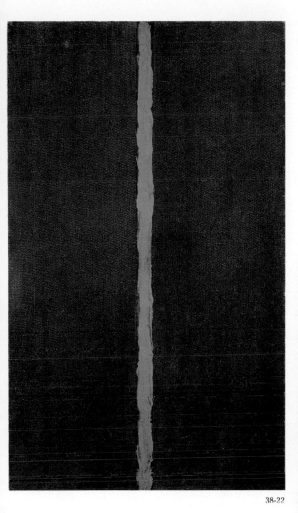

38-22

White and Greens in Blue, of 1957 (fig. 38–23), is typical of Rothko at his greatest. Scale is extremely important in Rothko's pictures (this one is slightly more than eight feet high). He preferred to hang his pictures low so that, as he put it, the observer would have an intimate encounter "at close quarters," and he further encouraged close looking by requesting that his pictures be shown in fairly dim light, requiring the viewer's careful scrutiny. The effect of several Rothkos together in the same room may amount to a mystical experience; one's voice is hushed in their brooding presence. Rothko was commissioned during the 1960s to produce a number of murals, not all of which have survived poor handling and the artist's sometimes careless mixing of materials. The most resonant of these is a group of eight dark maroon and black canvases for a chapel designed by the architect Philip Johnson for the Menil Foundation in Houston, Texas. The murals form a unity provoking intense meditation.

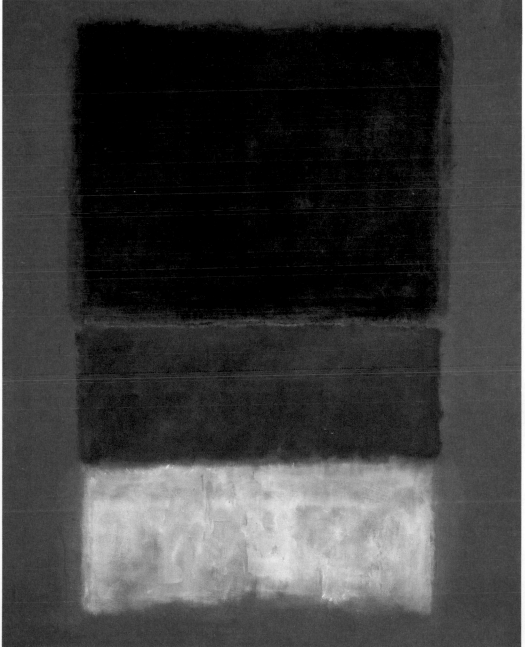

38-23. MARK ROTHKO. *White and Greens in Blue.* 1957. Oil on canvas, 8′4″ × 6′10″ (2.54 × 2.08 m). Collection Mr. and Mrs. Paul Mellon

38-23

The Reaction to Abstract Expressionism

It was perhaps implicit in the intensely emotional nature of the Abstract Expressionist movement that it would soon play itself out. Furthermore, the ground swell of optimism that had followed the end of World War II and helped to encourage the birth of a great American style was no longer a real force, as the disaster of the Korean War moved toward the tragedy of the American involvement in Indochina. Considering the intensity and speed of twentieth-century life as compared with the more relaxed pace of the late-nineteenth century, it is surprising that Abstract Expressionism remained dominant as long as it did before the inevitable reaction set in—a period of about fifteen years, which corresponds more or less to the duration of the Impressionist movement prior to the emergence of the first Post-Impressionist countercurrents. Most of the greater and lesser survivors among the Abstract Expressionists continued to paint in the same vein, and some younger artists also embraced the style with fervor. Some of the latter changed it as well.

THE SECOND GENERATION JOAN MITCHELL (born 1926), a Chicagoan who moved to Paris after attending college and art school and lives there still (an unusual choice for an American of her generation), developed a tough yet lyrical kind of gestural abstraction, grand in scale, that has roots in the work of Kandinsky, De Kooning, and Pollock. The result of both brushwork and pouring techniques, Mitchell's paint application tends to be linear, and this painterly drawing is often organized in verticals and horizontals very distantly reminiscent of the Cubist grid—as in *Hemlock* (fig. 38–24), of 1956. Much of Mitchell's work attempts to express her recollections of experiencing aspects of nature—a particular tree, a hurricane, a glistening lake, or a garden—and in recent years, while maintaining

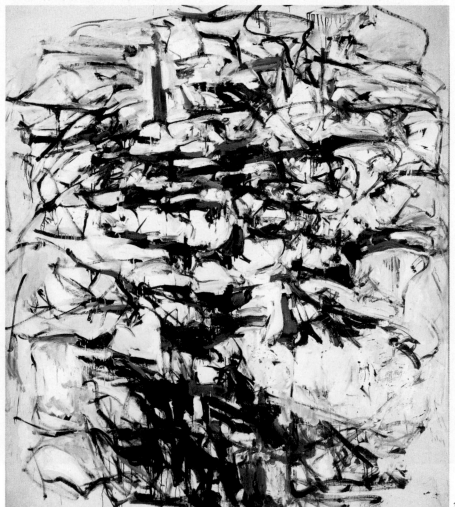

38-24. JOAN MITCHELL. *Hemlock*. 1956. Oil on canvas, 7'7″ × 6'8″ (2.31 × 2.03 m). Collection of Whitney Museum of American Art, New York. Purchase, with Funds from the Friends of the Whitney Museum of American Art

38-24

38-25. Richard Diebenkorn. *Seated Figure with a Hat*. 1967. Oil on canvas, 60 × 60″ (1.52 × 1.52 m). National Gallery of Art, Washington, D.C. Gift of the Collectors Committee and Partial Gift of Mr. and Mrs. Lawrence Rubin

her linear style, she has developed into a brilliant colorist. Indeed, in her work of the 1980s echoes of Monet's late landscapes can be discerned in canvases overflowing with the energies of water, wind, plant life, and sunlight.

Richard Diebenkorn (born 1922) worked initially in the San Francisco Bay area where, beginning in the late 1940s, he at first produced a rich group of Abstract Expressionist paintings influenced particularly by the gestural style of De Kooning but also reflecting the colors and patterns of Matisse. These culminated in his *Berkeley* series, of 1953–55, abstract landscapes based loosely on views of the hilly East Bay. The following year Diebenkorn (like several other Bay Area painters, such as David Park and Elmer Bischoff, about the same time) embarked on a long exploration of figurative painting. While Diebenkorn's works in this vein included landscapes and still lifes, he focused chiefly on the human figure, often a woman seated alone in an interior or on a porch. For *Seated Figure with a Hat* (fig. 38–25), the artist's wife, Phyllis, was the model, though her features are obscured. This painting of 1967 is a late example of Diebenkorn's pared-down yet opulent style of figuration. He has curtailed the painterliness of his earlier work, reduced the number of compositional elements from paint strokes to planes that lock together, and placed the figure in a shallow yet ambiguous space made to appear flat by his lush application of layers of paint. The next year, with his still-continuing *Ocean Park* series, Diebenkorn turned once again to abstraction, this time making quasi-geometrical arrangements of lines and planes in mixtures of pastel and more saturated color.

COLOR-FIELD AND HARD-EDGE PAINTING As the more painterly and more gestural wing of first-generation Abstract Expressionism diminished somewhat in influence during the 1950s, the example of such Color-Field innovators as Newman and Rothko seemed to a number of artists of the next generation a more significant direction to explore. As a young artist Helen Frankenthaler (born 1928) was deeply affected by Pollock's 1951 exhibition of new, partly figurative pictures in which skeins of narrow black lines broadened into puddled areas and fuller strokes of thinned paint that stained the canvas. After visiting Pollock at work in his studio,

38-26. HELEN FRANKENTHALER. *Mountains and Sea.* 1952. Oil on canvas, 7'2⅝" × 9'9¼" (2.2 × 2.97 m). Collection the artist, on extended loan to the National Gallery of Art, Washington, D.C.

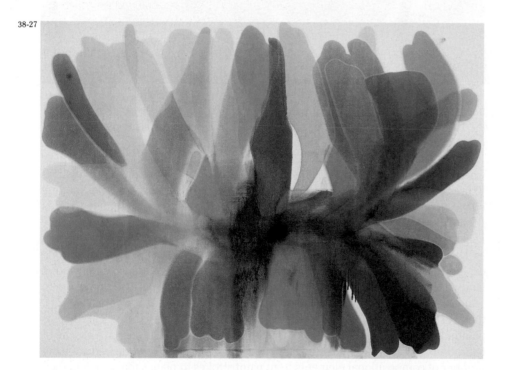

38-27. MORRIS LOUIS. *Point of Tranquility.* 1959–60. Magna on canvas, 8'5¾" × 11'3¾" (2.59 × 3.43 m). Hirshhorn Museum and Sculpture Garden, Smithsonian Institution, Washington, D.C. Gift of Joseph H. Hirshhorn, 1966

Frankenthaler soon developed her own manner of pouring diluted oil (and, later, acrylic) paint onto raw cotton duck. The liquid color stained the canvas in organic-looking pools, which Frankenthaler further manipulated by brushing, rubbing, and blotting. *Mountains and Sea,* of 1952 (fig. 38–26), was the first major work she created with this new technique, and it remains one of her most lyrical master-pieces. Unlike many Abstract Expressionists who worked with a heavily loaded brush, Frankenthaler's manner of staining the canvas in thin washes actually fused nonobjective figure and ground in a radical new way, permitting her paintings to have atmosphere and yet to appear flat because most of the color was in, not on top of, the raw canvas.

As a young artist, MORRIS LOUIS (1912–62) was based in Washington, D.C., but kept in touch with developments in New York through Clement Greenberg, who invited both Louis and Louis's colleague in exploring chromatic abstraction, Ken-

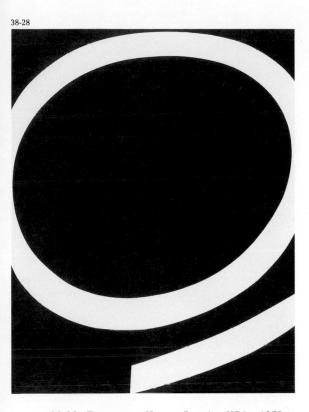

38-28. ELLSWORTH KELLY. *Running White*. 1959. Oil on canvas, 88 × 68″ (2.24 × 1.73 m). Collection, The Museum of Modern Art, New York. Purchase

38-29. AGNES MARTIN. *Night Sea*. 1963. Oil and gold leaf on canvas, 6 × 6′ (1.83 × 1.83 m). Private collection

neth Noland, to Frankenthaler's studio in 1953. There they examined her *Mountains and Sea* and were impressed by its qualities of flatness and luminosity and by her staining technique. Louis gradually began to develop paintings based entirely on staining unsized, unprimed cotton duck with heavily diluted acrylic paint in strong, luminous colors. The paint permeated the canvas so completely that, as Greenberg put it, the eye could sense the "threadedness and wovenness of the fabric." It seems that Louis usually poured his paint vertically down the canvas, using the flow of gravity to create diaphanous, fanned-out forms, as in *Point of Tranquility,* of 1959–60 (fig. 38–27). Pale yellow and richer colors—red orange, blue green, violet, pink, and dark green—flow over one another yet appear contained within the surface.

In addition to second-generation Abstract Expressionism and stained Color-Field abstraction, another kind of abstract painting known as Hard-Edge, distinctly nongestural, developed in the 1950s. These pictures differed greatly from the Cubist-inspired, balanced geometric abstraction of the 1920s and 1930s, whose leading practitioner was Mondrian. Among the pioneers was ELLSWORTH KELLY (born 1923), whose work was in its early stages partly inspired by the free forms of Arp and the cutouts of Matisse. After attending the art school of the Museum of Fine Arts in Boston, Kelly moved to Paris in 1948, and there he remained for six years, developing both monochrome white reliefs and paintings composed of several separately stretched, rectangular panels of pure, evenly applied oil in contrasting colors and in black and white. Having worked in considerable isolation from the New York scene, Kelly moved to what had become the art capital of the world in 1954. He began to expand the size of his canvases and to develop his compositions in new ways. One direction was the two-color painting with a single large, flat form on a ground of contrasting color. Often the single form appeared to bulge out at the perimeter of the canvas even though it did not actually touch the edges. In another type of picture—for example, *Running White,* of 1959 (fig. 38–28)—the forms touch the edges of the canvas in several places and, by strong implication, extend beyond them into the space of the observer. Kelly went on to make a number of two-color and monochrome canvases cut in nonrectangular shapes, such as lozenges and irregular parallelograms, declaring that the white walls on which he wished them hung constituted a kind of "ground." He also created a large number of strictly planar sculptures in a variety of single materials: flatly painted aluminum, stainless steel, Cor-ten steel, and bronze. These were produced by fabricators under his direct supervision.

A close friend of Kelly's from the time in the late 1950s and early 1960s when both artists had studios on different floors of an inexpensive waterfront building in lower Manhattan, AGNES MARTIN (born 1912) developed exquisitely refined, six-foot-square, pale pastel paintings often with the sparest of means, such as repeating parallel lines or grids. Sometimes these are eked out in fine pencil strokes that show slight changes in pressure from the artist's hand, giving the effect that a human presence has gentled the rigid geometry of the composition. In *Night Sea,* of 1963 (fig. 38–29), Martin first put down a layer of slate-blue oil paint and over this laid down a grid of thin lines in gold leaf. Within each rectangle of the gold-leaf grid she then painted another layer of blue, so as to create a slightly uneven relief surface that shimmers in the light and appears to breathe. A reclusive person, Martin has lived since the late 1960s in New Mexico but continues to show her work regularly in New York.

There were also more radical manifestations of independence from the aims and methods of Abstract Expressionism among artists who were deeply admiring of the first great American style but wished to assert their own originality. Soon it began to appear to interested observers of the art world that a new movement was emerging every few years: Neo-Dada, Environments and Happenings, Pop Art, Op Art,

Minimal Art, Kinetic Sculpture and Light Sculpture, Postminimal Art, Performance Art, Earth Art, Process Art, Body Art, Conceptual Art, Photo-Realism, Neo-Realism, and Neo-Expressionism—to name the best known. The variety and complexity of the new artistic movements of the later 1950s and of the 1960s, 1970s, and 1980s can only be suggested here.

NEO-DADA, EARLY MINIMALISM, AND POP ART Although, like most stylistic labels invoked to describe a new art movement, the term "Neo-Dada" is neither very accurate nor very helpful, it was used by numerous critics during the 1950s to characterize the startlingly innovative and subsequently very influential art of two New York painters, both raised in the South, ROBERT RAUSCHENBERG (born 1925) and JASPER JOHNS (born 1930). Rauschenberg's combine paintings, as he called his wall-hung works that incorporated found objects, at first reminded observers of the collages of Kurt Schwitters (see fig. 37–11), and Johns's deadpan wit and cerebral approach to making art seemed in several respects reminiscent of Duchamp; thus, the Neo-Dada label.

Rauschenberg enrolled in 1948 at Black Mountain, which during the 1940s and early 1950s was an important experimental arts college in North Carolina, in order to study with the painter Josef Albers, yet another influential émigré modernist, who had taught at the Bauhaus in Germany (see page 1072). At Black Mountain, Rauschenberg also met John Cage, an avant-garde composer, musician, and writer. Cage was a great admirer of Duchamp, and his importance as a transmitter of Duchamp's ideas—particularly the Dada artist's interest in cultivating the effects of accident in art and in soliciting the interpretations of a succession of viewers as a way to gather a variety of meanings for a work of art—was to be momentous for Rauschenberg and, slightly later, for Jasper Johns. In due course, many artists who came of age in the late 1950s and 1960s were profoundly influenced by the maker of the *Large Glass* as critical study of his work and thought proceeded apace.

Rauschenberg first exhibited his work in New York in 1951 at a gallery that showed the leading Abstract Expressionists, and, characteristically ebullient, he poked a little fun at what he perceived to be the pessimism and anxiety of the older artists in a number of works of the early 1950s, including a series of flat, white, monochrome paintings. *Tabulae rasae* of artistic style, these pictures have, in fact, no marks upon them at all. Another such work, probably made in response to the spirit of adulation with which the art of the reigning masters was being received, was Rauschenberg's *Erased De Kooning Drawing,* of 1953. The deadpan title indicates why this work does not need illustration. It was just that, a gilt-framed and glazed erasure of a grease-pencil and crayon drawing given to Rauschenberg by an amused De Kooning (who had earlier with considerable wit described Duchamp as a "one-man movement"). In fact, Rauschenberg greatly respected the achievements of the Abstract Expressionists, particularly the scale of their paintings, and he borrowed their painterly strokes and drips as a kind of glue to join the found-object parts of his combine paintings. These wall-hung assemblages are typically laid out on the canvas in a gridlike composition, with the individual rectangles set slightly askew to one another. During the 1950s, in the combines with found objects Rauschenberg reinvented the medium of collage, changing it from the Cubists' conception—small scissored bits which together add up to a whole image of some other thing, such as a still life—to something quite different: an accretion of found forms left more or less intact as recognizable entities and presented at the same scale as the people observing them. *Canyon,* of 1959 (fig. 38–30), is a stunning example of one of these skewed, gridded combines. The canvas is studded with found images that relate to one another and resonate yet do not narrate. These include a photograph of a young boy with his arm raised toward the sky; a print of the Statue of Liberty with her hand raised to lamplight the heavens; and, clearly about to soar skyward as well as forward into the viewer's space, a stuffed eagle, its wingspread contained by the visual rectangle of the picture. The bird is perched

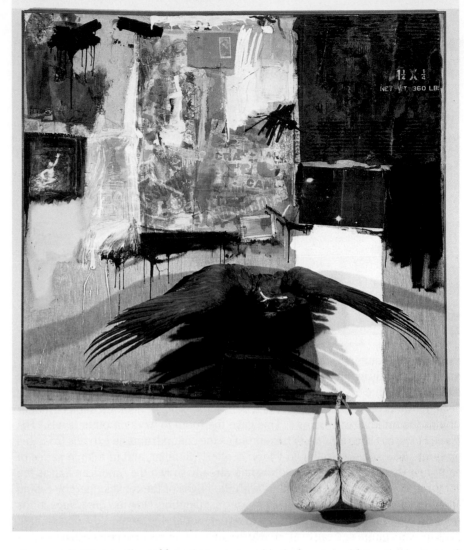

38-30. ROBERT RAUSCHENBERG. *Canyon.* 1959. Combine painting: oil, pencil, paper, metal, photograph, fabric, and wood on canvas, with buttons, mirrors, stuffed eagle, cardboard box, pillow, and paint tube; 81¾ × 70 × 24″ (208 × 178 × 61 cm). Collection Ileana Sonnabend, New York, on indefinite loan to the Baltimore Museum of Art

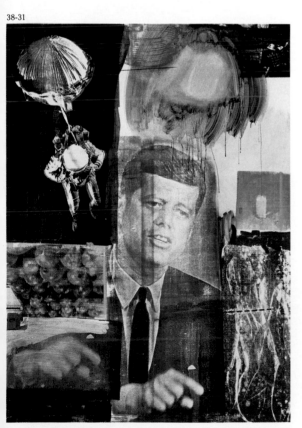

38-31. ROBERT RAUSCHENBERG. *Retroactive I.* 1964. Oil on canvas, 84 × 60″ (2.13 × 1.52 m). Wadsworth Atheneum, Hartford, Connecticut. Gift of Susan Morse Hilles

over a projecting cardboard box that acts as a kind of nest, and from the bottom of the canvas more nesting material dangles and projects outward in the form of a feather-stuffed pillow.

Photography and printmaking have greatly interested Rauschenberg throughout much of his career. His one-of-a-kind paintings are too costly for most people to buy, and by choosing to work in the reproductive mediums and in multiple editions he has found patrons among his less-affluent admirers. Indeed, on several occasions he has made fine-art prints in huge quantities (editions of up to two thousand), and in one case he arranged to distribute a photo-offset print randomly, so that it arrived in the morning newspaper of certain fortunate subscribers to the *Miami Herald.* In 1963 Rauschenberg introduced a reproductive technique into his painting. He had large photo silk screens made of certain images, for example, a parachuting astronaut, President John F. Kennedy, a group of apples, hard-hatted laborers, dancers in motion, and so on. These he inked and screened directly onto stretched canvases in the gridlike compositions he prefers and then added occasional strokes and drips of paint. Each of these paintings was unique, though Rauschenberg used some of the individual silk screens on several different canvases, occasionally changing their orientation or their color, and also repeated a few on the same canvas. In *Retroactive I,* of 1964 (fig. 38–31), in which the different spherical shapes appear to bounce off one another, brown-black paint drips down the screened image of Kennedy's head, inevitably evoking memories of his assassination, and Rauschenberg has twice repeated the screened image of the president's characteristic hand gesture of emphasis, thereby pointing a finger at the reproductive technique he used in this painting.

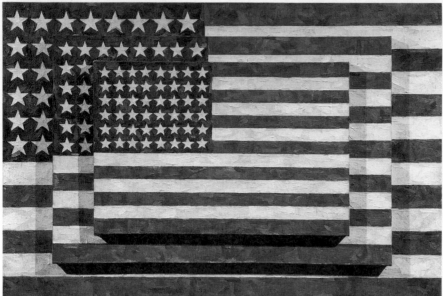

38-32

38-32. JASPER JOHNS. *Three Flags*. 1958. Encaustic on canvas, 30⅞ × 45½ × 5″ (78.4 × 115.6 × 12.7 cm). Collection of Whitney Museum of American Art, New York. Fiftieth Anniversary Gift of the Gilman Foundation, Inc., The Lauder Foundation, A. Alfred Taubman, an anonymous donor, and purchase

Largely self-taught as an artist, Jasper Johns (like Rauschenberg, with whom he was very friendly in the 1950s) was credited early in his career with bringing clearly recognizable imagery back to avant-garde art and with presenting it in a seemingly detached and often puzzling manner. Johns has said he took as subject matter "things the mind already knows. This gave me room to work on other levels." His *Three Flags*, of 1958 (fig. 38–32), exemplifies the conundrums he extracts from this program. The subject itself, Old Glory, is utterly familiar, and in a large series of paintings, drawings, and prints Johns had already shown the American flag as the flat thing it is, its edges coterminous with the edges of the canvas, thereby calling attention to the issue of flatness in all modernist painting. Now in *Three Flags* Johns went the anti-illusionism of modernism one better and presented the flag painted on three superimposed canvases in what appears to be reverse perspective, so that the flat, two-dimensional image projects forward, into the viewer's real space. The flags are painted in encaustic, an ancient Roman technique in which wax is used as a vehicle for the pigment, and in Johns's hands this results in a seductively rich, tactile surface, as painterly in its way as any Abstract Expressionist canvas. The blunt, cool image and the lush handling also confound one another, so that the meaning of the painting seems to be as much about issues of art as it is about what the flag as a sign of the United States might suggest: patriotism or, at the time Johns made the work, the nationalist politics of some partisans of the Cold War or a Revolutionary War hero after whom Johns was named, Sargeant William Jasper, who raised the flag in a heroic military action. In his masterpiece of the early 1960s, *According to What* (fig. 38–33), a sixteen-foot-wide oil painting on six separately stretched, joined canvases, Johns's imagery constitutes both a compendium of stylistic allusions and a veritable encyclopedia of kinds of signification. There is painted lettering, both stenciled on the canvas and in the form of three-dimensional aluminum letters, attached with hinges; there is a spectrum of color; a gray scale; gestural painting; Hard-Edge painting; a combination of gestural and Hard-Edge brushwork that appears to mimic Hans Hofmann (see fig. 38–20); silk-screen printing, in the form of a newspaper column that repeats horizontally across the canvas; and an indication of the scale of the real world in the form of a bent clothes hanger from a dry-cleaner's shop, which projects from the canvas and casts yet another kind of representation, a shadow. The painting in fact pays homage to Duchamp's *Tu m'* (see fig. 37–9), itself rich with different kinds of representation and a projecting found object. Duchamp himself makes a cameo appearance in *According to What*, in the form of a view of his profile on the back of the little canvas

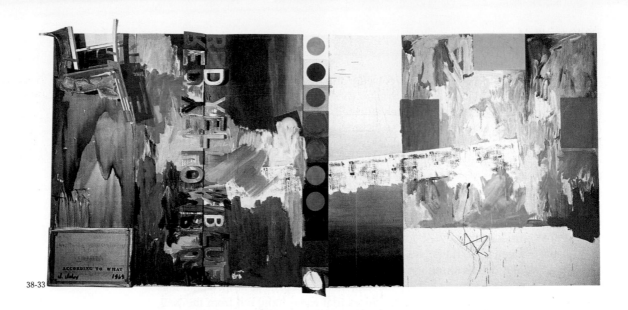

38-33. JASPER JOHNS. *According to What.* 1964. Oil on canvas with objects, 7'4" × 16' (2.24 × 4.83 m). Private collection

attached by hinges and hooks at the extreme lower left. Like *Tu m'*, Johns's picture challenges the mind as well as the eye. An occasional maker of sculpture—a well-known example is *Painted Bronze,* of 1960, a carefully painted cast, executed to scale, of two Ballantine Ale cans—Johns is one of the greatest printmakers of the postmedieval era. He continues to make art at the highest level of quality into the 1990s.

In terms of the issues his short-lived career raised, Rauschenberg's and Johns's Neo-Dada counterpart in Europe was the French artist YVES KLEIN (1928–62). An often outrageous provocateur, Klein was a painter, sculptor, and pamphleteer whose work embodies a range of meaning that shuttles between the utopian and the conspicuously fraudulent—"conspicuous" in the sense that his tricks are not really concealed but are typically left for the observer to notice, as in a seamless photomontage he made of himself soaring upward off a wall as if to fly, on the front page of a faked edition of a Paris Sunday newspaper. He not only painted on occasion with flames, he also took pains to have himself photographed doing so, holding not a mere candle but a large blowtorch. Among his well-known capers (events that were not unlike American "Happenings" of the same period; see pages 1048–49) was his 1958 exhibition in Paris called "Le Vide" ("The Void"), which consisted of a totally empty art gallery presented as a work of art or, as he termed it, "immaterial pictorial sensibility."

Klein is perhaps most famous for his monochrome pictures covered with a home-mixed ultramarine paint that he bound with a synthetic resin so that after it dried the pigment itself was left looking pure, dry, and powdery. With characteristic immodesty he called the paint "I.K.B." for "International Klein Blue." Klein's monochrome paintings are made of thin cotton stretched over rectangles of board with slightly curved corners, and Klein intended them to be hung some inches in front of the wall, to emphasize their object-like qualities. At his first one-person exhibition of the blue panels, in 1957, Klein showed eleven that were identical in size and facture; however, he charged a different price for each, thus mocking the commercial side of the art world to which he belonged. He also made reliefs, such as *Requiem* (fig. 38–34), of 1960, on which sponges and pebbles impregnated with I.K.B. are distributed on the board surface in a quasi-random fashion, like stones deployed in a Zen garden. Klein used his I.K.B. to make what he called Anthropometries, by having his nude female models cover themselves with the paint and imprint themselves on canvas. For all his jokes, Klein shared with Rauschenberg, Johns, and a number of other artists of their generation an interest in invading the space occupied by the observer, thus disregarding the traditional interest in fictional space behind the picture plane, and he shared with abstract painters as different as Rothko, Ellsworth Kelly, and Frank Stella an enthusiasm for the radiant power of highly saturated color.

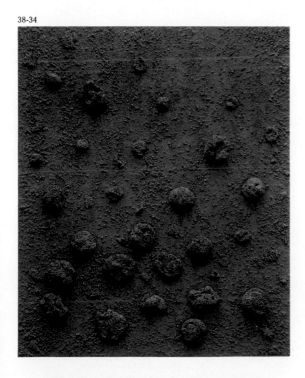

38-34. YVES KLEIN. *Requiem.* 1960. Sponges, pebbles, and dry pigment in synthetic resin on board, 78⅜ × 64⅞ × 5⅞" (199 × 165 × 14.9 cm). Courtesy of The Menil Collection, Houston, Texas

It is appropriate in this context to consider the early work of the brilliant and precocious abstract painter FRANK STELLA (born 1936), who as an artist just emerging from college was immediately affected by seeing, in the late 1950s, the *Flags* and *Targets* of Jasper Johns. These pictures of single, whole images that cover the entire field of the canvas—particularly the *Targets,* with their concentric circles and deep sides—suggested to Stella that he might make paintings based not on the gestural acting-out of his emotions but rather on a predetermined concept. Stella almost immediately developed a series of paintings of a single color, black, laid down sparely, symmetrically, and evenly in a concentric arrangement of stripes of equal width, separated by thin interstices of bare canvas. (The black paintings were *seen* almost immediately as well, for they were included in a group exhibition of new talent, "Sixteen Americans," held at the Museum of Modern Art in New York in 1959, making the twenty-three-year-old painter famous overnight.) Because the stretcher bars of Stella's canvases were several inches deep, these striped paintings projected forward and, like the panel pictures that Klein hung out from the wall, they looked like objects. Klein painted the sides of his panels, but Stella did not because he wished to emphasize the picture surface; he nevertheless intensified the "objecthood" (a slablike quality) of most of these pictures by changing the shape of the canvas from strictly rectangular to one of a variety of always symmetrical geometric forms. *Avicenna* (see Introduction fig. 28), one of a striped series in aluminum paint from the following year, for example, has notched corners and a rectangular opening at the center. The shape of the canvas, a design Stella established before he began to paint, determined the entire composition of evenly spaced stripes. In the course of the 1960s Stella's paintings grew very large, and he developed a number of variations on the pictorial problems he set himself. His repertory of color expanded too, and his metallic paints—the aluminum series was followed by a copper series and then by paintings in other metallic hues—as well as his austere presentation of forms, influenced Minimal sculpture and Pop painting as they developed almost apace with his work.

During the later 1960s, and in the 1970s and 1980s, Stella worked in series after series of large-scale paintings, which were given their titles after completion; the paintings grew eventually into deep reliefs. Their formal and coloristic variety and richness are impossible to summarize here; the shapes were partly based on the shapes of drafting instruments, such as T-squares, protractors, templates ("french curves"), and so on. In spite of their enormous size, the *Protractors* of the late 1960s, which consist wholly of superimposed and intersecting arcs painted in jarring Day-Glo, and the exquisitely calculated *Concentric Squares* of the early 1970s, in polymer, are still painted on canvas supports. But for his great honeycomb aluminum reliefs of the late 1970s and the 1980s, Stella made preliminary maquettes (small-scale models), which he sent to a factory for execution. These monumental layered constructions, recently including elements of fiberglass, magnesium, and sheet steel, were then etched and painted in the artist's studio. In the course of the 1980s, Stella became absorbed in a study of Baroque art, not only for its exuberance of form and color but also for its overflow into the observer's space. His magnificent later series include *Exotic Birds, Indian Birds, Circuits,* and a sequence with titles borrowed from Italian folklore. In works of 1991, Stella's explosive metal reliefs grew into fully freestanding sculpture.

The term "Pop Art" originated in England, where a group of British artists and intellectuals, among them the painter Richard Hamilton, the architectural historian Reyner Banham, and the art critic Lawrence Alloway, were the spirits behind a 1956 exhibition, "This Is Tomorrow," which surprised its audience by focusing laudatory attention on aspects of contemporary popular culture, particularly that produced by Hollywood, by Detroit in the form of shiny tail-finned cars, and by the mass media, including American advertising. By the early 1960s, however, after the appearance of Johns and Rauschenberg, the term "Pop Art" came to be applied chiefly to the fine arts, usually to paintings with imagery quoting popular culture or

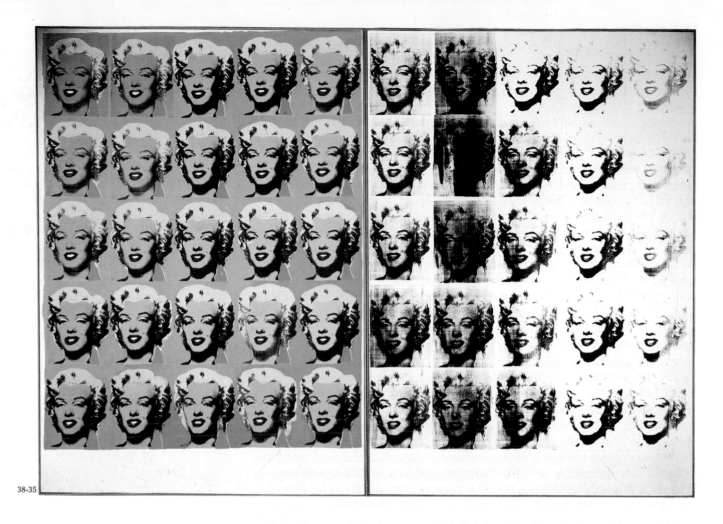

38-35. ANDY WARHOL. *Marilyn Diptych*. 1962. Acrylic and silk-screen ink on canvas; two panels, each 82 × 57″ (2.08 × 1.45 m). The Tate Gallery, London

the mass media. Like the hard edges of Ellsworth Kelly's pictures or the crisp, implacable surfaces of Stella's early paintings, much Pop art was characterized by a high degree of rigorous craftsmanship and neatness, as if to bypass definitively the expressive, gestural paint-handling of the many followers of De Kooning. In the parlance of the 1960s, Pop Art was "cool," and, like Minimal sculpture contemporary with it, its products were planned out before they were executed.

Pop Art's best-known practitioner, ANDY WARHOL (1930–87), was raised in Pittsburgh and studied both painting and commercial design at the Carnegie Institute of Technology there. In 1948 he moved to New York, where by the early 1950s he had become a very successful commercial graphic artist, making illustrations—chiefly rather elegant, quirky line drawings—for fashion magazines, Christmas cards, book jackets, and record covers. In the first years of the 1960s Warhol went from producing such personalized drawings *for* the mass media to making paintings that were enlargements of images he selected *from* the mass media and presented in deadpan fashion: frames from comic strips such as "Dick Tracy"; dance-step diagrams; paint-by-numbers kits; the front pages of tabloid newspapers; and so on. At first, with the aid of an opaque projector, he closely reproduced the media images by hand in acrylic on canvas. At some time in 1962 he began to use photo silk screens to apply images to canvas, usually in multiple form, and his repertory expanded to include such common, ordinary subjects as Campbell soup cans, the *Mona Lisa* (which had been loaned by the Musée du Louvre to American museums in 1962), and images of such celebrities as Elizabeth Taylor, Jacqueline Kennedy, Elvis Presley, and Marilyn Monroe. In the two-panel *Marilyn Diptych* (fig. 38–35), of 1962, a grid of twenty-five black-on-silver film-still images of the face of Monroe (by then a suicide) adjoins a grid of twenty-five multicolored versions of the same image. Having located the star on a "silver screen," Warhol appears to be commenting both on the ubiquity of her face in the

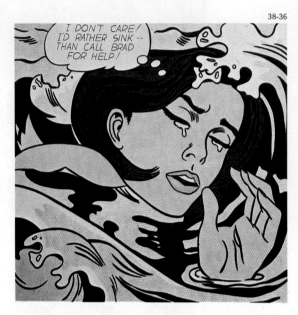

mass media and on Jasper Johns's practice at that time of painting a subject in color and then in a kind of *grisaille* (grayish monochrome).

Warhol's best-known utterance was his response to an interviewer that he believed everyone would be famous for fifteen minutes—a remark that indicates his understanding of America's fascination with celebrity (including his) and with democracy. There is no doubt that the subject of glamour interested him hugely, especially, perhaps, in combination with tragedy, and his parallel, very successful career as a maker of underground films produced a cast of mock superstars who became famous for brief periods. Warhol also produced photo-silk-screened paintings during the 1960s of what he termed "disasters," such as car crashes, empty electric chairs, and race riots, and much later in life a series of photo-silk-screened skulls. In 1963 he embarked on his first silk-screened portraits—of Pop art collector Ethel Scull—using photos from a booth in an arcade as the basis for his silk screens; later he did many serial portraits using Polaroids he took himself. Through much of his career he chronicled the vapid social life in which as a celebrity he engaged, and he produced diaries for publication by having an acolyte transcribe and edit the reports on parties that he recorded daily by speaking into a tape recorder. As the 1960s, 1970s, and 1980s recede into historical perspective, Warhol appears to have been a brilliant social critic of both the glitter and the harsher aspects of American life in those decades.

ROY LICHTENSTEIN (born 1923) made comic-book–style sketches of Walt Disney animals for his sons in the late 1950s, when he was still painting as an Abstract Expressionist. In 1961, working independently of Warhol but at just the same time, he began to make serious paintings that derive—with considerable editing and sharpening of composition—from single panels in war comics and romance comics as well as from printed ads for household goods, golf balls, and the like. By drawing from the wellsprings of sentimentalized popular culture, as he did for *Drowning Girl,* of 1963 (fig. 38–36), Lichtenstein was able to hint at emotions in a painting without being sentimental, since the irony of using a popular style in a work of high art was at that time overriding. Lichtenstein did not so much copy any particular comic-book artist's stylistic handwriting but rather developed a generic one that he has employed ever since, in various stages of development as his own work has become famous. Using both Magna (a trade name for acrylic colors, underpainting, and varnishes) and oil paint, Lichtenstein imitates by hand the tiny dots of Benday screens, which are used in mass-media photoengraving to establish tonal values. Lichtenstein's "Benday" dots are made by painting through stencils, and the tedious work is often performed in his studio by assistants. The style is thus essentially a graphic one, supplemented by filling in flat, outlined areas with cleanly laid-down color. Lichtenstein apparently wished to simplify and clarify representational art so that it had the visual impact of contemporary Hard-Edge painting. Almost immediately after introducing his Pop subject matter—the comic-book subjects and objects of everyday use—he began to make paintings in which the comic-book, Benday-dot style is used for quoting subjects drawn from high art, such as the ones reproduced in this book: paintings by Cézanne as diagrammed by Erle Loran, a studio-art professor from California, in a book on Cézanne's method of composition; works of Picasso from the 1930s; a classical Greek temple of Apollo; the pyramids at Giza; Monet's *Rouen Cathedral* series; isolated Abstract Expressionist brushstrokes rendered in clean lines and with crisply edged drips; and Surrealist, Futurist, and De Stijl art. Most recently, in 1991, Lichtenstein has carried wry quotation to new levels, in a series of *Interiors* at virtually the scale of the real world, wherein works of art by other artists are shown hanging in clichéd living rooms. His capacity to sustain formal punch and ironic humor at a high level of quality throughout his work, including printmaking in sundry mediums and flat, linear sculpture, has been remarkable.

Among the wittiest of the Pop artists is the painter-sculptor CLAES OLDENBURG (born 1929), who has taken ordinary mass-produced objects and foodstuffs from

38-36. ROY LICHTENSTEIN. *Drowning Girl.* 1963. Oil and synthetic polymer paint on canvas, 67⅝ × 66¾″ (1.72 × 1.7 m). Collection, The Museum of Modern Art, New York. Philip Johnson Fund and gift of Mr. and Mrs. Bagley Wright

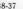

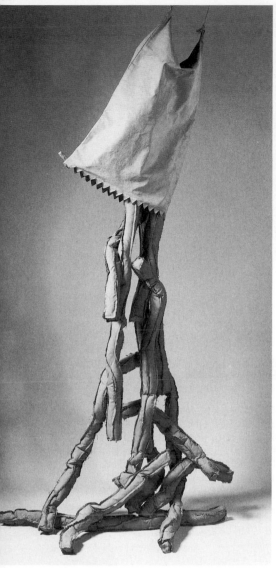

American life and reproduced them in three dimensions, at first in actual size in messily painted plaster, soon after immensely enlarged in fabric that was sewn, stuffed with kapok or foam, and painted. A 1962 *Giant Hamburger,* for example, six feet in width, was shown resting on the floor; *Shoestring Potatoes Spilling from a Bag,* of 1966 (fig. 38–37), is nine feet tall and hangs from the ceiling. Next it occurred to Oldenburg that standard objects on which we rely—wall switches, pay telephones, typewriters, toilets—could also be made in soft materials and shown as if collapsing. Oldenburg also designed colossally enlarged cigarette butts, scissors, peeled bananas, toilet floats, and teddy bears with mock seriousness as monuments for a variety of appropriate urban locations. Some have actually been set up, with immense, if controversial, effect. The most controversial of all was *Lipstick Ascending on Caterpillar Tracks,* of 1969. This mock tank is an antiwar monument Oldenburg constructed at the height of the Vietnam War. Himself an alumnus of Yale University, he sited the *Lipstick* at his alma mater in a plaza facing an earlier Neoclassical war memorial. There its pink-red vertical cylinder, rising to a height of twenty-four feet, mocked both the Corinthian columns on the site and the virility of the United States military, and irate members of the Yale community eventually effected its removal. (Interestingly, it was at Yale in 1981, in a distant echo of the controversy surrounding Oldenburg's antiwar *Lipstick,* that an undergraduate student of architecture, Maya Lin, produced the winning entry in the national competition to design the *Vietnam Veterans Memorial* for Washington, D.C.; see fig. 38–50.) In the long run, the power of an Oldenburg image remains after the laugh is over. His work is, in reality, a searing commentary on the trivial qualities of modern urban existence, drained not only of spiritual qualities but also of genuine physical satisfactions.

A number of artists working in California have been linked closely to Pop Art, among them WAYNE THIEBAUD (born 1920) and ED RUSCHA (born 1937). Thiebaud, who lives both in Sacramento, where for many years he was an inspiring teacher of art at the University of California at Davis, and in San Francisco, whose steep hills are a prominent subject of his paintings of the 1970s, in fact thinks of himself as a traditional artist and has a high regard for painters in the realist tradition, such as Vermeer, Chardin, and Eakins. In the course of the 1950s he worked in the still-life

38-37. CLAES OLDENBURG. *Shoestring Potatoes Spilling from a Bag.* 1966. Canvas, kapok, glue, and acrylic, 108 × 46 × 42″ (2.74 × 1.17 × 1.07 m). Walker Art Center, Minneapolis. Gift of the T. B. Walker Foundation, 1966

38-38. WAYNE THIEBAUD. *Cakes.* 1963. Oil on canvas, 60 × 72″ (1.52 × 1.83 m). National Gallery of Art, Washington, D.C. Gift in Honor of the Fiftieth Anniversary of the National Gallery of Art from the Collectors Committee, the Fiftieth Anniversary Gift Committee, and the Circle, with additional support from the Abrams family in memory of Harry N. Abrams

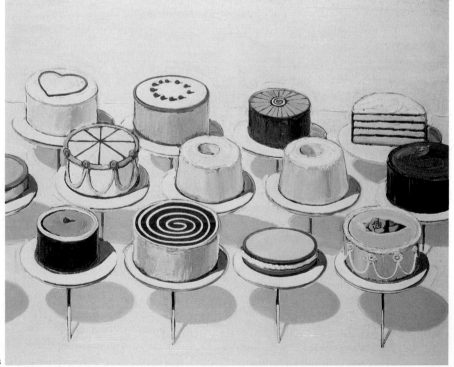

38-38

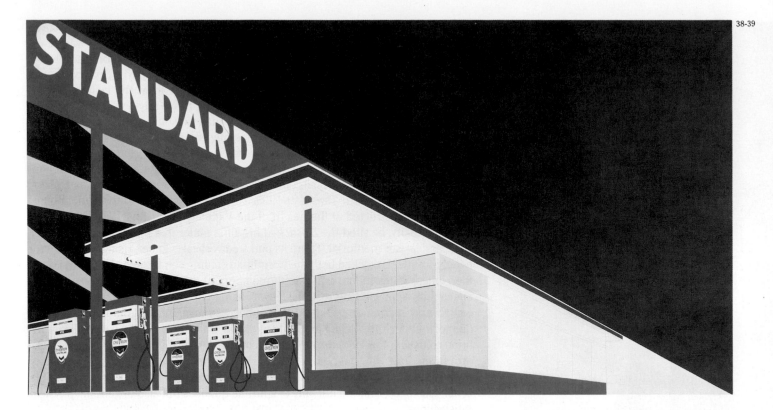

genre, but instead of painting traditional still-life subjects—artful tabletop arrangements of partially eaten fruit, bread, oysters, lemon peel, or nuts—Thiebaud gradually developed an imagery of contemporary equivalents: mass-produced American food, such as candy apples, hot dogs, pies, and jawbreakers in gumball machines. Although Thiebaud's foods are not brand-name goods, he tends to paint them in a straightforward, serial fashion, as the confections in his *Cakes* (fig. 38–38) are presented, and this, as much as the store-bought look of his foodstuffs, has linked him to Pop Art. The baker's dozen of celebratory cakes, viewed as if through a shop window or display case, are richly decorated with frosting, and in this monumental picture of 1963 Thiebaud has applied his oil paint in a heavy impasto with tremendous skill to create, almost literally, the feel and appearance of icing. It is an effect—he calls it "object transference"—for which he is well-known, and one he has repeated with a flourish when depicting other gooey substances, such as mustard. Close looking reveals also that Thiebaud is an extraordinarily fine colorist, who edges his objects with near-rainbows of hue. His is a system of modeling with color, rather than shading from light to dark, that derives from Cézanne, and it carries within it the intensity of color that characterizes the work of such an abstract painter as Morris Louis (see fig. 38–27).

Ed Ruscha, raised in Oklahoma City, moved to Los Angeles in 1955 to study art at the Chouinard Art Institute, a school known then as a training ground for Walt Disney animators and graphic designers. He majored in painting, also studied graphic design, and found fascinating the experience of seeing Jasper Johns's work in 1958—particularly a painting titled *Tennyson* because it contains the British poet's name in bold lettering. Ever since that date, words in a variety of forms—for example, in type styles taken from comic strips ("Little Orphan Annie") and from logos ("20th Century–Fox")—or in lettering invented by the artist to simulate viscous liquids, have occupied a central place in Ruscha's paintings, drawings, and fine-art prints. Sometimes his manner of presenting a word visually emphasizes its power to signify, as when he paints "Annie" in the familiar funny-paper type of her strip. At other times Ruscha may paint a word—"HONK," for example—in pale pastels, as if trying to render the meaning mute. His own particular invention are

38-39. ED RUSCHA. *Standard Station, Amarillo, Texas.* 1963. Oil on canvas, 5'5" × 10'1⅝" (1.65 × 3.09 m). Hood Museum of Art, Dartmouth College, Hanover, New Hampshire. Gift of James J. Meeker, Class of 1958, in memory of Lee English

carefully crafted, small printed books that offer deadpan photographs of ordinary buildings or sites such as parking lots or, as its title indicates, *Every Building on the Sunset Strip.* These present a cool, unvarnished view of southern California in the early 1960s. Ruscha's first little book, *Twenty-Six Gasoline Stations,* contained captioned photographs of humdrum gas stations on Route 66 between Oklahoma City and Los Angeles. One of these photos, "Standard Station, Amarillo, Texas," became the source of his 1963 painting of the same name (fig. 38–39). Ruscha has greatly glamourized the image in the painting, with a crisply rendered composition stretched out across a horizontal canvas rectangle that he then divided in half diagonally, as he had done in a painting of the Twentieth Century–Fox logo the year before. In *Standard Station* the five gas pumps appear to be standing at attention, the rest rooms are fastidiously removed, and the improbable klieg-light projections, borrowed from the *20th Century–Fox* painting, hint that driving into a service station is as exciting as attending a Hollywood premiere. The same light beams reinforce the diagonal thrust of the painting. The word "STANDARD" bears a double meaning in this canvas, reading not only as the oil-company logo but also as a reference to the standardization of American life on the freeway. By using words and photographs as content for high art in his perceptive narratives of the culture of southern California, Ruscha anticipated the techniques of Conceptual Art, which emerged in the 1970s and 1980s (see below).

Ruscha's acute reports on one subculture of the 1960s, man-made Los Angeles, are matched in pungency by the remarkable large collages of ROMARE BEARDEN (1912–88), depicting another subculture, black America, particularly the urban ghetto of Harlem immediately after the eruption of the Civil Rights movement in the early 1960s. Raised in New York City, with family summers spent in Charlotte, North Carolina, and high-school attendance in Pittsburgh, Bearden graduated from New York University with a degree in mathematics. He went on to study painting at the Art Students League in New York with George Grosz, the Berlin refugee painter-draftsman, whose art in the late 1910s and early 1920s was fiercely satirical on the subject of German militarism. It is highly likely that Grosz introduced Bearden to the photomontage methods of the Berlin Dadaists (see page 997). At the outset of his career as a painter, Bearden belonged to the social-realist tendency in American Scene painting, and he participated in the Harlem Renaissance with black poets, novelists, and other black painters, such as Robert Blackburn and Jacob Lawrence. During the late 1930s Stuart Davis, whom Bearden met through the Federal Art Projects, became a mentor; the two shared a passion for jazz. Supporting himself until the mid-1960s as a social worker, Bearden showed his work frequently in mainstream New York galleries and for a period painted colorful, multilayered abstractions. In 1963, following the first sit-ins to end segregation in Southern restaurants and buses, the Spiral group of black artists was formed in Bearden's Soho studio, including among its dozen members Charles Alston and Merton Simpson. The following year Bearden abandoned abstraction and embarked on his late style of figurative collages and enlarged photomontages, chiefly on the subject of black urban life. In formal terms his collages drew upon both the Cubism of Picasso and Braque and the photomontages of Hannah Höch and John Heartfield, although, perhaps feeling the same impulse as the Abstract Expressionists, Bearden made art that was considerably larger in scale than the work of the prewar Berlin Dadaists. Like the Pop artists of the 1960s, he used imagery drawn from the mass media to report on contemporary life. His manner of composing in grids and of slotting found urban imagery at one scale into found urban imagery at another scale somewhat parallels developments in Rauschenberg's silk-screen paintings of the same years. Bearden's collages have a vital, jumpy quality that appears related to his love for the finger-snapping music of the jazz pianist Earl Hines. *Serenade* (fig. 38–40), of 1968–69, its guitar evocative of the mainstream modernism of Picasso's and Braque's collage imagery but also of the sounds of folk music and jazz, exemplifies Bearden's late style at its best.

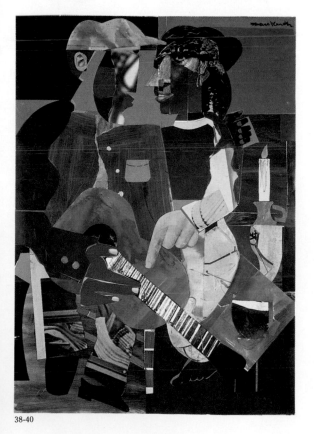

38-40. ROMARE BEARDEN. *Serenade.* 1968–69. Collage and paint on board, 43¾ × 32½″ (116.2 × 82.6 cm). Collection Madison Art Center, Madison, Wisconsin. Purchase, through National Endowment for the Arts grant with matching funds from Madison Art Center members

38-40

In the late 1960s and early 1970s, another painting movement made a brief appearance: Photo-Realism, related to Pop Art. Its practitioners, whose work varied greatly in subject and in style, agreed on two principles: first, that the picture be painted, unaltered, with an airbrush from a photographic slide projected on the actual canvas; and, second, that the subject be as banal as possible. In this latter respect the Photo-Realists appear to derive from the tradition of such American Scene painters as Hopper. They were also influenced by Pop Art's quotidian subject matter and by the tendency among Pop artists to experiment with mechanical methods (the Photo-Realists preserved in their paintings even the inevitable blurry focus of snapshots enlarged to great size). The apparent impersonality of the Photo-Realists is belied by the fact that they generally took the photographs from which they worked, so a considerable latitude of choice was available in subject, mood, lighting, composition, and color.

The undisputed leader of the group was RICHARD ESTES (born 1936), who preceded them and has survived them, and whose urban subjects are presented with stunning impact. Estes proceeds in a slightly different manner, utilizing the photograph rather than chaining himself to it. In order to create one of his townscapes, he sets forth laden with cameras of two different sizes on a Sunday morning to find as few people and as little traffic as possible and takes many views of the same subject. The skies he chooses are invariably blue, with seldom more than a sprinkling of white clouds. He lays out his canvas in acrylic and proceeds to paint in oil because of its greater depth and resonance. Although he occasionally alters reality in the interests of the final picture, enlarging distant passages for easier legibility, he paints with a precision of detail that no photographic enlargement could possibly retain. By means of luminous reflections in plate-glass windows, the dreary buildings, signs, and street litter in Estes' work of the 1970s are locked into spatial constructions displaying his knowledge of abstract art. All this was transformed in the 1980s by a new interest in breadth, monumentality, and hallucinatory spatial reality. In *Hotel Empire* (fig. 38–41), of 1987, a parked car, a corner of Lincoln Center, and a stopped New York City bus are mirrored in a plate-glass window—through which one does not see—to form a serene counterworld. For the first time in Estes' previously depopulated cities, humans appear, quietly sitting on a park bench, enjoying the beauty of mere existence, as does the observer.

38-41. RICHARD ESTES. *Hotel Empire.* 1987. Oil on canvas, 37½ × 87″ (95.3 × 221 cm). Collection Louis K. and Susan Pear Meisel

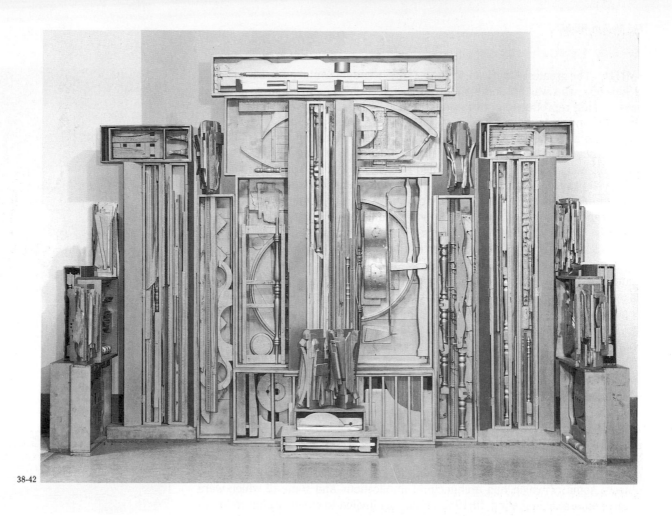

38-42

38-42. LOUISE NEVELSON. *An American Tribute to the British People.* 1960–65. Wood painted gold, 10'2" × 14'3" (3.1 × 4.34 m). The Tate Gallery, London

American Sculpture from the 1960s to the Early 1980s

Recent sculpture is as exciting as recent painting in the richness of its development. Sometimes, like Frank Stella's and Yves Klein's paintings and reliefs, it tends to approach a condition somewhere between painting and sculpture, and in this unpolarized state it has been called by one of the leading practitioners, Donald Judd, "specific objects." The tendency toward assembling and constructing sculpture, rather than carving or modeling, which we have observed in such early-twentieth-century works as Picasso's *Guitar* (see fig. 36–7) and his welded construction *Head of a Woman* (see fig. 36–9), found a new expression in the late 1950s in the metal junk culled from automobile graveyards and made by the American sculptors John Chamberlain and Richard Stankiewicz into compact compositions resembling sculptural groups or reliefs. These works, which corresponded in their tortured surfaces and sometimes brilliant color to the pictorial richness of Abstract Expressionism, exemplify a new mixed-media art form called *assemblage.* Among the most eloquent assemblages are those created by LOUISE NEVELSON (1900–1988), who belonged to the same generation as the Abstract Expressionists but came to artistic maturity in the 1960s. Nevelson worked by putting together found objects—boxes, pieces of wood, bits of furniture, and ornamental fragments from demolished Victorian buildings. Her towering, wall-like structures share both the echoes of haunted houses and glimmers of a new perfection. For years these assemblages were painted in a solemn, allover black; later, they gleamed in white, then in gold. Nevelson's *An American Tribute to the British People,* of 1960–65 (fig. 38–42), is a monumental, abstract successor to Lorenzo Ghiberti's *Gates of Paradise* and to Auguste Rodin's *Gates of Hell.* In the late 1970s and 1980s she created a monumental ensemble in wood in Saint Peter's Church in New York and also made several outdoor works in steel.

SMITH The greatest American sculptor of the twentieth century was David Smith (1906–65), who was fifty-nine and at the height of his creative powers when he died. Seeing reproductions of Picasso's and Julio González's welded metal constructions in issues of the French art journal *Cahiers d'art* in 1932 led Smith, who had begun as a painter, to undertake welded constructions himself the following year. This went against mainstream practice, for at that time in America most sculpture was carved. Smith had learned how to weld while working in an automobile plant as a young man, and he gained further technical experience with steel while employed at a munitions factory during World War II. Almost immediately after beginning to make sculpture, Smith fused Cubist-Constructivist ideas with Surrealist imagery, creating a succession of heads, reclining personages, mythical creatures, and even a house in a landscape. In the early 1950s, when he began to acquire a reputation as the Vulcan of the Abstract Expressionist generation, Smith undertook a highly original series of flat or nearly flat linear works in welded steel, its unusual subject matter ranging from giant birds of prey to the landscape of the upper Hudson River near his house at Bolton Landing, Lake George, New York. In the later 1950s, his works grew larger, and Smith produced several series of approximately life-size vertical "figures" welded out of cut pieces of steel and found objects, such as the tops of tanks, iron farm implements, and the like. These formed groups that he called *Tanktotems, Agricolas,* and *Sentinels.* Many of them were painted (with automobile paint, to withstand outdoor weather) in several colors. In the late 1950s Smith made more *Sentinels* and also other tall vertical sculptures by assembling and welding pieces of stainless steel he had precut into a variety of geometric shapes and randomly ground to score the surface with streaks of texture that would glitter in sunlight. These stainless-steel works culminated in the 1960s in the *Cubi* series, made from cylinders and cubes assembled into very large objects, some of which had architectural implications and some of which were anthropomorphic in feeling. In 1962 Smith was invited to create sculpture for an Italian arts festival, and, working in a disused steel factory near Genoa in the town of Voltri, he accomplished the remarkable feat of making twenty-six monumental sculptures out of steel scrap in a month, some residually anthropomorphic like the *Sentinels,* some, to which he affixed wheels, like railway cars or fanciful chariots.

Perhaps the most fascinating aspect of Smith's welded sculpture—along with its quirky syntax of pieces joined at odd angles that gives his work a distinctive appearance—is that while it is three-dimensional and rich with lines and planes, the lines and planes often do not create volumes, as was the case with many earlier examples of constructed sculpture—Gabo's, for example, or Picasso's. A magnificent case in point is *Zig IV,* of 1961 (fig. 38–43), in steel painted yellow-ochre, whose partial cylinders and planes resolutely do not add up to a single volume that the eye and mind can imagine or actually grasp from one viewpoint. Rather, the observer is forced to walk around the object to take in a complex succession of very different appearances.

MINIMAL ART AND PROCESS ART Although it was initiated about 1960, Minimal Art appeared before the public for the first time in 1963, with the first one-person exhibitions of the work of DONALD JUDD (born 1928) and ROBERT MORRIS (born 1931), who were joined soon afterward by Carl Andre, Dan Flavin, and still others. At first the movement seemed to be, as had Frank Stella's black and aluminum paintings of a few years earlier, a direct repudiation of gestural Abstract Expressionist painting (less so of Color-Field painting; in fact, Newman's barely modulated expanses of flat color particularly interested the Minimalist artists). Minimal sculptures consisted of very simple, modular geometric volumes. These were installed directly on the wall, as is, for example, Judd's cantilevered stack of seven galvanized-iron boxes dating from 1965 (fig. 38–44). They might also be installed, without pedestals, directly on the floor they shared with the observer, as, for example, are Morris's big, identical, painted-wood "L"s seen in fig. 38–45, a

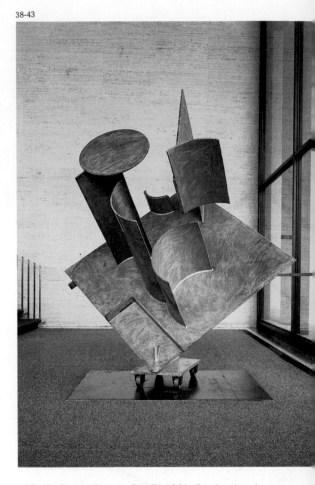

38-43

38-43. DAVID SMITH. *Zig IV.* 1961. Steel painted yellow-ochre, height 8'3/8" (2.5 m). Lincoln Center for the Performing Arts, Inc., New York. A Gift of Mr. and Mrs. Howard Lipman

38-44. DONALD JUDD. *Untitled.* 1965. Galvanized iron; seven units, each 6 × 27 × 24" (15.2 × 68.6 × 61 cm). Statens konstmuseer—The National Swedish Art Museums—Moderna Museet, Stockholm

38-45. ROBERT MORRIS. *Untitled (L-Beams).* 1965. Painted plywood; two L-beams (now dismantled), each 96 × 96 × 24″ (2.44 × 2.44 × 61 cm). Courtesy Leo Castelli Gallery, New York

38-45

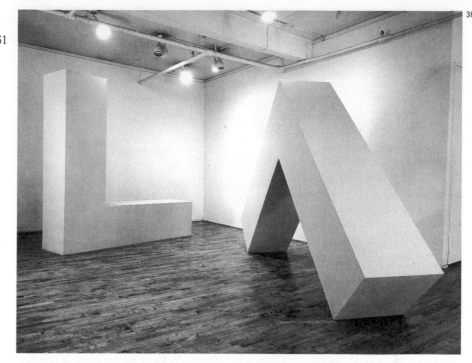

38-44

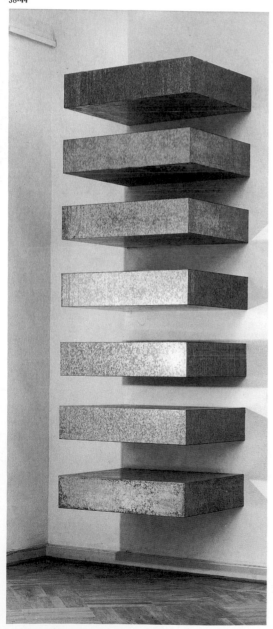

gallery-installation photograph of the same year. By contrast even with Newman's painting of the 1950s, the surfaces of Minimal objects are insistent, if not aggressive, in their refusal to show anything that might indicate the presence of the artist's hand. Morris, for example, spray-painted his early pieces gray until he discovered that fiberglass produced an even more anonymous finish, and Judd had his works fabricated in a shop so that they looked standardized and industrial. Flavin used actual mass-produced fluorescent lights for his works, and Andre worked in a variety of materials that kept his touch anonymous, such as identical chunks of Styrofoam, cedar, or lead. Judd later made his stacked works in several other materials, fashioning the horizontal surfaces of his galvanized-iron boxes in colored Plexiglas (the cantilevered elements, however, remained the same distance apart from one another as they were high). As the 1960s continued, the surfaces of his geometric arrangements, while remaining impersonal, became quite elegant, and it became clear that despite the stamped-out look of his art, there was no mistaking it for anyone else's.

In his early work Morris often showed his debt to Duchamp, as in the 1961 *Box with the Sound of Its Own Making,* which contained a three-hour-long recording of the noise of its fabrication. In 1965 Morris also made a work that seemed to demonstrate in didactic terms the copresence of a viewer and a sculpture without an idealizing pedestal. This consisted of four twenty-one-inch mirrored cubes placed directly on the floor, which inevitably contain reflections of the feet and calves of passersby.

To some, the Minimalists seemed relentlessly boring and their work—some of it is very large—to be deliberately conceived so that it would not be purchased for the living rooms of wealthy patrons. To others, the apparent sacrifices being made by the Minimalists because of the reductiveness of their art, because of what they were willing to give up as expressive means, seemed in itself moving, even poignant, and in some fashion related to the Puritan tradition. Minimal Art was recognized quickly as a major change in style, notably because of a large survey exhibition at the Jewish Museum in New York in 1966. Many critics also observed how profoundly Minimal sculpture had influenced the sensibilities of painters who emerged in the middle or late 1960s, such as Robert Ryman, Brice Marden, and Robert Mangold.

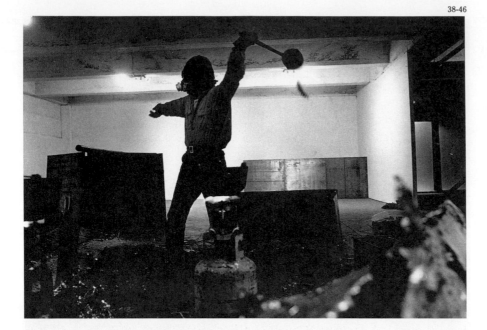

38-46

Process Art, also called Postminimalism, emerged almost apace with Minimalism itself. Process works share with a good many works of Minimalism a distinct avoidance of sensual color. Often, too, they have a modular, serial structure. But the elements of a Process work are not volumetric, unreducible units shaped by geometry. Instead, they conspicuously reveal the processes by which they were made, and in doing so they ironically recall Pollock's drip-painting techniques. Process Art was introduced at two important gallery exhibitions in New York: one, titled "Eccentric Abstraction," was organized by Lucy Lippard in 1966 at the Fischbach Gallery; the second, titled "Nine at Castelli," was organized by Minimalist Robert Morris at a warehouse annex of the Leo Castelli Gallery in 1968. Morris himself was clearly influenced by the German artist Josef Beuys and by the Process artists when he made for the latter exhibition large works of randomly piled, thick, unwieldy strips and folds of dark gray felt. Among the materials popular with the Process artists were fiberglass, latex, rubberized cheesecloth, twine, wire, and lead. A number of them emphasized even more than did the Minimalists the relationship between a work and its environment and thus also the connection that they wished to establish between the viewer and the environment around the viewer. To grasp fully such Process works the viewer often had to re-create mentally the actions of the artist. A revelatory instance is the sculpture made by RICHARD SERRA (born 1939) for a 1969–70 exhibition at the Castelli warehouse. He splashed molten lead along the junction between the floor and the wall, leaving the dried, lumpy lead to be viewed as the work (fig. 38–46). The photograph of Serra making the piece recalls photographs of Pollock in action, and these Serra (who had received a B.A. degree from the University of California and an M.F.A. degree from Yale) certainly knew. The work by Serra seen at left in the background of fig. 38–46 consists of lead plates that hold together to form a volume of sorts only by the action of other processes: propping and gravity. Like Serra's mask, these plates, too, suggest danger, for they are clearly at risk of falling down. Serra has gone on to make a number of brilliant very large-scale works that relate specifically to the site he has chosen or has been commissioned to work in.

As a toddler EVA HESSE (1936–70) came as a refugee from Nazi Germany to New York and she was raised there. After attending art school, first at Cooper Union in Manhattan, she, too, finished her art education at Yale. Gifted with an extraordinary capacity for expressing controlled eccentricity in her work, Hesse made a wall sculpture in 1966 titled, in the vernacular of the time, *Hang Up.* It consisted of a

38-47

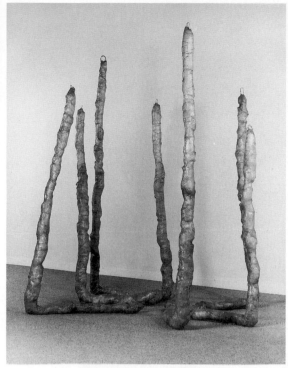

38-47. EVA HESSE. *Seven Poles.* 1970.
Reinforced fiberglass over aluminum wire and
polyethylene, 8′11⅛″ × 7′10½″ (2.72 × 2.4 m).
Musée National d'Art Moderne, Centre Georges
Pompidou, Paris

painted cloth wound on a wood frame from which a wire loop, attached to the top and bottom of the frame, projects out onto the floor. Hesse's *Seven Poles* (fig. 38–47), of 1970, is a group of seven "feet and legs" made also by a winding process. Over an armature of aluminum wire are wrappings of polyethylene sheeting, more aluminum wires, and, on top, bandages of liquid fiberglass. These poles, which resemble mummified limbs, originally intended to be grouped in a circular arrangement and held erect by wire, were ultimately shown more randomly, hung from the ceiling like the *Shoestring Potatoes* of Oldenburg, an artist Hesse greatly admired (see fig. 38–37).

EARTH ART AND SITE ART One recent offshoot of the development of sculpture into environments that make the viewer highly conscious of the space he or she is inhabiting has been Earth Art, a movement led by ROBERT SMITHSON (1938–73), who met death accidentally while exploring from the air a site for one of his gigantic projects. Characteristically enough, the forms of Earth Art, which derive from Minimalism, are vast in scale yet sometimes very direct, even simple, in shape; on occasion they have been no more than trenches. Such projects demanded both considerable financial expenditure and patrons who often did not see the works they paid for, contenting themselves with photographs documenting the existence of what was usually ephemeral. Smithson's most ambitious project was the colossal *Spiral Jetty,* of 1970 (fig. 38–48), constructed of earth, rocks, and salt crystals, jutting into Great Salt Lake in Utah. The whole process of moving earth to achieve the giant coil with standard mechanical equipment—a dump truck carried the rocks, which formed a road over which the truck then drove—was recorded by Smithson in a film. The film itself is a work of art, and in it the scenes of Smithson reshaping nature are intercut with scenes about the earth's distant past, showing species of dinosaurs on view at a museum of natural history. Smithson's fascination with nature on a huge, American scale is strangely reminiscent of the mind-set of such nineteenth-century American romantic landscape painters as Albert Bierstadt. Only Christo's wrappings and curtains (see below) rival Smithson's earthworks in their defiance of the difficulties posed by the manipulation of immensities. It is worthwhile mentioning that Earth Art had its predecessors in the activities of the pre-Columbian Mound Builders of North America, not to speak of the colossal mound-shaped tombs of many ancient European and Near Eastern societies and those of early Chinese emperors. Alas, the rising waters of Great Salt Lake have now drowned Smithson's remarkable road.

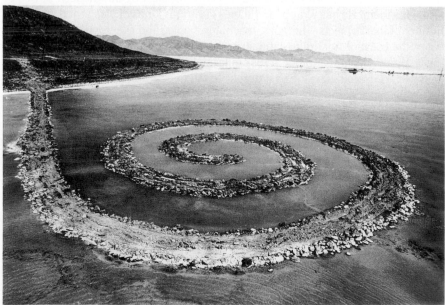

38-48. ROBERT SMITHSON. *Spiral Jetty.* 1970.
Rocks, salt crystals, earth, and algae; length of
coil 1,500′ (457.2 m), width of jetty 15′
(4.57 m); now submerged. Great Salt Lake, Utah

38-48

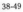

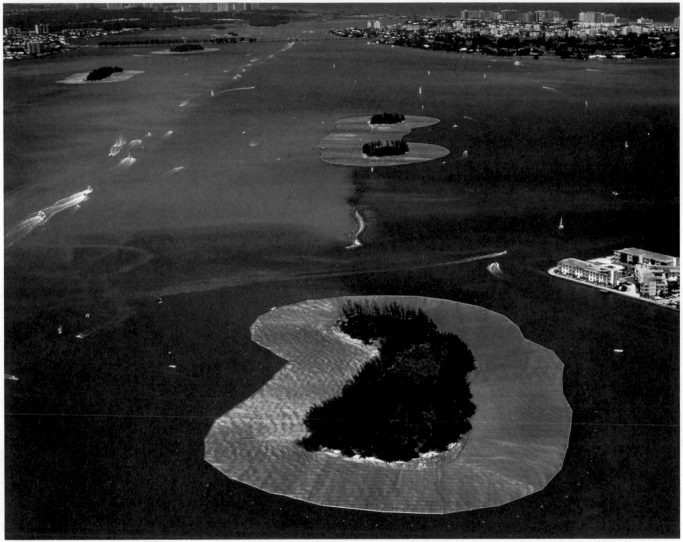

Deliberately less permanent is the work of the Bulgarian-born CHRISTO (Christo Javachef, born 1935), who dominates his surroundings by the modern device of packaging them. He has wrapped in sheets of various kinds of plastic and fabric any number of inert objects—bicycles, machines, books, and even one million square feet of the coast of Australia—and strung a vertical curtain across a valley in the Rocky Mountains and another across miles of California terrain to the Pacific. The wind itself is exploited as the vast draperies fall in accidental but predictable folds of great beauty. So, indeed, is the *Surrounded Islands, Biscayne Bay, Greater Miami, Florida,* of 1980–83 (fig. 38–49), its brilliant fuchsia circles shining against the blue-green lagoon. More than with Smithson, Christo's entire procedure, from initial surveys, to active solicitation of assistance from large bodies of local laypersons, to appearances before environmental-control boards, to the completion of the project, is considered part of the work of art and is carefully recorded. Given the large number of social groups that must be manipulated, persuaded, paid off, cajoled, and controlled, ultimately the content of one of Christo's earth-wrappings or curtain-raisings across miles of landscape seems to be the social activity the project required. Thus, in a highly contemporary manner he has raised issues about the power of the artist in society and about the rights of artistic creativity versus the rights of the public to preserve in pure form the natural environment. Christo himself funds his expensive projects, through prior sales of his drawings, which are costly.

38-49. CHRISTO. *Surrounded Islands, Biscayne Bay, Greater Miami, Florida.* 1980–83. Woven synthetic fabric, 6 million square feet (1.8 million square meters)

A younger artist who in one important work has shown tremendous sensitivity both to the site and to the affecting power of the Minimalist style is MAYA YING LIN (born 1960). In 1981 this Chinese-American woman, who was studying architecture as an undergraduate at Yale University, produced as a class assignment a project for a memorial to America's Vietnam veterans in Washington, D.C. Lin's design, which was chosen over 1,424 other entries in a name-blind competition, consists of two polished, black-granite walls, each 250 feet long, that meet at a wide oblique angle. Ten feet high at their point of intersection, the walls diminish at either end. On them, in the chronological order of their deaths between 1959 and 1975, with the first and last death dates listed, are the names of 57,692 American military personnel killed in the Vietnam War (fig. 38–50). Lin has said that she chose that order, rather than an alphabetical one, because she wanted to return the onlookers to the time frame of the war. Located on the gradually rising turf of Constitution Gardens, on the Mall midway between the Lincoln Memorial and the

38-50. MAYA YING LIN. *Vietnam Veterans Memorial,* Constitution Gardens, Washington, D.C. 1981–82. Black granite, approx. maximum height 10′ (3.05 m), length 500′ (152.5 m)

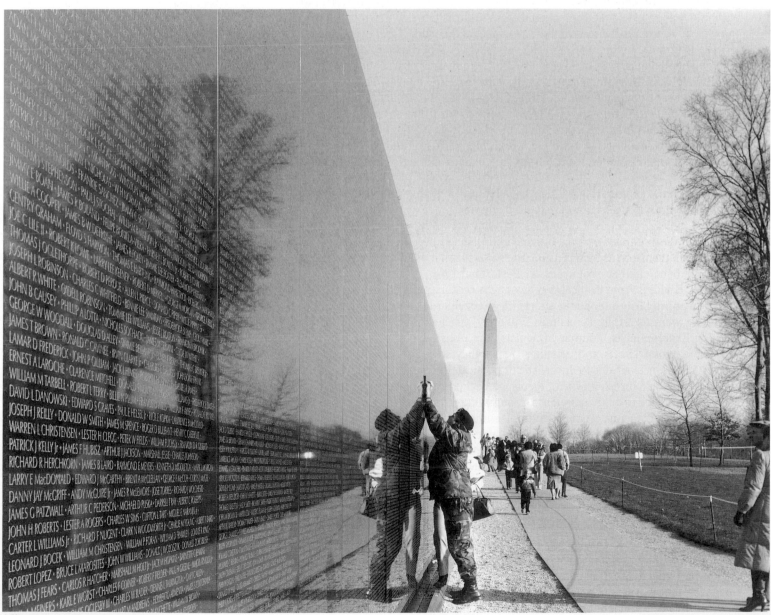

38-50

Washington Monument, the sloping sheets of black granite appear to grow out of the earth and are exceptionally harmonious on the peaceful, tree-dotted site. The effect of the totality of the names is very powerful, and visitors inevitably confront their own reflections in the highly polished stone. An elegant and thoughtful new kind of design solution for a city rich in Neoclassical memorial monuments, the *Vietnam Veterans Memorial* was dedicated on Veteran's Day in 1982.

Conceptual Art and Performance Art

The iconoclastic tendencies of the 1960s and 1970s (decades when it was sometimes maintained that "painting is dead") were nowhere more strongly expressed than in the two interrelated movements of Conceptual Art and Performance Art. Both had origins in the early-twentieth-century movements of Futurism and Dada; both sometimes contained along with elements of provocative originality an ingredient of posturing. Like Process Art, both were explicated by many artists' texts. Unlike early-twentieth-century avant-garde performances, such as those at the Café Voltaire in Zurich (see page 996), both Conceptual and Performance Art have been fairly widely seen and accepted. Conceptualism, which owes a great debt to Duchamp, was based on the contention that, as the artist Sol LeWitt wrote in 1967, "the idea or concept is the most important aspect of the work . . . all planning and decision are made beforehand and the execution is a perfunctory affair." Yves Klein's presentation in 1958 of an empty art gallery as a work of art anticipates both Conceptual Art and Performance Art, for the vernissage (private opening) was itself a theatrical event, complete with uniformed Republican Guards and service to the guests of a blue cocktail that caused their urine to turn blue soon after. Joseph Kosuth's *One and Three Chairs,* of 1965, in which a photograph of an ordinary folding chair was exhibited alongside an actual chair and a wall-hung blowup of the dictionary definitions of the word "chair," is a classic offering of the Conceptual movement.

Since the dawn of time visual artists have lent their creative talents to religious ceremonies, dramatic performances, and triumphal processions in the shape of costumes, settings, machines, even basic pageantry. Few, however, are the examples before the twentieth century of noncommissioned performances created by visual artists themselves, though Leonardo's machines made for pure entertainment have been cited as prototypes for Performance Art, as has the stage flood created by Bernini. From its inception, twentieth-century performance art (with a small *p*) was primarily intended to shock. Ideas considered politically and morally subversive were forcefully, sometimes brilliantly, enacted on stages before audiences by Expressionists, Futurists, Dadaists, and Constructivists. Generally, too, these were group efforts and, whether or not they were rehearsed, they were planned in advance, as aids to the artistic or political doctrines of these groups, or as attempts either to break down bourgeois intellectual and artistic complacency or actually to enhance revolutionary ideas. Along with recitals of deliberate nonsense or multiple simultaneous readings and noise music, obscene words and explicit actions were calculated as catalysts. The audiences did not enjoy being catalyzed and greeted the performances with howls of protest or derision and showers of unwelcome objects. To judge from the surviving evidence in preparatory drawings and in the photographic and literary record, many of these performances must have been beautiful. Many were witty and some uproariously funny.

Among the first of the post–World War II Performance artists was Allan Kaprow (born 1927), with his *18 Happenings in 6 Parts,* launched at the Reuben Gallery in New York in 1959; as Kaprow defined it, a "Happening is performed according to plan but without rehearsal, audience, or repetition. It is art but seems closer to life." Kaprow had studied in the 1950s with the composer John Cage, and he knew about the performance Cage had masterminded at Black Mountain College in the summer of 1952; at this legendary theatrical event Cage assigned poets to read their

work, Rauschenberg to show paintings and play records, David Tudor to play the piano, and Merce Cunningham to dance—and none of these activities had any cause-and-effect relationship with any other. Kaprow's Happenings were joined at the Reuben Gallery by mixed-media events put on by Oldenburg and by the Pop painter Jim Dine. Similar non-narrative, theater-related events by visual artists were also performed in Japan (by the Osaka-based Gutai group) and in France, Holland, Germany, and Austria. In 1960 the Swiss sculptor Jean Tinguely (1925–91) performed his *Homage to New York* in the garden of the Museum of Modern Art, during which, before a substantial invited audience, one of his assembled constructions of junk and machinery destroyed itself. In the late 1960s a pair of London art students who call themselves Gilbert and George performed music-hall duets standing on a table. With their faces sprayed with gold paint, they classified themselves as sculpture and have more recently marketed huge, more or less homoerotic works based on enlarged and commercially stylized color photographs. In the course of the 1970s and 1980s there have been many types of Performance Art, and performance has grown into a legitimate and important art form, with vast, untapped potential linked to drama, music, and the dance.

The Women's Movement

The feminist movement in the visual arts—that is, a belief in making art that in some way specifically addresses women's political consciousness—arose at about the same time that feminism became a widespread national political issue in the United States, about 1970. Among its initiators were the sculptor Judy Chicago and the painter MIRIAM SCHAPIRO (born 1923). Chicago organized the first feminist-art course, at California State College at Fresno in 1970, and the following year she and Schapiro initiated a Feminist Art Program at the California Institute of the Arts in Valencia, near Los Angeles. Both have lectured widely around the United States for many years. Schapiro, who studied art at the State University of Iowa, was a second-generation Abstract Expressionist painter living in New York in the 1950s. During the 1960s she was a painter of abstract Hard-Edge forms that depicted geometric solids in space. She partly generated these images with the assistance of computer graphics. Like her husband, Paul Brach, also a painter, Schapiro taught during the 1960s at the University of California, San Diego. Her program to make specifically feminist art involved a number of tactics that particularly exploit her gifted manner with design and color. One important strategy (which helped launch a style, practiced by both genders, called Pattern and Decoration) was to use richly patterned fabrics, such as needlework and ribbons—associated traditionally with women—as a prominent high-art material in large, canvas-backed collages that she calls "femmages." Her ten-panel *Anatomy of a Kimono,* of 1976, is based on the forms of the Japanese women's robe. With its huge length, vivid color, and labor-intensive construction from pieced-together bits of fabric as well as painted passages, this perhaps best-known of Schapiro's femmages calls attention to women's issues. Schapiro's work grew densely—indeed, aggressively—decorative as she strove to scotch the negative connotations often investing the word "decorative" when used by art critics reviewing the work of women. Another of Schapiro's tactics has been to include strong references to important—but sometimes overlooked—female artists of the past in her own work, bringing them new attention, and this has increasingly made her work figurative rather than abstract. Recently, for example, she made a group of paintings, *Collaboration Series: Frida and Me,* around the image and interests of Frida Kahlo (see page 1012), whose expression of female identity, including her manner of dressing in heavily patterned, traditional Mexican costumes, Schapiro apparently admires, perhaps in part because it melds with her own interest in color and pattern. In *Conservatory,* of 1988 (fig. 38–51), Schapiro used fabric as well as acrylic paint to show Kahlo in a colorful hothouse of tropical vegetation and pre-Columbian sculpture.

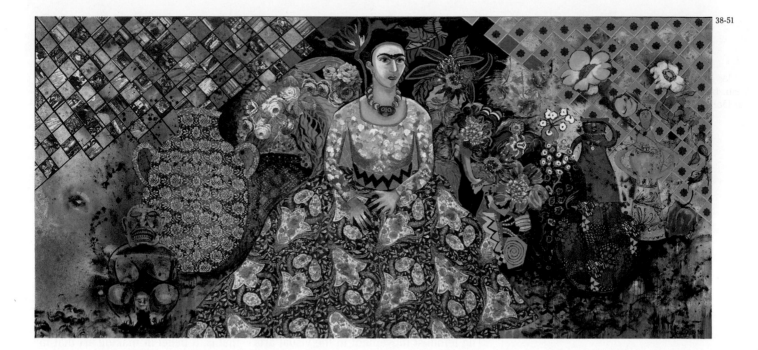

38-51

Recent Painting and Sculpture

By the second half of the twentieth century, the major force in patronage, with a formative influence on art equal to that of the Church in the Middle Ages, the monarchy in the Baroque, and the Salon in the early nineteenth century, had become and still remains the commercial art gallery. The adventurous early modern galleries had made relatively little profit. But by the 1970s and 1980s, dealing in contemporary art had become big business. Pictures sold originally by their creators for a few hundred or few thousand dollars have changed hands several times with no further payment to the artists, eventually coming to rest in private or public collections for prices that are, in the case of a few artists' work, sometimes in the seven figures. To some extent the dealer controls entrance to the art market, which is centered in New York, London, the Rhein-Ruhr region of Germany, and major Swiss cities. Few dealers show works of art they do not hope to sell, although often they mount exhibitions of museum quality. On occasion it appears that the promotion of art is governed by the principles of late-twentieth-century industrial marketing which, in combination with the modernist tradition of the avant-garde, deems that there must be a new model, or at least a new line, every year. Although it sometimes seemed during the 1980s that style, imagination, and content were often subordinated to shock value, there were signs at the end of the decade and in the early 1990s that the long tradition in modern art of the constantly new was waning in strength. The very nature of so-called postmodernism in all of the arts, which frequently involves self-conscious appropriation and quotation of the art of the past, seems to point to a certain cultural exhaustion with love of the new. Yet unquestionably, art will continue to change.

KIEFER An authentic new movement of the 1980s is Neo-Expressionism, which like its ancestor of seventy-five years earlier has its roots, at least partly, in Germany. The humiliation of the German defeat in World War II is over and so, finally, is the division of the country into two with opposing militaries and ideologies, but art created there in recent decades expresses some of the tensions of the postwar period and explores, to some extent, still-painful questions about the Third Reich. It was at the end of the 1960s that the new expressionist movement began to take

38-51. MIRIAM SCHAPIRO. *Conservatory (Portrait of Frida Kahlo)*. 1988. Acrylic and fabric on canvas, 6′ × 12′8″ (1.83 × 3.86 m). Miami University Art Museum, Oxford, Ohio. Funded through the Helen Kingseed Art Acquisition Fund and the Commemorative Acquisition Fund (Anonymous)

38-52. ANSELM KIEFER. *Isis and Osiris*. 1985–87. Mixed media (clay, porcelain, lead, copper wire, and circuit board) on canvas, 12′6″ × 18′4½″ (3.81 × 5.6 m). San Francisco Museum of Modern Art. Purchased through a gift of Jean Stein, by exchange, the Paul L. Wattis Fund, and the Doris and Donald Fisher Fund

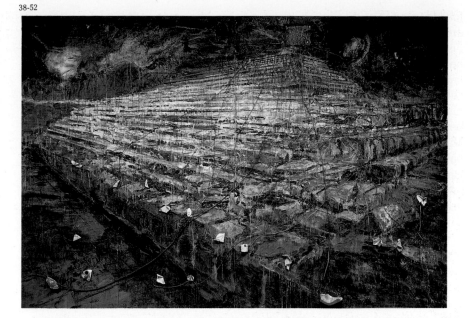

38-52

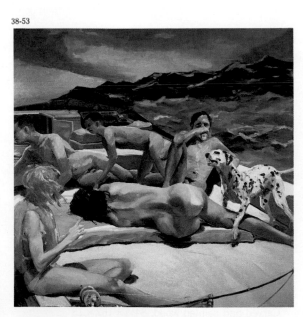

38-53

38-53. ERIC FISCHL. *The Old Man's Boat and the Old Man's Dog*. 1982. Oil on canvas, 7 × 7′ (2.13 × 2.13 m). The Saatchi Collection, London

shape in German painting, reaching a climax and international recognition in the 1980s. Similar stylistic developments got under way slightly later in Italy and the United States.

The most formidable of the new German painters, whose emotional depth is supported by technical prowess, is Anselm Kiefer (born 1945), who was deeply affected by the teaching and example of Josef Beuys, a generation older. Born in the very year the war ended, Kiefer has been haunted by the moral dilemma of Germany's guilt for the actions of the Third Reich, including World War II and the Holocaust, events in which his generation played no part, reminding one of the Christian doctrine of Original Sin, which implicates all humanity in the disobedience of Adam and Eve. In his painting during the 1970s Kiefer kept asking himself terrible and unanswerable questions in an almost mystical attempt to cope with the German historical past, from the battle of the Teutoburger Forest, in which the chieftain Hermann annihilated three Roman legions under Quinctilius Varus, to the empty grandiosity of the architecture of the Third Reich. The results, often resembling Wagnerian stage sets, rely on immense perspectives, projected with Renaissance accuracy on the impermanence of such materials as straw applied to the canvas, and on a chromatic gloom seldom varying from black-ochre-gray. Despite the title of this painting of 1985–87, drawn from ancient Egyptian religion, *Isis and Osiris* (fig. 38–52) deals symbolically with the nuclear menace through a parable of death and resurrection. The formal embodiment is a step-pyramid of overwhelming size and sharply exaggerated spatial recession.

FISCHL Several American painters in the course of the late 1970s and 1980s also began to employ expressionist paint-handling to novel ends. Outstanding among them is Eric Fischl (born 1948), who has fashioned a new edgy kind of realism that is in the tradition of Eakins, Homer, Beckmann, and Hopper, yet is also very much of the present in the bold way the large canvases portray disturbing subject matter in fragments of narrative about nuclear families or groups of acquaintances. Child abuse, incest, masturbation, bestiality, and other uncomfortable truths about what may occur in middle-class American homes or during middle-class American vacations are some of the implied subjects of Fischl's art in the 1980s. Raised on suburban Long Island, New York, Fischl was in the first class to graduate from the art school of the California Institute of the Arts in Valencia. A center of innovative activity in the 1970s, when Conceptual Art, taught by John Baldessari, was the

focus of studies at the school, "Cal Arts" trained a number of Fischl's well-known artist-contemporaries, including David Salle and Ross Bleckner. To some extent, Fischl rebelled against the Conceptual bias of his training when, in the mid-1970s, he turned to a gestural realism, at first by making life-size drawings. Mainly self-taught as a draftsman, Fischl works from sketches, notes, parts of photographs culled from newspapers and magazines, and from snapshots he often makes himself. Taking advantage of the freedom of collage, he often juxtaposes figures he borrows from different scenes and sources to create his own works (something Manet did before him; see pages 922–23 and figs. 33–2, 33–4). For some of his paintings he uses several different panels, attached but at varying heights, and the effect of this is to emphasize the disconnectedness of some of his characters from one another. *The Old Man's Boat and the Old Man's Dog,* of 1982 (fig. 38–53), is a beautiful yet disturbing work in which the warm-colored flesh of the naked sun-bathers contrasts viscerally with the cold blue-green water. As in a dream, the scene is intensely real yet strange. The towering waves through which the boat drifts apparently without human control, the sexual innuendo of the figural groupings, and the snarling dog that no one seems to fear all provoke an unfocused anxiety. As is often the case with Fischl's compositions, at least one figure is positioned between the rest of the scene and the viewer, who is thus made to feel like a Peeping Tom, nearly but not quite inside the picture. Fischl has also been active as a printmaker and in the early 1990s turned from American subject matter to a series of mysterious scenes of figures, animals, temples, and temple sculpture that he developed from photographs snapped on a trip to India.

PURYEAR Among sculptors who have come to international prominence recently, Martin Puryear (born 1941) stands out for his independence, his extraordinary attention to matters of craft, and his nuanced, witty forms. His artistic ancestor is surely Brancusi, not Picasso. Raised in Washington, D.C., Puryear studied painting at Catholic University there and later earned an M.F.A. degree in sculpture at Yale. Immediately after college he went to Sierra Leone with the Peace Corps and taught high-school subjects to Africans in a remote village, learning from tribal weavers and carpenters, particularly about building without electric tools. Al-

38-54. MARTIN PURYEAR. *Lever No. 3.* 1989. Carved and painted wood, 84½ × 162 × 13" (215 × 412 × 33 cm). National Gallery of Art, Washington, D.C. Gift of the Collectors Committee

38-54

though interested in African sculpture, in part because of his black heritage, he avoided introduction by Sierra Leone artists to rituals related to their making of art. Puryear also studied printmaking at the Swedish Royal Academy of Art and while in Stockholm learned more about working in wood from highly skilled craftsmen there. He has traveled widely in Japan as well.

Wood is Puryear's primary material, although he has also worked with rope, deerskin, metal mesh, and tar. In addition to crafting freestanding objects he has, like several other sculptors of his generation, such as Alice Aycock, Mary Miss, and Siah Armajani, made a number of houselike structures that enclose the viewer, as well as bridgelike works that induce observers to traverse a space. And like another sculptor of his generation, Nancy Graves, he has long been interested in natural history and ethnography. While his forms often evoke natural ones, such as gourds, they usually do not imitate a particular specific thing in nature. *Lever No. 3,* of 1989 (fig. 38–54), resembles an enlarged tool, the prow of a ship, or a humped creature we have never seen before, but it is none of these. Its "body" is hollow, while its elegantly curving forms are built up from horizontal slats of pine joined together and then carved, steamed, sanded, and painted. In 1989 Puryear represented the United States at the biennial art show in São Paulo, Brazil, and won the grand prize; the same year he was awarded a MacArthur Foundation "genius" fellowship.

Twentieth-Century Photography

By the end of the nineteenth century, a veritable revolution had taken place in the history of photography since its invention in 1839. No longer an arcane craft practiced by skilled professionals, photography was accessible to virtually anyone who could afford a camera and push a button. With the invention of hand-held cameras and faster kinds of film, photographers improved the quality of their product and no longer had to operate cumbersome equipment in the field or endure the tedium of prolonged darkroom work. Inexpensive cameras such as the Kodak, first marketed in 1888 by George Eastman, contained rolled film, meaning the owner did not have to reload after each shot. The owner sent the camera fully loaded back to the factory, where the film was developed and printed. The camera was then reloaded and returned; this launched a whole new photo-processing industry. In addition, the new cameras were equipped with shutters of higher speed and also better lenses, which produced more precise images and made stop-action shots easy. The technology of enlargers improved, so images could be easily cropped in the darkroom, and so did the quality of printing papers. In the early years of the twentieth century, color was introduced to photography, and by 1930 the photoflash had revolutionized the profession of photojournalism.

As the medium gradually lost its mystique, photography began to play very different public and private roles, infiltrating our lives in ways we now take for granted. Having one's portrait taken was no longer a once-in-a-lifetime affair, and the most mundane aspects of everyday existence could also be captured with relative ease. In fact, the kinds of subjects that could be recorded by the camera seemed virtually limitless. Improved technology led to increased commercialization of photography, and the print media exploited the photograph for purposes of advertising and journalism. By 1936, when the first issue of *Life* magazine appeared, the public appetite for photographic images seemed insatiable. Because the equipment was much easier to manipulate, thousands enthusiastically took up the camera on their own, and before long photography had become a popular national pastime. The skilled practitioners, who considered themselves serious professionals or even artists, naturally enough began to want to distance themselves from the ranks of the amateurs (although the Sunday-afternoon enthusiasts also often made first-class photographs), and this trend toward professionalism led to the first consciously organized international movement in the history of photography, Pictorialism.

All of these developments were of great concern to an artist who has been called the father of modern American photography, Alfred Stieglitz. Not only a great pioneer and innovator in photography (see below), Stieglitz was a towering figure in the development of modern art as a whole in America (see page 1006). Following nearly ten years of schooling in Germany, he returned to America in 1890, already a highly accomplished photographer. He soon joined forces with American Pictorialists to champion the cause of photography as a fine art and, like many of them, began exhibiting his work in British and continental European salons. Stieglitz's crusade resulted in the formation in 1902 of the Photo-Secession, an independent group of photographers committed to the "serious recognition of photography as an additional medium of pictorial expression." Over the next four years Stieglitz organized several international exhibitions for the group, and in 1903 he founded the quarterly magazine *Camera Work*. Written by many of America's leading critics, the articles on photography that appeared in *Camera Work* and the high-quality photogravure reproductions that accompanied them did much to elevate photography to a position of validity and prestige in the art world.

One of the most talented artists to join the Photo-Secession was a painter and photographer who, though born in Luxembourg, grew up in Michigan and Wisconsin. EDWARD STEICHEN (1879–1973), who had begun making photographs by 1895, returned to Europe in 1900 to study painting in Paris. Before leaving the country, however, Steichen introduced himself to Stieglitz, with whom he later collaborated on *Camera Work*. In Paris Steichen made the acquaintance of, and eventually photographed, some of France's most distinguished contemporary artists, and he in turn introduced many of them to Stieglitz, who exhibited their work at the gallery at 291 Fifth Avenue. One of these artists was Henri Matisse, whom Steichen photographed about 1909 while the artist was working on one of his sculptures, *The Serpentine*. In a classic Pictorialist style, Steichen's *Henri Matisse* (fig. 38–55) is reminiscent of Julia Margaret Cameron's *Whisper of the Muse* (see fig. 32–3) in its subject matter—homage paid to artistic genius—as well as in its soft resolution. After several years in France, Steichen had become fully conversant with Symbolist art and literature, and it is a Symbolist aesthetic that informs his portrait of Matisse. To the Symbolist, human imagination and sentiment counted for more than literal fact, and those qualities are best expressed pictorially through subtlety and nuance. Steichen allows details to be swallowed up by a beautiful sfumato effect made possible by the medium of the platinum print, which he masterfully exploited for its broad range of luminous tonalities. A diffuse light plays upon the artist's forehead and his hands and glints off the instrument he holds to sculpt the clay. This elegant portrait is not about empirical observation or the specifics of time and place. Rather, it springs from a universal idea about artistic creation that appeals to the imagination. In their struggle to rival painting, Pictorialist photographers sometimes manipulated prints in the darkroom with retouching or even hand-coloring, to the point where the images were sometimes indistinguishable from etchings or lithographs. They did not always produce such profoundly moving photographs as this one (countless are the hackneyed images of dewy landscapes and delicate maidens in virginal gowns), and their legacy survives today in the form, for example, of soft-focus wedding portraits. In the 1920s Steichen abandoned his early style and embarked on a successful career as a celebrity and fashion photographer. In 1947 he became the first director of the most prestigious museum photography department in the country, at New York's Museum of Modern Art.

Though he diligently promoted the cause of Pictorialism through his publications and gallery, ALFRED STIEGLITZ (1864–1946) did not himself make photographs in an orthodox Pictorialist style. He believed that photography should be regarded as a distinct medium with its own unique attributes and that photographs should look like photographs, not paintings or fine-art prints. Although he constantly pushed his craft to its limits to discover the potential inherent in the medium, Stieglitz rejected fancy retouching in the darkroom. This fundamental

38-55

38-55. EDWARD STEICHEN. *Henri Matisse.* c. 1909 (from *Camera Work,* no. 42–43, 1913). Photogravure. Collection, The Museum of Modern Art, New York. Gift of William A. Grigsby

38-56

respect for visual fact made Stieglitz an important forerunner of so-called "straight" photography, one that exploited the optical and aesthetic properties of photographic technique without dramatic light effects or darkroom enhancement. Stieglitz's preferred subject from the 1890s on was the city of New York—its streets and architecture, its modes of transportation. He made *The Steerage* (fig. 38–56), a photograph he later considered his finest work, in 1907 when traveling to Europe on an ocean liner, the SS *Kaiser Wilhelm II.* While promenading on the first-class deck, he gazed down into steerage class and recorded what was for the time a bold and radical vision, one that is far removed from the soft-focus and picturesque subjects of the Pictorialists. Seemingly haphazard, the image is divided into two zones—both compositionally and sociologically—by the brightly illuminated catwalk. There is no particular focal point to the composition; one's eye moves back and forth across the light-and-dark patterns of the crowd and the ship's crisscrossing architecture. Stieglitz later said that it was abstract form—a round straw hat, a mast cutting into the sky, the crossing of a man's suspenders—that attracted him to the subject. Because he was prompted by what he saw and did not fabricate a fiction for the camera, Stieglitz was employing a pictorial strategy that differed from that of other "artistic" photographers. His image of the poor in steerage class is unromanticized, yet what he meant by contrasting them with the first class of the upper deck, if anything, is not explicitly stated. In its shifting complex of spaces, *The Steerage* has been likened to Cubism, and it is a work Picasso is reported to have admired.

One American artist who frequented Stieglitz's Fifth Avenue gallery was the aspiring young painter MAN RAY (1890–1976). Together with French artists Marcel Duchamp and Francis Picabia, who were in New York much of the time between 1915 and 1918, Man Ray formed the New York branch of the international Dada movement. After meeting Duchamp, Man Ray gradually abandoned his Cubist-inspired paintings to devote himself to less-conventional mediums, such as airbrush drawing, and to witty assemblages made of found objects. He also experimented informally with photography, mostly to document his own work. In 1921 he went to Paris, where he was warmly welcomed by Duchamp, who had returned the same year, and by other Dada artists. There he successfully supported himself through society and fashion photography, working for *Vogue* and *Harper's Bazaar* magazines. In addition, he continued to do creative photography, which he contributed to such publications as *La Révolution surréaliste,* the first Surrealist journal. Experimental by inclination, Man Ray investigated many alternative ways of making photographs, and one day he chanced upon a marvelous technique in the darkroom. By placing objects on light-sensitive paper and exposing them to light, sometimes again and again, he produced magical images that somewhat resemble X rays. He called them rayographs. Man Ray's rediscovery of a technique as old as photography itself played into the Surrealist obsession with the inherent strangeness of everyday objects. A more traditional photograph in terms of technique is the 1926 portrait of Man Ray's mistress Kiki that he made for *Vogue* (fig. 38–57). Kiki, a model, singer, and occasional painter, was famous throughout the Montparnasse district of Paris for her beauty and free-spirited nature. She lays her perfectly ovoid head on a table next to a Baoulé mask from Africa's Ivory Coast, which she props up in her left hand. Her stylish, lacquered hair shines like ebony, while her serene brows, eyelids, and mouth, penciled in mock imitation of the mask, are reminiscent of Brancusi's sculpture *Sleeping Muse.* Man Ray knew the Romanian sculptor, who kept a studio in Paris, but he had first seen Brancusi's work at Stieglitz's New York gallery. The title of the photograph, *Noire et Blanche (Black and White),* refers not just to the contrasting tones of the two images, and, implicitly to two human races, but, of course, to photography itself. In a playful reversal of this idea, Man Ray also printed the image as a negative (fig. 38–58), in which Kiki becomes black and the sculpture white. Though Man Ray's elegant image is anchored in realism—no fancy darkroom machinations were involved—his photograph possesses a haunting, beguiling beauty and demonstrates how poetry can be made manifest by optical truth.

The 1920s were a highly experimental decade in the history of photography, years that witnessed, among other developments, an explosive new popularity for the cinema, with the addition of sound effects, music, and dialogue and the birth of Technicolor. And thanks in part to the efforts of crusaders like Stieglitz, photography and its offshoots, such as photomontage, had achieved avant-garde status in the art world. At the forefront of advanced photography in Europe was a Hungarian artist of prodigious talent and energy, LÁSZLÓ MOHOLY-NAGY (1895–1946). Rather than satisfy himself with mastery of a single medium, Moholy-Nagy applied his talents to virtually every realm of the visual arts and beyond. He was a painter, sculptor, photographer, and filmmaker who constantly explored new materials for his art. Moreover, he designed theatrical sets and was a respected teacher, writer, and, perhaps most important, an editor who significantly influenced modern typography and book design. After moving in 1920 to Berlin from Budapest, where he had already incorporated Russian vanguard ideas into his art, Moholy came into contact with artists of the Berlin Dada movement as well as the Russian Constructivist El Lissitzky, encounters that made a profound impact on his art. In 1922 he met Bauhaus founder Walter Gropius, who was so impressed with the young artist that he asked him to join the Bauhaus faculty in Weimar. Moholy taught at the Bauhaus from 1923 to 1928, moving to Dessau when the school was relocated there in 1925. He succeeded Paul Klee as the head of the metal workshop and, later,

38-57, 38-58. MAN RAY. *Noire et Blanche (Black and White).* 1926. Photograph, printed as a positive and a negative. Collection Lucien Treillard, Paris

38-57

38-58

38-59

38-59. LÁSZLÓ MOHOLY-NAGY. *Bauhaus Balcony, Worm's-Eye View.* 1926. Gelatin-silver print. International Museum of Photography at George Eastman House, Rochester, New York

taught the introductory foundation course that later so influenced American art education. Although there was no formal course in photography at the Bauhaus, Moholy, who had been experimenting with photographic techniques in his work with collage since 1920, incorporated it into the curriculum at large. He was naturally drawn to photography by a lifelong preoccupation with the phenomena of light and motion, and the camera provided him with the perfect technological means of exploring those interests. About the same time as Man Ray, Moholy also began to make photographs without a camera, and these he simply called photograms. However, when he exposed objects on light-sensitive paper (though he too courted unexpected results) it was to explore issues of form and light to achieve ultimately abstract ends, rather than to mine the mystery in everyday things. Collaborating with his photographer wife, Lucia, Moholy began experimenting with Constructivist-inspired photos in the early 1920s. The vigorous graphic structure of *Bauhaus Balcony, Worm's-Eye View,* of 1926, is typical of the unconventional perspectives that Moholy explored through photography (fig. 38–59). With the advent of modern architecture and transportation, Moholy felt art must respond with new systems of spatial orientation:

> *In the age of balloons and airplanes . . . the bird's-eye view and the worm's- and fish's-eye views become a daily experience. This fact introduces something extraordinary, almost indescribable, into our life. . . . architecture must be linked with movement.*

Moholy's vertiginous, careening views (possible only with a hand-held camera) that were his response to modern life emulate the dynamic compositional forms of abstract Constructivist painting. Comparable experiments were taking place elsewhere, particularly in the Soviet Union, where the Constructivist painter Alexander Rodchenko had even earlier adopted unconventional perspectives in his photographs to express the dynamic consciousness of a new Socialist society.

One artist who did not approve of the experiments of Man Ray and Moholy-Nagy was the American EDWARD WESTON (1886–1958). Although he had worked successfully in a Pictorialist mode, he rejected the aestheticized prettiness of that style by 1922 in favor of a clean, hard-edged style. Leaving behind his family and portrait business in California, Weston moved with his mistress, the Italian photographer Tina Modoti, to Mexico, where he was drawn into the circle of the muralist Diego Rivera. Weston's approach to photography was essentially realistic, but unlike the documentary photographers of the same period, he felt that the camera could see more than the unaided eye and that a precise transcription of the real world could imply something greater, something more real, than reality. He developed a style based on absolute clarity of form in order to render, as he said, "the very substance and quintessence of the thing itself." The effect of this philosophy, or perhaps obsession, can be detected in Weston's exquisite studies of nudes or close-ups of shells and vegetables. He refined and perfected his technique to achieve every nuance of tone in glossy, flawless prints, but he insisted that the photographer should find this perfection through the lens, with what he called previsualization, not in the darkroom.

In 1926 Weston returned to California, where he looked to the landscape for subject matter. The hyper-precision of *White Dunes, Oceano, California* (fig. 38–60), of 1936, illustrates the virtuosity of Weston's craft, how he could transform reality into a dazzling array of abstract patterns. He compresses the vast landscape, bringing even the distant dunes into sharp focus, revealing every crevice, every texture to the fullest, as if the atmosphere were pristine and particle-free. (It should come as no surprise that in the early 1930s Weston belonged to a photography group in San Francisco named "f64," which denotes the smallest aperture opening on a camera, permitting the greatest depth of field.) He increased the definition of his images by utilizing contact prints from a large-format camera, rather than

38-60

38-60. EDWARD WESTON. *White Dunes, Oceano, California.* 1936. Gelatin-silver print. Edward Weston Archives, Center for Creative Photography, University of Arizona, Tucson

enlarging the prints from small negatives and thereby possibly losing detail. Weston's vision of the world was an idealized one—we have little sense of the specifics of time or place in his landscapes—a universe governed by a natural order and reduced to its purest essence.

Before taking up photography in the late 1920s, HENRI CARTIER-BRESSON (born 1908) studied painting in Paris with the Cubist painter André Lhote. In an astonishingly short time he was making some of the most memorable photographs of the century. As a young man, Cartier-Bresson escaped the bourgeois influence of his well-to-do French family through extensive travels in Africa, Europe, and North America. In Paris he had come into contact with avant-garde artists and writers and about 1925 was attracted to the Surrealist movement, which became an important source for his early work. In 1932 he acquired a Leica, a small 35-millimeter camera capable of making instantaneous exposures and of quick film-advancing. Because of its agile, stop-action functions, this camera became a favorite of photojournalists in the 1930s. It was the Leica that made possible the recording of what Cartier-Bresson called the "decisive moment." As he defined it:

Photography is the simultaneous recognition, in a single instant, of on the one hand the significance of a fact and, on the other, the rigorous organization of the visually perceived forms which express and give meaning to that fact.

Cartier-Bresson came of age when Europeans were experiencing deepening anxiety over a deteriorating political situation. Although his photograph titled *Seville, 1933* (fig. 38–61) preceded by three years the outbreak of civil war in Spain, the rubble in which the children play suggests a place that has been ravaged by violent conflict. To capture the decisive moment on film, Cartier-Bresson selected his vantage point, one side of a large hole in a crumbling wall, and then patiently waited for that split second when the subject revealed itself in its most meaningful form. The scenic quality of the blown-out wall contrasts with the giddy games of the children, so strangely balletic in their movements. Like Man Ray, Cartier-Bresson could appreciate and seize upon the unreal and often unseen aspects of reality. It is not surprising that he would eventually work in film, for his attitude is fundamen-

38-61

38-61. HENRI CARTIER-BRESSON. *Seville, 1933.* 1933. Gelatin-silver print. Magnum Photos, New York

tally cinematic in its awareness that the world is changing from one moment to the next.

WALKER EVANS (1903–75), an American from Saint Louis, started making photographs in New York just about the same time as Cartier-Bresson, who was five years his junior. Evans had studied informally at the Sorbonne in Paris, planning on a writing career, but after he returned to New York in 1927, he took up the camera. Within little more than a decade, his work had been included in several New York exhibitions, including the first one-person photography show at the Museum of Modern Art. The beginnings of Evans's career as a photographer coincided with the onset of the Great Depression. During that period of national economic collapse, photographers were enlisted by the Resettlement Administration (later known as the Farm Security Administration, or FSA) of the U.S. Department of Agriculture to document the lives of the country's rural poor. Many of the resulting photographs vividly evoke the widespread deprivation during the era and helped mobilize support for government programs. Evans, who was hired by the FSA in 1935, chose to photograph the most ordinary subjects—junkyards, billboards, gas stations, vernacular architecture, and anonymous, unremarkable people. In 1936 he took a leave of absence from the project to work on assignment for *Fortune* magazine. He was to live with Southern sharecropper families and document their lives with his photographs. His companion on this now-celebrated trip to Alabama was the writer James Agee. Together they lived with three tenant families for up to four weeks each. As a photographer, Evans had little tolerance for the artistic claims of Stieglitz or the darkroom wizardry of Steichen. In fact, the only photograph ever reproduced in *Camera Work* that Evans admired was one of a blind woman on a street made in 1916 by the American Paul Strand, whose direct approach to subject matter anticipated Evans's own. Evans would later remark, "I was doing non-artistic and

38-62

38-62. WALKER EVANS. *Sharecropper's Family.* 1936. Gelatin-silver print. Collection, The Museum of Modern Art, New York. Gift of the Farm Security Administration

non-commercial work. . . . I think I was photographing against the style of the time, against Salon photography, against beauty photography, against art photography."

His photographs directly recorded without sentimentality the bitter poverty and squalid conditions of his subjects' lives, in fact, it seems, without any emotion at all. In *Sharecropper's Family,* of March 1936, he posed a family of Hale County, Alabama, in their home using a tripod and an 8-by-10 view camera (fig. 38–62). Typical of Evans's style is the frontal arrangement of the sitters, who are framed by the rectilinear forms of the architecture and engage us directly with their gaze. Though nothing has been done to embellish the subject, the image is almost classical in its severity, in its static, balanced composition. By such an arrangement Evans confers a certain dignity on his sitters. This new documentary style was intended for a specific sociological purpose, to bring the plight of the poor to the attention of the public, but it conveyed its message not through romanticized imagery and dramatic effects but through honest, understated depiction. *Fortune* (the magazine for which Evans eventually worked as photographer and editor for twenty years) never published the article, but the photographs and Agee's accompanying text were eventually made public in 1941 in the form of a remarkably moving book called *Let Us Now Praise Famous Men.*

It is difficult to overstate the influence of Evans's documentary style on subsequent generations of American photographers. His example was particularly decisive for a young Swiss photographer, ROBERT FRANK (born 1924), who came to New York from Paris in 1947. Disillusioned with his work as a fashion photographer, Frank traveled extensively in South America and Europe. It was with Evans's assistance that he received a Guggenheim grant to travel across the United States and take photographs in the mid-1950s. He published those photographs in an extraordinarily influential book, *The Americans,* which was first published in France in 1958. The following year the book appeared in the United States with a text by the Beat poet Jack Kerouac. Frank's devastating, deliberately graceless image of America conformed to no known photographic conventions. The style seemed artless, offhanded, almost accidental, and the subjects were ones usually passed over as inconsequential. Called a "shattering picture of humanity" by one sympathetic observer, the radical photographs in *The Americans* seemed to portray

38-63

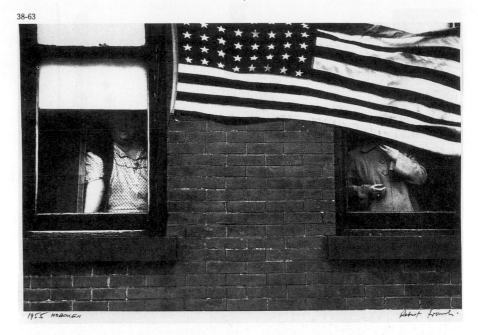

38-63. ROBERT FRANK. *Parade, Hoboken, New Jersey.* 1955. Gelatin-silver print. National Gallery of Art, Washington, D.C. Anonymous Gift in Honor of the Fiftieth Anniversary of the National Gallery of Art

a country bereft of hope and meaningful values. Frank's images angered critics not because they saw in them indictments of a fundamentally optimistic and progressive postwar America, but because they were ill-defined and open-ended and refused to divulge their meaning. His *Parade, Hoboken, New Jersey,* of 1955, contains no marching bands, no smiling beauty queens, but instead creates a record of the anonymous, isolated onlookers whose faces are obscured by shadow or entirely lost behind an American flag (fig. 38–63). Frank's style of stark frontality and shallow pictorial space may remind us of Evans, but his inclusion of the flag as a sadly ironic symbol suggests a sense of desolation that even Evans did not approach. For his book, Frank arranged the photographs into sequences, and the whole gains a cumulative power as one moves through the multiple layers of imagery. These photograph sequences anticipate his later career as a filmmaker of tremendous authority.

New Yorker DIANE ARBUS (1923–71) created some of the most startlingly original images of the 1960s, images that, once seen, are not easily forgotten. Like Robert Frank, whom she knew, Arbus worked sometimes as a commercial photographer, for leading magazines such as *Esquire,* photographing America's celebrities, writers, and socialites. She was the first photographer to be given an official exhibition at the prestigious Venice Biennale (after her death), and exhibitions of her work inevitably attract enormous audiences. With profound empathy, she concentrated her gaze on the existence of human beings caught in the toils of modern chaos. Even when she sought out such subjects as transvestites, giants, dwarfs, and the mentally handicapped, Arbus's images touch the very heart of human existence. And when she turned her camera on so-called normal elements of society, the clarity and directness of her vision could create images of heartbreaking power, as she disclosed the haunting realities of everyday life. She once explained it thus, "If you scrutinize reality closely enough, if in some way you really really get to it, it becomes fantastic."

38-64. DIANE ARBUS. *Child with a Toy Hand Grenade in Central Park, New York City, 1962.* 1962. Gelatin-silver print. Collection, The Museum of Modern Art, New York. Purchase

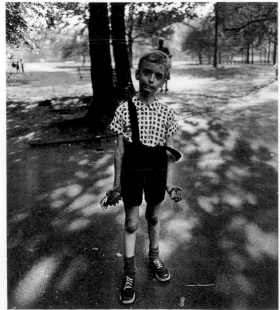

38-64

Child with a Toy Hand Grenade in Central Park, New York City, of 1962, is a work so agonized that words can hardly compete with the expressive language of the image (fig. 38–64). Through a straight photographic technique, Arbus extracted an almost surreal expression from the most innocent of subjects, a child with a toy. She understood the power of the camera to intensify the particulars of this image of a scrawny, grimacing child who seems engulfed by the surrounding space. The taut, clawlike hand, the fallen suspender, the dappled light through the trees—all these elements contribute to a palpable anxiety.

TIME LINE XV

Nostalgia of the Infinite, by De Chirico

Guitar, by Picasso

Woman with Amphora, by Matisse

Triumph and Glory, by Dubuffet

POLITICAL HISTORY	LITERATURE, MUSIC, ART	SCIENCE, TECHNOLOGY
1900 McKinley and T. Roosevelt win U.S. presidential election, 1900 Triple Entente: Great Britain, France, Russia, 1907	Alfred Stieglitz founds Photo-Secession group, New York, 1902; opens gallery at 291 Fifth Avenue, 1905 Maurice Ravel (1875–1937)	Sigmund Freud publishes *Interpretation of Dreams,* 1900 Wright brothers make first flight with power-driven airplane, 1903
1910 Revolution in China establishes republic, 1911 World War I, 1914–18	First Futurist manifesto, 1910 Armory Show, New York, 1913 Igor Stravinsky (1882–1971) Bauhaus founded, Weimar, 1919	Russell and Whitehead publish *Principia Mathematica,* 1910–13 Ernest Rutherford formulates theory of positively charged atomic nucleus, 1911
Bolshevik Revolution, 1917 League of Nations founded, 1919 **1920** Mussolini's Fascists seize Italian government, 1922	André Breton (1898–1966); Ernest Hemingway (1898–1961); Bertolt Brecht (1898–1956) First Surrealist manifesto, 1924	First radio station begins regularly scheduled broadcasts in U.S., 1920 Albert Einstein (1879–1955) First regularly scheduled TV broadcasts in U.S., 1928
Stock market crash in U.S., 1929; worldwide depression **1930** Spain becomes a republic, 1931	Jean-Paul Sartre (1905–81) Claude Lévi-Strauss (born 1908) Albert Camus (1913–60) Eugene O'Neill wins Nobel Prize, 1936	
Spanish Civil War, 1936–39 World War II, 1939–45 **1945** United Nations Charter, 1945	Edmund Wilson's *To the Finland Station* is published, 1940 Arnold Toynbee's 12-volume *Study of History* is in publication (1934–61)	Penicillin discovered, 1943
Israel becomes independent, 1948 Communists under Mao win in China, 1949 **1950** Korean War, 1950–53 Mau-Mau revolt against Kenya's white settlers, 1952	J. D. Salinger's *Catcher in the Rye,* 1951, and Beat poet Allen Ginsberg's *Howl,* 1956, are published	Transistor as substitute for radio vacuum tube is invented, 1947–48 Genetic code cracked, 1953 Second hydrogen bomb exploded, 1954 Sputnik, first satellite, launched, 1957
Common Market established in Europe, 1957 Fidel Castro leads guerrilla army into Havana and takes over Cuba, 1959 **1960** U.S. U-2 reconnaissance plane is shot down over Russia and pilot held by Soviets, 1960 East Germany begins to build Berlin Wall, 1961 John F. Kennedy assassinated, 1963 Massive U.S. intervention in Vietnam, 1965	John Cage composes *Imaginary Landscape No. 4,* 1953 Allan Kaprow stages *18 Happenings in 6 Parts,* New York, 1959 Musician Olivier Messiaen's 7-volume *Catalogue des Oiseaux,* 1959 *Webster's Third New International Dictionary* published, 1961 Jacques Derrida publishes *De la Grammatologie,* 1967, source of Deconstructivist theory	First manned space flight, 1961 Discovery of quasars, 1963, and pulsars, 1968 First manned landing on the moon, 1969
1970 Vietnam War ends, 1973 Accident at Three Mile Island nuclear reactor, 1979 **1980** Ronald Reagan elected president of U.S., 1980 U.S.-Soviet treaty to reduce nuclear arms is signed, 1987 East and West Germany are reunified, 1990	First feminist art education program in U.S. founded at Cal. State University, Fresno, 1970 One million people visit Picasso exhibition at Museum of Modern Art, New York, 1980 Compact discs revolutionize music industry, 1985 Van Gogh's *Sunflowers* sells for $39.9 million, 1987	First "test-tube" baby born in England, 1978 First report by Center for Disease Control on AIDS epidemic, 1981 Home computers are widely available, 1981
1990 Breakup of Soviet Union, 1990–91	U.S. House passes bill to end federal funding of art in violation of local obscenity laws, 1990	*Voyager 2* spacecraft encounters Neptune, 1989 Hubble Space Telescope put into orbit, 1991

The Steerage, by Stieglitz

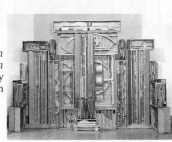

An American Tribute, by Nevelson

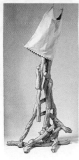

Shoestring Potatoes, by Oldenburg

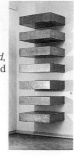

Untitled, by Judd

PAINTING, SCULPTURE, PHOTOGRAPHY

Kollwitz, *Outbreak*	GERMAN EXPRESSIONISM FAUVISM	1900
Matisse, *Bonheur de Vivre*	DIE BRÜCKE CUBISM (ANALYTIC)	
Picasso, *Les Demoiselles d'Avignon* Boccioni, *The City Rises* Duchamp, *Nude Descending a Staircase* Picasso, *Guitar* Kandinsky, *Improvisation 30* Gabo, *Constructed Head No. 1* Malevich, *Suprematist Composition* Tatlin, *Monument to the Third International*	FUTURISM DER BLAUE REITER RAYONNISM, SUPREMATISM AMERICAN MODERNISM CONSTRUCTIVISM DE STIJL	1910
Duchamp, *Bride Stripped Bare (Large Glass)* Mondrian, *Composition* (1925) Man Ray, *Noire et Blanche* Moholy-Nagy, *Bauhaus Balcony* Hopper, *Automat* Dali, *Persistence of Memory*	DADA CUBISM (SYNTHETIC) SURREALISM AMERICAN SCENE	1920
Orozco, *Departure of Quetzalcatl* Evans, *Sharecropper's Family* Picasso, *Guernica* Calder, *The Spider*		1930
Gorky, *The Liver Is the Cock's Comb* Newman, *Onement I* Pollock, *Number 1, 1950*	EUROPEAN AND AMERICAN MODERNISM ABSTRACT EXPRESSIONISM	1945
Davis, *Owh! in San Pao* Frankenthaler, *Mountains and Sea* Frank, *Parade, Hoboken, New Jersey* Rothko, *White and Greens in Blue* Rauschenberg, *Canyon* Kelly, *Running White*	COLOR-FIELD PAINTING NEO-DADA HARD-EDGE PAINTING POP ART	1950
Klein, *Requiem* F. Stella, *Avicenna* Smith, *Zig IV* Warhol, *Marilyn Diptych* Johns, *According to What* Judd, *Untitled* (1965) Oldenburg, *Shoestring Potatoes*	MINIMAL ART PERFORMANCE ART CONCEPTUAL ART	1960
Hesse, *Seven Poles* Smithson, *Spiral Jetty*	EARTH ART, SITE ART PATTERN AND DECORATION PHOTO-REALISM	1970
Lin, *Vietnam Veterans Memorial* Fischl, *The Old Man's Boat* Kiefer, *Isis and Osiris* Schapiro, *Conservatory*	NEO-EXPRESSIONISM	1980
Puryear, *Lever No. 3*		
		1990

CHAPTER THIRTY-NINE

Architecture has been characterized by W. R. Dalzell as the "indispensable art," and rightly so. Inevitably, the practical functions that shelters are designed to fulfill play a strong role in determining their appearance and thus, in part, their artistic character. So do the methods of construction available and practicable at any given moment. The strikingly new forms of architecture that appeared in the late nineteenth century and in the twentieth century were built to meet the needs of industry and of commerce based on industry, in a society whose essential character and internal relationships had been sharply transformed by the Industrial Revolution. Few new palaces were built for the nobility or monarchies, for example; the characteristic new structures were industrial or commercial buildings, and the techniques invited to fulfill the new functions were, in turn, adopted for such traditional types as dwellings and churches.

Richardson, Sullivan, and the Chicago School

About the middle of the nineteenth century, mechanized industrial production began to demand large, well-lighted interiors in which manufacturing could be carried on. The administration of giant industrial and commercial concerns required office buildings of unprecedented size, containing suites of offices easily accessible to employees and customers. The marketing of industrial products necessitated large-scale storage spaces and enormous shops selling under one roof a wide variety of items. Industrial and commercial pressures drew increasing populations to urban centers, and traditional housing was no longer adequate to contain them. Mechanized transportation of industrial products and industrial business personnel was essential. Leisure-time entertainment and cultural activities for the vast new urban populations required still a different kind of structure. Hence, the characteristic new architectural forms of the late nineteenth century and twentieth century have been the factory, the multistory office building, the warehouse, the department store, the apartment house, the railway station (eventually superseded by the air terminal), the large theater, and the gigantic sports stadium. None of these could have been built on the desired scale by traditional constructional methods.

Unfortunately, as a glance around any modern metropolis will show, only a small fraction of these new structures may be described as artistically interesting. And many that can have nostalgically clothed their new constructional framework and methods with a veneer of columns, arches, towers, and ornament drawn from the architecture of earlier periods. Worse, the immense demand for economically "viable" new constructions has already swept out of existence considerable numbers of really fine late-nineteenth-century and twentieth-century structures that were revolutionary when they were built and completely satisfied the commercial demands of the time. The present account will be limited almost entirely to innovative structures that deliberately broke with architectural tradition in one way or another.

Since the Gothic period no truly revolutionary practical techniques of construction arose until the late eighteenth century and early nineteenth century, when cast iron came into use for bridges, industrial structures, and temporary exhibition buildings. When used for more traditional architectural types, such as churches and libraries (see fig. 32–14), cast iron was generally restricted to roofs and their internal supports, and from the exterior the building presented itself as a masonry structure. Mid-nineteenth-century commercial buildings in some American cities did, however, display cast-iron façades whose elements were imitated from the columns and arches of Italian Renaissance palaces.

Cast iron had its faults as a construction material. Its tensile strength was low,

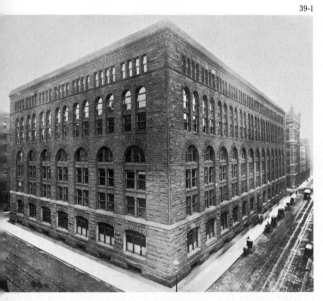

39-1. HENRY HOBSON RICHARDSON. Marshall Field Wholesale Store, Chicago (demolished 1930). 1885–87. Courtesy Chicago Historical Society

MODERN ARCHITECTURE

and so was its melting point; hence, it was prone to collapse and to conflagration. The invention of a process for the manufacture of steel by Sir Henry Bessemer in the 1850s led to steel's first widespread use in building in response to the new necessities. Only structural steel and concrete reinforced by steel could have made possible the characteristic multistory structure of the modern city. A concomitant invention, the power elevator, made such buildings practicable by providing vertical transportation for persons and objects. Hoists of one sort or another, operated manually, have been known since antiquity, but the first power elevator, driven by steam, made its appearance only after the middle of the nineteenth century. By the 1870s steam had given way to hydraulic power as the motive force for elevators, and during the 1890s electricity took over this job. The modern city was on its way, with all its insoluble problems of space and transportation, increased manyfold by the invention of the internal-combustion engine.

RICHARDSON Early commercial structures in most nineteenth-century metropolitan centers were not essentially distinguishable from any other kind of secular building—houses or hotels, let us say—save by their extent. The development of the multistory structure, and eventually the skyscraper, was immeasurably assisted by the great fire of 1871 that virtually destroyed the center of Chicago, then largely built of wood. A number of pioneer multistory buildings were constructed during the ensuing period of chaotic rebuilding. An early attempt to face the necessities of the commercial building and express them artistically was the Marshall Field Wholesale Store (fig. 39–1), built in 1885–87 by Henry Hobson Richardson (1838–86), who died before its completion. Richardson recognized that, although the ground story of a tall business building might have a real reason for being higher than the others, the needs of subsequent floors were pretty much the same. In his seven-story structure, therefore, he kept the heights of the six upper stories uniform but treated them as if they diminished by grouping them under massive, rusticated arches imitated from those of Roman aqueducts. The first arcade embraces the second, third, and fourth stories. The second arcade, with arches half as wide as those below them, contains the fifth and sixth stories. The windows of the seventh story, above a stringcourse, are rectangular and half the width of those of the lower floors.

Out of commercial necessity the immense number of windows was determined not by the external design of the building, as in many Renaissance and Baroque structures (some of which have false windows for symmetry's sake), but by the requirements of the interior. Internally, the floors were supported by an iron skeleton, as was general at the time, but the grand exterior arches and walls did bear weight. Unfortunately, in 1930 the building was demolished to make way for a parking lot. At the moment of its construction, however, the essential characteristic of the American multistory structure, the steel frame, was already in use elsewhere in Chicago in the artistically uninteresting Home Insurance Building, built in 1883–85 by William Le Baron Jenney (1832–1907). The steel frame, composed of vertical and horizontal beams riveted together, created a structure that stood almost independent of the laws of gravity, holding together not by downward thrust but by the tensile strength of the steel. When the Home Insurance Building was demolished in 1929, the walls were found to have been supported entirely by steel shelving protruding from the frame and to have been structurally useless.

SULLIVAN The steel-frame structure is a rectangular grid in which walls are reduced to curtains and have, in the twentieth century, often been replaced entirely by glass (see fig. 39–23). Hence, the impression of massiveness and of superimposed elements of constantly decreasing weight, which in the Marshall Field

39-2

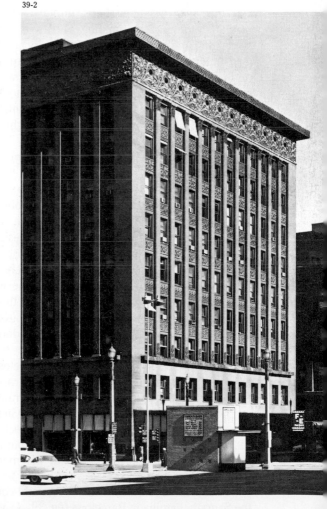

39-2. LOUIS SULLIVAN. Wainwright Building, Saint Louis (view from the southeast). 1890–91

structure corresponded to fact, was destined to be replaced by emphasis on an allover rectangular pattern, well-nigh universal in twentieth-century multistory buildings. Post and lintel, arch and vault were reduced to anachronistic ornaments. An early building in whose design this essential fact was recognized from the start is the Wainwright Building in Saint Louis, of 1890–91 (fig. 39–2), a masterpiece by Louis Sullivan (1856–1924), rescued from demolition in 1975 by enlightened governmental action. Sullivan grouped the first and second stories together as a pedestal, then handled the next seven as absolutely identical. He emphasized the verticality of the structure by treating the walls between the windows as slender shafts, running up seven stories, with delicate capitals and bases, achieving the effect that the building looks much taller than it really is. For the spaces between the windows, corresponding to the floors supported by horizontal beams, and for a splendid band at the top, he used a rich system of ornamentation devised by himself. The final cornice (to hide chimneys and water tower) gives the building a blocklike effect not unlike that of a Renaissance palace (see fig. 20–13). But if its massive appearance recalls Renaissance tradition, for its basic design the building depends entirely on frank recognition of its steel frame.

A still more revolutionary work, remarkably prophetic of much twentieth-century architecture, is the Carson Pirie Scott Department Store, built in Chicago by Sullivan in 1899–1901 and enlarged in 1903–4 (fig. 39–3). Here he recognized for the first time the basic identity between vertical and horizontal directions implicit in the very nature of the steel frame. In his design any reference to columns is reduced to the slender shafts running up ten stories between the windows at the rounded corner of the building. The areas between the windows on both façades are left flat and smooth, so that verticality and horizontality are perfectly balanced. Ornament is reduced to a delicate frame around each window and to a gorgeous outburst over the corner entrance to the store. Such ornamental passages are the only aspect of Sullivan's style that ties him to the work of his European contemporaries, discussed below. The crowning cornice, as compared to that of the Wainwright Building, is greatly reduced in height and projection.

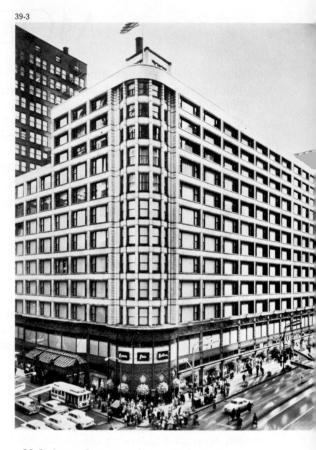

39-3. LOUIS SULLIVAN. Carson Pirie Scott Department Store, Chicago. 1899–1901; enlarged 1903–4

Art Nouveau and Expressionist Architecture

In sharp contrast to the rational criteria that guided the work of the architects who have come to be known as the Chicago School, a very different set of principles was evolving in Europe, related to those of the Nabis and the Symbolists (see pages 953–55) and to the movement in interior design and the decorative arts at the turn of the century known as Art Nouveau. European designers seem to have held the straight line in horror, substituting for it wherever possible (or where not, enriching it) exuberant curves recalling those of the Rococo (see figs. 29–7, 29–25) but surpassing them in freedom because of their emancipation from the rules of symmetry. The fresh naturalism of Art Nouveau and its related movements was often expressed in such characteristic modern materials as metal and glass.

GAUDÍ In the last two decades of the nineteenth century the new style appeared in Barcelona, and then just before the turn of the century burst forth in Paris, Brussels, Munich, Vienna, and even the traditionalist Italian cities. The greatest innovator, whose works are still astonishing in the liberty and scope of the imagination they disclose, was the Catalan architect and designer Antoni Gaudí (1852–1926). His work is limited to Barcelona, but his buildings are so richly scattered throughout the modern sections of the metropolis as to constitute one of its principal attractions.

In 1883 Gaudí took over the design and construction of the colossal Church of the Sagrada Familia in Barcelona (fig. 39–4), which had previously been projected and partly built as a rigorously Neo-Gothic edifice. Although Gaudí worked on the Sagrada Familia off and on until his death, the church remains a fragment; only the

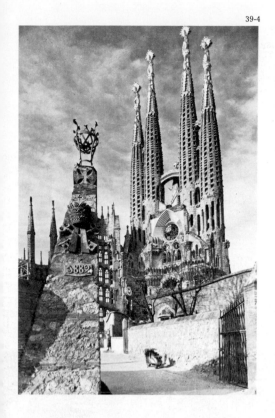

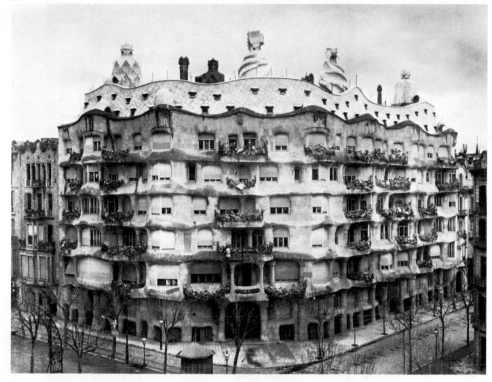

39-4. ANTONI GAUDÍ. Church of the Sagrada Familia, Barcelona. 1883–1926

39-5. ANTONI GAUDÍ. Casa Mila, Barcelona. 1905–7

39-6. ANTONI GAUDÍ. Plan of a typical floor, Casa Mila, Barcelona

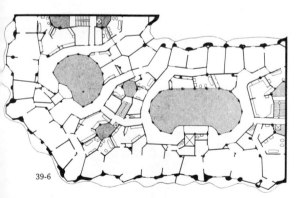

crypt is usable. The four bottle-shaped spires of one transept, pierced by unbelievably irregular spiral fenestration, tower above the earlier Gothic windows of the façade and the unprotected nave floor in shapes so fantastic that they seem to have grown there rather than to have been built.

Gaudí's masterpiece is the Casa Milá, of 1905–7 (figs. 39–5, 39–6), an apartment house, in whose plan and design, aside from the window mullions and transoms and some inner partitions, not a straight line remains. The building is convulsed as if it were gelatin. Balconies ripple and flow, bulge and retract in a constant turmoil; windows reject vertical alignment. Rich vegetable ornament in wrought iron drips from the balconies like flowering vines or Spanish moss. The chimneys—all different, of course—are spiral or imprinted with irregular lozenge shapes or freely conoid. Inner courtyards and corridors move with the random patterns of natural caverns, and the interior walls and partitions are so arranged that few are parallel and none meet at right angles. Although one might have expected so fluid a building to have been constructed of a plastic material such as concrete, the façade is actually made of cut stone, the pulsating roof of marble slabs, and the chimneys of marble fragments. (In much of his work in houses, chapels, and parks, Gaudí included bits of broken ceramics or glass, embedded in free-form mosaics.) Could Dali have had the Casa Milá in mind when he painted his "wet watches" (see fig. 37–14)? Neglected and even condemned during the heyday of the International Style (see below), Gaudí has recently taken his place as one of the great creative minds of modern architecture, and his ideas have influenced immeasurably the work of such architects as Eero Saarinen and Paolo Soleri (see figs. 39–27, 39–33).

HORTA A less vigorous but even more refined architect of the turn of the century, the true founder of Art Nouveau, was the Belgian Victor Horta (1861–1947). Horta studied with care the principles of Baroque and Rococo architecture and the structural ideas of the French nineteenth-century Neo-Gothic architect and theoretician Eugène Viollet-le-Duc (1814–79), who was responsible for the extensive restoration of many French Gothic buildings. In Horta's Salon for the Van Eetvelde

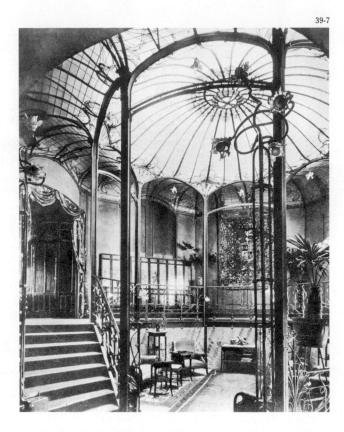

39-7

39-8. MAX BERG. Interior, Centenary Hall, Wroclaw, Poland (formerly Breslau, Germany). 1912–13

39-9. ERICH MENDELSOHN. Einstein Tower, Potsdam, Germany (destroyed). 1919–21

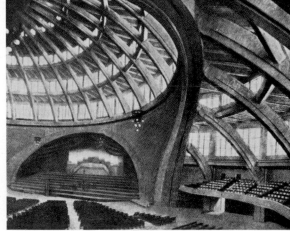

39-8

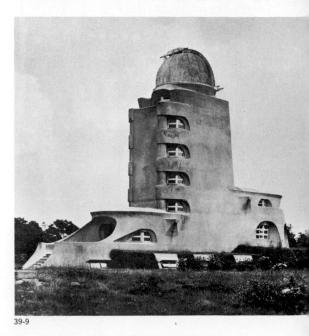

39-9

House in Brussels, built in 1895 (fig. 39–7), the only straight lines are the verticals he horizontals of the floors, steps, and balustrades, although even these are curved in plan. Every line flows with the grace of natural growth, the lamp stands curl like flowering vines, the light bulbs form the centers of huge flowers, and the framework that holds in place the glass of the central dome expands in natural curves like the ribs of a gigantic leaf.

EXPRESSIONIST ARCHITECTURE Parallel with the development of Expressionism in German painting, early-twentieth-century German architecture took on new and freer shapes, all strongly influenced by the structural innovations and imaginative fluidity of Art Nouveau. A brilliant example, displaying daring structural techniques, is the interior of the Centenary Hall at Wroclaw, Poland (formerly Breslau, Germany), built in 1910–13 by MAX BERG (1870–1948). Although the exterior is conventional and unimpressive, the vast interior space, based on an almost Leonardesque design, with four apses radiating from a central circular space, is unexpectedly original (fig. 39–8). The four colossal arches supporting the dome on pendentives are curved even in plan, and the vaulting of the dome and the semidomes over three of the four apses (the fourth is a stage) consists of nothing but ribs, open to views of seemingly endless tiers of windows. The thrilling effect of lightness and free space is clearly related to the inventions of Guarino Guarini (see fig. 26–33), which were built in masonry; Berg's new design could have been executed only in the material for which it was intended, reinforced concrete, which had been used with great advantage in Europe and adopted somewhat more reluctantly in the United States.

Another milestone in Expressionist architecture was the Einstein Tower at Potsdam, outside Berlin, built in 1919–21 by ERICH MENDELSOHN (1887–1953) and now destroyed (fig. 39–9). While a soldier in the trenches during World War I, Mendelsohn occupied many dreary hours by jotting down with a heavy stub pen in tiny sketchbooks hundreds of imaginative building designs, of which the idea for the Einstein Tower was one. He designed it to be constructed of poured concrete,

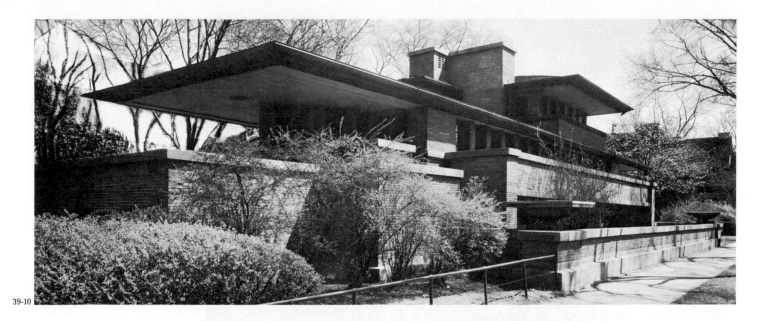

39-10

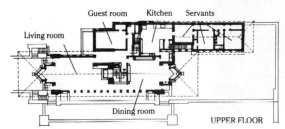

Guest room Kitchen Servants

Living room

Dining room

UPPER FLOOR

Entrance hall Boiler room Laundry

Billiard room

Garage

Court

39-11

Garden

LOWER FLOOR

Children's playroom

39-10. FRANK LLOYD WRIGHT. Robie House, Chicago, 1909

39-11. FRANK LLOYD WRIGHT. Plan of the ground floor and first floor, Robie House, Chicago

for which its fluid forms were obviously intended, but for technical reasons it had to be built in brick covered with stucco. All the forms, including staircase, entrance, walls, windows, and dome, flow smoothly into one another with great expressive effect, obliterating all straight lines other than, as in the Casa Milá by Gaudí, the inescapable window mullions and transoms.

Frank Lloyd Wright

A period and a law unto himself was Frank Lloyd Wright (1867–1959), one of the greatest American artists in any medium. Praise for him must be tempered by recollection of his weaknesses—his occasional lapses of taste and the egoism that made it difficult for him to admit into his interiors any object he had not designed himself. This was an obvious impediment to the success of his designs for the Solomon R. Guggenheim Museum in New York City, and a torment to its staff since before the building was erected. But when all is said and done, Wright was an extraordinary man, a prophet of a new freedom and at the same time of a new discipline in architecture, a molder of form and space, and a genius who experienced the relationship between architecture and surrounding nature as has perhaps no other architect in history, so that his buildings seem literally to grow out of their environments.

Wright's first success, which brought him international recognition, was in the field of private residences, his "prairie houses," such as the revolutionary Robie House in Chicago, built in 1909 (fig. 39–10). As is visible in the plan (fig. 39–11), Wright has to a considerable extent departed from the Western tradition of enclosed, self-sufficient spaces opening into each other by means of doors. His rooms are partially enclosed subdivisions of a common space, which in itself is felt as a concentration of motifs and forces outside the building. In plan and in elevation the house is at once invaded by outside space and reaches back dramatically into it. The influence on Wright of the Japanese Pavilion at the Chicago World's Fair of 1893 has often been pointed out, but it should also be recalled that as early as the 1870s American houses bristled irregularly with verandas at all levels, and interior spaces did indeed flow into one another (with room divisions often no more formidable than curtains or beaded dowel screens) off a central staircase hall utilized as the main living space. Wright's individual contribution lay in the daring of his assault on the outer world through cantilevered roofs projecting without vertical supports, seeming to float freely, and the purification of vertical and

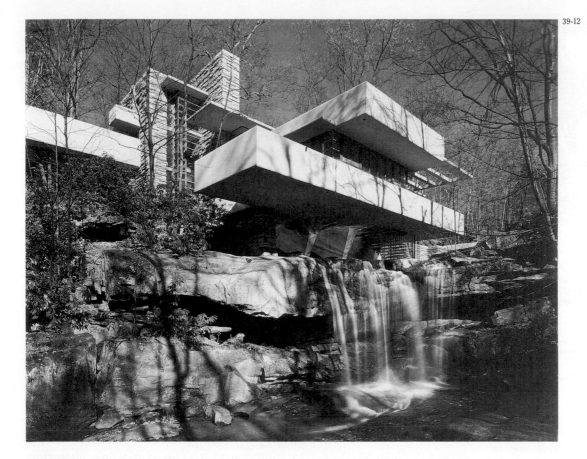

39-12

horizontal masses, as if by some sixth sense he had realized what was about to happen in Analytical Cubism in France. The Robie House combines cubic forms and projecting planes with a mastery never before seen in architecture.

39-12. FRANK LLOYD WRIGHT. Kaufmann House ("Falling Water"), Bear Run, Pennsylvania. 1936

More than a quarter of a century later, in 1936, Wright built one of his most original conceptions, the Kaufmann House at Bear Run, Pennsylvania, suspended over a waterfall (fig. 39–12). The idea did in a sense have a prototype in the French Renaissance château of Chenonceaux, built on a bridge across the river Cher. But Wright seems to have derived the masses of "Falling Water" from the very rock ledges out of which it springs. A central mass of rough-cut stone masonry blossoms forth in cantilevered concrete terraces, colored beige so as not to disrupt the tonal harmony of their woodland environment—a house really at one with the rocks, the trees, the sky, and the rushing water.

Wright could work only with sensitive, discerning, and fairly submissive patrons, and thus was destined never to receive the great commissions to which his genius entitled him. His dream of a mile-high skyscraper for Chicago, and his Broadacre City, an imaginative combination of industrial plants with houses and gardens for factory personnel, went unbuilt.

The International Style

After the close of World War I, a new architectural style arose almost contemporaneously in Holland, France, and Germany, and has thus received the name "International Style." Its consequences, for good or ill, are still with us today. The International Style is responsible for some of the most austerely beautiful creations of twentieth-century art, and once it became apparent to patrons and builders alike that the principles of the International Style could be used for cheap construction, these principles were eventually welcomed commercially. What began in the 1920s as a revolutionary ideal for a new architecture became in the 1960s and 1970s the

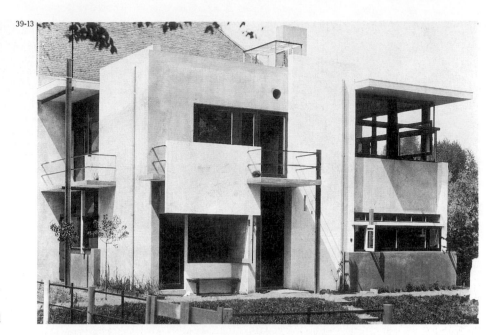

39-13

39-13. GERRIT RIETVELD. Schröder House, Utrecht, the Netherlands. 1924

39-14. GERRIT RIETVELD. Plans of the Schröder House, Utrecht. Top to bottom: entrance floor; upper floor; upper floor with partitions removed

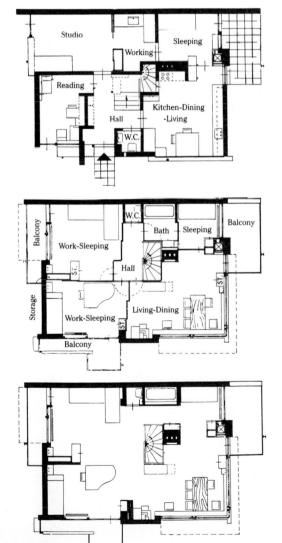

39-14

cliché of mass-produced building, which makes every major unprotected city on the planet look pretty much like every other one.

The International Style rejected ornament of any sort. It also denied the traditional concept of the building as a mass. Finally, it prohibited the use of such "natural" materials as stone or wood. This was no wonder, since the open planes and spaces of the International Style could only have been created with the use of modern materials, especially steel and reinforced concrete. These were used to form flat surfaces, kept as thin as possible and almost invariably white, alternating only with areas of glass, to enclose volumes rather than to create masses. The result is a boxlike appearance, reminding one less of architecture as it had been conceived in the West since antiquity (with the sole exception of the Gothic interlude) than of the cabin block on a steamship. Models for traditional European buildings were usually carved from wood, and some were modeled in clay and cast in plaster. A model for an International Style building could be, and often was, constructed of light cardboard and cellophane. Never in traditional architecture had there been anything so utterly weightless as the buildings of the International Style.

The principles of Cubism, with its exaltation of the plane to a position of supreme importance, played a part in the creation of the International Style. So did the new architecture of Wright, widely known in Europe after his Berlin exhibition of 1910. Especially important was the aesthetic of De Stijl (see pages 991–92 and figs. 36–33, 36–34), which in Holland had already reduced both the subject and the elements of art to flat planes, right angles, black, gray, white, and the three primary colors—with white predominating. One of the earliest buildings of the International Style is the Schröder House at Utrecht (figs. 39–13, 39–14), built in 1924 by GERRIT RIETVELD (1888–1964). In this extraordinary building the appearance of weightlessness characteristic of the International Style is first proclaimed, but in full conformity with the principles of De Stijl. The Schröder House, in fact, is the three-dimensional equivalent of a painting by Mondrian. Nothing weighs, thrusts, or rests; all planes are kept as slender as possible, as external surfaces bounding internal volumes. Some of the planes connect at the corners, some appear to slide over each other in space. The cantilevered roof and balconies, doubtless influenced by those of Wright, are restricted to concrete slabs instead of Wright's massive forms. Windows are continuous strips of glass. The only details are the mullions and the simple steel pipes used as railings. The plan of the upper floor was made completely flexible by the device of removable partitions, which could be stored to create space for entertaining.

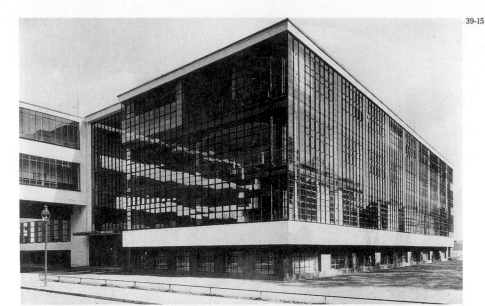

39-15

39-15. WALTER GROPIUS. Workshop wing, Bauhaus, Dessau, Germany. 1925–26

GROPIUS As early as 1911, the principles of the International Style had been foreshadowed in industrial architecture by Walter Gropius (1883–1969), who had used continuous glass sheathing as a substitute for walls, even at the corners of a building. The supports, entirely internal, were not visible on the exterior. Gropius's great opportunity, however, came in the building of the famous Bauhaus, an international center for design in all its forms. Originally two separate institutions, called the Saxon School of Arts and Crafts and the Saxon School of Fine Arts and located at Weimar, Germany, the institutions in 1919 came under the direction of Gropius, who merged them into one, reorganizing the curriculum and renaming the school. Bauhaus, derived from the German words for "building" (in the figurative as well as the literal sense) and "house," epitomized the purpose Gropius saw in the organization. It was to comprise instruction not only in the traditional arts of painting and sculpture but also in the crafts, from weaving to printing; instruction was to be directed toward industrial design and dominated by rational, up-to-date principles employing mechanized techniques. In later years the Bauhaus taught architecture as well. As we have seen, Klee, Kandinsky, and Moholy-Nagy came to the Bauhaus as professors; so did a number of other artists, designers, and architects, and a large group of gifted students. From the Bauhaus the new ideas radiated to all parts of the globe.

In 1925 Gropius moved the Bauhaus to Dessau, where he was building new quarters for the school from his own designs. In the workshop wing (fig. 39–15), constructed in 1925–26, Gropius carried out systematically the principles of the International Style. The building is a huge glass box, with panes as large as they could be economically manufactured held in a uniform steel grid. The four stories of the interior receive no external expression in this uninterrupted glass exterior, being separately supported on their own reinforced concrete columns. Walls are reduced to narrow, white strips at top and bottom. According to a principle of the International Style—as defiant of climate as its constructional principles are of gravity—the roof is completely flat. Such vast expanses of glass remained in fashion up to the energy crisis of the 1970s, and buildings utilizing them require enormous heating, ventilating, and cooling mechanisms, not to speak of death-defying external window-washing teams.

LE CORBUSIER Meanwhile, in France the principles of the International Style were being brilliantly exploited by the Swiss architect-painter Charles-Édouard Jeanneret (1887–1965), known by the pseudonym of Le Corbusier, who competes

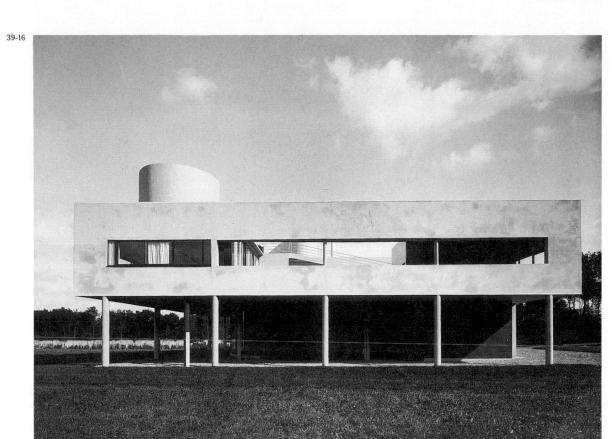

39-16

39-16. LE CORBUSIER. Villa Savoye, Poissy, France. 1928–30

39-17. LE CORBUSIER. Interior, Villa Savoye, Poissy (view of the living room looking toward the terrace)

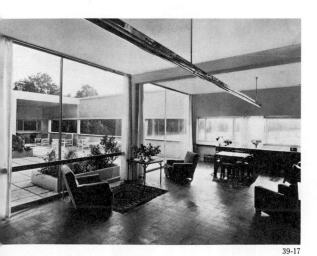

39-17

with Wright for leadership in the formation of twentieth-century architecture. Le Corbusier had already built several International Style houses when he undertook in 1928–30 the Villa Savoye at Poissy, France, even more severe and radical in its appearance than the Schröder House. At first sight the building, supported on stiltlike reinforced-concrete poles, seems to have no ground story; actually, there is one, recessed deeply under the overhanging second story, and containing entrance hall, staircase, servants' quarters, and carport (fig. 39–16).

Le Corbusier called his houses "machines for living in," and this one fulfills his designation to perfection. The second floor, dominated by a staircase tower that suggests the funnel of a steamship, is a box bounded by perfectly flat, continuous planes, acknowledging no possibility of overlap, and punctuated by windows reduced to unbroken horizontal strips of glass panels, sustained by slender mullions. The window strips not only light the interior rooms of the second floor but also provide outlook for a sunny, interior terrace, open to the sky and separated from the living room only by floor-to-ceiling panels of plate glass (fig. 39–17). Revolutionary in Le Corbusier's day, this method of creating a free interchange has become a commonplace of residential and even motel design since the 1950s. Electric lighting is confined to a long, chrome-plated fixture.

Le Corbusier did not restrict his revolutionary architectural ideas to single structures but, as Wright had—although on a far larger scale—dreamed of urban planning as well. He envisioned, designed, and theorized about a *ville radieuse* ("radial city") of three million people, with interrelated factories, office buildings, apartment blocks both high and low, and cultural and amusement centers, all connected by means of elevated highways and punctuated by green areas for recreation. As we contemplate our choked and polluted present-day urban agglomerations, which are not so unlike Le Corbusier's city plans, we can ask ourselves whether his dreams of a gridded metropolis were perhaps best left unrealized. Two of Le Corbusier's late works, very different in conception and effect from his International Style masterpiece, are discussed below.

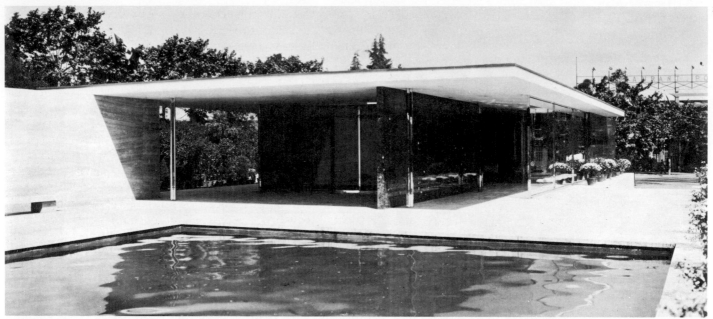

MIES VAN DER ROHE Under the initial influence of Gropius, the German architect Ludwig Mies van der Rohe (1886–1969) developed a new and purified personal version of the International Style, alongside which the work of Gropius and even of Le Corbusier seems heavy. The German Pavilion at the Barcelona International Exposition in 1929 delicately reinstated the use of such natural materials as veined marble and travertine (fig. 39–18). Mies's famous dictum "less is more" is expressed here in his extraordinary refinement of space, plane, and proportion, all reduced to absolute essentials. The eye moves serenely from interior to exterior spaces, unified by the movement of planes and separated only by plate glass. Marble, concrete, chrome, water, and air are formed into a harmony as carefully adjusted as a white-on-white painting by Malevich (see fig. 36–27).

39-18. LUDWIG MIES VAN DER ROHE. German Pavilion (dismantled), Barcelona International Exposition. 1929

39-19. CASS GILBERT. Woolworth Building, New York. 1911–13

The Skyscraper—Romance to Internationalism and Return

The history of the American skyscraper after Sullivan is colored by recollections of the past rather than by premonitions of the new era, of which that amazing American invention would have seemed to be the perfect herald. Skyscrapers went up apace in the first two decades of the century and created a delightful Dolomitic skyline in downtown New York and Chicago, but each individual building, however picturesque, attempted to clothe the steel frame with elements drawn from architectural history. Sometimes the results were absurd, but in 1913 the Woolworth Building in New York (fig. 39–19), by CASS GILBERT (1859–1934), proved that a skyscraper could be beautiful. The essentials of the steel frame are clearly stated on the exterior of the building, sixty stories high (for seventeen years the tallest habitable construction in the world). But the shape of the tower was derived from those of Netherlandish Flamboyant Gothic bell towers, similar to those visible over the treetops in the background of the *Ghent Altarpiece* (see fig. 21–14). At that height the rich ornamentation, in glazed white terra-cotta against green copper roofs and gilded finials, is read as a softening of the outline of the structure against the sky. (The pointed top conceals such utilities as the watertank and chimneys.) What still renders the building a delight is its elegance, lightness, and grace, surprising in so huge a mass. The romantic spire, now buried by taller and less distinguished structures, once formed the peak of New York's pyramidal skyline.

The beauty of the building was not equaled in its time by any other traditionalist

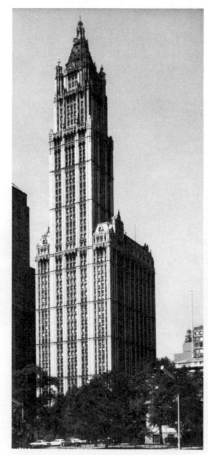

39-19

work, not even those by Cass Gilbert himself. But the tendency of advanced architects was all in the other direction. In 1922 Gropius submitted to the competition for the Chicago Tribune Tower a strongly International Style design (in association with Adolf Meyer), clearly related to the ideas of Sullivan and the Chicago School of twenty years before. His project was not selected; the choice went instead to a Neo-Gothic design by Raymond Hood (1881–1934), in unsuccessful emulation of the Woolworth Building.

In his later buildings, however, Hood began to adopt some of the principles of the International Style. Architects in New York City were bound by the conventions of the building code, including the so-called setback law, to terrace their structures progressively back from the street in order to allow sunlight to penetrate into what were becoming dark canyons. The result was a number of commercial buildings designed so as to profit from every cubic inch allowable under the law and promptly nicknamed "ziggurats." Imaginative architects had, nonetheless, to satisfy their materialistic clients. Hood discarded all reference to the historic past in the Daily News Building, which he designed with John Mead Howells (1868–1959) for New York in 1929. Constrained to set the building back in steps from the street, the architects compensated for this enforced irregularity of contour by corresponding irregularities within planes composing the sides — a handsome innovation marking a considerable advance in skyscraper design.

One of the most successful attempts to translate the language of historical forms into a twentieth-century idiom was the thrilling Chrysler Building in New York (fig. 39–20) by WILLIAM VAN ALEN (1882–1954), begun as a sort of hymn to the triumph of the American automobile in the heady atmosphere of 1928, the year before the stock-market crash, and completed two years later amid universal gloom. The upward zip of the tower was increased by contrasting the three vertical columns of windows on the center of each face with the horizontal window strips at the corners. The central window columns rise higher than those on either side and seem to explode at the top into constantly rising concentric arches, ribbed like the sunburst of the Chrysler logo, faced with stainless steel, and pierced by wedge-shaped windows. The almost Indian-looking pointed dome ends in a colossal needle. This was kept a secret, held in reserve, and then, when the neighboring Chanin Building declared itself the tallest in the world, run up overnight from inside to capture the record — which the Chrysler Building lost one year later to the far less witty and imaginative Empire State Building. One wonders what the design would have been like without the gigantic winged radiator caps perched on the corners. The author will never forget his own trip up the outside of the tower as a sixteen-year-old boy in 1930, on a platform elevator without enclosures or even railings, looking out over the sea of brownstones that then characterized most of midtown Manhattan. The forms of the Chrysler Building are related to the so-called Art Deco style, a name derived from the Exposition Internationale des Arts Décoratifs et Industriels Modernes, held in Paris in 1925. The building has enjoyed a revival of popularity along with Art Deco in general and at the moment of this writing is proving influential upon the current procession of more romantic shapes for skyscrapers.

A year later GEORGE HOWE (1886–1955) and WILLIAM LESCAZE (1896–1969) designed the Philadelphia Savings Fund Society Building (fig. 39–21), finished in 1932, a structure that can very easily be thought of as a building designed in the post–World War II era. The grid character of the steel frame is recognized in every aspect of the structure. Along the narrow sides of the building the windows are treated as strips of glass wrapped around the cantilevered corners. The only ornament on the exterior is the crowning acronym *PSFS*.

Mies van der Rohe had made a model (now lost) and drawings for an all-glass tower as early as 1919. This was probably the earliest design to recognize that a steel-frame or reinforced-concrete-frame structure is independent of principles of weight and support, and thus can be the same bottom to top. In 1951 Mies constructed the Lake Shore Drive Apartments in Chicago (fig. 39–22) as pure

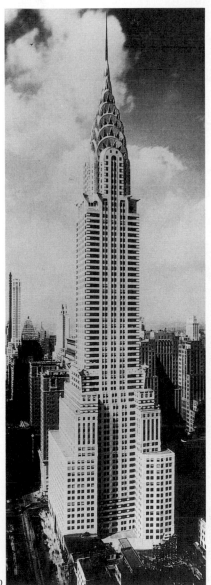

39-20. WILLIAM VAN ALEN. Chrysler Building, New York. 1928–30

39-20

International Style structures whose harmony resides in their exquisite subtlety of proportion. The two buildings, placed at right angles to each other, look absolutely uniform in fenestration until one discovers that after every fourth window, as after every fourth beat in four-four time, comes a sort of bar line in the form of a slightly wider vertical. The next development was the all-glass Lever House, of 1951–52, in New York, one of the few thrilling skyscraper designs in that metropolis, erected by the firm of Skidmore, Owings and Merrill, and largely the idea of their associate GORDON BUNSHAFT (1909–90). The building (fig. 39–23) consists of horizontal and vertical units—both elevated on pylons above the street so that the passerby can move directly into a partially shaded and open court. The tower is a shaft of glass, totally without masonry, tinted to avoid excessive glare, and the floors are marked by panels of dark green glass. To preserve the total unity of the building, the light fixtures, visible from the outside, are identical throughout. The result is one of the most harmonious of all modern buildings, whose beauty is only enhanced by many unsuccessful attempts to imitate it.

Alas, such imitations have continued uninterrupted, and on a worldwide scale. Glass boxes mechanically reproduced without the imagination and taste of Mies or Bunshaft have filled cities from Milan to Chicago to Tokyo to Cape Town, and disfigured even the historic beauty of London and Paris. A major New York firm recently celebrated the completion of its fiftieth such skyscraper, one of which can hardly be told from the other. For years architects and critics have rebelled against the tyranny of the glass box. Attempts have been made to model it into more interesting prismatic shapes, as in the IDS Center in Minneapolis by Philip Johnson (born 1906) and John Burgee (born 1933), or to reinstate traditional materials for the exterior walls, which makes sense in a period dangerously short of energy. The school that, in a reversal of logic, calls itself Post-Modern has proposed decorations ranging from Aztec to Art Nouveau, and Philip Johnson has crowned the AT&T Building in New York with a colossal broken pediment derived from a Chippendale chest. A more encouraging tendency has been that inspired by the romanticism of the 1920s, including brilliant designs by German-born Helmut Jahn for an eighty-two-story tower in Houston, Texas. His never-executed concept was explicitly intended to give Houston the same recognizable image that the Eiffel Tower has long conferred on Paris.

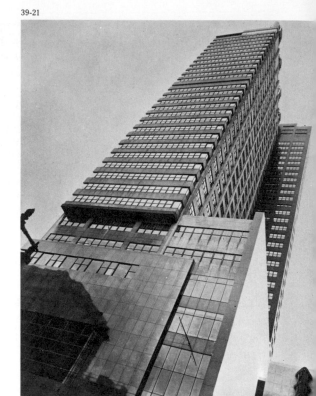

39-21. GEORGE HOWE and WILLIAM LESCAZE. Philadelphia Savings Fund Society Building. 1930–32

39-22. LUDWIG MIES VAN DER ROHE. Lake Shore Drive Apartments, Chicago. 1951

39-23. GORDON BUNSHAFT and SKIDMORE, OWINGS AND MERRILL (NEW YORK). Lever House, New York. 1951–52

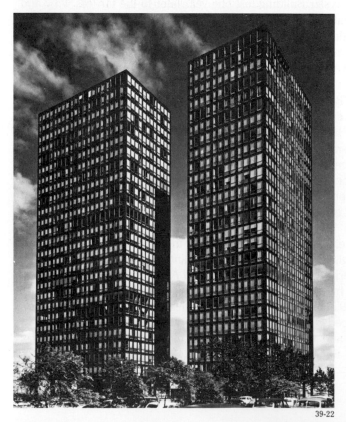

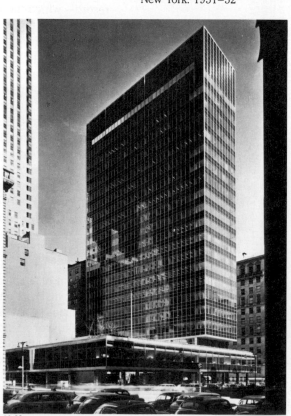

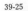

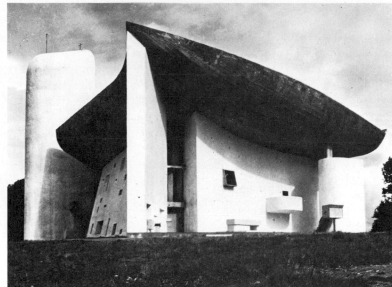

39-24. LE CORBUSIER. Unité d'Habitation, Marseilles. 1947–52

39-25. LE CORBUSIER. Notre-Dame-du-Haut, Ronchamp, France. 1950–54

39-26. LE CORBUSIER. Interior, Notre-Dame-du-Haut, Ronchamp

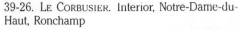

Countercurrents

After the close of World War II, the conventions of the International Style, too easily adaptable to the multistory business building, seemed unnecessarily confining to a number of gifted architects, including even Le Corbusier, one of the pioneers of that very style. His Unité d'Habitation, built on a hilltop in Marseilles from 1947 to 1952 (fig. 39–24), treats his favorite material, reinforced concrete, in a new and monumental fashion. The building seems a gigantic piece of abstract sculpture, with the surface of the concrete left in its rough state just as it emerges from the wooden molds and uncolored so that it turns a soft gray. The windowless end-walls can scarcely be called functional, but they are an outgrowth of the concept of the building, made up of a large number of identical living units, each with a bedroom on an inner balcony above kitchen and bath, overlooking a high living room, and each having access to a continuous outer balcony, with wall breaks between units. The structure is held aloft on massive columns rather than the slender shafts of the Villa Savoye.

When Dali was asked by Le Corbusier what he thought his new architecture should look like, he replied, "soft and hairy." This is very nearly what happened in the most striking of Le Corbusier's late works, the pilgrimage Chapel of Notre-Dame-du-Haut on a hilltop at Ronchamp, France, built in 1950–54 (fig. 39–25). Every convention of the International Style has been abandoned. The very plan is irregular, and the forms are modeled in the most surprising way into wall and roof shapes flaring, curving, and twisting as if organic and alive. Le Corbusier had visited the island of Mykonos in the Cyclades, east of mainland Greece, and had been impressed by the beauty of its simple buildings, chiefly the tiny churches and windmills. These structures have sloping, rounded walls in order to offer less resistance to the constant wind and are whitewashed every year, so that in time they develop a kind of fur coat formed by successive layers of whitewash. Le Corbusier emulated the sloping walls and the softness and richness of these shapes of folk architecture in a highly imaginative way. The dramatic cornices are based on the forms of ships, traditional symbols of the church. Even the fenestration of the chapel is irregular, with openings scattered at random over the curving walls. The effect in the interior is magical (fig. 39–26) because the windows are also of different sizes and proportions, their stained glass differs from window to window in color and design, and their embrasures slope at different angles, as if each

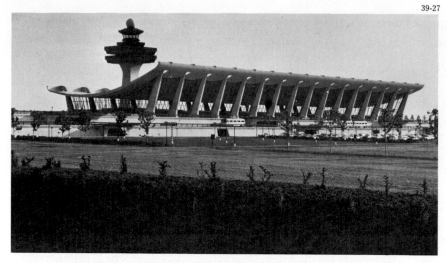

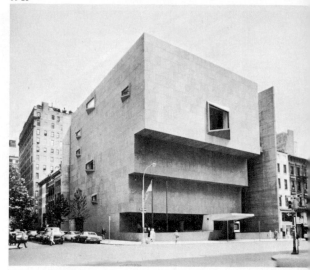

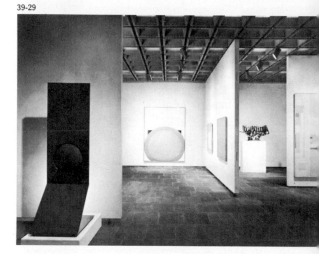

corresponded to the experience of an individual worshiper approaching in his own way the mystery of the altar.

In countries throughout the world the problem of the air terminal has been thrust into extreme prominence by the lightning growth in air travel. Thousands of weary air travelers can daily testify how seldom it has yet been rationally faced. Two of the all-too-few imaginative solutions are the contribution of the same gifted architect, EERO SAARINEN (1910–61), son and pupil of the equally celebrated Finnish-American architect Eliel Saarinen. Eero Saarinen's untimely death prevented him from seeing either of his great air-terminal designs completed. His beautiful Trans World Airlines Terminal, finished in 1962, with its curves flowing like air currents, is the only bright spot in the hopeless confusion of New York's Kennedy Airport. And his magnificent terminal for Dulles Airport, in rural Virginia outside Washington, D.C. (fig. 39–27), built in 1961–62, solves on a grand scale one of the major problems of airports—how to get passengers painlessly to and from planes, which must of necessity be widely separated on the ground—by the device of mobile lounges. At Dulles little of traditional building design is left. The sharply raking concrete columns form a kind of cradle, piercing the roof, which is concave like a colossal hammock and is suspended from them. Even the windows are canted outward. In both his air-terminal designs, each a highly original and unique solution, Saarinen suggested the principles of aircraft construction and of aerodynamics in the lightness, buoyancy, and rounded edges of his forms.

The insistent problem of the design of the art museum has received in recent years a number of strikingly different yet effective solutions. An impressive one is the building for the Whitney Museum of American Art (fig. 39–28), completed in 1966 in New York by the Hungarian-born American architect MARCEL BREUER (1902–81). The immense, blank masses of the building, constructed of raw concrete blocks and granite, are cantilevered outward in three stages alongside Madison Avenue. Since the building depends on artificial illumination, there are few windows, and these are scattered and differently shaped as in Le Corbusier's chapel at Ronchamp. The vast interiors are simple and flexible (the partitions are movable, attachable at any point under the ceiling grid) and the lighting system is extremely effective, one of the best in any New York museum (fig. 39–29). Few architects of recent museum buildings have been sufficiently self-sacrificing to recognize that in a museum the work of art comes first. To his everlasting credit, Breuer has done so.

An architect of vast influence at midcentury was LOUIS I. KAHN (1901–74), who after thorough study of Le Corbusier and architecture of the distant past—Roman and Romanesque, for example—turned to contemporary-design problems in a highly individual and often intuitive manner, producing solutions that have been

39-27. EERO SAARINEN. Terminal, Dulles Airport, Chantilly, Virginia (outside of Washington, D.C.). 1961–62

39-28. MARCEL BREUER. Whitney Museum of American Art, New York. Completed 1966

39-29. MARCEL BREUER. Third-floor gallery, Whitney Museum of American Art, New York

39-30. Louis I. Kahn. Kimbell Art Museum, Fort Worth, Texas. Completed 1972

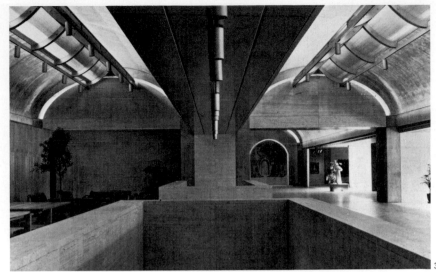

39-30

39-31. Renzo Piano and Richard Rogers. Pompidou Center, Paris. 1971–77

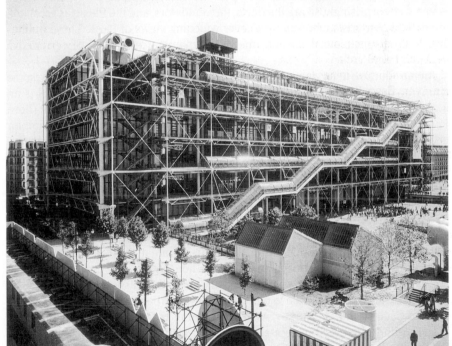

39-31

widely emulated. In his last major work, the Kimbell Art Museum in Fort Worth, Texas, completed in 1972 (fig. 39–30), Kahn offered a new proposal for the museum problem. In order to utilize the abundant natural light, Kahn devised a system of semi-elliptical concrete vaults, pierced by long skylights concealed by elaborate baffles. The combination of concrete and travertine provides a sympathetic and resonant background for works of art of all periods, and the magical illumination fills the interior with a pearly radiance that brings out the paintings' colors with great accuracy, yet prevents direct glare, and belies the somewhat ponderous appearance of the interior in photographs.

One of the most exciting, original, and still-controversial solutions to the problem of the museum in recent years has been the Pompidou Center in Paris (fig. 39–31), constructed in 1971–77 by Renzo Piano (born 1937) and Richard Rogers (born 1933). Is it a great new idea or a pretentious failure, a triumph of modern design or an insult to Paris, a vital center of intellectual and artistic activity or a

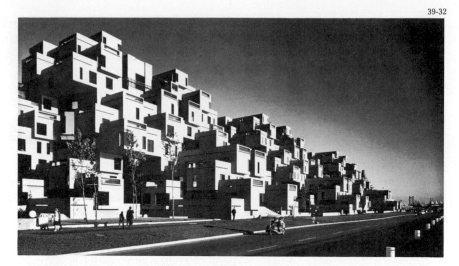

39-32. MOSHE SAFDIE. Habitat, EXPO 67, Montreal. 1967

supermarket of culture? The most extraordinary aspect of the structure is that, in emulation of the Gothic cathedrals with their celebrated exoskeletons, its bones are on the outside, for all the trusses are open and visible, outside the window-walls. Even more surprisingly, so are the ducts, the ventilators, and the Plexiglas escalator, the delight of tourists who sail up to ever-widening views of Paris. These utilities are, in true functionalist fashion, the only ornament, each category painted a separate bright color.

An introduction to modern architecture should consider visionary designs, some eminently practical and others that have yet to prove their merit. The first is an ingenious idea for a housing complex by the Israeli architect MOSHE SAFDIE (born 1938). In his Habitat for EXPO 67 in Montreal, Safdie devised a fresh solution for urban design, which combined ease of mass production with flexibility of plan (fig. 39–32). Habitat is composed of a theoretically infinite series of precast, one-piece concrete housing units, each a complete apartment, transported to the site and set in place in a preformed frame, which can also be extended in any direction and to any height. A great amount of individuality has been allowed in the shape and size of each tenant's dwelling, in the relationships of form and space, and in the constantly changing views of the outer world and the approaches, which, on each story, include play space for children. The result is dramatic in its freedom from the uniformity of previous concepts for multiple housing, as, for example, Le Corbusier's Unité d'Habitation. Perhaps the most startling aspect of Habitat is its uncanny exterior resemblance to one of the earliest urban complexes we know, the town of Çatal Hüyük, in Turkey, which dates from the seventh millennium B.C.

Equally imaginative, but less susceptible to actual realization, are the grand mushroom-shaped cities (fig. 39–33) envisioned by PAOLO SOLERI (born 1920), which tower above the surrounding landscape and contain within themselves facilities for all the necessities of modern life from manufacturing to living. Finally, the uninhibited and fearless pioneer designer R. BUCKMINSTER FULLER (1895–1983) preached and practiced for nearly half a century a totally new approach to architecture in terms of prefabricated, centrally planned units. His universal solution is the geodesic dome, a spheroid structure composed of mutually sustaining polyhedral elements, which can be constructed anywhere and of any material, including opaque or transparent panels, and at extremely low cost. Previously, Fuller's domes had been realized only in greenhouses and sheds, but the American Pavilion at EXPO 67 (fig. 39–34), the first large-scale realization of Fuller's eminently practical ideas, gives us a view into one kind of architectural future.

The 1970s and 1980s and very early 1990s have been years of exciting experimentation in architectural thinking, during which many of the shibboleths of early-twentieth-century architectural theory have been swept into the discard. Controversy is the hallmark of vitality in any period, and at the time of writing these words

39-33. PAOLO SOLERI. Elevation, Arcology "Babel II C," design for a Mushroom City. Date unknown

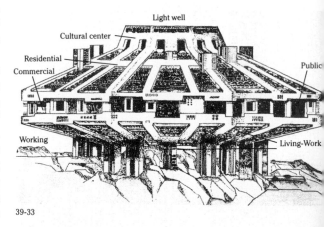

39-33

39-34. R. BUCKMINSTER FULLER. American Pavilion (Biosphere), EXPO 67, Montreal. 1967

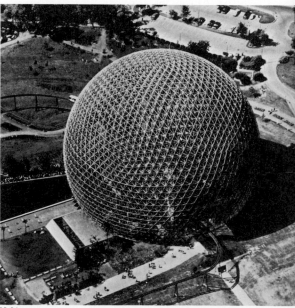

39-34

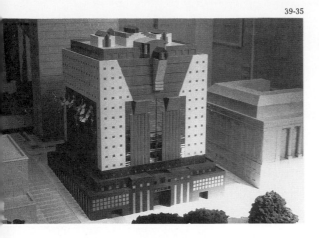

39-35. MICHAEL GRAVES. Drawing for Portland Public Services Building, Portland, Oregon (Fifth Avenue façade). 1980. Pencil and prismacolor, 11 × 7½″ (27.9 × 19.1 cm). Max Protetch Gallery (courtesy Michael Graves), New York

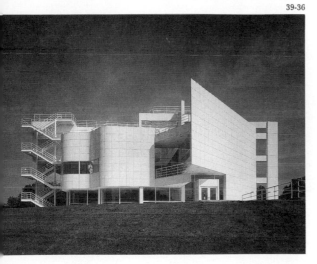

39-36. RICHARD MEIER. The Atheneum, New Harmony, Indiana. 1975–79

controversy boils happily along. Out of the scores of fascinating and sometimes supremely beautiful buildings built in recent years all over Europe, the Near East, the United States, Canada, Australia, and Japan, let us choose five, recognizing from the start that any choice among works so recent is sure to be a bit arbitrary. Three of the buildings are by Americans: MICHAEL GRAVES (born 1934), RICHARD MEIER (born 1934), and ROBERT VENTURI (born 1925), working in collaboration with his Rhodesian-born wife, DENISE SCOTT BROWN (born 1931); one is by a younger Spaniard—or, as he would probably prefer to be known, Catalan— RICARDO BOFILL (born 1939); and one is by a Japanese of the same generation, TADAO ANDO (born 1941).

Graves is among the most gifted and prominent of the Post-Modernists, and his work does not deserve critic William Curtis's devastating assessment "cosmetic." Merely applying broken columns, plus the wrong capitals, to walls painted bright red, arches bright yellow, and spandrels bright blue indeed does not constitute a style, and Michael Graves's Portland Public Services Building, of 1980–84, functions on a higher plane. Nevertheless, color, both muted in single tones and strident in combinations, is essential to its formidable presence. On a slate-green podium, whose portico with its cubic piers recalls Old Kingdom Egyptian architecture, stands a butter-colored cubic mass, implacably dotted by tiny square window openings at exactly regular intervals, counting vertically and horizontally. This mass is interrupted at the center by huge horizontal pink stripes, related to smaller vertical pink stripes, breaking into an enormous sheet of mullioned glass. Fig. 39–35, a watercolor rendering done before the building was completed, shows how the utilities sit on the roof like tiny temples on an acropolis. The irrationality of the relationships, as well as the traditional adherence of the entire mass to the rectangular perimeter of the site, would have infuriated the founders of the International Style.

A few years earlier, in 1975–79, Meier had created at New Harmony, Indiana, the Atheneum (fig. 39–36), a building that, like all Meier's structures, maintains the integrity and vitality of the very style against which Graves has pitted himself. In the exquisite adjustment of planes, the delicately integrated surfaces and spaces of both exteriors and interiors, and the stunning white, the energy of the modernist idiom is still apparent, as it is also in the severe neo-functional approach to all the essentials of the building (if to leave all the staircases with their iron-pipe railings open to the weather is actually functional in an Indiana winter). The spirit of Le Corbusier is revered and revived in this beautiful work, yet Meier has opened up the Le Corbusier box, which now radiates at will on the green lawn. He has also interrupted the severity of its planes by new arrangements of reticulated surfaces, diagonal edges, and curving walls in a manner alien to the dogmas of the International Style. The result, as slender, elastic, and proud as an egret, stands above the lawn in perfect equipoise, its interiors filled with white light.

Perhaps the most brilliant and influential reaction against the stylistic hegemony of the International Style was articulated in 1966 by Robert Venturi in his book *Complexity and Contradiction in Architecture*. There he called for richer, more allusive building than he perceived in most modernist work and proposed that new designs take into account architectural tradition and work with it. In the late 1980s Venturi and Scott Brown, having built a number of domestic and institutional structures, won the competition for their firm to design the Sainsbury Wing of the National Gallery, London (fig. 39–37), a museum addition to be located at one of London's most prominent sites, the northwest corner of busy, much-loved Trafalgar Square, facing Nelson's Column and, across the square, James Gibbs's early-eighteenth-century church, Saint-Martin-in-the-Fields, a jewel of design that itself combined traditions with a Corinthian-style portico and medieval steeple. The solution achieved by Venturi, Scott Brown and Associates balances the historical and the modern with great subtlety. They respectfully acknowledge the 1830s National Gallery building by William Wilkins (visible at right in the illustration) by

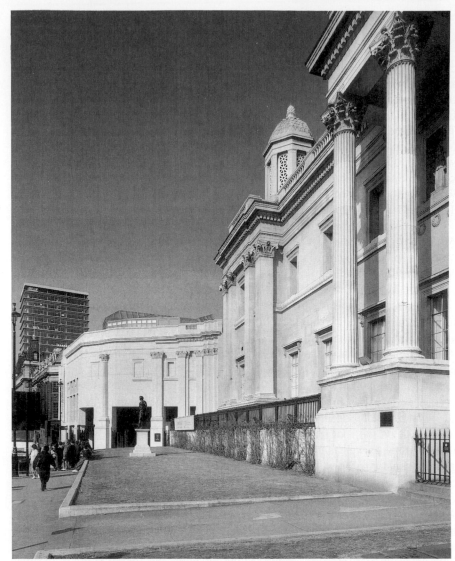

39-37. ROBERT VENTURI and DENISE SCOTT
BROWN and VENTURI, SCOTT BROWN AND
ASSOCIATES. Sainsbury Wing, National Gallery,
London. Completed 1991

adhering to the existing height line, by using the same Portland limestone cladding
material, and, on the main façade, by providing a crescendo of columns and
pilasters, increasingly closely spaced, whose capitals match exactly those of
Wilkins. The pilasters provide both a conspicuous quotation of the classical vocab-
ulary and a harmonious façade for Trafalgar Square. An oval bridge, not visible in
the illustration, links the galleries of the old National Gallery building to the
longitudinal axis of the new wing, which houses the museum's collection of early
Renaissance pictures, one of the world's finest. Inside, a grand staircase lures the
visitor up from the ground floor toward natural light that illuminates the paintings
from above, through loft lanterns of glass on the roof. The distinctive gallery spaces
also draw upon a classical vocabulary of form, albeit a very different one: the crisp
and elegant arches and taut elevations at Sir John Soanes's Dulwich Picture
Galleries.

A still-different conception of architecture, almost Gothic in the ease and the
flexibility of its infinite adjustment to circumstances, is that of Ricardo Bofill and his
Barcelona firm, Taller de Arquitectura. In most twentieth-century offices no com-
mission is more resented and therefore no building duller than a housing project.
The Viaduct Housing at St.-Quentin-en-Yvelines in France (fig. 39–38) started with
an amazing opportunity, a viaduct from which apartments, filling two out of every
three arches, descend almost to water level, separated only by the massive plinths
of the arches—the reverse of the Ponte Vecchio in Florence. The result is a spectac-
ular structure, without ancestry in architecture, whose consistency is carefully
maintained in the flatness of the balcony balustrades and upper story, and the

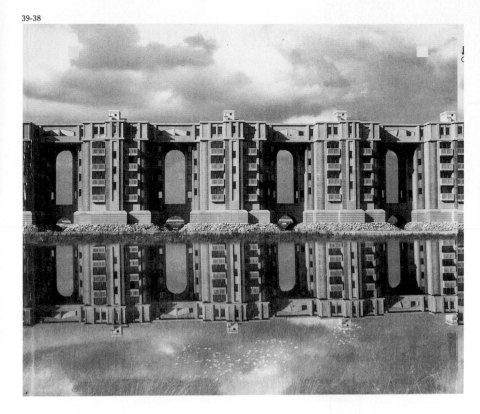

39-38

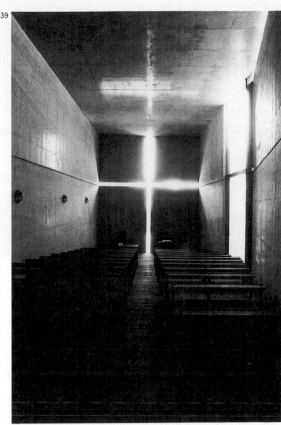

39-38. RICARDO BOFILL and TALLER DE ARQUITECTURA. Viaduct Housing, Les Arcades du Lac, St.-Quentin-en-Yvelines, France. 1981

39-39. TADAO ANDO. Church of the Light, Ibaraki, Osaka. 1987–89

quarter-round corners that suggest mighty columns. These are clothed in rows of narrow, vertically aligned brown-glazed tiles, contrasted in texture but not in color with the intervening masses of rough concrete stained tan, and made rougher by pebbles. The reflection of this amazing building is especially impressive, and very fortunate. But it must be remembered that a poor building is made twice as bad by its reflection. This one, like the structures by Graves, Meier, and Venturi and Scott Brown, points the way to more and constantly changing architectural developments in the future.

It is hardly surprising that, given Japan's incredibly rich cultural history and great industrial strength in recent decades, it has produced some of the most creative architects of the post–World War II years. Among them, Tadao Ando stands out for his seemingly magical ability to reconcile apparent opposites—traditional Oriental and Occidental seating arrangements and fenestration, for example, or a sensitive response to the natural environment and a masterful use of that quintessentially modern material, reinforced concrete. Born in Osaka, Ando never attended architecture school but taught himself his craft and his art, chiefly through travel in Europe and the United States to look at buildings during the 1960s and a brief apprenticeship with a Japanese carpenter, presumably to learn how to craft the wooden forms into which reinforced concrete is poured. A minimalist like so many of his generation (see Chapter Thirty-Eight), Ando is in many ways also an heir of Le Corbusier and Louis Kahn, for he is a builder of reinforced-concrete volumes inflected by light. In his work these volumes—rooms—are formed almost entirely by large, flat planes—walls—intersecting at different angles to define packages of space. In many of Ando's early buildings the rooms face inward, to define courtyards that allow escape from the chaos of Japanese urban development. Openings, whose placement in the otherwise plain reinforced-concrete walls is exquisitely calculated, control the entry and play of natural light. At Ando's Church of the Light, built in a suburb of Osaka in 1987–89 (fig. 39–39), a glazed, cross-shaped aperture, Christian symbol of the Crucifixion, and the defining planar elements combine to create a spiritually uplifting space that, like Matisse's chapel at Vence, suggests meditation whatever the creed of the observer.

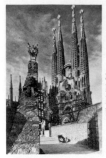

Sagrada
Familia,
Barcelona,
by Gaudí

Schröder
House,
Utrecht,
by Rietveld

Lever House,
New York,
by Bunshaft
and SOM

Biosphere,
EXPO 67,
by Fuller

EUROPE AND JAPAN

1885 Sagrada Familia, Barcelona, by Gaudí

1905 Casa Milá, Barcelona, by Gaudí
 Centenary Hall, Wroclaw, by Berg
1920 Einstein Tower, Potsdam, by Mendelsohn
 Schröder House, Utrecht, by Rietveld
 Bauhaus, Dessau, by Gropius
 Villa Savoye, Poissy, by Le Corbusier
 German Pavilion, Barcelona, by Mies van der Rohe
1930

1940 Unité d'Habitation, Marseilles, by Le Corbusier
1950 Notre-Dame, Ronchamp, by Le Corbusier

1960

1970 Pompidou Center, Paris, by Piano and Rogers

1980 Viaduct Housing, St.-Quentin-en-Yvelines, by Bofill
 Church of the Light, Osaka, by Ando
1990

UNITED STATES

Marshall Field Wholesale Store, Chicago, by Richardson
Wainwright Building, St. Louis, by Sullivan

Robie House, Chicago, by Wright
Woolworth Building, New York, by Gilbert

Chrysler Building, New York, by Van Alen
Philadelphia Savings Building, by Howe and Lescaze
"Falling Water" (Kaufmann House), Bear Run, by Wright

Lever House, New York, by Bunshaft and SOM
Lake Shore Apts., Chicago, by Mies van der Rohe
Dulles Airport Terminal, by Eero Saarinen
Whitney Museum, New York, by Breuer
Habitat, EXPO 67, by Safdie
Biosphere, EXPO 67, by Fuller
Kimbell Museum, Fort Worth, by Kahn
Atheneum, New Harmony, by Meier
Portland Public Services Building, by Graves

Sainsbury Wing, National Gallery, London, by Venturi, Scott
 Brown and Associates

GLOSSARY

ABACUS (pl. ABACI). In architecture, the slab that forms the uppermost member of a CAPITAL and supports the ARCHITRAVE.

ACADEMY. The word, meaning *place of study* or *learned society*, is derived from the name of the grove near Athens where Plato and his followers held their philosophical conferences during the fifth and fourth centuries B.C. Modern academies of fine arts have as their purpose the fostering of the arts through instruction, financial assistance, and exhibitions; the first was the Accademia di Disegno founded by Giorgio Vasari in Florence in 1563; the two most influential have been the Académie Royale de Peinture et de Sculpture, founded in 1648 in Paris by Louis XIV, and the Royal Academy of Arts, founded in London in 1768.

ACOLYTE. In the Roman Catholic Church, an altar attendant of a minor rank.

AERIAL PERSPECTIVE. See PERSPECTIVE.

AISLE. See SIDE AISLE.

ALTARPIECE. A painted and/or sculptured work of art that stands as a religious image upon and at the back of an altar, either representing in visual symbols the underlying doctrine of the MASS or depicting the saint to whom a particular church or chapel is dedicated, together with scenes from his or her life. Examples from certain periods include decorated GABLES and PINNACLES, as well as a PREDELLA. See MAESTÀ.

AMBULATORY. A place for walking, usually covered, as in an ARCADE around a CLOISTER, or a semicircular passageway around the APSE behind the main altar. In a church or mosque with a centralized PLAN, the passageway around the central space that corresponds to a SIDE AISLE and that is used for ceremonial processions.

AMPHORA (pl. AMPHORAE). A storage jar used in ancient Greece having an egg-shaped body, a foot, and two handles, each attached at the neck and shoulder of the jar.

APOCALYPSE. The Book of Revelation, the last book of the New Testament, in which are narrated the visions of the future experienced by Saint John the Evangelist on the island of Patmos.

APOCRYPHA. A group of books included at one time in authorized Christian versions of the BIBLE (now generally omitted from Protestant versions).

APOSTLES. In Christian usage the word commonly denotes the twelve followers or disciples chosen by Christ to preach his GOSPEL, though the term is sometimes used loosely. Those listed in the Gospels are: Andrew; James, the son of Zebedee, called James the Major; James, the son of Alphaeus, called James the Minor; Bartholomew; John; Judas Iscariot; Matthew; Philip; Peter; Simon the Canaanite; Thaddeus; and Thomas (Matthew 10:1–4; Mark 3:13–19).

APSE. A large semicircular or polygonal niche. In a Roman BASILICA it was frequently found at both ends of the NAVE; in a Christian church it is usually placed at one end of the nave after the CHOIR; it may also appear at the ends of the TRANSEPT and at the ends of chapels.

AQUATINT. A PRINT produced by the same technique as an ETCHING except that the areas between the etched lines are covered with a powdered resin that protects the surface from the biting process of the acid bath. The granular appearance that results in the prints aims at approximating the effects and gray tonalities of a WATERCOLOR drawing.

AQUEDUCT. From the Latin for *duct of water*. An artificial channel for conducting water from a distance, which, in Roman times, was usually built overground and supported on ARCHES.

ARCADE. A series of ARCHES and their supports. Called a *blind arcade* when placed against a wall and used primarily as surface decoration.

ARCH. An architectural construction, often semicircular, built of wedge-shaped blocks (called *voussoirs*) to span an opening. The center stone is called the *keystone*. The weight of this structure requires support from walls, PIERS, or COLUMNS, and the THRUST requires BUTTRESSING at the sides. When an arch is made of overlapping courses of stone, each block projecting slightly farther over the opening than the block beneath it, it is called a CORBELED arch.

ARCHBISHOP. The chief BISHOP of an ecclesiastical province or archbishopric.

ARCHITRAVE. The main horizontal beam and the lowest member of an ENTABLATURE; it may be a series of LINTELS, each spanning the space from the top of one support to the next.

ARCHIVOLT. The molding or moldings above an arched opening; in Romanesque and Gothic churches, frequently decorated with sculpture.

ARRICCIO, ARRICCIATO. The rough coat of coarse plaster that is the first layer to be spread on a wall when making a FRESCO.

ARTE (pl. ARTI). See GUILDS.

A SECCO. See FRESCO.

ATMOSPHERIC PERSPECTIVE. See PERSPECTIVE.

ATRIUM. The open entrance hall or central hall of an ancient Roman house. A court in front of the principal doors of a church.

ATTIC. The upper story, usually low in height, placed above an ENTABLATURE or main CORNICE of a building, and frequently decorated with PILASTERS.

BALDACHIN. From Italian *baldacchino*, a rich silk fabric from Baghdad. A canopy of such material, or of wood, stone, etc., either permanently installed over an altar, throne, or doorway, or constructed in portable form to be carried in religious processions.

BALUSTRADE. A row of short pillars, called *balusters*, surmounted by a railing.

BAPTISTERY. Either a separate building or a part of a church in which the SACRAMENT of Baptism is administered.

BARREL VAULT. A semicylindrical VAULT that normally requires continuous support and BUTTRESSING.

BASE. The lowest element of a COLUMN, PIER, PILASTER, temple, wall, or DOME, occasionally of a statue.

BASILICA. In ancient Roman architecture, a rectangular building whose ground PLAN was generally divided into NAVE, SIDE AISLES, and one or more APSES, and whose elevation sometimes included a CLERESTORY and GALLERIES, though there was no strict uniformity. It was used as a hall of justice and as a public meeting place. In Christian architecture, the term is applied to any church that has a longitudinal nave terminated by an apse and flanked by lower side aisles.

BAY. A compartment into which a building may be subdivided, usually formed by the space bounded by consecutive architectural supports.

BEATO (fem. BEATA). Italian word meaning *blessed*. Specifically, beatification is a papal decree that declares a deceased person to be in the enjoyment of heavenly bliss (*beatus*) and grants a form of veneration to him or her. It is usually a step toward canonization.

BENEDICTINE ORDER. Founded in 529 by Saint Benedict of Nursia (c. 480–543), at Subiaco, near Rome, the Benedictine ORDER spread to England and much of western Europe in the next two centuries. Less austere than other early orders, the Benedictines divided their time into periods of religious worship, reading, and work. The last is generally either educational or agricultural.

BIBLE. The collection of sacred writings of the Christian religion that includes the Old and the New Testaments, or that of the Jewish religion, which includes the Old Testament only. The versions commonly used in the Roman Catholic Church are based on the Vulgate, a Latin translation made by Saint Jerome in the fourth century A.D. An English translation, made by members of the English College at Douai, France, between 1582 and 1610, is called the Douay. Widely used Protestant translations include Martin Luther's German translation from the first half of the sixteenth century, and the English King James Version, first published in 1611.

BISHOP. A spiritual overseer of a number of churches or a diocese; in the Greek, Roman Catholic, Anglican, and other churches, a member of the highest order in the ministry. See CATHEDRAL.

BLIND ARCADE. See ARCADE.

BOOK OF HOURS. See HOURS, BOOK OF.

BOTTEGA (pl. BOTTEGHE). Italian word for *shop*, used to describe an artist's atelier in which assistants and apprentices worked with an artist on his commissions, and in which works were displayed and offered for sale.

BRACKET. A piece of stone, wood, or metal projecting from a wall and having a flat upper surface that serves to support a statue, beam, or other weight.

BREVIARY. A book containing the daily offices or prayers and the necessary psalms and hymns for daily devotions. Frequently illustrated and generally intended for use by the clergy.

BROKEN PEDIMENT. See PEDIMENT.

BURIN. See ENGRAVING.

BUTTRESS. A masonry support that counteracts the lateral pressure, or THRUST, exerted by an ARCH or VAULT. See FLYING BUTTRESS and PIER BUTTRESS.

CALLIGRAPHY. In a loose sense, handwriting, but the word usually refers to beautiful handwriting or fine penmanship.

CALVARY. See GOLGOTHA.

CAMEO. A carving in RELIEF upon a gem, stone, or shell, especially when differently colored layers of the material are revealed to produce a design of lighter color against a darker background. A gem, stone, or shell so carved.

CAMERA. Italian word for *room* or *chamber*.

CAMERA OBSCURA. Latin words for *dark room*. A box or cabinet with a small opening in one side through which light passes, projecting the inverted images of outside objects on the opposite wall. A mirror may be installed to reflect the images right side up, and a lens may be used for focusing. The principal on which the apparatus is based has been known since classical times and was described by Leonardo da Vinci. In the seventeenth century, European artists began to use the device as an aid to making pictures, and it became very popular with topographical artists in the eighteenth century.

CAMPAGNA. Italian word for *countryside*. When capitalized, it generally refers to the area outside Rome.

CAMPANILE. From the Italian word for *bell* (*campana*). A bell tower, either attached to a church or freestanding nearby.

CAMPO. Italian word for *field;* used in Siena, Venice, and other Italian cities to denote certain public squares. See PIAZZA.

CANONICAL HOURS. In the Roman Catholic Church, certain hours of each day are set aside for prayer and devotion; the seven periods are: matins, prime, tierce, sext, nones, vespers, and compline. These are strictly observed only in monastic establishments.

CANON OF THE MASS. The part of the Christian MASS between the Sanctus, a hymn, and the Lord's Prayer; the actual EUCHARIST, or sacrifice of bread and wine, to which only the baptized are admitted.

CANOPY. An ornamental rooflike projection or covering placed over a niche, statue, tomb, altar, or the like.

CANTILEVER. A projecting BRACKET that supports a balcony, CORNICE, or the like, or a projecting beam or slab of great length attached at one end only.

CAPITAL. The crowning member of a COLUMN, PIER, or PILASTER on which rests the lowest element of the ENTABLATURE. See ORDER.

CARDINAL. A member of the ecclesiastical body known as the Sacred College of Cardinals, which elects the pope and constitutes his chief advisory council.

CARDINAL VIRTUES. See VIRTUES.

CARTHUSIAN ORDER. An eremitic ORDER founded by Saint Bruno (c. 1030–1101) at Chartreuse, near Grenoble, in 1084. The life of the monks was, and still is, one of prayer, silence, and extreme austerity.

CARTOON. From the Italian word *cartone*. A full-scale preparatory drawing for a painting.

CARTOUCHE. An ornamental SCROLL-shaped tablet with an inscription or decoration, either sculptured or drawn.

CARVING. The shaping of an image by cutting or chiseling it out from a hard substance, such as stone or wood, in contrast to the additive process of MODELING.

CARYATID. A figure, generally female, used as a COLUMN.

CASSOCK. A long, close-fitting garment with sleeves and a high neck worn under the SURPLICE by the clergy, choristers, etc., at church services or as ordinary clerical costume.

CASTING. A method of reproducing a three-dimensional object or RELIEF by pouring a hardening liquid or molten metal into a mold bearing its impression.

CATHEDRAL. The principal church of a diocese, containing the BISHOP's throne, or cathedra.

CELLA. The body of a temple as distinct from the PORTICO and other external elements, or an interior structure built to house an image.

CERTOSA. Italian word for *Carthusian monastery (Chartreuse* in French). Adopted from the name of the town Chartreuse, where Saint Bruno founded a monastery in 1084. See also CARTHUSIAN ORDER.

CHALICE. Generally, a drinking cup, but specifically, the cup used to hold the consecrated wine of the EUCHARIST.

CHANCEL. In a church, the space reserved for the clergy and the CHOIR, between the APSE and the NAVE and TRANSEPT, usually separated from the latter two by steps and a railing or a screen.

CHARTREUSE. See CARTHUSIAN ORDER and CERTOSA.

CHASUBLE. A long, oval, sleeveless mantle with an opening for the head; it is worn over all other vestments by a priest when celebrating MASS and it is used in commemoration of Christ's seamless robe.

CHÂTEAU (pl. CHÂTEAUS or CHÂTEAUX). A French castle or large country house.

CHERUB (pl. CHERUBIM). One of an order of angelic beings ranking second to the SERAPH in the celestial hierarchy, often represented as a winged child or as the winged head of a child.

CHEVET. The eastern end of a church or CATHEDRAL, consisting of the AMBULATORY and a main APSE with secondary apses or chapels radiating from it.

CHIAROSCURO. From the Italian *chiaro* (*light*) and *oscuro* (*dark*). Used to describe the opposition of light and shade.

CHOIR. A body of trained singers, or that part of a church occupied by them. See CHANCEL.

CHOIR SCREEN. A partition of wood or stone, often elaborately carved, that separates the CHOIR from the NAVE and TRANSEPT of a church. In Byzantine churches, the choir screen, called an ICONOSTASIS, is decorated with ICONS.

CHRISTUS MORTUUS. Latin phrase for *dead Christ*.

CHRISTUS PATIENS. Latin phrase for *suffering Christ*. A cross with a representation of the dead Christ, which in general superseded representations of the CHRISTUS TRIUMPHANS type.

CHRISTUS TRIUMPHANS. Latin phrase for *triumphant Christ*. A cross with a representation of the living

Christ, eyes open and triumphant over death. Scenes of the PASSION are usually depicted at the sides of the cross, below the crossarms.

CLAUSURA. Latin word for *closure*. In the Roman Catholic Church the word is used to signify the restriction of certain classes of nuns and monks prohibited from communication with outsiders to sections of their convents or monasteries. Those living within these restrictions are said to be *in clausura* or CLOISTERED.

CLERESTORY. The section of an interior wall that rises above adjacent rooftops, having a row of windows that admit daylight. Used in Egyptian temples, Roman BASILICAS, and Christian basilican churches; in Christian churches, the wall that rises above the nave ARCADE or the TRIFORIUM to the VAULTING or roof.

CLOISTER. Generally, a place of religious seclusion; a monastery, nunnery, or convent. Specifically, a covered walk or AMBULATORY around an open court having a plain wall on one side and an open ARCADE or COLONNADE on the other. It is commonly connected with a church, monastery, or other building and is used for exercise and study. See CLAUSURA.

CLOSED DOOR or CLOSED GATE. Ezekiel's vision of the door or gate of the SANCTUARY in the temple that was closed because only the Lord could enter it (Ezekiel 44:1–4). Interpreted as a prophecy and used as a symbol of Mary's virginity.

CLOSED GARDEN. "A garden enclosed is my sister, my spouse; a spring shut up, a fountain sealed" (Song of Solomon 4:12). Used like CLOSED DOOR as a symbol of Mary's virginity.

COFFER. A casket or box. In architecture, a recessed panel in a ceiling.

COLLAGE. From the French verb *coller*, meaning *to glue*. A composition made by pasting various scraps of materials (such as newspaper, cloth, or photographs) onto a hard surface.

COLONNADE. A series of COLUMNS spanned by LINTELS.

COLONNETTE. A small COLUMN.

COLOR. See HUE, SATURATION, and VALUE.

COLUMN. A vertical architectural support, usually consisting of a BASE, a rounded SHAFT, and a CAPITAL. When half or more of it is attached to a wall, it is called an *engaged column*. Columns are occasionally used singly for a decorative or commemorative reason. See also ORDER.

COMPANY. See SCUOLA.

CONFRATERNITY. See SCUOLA.

CONSOLE. A BRACKET, usually formed of S-shaped SCROLLS, projecting from a wall to support a LINTEL or other member.

CONTÉ CRAYON. A rich black drawing stick.

CONTRAPPOSTO. Italian word for *set against*. A device introduced in late Greek art that freed representations of the figure from the rigidity present in Egyptian and Archaic Greek painting and sculpture; used to express the shift in axes when contrasting actions set parts of the body in opposition to each other around a central vertical axis.

COPE. A semicircular cloak or cape worn by ecclesiastics in procession and on other ceremonial occasions.

CORBEL. An overlapping arrangement of stones, each course projecting beyond the one below, used in the construction of an ARCH or VAULT, or as a support projecting from the face of a wall.

CORBEL TABLE. A horizontal piece of masonry used as a CORNICE or part of a wall and supported by CORBELS.

CORBEL VAULT. An arched roof constructed of corbeled masonry.

CORNICE. The crowning, projecting architectural feature, especially the uppermost part of an ENTABLATURE. It is frequently decorated. When it is not horizontal, as above a PEDIMENT, it is called a *raking cornice*.

COURSED MASONRY. Masonry in which stones or bricks of equal height are placed in continuous horizontal layers.

CROSSHATCHING. See HATCHING.

CROSSING. That part of a church where the TRANSEPT

crosses the NAVE; it is sometimes emphasized by a DOME or by a tower.

CROSS SECTION. See SECTION.

CRUCIFIX. From the Latin word *crucifixus*. A representation of a cross with the figure of Christ crucified upon it. See CHRISTUS MORTUUS, CHRISTUS PATIENS, and CHRISTUS TRIUMPHANS.

CRYPT. A VAULTED chamber, usually beneath the raised CHOIR of a church, housing a tomb and/or a chapel. Also, a vaulted underground chamber used for burial.

CUPOLA. A rounded, convex roof or VAULTED ceiling, usually hemispherical, on a circular BASE and requiring BUTTRESSING. See DOME.

CUSP. The pointed projection where two curves meet.

CYCLOPS. In ancient Greek and Roman mythology, a member of a race of giants with one round eye in the center of the forehead. The Cyclopes were believed to have forged thunderbolts for the king of the gods and to have built massive prehistoric walls.

DALMATIC. An ecclesiastical vestment with wide sleeves and two stripes, worn in the Western church by DEACONS and BISHOPS on certain occasions.

DEACON. A lay church officer or subordinate minister. The cleric ranking next after the priest in the Roman Catholic, Anglican, and Episcopal churches.

DEÉSIS. The Greek word for *supplication*. A representation of Christ Enthroned between the Virgin Mary and Saint John the Baptist, who act as intercessors for humankind, which appears frequently in Byzantine MOSAICS and in later depictions of the Last Judgment.

DIOCESE. See BISHOP.

DIPTYCH. A pair of wood, ivory, or metal plaques usually hinged together, with the interior surfaces either painted or CARVED with a religious or memorial subject, or covered with wax for writing.

DOME. A large CUPOLA supported by a circular wall or DRUM or, over a noncircular space, by corner structures. See PENDENTIVE and SQUINCH.

DOMINICAN ORDER. A preaching ORDER of the Roman Catholic Church founded by Saint Dominic in 1216 in Toulouse. The Dominicans live austerely, believe in having no possessions, and subsist on charity. It is the second great MENDICANT ORDER, after the FRANCISCAN.

DONOR. The patron or commissioner of a work of art, often represented in the work.

DORMER. A vertical window projecting from a sloping roof and having vertical sides and a flat or sloping roof.

DOUAY VERSION. See BIBLE.

DRUM. One of several sections composing the SHAFT of a COLUMN. Also, a cylindrical wall supporting a DOME.

ELEVATION. One side of a building or a drawing of the same.

EMBRASURE. A door or window frame enlarged at the interior wall by beveling or splaying the sides of the frame.

ENCAUSTIC. A method of painting on wood panels and walls with colors dissolved in hot wax.

ENGAGED COLUMN. See COLUMN.

ENGRAVING. A means of ornamenting metal objects, such as suits of armor or stones, by incising a design on the surface. In pictorial arts, the technique of reproducing a design by incising it on a copper plate with a steel instrument called a *burin*, which digs up a continuous shaving of the metal, leaving a groove. The plate is inked and the ink wiped off except for that remaining in the groove. Then, by subjecting the plate to great pressure on a moistened piece of paper, the image is reproduced and the resulting PRINT is called an *engraving*.

ENTABLATURE. The upper part of an architectural ORDER, usually divided into three major parts: ARCHITRAVE, FRIEZE, and CORNICE.

EPISTLE. In Christian usage, one of the apostolic letters that constitute twenty-one books of the New Testament. See also MASS.

ETCHING. The technique of reproducing a design by coating a metal plate with wax and drawing with a sharp instrument called a STYLUS through the wax down to

the metal. The plate is put in an acid bath, which eats away at the incised lines; it is then heated to dissolve the wax and finally inked and printed on paper. The resulting PRINT is called an *etching*. The plate may be altered between printings, and the prints are then differentiated as *first state, second state,* etc.

EUCHARIST. From the Greek word for *thanksgiving* or *gratitude*. The SACRAMENT of the Lord's Supper, the consecrated bread and wine used in the rite of Communion, or the rite itself.

EVANGELISTS, FOUR. Matthew, Mark, Luke, and John, generally assumed to be the authors of the GOSPELS in the New Testament. They are usually represented with their symbols, which are derived either from the four mysterious creatures in the vision of Ezekiel (1:5) or from the four beasts surrounding the throne of the Lamb in Revelation (4:7). Frequently, they are referred to by the symbols alone—an angel for Matthew, a lion for Mark, a bull for Luke, and an eagle for John—or by a representation of the four rivers of Paradise.

EXEDRA (pl. EXEDRAE). A semicircular PORCH, chapel, or recess in a wall.

FAÇADE. The front or principal face of a building; sometimes loosely used to indicate the entire outer surface of any side.

FAIENCE. Glazed earthenware or pottery used for sculpture, tiles, and decorative objects.

FAN VAULT. A complex VAULT, characteristic of late English Gothic architecture, in which radiating RIBS form a fanlike pattern.

FASCES. Latin plural of *fascis* (*bundle*). A bundle of rods containing an ax with the blade projecting, borne before Roman magistrates as a symbol of power.

FATHERS OF THE CHURCH. Early teachers and defenders of Christianity from the third century to the sixth century A.D. Eight in number, they include the four Latin Fathers: Saint Jerome, Saint Ambrose, Saint Augustine, and Saint Gregory; and the four Greek Fathers: Saint John Chrysostom, Saint Basil the Great, Saint Athanasius, and Saint Gregory Nazianzen.

FERROCONCRETE. See REINFORCED CONCRETE.

FINIAL. An ornament terminating a spire, PINNACLE, GABLE, etc.

FLUTING. The shallow vertical grooves in the SHAFT of a COLUMN that either meet in a sharp edge, as in Doric columns, or are separated by a narrow strip, as in Ionic columns.

FLYING BUTTRESS. An ARCH that springs from the upper part of the PIER BUTTRESS of a Gothic church, spans the SIDE AISLE roof, and abuts the upper NAVE wall to receive the THRUST from the nave VAULTS; it transmits this thrust to the solid pier buttress.

FONT. A receptacle in a BAPTISTERY or church for the water used in Baptism; it is usually of stone and frequently decorated with sculpture.

FORESHORTENING. In drawing, painting, etc., a method of reproducing the forms of an object not parallel to the PICTURE PLANE so that the object seems to recede in space and to convey the illusion of three dimensions as perceived by the human eye.

FORUM (pl. FORA). In ancient Rome, the center of assembly for judicial and other public business, and a gathering place for the people.

FOUR RIVERS OF PARADISE. See EVANGELISTS, FOUR.

FRANCISCAN ORDER. The first great MENDICANT ORDER. Founded by Saint Francis of Assisi (Giovanni de Bernardone, 1182?–1226) for the purpose of ministering to the spiritual needs of the poor and imitating as closely as possible the life of Christ, especially in its poverty; the monks depended solely on alms for subsistence.

FRESCO. Italian word for *fresh*. A painting executed on wet plaster with pigments suspended in water so that the plaster absorbs the colors and the painting becomes part of the wall. *Fresco a secco,* or painting on dry plaster (*secco* is the Italian word for *dry*), is a much less durable technique; the paint tends to flake off with time. The *secco su fresco* method involves the applica-

tion of color in a vehicle containing some organic binding material (such as oil, egg, or wax) over the still-damp plaster.

FRIEZE. The architectural element that rests upon the ARCHITRAVE and is immediately below the CORNICE; also, any horizontal band decorated with MOLDINGS, RELIEF sculpture, or painting.

GABLE. The vertical, triangular piece of wall at the end of a ridged roof, from the level of the eaves or CORNICE to the summit; called a PEDIMENT in classical architecture. It is sometimes used with no roof, as over the PORTALS of Gothic cathedrals, and as a decorative element on ALTARPIECES.

GALLERY. An elevated floor projecting from the interior wall of a building. In a BASILICAN church it is placed over the SIDE AISLES and supported by the COLUMNS or PIERS that separate the NAVE and the side aisles; in a church with a central PLAN, it is placed over the AMBULATORY; in an ancient Roman basilica, it was generally built over each end as well as over the side aisles.

GARDEN. See CLOSED GARDEN.

GENIUS (pl. GENII). In classical and Renaissance art, usually the guardian spirit of a person, place, thing, or concept; often purely decorative, genii are represented in human form, frequently seminude and winged.

GENRE PAINTING. The representation of scenes from everyday life for their own sake, usually with no religious or symbolic significance.

GESSO. A mixture of finely ground plaster and glue spread on wooden panels in preparation for TEMPERA painting.

GILDING. Coating paintings, sculptures, and architectural ornament with gold, gold leaf, or some gold-colored substance, by either mechanical or chemical means. In panel painting and wood sculpture, the gold leaf is attached with a glue sizing that is usually a dull red in color.

GLAZE. In pottery, a superficial layer of molten material used to coat a finished piece before it is fired in a kiln. In OIL PAINTING, a transparent film of the vehicle, customarily linseed oil mixed with turpentine, in which a small amount of pigment is dissolved, so as to change the appearance of the color beneath.

GLORY. The circle of light represented around the head or figure of the Savior, the Virgin Mary, or a saint. When the circle surrounds the head only, it is called a *halo*. See MANDORLA.

GOLGOTHA. From the Aramaic word for *skull;* thus, *the Place of the Skull.* The name of the place outside Jerusalem where Christ was crucified (Matthew 27:33). *Calvary,* from *calvaria,* meaning *skull* (Luke 23:33), is the Latin translation of the Aramaic word.

GOSPEL. In Christian usage, the story of Christ's life and teaching, as related in the first four books of the New Testament, traditionally ascribed to the Evangelists Matthew, Mark, Luke, and John. Also used to designate an ILLUMINATED copy of the same; sometimes called a Gospel LECTIONARY. See MASS.

GOUACHE. A type of WATERCOLOR paint mixed with a white pigment called *body color,* or a design executed with this paint. Not considered true watercolor because of its opacity, it has the delicacy of PASTEL and the suppleness of watercolor.

GREEK CROSS. A cross with four equal arms.

GROIN. The sharp edge formed by two intersecting VAULTS.

GROIN VAULT. A VAULT formed by the intersection at right angles of two BARREL VAULTS of equal height and diameter so that the GROINS form a diagonal cross.

GROUND PLAN. See PLAN.

GUILDS. *Arti* (sing. *Arte*) in Italian. Independent associations of bankers and of artisan-manufacturers.

HALLENKIRCHE. German word for *hall-church.* A church in which the AISLES are as high, or almost as high, as the NAVE; especially popular in the German Gothic style.

HALO. See GLORY.

HARPY (pl. HARPIES). From the Greek word for *snatcher.*

A female monster that carries souls to Hell; often represented with a woman's head and body and a bird's wings, legs, claws, and tail. She occasionally appears as a more benign spirit that carries souls to another world.

HATCHING. In drawing or engraving, the use of parallel lines to produce the effect of shading. When crossing sets of parallel lines are used, the technique is called *crosshatching.*

HIEROGLYPHS. Characters (pictures or symbols representing or standing for sounds, words, ideas, etc.) in the picture-writing systems of the ancient Egyptians and the Maya of Mesoamerica.

HORTUS CONCLUSUS. Latin phrase for CLOSED GARDEN.

HOST. From the Latin word for *sacrificial victim* (*hostia*). In the Roman Catholic Church it is used to designate the bread or wafer, regarded as the body of Christ, consecrated in the EUCHARIST.

HÔTEL. In French, a large private town residence.

HOURS, BOOK OF. A book for private devotions containing the prayers for the seven CANONICAL HOURS of the Roman Catholic Church. It sometimes contains a calendar, and often elaborate ILLUMINATION. The most famous examples are now known by the names of their original owners.

HUE. The name of a color. The spectrum is usually divided into six basic hues: the three primary colors of red, yellow, and blue and the secondary colors of green, orange, and violet.

ICON. Literally, any image or likeness, but commonly used to designate a panel representing Christ, the Virgin Mary, or a saint and venerated by Orthodox (Eastern) Catholics.

ICONOCLASM. Breaking or destroying of images, particularly those set up for religious veneration. Many paintings and statues were destroyed in Eastern Christian churches in the eighth and ninth centuries as a result of the Iconoclastic Controversy. In the sixteenth and seventeenth centuries, especially in the Netherlands, the Protestants also destroyed many religious images.

ICONOSTASIS. In Eastern Christian churches, a screen separating the main body of the church from the SANCTUARY; it is usually decorated with ICONS whose subject matter and order were largely predetermined.

ILLUMINATED MANUSCRIPTS. CODICES or SCROLLS decorated with illustrations or designs in gold, silver, and bright colors.

IMPASTO (pl. IMPASTOS). Pigment applied very thickly to a panel or canvas.

IMPERATOR. Freely translated from the Latin as *emperor,* but in Roman times it literally meant *army commander.*

IMPOST BLOCK. A block placed between the CAPITAL of a COLUMN and the ARCHES or VAULTS it supports.

JAMB. The vertical piece or pieces forming the side of a doorway or window. In Romanesque and Gothic churches, these supports were slanted or splayed outward to increase the impression of thickness in the walls and to provide space for sculptural decoration.

JESUIT ORDER. Founded as the Society of Jesus in 1540 by Saint Ignatius Loyola (1491–1556) for the purpose of achieving the spiritual perfection not only of its members but also of all people. It became a leading factor in the struggle of the Counter-Reformation to support the Catholic faith against the Protestant Reformation. It also became a teaching ORDER that was responsible for the propagation of the faith in Africa, Asia, and the Americas, as well as in Europe.

KEEP. The innermost central tower of a medieval castle, which served both as a last defense and as a dungeon and which contained living quarters, a prison, and sometimes a chapel; or a tower-like fortress, square, polygonal, or round, generally built on a mound as a military outpost.

KEYSTONE. See ARCH.

KING JAMES VERSION. See BIBLE.

LABORS OF THE MONTHS. Representations of occupations suitable to the twelve months of the year; frequently CARVED around the PORTALS of Romanesque and

Gothic churches, together with the signs of the ZODIAC, or represented in the calendar scenes of ILLUMINATED MANUSCRIPTS.

LANCET WINDOW. A high, narrow window with a pointed arch at the top.

LANTERN. In architecture, a tall, more or less open structure crowning a roof, DOME, tower, etc., and admitting light to an enclosed area below.

LAPIS LAZULI. A deep blue stone or complex mixture of minerals used for ornamentation and in the making of pigments.

LATIN CROSS. A cross whose vertical member is longer than its horizontal one.

LECTIONARY. A book containing portions of the Scriptures arranged in the order in which they are read at Christian services.

LIBERAL ARTS, SEVEN. Derived from the standard medieval prephilosophical education, they consisted of the trivium of Grammar, Rhetoric, and Logic, and the quadrivium of Arithmetic, Music, Geometry, and Astronomy. During the Middle Ages and the Renaissance, they were frequently represented allegorically.

LIGHT. A pane, or compartment of a window.

LINEAR PERSPECTIVE. See PERSPECTIVE.

LINTEL. See POST AND LINTEL.

LITANY. A form of group prayer consisting of a series of supplications by the clergy with responses from the congregation.

LITHOGRAPH. A PRINT made by drawing with a fatty crayon or other oily substance on a porous stone or a metal plate. Greasy printing ink applied to the moistened stone adheres only to the lines of the drawing; the design can be transferred easily to a damp sheet of paper.

LITURGY. A collection of prescribed prayers and ceremonies for public worship; specifically, in the Roman Catholic, Orthodox, and Anglican churches, those used in the celebration of the MASS.

LOGGIA (pl. LOGGIE). A GALLERY or ARCADE open on at least one side.

LUNETTE. A semicircular opening or surface, as on the wall of a VAULTED room or over a door, niche, or window. When it is over the PORTAL of a church, it is called a TYMPANUM.

MAESTÀ. Italian word for *majesty*, and in religion signifying the Virgin in Majesty. A large ALTARPIECE with a central panel representing the Virgin Enthroned, adored by saints and angels.

MAGUS (pl. MAGI). A member of the priestly caste in ancient Media and Persia traditionally reputed to have practiced supernatural arts. In Christian art, the Three Wise Men who came from the East to pay homage to the Infant Jesus are called the *Magi*.

MAJOLICA. A kind of Italian pottery, heavily glazed and usually decorated in rich colors.

MANDORLA. The Italian word for *almond*. A large oval surrounding the figure of God, Christ, the Virgin Mary, or occasionally a saint, indicating divinity or holiness.

MANSARD ROOF. A roof with two slopes, the lower steeper than the upper; named after the French architect François Mansart (1598–1666).

MASS. The celebration of the EUCHARIST to perpetuate the sacrifice of Christ upon the Cross, plus readings from one of the GOSPELS and an EPISTLE; also, the form of LITURGY used in this celebration. See CANON OF THE MASS and ORDINARY AND PROPER OF THE MASS.

MAULSTICK. From two Dutch words meaning *paint* and *stick*. A rod used to steady the hand while painting.

MAUSOLEUM. The magnificent tomb of Mausolus, erected by his wife at Halikarnassos in the middle of the fourth century B.C. Hence, any stately building erected as a burial place.

MAZZOCCHIO. A wire or wicker frame around which a hood or *cappuccio* was wrapped to form the turbanlike headdress commonly worn by Florentine men in the fifteenth century.

MENDICANT ORDERS. Religious societies or confraternities whose members are required to subsist on alms. See DOMINICAN ORDER and FRANCISCAN ORDER.

MINOTAUR. In Greek mythology, a monster with the body of a man and the head of a bull, who, confined in the labyrinth built for Minos, king of Crete, in his palace at Knossos, fed on human flesh and who was killed by the Athenian hero Theseus.

MITER. A tall cap terminating in two peaks, one in front and one in back, that is the distinctive headdress of BISHOPS (including the pope as bishop of Rome) and abbots of the Western Church.

MODELING. The building up of three-dimensional form in a soft substance, such as clay or wax; the CARVING of surfaces into proper RELIEF; the rendering of the appearance of three-dimensional form in painting.

MOLDING. An ornamental strip, either depressed or projecting, that gives variety to the surface of a building by creating contrasts of light and shadow.

MONSTRANCE. An open or transparent receptacle of gold or silver in which the consecrated HOST is exposed for adoration.

MOSAIC. A type of surface decoration (used on pavements, walls, and VAULTS) in which bits of colored stone or glass (*tesserae*) are laid in cement in a figurative design or decorative pattern. In Roman examples, colored stones, set regularly, are most frequently used; in Byzantine work, bits of glass, many with gold baked into them, are set irregularly.

MULLION. A vertical element that divides a window or a screen into partitions.

MURAL. A painting executed directly on a wall or done separately for a specific wall and attached to it.

MUSES. The nine sister goddesses of classical mythology who presided over learning and the arts. They came to be known as Calliope, Muse of epic poetry; Clio, Muse of history; Erato, Muse of love poetry; Euterpe, Muse of music; Melpomene, Muse of tragedy; Polyhymnia, Muse of sacred song; Terpsichore, Muse of dancing; Thalia, Muse of comedy; and Urania, Muse of astronomy.

NARTHEX. A PORCH or vestibule, sometimes enclosed, preceding the main entrance of a church; frequently, in churches preceded by an ATRIUM, the narthex is one side of the open AMBULATORY.

NAVE. From the Latin word for *ship*. The central aisle of an ancient Roman BASILICA or a Christian basilican church, as distinguished from the SIDE AISLES; the part of a church, between the main entrance and the CHANCEL, used by the congregation.

NEOPLATONISM. A philosophy, developed by Plotinus of Alexandria in the third century A.D., founded mainly on Platonic doctrine, Oriental mysticism, and Christian beliefs, in an effort to construct an all-inclusive philosophical system. Neoplatonism was of special interest to Italian humanists of the fifteenth century.

OBELISK. A tapering four-sided SHAFT of stone, usually monolithic, with a pyramidal apex, used as a freestanding monument (as in ancient Egypt) or as an architectural decoration.

OCULUS (pl. OCULI). Latin word for *eye*. A circular opening in a wall or at the apex of a DOME.

OFFICE OF THE DEAD. The burial service of the Christian Church.

OIL PAINT. Pigments mixed with oil; usually applied to a panel covered with GESSO, or to a stretched canvas that has been PRIMED with a mixture of glue and white pigment.

ORANT. From the Latin word for *praying*. Used to describe figures standing with arms outstretched in an attitude of prayer.

ORATORY. In the Roman Catholic Church, a religious society of priests who live in a community but are not bound by vows (as are monks). In architecture, a place of prayer; more specifically, a chapel or separate structure for meditation and prayer by a small group of people.

ORATORY OF DIVINE LOVE. A confraternity, founded in Rome, which by 1517 had the grudging approval of Pope Leo X. Its goals were the reform of the Church from within, the cultivation of the spiritual life of its members by prayer and frequent Communion, and the performance of charitable work. When it was dissolved in 1524, its members expanded their original work into the Theatine ORDER, which was founded in 1524 by Saint Cajetan. See SCUOLA.

ORDER (architectural). An architectural system based on the COLUMN (including BASE, SHAFT, and CAPITAL) and its ENTABLATURE (including ARCHITRAVE, FRIEZE, and CORNICE). The five classical orders are the Doric, Ionic, Corinthian, Tuscan, and Composite.

ORDER (monastic). A religious society or confraternity whose members live under a strict set of rules and regulations, such as the BENEDICTINE, Cistercian, DOMINICAN, FRANCISCAN, CARTHUSIAN, Cluniac, JESUIT, and Theatine.

ORDINARY AND PROPER OF THE MASS. The service of the MASS exclusive of the CANON. It includes prayers, hymns, and readings from the EPISTLES and the GOSPELS.

ORTHOGONALS. Lines that are at right angles to the plane of the picture surface but that, in a representation using one-point PERSPECTIVE, converge toward a common vanishing point in the distance.

PAGODA. In the Far East, a sacred tower or temple usually pyramidal in shape and profusely decorated. Also, a small ornamental structure built to imitate such a temple.

PALAZZO (pl. PALAZZI). Italian word for a *large town house;* used freely to refer to large civic or religious buildings as well as to relatively modest town houses.

PALETTE. A thin, usually oval or oblong tablet, with a hole for the thumb, upon which painters place and mix their colors. Also, by extension, a selection of colors or a color preference.

PALETTE KNIFE. A small knife with a thin, flexible blade used for mixing painters' colors and sometimes for applying the paint directly to the picture surface.

PANTHEON. From the Greek words meaning *all the gods;* hence, a temple dedicated to all the gods. Specifically, the famous temple built about 25 B.C. in Rome and so dedicated.

PAPYRUS. A tall aquatic plant formerly very abundant in Egypt. Also, the material used for writing or painting upon by the ancient Egyptians, Greeks, and Romans. It was made by soaking, pressing, and drying thin strips of the pith of the plant laid together. Also, a manuscript or document of this material.

PARAPET. A low protective wall or barrier at the edge of a balcony, roof, bridge, or the like.

PARCHMENT. A paper-like material made from animal skins that have been carefully scraped, stretched, and dried to whiteness. The name is a corruption of *Pergamon,* the city in Asia Minor where parchment was invented in the second century B.C. Also, a manuscript or document of such material.

PARNASSUS. A mountain in Greece, anciently sacred to Apollo and the MUSES; hence, used allusively in both painting and poetry.

PASSION. In the Christian Church, used specifically to describe the sufferings of Christ during his last week of earthly life; the representation of his sufferings in narrative or pictorial form.

PASTEL. A crayon made of ground pigments mixed with gum water, or a picture drawn with such crayons.

PAVILION. A projecting subdivision of a building, usually distinguished from the main structure by greater height or more elaborate decoration. Also, a light, ornamental building or pleasure house.

PEDESTAL. An architectural support for a COLUMN, statue, vase, etc.; also, a foundation or BASE.

PEDIMENT. A low-pitched triangular area, resembling a GABLE, formed by the two slopes of a roof of a building (over a PORTICO, door, niche, or window), framed by a raking CORNICE, and frequently decorated with sculpture. When pieces of the cornice are either omitted or jut out from the main axis, as in some late Roman and Baroque buildings, it is called a *broken pediment*. See TYMPANUM.

PENDENTIVE. An architectural feature, having the shape of a spherical triangle, used as a transition from a square ground PLAN to a circular plan that will support a DOME. The dome may rest directly on the pendentives or on an intermediate DRUM.

PERICOPE. Extracts or passages from the BIBLE selected for use in public worship.

PERIPTERAL. Having a COLONNADE or PERISTYLE on all four sides.

PERISTYLE. A COLONNADE or ARCADE around a building or open court.

PERSPECTIVE. The representation of three-dimensional objects on a flat surface so as to produce the same impression of distance and relative size as that received by the human eye. In one-point *linear perspective*, developed during the fifteenth century A.D., all parallel lines in a given visual field converge at a single vanishing point on the horizon. In *aerial* or *atmospheric perspective* the relative distance of objects is indicated by gradations of tone and color and by variations in the clarity of outlines. See ORTHOGONALS and TRANSVERSALS.

PHOTOGRAM. A photograph made without a camera, by placing objects on light-sensitive paper and exposing them to a source of light.

PHOTOMONTAGE. A type of composite work, popular with the Dadaists in the 1920s, in which parts of photographs are cut out and combined to form new images, either by careful pasting and fitting together of the pieces of a positive print or by creating composite negatives.

PIAZZA (pl. PIAZZE). Italian word for *public square*. See also CAMPO.

PICTURE PLANE. The actual surface on which a picture is painted.

PIER. An independent architectural element, usually rectangular in section, used to support a vertical load; if used with an ORDER, it often has a BASE and CAPITAL of the same design. See COMPOUND PIER.

PIER BUTTRESS. An exterior PIER in Romanesque and Gothic architecture, BUTTRESSING the THRUST of the VAULTS within.

PIETÀ. Italian word meaning both *pity* and *piety*. Used to designate a representation of the dead Christ mourned by the Virgin, with or without saints and angels. When the representation is intended to show a specific event prior to Christ's burial, it is usually called a *Lamentation*.

PIETRA SERENA. Italian phrase for *clear stone*. A clear gray Tuscan limestone used for building chiefly in Florence and its environs.

PILASTER. A flat vertical element, having a CAPITAL and BASE, engaged in a wall from which it projects. It has a decorative rather than a structural purpose.

PINNACLE. A small ornamental turret on top of BUTTRESSES, PIERS, or elsewhere; mainly decorative, it may also have a structural purpose.

PLAN. The general arrangement of the parts of a building or group of buildings, or a drawing of these as they would appear on a plane cut horizontally above the ground or floor.

PODIUM (pl. PODIA). In architecture, a continuous projecting BASE or PEDESTAL used to support COLUMNS, sculptures, or a wall. Also, the raised platform surrounding the arena of an ancient amphitheater.

POLYPTYCH. ALTARPIECE or devotional picture consisting of more than three wooden panels joined together.

PORCH. An exterior structure forming a covered approach to the entrance of a building.

PORPHYRY. A very hard rock having a dark purplish-red base. The room in the Imperial Palace in Constantinople reserved for the confinement of the reigning empress was decorated with porphyry so that the child would be "born to the purple," or "Porphyrogenitus."

PORTA CLAUSA. Latin phrase for CLOSED DOOR or CLOSED GATE.

PORTAL. A door or gate, especially one of imposing appearance, as in the entrances and PORCHES of a large

church or other building. In Gothic churches the FAÇADES frequently include three large portals with elaborate sculptural decoration.

PORTICO. A structure consisting of a roof, or an ENTABLATURE and PEDIMENT, supported by COLUMNS, sometimes attached to a building as a PORCH.

POST AND LINTEL. The ancient but still widely used system of construction in which the basic unit consists of two or more upright posts supporting a horizontal beam, or lintel, which spans the opening between them.

PREDELLA. PEDESTAL of an ALTARPIECE, usually decorated with small narrative scenes that expand the theme of the major work above it.

PRIMING. A preparatory layer of paint, size, or the like applied to the surface, such as canvas or wood, that is to be painted.

PRINT. A picture, design, or the like reproduced from an engraved or otherwise prepared block or plate from which more than one copy can be made. See ENGRAVING, ETCHING, AQUATINT, WOODCUT, and LITHOGRAPH. A photograph, especially one made from a negative, is often called a print.

PRIORI. Italian word for *priors*. The council or principal governing body of a town.

PROPYLAION (pl. PROPYLAIA). Generally, the entrance to a temple or other sacred enclosure. Specifically, the entrance gate to the Acropolis in Athens.

PROSTYLE. Used to describe a temple having a PORTICO across the entire front.

PSALTER. The Book of Psalms in the Old Testament, or a copy of it, used for liturgical or devotional purposes; many psalters illuminated in the Middle Ages have survived. See ILLUMINATED MANUSCRIPTS.

PYLON. Greek word for *gateway*. In Egyptian architecture, the monumental entrance to a temple or other large edifice, consisting of two truncated pyramidal towers flanking a central gateway. Also applied to either of the flanking towers.

QUATREFOIL. A four-lobed form used as ornamentation.

QUATTROCENTO. Italian term for *four hundred*, meaning the fourteen hundreds, or the fifteenth century.

RAKING CORNICE. See CORNICE.

REFECTORY. From the Latin verb meaning *to renew* or *restore*. A room for eating; in particular, the dining hall in a monastery, college, or other institution.

REGISTER. One of a series of horizontal bands used to differentiate areas of decoration when the bands are placed one above the other, as in Egyptian tombs, medieval church sculpture, and the pages of a manuscript.

REINFORCED CONCRETE. Poured concrete with iron or steel mesh or bars imbedded in it to increase its tensile strength.

RELIEF. Sculpture that is not freestanding but projects from the background of which it is a part. *High relief* or *low relief* describes the amount of projection; when the background is not cut out, as in some Egyptian sculpture, the work is called *incised relief*.

RELIQUARY. A casket, COFFER, or other small receptacle for a sacred relic, usually made of precious materials and richly decorated.

REPOUSSOIR. From the French verb meaning *to push back*. A means of achieving PERSPECTIVE or spatial contrasts by the use of illusionistic devices such as the placement of a large figure or object in the immediate foreground of a painting to increase the illusion of depth in the rest of the picture.

RETARDATAIRE. From the French meaning *to be slow* or *behind time*. Said of an artist (or work) whose style reflects that of the past rather than that of the present.

RIB. A slender projecting ARCH used primarily as support in Romanesque and Gothic VAULTS; in late Gothic architecture, the ribs are frequently ornamental as well as structural.

RIBBED (or RIB) VAULT. A compound masonry VAULT, the GROINS of which are marked by projecting stone RIBS.

ROSARY. A series of prayers primarily to the Virgin Mary,

or a string of beads invented by the DOMINICANS as an aid to memory in the recitation of these prayers. During the recitation the worshiper meditates on the five Joyful, the five Glorious, and the five Sorrowful Mysteries of the Virgin.

ROTUNDA. A circular building or interior hall usually surmounted by a DOME.

RUSTICATION. Masonry having indented joinings and, frequently, a roughened surface.

SACRAMENT. A rite regarded as an outward and visible sign of an inward and spiritual grace. Specifically, in the Roman Catholic Church, any one of the seven rites recognized as having been instituted by Christ: Baptism, Confirmation, the EUCHARIST, Penance, Matrimony, Holy Orders, and Extreme Unction.

SACRISTY. See VESTRY.

SALON. A reception room or drawing room in a large house. Also, the exhibition of work by living painters held in Paris at first biennially and since the mid-eighteenth century annually; so called because it was formerly held in the Salon Carré of the Louvre in Paris.

SANCTUARY. A sacred or holy place. In architecture, the term is generally used to designate the most sacred part of a building.

SARCOPHAGUS (pl. SARCOPHAGI). From the Greek words meaning *flesh-eating*. In ancient Greece, a kind of limestone said to reduce flesh to dust; thus, the term was used for coffins. A general term for a stone coffin often decorated with sculpture or bearing inscriptions.

SATURATION. The degree of intensity of a HUE and its relative freedom from an admixture with white.

SATYR. In classical mythology, one of the woodland creatures thought to be the companions of Dionysos and noted for lasciviousness, represented with the body of a man, pointed ears, two horns, a tail, and the legs of a goat.

SCRIPTURE. See BIBLE.

SCROLL. A roll of paper, PARCHMENT, or the like intended for writing upon. In architecture, an ornament resembling a partly unrolled sheet of paper or having a spiral or coiled form, as in the VOLUTES of Ionic and Corinthian COLUMNS.

SCUOLA (pl. SCUOLE). Italian word for *school*. In Venetian Renaissance terms, a fraternal organization under ecclesiastical auspices, dedicated to good works but with no educational function. Called a *company* elsewhere in Italy, except in Tuscany, where it was sometimes called a *confraternity*.

SECCO SU FRESCO. See FRESCO.

SECTION. A drawing or diagram of a building showing its various parts as they would appear if the building were cut on a vertical plane.

SERAPH (pl. SERAPHIM). A celestial being or angel of the highest order, usually represented with six wings.

SHAFT. A spire-shaped or cylindrical form; in architecture, the part of a COLUMN or PIER between the BASE and the CAPITAL.

SHOP. See BOTTEGA.

SIBYL. Any of various women of Greek and Roman mythology who were reputed to possess powers of prophecy and divination. In time, as many as twelve came to be recognized, some of whom Michelangelo painted in the frescoes adorning the Sistine Chapel ceiling because they were believed to have foretold the first coming of Christ.

SIDE AISLE. One of the corridors parallel to the NAVE of a church or BASILICA, separated from it by an ARCADE or COLONNADE.

SILK SCREEN. A printmaking technique in which a design is blocked out on a piece of stretched silk gauze by means of a stencil, glue sizing, etc. Paint is then forced through the untreated spaces in the silk onto a piece of paper.

SINOPIA (pl. SINOPIE). An Italian term taken from *Sinope*, the name of a city in Asia Minor famous for its red earth. Used to designate the preliminary brush drawing, executed in red earth mixed with water, for a painting in FRESCO; usually done on the ARRICCIO.

SINS, SEVEN DEADLY. See VICES.

SIREN. In classical mythology, one of several fabulous creatures, half woman and half bird, who were reputed to lure sailors to destruction by their seductive singing.

SLIP. Potter's clay reduced with water to a semiliquid state and used for coating or decorating pottery, cementing handles, etc.

SOCLE. A square block supporting a COLUMN, statue, vase, or other work of art, or a low BASE supporting a wall.

SPANDREL. An area between the exterior curves of two adjoining ARCHES; or an area enclosed by the exterior curve of an arch, a perpendicular from its springing, and a horizontal through its apex.

SPHINX. In Egyptian mythology, a creature with the body of a lion and the head of a man, a bird, or a beast; the monumental sculpture of the same. In Greek mythology, a monster usually having the winged body of a lion and the head of a woman.

SQUINCH. An architectural device that uses ARCHES, LINTELS, or CORBELS across the corners of a square space to support a dome and to make the transition from the square space to a polygonal or round one.

STANZA (pl. STANZE). Italian word for *room*.

STATE. See ETCHING.

STIPPLING. In painting, drawing, and ENGRAVING, a method of representing light and shade by the use of dots.

STOA. In Greek architecture, a PORTICO or covered COLONNADE, usually of considerable length, used as a promenade or meeting place.

STRINGCOURSE. A horizontal MOLDING or band of stone, usually projecting and sometimes richly carved, that runs across the face of a building.

STUCCO. Any of various plasters used for CORNICES, MOLDINGS, and other wall decorations. A cement or concrete for coating exterior walls in imitation of stone.

STYLUS. A pointed instrument used in ancient times for writing on tablets of a soft material, such as clay. Also an etcher's tool. See ETCHING.

SUPERIMPOSED ORDERS. One ORDER on top of another on the face of a building of more than one story. The upper order is usually lighter in form than the lower.

SURPLICE. A loose, broad-sleeved white vestment, properly of linen, worn over the CASSOCK by the clergy, choristers, and others taking part in church services.

TABERNACLE. The portable SANCTUARY used by the Israelites in the wilderness before the building of the Temple. Generally, any place or house of worship. In architecture, a canopied niche or recess, in a wall or a pillar, built to contain an image.

TABLES OF THE LAW. The stone slabs on which the Ten Commandments were inscribed.

TEMPERA. Ground colors mixed with yolk of egg, instead of oil, as a vehicle; a medium widely used for Italian panel painting before the sixteenth century.

TENEBROSI. Italian word for *shadowy ones*. A group of Neapolitan followers of Caravaggio who adopted and exaggerated his strong contrasts of light and dark.

TERRA-COTTA. Italian words for *baked earth*. A hard glazed or unglazed earthenware used for sculpture and pottery or as a building material. The word can also mean something made of this material or the color of it, a dull brownish red.

TERRA VERDE. Italian words for *green earth*. The color used for the underpaint of flesh tones in TEMPERA painting.

TESSERA (pl. TESSERAE). See MOSAIC.

THEATINE ORDER. See ORATORY OF DIVINE LOVE.

THEOLOGICAL VIRTUES. See VIRTUES.

THRUST. The outward force exerted by an ARCH or VAULT that must be counterbalanced by BUTTRESSING.

TIARA (papal). The pope's triple crown, surmounted by the orb and cross. It is the emblem of sovereign power but has no sacred character; at LITURGICAL functions the pope always wears a MITER.

TIE-ROD. An iron rod used as a structural element to keep the lower ends of a roof or ARCH from spreading.

TOGA. A loose outer garment consisting of a single piece of material, without sleeves or armholes, which covered nearly the whole body, worn by the citizens of ancient Rome when appearing in public in times of peace.

TONDO. Italian term for a *circular work of art:* painting, RELIEF sculpture, or the like.

TRACERY. Ornamental stonework in geometric patterns used primarily in Gothic windows as support and decoration, but also used on panels, screens, etc. When the window appears to be cut through the solid stone, the style is called *plate tracery;* when slender pieces of stone are erected within the window opening, the style is called *bar tracery.*

TRANSEPT. In a BASILICAN church, the crossarm, placed at right angles to the NAVE, usually separating the latter from the CHANCEL or the APSE.

TRANSVERSALS. Horizontal lines running parallel to the PICTURE PLANE and intersecting the ORTHOGONALS.

TRAVERTINE. A tan or light-colored limestone used in Italy, and elsewhere, for building. The surface is characterized by alternating smooth and porous areas.

TREE OF LIFE. A tree in the Garden of Eden whose fruit gave everlasting life and was thus equated with Christ in medieval theology (Genesis 2:9, 3:22). Also, according to a vision of Saint John the Evangelist, a tree in the heavenly city of Jerusalem with leaves for the healing of nations (Revelation 22:2).

TREE OF THE KNOWLEDGE OF GOOD AND EVIL. A tree in the Garden of Eden bearing the forbidden fruit, the eating of which destroyed Adam's and Eve's innocence (Genesis 2:9, 3:17).

TREFOIL. A three-lobed form used as ornamentation or as the basis for a ground PLAN.

TRIFORIUM. The section of the wall in the NAVE, CHOIR, and sometimes in the TRANSEPT above the ARCHES and below the CLERESTORY. It usually consists of a blind ARCADE or a GALLERY.

TRIPTYCH. ALTARPIECE or devotional picture consisting of three panels joined together. It is frequently hinged so that the center panel is covered when the side panels are closed.

TRITON. In classical mythology, a son of Poseidon and Amphitrite, represented as having the head and trunk of a man and the tail of a fish, and carrying a conch shell that he blows to raise or calm the waves. Later, one of a race of subordinate sea-gods.

TRIUMPHAL ARCH. In ancient Rome, a freestanding monumental ARCH or series of three arches erected to commemorate a military victory; usually decorated with sculptured scenes of a war and its subsequent triumphal procession. In a Christian church, the transverse wall with a large arched opening that separates the CHANCEL and the APSE from the main body of the church, and that is frequently decorated with religious scenes executed in MOSAIC or FRESCO.

TROPHY. A memorial erected by the ancient Greeks and Romans in commemoration of a victory. It usually consisted of arms and spoils taken from the enemy and hung on a tree or pillar. Also, the representation

of such a memorial as an allegory or simply as decoration.

TUNIC. In ancient Greece and Rome, a knee-length garment with or without sleeves usually worn without a girdle by both sexes.

TYMPANUM (pl. TYMPANA). In classical architecture, the vertical recessed face of a PEDIMENT; in medieval architecture, the space between the ARCH and the LINTEL over a door or window, which was often decorated with sculpture.

VALUE. The degree of lightness or darkness of a HUE.

VAULT. An ARCHED roof or covering made of brick, stone, or concrete. See BARREL VAULT, GROIN VAULT, RIBBED VAULT, and CORBEL VAULT.

VELLUM. A fine kind of PARCHMENT made from calfskin and used for the writing, ILLUMINATING, and binding of medieval manuscripts.

VESTRY. A room in or a building attached to a church where the vestments and sacred vessels are kept; also called a *sacristy.* Used in some churches as a chapel or a meeting room.

VICAR. An ecclesiastic of the Roman Catholic Church who represents a pope or BISHOP; the pope himself as the vicar of Christ.

VICES. Coming from the same tradition as the VIRTUES, and frequently paired with them, they are more variable but usually include Pride, Avarice, Wrath, Gluttony, and Unchastity. Others such as Sloth, Folly, Inconstancy, or Injustice may be selected to make a total of seven.

VICTORY. A female deity of the ancient Romans, or the corresponding deity the ancient Greeks called *Nike.* The representation of the deity, usually as a winged woman in windblown draperies and holding a laurel wreath, palm branch, or other symbolic object.

VILLA. A Latin and Italian word originally describing a country house of some size and pretension, but now also used to designate a rural or suburban residence or a detached house in a residential area.

VIRTUES. Divided into the three Theological Virtues of Faith, Hope, and Charity (Love) and the four Cardinal Virtues of Prudence, Justice, Fortitude, and Temperance. As with the VICES, the allegorical representation of the Virtues derives from a long medieval tradition in manuscripts and sculpture, and from such literary sources as the *Psychomachia* of Prudentius and the writings of Saint Augustine.

VOLUTE. An ornament resembling a rolled SCROLL. Especially prominent on CAPITALS of the Ionic and Composite ORDERS.

VOUSSOIR. See ARCH.

VULGATE. See BIBLE.

WASH. Used in WATERCOLOR and GOUACHE painting, brush drawing, and occasionally in OIL PAINTING to describe a broad, thin layer of diluted pigment or ink. Also refers to a drawing made in this technique.

WATERCOLOR. Paint in which the pigment is mixed with water as a solvent, or a design executed with this paint.

WOODCUT. A PRINT made by cutting a design in RELIEF on a block of wood and printing only the raised surfaces.

ZODIAC. An imaginary belt encircling the heavens within which lie the paths of the sun, moon, and principal planets. It is divided into twelve equal parts called *signs,* which are named after twelve constellations: Aries, the ram; Taurus, the bull; Gemini, the twins; Cancer, the crab; Leo, the lion; Virgo, the virgin; Libra, the balance; Scorpio, the scorpion; Sagittarius, the archer; Capricorn, the goat; Aquarius, the water-bearer; and Pisces, the fishes. Also, a circular or elliptical diagram representing this belt with pictures of the symbols associated with the constellations.

BOOKS FOR FURTHER READING

The following list of suggested works for further reading was prepared for this edition by Carol Anne Dickson, assistant to Frederick Hartt. Citations include classic works of art-historical writing as well as recent publications that reflect new approaches to the discipline. For a comprehensive listing of art books (excluding monographs) published prior to 1980, see *Guide to the Literature of Art History* by Etta Arntzen and Robert Rainwater (American Library Association, Chicago, 1980). *Art Books: A Basic Bibliography of Monographs on Artists* by Wolfgang Freitag (Garland, New York, 1985) provides citations on individual artists from all periods and cultures. An excellent research guidebook for students is *Art Information: Research Methods and Resources* by Lois Swan Jones (3d ed., Kendall/Hunt, Dubuque, Iowa, 1990). It provides detailed information on indices, general bibliographies, and databases pertaining to the history of art. *A Short Guide to Writing about Art* by Sylvan Barnet (3d ed., Scott, Foresman, Glenview, Illinois, 1989) and *The Artist's Handbook of Materials and Techniques* by Ralph Mayer (5th ed., Viking, New York, 1991) are other valuable resources.

INTRODUCTION

ARNHEIM, RUDOLF, *New Essays on the Psychology of Art*, University of California Press, Berkeley, 1986

BROUDE, NORMA, and GARRARD, MARY, eds., *The Expanding Discourse: Feminism and Art History*, HarperCollins, New York, 1992

———, eds., *Feminism and Art History: Questioning the Litany*, Harper & Row, New York, 1982

BRYSON, NORMAN, *Vision and Painting: The Logic of the Gaze*, Yale University Press, New Haven, Conn., and London, 1988

FOCILLON, HENRI, *The Life of Forms in Art*, 2d ed., Wittenborn, New York, 1958; repr. ed., Zone Books, New York, 1989

GOMBRICH, ERNST H., *Art and Illusion*, 4th ed., Phaidon, London, 1972

———, *Art, Perception and Reality*, Johns Hopkins University Press, Baltimore, 1972

HAUSER, ARNOLD, *The Social History of Art* (tr. S. Goodman, in collaboration with the author), Knopf, New York, 1951; repr. ed., Vintage Books, New York, 1985

HOLT, ELIZABETH B., *A Documentary History of Art*, 2d ed., 2 vols., Doubleday, Garden City, N.Y., 1981

KLEINBAUER, W. EUGENE, *Modern Perspectives in Western Art History*, University of Toronto Press and Medieval Academy of America, 1989

KOSTOF, SPIRO, *The City Shaped: Urban Patterns and Meanings Through History*, Thames & Hudson, London, and Little, Brown, Boston, 1991

———, *A History of Architecture: Settings and Rituals*, Oxford University Press, New York and Oxford, 1985

PETERSEN, KAREN, and WILSON, J. J., *Women Artists: Recognition and Reappraisal from the Early Middle Ages to the Twentieth Century*, New York University Press, 1976

ROSKILL, MARK, *What Is Art History?*, University of Massachusetts Press, Amherst, 1989

Part Five: The Renaissance

ALBERTI, LEONE BATTISTA, *On Painting and On Sculpture* (tr. C. Grayson), Phaidon, New York, 1972

———, *Ten Books on Architecture*, Transatlantic Arts, New York, 1966

AMES-LEWIS, FRANCIS, *Drawing in Early Renaissance Italy*, Yale University Press, New Haven, Conn., 1981

ANTAL, FREDERICK, *Florentine Painting and Its Social Background*, Boston Book & Art Shop, 1965

BERENSON, BERNARD, *The Drawings of the Florentine Painters*, 2d ed., 3 vols., University of Chicago Press, 1970

———, *Italian Painters of the Renaissance*, Cornell University Press, Ithaca, 1980

———, *Italian Pictures of the Renaissance*, 7 vols., Phaidon, London, 1957–68

BLUNT, SIR ANTHONY, *Artistic Theory in Italy 1450–1600*, Oxford University Press, New York, 1963

BOBER, PHYLLIS PRAY, and RUBINSTEIN, RUTH, *Renaissance Artists and Antique Sculpture: A Handbook of Sources*, Oxford University Press, New York, 1991

BOORSOOK, EVE, *The Mural Painters of Tuscany from Cimabue to Andrea del Sarto*, Oxford University Press, New York, 1981

BURCKHARDT, JAKOB C., *The Altarpiece in Renaissance Italy* (tr., ed. Peter Humfrey), Cambridge University Press, Cambridge and New York, 1988

———, *The Civilization of the Renaissance in Italy* (tr. S. G. C. Middlemore), 4th ed., Phaidon, London, 1960

CENNINI, CENNINO, *The Craftsman's Handbook* (tr. D. V. Thompson, Jr.), Dover, New York, 1960

CHASTEL, ANDRÉ, *The Age of Humanism: Europe 1480–1539* (tr. K. M. Delavenay and E. M. Gwyer), McGraw-Hill, New York, 1964

———, *Studios and Styles of the Italian Renaissance* (tr. J. Griffin), Braziller, New York, 1971

CLARK, KENNETH M., *The Nude: A Study in Ideal Form*, Princeton University Press, 1972

COLE, BRUCE, *The Renaissance Artist at Work: From Pisano to Titian*, Harper & Row, New York, 1983

GOMBRICH, E. H., *Norm and Form: Studies in the Art of the Renaissance*, 4th ed., University of Chicago Press, 1985

———, *Symbolic Images: Studies in the Art of the Renaissance*, 3d ed., University of Chicago Press, 1985

HARTT, FREDERICK, *History of Italian Renaissance Art*, 3d ed., Abrams, New York, 1987

HEYDENREICH, LUDWIG H., and LOTZ, WOLFGANG, *Architecture in Italy 1400–1600* (tr. Mary Hottinger), Penguin, Baltimore, 1974

LAVIN, MARILYN ARONBERG, *The Place of Narrative: Mural Decoration in Italian Churches, 431–1600*, University of Chicago Press, Chicago and London, 1990

LEONARDO DA VINCI, *Treatise on Painting* (tr. A. P. McMahon), 2 vols., Princeton University Press, 1956

LEVENSON, JAY, ed., *Circa 1492: Art in the Age of Exploration*, National Gallery of Art, Washington, D.C., and Yale University Press, New Haven, Conn., 1991

LIEBERMAN, RALPH, *Renaissance Architecture in Venice*, Abbeville Press, New York, 1982

MARLE, RAIMOND VAN, *The Development of the Italian Schools of Painting*, vols. X–XIX, Hacker, New York, 1970

MARTINEAU, JANE, and HOPE, CHARLES, eds., *The Genius of Venice*, Abrams, New York, 1984

PANOFSKY, ERWIN, *Meaning in the Visual Arts*, University of Chicago Press, 1982

———, *Renaissance and Renascences in Western Art*, Harper & Row, New York, 1972

———, *Studies in Iconology: Humanistic Themes in the Art of the Renaissance*, Harper & Row, New York, 1972

PATER, WALTER, *The Renaissance: Studies in Art and Poetry* (ed. Donald L. Hill), University of California Press, Berkeley, 1980

POPE-HENNESSY, SIR JOHN, *An Introduction to Italian Sculpture*, 2d ed., 3 vols., Phaidon, New York, 1970–71

———, *The Portrait in the Renaissance*, Pantheon, New York, 1966

RUSSELL, DIANE, *Eva/Ave: Woman in Renaissance and Baroque Prints*, National Gallery of Art, Washington, D.C., and The Feminist Press, New York, 1990

SNYDER, JAMES, *Northern Renaissance Art*, Abrams, New York, and Prentice-Hall, Englewood Cliffs, N.J., 1985

STECHOW, WOLFGANG, *Northern Renaissance Art 1400–1600: Sources and Documents*, Prentice-Hall, Englewood Cliffs, N.J., 1966

VASARI, GIORGIO, *The Lives of the Painters* (ed. Kenneth Clark), 3 vols., Abrams, New York, 1979

WIND, EDGAR, *Pagan Mysteries in the Renaissance*, 2d ed., Barnes & Noble, New York, 1968

WITTKOWER, RUDOLF, *Architectural Principles in the Age of Humanism*, 4th ed., St. Martin's Press, New York, 1988

CHAPTER NINETEEN: THE DAWN OF INDIVIDUALISM IN ITALIAN ART— THE THIRTEENTH AND FOURTEENTH CENTURIES

BAXANDALL, MICHAEL, *Giotto and the Orators (1350–1450)*, Clarendon Press, Oxford, 1971

CHIELLINI, MONICA, *Cimabue*, Scala Books, Florence, 1988; distr. by Harper & Row, New York

COLE, BRUCE, *Sienese Painting: From Its Origin to the Fifteenth Century*, Indiana University Press, Bloomington, 1985

CRICHTON, GEORGE H., and CRICHTON, SYLVIA R., *Nicola Pisano and the Revival of Sculpture in Italy*, Cambridge University Press, Cambridge, 1938

FREMANTLE, RICHARD, *Florentine Gothic Painters from Giotto to Masaccio: A Guide to Painting in and near Florence*, Martin Secker & Warburg, London, 1975

FRUGONI, CHIARA, *Pietro and Ambrogio Lorenzetti*, Scala Books, Florence, 1988; distr. by Harper & Row, New York

GILBERT, CREIGHTON, *Italian Art 1400–1500: Sources and Documents*, Prentice-Hall, Englewood Cliffs, N.J., 1980

MEISS, MILLARD, *Painting in Florence and Siena after the Black Death*, Princeton University Press, 1978

POPE-HENNESSY, SIR JOHN, *Italian Gothic Sculpture*, Vintage Books, New York, 1985

STUBBLEBINE, JAMES H., ed., *Giotto: The Arena Chapel Frescoes*, Norton, New York, 1969

CHAPTER TWENTY: THE EARLY RENAISSANCE IN ITALY—THE FIFTEENTH CENTURY

BALDINI, UMBERTO, and CASAZZA, ORNELLA, *The Brancacci Chapel*, Abrams, New York, 1992

BATTISTI, EUGENIO, *Filippo Brunelleschi: The Complete Work*, Rizzoli, New York, 1981

BAXANDALL, MICHAEL, *Painting and Experience in Fifteenth Century Italy*, 2d ed., Oxford University Press, New York, 1989

CHRISTIANSEN, KEITH, *Gentile da Fabriano*, Cornell University Press, Ithaca, 1982

———, et al., *Painting in Renaissance Siena, 1420–1500*, Metropolitan Museum of Art and Abrams, New York, 1989

CLARK, KENNETH M., *Piero della Francesca*, 2d ed., Phaidon, London, 1969

COLE, BRUCE, *Masaccio and the Art of Early Renaissance Florence*, Indiana University Press, Bloomington, c. 1980

———, *Piero della Francesca: Tradition and Innovation in Renaissance Art*, Icon Editions, New York, 1991

EDGERTON, SAMUEL Y., JR., *The Heritage of Giotto's Geometry: Art and Science on the Eve of the Scientific Revolution*, Cornell University Press, Ithaca and London, 1991

———, *The Renaissance Rediscovery of Linear Perspective*, Harper & Row, New York, 1976

EISLER, COLIN, *The Genius of Gentile Bellini: The Complete Paintings and Drawings*, British Museum Publications, London, and Abrams, New York, 1989

GOFFEN, RONA, et al., *Life and Death in Fifteenth-Century Florence*, Duke University Press, Durham, N.C., 1989

HALE, JOHN R., *Italian Renaissance Painting from Masaccio to Titian*, Dutton, New York, 1977

HARTT, FREDERICK, et al., *The Chapel of the Cardinal of Portugal, 1434–1459, at San Miniato in Florence*, University of Pennsylvania Press, Philadelphia, 1964

———, and FINN, D., *Donatello: Prophet of Modern Vision*, Abrams, New York, 1973

HORNE, HERBERT, *Botticelli: Painter of Florence*, Princeton University Press, 1980

JANSON, H. W., *The Sculpture of Donatello*, 2 vols., Princeton University Press, 1963

KRAUTHEIMER, RICHARD, and KRAUTHEIMER-HESS, T., *Lorenzo Ghiberti*, Princeton University Press, 1982

LIGHTBOWN, RONALD, *Mantegna*, University of California Press, Berkeley, 1986

———, *Sandro Botticelli: Life and Work*, Abbeville Press, New York, 1989

MANETTI, ANTONIO DI TUCCIO, *The Life of Brunelleschi*, Howard Saalman, ed., Pennsylvania State University Press, University Park, 1970

MARTINDALE, ANDREW, ed., *The Complete Paintings of Mantegna*, Abrams, New York, 1967

MURRAY, PETER, and MURRAY, LINDA, *The Art of the Renaissance*, Thames & Hudson, New York, 1985

PASSAVANT, GÜNTER, *Verrocchio* (tr. K. Watson), Phaidon, London, 1969

POPE-HENNESSY, SIR JOHN, *The Complete Work of Paolo Uccello*, 2d ed., 2 vols., Phaidon, London, 1969

———, *Fra Angelico*, Scala, Florence, 1981

SEYMOUR, CHARLES, JR., *Jacopo della Quercia: Sculptor*, Yale University Press, New Haven, Conn., 1973

———, *Sculpture in Italy, 1400–1500*, Penguin, Baltimore, 1966

———, *The Sculpture of Verrocchio*, New York Graphic Society, Greenwich, Conn., 1971

CHAPTER TWENTY-ONE: THE EARLY RENAISSANCE IN NORTHERN EUROPE

BLUM, SHIRLEY N., *Early Netherlandish Triptychs*, University of California Press, Berkeley, 1969

CHÂTELET, ALBERT, *Early Dutch Painting*, Rizzoli, New York, 1981

CHRISTENSEN, C., *Art and the Reformation in Germany*, Ohio University Press, Athens, and Wayne State University Press, Detroit, 1979

CONWAY, WILLIAM M., *The Van Eycks and Their Followers*, AMS Press, New York, 1979

COREMANS, PAUL, ed., *Flanders in the Fifteenth Century: Art and Civilization*, Detroit Institute of Arts, 1960

DAVIES, MARTIN, *Rogier van der Weyden*, Phaidon, London, 1972

FRIEDLANDER, MAX J., *Early Netherlandish Painting* (tr. H. Norden), 14 vols., Praeger, New York, and Phaidon, London, 1967–76

———, *From Van Eyck to Bruegel*, Cornell University Press, Ithaca, 1981

HIND, ARTHUR M., *History of Engraving and Etching*, 3d ed., Dover, New York, 1963

———, *An Introduction to a History of Woodcut*, 2 vols., Dover, New York, 1963

HOLLSTEIN, F. W. H., *Dutch and Flemish Etchings, Engravings, and Woodcuts*, 31 vols., Menno Hertzberger, Amsterdam, 1949–87

HUIZINGA, JOHAN, *The Waning of the Middle Ages*, Doubleday/Anchor, New York, 1970

LASSAIGNE, JACQUES, *Flemish Painting* (tr. S. Gilbert), Vol. 2 (*Bosch to Rubens*), Geneva, 1958

MEISS, MILLARD, *French Painting in the Time of Jean de Berry: The Boucicaut Master*, Braziller, New York, 1974

———, *French Painting in the Time of Jean de Berry: The Late Fourteenth Century and the Patronage of the Duke*, 2 vols., Phaidon, London, 1967

———, *French Painting in the Time of Jean de Berry: The Limbourgs and Their Contemporaries*, 2 vols., Braziller, New York, 1974

———, ed., *The Belles Heures of Jean, Duke of Berry*, Braziller, New York, 1974

MÜLLER, THEODOR, *Sculpture in the Netherlands, France, Germany and Spain: 1400 to 1500*, Penguin, Baltimore, 1966

PANOFSKY, ERWIN, *Early Netherlandish Painting*, 2 vols., Harvard University Press, Cambridge, Mass., 1953; repr. ed., Harper & Row, New York, 1971

PHILIP, LOTTE BRAND, *The Ghent Altarpiece and the Art of Jan van Eyck*, Princeton University Press, 1980

SEBBA, HELEN, *Hieronymus Bosch*, Dorset Press, New York, 1989

STERLING, CHARLES, ed., *The Hours of Étienne Chevalier by Jean Fouquet*, Braziller, New York, 1971

WOLFTHAL, DIANE, *The Beginnings of Netherlandish Canvas Painting, 1400–1530*, Cambridge University Press, New York, 1989

CHAPTER TWENTY-TWO: THE HIGH RENAISSANCE IN CENTRAL ITALY

ACKERMAN, JAMES S., *The Architecture of Michelangelo*, 2d ed., University of Chicago Press, 1986

ANDRES, GLENN M., et al., *The Art of Florence*, Abbeville Press, New York, 1988

CHIERICI, GINO, *Donato Bramante* (tr. P. Simmons), Universe Books, New York, 1960

CLARK, KENNETH M., *Leonardo da Vinci*, rev. ed., Viking, London, 1988

DE TOLNAY, CHARLES, *Michelangelo*, 2d ed., 5 vols., Princeton University Press, 1969–71

DUSSLER, LUITPOLD, *Raphael: A Critical Catalogue*, Phaidon, New York, 1971

FREEDBERG, SYDNEY J., *Painting in Italy: 1500–1600*, 2d ed., Penguin, Harmondsworth, 1983

———, *Painting of the High Renaissance in Rome and Florence*, rev. ed., Hacker, New York, 1985

GOLDSCHEIDER, LUDWIG, *Leonardo da Vinci*, 8th ed., Phaidon, London, 1967

———, *Michelangelo: Paintings, Sculpture, and Architecture*, 5th ed., Phaidon, London, 1975

HARTT, FREDERICK, *Michelangelo*, 3 vols., Abrams, New York, 1965–71

———, et al., *The Sistine Chapel*, 2 vols., Nippon Television, Tokyo, and Knopf, New York, 1991

JONES, ROGER, and PENNY, NICHOLAS, *Raphael*, Yale University Press, New Haven, Conn., 1983

KLEIN, ROBERT, and ZERNER, H., *Italian Art 1500–1600: Sources and Documents*, Prentice-Hall, Englewood Cliffs, N.J., and Northwestern University Press, Chicago, 1989

PEDRETTI, CARLO, *Raphael: His Life and Work in the Splendors of the Italian Renaissance*, Giunti, Florence, 1989

POPE-HENNESSY, SIR JOHN, *Italian High Renaissance and Baroque Sculpture*, 3d ed., Phaidon, Oxford, 1986

SUMMERS, DAVID, *Michelangelo and the Language of Art*, Princeton University Press, 1981

WASSERMAN, JACK, *Leonardo*, Doubleday, New York, 1980

WÖLFFLIN, HEINRICH, *Classic Art*, Cornell University Press, Ithaca, 1980

CHAPTER TWENTY-THREE: MICHELANGELO AND MANNERISM

The Age of Correggio and the Carracci: Emilian Painting of the Sixteenth and Seventeenth Centuries, National Gallery of Art, Washington, D.C., 1986

AVERY, CHARLES, and FINN, DAVID, *Giambologna: The Complete Sculpture*, Moyer Bell, Mt. Kisco, New York, 1987

CHASTEL, ANDRÉ, *The Sack of Rome*, Princeton University Press, 1983

FREEDBERG, SYDNEY J., *Andrea del Sarto*, 2 vols., Belknap Press, Cambridge, Mass., 1963

———, *Parmigianino: His Works in Painting*, Greenwood Press, Westport, Conn., 1971

FRIEDLAENDER, WALTER F., *Mannerism and Anti-Mannerism in Italian Painting*, Schocken Books, New York, 1965

GOULD, CECIL, *The Paintings of Correggio*, Cornell University Press, Ithaca, 1976

HAUSER, ARNOLD, *Mannerism: The Crisis of the Renaissance and the Origin of Modern Art* (tr. Eric Mosbacher), Belknap Press, Cambridge, Mass., and London, 1986

McCORQUODALE, CHARLES, *Bronzino*, Harper & Row, New York, 1981

PANOFSKY, ERWIN, *The Iconography of Correggio's Camera di San Paolo*, Warburg Institute, London, 1961

POPHAM, ARTHUR E., *Correggio's Drawings*, Oxford University Press, London, 1957

———, *The Drawings of Parmigianino*, 3 vols., Yale University Press, New Haven, Conn., 1971

SHEARMAN, JOHN K. G., *Andrea del Sarto*, Clarendon Press, Oxford, 1965

———, *Mannerism*, Penguin, Baltimore, 1978

SMYTH, CRAIG H., *Mannerism and Maniera*, J. J. Augustin, Locust Valley, N.Y., 1963

CHAPTER TWENTY-FOUR: THE HIGH AND LATE RENAISSANCE IN VENICE

ACKERMAN, JAMES S., *Palladio*, Penguin, New York, 1978

BIADENE, SUSANNA, and YAKUSH, MARY, *Titian: Prince of Painters*, Marsilio Editori, Venice, 1990

BROWN, PATRICIA FORTINI, *Venetian Narrative Painting in the Age of Carpaccio*, Yale University Press, New Haven, Conn., and London, 1988

GOFFEN, RONA, *Piety and Patronage in Renaissance Venice: Bellini, Titian, and the Franciscans*, Yale University Press, New Haven, Conn., 1986

HOWARD, DEBORAH, *Jacopo Sansovino: Architecture and Patronage in Renaissance Venice*, Yale University Press, New Haven, Conn., 1975

HUSE, NORBERT, and WOLTERS, WOLFGANG, *The Art of Renaissance Venice: Architecture, Sculpture, and Painting, 1460–1590* (tr. Edmund Jephcott), University of Chicago Press, Chicago and London, 1990

NEWTON, ERIC, *Tintoretto*, Greenwood Press, Westport, Conn., 1972

PIGNATTI, TERISIO, *Giorgione*, Phaidon, London, 1971

ROSAND, DAVID, *Painting in Cinquecento Venice: Titian, Veronese, Tintoretto*, Yale University Press, New Haven, Conn., and London, 1986

CHAPTER TWENTY-FIVE: THE HIGH AND LATE RENAISSANCE OUTSIDE ITALY

BENESCH, OTTO, *The Art of the Renaissance in Northern Europe*, 2d ed., Phaidon, London, 1965

———, *German Painting from Dürer to Holbein* (tr. H. S. B. Harrison), Skira, Geneva, 1966

BLUNT, SIR ANTHONY, *Art and Architecture in France: 1500 to 1700*, 4th ed., Penguin, New York, 1988

BROWN, JONATHAN, et al., *El Greco of Toledo*, Little, Brown, Boston, 1982

GIBSON, WALTER S., *Bruegel*, Oxford University Press, New York, 1977

KUBLER, GEORGE, and SORIA, M., *Art and Architecture in Spain and Portugal . . . 1500–1800*, Penguin, Baltimore, 1959

LAVALLEYE, JACQUES, *Pieter Brueghel the Elder and Lucas van Leyden: The Complete Engravings, Etchings and Woodcuts*, Abrams, New York, 1967

OSTEN, GERT VON DER, and VEY, H., *Painting and Sculpture in Germany and the Netherlands: 1500–1600*, Penguin, Baltimore, 1969

PANOFSKY, ERWIN, *The Life and Art of Albrecht Dürer*, 4th ed., Princeton University Press, 1971

PEVSNER, NIKOLAUS, and MEIER, M., *Grünewald*, Abrams, New York, 1958

POST, CHANDLER, R., *History of Spanish Painting*, 14 vols., Harvard University Press, Cambridge, Mass., 1930–66

ROWLANDS, JOHN, *Holbein: The Paintings of Hans Holbein the Younger*, D. R. Godine, Boston, 1985

——, with BARTRIUM, GIULIA, *The Age of Dürer and Holbein: German Drawings, 1400–1550*, British Museum, London, and Cambridge University Press, Cambridge and New York, 1988

RÜHMER, EBERHARD, *Cranach* (tr. J. Spencer), Phaidon, London, 1963

SMITH, ALLISON, *The Complete Paintings of Dürer*, Abrams, New York, 1968

STECHOW, WOLFGANG, *Pieter Bruegel the Elder*, concise ed., Abrams, New York, 1990

STRAUSS, WALTER L., *The Complete Drawings of Albrecht Dürer*, 6 vols., Abaris, New York, 1974

SUMMERSON, SIR JOHN, *Architecture in Britain: 1530–1830*, 6th rev. ed., Penguin, New York, 1971

WATERHOUSE, ELLIS K., *Painting in Britain: 1530–1730*, 4th ed., Penguin, New York, 1978

Part Six: The Baroque

BLUNT, ANTHONY, ed., *Baroque and Rococo: Architecture and Decoration*, Harper & Row, New York, 1982

HARTT, FREDERICK, *Love in Baroque Art*, J. J. Augustin, Locust Valley, N.Y., 1964

HELD, JULIUS S., and POSNER, D., *17th and 18th Century Art*, Abrams, New York, 1971

LAGERLÖF, MARGARETHA R., *Ideal Landscape: Annibale Carracci, Nicolas Poussin and Claude Lorrain*, Yale University Press, New Haven, Conn., and London, 1990

LEVEY, MICHAEL, *Rococo to Revolution*, Oxford University Press, New York, 1977

MARTIN, JOHN RUPERT, *Baroque*, Penguin, Harmondsworth, 1989

NORBERG-SCHULZ, CHRISTIAN, *Baroque Architecture*, Rizzoli, New York, 1986

——, *Late Baroque and Rococo Architecture*, Rizzoli, New York, 1985

PEVSNER, NIKOLAUS, *An Outline of European Architecture*, 7th ed., Penguin, Baltimore, 1985

THORNTON, PETER, *Seventeenth Century Interior Decoration in England, France and Holland*, Yale University Press, New Haven, Conn., 1978

WINTERMUTE, ALAN, *Claude to Corot: The Development of Landscape Painting in France*, Colnaghi, New York, and University of Washington Press, Seattle, 1990

WÖLFFLIN, HEINRICH, *Principles of Art History*, Dover, New York, 1956

CHAPTER TWENTY-SIX: THE SEVENTEENTH CENTURY IN ITALY

BLUNT, SIR ANTHONY, and CROFT-MURRAY, E., *Venetian Drawings of the XVII and XVIII Centuries . . . at Windsor Castle*, Phaidon, London, 1957

CHARPENTRAT, PIERRE, *Living Architecture: Baroque, Italy and Central Europe* (tr. C. Brown), Grosset & Dunlap, New York, 1967

ENGGASS, ROBERT, and BROWN, JONATHAN, *Italy and Spain, 1600–1750: Sources and Documents*, Prentice-Hall, Englewood Cliffs, N.J., 1970

FREEDBERG, S. J., *Circa 1600: A Revolution of Style in Italian Painting*, Belknap Press, Cambridge, Mass., and London, 1986

FRIEDLAENDER, WALTER F., *Caravaggio Studies*, Schocken Books, New York, 1969

——, *Mannerism and Anti-Mannerism in Italian Painting*, Schocken Books, New York, 1969

GARRARD, MARY D., *Artemisia Gentileschi: The Image of the Female Hero in Italian Baroque Art*, Princeton University Press, 1989

GOLDSTEIN, CARL, *Visual Fact over Verbal Fiction: A Study of the Carracci and the Criticism, Theory, and Practice of Art in Renaissance and Baroque Italy*, Cambridge University Press, Cambridge and New York, 1988

HASKELL, FRANCIS, *Patrons and Painters: A Study in the Relations between Italian Art and Society in the Age of the Baroque*, Yale University Press, New Haven, Conn., and London, 1980

HIBBARD, HOWARD, *Caravaggio*, Harper & Row, New York, 1985

——, *Carlo Maderno and Roman Architecture, 1580–1630*, Pennsylvania State University Press, University Park, 1971

MAHON, DENIS, *Studies in Seicento Art and Theory*, Warburg Institute, London, 1947; repr. ed., Greenwood Press, Westport, Conn., 1975

MOIR, ALFRED, *Caravaggio*, Abrams, New York, 1982

Painting in Naples, 1606–1705, National Gallery of Art, Washington, D.C., 1983

PORTOGHESI, PAOLO, *Roma Barocca: The History of an Architectonic Culture*, MIT Press, Cambridge, Mass., 1970

SCRIBNER, CHARLES, III, *Gianlorenzo Bernini*, concise ed., Abrams, New York, 1991

SPEAR, RICHARD, *Caravaggio and His Followers*, rev. ed., Harper & Row, 1975

WATERHOUSE, ELLIS K., *Italian Baroque Painting*, 2d ed., Phaidon, London, 1969

WITTKOWER, RUDOLF, *Art and Architecture in Italy: 1600 to 1750*, 3d rev. ed., Penguin, New York, 1982

——, *Gian Lorenzo Bernini: The Sculptor of the Roman Baroque*, 2d ed., Cornell University Press, Ithaca, 1981

——, *Gothic v. Classic: Architectural Projects in Seventeenth-Century Italy*, Braziller, New York, 1974

——, *Studies in Italian Baroque*, Thames & Hudson, London, 1975

CHAPTER TWENTY-SEVEN: THE SEVENTEENTH CENTURY IN CATHOLIC EUROPE OUTSIDE ITALY

BLUNT, SIR ANTHONY, *Art and Architecture in France: 1500 to 1700*, 4th ed., Penguin, New York, 1988

——, *Nicolas Poussin*, 2 vols., Pantheon, New York, 1967

BROWN, JONATHAN, *The Golden Age of Painting in Spain*, Yale University Press, New Haven, Conn., 1991

——, *Velázquez: Painter and Courtier*, Yale University Press, New Haven, Conn., and London, 1986

——, *Zurbarán*, concise ed., Abrams, New York, 1991

——, and ELLIOTT, J. H., *A Palace for a King: The Buen Retiro and the Court of Philip IV*, Yale University Press, New Haven, Conn., and London, 1986

FELTON, CRAIG, and JORDAN, WILLIAM B., eds., *Jusepe de Ribera lo Spagnoletto*, Kimbell Art Museum, Fort Worth, 1982; distr. by University of Washington Press, Seattle

FOX, HELEN M., *André Le Nôtre*, Crown, New York, 1962

FRIEDLAENDER, WALTER F., *Nicolas Poussin: A New Approach*, Abrams, New York, 1965

FROMENTIN, EUGÈNE, *The Old Masters of Belgium and Holland* (tr. Mary C. Robbins, intro. Meyer Schapiro), Schocken Books, New York, 1963

FURNESS, S. M. M., *Georges de la Tour of Lorraine, 1593–1652*, Routledge & Kegan Paul, London, 1949

GERSON, HORST, and TER KUILE, E. H., *Art and Architecture in Belgium, 1600–1800*, Penguin, Baltimore, 1960

HELD, JULIUS S., *Rubens: Selected Drawings*, rev. ed., Moyer Bell, Mt. Kisco, N.Y., 1986

LEES-MILNE, JAMES, *Baroque in Spain and Portugal and Its Antecedents*, Batsford, London, 1960

MAGURN, RUTH S., ed., *The Letters of Peter Paul Rubens*, Harvard University Press, Cambridge, Mass., 1971

OBERHUBER, KONRAD, *Poussin, the Early Years in Rome: The Origins of French Classicism*, Kimbell Art Museum, Fort Worth, and Hudson Hills Press, New York, 1988

ROSENBERG, PIERRE, *France in the Golden Age*, Metropolitan Museum of Art, New York, 1982

RUSSELL, H. DIANE, *Claude Lorrain*, National Gallery of Art, Washington, D.C., 1982

SAVAGE, GEORGE, *French Decorative Art, 1638–1793*, Praeger, New York, 1969

SÉRULLAZ, MAURICE, *Velázquez*, concise ed., Abrams, New York, 1987

SMITH, P., and GRAHAM, A., *François Mansart*, A. Zwemmer, London, 1973

WHEELOCK, ARTHUR K., and BARNES, SUSAN, et al., *Anthony van Dyck*, National Gallery of Art, Washington, D.C., 1990

WHITE, CHRISTOPHER, *Peter Paul Rubens: Man and Artist*, Yale University Press, New Haven, Conn., and London, 1987

WRIGHT, CHRISTOPHER, *The French Painters of the Seventeenth Century*, Little, Brown, Boston, 1985

CHAPTER TWENTY-EIGHT: THE SEVENTEENTH CENTURY IN PROTESTANT COUNTRIES

ALPERS, SVETLANA, *The Art of Describing: Dutch Art in the Seventeenth Century*, University of Chicago Press, 1983

——, *Rembrandt's Enterprise: The Studio and the Market*, University of Chicago Press, Chicago and London, 1988

BERGSTRÖM, INGVAR, *Dutch Still Life Painting in the Seventeenth Century* (tr. C. Hedström and G. Taylor), Yoseloff, New York, 1956; repr. ed., Hacker, New York, 1983

BLANKERT, ALBERT, *Vermeer of Delft*, Phaidon, New York, 1978

DOWNES, KERRY, *The Architecture of Wren*, Universe Books, New York, 1982

FROMENTIN, EUGÈNE, *The Old Masters of Belgium and Holland* (tr. Mary C. Robbins, intro. Meyer Schapiro), Schocken Books, New York, 1963

FUCHS, R. H., *Dutch Painting*, Oxford University Press, New York, 1978

HAAK, BOB, *The Golden Age: Dutch Painters of the Seventeenth Century* (tr. E. Willems-Treeman), Abrams, New York, 1984

HAVERKAMP-BEGEMANN, E., *Rembrandt: The Night Watch*, Princeton University Press, 1982

HELD, JULIUS, *Rembrandt Studies*, rev. ed., Princeton University Press, 1991

Masters of Seventeenth-Century Dutch Genre Painting, Philadelphia Museum of Art, 1984

MONTIAS, JOHN MICHAEL, *Vermeer and His Milieu: A Web of Social History*, Princeton University Press, 1989

NICOLSON, BENEDICT, *Hendrick Terbrugghen*, Lund, Humphries, London, 1958

ROSENBERG, JAKOB, *Rembrandt*, 2d ed., Phaidon, London, 1964

ROSENBERG, JAKOB; SLIVE, S.; and TER KUILE, E. H., *Dutch Art and Architecture, 1600–1800*, 2d ed., Penguin, Harmondsworth, 1979

SLIVE, SEYMOUR, *Frans Hals*, Prestel-Verlag, Munich, 1989

STECHOW, WOLFGANG, *Dutch Landscape Painting of the Seventeenth Century*, Cornell University Press, Ithaca, 1981

SUMMERSON, SIR JOHN, *Architecture in Britain: 1530–1830*, 7th rev. ed., Penguin, New York, 1983

——, *Inigo Jones*, Penguin, Harmondsworth, 1966

SUTTON, PETER C., *Masters of 17th-Century Dutch Landscape Painting*, Museum of Fine Arts, Boston, 1987

WHEELOCK, ARTHUR K., JR., *Vermeer*, Abrams, New York, 1981

WHINNEY, MARGARET D., and MILLAR, O., *English Art 1625–1714*, Clarendon Press, Oxford, 1957

WHITE, CHRISTOPHER, *Rembrandt*, Thames & Hudson, New York, 1984

WRIGHT, CHRISTOPHER, *The Dutch Painters: One Hundred Seventeenth Century Masters*, Barron, Woodbury, N.Y., 1978

CHAPTER TWENTY-NINE: THE EIGHTEENTH CENTURY

ASHTON, DORE, *Fragonard in the Universe of Painting*, Smithsonian Institution Press, Washington, D.C., 1988

BARCHAM, WILLIAM L., *Tiepolo*, Abrams, New York, 1992

BOURKE, JOHN, *Baroque Churches of Central Europe*, Faber & Faber, London, 1978

BROWN, MILTON, *American Art to 1900*, Abrams, New York, 1979

CONISBEE, PHILIP, *Chardin*, Bucknell University Press, Lewisburg, N.J., 1986

CONSTABLE, WILLIAM G., *Canaletto: Giovanni Antonio Canal, 1697–1768*, 2 vols., 2d rev. ed., Clarendon Press, Oxford, 1989

CROW, THOMAS E., *Painters and Public Life in Eighteenth-Century Paris*, Yale University Press, New Haven, Conn., and London, 1985

ERFFA, HELMUT VON, and STALEY, ALLEN, *The Paintings of Benjamin West*, Yale University Press, New Haven, Conn., 1986

HITCHCOCK, HENRY-RUSSELL, *Rococo Architecture in Southern Germany*, Phaidon, London, 1968

HUDSON, DEREK, *Sir Joshua Reynolds: A Personal Study*, G. Bles, London, 1958

KALNEIN, WEND GRAF, and LEVEY, M., *Art and Architecture of the Eighteenth Century in France*, Penguin, Baltimore, 1972

KIMBALL, SIDNEY FISKE, *The Creation of the Rococo*, Philadelphia Museum of Art, 1943; repr. ed., Norton, New York, 1964

LEVEY, MICHAEL, *Painting in XVIII Century Venice*, Phaidon, London, 1959

MCINNES, IAN, *Painter, King and Pompadour: François Boucher at the Court of Louis XV*, F. Muller, London, 1965

MASSENGALE, JEAN MONTAGUE, *Jean-Honoré Fragonard*, Abrams, New York, 1993

MAYOR, A. HYATT, *Giovanni Battista Piranesi*, H. Bittner, New York, 1952

MONTAGNI, E. C., *The Complete Paintings of Watteau*, Abrams, New York, 1971

MORASSI, ANTONIO, *G. B. Tiepolo*, Phaidon, New York, 1955

New England Begins: The 17th Century, 3 vols., Museum of Fine Arts, Boston, 1982

PAULSON, RONALD, *Hogarth: His Life, Art and Times*, rev. ed., Rutgers University Press, New Brunswick, 1991

POSNER, DONALD, *Antoine Watteau*, Cornell University Press, Ithaca, 1984

PROWN, JULES D., *John Singleton Copley*, 2 vols., Harvard University Press, Cambridge, Mass., 1966

ROSENBERG, PIERRE, *Chardin*, Rizzoli, New York, 1991

SAVAGE, GEORGE, *French Decorative Art, 1638–1793*, Praeger, New York, 1969

SUMMERSON, SIR JOHN, *Architecture in Britain: 1530–1830*, 7th rev. ed., Penguin, New York, 1983

WATERHOUSE, ELLIS K., *Gainsborough*, 2d ed., Spring Books, London, 1966

———, *Painting in Britain: 1530 to 1790*, 4th ed., Penguin, New York, 1978

Watteau, National Gallery of Art, Washington, D.C., 1984

Part Seven: The Modern World

ADES, DAWN, et al., *Art in Latin America: The Modern Era, 1870–1980*, Hayward Gallery, South Bank Centre, London, 1989

American Paradise: The World of the Hudson River School, Metropolitan Museum of Art and Abrams, New York, 1987

ARMSTRONG, TOM, et al., *200 Years of American Sculpture*, Whitney Museum of American Art, New York, 1976

ARNASON, H. H., *History of Modern Art*, 3d ed., Abrams, New York, 1986

ASHTON, DORE, *Twentieth-Century Artists on Art*, Pantheon, New York, 1985

BERMINGHAM, ANN, *Landscape and Ideology: The English Rustic Tradition 1740–1850*, University of California Press, Berkeley, 1986

BOIME, ALBERT, *The Art of Exclusion: Representing Blacks in the Nineteenth Century*, Smithsonian Press, Washington, D.C., 1990

BOWNESS, ALAN, *Modern European Art*, Harcourt Brace Jovanovich, New York, 1972

BROWN, MILTON; HUNTER, SAM; and JACOBUS, JOHN, *American Art: Painting, Sculpture, Architecture, Decorative Arts, Photography*, Abrams, New York, 1979

CHIPP, HERSCHEL B., *Theories of Modern Art*, University of California Press, Berkeley, 1968

EITNER, LORENZ, *An Outline of 19th Century European Painting: From David through Cézanne*, 2 vols., Harper & Row, New York, 1988

HAMILTON, GEORGE H., *Painting and Sculpture in Europe, 1880–1940*, 3d ed., Penguin, New York, 1990

HARRIS, NEIL, *The Artist in American Society: The Formative Years, 1790–1860*, University of Chicago Press, 1982

HATJE, GERD, ed., *Encyclopedia of 20th-Century Architecture*, rev. ed., Abrams, New York, 1986

HERBERT, ROBERT L., ed., *Modern Artists on Art*, Prentice-Hall, Englewood Cliffs, N.J., 1965

HOLT, ELIZABETH GILMORE, ed., *From the Classicists to the Impressionists: Art and Architecture in the 19th Century*, 2d ed., Yale University Press, New Haven, Conn., and London, 1986

HUGHES, ROBERT, *The Shock of the New*, rev. ed., Knopf, New York, 1991

HUNTER, SAM, and JACOBUS, JOHN, *Modern Art*, 3d ed., Abrams, New York, and Prentice-Hall, Englewood Cliffs, N.J., 1992

JANSON, H. W., *19th-Century Sculpture*, Abrams, New York, 1985

JOACHIMIDES, CHRISTOS M., et al., *German Art in the 20th Century*, Prestel-Verlag, Munich, 1985

LYNES, RUSSELL, *The Art-Makers of Nineteenth Century America*, Atheneum, New York, 1970

MCCOUBREY, JOHN, *American Art, 1700–1960: Sources and Documents in the History of Art*, Prentice-Hall, Englewood Cliffs, N.J., 1965

MARCHIORI, GIUSEPPE, *Modern French Sculpture* (tr. J. Ross), Abrams, New York, 1963

MILNER, JOHN, *The Studios of Paris: The Capital of Art in the Late Nineteenth Century*, Yale University Press, New Haven, Conn., 1989

MONRAD, KASPER, *Danish Painting in the Golden Age*, National Gallery, London, 1984

MYERS, BERNARD S., *Mexican Painting in Our Time*, Oxford University Press, New York, 1956

NEWHALL, BEAUMONT, *The History of Photography from 1839 to the Present*, rev. ed., Museum of Modern Art, New York, 1982

NOCHLIN, LINDA, *The Politics of Vision: Essays on 19th-Century Art and Society*, Harper & Row, New York, 1989

NOVAK, BARBARA, *Nature and Culture: American Landscape Painting, 1825–1865*, Oxford University Press, New York, 1980

NOVOTNY, FRITZ, *Painting and Sculpture in Europe, 1780–1880*, 2d ed., Penguin, Harmondsworth, 1971

ROSENBLUM, ROBERT, and JANSON, H. W., *19th-Century Art*, Abrams, New York, 1984

RUSSELL, JOHN, *The Meanings of Modern Art*, Museum of Modern Art and Harper & Row, New York, 1981; rev. ed., 1991

SARABIANOV, DMITRI V., *Russian Art: From Neoclassicism to the Avant-Garde, 1800–1917*, Abrams, New York, 1990

SELZ, PETER, *Art in Our Times: A Pictorial History 1890–1980*, Harcourt Brace Jovanovich and Abrams, New York, 1981

SPALDING, FRANCES, *British Art Since 1900*, Thames & Hudson, New York, 1986

STEINBERG, LEO, *Other Criteria: Confrontations with Twentieth-Century Art*, Oxford University Press, New York, 1972

WALDMAN, DIANE, *Collage, Assemblage, and the Found Object*, Abrams, New York, 1992

WILMERDING, JOHN, *American Art*, Viking, New York, 1976

———, et al., *American Light: The Luminist Movement, 1850–1875*, National Gallery of Art, Washington, D.C., and Princeton University Press, 1989

CHAPTER THIRTY: NEOCLASSICISM

ARNASON, H. HARVARD, *The Sculptures of Houdon*, Oxford University Press, New York, 1975

BOIME, ALBERT, *Art in an Age of Bonapartism, 1800–1815*, University of Chicago Press, 1990

———, *Art in an Age of Revolution*, University of Chicago Press, 1987

EITNER, LORENZ, *Neoclassicism and Romanticism, 1750–1850: Sources and Documents in the History of Art*, 2 vols., Prentice-Hall, Englewood Cliffs, N.J., 1970

FRIEDLAENDER, WALTER F., *From David to Delacroix*, Harvard University Press, Cambridge, Mass., 1974

HAMLIN, TALBOT F., *Benjamin Henry Latrobe*, Oxford University Press, New York, 1955

———, *Greek Revival Architecture in America*, Dover, New York, 1964

HONOUR, HUGH, *Neo-Classicism*, rev. ed., Penguin, New York, 1977

NANTEUIL, LUC DE, *Jacques-Louis David*, Abrams, New York, 1985

PICON, GAËTON, *Ingres*, Rizzoli, New York, 1991

ROBERTS, WARREN E., *Jacques-Louis David, Revolutionary Artist: Art, Politics, and the French Revolution*, University of North Carolina Press, Chapel Hill, 1989

ROSENBLUM, ROBERT, *Jean-Auguste-Dominique Ingres*, concise ed., Abrams, New York, 1990

———, *Transformations in Late Eighteenth Century Art*, Princeton University Press, 1970

CHAPTER THIRTY-ONE: ROMANTICISM

BINDMAN, DAVID, *William Blake: His Art and Times*, Yale Center for British Art, New Haven, Conn., 1982

BRION, MARCEL, *Art of the Romantic Era*, Praeger, New York, 1966

BUTLIN, MARTIN, *William Blake, 1757–1827*, Tate Gallery, London, 1990

———, and JOLL, EVELYN, *The Paintings of J. M. W. Turner*, rev. ed., Yale University Press, New Haven, Conn., 1984

CLAY, JEAN, *Romanticism*, Vendome, New York, 1981

EITNER, LORENZ, *Géricault: His Life and Work*, Cornell University Press, Ithaca, 1982

———, *Géricault's Raft of the Medusa*, Phaidon, London, 1972

———, *Neoclassicism and Romanticism, 1750–1850: Sources and Documents*, 2 vols., Prentice-Hall, Englewood Cliffs, N.J., 1970

FRIEDLAENDER, WALTER F., *From David to Delacroix*, Harvard University Press, Cambridge, Mass., 1974

Géricault, Réunion des musées nationaux, Paris, 1991

GUDIOL I RICART, JOSÉ, *Goya*, concise ed., Abrams, New York, 1985

HITCHCOCK, HENRY-RUSSELL, *Architecture: Nineteenth and Twentieth Centuries*, 4th ed., Penguin, New York, 1978

HONOUR, HUGH, *Romanticism*, Harper & Row, New York, 1979

JOHNSON, LEE, *The Paintings of Eugène Delacroix, a Critical Catalogue: 1816–1831*, 2 vols., Oxford University Press, New York, 1981

KOERNER, JOSEPH, *Caspar David Friedrich and the Subject of Landscape*, Yale University Press, New Haven, Conn., 1990

LICHT, FRED, *Goya: The Origins of the Modern Temper in Art*, Harper & Row, New York, 1983

ROSENBLUM, ROBERT, *Modern Painting and the Northern Romantic Tradition: Friedrich to Rothko*, Harper & Row, New York, 1975

ROSENTHAL, MICHAEL, *Constable*, Thames & Hudson, New York, 1987

SCHIFF, GERT, *German Masters of the Nineteenth Century*, Abrams, New York, 1981

THOMAS, HUGH, *Goya: The Third of May, 1808*, Viking, New York, 1973

VAUGHAN, WILLIAM, *German Romantic Painting*, Yale University Press, New Haven, Conn., and London, 1980

WALKER, JOHN, *Constable*, concise ed., Abrams, New York, 1991

———, *Turner*, concise ed., Abrams, New York, 1983

CHAPTER THIRTY-TWO: REALISM

CIKOVSKY, NICOLAI, *Winslow Homer*, Abrams, New York, 1990

———, *Winslow Homer, Watercolors*, H. L. Levin, New York, 1991

FAXON, ALICIA CRAIG, *Dante Gabriel Rossetti*, Abbeville Press, New York, 1989

FRIED, MICHAEL, *Courbet's Realism*, University of Chicago Press, 1990

GALASSI, PETER, *Corot in Italy*, Yale University Press, New Haven, Conn., and London, 1991

GOODRICH, LLOYD, *Thomas Eakins*, 2 vols., Harvard University Press, Cambridge, Mass., 1982

HARDING, JAMES, *Artistes Pompiers: French Academic Art in the Nineteenth Century*, Rizzoli, New York, 1979

HERBERT, ROBERT L., *Barbizon Revisited*, Museum of Fine Arts, Boston, 1962

———, *Jean-François Millet*, Hayward Gallery, London, 1976

HOURS, MADELEINE, *Jean-Baptiste-Camille Corot*, concise ed., Abrams, New York, 1984

JOHNS, ELIZABETH, *Thomas Eakins: The Heroism of Modern Life*, Princeton University Press, 1983

LAUGHTON, BRUCE, *Daumier and Millet, Drawings*, Yale University Press, New Haven, Conn., 1991

MARKOWSKI, GENE, *The Art of Photography: Image and Illusion*, Prentice-Hall, Englewood Cliffs, N.J., 1984

NOCHLIN, LINDA, *Realism*, Penguin, New York, 1971

———, and FAUNCE, SARAH, *Courbet Reconsidered*, Brooklyn Museum, New York, 1988

PROVOST, LOUIS, *Honoré Daumier: A Thematic Guide to His Oeuvre*, Garland, New York, 1989

REY, ROBERT, *Honoré Daumier*, concise ed., Abrams, New York, 1985

WEISBERG, GABRIEL, *The Realist Tradition: French Painting and Drawing, 1830–1900*, Cleveland Museum of Art, 1980

WOOD, CHRISTOPHER, *The Pre-Raphaelites*, Abrams, New York, 1981

CHAPTER THIRTY-THREE: IMPRESSIONISM

BOGGS, JEAN SUTHERLAND, et al., *Degas*, Metropolitan Museum of Art, New York, and National Gallery of Canada, Ottawa, 1988

BREESKIN, ADELYN D., *Mary Cassatt: A Catalogue Raisonné of the Oils, Pastels, Watercolors, and Drawings*, Smithsonian Press, Washington, D.C., 1970

BRETTELL, RICHARD R., et al., *A Day in the Country: Impressionism and the French Landscape*, Los Angeles County Museum, and Abrams, New York, 1984

BROUDE, NORMA, ed., *World Impressionism: The International Movement, 1860–1920*, Abrams, New York, 1990

BUTLER, RUTH, ed., *Rodin in Perspective*, Prentice-Hall, Englewood Cliffs, N.J., 1980

CHAMPIGNEULLE, BERNARD, *Rodin: His Sculpture, Drawings and Watercolors*, Thames & Hudson, New York, 1986

CLARK, T. J., *The Painting of Modern Life: Paris in the Art of Manet and His Followers*, Princeton University Press, 1986

ELSEN, ALBERT EDWARD, and ALHADEFF, ALBERT, *Rodin Rediscovered*, National Gallery of Art, Washington, D.C., 1981

GORDON, ROBERT, and FORGE, ANDREW, *Monet*, Abrams, New York, 1983

HAMILTON, GEORGE H., *Manet and His Critics*, Yale University Press, New Haven, Conn., 1986

HERBERT, ROBERT L., *Impressionism: Art, Leisure, and Parisian Society*, Yale University Press, New Haven, Conn., and London, 1988

HIGGONET, ANNE, *Berthe Morisot*, Harper & Row, New York, 1990

HILLS, PATRICIA, *John Singer Sargent*, Whitney Museum of American Art and Abrams, New York, 1986

HOUSE, JOHN, et al., *Renoir*, Arts Council of Great Britain, London, 1985

ISAACSON, JOEL, *The Crisis of Impressionism: 1878–1882*, University of Michigan Museum of Art, Ann Arbor, 1979

Manet: 1832–1883, Metropolitan Museum of Art and Abrams, New York, 1983

MATHEWS, NANCY M., *Mary Cassatt*, National Museum of American Art, Washington, D.C., and Abrams, New York, 1987

MILLARD, CHARLES, *The Sculpture of Edgar Degas*, Princeton University Press, 1979

MOFFETT, CHARLES S., et al., *The New Painting: Impressionism, 1874–1886*, Fine Arts Museums of San Francisco, and National Gallery of Art, Washington, D.C., 1986

ORIENTI, SANDRA, *The Complete Paintings of Manet*, Penguin, Harmondsworth, 1985

RATCLIFF, CARTER, *John Singer Sargent*, Abbeville Press, New York, 1982

REWALD, JOHN, *Camille Pissarro*, concise ed., Abrams, New York, 1989

———, *Degas's Complete Sculpture*, Alan Wofsy, San Francisco, 1990

———, *The History of Impressionism*, 4th rev. ed., New York Graphic Society for Museum of Modern Art, New York, 1987

———, ed., *Camille Pissarro: Letters to His Son Lucien*, 3d ed., P. P. Appel, Mamaroneck, N.Y., 1972

SEITZ, WILLIAM C., *Claude Monet*, Abrams, concise ed., New York, 1982

THOMSON, RICHARD, *Camille Pissarro: Impressionism, Landscape and Rural Labor*, New Amsterdam, New York, 1990

TUCKER, PAUL HAYES, *Monet in the Nineties: The Series Paintings*, Museum of Fine Arts, Boston, and Yale University Press, New Haven, Conn., 1989

VARNEDOE, KIRK, *Gustave Caillebotte*, Yale University Press, New Haven, Conn., and London, 1987

WALKER, JOHN, *James McNeill Whistler*, National Museum of American Art, Washington, D.C., and Abrams, New York, 1987

WHITE, BARBARA EHRLICH, *Renoir*, Abrams, New York, 1984

———, ed., *Impressionism in Perspective*, Prentice-Hall, Englewood Cliffs, N.J., 1978

YOUNG, ANDREW McLAREN; MacDONALD, MARGARET; and SPENCER, ROBIN, *The Paintings of James McNeill Whistler*, 2 vols., Yale University Press, New Haven, Conn., 1980

CHAPTER THIRTY-FOUR: POST-IMPRESSIONISM

BOE, ALF, *Edvard Munch*, Rizzoli, New York, 1989

BROUDE, NORMA, ed., *Seurat in Perspective*, Prentice-Hall, Englewood Cliffs, N.J., 1978

CHAPPUIS, ADRIEN, *The Drawings of Paul Cézanne*, 2 vols., Thames & Hudson, London, 1973

DANIELSSON, BENGT, *Gauguin in the South Seas*, Doubleday, Garden City, N.Y., 1966

FLETCHER, IAN, *Aubrey Beardsley*, Twayne Publishers, Boston, 1987

GERHARDUS, MALY, and GERHARDUS, DIETFRIED, *Symbolism and Art Nouveau*, Phaidon, Oxford, 1979

GOGH, VINCENT VAN, *The Complete Letters of Vincent Van Gogh* (tr. Mrs. J. van Gogh-Bonger and C. de Dood), 2d ed., 3 vols., New York Graphic Society, Boston, 1981

GOLDWATER, ROBERT, *Symbolism*, Harper & Row, New York, 1979

GOWING, LAWRENCE, et al., *Cézanne: The Early Years, 1859–1872*, Abrams, New York, 1988

HERBERT, ROBERT, et al., *Seurat*, Metropolitan Museum of Art, New York, 1991

HOBBS, RICHARD, *Odilon Redon*, New York Graphic Society, Boston, 1977

HULSKER, JAN, *The Complete Van Gogh: Paintings, Drawings, Sketches*, Abrams, New York, 1984

LÖVGREN, SVEN, *The Genesis of Modernism: Seurat, Gauguin, Van Gogh and French Symbolism in the 1880s*, 2d ed., Indiana University Press, Bloomington, 1971

MAUNER, GEORGE L., *The Nabis: Their History and Their Art, 1888–1896*, Garland, New York, 1978

NOCHLIN, LINDA, *Impressionism and Post-Impressionism, 1874–1904: Sources and Documents*, Prentice-Hall, Englewood Cliffs, N.J., 1966

PICKVANCE, RONALD, *Van Gogh at Arles*, Metropolitan Museum of Art and Abrams, New York, 1984

———, *Van Gogh in Saint-Rémy and Auvers*, Metropolitan Museum of Art and Abrams, New York, 1986

REWALD, JOHN, *Paul Cézanne: A Biography*, Abrams, New York, 1986

———, *Seurat*, Abrams, New York, 1990

———, et al., *Studies in Post-Impressionism*, Abrams, New York, 1986

ROOKMAAKER, HENDRIK R., *Gauguin and 19th Century Art Theory*, Swets & Zeitlinger, Amsterdam, 1972

RUBIN, WILLIAM, ed., *Cézanne: The Late Work*, Museum of Modern Art, New York, 1977

SCHAPIRO, MEYER, *Paul Cézanne*, concise ed., Abrams, New York, 1988

———, *Vincent van Gogh*, concise ed., Abrams, New York, 1983

SCHMUTZLER, ROBERT, *Art Nouveau* (tr. E. Roditi), Abrams, New York, 1978

SHIFF, RICHARD, *Cézanne and the End of Impressionism*, University of Chicago Press, 1984

THOMPSON, RICHARD, *Toulouse-Lautrec*, Yale University Press, New Haven, Conn., 1991

THOMSON, BELINDA, *Gauguin*, Thames & Hudson, London and New York, 1987

Toulouse-Lautrec, Hayward Gallery, London, and Galeries nationales du Grand Palais, Paris, 1991

VALLIER, DORA, *Henri Rousseau*, Crown, New York, 1990

VARNEDOE, KIRK, *Northern Light: Nordic Art at the Turn of the Century*, Yale University Press, New Haven, Conn., and London, 1988

WECHSLER, JUDITH, ed., *Cézanne in Perspective*, Prentice-Hall, Englewood Cliffs, N.J., 1975

CHAPTER THIRTY-FIVE: THE FAUVES AND EXPRESSIONISM

BARR, ALFRED H., JR., *Matisse, His Art and His Public*, Museum of Modern Art, New York, 1974

COURTHION, PIERRE, *Georges Rouault*, Abrams, New York, 1977

COWART, JACK, et al., *Henri Matisse: Paper Cut-Outs*, Detroit Institute of Arts, and Abrams, New York, 1978

ELDERFIELD, JOHN, *Henri Matisse: A Retrospective*, Museum of Modern Art, New York, 1992

———, *The "Wild Beasts": Fauvism and Its Affinities*, Museum of Modern Art, New York, 1976

ELSEN, ALBERT E., *The Sculpture of Henri Matisse*, Abrams, New York, 1972

FINBERG, JONATHAN, *Kandinsky in Paris, 1906–7*, UMI Research Press, Ann Arbor, Mich., 1984

FLAM, JACK D., ed., *Matisse: A Retrospective*, H. L. Levin, New York, 1988

FREEMAN, JUDI, *The Fauve Landscape: Matisse, Derain, Braque, and Their Circle, 1904–1908*, Abbeville Press, New York, 1990

GORDON, DONALD E., *Expressionism: Art and Idea*, Yale University Press, New Haven, Conn., and London, 1991

JACOBUS, JOHN, *Henri Matisse*, concise ed., Abrams, New York, 1982

LE TARGAT, FRANÇOIS, *Kandinsky*, Rizzoli, New York, 1987

LEYMARIE, JEAN, *Fauves and Fauvism*, Rizzoli, New York, 1987

LIEBERMAN, WILLIAM S., *Matisse: Fifty Years of His Graphic Art*, Braziller, New York, 1981

NAGEL, OTTO, *Käthe Kollwitz*, New York Graphic Society, Greenwich, Conn., 1971

POLING, CLARK V., ed., *Kandinsky: Russian and Bauhaus Years*, Solomon R. Guggenheim Museum, New York, 1983

ROETHEL, HANS K., and BENJAMIN, JEAN K., *Kandinsky: Catalogue Raisonné of the Oil Paintings*, 2 vols., Cornell University Press, Ithaca, 1982, 1984

VOGT, PAUL, *Expressionism: German Painting 1905–1920*, Abrams, New York, 1980

WEISS, PEG, ed., *Kandinsky in Munich: 1896–1916*, Solomon R. Guggenheim Museum, New York, 1982

WHITFORD, FRANK, *Oskar Kokoschka*, Atheneum, New York, 1986

CHAPTER THIRTY-SIX: CUBISM AND ABSTRACT ART

APOLLINAIRE, GUILLAUME, *The Cubist Painters* (tr. L. Abel), Wittenborn, Schultz, New York, 1970

BLUNT, SIR ANTHONY, and POOL, P., *Picasso, The Formative Years: A Study of His Sources*, New York Graphic Society, Greenwich, Conn., 1962

COGNIAT, RAYMOND, *Georges Braque*, Abrams, New York, 1980

DAIX, PIERRE, and BOUDAILLE, G., *Picasso: The Blue and Rose Periods* (tr. P. Pool), New York Graphic Society, Greenwich, Conn., 1967

———, and ROSSELET, JOAN, *Picasso: The Cubist Years 1907–16*, New York Graphic Society, Boston, 1980

DE FRANCIA, PETER, *Fernand Léger*, Yale University Press, New Haven, Conn., 1983

D'HARNONCOURT, ANNE, *Futurism and the International Avant-Garde*, Philadelphia Museum of Art, 1982

DOESBURG, THEO VAN, *Principles of Neo-Plastic Art*, New York Graphic Society, Greenwich, Conn., 1968

GEIST, SIDNEY, *Brancusi: The Sculpture and Drawings*, Abrams, New York, 1975

GOLDING, JOHN, *Cubism: A History and an Analysis, 1907–1914*, 3d ed., Belknap Press, Cambridge, Mass., 1988

———, and PENROSE, ROLAND, eds., *Picasso in Retrospective*, Harper & Row, New York, 1980

GRAY, CAMILLA, *The Great Experiment: Russian Art 1863–1922*, Abrams, New York, 1971

GREEN, CHRISTOPHER, *Cubism and Its Enemies: Modern Movements and Reaction in French Art, 1916–28*, Yale University Press, New Haven, Conn., 1988

HAMMACHER, A. M., *Jacques Lipchitz: His Sculpture*, 2d ed., Abrams, New York, 1975

JAFFÉ, HANS L. C., *De Stijl, 1917–1931: The Dutch Contribution to Modern Art*, Belknap Press, Cambridge, Mass., 1986

———, et al., *De Stijl, 1917–1931: Visions of Utopia*, Walker Art Center, Minneapolis, and Abbeville Press, New York, 1982

Kazimir Malevich, 1878–1935, Armand Hammer Museum of Art and Cultural Center, Los Angeles, in assoc. with University of Washington Press, Seattle, 1990

LEMOINE, SERGE, *Mondrian and de Stijl*, Universe Books, New York, 1987

LISTA, GIOVANNI, *Futurism*, Universe Books, New York, 1986

LODDER, CHRISTINA, *Russian Constructivism*, Yale University Press, New Haven, Conn., 1983

MOSZYNSKA, ANNA, *Abstract Art*, Thames & Hudson, New York, 1990

RICHARDSON, JOHN, with MARILYN McCULLY, *A Life of Picasso*, Vol. 1, Random House, New York, 1991

ROSENBLUM, ROBERT, *Cubism and Twentieth-Century Art*, rev. ed., Abrams, New York, 1976

RUBIN, WILLIAM, *Picasso and Braque: Pioneering Cubism*, Museum of Modern Art, New York, 1989; distr. by Bulfinch Press, Boston

———, ed., *Pablo Picasso: A Retrospective*, Museum of Modern Art, New York, 1980

———, ed., *"Primitivism" in 20th Century Art*, 2 vols., Museum of Modern Art, New York, 1984

RUDENSTINE, ANGELIKA ZANDER, ed., *Russian Avant-Garde Art: The George Costakis Collection*, Solomon R. Guggenheim Museum and Abrams, New York, 1981

SCHIFF, GERT, *Picasso: The Last Years, 1963–73*, Solomon R. Guggenheim Museum and Braziller, New York, 1984

———, ed., *Picasso in Perspective*, Prentice-Hall, Englewood Cliffs, N.J., 1976

SCHMALENBACK, WERNER, *Fernand Léger*, concise ed., Abrams, New York, 1985

SPIES, WERNER, *Picasso Sculpture; with a Complete Catalogue*, Thames & Hudson, London, 1972

CHAPTER THIRTY-SEVEN: FANTASTIC ART, DADA, AND SURREALISM

BRETON, ANDRÉ, *Surrealism and Painting* (tr. S. W. Taylor), Harper & Row, New York, 1972

DESCHARNES, ROBERT, *Dali: The Work, The Man*, Abrams, New York, 1984

D'HARNONCOURT, ANNE, and McSHINE, K., *Marcel Duchamp*, New York Graphic Society, Greenwich, Conn., 1973

ELDERFIELD, JOHN, *Kurt Schwitters*, Thames & Hudson, New York, 1987

GIMFERRER, PERE, *Giorgio de Chirico*, Rizzoli, New York, 1989

GROHMANN, WILL, *Paul Klee*, concise ed., Abrams, New York, 1985

HAFTMANN, WERNER, *Marc Chagall* (tr. Heinrich Baumann and Alexis Brown), concise ed., Abrams, New York, 1984

LANCHNER, CAROLYN, ed., *Paul Klee*, Museum of Modern Art, New York, 1987; distr. by New York Graphic Society Books/Little, Brown, Boston

MASHECK, JOSEPH, ed., *Marcel Duchamp in Perspective*, Prentice-Hall, Englewood Cliffs, N.J., 1974

MEYER, FRANZ, *Marc Chagall*, Abrams, New York, 1964

MOTHERWELL, ROBERT, ed., *The Dada Painters and Poets: An Anthology*, 2d ed., Belknap Press, Cambridge, Mass., 1989

PENROSE, ROLAND, *Miró*, Thames & Hudson, New York, 1985

PLANT, MARGARET, *Paul Klee: Figures and Marks*, Thames & Hudson, London, 1978

READ, SIR HERBERT, *The Art of Jean Arp*, Abrams, New York, 1968

RICHTER, HANS, *Dada: Art and Anti-Art*, Oxford University Press, New York, 1978

RUBIN, WILLIAM S., *Dada and Surrealist Art*, Abrams, New York, 1968

———, ed., *De Chirico*, Museum of Modern Art, New York, 1982

RUSSELL, JOHN, *Max Ernst: Life and Work*, Abrams, New York, 1967

SCHWARZ, ARTURO, *The Complete Works of Marcel Duchamp*, Abrams, New York, 1985

SPIES, WERNER, *Max Ernst: A Retrospective*, Prestel-Verlag, Munich, 1991; distr. by te Neues, New York

STICH, SIDRA, *Anxious Vision: Surrealist Art*, University Art Museum, University of California, Berkeley, and Abbeville Press, New York, 1990

TORCZYNER, HARRY, ed., *Magritte: Ideas and Images*, Abrams, New York, 1980

CHAPTER THIRTY-EIGHT: THE SPREAD OF MODERNISM

Painting and Sculpture

ALBEE, EDWARD, *Louise Nevelson: Atmospheres and Environments*, C. N. Potter, New York, 1980

ALBRIGHT, THOMAS, *Art in the San Francisco Bay Area: 1945–1980*, University of California Press, Berkeley, 1985

ASHTON, DORE, *American Art Since 1945*, rev. ed., Oxford University Press, New York, 1982

BARRON, STEPHANIE, *Degenerate Art: The Fate of the Avant-Garde in Nazi Germany*, Los Angeles County Museum of Art, 1991

BATTCOCK, GREGORY, *Minimal Art: A Critical Anthology*, Dutton, New York, 1968

———, *The New Art: A Critical Anthology*, rev. ed., Dutton, New York, 1973

———, *New Artists Video: A Critical Anthology*, Dutton, New York, 1978

BERNSTEIN, ROBERTA, *Jasper Johns' Paintings and Sculptures, 1954–1974*, UMI Research Press, Ann Arbor, Mich., 1985

Black Art: Ancestral Legacy, Dallas Museum of Art, 1989; distr. by Abrams, New York

BROWN, MILTON W., *American Painting from the Armory Show to the Depression*, Princeton University Press, 1970

CHAVE, ANNA, *Mark Rothko: Subjects in Abstraction*, Yale University Press, New Haven, Conn., 1989

COLPITT, FRANCES, *Minimal Art: The Critical Perspective*, UMI Research Press, Ann Arbor, Mich., 1990

COOPER, HELEN A., *Eva Hesse: A Retrospective*, Yale University Art Gallery and Yale University Press, New Haven, Conn., 1992

COPLANS, JOHN, *Ellsworth Kelly*, Abrams, New York, 1971

COWART, JACK, *Roy Lichtenstein: 1970–1980*, Hudson Hills Press, New York, and Saint Louis Art Museum, 1981

———, ed., *Expressions: New Art from Germany*, Saint Louis Art Museum, 1983

———, et al., *Georgia O'Keeffe, Art and Letters*, National Gallery of Art, Washington, D.C., and New York Graphic Society, Boston, 1987

ELDREDGE, CHARLES C., *Georgia O'Keeffe*, National Museum of American Art, Washington, D.C., and Abrams, New York, 1991

FINN, DAVID, *Henry Moore: Sculpture and Environment*, Abrams, New York, 1976

FRANK, ELIZABETH, *Jackson Pollock*, Abbeville Press, New York, 1983

FRANZKE, ANDREAS, *Dubuffet*, Abrams, New York, 1981

FRASCINA, FRANCIS, ed., *Pollock and After: The Critical Debate*, Harper & Row, New York, 1985

GOLDBERG, ROSELEE, *Performance: Live Art 1909 to the Present*, rev. ed., Abrams, New York, 1988

GOODYEAR, FRANK H., *Contemporary American Realism Since 1960*, New York Graphic Society, Boston, 1981

HASKELL, BARBARA, *Donald Judd*, Whitney Museum of American Art and Norton, New York, 1988

HERBERT, ROBERT L., ed., *Modern Artists on Art*, Prentice-Hall, Englewood Cliffs, N.J., 1965

HOBBS, ROBERT, *Robert Smithson: Sculpture*, Cornell University Press, Ithaca, 1981

———, and LEVIN, GAIL, *Abstract Expressionism: The Formative Years*, Whitney Museum of American Art, New York, 1981

HUNTER, SAM, and JACOBUS, JOHN, *American Art of the 20th Century: Painting, Sculpture, Architecture*, Abrams, New York, 1973

JORDAN, JIM, and GOLDWATER, ROBERT, *The Paintings of Arshile Gorky: A Critical Catalogue*, New York University Press, 1982

KAPROW, ALLAN, *Assemblage, Environments & Happenings*, Abrams, New York, 1966

KOTZ, MARY LYNN, *Rauschenberg, Art and Life*, Abrams, New York, 1990

KRAUSS, ROSALIND E., *The Originality of the Avant-Garde and Other Modernist Myths*, MIT Press, Cambridge, Mass., 1985

————, *Passages in Modern Sculpture*, Viking, New York, 1977

————, *Richard Serra/Sculpture*, Museum of Modern Art, New York, 1986

————, *Terminal Iron Works; The Sculpture of David Smith*, MIT Press, Cambridge, Mass., 1971

KUSPIT, DONALD, *The New Subjectivism: Art in the 1980s*, UMI Research Press, Ann Arbor, Mich., and London, 1988

The Latin American Spirit: Art and Artists in the United States, 1920–1970, Abrams and Bronx Museum of the Arts, New York, 1988

LEVIN, KIM, *Beyond Modernism: Essays on Art from the Seventies and Eighties*, Harper & Row, New York, 1988

LIPPARD, LUCY R., *Overlay: Contemporary Art and the Art of Prehistory*, Pantheon, New York, 1983

LUCIE-SMITH, EDWARD, *Art in the Seventies*, Cornell University Press, Ithaca, 1980

McSHINE, KYNASTON, *Andy Warhol: A Retrospective*, Museum of Modern Art, New York, 1989

————, *An International Survey of Recent Painting and Sculpture*, Museum of Modern Art, New York, 1984

MEISEL, LOUIS, *Richard Estes: The Complete Paintings 1966–1985*, Abrams, New York, 1986

MERSKERT, JORN, et al., *David Smith, Sculpture and Drawings*, Prestel-Verlag, Munich, 1986

NEWMAN, BARNETT, *Barnett Newman: Selected Writings and Interviews*, ed. John Philip O'Neill, Knopf, New York, 1990

O'CONNOR, FRANCIS V., and THAW, EUGENE V., *Jackson Pollock: A Catalogue Raisonné of Paintings, Drawings, and Other Works*, Yale University Press, New Haven, Conn., 1978

ROSE, BARBARA, *American Art Since 1900*, rev. and expanded ed., Praeger, New York, 1975

————, *Autocritique: Essays on Art and Anti-Art, 1963–1987*, Weidenfeld & Nicolson, New York, 1988

————, *Claes Oldenburg*, Museum of Modern Art, New York, 1970

ROSE, BERNICE, *The Drawings of Roy Lichtenstein*, Museum of Modern Art, New York, 1987

ROSENBERG, HAROLD, *Barnett Newman*, Abrams, New York, 1978

ROSENTHAL, MARK, *Anselm Kiefer*, Art Institute of Chicago, 1987

ROSENTHAL, NAN, and FINE, RUTH E., *The Drawings of Jasper Johns*, National Gallery of Art, Washington, D.C., and Thames & Hudson, New York and London, 1990

ROSS, CLIFFORD, ed., *Abstract Expressionism: Creators and Critics*, Abrams, New York, 1990

RUBIN, LAWRENCE, *Frank Stella: Paintings, 1958 to 1965*, Stewart, Tabori & Chang, New York, 1986

RUBIN, WILLIAM STANLEY, *Frank Stella, 1970–1987*, Museum of Modern Art, New York, 1987

RUSSELL, JOHN, *Francis Bacon*, Thames & Hudson, London, 1971

SANDLER, IRVING, *American Art of the 1960s*, Harper & Row, New York, 1988

————, *The New York School: The Painters and Sculptors of the Fifties*, Harper & Row, New York, 1978

————, *The Triumph of American Painting*, Harper & Row, New York, 1976

SIMS, LOWERY STOKES, *Stuart Davis: American Painter*, Metropolitan Museum of Art, New York, 1991

SMITH, PATRICK S., *Andy Warhol's Art and Films*, UMI Research Press, Ann Arbor, Mich., 1986

STICH, SIDRA, *Made in USA: An Americanization in Modern Art, the Fifties and Sixties*, University of California Press, Berkeley, 1987

TISDALL, CAROLYN, *Joseph Beuys*, Solomon R. Guggenheim Museum, New York, 1979

UPRIGHT, DIANE, *Morris Louis, The Complete Paintings: A Catalogue Raisonné*, Abrams, New York, 1985

VARNEDOE, KIRK, and GOPNIK, ADAM, *High & Low: Modern Art and Popular Culture*, Museum of Modern Art and Abrams, New York, 1990

WALDMAN, DIANE, *Arshile Gorky, 1904–1948: A Retrospective*, Solomon R. Guggenheim Museum, New York, 1981

————, *Mark Rothko, 1903–1970: A Retrospective*, Solomon R. Guggenheim Museum, New York, 1978

————, *Roy Lichtenstein*, Abrams, New York, 1971

————, *Willem de Kooning*, Dallas Museum of Art, and Abrams, New York, 1987

WYE, DEBORAH, *Louise Bourgeois*, Museum of Modern Art, New York, 1982

Yves Klein, 1928–1962: A Retrospective, Institute for the Arts, Rice University, Houston, and Arts Publisher, New York, 1982

Photography

GOLDBERG, VICKI, *The Power of Photography: How Photography Changed Our Lives*, Abbeville Press, New York, 1991

GREENOUGH, SARAH, et al., *On the Art of Fixing a Shadow: One Hundred and Fifty Years of Photography*, National Gallery of Art, Washington, D.C., and Art Institute of Chicago, 1989

LEMAGNY, JEAN-CLAUDE, and ANDRÉ ROUILLÉ, eds., *A History of Photography*, Cambridge University Press, Cambridge, 1987

SZARKOWSKI, JOHN, *Photography Until Now*, Museum of Modern Art, New York, 1989

CHAPTER THIRTY-NINE: MODERN ARCHITECTURE

ARNHEIM, RUDOLF, *The Dynamics of Architectural Form*, University of California Press, Berkeley and Los Angeles, 1977

BAKER, GEOFFREY, *Le Corbusier: An Analysis of Form*, Van Nostrand, New York, 1984

BANHAM, REYNER, *Design by Choice*, ed. Penny Sparke, Rizzoli, New York, 1981

————, *Theory and Design in the First Machine Age*, 2d ed., Praeger, New York, 1967; repr. ed., MIT Press, Cambridge, Mass., 1980

BARNETT, JONATHAN, *The Elusive City: Five Centuries of Design, Ambition and Miscalculation*, Harper & Row, New York, 1986

BAYER, HERBERT, *Bauhaus 1919–1928*, New York Graphic Society, Greenwich, Conn., for Museum of Modern Art, New York, 1976

BENEVOLO, LEONARDO, *History of Modern Architecture*, 2 vols., MIT Press, Cambridge, Mass., 1977

BLAKE, PETER, *Form Follows Fiasco: Why Modern Architecture Hasn't Worked*, Little, Brown, Boston, 1977

BLASER, WERNER, *Mies van der Rohe: The Art of Structure* (tr. D. Q. Stephenson), rev. ed., Praeger, New York, 1972

BROOKS, H. ALLEN, ed., *Writings on Wright: Selected Comments on Frank Lloyd Wright*, MIT Press, Cambridge, Mass., 1981

————, and BANHAM, REYNER, *Le Corbusier*, Princeton University Press, 1987

CARTER, PETER, *Mies van der Rohe at Work*, Pall Mall Press, London, 1974

COLLINS, GEORGE R., *Antoni Gaudí*, Braziller, New York, 1960

CROOK, J. MORDAUNT, *The Dilemma of Style: Architectural Ideas from the Picturesque to the Post-Modern*, University of Chicago Press, 1987

CURTIS, WILLIAM J. R., *Modern Architecture Since 1900*, 2d ed., Prentice-Hall, Englewood Cliffs, N.J., 1987

DREXLER, ARTHUR, and HINES, THOMAS S., *The Architecture of Richard Neutra: From International Style to California Modern*, Museum of Modern Art, New York, 1982

FITCH, JAMES MADISON, *Walter Gropius*, Braziller, New York, 1960

FRAMPTON, KENNETH, *Modern Architecture, 1851–1945*, 2 vols., Rizzoli, New York, 1983

FRANCISCONO, MARCEL, *Walter Gropius and the Creation of the Bauhaus in Weimar*, University of Illinois Press, Urbana, 1971

GIEDION, SIGFRIED, *Space, Time and Architecture*, rev. ed., Harvard University Press, Cambridge, Mass., 1982

GOLDBERGER, PAUL, *On the Rise: Architecture and Design in a Post-Modern Age*, Penguin, New York, 1985

————, *The Skyscraper*, Knopf, New York, 1981

GROPIUS, WALTER, *Scope of Total Architecture*, Collier Books, New York, 1962

GUITON, JACQUES, ed., *The Ideas of Le Corbusier: On Architecture and Urban Planning*, Braziller, New York, 1981

HATJE, GERD, ed., *Encyclopedia of 20th-Century Architecture*, 3d ed., Abrams, New York, 1986

HINES, THOMAS, *Richard Neutra and the Search for Modern Architecture*, Oxford University Press, New York, 1982

HITCHCOCK, HENRY-RUSSELL, *Architecture: Nineteenth and Twentieth Centuries*, 4th ed., Penguin, New York, 1978

————, *The Architecture of H. H. Richardson and His Times*, rev. ed., MIT Press, Cambridge, Mass., 1966

————, *In the Nature of Materials: The Buildings of Frank Lloyd Wright, 1887–1941*, Da Capo Press, New York, 1975

————, and JOHNSON, PHILIP, *The International Style*, Norton, New York, 1966

JENCKS, CHARLES, *Architecture Today*, rev. ed., Abrams, New York, 1988

————, *The Language of Post-Modern Architecture*, 6th ed., Rizzoli, New York, 1991

————, *Le Corbusier and the Tragic View of Architecture*, Harvard University Press, Cambridge, Mass., 1973

KLOTZ, HEINRICH, *The History of Postmodern Architecture*, MIT Press, Cambridge, Mass., 1988

LESNIKOWSKI, WOJCIECH G., *The New French Architecture*, Rizzoli, New York, 1990

LOBELL, JOHN, *Between Silence and Light: Spirit in the Architecture of Louis I. Kahn*, Shambhala, Boulder, Colo., 1979

O'GORMAN, JAMES F., *Three American Architects: Richardson, Sullivan, and Wright, 1865–1915*, University of Chicago Press, 1991

PEHNT, WOLFGANG, *Expressionist Architecture*, Praeger, New York, 1973

PEVSNER, NIKOLAUS, *Pioneers of Modern Design*, Penguin, Harmondsworth, 1975

ROBINSON, CERVIN, and HAAG BLETTER, ROSEMARIE, *Skyscraper Style: Art Deco New York*, Oxford University Press, New York, 1975

ROTH, LELAND M., *A Concise History of American Architecture*, Harper & Row, New York, 1980

SAARINEN, ALINE B., ed., *Eero Saarinen on His Work*, 2d ed., Yale University Press, New Haven, Conn., 1968

SCULLY, VINCENT, *American Architecture and Urbanism*, H. Holt, New York, 1988

SHARP, DENNIS, *Modern Architecture and Expressionism*, Braziller, New York, 1967

SWEENEY, JAMES J., and SERT, J. L., *Antoni Gaudí*, 2d ed., Praeger, New York, 1970

TAFURI, MANFREDO, *The Sphere and the Labyrinth: Avant-Gardes and Architecture from Piranesi to the 1970s*, MIT Press, Cambridge, Mass., 1987

TWOMBLY, ROBERT C., *Louis Sullivan: His Life and Work*, Viking, New York, 1986

VENTURI, ROBERT, *Complexity and Contradiction in Architecture*, rev. ed., Museum of Modern Art, New York, 1977

WHIFFEN, MARCUS, and KOEPER, FREDERICK, *American Architecture*, MIT Press, Cambridge, Mass., 1983

INDEX

CREDITS